# Biomedical
# Photography

# Biomedical Photography

*Edited by* **John Paul Vetter, R.B.P., F.B.P.A., Hon. F.I.M.I.**
*Consultant*
*Medical Media Imaging*
*Pittsburgh, Pennsylvania*

*With 24 Contributors*

*Foreword by Peter Hansell*

**Butterworth–Heinemann**
Boston London Oxford Singapore Sydney Toronto Wellington

Focal Press is an imprint of Butterworth–Heinemann.

Recognizing the importance of preserving what has been written, it is the policy of Butterworth–
Heinemann to have the books it publishes printed on acid-free paper, and we exert our best
efforts to that end.

**Library of Congress Cataloging-in-Publication Data**

Biomedical photography / edited by John Paul Vetter : with
  24 contributors.
       p.   cm.
     Includes bibliographical references and index.
     ISBN 0-240-80084-2
     1. Medical photography.   I. Vetter, John Paul
  TR708.B55   1992
  610′.28—dc20
                                                    91-31077
                                                       CIP

**British Library Cataloguing in Publication Data**

  Biomedical photography.
    I. Vetter, John Paul
    778.9961

    ISBN   0-240-80084-2

Butterworth-Heinemann
80 Montvale Avenue
Stoneham, MA 02180

10 9 8 7 6 5 4 3 2 1

Printed in the United States of America

# Contents

# Contributing Authors

**Marian L. Beck, B.A., F.B.P.A.,** is coordinator of television production for The College of Veterinary Medicine of The Ohio State University. She holds a bachelor of arts in photography and cinema from The Ohio State University and is a registered biological photographer and a member of the Board of Registry of the Biological Photographic Association. Ms. Beck is internationally known for her lectures and publications on medical videography and editing and is a pioneer researcher in the development of media/model-based teaching methods in veterinary surgery. Her current research interests include further development of surgical simulators, advanced television computer graphics imaging, and investigation of new technologies in interactive computer/video education.

Marian L. Beck, *Biomedical Media, The Ohio State University, College of Veterinary Medicine, 1935 Coffey Road, Columbus, Ohio 43210.*

**Lewis J. Claman, D.D.S., M.S.,** is an associate professor at The Ohio State University College of Dentistry, having held a full-time faculty position since 1974. He also maintains a part-time dental practice limited to the specialty of periodontics. He received a B.S. degree from the City College of New York in 1964, his D.D.S. degree from New York University in 1969, and his M.S. degree and specialty certificate from The Ohio State University in 1974. Over the past 15 years, Dr. Claman has applied his knowledge, acquired through courses in basic and biomedical photography, to the area of dental photography. He has provided courses in dental photography to dental students, graduate students, dentists, and dental auxiliaries. He has numerous publications in major dental journals and chapters in textbooks, and has made several presentations at national dental meetings. Dr. Claman was recognized by the graduating class of 1984 as the outstanding dental educator, was inducted into Omicron Kappa Upsilon Honorary Dental Society, and is a diplomate of the American Board of Periodontology.

Lewis J. Claman, *College of Dentistry, The Ohio State University, 305 West 12th Avenue, Columbus, Ohio 43210.*

**William H. deVeer, R.B.P., F.B.P.A.,** has been the director of biomedical photography at The University of Mississippi Medical Center in Jackson, Mississippi, since 1975. His formal education includes a baccalaureate degree in biology from Hofstra University, Hempstead, New York, as well as commercial and specialized photographic training at various schools.

His photographic experience includes military service in the U.S. Marine Corps; medical photographer at The Brooklyn Hospital; photographic technician at the Brookhaven National Laboratory; and senior medical photographer at The University of Rochester School of Medicine and Dentistry.

Mr. deVeer is a registered biological photographer and has served as an instructor at the Biological Photographic Association workshops, presented numerous papers at local and national meetings, and is a frequent contributor to the *Journal of Biological Photography*.

William H. deVeer, *Biomedical Photography, University of Mississippi, 2500 N. State Street, Jackson, Mississippi, 39216.*

**Julie A. Dorrington, Hon. F.I.M.I., A.R.P.S.,** is currently working for Graves Educational Resources, having joined as assistant director in 1990. After completing a full-time course in photography at The Regent Street Polytechnic in London, she began her career and training in medical photography at St. Bartholomew's Hospital, London. Shortly thereafter she passed the British Institute of Professional Photographers' final examination in medical photography. Remaining at St. Bartholomew's Hospital until her recent job change, Ms. Dorrington became chief photographer and subsequently assistant director. As an associate of the Royal Photographic Society, she has received various RPS medical photography awards. She was the recipient of the first Harrison medal in 1972 and was awarded an Honorary Fellowship of the Institute of Medical Illustrators in 1985.

Julie A. Dorrington, *Graves Educational Resources, 220 New London Road, Chelmsford, Essex CM2 9BJ, England.*

**D. Anthony Gibson, A.B.I.P.P., R.B.P., F.R.P.S.,** acquired his early training and experience in medical/scientific photography in England. Later, in western Canada, he became interested in applying ultraviolet and infrared photography to clinical and research studies. A move to the east coast of Canada in the late 1960s coincided with a growing interest by the medical community in applying media, including television, to the preparation of learning resources for teaching and research. Recently, Mr. Gibson moved to Trinidad in the West Indies, where he has an opportunity to do many of the same things professionally, although in quite a different environment.

D. Anthony Gibson, *Eric Williams Medical Sciences Complex, University of the West Indies, Trinidad and Tobago, West Indies.*

**Robert M. Grom, B.A.,** received his bachelor of arts degree in political science from Edinboro University in 1973. Following graduation, he began his professional career in the management of audiovisual resources at The Western Pennsylvania Hospital in Pittsburgh, Pennsylvania, under the tutelage of John Paul Vetter.

During the last 17 years, he has directed the audiovisual portion of over 1000 major biomedical workshops and seminars, organized and directed a number of programs, served continuously on the hospital's program planning committee, and assisted many other institutions and specialty societies in program planning and development. He is the manager of the media and graphic services department, as well as manager of printing services at The Western Pennsylvania Hospital.

In 1987, Mr. Grom was named director of The West Penn Hospital Antiquity Project. This endeavor is designed to present a permanent exhibition of hospital and community history throughout the institution and includes the James I. McGuire Antiquity Center, which was dedicated in July 1990. In addition to directing the project, Mr. Grom has researched, written, and/or edited significant portions of the display and promotional material.

Robert M. Grom, *Media and Graphic Services, The Western Pennsylvania Hospital, 4800 Friendship Avenue, Pittsburgh, Pennsylvania 15224.*

**Ronald F. Irvine, R.B.P., A.R.P.S., F.B.P.A., A.I.M.I.,** began his career as a chemist with Imperial Chemical Industries in England. In 1957, he emigrated to Canada, where he was employed by Du Pont of Canada for 3 years. During this time he developed an interest in industrial photography and established the company's first photographic department. In 1960, Mr. Irvine was appointed director of the Medical Art and Photography Unit at Queen's University at Kingston. An instructor in the Faculty of Medicine, he is also an assistant professor of art conservation.

Mr. Irvine is a registered biological photographer, an associate of the Royal Photographic Society of Great Britain, a fellow of the Biological Photographic Association, and an associate of The Institute of Medical Illustrators. He has also lectured widely in Canada, the United States, and the United Kingdom. He has a number of published papers to his credit in major journals and more than fifteen International Awards, including the William V. Gordon Award in Recognition of Outstanding Achievements in Scientific Photography.

Ronald F. Irvine, *Medical Art and Photography, Queen's University, Kingston, Ontario, K7L 3N6, Canada.*

**James P. Kendrick, R.B.P., F.B.P.A.,** received his initial photographic training in the U.S. Navy and is a graduate of The Photographer's Mate "A" School in Pensacola, Florida. After completing his enlistment in the motion picture division of the Naval Photographic Center in Washington, D.C., he became a medical photographer at The University of North Carolina in Chapel Hill. For the past 23 years he has been employed by The George Washington University School of Medicine and Health Sciences in Washington, D.C., where he is currently the chief of photography and duplicating services. A graduate of The University of Maryland and a long-term member of the Biological Photographic Association, Mr. Kendrick is a registered biomedical photographer and a fellow of the association. In addition to serving in a number of offices for the BPA, he has taught at and directed the Annual Biomedical Photography Workshop in Rochester, New York.

James P. Kendrick, *Biomedical Communications, The George Washington University Medical Center, 2300 Eye Street, N.W., Washington, D.C. 20037.*

**Scott Kilbourne, R.B.P.,** is the chief of the Section of Medical Photography in the Division of Biomedical Communications of The Southern Illinois University School of Medicine. Prior to graduating in 1974 from Cornell University with a major in anatomy and behavior, he began his photographic career by working as a staff photographer for the Cornell *Daily Sun.* He also participated in research in homing pigeon orientation behavior while at Cornell. After graduation, he worked for The University of Rochester (New York) Medical School's medical photography unit, where he also received his registered biological photography certification in 1977. In 1977 Mr. Kilbourne accepted a position at Southern Illinois University School of Medicine as medical photographer and was promoted to chief medical photographer in 1980.

Mr. Kilbourne has held numerous positions in the Biological Photographic Association, including regional chapter president and Oral Exam Coordinator of the Board of Registry, and has won many salon awards at national meetings. He has presented papers and workshops at several meetings and organized the digital imag-

ing session and workshop for the 1991 annual meeting of the Biological Photographic Association in Tampa, Florida.

Scott Kilbourne, *Medical Photography, Southern Illinois University, School of Medicine, P.O. Box 19230, Springfield, Illinois 19230.*

**Leon J. LeBeau, Ph.D., F.B.P.A., F.I.M.I.,** received his Ph.D. degree in microbiology and immunology from The University of Illinois. Among the many positions and titles he has held in his 44 years of teaching at The University of Illinois are positions in the Departments of Microbiology and Pathology in The College of Medicine and in Biomedical Visualization in The College of Associated Health Professions, where he also serves as Associate Dean for International Programs.

For almost 20 years he has taught medical photography at Rochester Institute of Technology, where he holds the rank of adjunct professor. In addition, for 21 years he has been a member of the faculty for the Biological Photographic Association workshops. His research and publications have emphasized the photography of small objects from the research and diagnostic laboratory, a subject on which he has also lectured and presented workshops throughout the world. He has illustrated more than 100 books and has published more than 100 technical papers. Mr. LeBeau is past president of the BPA and a fellow of both the BPA and the Institute of Medical Illustration. He is also a recipient of the BPA's Louis Schmidt Award.

Leon J. LeBeau, *Department of Biomedical Visualization, College of Associated Health Professions, University of Illinois at Chicago, 1919 West Taylor Street, Chicago, Illinois 60612.*

**Lawrence M. Merin, R.B.P.,** is presently an instructor in ophthalmology at The Cullen Eye Institute, Baylor College of Medicine, where he is responsible for the Ophthalmic Photography and Diagnostic Services Department. In addition to coordinating all clinical photography, he also collaborates in the design and implementation of imaging technologies to intramural and multicenter research studies in ophthalmology.

Mr. Merin is a graduate of Wayne State University in Detroit, where he received training in fine art photography and photojournalism. He has worked in ophthalmic photography since 1973 and is a registered biological photographer, a director of the Ophthalmic Photographers' Society, and a consultant to several corporations. Mr. Merin has written twenty-five technical papers and has served as lecturer, meeting planner, and chairman of major national and international ophthalmology and ophthalmic photographic meetings.

Lawrence M. Merin, *Cullen Eye Institute, Baylor College of Medicine, 6501 Fannin, Houston, Texas 77030.*

**Kenneth V. Michaels, A.A.S., F.B.P.A.,** graduated magna cum laude with an associate of applied science degree from the Biomedical Photography Program of The Rochester Institute of Technology in 1972. Upon graduation, he began working at The University of Arkansas for Medical Sciences as chief of photographic services, was promoted to director of printing and publications in 1979 and to director of Media Services in 1981. In 1984 he was awarded the honor of Fellowship of the Biological Photographic Association.

He was elected vice president of the Biological Photographic Association in 1983 and served in that capacity during 1984 and 1985 and as president in 1986 and 1987. Mr. Michaels has presented numerous technical papers and has published a number of papers in the *Journal of Biological Photography.*

Kenneth V. Michaels, *Media Services, University of Arkansas for Medical Sciences, 4301 West Markham Street, Little Rock, Arkansas 72205.*

**Richard A. Morton, M.Sc., F.R.P.S., A.I.M.I.,** graduated from The London School of Medical Photography in 1957. He holds a master's degree from The University of Aberdeen and is a fellow of the Royal Photographic Society and an associate of The Institute of Medical Illustrators. In 1984 he was awarded a Fellowship of the Biological Photographic Association and he was the recipient of the Royal Photographic Society Combined Royal Colleges Medal in 1987.

Mr. Morton is the Director of Graves Educational Resources, a nonprofit organization involved in the development and distribution of educational materials for the health-care professions. He was previously director of medical illustration at The University of Aberdeen. From 1976 to 1981 he was editor of the *Journal of the Audiovisual Media in Medicine.* He has published more than twenty journal articles, has coauthored several books, and was editor of the second edition of *Photography for the Scientist,* published in 1984.

Richard A. Morton, *Graves Educational Resources, 220 New London Road, Chelmsford, Essex CM2 9BJ, England.*

**Gigi Nieuwenhuis, B.App.Sc., F.R.P.S., R.B.I.,** is the head of medical photography at The Royal Children's Hospital in Melbourne, Australia, where she has worked for 10 years. She has a bachelor of applied science degree from The Royal Melbourne Institute of Technology in medical photography. After graduating, she worked as a medical photographer at the Royal Melbourne Hospital, and is a registered biological photographer in Australia.

Ms. Nieuwenhuis is the author of many publications on medical photography, especially in the fields of photogrammetry and invisible radiation photography. She lectures extensively on medical photography and has been the recipient of many awards in the field, including a traveling scholarship to the United States and Europe. She recently worked in London as a research fellow ex-

ploring the forensic applications of ultraviolet and in-
frared radiation.

igi Nieuwenhuis, *Medical Photography, The Royal Chil-
dren's Hospital, Flemington Road/Parkville, Melbourne, Aus-
tralia 3052.*

**Dan R. Patton, B.F.A., R.B.P., F.B.P.A.,** is the director of
biomedical media at The Ohio State University, College
of Veterinary Medicine. He holds a B.F.A. degree in
professional photography from Ohio University. Patton
is a registered biological photographer and a fellow of
the Biological Photographic Association. He is an associ-
ate of the Institute of Medical Illustrators and a corre-
sponding member of the German Photographic Society.

For a number of years, Mr. Patton has conducted lec-
tures and workshops throughout the world on many
topics, including graphic slide production techniques
and the preparation and presentation of a slide lecture.
He has served as president of the BPA and as chairman
of the Board of Registry, the body that certifies the com-
petency of biological photographers.

Dan R. Patton, *Biomedical Media, The Ohio State University,
College of Veterinary Medicine, 1935 Coffey Road, Columbus,
Ohio 43210.*

**Michael R. Peres, M.Sc., R.B.P.,** is the chairman of the
Biomedical Photographic Communications Program at
The Rochester Institute of Technology. Prior to ac-
cepting the chairman's position in 1989, he held the po-
sition of coordinator for the Laboratory of High Magni-
fication Photography, as well as being an assistant
professor in the Biomedical Photographic Commu-
nications Program. Before coming to RIT, Mr. Peres was
coordinator of programming and education in the Audio
Visual Services Department, Henry Ford Hospital, De-
troit, Michigan, and the chief of medical photography at
West Virginia University, Charleston Division.

Mr. Peres received a master of science degree in In-
structional Technology as well as a bachelor of science
degree in biomedical photographic communications
from The Rochester Institute of Technology. He also
received a bachelor of science in biology from The Brad-
ley University, Peoria, Illinois, in 1978. A registered bio-
logical photographer and a member of the Biological
Photographic Association, Ophthalmic Photographic So-
ciety, and the Rochester Microscopical Society, he is ac-
tive in conducting workshops in high magnification pho-
tography at RIT and with the BPA. He has presented
numerous technical papers and has published in a variety
of periodicals. In 1989, he received the Medical News
Award from the Biological Photographic Association for
his excellence in photomicrography.

Michael R. Peres, *Biomedical Photographic Communications,
Rochester Institute of Technology, 1 Lomb Drive, Rochester,
New York 14623.*

**Robert Rashid, D.D.S.,** is a graduate of The University of
Washington College of Dentistry. An amateur photogra-
pher since age 6, he received training in dental photogra-
phy at The University of Washington from Clifford
Freehe. He has used dental photography in his private
dental practice. He has also written in the field and
teaches graduate and continuing education courses in
dental photography. Dr. Rashid currently teaches den-
tistry at The Ohio State University, where he is also pur-
suing an advanced degree in statistics.

Robert Rashid, *College of Dentistry, The Ohio State Univer-
sity, 305 West 12th Avenue, Columbus, Ohio 43210.*

**Sidney F. Ray, B.Sc., M.Sc., F.B.I.P.P., F.M.P.A., F.R.P.S.,**
is senior lecturer in photographic and electronic imaging
sciences at the Polytechnic of Central London, England,
where he has worked since 1966 in the School of Com-
munication, following employment in the photographic
industry as a photographic scientist. Holding a bachelor's
degree in chemistry from The University of London and
a master's degree in physiological optics from The City
University, London, he is also a fellow of The British
Institute of Professional Photography, the Master Pho-
tographers Association, and the Royal Photographic So-
ciety, and is a member of several other photographic
organizations.

In addition to teaching and supervising applied pho-
tography and photographic optics in a range of courses
at educational levels from doctoral to recreational, he
also acts as photographic consultant to various organiza-
tions and has a professional photographic practice. He is
the author or coauthor of twelve textbooks, as well as
having published over 150 papers and articles.

Sidney F. Ray, *Polytechnic of Central London, 18-22 Riding
House Street, London, W1P 7PD, England.*

**Martin L. Scott, F.B.P.A., A.I.M.I.,** is a consultant in
imaging technology applied to science. After graduating
from Lafayette College with a bachelor's degree in chem-
istry, he joined the Eastman Kodak Company, working as
a chemist, researcher in graphic arts printing processes,
and adviser in applying photography to all fields of sci-
ence, from the microscope to the telescope. He retired as
director of scientific imaging. He is particularly inter-
ested in the biomedical photographic field and is active in
the Biological Photographic Association, having served
in many elected and appointed positions, as well as presi-
dent of the organization. Mr. Scott is a fellow of the
Biological Photographic Association and is recipient of
their most prestigious award, the Louis Schmidt Award.
His related interests include photographic history and
the preservation of images. He is a consultant on technol-
ogy to the International Museum of Photography at
George Eastman House.

Martin L. Scott, *Consultant in Scientific Imaging, 231 Vassar
Street, Rochester, New York 14607.*

**C. Allen Shaffer, B.S., R.B.P., F.B.P.A.,** is currently the director of public relations and assistant director of biomedical media at The College of Veterinary Medicine of The Ohio State University. He holds a bachelor of science in biomedical communications and higher education from Empire State College of The State University of New York and is a registered biological photographer and a fellow of the Biological Photographic Association. His original research in photographic data acquisition for exercise physiology and his work with Eastman Kodak Company in electronic still photography applications in medicine have led to many publications and presented papers. His more than 300 television productions have earned numerous awards, including the Gold Medal in Television Production of the Council for Advancement and Support of Education.

C. Allen Shaffer, *Biomedical Media, The Ohio University, College of Veterinary Medicine, 1935 Coffey Road, Columbus, Ohio 43210.*

**Debi Stambaugh, M.B.A., B.S., R.B.P.,** is a technical sales representative for Eastman Kodak Company. She was a biomedical photographer for 14 years at Iowa State University College of Veterinary Medicine in Ames, Iowa. Ms. Stambaugh is a registered biological photographer and an active member of the Biological Photographic Association. After graduating from Brooks Institute of Photography with a bachelor's degree majoring in industrial/scientific photography, she did an internship at hospitals in the Los Angeles area. More recently, she completed an M.B.A. degree. She has received awards for her medical and natural science photographs.

Debi Stambaugh, *Eastman Kodak Company, 12100 Rivera Road, Whittier, CA 90606.*

**Leslie D. Stroebel, Ed.D.,** graduated from The Rochester Institute of Technology (RIT) School of Photography in 1942 and The U.S. Air Force Photo Cadet School the following year. After joining the RIT faculty in 1946, he earned a master's degree in education and a doctorate in educational psychology at The University of Rochester. He has served as chairman of the Professional Photography Department and the Department of Imaging and Photographic Technology in the RIT School of Photographic Arts and Sciences where he holds the position of professor emeritus.

Dr. Stroebel is the author or coauthor of a number of books and other publications. He is an associate in the Photographic Society of America and has served on two committees of the American National Standards Institute (ANSI).

Leslie D. Stroebel, *266 Antlers Drive, Rochester, New York 14618.*

**John Paul Vetter, R.B.P., F.B.P.A., Hon. F.I.M.I.,** schooled as a military newsreel cameraman at Paramount Studios, Astoria, New York, has held positions as chief of medical photography at The William Singer Memorial Research Laboratory, director of Medical Media and director of The School of Medical Photography at The Western Pennsylvania Hospital, where he recently retired after 42 years of employment. Mr. Vetter is a registered biological photographer and a member of the Biological Photographic Association and The Institute of Medical Illustrators. In 1971 Mr. Vetter was appointed to the Medical Staff as Allied Professional Staff, Division of Pathology of The Western Pennsylvania Hospital.

An internationally recognized expert in many facets of photography, including photomicrography and standardized procedures, Mr. Vetter has lectured throughout North America, the United Kingdom, Scandinavia, and Australia. He has published over fifty-eight articles and thirty-one technical papers and has conducted ninety-seven workshops. The awards he has received include the Louis Schmidt Award from the BPA, the Rodman Medal from The Royal Photographic Society, United Kingdom, and the Gold-Headed Cane Award, the highest honor given medical staff members at The Western Pennsylvania Hospital.

John Paul Vetter, *Consultant, Medical Media Imaging, 446 South Graham Street, Pittsburgh, Pennsylvania 15232.*

**A. Robin Williams, Ph.D., F.I.S.T.C., F.R.M.S., F.B.P.A., F.B.I.P.P., F.I.M.I.,** trained as a medical photographer at The North East London Polytechnic and Cambridge University Medical School. He worked at Westminster Hospital and Charing Cross Hospital, London, for 18 years where he was the Director of the Department of Medical Illustration and Teaching Services at The Charing Cross and Westminster Medical School, one of the largest and most prestigious departments in the world. Dr. Williams has recently been appointed to the position of Professor of Photography at The Melbourne Institute of Photography in Melbourne, Australia. He has both master's and doctoral degrees from the Faculty of Medicine of The University of London and is a fellow of The Royal Society of Medicine, The Institute of Scientific and Technical Communicators, The Royal Microscopical Society, The Biological Photographic Association of America, The Royal Photographic Society, The British Institute of Professional Photographers, and The Institute of Medical Illustrators. He is the author of over 70 publications and has lectured extensively on all aspects of medical photography around the world. Dr. Williams has been the recipient of many medals and awards, including the Combined Royal Colleges Medal, the highest award in the field of medical photography.

A. Robin Williams, *Head of Department of Photography, Royal Melbourne Institute of Technology, GPO Box 2476V, Melbourne, Victoria 3001, Australia.*

**John F. Zacher, R.B.P.,** served as a photographer's mate in the U.S. Navy from 1970 to 1974. He graduated from The Naval School of Photography in Pensacola, Florida, and then served in the fleet air photographic laboratory at the Naval Air Station, Albany, Georgia, and the Naval Air Station, Key West, Florida. Mr. Zacher has worked at St. Jude Children's Research Hospital, Memphis, Tennessee, for many years and holds the position of assistant director of the biomedical communications department. He has been active in the Biological Photographic Association since 1976, receiving both local and national honors. In 1981 he received his certification as a biological photographer. Elected to the Board of Registry in 1986, he later served as the board's chairman. He has also been a faculty member of the BPA workshop in Rochester, New York.

His efforts in the field of public relations photography have been recognized by his peers, who selected his work for the First Award, Scientific Oral Paper, at the 1986 BPA Annual Exhibition. Other awards, such as the Tennessee Public Relations Association Prism, add to his list of professional credits.

John F. Zacher, *Biomedical Communications, St. Jude Children's Hospital, 332 N. Lauderdale, Memphis, Tennessee 38101.*

# Foreword

First things first. It is indeed a privilege to be invited to proffer a word of introduction to a compendium of this magnitude, but it is no easy task. In any case, very few people spend time reading the publication details on the flyleaf, the foreword, the acknowledgments and the references, roughly in that order. The more is the pity, as there are some vital clues both to intent and breadth of achievement in these preliminary pages. However, I have a fairly strong message, so please read on.

While I may appear to be looking backwards, my concern is rather to draw attention to the foundations that those followers of biophotography as a profession need to build upon today. As I see it, these include good basic education; training for the job; recognition by qualification; a wide perspective of the field; managerial and business skills; *and above all, a thundering good text to consult at all times.* In this book, the latter important aim has undoubtedly been achieved. It possesses universality and recognizes the need for a multi-authored publication in order to attain maximum authority. By and large, we are a small community and as such it is sometimes difficult to persuade publishers of our particular needs; hence there are few, if any, earlier texts on the subject still extant, which makes the present work such a valuable enterprise.

Although written primarily by biomedical photographers for their own kith and kin, there is a wealth of knowledge here that would prove of great service to other disciplines, because it delves much deeper than the simple practice of biophotography itself, thus providing at the same time fundamental core material. There must, for example, be schools and colleges whose courses would benefit from a study of Chapters 1–11, which offer a deal of common ground.

Times are forever changing—automation is tapping us on the shoulder. There are two fairly evident consequences of this trend; one is that the professional biophotographer is relieved of much knob-twiddling and calculation and can thus pay more attention to a proper study of his subject matter; the other is that the biologist or physician can now take photographs with greater confidence and certainty when out on a limb. It is fitting that we should not remain immune and aloof experts, but rather attempt to assist and educate our clients in the same way that they can help our own understanding. Both factions will benefit from this book. Again, read on.

Turning away from the generalities for a moment and moving on to the specialized applications of biophotography, one begins to examine the bedrock of this edifice. Detailed consideration of the sub-specialties is undertaken with a thoroughness seldom encountered.

You may indeed be a general practitioner in biophotography, away from a large city centre and distanced from meetings with your immediate colleagues. While this book is by no means a pocket vade-mecum, but a full reference work for the outer office, the answers are all there when you are suddenly confronted with an ophthalmic emergency or a tricky laboratory animal requiring photography—such is the diversity of our work and the occasional nature of many applications that require specific expertise.

Finally, the principles of management, the recognition of health hazards and the organization and conservation of collections of photographic material do not usually enjoy such worthwhile consideration. The balance is good.

The chosen publishers have a long tradition and wide experience in this particular field of communication. One has merely to reflect on the enduring success of post-war *Longmore's Medical Photography*, published by them in Britain, which ran to eight editions between 1944 and 1969, and it is comforting to know that they are to continue publishing in this vein. Thus, if their discriminating colophon is anything to go by, the future of this encyclopaedic work augurs well.

Once stored on computer, this abundance of material could well be manipulated for further use in a variety of ways and lends itself readily to revision, in part or whole,

or rearrangement as circumstances may dictate—but this is looking into the future.

I have read as much of the book as was practicable at proof stage before that last minute necessity to construct an appropriate Foreword. I am impressed. I ask myself questions. Am I to read this book and learn, or do I treat it as reference? —the answer is that it clearly serves both aims. Will I ever consult it in a practical sense myself?—possibly not very often now, but you, dear reader, certainly must!

If my opinion as a lifelong practitioner and contributor is of any value, I would most certainly endorse this work and wish it every success.

*Peter Hansell*
Bath
England

# Preface

The incentive to gather acknowledged authorities in the field of biological photography to produce a collective publication was prompted by the apparent need for a modern and comprehensive textbook for the biological worker. Although a wealth of photographic information for the biological photographer and research workers in related fields is currently spread over many publications and new procedures are being discussed at meetings and workshops, rarely are all the components gathered into one source. This can create a serious problem for the photographic worker seeking information. Of course, the necessary information can be located by extensive searches through the literature, but seldom is one permitted the luxury of such a thorough and time-consuming search.

Despite the extensive photographic information offered, this book is limited in its clinical applications to human medicine and veterinary medicine. The limitation is both logical and practical, since to do otherwise would result in an unwieldy text and limit the wealth and depth of the information presented under any one subject. It covers those fields that are functionally correlated and allows sufficient treatment of each specialty to provide practical applications for the biological photographer, clinician, research worker, and scientist.

The style of presentation emphasizes practical application with just enough theory and references to enrich the inquisitive worker. Readers are guided in a logical progression through each procedure, enabling them to apply the techniques with sufficient skill to ensure success. The information represents the latest photographic technology available.

The book is divided into four major parts. Part I, Basic Principals in Biomedical Photography, includes basic photographic information with emphasis on the principles and procedures relative to all the subjects covered in this textbook. The three chapters in this section should be the first order of business for any reader not thoroughly familiar with the photographic process. Part II, Common Applications in Biomedical Photography, includes those applications and techniques common to all biomedical photography. Part III, Specialized Applications in Biomedical Photography, includes certain clinical applications employed by photographers in particular disciplines. Part IV, Management Principles, provides information on department management, storing, filing, and retrieval of photographic images and everyday health hazards in a clinical environment.

Also enclosed is The Gallery of Biomedical Photography contributed by the authors of the book. These images along with the illustrations accompanying the chapters, exemplify the wide variety of subjects frequently imaged by biomedical photographers.

The contents of this book represent the efforts of some of the most distinguished professionals, teachers, and researchers in the field of biomedical photography. It is indeed an honor to have had their interest, cooperation, and enthusiasm in developing this book.

*John Paul Vetter*
Editor

# Acknowledgments

The impetus for developing a book of this nature stems from the belief that we are here to give as much as we are to receive. I have had the good fortune to be associated with dedicated and talented physicians, administrators, employees, students, and peers who, in addition to the textbooks consumed over a lifetime, have all been my teachers. It is not possible for me to recognize all those to whom I am indebted for the motivation and education received early in my career, nor the many individuals who provided assistance and encouragement in the preparation of this book. An abbreviated list would include my father, whose devotion to his family and career has influenced my life, Drs. Richard McManus and Ralph Erickson who have inspired me to teach and publish, my mentor Dr. Roger Loveland and my peers Charles Hodge, Dan Patton, Martin Scott, and Allen Shaffer, just to name a few, the Biological Photographic Association which provided the vehicle for my teaching and publication efforts and my wife, Mary and family for their emotional support.

The authors, the editor, and the publisher wish to acknowledge the support of the following individuals and corporations without whose enthusiasm and contributions this book would have not been possible to produce: Steven A. Caywood, former Chief Executive Officer of The Western Pennsylvania Hospital, who opened the door for this project by providing me with a private office during the initial stage of the program; The Governing Board of the Hospitality Shops of The Western Pennsylvania Hospital; and The Eastman Kodak Company, A. Jeffrey McLeod, Director, U.S. Marketing Operations, and Sally D. Robson, Marketing Coordinator, Scientific and Law Enforcement Imaging, for their indispensable support in developing this well-defined and important technical presentation.

*John Paul Vetter*
Editor

# Part I

# Basic Principles in Biomedical Photography

# Chapter 1
# Understanding the Photographic Process

## Martin L. Scott

*"The production of a perfect picture by means of photography is an art; the production of a technically perfect negative is a science."*

From "Photo-chemical Investigation and a New Method of Determination of the Sensitiveness of Photographic Plates." *Journal of the Society of the Chemical Industry.*

Ferdinand Hurter, Ph.D., and Vero Driffield, May 31, 1890

Biomedical photographers are often problem solvers in difficult imaging situations, both for themselves and for others in their institutions. The chapters on special topics in this book will assist photographers in solving many difficulties. There will always be, however, novel situations, the ones "not in the book." To tackle these it is helpful to understand the physical and chemical principles that underlie photography. Sections of this book provide answers on how film and paper respond to light; how the image is made visible and permanent; how to manage speed, contrast, granularity, and resolution; and how to manipulate color. Since many biomedical subjects are subtle, this book explores ways to make them more boldly visible.

## INTRODUCTION

This is the threshold of a new era in imaging, with electronic technology challenging the silver halides that have been used in biomedical imaging for a century and a half. What, then, is the relevance of extensively considering silver systems in a book such as this? In the past 150 years, silver technology has been brought to a high state of refinement as regards sensitivity, color quality, tonal gradation, detail resolution, portability, compactness, variety of display formats, international standardization, interconvertability of formats, and archivability. Electronic systems have been with us for only a small fraction of that time; they are rapidly growing in quality and capability. Hybrid systems using elements of old and new technologies will probably be the tools of the near future.

Electronic components are now making their bid for acceptance and are successful in certain areas. Medical motion pictures in 16-mm format were very important until the mid-1970s; in the 1980s video had assumed 95% or more of this application. Here electronics are used for original image capture, manipulation, editing, multiplication of copies, distribution, and display—a virtual total takeover.

Because the high image quality of conventional photography, especially color, sets a difficult target for electronic imaging, most applications of clinical photography and of photomicrography will probably resist any compromise in quality for some time. Diagnostic images such as ocular fluorescein angiography, where the slowness of wet processing delays patient treatment, are ripe for still video now.

In the 1990s silver and silicon will coexist. Wise and skilled practitioners of current methods are needed to evaluate new tools as they come along, assessing which meet the requirements for good medical and scientific documentation. Best estimates would say that silver systems will have important roles at least until the millennium, and perhaps beyond.

Understanding and solving the problems that set biomedical and scientific photography apart from technically less-challenging applications demands a look at the scientific underpinnings. So often good, clear-thinking people who plow through all other professional and personal problems with logic and common sense switch their brains off when their pictures "don't come out," as though there were a Silver God of Photography who capriciously sprinkles imaging success on some persons and failure on others. The reliability of modern apparatus and sensitive materials coupled with a thoughtful approach by the photographer will win through. Failures can be analyzed. Trial and error becomes trial and success. There is no visible phenomenon of science that cannot be photographed; indeed, there are even invisible ones that can be photographed.

### Beginnings of Biomedical Photography

The first practical process for pictorial photography was announced in 1839, if you consider an exposure of 20 minutes in full sunlight to be practical. Even then, before medical photography was a formal field, doctors sometimes sent patients to the local portrait photographer's studio for unusual conditions to be recorded. One-millionth that exposure time is now routinely used to

record a far more detailed picture, with much less stress to the patient (and to the photographer). As technological improvements are, they are rightly taken for granted. So vast are those improvements—in films, optics, mechanisms—that for most users of photography the technology has become virtually invisible. In most picture-taking situations "point and shoot" systems work very well. If this were true of the field of biomedical photography, this book would not be needed. This is not to say that modern automated equipment has no place in biomedical photography, but there is a need to know what that place is and how to manage situations that automation, unguided by a thinking human, cannot handle.

### Different Photographers, Different Needs

Most photographic materials are designed for conventional pictorial photography, some for special applications where ordinary materials are inadequate. Throughout this book conventional materials are recommended wherever possible, with special materials being reserved for those situations needing their unusual properties. But even conventional photography has its differing needs: snapshotters and professionals, although they may be photographing similar things, work in different ways and have different quality standards.

Snapshotters want a picture of a dear thing, with the very minimum of fuss. Highly automated "point-and-shoot" cameras, aided by computer-controlled processing laboratory machinery, serve the snapshotter so well that the lowly roll of film is almost forgotten. That roll, though, embodies very sophisticated chemistry and physics that contribute just as much to reliable snapshotting as do the camera and lab. Snapshotters buy their film on whim from open display racks in all sorts of stores. Film may remain in the camera for most of a year, while the camera languishes on the seat of a closed, hot car. Snapshotter's film must have built into it great forgiveness for wrong exposure, delayed processing, poor storage, nonstandard lighting, and other abuses.

The amateur photographer is not a snapshotter but is really much closer to the professional in attitude, practices, standards, and needs. Professional photographers working in portraiture, photojournalism, and commercial and advertising photography are willing to take trouble to learn the technology of photography in order to excel in their fields. Realizing that film changes its characteristics at room temperature, they are willing to keep stocks cold in order to minimize unwanted color variation. They also need to know precisely the speed and color balance of the particular emulsion batch they are using. Very-long-term latent image stability is of little interest to a professional, since film is always processed promptly after exposure or is stored cold.

Because the needs of these two classes of photographer—the snapshotter and the professional—are so different, it is not possible to design a single set of films to meet all needs. Thus separate families of films have evolved; major manufacturers provide both kinds. Even separate classes of retail dealers exist to serve both groups of customers. The biomedical photographer and the scientist will find their films at dealers catering to the professional.

### Biomedical Photographers' Subtle Challenge

This book's readers are neither snapshotters nor professional photographers in the sense of the words thus far. However, biomedical photographers, along with the medical, biological, and materials-science researchers who use photography to record their findings, desire—like the snapshotter—minimum obtrusion of the image-making process on their lives.

That minimum, however, is greater than for the snapshotter. In many cases, biomedical and scientific photographers are pushing photography to record subjects that are far more sophisticated than those of the snapshotter: a fluorescence photomicrograph of a dim and rapidly fading field, infrared luminescence of a dermal condition, faint bands in a chromatogram, quantitative mapping of nevi. Recording these requires the photographer to marshal apparatus, film, and processing in extraordinary ways.

The subtle nature of many biomedical and scientific subjects presents a major challenge. In photographic terms: they are of low contrast, that is, they have a low brightness ratio. Most scenes the snapshotter or professional photographer records are fairly contrasty; that is, they have a great brightness ratio. Indeed, the typical outdoor scene, from its white, fluffy clouds to the texture of rocks and tree bark, may have a brightness ratio of 1000:1 or more. Conventional films, processes, and printing techniques are perfect for this. A Giemsa-stained blood smear through the microscope, however, may have a brightness ratio of only 4:1. Here the materials and processes used in the previous example would be totally inadequate; they would give a very *flat* image, or one that is lacking in contrast. A special film and developer are needed for the blood slide to give a print with a full range of tones from black to white. A photographic system designed for one of these scenes will not do well for the other.

Many biomedical and scientific subjects fall somewhere between these extremes. They may not require a special film, but only a special processing of a conventional professional film.[1] Such films are provided by the manufacturer with supplementary processing data for just such situations.

## Brightness Ratio of Scene and Photograph

It is useful to think in terms of brightness[2] ratio when considering how and where the picture will finally appear. The best of photographic glossy-surface papers rarely exceed a brightness ratio of 100:1. Publishers' printing processes only approach that ratio in very special and expensive reproduction, as in some art books. Even these ultimate processes miss by a factor of 10 in their ability to reproduce the outdoor scene described above. So where does the excess range go? One answer would be to reproduce exactly some portion of the range, say the midtones, and let all darker parts go pure black, all lighter pure white. Aesthetically, this may work for certain scenes, but not for all. Too much information is lost. What has been found to work best in most cases is to compress, more or less evenly, the whole scale, where each tone in the original scene is differentiated in the reproduction to a proportionately lesser degree from its neighbor.[3]

Other publishing processes have even lesser brightness ratios: 60:1 for a good book illustration on glossy stock, 25:1 or less for uncoated stock. Of course, even more compression occurs here, so much that a decision to give up voluntarily some lesser part of the scale may be the best route. A color slide projected in a totally dark room has the greatest brightness range of any photographic display, approaching 400:1. The skillful photographer adjusts the brightness ratio of the scene to that of the display by the skillful choice of film and process.

The film needs of biomedical photographers are special in two ways: professional-grade films are needed for their consistency and calibration and unusual films are needed for difficult subjects and exotic techniques.

## HOW FILM SEES

### The Photographic Spectrum

The phenomenal sensitivity of the silver halides to radiant energy sets them far apart from all other substances. The spectrum of radiation to which these silver compounds can be made to respond includes the near-infrared (IR), ultraviolet (UV), x-ray, and gamma-ray regions, in addition to the visible. This book is concerned with all but x-ray and gamma-ray regions; see Figure 1.1. Unless otherwise stated, you may assume that a film responds to the visible range only, with some response in the UV in the case of black-and-white (BW) films. Such films are called panchromatic. So-called "blue-sensitive" films are BW materials that respond only to UV and blue radiation. Orthochromatic BW films respond to green, blue, and UV. Most color films respond to the visible region only.

### Safe Light in the Darkroom

A safelight for darkroom illumination must not emit light to which the film or paper is sensitive. Figure 1.1

**FIGURE 1.1 Spectral sensitivity of various film types (idealized).**

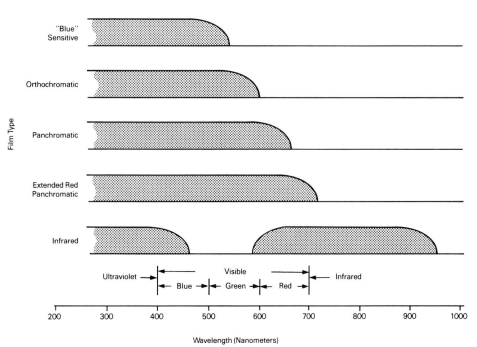

indicates that blue-sensitive films should be safe under a lamp emitting green and red light. Such a lamp appears yellow. An orthochromatic film should be safe under red light. IR films might be handled under a filter that took advantage of the depression in the green region; panchromatic films, however, would not appear to be safe under any light.[4]

## Sensitive Compounds

All practical films and papers for camera and darkroom, in BW and color, contain silver bromide, chloride, iodide, or some mixture of these. In BW materials the final image is actually composed of metallic silver in finely divided form, appearing black. In color materials the final image is composed of dyes formed in side reactions of silver halide development. Little or no silver remains in color materials after processing.

## The Latent Image

When the camera shutter clicks or the enlarger lamp flashes on, the same basic interaction between radiation and matter starts the image-making process in virtually all films and papers, color and BW. A general example using film follows, but the same reactions occur in paper. Film "remembers" its exposure to light by a subtle change in the positions of a few ions and electrical charges within the microscopically small silver bromide crystals that populate its emulsion. The change is not visible, but yet that light-impressed memory, that *latent image,* will persist for years, with no further effort required. A crystal of silver bromide that bears a latent image is attackable by the reducing agents in a developer. The latent image sites become development centers. The development process wakes that latent image and renders it visible by reducing ionic silver to black metallic silver. Subsequent processing steps make the resultant silver image resistant to further change.[5]

Newly manufactured film can wait for years to receive an image. It remains fresh for a long time and would probably stay fresh indefinitely, except for the slow, inexorable, natural forces of thermal effects and of background ionizing radiation, which degrade speed, contrast, tonal range, and color. The thermal effects can be retarded by cold storage, but the ionizing radiation of the surroundings, particularly cosmic radiation, is unavoidable. Although films have an expiration date, there is no exact point of expiration, but, rather, it depends on the criticality of the intended use. BW films officially beyond this expiration date are often quite usable, perhaps needing only modified exposure and processing.

## The Developed Image

The way any photographic material responds to light is to form an invisible latent image. After processing makes the image visible, a conventional BW film has a negative image of the original scene in which light and dark are reversed. This is because the bright areas of the scene caused the strongest latent image, which resulted in the most development of silver and the greatest blackness. The science of *sensitometry* quantifies this in terms of the energy that fell on the film and of the resultant optical density in the developed negative.

The discussions that follow, while technical, are not rigorous enough to equip you to make your own film or to run a sensitometric control lab. They will help you bend the photographic process to your needs. After you get the main concepts, if you want more rigorous material, you can go to the sources in the bibliography and beyond.

## The Characteristic Curve

Plotting optical density against the logarithm of the exposure causing that density gives the photographic characteristic curve.[6] See Figure 1.2. (The relationship of the original scene to the characteristic curve is given in Figure 1.3.) The unexposed regions of the film have the least density, called *D-min,* or *base-plus-fog,* or, commonly, *fog.* Other regions sufficiently exposed to yield maximum developability have the greatest density, called *D-max.*

When a graded series of exposures are given and the film is developed and then read on a densitometer, the plotted results give the *lazy-S* curve in Figure 1.2. The region of linear relationship between density and log exposure is called the *straight-line region.* There are also

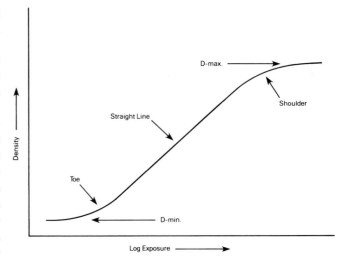

**FIGURE 1.2   The characteristic curve for a negative film.**

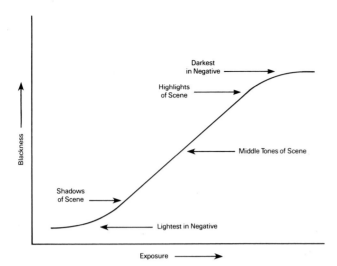

**FIGURE 1.3 The characteristic curve related to scene elements.**

two nonlinear regions: the low-exposure part called the *toe*, and the part approaching D-max called the *shoulder*.

## Speed Measurement

The *characteristic curve* is used to measure the major properties *speed* (or sensitivity) and *contrast*. Speed is related to the minimum exposure that gives an arbitrary detectable density difference above D-min. Speed is thus related to the minimum definitely detectable signal. The International Standards Organization (ISO) uses a speed-point of 0.1 above D-min and defines photographic speed of films for pictorial purposes as ISO = 0.8/*E*, using a prescribed development. *E* is the exposure in meter-candle-seconds required to produce the density at the speed-point; see Figure 1.4.

## Contrast Measurement

Contrast is another important film characteristic, especially in biomedical and scientific photography, where unusual subjects need contrast adjustment. Referring to Figure 1.5, consider the angle of the major portion, the straight line, of the characteristic curve. This line represents the coupling between input (the exposure due to the original scene) and output (the shades of gray on the developed negative). The steepness of its angle shows how much of a change in density is caused by a given change in scene brightness. The more vertical that line, the more contrasty the image. The closer to horizontal, the flatter or less contrasty the image. The simplest measurement of contrast is the tangent of the angle that the line makes with the horizontal, a quantity called *gamma*. Higher numbers mean more contrast.

Gamma as a measure of contrast serves very well for films having the classic straight-line curve shape. Many modern films do not have any significant straight line in their characteristic curve but, rather, a very long sweeping toe extending almost to the shoulder. Without a straight line on which to measure gamma, some other measure of contrast is needed. That is supplied by the concept of *contrast index* (CI), which constructs a representative straight line over the useful portion of the curve according to a formula, then measures its tangent (Figure 1.6). Manufacturers use gamma or CI as appropriate in their technical publications describing methods of film processing for different applications.

For pictorial outdoor scenes, film developed to about CI = 0.56 yields a negative that will print on a paper of normal contrast, (a grade 2 paper, in the case of graded papers). With variable-contrast papers that change their contrast with changes in the color of the enlarger light, a

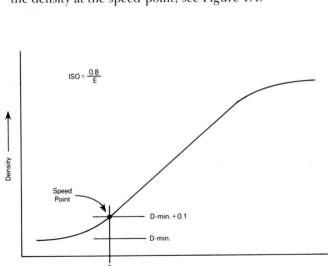

**FIGURE 1.4 Film speed related to minimum exposure.**

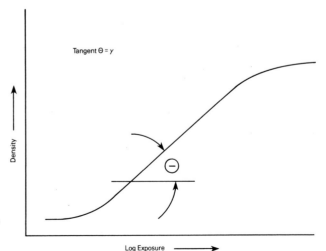

**FIGURE 1.5 Gamma as a measure of contrast.**

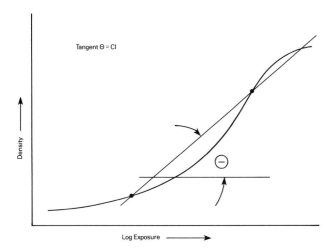

**FIGURE 1.6    Contrast index as a measure of contrast.**

**Table 1-1    Image Structure Measurements of Kodak Black-and-White Films**

| Film | Speed | Resolving Power (High/Low Test Object Contrast) | RMS Granularity |
|------|-------|------------------------------------------------|-----------------|
| T-Max 100 | 100 | 200/63 | 8 |
| T-Max 400 | 400 | 125/50 | 10 |
| T-Max P3200 | 3200+ | 125/40 | 18 |
| Technical Pan | 25–200 | 320/125 | 5–8 |
| Plus-X | 125 | 125/50 | 10 |
| Tri-X | 320 | 100/32 | 17 |
| Commercial | 50 | 100/40 | 12 |
| Ektapan | 100 | 125/50 | 12 |
| Royal Pan | 400 | 80/40 | 20 |

number 2 filter would be used. As examples of the need to use something other than pictorial contrast, note that photomicrographs and photographs of chromatograms usually need to be developed to higher contrast, whereas copy negatives from transparencies and radiographs need a lower contrast. Achieving these differing contrasts from one kind of film requires different degrees of development, perhaps even different developer formulations. In some cases where unusual contrast is needed (high or low), the best choice is not exotic development of an ordinary film, but, rather, special films that have been designed for purposes other than pictorial photography. The skillful use of these special films is often the hallmark of the professional biomedical photographer.

### Other Film Properties

Speed and contrast are aspects that set one film apart from another, but there are several others. Among them, image structure, spectral sensitivity, and reciprocity behavior, are significant for technical applications. These properties apply to all films; color films have yet other properties, which are discussed later in this chapter under "Managing Color."

Since there are minute crystals in the sensitive emulsion and small clumps of developed silver in the processed film, there is physical structure in the image, which will be visible at some degree of enlargement. In the 1800s when large-format photography was the only photography, the photographer made a large negative, contact printed it, and looked at the print. No enlargement, no projection. The image structure of those early emulsions was good enough for that use. Similar emulsions a few decades later when photographers wanted smaller, more portable cameras, produced little negatives that needed enlargement. The enlarged images were often grainy or lacking in fine detail. The quest for the same old image quality in prints from ever-smaller negatives drove research into better emulsions and into studies of just what makes a fine image fine. Quantification of what were previously aesthetic evaluations came about. The chief measurements became resolving power, granularity, and modulation transfer function. At any point in the evolution of the technology of emulsion making, there is a more-or-less fixed relationship between film speed and image structure.

High speed is achieved at the sacrifice of image structure, as a study of Table 1-1 will show. About every decade there occurs an advance in the technology that provides a leap in the level of quality available at a given speed. The introduction by Kodak of tabular-grain emulsions a few years ago is a case in point. The first three films in Table 1-1 represent state-of-the-art tabular-grain technology. The fifth and sixth films are a technological generation before that. The seventh film is before even those. A study of the numbers will show the advances that have been made in speed-grain and speed-resolution ratios.

### Resolving Power

Photographic resolving power is measured using a test object made of alternate black bars and white bars in groups of increasing fineness; the unit of measure is *line-pairs per millimeter* (lp/mm).[7] A line-pair consists of one set of one black line plus one adjacent white line. Film resolving power is often reported for two test object contrasts: 1000:1 and 1.6:1. The higher ratio extracts the highest performance from the film but may not represent performance in practical imaging situations. The lower ratio (gray-on-gray) is more representative of the film's ability to record shadow detail.

Photographers are usually interested in the performance of a whole imaging system, not just the resolving

power of the film. The resolving power of lenses and papers can also be measured. Contemporary lenses and films are a pretty good match for each other, but probably the next advance in performance will be from optics. A reliable rule-of-thumb states that if the resolving power of the lens exceeds that of the film by a factor of 3, or the other way around, the system performance is determined by the weaker one alone. Since most papers are slow and of quite high resolving power, and since their image is usually not further magnified, they can be effectively ignored in overall system performance.

System performance, then, is the cascaded performance of the camera with its lens, the film, and the enlarger with its lens. Where the final result will be judged by a human looking at it, all this needs to be assessed in terms of the eye's criterion for sharpness. Beginning with the spacing of the sensitive cells in the retina of the eye and projecting that into the plane where a picture is normally held for viewing (about 10 inches from the face), about seven[8] line-pairs per millimeter in the print are needed. More resolution than that would be detectable to most viewers only by the use of a magnifying glass. Less resolution than that would be perceived as unsharpness.

Take a numerical example. With a tripod-mounted 35-mm camera having a lens capable of 80 lp/mm expose a film that can resolve 250 lp/mm. Under the above rule this is a lens-limited case. This negative is enlarged seven diameters to produce an 8 × 10 inch print. The enlarger is capable of 100 lp/mm, and degrades the image only slightly. The original negative had about 80 lp/mm, which is now diminished by the degree of enlargement: 80 divided by 7 is about 11 lp/mm in the print. Since that is more than the 7 lp/mm the eye needs, the print is seen as tack-sharp. Indeed, an 11 × 14 inch print would also look very acceptable. A 16 × 20 would need 14 times magnification, yielding only about 5.5 lp/mm, probably the ragged edge for sharpness for a print to be judged at close reading distance. However, who holds a 16 × 20 print at 10 inches? It would more likely be held at arms' length, about 20 inches. Thus, viewing distance adds another factor. The 16 × 20 print at 20 inches will look just as sharp as the 8 × 10 print at 10 inches to a person with average sight.[9]

## Modulation Transfer Function

The idea of single-number resolving power as the measure of image quality implies that there is a magic number and that on one side of it all is acceptable, and on the other side of it nothing is acceptable. Intuition and experience tell us, rather, that there is a continuum of decreasing quality, with no knife-edged demarcation between good and bad. For this reason the concept of modulation transfer function (MTF) was developed.

In MTF measurements the input signal (test object) is a sine wave of increasing frequency. The strength of the output of an imaging component or system is then measured across the spectrum of frequencies. The plot of percent modulation versus spatial frequency then gives a much more telling picture of performance than the single-number resolving power test. Since MTF is closely related to information theory and is just as applicable to electronic imaging as to conventional photographic systems, it will be useful in evaluating hybrid imaging systems.

## Sharpness and Acutance

*Sharpness* is a subjective image quality, not a measured quantity, and not easily defined. *Acutance* is a measurable film property derived from an ideal edge image, which correlates somewhat with sharpness.

## Grain

One more aspect of image structure remains to be considered: grain. Sometimes the finest structure seen in a photograph is not in the original subject but is from the photographic process itself. The developed clumps of silver in BW films and the dye clouds of color films are too small to be seen without magnification[10] but show up at some degree of enlargement. It is a combination of resolution loss and obtrusion of graininess that causes us to limit magnification of a print; at some degree of enlargement image quality drops to an unacceptable level. *Empty magnification,* describes the situation where additional enlargement reveals no more detail.

The term *grain* refers to the actual clumps of silver or dye clouds in an emulsion. *Graininess* is a subjective term standing for the observer's sensation while viewing an image; it is not quantitative. *Granularity*[11] is a physical measurement of image structure intended to correlate with graininess. A frequently encountered form is root-mean-square granularity (RMSG). The RMSG numbers published by film manufacturers are useful, along with speed and resolving power data, in selecting a film for a special purpose. Studying the relationships among speed, resolving power, and granularity in Table 1-1 shows possible tradeoffs in film selection.

## CONTROLLING EXPOSURE

### Exposure

The exposure[12] and processing given to a film determine its response. Let us take up the two variables that determine exposure: *intensity* and *time,* and their interdepen-

dence. A given quantity of energy, that is, a certain number of photons, falling on a given area of film should always produce the same effect, the same degree of blackness, of density, upon processing. It should not matter if that number of photons falls in a brief, intense flash or falls more slowly and in a dimmer beam. In conventional pictorial photography exposure meters and automatic cameras always make this assumption. Look at the scales of an exposure meter with shutter speeds lined up opposite lens apertures. These assume you can halve the shutter speed and simultaneously open the aperture one stop (factor of 2) again and again over an extended range.

## Reciprocity Law

The assumption that intensity and time can be traded against each other is called the *reciprocity law of exposure.* For most films, it works reliably over the practical range of fractional-second exposures and the usual light intensities. In a number of scientific and technical applications the reciprocity law does not strictly apply. This is rightly called *reciprocity failure.*[13] As a rough guide, these cases occur at extremes of intensity where exposure times are longer than a second or shorter than 1/1000 second.

Manufacturers can usually patch up one end or the other of the time scale with emulsion technology; this is done with films intended for special applications. Emulsions for astronomy are treated for best performance in the range of hours of exposure. Films for phototypesetting that receive flash exposures of 1/50,000 second or less are optimized for that. Neither would work well in the other application.

Elaborate exposure meters often ignore reciprocity failure and assume that their readings of very low light intensity can be used to reliably calculate exposures of several hours. In practice the user needs to adjust the meter's indicated camera settings using film manufacturers' reciprocity data.

In biomedical photography there are situations that can get us in trouble at both ends of the scale. At the low-intensity, long-duration end there are fluorescence photomicrography, IR techniques (especially luminescence), and UV photography. At the brief-duration, high-intensity end there is photomacrography using autoflash. The professional-grade films best for these and other applications where reciprocity failure occurs are supported by technical publications giving correction factors for exposure and development.

Correction for reciprocity failure in color films takes on yet another factor: *color shifts.* Color films have separate emulsion layers responding to red, green, and blue light. Often these emulsions have different degrees of adherence to the reciprocity law, meaning that a film that has perfect color balance at ordinary exposure times will show color shifts at very long or very short times. Makers of professional films publish filter and exposure corrections for these. Makers also adjust the reciprocity behavior for the most likely use of a given film. Tungsten-balanced films are optimized for long exposures; daylight-balanced films for short exposures, as may be needed with electronic flash.

## Varying Exposure Time

The usual way to vary exposure time is to change shutter speed. On program-controlled cameras the camera itself, guided by its reading of scene brightness and the programs stored in its chips, selects both shutter speed and aperture. In some cases the photographer may select one and let the camera choose the other. The exposure controller of photomicroscopes is simply an exposure time selector. The more sophisticated of these have special circuits to introduce reciprocity correction at long times. Exposure time in enlarging is usually controlled by turning the lamp on and off.

## Varying Exposure Intensity

The usual way to vary intensity is with lens aperture, but there are cases where this is not possible or desirable. The long focal-length lenses of *catadioptric construction* have no adjustable aperture. The aperture diaphragm of a microscope should be used to optimize image appearance, not to control illumination intensity. In photomacrography the aperture is best chosen for resolution and depth-of-field, not for exposure control.

Light intensity can be controlled in a number of other ways beside lens aperture: filters, lamp current, and lamp distance. Not all of these are available in all cases.

Filters are applicable in many situations. Neutral-density filters absorb all wavelengths of light equally and, hence, appear gray. They are supplied in various degrees of attenuation. Those sold through amateur camera shops are usually designated in terms of filter factor, for example 2×, 4×, needing a one and two f-stop exposure increase, respectively. Neutral filters may be of tinted glass or plastic, of evaporated metal films on glass, or of dyed gelatin. These are usually labeled in optical density, rather than filter factor. Gelatin filters are sold in increments of 0.1 density, corresponding to one-third stop change for fine control. For use outside the visible spectrum, evaporated metal films are best. See Table 1-2 for a comparison of filter-marking systems and the corresponding attenuation by lens-aperture change.

Another type of filter sometimes used for attenuation consists of two polarizing filters, one fixed, one rotating. When their axes of polarization are at right angles, attenuation will be maximum; when they coincide, minimum.

**Table 1-2   Light Attenuation by Neutral-density Filters With Filter Factors and Equivalent Aperture Changes**

| Density | Filter Factor | Aperture Change (Stops) |
|---|---|---|
| 0.0 | 1× | 0 |
| 0.1 | | 1/3 |
| 0.2 | | 2/3 |
| 0.3 | 2× | 1 |
| 0.4 | | 1 1/3 |
| 0.5 | | 1 2/3 |
| 0.6 | 4× | 2 |
| 0.7 | | 2 1/3 |
| 0.8 | | 2 2/3 |
| 0.9 | 8× | 3 |
| 1.0 | | 3 1/3 |
| 1.1 | | 3 2/3 |
| 1.2 | 16× | 4 |

Polarizing attenuators must be used with regard to any polarizing properties of the light source or specimen.

The more versatile electronic flash units produce flashes that differ in intensity and duration at different power settings. The equipment itself may be marked only in power numbers, but the instruction book may have duration numbers that can then be used with film makers' data to find filtration needs, if any. Small, auto-controlled flash units produce extremely brief exposures (1/70,000 second) at close distances.

Light intensity may be adjusted in some cases by moving the source toward or away from the object. If the source is small, and the distance not too close, intensity will be proportional to the inverse square of the distance.

A last way to change light intensity for exposure adjustment is by varying the current through a tungsten or quartz–halogen lamp. This is only of use in BW photography, since color temperature also varies along with intensity as current is changed.

## Exposure Latitude

*Latitude* is forgiveness for bungled exposure; latitude is the tolerance of a film for under- and overexposure. Latitude is not a fixed quantity that can be exactly expressed in numbers on the film box, since it depends on the brightness range of the scene and other variables. Latitude is fixed by the chemistry and physics of the imaging process. The film maker wants your images to be good just as much as you do and therefore provides as much latitude as possible. Some films will always have little latitude, despite efforts toward improvement.

## Latitude in Pictorial Photography

Figure 1.7 diagrams the sensitometric basis for exposure latitude in generalized pictorial photography. Each of

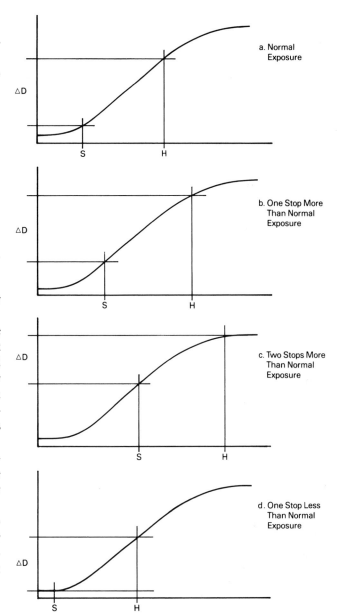

**FIGURE 1.7    (a–d) Exposure latitude in pictorial photography. The range of scene brightnesses is constant, running from *S*, the shadows, to *H*, the highlights.**

the four cases represents a different exposure of the same scene. We see the D-log E curves for a typical negative film, with the range of scene brightnesses running from *S*, the shadows, to *H*, the highlights. These points are reflected from the characteristic curve to the density scale, where they produce the density range ΔD.

Normal exposure is shown in curve 7a. The shadows fall low on the curve but not too low to be differentiated. The highlights fall well up on the curve. The ΔD is adequate to print well on a normal-contrast paper.

One-stop overexposure is shown in curve 7b. The shadows fall considerably higher on the curve, as the

whole density range has been moved up. The highlights still fall on the straight-line portion. This negative will appear dark and take longer to expose at the enlarger, but the ΔD is the same. The negative will make a good print on normal paper.

Two stops overexposure is shown in curve 7c. The shadows are now very high on the curve, pushing the highlights onto the shoulder almost to D-max. This compresses the lighter tones. The ΔD is reduced, requiring a more contrasty printing paper, a higher grade number. The negative will appear very dark and take a long time to print. It will be difficult to focus the enlarger, due to dim light. Print quality will be lessened.

One stop underexposure is shown in curve 7d. The shadows fall on the undifferentiated part of the curve in D-min. The highlights fall at a lower point than normal. The ΔD is reduced, requiring a more contrasty printing paper. The lower tones and shadows will print as black to muddy gray. The negative will appear very light, and enlarger exposure time will be very short and hard to control. A really good print is impossible.

In the hypothetical example of Figure 1.7, the realities of modern negative films were slighted to make a point. Current pictorial BW films in ordinary usage might have a latitude of at least one stop underexposure and two or more stops over.[14]

## Latitude/Biomedical and Scientific

The same principles apply to scientific subjects as to pictorial photography, but the conditions are more severe. Consider the set of conditions in Figure 1.8. The scene has a small brightness ratio, so a special higher-contrast film was selected.

Normal exposure is shown in curve 8a. Both shadows and highlights fall appropriately on the curve. The film chosen gives the same ΔD as in Figure 1.7, so the negative will print well on a normal paper.

In curve 8b one-stop overexposure places the shadows very far up the curve and the highlights just shy of D-max. The negative will appear quite dark, and printing time in the enlarger will be long. The ΔD is somewhat reduced. The highlights are a bit compressed; they are off the straight line and on the shoulder.

In curve 8c two stops overexposure produces disaster. Virtually the entire tonal scale winds up at D-max, and ΔD has shrunk to almost zero. This negative, in addition to being almost opaque, is unprintable.

In curve 8d, one stop underexposure again yields a greatly diminished ΔD. All the shadows fall in undifferentiated D-min and will print solid black. The midtones are on the lower contrast part of the toe and will print as muddy grays. What remains of the highlights may be helped by printing on a higher contrast paper. No acceptable print can be made. This case has been somewhat

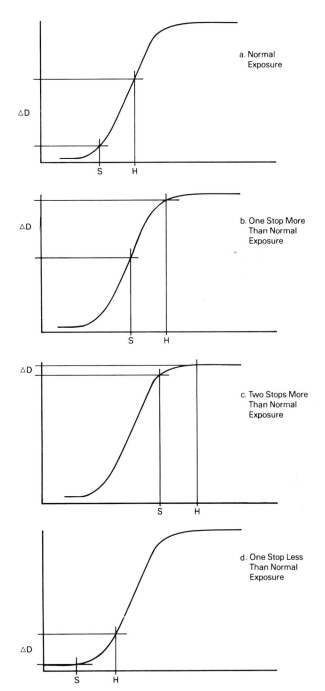

**FIGURE 1.8    (a–d) Exposure latitude in scientific photography. The short range of scene brightnesses calls for high-contrast film.**

exaggerated to make a point, but it shows why there is less latitude with small scene brightness ratio, as is frequently the case in biomedical and scientific photography.

## Latitude and the Darkroom

Latitude depends heavily on salvation in the darkroom by the choice of paper grade and enlarger exposure. In

some cases you might not be proud to show another photographer the negative from which you made a passable print. In slide films (transparencies), however, there is no place to hide: the film you shot goes right in the projector. More on that when we take up slide films.

## SELECTING THE PROCESS

### Pushing

*Pushing*[15] is extended or special development following exposure at an index higher than normal. Many photographers are unaware of the effect that such treatment has on contrast. The pictorial photographer today has little need to push films merely to gain speed: there are films with natural speeds from 25 to 3200. For any needed speed it is usually best to pick a film of that natural speed, rather than to take a slower film and push it. Pushed film is always of higher contrast, perhaps too high for pictorial photography.

For biomedical and scientific photography the first question should be: "What contrast is needed?" *not* "How much speed is needed?" When this question is answered, find the several film/process combinations that will give that contrast, and pick the one giving adequate speed with acceptable image structure.

A film made for pushing to the highest speeds is Kodak T-Max P3200 (Eastman Kodak Company, Rochester, NY). An extensive pamphlet supplied for this film gives directions for developing to speeds of 25,000. Photojournalists have used it at 50,000.

### Hypersensitizing—Beyond Pushing

Under conditions of extremely weak illumination, as in astrophotography, hypersensitization of film before exposure greatly increases film speed. Some workers have applied this technique to biomedical imaging, particularly in fluorescence photomicrography and in autoradiography. The technique aims to increase the efficiency of photon trapping by the silver halide crystals. Film is subjected to a sequence of vacuum and dry inert gas treatments at elevated temperatures before exposure. The procedure allows slower, fine-grain films to behave like fast films. In the photomicrographic application mentioned above, Kodak Technical Pan film with a normal speed of 32 was *hypered* to 1200, giving much finer grain than a film of normal 1200 speed.

### Filters in BW Photography

Many photographers seem to believe that if color is important to a picture, the photograph must be made in color. What if the image is for publication, however, and the client's budget cannot afford color reproduction? In many cases careful use of a colored filter on BW film can lift a specific object out of the middle grays into bold contrast. The principle is simple. A filter the same color as the object will lighten its rendition; a filter complementary to the object's color will darken its rendition.

A well-equipped kit for general BW photography would include these numbers and colors from the Kodak Wratten line: 8 (light yellow), 12 or 15 (yellow), 13 (light green), 22 (orange), 25 or 29 (red), 47 or 47B (blue), 58 or 61 (green). All of them is not too many. In the days before color photography a skillful technical photographer rarely made an exposure without a filter before the lens.

Filtration is a way to selectively manipulate the contrast of certain scene elements independent of overall process contrast, which is determined by film choice and development conditions. A case frequently encountered is the BW photomicrography of multistained specimens, as is discussed in Chapter 7.

### Choosing Film and Process

Film processing is a powerful variable of great usefulness to the biomedical photographer and the scientist.[16] Processing, in general, is fully laid out in Chapter 3. Professional photographers working in other fields will find the manufacturers' basic recommendations adequate for most of their needs. For them, processing can become dull and boring, as they perform the same routine over and over. Biomedical photographers and scientists, however, have such a variety of imaging demands that they have a challenge in finding working solutions to their problems.

To manipulate processing to meet different imaging challenges, biomedical photographers and scientists need information from the publications of film manufacturers. These will show the various development conditions and how they affect contrast and speed; see the Bibliography for sources.

### Development Controls Contrast

The basic relationships among development, contrast, and speed can be learned from Figure 1.9. Consider the trivial case: an undeveloped film has no contrast. Its D-log E curve would be a horizontal line at the D = 0 level. Then a film that had a very brief development would pivot slightly above the horizontal. More development would pivot it more, and so on. Curves 9a through 9e show such increasing development. Increasing development time thus increases contrast. (Actually, the curves do not seem quite to pivot but more to bend like a strip of spring steel).

Curve 9e seems to belong with all the rest, except in the D-min region. There it is detached from its mates. This shows an increase in chemical fog, due to extended development. This is the film's way of saying it has reached its maximum practical contrast with that particular developer. If this family of curves had been generated with a conventional pictorial developer such as Kodak D-76, perhaps higher contrast might be achieved with a more vigorous developer such as Kodak D-19. Another route to higher contrast is to change films. If this family of curves had been made on a pictorial film such as Kodak T-Max 100, higher contrast might be reached with an inherently more contrasty film like Kodak Technical Pan.

### Development Controls Speed

Speed also varies with development. Review the criterion for photographic speed in Figure 1.4, and look again at the curves of Figure 1.9. The speed-point located slightly above D-min moves to the left with increasing development, indicating lower levels of exposure, E. Since E appears in the denominator of the speed formula, increased development gives lower E values, which give greater speed. Thus, lengthening development increases speed.

We have seen that the time of development affects film contrast and so does developer composition. Some developers can be used at differing degrees of dilution to give different degrees of contrast. A prime example is Kodak HC-110, a very versatile developer, which is usable over an extreme range of concentrations. Dilution of some developers also affects image structure, especially granularity, which improves with dilution in most cases.

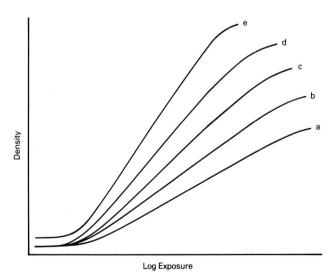

**FIGURE 1.9  Film response, with development time increasing from *a* to *e*. Contrast and speed increase with development.**

### Varying Development Temperature

Temperature is the last development variable that affects speed and contrast. Over a reasonable range, development time and temperature may be traded off without ill effect.[17] Temperature of development in BW processing should be controlled to the nearest degree Fahrenheit. Temperature of other BW baths is less critical. Manufacturers' data often give development times at different temperatures.[18] Temperatures below 60° F usually result in development times too long to be practical. Temperatures above 85° F may not be tolerated by some films.

### Agitation

Film must not remain motionless during development; it should be agitated. Many conventional films tolerate different methods of agitation; so the many stylistic variations developed by photographers work reasonably well. The trouble comes with some of the special films needed in unusual applications. For some of these films, the manufacturer has specified a certain regimen of agitation. When these films disappoint a new user, the problem is often agitation. When in trouble, try it the manufacturers' way.

### After Development

Much is written about development in photographic processing and little about the remaining steps. Development does indeed control speed and contrast and influence image quality. The remaining steps cannot make such grand claims, but neither can they be ignored. They provide image permanence. This book assumes a general familiarity with and ready access to general texts on photography. A few notes follow on the remaining steps.

Control of development is essential to good photography. Stopping development promptly is part of that control, which means a proper acetic acid stop bath. The acidity of a stop bath neutralizes the alkalinity of the developer, cutting off development instantly. A water bath, in lieu of an acid stop bath does not have the same instant effect and allows alkali to be carried over into the fixer, which prematurely kills the fixer. Indicator stop baths that change color when exhausted are a reassuring convenience.

The fixing bath, or hypo, is necessary for the permanence of the image. It contains a solvent[19] for undeveloped silver halide, which if left in the film or paper will in time discolor and destroy the image. Use it for the full recommended time, and do not forget the agitation. Test its strength with hypo test solution, and discard it when exhausted.

Washing is necessary following fixation. While the

fixer is dissolving the undeveloped silver halide, some of the complexed silver leaches into the bath itself. Some, however, remains in the film or paper to be washed out in running water. Films and resin-coated papers wash in a short time; only the emulsion has absorbed chemicals. Fiber-base papers require extended washing, largely due to the vast absorptive area of the paper fibers.

Washing can be speeded up using an extra bath. There are two similar-sounding products: *hypo clearing agent* and *hypo eliminator*. These baths were both once considered benign and beneficial, but now one is in question. Hypo clearing agent works by physicochemical means and appears harmless to long-term image stability. Hypo eliminator, containing a peroxide oxidizer, is no longer recommended for images to be kept a long time. Hypo clearing agent reduces washing time and water consumption considerably, especially with fiber-base papers.

## PRINTING THE NEGATIVE

### Printing

Printing in most cases is by enlargement. The goal of the photographer is to make negatives that print easily on a normal paper, that is, contrast-grade two paper. In the case of variable-contrast papers this corresponds to a number two filter. Papers are made in at least five grades. They are shown, idealized, in Figure 1.10. They differ from each other chiefly in contrast,[20] increasing from one to five. Some paper families have even higher and lower members.

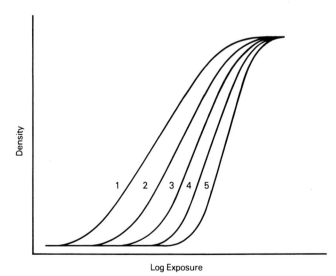

FIGURE 1.10  A family of curves representing different paper grades or different printing filters for variable-contrast papers. The most contrasty is 5, the least contrasty is 1.

### Print Contrast

The reason for aiming the general run of negatives at a number two paper has to do with the usual types of failure. When things go wrong photographically, there is often a loss of contrast in the negative. Extra grades of contrasty paper are therefore good to have in reserve. It is rare that an error leads to too much contrast in the negative; so few softer grades are needed. If your routine negatives printed on a grade five paper, what would you do if something went wrong? (It could be as slight as misreading the thermometer and having the developer a few degrees too cold, resulting in weak contrast in the negatives.)

*Variable-contrast papers* provide a full range of contrasts in a single paper, requiring no stocking of different grades. They also permit contrast changes finer than full grades by the use of half-grade filter changes. Very difficult negatives can be printed by *dodging* and *burning techniques* using different filters for different areas of the scene, something impossible with conventional graded papers.

The special enlarger filter heads for printing in color can also be used for BW printing with variable-contrast papers. By dialing in various amounts of yellow or magenta filtration, the different contrasts are achieved.[21]

Variable-contrast papers achieve that effect in a clever way. They are coated with two emulsions, a blue-sensitive one of high contrast, and a green-sensitive one of low contrast. By using varying amounts of each, a broad range of contrasts is possible. The yellow and magenta filters both transmit red light, which neither emulsion can see, but which is, of course, visible to the photographer. This makes the image easier to see for focusing and dodging.

### Paper Categories

Papers can be classed according to the type of development for which they are designed. Regular papers are intended for tray processing through the standard set of baths: developer, stop, and fixer. Incorporated-developer papers[22] are intended for rapid machine processing. All chemicals necessary for development are built into the emulsion, except one, the supply of alkalinity. In automatic processing machines the first bath provides that alkalinity, and full development takes place within several seconds. The next (and last) bath in those machines is a specially formulated fixer.

In tray processing regular papers develop fairly slowly, taking three-quarters to two-and-a-half minutes. This greater time allows some degree of control of overall density and contrast. Incorporated-developer papers

may also be tray-processed, but because the image "pops up" so rapidly, there is no time to exercise much control.

Another major distinction divides papers according to the type of base material. Most papers in general use are on resin-coated (RC) base. A plastic coating is extruded and bonded onto both sides of the paper sheet before the emulsion is coated. In processing only the emulsion absorbs water and chemicals; therefore washing and drying are very rapid. Fiber-base paper has a bright, smooth or textured clay coat on one side over which the emulsion is coated. The fiber base and the clay coat, as well as the emulsion, absorb water and chemicals. Washing and drying take considerably longer.

Properly processed and stored, fiber-base papers can probably last for hundreds of years.[23] For archival purposes many photographers consider negatives the primary archive, since they can be reprinted at any time. Films can be processed for permanence more easily than papers and, usually being smaller, are more easily stored.

## Printing Devices

Negatives are either enlarged or contact printed. The printing devices also have an influence on image contrast and sharpness. Nothing exceeds the quality of a contact print from an excellent large negative. There will be no detectable loss in contrast or sharpness, and grain will be absent. Enlargement, while it offers many opportunities for image manipulation, offers also many chances for image degradation.

Enlargers influence contrast. From a given negative, a condenser enlarger gives more contrast than a diffuser enlarger. The difference may be as much as one grade of paper. A carefully aligned point-source condenser enlarger offers the most contrast of all.[24] Either type of enlarger is acceptable, but for diffuser enlargers you may want to increase negative development time to build contrast. As stated before, the goal should be for most negatives to print on a number two paper.

A major thief of contrast is dirt or smoke film on the enlarger optics. The heat of the enlarger lamp draws air currents continually through the optics. Smoke and dust are soon deposited in sufficient amount to lose contrast equal to one grade of paper. Vibration of the enlarger due to the operation of nearby machinery can destroy sharpness.

## MANAGING COLOR

### Color Imaging

Most attention will be given to making transparencies with slide films and larger-format reversal[25] films, since these are the predominant materials used in biomedical

photography. Their advantages over negative materials will be considered, but negative films and their applications will not be ignored.

The 2-inch-square teaching slide containing a frame of 35-mm film became a significant format in medical education beginning in the late 1930s with the invention of Kodachrome film. Its faithful rendition and brilliant projection of colors revolutionized the teaching of histology and pathology and greatly improved clinical and other applications. Soon color slides were also used for text and graphs. By the late 1940s the old standard teaching slide, 3 1/4 × 4 1/4 inches, was well on the road to retirement. Automatic, remote control projectors for 2 × 2 inch slides finished off the big ones. The high resolving power of films for 35-mm photography carried as much information to the screen as did the older slides, which had an image area six times as big.

## Reversal Film Advantages

The most direct route to a positive slide for projection is a reversal film: one film, one process, no chance for color variance. You might also make a color negative and print that on a color negative print film to get a positive transparency: two films, two processes, and the possibility for unwanted color variance in the printing step. The only way this longer method can be made to work reliably is with a color reference standard in every scene.

## The Color Reversal Characteristic Curve

Look at a typical characteristic curve for a reversal film in Figure 1.11. The first thing to strike us in this curve is

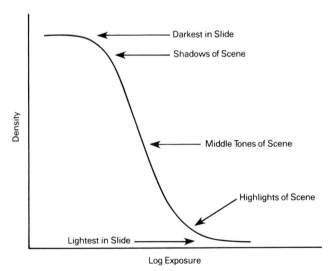

FIGURE 1.11  Characteristic curve for a slide film. Compare Figure 1.3. Note higher contrast and reversal of tones.

that it goes in the opposite direction from the negative curves seen before; compare Figure 1.3. Now the highlights are in the low-density region, and the shadows in the high-density region. So darks look dark and lights look light. You might think that for good tone reproduction you might want the contrast, the slope of the straight line, to be about minus one,[26] a 45-degree line. Studies of viewer preference show rather that higher contrasts are consistently preferred, and so they are supplied.

As fully explained in Chapter 6, color films have three sensitive components responding to the three spectral regions. These, in turn, correspond to the three types of color receptors in the human eye: red, green, and blue. Dyes are formed in the film during development; these dyes control the amounts of these three visible primaries. These dyes are the complements of the primaries and are, respectively, cyan (bluish green), magenta (reddish blue), and yellow. This set is sometimes called the secondaries. Another pair of terms is additive for red, green, and blue and subtractive for cyan, magenta, and yellow. Doing the experiments set out in Chapter 6 is highly recommended for understanding these color concepts.

Although only one curve is shown, an ideal film that has its three color components matched will look like Figure 1.11. Here the three curves, red, green, and blue, exactly coincide. Such a film should give good color reproduction without unwanted color casts from the highlights, through the midtones, to the shadows.

## COLOR FILM AND FILTERS

### Filters Help Some Color Problems

Curves help in visualizing what happens in the use of filters to adjust film response. Consider the situation in Figure 1.12. This film shows everything to be too cyan, too blue-green. (Very old film can develop a condition like this.) Graphically, this is seen in the red curve being displaced right of the blue and green curves by a distance of 0.2 log E. The curves are parallel and identical in all other respects. You can say green and blue are two-thirds of a stop fast, or red is two-thirds of a stop slow. A filter can correct this. Since filters cannot add light, only subtract light, the faster layers need to be slowed down to match the speed of the slow one. Blue and green are the fast ones. A red filter transmits red light, and absorbs blue and green light. Therefore, a red filter with a density of 0.2 to blue and green light should move the blue and green curves over to match the red one. A color correction filter CC20R (Eastman Kodak Company, Rochester, NY) is what is needed. It looks pale red. An exposure increase of two-thirds of a stop is also needed.

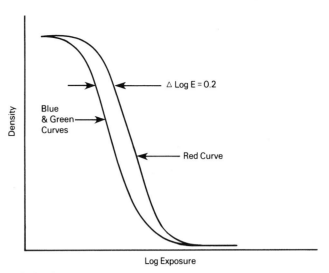

**FIGURE 1.12     Response of a slide film rendering scenes too cyan (blue-green). A CC20R filter (red filter with a density of 0.2) over the camera lens will merge all three curves for correct color balance.**

### Filters Do Not Help All Problems

A different situation is shown in Figure 1.13. In this film improper storage has resulted in mismatched curves. The blue-sensitive layer has lost speed, contrast, and maximum density. In effect, filters can only shift curves sideways; they cannot change their slope nor add to density. Blue filters transmit blue light and absorb red and green. A moderate bluish CC filter would move the red and green curves to the right, but there is no position where all three would coincide. There is a very partial match near the shadows now. A small amount of bluish filtration would match part of the midtones, but not the

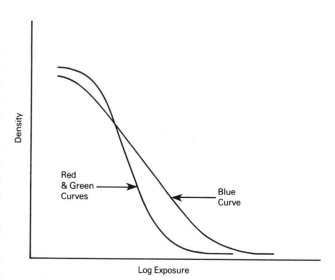

**FIGURE 1.13     This slide film renders shadows bluish, and all else increasingly yellow. No filtration will correct this.**

highlights or shadows. Similarly, correcting the high-lights would vastly upset midtones and shadows. There is no way filters can correct a contrast mismatch. The best that can be done is to correct the most critical part of the tone scale, depending on the subject matter. (In pictures of people this may be the flesh tones.)

## Color Correction Filters

Color correction (CC) filters are to a photographer what spices are to a chef: they can enhance the good, and, in some cases, mask the spoiled. They are supplied by Kodak in six colors: the additive primaries red, green, and blue; and the subtractives cyan, magenta, and yellow. These are each listed in several intensities from vanishingly pale CC025 to the twenty-times-stronger CC50.

Among the many uses of CC filters are correcting batch variations in color film, neutralizing color casts in lenses, correcting reciprocity effects, and enhancing specific scene colors. They can also be bound with slides to correct colors on projection.

## Color Transparency Films

No film records the world exactly as it is. Every film tries with a mixture of three dyes to simulate the colors of nature, each film in its own way. This is most noticeable in *families* of films, where certain family characteristics (flesh rendering, contrast, saturation) become recognizable. Because each film is different, and because people differ in their preferences, there is no general agreement on a "best" film, nor should there be. The peculiarities of certain films will be seen as a good fit for certain jobs. Several aspects set one film apart from another: process family, color balance, speed, image structure, and color enhancement.

## Slide Film Families

In practical terms there are two major families of slide films: those that can be processed by the user, and those that cannot. The biomedical photographic field relies strongly on the user-processible films because of quick access to the image and medical confidentiality. The *user-processible films* are exemplified by Kodak Ektachrome, Fujichrome, (Fuji Photo Film U.S.A. Elmsford, NJ) Agfachrome, (Agfa Corporation Ridgefield Park, NJ) and other films for the E-6 process. Chief among the films that must be sent to special labs are the Kodachrome films, which are still regarded by many as the standard of excellence.

Technically, the difference between the two families is related to the physical and optical properties of their emulsions. Kodachrome film is structurally quite simple. In principle, three layers respond to red, green, and blue light. The layers merely remember the relative amounts of those primaries to which each point is exposed. There are no color-forming materials of any kind in the films. This keeps light scatter to a minimum and allows high resolving power and low granularity. The processing of Kodachrome films is very complex; the current K-14 process requires four different developers and a total of fifteen steps. Only a few labs offer Kodachrome processing. If you are near one and courier service is available, 1-day access is possible.

Ektachrome and related films are much more complex in structure; they contain color-forming couplers within their emulsions. Because more is built into the films, the process is much simpler, but granularity is slightly higher. The current Ektachrome E-6 process has only six steps, requiring half an hour, as usually practiced on a commercial basis.[27]

Many years ago the difference in emulsion content caused great differences in image quality, favoring Kodachrome. Similarly, the differences in processes caused considerable differences in image stability over time, again favoring Kodachrome. Great improvements have been made in Ektachrome films, so that current E-6 films have vastly improved resolution, decreased granularity, and, in some cases, better image stability than Kodachrome. Many biomedical photography departments offer half-day (or even faster) E-6 processing service.

## Latitude in Color Slides

Because it is the original camera film that is projected, correct exposure is essential. Overexposure wipes out the highlights. Underexposure sinks the midtones into the shadows. In most cases only about one-third stop latitude, plus and minus, exists. A slide that was one stop (perhaps a little more) underexposed can often be redeemed by remedial copying onto slide-duplicating film.

## Color Balance

Color films are made to give believable renditions with specific light sources. The major distinction is between daylight and tungsten types of sources. The daylight-type sources include, of course, daylight itself and electronic flash.

A word here about the scale designating color temperature. An ideal black-body when heated to incandescence emits radiation at various wavelengths in relation to its absolute temperature measured in degrees Kelvin (K). At lower temperatures most radiation is at the longer wavelengths; at higher temperatures, shorter wavelengths. In practical terms low color temperature

light sources appear reddish; high color temperature sources, bluish.[28]

Daylight films are balanced for ideal reproduction with noon daylight, which is considered to be photographically equivalent to a black-body radiator at 5500 K. This is a compromise, since a before-dawn and after-sunset daylight can be equivalent to 12,000 K or more and, just before sunset, close to 2000 K. Daylight is taken to be the combination of sunlight and skylight. Electronic flash varies slightly but, if anything, is often higher than nominal daylight, a little bluer, around 6000 K.[29]

Tungsten-type sources include incandescent lamps. Most household lamps have color temperatures of 2900 K or below; lower wattages have lower temperatures. The lamps made for photography will be either 3200 K or 3400 K when operated at their design voltage. The tungsten film in the Kodachrome family is balanced for 3400 K: the two tungsten films in the Ektachrome family, 3200 K.

Some special techniques, especially fluorescence, fall outside the above considerations. In situations where almost pure spectral colors need to be recorded, you should choose the film with the best sensitivity in that region of the spectrum. Thus you record red fluorescence on a daylight film, even though the exciting radiation may have come from a tungsten lamp.

### Filters for Color Balance

If the light source is not right for the film at hand, a filter can help in any case where the source resembles a black-body radiator. Major changes are made with Kodak Wratten conversion filters. Those in the bluish 80 series rebalance a tungsten film to daylight; the orangish 85 series rebalances a daylight film to various tungsten sources. For lesser changes in color balance, Kodak Wratten light-balancing filters are used. The pale bluish 82 series raises color temperature; the straw-colored 81 series lowers it.

### Odd Light Sources

Some light sources do not resemble a black-body radiator at all. The mercury vapor (blue-greenish), sodium vapor (yellow), and other metallic vapor (pinkish, purplish) lamps emit only a portion, often only a small portion, of the visible spectrum. The very fact that colors look unnatural under these lights should tip us off that they are unfit for photography. Since they only emit part of the spectrum, and since a filter can only subtract light, not add it, there is no way true color photography can be done under such lamps. Some filters have been recommended, but all these depend on a drastic lowering of standards on the part of the viewer.

Fluorescent lamps fall somewhere between the black-body, full-spectrum sources and the odd partial-spectrum and monochromatic sources. Their output is a combination of narrow-band line emission and broader, but not complete, phosphor emission. There are many different blends of phosphors in fluorescent tubes,[30] some of which can be used for photography with the proper filter. Each different type of tube needs its own filter combination. The single all-purpose filter sometimes sold for this is a compromise. In general, fluorescents are deficient in red and too rich in green. Color photographs made under them appear greenish, to some degree, the last thing wanted in pictures of people.

## SPEED AND QUALITY IN COLOR

### Color Film Speeds

Slide films are made with speeds from 50 to 1600, following normal processing. As with BW films, color slide films respond to changes in development by changes in speed, contrast, and image structure. As a general rule, all but the very fastest films are amenable to process variation. In most cases the best choice of a film for a given speed will be one that has that speed as its normal-rated speed, not as the result of push processing. An exception would be where a different contrast is wanted. Photomicrography is a good example, where a slow film is pushed one stop, not for the speed increase, but to enjoy the extra contrast that comes with increased development.

### Pushing and Pulling

Color slide films can be pushed or pulled[31] in processing by changing the timing of the first developer.[32] Pushing raises speed and contrast. Excessive pushing raises granularity and reduces D-max, resulting in smoky shadows. In general, a one-stop push is without serious ill effect, two is marginal, and more than two definitely shows image degradation. There seems little reason to pull film, except to correct an exposure error, for example, as if a 100-speed film had been mistakenly shot at 50.

Another problem in pushing is that sometimes not all three color components of the film behave the same way. A given push might affect, say, the blue layer more than the red and green. This could be just a speed shift, which can be corrected by CC filtration. This can be self-defeating. If you have pushed to gain speed but also got a color shift that needs a filter for correction, the exposure increase needed for the filter could wipe out most of the speed gain of the push. Worse than a straight color shift would be a contrast mismatch in one layer,

which no filtration can cure. Review Figures 1.12 and 1.13.

There is a color slide film made for pushing: Kodak Ektachrome P800/1600 Professional film. As the name suggests, it can be used at speeds to 1600, with good results. Even 3200 is possible with some additional loss of image quality. Emulsion changes in manufacture somewhat "immunize" it from the degradation usually found at high speeds, especially color shifts.

## Image Structure

As in BW films there is a relation between speed and image quality, especially granularity in color films; see Table 1-3. Note especially the image structure of the P800/1600 film processed to four speeds. Its response is typical of all color slide films. The more it is pushed, the more it deteriorates. Still, suprisingly good images are possible at very high speeds. When great speed is needed, it is usually best to start with the fastest film and to push no more than needed.

The granularity of color film is not due to clumps of developed metallic silver, as in BW. In color film, silver chemistry is still the basis of sensitivity, but colored dyes form the final image, dyes that were formed proportional to the silver development. Clouds of dye can be seen under the microscope.

**Table 1-3   Image Structure Measurements of Kodak Color Slide Films**

| Film (D/Daylight T/Tungsten) | Speed | Resolving Power (High/Low Test Contrast) | RMS Granularity |
|---|---|---|---|
| *Ektachrome professional* | | | |
| 50T | 50 | 125/50 | 13 |
| 64D | 64 | 125/50 | 12 |
| 64T | 64 | 125/50 | 11 |
| 100D | 100 | 100/50 | 11 |
| 100PlusD | 100 | 100/50 | 11 |
| 160T | 160 | 125/50 | 13 |
| 200D | 200 | 125/50 | 13 |
| 400D | 400 | 80/40 | 17 |
| P800/1600D | 400 | 80/40 | 17 |
| | 800 | 80/40 | 22 |
| | 1600 | 63/32 | 28 |
| | 3200 | 63/32 | 36 |
| *Duplicating* | — | 125/63 | 9 |
| *Kodachrome professional* | | | |
| 25D | 25 | 100/63 | 9 |
| 40T | 40 | 100/63 | 9 |
| 64T | 64 | 100/63 | 10 |
| 200T | 200 | 100/50 | 16 |

## Color Enhancement

Painters found out centuries ago that sitters prefer an idealized image of themselves, rather than a stark, true likeness. Very early photographers were strongly criticized for too much candor, too much realism. They quickly found ways—soft-focus lenses, clever lighting, retouching—to please their sitters. When color films came along, their makers had similar lessons to learn. Most color films today are made to enhance the natural scene to some extent. Grass must look greener. Skies must look bluer. Desirable flesh tone in a picture does not match real skin any more than does a "flesh-colored" bandage. You cannot just bias the film to green, or to blue, or to flesh, however. That would affect all colors. With it all, neutrals must record as neutrals. (No one wants a green or blue sidewalk).

How is this to be done—this flattering rendition that heightens some colors but that is still true to neutrals? Interlayer, interimage effects do the trick. Chemical messengers are released in one layer during processing; these messengers modulate what is happening in other layers directly above and below, strengthening certain intensities of colors and increasing their vividness.

Different films have these interimage effects to differing degrees. A good example is found in the two professional slide films Kodak makes at speed 100. One is Ektachrome 100-Plus Professional film. As the name suggests, this film has considerable color-enhancing ability. The other 100-speed film has these properties to a minimal extent. Ektachrome 100 Professional film (no "Plus") is chosen by many careful workers for dermatological, dental, and general clinical studies.

Consider the choice of film for clinical photography. The dermatologist wishing to study the effect of a topical preparation to reduce erythema may want to show the redness of the skin as realistically as possible. The normal Ektachrome 100 Professional film is the choice here. On the other hand, exaggeration may be wanted. There are many phenomena in medicine that require some enhancement for study. They are too subtle to be seen unaided. This is why the microscopical contrast-enhancement techniques such as phase and differential interference contrasts were developed. Similarly, just as optical science was called on for the microscopical assist, so can photographic science provide enhancement of subtleties. In the dermatological example the 100-Plus film can enhance small differences that might have been overlooked. It is important in either case that the interpreter of the photographs knows the characteristics of the film being used. It is also important that the same film and technique be used throughout an extended study.

For another example, consider a dental photograph in which capillary detail in the gingiva is important. If the photograph were of the color-enhancing type, even normal tissue might look somewhat inflamed. Such a photo

might be misinterpreted in a court case where a cure for gingivitis was being disputed.

## Slide Duplicates

If you know at the time of taking the original picture that multiple copies of a slide will be needed, multiple originals are the best answer. If the need for copies comes up afterward, duplicates must be made. Whatever the film chosen for the original photography, it is not the best film for rephotographing an existing slide. The contrast of conventional film is fairly high, and that is fine for the original scene. To copy a slide on a conventional film compounds that contrast, giving a copy that is not a "duplicate," but a harsh, contrasty copy. What is wanted is a reproduction that matches the original in color and in contrast. This calls for a gamma of exactly minus one. Ektachrome Duplicating films are built with a gamma of just slightly above minus one to compensate for slight contrast loss due to flare in the copying lens. Another property sets these duplicating films apart from regular films: the peaks of sensitivity of the three layers are made to match the peaks of the dye curves of regular films. This leads to faithful color rendition. A well-made duplicate by this method will be virtually indistinguishable from the original.

## Color Fidelity in Prints and Slides

Workers in BW photography welcomed the forgiveness of the darkroom to take advantage of latitude in films and processes. Of course, all photography is an abstraction, but BW photography is the greater abstraction in that all colors, as well as all brightnesses, are rendered as shades of gray. Thus a given shade of gray could represent any of a multitude of colors at some level of brightness. Colors should not be assigned to objects in BW photographs unless the color of that object is known: green grass, for example. In attempting to answer Whitman's question, "What is grass?," one would undoubtedly begin with a statement about its greenness. In BW photography, however, it is this very greenness that is forever absent. In a photograph grass does not always need to be some specific shade of gray. Its texture and position identify it as grass. It only needs to be somewhat believable in the context of the way other objects are rendered. Viewers mentally add the green, if it is important to appreciation.

In color photography abstraction gives way, to some extent, to realism. The image makes its own statement about the color of objects. In color slides, if the film is good, the light source appropriate, and the processing accurate, the image will be very believable for color. Not necessarily so with the color-negative process. If you ex-

pose a color-negative film and print it with all the possible filter controls the printer provides, how is proper color balance achieved? Without some color standard of reference in the scene, there is nothing reliable to guide the color printer, whether the latter is an automatic machine or a real person.

It is largely this disconnection between the original scene and its image that has prevented the color negative system from being much used in the biomedical field.[33] The greater color reliability of the color slide system is a strong point in its favor.

## Color Negative Film Selection

As with color slide films, there are several ways of categorizing color negative films. The snapshotter/professional arguments apply here. In general, snapshotter films have high interimage effects for "punchier" colors. The films for professional portraiture have less of this. Professional films labeled "commercial" will also have considerable color enhancement.

## Color Prints

The valued latitude of the negative–positive process in BW photography can too easily lead to chaos in color photography. An internal standard in the image is needed to carry us across the gap caused by vagaries in the printing step. That standard is simple: a neutral reference. The Kodak gray card with 18% reflectance is the universal tool. Color patches are not needed for consistent control of color rendition, only that neutral of known reflectance. If it is included in every scene and receives the same illumination as the subject, it can be used in the darkroom to determine the proper exposure and filtration at the enlarger. For aesthetic and clinical reasons, the card may not be wanted in the print delivered to the client. Often, two frames are exposed: one with and one without the card. Enlarger exposure and filtration are determined from the frame with the card, but the frame without is printed. It is only through careful control such as this that color prints can be trusted for their color in clinical photography.

## AFTERWORD

Whole books have been written on just the topic of this chapter. If you want to look further into the fascinating world of photography, the books in the bibliography were chosen for their usefulness. *Photographic Materials and Processes* by four professors from the School of Photography at Rochester Institute of Technology is an excellent next step. For a sense of where you as a photographer fit into the history of image making, read Newhall's

*History.* Photography is a wonderful field in which to work; the more you know about it, the more you will enjoy it.

## ENDNOTES

1. This is why taking film exposed in the laboratory to a local quick processor often gives poor results.
2. *Brightness* is the better understood term, but *luminance* is the preferred scientific term.
3. That this is aesthetically acceptable to us is evident in the use of this principle ever since humans began making shaded sketches.
4. A very dark green safelight is made for panchromatic films with the caution that it only be switched on briefly after development is half over. This depends on two phenomena: The filter emits light at the peak sensitivity of the dark-adapted eye, and any film's sensitivity drops greatly when it is wet.
5. A few very special films are exceptions to the latent image theory as described. They are manufactured with marginally stable development centers on every grain. Light exposure degrades these to a nondevelopable state. This produces a film that requires only conventional processing but gives a positive in one step. All these films have exposure indices of less than 1.
6. This curve goes by several names: *D-log E*, the most common; *D-log H*, among physicists, to whom *H* is exposure; and *H&D* for Hurter and Driffield who invented *sensitometry* and who first plotted these curves in 1890.
7. *Resolving power* of the microscope is a similar concept but is measured in reciprocal terms: the linear separation of two just-distinguishable objects. For microscopes, smaller numbers indicate excellence: for photographic materials, larger.
8. Values of from 5 to 10 are sometimes used.
9. This is why enormous enlargements are possible where they are used as murals or hung in galleries where viewers never approach within several feet of the image. Thinking in terms of angular subtense of the picture and relating this to normal viewing conditions is useful.
10. It is interesting to examine processed films under a microscope, beginning at very low power and proceeding to high. Observe the differences between a low-speed, fine-grain film and very-high-speed coarse-grain film. Examine different densities. Examine the image of a sharp edge. Consider that the graininess seen in a print results from light shining through the spaces between the grains seen in the negative.
11. Trained observers viewing midscale uniform patches can distinguish 6% changes in RMSG. In a scene with detail an average viewer would be much less sensitive to such small differences.
12. See Chapter 3 for a fuller treatment of exposure.
13. The term *reciprocity law failure* is often heard, but it is a misnomer. The law never fails; film fails to follow the law.
14. Snapshot color negative films, where great latitude is needed and quality standards are not as strict as professional ones, have about two stops underexposure and five stops overexposure latitude.
15. Photographers should not push film for the sake of pushing. Push processing is only professionally justifiable when it provides simultaneously ideal contrast, speed, and grain.
16. Even those skillfully using process variation as a valuable tool often find the wetness annoying. The dissatisfaction with wetness seems to be one of the strongest forces propelling electronics to replace silver.
17. There is nothing magic or sacred about 68° F. It was the standard room temperature of British physical and chemical laboratories in the nineteenth century.
18. Earlier editions of the Kodak *Black-and-White Darkroom Dataguide* had a handy dial calculator to convert any known combination of time and temperature to the proper time at the temperature of your choice.
19. Sodium thiosulfate in the commercial powders, ammonium thiosulfate in the liquid concentrates. The old (and mistaken) name for the thiosulfate radical was hyposulfite, hence *hypo*.
20. The family of paper grades shown also differ in speed. Some families of papers are speed-matched in the midtones, needing little or no exposure change when changing paper grades.
21. Since the calibration of different brands of enlarger varies, these values can be taken as a starting point for Kodak papers. Approximate equivalents are shown as grade/CC: 0/24Y, 1/22M, 2/40M, 3/70M, 4/110M, 5/150M.
22. Kodak papers with a *II* or *III* in their names have incorporated developer.
23. Some universities specify fiber-base paper for photographs incorporated in doctoral theses.
24. An improperly adjusted point-source condenser enlarger produces a poor image. Unless you are willing to focus and center the illumination for every change in magnification, you are better off without one. The illumination principle is similar to the Köhler method for transmitted brightfield microscopy. Many electron micrographers use point-source condenser enlargers for printing EM negatives.
25. *Reversal* is perhaps the most ill-chosen term in all photography. The linguist would rightly expect a reversal photograph to be the reverse of the original scene in some major aspect. Not so; it resembles the original scene very closely. For most of the early history of photography the negative process reversed the tones of the original scene, and this dark-for-light version became the norm. (These negatives were, of course, printed by a repetition of the same process to give a light-for-light print.) Later, when a process was finally invented that gave light for light on the original piece of film, this was called reversal. In that process there are two development steps. The first developer generates a negative image, which is then destroyed. The remaining silver halide is then developed by the second developer, giving a positive image.
26. The contrast of reversal film is measured in negative numbers, for example, gamma = −2.
27. An amateur version has only four baths but is only economical for occasional use.
28. For evidence that there really is a *Law of the Perversity of Nature* consider that physically hotter light sources appear "cooler," that is, bluer and that physically colder sources appear "warmer," that is, redder.
29. Some makers of flash equipment "gold coat" their tubes, which lowers color temperature to about 5500 K.
30. A glance at a ceiling of wall-to-wall institutional fluorescent lighting usually shows a "janitor's choice" of different tubes. How could one filter serve to correct all of these?
31. *Pulled* is a term not often seen, but it is useful nonetheless. It stands for using shorter-than-normal development time.

32. The first developer is really the only bath in the E-6 process that can be safely varied by the average photographer, and then only in timing.
33. The other force is the predominant need for lecture slides, rather than prints.

## BIBLIOGRAPHY

Carroll, B. H., Higgins, G. C., and James, T. H., 1980. *Introduction to Photographic Theory: The Silver Halide Process.* New York: Wiley.

Haist, G., 1979. *Modern Photographic Processing,* Vols. 1 and 2. New York: Wiley-Interscience.

Mitchell, E. N., 1984. *Photographic Science.* New York: Wiley.

Newhall, B., 1964. *The History of Photography.* New York: Museum of Modern Art.

Stroebel, L., Compton, J., Current, I., and Zakia, R., 1986. *Photographic Materials and Processes.* Boston: Focal Press.

Thomas, W. (ed), 1973. *Handbook of Photographic Science and Engineering.* New York: Wiley-Interscience.

Wall, E. J., and Jordan, F. I. (revised by Carroll, J. S.), 1975. *Photographic Facts and Formulas.* Englewood Cliffs, NJ: Prentice-Hall.

# Chapter 2
# Optics for the Biomedical Photographer

## Sidney F. Ray

*"Those who are in love with practice without knowledge are like the sailor who gets into a ship without rudder or compass and can never be certain whither he is going. Practice must always be founded on sound theory."*

Leonardo da Vinci 1452–1519

The effective use of photography for biomedical applications is assisted by an understanding and working knowledge of the optical principles involved. These find application at every step from the choice of suitable equipment to evaluation of the final image. This chapter offers information on the behavior of light and optical materials, image formation, general and specific properties of lenses and accessories, plus advice on their selection and testing. Appropriate references give details of mathematical treatment plus case histories and application notes.

## PROPERTIES OF LIGHT AND RADIATION

### The Electromagnetic Spectrum

Energy in the form of electromagnetic radiation is produced by a variety of thermal and other sources. It travels as rays in straight lines, termed *rectilinear propagation*, at a constant velocity in a homogeneous medium and can be considered behaving either as a sinusoidal wave phenomenon or as separate quanta of energy. In the *visible spectrum,* which the eye perceives, such quanta are called *photons.* Deviation of the ray path is caused by reflection, refraction, and diffraction.

Light velocity in a vacuum, irrespective of wavelength, is approximately 299,793 km s$^{-1}$, taken conveniently as $3 \times 10^{10}$ cm s$^{-1}$. A reduced velocity is given in other media, dependent on density.

As a waveform, light *intensity* is the square of the amplitude, while wavelength is the peak-to-peak distance in nanometers (nm). One nanometer is $10^{-9}$ meter. The visible spectrum extends from some 400 to 700 nm; see Figure 2.1.

Light (or radiation) may also be characterized by its frequency, given by dividing the distance traveled in 1 second by the wavelength. Light of wavelength 600 nm and velocity $3 \times 10^{17}$ nm s$^{-1}$ has a frequency of $5 \times 10^{14}$ cycles s$^{-1}$ or hertz (Hz).

## Detection

Electromagnetic radiation is detected and recorded in various ways, depending on the spectral region. Photographic materials may use direct means such as formation of a latent image or indirect means such as fluorescence effects as used in radiography. The natural spectral sensitivity of a silver halide emulsion to wavelengths shorter than 500 nm can be extended to 700 nm by dye sensitization, with a far limit of some 1200 nm for infrared (IR) materials. Beyond this, in the thermal IR bands of 3 to 5.5 $\mu$m and 8 to 14 $\mu$m, other detectors are needed.

Alternative detectors include the photocathode of a TV image tube that emits photoelectrons, accumulation of charge in a focal plane array of charged coupled devices (CCD), changes in electrical conductivity as in photo resistors, and heating effects as in thermopiles.

These latter systems are *point detectors*, rather than *area detectors* like photographic film. A camera uses a lens to form a planar image of the subject on film for recording by a single exposure when a range of intensities can be recorded simultaneously. Other systems can only record intensity at a point so either the scene must be scanned sequentially or a mosaic array of addressable separate detectors used. An imaging system can use an optical system either to form an image directly onto a photosensitive surface or to scan the subject as successive small regions onto a static point detector. The choice depends on circumstances, cost, and logistics.

## Reflection and Refraction

Light interacts with materials in various ways. When light encounters an opaque surface, *specular* or *diffuse reflections* occur.

A perfectly diffuse surface reflects the incident light equally in all directions so that its brightness is seen as constant, irrespective of viewpoint. Few surfaces have

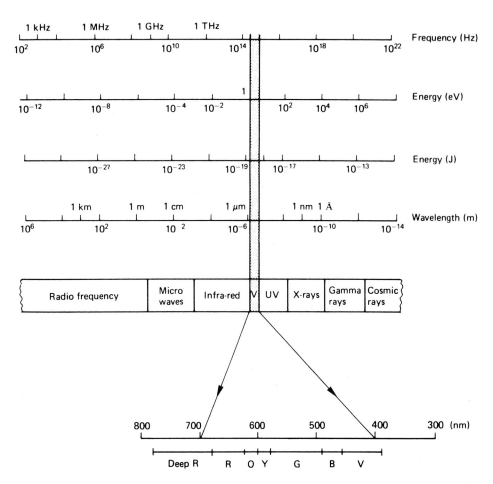

**FIGURE 2.1** The electromagnetic spectrum: the position of the visible portion of the spectrum relative to the other regions of the full spectrum. From *Applied Photographic Optics*, by S. F. Ray, Focal Press, London and Boston (1988), page 11.

such properties, and there is usually a slight sheen, depending on the degree of gloss. Most surfaces have a *reflectance* in the range 2% to 90%, represented by matte black paint and white paper, respectively.

A glossy surface gives little scattering, and a specular reflection of the light source is seen. The incident light is reflected at an angle equal to the angle of incidence, both measured from the normal to the surface. Suppression of reflections may be possible using the properties of polarized light.

Light meeting a transparent surface is partially reflected at the surface, but otherwise transmitted, usually undergoing refraction at this interface between two optical media; see Figure 2.2. The transmitted ray in the second medium has altered velocity, being slower in a denser medium. The ratio of velocities in a vacuum and the medium give the *refractive index* of the medium.

A decrease in velocity causes the ray to be deviated toward the normal and vice versa. This deviation is termed *refraction*. The relationship between the *angle of incidence* ($i$), *angle of refraction* ($r$), and the refractive indices $n_1$ and $n_2$ of the two media is given by Snell's law:

$$n_1 \cdot \sin i = n_2 \cdot \sin r$$

The refractive index of materials varies with wavelength, producing chromatic aberrations. The usual value is quoted for the d-line in the helium spectrum, see Table 2-1, at 587 nm and denoted $n_d$. Gases and liquids change in density with variations in temperature or pressure, causing refraction changes.

A plane parallel-sided block of glass does not change the direction of an incident oblique ray, but the emergent ray is laterally displaced. This can cause image aberrations or a focus shift in the case of glass filters.

Refraction of a ray emerging from a dense medium increases as $i$ increases until a critical value is reached when the ray does not emerge as it has undergone *total internal reflection*. This property is used in reflector prisms and fiber-optic devices.

**Interference and Diffraction**

Certain properties of light are explained only by considering light as a wave motion. Under certain conditions, two monochromatic waves may undergo *interference,* and the resultant intensity may vary between zero for complete destructive interference when the two

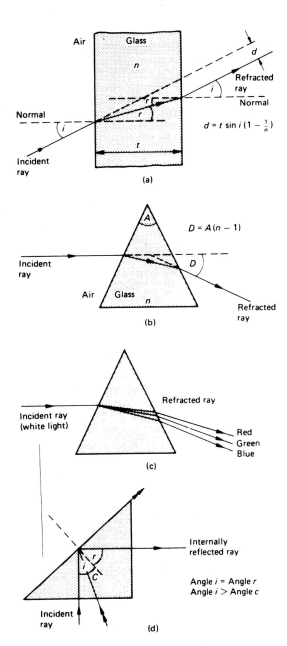

**Table 2-1  Wavelengths and Designations of Spectral Lines (Fraunhofer Lines) Used in Determining Values of Refractive Index and Color Correction of Lenses**

| Designation | Wavelength (nm) | Element | Line Color |
|---|---|---|---|
| h | 404.66 | Hg | Violet |
| g | 435.83 | Hg | Blue |
| F' | 479.99 | Cd | Blue |
| F | 486.13 | H | Blue |
| e | 546.07 | Hg | Green |
| d | 587.56 | He | Yellow |
| C' | 643.85 | Cd | Red |
| C | 656.27 | H | Red |
| r | 706.52 | He | Red |

From *Applied Photographic Optics*, by S. F. Ray, Focal Press, London and Boston (1988), page 24.

**FIGURE 2.2   The interaction of light with transparent glass material and various forms of refraction: (a) light passing obliquely through a parallel-sided glass block, and resultant displacement *d*; (b) refraction of light caused by its passage through a prism, and resultant deviation *D*; (c) dispersion of white light by a prism; (d) total internal reflection in a right-angled prism, critical angle *C*. From *The Manual of Photography*, 8th edition, R. Jacobson, S. Ray, and G. Attridge, Focal Press, London and Boston, page 30.**

waves are exactly 180 degrees out of phase, to a doubling of intensity by constructive interference when they are exactly in phase. One condition is that the waves are *coherent*, usually given by means that will split a wavefront in two, such as two closely spaced slits or pinholes. Another method such as a *thin film* will produce interfering waves by division of the amplitude of an incident beam.

Destructive interference for a particular wavelength removes that wavelength from a beam. Interference effects are usually seen as light or dark or colored bands, called *fringes*.

Note that photography records only the amplitude of light waves as their intensity, but *holography* records both phase and intensity information about the subject in the form of fine interference fringes derived from two coherent beams of light; one is a reference beam and the other is reflected from the subject.

Interference finds practical applications as single or multilayer *antireflection coatings* on lenses and as interference or *dichroic filters* for selective filtration of broad or narrow spectral bands. Interference effects also limit the performance of an otherwise perfect lens by the effects of *diffraction*.

This phenomenon may be considered simply as the tendency for light to spread round the edge of an opaque obstruction. For example, a diffraction grating gives a regular array of obstructions, and transmitted light is spread into a spectrum, as diffraction is wavelength-dependent.

The aperture stop of a photographic lens is variable in size, and at the smaller diameters or large *f*-numbers, diffraction may occur at the perimeter of the iris diaphragm, giving an image of lesser resolving power than expected. For this reason, many lenses have minimum values of *f*/16 or *f*/22, as performance could be degraded progressively beyond this limit. A lens without residual aberrations under specific conditions such as monochromatic light and at a fixed magnification is said to be *diffraction-limited* in performance. Most nonspecialist lenses are *aberration-limited*, as residual aberrations are greater than the diffraction effects, certainly at larger apertures.

## Polarization

A monochromatic beam of "natural" light consists of a series of wavetrains of equal amplitude, identical wave-

length, and random phase relationships. A cross-section of the beam shows component waves to be vibrating in all possible directions, termed an *unpolarized* beam. By passing this beam through a *linear polarizing filter,* only the waves and components of other waves vibrating in a particular direction are transmitted. Light intensity is reduced as well. The phenomenon of polarized light is discussed by Können (1985).

A beam of linear or *plane* polarized light can be converted into *circularly polarized light* by means of a *quarter wave plate,* which is a birefringent material of specific thickness that splits the plane polarized light into two equal perpendicular components with a phase difference of a quarter of a wavelength. The emergent beam proceeds with a circular helical motion. Left- and right-handed circular polarization is possible. A particular use is for control of *glare* due to ambient reflections from instrument and video display unit screens, for after reflection, circular polarized light is not transmitted by the quarter wave plate used to produce it. Such polarized light is also used in *stress analysis* techniques, where birefringent models are stressed in a circular polariscope device.

Circular polarized light is a special form of *elliptically polarized light,* where the two perpendicular components are of unequal amplitude. Circularly polarizing filters have a specialized photographic application with some single-lens reflex cameras that use metal film beamsplitters to sample the light from the lens for exposure determination or for an autofocus system. The beamsplitter varies its percentage split of an incident beam, depending on its amount of linear polarization, which, in turn, can affect exposure determination or light reaching the autofocus module. Circularly polarized light is unaffected.

A linear polarizing filter is very useful in controlling surface reflections from dielectric materials, that is, most materials except metals, which become partly or wholly polarized. Color saturation can be improved. Blue skies may be darkened as scattered light is polarized relative to the sun's position.

## Photometry

Photometry is concerned with the measurement of light and so refers to the visible spectrum with its own unique units. Both Dunn and Wakefield (1981) and Stimson (1974) give detailed information on all aspects of photometry and exposure determination.

The *illuminance* (E) of the real image produced by a lens on film depends mostly on geometrical factors. The *exit pupil* of the lens (the virtual image of the iris diaphragm as seen from behind the lens) is effectively the light source and its center the apex of a cone of light terminating at an image "point." The inverse square law of illumination for point sources, and here there is an

approximation to that, states that illuminance normal to a surface is inversely proportional to the square of the distance from the source. The cosine law of illumination similarly states that for a surface illuminated obliquely at an angle $\phi$ to the normal, illuminance is proportional to $\cos \phi$. Finally, a circular image pupil changes to an elliptical one of reduced area when viewed obliquely. These three effects are independent of f-number. So for an image point at an angle $\phi$ from the axis, attenuation factors of $\cos^2 \phi$, $\cos \phi$, and $\cos \phi$, respectively, are contributed by the three factors above so that:

$$E_\phi = E_0 \cdot \cos^4 \phi$$

where $E_0$ is the axial illuminance and $E_\phi$ the illuminance at angle $\phi$. This relationship determines the natural "falloff" of image illuminance and the covering power of the lens, giving the *image circle.* Wide-angle lenses, where $\phi$ is large and can approach 60 degrees, are most prone to falloff at the periphery of the image.

Various measures are used to counteract this effect. A mechanical method is to use a graduated neutral density filter with maximum central density. A lens design technique involves the use of large negative meniscus lenses as first and last elements, to reduce the ray incidence angles at the aperture stop. Retrofocus construction has a similar effect, reducing the $\cos^4 \phi$ law to about $\cos^3 \phi$. Abandoning distortion correction and permitting extreme barrel distortion gives *fisheye lenses* with semiangular fields of 90 degrees or more and even illumination.

An effect added to these factors is that of *vignetting* by the lens, where, because of its design, off-axis beams are reduced in diameter compared with an axial beam when traversing the lens via an aperture stop. Such beams form the periphery of the image circle, and their loss of intensity shows as a darkening of the image in this region. The effect is aperture dependent, being reduced by progressive stopping down. A detailed explanation is given by Ray (1988).

For photographic purposes such as estimation of camera exposure, photometry of the subject luminance (L) is by means of a hand-held light meter or in-camera metering systems. Suitable combinations of exposure duration (t) and f-number (N) for a given film speed (S) in ISO are given then by solving the equation

$$t = \frac{KN^2}{LS}$$

where K is a constant for the meter.

## PROPERTIES OF OPTICAL MATERIALS

### Glasses, Plastics, and Crystals

Optical glass is the traditional refracting material used for lenses. Early glasses were *crown* and *flint* types whose dispersion increased with refractive index; later varieties

from Schott in 1886 allowed improved correction of lenses, particularly in the flattening of image fields to provide *anastigmatic* lenses. Modern glasses provide adequate means of correcting lenses without excessive surface curvatures.

Transparent plastics have been used for lenses since the 1930s and offer advantages in molding to complex shapes, termed *aspheric* surfaces. Practical difficulties include changes in properties with temperature, their hygroscopic nature, and susceptibility to scratching. Many ancillary optical devices such as diffusers, light guides, focusing screens, and viewfinder elements are conveniently made from polymers.

For recording in spectral regions outside the visible, other materials are used because glass is opaque outside the approximate range of 250 to 2800 nm. Many glasses are opaque below 380 nm so for the ultraviolet (UV), synthetic quartz or fused silica is used instead; the latter are transparent to 170 nm and can be combined with calcium fluoride (*fluorite*) for achromatization. Fluorite is dimensionally unstable with temperature, so the infinity focus setting of the lens also varies. For imagery in the far IR, crystalline materials such as germanium are used to make single element, aspheric lenses for image tubes as used in thermal imaging cameras.

### Reflection, Absorption, and Transmission

The energy budget of light transmission by a lens is $R + A + T = 1$, where $R$, $A$, and $T$ are surface *reflectance*, *absorption* by the medium, and *transmittance*, respectively. To maximize $T$, $R$ and $A$ must be minimized.

Surface reflectance can be reduced by blooming the surface with very thin coatings of material applied by vacuum deposition and electron beam methods. The principle of a single thin layer is that reflections from the air–layer and layer–medium interfaces interfere destructively to enhance transmission. The condition is that the coating has a thickness of one-quarter wavelength ($\lambda/4$) and index $n^{1/2}$, where $n$ is the refractive index of the glass.

In practice, magnesium fluoride is used to give a single hard coating, giving a characteristic purple appearance to the surface by reflected light. Reflectance is reduced to under 2%. A double layer gives less than 1%, while progression to multiple layer "stacks" of coatings in layers of differing thicknesses and refractive indices can reduce values to much less than 1%. Some seven to fifteen layers may be used as needed.

Multiple coatings can also be used to enhance reflectance, as in mirrors for single-lens reflex cameras, or can be spectrally very selective and reflect (or transmit) very narrow spectral bands with sharp cutoff. These are termed *interference filters* and find use in applications such as multispectral photography and color printing. Multilayer coatings can also be used to make IR transmitting or reflecting filters, often called "cold" or "hot" mirrors, respectively.

Optical glass should ideally be spectrally nonselective as regards absorption, but lower-grade glass as sometimes used for condenser lenses absorbs slightly in the red and blue, giving a greenish tinge to the element. By addition of certain minerals to the glass melt, "dyed-in-the-mass" glass is obtained and used for optical filters using absorption effects.

Depending on the nature and number of glasses used in a lens, the image can have a distinctive color bias, noticeable if a range of lenses is used from different manufacturers. Surface coatings may be used to help normalize such effects.

The transmittance ($T$) of a lens is of considerable importance when precise exposures have to be determined, as in cinematography. Light transmittance is usually measured as the *f-number* ($N$) or *aperture stop*, which is defined geometrically. The true *f*-number may be significantly different, so a photometrically determined value, the *T-stop* or *T-number* is preferred instead, defined as

$$T\text{-number} = \frac{N}{(T)^{1/2}}$$

So an $f/2$ lens with transmittance 0.85 has a *T*-stop of $T/2.2$

### Dispersion

Refraction of light is wavelength dependent in that shorter wavelengths are refracted more than longer ones, but in a nonlinear manner. A variety of glasses are needed for lens design correction techniques (Kingslake 1978).

Dispersion by simple glass lenses causes two distinct forms of chromatic or color aberrations. Due to *axial chromatic aberration*, the lens changes focal length with wavelength, increasing with wavelength. Color correction is achieved by combining suitable positive and negative elements of different types of glass, to equalize focal length for two chosen wavelengths. These are commonly the Fraunhofer F and C spectral lines located at opposite ends of the visible spectrum. The lens so corrected is termed *achromatic*. This achromatic doublet has an uncorrected *secondary spectrum*, further corrected by using three glasses optimized for three wavelengths, termed *apochromatic*, although this may just mean a reduced secondary spectrum by the use of special low-dispersion glasses, often termed Extraordinary Dispersion or Extra "low" Dispersion ED glasses.

A lens is not normally corrected for the IR and UV regions, and a *focus correction* must be made after visual focusing, to allow for the different focal lengths of the lens in these regions. The focusing scale may have an IR focusing index. A special form of correction, *superachromatic*, extends correction from 400 to 1000 nm.

By contrast, *transverse chromatic aberration*, or *lateral color*, is dispersion of obliquely incident rays, and the "color-fringing" effects observed worsen rapidly as the image point moves off-axis. It is a difficult aberration to correct, but for general purpose lenses, symmetrical construction is effective. Lateral color sets the performance limits to long-focus refracting lenses, but fluorite and ED glass elements have proved very effective for correction.

Reflecting elements such as full or partial mirrors do not disperse light, and *mirror lenses* can be used for long-focus lenses as well as for UV and IR work and microscopy. Pure mirror designs are called *catoptric* and are not suitable for photography. Additional refracting elements are needed for full aberration correction, giving *catadioptric* lenses.

## PROPERTIES OF LENSES

### Image Formation by Simple Lenses

A *simple lens* consists of a single *element* with two surfaces. One surface may be flat, and the curved surface may be concave or convex. The focal length ($f$) and power ($P$) are given by the lens makers' formula

$$P = 1/f = (n_d - 1)(1/R_1 - 1/R_2)$$

where $R_1$ and $R_2$ are the radii of curvature of the surfaces, being positive in value measured to the right of the vertex of the surface and negative in value measured to the left. Depending on the values for $R_1$ and $R_2$, $f$ can be positive or negative. In terms of image formation, a positive or *converging lens* refracts parallel incident light to deviate it from its original path and direct it toward the *optical axis* and form a *real image* that can be focused or projected on a screen. A negative or *diverging lens* deviates parallel light away from the axis, and a *virtual image*, which can be seen or can act as a virtual object for another lens but cannot itself be focused on a screen, is formed. The location, size, and orientation of the image may be determined by simple calculations. The object and image distances from the lens are termed *conjugate distances* and commonly denoted by the letters $u$ and $v$, respectively. Details of image formation are shown in Figure 2.3.

### Compound Lenses and Cardinal Planes

A simple thin lens is unsuitable as a photographic lens due to aberrations. A practical lens consists of a number of separated elements or *groups* of elements, the physical length of which is a significant fraction of its focal length. This is a compound, thick, or complex lens. The term *equivalent focal length* (EFL) is often used to denote the composite focal length of such a system. For two thin

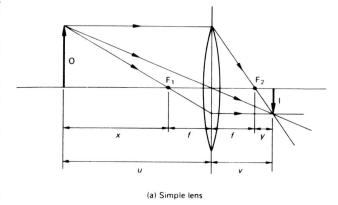

(a) Simple lens

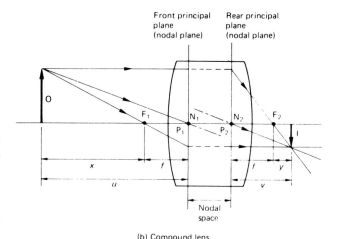

(b) Compound lens

**FIGURE 2.3   Image formation by simple and compound lenses: (a) for a simple lens, distances are measured from the center of the lens; distance *y* is the focusing extension; (b) for a compound or thick lens, distances are measured from the principal or nodal planes (the principal planes coincide with the nodal planes when the lens is wholly in air). From *The Manual of Photography*, 8th edition, R. Jacobson, S. Ray, and G. Attridge, Focal Press, London and Boston, page 33.**

adjacent lenses of focal lengths $f_1$ and $f_2$, the EFL ($f$) is given by

$$1/f = 1/f_1 + 1/f_2 - d/f_1 f_2$$

where $d$ is their axial separation.

Thin-lens formulas can be used with thick lenses if conjugate measurements are made from two specific planes perpendicular to the optical axis. These are the first and second *principal planes*, which are planes of unit transverse magnification. For thin lenses in air, the two planes are coincident. For thick lenses in air, the principal planes are coincident with two other planes: the first and second *nodal* planes. An oblique ray incident on the first nodal plane emerges undeviated on a parallel path from the second nodal plane. The two terms *principal* and *nodal* are used interchangeably, but when the surrounding optical medium is different for object and image spaces, such as for an underwater lens with water in

contact with its front element or an immersed microscope objective, then the two planes are not coincident.

For a symmetrical lens, the nodal planes are located approximately one-third of the way in from the front and rear surfaces. Depending on lens design, they may or may not be crossed over or even located in front of or behind the lens. Detailed information is normally available from the manufacturer of the lens in question.

The third pair of these *cardinal* or *Gaussian* planes are the front and rear *focal planes* through the front and rear principal foci on the axis. Gaussian or *paraxial optics* are calculations involving subjects located close to the optical axis and small angles of incidence. Detailed information about the image and aberrations is not given; instead, ray path traces, using Snell's law at each surface, are necessary. The focal "plane" is curved slightly, even in highly corrected lenses, and only approximates to a plane close to the optical axis.

## Focal Length

A thin, positive lens converges parallel incident light to the rear principal focus on axis. The distance from this point to the optical center of the lens is the *focal length* ($f$). For a thick lens, focal length is measured from the second principal or nodal plane. Parallel light from off-axis points is also brought to an off-axis focus to form the rear principal focal plane. As light is reversible in an optical system, there is also a front principal focus.

The rear principal focus is the closest to a lens an image can be formed. An object inside the front principal focus will give a virtual image, as formed by a simple magnifier or loupe. As the object distance decreases from infinity, the principal focus recedes from the lens, so in practical terms, the lens is shifted away from the film plane or focal plane to focus on close objects.

The conjugate distances and focal length are related by the *lens conjugate equation*

$$1/u + 1/v = 1/f$$

The Cartesian sign convention is suitable, and the lens is taken as the origin so distances measured to the right are positive and to the left are negative.

Useful derived equations are

$$u = vf/(v - f) \qquad v = uf/(u - f)$$
$$u = f(1 + 1/m) \qquad v = f(1 + m)$$

where the image magnification ($m$) is defined as $m = v/u$. For large values of $u$, $v \sim f$ hence $m \sim f/u$. So focal length in relation to a film format determines the *size* of the image. Focal length can be specified also as *dioptric power* ($P$) of the lens, where, for $f$ in millimeters $P = 1000/f$ diopters (D).

Normal sign convention is applicable. A photographic lens of focal length 100 mm has a *power* of +10D and one

of 50 mm a power of +20D. This term is used in optometry and is also used to specify a close-up lens, although other numbering systems may be used by some makers. An advantage of powers is that they are additive; two thin lenses of powers +1D and +2D, placed in contact, give a combined power of +3D.

## Stops, Pupils, and Apertures

As an energy-collecting device, a lens is limited by its physical periphery, with its unobstructed or clear diameter acting as the energy-collecting *aperture*. In a multielement lens the iris diaphragm or element rim that determines the amount of light reaching the film is called the *aperture stop*. The element that limits the angular field of the image is the *field stop*. In a camera this is the *film gate*, and it determines the *film format*. Opening the aperture stop admits more light, while opening the field stop images more of the subject.

A lens also has *entrance* and *exit pupils*, which are the virtual images of the aperture stop as seen axially from the front and rear of the lens, respectively. The cones of light entering and leaving the lens are controlled by the pupils. The *chief ray* of the system passes through the centers of both pupils and the aperture stop. The *viewpoint* of the lens is the center of the entrance pupil. For practical exposure control the aperture stop is made variable as an iris diaphragm, requiring some form of calibration.

The energy admitted is proportional to the area of the entrance pupil, which, if circular, is proportional to the square of its diameter ($D$). The image area illuminated is inversely proportional to the square of the focal length. So the energy flux density at the image plane is proportional to $(D/f)^2$. The ratio $D/f$ is called the *relative aperture* and its inverse ratio $f/D$ is the *f-number* ($N$). The two terms are often confused.

An iris diaphragm usually has *f*-number calibrations 1.4, 2, 2.8, 4, and so on. The largest aperture is $f/1.4$, while each consecutive setting increases the *f*-number by a factor $\sqrt{2}$, which gives a decrease in relative aperture by a factor $1/\sqrt{2}$ and therefore a decrease of flux density by one-half. So $f/2$ admits half as much light as $f/1.4$. Various alternative calibration systems have been tabulated by Ray (1979).

An equation relating exposure durations $t_1$ and $t_2$ required to give equivalent exposures at two *f*-numbers $N_1$ and $N_2$ is

$$t_1/t_2 = (N_1)^2/(N_2)^2$$

The *f*-number may also be defined as $N = \dfrac{\sin \phi}{2}$, where $\phi$ is the semiangle of the cone subtended by the clear diameter of the lens at the focal point. As an alternative to the concept of *f*-number, some optical systems,

particularly microscope objectives, are calibrated in *numerical aperture* (NA) defined as

$$NA = n_d \cdot \sin \phi$$

where $\phi$ is now the semiangle of the cone subtended by the entrance pupil at the object point and $n_d$ refers to the medium in the object space. In air a lens has a maximum NA of 1.0, with values of 0.95 reached in practice. Use of an immersion oil of index 1.5 allows microscope objectives to achieve an NA of 1.42.

For a lens in air the relationship between *f*-number and NA is given by

$$f\text{-number} = 1/(2 \cdot NA)$$

For close-up photography and photomacrography when the lens is considerably extended from the film plane, because of the inverse square law of illumination, the marked *f*-numbers on the lens are no longer correct for exposure calculation purposes. They can be replaced by the *effective f-number* (A) also referred to as the *effective aperture*, where image conjugate *v* replaces focal length, hence

$$A = v/D$$

Other useful relationships are:

$$A = N(v/f) \text{ and } A = N(1 + m).$$

Note that lenses of near symmetrical construction have pupils of approximately the same diameter, but for designs such as telephotos, zooms, and retrofocus lenses the pupils differ markedly in diameter.

The *pupil factor* or *pupil magnification* (P) is defined as the ratio of exit to entrance pupil diameters. Typical values are 0.85, 1.0, 0.6, and 1.4 for a *triplet, symmetrical, telephoto,* and *retrofocus* lens, respectively. Pupil factor is significant in that it modifies exposure calculations for close-up work, and magnification *m* must be replaced by the term *m/P* in relevant calculations or formulas.

## Covering Power

From the laws of illumination a lens produces a circular image, irrespective of the shape of the aperture stop. The film format is positioned inside this *circle of illumination.*

The format dimensions determine the *field angle of view* (W) of the lens. A rectangular format gives three possible values, namely horizontal, vertical, and diagonal. Normally the diagonal value being the largest, is quoted. Field angle is calculated from

$$W = 2 \cdot \tan^{-1}(k/2f)$$

where *k* is the format diagonal.

The value of *W* is maximum for infinity focus; it decreases as the lens is focused closer and reduces to half

this value at unit magnification. For example, the field angle of a 50-mm lens covering the 24 × 36 mm format is 46.5 degrees at infinity focus, but only 24.3 degrees at unit magnification. The lens, however, is still emitting the same size cone of light, and the *covering power* has increased to a circle of diameter 86 mm; this lens at double extension will now cover the 60 × 60 mm format. At sufficiently long focusing extensions for close-up work, large formats can be covered by lenses designed for much smaller formats. Lenses may also be categorized into *standard, wide-angle,* and *long-focus* types in terms of their angle of view; 53 degrees is the value for a standard lens defined as having a focal length equal to the format diagonal; see Table 2-2 for details. This avoids confusion, as the use of focal length to describe a lens can be misleading. A lens of focal length 50 mm could be a standard lens for the 24 × 36 mm format or a wide-angle

**Table 2-2  Classification of Lens Types Related to Focal Length and Format Coverage**

| Focal Length (mm) | Nominal Format (mm) | Angle of View (Degrees on Diagonal) | Lens Type |
|---|---|---|---|
| 15 | 24 × 36 | 110 | EWA |
| 20 | 24 × 36 | 94 | EWA |
| 24 | 24 × 36 | 84 | WA |
| 35 | 24 × 36 | 63 | SWA |
| 40 | 24 × 36 | 57 | S |
| 40 | 60 × 60 | 94 | EWA |
| 50 | 24 × 36 | 47 | S |
| 50 | 60 × 60 | 81 | WA |
| 50 | 60 × 70 | 85 | WA |
| 65 | 24 × 36 | 37 | MLF |
| 65 | 60 × 60 | 66 | SWA |
| 65 | 4 × 5 in | 103 | EWA |
| 80 | 60 × 60 | 56 | S |
| 90 | 24 × 36 | 27 | MLF |
| 90 | 4 × 5 in | 84 | WA |
| 135 | 24 × 36 | 18 | LF |
| 135 | 60 × 60 | 35 | MLF |
| 135 | 4 × 5 in | 62 | S |
| 150 | 60 × 60 | 32 | LF |
| 150 | 4 × 5 in | 57 | S |
| 200 | 24 × 36 | 12 | LF |
| 200 | 8 × 10 in | 78 | WA |
| 250 | 60 × 60 | 19 | LF |
| 300 | 24 × 36 | 8 | VLF |
| 300 | 8 × 10 in | 57 | S |
| 500 | 24 × 36 | 5 | VLF |
| 500 | 60 × 60 | 10 | LF |
| 500 | 4 × 5 in | 19 | LF |
| 1000 | 24 × 36 | 2.5 | ELF |
| 1000 | 60 × 60 | 5 | VLF |
| 1000 | 4 × 5 in | 9 | LF |
| 1000 | 8 × 10 in | 19 | LF |

EWA, extreme wide-angle; WA, wide-angle; SWA, semi wide-angle; S, standard; MLF, medium long-focus; LF, long-focus; VLF, very long-focus; ELF, extreme long-focus.
From *The Manual of Photography,* 8th edition, R. Jacobson, S. Ray, and G. Attridge, Focal Press, London and Boston, page 37.

lens for the 60 × 60 mm format. Most lenses, especially those of large maximum aperture, produce a circle of illumination that is just greater than the *circle of good definition,* which, in turn, just circumscribes the format.

Lenses for large format cameras are designed to have *extra covering power* to allow displacement and swing *movements* of the lens, with the format staying inside the circle of good definition. A covering power of 70 to 80 degrees is common for a standard lens, with the format only requiring some 52 degrees. Even wide-angle lenses for these formats allow a few millimeters displacement for camera movements. Covering power increases slightly but usefully as the lens is stopped down. The lens specification will usually quote the image circle diameter at infinity focus and full aperture plus the amounts of displacement movements possible. Usually an aperture of *f*/22 is regarded as the "working" aperture of such lenses. For smaller formats only, *perspective control* (PC) lenses have additional covering power.

The object field dimensions covered may be calculated for planning of photographic work, to determine the subject area covered by a given lens at a given camera distance by the equation

$$v/u = I/O$$

where $I$ and $O$ are the image and object sizes, respectively. Taking $I$ as a format dimension and for $u$ greater than $20f$ when $v$ may be replaced by $f$, an approximate value for $O$ can be calculated. For example, using a 60 × 60 mm format camera with an 80-mm lens, at a distance of 2 m the object field covered will be approximately 1.5 m square.

## Lens Aberrations

Lens aberrations are imperfections of refraction and image formation that limit the performance of most practical lenses. They are due to the use of spherical glass surfaces for refraction and the variation of refraction with wavelength. There are many aberrations, but only the primary or third order will be described here; all are observable in a simple lens of power say +10D and diameter 50 mm.

A practical lens has many elements for correction, leaving an acceptable residual level of aberrations, which are difficult to detect and isolate.

Introduction of another optical element into a system, such as a poor-quality filter, a close-up lens or a zoom lens in a close-focus mode, may cause a detectable amount of one or more of the primary aberrations.

*Spherical aberration* is due to the use of spherical surfaces and may cause a focus shift on stopping down, although this reduces its effects. The aberration is difficult to cure at large apertures, an *f*/2 lens requiring six elements. Residual amounts cause low-contrast images.

*Coma* causes off-axis image points to be smeared out into comma shape. It is very difficult to cure for large apertures. *Astigmatism* is the inability of the lens to form a point image off-axis, the result being orthogonal lines in focus on two different image surfaces. Almost all lenses are now "anastigmatic" since they are suitably corrected.

*Curvilinear distortion* is the condition where straight lines are rendered as curves. Two distinct types, *barrel* and *pincushion,* can be found, and are due to asymmetry of lens design. Distortion-free lenses are essential for copying work. Zoom lenses in close-focus mode often show barrel distortion.

*Curvature of field* means that the image topography is not flat but curved so that the corners may not be in focus. Again, some zoom lenses in close-focus mode show this aberration. *Axial chromatic aberration* has been discussed, and *transverse chromatic aberration* is an asymmetrical color fringing of image points cured by symmetrical design and ED glasses.

## Flare

Flare or *veiling glare* is a general term for the effects of non-image-forming light that degrades the image in terms of contrast measured as the *flare factor.* The latter is defined as the ratio of subject luminance range (SLR) to image illuminance range (IIR). For a subject of SLR 128:1, the addition of 3 units of flare light uniformly alters the IIR to 131:4, or 33:1.

Flare has three principal sources: camera, lens, and enlarger. The camera body should have suitable blackened surfaces inside as well as for lens hoods and extension bellows. Lens flare is due to both the distribution of highlights within and around the subject and reflections at lens interfaces. An effective lens hood and multilayer coatings on lenses are efficient at reducing flare. Enlarger flare is reduced by suitable masking of the negative and dark surrounds to the enlarger.

## Physics of the Image

A perfect, aberration-free lens still suffers from diffraction, which causes the image of a subject point to be given as the *Airy pattern* of alternating dark and light rings from interference effects. The *Airy disk* is the diameter ($D$) of the first dark ring of the pattern given by

$$D = 2.44\lambda N$$

where $N$ is the *f*-number. For light of wavelength ($\lambda$) 400 nm, $D$ is approximately $N/1000$, that is, 0.008 mm for an *f*/8 lens.

The *resolving power* (RP) of a lens is its ability to resolve fine detail and is quantified by the *Rayleigh criterion* where

two adjacent point sources are just resolved if their Airy disk images overlap to the extent of their radii, hence

$$RP = 1/1.22\lambda N \quad \text{lpm (mm}^{-1})$$

expressed as units of line pairs per millimeter (lpm). An Airy disk of 0.008 mm gives an RP of 250 lpm, but few practical lenses achieve this figure. It is seen that RP increases as wavelength ($\lambda$) decreases and $f$-number decreases, properties used in microscopy.

Resolving power is greatly influenced by subject contrast and shape, and special *test charts* can be used to estimate its value in fixed circumstances. A different idea of lens behavior is given from consideration of its *spatial frequency response*.

An image formed by a lens can be considered as a convolution (summation) of all the Airy patterns from each subject point. The Airy pattern is also called the *point-spread function*. When regular subject intensity patterns—for example, rectangular variations—undergo convolution, as the subject spatial frequency increases (fineness of pattern) the image pattern contrast degrades and then vanishes finally, with uniform intensity. This change in contrast or *modulation* provides a basis of image evaluation.

The spatial frequency ($V$) of a test pattern is the number of complete intensity cycles per millimeter (mm$^{-1}$). The modulation ($m$) of a pattern is given by

$$m = (I_{max} - I_{min})/(I_{max} + I_{min})$$

The change in modulation (contrast) after imaging is given by the *modulation transfer factor* ($M$) where

$$M = m_I/m_O$$

where $I$ and $O$ denote image and object, respectively.

A graph of $M$ against $V$ gives a curve called the *modulation transfer function* (MTF), which is used to evaluate imaging behavior of a lens.

If the intensity pattern is sinusoidal, the pattern after imaging is still sinusoidal, but with a reduction in amplitude. Changes in the positions of the peaks are due to aberrations and are given by the *phase transfer function* (PTF). The composite of the MTF and PTF is the *optical transfer function* (OTF).

MTF data can be useful. A direct use is the determination of best focus setting by the maximum response obtained. MTF theory is applicable to every component in an incoherent imaging chain; their individual responses can be "cascaded" together by simple arithmetic to give the overall response of the system.

A single MTF curve does not fully describe lens performance; many curves have to be generated at different apertures, in monochromatic and white light, at different focus settings, conjugates, and orientations for a better understanding. Lenses may be compared directly under similar conditions and often may be characterized by inspection of their MTF data as being, say, "high image

contrast but limited RP" or "moderate contrast but high RP." Both types give distinctive images and are preferred for specific types of practical work, typically for general purpose recording by the former and copying by the latter. Separate assessments have to be made of other image characteristics such as distortion and flare.

## THE LENS IN USE

### Close Focusing

Most lenses are designed for use with distant subjects (infinity) but may be focused closer over a continuous range. Details of suitable viewfinder systems to assist accurate focusing have been described by Ray (1988). The lens conjugate equation (see section on Focal Length) shows that as the object conjugate decreases, the image conjugate increases, until they are equal to each other at life-size reproduction (unit magnification).

The necessary lens *extension* is provided by a focusing mount or by a bellows extension in the case of large-format cameras. Alternative optical systems may be used; see Figure 2.4. Front cell focusing shifts only the front element or group and is used both in low-cost cameras and some zoom lenses. A better optical performance is given by *internal focusing* where a "floating" negative group is moved axially to give close focus. Practical ad-

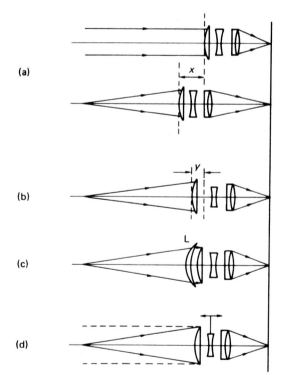

**FIGURE 2.4  Methods of focusing a lens: (a) unit focusing, (b) front cell movement, (c) by use of a supplementary lens L, (d) internal focusing. From *Applied Photographic Optics*, by S. F. Ray, Focal Press, London and Boston (1988), page 167.**

vantages are that only small movement is needed, the lens size may remain constant, and the lens barrel may be sealed against dust. Internal focusing is used with some autofocus lenses. Macro lenses are designed specially for close-up work and may focus to unit magnification.

## Image Magnification

The magnification ($m$) referred to in photography is strictly the transverse magnification, or ratio of image height ($i$) to object height ($o$), both perpendicular to the optical axis. The geometry of image formation gives

$$m = i/o = v/u$$

Magnification can be determined by direct measurement of both $i$ and $o$, or by use of a scaled focusing screen or a scale on the lens-focusing control. Measurements of $u$ and $v$ are more difficult, as the exact location of the nodal planes may not be known. The values of $u$ and $v$ may be calculated from the derived equations (see section on Focal Length) using $m$.

These equations allow calculation of values such as the length of extension tube needed for a specific magnification or the working distance from object to lens for a given magnification. If image magnification is to be set exactly by incremental adjustment of conjugate distances, Wilson's rule may be used as described by Wilson (1964).

At magnifications greater than about 0.1, the exposure corrections necessary to the values of $t$ and $N$ indicated by a hand-held light meter are given by the equations

$$t_c = t(1 + m)^2 \quad \text{when } m \text{ is known}$$
$$t_c = t(v/f)^2 \quad \text{when } v \text{ is known}$$
$$A = N(1 + m)$$
$$A = N(v/f)$$

where $t_c$ is the corrected exposure duration and $A$ is the effective $f$-number.

For certain types of zoom lenses, the exit pupil stays constant, so exposure corrections are not needed in the close-focus region. Naturally, cameras with in-camera through-the-lens (TTL) exposure metering allow automatically for image magnification and changes.

## Depth of Focus and Depth of Field

When viewing photographic images, their apparent sharpness is determined largely by image contrast and the detail resolved. The average eye has a resolving power for low-contrast subjects of some 3 minutes of arc, corresponding to a circle of diameter 0.25 mm at the least *distance of distinct vision* ($D_V$), usually 250 mm. This circle is the *blur circle* or *circle of confusion* ($C$), as an image point with this diameter or less will appear sharp or pointlike.

The diffraction and aberrations present in a practical lens plus the recording medium give an image point as a blur circle. If viewed at $D_V$, image patches smaller than $C$ will be judged as sharp points and unsharp if they are larger. Prints made by enlargement mean that $C$ in the negative must be smaller by the same factor as the degree of enlargement or print magnification ($M$). Typically, for a 24 × 36 mm negative, $C$ is given the value 0.03 mm, giving a blur circle diameter of 0.24 mm when enlarged X8 to give a print size of 192 × 288 mm (7.5 × 11.4 in), which can be viewed comfortably at 250 mm distance.

The value of $C$ is constant for a range of lenses for a given format, but varies with format. Values of 0.06 mm and 0.1 mm are used for the 60 × 60 mm and 4 × 5 inch formats, respectively.

Theoretically, a cone of light emerging from a lens forms an image point at its apex on the film surface when sharply in focus. As the point image cannot be distinguished from a blur circle, however, two imaging situations are possible.

First, the film plane may be displaced axially either side of the optimum focus to intersect the light cone to the diameter of the blur circle, that is, the film plane may be moved a finite distance before the image of a flat subject becomes noticeably unsharp. This total axial distance is the *depth of focus* ($t$) and refers to the image space only. Values of $t$ are given by

$$t = 2CN(1 + m)$$

Usually, except for close-ups, $m$ is small, and the equation simplifies to $t = 2CN$. Note that depth of focus increases for photomacrography when $m$ is large. It is vanishingly small at large apertures, requiring accurate focusing and small tolerances on the flatness and perpendicularity of the film plane. Large-format cameras have increased depth of focus useful to conceal differences between the focusing screen and the film plane in a film holder.

The second consequence is that for a fixed focal plane distance, cones of light from subjects at nearer or farther distances than the focused distance will intersect the film plane with blur circles up to the permissible diameter. The visual effect in the image is of a zone of sharp rendering extending asymmetrically about the focused distance. This zone is the *depth of field* (Figure 2.5) and refers only to the object space in front of the lens. The zone extends farther behind the focused distance than in front. The exact values depend on the focused distance (object conjugate $u$), focal length $f$, $f$-number $N$, and blur circle $C$. The values of the far point limit $D_F$ and near point limit $D_N$ are given by approximate formulas

$$D_F = uf^2/(f^2 - uCN)$$
$$D_N = uf^2/(f^2 + uCN)$$

So depth of field T is given by $T = D_F - D_N$. Depth of field increases as focal length decreases and as the fo-

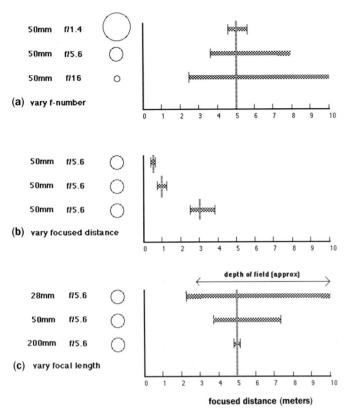

**FIGURE 2.5  Factors controlling depth of field. The effects of the variables focal length (f), f-number (N), and focused distance (u) at a constant value for the circle of confusion (0.033 millimeters). (a) lens aperture varying from f/1.4 to f/16 with 50-millimeter lens focused on 5 meters; (b) focused distance varying from 0.3 to 3 m, with 50-millimeter lens used at f/5.6; (c) focal length varying from 28 to 200 mm focused on 5 meters and used at f/5.6.**

cused distance, f-number, and circle of confusion all increase.

If necessary, values of T can be obtained from a calculator or tables provided with the lens. A *depth of field scale* may be provided on the focusing mount of a lens in the form of a symmetrical array of f-numbers adjacent to the focusing scale. Autofocus lenses do not usually have such information.

An idea of depth of field may be obtained by visual inspection of the image on the ground-glass focusing screen of a large-format camera but is difficult in dim light and small apertures. Few cameras now have a stop-down control on the lens iris for depth-of-field preview.

Maximum depth of field with given values of focal length and f-number is given by setting the focus to the *hyperfocal distance* (H) when sharp focus extends from infinity to H/2. H is calculated from

$$H = f^2/CN$$

This idea is used on fixed focus or "focus-free" cameras, so if C is 0.03 mm, N is f/5.6, and f is 38 mm, then H is 8.6 m and depth of field is from infinity to 4.3 m.

Control of depth of field is one of the most important operating and creative aspects of photography, and manipulation of the variables to achieve adequate sharp focus can be a skilled task. Nowhere is this more evident than in close-up photography and photomacrography. In this work the depth of field is vanishingly small and approximates a plane. The correct viewing distance of the result depends only on the final magnification m, and the equations above can be replaced by one:

$$T = 2CN(1 + m)/m^2$$

When working with technical cameras, the "swings" and "tilts" on the lens panel and at the film plane can be used to manipulate the depth of field in selected regions of the subject. (For details see Stroebel 1986). An object inclined to the optical axis gives an image also inclined to the film plane. To provide overall sharpness, the film back may be "swung" so that the film plane coincides with the inclined image. The depth of field is now inclined to the optical axis and encompasses the subject. The optimum condition is when the extended object plane, lens rear nodal plane, and film plane meet in a common line. This is termed *Scheimpflug's rule* or *condition*.

There are several points of technique in the use of camera movements. Swinging the camera back alters the image shape as well as sharpness, however; swinging the lens panel only affects sharpness. Provided that the lens has adequate covering power, swinging or tilting the lens panel or a combination of front and rear movements may be preferred to accomplish the Scheimpflug condition.

## Perspective

An observer sees a scene in *perspective* in that within the cone of rays entering the visual system, the relationships of size, shape, and distance of the various elements of the scene are fixed. This perspective is due solely to the *viewpoint*, which corresponds to the apex of the cone of rays, or *center of projection*. Photographic lenses normally use *central projection*, where all the rays from the subject converge to this one point and then diverge to the film plane. Alteration of viewpoint changes the perspective of the elements of the scene, while altering the focal length of the lens from the same viewpoint only alters the size of the image.

Perspective in a photograph is considered "correct" when viewing at a distance corresponding to the separation of lens and film when the photo was taken. Usually this distance is the focal length. For an enlarged print, the viewing distance is the product of focal length and print magnification. In practice, photographs taken with lenses of very short or long focal length are viewed in-

stead at a comfortable distance, giving rise to the visual effects of exaggerated and flattened perspective, respectively.

The use of rear swing movements in a technical camera gives changes in image shape due to local changes in magnification. A tall building photographed by pointing the camera upward is recorded as having vertical lines receding to a "vanishing point" of perspective; this gives an unacceptable visual result due to "converging verticals." Suitable camera movements can distort this true quadrilateral shape into a rectangle to remove the converging verticals. Such use of movements is called perspective control, to produce a preferred rendering of perspective of the subject. (For details see Stroebel 1986).

## TYPES OF LENSES

### The Standard Lens

The standard lens is defined as one whose focal length is the same as the diagonal of the format, with an angle of view of some 53 degrees. There are considerable departures from this requirement, and for the 24 × 36 mm format, values of 35 to 58 mm are encountered, rather than the "correct" 43 mm. The development of the photographic lens has been fully documented by Kingslake (1989). Modern lenses are of several distinct design types, as summarized in Table 2-3.

The *triplet* lens uses three air-spaced elements just sufficient to correct the third-order aberrations adequately. It is a low-cost, modest aperture lens used up to about $f/3.5$. More significant are its *derivatives* given by splitting its single elements into multiple ones and compounding by cementing elements. The Tessar-type design is a triplet, with a rear-cemented doublet group, giving excellent performance to $f/2.8$, provided camera movements are not needed.

Symmetrical *double anastigmatic* lenses use similar groups of components in mirror image either side of the iris diaphragm. They have exceptional covering power, allowing use of camera movements, and have low distortion for copy or architectural work. Residual uncorrectable aberrations limit the maximum aperture to $f/5.6$, however.

The *double-Gauss* design was originally made by using two telescope objectives in a symmetrical arrangement. This provided excellent results; further compounding into derivatives gave designs such as the *Planar*, so named for its flat image field. Similar designs are now dominant for any standard lens needing an aperture larger than $f/2.8$. Six elements offer good results at $f/2$, while seven are needed for $f/1.4$. The design has also been adapted for macro lenses and for enlarger lenses.

### Long Focus Lenses

This type has a focal length exceeding the format diagonal. Note that "standard" lenses for cine and video have a greater focal length than the diagonal so as to give greater working distances and hence better perspective.

Long focus lenses are useful for giving large images of distant or inaccessible subjects and to control perspective by use of camera position. The original *Petzval portrait lens* was used as such, since it only gave an acceptable performance over a narrow field. Modern triplet and double-Gauss designs and their derivatives can provide both long focus and a large aperture if required. Lens design becomes simpler with increase in focal length, as a narrower field is covered. Performance is limited by the cost of the large elements needed and presence of uncorrected lateral color. Costly ED glass may be used for improved performance. Many designs aim for high-contrast images at full aperture at the expense of resolving power, so as to offset the effects of haze and to allow use of short shutter speeds to reduce camera shake. For hand-held use, a useful guide to shake-free use is to use a shutter speed numerically equal to or less than the reciprocal of focal length, so a 500-mm lens needs a shutter speed of 1/500 second or less.

An efficient and long lens hood is needed to reduce flare. The focusing extension needed for close focus is considerable, so for economy of design, close-up lenses may be used instead. The length of the lens means that an automatic iris diaphragm may not be fitted. Refracting long focus lenses are often preferred to more compact mirror lenses, as they can be stopped down well to provide the necessary depth of field.

### Telephoto Lenses

The term *telephoto* is often used to describe any long focus lens, but it is specific to an optical construction that gives a physical length significantly shorter than the focal length. This is done by having the rear group of negative power in the manner of the Barlow lens in astronomy and the addition of a *teleconverter* attachment.

Depending on the aperture required, variants of the triplet and double-Gauss designs are used. Early designs suffered from pincushion distortion due to their asymmetry, but this has largely been cured. Advances in optical glasses and optical design allow telephoto lenses to have improved close-up performance and large apertures up to $f/2$, giving the class of lenses termed *super telephotos*. Particularly useful is the provision of internal focusing, whether manual or autofocus, where the dimensions of the lens do not alter and the barrel may be sealed. The compact nature of the lens is an advantage in a number of ways, especially for portability and hand-

**Table 2-3  Summary of Types of Lenses and Their Uses**

| Name or Type | Basic Optical Construction | Exceptional for | Poor for | Special Features or Advantages of This Design or Construction | Uses |
|---|---|---|---|---|---|
| Meniscus | | | A,D,F | Cheap, low flare | Simple cameras, close-up lenses |
| Landscape | | CA | A,F | Achromatic | Simple cameras, close-up lenses |
| Soft-focus portrait | | | Deliberate spherical aberration | Controllable residual aberrations | Portraiture |
| Petzval | | S | A,F | Large aperture, good correction | Portraiture, projection |
| Symmetrical | | D | F | Distortion-free | General |
| Double anastigmatic | | D | S | Distortion-free, components usable separately | General |
| Double-Gauss | | S,C | D | Large apertures possible | Low light level work |
| Triplet | | | | Good correction for all aberrations, cheap | General |
| Quasi-symmetrical | | D | | Wide-angle lens, distortion-free | Aerial survey work, rangefinder cameras |
| Process | | All | | Highly corrected | Copying and close-up work |
| Telephoto | | | D | Short back focus, compact | Long-focus lens |
| Retrofocus | | | D | Long back focus, reflex focusing | Wide-angle lens for SLR cameras |
| Fisheye | | | Deliberate distortion | Field angle exceeding 180°, reflex focusing | Cloud studies, special effects |
| Zoom | | | D | Variable focal length with constant $f$-number | General |
| Mirror | | S,CA,L | A,F | Compact construction, lightweight | Long focus lens |

S, spherical aberration; CA, chromatic aberration; L, lateral color; C, coma; A, astigmatism; D, distortion; F, field curvature.
From *The Manual of Photography*, 8th edition, R. Jacobson, S. Ray, and G. Attridge, Focal Press, London and Boston, page 73.

held use, but the rule for minimum shutter speed still applies.

## Mirror Lenses

Without special ED glasses or use of fluorite, long lens performance is limited by chromatic aberrations. The use of a mirror surface, which does not disperse light, is a viable alternative.

A practical design is of the Cassegrainian configuration, which folds the light path back on itself twice for compactness, and the user points the lens toward the subject. The main mirror has a central hole to transmit the light from the secondary mirror.

Spherical mirrors are used because they are much more economical than the aspherical astronomical kinds, but the aberrations created need correction. Two possibilities are to use thick, curved refracting elements near the center of curvature and to support the secondary mirror (Bouwers-Maksutov lenses), or to make the mirrors rear-silvered types behind thin meniscus lenses (Mangin mirror-type lenses). An all-mirror design is termed *catoptric*, but use of refracting elements as well gives a *catadioptric* type. Compact designs of specifications such as 500-mm $f/8$ and 1000-mm $f/11$ are available. The unique design of such a lens has some practical consequences. The entrance pupil is annulus shaped due to the central obscuration and so the out-of-focus highlights in the image take on a doughnut shape.

An iris diaphragm is not provided due to mechanical problems, and exposure is controlled by varying the shutter speed only or by use of neutral density filters. Filters in front of the lens need to be of very high quality and large. More conveniently, rear mounted filters or an internal "turret" of filters may be used. A filter must always be in place, as the lens has been designed on this assumption. The maximum aperture in practice may be found to be less than quoted due to the obscuration of the secondary mirror.

Close focus to very near distances may be given by a very small movement of the secondary mirror, in contrast to problems with long focus lenses. The catadioptric design means that IR focusing still needs separate calibration due to residual dispersion.

The optical design needs very careful internal baffling to prevent flare, and a lens hood is vital. The mounting and assembly of the lens is critical for good performance. There may not be an infinity stop on the focus control, as thermal effects can give a small change in focal length.

## Wide-Angle Lenses

A wide-angle lens is one whose focal length is significantly less than the diagonal of the format in use, given that the format is covered at infinity focus. Note that a *short focus* lens of similar or lesser focal length may be capable of covering the format only with a considerable bellows extension, for example, in photomacrography.

Desirable properties are a wide field of view with a large, usable aperture and uniformity of image illumination. Several distinct design types are available.

Symmetrical designs with short back focus distance (BFD) are widely used in rangefinder and technical cameras, giving excellent correction with low distortion. The maximum aperture is limited to about $f/6.3$ for focusing only, and $f/22$ is the useful "working" aperture.

Both aperture and image illumination can be significantly improved by adding large negative lens groups in front and behind to give a *quasi-symmetrical* derivative design. A maximum aperture of $f/5.6$ and field of 100 degrees is typical. Retention of symmetry of configuration gives distortion-free results. The use of a *center-spot* or *radially graduated ND filter* improves edge illumination at the usable larger apertures. Apertures of $f/2.8$ are possible in lenses for rangefinder cameras.

Both types of lenses have their nodal planes located inside the lens itself, giving very short BFD, with their rear elements very close to the film plane. Obviously, there is insufficient clearance for a reflex mirror.

The alternative is to use a *retrofocus* lens design, sometimes called an *inverted telephoto* lens. This departs from symmetry by using a front negative, divergent group with a rear positive, convergent group. This arrangement causes the nodal planes to be located between lens and focal plane, so the BFD is greatly increased. For example, with a 35-mm single-lens reflex camera, a BFD of some 46 mm may be needed, but lenses of focal length 35 to 15 mm may be fitted for reflex focusing. Prior to such designs, the reflex mirror had to be locked up and a symmetrical lens used with a separate viewfinder. The effect of lens configuration on the positions of nodal planes is illustrated in Figure 2.6.

The retrofocus design has some advantages. The negative front group reduces the angle of incidence of rays at the aperture stop, permitting wide angles with uniform illumination. The negative group also reduces Petzval field curvature. To achieve the necessary performance, the lens may need from seven to fifteen elements, giving a bulky, heavy, and expensive lens. The asymmetry of design may cause barrel distortion, but recent designs have reduced this residual aberration to acceptable levels.

Maximum apertures as large as $f/1.4$ are available but may necessitate an aspherical element or two for correction. Many lenses feature close focusing to 300 or 200 mm, as the necessary focusing extension is only a few millimeters, but lens performance usually falls off markedly at such conjugates, especially at large apertures. To correct for this, some lenses feature a floating

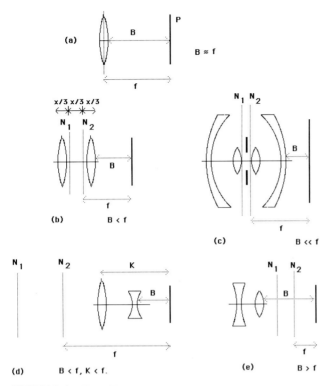

**FIGURE 2.6** The effects of lens design configurations on the positions of nodal planes and back focal distance: (a) a simple lens or "singlet"; (b) symmetrical; (c) quasi-symmetrical; (d) telephoto, where K/f is the telephoto ratio; (e) retrofocus. *P*, film plane; *B*, back focal distance; *f*, focal length; $N_1$, front nodal plane; $N_2$, rear nodal plane.

element, where an element or group moves axially, usually coupled to the focusing control.

Many retrofocus lenses give excellent performance when used for photomacrography if mounted in reverse by a suitable *lens reversing ring*. This arrangement also gives a usefully long *working distance* from lens to subject.

The design is suitable for field angles up to about 110 to 120 degrees when correction becomes difficult and uniform illumination a problem. If, however, distortion correction is abandoned and large amounts of barrel distortion are permitted, then field coverage is possible up to 180 to 220 degrees. Such an extreme retrofocus design is called a *fisheye lens*. Reflex focusing is still possible, even with a focal length of 6 to 8 mm.

There are two varieties of fisheye lens. The quasi-fisheye or full-frame type has a field angle in azimuth of some 180 degrees along the diagonal, and the image circle just circumscribes the format. There is pronounced barrel distortion.

The true fisheye lens has a specific form of barrel distortion and gives a circular image within the format dimensions. For a conventional lens, the condition for distortion-free results is that an incident ray of semifield angle *x* emerges inclined at an angle *y* to the optical axis and that *x* and *y* are equal. This is called *central* or *rectilin-*

*ear projection*. The distance *Y* of an image point from the optical axis in the film plane is given by the formula

$$Y = f \cdot \tan(x)$$

By comparison, a fisheye lens may use either $Y = f \cdot x$ (where *x* is in radians) or $Y = 2f \cdot \sin(x/2)$, referred to as *equidistant* and *equisolid angle* projection, respectively. Fisheye lenses find numerous applications in biomedical work such as cloud cover, foliage growth, and in-water photography, where extreme angular coverage is needed.

## Zoom Lenses

A zoom lens is one whose focal length can be varied continuously between fixed limits while the image stays in sharp focus. The visual effect is that of a bigger or smaller image of the subject as the focal length is increased or decreased, respectively.

Zoom lenses are sometimes alternatively called *pancratic* or *parfocal* lenses. A variant is the varifocal lens where the focus is not held constant during zooming, but needs a slight correction after each change in focal length. For this slight inconvenience the lens can be of improved performance. Zoom lenses for still and cine projectors are often varifocal types.

The *zoom ratio* is the ratio of longest to shortest focal length, so that a 70 to 210 mm zoom lens has a zoom ratio of 3:1. For 35-mm still photography zoom ratios of 2:1 to about 7:1 are used, but for cinematography and video, where the formats are physically much smaller, zoom ratios of 10:1 and 20:1 are common and even 50:1 is available.

The optical theory of a zoom lens is simple. Since the equivalent focal length of a number of separated elements is a function of their individual powers and separations, then an axial movement of one element will change the equivalent focal length. A simple zoom lens would be a front negative lens plus a rear positive lens when reducing their separation increases the equivalent focal length. Such a simple lens, however, would suffer horribly from residual aberrations, and the image would not stay in focus. Between eight and twenty elements may be needed to provide a sharp, in-focus image.

The true zoom lens retains a sharp image by means of *compensation*, where one or more groups of elements move in conjunction. With *optical* compensation, the groups are coupled together and move similar amounts, but with *mechanical* compensation the groups move at different rates and in different directions. The latter arrangement gives improved possibilities of correction.

The classic form of zoom lens uses four groups of elements. Two movable zoom groups are located between a front group used to focus the lens and a rear fixed group, which also contains the iris diaphragm.

Aperture is kept constant as focal length changes, since *f*-number depends on the size of the exit pupil.

The front cell focusing arrangement limits close focus to 1 m or more, which is an operational inconvenience. Often a so-called *macrozoom* or *close-focus mode* is provided that uses the zoom groups in another way. Thus at a fixed focal length, which may be the maximum or minimum value, one group is moved to provide internal focusing over limited close-up range. There may be a "focus gap" between the normal close focus distance and the far point of the close-up range. The *f*-number may stay almost constant over the close-up range, but optical performance is generally poor, with noticeable curvature of field and distortion.

Zoom lenses are prone to suffer from residual distortion due to their asymmetrical construction, giving pincushion distortion at the long focal-length setting and barrel distortion at the short focal-length setting. Distortion may be lower at an intermediate value, but its presence does limit the use of zoom lenses for work where accurate rendering of straight lines is important.

Contemporary zoom lenses now make extensive use of mechanical correction, often with up to four groups moving in nonlinear manner. Additionally, with the use of aspheric elements and low-dispersion glass, the lenses may be very compact and need fewer elements. Continuous close focusing is now common by movement of the whole lens. The previously difficult zoom range from wide-angle to standard focal length is now common.

A significant penalty has been that the *f*-number usually changes with focal length, causing a loss of one-half to one full stop from minimum to maximum focal length. This is due to the change in exit pupil size as the rear group moves. Fortunately, since most cameras are equipped with TTL metering, this change in *f*-number is automatically compensated.

The zoom lens is primarily a viewfinder-oriented lens and carries little information on its controls as to focal length, focus, or depth of field, especially so in the case of autofocus varieties. The zoom lens is a useful tool for general purpose, noncritical photography. A single lens, possibly of 28 to 90 mm specification, with close focus to a magnification of 0.25, can perform adequately for many tasks, especially if a medium aperture of *f*/8 to *f*/11 can be used. Zoom lenses are of modest maximum aperture, typically *f*/4 and rarely *f*/2.8, and likely to remain so. For tasks demanding a large aperture lens, the prime fixed focal length lens is needed. There are very few zoom lenses for medium formats, and these are of modest range and aperture.

## Macro Lenses

The aberration correction of a lens design is specific for only one object conjugate distance, and since most lenses are used to record distant scenes, this conjugate is taken as being infinity. For photographic purposes, *infinity* may be defined as more than 200 focal lengths distant.

Lenses are corrected for infinity focus, and, in general, their performance will deteriorate at close focus, dependent upon their particular design and the aperture used. Measures such as floating elements and lens reversal rings can improve performance, but it is preferable to use a lens designed with optimum correction for a finite object conjugate. These are usually called *macro lenses*, and various types are available. The designation *macro* should strictly be reserved for lenses that are capable of giving life-size reproduction or unit magnification. Many do not.

The macro lens available as an alternative to the standard lens for a single-lens reflex camera features an extended focusing mount using a double helical arrangement. This may have enough extension for a magnification of 0.5, but some give 1.0, especially the variety for autofocus cameras, as provision of extension tubes and bellows is difficult. The reduced range to one-half life size gives a more compact lens, and a special extension tube is used for the 0.5 to 1.0 range. Lenses have full automation of aperture and metering at maximum aperture. Correction is optimized for a magnification of 0.1 and holds well down to 1.0, when the lens is best used in reverse, usually with loss of most of the automatic features.

The lens barrel carries additional scales of magnification and exposure correction factors. The latter is used with conventional electronic flash as TTL metering systems cope with exposure corrections for magnification, when electronic flash of the dedicated variety is used, controlled by a photocell in the camera.

Macro lenses use triplet or double-Gauss derivative designs to provide flat image fields and the distortion correction essential for critical copying work. The maximum aperture is seldom better than *f*/2.8, and for distant subjects it is advisable to close down two stops from maximum for optimum results. Contemporary designs often make use of a floating element for additional correction, and eight to ten elements may be needed. The lenses also tend to have a longer than standard focal length, typically in the range from 55 to 135 mm, to give longer working distances to the subject and, again, to ensure better correction over the smaller subject field covered. The macro lens is a most versatile, high-quality lens. It is a recommended alternative to the conventional standard lens if a large aperture is not needed. It is possible to purchase just a *lens head*, which is the optical unit minus the focusing mount and meant for attachment directly to an extension bellows so as to give continuous focusing from infinity to twice life size or better.

The true form of macro lens, as exemplified by the Luminar range from Zeiss (Oberkochen, Germany), is just an optical unit in a lens mount using the Royal Micro-

scopical Society (RMS) microscope thread fitting for attachment to an extension bellows or camera via a conical lens panel. The lenses are optimized for an image conjugate of typically 250 mm in much the same manner as microscope objectives are for 160 mm. A range of focal lengths is needed for a range of magnifications. The true photomacrography range from magnification 1.0 to about 50 can be covered. The iris diaphragm is usually calibrated not in $f$-numbers, as these are meaningless at such magnifications, but in *exposure increase factors,* with maximum aperture having a value of one.

## Copying Lenses

A variety of lenses are designed for copy work with specific values or ranges of magnifications. These include *process lenses* and cathode-ray tube (CRT) display *copy lenses.*

A process camera is a precision copy camera for originals and formats up to 30 × 40 inches or more. Primary uses are for line or screen work and color separations for photomechanical printing processes. The magnifications used vary from about 0.5 to 2.0, in general. Highly corrected lenses of long focal length are needed to cover such large areas. To give the high levels of color correction needed and distortion-free flat image fields, lens designs are apochromatic with symmetrical configurations and maximum apertures of $f/9$ or less, reduced to $f/22$ or $f/32$ for a working aperture. Focal lengths of 150 to 2000 mm are used.

Wide-angle versions covering a field of 70 degrees save darkroom space. The aperture may be in the form of individual Waterhouse stops or calibrated in millimeters. The lenses are generally unsuitable for use on conventional large format cameras for distant subjects.

A video monitor or oscilloscope screen showing a static or transient phosphorescent trace presents a different copying task. The need is for a large aperture lens to record the images of low luminance or high writing speeds. Fortunately, as the screen image is monochromatic, the lens may be color corrected for this wavelength alone, permitting apertures as large as $f/0.7$. Also by specifying a fixed magnification such as 0.25, optimum results may be obtained and the image corrected to be flat from a curved phosphor screen. Special recording materials may be used.

## Enlarger Lenses

While contact printing is still useful for large-format negatives, the majority of film formats are enlarged by projection printing. Specific lenses are designed for enlarging so as to retain, as far as possible, the detail inherent in the negative.

In general, the enlarger lens should cover the format and have a focal length equal to the length of the diagonal of the format. Wide-angle lenses of shorter focal length are useful, as they allow greater enlargements with a fixed column length and easier access to controls.

Large apertures, as given by double-Gauss-type lenses, are seldom needed other than to facilitate focusing. In use, the lens is normally closed down two or three stops to operate optimally. Use of large apertures of, say, $f/2.8$ would require the negatives always to be held flat between glass to give overall sharp focus. Use of a symmetrical construction is ideal for enlarger lenses in spite of the modest maximum aperture of $f/5.6$, as distortion-free results are possible at the close conjugates used. Budget-priced lenses may be of triplet or Tessar-type constructions but are used in reverse mode compared with camera use. A camera lens may be adapted to enlarger use but is not the preferred choice.

Enlarger lenses need an astigmatically flat image field perpendicular to the optical axis and parallel to the object plane, which is the negative. Better-quality lenses are optimized for a given magnification (degree of enlargement), typically 10, or a specific range.

Color correction must suit color paper and variable grade papers as well as the normal blue-sensitive materials, and so it is achromatic, but apochromatic versions are available too.

The aperture control operates a click-stopped or preset iris diaphragm, which may be calibrated in $f$-numbers or more usefully, exposure increase factors relative to unity at full aperture. An illuminated scale is a great operational convenience. Good image contrast is ensured by multicoatings and antiflare measures.

Enlarger lenses may readily be adapted for close-up photography, photomacrography, and slide duplication, as their correction for finite conjugates suits them to these tasks. Conveniently, many lenses have a 39-mm screw fitting as standard.

## Projector Lenses

Photographic images in the form of *diapositives* or film sequences may be optically enlarged by projection in a slide projector or cine projector, respectively. The lenses used differ significantly from camera lenses.

For slide projection, interchangeable lenses allow a focal length to be chosen to cover the format size and to fill a standard screen at various projection distances. The usual focal length for a 24 × 36 mm slide is 85 to 90 mm, to give an image at a distance of some 4 m for convenient viewing.

The heat from the illumination system may cause an unglazed image to pop out of focus, necessitating some form of autofocus system or use of special lenses that

variations in resolving power expressed as line pairs per millimeter. The criterion for limiting resolution is that a pair of targets are just visibly resolved from the background. With care, repeatability may be of the order of 10%.

The main limitation is that a single figure of merit is not given for performance, and it is a composite value. Also general purpose films may not be able to fully resolve the detail given by highly corrected lenses, but the use of fine grain, high-contrast materials may not be representative of the system in use.

Another serious criticism is that the chart is used at finite conjugates when lenses are optimized for distant subjects. Photographs of a distant scene can form an additional check, especially for evenness of illumination.

Nevertheless, the lens test chart is a useful tool for comparative purposes. A lens may be evaluated at each aperture and the optimum found. Lenses can be compared, given suitable precautions regarding processing of the film. The accuracy of focusing or lens-to-film registration can be checked by a series of exposures through the visual focus setting.

Enlargers and enlarger lenses can be aligned and evaluated by projection of a test negative. Test slides may be used for projectors, and a range of test·films are available for checking cine projectors.

### Modulation Transfer Function Testing

MTF data give additional information on lens performance, complementary to resolving power tests. Access to MTF test equipment is limited due to cost, but lenses having such data may be purchased.

It is important to remember that the information applies to the lens performance alone. Other systems in the imaging chain such as film, image intensifiers, and enlarger lenses may be evaluated in the same way for the cascading of data.

Lens manufacturers routinely use MTF measurements on the lens production line, where an MTF trace produced under standard conditions may be compared with pass–fail limits for acceptance or rejection of the lens. Such measurements accurately give the best focus position that allows flange focal distance and focal length to be determined accurately. The variation of MTF with axial rotation of the lens can detect asymmetrical performance due to incorrect assembly or centering of the lens elements.

### REFERENCES

Dunn, J., and Wakefield, G., 1981. *Exposure Manual,* 4th ed. Watford, U.K.: Fountain Press.

Kingslake, R., 1978. *Lens Design Fundamentals.* London: Academic Press.

Kingslake, R., 1989. *A History of the Photographic Lens.* London: Academic Press.

Können, G., 1985. *Polarized Light in Nature.* Cambridge, U.K.: Cambridge University Press.

Ray, S., 1979. *Focalguide to Larger Format Cameras.* London: Focal Press.

Ray, S., 1979. *The Photographic Lens.* London: Focal Press.

Ray, S., 1988. *Applied Photographic Optics.* London: Focal Press.

Stimson, A., 1974. *Photometry and Radiometry for Engineers.* Chichester, U.K.: Wiley.

Stroebel, L., 1986. *View Camera Technique,* 5th ed., London: Focal Press.

Wilson, E., 1964. Camera adjustments for accurate size images. *J. Photogr. Sci.* 12:328–330.

### BIBLIOGRAPHY

Arnold, C., Rolls, P., and Stewart, J., 1971. *Applied Photography.* London: Focal Press.

Beynon, J., 1988. *Waves and Optics.* Basingstoke, U.K.: Macmillan Education.

Blaker, A., 1989. *Handbook for Scientific Photography,* 2nd ed. London: Focal Press.

Brandt, H., 1968. *The Photographic Lens.* London: Focal Press.

Brock, G. C., 1970. *Image Evaluation for Aerial Photography.* London: Focal Press.

Consitt, F., and Mandler, W., 1971. OTF techniques in the routine testing of lenses. *Optica Acta* 18:123–130.

Cox, A., 1964. *Photographic Optics.* London: Focal Press.

Dainty, C., and Shaw, R., 1974. *Image Science.* London: Academic Press.

Dobrowolski, J., and Mandler, W., 1979. Color correcting coatings for photographic objectives. *Appl. Optics* 18:1879–1881.

Driscoll, W., 1978. *Handbook of Optics.* New York: McGraw-Hill.

Franke, G., 1966. *Physical Optics in Photography.* London: Focal Press.

Franks, E., 1970. Testing the performance of slide projectors. *Br. J. Photogr.* 117:622–626.

Glatzel, E., 1978. Novel lens designs for motion picture cameras. *J. Soc. Motion Pict. TV Engrs.* 87:1–10.

Goldberg, N., 1976. Lens faults can be beautiful. *Popular Photogr.* 83(7):82–90.

Goldberg, N., and Frank, M., 1974. Hell on hardware. *Popular Photogr.* 81(8):69–78.

Hecht, E., 1975. *Schaum's Outline Series: Theory and Problems of Optics.* New York: McGraw-Hill.

Hecht, E., and Zajac, A., 1979. *Optics.* London: Addison-Wesley.

Hoogland, J., 1980. Systematics of photographic lens types. *Proc. SPIE* 237:216–220.

Horne, D., 1972. *Optical Production Technology.* Bristol, U.K.: Adam Hilger.

Horne, D., 1980. *Optical Instruments and Their Applications.* Bristol, U.K.: Adam Hilger.

Jacobs, D., 1943. *Fundamentals of Optical Engineering.* New York: McGraw-Hill.

Jacobson, R., Ray, S., and Attridge, G., 1988. *The Manual of Photography,* 8th ed. London: Focal Press.

Jenkins, F., and White, H., 1981. *Fundamentals of Optics,* 4th ed. London: McGraw-Hill.

Kingslake, R., 1983. *Optical System Design*. London: Academic Press.

Kondo, H., and Yamaoka, H., 1977. New criteria for the evaluation of interchangeable lenses. *Opt. Engng.* 16:601–616.

Kondo, H., et al., 1981. Veiling glare in photographic systems. *Phot. Engng.* 20:343–350.

Kornder, F., 1972. Circular polarisers for the Leicaflex SL, *Leitz Information* 2:82–84.

Lefkowitz, L., 1983. Lenses: Facts and fallacies. *Modern Photogr.* 46(9):75–82.

Macher, K., 1980. New projection lenses for 35mm cinema projectors. *J. Soc. Motion Pict. TV Engrs.* 89:465–470.

Macher, K., 1981. Variable focal length lenses for color television cameras. *J. Soc. Motion Pict. TV Engrs.* 90:695–702.

Malacara, D., 1978. *Optical Shop Testing*. Chichester, U.K.: Wiley.

Mandler, W., 1980. Design of basic double Gauss lenses. *Proc. SPIE* 237:222–230.

Matsuda, S., and Tadayoshi, H., 1972. Flare as applied to photographic lenses. *Appl. Optics* 11:1850–1856.

Matsui, Y., 1981. Use of calcium fluoride for zoom lenses. *J. Soc. Motion Pict. TV Engrs.* 80:22–24.

Miyamoto, K., 1964. Fisheye lenses, *J. Opt. Soc. Am.* 54:1060–1061.

Morton, R. (ed.), 1984. *Photography for the Scientist*, 2nd ed. London: Academic Press.

Neblette, C., 1965. *Photographic Lenses*. London: Morgan & Morgan.

Osterloh, G., 1984. 280 mm f/2.8 Apo-Telyt-R. *Leica Fotografie* 36(4):38–39.

Ostroff, E., 1984. Photographic enlarging: A history. *Photogr. Sci. Engng.* 28:54–70.

Parker, S. (ed.), 1987. *Optics Source Book*. New York: McGraw-Hill.

Pfaender, H., 1983. *Schott Guide to Glass*. New York: Van Nostrand Reinhold.

Pollard, W., 1975. Wide range depth of field calculators. *Br. J. Photogr.* 127:68.

Ray, S., 1978. *Focal Guide to Close-ups*. London. Focal Press.

Ray, S., 1979. *The Photographic Lens*. London: Focal Press.

Ray, S., 1983. *Camera Systems*. London: Focal Press.

Ray, S., 1987. Soft focus: A practical primer. *The Master Photographer* 40:19–21.

Ray, S., and Taylor, J., 1985. *Photographic Enlarging in Practice*. Newton Abbot, U.K.: David & Charles.

Sauer, H., 1970. Focusing of photographic lenses. *Br. J. Photogr.* 117:254–257.

Sauer, H., 1976. Zeiss Sonnar Superachromat. *Br. J. Photogr.* 123:166–168.

Schwalberg, R., 1983. All about teleconverters. *Popular Photogr.* 90(4):64–67.

Schwalberg, R., 1985. Perspective for photographers. *Popular Photogr.* 92(1):38–40.

Scott, P., 1977. The pupil in perspective. *Photogramm. Rec.* 9:83–87.

Smith, W., 1966. *Modern Optical Engineering*. New York: McGraw-Hill.

Stuper, J., 1962. *Die Photographische Kamera*. Vienna: Springer.

Takano, E., 1980. Changes in aberrations due to focusing. *Proc. SPIE* 237:496–499.

Tiffen, J., 1982. Filters for special effects. *British Kinematography, Sound TV Soc. J.* 64:280–283.

Thomas, W. (ed.), 1972. *SPSE Handbook of Photographic Science & Engineering*. New York: Wiley.

Walker, B., 1982. The fundamentals of magnification. *Photonics Spectra* 16(2):81–82.

Williams, C., and Becklund, O., 1972. *Optics: A Short Course for Engineers and Scientists*. Chichester, U.K.: Wiley.

Williams, J., 1990. *Image Clarity: High Resolution Photography*. London: Focal Press.

Wöltche, W., 1980. New developments and trends in photographic optics at Zeiss. *Br. J. Photogr.* 127:76–80.

# Chapter 3
# Exposure and Development

## Leslie D. Stroebel

*"The seeming complexity of photography can never be resolved unless a fundamental understanding of both technique and application is sought and exercised from the start."*

Ansel Adams 1902–1984

A large variety of camera films and printing materials are provided by photographic manufacturers to satisfy the photographer's needs in a wide range of picture-making situations. Once a specific sensitized material has been selected, however, the tone-reproduction quality of the final image depends to a large extent on lighting, exposure, and development. The last two of these factors, *exposure* and *development,* are considered in this chapter.

Photographic exposure and camera exposure are defined and distinguished from each other. Other topics covered include camera exposure controls, the measurement of light, advantages and disadvantages of the various methods of using exposure meters, alternatives to exposure meters, film and paper speeds, development considerations, subjective and objective evaluation of tone reproduction, and a checklist of exposure factors that should be considered before tripping the shutter. Useful exposure tables for a range of magnifications and for reciprocity effects are also included.

## EXPOSURE

Photographs of the highest quality can be obtained only when the camera film and printing material receive the correct exposure and development. Whereas the processing of films and papers tends to be highly standardized, correct exposure of film in a camera requires photographers to take into account and to compensate for constantly changing conditions.

Reversal color films provide very little exposure latitude before the deviation from the correct exposure produces unsatisfactory images. Deviations as small as one-third stop may be objectionable for some critical applications. Although it may be possible to obtain satisfactory prints with considerable overexposure of negative type black-and-white (BW) and color films, some loss of quality should be expected in addition to printing complications with the denser negatives.

Negative-type films have little exposure latitude on the underexposed side. Most professional photographers feel that it is well worth the effort to perfect their exposure technique so that they can consistently obtain correctly exposed images.

When information about the exposure of negatives and transparencies is required, the shutter speed and the *f*-number are usually specified by the photographer. This is appropriate since these camera settings are the variables normally used to control film exposure, but exposure time and *f*-number are only two of a number of factors that determine the amount of light received by the film.

## Photographic Exposure

*Photographic exposure* is defined as the quantity of light per unit area received by photographic film or paper; it is determined by multiplying the exposure time and the illuminance of the light falling on the sensitized surface. Whereas the shutter speed is a measure of exposure time, the *f*-number only indicates the relative amount of light transmitted by the lens, rather than the actual amount. Each time the shutter is tripped, the film receives not just one exposure but a whole series of exposures, due to the variation in the luminance of the different parts of the scene, from the brightest highlight to the darkest shadow. To avoid confusion, *photographic exposure* is used to indicate the amount of light received by the film, and *camera exposure,* or *camera exposure settings,* is used to indicate the *f*-number and shutter speed settings.

Similarly, when making prints from negatives or transparencies, the exposure data are normally recorded as the exposure time and the *f*-number at which the enlarger lens is set. Photographic exposure remains the total amount of light received by the sensitized material at a given point; each print receives a wide range of different exposures. It is, of course, the differences of these exposures that form the image.

Photographers, fortunately, do not need to determine the total amount of light received by photographic film or paper in order to make successful photographs, but

**49**

photographic technologists who prepare film and paper characteristic curves must be able to make such measurements. Since photographers need to be able to understand characteristic curves, this chapter details the procedure for their preparation. The first considerations, however, are controlling the exposure of film in the camera and measuring light for the purpose of determining correct camera exposure settings.

## F-Numbers

Most camera lenses and enlarger lenses are calibrated with f-numbers, although some professional motion picture camera lenses are calibrated with T-numbers. F-numbers vary inversely with the size of the diaphragm opening; so $f/1.2$, a small f-number, represents a large opening and $f/16$, a larger f-number, represents a smaller opening.

The f-number is calculated by dividing the focal length of the lens by the diameter of the effective aperture, where effective aperture is defined as the diameter of the entering beam of light that just fills the diaphragm opening. Thus, a 50-mm focal length lens that has a 25-mm diameter effective aperture, with the diaphragm wide open, will be identified as an $f/2$ lens (50 mm divided by 25 mm) (Figure 3.1a).

The effective aperture, used in the calculation of the f-number, is seldom the same size as the actual diaphragm openings or aperture. The effective aperture and the diaphragm opening are the same size only when the diaphragm is located in front of a lens. Reversing this lens so that the diaphragm is located behind the lens produces an increase in the size of the effective aperture and, therefore, a decrease in the calculated f-number (Figure 3.1b).

Although photographers seldom reverse lenses, so that the light enters the back of the lens (except on enlargers), this is a recommended procedure when using conventional lenses for close-up photography and photomacrography where the object distance is very small, since this minimizes certain lens aberrations. Some camera manufacturers provide adapters for reversing the lens. It should be noted, however, that unless the lens elements are symmetrical on both sides of the diaphragm, the f-numbers for the reversed lens will be different from the marked f-numbers.

*Whole stops* is a term used to identify sequential f-number settings that double or halve the amount of light transmitted. This sequence of numbers tends to be viewed as awkward by beginning photographers for these reasons: (1) because the numbers vary inversely with the size of the diaphragm opening, (2) because the amount of light transmitted is not halved when the number is doubled, and (3) because the numbers do not form a sequence that is easy to memorize.

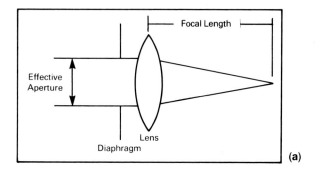

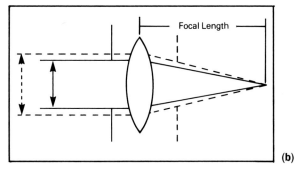

FIGURE 3.1   (a) f-numbers are found by dividing the focal length of the lens by the diameter of the effective aperture. (b) Turning this lens around changes the size of the effective aperture and, therefore, the f-number.

It is important, however, for professional photographers to be so familiar with the sequence of whole-stop f-numbers that they can easily translate changes in stops into changes in exposure, and vice versa. The following f-number sequence represents whole stops: $f/0.5$, 0.7, 1.0, 1.4, 2, 2.8, 4, 5.6, 8, 11, 16, 22, 32, 45, 64, 90, 128. Consecutive numbers increase by a factor of approximately 1.4, the square root of 2, which means that alternate numbers vary by a factor of 2. Thus, by remembering any two consecutive numbers, such as $f/8$ and $f/11$, the series can be extended in either direction by leapfrogging and doubling or halving alternate numbers. Most lenses have a range of f-numbers of approximately seven stops, with lenses for small-format cameras occupying the left end of the sequence (for example, $f/1.4$ to $f/16$) and lenses for larger-format cameras occupying positions farther to the right (for example, $f/5.6$ to $f/64$ for a 4 × 5 inch view camera lens). The major reason for this difference in ranges of f-numbers for small- and large-format cameras is that stopping a 35-mm camera lens down beyond $f/22$ would produce an objectionable loss of image definition due to diffraction. (The same diffraction-limited resolving power is produced on the film with a 35-mm camera and an 8 × 10 inch view camera with both lenses set at $f/22$, but since the 35-mm negative must be magnified eight times to match the size of a contact print from the 8 × 10-inch negative, the corresponding diffraction-limited resolving powers will be in a ratio of 1:8 in the prints.) Other reasons for larger

*f*-numbers on large-format cameras are that very fast long focal-length lenses would be large and expensive, and they would produce a shallow depth of field when used at the maximum aperture.

Since the amount of light transmitted by a lens is halved when the diaphragm is stopped down one whole stop, the series of relative exposures produced by stopping down from one stop to six stops would be 1/2, 1/4, 1/8, 1/16, 1/32, and 1/64. The corresponding increases in exposure time that would be required to maintain the same exposure of the film as the lens is stopped down would be 2, 4, 8, 16, 32, and 64.

It is not necessary to write down the series of *f*-numbers to determine the corresponding exposure time for *f*/2 and *f*/16, for example, since the exposure time varies directly with the *f*-number squared (and the amount of light transmitted varies inversely with the *f*-number squared). Thus, 2 squared = 4, and 16 squared = 256, a ratio of 1:64. The ratio of exposure times at *f*/2 and *f*/16 is therefore 1:64.

The *f*-number of the largest opening on some lenses, such as *f*/1.2 and *f*/1.7 for 35-mm cameras and *f*/4.5 and *f*/6.3 for large-format cameras, may not correspond to any of the *f*-numbers in the whole-stop series. The same process of squaring the *f*-numbers can be used to determine the relative speeds of an *f*/1.7 lens and an *f*/1.4 lens, for example, where *f*/1.4 is in the whole-stop series. The ratio of the squares of the *f*-numbers is approximately 1:1.5, indicating that the *f*/1.1 lens is about half a stop faster than the *f*/1.7 lens.

The scales on many exposure meters have marks to indicate thirds of a stop, even though the *f*-numbers are not listed for the intermediate positions between whole stops. In practice, the aperture pointer is placed at the estimated position between whole-stop numbers. Published film speeds are also rounded off to increments corresponding to thirds of a stop, with numbers such as 64, 80, 100, 125, 160, and 200, where every fourth number is doubled. It is generally considered that one-third of a stop is the smallest change in exposure worth considering, even though electronic exposure meters with digital readouts commonly indicate *f*-numbers to tenths of a stop, where *f*/11.8 indicates eight-tenths of a stop between *f*/11 and *f*/16.

## Shortcomings of *f*-Numbers

The *f*-number system does have shortcomings, which, if not recognized, can result in exposure errors. Strictly speaking, *f*-numbers are accurate only when the camera is focused on infinity. In practice, it is not necessary to correct for the increased lens-to-film distance when photographing closer objects until the camera is focused on an object distance of ten focal lengths or less. Ten focal lengths for a 35-mm camera equipped with a 50-mm (2

inch) lens is 20 inches or 1.7 feet, which is obviously close, but when a 4 × 5 inch view camera is equipped with a 210-mm (8 1/4 inch) lens, the minimum distance is 82 inches or nearly 7 feet. Since 7 feet, for example, does not seem close, it is easy to overlook the need to compensate for the increased lens-to-film distance when using long-focal-length lenses.

With an object distance of ten focal lengths, failure to compensate for the increased lens-to-film distance would result in an exposure error of approximately one-fourth of a stop—which is large enough to produce a just-noticeable difference in density with reversal-type color films. The exposure error increases rapidly, however, as the camera is focused on shorter distances, and at an object distance of two focal lengths (which produces a 1:1 scale of reproduction) the film would be underexposed by two stops.

Various methods can be used to compensate for this error in the marked *f*-numbers on lenses, including (1) calculating an exposure factor based on the increased lens-to-film distance, and (2) calculating an exposure factor based on the scale of reproduction (commonly called *magnification*). For the first method, the exposure factor equals the square of the ratio of the image distance to the focal length, or exposure factor = (image distance/focal length)$^2$. With normal-type lenses on large-format cameras, the image distance is approximately the distance from the center of the lens to the film plane. The exact image distance is measured from the film to the lens image nodal plane—close to the middle of lenses of normal design but tending to be in front of telephoto lenses and behind retrofocus wide-angle lenses. The position of the image nodal plane of any lens can be determined by focusing the camera on infinity or a distant object and measuring one focal length forward from the film plane (Figure 3.2).

This method may be more difficult to use with some 35-mm cameras since it is not easy to estimate the center of the glass elements when they are mounted in a long barrel. Even measuring one focal length from the film plane, with the camera focused on infinity, commonly reveals that the image nodal position on the lens barrel is covered by the focusing ring. When this occurs, the change in position of the front edge of the lens barrel between infinity focus and focus on the close-up object is added to the lens focal length to find the image distance (Figure 3.3).

With the scale-of-reproduction method it is not necessary to measure image or object distances. Since the short dimension of the image area on 35-mm film is approximately 1 inch, the scale of reproduction is 1 inch divided by the subject dimension that fills the 1-inch width of the film or that occupies the short dimension of the viewfinder. Thus, if a ruler is positioned at the subject, parallel to the film plane, and 1/2 inch of the ruler fills the narrow dimension of the viewfinder, the scale of re-

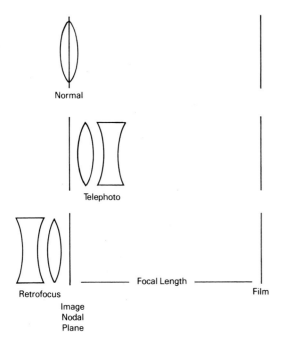

**FIGURE 3.2  The location of the image nodal plane can be determined for any lens by focusing the lens on infinity and then measuring one focal length forward from the film plane.**

production is 1 divided by 1/2, or 2. The exposure factor is the square of the sum of the scale of reproduction plus 1, or exposure factor = (scale of reproduction + 1)². With a scale of reproduction of 2, the exposure factor is (2 + 1) squared, or 9. The exposure correction can be applied by multiplying the indicated exposure time by 9, by opening the diaphragm slightly more than three stops, or by a combination of changes of exposure time and *f*-number. The graph in Figure 3.4 provides exposure factors and *f*-number corrections for scales of reproduction from 1/8 to 8.

Another possible cause of error in the *f*-number system is variation in the amount of light lost due to reflection and absorption of light by different lenses. The use of antireflection coatings on the elements of modern lenses

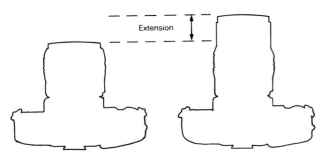

**FIGURE 3.3  When photographing close objects, the image distance can be determined by adding one focal length to the change in position of the front edge of the lens barrel from infinity focus.**

has reduced the seriousness of this problem, but lenses that have a large number of elements can still lose the equivalent of half a stop or more of light due to reflection and absorption. T-numbers compensate for this loss of light.

Any filter placed on the camera lens will also absorb light, requiring an exposure adjustment. Filter factors are published by film and filter manufacturers, although they recommend that for critical work the factors be verified with a practical test.

Behind-the-lens exposure meters will automatically compensate for a loss of light due to an increase in lens-to-film distance, reflection and absorption of light by the lens, and the addition of a filter to the lens. There is a danger of exposure error when using color filters, however, due to a difference in spectral sensitivity of the camera exposure meter and the film.

## Exposure Time

The second factor that determines photographic exposure, in addition to image illuminance, is exposure time, which is normally controlled in cameras with a shutter within or close to the lens (*between-the-lens shutter*, or lens shutter), or a shutter located close to the film (*focal-plane shutter*). Whereas *f*-numbers only indicate relative illuminance, and therefore relative exposures, shutters indicate the actual exposure times, if they are accurate.

Shutter speed settings on most cameras conform to the sequence where the exposure time is halved or doubled between adjacent settings, that is, 1–1/2–1/4–1/8–1/15–1/30–1/60–1/125–1/250–1/500–1/1000– . . . seconds. Since this corresponds to the change of illuminance by a factor of two between adjacent whole-stop *f*-numbers, photographers have a choice of many different combinations of *f*-numbers and shutter speeds that will produce the same exposure of the film. In fact, some small-format cameras permit the shutter and aperture controls to be interlocked so that turning a single knob provides different combinations of shutter speed and *f*-number that produce the same exposure. The choice depends on depth of field and motion-stopping needs.

Although 4 × 5 inch press cameras equipped with both a lens shutter and a focal-plane shutter have been manufactured in the past, cameras are now designed to use one or the other type of shutter; the choice is made when the photographer selects a camera. A comparison of between-the-lens shutters and focal-plane shutters reveals advantages and disadvantages of each type other than the obvious increased expense of having to provide a separate lens shutter with each lens, in contrast to a single focal-plane shutter on cameras that use lenses without shutters.

It has been easier to synchronize electronic flash with lens shutters at high shutter speeds—1/500th of a sec-

**FIGURE 3.4** To determine the exposure increase required when the camera is close to the subject, locate the magnification or the ratio of the image distance to the focal length on the horizontal axis and read the increase on the vertical axis.

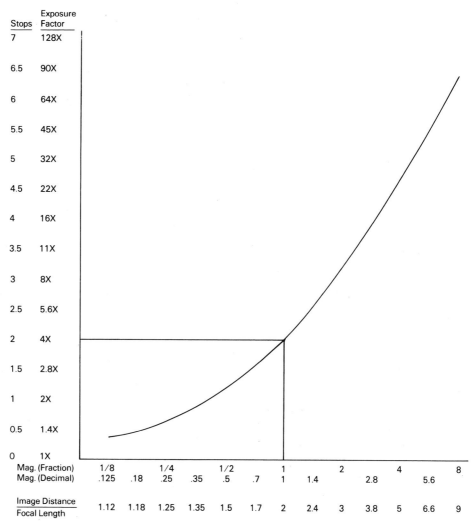

| Stops | Exposure Factor |
|---|---|
| 7 | 128X |
| 6.5 | 90X |
| 6 | 64X |
| 5.5 | 45X |
| 5 | 32X |
| 4.5 | 22X |
| 4 | 16X |
| 3.5 | 11X |
| 3 | 8X |
| 2.5 | 5.6X |
| 2 | 4X |
| 1.5 | 2.8X |
| 1 | 2X |
| 0.5 | 1.4X |
| 0 | 1X |

| Mag. (Fraction) | 1/8 | | 1/4 | | 1/2 | | 1 | | 2 | | 4 | | 8 |
|---|---|---|---|---|---|---|---|---|---|---|---|---|---|
| Mag. (Decimal) | .125 | .18 | .25 | .35 | .5 | .7 | 1 | 1.4 | | 2.8 | | 5.6 | |
| Image Distance / Focal Length | 1.12 | 1.18 | 1.25 | 1.35 | 1.5 | 1.7 | 2 | 2.4 | 3 | 3.8 | 5 | 6.6 | 9 |

ond, for example—than with focal-plane shutters. For many years 1/60th of a second was the maximum speed at which focal-plane shutters could be synchronized with flash, but the maximum synchronization speed has been increased to 1/125th and 1/250th of a second in some newer 35-mm focal-plane cameras.

A disadvantage inherent in lens shutters is that the effective exposure time at a given shutter speed setting actually increases as the diaphragm is stopped down. This increase in exposure time is negligible at slow shutter-speed settings, but the effective exposure time can nearly double when the diaphragm is stopped down in combination with high-speed settings. The reason for this increase is that lens shutters are calibrated with the diaphragm in the wide-open position, but when the diaphragm is stopped down, the smaller opening is completely uncovered sooner and remains completely uncovered longer by the shutter blades, which open from the center outward (Figure 3.5).

Since this increase in effective exposure time (and exposure) is consistent and predictable, it can be com-

pensated for by simply stopping down beyond the f-number previously selected. Table 3-1 provides the corrections needed for different combinations of f-numbers and shutter speed settings (Stroebel et al. 1986).

Focal-plane shutters are capable of providing a larger range of exposure times than lens shutters. Although a range from 1 second to 1/1000th second was traditional for 35-mm cameras for many years, some 35-mm cameras now cover ranges as large as 30 seconds to 1/8000 second. Since conventional lens shutters have blades that must change direction of movement between opening and closing, it is difficult to obtain shutter speeds faster than 1/500th second with lens shutters.

When an accurate focal-plane shutter is set at 1/1000 second, for example, each point on the film is exposed for that time, but it takes considerably longer for the exposing slit of light to move from edge to edge across the film. For this reason, the images of rapidly moving objects may be distorted in shape, so the wheels of a speeding automobile may not be circular in a side-view photograph. The exposure can also vary from edge to

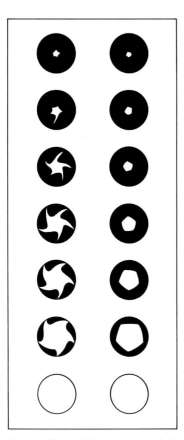

**FIGURE 3.5** The positions of the opening shutter on the left indicate when each of the corresponding whole-stop diaphragm openings on the right is completely uncovered. Since the smaller diaphragm openings are uncovered sooner and remain completely uncovered longer, the effective exposure time is longer than with a larger diaphragm opening.

edge in photographs made with malfunctioning focal-plane shutters.

Focal-plane and lens shutters can be classified as mechanical, electromechanical, or electronic, and the evolution of focal-plane shutters has proceeded in that order. The accuracy of shutters has increased with the evolution of design, and tests of professional-quality new shutters reveal that they are usually within plus or minus 10% of the marked speed. The accuracy of all shutters cannot be taken for granted, however, as tests of cameras that have been used for varying lengths of time show considerable variability in accuracy. A suspect shutter should be tested by a professional camera repair person.

## Other Exposure Controls

In addition to the two basic controls over exposure of film in a camera, the *f-number* and the *shutter speed*, it is possible to alter the exposure by other means, such as by changing the illuminance on the subject. With some electronic-flash units an adjustment is provided to reduce the light output, for example, from full power to 1/64th full power, the equivalent of a six-stop change in *f*-numbers. Since camera shutter speeds do not provide a useful means of controlling exposure of the film with electronic flash due to the short duration of the light emission, control over the intensity of the light source provides the photographer with greater flexibility in selecting an appropriate *f*-number based on depth-of-field requirements, rather than exposure requirements.

Another exposure control that can be used with any type of light source, including electronic flash, tungsten,

**Table 3-1 Exposure Compensation with Lens Shutters**

| Maximum Aperture | Stopped Down | | | | | | | | |
| | 1 | 2 | 3 | 4 | 5 | 6 | 7 | 8 | Stops |
|---|---|---|---|---|---|---|---|---|---|
| f/1.4 | f/2 | f/2.8 | f/4 | f/5.6 | f/8 | f/11 | f/16 | f/22 | |
| f/2 | f/2.8 | f/4 | f/5.6 | f/8 | f/11 | f/16 | f/22 | f/32 | |
| f/2.8 | f/4 | f/5.6 | f/8 | f/11 | f/16 | f/22 | f/32 | f/45 | |
| f/4 | f/5.6 | f/8 | f/11 | f/16 | f/22 | f/32 | f/45 | f/64 | |
| f/5.6 | f/8 | f/11 | f/16 | f/22 | f/32 | f/45 | f/64 | f/90 | |
| f/8 | f/11 | f/16 | f/22 | f/32 | f/45 | f/64 | f/90 | f/128 | |
| *Exposure Time* | | | | | | | | | |
| 1/60 | 0 | 0 | 0 | 0 | 0 | 0--1/4 | 0--1/4 | 0--1/4 | |
| 1/125 | 0--1/4 | 1/4 | 1/4 | 1/4 | 1/4 | 1/4 | 1/4 | 1/4 | |
| 1/250 | 1/4 | 1/4 | 1/2 | 1/2 | 1/2 | 1/2 | 1/2 | 1/2 | |
| 1/500 | 1/2 | 3/4 | 1 | 1 | 1 | 1 | 1 | 1 | |

Additional stopping down required to compensate for changes in shutter efficiency with between-the-lens shutters.
The numbers in the table indicate how much the diaphragm should be stopped down, in stops, beyond the *f*-number indicated by an exposure meter reading to compensate for the increase in the effective exposure time at smaller diaphragm openings and higher shutter speeds with lens shutters.
From Stroebel et al. 1986. *Photographic Materials and Processes.* Boston: Focal Press, p. 102.

and daylight, consists of placing a *neutral density* (ND) *filter* over the camera lens. An ND filter with a density of 0.3 will reduce the amount of light entering the lens to one-half, the equivalent of stopping the diaphragm down one stop. Each addition of 0.3 in density corresponds to another stop. A 0.1 ND filter corresponds to one-third stop and a 0.9 ND filter corresponds to three stops.

If an ND filter is used for the purpose of increasing the exposure time, rather than obtaining a larger diaphragm opening, filter factors are more useful than densities. Filter factors correspond to the antilogarithm (or antilog) of the filter density. The antilog of 0.3 is approximately 2, so that doubling the exposure time would compensate for the addition of a 0.3 ND filter. Antilogs can be determined with a pocket calculator that has a logarithm function or looked up in a table of logarithms, but they also can be estimated by noting that each addition of 0.3 in density (0.3, 0.6, 0.9, 1.2) requires a doubling of the exposure time (2×, 4×, 8×, 16×).

### Print Exposure

Exposure, when making prints with an enlarger, is also normally controlled with adjustments of the *f*-number and the exposure time. Since exposure times tend to be relatively long, the time is usually controlled with a separate timer that turns the enlarger light on and off, rather than with a shutter in the enlarger lens. Newer electronic darkroom timers provide a large range of exposure times, including tenths of a second. A complication that can be encountered when making color prints with a very short exposure time is the change in the amount and color quality of the light emitted as the lamp filament is heating up to operating temperature when turned on and cooling down when turned off. Three different approaches to solving this problem consist of (1) using a shutter on the enlarger lens, (2) using a lighting system that produces more abrupt changes in light output when the current is turned on and off, and (3) using a stroboscopic-type electronic flash light source where the total light output is controlled by adjusting the number of flashes.

### Reciprocity Effects

Photographers have a choice of many different combinations of shutter speed and *f*-number settings that will produce the same film exposure when making a photograph. Negatives or transparencies exposed with different equivalent combinations of shutter speed and *f*-number, such as 1/30 second at *f*/16 and 1/60 second at *f*/11, would be expected to be identical in density, even though they would be different with respect to depth of field and action-stopping characteristics. When this reciprocal relationship is carried to extremes, however, it is found that the density does not remain constant.

Numbers can be inserted in the formula photographic exposure = illuminance × time to demonstrate that a constant exposure can be obtained with different combinations of illuminance and time. For example, 100 lux × 1/100 second and 1/100 lux × 100 seconds both equal an exposure of 1 lux second. According to the *reciprocity law,* the resulting densities of the developed images will remain constant as long as the exposure remains constant, regardless of the individual values of illuminance and time. Although the reciprocity law is valid for x-ray exposures and for exposures with certain nonsilver processes, photographers should not expect to obtain images of normal density with combinations of a very long exposure time and low illuminance or a very short exposure time and high illuminance. This appearance of underexposure—less than normal density with negative materials and more than normal density with reversal materials—is identified as a *reciprocity effect* or *reciprocity law failure.*

The most commonly encountered reciprocity effect occurs with low light levels and long exposure times. For general-purpose BW-negative films the reciprocity effect becomes evident as a decrease in density and an increase in contrast. The increase in contrast can be compensated for at the printing stage, or the development of the film can be adjusted, but decreasing the degree of development of the film to compensate for the increase in contrast produces a further decrease in the effective speed of the film.

The loss of effective film speed with low-illuminance and long-exposure-time reciprocity failure can be compensated for by either opening the lens diaphragm or increasing the exposure time. However, the exposure factor must be larger when the exposure time is increased because the reciprocity effect decreases when the image illuminance is increased by opening the diaphragm. The recommended *f*-number change for an indicated exposure time of 100 seconds is three stops (an exposure factor of 8) for a typical film, whereas the corresponding recommended time change is an increase from 100 seconds to 1200 seconds (an exposure factor of 12).

Recommended time exposure adjustments for typical BW-negative films are given in Table 3-2 for indicated exposure times from 1 second to 100 seconds. The magnitude of the reciprocity effect varies with different types of film, and, to a much smaller extent, with different emulsion batches of the same film. For critical work, the film manufacturer's exposure adjustment recommendations should be tested.

High illuminance with short exposure times of 1/10,000 second and less also produce a loss of effective film speed, due to the reciprocity effect. Whereas low illuminance with long exposure times produce an in-

**Table 3-2   Exposure and Development Adjustments for Black-and-White Films**

| If Calculated Exposure Time Is (Seconds) | Use This Lens-Aperture Adjustment | OR | This Adjusted Exposure Time (Seconds) | AND Use This Development Adjustment |
|---|---|---|---|---|
| 1/100,000*†‡ | +1 stop | | Adjust aperture | +20% |
| 1/10,000*†‡ | +1/2 stop | | Adjust aperture | +15% |
| 1/1000 | None | | None | +10%§ |
| 1/100 | None | | None | None |
| 1/10 | None | | None | None |
| 1 | +1 stop | | 2 | −10% |
| 10 | +2 stops | | 50 | −20% |
| 100 | +3 stops | | 1200 | −30% |

\* Not applicable to Ektapan Film.
† Not recommended for Tri-X Pan Professional Film/4164.
‡ Not recommended for Royal Pan film or Super-XX Pan Film.
§ Ektapan Film does not require an adjusted development time at 1/1000 second.
Reprinted Courtesy of Eastman Kodak Company

crease in negative contrast, high illuminance with short exposure times result in a loss of contrast. This is not inconsistent, since contrast increases with decreasing image illuminance and increasing exposure time. So-called normal developing times are based on the range of exposure times of 1/10th to 1/1000 second, where the loss of density due to the reciprocity effect is at a minimum and intermediate image contrast is produced.

The loss of effective film speed with high illuminance and short exposure times is encountered less frequently than the loss with low illuminance and long exposure times. Only recently have camera shutters been available with top speeds that approach 1/10,000 second. High illuminance and short exposure times that involve reciprocity effects can be produced with electronic flash light sources. Although the action-stopping characteristics of the highest-speed units are needed for various technical photographic applications, the manufacturers of some electronic flash units have purposely designed them to have flash durations long enough, with correspondingly lower peak intensities, to avoid significant reciprocity effects.

In addition to the density and contrast reciprocity effects mentioned, changes in color balance of color film images can occur with long and short exposure times due to different reciprocity characteristics of the three emulsion layers. (Even though reciprocity effects are directly related to low and high illuminance of the light falling on the film rather than long and short exposure times, exposure times are specified in the literature because photographers have no way of knowing the actual illuminances.) With negative-type color films, compensation can be made for color shifts, using filters at the printing stage. With reversal color films, however, the color shifts must be anticipated so that appropriate filters can be placed on the camera lens.

## LIGHT MEASUREMENT

Before light-measuring instruments were available, photographers determined the correct exposure by trial and error. Indeed, many photographers still use trial and error when making prints with an enlarger by making exposure test strips. Where the illumination remains constant, as with a permanent copying setup in a studio or sunlight on a clear day, there is no need to measure the light once a test has determined suitable exposure settings. The well-known rule of using a shutter setting equal to the reciprocal of the film speed (1/125 sec for ISO 125 speed film) at $f/16$ in direct sunlight is an example of the application of test results to a standardized situation. For most picture-making situations, however, light measurements are necessary to obtain predictable results under a variety of conditions.

### Photometers and Exposure Meters

*Photometry* is the branch of physics concerned with the measurement of light. It would not be helpful to most photographers to know the *illuminance* (the light falling on an object) in footcandles or lux, or the *luminance* (the light reflected or emitted by a surface) in candelas per square foot, photometric units. Some early *exposure meters* did measure in photometric units. The Weston exposure meter, for example, measured luminance in candelas per square foot, but a dial transformed that information to

combinations of lens f-numbers and shutter speeds. Later meters used scales with arbitrary numbers, such as 1, 2, 3, 4, and so on, or scales with a central null line on which a needle is positioned by turning a dial. Electronic meters do not have a conventional scale but, instead, indicate the f-number and shutter speed in the form of a digital readout.

Hand-held exposure meters are designed to measure reflected light (luminance), incident light (illuminance), or, by making an adjustment on the meter, both. It would be more appropriate to call reflected-light meters *luminance meters*, since they can be used to measure light that is emitted by a source, such as a fluorescent tube, and light that is transmitted by transparent or translucent materials, in addition to measuring reflected light. However, the term *reflected-light meter* is firmly entrenched in our vocabulary.

Early photoelectric exposure meters consisted of a simple electric circuit containing a selenium photocell and an ammeter. Light falling on the photocell created an electric current that caused a pointer on the ammeter to rotate over a calibrated scale. A calculator dial was then used to convert the scale number to combinations of shutter speeds and f-numbers for specified film speeds. The major disadvantage of selenium photocell exposure meters was low sensitivity, even when the photocell was enlarged to over 1 1/2 inches in diameter. Major advantages of this type of meter were that the selenium photocell had a relatively good balance of response to different colors of light, and the meters operated without batteries.

Many other types of photocell materials have been used in the evolution of the state-of-the-art contemporary exposure meters, including cadmium sulfide, silicone, silicon photodiode, and gallium arsenide phosphide photodiode. All of these materials respond to light by reducing the resistance to an electric current supplied by a battery in the circuit. Exposure meters with these types of photocells are on the order of magnitude of 500 times as sensitive as selenium-cell exposure meters, with photocells that are only 1/4 inch in diameter or less. The color responses of these photocells are less balanced than with the selenium photocells, but filters are used in some exposure meters to improve the color balance, at the expense of some reduction of sensitivity.

## Reflected-Light Exposure Meters

Reflected-light exposure meters are calibrated to produce the correct exposure when the reading is taken from a middle-tone area in the scene being photographed. Since different photographers would seldom agree as to which tone in a scene is exactly midway between the lightest tone and the darkest tone, a gray surface having a reflectance of 18% can be used as an artificial midtone. If one looks at a gray scale that has a white

patch on one end (a density of 0.00) and a black patch on the other end (a density of approximately 2.00), a gray having a density of 0.70 should appear to be about midway between the white and the black in lightness. A reflectance of 18% corresponds to a density of 0.74.

This medium tone of gray was arrived at by presenting individuals with a large number of gray patches ranging from white to black with just-noticeable differences in lightness and asking each person to arrange the patches in order from darkest to lightest. The average of middle patches in the series for a large number of people was determined to have a reflectance of approximately 18%.

Since typical hand-held reflected-light exposure meters have angles of acceptance in the range of 30 degrees and larger, it is necessary to hold the meters quite close to small midtone areas or 18% reflectance gray cards to avoid including any surrounding area that could influence the reading. Some meters will accept spot attachments to restrict the angle of acceptance, and other meters that are designed as spot meters have angles of acceptance as small as one degree.

## Incident-Light Exposure Meters

Incident-light exposure meters measure the light falling on the subject, rather than the light reflected, transmitted, or emitted by the subject. One arrives at the same indicated camera exposures with reflected-light and incident-light exposure meter readings when the reflected-light reading is taken from a suitable midtone area such as an 18% reflectance gray card. If the same exposure meter is to be used for both types of readings, turning the meter around to measure all of the light falling on the subject (100%), instead of the 18% that is reflected from the midtone, would require the addition of an ND filter having a transmittance of 18% over the photocell. This ND filter is normally made of white plastic and has a hemispherical shape that integrates light falling on the meter (and the subject) from different directions. Some exposure meters will also accept a flat *cosine-corrected* diffuser that is recommended for use when making photographic copies of flat originals.

## Camera Exposure Meters

With the introduction of small and highly sensitive photocells, it became feasible to design single-lens-reflex cameras with through-the-lens (TTL) metering. The photocell can be placed in any of various positions in the reflex viewing system, including different surfaces on the pentaprism and on the back of the mirror. A number of technical problems are inherent with TTL metering, such as the need for the metering system to compensate for changes in the diaphragm opening between measur-

ing the light with the lens wide open and exposing the film with the diaphragm stopped down. TTL metering automatically compensates for the decrease in illuminance of the image light at the film plane when the lens-to-film distance is increased to focus on close-up objects, but taking meter readings through contrast filters on the camera lens may not produce the correct exposure due to differences in spectral response of the photocell and the film. A photocell having high red sensitivity, for example, will produce a false high reading with a red filter, resulting in underexposure of the film.

There has not been universal agreement concerning the most satisfactory way to sample the light that is transmitted by the camera lens with TTL metering. A variety of systems have been introduced by different camera manufacturers, such as measuring a small area, integrating the light over a larger area, and measuring two or more small areas and averaging the readings. Some cameras offer the photographer a choice of systems.

### Electronic-Flash Exposure Meters

Although conventional exposure meters are not capable of measuring the short-duration light from electronic flash units, specially designed flash meters can do so, and some meters can measure both flash and ambient light. An adjustable time gate feature on some flash meters provides for the measurement of the combined light from the flash and the ambient light for different lengths of time that can be selected to correspond to camera shutter speed settings. Measurement of incident light has been the preferred mode for hand-held flash meters, but some can also measure reflected light. TTL flash metering is now commonly available in small-format cameras. All TTL meters, whether ambient or flash, measure reflected light.

### Enlarging Exposure Meters

Exposure meters can also be used to determine the correct exposure when making prints with an enlarger. Enlarging attachments are available for some hand-held exposure meters, making it possible to measure a small area of the projected image, close to the easel surface. Since conventional exposure meters are calibrated for film speeds rather than paper speeds, it is necessary to calibrate the meter for printing by first making a good print with the test-strip method. At this time it is necessary to make a decision concerning the image area to select for the reading—midtone, highlight, shadow, or an average of the highlight and shadow readings. Highlight and shadow readings can also be used to determine the best contrast grade of printing paper to use for negatives that vary in contrast.

More sophisticated darkroom meters are made specifically for the purpose of determining the exposure time and the color filtration to be used in the enlarger for making color prints. The term *color analyzer* is sometimes used to identify this type of meter. Color analyzers can measure red, green, and blue light separately in addition to measuring white light. Red, green, and blue measurements of a reference area in the image, such as the image of an 18% reflectance gray card in the original scene, can be used to determine recommended density settings for cyan, magenta, and yellow filters in the enlarger; a white-light measurement can be used to determine the exposure time.

Whereas this procedure is appropriate for use in making quality color prints, it is too cumbersome to use where large quantities of prints must be made quickly, as when making photofinishing prints. Printers designed for this purpose contain sophisticated metering systems that can obtain readings from a number of different areas of the image and computers to analyze the readings and control the color balance of the illumination and the exposure automatically and rapidly.

### Color Temperature Meters

The measurement of red, green, and blue light by darkroom color analyzers and color printers is similar in principle to color-temperature meters used by photographers to determine the proper color filtration to use on a camera for varying combinations of types of color film and illumination. *Color-temperature meters* determine the color temperature of light by simultaneously measuring the relative amounts of red, green, and blue light. Whereas measuring color temperature and measuring the amount of light for the purpose of determining the camera exposure settings are two separate operations, some meters are capable of making both types of measurements.

## REFLECTED-LIGHT EXPOSURE METER READINGS

There are a number of methods of using reflected-light exposure meters. These include taking an integrated reading from the camera position, taking a close-up reading of a midtone area, and averaging close-up readings of the lightest and darkest areas in the scene.

### Camera-Position Readings

The most convenient method of using a hand-held reflected-light exposure meter is to aim the meter at the scene being photographed from the camera position. The success of this method in obtaining the optimum

exposure obviously depends upon the range and balance of tones in the scene. Exposure meter instruction manuals warn the photographer to tilt the meter down when making camera-position readings outdoors to avoid the effect a bright sky would have of inflating the reading and producing underexposure for the main subject. In a similar manner, a reflected-light reading of a document consisting of black type on white paper would be dominated by the large white areas, resulting in underexposure.

Many small-format cameras have been marketed in recent years with either TTL or front-mounted metering systems that integrate the light from the different areas of the scene being photographed in the same manner that hand-held meters integrate the light from the camera position. Since such cameras have a reputation for producing a large proportion of acceptable exposures, most of the subjects photographed with the cameras must have had a reasonable balance of light and dark tones. It should be noted that safety features are commonly incorporated in these metering systems to minimize the effect of a bright sky in outdoor photographs.

It is obvious that scenes made up of large areas of midtones that are not much different from an 18% re-

flectance gray should produce normal exposures with camera-position reflected-light exposure meter readings. If a scene is made up entirely of black tones and white tones, however, it is less obvious as to the proportions of black tones and white tones required to produce a meter reading that would match a reading from an 18% reflectance gray card. It might seem that half black and half white would combine to produce a good midtone. If the problem is simplified by assuming that the black reflects no light and the white reflects 100% of the light, a scene made up of half white and half black would produce an integrated reading equivalent to 50% reflectance rather than 18%. This effect can be demonstrated by covering half of a transparency illuminator with a black card, taking a reflected-light-type exposure meter reading that includes equal areas of the illuminator and the black card, and comparing the reading with one taken of the illuminated area alone. There will be only about one stop difference between the two readings. This is why a bright sky or any large light area has such a damaging effect on camera-position reflected-light exposure meter readings.

The equivalent gray produced by integrating different proportions of black and white can be demonstrated by rotating black and white paper samples on a Munsell motor. The photographs in Figure 3.6 show that equal areas of black and white produce a light gray, and that the 18% reflectance gray card is matched when the white occupies only about 18% of the total area.

FIGURE 3.6  Stationary and rotating BW disks on Munsell motors. (Top) Equal areas of black and white produce a gray that is considerably lighter than an 18% reflectance gray card. (Bottom) A mixture of 18% white and 82% black produces a close match with the 18% reflectance gray card.

## Midtone Reflected-Light Readings

Since reflected-light exposure meters are calibrated to produce optimum exposures with readings from midtone areas, such readings will tend to produce more consistent results than camera-position reflected-light readings, due to variations in the balance of light and dark tones in different scenes. A disadvantage of the midtone method is the extra time required to select an appropriate midtone area and to take the reading from a close position. Also, some scenes do not have an appropriate midtone area, in which case an artificial midtone, such as the 18% reflectance gray card, may be used.

Precautions that should be observed in using the gray card with three-dimensional scenes are

1. Hold the card close to the main subject.
2. Aim the card midway between the dominant light source and the camera.
3. Hold the meter close enough to the card to avoid including a lighter or darker background in the reading, but not so close as to cast a shadow on the card.
4. Adjust the angle of the meter to the card to avoid glare reflection of a light source.

When making photographic copies of two-dimensional originals, the gray card should be placed flat against the original, facing the camera, so that the lighting angles are the same for the gray card and the subject. Since the conventional lighting arrangement for copying consists of two lights at equal angles on opposite sides of the camera, there is no dominant light, as there is for most three-dimensional subjects.

The gray-card artificial midtone is especially useful when photographing small objects, where a conventional reflected-light meter reading could not be made. There are, of course, situations where the gray card cannot be used, including (1) when the subject cannot be approached and the lighting is not the same at the camera position, (2) when there is insufficient time to allow this procedure, and (3) when the object itself is emitting the light or when transparent or translucent objects are illuminated from the rear.

### Calculated Midtone Readings

Some of the problems encountered with midtone readings can be avoided by taking reflected-light meter readings of the lightest and darkest areas in the scene where detail is desired and calculating a midtone reading. The calculated midtone reading is not found by adding the two luminances and dividing by 2 to find a mathematical average. Instead, it represents the middle between the two readings on a ratio scale. Meters that measure luminance in candelas per square foot have ratio luminance scales such as 1–2–4–8–16–32–64, where each number is double the preceding number. Thus, if the shadow reading is 1 and the highlight reading is 64, the calculated midtone reading is the number midway between 1 and 64 on the scale, which is 8.

Most modern exposure meters display readings in terms of $f$-numbers, shutter speeds, and exposure value (EV) numbers rather than light units, but since the scales for all three of these variables represent doubling or halving the exposure between adjacent numbers, the same procedure can be used to determine a calculated midtone reading. For example, if the shutter speed is to remain constant, the shadow and highlight readings would be represented as different $f$-numbers. If the shadow reading indicates $f/2$ and the highlight reading indicates $f/16$, the $f$-number that is midway between $f/2$ and $f/16$ on the following scale of $f$-numbers is $f/5.6$: $f/2$–2.8–4–5.6–8–11–16.

In a similar manner, if the $f$-number is to remain constant, the shadow and highlight readings would be represented as different shutter speeds. If the shadow reading indicates 1 second and the highlight reading indicates 1/60 second, the shutter speed that is midway between 1 second and 1/60 second on the follow-ing shutter-speed scale is 1/8 second: 1–1/2–1/4–1/8–1/15–1/30–1/60.

Even though the numbers in the EV sequence, 1–2–3–4–5–6–7, form an interval scale rather than a ratio scale of numbers, adjacent numbers represent the same doubling or halving of the exposure as the $f$-number and shutter-speed scales, so the same procedure is used to determine a midtone value, which in the above sequence would be 4. Some electronic exposure meters have the capability of averaging highlight and shadow readings electronically.

### Keytone Method

There is no reason why the correct exposure cannot be obtained by taking a reflected-light reading from a lighter or darker area than a midtone, providing that an appropriate adjustment is made to compensate for the difference. For example, if a reading is taken from a light gray that reflects 36% of the incident light and no adjustment is made, the exposure meter will recommend giving the film half the exposure that it would have recommended for a reading from an 18% reflectance gray. Therefore it would be necessary to compensate by doubling the exposure indicated by the meter (Dunn and Wakefield 1974).

In a similar manner, if a photographer did not have an 18% reflectance gray card, the same result could be obtained by taking a reflected-light reading of a piece of white paper (reflectance of approximately 90%) and multiplying the indicated exposure by 5, since 90%/18% = 5. White-card exposure indexes have been published for some films designed for copying purposes, where the white-card exposure index would be one-fifth the conventional film speed, for example, 20 for a film with an ISO film speed of 100.

### Zone System

A basic concept of the *zone system* is that the photographer should be able to visualize how selected areas in a scene will be reproduced in terms of tones of gray in the print and be able to modify exposure and development to achieve desired tone-reproduction effects. The system is based on the early Weston exposure meter dial that had, in addition to a midtone arrow, shadow and highlight markers covering the seven-stop range of luminances that represents a normal scene (Adams 1971). Seven stops equals a luminance ratio of 1:128.

The visualization process can be facilitated by attaching patches of paper, representing print tones, to the dial with a just-lighter-than-black tone at the shadow position (value I), a just-darker-than-white tone at the

FIGURE 3.7 The *U* and *O* positions on the Weston exposure meter represent the detailed shadow and highlight limits of a normal seven-stop scene. These positions correspond to subject values I and VIII in the zone system. The normal exposure arrow on the meter corresponds to subject value V.

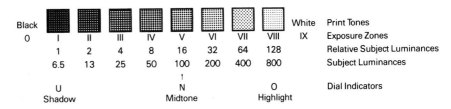

| | | | | | | | | | | |
|---|---|---|---|---|---|---|---|---|---|---|
| Black | | | | | | | | | White | Print Tones |
| 0 | I | II | III | IV | V | VI | VII | VIII | IX | Exposure Zones |
| | 1 | 2 | 4 | 8 | 16 | 32 | 64 | 128 | | Relative Subject Luminances |
| | 6.5 | 13 | 25 | 50 | 100 | 200 | 400 | 800 | | Subject Luminances |
| | | | | | ↑ | | | | | |
| | U | | | | N | | | O | | Dial Indicators |
| | Shadow | | | | Midtone | | | Highlight | | |

highlight position (value VIII), and a corresponding tone of gray at each stop in between (Figure 3.7). Paper white is positioned one stop above the highlight at value IX, and the maximum black of the printing paper is positioned one stop below the shadow at value 0.

With a normal contrast scene having a luminance range of seven stops (or a luminance ratio of 1:128), the film would be given the same exposure with a reflected-light reading of the shadow area of the subject aligned with the shadow position on the dial (value I), a reading of a midtone subject area aligned with the normal exposure arrow on the dial (value V), or a reading of the highlight area of the subject aligned with the highlight position on the dial (value VIII). Any selected subject tone, however, can be reproduced lighter or darker than its normal reproduction tone by taking a reflected-light meter reading in that subject area and then positioning the reading opposite a lighter or darker tone on the dial. In photographing a black object, for example, it may be decided that the detail would be too subtle if reproduced with the normal shadow density (value I) so the reading for that area could be positioned opposite the next lighter patch (value II), the equivalent of doubling the exposure.

Although the zone system is commonly used for BW photography, which may involve intentional variations in the degree of development of the film, application of the system to camera exposure control is more vivid if it is assumed that a reversal color film is being used so that the final image densities are locked in when the film is exposed in the camera. Variations in effects using the zone system can be illustrated by assuming that the subject is a profile view of a person in front of a window with a bright background and normal room illumination. A normal exposure effect can be obtained by taking a reflected-light meter reading of an 18% reflectance gray card held in front of the person's face and aligning the reading with the normal exposure arrow, or by taking the reading from the person's face and aligning it with the patch that matches the person's skin tone (Figure 3.8). To obtain a semisilhouette, the reading of the face would be set opposite the shadow position on the dial (value I) for just-perceptible detail, or one or two stops higher (value II or III) for increasing amounts of detail. To obtain a silhouette without detail, the reading would be

set opposite the patch representing maximum black (value 0), one stop below the shadow position.

Consideration should be given to determination of the camera exposure settings with scenes that exceed the seven-stop luminance range that has been assumed as an average or typical scene. Experimental studies have determined that the average luminance ratio for outdoor scenes is approximately 160:1 and that the average luminance ratio for indoor scenes is nearly the same. This ratio corresponds to a luminance range of seven and one-third stops. No great harm is done in ignoring the extra one-third stop of contrast, but exposure decisions need to be made when the scene contrast exceeds the average by larger amounts.

A gray scale illuminated evenly has a luminance ratio of approximately 100:1 between the white end and the black end. If two gray scales are placed at right angles to each other so that one is illuminated with sunlight and the other is illuminated with indirect daylight, combining the luminance ratio for each gray scale (100:1) and the lighting ratio (typically 8:1) produces a total scene luminance ratio of 800:1 between the white patch in sunlight and the black patch in the shade, which is a luminance range of nearly ten stops.

Ruling out contrast control procedures, a choice would have to be made between exposing for the gray scale in sunlight, exposing for the gray scale in the shade, or averaging the two exposures and losing detail in both the lightest and darkest areas. When a choice of this type must be made, it is better to sacrifice detail in the areas that are considered to be less important. With front-lit scenes, where shadow areas are relatively small, detail in the shadows is less important than detail in the larger light areas. Conversely, with back-lit scenes where the main light is rim-lighting objects, detail in the relatively small highlight areas can be sacrificed more safely.

## Exposure–Development Nomograph

The exposure–development nomograph (Eastman Kodak Company 1976) in Figure 3.9 enables photographers to adjust the degree of development of BW films to compensate for different contrast scenes (from five-stop to nine-stop luminance ranges) and to compensate for dif-

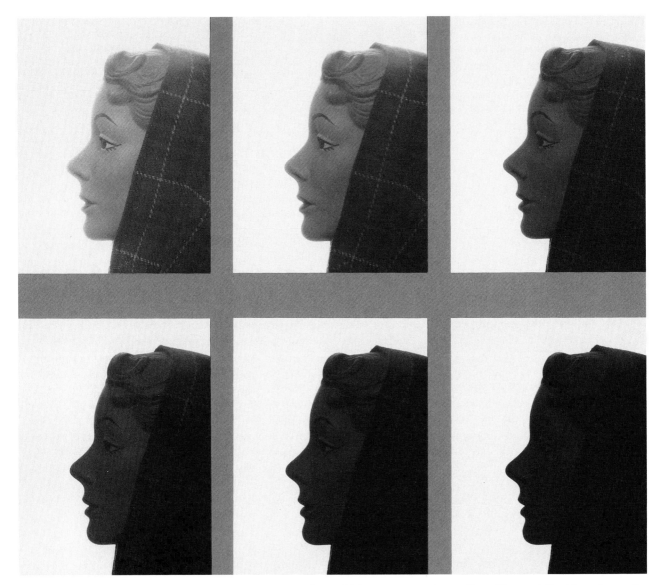

**FIGURE 3.8** Six negatives were exposed as indicated by a reflected-light exposure meter reading of the model's skin and exposing for subject values VI (normal), V, IV, III, II, and I. (In the original prints, detail is visible in the value I exposure.)

ferent amounts of camera flare light that result when photographing scenes containing large light or dark areas. It also takes into account the fact that condenser enlargers tend to produce higher print contrast than diffusion enlargers.

The recommended development is specified in terms of contrast index, which is a measure of degree of development. This enables photographers to obtain consistent development contrast with different combinations of film and developer.

Since the effective film speed varies with the degree of development, the exposure–development nomograph recommends an exposure adjustment based on the change in the degree of development from normal. The

lines drawn on the nomograph in Figure 3.9 show that with a condenser enlarger, a slightly contrasty eight-stop scene, and average camera flare, the film should be developed to a contrast index of 0.39 and the indicated exposure should be increased by two-thirds of a stop. Published film speeds are based on the use of diffusion enlargers and development of the film to a contrast index of 0.67.

## Limitations of Reflected-Light Meter Readings

The major disadvantage of reflected-light type exposure meter readings is the constant need to be concerned

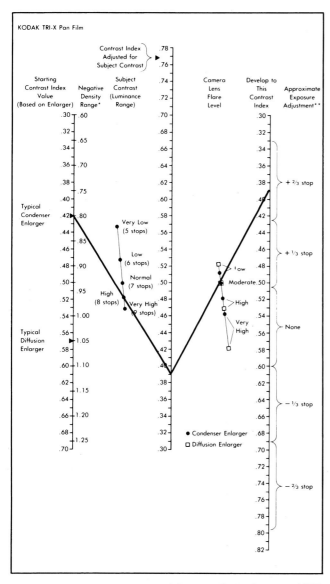

KODAK TRI-X Pan Film

© Eastman Kodak Company 1976

\* These are the typical negative density ranges that result when normal luminance range subjects (7 stops range) are exposed with moderate flare level lenses and developed to the contrast index shown in the left scale.

\*\* Some film and developer combinations may require more or less exposure adjustment than these average values shown here, especially when the adjusted contrast index is less than .45 or greater than .65. Some of the finest-grain developers cause a loss in film speed that must be considered in addition to the losses caused by developing to a lower contrast index.

**FIGURE 3.9   An exposure–development nomograph that recommends adjustments in the exposure and development of BW film for variations in the type of enlarger used, the luminance range of the subject, and camera flare. Reprinted Courtesy of Eastman Kodak Company.**

about whether the reading is being taken from an appropriate area that will result in correct exposure of the film. For camera-position readings, decisions need to be made concerning the balance of light and dark tones in the scene. For close-up readings, decisions need to be made concerning which area best serves as an appropriate midtone. Some scenes may not contain an appropriate midtone; the photographer may not be able to approach the subject to make a close-up reading; or the area of interest may be too small to permit making a close-up reading, perhaps even with a spot meter. Finally, the extra time and effort required to insert an artificial midtone into the scene or to make multiple close-up readings to obtain an average may be unacceptable in situations where any delay means a lost opportunity.

### Close-up Measurements with a Spot Meter

The optical system of spot meters includes one or more opaque masks to restrict the angle of acceptance, which is as small as one degree in some meters, and a fixed-focus lens that is focused on a relatively large object distance. Fixed-focus cameras are normally focused on the hyperfocal distance to obtain the maximum depth of field, which extends from infinity to one-half the hyperfocal distance. An attempt to photograph a close object with such a fixed-focus camera will result in an unsharp image because the converging rays of light will come to a focus well behind the film. A similar effect occurs when a fixed-focus spot meter is used close up to measure the luminance of a small area. The light from the subject area indicated by the one-degree viewfinder circle, for example, is spread over a larger area at the photocell due to the focus error, which produces a proportionately lower illuminance. This would result in a lower exposure meter reading and overexposure of the film.

A simple experiment can demonstrate the exposure error produced with closeup spot-meter readings. First, take a reading of the center of a transparency illuminator from a distance of several feet. Cover the illuminator with a piece of opaque black paper that has a small circular opening in the center. Move the meter close enough so that the illuminated opening appears a little larger than the circular reticle in the viewfinder, and take another reading. This reading may be as much as several stops lower than the original reading.

If the black paper is now removed from the illuminator and another reading is made from the same closeup distance, it will be found that this reading will agree with the original reading made from the larger distance. In this situation the light that is lost from the area being measured is compensated for by light gained from the surrounding area. Closeup readings, therefore, are affected only when the area being measured is adjacent to or surrounded by a darker or lighter area. The

situation is more complicated when the small area that is to be measured is surrounded by a much brighter area, as the bright area can introduce considerable flare in the meter's optical system to inflate the reading.

It is possible to correct the focus of a spot meter for closeup readings in the same way that is used with fixed-focus cameras, by adding a positive supplementary lens. The focal length of the supplementary lens should be approximately equal to the distance between the meter and the subject. For lenses marked in diopters, the focal length of the lens (in meters) equals the reciprocal of the power of the lens in diopters. Thus, the focal length of a 4-diopter lens is 1/4 m, or 250 mm, or approximately 10 in. The accuracy of the correction with a supplementary lens can be checked with the test described above with an illuminator. Adding a supplementary lens over the meter's objective lens will not affect the visual focus of the viewfinder reticle or on the accuracy of the reticle in indicating the area being measured.

## INCIDENT-LIGHT EXPOSURE METER READINGS

All of the procedures for using reflected-light exposure meters involve some decision making. The incident-light exposure meter was designed so that the photographer can avoid making decisions.

### Basic Concept

The basic concept of incident-light exposure meters is the ultimate in simplicity: hold the meter directly in front of the subject, aim the meter at the camera, and expose as the meter indicates. Success of this system is based on the assumptions that (1) the amount of light that illuminates a subject is more important than the tonal makeup of the scene, and (2) the meter will automatically compensate for changes in the direction of the main light. While there are situations where these assumptions break down, they are, in general, valid.

If an attempt is made to use a reflected-light exposure meter as an incident-light meter by aiming the meter at the light source rather than at the subject, the meter will measure 100% of the light falling on the subject instead of the 18% that is reflected by the average midtone. Adding a diffuser that transmits 18% of the light to a reflected-light meter will therefore convert it to an incident-light meter that will indicate the same camera exposure settings when used with an average scene.

### Cosine-Corrected Diffusers

Using a flat diffuser over an exposure meter photocell should cause the meter to respond to changes in the direction of light in the same way that the luminance of a gray card, or any flat original that is being copied, would change in response to changes in the direction of the light.

With the standard copying lighting setup, two lights are placed at angles of 45 degrees to the lens axis on opposite sides of the camera. The cosine law predicts that the illuminance will decrease in proportion to the cosine of the angles with a light at the camera (0 degrees) and off axis. The cosine of 0 degrees is 1 and the cosine of 45 degrees is approximately 0.7. Incident-light exposure meters equipped with flat diffusers respond approximately as predicted by the cosine law, and the meters are therefore referred to as *cosine-corrected meters*.

How should a meter equipped with a flat diffuser be used with three-dimensional subjects? The logical answer is that they should be positioned the same as a gray card used for reflected-light meter readings, that is, the meter should be aimed midway between the dominant light source and the camera.

### Hemispherical Diffusers

In 1950 Don Norwood published an article in the *Journal of the Society of Motion Picture and Television Engineers* (Norwood 1950). In this article he explained his theory that an incident-light exposure meter equipped with a hemispherically shaped diffuser over the photocell would indicate the optimum camera exposure for three-dimensional subjects regardless of the angle of the main light, with the exposure meter remaining aimed at the camera. A Norwood exposure meter with a hemispherical diffuser was manufactured for a number of years. Now diffusers having this shape are used universally, with cosine-corrected flat diffusers offered as an option with some exposure meters.

The basic principle of the *hemispherical diffuser* is that as the direction of the main light changes from front lighting to side lighting, less of the subject is illuminated, as seen from the camera position, and less of the diffuser on the exposure meter is illuminated. With the main light at an angle of 90 degrees to the lens axis, half of the diffuser is illuminated, and the exposure meter specifies a one-stop increase in exposure over that specified for front lighting. With 180-degree backlighting, the exposure is based entirely on the front-fill illumination.

### Limitations of Incident Light Readings

There are situations where incident-light meter readings cannot be made, such as when photographing luminous objects, and with transparent or translucent objects that are photographed with transmitted light. A specific ex-

ample is making a photographic copy of a color transparency on a transparency illuminator.

In other situations modification of the camera exposure specified by an incident-light meter reading is recommended—namely, where the main subject is very dark or very light. Even though it is possible to record the full range of tones from white to black, as represented at the ends of a gray scale, on reversal color film (or with negative-positive processes, using normal procedures), the contrast is reduced at both ends of the gray scale since the lightest and darkest tones fall on the toe and shoulder of the film's characteristic curve. This local reduction in contrast is acceptable for scenes having a reasonable balance of light and dark tones. When a large dark object dominates a scene, however, more vivid detail and texture is desirable; this can be achieved by increasing the camera exposure by approximately one stop to move these tones from the shoulder of the film curve downward onto the straight-line part of the curve where the slope is steeper (Figure 3.10). Conversely, the contrast can be increased in a large light area by decreasing the exposure by approximately one stop to move these tones from the toe of the curve upward onto the straight line.

## CAMERA EXPOSURE METER READINGS

A disadvantage of the early selenium-photocell exposure meters was that a fairly large photocell was needed to

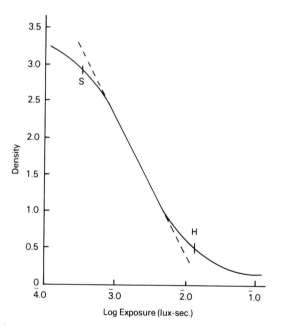

**FIGURE 3.10** Since the lightest and darkest areas of a normal scene are located on parts of the curve for reversal color film where contrast is lower than for midtones, it is recommended that low-key scenes be given more exposure and high-key scenes less exposure than indicated by an incident-light (or gray card reflected-light) exposure meter reading.

obtain reasonable sensitivity. Only when cadmium sulfide and other more sensitive materials became available could photocells be made small enough to meet the requirements of in-camera exposure meters.

### Incident-Light and Reflected-Light Readings

Almost all exposure meters that are an integral part of a camera measure subject *luminance* (reflected light), as distinct from *illuminance* (incident light), but there have been exceptions. An early single-lens-reflex camera featured a photocell mounted on the body that could be used as a reflected-light meter or as an incident-light meter by adding a flat translucent diffuser and holding the camera at the subject to make the reading. More recently, an accessory in the form of a hemispherical diffuser that can be placed over the front of any camera lens having TTL metering has been marketed, allowing the camera to be placed at the subject to make incident-light readings.

### Sensitivity Patterns

The photocells for reflected-light exposure meters in small-format cameras are usually on the front of the camera body or lens barrel with between-the-lens shutter cameras, and behind the lens for TTL lens readings with cameras having focal-plane shutters. In either case, however, it is useful for the photographer to know the *sensitivity pattern* of the meter. If, for example, the meter is capable of functioning as a spot meter, the photographer has the options of making readings of a midtone area, of highlight and shadow areas for a calculated midtone value, or selected areas for use with the keytone or zone-system procedures without having to move in close to the selected areas.

It should be possible to obtain information about the exposure meter sensitivity pattern for a specific camera from the camera manufacturer's literature or a photographic magazine that publishes results of tests conducted in their own lab as new camera models are introduced to the market. Variations of sensitivity patterns include: averaging of the entire picture area, averaging with more emphasis in one area such as the center or the center bottom, spot sensitivity, and multiple cell meters that average readings from different areas and compensate for large differences by favoring the reading from a certain area or otherwise manipulating the input.

Sensitivity patterns are sometimes presented in graph form, as illustrated in Figure 3.11. Word descriptions of sensitivity patterns include *center-weighted averaging type, center-weighted with 60% emphasis on 12-millimeter center area, spot reading of 5-millimeter center area, contrast-light*

*compensation with two photocells,* and *five-segment matrix metering.*

When useful information about a camera meter sensitivity pattern is not available, a simple experiment will provide some insight. By placing a bright lightbulb, preferably a bare bulb, in front of a dark background in a darkened room, the camera can be panned from side to side and top to bottom to determine the area or areas of maximum sensitivity. If more information than this is desired, a grid can be placed on the dark background, and, with the camera mounted on a tripod, the light bulb can be moved from side to side and top to bottom to determine not only the point or points of maximum sensitivity but also where the sensitivity decreases by fixed amounts such as one-half stop and one stop. These locations can then be plotted as lines on a graph similar to that in Figure 3.11.

### Limitations of Camera Exposure Meter Readings

The same limitations apply to camera exposure meters as were mentioned for hand-held reflected-light exposure

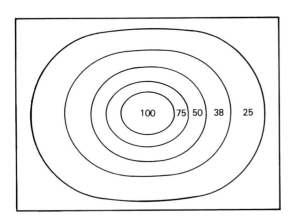

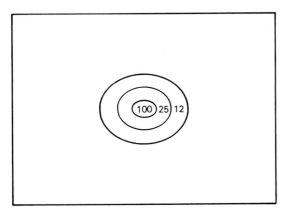

**FIGURE 3.11   Through-the-lens exposure meter sensitivity patterns for a normal center-weighted meter (top), and a spot meter (bottom).**

meters. It should also be noted that differences in spectral sensitivity of the meter and the film being used can cause errors in exposure. This is a more serious problem for camera meters because exposure meter readings are commonly made through color filters on the camera lens.

### ALTERNATIVES TO EXPOSURE METERS

Most photographers would feel lost without an exposure meter. There are many situations, however, where other methods can be depended upon to indicate the correct exposure.

### Standardized Lighting Conditions

When lighting conditions remain constant, there is no need to make an exposure meter reading for every photograph once the correct camera exposure settings have been determined. In addition to the $f/16$ rule, mentioned earlier for determining the camera settings on a clear day, exposure tables are available that provide recommended camera exposure settings for other daylight lighting conditions such as hazy sun, cloudy bright, and heavy overcast. The *American National Standard Photographic Exposure Guide* provides camera exposure settings for a wide range of day and night natural lighting conditions and indoor and outdoor artificial lighting conditions (American National Standards Institute 1986).

There are other situations where artificial lighting can be kept constant over long periods so that measurement of the illumination is unnecessary once the correct camera exposure settings have been established, as in a photographic copying setup. Existing artificial lighting in most buildings can be expected to remain constant over time, and in a newer building all of the areas designed for the same type of activity, such as offices, can be expected to have the same level of illumination.

### Guide Numbers and Light Sensors

In the past, guide numbers have been used with flash-bulbs and electronic flash light sources, where the recommended $f$-number is found by dividing the guide number by the distance between the light source and the subject. For example, with a guide number of 160 for a given film-flash combination, the recommended $f$-number for a subject at a distance of 10 feet would be $160/10 = f/16$. Some electronic flash units and cameras now have light sensors that serve to quench the flash when a predetermined amount of light, based on the film speed and the $f$-number, is reflected from the subject to the sensor.

## FILM AND PAPER SPEEDS

Film and paper speeds are numbers that are directly related to the sensitivities of the emulsions. They enable photographers to obtain correctly exposed images by measuring the light at some stage of the image-forming process or to determine the change in exposure required when switching from one sensitized material to another.

### Film Speeds

If a photographer has a quantity of film of unknown film speed, exposure meter readings would be of little use without first conducting practical tests. The latter include making a series of negatives with systematic increments of exposure, selecting the thinnest negative that would produce an excellent print, and determining what film-speed setting on the exposure meter would have produced that exposure. If the negatives were made with a subject in direct sunlight, the $f/16$ rule could be used, where the film speed would be the reciprocal of the shutter-speed setting at a relative aperture of $f/16$. The purpose of publishing film speeds is to make such testing unnecessary.

The exact sensitometric procedures for determining film speeds vary somewhat for different types of films such as pictorial BW film, high-contrast BW film, negative color film, and reversal color film, but the basic concept remains the same—namely, to determine the amount of exposure (that is, light) required to produce a specified density.

In the case of conventional BW films, the specified density is 0.1 above base-plus-fog density, the density of unexposed processed film. The exposure required to produce the specified density can be determined from a sensitometric D-log H curve. This exposure number is then divided into a constant, 0.8 for BW film, to obtain the film speed. Thus, 0.8 divided by 0.008 (lux seconds) equals 100, the ISO arithmetic film speed.

### Effective Film Speeds

When a photographer finds that better results are obtained by adjusting the published film speed upward or downward, it most likely means that the conditions under which the film is being used are not identical to those used by the manufacturer in establishing the film speed.

Photographers should be aware of possible reasons why using the published film speed might not produce the optimum camera exposure in a given picture-making situation other than an error in the exposure meter or method of using it, or, possibly, a difference in criteria for judging image quality by the photographer and the

standards organization that established the procedure for determining film speed. One important factor is that the negative used to plot the characteristic curve must be developed to a specified contrast, which corresponds to that recommended for printing with a diffusion-type enlarger. If a photographer now develops a negative to a lower contrast for printing with a condenser enlarger, the negative will be a little thinner than desired. Photographers may use a higher or lower number than the published film speed to compensate for consistent over-exposure or underexposure, but the modified number should be identified as an *exposure index* or *effective film speed*, rather than as an *ISO film speed*. Reciprocity effects lower the effective speeds of photographic emulsions, but the compensations are normally published in terms of an increased exposure time or a change in the *f*-number, rather than as an adjusted film speed.

The third and less-important factor that can produce different-than-expected exposure results is that ISO film speed numbers are rounded off to the closest number in a series of numbers representing one-third stop changes in speed. The largest error that could be introduced with this rounding process is one-sixth of a stop, although two different emulsion batches of the same film could differ from each other by nearly one-third of a stop.

It should be recognized that the effective speed of a film can change between the time it is made and tested by the manufacturer and the time it is exposed in a camera. The amount of change varies with the type of film, the length of time between manufacture and use, and the storage conditions. In some cases the manufacturer assumes that a film designed for use by amateurs will be stored at room temperatures, and considerable time will elapse before it is used, whereas a film intended for use by professional photographers will be stored in a refrigerator or freezer and will be used sooner.

An exposure meter that indicates too much or too little exposure creates the impression that the effective film speed is higher or lower than the published value. If the meter error is consistent, it can be compensated for by adjusting the film-speed setting on the meter.

### Arithmetic and Logarithmic Speeds

Published ISO film speeds include two numbers, an arithmetic film speed and a logarithmic film speed. The arithmetic film speed corresponds to the ASA film speed system that was used previously in the United States, and the logarithmic film speed corresponds to the DIN film speed system that was used previously in Europe. Both series of numbers represent one-third stop changes in speed, as shown in Table 3-3 (International Standards Organization 1981).

**Table 3-3   ISO Film Speeds**

| Arithmetic | Logarithmic |
|:---:|:---:|
| 4 | 7° |
| 5 | 8° |
| 6 | 9° |
| 8 | 10° |
| 10 | 11° |
| 12 | 12° |
| 16 | 13° |
| 20 | 14° |
| 25 | 15° |
| 32 | 16° |
| 40 | 17° |
| 50 | 18° |
| 64 | 19° |
| 80 | 20° |
| 100 | 21° |
| 125 | 22° |
| 160 | 23° |
| 200 | 24° |
| 250 | 25° |
| 320 | 26° |
| 400 | 27° |
| 500 | 28° |
| 640 | 29° |
| 800 | 30° |
| 1000 | 31° |
| 1250 | 32° |
| 1600 | 33° |
| 2000 | 34° |

## Paper Speeds

Paper speed standards are published for BW photographic papers, even though exposure meters calibrated in paper speeds are not common. A comparison of ANSI/ISO paper speeds reveals whether it is necessary to change the exposure when switching to a different contrast grade of the same paper, when changing filters with some variable-contrast papers, and when using different brands of paper. It could be predicted, for example, that after making a test print with white light on a variable-contrast paper, with paper speed of 250, a print exposed through a PC-3 filter, with paper speed of 125, would require double the exposure.

## DEVELOPMENT

Normal exposure of film in a camera produces an invisible change in the emulsion layer known as a latent image. Within individual silver halide grains, the change consists of the accumulation of silver atoms at certain locations identified as sensitivity centers. It is thought that as few as four atoms of silver at one sensitivity center can make that silver halide grain developable. Although latent im-

ages are not visible, visible images can be produced with exposure alone on conventional films and papers if the exposure is increased sufficiently. This effect can be demonstrated by partially covering a piece of photographic film or paper with an opaque object and leaving it exposed to normal room illumination. Even with prolonged exposure, however, insufficient silver is formed for the image to match a conventional developed image, except with a material such as printing-out paper (POP), a portrait proof paper specifically designed to produce nonpermanent but otherwise usable printout images.

## Film Development

Development of a normally exposed piece of film increases the amount of silver that is formed by exposure alone by as much as one billion times. Development is a rate process whereby silver atoms continue to form around the latent image centers until the entire silver halide grain is converted to metallic silver. The two basic controls over the degree of development for a given film and developer are the developing time and developer temperature. Time-temperature charts enable the photographer to obtain a constant degree of development with different combinations of developing time and temperature.

## Degree of Development

Increasing the developing time or temperature not only increases the amount of silver formed, the *density*, but it also increases the contrast or density differences between areas that received different amounts of exposure. Thus, it is possible for a photographer to compensate for high-contrast and low-contrast scenes by adjusting the degree of development so that a normal contrast grade of printing paper can be used to print all of the negatives. Although this is possible, it is not always convenient to adjust the degree of development, especially when using roll film, in which case different contrast grades of printing paper or variable-contrast printing paper can be used to compensate for differences in contrast of the negatives.

Developers are supposed to distinguish between exposed and unexposed silver halide grains, but some unexposed grains will be developed, even with normal developing times. Increasing the developing time to increase image contrast also increases the number of unexposed silver halide grains that will be developed, and if this procedure is carried to an extreme, excessive development fog density will be produced that will lower the overall image contrast. Whereas most pictorial BW films respond to changes in degree of development over a wide range to obtain both higher and lower than nor-

mal contrast, other photographic materials are designed for a standardized degree of development. These materials include color films, BW and color-printing papers, and high-contrast lithographic films.

## Contrast Control with Color Materials

With color films and papers, other means of modifying the contrast than changing the degree of development are available. An inherent difference in contrast can be found among different reversal color films designed for general-purpose photography. Duplicating-type reversal color films have considerably lower contrast. *Flashing,* which consists of combining a weak uniform exposure with the image exposure, can also be used to reduce contrast. Some slide copiers have a built-in flashing capability. There are also inherent differences in contrast among color-printing papers for printing from color transparencies and from color negatives.

## Developers

Processing solutions, times, and temperatures for processing color films and papers are specified by the film manufacturers; these should be closely adhered to for best results. Photographers, however, are given a choice of developers for processing BW films and papers. Specialized film developers include fine-grain, rapid, high-contrast, low-contrast, and tropical developers. Normal development of BW printing papers produces close to the maximum contrast the paper can yield, but special developers are available to obtain lower contrast or modified image color.

## Agitation

Because the byproducts of development act to restrain development and the amount of byproducts formed is largest in the areas that received the most exposure, it is important to remove the byproducts from the surface of the emulsion with agitation. Since the byproducts are also heavier than the fresh developer, they flow downward from the more heavily exposed areas, causing *bromide streaks* of lower density when film is suspended in a vertical position in a tank. It might seem that the way to prevent uneven development would be to agitate the film constantly and vigorously during the entire development cycle. However, when constant agitation is used with sheet film suspended in a tank with hangers or with roll film on a spiral reel in a small tank, very uneven development occurs due to the establishment of repetitive uneven flow patterns. Intermittent agitation is therefore recommended for tank development, although the ex-

perts do not all agree on the optimum type and frequency of agitation.

Constant agitation is recommended for the development of sheet film in a tray, and it can be used with certain other developing procedures such as processing drums where uneven flow patterns are not encountered. The recommended developing time decreases as the amount of agitation increases. Film manufacturers sometimes provide separate developing times for tray development with continuous agitation, small tank development with agitation at 30-second intervals, and large tank development with agitation at 1-minute intervals. For one film-developer combination the recommended developing times are, respectively, 8, 9, and 10 minutes for the three types of agitation.

Uneven development is less of a problem with photographic materials that are developed to completion or close to completion, as is done with photographic printing papers, although uneven development can occur if several prints are allowed to pile up in a developing tray, with little or no agitation. The lower degree of development recommended for negatives that are to be printed with a condenser enlarger, rather than a diffusion enlarger, tends to produce more uneven development, whereas negatives that are push processed for the purpose of increasing the effective film speed run less risk of encountering objectionable uneven development.

## TONE REPRODUCTION

It is difficult to make a BW photograph that matches the original subject exactly tone for tone. It is even more difficult to make a color photograph that matches the original subject, where the hue and saturation of colors are compared in addition to lightness.

### Limitations of the Photographic Process

An inherent limitation of the photographic process is that the maximum density of printing papers is approximately 2.0, which represents a maximum luminance ratio in the print of approximately 100:1, whereas the average luminance ratio of the scenes that are photographed is approximately 160:1. Some tonal compression is therefore required when a typical scene is reproduced photographically in a print, and considerable compression is required for more contrasty scenes.

### Subjective Evaluation

Photographs can be compared subjectively and objectively with the corresponding original scenes. A valid subjective comparison requires that the photograph and

the original scene be viewed at the same time, side by side. This can seldom be done. Even when the photographer can return to the original scene with the photograph, the lighting and other aspects of the scene are usually different. Exceptions, however, do exist, as when making a photographic copy of a painting, photograph, or other two-dimensional original, and when instant pictures are made of scenes that do not quickly change.

Usually when photographs are evaluated by the photographer, the photographs are compared with mental images based on memories of what the original scenes looked like. When photographs are evaluated by other persons who were not present when the photographs were made, they are again compared with mental images of what it is assumed the scenes should look like. Even though most of us have reasonably good memories for colors such as blue sky, green grass, and red barns, controlled experiments reveal that certain changes do tend to occur between viewing subject colors and the memories of those colors. It was found, for example, that most people remember skin color as being slightly more red than it actually is (Bartleson 1960).

## Objective Evaluation

The most meaningful method of objectively comparing a photograph with the original scene or subject is to make a graph in which the tones of the subject are represented on the horizontal axis as input and the tones of the print are represented on the vertical axis as the output. Print tones are most conveniently measured with a reflection densitometer as densities. By including a gray scale that is calibrated in densities in the original scene, density units can be used on both axes of the tone reproduction graph. The graph in Figure 3.12 has two tone reproduction curves. The straight line represents a theoretical facsimile reproduction in which the subject and print tones match exactly, which is referred to as *ideal tone reproduction*. Although facsimile reproduction may be considered as ideal for photographic copies and other specialized types of photographs, it is not considered ideal for pictorial photography. The *s*-shaped curve in the tone reproduction graph is referred to as the *preferred tone reproduction curve* for photographic prints, since it represents the average of the choices of a large number of people who were asked to judge the quality of many photographs of various subjects that varied systematically in print quality.

Differences between a preferred photographic print and the original subject can be determined by comparing the preferred curve with the straight line, noting that the height of each point on the curve represents density, and the slope of each part of the curve represents contrast. The print midtones therefore are a little lighter (lower

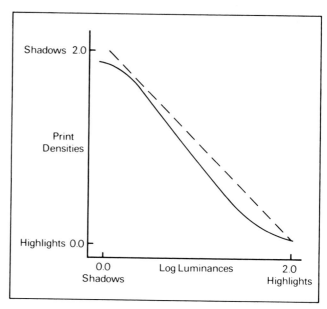

**FIGURE 3.12    Ideal (dashed line) and preferred (solid line) tone reproduction curves.**

density) and more contrasty (higher slope) than the corresponding tones in the subject. The highlights and shadows have less contrast in the print, since the two ends of the curve have lower slopes than the corresponding parts of the straight line.

An answer to the question of why it is so difficult to obtain facsimile tone reproduction can be found by looking at tone reproduction curves for each of the components of the photographic process, rather than just comparing the final print and the original subject. Such curves for photographic films and papers are provided by the manufacturers in the form of *D-log H* curves (density versus log exposure curves). The log exposures represented on the horizontal axis were received by the film or paper in a *sensitometer*, a device that exposes the sensitized material through a step tablet that produces uniform increments of log exposure.

## Film Curves

The family of film *D-log H* curves in Figure 3.13 reveals the changes in negative contrast produced with different developing times, along with information about tone reproduction for the part of the curve used with a normal subject and normal exposure. The low slope of the middle film curve, representing the recommended degree of development, indicates that negatives tend to be lower in contrast than the subject, and the even lower slope in the toe part of the curve indicates that the shadow areas of the negative will have less contrast than the midtones and highlights. Although all of the subject tones could be

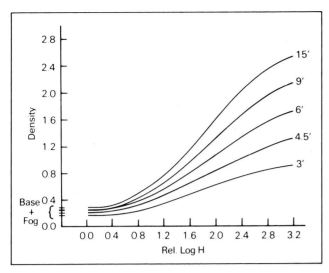

**FIGURE 3.13  A family of film characteristic curves representing variations in developing time.**

represented on the straight-line part of the film curve by increasing the film exposure, the resulting loss of effective film speed, increase in graininess of the negative, and the increase in print exposure time make this an unattractive option.

## Paper Curves

The steep slope of the number 2 grade printing paper *D-log H* curve in Figure 3.14 shows that the low contrast of the negative is partially compensated for by the higher contrast of the paper. In addition, the lower slopes at the two ends of the paper curves indicate another loss of contrast in the shadow areas, in addition to the loss in-

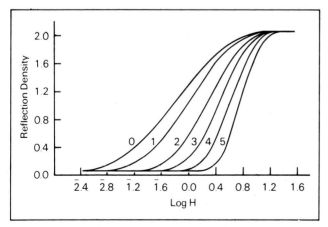

**FIGURE 3.14  A family of printing paper characteristic curves representing six different contrast grades.**

curred in the negative, plus a reduction of contrast in the highlight areas.

## Camera Flare

An important tone reproduction factor that is not included in the curves considered above is that of *camera flare*. The flare curves in Figure 3.15 show that there is a significant loss of contrast in the darker subject areas, a loss that increases with the lightness of the subject surround.

## Quadrant Graphs

*Quadrant tone reproduction graphs* make it possible to combine all of the separate factors that have an effect on tone reproduction into a single tone reproduction curve. In Figure 3.16 the subject log luminance range is represented at the top of quadrant I, the reduction of contrast due to camera flare is introduced by the flare curve, exposure and development of the film are represented in quadrant II, exposure and choice of printing paper contrast grade are represented in quadrant III, and the final tone reproduction curve that compares the tones in the print with the corresponding tones in the subject is in quadrant IV. All of the factors in this quadrant graph are normal: a subject with a luminance ratio of 160:1 (or a log luminance range of 2.2), average flare, normal exposure and development of the film, and normal exposure of the print on contrast grade 2 paper. As would be expected, the tone reproduction curve in quadrant IV conforms closely to the preferred curve that represents a good-quality print.

For comparison, the quadrant graph in Figure 3.17 shows the effect of push processing film in an attempt to increase the effective film speed. This film was purposely underexposed by a factor of 4 (or two stops) and then overdeveloped. Underexposure with normal development results in a decrease in density in all areas, with a loss of shadow detail and a decrease in contrast. Increasing the degree of development of the film produces only a slight increase in shadow detail but is more successful in increasing the overall contrast of the negative, making it unnecessary to use a high-contrast grade of printing paper. The tone reproduction curve in quadrant IV shows that while the darkest shadow and lightest highlight have the correct densities, the horizontal line in the darker subject areas indicates a loss of shadow detail, and the steep slope of the line in the midtone and highlight areas indicates that they have excessive contrast.

It is assumed that contact prints were made in these two four-quadrant graphs. If enlargements were made, it would be necessary to add a fifth section to the graph for an enlarger flare curve.

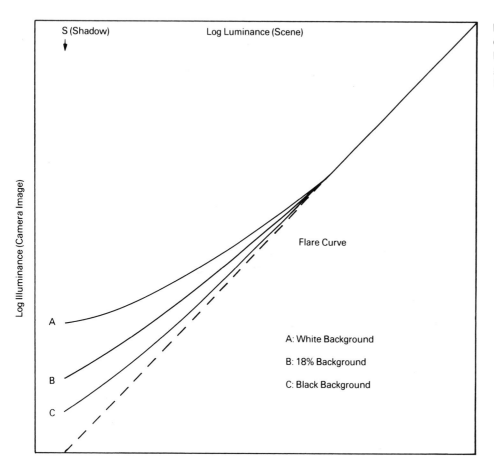

FIGURE 3.15 (a–c) A family of camera-flare curves produced by using a white background, a gray background, and a black background.

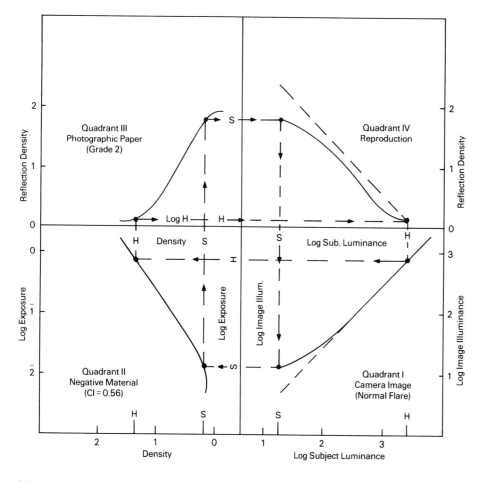

FIGURE 3.16 A four-quadrant tone reproduction system with a normal scene and average flare. The reproduction curve in quadrant IV closely resembles the preferred tone reproduction curve.

**FIGURE 3.17 A four-quadrant tone reproduction system with a normal scene, but with two stops underexposure of the film and push processing. The reproduction curve in quadrant IV reveals a loss of shadow detail and high contrast in the midtones and highlights.**

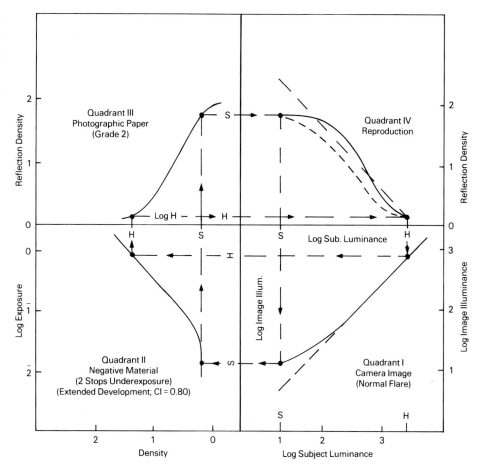

## SUMMARY OF EXPOSURE FACTORS

Following is a checklist of factors that can affect the exposure of film in a camera. Although the exposure latitude of some films will accommodate a certain amount of deviation from the optimum exposure, the following factors should be taken into consideration to obtain consistent results.

1. Exposure meter accuracy. A suspect meter can be compared with other meters on a transparency illuminator.
2. Method of using the meter. Choice of appropriate subject area for reflected-light readings and correct positioning of meter. Correct positioning of incident-light meter and allowance for very light or very dark subject.
3. Closeup exposure factor. Compensation for the increased lens-to-film distance for closeup photographs.
4. Filters. Appropriate increases in exposure are required to compensate for absorption of light by a filter.
5. Reciprocity. Appropriate increases in exposure for

long and short exposure times, and use of a filter to compensate for color shift with reversal color films.
6. Shutter accuracy. Suspect shutters should be checked by a professional camera repair person.
7. Shutter efficiency. The effective exposure time is longer than the marked exposure time with between-the-lens shutters with combinations of high shutter speeds and small diaphragm openings.
8. Lens transmittance. A significant amount of light can be lost due to absorption and reflection with lenses having many elements and with uncoated lenses.
9. Flare light. Bright backgrounds and light sources included in the picture can increase the exposure, especially in the darker areas, due to flare light.
10. Illumination color. Panchromatic films tend to be slightly more sensitive to daylight illumination than to tungsten illumination. The difference can be dramatic with orthochromatic and blue-sensitive films. The spectral sensitivity of the exposure meter can also be a factor, especially if readings are made through filters with behind-the-lens meters.
11. Film development. The effective film speeds of BW films increase with the degree of development.

## REFERENCES

Adams, A., 1971. *The Negative*. Dobbs Ferry, NY: Morgan & Morgan, p. 14.

American National Standards Institute, 1986. *Photographic Exposure Guide*. (ANSI PH2.7). New York: American National Standards Institute, pp. 31-35.

Bartleson, C., 1960. Memory colors of familiar objects. *J. Optical Soc. Am.* 50:73–77.

Dunn, J., and Wakefield, G., 1974. *Exposure Manual,* 3rd ed. London: Fountain Press, p. 66.

Eastman Kodak Company, 1976. *Kodak Professional Black-and-White Films*. Rochester, NY: Eastman Kodak Co., p. 19.

International Standards Organization, 1981. *Determination of ISO Speed of Color Reversal Camera Films*. Geneva, Switzerland: International Standards Organization.

Norwood, D., 1950. Light measurement for exposure control. *J. Soc. Motion Pict. TV Engrs.* 64:585–602.

Stroebel, L., Compton, J., Current, I., and Zakia, R., 1986. *Photographic Materials and Processes*. Boston: Focal Press, p. 102.

## BIBLIOGRAPHY

Adams, A., 1971. *The Negative*. Dobbs Ferry, NY: Morgan & Morgan.

Adams, A., 1974. *Camera and Lens*. Dobbs Ferry, NY: Morgan & Morgan.

American National Standards Institute, 1986. *Photographic Exposure Guide*. (ANSI PH2.7). New York: American National Standards Institute.

Bartleson, C., 1960. Memory colors of familiar objects. *J. Optical Soc. Am.* 50:73–77.

Blaker, A., 1988. *Photography: Art and Technique*. Stoneham, MA: Focal Press.

Dunn, J., and Wakefield, G., 1974. *Exposure Manual,* 3rd ed. London: Fountain Press.

Eastman Kodak Company, 1976. *Kodak Professional Black-and-White Films*. (F-5) Rochester, NY: Eastman Kodak.

Eastman Kodak Company, 1989. *Reciprocity Data: Kodak Films*. (E-31). Rochester, NY: Eastman Kodak.

International Standards Organization, 1981. *Determination of ISO Speed of Colour Reversal Camera Films*. Geneva, Switzerland.

Jacobson, R., Ray, S., and Aitridge, G., 1988. *The Manual of Photography*, 8th ed. London: Focal Press.

Langford, M., 1986. *Basic Photography*. London: Focal Press.

Norwood, D., 1950. Light measurement for exposure control. *J. Soc. Motion Pict. TV Engrs.* 64:585–602.

Stroebel, L., 1986. *View Camera Technique*, 5th ed. Boston: Focal Press.

Stroebel, L., Compton, J., Current, I., and Zakia, R., 1988. *Photographic Materials and Processes*. Boston: Focal Press.

White, M., Zakia, R., and Lorenz, P., 1976. *The New Zone System Manual*. Dobbs Ferry, NY: Morgan & Morgan.

# Part II

# Common Applications in Biomedical Photography

# Chapter 4
# Photographic Copying

## William H. deVeer

*"A word fitly spoken is like apples of gold in pictures of silver."*

Proverbs 25:11

This chapter explains how to assemble and use a biomedical copying system. Such a system can be assembled from commonly available photographic equipment. The selection of equipment depends on the type and amount of work to be done, but also on the availability of space and funding. The copying setup must be correctly placed, adjusted, tested, and maintained to ensure reliable and reproducible results. These considerations will be addressed as the parts of the system are described.

A typical copying system will be given a wide range of originals to duplicate. No single approach will work with all such originals. The challenge is to anticipate and deal with the problems inherent in a particular type of original. The range of such items includes line and fine-line originals, tone matter such as photographs and artist's renderings, typed matter and illustrations in books, transparencies, graphic traces such as electrocardiograms (ECGs), and slides for duplication. Included in this presentation are several suggestions for dealing with combinations of the above originals.

## SETTING UP SYSTEMS

### Environment

The first choice to make for a copying operation is the *location*. The room chosen should be large enough to hold the equipment, of course, but there are other requirements that need to be addressed.

In the best case, a room should be found that can be devoted exclusively to this work, if only because there will be so many times when the lights must be off. However, if this is not possible, then a corner of a large room may be used. The minimum clear floor space should be no less than 8 × 12 feet with an 8-foot ceiling.

The copy area will need plenty of counter space. However, if this is not built in or available as furniture, a cost-effective solution is to use library book wagons or similar portable carts that can be moved around as needed.

The wall against which the copy stand is placed should be painted black. Otherwise, the wall will behave like a reflector operating exclusively from the back, causing uneven illumination. The other walls do not have to be black, but they should not be a brilliant color. A good arrangement is shown in Figure 4.1.

For the same reasons, a substantial area of the ceiling above the copy stand, or behind a horizontal camera, should also be painted black. Moreover, ceiling light fixtures directly above the copy stand can produce reflections and should be removed or covered with a dark material.

Proper control of lighting is important. If the room has windows, it must be possible to shut out all light coming from them. Common office illumination is acceptable for most activities in the room, but the lighting must be reducible to a very low level when copying is taking place.

The power requirements for equipment such as lights, timers, relays, viewers, and vacuum pumps can be supplied by two or three 30-ampere duplex outlets. Another such outlet on an opposite wall can be convenient for accessory equipment.

Finally, the room must be well ventilated. Tungsten lamps, the most popular for copy illumination, convert 90% of the energy they consume directly into heat. To keep such equipment from overheating the area, a ventilation rate that is twice that of a normal office area is recommended. An alternative is to rely exclusively on electronic flash and fluorescent lamps, which produce very little heat and can be operated in a normal office environment.

### Horizontal and Vertical Systems

Copying systems can generally be classed as horizontal or vertical. *Horizontal systems* are very popular in printing and graphic arts. Their advantages are:

1. Large size—to make large negatives or plates
2. Precision—strong, permanent alignment of all parts

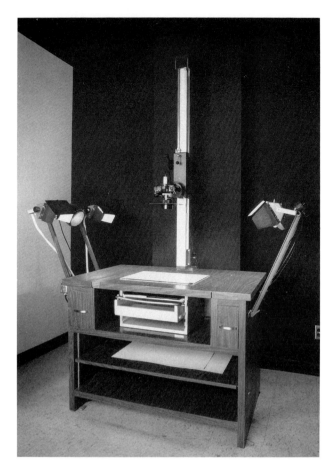

**FIGURE 4.1    A custom-built copy stand for 35-mm or 4 × 5 inch cameras. A pair of round lights are for focusing only; four rectangular lights provide good illumination. A focusing light is on the camera viewer also, made by Hama in Germany. The post and light supports are from the Polaroid MP-4 multipurpose camera system.**

3. Micrometer focusing—with numbers rather than by eye
4. No need to use a ladder to examine the focusing screen as would be necessary with a large vertical stand

However, the large size of horizontal copying systems makes them impractical for biomedical applications, where space is at a premium. Moreover, such systems have not been designed to support the small 35-mm camera that is standard in biomedical institutions.

In contrast, *vertical systems* have four distinct advantages:

1. Little floor space is required.
2. All copy functions can be performed from one operator position.
3. The originals lie flat on the base or copy deck of the copy stand, instead of being held or hung up in a vertical position (books are especially hard to hang).

4. The standard 35-mm system, which is inexpensive and allows cameras to be exchanged with other sites, is supported.

Because a horizontal system is beyond the capacity and need of most biomedical institutions, the setup of a vertical system will now be described in detail. Such a system is the best choice for small- and medium-film formats. In the context of this presentation 35-mm roll films up to 4 × 5 inch sheet films are considered to be small- to medium-format films.

### The Copy Stand or Base

In a vertical system, the camera post must have a substantial base support. This means either a strong, flat desk top or a reinforced area where the camera post can be securely attached. The base or copy deck height should be chosen to accommodate a standing or sitting operator. The standard office desk height of 29 inches can take care of both quite well.

### The Camera Post

The *camera support post* should be vertical, not slanted. The vertical post or column will keep the original centered to the camera axis as the camera is moved up and down. Some posts offer an adjustable bar for lateral movement of the camera, which is helpful for centering the camera when the attachment point (tripod socket) is not directly in line with the axis of the lens. However, a camera stand with many joints and springs must be avoided. As with enlargers, a gear type movement with a good size hand crank makes such a post easy to use. If the copy stand is in constant use, this may not be enough, and a motorized elevator should be considered.

The post must be aligned at a right angle to the copy deck. During the alignment procedure, the camera should be attached and positioned high on the post. A machinist's spirit level and thin metal shims should be available.

Begin by leveling the copy deck itself along its length and width, using shims under the copy stand legs. The stand or desk should now be "rock steady." Next, hold the machinist's level against the camera post on the front and on one side to determine if the post is exactly 90 degrees vertical from the copy deck, commonly referred to as being plumb. If further shimming is required, firmly tape the level to the front or back of the post while shims are placed under the post support. Repeat on the left or the right side.

Finally, look at the moving arm section. Some models have wheel bearings, which are on eccentric bolts; these can be adjusted to position the arm horizontally. A sagging arm will make copying nearly impossible.

The method of attaching the camera to the movable arm is the last and usually the weakest link in the whole system. A copy camera must be held so that all three planes (film plane, lens, and original or copy deck) are parallel. If they are not perfectly parallel, there will be perspective distortion, and the image will not be in precise focus over the full image area. A method of determining if the three planes are absolutely parallel is described below.

Small cameras are not so small or light when a motor drive, lens, lens hood, camera shield, and viewer are added. The small threaded tripod sockets on 35-mm cameras provide insufficient support when a camera is positioned at the end of the moving arm. In any significant operation it will be difficult to maintain the camera in alignment over extended working periods; therefore an additional camera support will be required. Camera support brackets are available from professional camera stores or can be fabricated by the institution's machinist.

The Polaroid MP-3 and MP-4 Multipurpose (Polaroid Corp., Cambridge, MA) camera systems are excellent medium-format systems; they are primarily designed for copying and have adequate support. Although the system is designed for medium-format films, there are small camera adapters available from Polaroid and other manufacturers. It is well to inspect any of these adapters to be sure that the camera can be securely attached to the arm and positioned close to the copy board.

## Final Alignment

The final camera alignment can easily be checked by using the camera reflection.[1] Put a piece of black film or paper under glass on the copy deck or book holder. Then turn on the copy lights, and look for the reflection of the camera lens in the viewer. Move the camera up and down on the post. If the image of the lens remains centered in the viewfinder, the image (film plane), lens, and copy deck are parallel. But if the reflection is off-center, some kind of tilt is occurring and must be corrected to prevent *keystoning* (wedge-shaped images) and to ensure edge-to-edge sharp focus. This test should be repeated from time to time, as equipment tends to wander out of alignment during use.

## Lights

Copying needs light that is bright, even, and without specular reflection. If color film is in use, the light must also be color balanced. The proper selection of the lighting system is not easy. Systems made for everyday photography are usually not suitable for the copy stand.

There are three types of lighting to consider:

1. Filament or tungsten lamps should be chosen for color temperatures and consistency. Tungsten–halogen (T–H) lamps are the best for copying. Their intensity remains constant over their life span, which far exceeds the life of the common household bulb. The light they emit has a consistent color temperature, which will range between 3200 K and 3400 K, depending on the design of the lamp and the operating voltage. The series of 650-watt T–H lamps with an operating color temperature of 3200 K is an ideal light source, as it matches the color temperature of tungsten color film at 120 volts and produces intense levels of illumination. When employing very slow films (those with a low International Standards Organization [ISO] speed index), a great amount of light is needed to keep the exposure time within reasonable limits.

2. *Flood* and *photoflood* lamps with built-in reflectors are good for short-term copy setups. They are inexpensive, and they fit the common household screw socket. The *flood* lamps come in wattages ranging between 150 and 500 watts. The 500-watt lamps, frequently called *photofloods*, are available with a color temperature rating of 3200 K or 3400 K, which matches type B and type A tungsten films, respectively. These lamps do not last long; they lose intensity as the glass envelope darkens; and their colors shift with age. Hence, they are not recommended for long-term or professional use. However, most of the flood lamps that operate at 2800 K or below are acceptable light sources for black and white (BW) films and for color films with the appropriate color balancing filter on the camera lens.

3. Electronic flash lamps are ideal for photography of colored originals and most BW continuous-tone originals. There is no annoying heat produced by the lamps, although the preferred units do have low-wattage filament lamps for focusing purposes. The color temperature of electronic flash units is nearly perfect for use with daylight color film; this should be confirmed by test exposures, however, as some units may wander from the ideal. Electronic flash units are not suitable for use with certain direct copy films and lithographic films. A stand can be fitted with both tungsten and electronic flash units, thus offering a lighting system best suited for any subject that might be encountered.

4. Fluorescent lamps can also be used for copying and are often seen in the illuminator or transparency viewing part of a copy stand. Light from such lamps has some inherent defects that must be corrected or adjusted for, however.

*Fluorescent emission* is partly a "continuous" spectrum of light from the mixture of phosphors lining the tube walls, and partly a series of four "line" emissions from the exciter radiation, which leaks through the phosphors on the tube walls. The four lines are in the deep blue, blue,

green, and yellow spectrum. Such illumination is acceptable for BW films, where there is no possibility of distorting the color of the image.

However, color photographs made under common fluorescent light have a blue-green to green-yellow tint. Acceptable, although not ideal, color correction can be made by placing one or more color-correcting filters on the lamp or the camera lens. Photographic supply houses stock camera filters specifically for fluorescent lamps of known spectral distribution.

Of special note are the fluorescent lamps uniquely designed for transparency illuminators and viewers, which have a correlated color temperature of 5000 K, such as the Macbeth F40T1250[2] (Macbeth, Div. of Kollmorgen, Newburgh, NY). This particular lamp produces an illumination that is a good match for daylight film.

The color quality of the image may need to be further enhanced by a very mild color-compensating filter on the camera lens. The necessity of a filter and its tint and density is best determined by empirical testing.

Another problem that needs to be avoided is the cycling output of fluorescent lamps. Dark shadows may appear across the picture when a focal plane shutter is operated at speeds above 1/60 second. Since most single-lens reflex (SLR) cameras have focal plane shutters, this is a common problem. The lights are actually flickering at the speed of the electrical supply, which will leave certain areas underexposed by the focal plane shutter, as it is traveling in front of the film plane. The only corrective action possible is to use a slower shutter speed. This allows the light to go through several cycles while the shutter is wide open; 1/30 or 1/15 of a second or slower is recommended.

Once the lighting system has been chosen, it is necessary to ensure that a large area containing the copy board is evenly lit and free of reflections and highlights. *Reflectors* have a significant effect on the distribution of light across the copy board. Round reflectors throw round hot spots and are not as good as rectangular reflectors, which throw a smoother spread of light across the copy board (Figure 4.2).

With only two lights, a "hot" or brighter area will be produced across the middle of the copy board. A better distribution of light is possible using four lights with rectangular reflectors at the four corners of the copy board.

Positioning the lights 45 degrees from the outer edges of the copy board yields a large area of relatively even illumination. Whatever arrangement of lights is chosen, the lights must be symmetrical to each side and aimed so as to cross in the center of the board. Symmetry of illumination can be judged by holding a pencil vertically at the center of the copy board and observing its shadows. All the shadows should be equal in length and symmetrical.

An incident exposure meter with a flat integrating

**FIGURE 4.2 Rectangular reflectors with tungsten–halogen bulbs work best for copying.**

disk, such as the Sekonic Studio Deluxe Meter No. L-398 (Sekonic RTS, Farmingdale, NY), can be used to verify the even distribution of light over the total area of the copy board. A more sensitive test for even lighting is to make a slightly underexposed copy of plain paper using high-contrast film. The developed negative will unerringly show hot areas if any exist.

Objects above the subject level can cause reflections that interfere with the desired smooth lighting. There are some simple steps that can be taken to eliminate all equipment and operator reflections from shiny subjects and the glass on the copy holder. The copy lights should have "barn doors" to limit the spread of light to the copy deck. A black camera shield, with a hole for the lens, must be fabricated from matte black poster board, or from similar stiff material. The shield is suspended from the lens of the camera to eliminate reflections of the camera body (Figure 4.3). In addition, a long, black cloth-covered cable release should be used to make the exposure.

Specular highlights will always be seen on the copy board. This image-destroying highlight effect can be reduced by using *crossed polarizing filters* on the light source and the camera lens. If tungsten lights are used, the filters must be placed about 6 inches in front of the lights to prevent overheating the filters.

*Crossed polarization* can be visually determined. Place a coin in the center of the copy board. While viewing the image of the coin in the viewfinder, turn the filter on the camera lens until the coin is rendered the darkest. At this point, the filters are crossed. When a focusing and viewing light is attached to a viewfinder such as in Figure 4.3, crossed polarization can be verified with the focusing light and viewing the coin through the polarizing filters attached to the copy lights.

**FIGURE 4.3** A shield to prevent reflections is needed at all times and should be big enough to cover all of the camera equipment. The camera shown here is a Canon F-1 and is fired with a remote switch to the autowinder. A focusing and viewing light is attached to the viewfinder, made by Hama in Germany. The lens is a 50-mm macro, and the shield is a piece of cardboard held up by the lens shade.

There is a small but noticeable gain in contrast for printed material when polarization filters are used, and for this reason, many professional photographers routinely use them. Due to the density of the filters and the polarization effects, the basic exposure as determined with a hand-held meter, must be increased by three stops or, preferably, the exposure time increased eight times. Polarizing filters vary slightly in color, density, and effects so a test should be made to determine the exact exposure and filtration, if any, for the particular setup in use.

## Camera

Most workers in the biomedical field use 35-mm cameras, and there is a film in this size to fill almost every need. Medium- to large-film-format cameras, 4 × 5 inches and above, were once considered necessary to make sharp images, and large film sizes are still needed for painting, retouching, cutting, or taping negatives. However, for most other purposes, a 35-mm camera with a better lens can outperform a large camera.

1. Many 35-mm cameras are not suitable for use in copying because of a poor *viewfinder*. Some viewfinders restrict the visual image to 90% of what the negative actually records. Also, the viewfinder may not be parallel to the film gate.

The accuracy of the focusing screen is crucial, since many originals are reproduced as direct reversal slides where no further opportunity exists to crop or align the image. Cameras suitable for copying must have a right-angle viewfinder and a screen that shows the entire area being recorded without any prismatic focusing aid in the center of the screen.

An excellent help for aligning the copy and focusing the image is a screen with grid lines and a centered clear spot with crosshairs. A focusing magnifier attached to the viewfinder is useful to compose and focus the image. These features may only be available for some camera models, and only as replacements for the standard system.

2. A *pin registration camera* is required when work is being done for multiprojector shows where several images must accurately overlap. Effects such as animation, dissolves, and progressive revealing require the exact placement of images in the camera and the mounts.

Some small cameras can be converted for pin registration, but a good camera system built for copying will come with this feature. Pin registration in the camera makes use of the 35-mm sprocket holes to ensure exact placement of each image from one frame to another. This image placement is maintained by mounting processed film in a pin register mount, which also has pins for the sprocket holes. If the camera image is aligned correctly, the projected image will also be properly aligned. A proper camera, mount, and mounting machine must be on hand for a complete system to produce perfectly oriented and straight images (see Chapter 6, "Graphic Slide Production").

3. The critical task of focusing can be made easier with a projected screen. This fact can be demonstrated by turning off the copy lights and holding a pocket flashlight against the camera eyepiece. When the lens is correctly focused, the focusing screen and *reticle* (if any) will be seen on the copy deck.

Several companies offer a fiber-optic light, which is ideal for this method of focusing.[3] Composing and focusing this way is quite fast, and avoids the use of the hot copy lights. The method is as accurate as the camera itself. If the screen and camera are well made, the images will be straight and sharp. A right-angle viewfinder is not required, although the screen listed previously is much to be desired. Long-focal-length lenses and taller posts are then no problem for the operator.

4. Lenses for copying should be able to focus very close to the subject. Not all lenses that can focus close to the subject are suitable as *copy* lenses. The designation of *macro* on a lens is also no assurance that the lens is ideal for copy work. All quality manufacturers of 35-mm cameras offer specific lenses for copy work, which may or may not be described as macro lenses. You must refer to the technical specifications to be sure the lens is designed for copy work.

Copying can be done with either a 50- or 100-mm lens. The size of the original will determine which lens is most convenient. The shorter focal-length lenses are best for large originals, since there is little need to stand on a stool to operate the camera. The opposite is true for small originals, where the 50-mm lens may be so close to the original that the copy lights will cause discomfort to the operator and heat the camera excessively.

The focal length of the lens controls how much coverage one can get at any given distance. As a rough guide, a 50-mm lens on a 4-foot post will cover up to $20 \times 30$ inches of copy on 35-mm film. Using a 100-mm lens will give half the coverage at the same height.

5. Bellows factor compensation is another important consideration in the purchase of a lens. The *bellows factor* is the increased extension of the lens that occurs when focusing on close objects. Nikon's original Micro-Nikkor lens (55-mm, $f 3.5$) (Nikon, Inc., Melville, NY) automatically corrected the lens aperture for this effect. This eliminated the need to determine the lens aperture for each new extension of the lens to focus on objects at varying distances. Most newer copy lenses do not contain this automation. Instead, exposure determination is made through the lens at or near the film plane or its optical equivalent, which automatically compensates for the bellows factor.

Unfortunately, the variety of material that is the normal fare of copy originals precludes the value of any off-the-film measurements. Automatic bellows factor compensation by the lens is a very important feature in a copy lens. Any of the new Nikon Micro-Nikkor lenses can be fitted with this feature by professional camera repair shops.[4] It may be possible for other makes of lenses to be fitted with this feature by the manufacturer's proprietary repair facilities, but this should be determined *before* the purchase of a camera and lens.

Another desirable feature that increases the speed and accuracy of exposures is to have the camera repair shop place one-third stop indents on the aperture ring. The normal one-half stop indent is sometimes too coarse for color film and always too much for high contrast films.

Lenses for copying on $4 \times 5$ inch film need to be looked at carefully. There is less depth of focus on a larger image, and bad images are easy to see. Focal lengths for $4 \times 5$ inch work can go from 135-mm to about 200-mm. Many of the best copying lenses are not made short enough for a vertical stand, so the choice of lens is limited.

Shutter mounted lenses are the best choice in this type of work, along with flash synchronization. A desirable feature available on some models is a focus setting that automatically opens the diaphragm for viewing and then sets it back to the selected aperture for the exposure.

6. The amount of *aberration* in a lens must be known to be small if it is to be used for copy work. Two types, *curvature of field* and *spherical aberration*, must be reduced

to the very minimum in a copy lens. All quality lens manufacturers will indicate if a lens is sufficiently corrected to be a copy lens. It is recommended that the reader review Chapter 2 for in-depth information on lenses. For lenses with focal lengths of 100 mm or longer, the manufacturer may specify the range of magnification/reduction where the lens is specifically designed to operate.

Most readers will not have the luxury of testing a lens before purchase and should acquire a high-quality copy lens only from a recognized optical manufacturer. The following tests can be employed to determine if a previously purchased and untested lens is sufficiently corrected for use on the copy setup.

If a testing bench or optical tools are not available, a good practical test can be done by actually making negatives and reading them with a magnifier. The trick to getting a good test is to make a set of resolution targets that will show depth of field at three levels. Make a set of five targets on a little three-step arrangement (Figure 4.4),[5] each step about 1 cm (or 3/8 inch) higher than the other. Five of these step sets can be placed to cover the copy area—one on each of the four corners and one in the center. The height of the camera should be adjusted so that the four corner targets are near the edge of the viewing screen when the copydeck is in full view. Once the step targets are in the camera view, the focus should be made for the middle height of the center target.

Curvature of field can distort the image as though it were slightly dish-shaped, with the edges closer to the lens. Many lenses are really sharp edge-to-edge, but not on the same plane. To test for curvature of field, adjust the lens aperture to $f/8$ for a 35-mm camera or $f/11$ for a $4 \times 5$ camera and focus very carefully on the center target. Expose and process the film. Carefully examine the negative with a $5\times$ to $10\times$ achromatic magnifier.[6] The

FIGURE 4.4   Five three-step targets were fabricated from three 1-inch strips of 1/4-inch foam core and 1/8-inch mounting board and sandwiched together. The targets and steps were assembled with double-sided tape.





image should be sharp on the middle step on all five targets.

Spherical aberration is more difficult to determine. A lens naturally has the outer zones focus closer than the center zones and must be corrected to minimize this effect. The common practice is to focus when the lens is at maximum aperture (wide open) and then reduce the aperture for the exposure. Since the outer zones of the lens are used to focus and the central zones to make the exposure, you may find that the images are not as crisp as they should be. This is because the point of sharp focus has actually shifted farther from the lens.

You can test your lens for spherical aberration by carefully focusing the top step of the center target. Do not reduce the aperture for the exposure but, rather, change the shutter speed to make the proper film exposure. Then make a second film exposure with the lens stopped down to the smallest aperture you may expect to use. This aperture would be about $f/11$ for a 35-mm camera or $f/22$ for a $4 \times 5$ camera. After processing, examine the center target with the $5\times$ to $10\times$ achromatic magnifier. The image on the top target step should be the sharpest with the lens wide open *and* closed down. Spherical aberration also shows itself as a loss of contrast. A loss of contrast can mean loss of very fine lines in the negative as they blend into the background.

Poor alignment, such as a tilted lens mount or a tilted camera, will show up on the stepped targets if the higher targets on one side are sharpest, while the lower targets are sharp on the opposite side. If the targets are not evenly sharp, you will have to realign the setup and ensure that all planes are parallel by using the previously listed lens test in the section on Final Alignment.

## Copy Holders

*Copy holders* are a necessary part of any system. This is where the vertical camera has the advantage, since the copy is placed on a table. The table top, or "deck" needs to be larger than the largest copy so that the work can be shifted around under the camera, much as an enlarging easel is aligned under an enlarger. A fairly large double- or triple-weight mounting board ($16 \times 20$ inch) and two somewhat smaller pieces of 1/4 inch thick glass ($12 \times 18$ inch and $7 \times 11$ inch) with rounded edges will accommodate most types of two-dimensional originals (typed matter, tracings, tear sheets from a magazine, and so on). The glass should meet the following specifications: clear glass, mirror select, water white American Society for Testing and Materials (ASTM) type 1, class 1, Q1. Note that *mirror select* refers to the quality of the finish. The board should have a dark-gray side to reduce the effects of diffused light outside of the viewing area from entering the lens. The effect is not unlike that discussed in the section on duplication. The original is sandwiched be-

tween the glass and the mounting board. Originals that lie flat naturally can be photographed without the glass. The glass does not cause problems, except for reflections, but it must be kept clean and free of all scratches. Of late there has been an interest in antireflection glass. This glass is finely etched to decrease the effects of reflection, but it also causes optical degradation and should be avoided.

Several companies offer hinged copy holders with pressure plates beneath the glass. This is ideal for work with art and overlays (cells). Book holders are a great help in the difficult task of copying pages from a book. Some manufacturers offer a kind of tray with foam pad inserts, so the unequal levels of an open book can be pressed smoothly against a glass top. Another type has a sliding press that will push the book tightly against a glass top. This kind of holder is rather tall and will change the focusing level, the angle, and level of illumination. The illustrated copy setup has a removable copy deck and deep well for this holder, which makes the focusing and illumination levels identical to the copy deck when it is in place (Figure 4.5). The sliding press book holders are very desirable, since the entire book and holder can be moved around as needed to center the picture. These holders are very difficult to find, since they are no longer manufactured. A schematic of a sliding press is illustrated for the project-oriented reader (Figure 4.6).

Any paper or page that has printing on both sides may show a faint image of the backside when placed on a white surface or another page in a book. This is especially true if the paper is thin. The backside image can be eliminated by inserting a sheet of black paper behind the page to be photographed. The black paper also reduces the "whiteness" of thin paper and therefore a slight ex-

**FIGURE 4.5 This book holder is tall but may be used in a deep well so that the top surface is at the right level (see Figure 4.1). The original model, marketed by Leitz, is no longer available.**

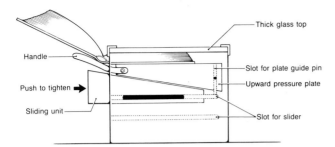

Thick glass top

Handle

Slot for plate guide pin

Upward pressure plate

Push to tighten

Sliding unit

Slot for slider

**FIGURE 4.6    The schematic of the sliding book press.**

posure increase is desirable. The above recommendations should be a routine procedure when copying pages from books.

## Slide Duplicators

Duplicators or optical printers are specialized camera systems that can focus in the range of 1:1 and integrally include the illumination system. The systems are available in an extremely wide range of sophistication and price. The choice of model depends on the quantity of duplication, the need for optical effects, and whether the slides will require the accuracy of pin registration. If copying needs suggest that an advanced duplicator is needed, the reader should study the three articles by Bunker (1975); de Veer (1975); and Smialowski and Currie (1960), and also visit an establishment that has a duplicator set up and running. This section will address the more common case involving simple slide duplication with a copy stand setup or with one of the many basic duplicators available at photographic supply houses.

The lowest-cost system involves fitting a 35-mm camera with a small bellows, close-up lens, and a built-in slide holder. This modification is possible on most such cameras. Some units also incorporate an attached flash aimed toward the lens. These systems are awkward to use, and it is difficult to standardize the exposure and color balance for consistent results. A simple system like this would only be appropriate if duplication were strictly occasional.

The copy camera stand listed previously can be used with duplicating systems that are basically integrated light sources and slide holders but without any camera attachment. The only requirement of the copy camera system is that it will permit a 1:1 image size and, possibly, an increase of the image size for cropping purposes. The light source is fitted with filters to color balance the light source or color-correct an imperfect color slide. The equipment is relatively small and is often a manufacturer's adaptation from their enlarger color-head. It is placed on the copy deck and the camera is lowered and focused to produce the required image size.

This type of duplicating system extends the versatility of the copy setup and is suitable for a moderate quantity of duplication. The project-oriented reader can also construct a similar item without too much difficulty. Photographic magazines occasionally publish the plans for similar construction projects, from which an interested reader may find guidance.

Finally, there are the semiprofessional and professional setups sold at professional photographic supply houses. These range in price from several hundred to more than a thousand dollars, with the price determined by the degree of sophistication. These are solidly constructed systems with sufficient versatility and ease of operation to suit the busy photographer. These systems do not, however, allow for optical effects or pin registration. They include specific camera adapters so that the user's camera body can be attached to the integrated lens system. Methods of reducing image contrast and exposure determination are often included in the system.

Since the above system requires using a camera body, the user should consider the camera viewfinder and its screen with the same scrutiny as the copy camera. Focusing must be done through the viewing system and not by projecting the screen reticle onto the surface of the slide.

**Viewing and Cropping.**    Most, if not all, hand-held cameras do not show the entire field being photographed. Many screens, especially the removable ones, can shift in their housing and are seldom accurately aligned with the film gate. These facts make it difficult to set and maintain image placement.

The viewing system in a high-quality commercial duplicator will have an attached magnifier, a screen image slightly larger than the photographed image, and a format with grid lines for exact placement of the image. This makes multiple exposures and composite images easier to plan and execute.

**Contrast.**    The common duplicating setup increases the contrast of the duplicated image. Shadows will be slightly darker, and very light highlights may even disappear. The use of special slide-duplicating film is highly recommended for controlling this problem. Such films have a gamma (contrast) rating of about 1, compared with regular daylight film having a gamma rating of 1.2. The lower contrast of the duplicating films keeps near-black areas from going black, and in most cases, preserves the highlight details, thus making a good duplicate possible. Fortunately, the films are available in 135-36 magazines (cassettes) and in long rolls, with a substantial saving in cost for those willing to roll their own. The films are balanced for tungsten illumination at a 1-second exposure time. Eastman Kodak also offers a film balanced for daylight or electronic flash (Ektachrome SE Duplicating Film SO-366).

The careful user will need to fine-tune the color quality

of the light source to match the color balance of the particular film emulsion in use. Color-correcting or color-printing filters can be placed between the original slide and the light-exit port. The filter should not be placed between the slide and the camera lens.

Filters may be used to correct undesirable color tints in the duplicate due to the light source or film emulsion. They may even be used to correct the same problems in an imperfect original slide. Kodak color print viewing kit (Cat. No. 150-0735) may be used to choose a filter with suitable color and density to correct the problem. Moreover, the kit includes viewing filters, which may be removed and used for the duplicating stand, rather than purchasing such filters separately. This is only possible for 35-mm slides, however.

Another way to reduce contrast, using typical camera films, is by *postflash*, which involves a double exposure. First, a normal exposure of the subject is made. Then a second, *flash* exposure, is made using the same light source with a 1.6 to 2.0 neutral-density filter replacing the original slide on the slide holder. Some slight variations of the flash exposure will yield different grades of contrast and can make shadow areas much lighter without affecting highlights.

The technique is particularly useful for correcting underexposed or very-low-contrast original slides. Overexposed original slides can be improved by using ordinary camera films and eliminating the postflash. These types of contrast control require making several empirical exposure tests. Use standard, under- and overexposed slides and low- and high-contrast subject slides to arrive at the best combination of normal and flash exposures for the type of slide being duplicated.

This type of contrast control can be purchased and can be made to work with only one exposure—a great advantage. This trick is done with a 45-degree glass or *beamsplitter* under the lens, or with a fiber-optic pipe that carries a controlled amount of light from the light source into the camera. This makes a flash exposure from behind the lens. This method is preferred, since there are then no optical elements in front of the objective lens. The use of flash exposures to control contrast with typical camera films has some benefits over the specially designed slide-duplicating films, but it is not recommended for the casual worker, due to the necessity of maintaining very accurate control of the flash exposures.

**Sharpness.** Sharpness is a subjective quality, difficult to measure. However, it is often judged to decrease in a duplicate of a sharp original. The loss is usually attributed to a low-quality lens, but the effects of diffused illumination entering the lens may be a more significant factor. A high-quality lens is a prerequisite in copying, but no matter how good the lens, diffused illumination will set the limit on sharpness, just as it does in an enlarger, or even a microscope. A light-source setup with condensers, such as Köhler illumination with the microscope, will make any lens produce sharper images (Vetter 1961). The effect is most noticeable with low-quality lenses, where condenser illumination reduces residual aberration and flare. At some point, however, the contrast will reach a point where dust and scratches become very evident and further increase in contrast undesirable. Such problems can be overcome, if necessary, but this requires equipment and techniques beyond the scope of this publication. Where the ultimate in resolution is required, Köhler is the illumination of choice. For everyday duplication, diffusion illumination is the usual choice, using the specially designed duplicating films.

## USING THE SYSTEMS

### High-Contrast Line Copy

High-contrast line copy, such as printed matter, schematics, and charts, contains just two tones: black and white. When copying such items, high-contrast film and chemicals should be used to eliminate all other tones from the duplicate. A good line-copy negative will have a very transparent image wherever the subject is black, and a very dense black area where the subject is white. A *densitometer* is desirable in this situation, and it should measure a *D-max* (or maximum density) of 3.00 or higher on the negative.

Visual evaluation and experience can make the exposure and processing of line films a reliable procedure. If you can see through the black areas, even a little bit, then the negative will not be good enough to use as a negative slide, nor will it make good colored negative slides or *diazos*. (See Chapter 6)

Line copies can be made on two general types of film. The *lithographic* type is developed in lithographic chemistry, stored in two parts, and mixed just prior to use. The processing is extremely sensitive to agitation, temperature, and timing and is difficult to repeat unless care is taken. The film and recommended processing procedures are packaged with the film or available from the manufacturer without cost.

There are some lithographic films that can be used in more than one type of developer. However, most other developers, when applied to lithographic film, will change its speed dramatically, producing fogged negatives. It is important to read the directions accompanying the film.

A second type of line copy film is made for *machine processing* or in *rapid-access developers*. This type of film will yield almost the same high contrast and D-max as lithographic films, with the added benefit of ease in processing and more consistent results for the average photographer. In 35-mm size, these films are a better choice, since a slight variation in processing will still produce an

acceptable printable negative. Such films do well even in high-speed x-ray processors.

Getting the right exposure in line copy is not easy. All lines are not alike, and even white fields differ. A heavy exposure is usually desirable to maintain a good black negative, but lines become thinner and thinner as exposure is increased. The very fine lines and points may even disappear. This should be checked with a magnifying lens, or loupe. At the other extreme, lines and letters will get wider if there is not enough exposure. Bold type will actually merge together. This should also be checked for with a magnifying lens. One should look for the finest black lines and the finest white spaces to see if the exposure falls between the two; the fine lines must not be pinched off or closed, and the finest spaces must be recorded clearly on the negative.

### Poor Originals

A poor original will test the power of a copying system and the expertise of the photographer. An in-house photographic service must learn to deal with the problems of gray or faint lines, pencil work, dot-matrix printing, and black ink that varies in tone. The task in copying a poor line original is to make the not-so-black lines black while maintaining the absolute whiteness of the background. High-contrast films can be used to separate two closely related tones of gray by reducing the basic exposure until the dark gray tones are recorded without any trace of density in the clear areas. This may create other troubles such as a very thin negative full of *pinholes*. If this kind of negative has the image, however, then the pinholes can be opaqued. As bad as it may look, the negative can be printed using high-contrast papers or high-contrast printing filters. The result can be an excellent copy of a very poor line original. To the uninitiated, the results will be amazing.

A mixed poor and good original may have very fine line areas, along with very heavy black lines. Duplication is best done by using two negatives that are exposed and processed to suit the extremes of the original. The negatives can then be cut and taped together to form a printable composite. This labor-intensive technique is only possible with medium- or large-format negatives.

### Fine-Line Originals

Fine-line originals, typified by pen-and-ink drawings, are another test of the copy photographer's skill. The goal is to maintain the original contrast and resolution and, perhaps, to increase the density of the fine inked lines. This requires absolute control of exposure and processing of the negatives and the prints.

The lines in a drawing may become very fine and gray

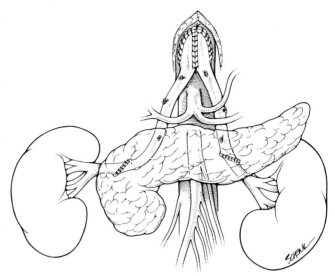

FIGURE 4.7  Fine-line artwork is a most difficult subject, and tests every part of the system. (Reproduced with permission from *Journal of Surgery, Gynecology and Obstetrics*, February 1989, Volume 168, p. 181, artwork by Michael Schenk).

as the supply of ink in a quill pen decreases. In addition, the fine lines are often grouped together to simulate shading in three-dimensional objects. Such pen-and-ink drawings should be treated as line copies. The exposure should usually be reduced to one-half the exposure for a normal BW illustration (Figure 4.7).

If the copy loses fine detail, then a better copy may be possible by employing films with less contrast, such as the *process-type* films, or a *microfilm-type* emulsion. Such films record some intermediate tones and are better able to retain a wide variety of line widths than lithographic films. A negative made in this way will not have a totally black D-max, but it can produce a fine print by employing common darkroom techniques. Such a print may even have some gray lines, but this will likely mimic the original. Experience has shown that an underexposed negative is better. A fully exposed negative will look good, but will not produce a corresponding print. This is because the negative will require long exposure times when printing. This causes "blooming" of the thicker black lines on the print. Suffice it to say that excellent and consistent results are only obtained by careful control of all exposure, processing, and printing processes.

Finally, if outstanding results are required, and time and effort are available, there is another method to consider. Eastman Kodak's Kodalith Ortho film may be processed in a Kodalith Fine Line developer. Remarkable copies of etchings or other very fine ink originals can be made in this way. The process involves tray developing, one sheet at a time, with continuous agitation, followed by 2 minutes of complete stillness. This will produce very fine details at high contrasts. Information on this process is available from the manufacturer. The

process is not recommended for the casual photographer.

### Traces on Graph Paper

*Traces* on graph paper, such as ECG or EEG, are among the most difficult originals to copy. Usually the graph, or grid, is lighter in tone than the actual ink tracing. Sometimes it is not lighter, but colored. Line-copy methods should not be used in this case. Some of the lines of the original are not black, and the copying process should not make them appear so. Otherwise some traces could actually be blended into the grid lines and be missed.

A light or colored grid should be rendered light, as either thin or gray lines. This can be done with a medium-high-contrast film, of the technical or microfilm type, which can yield a good black trace, along with a grid of lesser density. A high-contrast panchromatic film is the best choice, since different colors are often encountered (Figure 4.8).

Often a request is made to drop out the grid and retain the traces alone. This can be done using separation in color or contrast. If the grid is a light color, such as blue or gray, then an increased exposure may cause it to disappear without affecting the traces themselves. High-contrast film is needed in this case, to separate the two parts.

If the grid is a different color from the trace, such as a red grid with blue traces, then the grid and trace can be separated by filtering. A high-contrast panchromatic film is necessary. The selection of filter will depend on whether the grid is to disappear or be rendered very light on the print. Exposure, contrast, and filters are the re-

quired tools for trace copying. Here again, a less than normal exposure will usually make the best print.

### Continuous-Tone Copy

*Continuous-tone copy,* such as a photographic print, may have a full range of tones from dark to light. For simplicity, consider the original in three broad areas: dark, medium, and light tones. If all three areas are important in the copy, then a film with a long-toed characteristic curve of quite low contrast should be used, with a soft-working developer. Two films that produce satisfactory results are Ilford XP-1 (Ilford, Paramus, NJ) and Kodak Super XX. Using films of a somewhat higher contrast will make every area look better, except the shadow area which gets darker and loses detail. If this is not important in the originals, then this choice can be made.

If highlight contrast is desired, and dark areas are not too large, then a special copy film may be necessary. Eastman Kodak's Professional Copy film will build up contrast in the highlight areas while maintaining lower contrast in the darker areas. The overall contrast of both areas varies with development choice, and the highlight contrast will vary with exposure. Longer development times or switching to a more active developer will build overall contrast, while heavier exposures can build up highlight density and contrast. This same film is a good choice for a mixture of tone and line, or to hold a true white anywhere such as a white border around a picture.

### Halftone Originals

*Halftone originals* are screened continuous-tone originals for reproduction on the printing press. Close examination of these originals will indicate that the tonal effect is created by the size, type, or quantity of inked dots.

The treatment of such originals depends on the quality of the dots and whether they will be easily resolved by the photographic process. Some originals will have to be treated as line originals and others as continuous tone originals.

When the dots are sharp and dense as viewed on the focusing screen, *contrast-process films* will provide excellent quality negatives for reproduction prints. If the dot effect is not apparent on the focusing screen, then the halftone original can be treated as a continuous-tone original.

Colored halftone originals must be treated as continuous-tone originals, as there are no high-contrast color films available. There is one alternative, however. deVeer was able to produce higher contrast color slides by developing reversal color films in color negative chemicals (deVeer 1987).

**FIGURE 4.8** Traces such as this (the original grid lines are light red) require contrast and color control to reproduce well.

## Mixed Line and Continuous-Tone Originals

*Mixed line* and *continuous-tone originals*, such as a photograph mounted on white paper with black labels, may be handled two ways. (1) A single negative may work, using a special highlight-boosting film such as Kodak's Professional Copy. However, this may not match the photo contrast very well. (2) The very best copies will require two different negatives: one for the tone, and one for the line. These negatives are then painted (opaqued). The tone film is to show tone only, and the line film is to show lines only. Then, two enlargers should be set up and the printing done in sequence. The images should be carefully registered (Figure 4.9).

## Colored Originals

*Colored originals* are handled in the same way as BW except for the added necessity to balance the color temperature of the light source with the color film in use. T–H lamps are nominally expected to produce light at 3200 K and match the color balance of Kodachrome B film and other tungsten-balanced films.

Daylight-balanced films are best exposed with the light from electronic flash lamps. A good setup will have focusing lights either built-in, or alongside the flash heads. Copying with flash is not practical for the very slow lithographic films but is ideal for color. One advantage is coolness for the operator. Another advantage is easier fitting of polarizing filters over the light heads without the danger of overheating the filters.

Colored originals with overlays, or *cells* used in animation bring their own special problems. First, clear overlays must be held down tight to the art background. A vacuum frame can do this, but the tight fit causes Newton rings around every little irregularity in the material. A better choice is a spring-loaded copy holder whose grip is looser. If the artwork is made up of several layers, each layer has some density, which requires an exposure adjustment—about one-fourth stop increase for each cell layer.

Reflections in these types of art can be very persistent and difficult to eliminate. The cells rarely lie absolutely flat. They pick up reflections from equipment that would not occur with the glass overlay. A large black shield is necessary to cover the equipment as well as the hand that holds the cable release. Black cloth drapes are often required to cover other equipment in the area.

## Transparencies

*Transparencies*—or large, colored film positives—are easier to copy than one may think at first. Instead of looking for a special light box, or special back lighting, try using the regular copying lights and place a large white card in the copying field. Then suspend a piece of glass over the white card, using two boxes, about 10 inches high. Place the transparencies on top of the glass. This way, you have a known quality of light and can proceed as with any reflected light original (Figure 4.10). Just watch for shadows to be sure the white card is evenly illuminated. A blackened box should be used to keep light off the top of the transparency and to mask extra light. Cut an opening in the open box bottom to fit the transparency. Set this box over the original, and the sides will provide a good light barrier.

Films to be used in color copying include all of the normal types, and some special films. Color negatives, like BW copies, will tend to be too low in contrast at the highlights. This can be overcome using special internegative films that can boost highlight contrast.

Another problem may be a lack of overall contrast. Color-negative films cannot be overdeveloped to gain contrast. To make a good high-contrast color negative, use regular Kodak Ektachrome reversal film and process it in color negative chemistry (deVeer 1987). The resulting color negative is very useful for originals with white backgrounds, color charts, graphs, cartoons, or artwork with pastel colors.

## Exposure Control

The method of exposure determination and control of the related factors are also important. All exposures made at the copy deck can be predetermined and maintained easily. It is important to establish a standard set of procedures, such as the use of T–H lamps and a standard voltage level to the lamps with a constant-voltage transformer or a variable-output transformer with a line monitor such as the Viz Power-line monitor No. WV-120B (Viz Mfg. Co., Philadelphia, PA). The photographer need only check the monitor and adjust the voltage

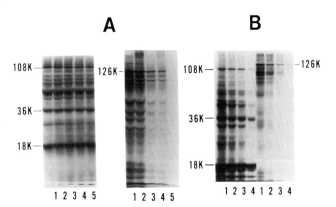

**FIGURE 4.9    Mixed line and tone composites are best done with two separate negatives, printed in sequence with two enlargers.**

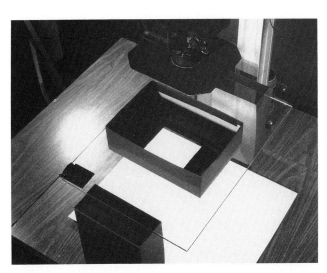

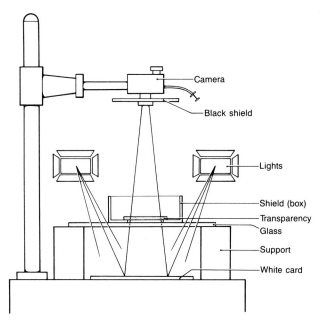

**FIGURE 4.10** Transparencies may be copied easily when placed over an elevated piece of glass. The regular copying area is covered with a white card, to reflect light up through the subject.

(if necessary) to a predetermined voltage level. The exposure as determined by empirical testing will remain the same. Of course, bellows factors, if not compensated by the lens, must be entered into the basic exposure.

The following is a suggested system to establish the standard exposures. It is assumed that the lights have been balanced for even illumination, and that T–H lamps are in use.

1.  Produce a standard test chart (Vetter 1979) (Color Plate 1). This chart should contain:

> a color spectrum
> a gray scale
> a continuous-tone BW photograph
> a color photograph with an array of pastel colors
> a lens test chart or original line art

The listed items should be mounted on a stiff piece of 10 × 15 inch card stock. Since this chart will be used again and again for comparing films, filters, and the like, it should be filed in a clean envelope for safekeeping.

2.  Use an incident-type light meter to determine the exposure for a tungsten-balanced color film. Compose the standard test chart to almost fill the viewfinder. Add the bellows factor, if not compensated by the lens. Make a series of bracketing exposures in one-third stops, in a range one full stop above to one full stop below the indicated exposure. If you have polarizing filters, you may wish to repeat the test with the exposure increase as recommended above. This is also the time to test any other filters, lenses, and lights. It is important that each exposure be labeled with the values of the parameters used to make it.

3.  Have the film processed but not mounted. It is easier to compare adjacent exposures on processed film than mounted on separate slides. Select the best exposures and make a note of the photographic parameters for future use. You may wish to repeat the test to fine-tune the exposures and filters.

4.  Repeat the test for each type of film and system you expect to use. When all the tests are finished and results have been validated by repeated tests, develop a wall chart for ready reference. Remember to list the voltage as well; 120 volts is considered normal for most T–H lamps. If the tests have been made carefully and are occasionally repeated, the data collected can be used to make copying a routine procedure for all but the most unusual subjects.

## SUMMARY

Choices of equipment and processes for copying are determined by the product desired and the type of original to be copied. These influence decisions more so than in other kinds of photography because the original subject dictates, and even limits, what the copy should look like. The challenge is to reach that limit.

Occasionally, there is also an opportunity to improve on the poor quality of the original. In normal copying situations, the photographer is limited to producing a facsimile of the original, but when working with a poor original the photographer can be a superstar. This presentation provides the means and the methods to produce excellent facsimiles, prints, and transparencies of almost any two dimensional object.

## ENDNOTES

1. A super-accurate alignment test kit for copy setups is available from:
   Zig-Align
   P.O. Box 765
   Menlo Park, CA 94026
   415–324-3704
2. The Macbeth fluorescent lamps are ideally suited for evaluating color photographs and suitable for photography with daylight-balanced color film. Similar lamps are also available from other manufacturers.
   Macbeth Color & Photometry
   P.O. Box 950
   Little Britain Road
   Newburgh, NY 12550
   914–565-7660
3. One manufacturer of such illuminators is:
   Kinex Corporation
   34 Elton Street
   Rochester, NY 14607
   716–442-2360
4. One such repair facility is:
   Professional Camera Repair
   37 West 47th Street
   New York, NY 10036
   212–382-0550
5. Resolution targets can be purchased from:
   Rochester Institute of Technology
   Technical and Educational Center of the Graphic Arts
   Frank E. Gannett Memorial Building
   Rochester, NY 14623-0887
   Cat. No. 200-610-FNEG
6. Edmund Scientific Co.
   224 101 E. Gloucester Pike
   Barrington, NJ 08007-1380
   609–547-8880
   Item: F30,056, 9X opaque base magnifier

## REFERENCES

Bunker, W. E., 1975. Custom line copying for journal reproduction. I. *J. Biol. Photogr. Assoc.* 43(3):103–109.

Bunker, W. E., 1975. Custom line copying for journal reproduction. II. *J. Biol. Photogr. Assoc.* 43(4):150–156.

deVeer, W. H., 1975. High contrast copying. *J. Biol. Photogr. Assoc.* 43(1):16–17.

deVeer, W. H., 1987. Contrast process color. *J. Biol. Photogr. Assoc.* 55(3):90–91.

Eastman Kodak Company, 1985. *Copying and Duplicating in Black-and-White and Color.* (M-1). Rochester, NY: Eastman Kodak.

Smialowski, A., and Currie, D., 1960. *Photography in Medicine.* Springfield, IL: Charles C Thomas.

Vetter, J., 1961. Reproduction of 35mm color transparencies with Ansco No. 544 duplicating film. *J. Biol. Photogr. Assoc.* 29(3):99–105.

Vetter, J., 1979. Standardization for the biomedical photographic department. *J. Biol. Photogr. Assoc.* 47(1):3–18.

# Chapter 5
# Photographic Reproduction of Diagnostic Images

## James P. Kendrick

*"If the hand be held between the discharge-tube and the screen, the darker shadow of the bones is seen within the slightly dark shadow-image of the hand itself. . . . For brevity's sake I shall use the expression 'rays' and to distinguish them from others of this name, I shall call them 'x-rays.'"*

Wilhelm Conrad Roentgen 1845–1923

The radiographic image is a very important information-gathering device available to medical science for the diagnosis of injury and disease. The field of radiology and the variety of images that can be produced have expanded in recent years with the introduction of many electronic imaging systems. The radiograph also has the well-deserved reputation as a difficult original material to copy, and it is the responsibility of the biomedical photographer to produce an accurate reproduction of these images.

This chapter will first briefly review a few of the most common types of original materials and their unique characteristics. It will then address some of the many ways these materials may be photographed using a variety of techniques, films, and processes. Some of the techniques are simple; others more complex and time-consuming. The method chosen by the photographer will depend on the final product required, the equipment available, the number of radiographic reproductions made in a particular photography laboratory, the quality necessary, and the time available.

## INTRODUCTION

The professionals in the radiology department frequently refer to the original radiograph (with white bones) as a *negative* image and the intermediate copy (black bones) as a *positive*. To maintain standard photographic terminology, this chapter will address an original radiograph (light bones) and its copies with like tonal values as *positive images* and the intermediate (dark bones) copies with reversed tonality as *negative images*.

## RADIOGRAPHIC ORIGINALS

### The General Radiographic Image

The standard *radiograph* is often referred to as an *x-ray*, even by the radiologists and other professionals who pro-

duce or use the images. Actually, the term is incorrect because it is referring to the *exposure-generating medium*, which is from the x-ray portion of the electromagnetic spectrum. These rays will pass directly through the body. On film, the denser tissue, such as bone, will absorb more of the radiation than will soft tissue, such as organs and muscle. Therefore, bone will be rendered lighter, and other tissues as darker, shades of gray.

Many routine studies require no special patient preparation. The basic chest study or a study of a bone fracture are good examples. However, in order to show specific soft-tissue features, it may be necessary for the patient to consume or be injected with special radiopaque dyes that will absorb enough radiation to allow the detail to be imaged.

In photographic terms, a radiograph is somewhat like a *contact print* of some part of the body on a special radiographic film (Figure 5.1). The patient is positioned close to the film, between the x-ray source and the film, in much the same way as a photographic proof-print would be made using an enlarger as the energy source (light) and placing the subject (negatives) in contact with the photographic paper.

In the electromagnetic spectrum, the x-ray wavelengths are about 10,000 times shorter than those of visible light. These very short rays are highly penetrating and very difficult to record. They tend to pass through photographic film without much effect. Therefore, in order to record a usable image, the film cassettes used for radiography contain special intensifier screens of fluorescent material that are placed in contact with the film emulsions. Phosphor particles in the screens will light up in response to x-ray exposure. (Radiologists refer to this effect as *blooming*.) The actual image is recorded by the light emitted from the intensifier screens.

Films for radiology generally consist of blue- or blue/green-sensitive photographic emulsions similar to those used in conventional films. To increase the tone range the film is capable of recording and to reduce the amount of radiation required for the exposure, many radiographic films are double coated. That is, unlike conven-

## Top View

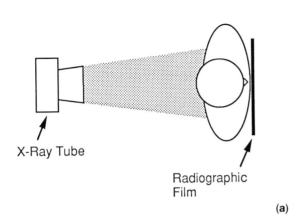

X-Ray Tube

Radiographic
Film

(a)

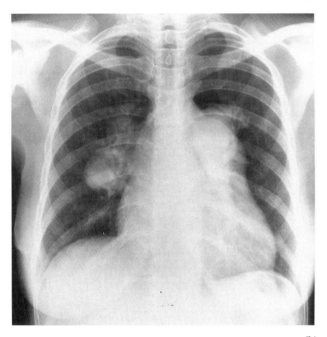

(b)

**FIGURE 5.1    (a) The typical set up for a PA chest radiograph.
(b) A sample chest radiograph of a lung cancer patient.**

tional photographic films, they have emulsion on both sides of the film base. This is the major characteristic that makes these images so difficult to copy. A good radiograph may have a tone range of 1000:1, a standard photographic negative film only slightly over 100:1, and a good print only about 15:1.

The photographer must know which detail in a film is the most important. It may be necessary to sacrifice the detail in one area to hold the required detail in another. For example, some shadow (dense) detail may need to be sacrificed if the detail in the highlights is more important. When sufficient time is available, there are some techniques that will help preserve highlight and shadow detail with equal visibility. (See the sections on Contrast Control throughout the chapter).

## Computed Tomography Scans

These images are also produced by exposure to x-radiation and, as such, are based on the varying densities of body tissues. *Tomography* in the name of this procedure indicates that the x-ray source and the recording medium are in motion, not fixed. The patient is positioned at the center of a circle and is exposed to a pencil-thin beam of radiation from a source that is rotated around the circumference of the circle. The varying densities of multiple exposures are recorded by sensors aligned opposite the x-ray source (Figure 5.2). The information is fed into a computer that assembles an image on a TV monitor or *cathode-ray tube* (CRT). The resulting study is a narrow cross section of the body. Current computer technology allows these images to be combined to produce other types of studies, including three-dimensional images.

While often fairly high in contrast, computed tomography (CT) scans are not as difficult to duplicate as conventional radiographic films. The tone range is designed for easy viewing. Images for photography may be recorded directly from the CRT screen but are most often made from film copies produced by sophisticated laser scanners. There are usually nine to sixteen originals recorded on a special 11 × 14 or 14 × 17 inch sheet of film that has a single coating of emulsion. A great deal of patient information and technical data are printed with the image, including a centimeter scale and a gray scale.

## Magnetic Resonance Imaging

The images produced for clinical evaluation by *magnetic resonance imaging* (MRI) are often cross-sectional studies like those generated by a CT scan. However, the information obtained during the procedure provides a volume study of the entire area of the body in the scanner. The images are similar in appearance to CT scans but are not generated by x-rays. The patient is placed in a chamber surrounded by a very strong magnetic field and radio frequency coils (Figure 5.3).

The spin of the nucleus in the atoms of each element within the body is influenced by the north/south polarity of the magnetic field. When a radio-frequency (RF) field is applied, the elements within the cells will absorb the RF energy and deviate slightly from magnetic polarity. When the RF is removed, they give up the energy and resume magnetic alignment. The time it takes an element to realign provides the information for the magnetic resonance image. All atomic structures give off an electromagnetic signal. The signal generated by one atomic nucleus is too small to be detected easily. By having all the nuclei of one element responding together, enough power is created to produce a readable signal. Hydrogen is the most common element to target because of its

**FIGURE 5.2** (a) The relationship of the patient to the x-ray source and detector array in the CT scanner. (b) This image shows a typical CT scan of the area of the head through the orbits. Note the tumor in the optic nerve pathway behind the orbit on the left. The sample MRI in Figure 5.3b shows the same patient. Compare the image characteristics of CT and MRI.

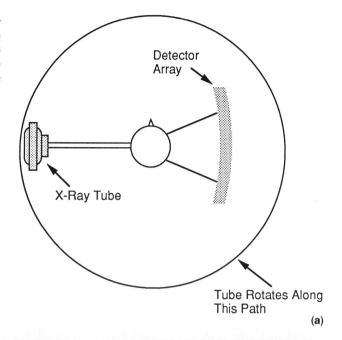

(a)

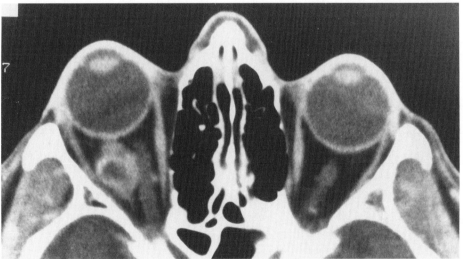

(b)

abundance in the body and because its nucleus has good magnetic properties. A computer collects the data and assembles the image.

Originals submitted for photography are similar in appearance to CT scans and are also generally submitted as multiple small images on a 14 × 17 inch sheet of film. One quick way to tell the difference between the two: bone renders light in a CT and dark in an MRI (compare Figures 5.2b and 5.3b).

**Positron Emission Tomography**

While CT and MRI scans are generally done in the radiology department and produce images based on anatomy (CT) and chemistry (MRI), producing *positron emission tomography* (PET) scans is a nuclear medicine procedure that allows the study of the metabolic processes in the body. Initial human studies were of mental neurological functions and the effects of diseases such as Parkinson's and Alzheimer's.

The patient is injected with a compound containing molecules labeled with a radioactive isotope that decays by the emission of positrons. The metabolic process to be studied determines the molecule used. In the body, a positron emitted from the isotope and a free electron combine to form two *photons*, which travel away from each other in a straight line. This action is called an *annihilation event*. The two photons are picked up by crystal detectors that surround the patient, and the line they travel is identified. As the millions of annihilation events occur, the electronic system that collects the data

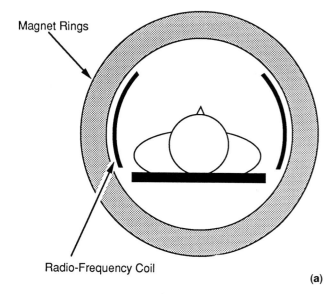

Magnet Rings

Radio-Frequency Coil

(a)

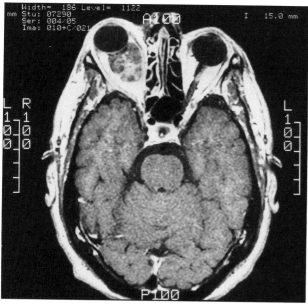

(b)

**FIGURE 5.3** (a) The relationship of the patient to the magnetic and radio-frequency coils in a magnetic resonance image (MRI) scanner. (b) This image shows a typical MRI of the area of the head through the orbits.

and the computer can map the distribution of the events and produce an image on a CRT. This is a simplified description of a very complex process.

The images produced are in color and are either photographed directly from the CRT or copied from Polaroid prints (Color Plates 2e,f).

## Radioisotope Scans

Also a nuclear medicine procedure, radioisotope scans are not generated by x-rays. A trace amount of radioactive material is injected into the patient and allowed to

settle into, or be collected by, the target area or organ. The patient is placed within the field of a sensitive radiation counter that reads "hot spots" in the body to produce an image. There are two types of imaging systems in use today: the *gamma camera*, which is static, and the *rectilinear camera*, which scans across the body to collect data for the image. The radioactive isotope given to the patient is combined with an element that is naturally attracted to, or absorbed by, the area of interest. For example, calcium would be the carrier for a bone scan and iodine would be used for a thyroid study (Figure 5.4a). Other radioactive isotopes can be used to identify other parts of the body (Figure 5.4b). The images are made up of an array of black dots on a light gray background. The original is usually an 8 × 10 inch sheet of film with several small images.

## Autoradiographic Images

An *autoradiograph* generally comes to photography from the research laboratory rather than a clinical department. There may be many types of subject matter involved in these studies, including tumor or other tissue sections and electrophoresis gels. In all cases, the film original is exposed by contact with slightly radioactive or fluorescent material for a period of hours, days, or even weeks (Figure 5.5a). Often the exposures are made in a "sandwich" of the film and the subject being recorded between two intensifier screens. The originals are generally 8 × 10 inch sheets of film. However, autoradiographs can be made in many forms, even on microslides.

Images of gels consist of columns of narrow bands with varying densities (Figure 5.5b). Studies of tissue sections will record their shape and size in an array of black dots with patterns reflecting the intensity of the radiation or fluorescence in the tissue. Photographic records must maintain the subtle differences in the densities of the originals.

## Ultrasound

Ultrasound studies, also known as *sonograms*, are created by sound waves. The wave frequencies used are in the million hertz (cycles per second) range, far above those frequencies associated with human hearing, which are measured in the thousands.

A transducer placed against the skin transmits the waves, like sonar on a ship, and receives the echoes from inside the body (Figure 5.6). An image is formed on a CRT from the data received. A computer may be used to enhance the image. These studies are often done on women in the early stages of pregnancy when exposure to x-rays may be harmful to a developing fetus. Photo-

**FIGURE 5.4** (a) A radioisotope scan of the thyroid gland. (b) A radioisotope scan of the kidneys of an infant.

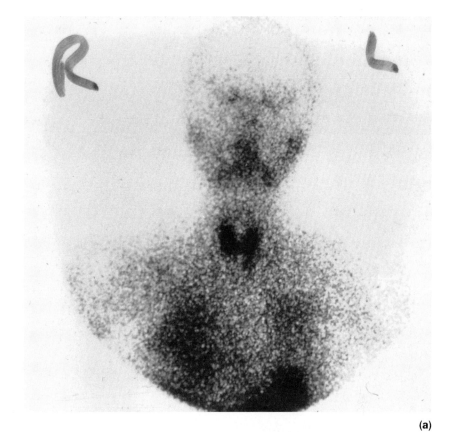

(a)

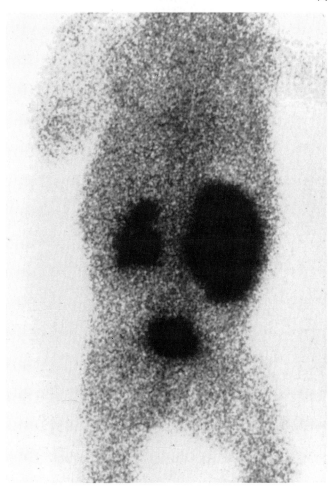

(b)

FIGURE 5.5 (a) An autora-
diograph of a section of rat
brain. The original section mea-
sures about 1.5 centimeters
(1.25 inches) across. (b) An
autoradiograph of a slab gel.
The original gel measures about
12.7 centimeters (5 inches)
across.

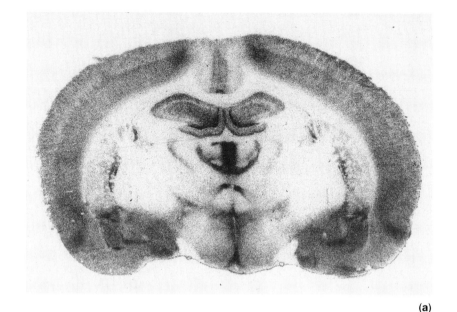

(a)

(b)

graphic originals usually consist of about nine images on
an 8 × 10 inch sheet of film.

## Other Imaging

Medical science continues to find more uses for elec-
tronic radiology and computer technology, and the vari-
ety of images continues to increase. Many procedures,
such as vascular studies, which have been done for many
years using conventional radiographic techniques, are
now being done using all electronic systems. These newer
imaging methods record images through computers on
disks or tape. Eventually, slide or print imaging will be
done directly from digital recordings on high-resolution
cameras such as those used now for computer-graphic
imaging. For the present, most equipment that produces
images electronically offers the option of making hard
copies on either Polaroid material or a special film that is
exposed using a sophisticated laser printer. The Polaroid
prints may be fine for office viewing or patient records,
but clients should be encouraged to provide the film

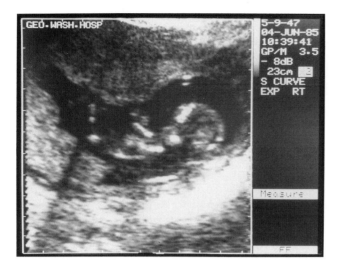

**FIGURE 5.6   An ultrasound scan of a human fetus.**

copies for photographic reproduction. The slides and prints produced from transparent film originals are of much higher quality.

Some of the electronic systems, such as PET scans, produce color images. These images may be recorded directly from the CRT screen or from Polaroid prints. To make photographs of the original prints, see Chapter 4, which deals with flat art color copy. To record images directly from the CRT, see the following section.

## DIRECT COPIES OF ELECTRONIC IMAGES

### Basic Equipment

The electronic radiology systems that produce images digitally on a CRT allow the option of direct photography from the screen. The following basic equipment is recommended for this type of photography:

1. A 35-mm single-lens-reflex camera.
2. A sturdy tripod to allow exposures of 1/8 second or longer.
3. A lens of appropriate focal length and close focusing capability to allow a full-frame image. Generally an 80-mm to 135-mm lens is best.
4. A hood designed for photography of CRT screens, which allows photographs to be made without darkening the room.

Place the camera on the tripod in front of the CRT with the film plane parallel to the screen. Focus and fill the frame as much as possible. Use of a hood designed for this type of photography will help in aligning the camera and screen and will allow photographs to be made with the room lights on. Without the hood or shielding, it will be necessary to darken the room to prevent reflections on the screen.

### Color Slide Film

*Color film* is necessary when recording color scans (PET scans and a variety of other computer images) but will also effectively reproduce CT and MRI scans that are black and white. For best results, choose a medium-speed, daylight-balanced film, such as Ektachrome 100 Professional. The resolution will be good, and the film selected must allow exposures of 1/8 second or longer. Low shutter speeds are necessary because the image on the CRT is electronically scanned onto the screen at a rate of 30 frames per second. Shorter exposures will pick up the scan (*raster*) lines from the screen, which will show on film as a diagonal bar across the image.

Many television screens are very near the proper balance for daylight slide films. One test roll will indicate any color correction that may be necessary. Use *color-compensating* (CC) filters to make minor corrections as needed. See Chapter 1 for more information on the use of CC filters.

### Black-and-White Film

Almost any medium-speed negative film may be used when making copies of black-and-white (BW) images. However, Agfa Scopix CR-1B and Kodak cinefluorography film (CFT) are both low-speed, fine-grain, medium-contrast films that will produce both negatives and slides directly from the CRT screen. These films are available only from radiographic products dealers, not conventional photographic suppliers.

The Agfa Scopix film is marketed specifically for reproducing electronic images and is available in 36-exposure rolls. Developing may be done in a 90-second processor such as the Kodak RP X-OMAT or by hand in radiographic chemicals. Information on this film is available from Agfa-Matrix.[1]

The Kodak CFT film is designed for recording motion pictures (cine) of fluorographic procedures such as cine-angiography of the coronary arteries. The output device for these studies is a phosphor screen with characteristics similar to a CRT; therefore the film adapts well to this photographic use. Recommended developing is in a radiographic cine processor; however, 90-second and hand processing are possible. As it is a motion picture film, CFT is available only in bulk rolls of 200 or more feet. For additional information on the film, contact Eastman Kodak Company.[2]

To produce negatives for printing with either of these films, expose the film to the CRT image with the tonality set for normal viewing. The resulting image will be of opposite tonality (Figure 5.7a), or a negative image, which may be taken into the darkroom and printed.

To produce slides with the same film, change the setting on the CRT to reverse the tones in the image (white

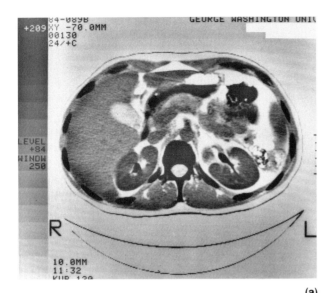

(a)

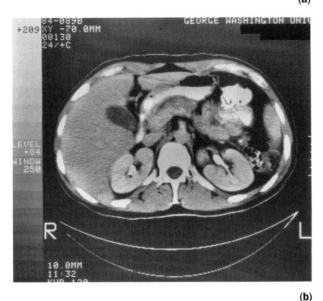

(b)

**FIGURE 5.7    (a) A negative CT scan. (b) A positive CT scan.**

becomes black, black becomes white). The resulting image on the film will be a positive as seen in normal viewing and may be projected as a slide (Figure 5.7b).

**Contrast Control and Exposure Determination.**    The film speed and contrast level of these BW films can vary greatly (two or more *f* stops) with the type of processing selected, the time of development, and the temperature of the solutions. In addition, the manufacturers provide no information on film speed. Therefore, testing is the only way to set standards.

Begin with a film speed (ISO) of 50 to 100 and use an exposure meter to calculate a starting point. With a shutter speed of 1/8 second or less, make several rolls with an identical set of exposures representing over- and under-exposures in one-half *f* stop increments. Keep a careful

record of exposures. Process the rolls of film using different methods. In addition to radiographic chemicals, try a test with conventional processing in a developer such as Kodak DK-50 (10 minutes at 68°F). Compare the images for contrast, detail, and grain characteristics. Select the process that meets the necessary quality and time requirements. Once the standards for exposure and development have been established, minor adjustments in contrast may be made by changing the contrast and brightness settings for the CRT screen. Be careful to maintain the detail in the image when making adjustments. (With color slide film, this is the only practical method of contrast control.) As long as the CRT, its basic settings, the film, and the processing remain constant, exposures will be consistent and bracketing will not be necessary.

Note: Prints and slides produced using these methods will lack some of the quality possible when reproducing film copies made with a laser printer. Film originals made with the laser printer have longer gray scales and higher resolution than the CRT image.

## COPIES OF RADIOGRAPHIC FILM ORIGINALS

### Basic Equipment

The following items are necessary to begin making copies of radiographic films (Figure 5.8):

1. A standard 14 × 17 inch *viewbox* for radiographs or other light source with similar characteristics, such as the Model MR-10 from Kinex.[3] The surface should be blemish-free and the illumination of even brightness from the center to all edges.

2. A sturdy *copy stand*, rather than a tripod, to allow the viewbox to be freely positioned underneath the camera. Working with the viewbox in a tabletop (horizontal) position is much easier when there are many films to copy, particularly when long exposures, dodging, masking, or cropping techniques are required.

3. A 35-mm single-lens reflex *camera* with a 50 to 55 mm copy lens (see Chapter 4). In order to accommodate all sizes of original radiographs from a full 14 × 17 inch film down to a 3 × 4 inch scan, it is important to use a macro or close-focusing lens. A standard lens generally will not focus closer than about 18 inches from the subject. The 35-mm format does very well in making projection slides; however, a larger-format camera may be desirable when making negatives for prints.

4. A set of *masks* made of black matte board or fully exposed and developed (opaque) x-ray film cut into L-shaped pieces for cropping and masking unwanted or irrelevant information. Other masks, which cover the entire surface of the viewbox and have cutouts in the center in sizes to match small scans and round images, can also be helpful in working quickly and neatly.

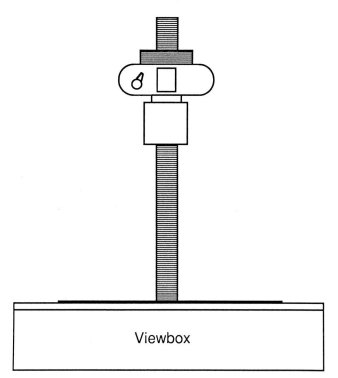

**FIGURE 5.8  The typical copy stand setup for making copies of radiographs with a 35-mm camera. The film plane in the camera and the surface of the viewbox must be parallel.**

### Projection Slides with Color Film

Color film is used by photographers and clinicians to produce slides of radiographs because it is frequently in the camera to record other subjects, has relatively high speed for short exposures, and convenient processing is available. The major disadvantage of color film is the difficulty in achieving proper color balance. The standard viewbox for radiographs is illuminated with fluorescent lamps. The lamps are available in many different colors, such as cool white, warm white, and daylight (not the same as daylight film). Copies made with either daylight- or tungsten-balanced color film will result in slides with strong blue or green coloration (Color Plate 2a).

One way to correct this problem is by using color-compensating filters, which are available in six different colors and a variety of densities (see Chapter 1). Using standard daylight fluorescent lamps, expose a test roll of daylight-balanced slide film to a typical radiographic original through a CC40R (red) filter. Review the results to see how close to neutral gray the image has been recorded. Further correction may be necessary. For example, if the image is too blue, add yellow. If it is too green, add magenta filtration for the next test.

Once satisfactory results are achieved, use the same viewbox, film, and filters for all copies. Replacing the fluorescent lamps with special color-corrected lamps is a more effective way to achieve proper color balance (Color Plate 2b). Several companies make fluorescent lamps[4] that contain special phosphor coatings to more closely match the color balance of daylight films (Color Plates 2c,d). The American National Standards Institute (ANSI) recommends a color temperature of 5000 K for this type of fluorescent tube. Follow the procedure above (no filters) for a test roll and make minor corrections if necessary. A list of some of the ANSI approved lamps that are available and their manufacturers is included in the Endnotes.[4] Contact the manufacturer for more product and dealer information. The Kinex viewbox noted above is normally equipped with Vitalite lamps but is available with whatever light source is requested.

**Exposure Determination.**  *Exposure meters* are designed to read an average subject and guide its reproduction on film as an 18% middle-gray tone. Most radiographs cannot be considered "average" subjects because of their extremes of contrast and very high maximum densities. Accurate metering for exposure can be very difficult. Rather than reading an entire film, use a hand-held meter or move the camera with through-the-lens metering close enough to read only a middle-gray area or area of major interest. A "spot meter" can be used to measure very small areas of the film that represent an 18% gray tone. In order to obtain accurate readings at close range (about 10 inches) it is necessary to attach a 4+ diopter lens to the front of the meter's lens. This will not only produce a visually sharp image in the meter's viewfinder but, more importantly, accurately focus the measured area on the meter's photocell for a reliable reading (see Chapter 3). Avoid areas of extreme contrast. Use the following procedure to set up a meter:

1. Obtain a typical radiograph that may be kept as a standard.
2. Expose a test roll at the calculated exposure and several *f* stops over and under in one-half *f* stop increments. Keep a careful record of the exposures.
3. After the film is processed, write the corresponding exposure on each slide frame.
4. Correlate the best exposure to the meter readings used to calculate the original exposure. If, for example, the best slide was exposed at one-half *f* stop more than the meter indicated, adjust the ISO setting on the meter to one-half stop less than that recommended for the film used (an ISO 100 film would change to ISO 80). By telling the meter there is a slightly less sensitive film in the camera, more light is let in when the exposure is made. For future calculations, read areas on the radiographs that approximate the tones read on the "standard" film.

After some experience with the same setup and film, most photographers will be able to determine exposures

quite accurately without metering each film. Visual evaluation of contrast and density will be sufficient.

**Obtaining Proper Color Balance by Using Electronic Flash.** It is possible to build a special copy system for making slides that has a perfectly balanced light source (Color Plate 2c) and will automatically control exposure by using an *electronic flash unit* (Figure 5.9). In addition to an automatic flash unit, this technique requires a camera that reads its exposures from the film surface [off the film (OTF) metering] inside the camera. A special connecting cable allows the flash to be removed from the camera and still maintain the automatic function. The Aristo DA-17 lightbox, which has its light source around the surface to provide a focusing light and is open on the bottom, is ideal for this purpose.[5] Attach the Aristo unit to the top of a large box (the carton for ten Kodak Carousel slide trays is just the right size), which has been painted white or lined inside with white paper. The electronic flash is placed through an opening in the side and angled so that no light falls directly on the opal glass surface above. The idea is to fill the box with very bright, properly color-balanced light that evenly illuminates the entire surface.

Test the system using the camera manufacturer's guidelines. In most cases, with medium speed slide film, select an *f* stop in the middle of the range (about *f*/8) and make exposures to a variety of sizes and densities of originals. The resulting slides should have very neutral tones and be relatively consistent in density. Exposures cannot be corrected by changing the *f* stop setting. If they are consistently dark or light, change the ISO setting on the flash to compensate. For example, if the slides are consistently too dark using ISO 100 slide film, change the setting on the flash to ISO 80 or 64 to increase the light output of the flash.

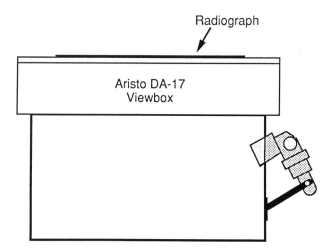

**FIGURE 5.9** A white-lined box with an Aristo DA-17 viewbox attached and an electronic flash installed through the side to provide a viewbox with a daylight-balanced light source.

This system does not allow much control of contrast and exposure. The best and most consistent results will be with originals that have moderate to low contrast. Radiographs of barium studies or artificial joint implants, which have large areas of clear film, may be a problem. The larger the light area on the original, the darker the final slide will be. Variation of the exposure to lighten the image is possible; however, changing the *f* stop on this type of metering system will not change the exposure. As the *f* stop is changed, the flash will put out more or less light to satisfy the sensor inside the camera that is reading the exposure. All the slides will be the same. To compensate, use the plus or minus exposure settings on the camera (often found around the film rewind) or adjust the ISO setting on the flash unit as described above.

As with making fluorescent viewbox copies, some experience with the system will allow very accurate adjustments to be made by visual evaluation of the originals and little, if any, bracketing of exposures will be necessary.

## PROJECTION SLIDES WITH BLACK-AND-WHITE FILMS

### Black-and-White Positive Films

**Kodak Rapid-Process Copy Film (RPC).** This film is made especially for producing slides of radiographic originals. It is probably the most widely used and best-known BW film used for this purpose. The contrast and tones produced match the original films very closely. *This film must be stored under refrigeration until it is exposed and processed to maintain its maximum densities.* Stored at room temperature, RPC loses contrast and slides will appear very gray. Radiographic products dealers distribute RPC in bulk and in single, thirty-six exposure rolls. Contact Kodak for dealers and other information.[2]

RPC is a *direct-reversal film*. It produces a positive image (exact duplicate of the original) in a one-step developing process (Figure 5.10). It is designed for processing in a 90-second radiographic processor such as the Kodak RP X-OMAT but may also be hand processed. At a temperature of 68°F, use Kodak GBX radiograph developer for 5 minutes (with no agitation) or DK-50 developer for 10 minutes.

The major disadvantage in using this film is its very low speed. RPC has an ISO of 0.06. On a standard x-ray viewbox with two 15-watt fluorescent lamps, an average radiograph may require 40 or more seconds of exposure. To reduce exposure time, take advantage of RPC's very high sensitivity to blue light by changing to T-8B (blue) lamps in the viewbox. In addition, have the viewbox altered to hold double the number of lamps (Figure 5.11).

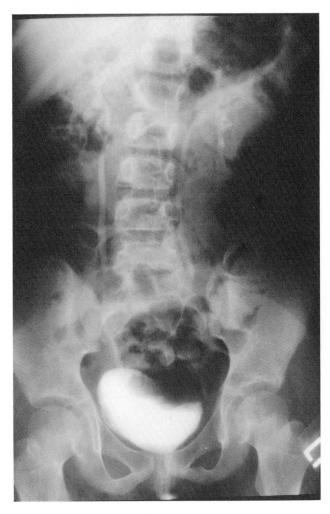

**FIGURE 5.10    A copy slide made on Kodak Rapid Process Copy (RPC) film.**

**Exposure Determination.**    Calculating the proper exposure with this film can be very difficult because of its very low film speed. Most exposure meters cannot be set lower than ISO 25. Kodak recommends the following procedure:

1. Set the exposure meter at ISO 25.
2. Read a middle gray area or major area of interest.

**FIGURE 5.11    A viewbox that has had extra fluorescent tubes of the T-8B (blue) type added to allow shorter exposures on RPC film.**

3a. Increase the calculated exposure *time* by a factor of 2000. For example, if the metered reading indicated an exposure of 1/60 second at $f/4$ multiply the exposure time by 2000 for the correct exposure time for RPC film. Thus for the above example $1/60 \times 2000$ (or 2000/60) = 33 seconds at $f/4$. A simple pocket calculator can solve these equations quickly and accurately.

3b. Another method of determining the exposure is to increase the calculated ISO 25 exposure time by the equivalent of 11 stops. With an initial exposure time of 1/60 second at $f/4$, the exposure cannot be changed by using the lens diaphragm. It is already almost wide open at $f/4$. *Time* is the only factor available for adjustment. Changing shutter speed to double the time, doubles the amount of light reaching the film and makes an increase in exposure of 1 $f$ stop. So, 1/60 second to 1/30 second = 1 $f$ stop. Continue these changes through 11 stops:

  1/30 to 1/15 = 2 stops
  1/15 to 1/8 = 3 stops
  1/8 to 1/4 = 4 stops
  1/4 to 1/2 = 5 stops
  1/2 to 1 sec. = 6 stops
  1 sec. to 2 sec. = 7 stops
  2 sec. to 4 sec. = 8 stops
  4 sec. to 8 sec. = 9 stops
  8 sec. to 16 sec. = 10 stops
  16 sec. to 32 sec. = 11 stops.

The calculated correct exposure would be 32 seconds at $f/4$.

4. Post this chart next to the viewbox which correlates a variety of common meter readings with the correct RPC exposure at $f/4$:

  1/125 = 15 seconds
  1/60 = 30 seconds
  1/30 = 60 seconds

**Polaroid Film.**    PolaPan, the 35-mm Polaroid film for continuous-tone BW slides, may also be used to copy radiographs. The film is packaged in twelve and thirty-six exposure rolls, and each comes with its own chemical cartridge for processing. Development takes 60 seconds and is done in a small, special processing unit. There are two versions of the processor in the field, one electric and one manual. The film cassette and the chemical pack are placed in designated places inside the processor, and the lid closed. With the manual unit, the film is cranked out of the cassette, the process timed, and then cranked back into the cassette. The powered unit does all the processing steps and beeps when the job is complete. In either case, as the film is pulled from the cassette, the processing chemicals are spread evenly over the film through a set of pressure rollers. When the development is completed, the film is rewound, and the negative layer and the chemicals are stripped away from the slide images. The

**FIGURE 5.12   A copy slide made on Polaroid PoloPan BW slide film.**

film may then be removed from the cassette, and the slides are ready to mount and project (Figure 5.12). With its relatively high speed (ISO 125) and quick processing, this film is very handy for those occasions when a few slides must be done immediately. PolaPan is a fairly contrasty film, so it works best with low to moderate contrast originals.

**Reversal Films.**   Any BW film can be reversal processed. That is, with a few extra steps in the developing process, the film can be made directly into slides rather than negatives. While this option makes many films available for radiograph copies, the quality of the results will vary greatly with the type of film and process selected. For many years, the reversal processes available were very similar in chemical composition. Kits were available from Kodak for processing small quantities of film such as Panatomic-X and Direct-Positive films. Some photographers used the chemicals from motion picture or microfilm processors. Generally, the results were very good.

The revolution came with the new *T-grain technology* in film manufacturing. These films offered new levels of resolution, grain, and speed, but the old reversal processes did not produce the high-quality images needed. Low-contrast slides with poor maximum densities and a very warm tone were the result. Now Kodak offers the T-MAX 100 Direct-Positive film developing outfit[6] (Figure 5.13) designed for the new generation of films. The kit contains liquid concentrates to make 1 quart each of first developer, bleach, clearing bath, and redeveloper. It is a good, reliable, and consistent process. Including the necessary additional steps of fixing and washing, the process takes about 40 minutes (at 75°F). One processing kit will develop a maximum of twelve rolls of film.[6]

**Exposure Determination.**   Most BW films will require some modification of the usual film speed when reversal processing is to be done. With T-MAX 100, Kodak suggests a change of ISO from 100 to 50 (one stop more exposure). Some films, particularly those that do not use

**FIGURE 5.13  A copy slide made on T-MAX 100 BW film, which was reversal processed in the T-MAX Direct-Positive Film Developing Kit.**

the T-grain technology, will require an exposure shift in the opposite direction (less exposure, not more). Testing is the only way to properly evaluate the effective film speed for a particular setup. Use the same exposure determination and testing procedure as indicated under color slide film. When working with any reversal film product, remember that less exposure makes the slides darker and more exposure makes them lighter.

**Contrast Control with Reversal Films.**    With the possible exception of RPC film, all the films mentioned in this chapter are contrast amplifiers. That is, the contrast in the finished slide will be higher than that of the original. This increase in contrast is a major problem in trying to maintain the detail seen in copies of radiographs. The information in the extremes, the highlight (brightest) and shadow (darkest) areas, of the original are the first to be lost when contrast increases.

The T-MAX reversal developing kit includes instruc-

tions for modifications to the process that can help control contrast.

One way to reduce contrast is preflashing the film by giving the entire frame of film a very slight exposure to white light before making an exposure to the radiograph. The idea is to reduce the maximum density areas (D-max) of the slide by *fogging* the film. Remember that when working with reversal films, added exposure results in lighter images. A preflash of about 1% of the total exposure is generally sufficient (Color Plate 2d). It is necessary to have a camera that allows double exposures.

Begin by placing the radiograph on the viewbox and calculating the proper exposure. Remove the radiograph and make the calculated exposure to the blank viewbox through a 2.0 neutral-density filter. This is a 1% preflash. Remove the filter, replace the radiograph, and expose as usual. Initially, make two slides of the radiographs, one with and one without a preflash exposure, to compare the differences in the detail recorded in the shadow areas.

## Negative to Positive

**Negatives.**    While it is more time consuming, the two-step process of making a negative and then the positive slide offers more control of the tones reproduced. The contrast of both the negative and the slide can be manipulated separately as desired. This is the only way to make quality prints for publication or display.

There are many films that may be used to make intermediate negatives. Larger-film formats (120 roll and 4 × 5 inch sheet films) make handling easier and produce images of superior quality. The following is a list of preferred Kodak films although suitable films are available from other film manufacturers.

| | |
|---|---|
| 4 × 5 films | T-MAX 100 |
| | Plus-X Pan |
| | Super XX |
| | Ektapan |
| | Professional Copy Film |
| Roll films | T-MAX 100 |
| (35-mm, 120) | Plus-X Pan |

**Exposure Determination and Contrast Control.**    For some radiographic originals (those with low to moderate contrast) normal exposure and development will provide adequate negatives for good slides and prints. For standard radiographs and other images with higher contrast, exposure and development manipulation can be very helpful in improving the detail in the finished product. Remember, contrast can be controlled to some extent by development, and density by exposure.

To make negatives of radiographs, calculate the proper exposure using the methods already detailed, but overexpose the image by two or three stops (two or four times the indicated exposure time). Then underdevelop the film by 50%. For example, with T-MAX 100 expose at an ISO of about 25 and develop in Microdol-X for 6 1/2 minutes at 68°F (normal is 13 minutes).

Special care must be taken in following the manufacturer's recommendations for agitation during processing with short development times; otherwise streaking and other flaws may occur in the negatives. Testing must be done to determine the best combination of film, exposure, and development for the types of radiographs that are routinely copied. Careful evaluation of the detail in the negatives, particularly in the highlights areas, is important. With this type of process manipulation, the separation of faint image details in the lighter areas may be lost.

**Slides.**    Excellent slides can be made from the resulting negatives with a number of different films and processes (Figure 5.14). Begin by placing the negative on the viewbox. With sheet film negatives, no support is necessary. However, a film holder or carrier from an enlarger is helpful in holding roll film flat and in place. Use the holder for a negative size larger than the film to be copied (120 for 35-mm film, 3 1/4 × 4 for 120 film). This will hold the film securely, and the clear area around the negative will record black on the slide, eliminating the need for taping or masking the slide when it is mounted. Focus the camera containing the selected positive film on the negative and make the exposures. Note: if 35-mm negatives are made, the copy camera must have a lens capable of producing a 1:1 image.

For routine negatives and hand processing, try Eastman Fine-Grain Release Positive (5302) in D-11 developer. The film is actually a motion picture print stock and has a low speed. When making slides with a standard viewbox (two 15-watt lamps), shutter speeds may be 1/4 second or slower. For best results, development should be in the range of 4 to 6 minutes. Shorter development may result in poor contrast and loss of maximum density. This method will make excellent slides from any good BW negative; these slides are generally superior to any copy slide from a BW print.

For those situations where the negatives lack sufficient contrast to reproduce well on 5302, Kodalith Ortho will make excellent slides. Some processing manipulation is required. Sold in bulk rolls as Kodalith and single rolls as Ektagraphic HC film, this product is made for producing very high-contrast negatives of text and line art (see Chapter 4). When processed in a developer such as D-11, it will produce an excellent slide of a continuous-tone negative. It does especially well with some of the lower-contrast radiographic images, such as subtraction studies, and makes superior slides of negatives from the electron microscope. Exposure times will be a stop or two longer than those on 5302. Development should be about 2 minutes in D-11, with continuous and gentle agitation.

Try Technical Pan film when machine processing in a developer such as Kodak Duraflo. About 2 minutes in the developer at 75°F is a good place to begin testing. Exposures will be shorter than the other films listed. Technical Pan has a slightly gray-tinted film base, while Kodalith and 5302 both have clear bases, so highlights may not appear quite as bright.

**Prints.**    It is more difficult to maintain the detail in a print from a radiographic original than in a slide. Just as the conventional film negative has only about 10% of the tone range of radiographic film, a photographic print is capable of reproducing only about 10% to 15% of the possible tone range in the negative. This potential loss of information makes knowledge of the subject and care in making both the negative and the print very important. Every effort should be made to assure that the necessary detail is clearly recorded in the negative in order to make a satisfactory print. Even with that effort, many good prints will be the result of careful "burning" and "dodging" to control highlight and shadow detail.

(a)                                                                                              (b)

**FIGURE 5.14**   (a) A copy negative made on T-MAX 100 BW film that was overexposed 2 *f* stops and underdeveloped 50% in Microdol X developer. (b) A slide made from the same negative on fine-grain positive film processed 4 minutes in D-11 developer.

When tray developing is done, process manipulation may be used to control contrast in the print, just as it is done in the negatives. Photographic paper can be overexposed and underdeveloped to lower contrast (the most common need) and underexposed and overdeveloped to increase contrast. To prevent flaws in the print, careful agitation of the paper while the image develops is important, particularly with short development times (1 minute or less). In the final print, shadow areas should be clean and black with clear separations in the darker tones. There should be no mottling or streaks. The highlight areas should be bright and have just enough gray to separate the lighter tones. Highlights that are too gray make the prints look dull and flat. "Muddy" is a common description.

The quality standards for all finished prints are the same, regardless of the paper and process selected, but machine-processing prints in equipment such as the Kodak Royalprint 417 eliminates the option of process ma-

nipulation. In this case, variable-contrast photographic paper offers the best opportunity to make a print with the contrast desired. It is better to use variable-contrast filters that fit into the head of the enlarger and change the color of the light source, rather than those that attach in front of the enlarger lens where they may affect the sharpness of the printed image.

## TIPS, TECHNIQUES, AND TERMINOLOGY

### The Basic Techniques

The following are guidelines and suggestions for producing images using the films and equipment already discussed.

Set up the camera, copy stand, and viewbox as shown in Figure 5.9. The camera should be centered over,

and the film plane parallel to the viewbox surface to assure image sharpness from edge to edge.

Keep a supply of glass cleaner for the viewbox surface and film cleaner for the radiographs. Use them.

Mask the image to cover all but the area desired in the photograph. Cover all clear areas of the viewbox to prevent flare.

The client may add arrows and other data to the radiographs for clarification and identification with a wax pencil (china marker, grease pencil) or other easily removed marker. These marks should be placed in lighter areas of the radiograph, where there will be sufficient contrast to allow them to be easily seen. Use dry transfer letters and arrows of varying sizes cut from black paper to replace the hand-written information to make more attractive, professional-appearing copies (Figure 5.15).

It is possible to produce white markings in the darkest areas of the original by making a double exposure. The white letters, arrows, or other information must be bright and opaque to record with sufficient contrast. During the first exposure, these markings are silhouetted by the viewbox illumination and will record as black. A second exposure with top lighting can be made to record the white image. Care must be taken when lighting for this exposure to avoid creating reflections, flare, or shadows through the thinner areas of the radiograph on the viewbox surface. Shadows may show in the finished photograph as false clinical detail; reflections, and flare degrade the contrast and detail in the entire image. For this technique to be most effective, the radiograph and the

white opal glass surface of the viewbox should be separated by at least two inches. A sheet of plate glass on supports to hold it above the viewbox works well. Left in contact with the opal glass, the highlight detail in the original radiograph will be overexposed. It will receive one exposure through the viewbox when transilluminated and another with the light reflected off the white opal glass surface with the top lights. Experimenting with this procedure is the only way to determine the best materials, lighting, and exposure to use with a particular type of radiograph.

## Terminology

The photographer should understand what a particular radiograph is intended to show and some of the terminology used in radiology to describe the procedures and films produced. Ask questions about the films submitted, what they are called, and what the client needs to demonstrate with the finished slide or print. As in surgical or patient photography, it is important to be able to discuss what is needed, using the proper terminology and with an understanding of the anatomy demonstrated in a radiograph.

Orientation in radiographic images is described in terms of the patient's position relative to the x-ray source. For example, the routine chest film is often referred to as a *PA* because the x-rays passed from back (*P, posterior*) to front (*A, anterior*) to expose the film while the patient was positioned with the x-ray source behind and the film cassette against the chest. Frequently, a small *L* or *R* is included in the image to designate the patient's *left* or *right* side. When correctly viewing a PA chest film, the *R* should be on the left side of the radiograph, as though facing the patient. The letters may also indicate which extremity is shown in a film or, in a lateral study, which side the patient was facing.

The names given to radiographic studies are usually derived from the anatomy demonstrated. For example, the prefix *angio-* denotes the blood vessels. Therefore, an *angiogram* is a study of some part of the vascular system. The prefix *pyelo-* designates the kidney, so an *intravenous pyelogram* (IVP) is a study of the kidney using a contrast medium administered intravenously to delineate the soft tissues. This study (also referred to as an *intravenous urogram* or IVU) shows all parts of the urologic system, which includes the kidneys, the ureters, and the bladder. For more information, refer to the medical prefixes and suffixes listed in the Glossary.

### Other Methods of Contrast Control

**Masking.** *Masking* refers to methods of adding density to the *highlight* (lighter) areas of a radiograph to re-

**FIGURE 5.15  Dry transfer letters and cutout arrows for use in making neat, professional labels and indicators on copy slides and prints.**

**FIGURE 5.16 A simple highlight mask. Masking.**

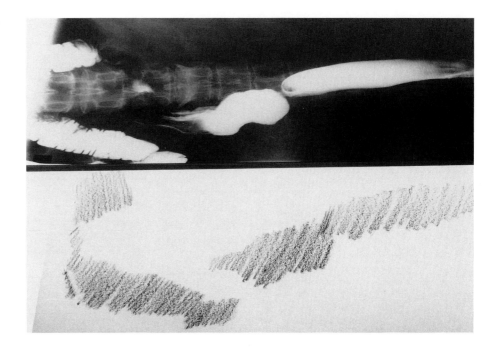

duce the contrast range to be duplicated (Figure 5.16). Adding density to the highlights aids in making better copies by allowing sufficient exposure to be given to an original film to bring out detail in the *shadow* (*darker*) areas without burning out the highlight detail. It is not a very common practice because it is time consuming, and film masks, which are the same size as the original radiograph, are expensive to produce.

**Simple Masking.**    The simplest mask requires a viewbox with two surfaces (one above the other) about 2 inches apart, somewhat like a contact printer with its dodging shelf. The top surface is for the radiograph; the lower surface is for the mask. The separation should be sufficient to keep the *shadow* of the mask unsharp on the back of the radiograph. A mask can be made with torn bits of translucent paper (such as vellum) placed on the lower surface under the brightest areas of the radiograph. Add more layers of paper to add density. Another method is to place a sheet of vellum over the radiograph and *color* the highlights with a crayon, china marker, or pencil (Figure 5.16). The mask is then visually registered under the original before the photographs are made.

**Unsharp Masking.**    Producing an *unsharp mask* involves making a contact print with a piece of glass about 1/8 inch (3 millimeters) in thickness separating the original radiograph and the copy film (Figure 5.17a). Kodak makes a special film, Subtraction Masking Film, which is ideal for this purpose. Information about the film and its availability can be obtained from the Kodak Health Sciences Division.[2]

The mask produced should be low in contrast; while the masking film may be developed in a 90-second radiograph processor such as the Kodak RP X-OMAT, better results can be obtained by hand processing. Try developing the film for about 3 minutes (at 68°F) in DK-50, diluted 1:1 with water. Fix, wash, and dry the film as usual.

When the mask is completed, a negative or slide can be made by visually aligning the mask under the original radiograph on the viewbox and then copying as desired. The additional exposure allowed by the denser highlights will bring out more detail in the shadow areas.

**Double Masking.**    This method offers the benefits of unsharp masking plus the ability to enhance the detail in the highlights that must be preserved in the photographic copies. *Double masking* begins with a sharp highlight mask (Figure 5.17b) made on a lithographic film such as Kodalith Ortho, type 3 (available through graphic arts products dealers).

Add registration marks on two opposite corners of the original radiograph to help when aligning the images later in the procedure. Make a contact exposure with the face of the radiograph in contact with the emulsion of the Kodalith. The work can be done under red safelights. Process the film in D-11 developer for about 2 minutes (68°F). The resulting mask should be fairly low in density but show sharp detail of the highlights. If the highlights look muddy and flat in the final slide or print, the density of the mask was too low. Washed-out highlights that lack detail indicate the mask was too dense.

An area mask can be made in somewhat the same manner as the unsharp mask (Figure 5.17b). Place the highlight mask, emulsion up, on top of the Subtraction

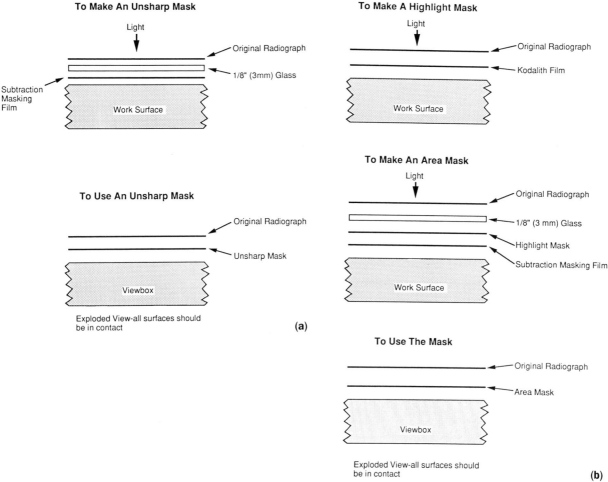

**FIGURE 5.17** **(a) The steps in making and using an unsharp mask. (b) The steps in making and using double masking.**

Masking Film, the glass next, and finally the original radiograph. Use the registration marks to visually align the images (under safelights) and expose the mask. Process as indicated above under unsharp masking.

To make the final slide or negative, align the area mask under the original radiograph on the viewbox and copy as desired. This copy, in addition to having improved shadow detail, should also have improved contrast in the highlight detail.

### Electronic Scanning

**LogEtronic Equipment.** For many years, LogEtronic Corporation has manufactured special scanners to reproduce radiographic images.[7] The LogE process uses a large cathode ray tube as a scanning light source. The inventor, Dwin Craig, first used the technology in the 1950s in a contact printer designed to enhance the images from large-format aerial photographic negatives. Later, other equipment was similarly modified, including the first unit designed specifically for copying radio-

graphic images, the R-45, which was introduced in the late 1960s.

Over the years there have been several models on the market, some for general radiographic copy, photography and others for special functions such as microfilming. The current models, the MC series, are available with a variety of camera formats to meet different needs; the electronic control console (called a MultiDodge) will also operate a scanning enlarger.

While the scanning function has become more efficient with the newer models, the basic principles and configuration have remained the same (Figure 5.18). The radiographic original is placed over the surface of the CRT, which functions as the light source. The area of the tube surface illuminated (referred to as *raster size*) can be varied to match the size of the film being copied.

The camera shutter is opened, and a small dot of light is *scanned* under the radiograph to make the exposure. The dot moves so fast it appears as a line moving across the screen. A fiber-optic cable mounted beside the camera lens picks up light transmitted through the radiograph and sends it to a sensitive photomultiplier tube

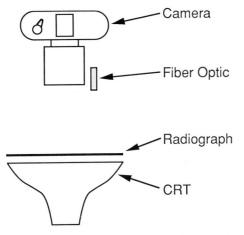

**FIGURE 5.18    The basic configuration of a LogEtronic scanner for the copy of radiographs.**

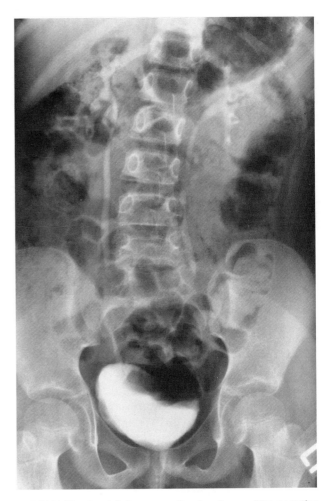

**FIGURE 5.19    A print from a professional copy film negative produced using the LogEtronic MC-105 reducer.**

(PMT). The speed and brightness of the scanning dot is changed to dodge the image as the exposure is made. The LogE functions as a moving *transmission densitometer.* When the dot passes under a dense area, it becomes brighter and travels more slowly, giving more exposure. Conversely, in thin areas the dot moves faster and dims to reduce exposure. The controls on the MultiDodge console allow manipulation of the dodging function to alter the contrast recorded on film.

The LogE system allows production of very good prints and slides from difficult radiographic originals (Figure 5.19). To make the most effective use of its features, it is important to spend sufficient time with the equipment to thoroughly understand its effect on images with different characteristics. One of the most common mistakes is overdodging, producing images that lack brightness and that may have artifacts in the form of lighter or denser areas not found in the original. For example, in barium studies and other radiographs where there are large, very light areas adjacent to much denser parts of the film, the higher dodging ranges may cause edge enhancement. That is a false highlight or bright area along the edge of the thin part of the film. The following information and guidelines may be helpful when setting up and testing a LogE reducer.

### The Cathode-Ray Tube

The size of the scanning dot (set by the installing technician) is about 1/8 inch in diameter. A smaller dot may show dark lines between the scan lines of the raster (called *barring*), and a larger dot reduces the effectiveness of the dodging function. The LogE cannot effectively dodge detail smaller than the scanning dot.

### The Key MultiDodge Console Controls (Figure 5.20)

**Sensitivity.** This control consists of a three-digit display and a thumbwheel switch. It is used to compensate for the perceived differences in light intensity caused by changing the distance between the fiber optic and the CRT. Adjusting the sensitivity of the PMT helps assure consistent exposures whether photographing a 3 × 4 inch CT scan with the lens and fiber optic 10 inches from the CRT or a 14 × 17 chest film at a distance of 28 inches.

With the 35-mm camera and a variable focal length lens, it is usually only necessary to make this adjustment occasionally, since originals of many different sizes may be photographed from the same camera position.

When a unit with the 4 × 5 camera is installed (it comes with a Polaroid MP-4), several steps may be required. First, make several masks that will cover the entire CRT surface. Cut openings that center the image under the camera for the basic sizes of radiographic originals to be

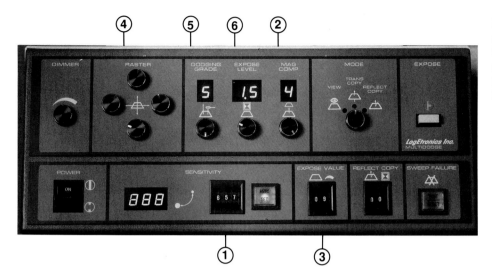

FIGURE 5.20 The control console (MultiDodge unit) for the LogEtronic MC-105 reducer: sensitivity (1), mag comp (2), expose value (3), raster (4), dodging grade (5), expose level (6).

photographed. Masks of $4 \times 5, 8 \times 10, 10 \times 12, 11 \times 14$ and $14 \times 17$ inches are probably sufficient. Second, focus the camera on an image using each of the masks in turn from the smallest to the largest.

Make note of the exact camera position for each image size using the millimeter scales on the camera support and focusing columns. Have the LogEtronic technician adjust the sensitivity and the raster size inside the Multi-Dodge console for each camera position. These values can be accessed by using the magnification compensation (mag comp) dial.

Each mask will have its own mag comp preset number and camera position. It will not be necessary to determine the sensitivity setting, adjust the raster size, or visually focus when photographing any standard size film.

**Magnification Compensation.** This switch has six positions. Each stores the calibrated data for raster size and sensitivity for a particular image size and camera position, allowing quick compensation when changing from one size original radiograph to another.

**Exposure Value.** To control exposure, these switches change the number of scan lines per inch and the number of sweeps the dot makes across the CRT. The *tens* switch is calibrated in full *f* stops, the *ones* switch in tenths of an *f* stop. For example, changing the setting from 10 to 15 increases the exposure by one-half stop (5/10), while a change to 20 would be an increase of one full *f* stop.

**Raster.** Each dial (four) controls one side of the raster (the area the dot scans). They are used to change the position or size of the area scanned by the raster. This information may be preset for originals of different sizes and accessed through the mag comp switch.

**Dodging Grade.** There are nine positions for this switch. Positions 0 through 7 step the LogE from minimum to maximum dodging effect. Zero represents no dodging and, in terms of contrast, would produce the same image as a regular viewbox. Seven represents the maximum dodging possible. The effect on a typical characteristic curve can be seen in Figure 5.21. The contrast of the radiograph to be copied will determine the setting for this function. For typical medical films, dodging grades of 3 to 6 will probably be used most often. There is also an *auto* position, which allows an automatic exposure when using the 35-mm camera system. In automatic mode, the LogE opens the camera shutter and makes an exposure based on information it receives in a quick prescan to determine the contrast and density of the original radiograph. At present, the $4 \times 5$ system does not operate in automatic mode.

**Exposure Level.** This indicator should be set at about the middle of the density range of the original radiograph to be copied. For example, use a transmission densitometer to read the maximum density with detail (D-max) to be recorded. Also take a reading of the minimum density (D-min) and subtract it from the maximum reading. Set the exposure value at one-half the difference. Expressed as a formula it is

$$\text{D-max} - \text{D-min} \times 0.5 = \text{E.V.}$$

Example:

$$3.2 - 0.40 = 2.8 \times 0.5 = \text{E.V. of } 1.4$$

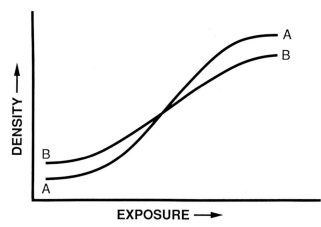

**FIGURE 5.21** *Line A* represents a typical characteristic curve, *line B* represents how the dodging function of the LogEtronic scanner effects the curve.

With some practice, this value can be determined quite accurately by visual evaluation. Like the dodging grade, this function can be done in automatic mode with the 35-mm camera, but must be set manually with the 4 × 5 system.

### Films

A direct reversal BW film such as RPC is not acceptable for use with the LogE. Its very low film speed would make exposures unacceptably long, if they could be done at all. Most photographers making slides with the LogE system use films such as T-MAX 100 with reversal processing and achieve excellent results. For more information on the film, see section on Projection Slides With Black-and-White Films, Reversal Films. The negative to positive method also works very well, particularly from

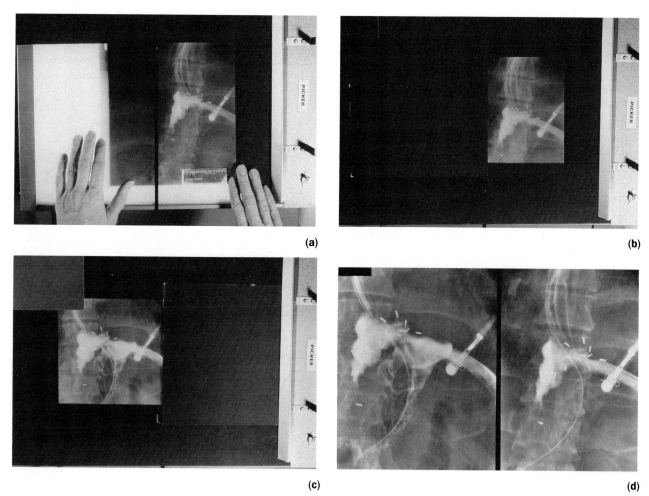

**FIGURE 5.22** The steps involved in making negatives and slides with multiple images. (a) Divide the viewbox with a narrow strip of black tape and position the first radiograph to be copied. (b) Mask out all undesired information and the rest of the viewbox with opaque materials. (c) Remove the first radiograph; position the second and mask as required. (d) Sample of the composite slide produced.

larger format negatives. The LogE is equipped with a monochrome CRT with a high blue phosphor coating, therefore color films are not practical.

*Note:* The preceding information is not intended to cover all the functions of the LogE equipment. The controls and procedures discussed are to help in understanding what the equipment does to an image and the variables that may be used in controlling the results obtained when making copies from a variety of radiographic originals.

## Multiple Exposures for Composite Images

It is relatively easy to combine two or more radiographic images on one slide or print. One method is to make separate slides or negatives and tape them together to form the composite images desired. However, making multiple exposures on one piece of film can provide better results and save time. To combine two images try the following steps:

1. Position the camera to cover the entire composite image area.
2. Divide the viewbox into two parts of appropriate size with a thin strip of black tape (available in art supply stores) (Figure 5.22a).
3. Position the first radiograph on one side of the tape, and mask all other areas with black matte board (Figure 5.22b). Determine and make the proper exposure. The blacked-out area will not record on the film.
4. Remove the first original and set up the second on the other side of the tape. Once again, mask all other areas with black matte board (Figure 5.22c). Determine and make the proper exposure for the second image on the same frame or sheet of film.
5. Process as usual.

The resulting slides will have a narrow black space between the images that looks appropriate on the screen (Figure 5.22d). For the best print for publication or display, overlay the spaces between image parts with thin black tape before printing to provide a white space.

## Very Light Originals

A very thin original radiograph, one with almost no image visible, is a special problem. Any form of transillumination only weakens what little image is present. For this type of original, use the copy procedures for continuous-tone, flat art copy found in Chapter 4. Place the radiograph on a sheet of plain white paper (no texture), and photograph it on a copy stand (Figure 5.23a). Try to avoid placing glass on top of the film. Often sliding a hand across the radiograph will create enough static electricity to hold the paper and radiograph in good contact while the exposure is made. Select a film and

(a)

(b)

FIGURE 5.23    (a) A viewbox copy of a radiographic original with very little density (thin). (b) A reflected light copy of the same radiograph.

process that will increase contrast somewhat. The resulting prints or slides generally will not have the bright highlights and full contrast range of a more normal original but will enhance the very weak detail (Figure 5.23b).

## CONCLUSION

Modern radiographic images are the products of many technologies and are filled with valuable information for the clinician, researcher, and other scientists who use them. The challenge to the photographer is to utilize photographic technologies to accurately reproduce the information contained in those images. The methods and equipment that have been discussed in this chapter are by no means "the only way." There are many other combinations of lighting, film, and development in use today created by a useful knowledge of the subject matter, an inquisitive mind, some imagination, and a desire to produce the best image possible. By listening to and sharing these techniques with others, medical photographers improve education and communication and become more valuable to the medical community.

## ENDNOTES

1. Agfa Scopix CR-1B Film,
   12–36 exposure rolls per box
   Agfa-Matrix Corporation
   100 Challenger Road
   Ridgefield Park, NJ 07660
   201–440-2500
2. Kodak CFT Film
   35-mm × 200 feet
   Code CFT746, Cat. No. 830 9338
   Kodak Rapid Process Copy (RPC) Film
   35-mm × 150 feet, Cat. No. 174 6031
   36-exposure rolls, Cat. No. 175 3151
   Eastman Kodak Company
   Health Sciences Division
   343 State Street
   Rochester, NY 14650
   800–242-2424, extension 12
3. Kinex Model MR-10 Viewbox
   Kinex
   34 Elton Street
   Rochester, NY 14607
   716–442-2360
4. VitaLite
   Duro-Test Corporation
   2140 W. Henrietta Road
   Rochester, NY 14623
   800–937-0900, extension 7141
   716–937-1321

Sylvania Design 50
GTE Products Corporation
National Customer Service Center
P.O. Box 275
18725 N. Union Street
Westfield, IN 46074
800–255-5042
MacBeth, Division of Kollmorgen
P.O. Box 230
Little Britain Road
Newburgh, NY 12250
800–431-4950
Aculite
Bretford Manufacturing, Inc.
9715 Soreng Avenue
Schiller Park, IL 60176
800–343-1779
G.E. Chroma 50
General Electric
Nela Park
Cleveland, OH 44112
800–626-2000
216–266-3900

5. Aristo DA-17 Viewbox
   Aristo Grid Lamp Products, Inc.
   Port Washington, NY 11050
   800–221-1322
6. Kodak T-MAX 100 Direct Positive
   Film Developing Outfit
   To make 1 quart for processing 12 rolls
   Cat. No. 195 4155
   Eastman Kodak Company
   Scientific Imaging
   343 State Street
   Rochester, NY 14650
   800–242-2424, extension 12
7. LogEtronics MC Series Radiographic Reducers
   and Enlargers
   EgolTronics Corporation
   354 South Pickett Street
   Alexandria, VA 22304
   703–751-5522

## BIBLIOGRAPHY

Cardew, P. N., 1984. Copying radiographs and electronic images. *Medical Photography Study Guide*, 4th ed., pp. 317–334.

Kodak Publication M1-18, 1980. *The Fundamentals of Radiography*, 12th ed. Rochester, NY: Eastman Kodak Company, Health Sciences Division.

Kodak Publication M3-106, 1990. *Making Effective Lecture Slides*. Rochester, NY: Eastman Kodak Company, Health Sciences Division.

Vetter, J. P., 1986. Guidelines for illustrations. *Pediatr. Neurosci.* 12:38–42.

# Chapter 6
# Optical and Computer Graphic Slide Production

## Dan R. Patton

*"Enthusiasm is the germ of success...and no one can accomplish anything without it."*

James William Patton
1919–

Scientific photography has numerous areas of specialization; the table of contents of this book gives some idea of its range. There are scientific photographers who produce photographs through the microscope, while others employ a fundus camera in photographing the retina of the eye. Some macrophotography techniques capture the smallest insects as they feed on a farmer's crop; others document the drama of open-heart surgery. This list could go on and on. While each area of specialization tends to divide scientific photographers into groups, there is one aspect that binds them together, the production of graphic slides. The specialty does not matter; interspersed with the scientific images are word slides, flowcharts, and graphs.

This is not by accident. Good scientific presentations use graphic slides in many beneficial ways. Graphic slides act as organizers. When properly used, word slides substitute for a speaker's notes. This allows the presenter to come out from behind the podium barrier and develop a rapport with the audience. It eliminates the need for clumsy cards or pages of handwritten copy. All the speaker has to do is push on the hand control and glance at the screen to be cued for the next point in the presentation.

The other side to this coin is that graphic slides keep the audience in step with the speaker. They announce changes in subject by acting as transitions between topics. Graphic slides can cover gaps when other images do not exist. Graphs serve to simplify complex lists of data, allowing the audience to see trends and to understand what is important. At the conclusion of the presentation, word slides summarize and reinforce points.

Graphic slides provide the common thread that makes a lecture look as if it was produced as a unit and not a hodgepodge of material thrown together. When properly produced, graphic slides help, not hurt; they add, not detract; they simplify, not confuse. Because graphic slides are so important and also because so many of these slides are produced, it is necessary to look at the design and production of these images.

For the purposes of this discussion, graphic slide production is divided into two categories: those produced by optical means and those produced using a computer and a color film recorder. Before considering production techniques, it is essential to discuss the common design factors that apply to all graphic slides, no matter how they are produced.

## COMMON PRINCIPLES

There is a difference between graphics designed for publication and graphics designed for projection. This difference causes problems because people often photograph publication graphics without modification and wonder why the resulting slides are less than effective when used in a lecture.

Graphics for publication can contain more detail than those created for projection. This results from several factors. Graphics used in publications must be limited in number because they take up space, a fact that ultimately will affect the cost of the publication. Thus when publication graphics are used, they contain as much information as can be placed in the allotted area. Readers viewing graphics in print view the image from approximately 40 centimeters away. A magnifying glass can be used to examine detail if needed, and the graphic can be reviewed many times. In this respect, the reader controls the time devoted to each image.

This is not true with the projected image. The viewer of a projected graphic is located at one place in the auditorium. The viewer does not move and has no means of magnifying the image. The amount of time the viewer has to acquire information from the image is controlled by the speaker. Once the slide is advanced, the viewer does not have the ability to review the image again. Thus care should be taken to simplify the material included in the projected graphic.

For years, *keep it simple* has been the challenge given to people preparing lecture graphics. The number one

problem with graphic slide production is putting too much information on one slide. This has always been the case, and it will continue to be the number one problem. If you review the literature available on graphic slide production, you will see that "overcrowded" slides has been a problem existing as far back as when lantern slide projectors used candles as a light source.

Why is there no progress in solving this problem? It is related to the fact that the speaker is always placed close to the screen. Fine detail in the slide is visible to a speaker who stands beside an image that is 20 feet wide. To see your slides from the audience's perspective, always rehearse your presentations from the projection booth. From this perspective, it becomes clear that well-designed slides, which have been simplified, are the most effective in projected media. Several rules of thumb can be applied to the design of graphic slides in an attempt to prevent overcrowding. The following are among my favorites:

- Hold a slide at reading distance. Without using a magnifier, determine if you can read the text. If you can, drop it into the slide tray. If you cannot read the text at normal reading distance without a magnifier, drop it into the trash, because the people in the back of the audience will not be able to read it either.
- The *rule of 7s* states that you measure the short axis of the original material that you want to photograph. Multiply that measurement by 7. Now stand back from the original material at a distance equal to the result of your calculation. Ask yourself, "can I read the text at this distance?" If you can, go ahead and photograph it; if you cannot read it, the people in the back of the auditorium will not be able to read the slide. Save your film and redesign the original material.
- Take the billboard approach to graphic slide production. Advertisers who produce material to be used on billboard advertisements know that they only have 15 seconds to sell you the product before you are past the sign. This philosophy also works in designing graphic slides. Your audience should be able to analyze each slide in about 15 seconds. If it takes longer, there is a good chance that the slide is overcrowded.
- Never use more than thirty words or seven lines of text when designing a graphic slide.
- Never put more words on a slide than can be comfortably typed on an index card.
- Never put more words on a slide than are readable on the front of a T-shirt.
- Never include more than one concept on a slide, but always have at least one slide per concept.
- Slides used in support of scientific lectures should be changed every 30 to 60 seconds. If it takes longer than 60 seconds to explain the slide, consider breaking it down into several slides. Advancing the projector "sets the pace" in a presentation. The proper pace is critical to the success of the presentation.
- Word slides should be used to outline and emphasize key words. They should not contain typed paragraphs that the speaker reads to the audience.

## Progressive Disclosure Techniques

Do not show the audience what is to be talked about until you are ready to talk about it. If a speaker projects a list of ten points and begins to talk about the first one, within 15 seconds everyone in the audience knows what the next 9 points are going to be. The audience's concentration drifts as they wait for the speaker to catch up with them. Highlighting the point in the list that is currently being talked about helps to inform the audience of where the speaker is, but it does not solve the problem.

The use of *progressive disclosure* slides provides a solution. The progressive disclosure technique takes the same list and only reveals each point in progression as the speaker begins to discuss it. This technique has been used for years by speakers using overhead transparencies. They accomplish progressive disclosure by placing an opaque card over the overhead transparency, sliding it down as they proceed from one point to the next.

The same technique can be used with slides. As the list is disclosed, the new point is highlighted and the point just discussed is subdued. The advantage to this technique is that what is to be talked about is not yet known to the audience. The progressive disclosure technique promotes audience attention (Color Plate 3).

You will have to produce several slides, instead of only one if you use this technique. Why would you want to do that? It comes back to the concept of *pace*. Runners develop a pace at which they are comfortable, and the same can be said of an audience. Something should change on a regular basis, or audiences become bored. They need something new to look at and something new to think about on a regular basis. If it is only going to take 30 seconds to cover ten items, then use only one slide. If it will take 10 minutes to properly cover all the points, choose progressive disclosure slides to speed up the visual pace and keep the audience's attention.

## Dual Projection Technique

Comparison enhances learning and dual "side-by-side" projection provides comparison. Dual projection gives the audience a visual Ping-Pong game to play, which has the effect of increasing the pace without having to speed up the rate of slide changes. At the College of Veterinary Medicine at Ohio State University all auditoriums and conference rooms are equipped for dual projection.

Why mention dual projection in a chapter about graphic slide production? The use of dual projection techniques requires that more graphic slides be produced. With dual projection, the left screen in a presentation may project a graphic slide with the disease entity spelled out and a brief list of its causes. On the right there may be a series of photographs of a patient with that condition. For the audience, this is a more stimulating learning experience. The graphic slides also reinforce the lecture by showing the proper spelling of difficult words. Dual projection is a powerful teaching tool used by many successful lecturers.

## Selecting Colors

One of the key factors in designing graphic slides is the proper selection and use of color. Providing a list of what is right and what is wrong, with regard to color selection, is difficult because much of color selection is viewed by producers as personal taste. However, there are certain points that should be made.

- White is always dominant. Audiences are drawn to the white areas of a slide first. Therefore, if white is used in a slide, it should be to bring out what is being discussed. White is the best color to use for highlighting text.
- While the eye is sensitive from 400 to 700 nm of electromagnetic energy, it does not have equal sensitivity throughout the range. The eye peaks in the 600 to 650 nm range, which is seen as yellow. The eye does not have good sensitivity at the extremes of the spectrum. This means that yellow letters will come forward, while dark blues and deep reds will recede in comparison.
- Never use blue letters on a black field, or worse yet, black letters on a blue field. This is the worst combination for readability in projected media. Because your eye is not very sensitive to blue, there is little contrast between the background and the letters; contrast is required for readability.
- Reserve the use of red letters for statements like "Caution" or "Danger" or "Stop: Do Not Proceed."
- The three sets of complementary colors can be remembered by extracting the first letters from the phrase: *Red Cadillac BY General Motors.* (Red–Cyan, Blue–Yellow, and Green–Magenta) Two of the three complementary color sets should not be used in graphic slide combinations. The Red–Cyan and the Green–Magenta combinations cannot be tolerated by the eye. Only the Blue–Yellow combination works.
- Males designing graphic slides tend to use saturated primary colors, while females tend to use the more pleasing subtle or muted color combinations.
- Remember that a portion of your audience will be color blind, so avoid selecting a single color of letters on a black field. You run the risk of someone in the audience not seeing anything because they are blind to the only color you selected.

## Background Selection

For years, all graphic slides were produced optically from flat copy. The choice of backgrounds was usually limited to a solid color, which was selected by using Wratten filters, Pantone papers, or Diazochrome film. Now that computers are used to create graphic slides, a designer can choose from 16.7 million colors.

The ease of placing graphic design elements, such as bullets, static lines, boxes, grids, and the like, has had a major effect on the appearance of graphic slides. This has not always produced a positive effect, because graphic design is often in the hands of the end users who have no training or experience with the proper use of graphic design elements.

It is difficult, in a book like this, to give advice about the design of backgrounds, except to say; *keep it simple.* Popular backgrounds are the product of current trends. A few years ago, infinity grids were popular in graphic slides. Because of overuse, they have now fallen out of vogue. Gradient backgrounds are now popular. A few factors will hold true, no matter what is in vogue for backgrounds.

- Seals, logos, icons, and watermarks lend an identity factor to a presentation. The audience is reminded of the presenter's institution. These elements should be used subtly, so as to be visible but not dominating.
- Once having selected a graphic slide style, *do not change it* during that presentation. Just because the computer can produce 16.7 million colors is no reason to try to use all of them in one lecture. Changing graphics without a reason is distracting to the audience. Well-designed graphic slides form the common thread that holds a lecture together.
- *Do not let media overpower the message.* The reason the audience is attending the lecture is to gain information about the topic, not see what your new software allows you to do with slides. They should not be distracted by flashy slides that draw attention away from the message. Graphic slides should be designed to support a presentation. Audiences should not walk out of the room forgetting what the speaker said but remembering how the slides looked.
- When in doubt, use blue backgrounds. Blue is the easiest color for an audience to look at over an extended period of time. Because the eye is not as sensitive to blue, it provides a good contrast for the other colors that can be used for text.

## Font Selection

In the early days of graphic slide production, *font selection* was limited to what was available from the companies that manufactured three-dimensional ceramic letters. These letters were aligned on a poster board and illuminated from the top left to create a drop shadow falling to the bottom right. After this, typewriters equipped with the Orator ball set text. Next, the strip printers, headliners, and lettering machines accomplished the same task; now laser printers and color film recorders are used. Font selection has grown from just a few to hundreds, if not thousands, of fonts from which to choose.

As in the case of color selection, once you have made a decision about which font to use, do not change it during the presentation. Mixing font styles in a presentation is a distraction that can easily be avoided.

Fonts fall into three main categories: *serif, sans serif,* and *stylized.* You should avoid all of the stylized fonts for routine graphic slide production. Stylized fonts include such selections as Script, Old English, Zapf Chancery, Los Angeles, and so on. They are difficult for an audience to read in projected media. An audience should be able to read the slide in 15 seconds or less. Because stylized fonts are not commonly used, they tend to trip the eye as it scans a line of type. Your goal is to remove obstacles, not create them for the audience.

The remaining two families: serif and sans serif are good choices for graphic slide production (Figure 6.1). Newspapers traditionally use serif type. This is type that has serifs or protrusions at selected terminating points of the letter. Serifs provide clues to the eye in determining which letter of the alphabet is being viewed. They also provide transitions to allow the eye to easily scan a line of type. The most commonly used serif fonts are Courier and Times Roman. Of these two, Times Roman is the hands-down choice for graphic slide production.

Sans serif (*sans* is French for *without*) is a block style letter. The most common font in this family is Helvetica. For years this has been our standard font for graphic slide production. It provides a clean look that is easy to read from the back of the room.

It is becoming increasingly more popular to use Helvetica for the headlines and Times Roman for the body text or vice versa. This is an exception to the rule that says never mix fonts. These two font styles are usually separated by a static line (Color Plate 4). The title is highlighted by choosing a different color than that used for the body text. The combination of these two particular fonts is successful. Remember, if this is a style that you find acceptable, adopt it, and do not change it throughout the presentation.

Drastic variations in the font size should be avoided. This is easy to accomplish in slides produced with a computer and color film recorder. In the case of slides photographed on a copy stand, varying the camera height causes the point size to vary.

Information should occupy 70% of the projected slide area. The slide's *comfort zone* is defined by the remaining peripheral area (Figure 6.2). It is important that text not extend into this area. When text spills into the comfort zone, a tension is created, and the slide instantly takes on a crowded appearance.

When graphic slides are to be transferred to the television medium, care should be taken not to place text in the *safe action area.* This safety area is required because you

**FIGURE 6.1   This diagram shows you the difference between the two major typeface families: serif and sans serif.**

**FIGURE 6.2   The 30% area between the type and the edge of the slide is known as the *comfort zone.* When text is allowed to intrude into this area, the slide instantly takes on an overcrowded appearance.**

are forcing a slide with a 2:3 ratio into a television image format, which is a 3:4 ratio. For a 35-mm slide to fill the TV screen, portions of the image must be cropped. It should also be pointed out that television cannot reproduce all of the subtle colors contained in a slide, so care must be taken to simplify the design when the final use of a slide is as television media.

### Drop Shadows

*Drop shadows* are effective on titles and headers but should be avoided on body text. For headers, drop shadows add an element that separates the text from the background and gives the slide a three-dimensional feeling. For body text, which is usually smaller, drop shadows make it difficult to read.

The theory behind drop shadows is that light from a single light source strikes an opaque letter and casts a shadow on the background below. If that is the theory, then the drop shadow should be darker than, but the same hue as, the background (or it should be black). Visual contrast plays a role when choosing to use drop shadows. If you have a blue background with a black drop shadow, there is a good chance that the audience will never know the drop shadow is there. Drop shadows are more effective on lighter backgrounds. In graphic slides they should always fall in the same direction. The most common placement of shadows is the bottom right, suggesting the effect of the light source placed above and to the left, which is where one starts to read.

## OPTICAL SLIDES

### Equipment Requirements

The production of *optical graphic slides* requires the use of a good copy stand. The copy stand is the backbone of any media production center operating in the scientific community. See Chapter 4 for information about acquiring and operating a copy stand.

Graphic slide production also requires the use of a quality slide duplicator, which some manufacturers prefer to call an *optical printer*. This piece of equipment must have several features to meet the requirements of a production tool. Here is a check list to use when purchasing a slide duplicator:

• A 3200-tungsten light source, rather than flash
• Diffusion, rather than condenser, illumination
• A 4 × 5 inch illuminating stage, rather than 2 1/4 inch
• A stable camera and lens mount
• Dichroic color filters
• Ability to easily do multiple exposures
• High-quality flat field optics

Before discussing color, it is important to include the options for black and white. You must be able to cover the basics by providing a black and white (BW) slide service before you progress to computer-generated graphics.

### Positive Black-and-White Line Copy

The "bread and butter" of graphic slides is the positive BW *line copy slide. Line* is a term used in the graphic arts industry to describe a material that is sensitive only to black or white. This is the ultimate in high contrast because it cannot reproduce shades of gray. One film used for line copy slides is Kodak's LPD-4 Precision Line Film. This film comes in 150-foot rolls, which should be a clue as to its film base. LPD-4 is coated on an Estar film base, rather than acetate. Estar is dimensionally stable and very strong. Have a pair of scissors handy when you go into the darkroom with an Estar-based film. Biting the film and tearing it loose from the spool, which works with acetate-based films, will not work with Estar. Once processed, Estar-based films require very sharp knives in the automated slide mounters, or the mounter will jam.

LPD-4 is a very slow film. With 1000 foot candles of light on the copy stand, my standard exposure is 1 second at *f*/4 for copying line art. The film is an orthochromatic emulsion, allowing it to be handled under a red safelight in the darkroom. Development requires equal parts of the A and B solutions of Kodak's Kodalith Super RT A & B developer. Develop the film for 3 minutes at 70° F. The resulting slide is one of the best at resolving fine detail and has a crisp projected image.

This slide is the fastest to produce. LPD-4 is used for offering emergency service to clients. It provides the ability to deliver slides within an hour's time from a limited quantity of BW line originals.

### Kodalith Slides with Color Gels

*Kodalith* has become a term used in graphic slide production, like *Jell-O* in the food industry. Kodalith is used to describe any high-contrast BW negative line image, just as some people use the word *Jell-O* (General Foods Corp., White Plains, NY) to describe all food gelatins. These terms are specific brand names for one manufacturer's product. Although the term *Kodalith* (Eastman Kodak Co., Rochester, NY) is used here, there are several companies that produce a film with similar characteristics.

Kodalith is one of the most versatile films used in graphic slide production. While it is a critical intermediate step in the production of lithochromes, burn-in duplicates, and almost all special effect slides, it can be projected directly to the screen.

Kodalith is a negative BW line film with an exposure

index of about 6. It is a sister to LPD-4 Precision Line Film, but it is coated on a conventional acetate base rather than Estar. The exposure used, with 1000 foot candles of light is 1 second at $f/8$. The process is the same as for the LPD-4 film. This is convenient, because both the positive and negative versions can be processed in the same tank.

Once processed, the film will require spotting with opaque to remove the small holes in the black area that let light through. These artifacts are called *pinholes*. If you have to spend a great deal of time spotting pinholes, you are probably underexposing the film. Some producers use Kodaline film, which tends to produce fewer pinholes.

The most common problem encountered in the field is that the photographer's Kodalith images fail to have a maximum black. The black areas of the film should be opaque (measuring 4.00+ on a densitometer). If you are able to see your spotting brush under the black areas when the film is transilluminated, your film is not being exposed or processed properly. This is usually because a continuous-tone developer was used in place of a proper line quality developer.

At this point, the film can be mounted and the images projected. People who use dual projection like to use Kodalith slides directly. This is because of the striking effect created when you cannot see a frame reference. The projected text, just to the left of the conventional image, seems to float in space. (If you made the mistake of forgetting to spot out the pinholes, it really looks like space.)

It is easy to go one more step and dress up the projected Kodalith image. While seated at your slide duplicator, remove the slide from the gate and zero the filter dials. Adjust the cyan filter and magenta filter wheels to half the maximum density available. Using your standard duplicate exposure and slide duplicating film, expose ten frames and process the film.

The resulting ten blue images are called *gels* and are used as a sandwich in the mount of the Kodalith slide. *Sandwiching* means that you mount two or more frames of film in the same slide mount. The gel causes the white line or text of the Kodalith to take on the color of the gel. You can experiment with dials on the dichroic light source of the duplicator to produce the exact color you want. Medium-density pastel colors work best. Keep sleeves or rolls of the most popular gels readily available beside the light table.

Gels produced in this way have several advantages over those purchased as sheets or in kits. The biggest advantage is that when you run out, it is fast and easy to replenish your stock. A discontinued color is never a problem. The gels have sprocket holes and fit in the mounts easily. The list of advantages could go on.

Because audiences are drawn to the white areas of an image first, it is easy to create emphasis with a gel and an X-Acto knife. While on the light table, lay the gel on top of the Kodalith. Lightly scratch the gel where you want to project white in the image. Now remove the gel, and you will see the scratch marks. Apply pressure with the X-Acto knife and cut out the area that is formed by the encircled scratch. When you sandwich the Kodalith and the gel with the hole in it, the area of emphasis will be white, and the rest of the area will take on the color of the gel (Color Plate 5). This does require a Kodalith with a proper maximum density. The white area gives the graphic slide the needed contrast to make it come alive.

## COLOR THEORY

All photographers should have a good working knowledge of color theory. This is particularly true in order to be able to predict what will happen when Wratten filters are used to expose color film. While it is impossible to cover all of color theory in a chapter on graphic slide production, the points most needed to produce graphic slides will be covered.

**Producing a Set of Visual Aids.**    Produce six slides according to the following directions and keep them beside you as you read this section on color theory. These six slides will be used to help you understand color theory.

1. Check your stock or call your photo supplier and order five items:
   one 3-inch Wratten 12 yellow filter
   one 3-inch Wratten 32 magenta filter
   one 3-inch Wratten 44 cyan filter
   one Kodak 8 × 10 inch gray card
   one 24-exposure roll of Ektachrome EPY 50T
2. Take the above items to a copy stand equipped with tungsten lights, and load the film in the camera.
3. Focus on the gray card and adjust the meter (in the manual mode) for the proper indicated correct exposure.
4. Without changing focus, flip the gray card over so that the camera is looking at the clean white side of the card.
5. Open the aperture one stop.
6. Hold the Wratten 44 filter over the camera lens and make an exposure. This will be the first of the six slides.
7. Hold the Wratten 32 filter over the camera lens and take an exposure. This will be the second of the six slides.
8. Hold the Wratten 12 filter over the camera lens and take an exposure. This will be the third of the six slides.
9. Combine the Wratten 12 and the Wratten 32 and hold them over the camera lens and take an exposure. This will be the fourth of the six slides.
10. Combine the Wratten 32 and the Wratten 44; hold

them over the camera lens and take an exposure. This will be the fifth of the six slides.

11. Open the aperture one additional stop.

12. Combine the Wratten 44 and the Wratten 12; hold them over the camera lens and take an exposure. This will be the last of the six slides.

13. Repeat steps 3 through 11, which will create a second set of six slides, in case you lose the first group. NOTE: the same set of slides can be produced using the filters and an optical printer.

14. Process and mount the slides. You should have six solid color slides (one each of: cyan, magenta, yellow, red, green, and blue). These aids are easy to handle because they are in slide mounts. It does not matter if they get scratched as you use them to study color theory. Place the three filters back into their covers, and save them to use for the *Lithochrome* production techniques.

15. Keep the six slides handy. You will need them as visual aids for the next two sections.

**The Additive Color System.**    There are two systems used to produce color images: the *additive system* and the *subtractive system*. The electromagnetic spectrum is made up of energy that travels in waves. Your eye is sensitive to a very narrow portion of the total electromagnetic spectrum. The visible portion of the spectrum covers the wavelengths from 400 to 700 nm. When the eye is exposed to energy that has a wavelength between 400 and 500 nm (the shorter end of the visible spectrum), the blue cones in your retina are stimulated. Wavelengths from 500 to 600 nm stimulate the green cones, and those from 600 to 700 nm stimulate the red cones. When all three sets of cones in the retina are stimulated, the brain tells you that you are looking at something that is white.

Red, green, and blue light combined in equal parts form white light. This is known as the *additive color system*, and red, green, and blue are called the additive *primaries*. The system gets its name from the fact that wavelengths of energy are added together to form various colors.

**Selective Absorption.**    When white light (made up of red, green, and blue wavelengths) strikes an object, certain wavelengths are reflected, while others are absorbed. By the *selective absorption* of wavelengths and the reflection of the others, different cones are stimulated, causing every object seen to take on a color. If white light falls on an object and the blue is absorbed and the green and red are reflected, what color would the eye see? The answer is yellow.

It is difficult to believe that red and green light form yellow. Remember that you are mixing light, not pigments. To prove this theory, use the slides you produced. Take the red and the green slide, and put them in two separate projectors. The projectors must be matched projectors with the same intensity of bulbs and the same

lenses. Turn the bulbs on, and begin to shift one projected image over the other. Red and green do form yellow. Once a photographer has conducted this experiment, he or she will begin to believe that they can make sense of color theory.

Continue the experiment by projecting the red over the blue. The hot pink color that is formed is called magenta. Finally, project the blue over the green. The color formed is called cyan. Cyan, magenta, and yellow are byproducts of the additive system and are referred to as *secondary* colors. Projecting the red, green, and blue together would produce a pseudowhite. It would take perfect filters and exactly the same quality of light from each projector to produce a true white. Remember that you are combining wavelengths of light that stimulate the cones in your retina.

Try another question. If white light falls on an object and one-half of all three wavelengths are absorbed equally and the other halves of all three are reflected, what color would the object appear to the eye? The object would appear gray. Gray is the most difficult color to reproduce because any imbalance in the three colors will cause the gray to become a warm gray or a cool gray.

Television uses the additive system to reproduce color. Your TV set is constantly changing the percentage of glowing red, green, and blue phosphors on the screen. From a distance your eye cannot resolve separate dots, as they blend together to form all of the colors of the rainbow. To summarize, in the additive system of color you mix together the primaries of red, green, and blue light to form white light.

**The Subtractive Color System.**    Film uses the subtractive system to reproduce color images. The three primary colors of the subtractive system are cyan, magenta, and yellow. (These were the secondary colors of the additive system.) *The additive system must be present in order for the subtractive system to work.* The subtractive system gets its name from the fact that it subtracts from the additive system in order to reproduce all of the colors. The subtractive primary colors are represented by the dyes suspended in a film's emulsion. Cyan will subtract the red wavelength; magenta subtracts the green wavelength; and yellow subtracts the blue wavelength from the additive system.

Use your slides as an example to help you understand this part of color theory. Put away the red, green, and blue additive primary slides and the projectors. Get out the cyan, the magenta, and the yellow slides. Write *blue sensitive* on the yellow slide mount. Write *green sensitive* on the mount of the magenta slide and *red sensitive* on the cyan slide. Take the three slides and sit down at a light table.

Start with the light box because it produces the required additive system. Lay out the slides. Why does the yellow slide appear yellow? It is *not* because the yellow

slide dyes the white light yellow. It is because yellow subtracts blue from the additive light box. If blue is missing, what is left? Red and green. Red light combined with green light stimulates the eye to see yellow. (Remember your projector experiment.) That is why the yellow is *yellow*—because the blue is missing. Can you explain why the other slides are the color that they appear? (Hint: Magenta subtracts green and cyan subtracts red.)

If cyan, magenta, and yellow are the primary colors of the subtractive system, what are the secondary colors of the subtractive system? Secondary colors are the colors formed by combining two of the primary colors. Lay the magenta over the cyan slide. What color do you see? Why? Answer: Because the cyan subtracts the red from the additive light box, and the magenta subtracts the green, you see blue, because that is all that remains. Blue is one of the secondary colors of the subtractive system because it is formed by combining the subtractive effect of the magenta and cyan primaries. What are the other two secondary colors?

**Making a Color Film Model.** With the three subtractive primary slides in hand at a light box, you can see how a positive color film uses the subtractive system to reproduce an image (Color Plate 6). Superimpose all three slides by placing the cyan slide in the back, the magenta slide in the middle, and the yellow slide on top. Look through this stack at the light box below. What you have in your hand is a working model of an E-6 color film.

There are three black and white emulsions, coated one on top of the other in color film. The top layer is sensitive to blue light, and the dye couplers are yellow. The middle layer is sensitive to green light, and the dye couplers are magenta. The bottom layer is sensitive to red light, and the dye couplers are cyan.

What you are looking at is black. The dye couplers are completely formed in each layer. The light box is your additive system. The bottom layer is cyan, which subtracts red from the light box. The middle layer is magenta, which subtracts green light from the box. The top layer is yellow, which subtracts blue light from the box. If the red, green, and blue have been subtracted from the additive system, what is left? Nothing. The absence of light is dark; therefore, no cones are being stimulated and your brain "sees" this as black. Therefore, in the black areas of the slide, all of the dyes are present, and no additive light is allowed to pass. This film model is not opaque; some light is getting through. The maximum black of color film is not opaque. The film dyes that filter the light are not perfect, and a small quantity of light does pass through.

This model represents unexposed, but processed, color slide film because all of the dye has been formed in each layer. Before the film is processed, the dye couplers in each layer are clear. *The couplers are triggered to form their color when the color developer is working on the silver halides that did not see light during the initial exposure. Here is an example.*

Suppose that the shutter opens and red light strikes the film model in your hand. As the film is processed, the layer closest to you is the blue-sensitive layer, and red light passed through it, having no effect. It passed through the middle (green-sensitive) layer with no effect.

Only the silver in the red layer was exposed. The ability of the silver halides to "remember" the light is called the *latent image*. This means that when the film is processed, the latent image in this bottom layer will be converted to black metallic silver by the first developer. If metallic silver is already formed when the film arrives in the color developer, no color dyes will be triggered. Remember that the dye in the red-sensitive layer would have been cyan if it had been formed.

If no cyan dye is formed in our example, remove the bottom layer from the stack of slides you are holding. What color does your eye see? Red light made the exposure, and red is what you see in the film. The red light passed through the top and middle layers (which are the blue- and green-sensitive layers), making no exposure. The color developer will develop these unexposed silver halides. This means that all of the dye is formed in these two layers. Your eye sees red in a slide because the yellow dye subtracts the blue from the additive system, and the magenta dye subtracts the green light. All that is left is red, and red is what made the initial exposure.

Try this again. Reassemble the unexposed film model. This time suppose that the cyan light comes through the shutter to expose the film in your hand. Cyan is not one of the additive primaries; it is a combination of green and blue light. Therefore, cyan light is really green plus blue exposure. If green and blue (cyan) light pass to the film, the top and the middle layers will be exposed, and the bottom will not. This means that metallic silver in the top two layers will be formed by the first developer, but no metallic silver in the bottom layer. If metallic silver is present when the film reaches the color developer, no dye will be formed. If the blue layer was exposed, no yellow will form, so remove the top layer. The same was true for the middle green layer. It was exposed, so no dye will form; therefore remove it. What do you see? No exposure was made in the red-sensitive layer, so it was developed by the color developer, which triggered the cyan dye. Cyan made the exposure, and cyan is what you see.

Use your film model over and over. Each time pick a different exposing color and work through what happens to the film. If you do it enough it begins to make sense; keep working the different possibilities until you feel comfortable. The key is that if a film layer was exposed in the initial exposure, no dye will form. Dye is formed in the layers that were not exposed in the initial exposure.

To summarize, in the subtractive color system you mix

the primaries of cyan, magenta, and yellow to subtract light from the additive system. When all three are combined, there is an absence of light, which we call *black*.

## Color Chart

The *Star of David* color chart (Color Plate 7) helps me keep the two systems straight. Contained in the triangle that points up are the three primary colors of the additive system. In the triangle that points down are the three primary colors of the subtractive system. The color between any two colors as you go around the chart is formed by combining the colors that are on each side. For example, magenta is between red and blue because magenta is formed when you combine red and blue light.

The colors opposite each other on this chart are the colors that nullify each other. For example, cyan will subtract red; yellow will subtract blue; and so on. If you understand how film works, you can predict what will happen when you use Wratten filters to produce graphic slides. Review the color theory section again. Do not get discouraged if you do not understand it the first time. Understanding color theory is like riding a bike, you never understand the technique on your first attempt but once learned you will never forget.

## Lithochromes

*Lithochromes* are burn-through slides. A trusted standard in graphic slide production, *litho* comes from the fact that a Kodalith intermediate slide must be produced. The final product is delivered on Ektachrome film stock, which adds *chrome* to the name. This technique needed a different name from its predecessor, the *diazochrome*. *Diazochrome* is the film used for graphic slide production in medical photography laboratories years ago. Diazochrome was a material that was placed in contact with a Kodalith negative and exposed to a brilliant light source for several minutes. The exposed diazo film, which could be handled in room light, was ritually lowered into a container of ammonia fumes called a "deluxe pickle jar." This act was performed many times each day by scientific photographers of old.

After several minutes in the ammonia fumes, the color of the film would begin to form where the maximum density of the litho film had prevented the light from passing. The resulting slides, which were in sheets with no sprocket holes, had to be cut and taped into the mounts by hand. The resulting slides were usually blue with white letters. Different background colors meant stocking different types of diazo film. The image was not permanent and faded with repeated projection. It was a slow and clumsy process, and because it did not use pho-

tographic dyes, it was impossible to duplicate a diazo accurately.

Lithochromes are an improvement over diazos because they form a permanent image, they can be duplicated, and they can be machine mounted. They do not require stocking special supplies, and the color of the letters can be in colors other than just white.

## Making a Set of Test Slides

To produce a set of test master slides, start by producing a piece of camera ready copy. Place a word on the first line, followed by a space and a brief definition of that word on the next few lines. (Remember, when laying out type it should always be in a 2:3 ratio.) Place the type on the copy stand baseboard, frame the camera, and tape the copy down. Cover up the definition with white paper and shoot a Kodalith of the word only. Now cover up the word and shoot a Kodalith of the definition. Process, spot, and mount the two Kodalith slides, and take them to your film duplicator.

With color-duplicating film in the camera and no slide in the gate, hold a Wratten 99 green filter over the lens and use an exposure two stops less than your standard duplicate exposure to expose the film to raw (green) light. Arrange to double expose and return to your standard exposure. Now slide the Kodalith of the word into the gate. Hold a Wratten 15 yellow filter over the lens and give the film a second exposure. Arrange to triple expose. Remove the Kodalith of the word, and place the Kodalith of the definition in the gate. Without a filter over the lens, make the third exposure. Process the color film (Color Plate 8).

The resulting slide is a three-toned lithochrome. The color of the word could have been cyan instead of yellow by replacing the Wratten 15 with a Wratten 44 cyan. (Color theory: if you see green, there is a layer of cyan superimposed over yellow.) The letters can never be magenta because the first exposure fogged the frame green. (Color theory: if green light makes the exposure, no magenta will be formed when the film is processed.)

Using these two Kodaliths and the following chart, produce a set of slides to demonstrate all of the possible combinations:

**Lithochrome (Burn-Through) Color Combinations.** The numbers in brackets are the Wratten filter numbers used to produce the color:

| Background Color | Letter Colors Possible |
|---|---|
| Red (12 + 32) | White |
| | Lighter red |
| | Yellow (12) |
| | Magenta (32) |

| | |
|---|---|
| Green (44 + 12) | White |
| | Lighter green |
| | Yellow (12) |
| | Cyan (44) |
| Blue (32 + 44) | White |
| | Lighter blue |
| | Cyan (44) |
| | Magenta (32) |
| Cyan (44) | White |
| | Lighter cyan |
| Magenta (32) | White |
| | Lighter magenta |
| Yellow (12) | White |
| Black | Any color you want |
| White | Nothing at all |

These are the only color-letter combinations possible with each background using the burn-through technique. If you thought others would be possible, review the section on color film theory.

Just because a combination is possible, that is no reason to use it. A magenta or yellow background should not be used for a slide. Likewise, do not use a red or blue background with magenta letters. The most popular combination in graphic slides is a blue background with yellow letters. Theoretically, this is impossible with the burn-through lithochrome technique.

To see blue in the film, the yellow layer must be absent. Many photographers routinely produce this combination by burning yellow letters into blue backgrounds. How is this possible? Their background is a deep midnight blue, which means a portion, but not all, of the yellow dye is present. If all the yellow was formed, the background would be black. The resulting slide consists of pastel yellow letters on a midnight blue background. The effect is quite pleasing.

To make brown, take the Wratten 22 orange and underexpose it three stops. This results in a brown that looks great with yellow or white letters.

### Producing Lithochromes by Prefogging.

James Kendrick, author of Chapter 5, takes Ektachrome film into a darkroom and tapes the leader of the film to the wall. In the dark, he pulls the film out of the cassette with the emulsion facing away from the wall. At a pretested distance, (still in the dark) he aims a flash with a Wratten 47B filter taped over the flash head in the direction of the film. He presses the open flash button. For an instant, the room is filled with blue light that fogs the film. Back in the dark, he respools the film and takes it out to the duplicator, where he marks the cassette with the color of the filter. Prefogging the film eliminates the need to conventionally double expose the film. Burning the letters into the pre-fogged film is all that is required.

The advantage to this technique is that he can produce more slides per hour. The disadvantage is that there are no frame lines, because all of the film is blue (even out in the sprocket areas). This can make alignment of an automatic mounter difficult, unless a blank white frame is placed on the beginning of each roll.

The color of the background is altered by changing the filter over the flash head. Once a prefogged roll is loaded into the duplicator, you cannot change backgrounds until you change film.

Steps that will speed up your lithochrome production are:

- Produce your camera-ready type by laser printer. Use legal size paper and cut it in half after it is printed, resulting in 4 1/4 × 14 strips of paper. On each strip is the text of four slides. Be sure to leave adequate white areas between the text for each slide. This allows the photographer to slip the paper and shoot each slide. It is much faster than having an individual piece of paper for each slide.
- Do not change the camera height. Changing the camera height takes time and causes the size of the text to change when the slides are projected. Audiences do not like a slide with giant letters followed by one with miniature type.
- Use projection focus devices on your copy stand (See Chapter 4. deVeer gives an excellent explanation of projection focus and also lists several manufacturers). This eliminates the need to stand and view through the camera. Cropping and focusing is accomplished by projecting the reticle of the camera onto the copy.
- Standardize only one color background per job. Pausing to determine what color should be used on each slide in a job takes time.

### Polablue Instant Film

The Polaroid Corporation (Cambridge, MA) produces several instant 35-mm films that have applications in graphic slide production. One of the most popular of their films is Polablue. This film allows you to photograph from black line/white background originals and produce blue background/white letter slides direct. This process does not require a Wratten filter over the lens. Polablue is a special application film that can only be processed in Polaroid's AutoProcessor. Slides produced in this manner can be projected within minutes of the time they were photographed. This film is praised by last-minute slide producers. It is also a good choice if you do not have access to a conventional darkroom. For this reason, it has applications in physicians' offices and research laboratories.

Most media production facilities find the cost per slide of the instant films prohibitive compared with conventional solutions. They reserve the use of this film for emergency, rather than routine, situations. Polaroid also

makes a line BW positive film called Polagraph. Polapan is a continuous-tone positive BW slide film, and Polachrome rounds out this family of films as a 35-mm color film.

## Vericolor and C-41

Kodak Vericolor slide film is a continuous-tone color negative film coated on a clear acetate base. When used for graphic slide production, it eliminates the need to produce the intermediate Kodalith slide. With the Vericolor film you photograph the camera-ready copy through a Wratten filter. Because Vericolor is a color negative film, the white area of the art takes on the complementary color of the filter used over the lens. For example, when black type on a white page is photographed through a Wratten 22 orange (dark yellow) filter, the slide produced will have a blue background with white letters. A Wratten 32 magenta will produce a green background and so on (Color Plate 7).

The Vericolor technique requires the C-41 color process. If you run C-41 in-house, look into the Vericolor possibility, as it could save you time. One factor to keep in mind is that Vericolor is a continuous-tone film, which means that *paste-up* in the original copy will show in the final slide. When this occurs, technicians photocopy the original and photograph from the copy. The paste-up does not show in the photocopy and therefore will not show in the slide.

## Optical Special Effect Slides

Media producers use special effect slides for emphasis in their programs. These slides have names like "neons," "glows," "step and repeats," and "roller coasters." They are produced optically via multiple exposures through Wratten filters to sets of positive and negative Kodaliths called *mechanicals*. Special effect slides are time-consuming, with some slides requiring over 50 exposures, but the results are impressive.

**Watermark Slides.**    The optical slide that takes the least work but delivers the most client satisfaction is the watermark slide. It is so named because it resembles the watermarks placed in quality typing paper. The effect is subtle and lies behind the text. The logo or seal of the institution is usually used for the watermark. Here is the cookbook step-by-step approach to producing the watermark graphic slide.

1. Locate a *camera ready* line-art copy of the seal or logo of your company or institution.
2. Photograph this camera-ready copy in a horizontal arrangement onto a negative lith film such as Koda-

lith. Care should be taken so as not to completely fill the frame. You want a loose cropping that leaves room on all four sides.
3. Process, spot, and mount the resulting image (Color Plate 9a).
4. Place the mounted Kodalith slide of the seal or logo in the gate of your slide duplicator or optical printer. The camera should have color slide duplicating film loaded.
5. Select a Wratten 47 blue filter.
6. With the light source on and using the standard filter pack, open the lens one stop from your standard exposure. Hold the 47 filter over the camera lens and make an exposure. The resulting image on the film is a dark blue seal in a sea of black (Color Plate 9b). Close the lens aperture to your standard exposure.
7. Arrange to double-expose the film.
8. Remove the Kodalith slide of the seal from the gate of the duplicator.
9. Hold the same Wratten 47 filter used in the first exposure back over the lens, and make a second exposure to raw blue light. The resulting image on film has now changed. The sea of black has changed to a sea of blue. However, the area where the seal was imaged in the first exposure is now slightly lighter because that area of the film has been given two doses of the blue light.
10. Process and mount the color film.
11. This slide, which has a solid blue background with a slightly lighter blue seal, becomes your *master* watermark background slide and should be so marked and kept beside the duplicator (Color Plate 9c).

With the master background slide, it is as easy to produce slides using custom watermark background as it is to produce standard blue slides. Shoot your next typeset job on Kodalith as you always do, but this time, instead of reexposing them to raw blue light, place your master watermark slide in the gate and prepare to double expose the film, once to the watermark slide and once to the litho text slide. The final graphic slide is made up of white text on a blue background, with a watermark of the institution subtly behind the text (Color Plate 9d).

Judge your final results by projection only. Looking at these slides on a viewer, without magnification, makes it difficult to see the watermark. Once projected, the watermark becomes visible. Remember that you do not want the watermark to stand out or dominate. Some of the audience will not even realize it is there until a slide containing only a small amount of text is projected. Clients like this type of graphic slide. It requires no more work once the master slide has been produced.

For other colors, aside from the Wratten 47 blue, try the Wratten 99 green, the Wratten 70 red, or two thicknesses of the Wratten 44 cyan. It is convenient to keep the

watermark seals of the other colleges within the university (in case a job comes in from one of these groups).

## COMPUTER-GENERATED SLIDES

### Introduction

In 1977, Steve Jobs launched the personal computer (PC) industry with the introduction of the Apple computer (Apple Computers, Inc., Cupertino, CA). IBM (International Business Machines, Armonk, NY) realized what Jobs had started and introduced the first IBM-PC computer in 1981. Lotus (Lotus Development Corp., Cambridge, MA) followed quickly with a powerful software product in 1982, which included the ability to produce

graphs. This was the start of the biggest change in many years in the way media departments produce their graphic slides. Each following year there have been more powerful PCs, more capability in the software products, and upgrade after upgrade. Because it is impossible to keep current with all of the hardware and software, it would be foolish to write about the advantages and disadvantages of current products. There are several weekly and monthly magazines that exist solely to review the current state of this art; subscribe to the publication you find most informative and unbiased in their reviews.

Because the acquisition of a computer graphics system will be one of the largest expenditures made by your facility (Figure 6.3), an explanation of how most of the products work is given here. If you understand how things work, you are better prepared to do your job.

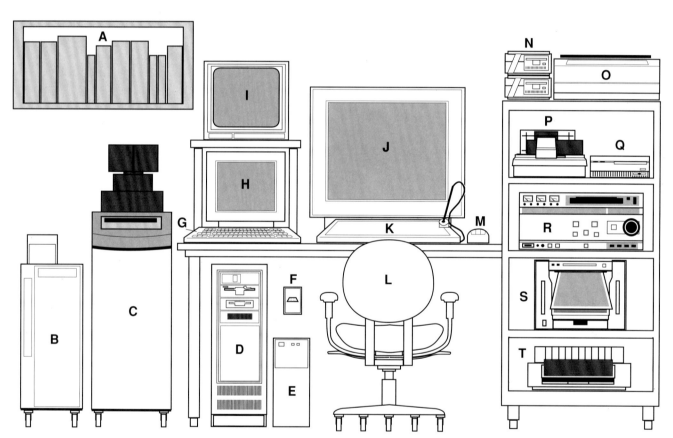

**FIGURE 6.3** The Ultimate Computer Design/Imaging Workstation: (a), software/hardware manuals; (b), 3000dpi black & white image setter (Output Device); (c), 8000 line color film recorder with long roll film back (Output Device); (d), the fastest computer you can afford with the most RAM and a tape backup drive (the heart of the system); (e), uninterrupted power supply/surge protector; (f), local area network wall connection; (g), keyboard (Input Device); (h), text monitor (Output Device); (i), color playback monitor connected to the VCR (r); (j), large screen, hi-res, 24 bit RGB graphics display with computer card and accelerator (Output Device); (k), pressure sensitive digitizing tablet (Input Device); (l), a comfortable chair than you can sit in for five hours at a time; (m), mouse (Input Device); (n), mass storage removable optical drive unit (Input/Output Device); (o), flatbed color scanner (Input Device); (p), color transparency scanner (Input Device); (q), CD-ROM drive (Input Device); (r), color video tape recorder/player (Input/Output Device); (s), color thermal dye sublimation printer (Output Device); (t), B&W ink jet text printer (Output Device). The difficulty is getting each item to work properly and not conflict with something else. (Not every peripheral shown is required.) Most facilities separate the input and the output operations into two workstations which require two computers. (*Computer illustration by Ron McLean*).

## Platforms

The hardware (or computer) on which a software product is designed to run is called a *platform*. There are three platforms commonly used to produce graphic slides in biocommunication facilities: Turnkey, MS-DOS, and Macintosh.

**Turnkey Systems.**    As the microcomputer began to find its way into media production facilities, the early graphic programs were limited. A number of entrepreneurs with very sophisticated programming talents started their own companies to fill the need for quality graphic software. They soon found that they were limited by the hardware available. To solve the problem they bought, modified, and built their own computers and output devices. They wrote their own custom software to specifically address the needs of graphic designers. These platforms get their name *turnkey* because, from one vendor for one basic price you get a complete system. Turnkey systems include everything you need to produce graphic slides in one package.

The advantages to turnkey systems are that they provide the graphic designer with the most powerful software available, while producing the highest quality final product available. Not only does the software offer the most sophistication, the platform operates at the fastest speed. Thus the operator does not have to wait for the computer to do its work.

Another advantage is that you have one vendor to turn to for technical support and service. There is no finger pointing between the hardware and the software manufacturers when a problem arises. You develop a good working relationship with the turnkey manufacturer because there are a limited number of producers who can afford these systems. Of the three types of platforms, the turnkey systems are the most expensive, ranging from $45,000 to over $100,000.

The disadvantage is that the turnkey systems file formats are not compatible with anything except their own system. Their formats were designed to be unique and will only output from their custom computers to their output devices. When the system goes down, you must find someone with the same platform in order to get your slides imaged while a trained service technician flies in from a distant location. For this reason, service calls and contracts can be an expensive annual cost of operation.

The more sophisticated the software, the longer the learning curve will be for the operator. Training can take some time before an operator is able to take advantage of all of the capabilities the software has to offer. The amount of time invested in the training of a turnkey operator makes the employee difficult to replace.

The size of the companies that produce turnkey systems are small in comparison with the major computer and software manufacturers. Therefore, the amount of capital available for research and design is dependent on the projected volume of sales of future systems. For that reason, turnkey systems have been slow in keeping pace with the needed software improvements. For example, most turnkey vendors have been delayed in developing the ability to import client-produced images. Some still do not offer this *pass-through* capability.

**Microcomputer Platforms.**    While the turnkey systems were being developed, the power of the PC grew rapidly. The battle for funds available for microcomputer graphic systems comes down to two major corporations: IBM and Apple. To understand why these two styles of PCs operate as they do, one has only to look at where the two manufacturers have their roots. Apple began in a garage in California, with the goal of producing the first PC which anyone could use. IBM comes from mainframe corporate America and was looking to share in the market uncovered by Apple.

**The Macintosh Platform.**    Apple succeeded in the education market and used its profits to set its sights on the business world. This was a difficult nut to crack until the announcement of the Macintosh II product line. This was the first time color had been available in the Macintosh line (something that is essential for graphic slide production). It was also the first time multiple expansion cards could be installed, to allow the computer to do more things.

The original philosophy, that children would learn faster if the operating system used a device called a "mouse" to select files (represented by small pictures called icons), was continued in the Macintosh line. Suddenly, all of the "right-brain" (or artistic) adults found happiness in computers that did not require them to remember strange strings of commands. For example, to erase files on the Macintosh, you drag the file icon into another icon that looks like a trash can. What could be simpler?

Apple began to advertise what its customers were saying—that the Macintosh was easier to use. Part of the reason for this ease of use lies in the fact that the Macintosh software developers conform to a standard interface. Each new software announcement has a similar look, and its options are displayed in pull-down menus. It has been said that a Mac user can open a new piece of software, install it, boot the software, and print something without ever having opened the manuals. This is not as likely to happen on the other platforms.

With the Mac II line came huge amounts of memory. It is not uncommon to have 8,000,000 bits of random access memory (RAM) in the computer and another 80,000,000 bits that can be saved on a hard disk. The early mainframe computers did not have this amount of powerful memory. Now software manufacturers could bring the sophisticated options, once reserved for the turnkey systems, to the microcomputer. The trend toward pro-

ducing graphics on the Macintosh platform has been steadily increasing. The Macintosh platform, however, is expensive compared with the same class of microcomputer available in the IBM-compatible arena.

**The IBM Platform.** If "right-brained" artistic people prefer the Macintosh platform because it makes sense and is easier to use, this statement should lead you to believe that there are "left-brained" people in the world also. This is true; however, neither is better than the other, it is just that each prefers to work in a different way. It does not make sense to logical left-brained people to take the time to move the mouse toward the little drawing, click on the icon, and slowly drag it toward the trash can, dropping it two times along the way. What does make sense to the left-brained person is that to erase that text file (called "Letter") you should type ERASE LETTER.TXT, hit the return key, and be done with it.

IBM came from mainframe corporate America, which used strings of strange one-line commands to accomplish tasks. This method was quicker, assuming that the operator knew how to type. It made sense to use a similar command structure when IBM introduced its first PC in 1981. The new users could be trained to respond to messages like: "Not ready error reading drive A, Abort, Retry, Fail?"

Big Blue, as IBM has been called because of its blue corporate logo, was a powerful player. For many people in the business world IBM was the only choice management would allow. Because of its reputation, sales force, and service structure, IBM set a standard very quickly in the microcomputer world. At first, IBM employees gave the impression that they did not want to be bothered with these toys called desktop computers, but it became evident very quickly that microcomputers would play a major role in the working world.

IBM made a wise decision by encouraging third-party manufacturers to make cards that would take advantage of their expansion slots. Manufacturers of color film-recorders took advantage of this "open-architecture" approach by using the IBM as the host computer to drive their film recorder. This capability, which was not available on the early "closed-architecture" Macintosh system, allowed IBM to enter media production facilities and become the early standard platform.

**Clones.** Because of IBM's open architecture approach and relatively lenient stance on copyright infringement, a number of third-party manufacturers have adopted the IBM MS-DOS (Microsoft–Disk Operating System) standard. This has allowed microcomputers to become available at a lower price. These machines are called *clones* or IBM-compatible computers. When they were first introduced, there were many skeptics. At first, the clones were only compatible some of the time, but now those problems are less frequent. It is common to see machines from several manufacturers in any facility you visit. Many of the reasons used to explain why parking lots are full of different makes of automobiles (all of which accomplish the same task of bringing the employees to work) can be used to explain why institutions use so many different kinds of PCs.

**Windows Environment.** Because of the growing success of the Macintosh desktop graphic interface, and the desire to sell icon-based software to the left-brained IBM world, Microsoft Corporation (Redmond, WA) developed "Windows." Microsoft is the company that wrote the disk operating system (DOS) for IBM, and Windows is an intermediate software product designed to run between DOS and the application software. The graphic look of the program, with its pull-down menus is similar to the Macintosh desktop (including the required mouse).

Respected software manufacturers that had successful programs running on the Macintosh platform have now adapted their programs to also run under Windows on the MS-DOS platform. In many cases, the files created on one platform can be opened on the other platform without the need for a conversion process.

As evolution of the microcomputer has taken place, both the IBM and the Mac platforms have introduced products that look like their competition. IBM now has a low-end computer that looks like the early Macs, and Macintosh has a high-end color system that is made up of three separate parts and that has multiple expansion slots like the IBM. By the time you read this, all the players and the products may have changed.

Microcomputers have revolutionized the way in which media departments produce brochures, booklets, and newsletters with the use of desktop publishing software. The same thing is happening with desktop presentation software. Powerful computers and software programs bring the ability to produce professional-quality graphic slides to the end user. Our role as media producers is changing from doing all the work to advising and training end users before passing their images on to the color-film recorder. Some people have worried that this marks the end for the graphic slide producer. The same thing was probably said by photographers of the early 1900s when George Eastman introduced the Kodak camera and made photography available to everyone.

## Vector Graphics

Vector graphic programs are often called *draw* programs. The best way to explain vector graphic programs is to take you back to kindergarten, where the teacher passed out colored construction paper and scissors and taught you how to cut out shapes and paste them down to a larger piece of paper to form an image. First, you started with a large piece of blue paper for the sky. Next you cut a mountain range out of a piece of darker blue paper and pasted it over the sky. The distant trees came

next, and were placed in front of the mountains. How about a cabin and maybe a dog in front of the porch? This was your first exercise in vector graphics, which is also called object-oriented graphics. Each piece of the image is an object that has a location, size, shape, and color. They are placed on the "paper" in a specific order. You would not, for example, paste the distant mountain range over the cabin.

Put away the construction paper, paste, and scissors and get out your computer, digitizing table, and a vector graphic software program. Start by creating a large rectangle, filling it, and giving it a color of sky blue (Color Plate 10a). Next put in the mountain range by selecting *polygon*. Touch the stylus to the tablet starting in the middle of the screen at the far left. Move from left to right, angling up as you go. Before you reach the center of the screen, touch a point and start angling down. Repeat this action again to create a second mountain peak. Before you stop on the right side, drop down a little, touch a point, come straight across to the far left, and touch and close the polygon by touching on the starting point. Fill this polygon and color it a dark blue (Color Plate 10b). The distant tree line comes next in much the same way as the mountains—only with many peaks closer together. Color this polygon forest green (Color Plate 10c). By selecting various rectangles, you can create the cabin and finally a polygon for the dog (Color Plate 10d). The computer remembers all of these objects by placing them in a *display list*. Objects are placed in the display list in the order they are created. For this reason it is important to work from the back to the front. Along with each object, there is a record of its *attributes*. Attributes are the type of object, its location, size, color, and whether the object is filled, open, or has some degree of transparency.

Each time you ask the computer to redraw your image, the computer reads the display list and renders each object, one at a time, according to its attributes. The advantage of this type of graphic program is that any single (or group of) object(s) can be *selected* and their attributes changed at will. An object must be selected for anything to be changed. If you decide that the distant mountain range is a little too low and too dark, it can be changed. First, select the object by placing the cursor on the object and touching it. The computer usually changes the border of the object to let you know that you have, in fact, selected that object. Once the object is selected, you can now move it up and change the color to a lighter blue. The ability to move and change the attributes of objects is an advantage that is not possible in raster graphic programs.

Vector graphic programs have another advantage: that of *resolution*. When you draw a circle, it is a perfect circle, since the computer is making the calculations. As you enlarge the image, the circle remains perfect. The resolution of the image is only limited by the final output device. If the circle develops "jaggies" in the final image, it is because the output device cannot record the resolution of the software.

The disadvantage of vector graphics is that objects can only have one color. This makes shading difficult. If a gray rectangle really represents a metal pipe, then it should be constructed by a series of long, thin rectangles, each rectangle adjacent to the next. The center rectangle is colored white; each progressive rectangle toward the edge is colored a darker gray. This series of rectangles now takes on the rounded appearance of the pipe. The more rectangles, the more realistic the pipe looks (Figure 6.4).

Each object increases the file size and lengthens the time required to redraw the image on screen or record it on film. If the artist is striving for realism, then the display list soon goes from hundreds of objects to thousands (Color Plate 11). At this point, you need a computer with the fastest processor available and a huge amount of memory and storage space.

Using a vector graphic program will not let you produce an illustration of a patient's face that looks real. For this, you need a raster graphic program. (See Table 6-1 for a listing of both Vector and Raster Graphic Programs.)

## Raster Graphics

*Raster graphic programs* are often called *paint* programs. In raster graphics the screen is divided into rows and columns much like a spreadsheet. Instead of creating *cells*, as with spreadsheets, the product of the rows and col-

**FIGURE 6.4** Shading in vector graphic images is achieved by producing hundreds of small objects (in this case rectangles) and assigning them slightly different colors. This has an effect on file size. Image (a) requires 7972 bytes to store on disk, while image (b) requires 30,954 bytes. The more detail you include the larger the file size and the longer the imaging time will be.

**Table 6-1**

| Vector Graphic Programs: | Raster Graphic Programs: |
| --- | --- |
| Adobe Illustrator | Adobe Photoshop |
| Aldus Freehand | Aldus Digital Darkroom |
| Aldus Persuasion | Aldus Photo Styler |
| AT&T Rio | Aldus Super Paint |
| Claris MacDraw II | AT&T Sable |
| Corel Systems Corel Draw | Claris Mac Paint |
| Computer Support Arts and | Electric Arts Studio 8/32 |
| Letters | Lectraset Color Studio |
| IBM Hollywood | Time Arts Lumena |
| Lotus Freelance Plus | Ron Scott Hi-Res QFX |
| Micrografx Designer | Super Paint Pixel Paint |
| SPC Harvard Graphics | Professional |
| Zenographics Mirage | Truevision Tips |
| Zenographics Pixie | |

This is only a partial list

umns in raster graphics is *pixels*. (*Pixel* is short for picture element.) With a spreadsheet, each cell has a unique address, such as D14. This defines the location of the cell, which is four columns over from the left and fourteen rows down from the top. Likewise, the computer uses the same system to keep track of the pixels used in an image.

If the screen used to display an image had four columns and three rows, it would have twelve pixels. This means that only twelve things would have to be remembered in order to save the image on disk. Imagine a piece of mosaic art that only had twelve tiles; it would be impossible for you to resolve the sky, mountains, trees, a cabin and the dog with just twelve tiles. If an artist is allowed to use thousands of very small tiles in the mosaic, the amount of detail in the art would increase. This is the way raster graphics works. The more rows and columns used in the image, the larger the quantity of smaller pixels. A larger quantity of smaller pixels increases the ability to resolve detail in the image and provide realism.

A standard video graphics adapter (VGA) card, used by a computer to display an image, has 640 rows by 480 columns, which form a grid of 307,200 pixels. You would think that this would be adequate to provide a realistic photographic image. Actually, it is far short of the amount needed. The standard 35-mm Kodachrome transparency has the equivalent of 18 million pixels. So why not develop a grid of pixels that can provide the same capability as film? This is easier said than done. Present technology does not allow for such a device to be constructed, and, even if it could be built, it would not be affordable.

There would be another problem if a computer raster graphic contained 18 million pixels. The amount of memory required on a disk to store such an image would be outrageous—approximately 72 megabytes per image if each pixel was limited to one of three colors or clear.

Mainframes, with all their memory, would be able to store fewer images than you carry in your wallet. Personal computers would not be able to call up one such image. For these reasons, we compromise our raster graphic images to what is practical and what is affordable.

All the pixels in a particular raster-based image are the same size and shape. The only thing that is different is their color which is called *hue* and their brightness level, which is called *luminance.* In the VGA image, if all the 307,200 pixels were only allowed to be either black or white, line art only could be displayed. If each pixel could only be black, two shades of gray, or white, this would be the beginning of the ability to display crude continuous-tone images. This is what is referred to in computer graphics as a *bit palette*. With a 2-bit palette you can only display black or white. Because bit palettes are derived from the mathematical combinations possible, a small increase in the number of bits available to each pixel dramatically increases the number of colors possible. The following chart will demonstrate my point:

| | |
| --- | --- |
| 4 bit palettes | 16 colors |
| 8 bit palettes | 256 colors |
| 16 bit palettes | 32,768 colors |
| 24 bit palettes | 16,777,216 colors |

With 24-bit color graphic cards it is possible to approach what the eye considers realistic images. The trade-off is the cost of the equipment and the time required to repaint the screen as you change from one image to the next. Just as with a vector graphic image with thousands of objects, when you go to 24- or 32-bit raster images, you want a computer with the fastest processor and most memory available.

The small square picture elements can be seen when the image is magnified (Color Plate 12). They are all the same size, and each one can only contain one color. In some respects a raster graphic image is similar to a vector graphic image, which is limited to thousands of small square objects.

The way images are manipulated or edited in raster-based graphics is quite a bit different than in vector graphics images. Go back to the previous mountain cabin image for a moment. In a vector graphic image, the cabin is a set of rectangular objects that can be selected and moved easily from the left side of the screen to the right side. Once moved, you can see objects that were behind the cabin. The same image in raster graphics would have the cabin made up of uniform pixels of varying hue and luminance. You cannot select just the cabin and move it, because the computer does not know that the cabin is a separate object.

Your first reaction is that editing raster graphics is limited. Quite the contrary, the manipulation of raster images opens up a whole new world. For example, it is possible to enlarge a section of a raster image until the

individual pixels are visible. You can then select a single pixel and change its hue or luminance level. With this capability, someone with brown eyes can have blue at the stroke of a stylus. Manipulating raster graphic images is very similar to conventional photographic retouching. The advantage is that retouching raster images is faster and easier and the option exists to *undo* your mistakes.

The term *electronic darkroom* is gaining popularity. Photographers are supplementing the conventional darkroom, with all its chemicals, with a dry electronic darkroom. A photographic portrait can be scanned as a raster graphic into computer memory. While there, it is possible to remove skin blemishes by enlarging that section, touching on a pixel in the clear skin area and telling the computer to replace the color of each pixel you touch in the blemish area with the color acquired from the first pixel. When you zoom out, the blemish is gone.

You can also work on groups of pixels at the same time. It is possible to change the contrast of the entire image, or in just one area such as the shadow area. The red, green, or blue layers of the image can be selected individually and the brightness, contrast, or color balance altered. If you do not like it, just touch the *undo* area on the software's menu and the image returns to its previous state.

This is a tremendous tool to have available. It has also opened up a whole new controversy over who owns the copyright on an image. Is the electronically manipulated photograph the same or a different image than the one the photographer exposed?

Raster graphic images are being used daily in the medical and scientific community. Plastic surgeons are *frame grabbing* an image of the patient before surgery and then manipulating that image to show the anticipated results of the proposed surgery. The patient is then asked to approve the retouched image. Radiology departments are moving toward a computer-based image system. The amount of memory required to store hundreds of thousands of images is the only drawback. Software programs now apply compression algorithms to manage large files. Ophthalmic photographers are looking to raster graphic images for recording their fluorescein angiograms, and the list continues to grow.

The real world is vector graphics. As you walk through your neighborhood, you see images comprised of many objects, each having specific attributes such as type, size, location, and color. You can select an object by reaching out and touching it. The child's tricycle left on the sidewalk in front of you is an object that can be moved. When you move it, the objects under the tricycle become visible. As you look at the front of a house, it is made up of smaller rectangular objects called bricks. If you could select all the bricks, and assign them a transparent attribute, you would be able to see the objects in the house. This explains the layer concept of vector graphics.

When you get out your camera and take a photograph of your neighborhood, you are converting this vector-based reality into a raster-based reproduction. The tricycle in the image is no longer a separate object that can be selected and moved. If you get out your scissors and cut out the image of the tricycle, you will not see the objects that were under it. You will simply leave a hole where the picture elements of the tricycle were located.

If you scanned the photograph of your neighborhood to a raster image, you could touch on one of the pixels that made up the sidewalk and retouch the tricycle out of the scene by reassigning its pixels to the color of the sidewalk. Image manipulation is now easier than was previously possible. The prediction is that the days of the silver-based image are numbered and that all images will be raster-based graphics stored in computers and output to hardcopy when required.

## Scanners

Because of the power to electronically retouch raster-based images, there is a need to convert existing photographs to raster-based computer files. To accomplish this, an instrument called a *scanner* is employed. The converted images are referred to as *bit-mapped* images. This is because the photography is scanned from top to bottom in rows, and subsequent pixels are assigned (or mapped) a bit value for each minute area of the photograph. Color scanning is possible by making a separate red, green, and blue pass of the photograph.

This is similar to the way a photocopier works. The difference is that the information derived from the scan is stored in computer memory and not placed on a drum to be deposited on paper. Television cameras also scan the face plates of their pickup tubes to reproduce an image. It is possible to connect a television camera to a computer and *grab* a single frame of video in computer. This *frame-grabbed image* is a raster image that can be manipulated.

The only problem with using a television camera to capture a raster-based image is that you are limited to the resolution of the TV camera, which is 525 lines in the United States. This is not adequate for clients who are accustomed to viewing photographic images. Scanners can provide 6000 lines of information; they open a new world by allowing photographs to be included in a *window* of a graphic slide (Color Plate 12d). *Window graphic slides* have always been possible using photographs and conventional optical duplicators. A registered set of positive and negative masks were produced to hold back and burn in the respective images. Scanners have made this process much easier.

Scanners come in black and white, gray-scale, and color versions. They also come in flatbed and transparency models. *Flatbed scanners* resemble small photocopiers and are designed for scanning images that exist on paper. *Transparency scanners*, as the name suggests, are

designed to scan photographs that exist on a transparent base.

Most of you have tried your hand at duplicating slides. You know that it is difficult to get the duplicate to look like the original. Loss of shadow and highlight detail and color shifts are only a few of the problems. In the case of slide duplicates you are dealing with the output of the duplicator's lamp, the light-balancing filters, the dye couplers of films, and the chemical process when you try to get accurate duplicates. Including scanned images in your slides (and having them come out looking like the original images) is even more complicated. You can add the variations of the three light sources in the scanner and those changes caused by the glowing phosphors of the color film recorder to the list. To reproduce a scanned image so it looks like the original usually requires that the color lookup tables used by both the scanner and the color film recorder be adjusted to your liking. A *color lookup table* is a computer file used by a color device to standardize the proper color balance. Changes to the lookup table are like changing the color correction filters in the duplicator. Calibration and standardization are the name of the game.

## File Formats

When the work on your computer-generated graphic is finished, it is time to save the file. Actually, you should save the image many times throughout its development. Experience is the best teacher; you have only to lose 4 hours of work to a momentary power outage to learn the value of frequent saves.

Each graphics software program saves the image in its own format. In most cases, the various formats used by one manufacturer cannot be read by another software vendor's program. Attempts have been made to standardize file formats with limited success. Why should computer graphics be different than any other area of media? Consider the war that is being fought in television concerning format standards.

The important thing is to determine what file formats are acceptable to the color film recorder. Most software programs save images in their own format, and then "export" to a format acceptable to various output devices. It should be pointed out that, once exported to a different format, the file can no longer be opened and manipulated by the original software program. (This can be another learning experience.)

A case in point. Aldus Corporation (Seattle, WA) manufactures a program called *Persuasion* for the Macintosh (and Windows) platform. The files it saves can only be opened by Persuasion. When you are ready to send the graphic slides created in the program to a color film recorder, you must export them to a PICT format. The Matrix-PCR film recorder only accepts SCODL files, so a conversion box must be installed in the line to convert PICT to SCODL.

This can be frustrating to the individual just getting started in computer-generated graphics. Nothing is worse than spending months, if not years, getting approval for the major purchase of a computer graphics system and finding out that additional equipment is required to get it to work. You should develop a good working relationship with a vendor that you can trust; this can save you a lot of embarrassment.

The standard file formats at the present time are CGM, Targa, and SCODL on the IBM; PICT on the Mac; and PostScript on both platforms.

## Color Film Recorders

Computer-generated graphics have little value unless they can be *output* to a usable image. A usable image is one that can be projected in an auditorium or reproduced in a book. Taking the image created on the computer screen and recording it on film is the job of the color film recorder (CFR), which is referred to by software manufacturers as a *hard copy output device*. Most film recorders operate in the same way, but vary in the quality and speed of output. As the quality and speed increases so does the cost of the CFR.

**How Color Film Recorders Work.** The outside of the CFR is not very impressive. It is usually a plain rectangular box that takes up a large amount of space on a desk. The power cord attaches to one end, and a camera attaches to the other. Some manufacturers have added a few LEDs on the camera end to make it a little more interesting, but from the outside, it does not look like it should cost as much as you paid.

What is contained within is what makes it expensive (Color Plate 13). A complete image-processing computer is inside. Just beyond the sophisticated power supply there are a number of printed circuit boards that take the information about the image from the host computer and divide it into the image's additive primary values of red, green, and blue. The computer inside the film recorder then takes each one of these electronic separations and further divides each of them into thousands of horizontal lines of information. The number of lines used is usually 2000, 4000, or 8000. This information is stored in the memory of the CFR, and when it is ready, the CFR tells the camera's shutter to open and start the exposure. The camera is loaded with Ektachrome EPN 100 but can be changed to several different film stocks, depending on the desired final results. The shutter is set on the *B* (bulb) setting because the exposure will take some time to complete.

At this point, the cathode-ray tube (CRT) (Color Plate 13) inside the CFR is activated by sending line one of the

red image. The CRT is a small, flat-screen, high-resolution, black and white tube. It is the most expensive single component of the film recorder. A black and white tube must be used because, to date, there is no color tube manufactured that can deliver acceptable resolution.

If you were to open the film recorder at this point and look at the first line of the red image being scanned on the CRT, you would see an extremely thin line glowing white at varying intensities along its length. The question is, if this is a black and white CRT, how is the color recorded on the color film in the camera? The secret is that there is a filter wheel between the camera lens and the face of the CRT. Just before the CFR triggered the shutter in the camera to open, it turned the motor attached to the filter wheel and positioned the wheel so that the lens (which is prefocused on the face of the CRT) looked through the red filter while the CFR sent the red lines of the image.

Once line one has been displayed long enough to make an exposure, it is turned off, and line two is scanned. This continues until all of the horizontal lines of information have been scanned, one at a time, down the face of the CRT. At this point, the CRT is turned off, the shutter remains open in the dark, and the CFR positions the green filter in front of the lens. Once in place, the CRT resets to the top and, one by one, each line of the green image is scanned. The same cycle is done for the blue. Once the blue image is completely recorded, the shutter is closed, and the film is advanced.

There is never a time when the entire image is displayed on the screen. Each image is triple exposed, even though the shutter only opened once. The saturation of the colors in the final transparency is due to the fact that sharp-cutting high-quality glass filters are used in the filter wheels. The CFR clears its memory and signals the host computer to send the next image. This continues until the host computer tells the CFR that all of the requested images have been sent.

The higher the number of horizontal lines used to divide the image, the higher the resolution of the final product will be. It can be compared to the quality of your photo when it is reproduced in a newsletter using a fifty dots-per-inch screen versus the quality of the same photo reproduced in a magazine using a 150 dots-per-inch screen. For the film recorder, the trade-off is that the time required to record the image on film increases as the lines of resolution are increased. For example, a test image was recorded at 2000 lines and took 2 minutes 45 seconds for the CFR to complete. The same image recorded at 4000 lines took 9 minutes and 5 seconds to complete. If you have 200 images to record overnight, this becomes a major factor. Many producers routinely run images for projection at 2000 lines and images for printing at the higher levels.

Another factor that affects the quality of the final product, but that is not often discussed, is the size of the illuminating dot used to create each line of information. It is possible to have a 4000-line image that looks like a 2000-line image because the size of the illuminating dot was so large that it overlapped into the adjacent lines as the scan was completed. The dot size must not exceed the thickness of each line. The line thickness is determined by dividing the number of lines desired (resolution) into the size of the imaging area of the CRT's face plate. Before purchasing a CFR, have sample slides made, and compare them under magnification.

Color film recorders cost between $5,000 and $80,000. What is the difference?

- The repeatability, exposure after exposure
- The time required to image a file
- The number of lines of resolution available
- The quality of the image at any resolution
- The volume of images it is designed to handle
- The film formats available

## Operating a Computer Generated Slide Service

One of the frequent subjects people ask about is the process that leads to a decision to provide a computer-generated slide service. The "1989 Biophotography Survey" (*Journal of Biological Photography*, Vol. 58, No. 3) indicates that there are many similar media production facilities operating a computer generated slide service. The following is a typical scenario.

## A Profile of John Doe's Media Center

By 1985 John Doe's service was no longer producing *diazochrome* slides and the *lithochrome* process was averaging 800 slides per month. All of the typesetting for lithochromes was produced by one staff member using an IBM Composer. Lithochrome slides were one of the most requested services offered but it was a very labor-intensive process requiring three staff members to get the product out of the door. At the same time the department produced high-quality optical special effect slides for extraordinary programs.

Following the introduction of the IBM computer, computer-generated slides were beginning to be offered by large media production services. John Doe's small facility investigated the feasibility of this service by sending out a job to a new computer slide service bureau, which produced thirty-two word slides as multicolored slides that had very crisp letters. The bill arrived: $510! Under the old lithochrome system the client would have paid $60. No matter how impressive the new slides were, this facility could not afford to send 800 slides out each month. Based on this experience, John Doe's facility investigated the acquisition of a computer-generated slide system for internal use.

The following is the list of objectives compiled for the search:

- The quality of the letters in the computer slides had to be equal to the optical slides with which clients were familiar.
- At least 200 slides had to be imaged overnight in an unattended mode.
- The bottleneck of having one individual do all of the typesetting had to be eliminated.
- The system had to be easy to use, and multiple members of the existing media staff had to be trained to operate it, without hiring new people.
- The system had to be affordable.

A vendor came up with a series of off-the-shelf products that met all the requirements. The key factor was negotiating a *site license* for the use of one version of the graphic software. This meant that clients requesting a copy of the software for their computers could have one. Clients would attend a 1-hour training class, which is all they would need to be able to produce slides that meet 90% of their word slide needs (Color Plate 14). John Doe's institution purchased the system.

The average of 800 lithochrome slides per month has increased to well over 2000 computer slides per month. The slides of a client who brings in a disk by 4 P.M. on one day will be ready to be picked up after 4 P.M. the following working day. This schedule works 95% of the time. The lithochromes, which are still produced, require 5 working days.

The key to the unattended overnight imaging is a long-roll film back on the film recorder and the ability to produce a slide queue in the software. With a 100-foot roll over 750 slides can be produced per roll. Each slide averages 4 minutes to image at 2000 lines per slide. This means that 225 slides can be produced between 5 P.M. on one day and 8 A.M. the next morning.

The new system is more successful than anyone imagined.

## Pitfalls in Computer Graphics Service Centers

When you decide to provide in-house color film processing, there are a number of things to consider in making that decision. Likewise, a decision to provide an in-house computer slide service has its own list of things that might be overlooked. The following is a list of some of those items:

- All media staff members are not computer literate. Provide adequate training and time for your staff to learn. Anticipate some resistance to change.
- Software upgrades are a fact of life. Just when you become comfortable with the software, the new version is released, and the learning curve starts all over. You never want to be more than two versions behind the

current release, because the manufacturers stop supporting older versions of their product. This means that you cannot get technical support. The bottom line is that you should build in a line item in your budget for software upgrades.
- Even though the software vendor has a toll-free number for technical support, it does not mean that it will not ring busy from 8 A.M. to 5 P.M. This can be frustrating as your deadline is approaching and you cannot get the computer to do what you want it to do. This is another reason to have a knowledgeable vendor behind you.
- If your clients bring you slides on disk, this means that you should provide the training they need to produce good-quality graphic slides. It also means that they will turn to you for trouble-shooting their problems or providing answers when they forget how to use the software.
- Even when you lower the turnaround time on graphic slides, this does not mean that your clients will plan any further ahead. Quite the contrary. Clients routinely bring in disks at 10 A.M. and need the slides by 2 P.M. the same day. Next day service means that there is no time to correct errors.
- Unattended overnight imaging sounds great until there is a momentary power failure, or the film snaps during transport, or the film unexpectedly ends, or the computer stops to display an error message, and there is no one there to read it. Once, someone forgot to attach the takeup drive belt to the camera. The next morning all 225 exposures were crinkled into one small area of film chamber. What is the chance that every one of those clients planned ahead and really did not need their slides until the next day?
- Plans for when the CFR is down for repair should be in place. Clients become dependent on this service and 4 days of down time is a disaster. Budget for repair—it is expensive. A backup film recorder is ideal but expensive. Check out the used market. There are some great buys.
- Management of the hard disk on an imaging computer station where files are coming from a number of clients requires time. Watch out for computer viruses.
- Carry a spare hard disk for the imaging computer. It will probably never be turned off and is destined to fail. Make sure that you have the information on the disk backed up so the recovery from a crash will not take long.
- Budget for ongoing training for staff members and staff transition.

## The Future

It is possible that when you read this, each of you will have a three-dimensional cellular workstation that you

carry with you. These workstations are probably networked to your super computer, which is more powerful than today's Cray and yet fits in a desk drawer. Your graphic images will not exist on silver-based film but will be displayed from computer memory on common large-screen high-resolution display devices.

With all of this power, you may still have received complaints about "overcrowded" super-computer images. The common principles related to projected graphic images, no matter how those images were produced, will not change until reading is no longer a part of learning.

## ACKNOWLEDGMENTS

The author wishes to recognize Allen Shaffer for his years of outstanding support and assistance with many of the author's projects including this chapter. A special thank you is given to Tim Vojt, John Jewett, Tim Hayes, and Ron McLean for their assistance with these illustrations.

## SUPPLIERS

**Film Companies:**
Eastman Kodak Company
Scientific Imaging Division
343 State Street
Rochester, NY 14650

Polaroid Corporation
575 Technology Square
Cambridge, MA 02139

**Computer Companies:**
IBM
International Business Machines
Old Orchard Road
Armonk, NY 10504

Apple Computers, Inc.
20525 Mariani Ave
Cupertino, CA 95014

**Software Companies:**
Aldus Corporation
411 First Avenue South
Seattle, WA 98104-2871

Microsoft Corporation
One Microsoft Way
Redmond, WA 98052-6399

**Turn Key System Companies:**
Autographix
100 Fifth Avenue
Waltham, MA 02154

Genographics Corp.
Two Corporate Drive, Suite 340
Shelton, CN 06484

Management Graphics
1401 E. 79th Street
Minneapolis, MN 55425

Slide Tek, Inc.
900 Larkspur Landing Circle Suite 100
Larkspur CA 94939

**Film Recorder Companies:**
Agfa Corporation
Business Imaging Systems
One Ramland Road
Orangeburg, NY 10962

Management Graphics
1401 E. 79th Street
Minneapolis, MN 55425

Polaroid Corporation
575 Technology Square
Cambridge, MA 02139

Presentation Technologies
743 N. Pastoria Ave.
Sunnyvale CA 94086

**Scanner Companies:**
Eastman Kodak Company
343 State Street
Rochester, NY 14650

Howtek
21 Park Avenue
Hudson, NH 03051

Microtek Lab, Inc.
680 Knox Street
Torrance, California 90502

Nikon Electronic Imaging
Department B2
101 Cleveland Avenue
Bayshore NY 11706

## BIBLIOGRAPHY

Becker, D., 1984. Selecting a computer graphics system and justifying its purchase. *J. Biocommun.* 11:6.

Blaker, A. A., 1977. *Handbook for Scientific Photography.* San Francisco: W. H. Freeman.

Brown, P., 1987. Digital pictures: Representation and storage. *J. Audiovisual Media Med.* 10(2):61–65.

Brown, S., 1987. Exploring low-cost computer graphics software. *J. Audiovisual Media Med.* 10(2):52.

Cepull, J. C., 1984. Purchasing a computer-graphics system: Applications and considerations. *J. Biol. Photogr.* 52(2): 33–36.

Eastman Kodak Company, Rochester, New York, 14650
  1. S-26 *Reverse-Text Slides*
  2. S-30 *Planning and Producing Slide Programs*
  3. S-25 *Speechmaking . . . More Than Works Alone*
  4. *Making Effective Lecture Slides, Health Sciences*
  5. *Slides With a Purpose for Business and Education*

Edey, M. A., 1970. *Light and Film.* New York: Life Library of Photography, Time-Life Books.

Finch, M., and Richter, L., 1984. Computer graphics in a full-service department: A three year experience. *J. Biocommun.* 11:17.

Giannavola, S., 1987. A high resolution computer graphics system for a small media department: A case study. *J. Biol. Photogr.* 55(1):27–29.

Giannavola, S., 1990. The imaging center concept: Its place in a medical media center. *J. Biol. Photogr.* 58(2):61–63.

Glickman, J., and Field, T., 1984. Computer graphics: A challenge for biocommunicators. *J. Biocommun.* 11:49.

Hague, J., 1991. Graphic design for desktop publishing, Part1: Typography. *J. Biol. Photogr.* 59(3):117–123.

Hansell, P., 1979. *A Guide to Medical Photography.* Lancaster, U.K.: MTP Press.

Kilbourne, S., 1991. A primer on digital imaging—Post production for still photography: Part 1. *J. Biol. Photogr.* 59(2):43–48.

Kilbourne, S., and Dodd, R., 1991. A primer on digital imaging—Post production for still photography: Part 2. *J. Biol. Photogr.* 59(3):125–132.

Kilbourne, S., and Dodd, R., 1991. A primer on digital imaging—Post production for still photography: Part 3. *J. Biol. Photogr.* 60(1).

Korn, J., 1970. *Color.* New York: Life Library of Photography, Time-Life Books.

Kyle, S., 1989. Painting with pixels. *J. Audiovisual Media Med.* 12(2):76–79.

Lund, R. E., 1986. Computer graphics in a large photographic department. *J. Audiovisual Media Med.* 9(3):95–98.

Meyer, S., and Radtke, B., 1989. Computergraphische Gestaltung von Diapositiven—ein Erfahrungsbericht. *Photomed'* 4:303–306.

Mueller, C. G., and Rundolph, M., 1972. *Light and Vision.* New York: Life Science Library, Time-Life Books.

Nicotera, D. J., 1989. Practical image stability tests of Polaroid PolaBlue slide material. *J. Biol. Photogr.* 57(1):21–25.

Screnci, D., 1987. An overview of computer application of biophotography. *J. Biol. Photogr.* 55(2):47–51.

Williams, A. R., 1988. Networking personal computers for desktop publishing and graphics production. *J. Audiovisual Media Med.* 11(2):41–48.

Young, W. A., and Benson, T. A., 1984. *Copying and Duplicating in Black and White and Color.* Rochester, N.Y.: Eastman Kodak, M-1.

# Chapter 7
# Photomicrography

## John Paul Vetter

*"Come, come, and sit you down.*
*You shall not budge! You go not till I set you up a glass (microscope)*
*Where you may see the inmost part of you."*

William Shakespeare 1564–1616

Although the microscope is easily recognizable, its appearance can be quite intimidating, resulting in the belief that its operation requires considerable optical knowledge. This belief is reinforced by its physical complexity and numerous knobs and lenses engraved with figures that are meaningless to the uninitiated. By comparison, the common, hand-held camera features one major lens with symbols that most learn to use at an early age. Rest assured that the laws of nature that permit us to take those priceless family photographs with the hand-held camera are the same laws that reveal the world of the microcosm to us with the aid of the microscope. By applying the same basic principles used in operating the camera you will be surprised at the ease with which you can create photomicrographs with the microscope. The following presentation will provide several avenues for learning about the microscope and how to take pictures through it.

The uninitiated reader can sit down at the microscope with this book and, by applying the information presented, along with thoughtful observation and operation of the microscope, create successful photomicrographs on his or her initial attempts. The reader with cursory knowledge of the instrument may wish to skip one or more sections and study only those portions that provide new and useful information. Whenever possible, the use of formulas, obscure terminology, and optical theory are avoided in this presentation, as the goal is to create a presentation on the practical understanding and use of the microscope.

Absolute accuracy of the definitions has occasionally been sacrificed for the sake of simplicity. Readers who desire an in-depth or theoretical understanding of the microscope should note the bibliography and references at the end of the chapter.

## PHYSICAL PROPERTIES OF THE MICROSCOPE

Before starting assume that the microscope has been set up and properly adjusted by an experienced operator or,

if new, by the manufacturer's representative. It is important that you do not turn or adjust any of the knobs at this time.

Almost all modern microscopes have the same basic physical configuration as the common laboratory microscope (Figure 7.1). Various makes and models may have additional features, which, for this basic examination, can be disregarded. A few microscopes designed for specialized examinations, such as the *inverted microscope*, will have the basic features implemented in an unusual way. For this reason, the operator's manual for these models should be kept nearby.

The prevailing name of each part, in italics, may be followed by a common, or conventional, name enclosed in parentheses or, if outdated, in quotation marks. Example: *field diaphragm* (iris diaphragm), "radiant field stop". It is convenient and logical to begin with the light source and then, by following the light rays as they course their way through the microscope, arrive at the final destination, the eye or film plane.

Begin by adjusting the chair or stool to a comfortable position so that the microscope eyepieces are at the level of your eyes. Then turn on the microscope lamp and adjust the brightness to a comfortable viewing level. The *light source* (lamp) is at the rear of the microscope base. In most laboratory microscopes the light source is not visible, as it is housed within the base of the microscope. Microscopes that are equipped for specialized lighting techniques will have a large individual housing attached to the base. While the former internal light source lamp is restricted to low wattage (15 to 30 watts), the larger external housing can accommodate lamps from 50 to 100 watts.

Although the light path in the base of the microscope may not be visible to the operator, it proceeds through the base, passes through several lenses, the *field diaphragm* ("radiant field stop"), a prism or mirror, and finally, a *field lens* at the *light-exit port*. This is the first location where the light beam can be observed.

The effects of the field diaphragm can be observed by placing a semitransparent piece of paper on the light exit

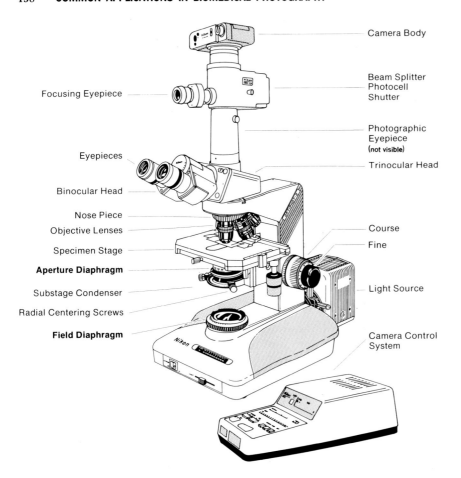

Camera Body

Beam Splitter
Photocell
Shutter

Focusing Eyepiece

Photographic
Eyepiece
(not visible)

Eyepieces

Trinocular Head

Binocular Head

Nose Piece

Objective Lenses

Course

Specimen Stage

Fine

**Aperture Diaphragm**

Substage Condenser

Light Source

Radial Centering Screws

**Field Diaphragm**

Camera Control
System

**FIGURE 7.1** All laboratory microscopes have similar features. Certain microscopes, such as the *inverted microscope*, will have the same features in reverse positions. The substage condensers focusing knob, which is positioned below and left of the specimen stage, and the photographic eyepiece are not visible in this illustration.

port and moving the field diaphragm ring, or lever, back and forth. Then open the field diaphragm to its fullest extent (brightest illumination). Do not forget to remove the paper.

The light, now a vertical beam, enters the *substage condenser* (condenser), where the *aperture diaphragm* (condenser diaphragm) is located. The unit is mounted on a rack and pinion device coaxial to the microscope's optical axis. The condenser, in conjunction with its associated aperture diaphragm, is one of the major optical components of the microscope. For now, the aperture diaphragm should be fully opened (highest number).

Behind the condenser, there is a small *condenser focusing knob* on the rack and pinion device that allows the condenser to be raised or lowered. Two *radial centering screws* on the condenser holder permit precise alignment of the light beam with the objective axis. Note the location of the focusing knob and radial centering screws, but avoid making any adjustments. On the supporting stand of the microscope are the coaxial pairs of the *coarse and fine focusing knobs*. Again, do not make any adjustment at this time.

Above the substage condenser is the *specimen stage* (mechanical stage). The stage is typically equipped with a

slide holder and a mechanical system, which permits the specimen to be precisely moved in any direction across the stage. The mechanical stage may be fitted with horizontal and vertical vernier scales, thus permitting accurate readings of the specimen location for later reference and photography. If one is not already in place, position a specimen slide on the stage and center the tissue section immediately above the condenser. The specimen will light up when it intersects the light beam from the condenser.

Mounted on a *nosepiece* (revolver) are the *objective lenses* (objective). The objective lens is the principal, but not the only, magnifying optic in the microscope. The objective magnification (objective power) is prominently engraved on the lens, along with other optical characteristics. The common assortment includes a 2-, 10-, 40-, and 100-power objective. Rotate the nosepiece until the 10-power objective is above the condenser and the specimen slide.

Above the nosepiece and the objective lenses is the *binocular head* (or a trinocular head for supporting a camera) and the binocular *eyepieces* (oculars). The eyepieces are the second most important magnifying optics in the microscope. A *compound microscope* has been described. It has two magnifying components: the objective lens and

the eyepiece lens. If a camera is unavailable, you may wish to pass over the following section and proceed to the section on Optical Properties of the Microscope.

### The Basic Camera Systems

There are three major types of camera systems. They are described here.

**Add-on Cameras (Eyepiece Cameras).** These are attached to a vertical monocular eyepiece tube or the vertical tube on a *trinocular head*. Cameras are available in a wide range of sophistication, from simple tie-on units without exposure control to fully automatic cameras that require little more than the touch of a button.

**35-mm Single Lens Reflex (SLR) Cameras.** These cameras are either attached to the vertical tube via a clamp-on device or suspended above the microscope on a vertical stand. This is a popular method of making photomicrographs with minimal expenditure for equipment. Since several problems are inherent with attaching the common hand-held 35-mm SLR camera to the microscope this system is not recommended for the serious microscope user. For those occasional users who find it necessary to use the SLR camera, there is a section on the photographic system with recommendations on how to eliminate, or at least reduce, these problems.

**Integrated Cameras.** These are frequently called *photomicroscopes*. The camera, microprocessor, motorized controls, and automated exposure system are integral parts of the microscope. Photomicroscopes represent the epitome of the microscope maker's art. They are highly recommended for all microscopy requiring a wide range of illumination techniques for contrast enhancement, quantitative fluorescence, image analysis and the like. The operator's manual is a *must read* publication for the user of these high-tech photomicroscopes.

The following descriptions identify the major parts of the common add-on cameras. The vertical phototube houses the *photographic eyepiece* (photo eyepiece, projection lens) and serves as a support for the camera system.

The *add-on system* (eyepiece camera) consists of various elements that are not visible to the user, such as the *beam splitter* (dividing prism), which splits the light rays between the *focusing eyepiece* (focusing telescope), and the exposure control system (photocell and shutter). Several types of attached *camera bodies* (dark box) are available from the manufacturer to accommodate all popular film sizes.

Finally, a *camera control system* is connected electrically to the exposure control portion of the camera system.

The control box has various readouts for film, shutter speed, exposure adjustment, and proprietary functions.

## OPTICAL PROPERTIES OF THE MICROSCOPE

The following sections highlight the functions of the illuminating, imaging, and camera systems. Their relation to each other is also discussed.

### The Illuminating System

The *illuminating system* consists of the (1) *light source* (a lamp and a collector lens), the (2) *field diaphragm* and a field lens, the (3) *substage condenser,* and the (4) *aperture diaphragm*. These four components constitute the basic elements of *Köhler illumination*.

**Light Source.** The majority of photographic applications using the microscope are to make color transparencies (slides). In color photography the spectral quality of the *light source* must remain consistent between shooting sessions. It is not necessary to know the precise operating color temperature (degrees Kelvin) of the light source, since the *total optical system* can be color balanced with filters to produce light that is photographically equivalent to daylight or tungsten illumination. Color balancing the optical system will be discussed in the section titled The Photographic System. BW materials are not as sensitive to color temperature, so an approximation of tungsten or daylight illumination is all that is required.

**Field Diaphragm.** The *field diaphragm* is an adjustable stop that is used to limit the field of illumination at the specimen plane. In microscopy it is advisable to illuminate only that portion of the specimen under examination or to be photographed. Illumination outside of the area of interest may cause a degradation of the image, due to the production of light rays not essential to the image formation.

**Substage Condenser.** The *substage condenser* brings the field diaphragm into focus at the specimen plane and provides a cone of illumination at an angle and size to satisfy the optical requirements of the objective lens in use.

**Aperture Diaphragm.** The *aperture diaphragm* limits the angle, amount of illumination, and depth of focus in the specimen, and the ratio of ordinary and diffracted rays delivered to the objective lens. *The setting of the aperture diaphragm is the most important optical adjustment one can make on the modern microscope.* More about the aperture diaphragm is contained in the section titled Aligning the Illumination System.

## Köhler Illumination

The *Köhler system of illumination* is the accepted standard for critical examination and photography, since it provides a very bright and homogenous field of illumination from a nonuniform light source (coiled filament of the lamp) and satisfies all known optical requirements. If the microscope is fitted with a field diaphragm and a condenser, it can be assumed that the microscope is equipped with Köhler illumination. Most older microscopes can be retrofitted with a Köhler illuminator by a knowledgeable optical repairer. The American Optical Company sold a simple and economical do-it-yourself Köhler upgrade kit for their brand of microscopes. E. Leitz Inc. (Rockleigh, NJ), which now represents American Optical, may be able to supply or recommend a source for this valuable piece of equipment. More information about the Köhler system of illumination may be found in the section titled Aligning the Microscope for Köhler Illumination.

## THE IMAGING SYSTEM

The imaging system for visual examinations consists of the *objective lens* and the *eyepiece*, or the *binocular eyepieces*. When a camera system is attached to the microscope other lenses come into play. The rays from the objective lens are directed to the *projection eyepiece* and are then divided by a prism to the *focusing eyepiece* and the film plane.

## Objective Lens

The *objective lens* is the first and principal lens in the image-forming system. It produces a magnified image of the specimen at the entrance pupil of the eyepiece. All other optical components serve to assist the objective lens in producing a quality image with meaningful detail and magnification.

The quality of the objective lens is the principal determining factor of the microscope's ability to resolve detail. The image capability of an objective lens of inferior quality cannot be improved by any other lens in the imaging system. Due to the eminent position of the objective lens in the imaging process, more details about it are included than for other optics in the microscope.

Objectives are available in several optical degrees of correctness. *Correctness* in optics refers to the degree of perfection a lens can obtain. The following terms have relative value, since they do not precisely identify the optical qualities of the lens but place the lens in general categories for comparison. For example, *achromats* are corrected spherically for one color and chromatically for two colors, but achromats from two different manufac-

turers may differ significantly in their correctness. In practice, the price of the lens will indicate which is the superior optic.

A *planachromat* is an *achromat* that has been corrected to produce a relatively flat image. The prefix *plan* is used to indicate that the lens has been designed to reduce the normally curved image field common to *all* lenses. When a planachromat is purchased from a quality manufacturer, it is an excellent choice where funds are limited. It is the most popular lens for visual examinations, as well as for photography.

*Planapochromats* are corrected spherically for two colors and chromatically for three colors. They represent the epitome of the lens-maker's art. Their superior correctness and high numerical apertures ensure images of the highest resolution and contrast. Although planapochromats are desirable for color photography, they may be essential when photographing stained specimens using multiband pass filters with black-and-white (BW) films. (See the section titled The Photographic System.)

**Engraved Nomenclature.** Close examination of the objective lens barrel will reveal several engraved markings not found on any other lens in common use. It is very important that you understand the meaning of these engravings to appreciate their value in the imaging process. The following is a list of the terms and a short explanation of their pertinence to the viewer and the photograph (Figure 7.2).

**Maker.** All manufacturers of value are proud to identify their product. Be suspect of lenses without this designation.

**Classification (Type of Objective).** This represents the correctness of the lens. The name is usually abbreviated. *Plan Apo = planapochromat*. The name may be preceded by letters indicating intended use: for example, DIC = differential interference contrast illumination technique.

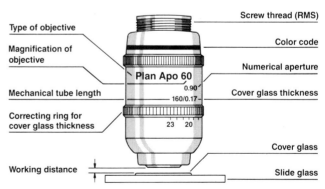

FIGURE 7.2 Manufacturers may employ terms different than those listed here, but similar enough to identify them as being the same. Reprinted with permission from John P. Vetter, 1987. "Photomicrography: A Translation into the Vernacular". Part II, *Journal of Biological Photography*, Volume 55, Number 4, p. 139.

**Magnification.** This is the magnification of the objective lens only. The total magnification of the microscope includes the intermediate lenses (if any), eyepiece (visual) or photo-eyepiece, and projection distance (in photography).

**Numerical Aperture (NA).** A mathematical relationship that directly relates the resolving power and the light-gathering quality of an objective lens with its aperture. The greater the NA the higher the resolving power (directly proportional) and the brighter the image (square of the ratio). Apochromats have a higher NA than achromats and therefore are brighter with increased resolution and contrast.

**Black Ring.** The ring engraved near the front lens indicates an objective that must have its front lens immersed (in contact with) a liquid. The type of immersion fluid will be engraved following the NA—1.30 *oil.*

**Mechanical Tube Length.** The free space distance between the shoulder of the objective and the top of the microscope tube where the eyepiece fits. The specified *tube length* of the lens and the microscope tube specifications should be identical. The tube length and the cover glass thickness are listed on the same line separated by a slash—*160*/0.17. Certain manufacturers have elected to design their objectives for infinity projection. In place of the tube length is the infinity sign (∞), usually followed by the cover glass thickness.

**Cover Glass Thickness.** The thickness of the cover glass is specified in millimeters. A thickness of 0.17 has been adopted as standard by most manufacturers. Objectives below NA 0.16 may not require a cover glass; therefore, no designation will be present. As the NA of a lens increases, the permissible deviation from the standard thickness decreases. As objectives increase in power and NA, the free working space (working distance) is reduced; thus the thickness of the cover glass becomes increasingly important. High-dry, high-aperture lenses have correction collars to compensate for nonstandard cover glasses or excessive mounting medium.

**Adjusting the Correction Collar.** Any departure from the standard glass thickness will introduce spherical aberration. The correction collar can be adjusted to offset overly thick or thin cover glass and excess mounting medium between the specimen and the cover glass (Figure 7.3). The following method of adjusting the collar is sure and quick.

1. Locate an area in the specimen with small, dark features.
2. Since spherical aberration is most obvious at wide apertures, open the aperture diaphragm to fill the objective lens with light.
3. While the specimen is under observation, rotate the collar back and forth with one hand, while at the same time maintaining sharp focus of the specimen's image

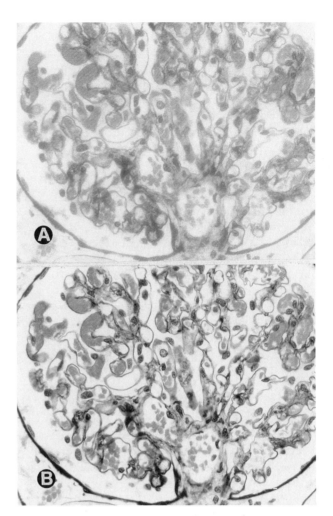

**FIGURE 7.3** (a) Overly thick or thin coverslips and/or excess mounting medium will produce spherical aberration. (b) By adjusting the correction collar, the aberration can be eliminated. Reprinted with permission from John P. Vetter, 1987. "Photomicrography: A Translation into the Vernacular". Part II, *Journal of Biological Photography,* Volume 55, Number 4, p. 140.

with the fine focus knob with the other hand. The setting is correct when the out-of-focus image is the same above and below sharp focus, and it exhibits maximum contrast at critical focus.

Following this adjustment, return the aperture diaphragm to its original setting for optimum imaging of the specimen in use.

**Using an Immersion Lens.** *Immersion lenses* can have numerical apertures far exceeding those of dry lenses. The large apertures are possible due to the elimination of the *critical angle* effect. Care must be taken to use the immersion fluid specified by the manufacturer to ensure the highest quality image.

First, focus the specimen with a dry lens. Then apply the fluid to the slide after rotating the dry lens to one side. The immersion lens should then be rotated into

place, rather than dipped into the immersion fluid by focusing. The latter drastically increases the possibility of introducing detail-destroying air bubbles or causing injury to lens and slide by accidentally focusing below the normal specimen plane when no specimen image is in view. Caution: Avoid rotating a high-dry lens into the immersion fluid. See section on Care of Microscope Lenses if the lens is accidently coated with immersion fluid.

**Critical Angle.** Objectives (and condensers) with numerical apertures at NA 1.0 or above must be immersed with the specimen slide to fully realize their maximum aperture and correctness. For example, if an immersion objective is not immersed (air in place of fluid) the rays (illuminating or image-formed diffracted rays) at a certain *"critical angle"* will not emerge from the slide. Since these rays cannot emerge, the maximum effective aperture of the lens is reduced. Spherical aberration will also be present, since the refractive power of the fluid is not present.

This is also true with condensers, since the high NA *"illumination"* rays will not emerge from the condenser. Regardless, for the most part, the condenser is serviceable, even though not immersed. The reduced condenser aperture *does not reduce the effective aperture of the objective.* As long as the objective lens is immersed, the image-forming rays, which include the diffracted rays generated by the specimen, will be accepted by the objective to its maximum aperture.

### Intermediate Lens Systems

Additional lenses and other optical components are often placed by the manufacturer between the objective and the eyepiece lenses. The most common component provides small fractions of *intermediate* magnifications in addition to the basic range provided by the objectives. This is especially valuable to the photographer using reversal color film, since there is no further opportunity to adjust the image size following the initial exposure. The range of increasing magnification with intermediate optics is 1.25×, 1.6×, and 2.0×.

Another lens system, sometimes referred to as a *Bertrand* or *Ph lens,* may be included in the same setup as the previously listed optics. The lens provides an enlarged image of the rear focal plane of the objective originally installed to allow centering of a phase condenser's annular ring with the phase plate ring in the objective. The convenience of the Ph lens is desirable, even if no phase optics are in use. The lens allows close inspection of the exit pupil of the objective, where the size and centralism of the aperture diaphragm can be verified and the cleanliness of the objective, slide, and condenser can be confirmed.

In addition to the above lenses, several models of microscopes provide an opening between the objective and the eyepiece where optics with plane-parallel surfaces can be inserted; these optics include filters, retardation plates, and polarizing elements. The image beam at this point is nearly parallel due to a *telex* lens; therefore, no refraction or aberration will occur due to the thickness of the respective optic.

### Eyepiece

The *eyepiece* is the second magnifier in a compound microscope. It is designed to further magnify the primary image formed by the objective lens. A word of caution: eyepieces (or objectives) should not be interchanged among different makes of microscopes. This was a common practice after World War II when all manufacturers followed rather closely the design principles of E. Abbe of Carl Zeiss, Inc. More recently, manufacturers have designed microscopes and lenses to best suit their marketing endeavors. For example, Nikon Inc. (Melville, NY) has corrected its objectives to be color free (CF) without an "assist" from the eyepiece, as in previous formulations. American Optical (now part of E. Leitz, Inc.) and several other manufacturers have elected to design their objectives for infinity projection. Hidden from view in the microscope body is an additional lens that provides the necessary refraction for positive magnification. Interchanging the Nikon objective with infinity corrected objectives would result in no useful image in either microscope. Interchanging the eyepieces would produce images of inferior quality. The best advice is to follow the manufacturers' recommendations for the microscope and objectives selected.

### Care of Microscope Lenses

- Do everything practical to keep lenses immaculately clean.
- Do not touch the glass surface. Do not smoke near the microscope.
- Prevent dipping a high-dry lens into the remaining fluid from an immersion objective.
- Do not disassemble *any* lens.
- Cover the microscope when not in use.

Any cleaning of a lens, for whatever reason, will probably cause scratches. The scratches are extremely small and, at first, impossible to see without a high-power magnifier and oblique illumination. However, when a lens that has been repeatedly cleaned is compared with a new lens, the lack of a fine polish is very evident. If you need to clean a lens, comply with the manufacturer's recommendation or follow these procedures:

1. Closely inspect the front and back lens surfaces with a small hand magnifier (6× to 10×). View the lens against a dark background. An eyepiece held in reverse direction is an excellent and convenient magnifier. (Most, but not all, eyepieces can be used as hand magnifiers.) A small pocket flashlight held at an acute angle to the lens will highlight blemishes and dirt. This test should be made in a darkened room.
2. Blow any dust off with a 2- or 3-ounce ear syringe. *Do not* blow with your breath or use a high pressure air line. Canned Freon (refrigerant) is to be avoided, as it may leave a residue not easily removed.
3. Continue inspection and blowing until you are sure no further improvement can be made.
4. Partially dip a cotton swab into a solvent such as xylene; 1,1,1, trichlorethane; or equal quantities of ether and grain alcohol. (Use very small quantities and observe laboratory rules for safe use of ether.) Do not touch the cotton tip. The cotton swab should be almost dry. Without any pressure, apply to the lens in a circular motion starting at the center and proceeding to the edge. The lens should dry almost immediately. If any liquid remains, immediately remove by blowing with an ear syringe or touching with a dry swab.
5. Inspect the lens again. Repeat cleaning procedure *only* if absolutely necessary. If you are not able to remove any foreign substance, have a qualified optical repair specialist inspect and clean the lens.

A few more suggestions: When handling the lens, provide a close (3 to 4 inches) soft work place to prevent injury to the lens, if accidently dropped. Xerox cottonlike rayon (see your Xerox copier representative) is better than cotton. The cottonlike rayon can be twisted around the reverse end of the cotton swab. The wooden tip can also be sharpened to accommodate the very small lenses of high-power objectives.

**Cleaning Glass Specimen Slides**

For the most part, specimen slides are left uncovered and are examined by a number of individuals resulting in accumulation of ever-present dust, which is in the air, and fingerprints. Holding the slide in the intense illumination beam from the light port in the base of the microscope will reveal the need for cleaning. It is recommended, as a matter of good practice, to clean all slides, even though they may appear clean, by using the quick examination described above. The following procedures will remove all commonly collected dirt, water soluble substances, fingerprints, misplaced mounting medium, and immersion oil.

1. Make sure that the slide is not "fresh," that is, the mounting medium has dried sufficiently to permit wiping.

2. Put a drop of an equal mixture of distilled water and grain alcohol on both surfaces and wipe off with laboratory absorbent tissue or lens-cleaning tissue.
3. Position a previously cut (1 × 2 inches) piece of lens cleaning tissue on the top surface of the slide.
4. Place a drop of xylene on the tissue nearest the left edge of the cover slip, and promptly but slowly draw off to the right (reverse the procedure if you are left handed). The wet portion of the lens tissue will move off the slide with the tissue, and the exposed surface of the slide should be dry and clean.
5. Repeat for the bottom side of the slide.

The easiest and surest method to place a measured quantity of xylene on the slide is to use a *Pasteur capillary pipette*, 5 3/4 inches long. This pipette is a common laboratory item. Dip the small end of the pipette into a bottle (2 to 4 ounces) of xylene. Do not block the large free end of the pipette. The pipette will hold the correct amount of xylene by capillary action. Touch the lens tissue with the small end of the pipette, and the xylene will flow freely from the pipette to the tissue.

**THE PHOTOGRAPHIC SYSTEM**

**Add-on Camera Systems**

The *add-on camera* is the most popular camera, since it provides many of the conveniences of an integrated system at a relatively low cost. Certain add-on cameras have an additional advantage over integrated systems in that they can be freely interchanged among microscopes of identical make and often with microscopes of another make. For the laboratory that uses photography only occasionally, it provides a real savings of funds.

**The Single-Lens Reflex (SLR) Camera as an Add-On Camera System.** The combination of an SLR camera and microscope, although satisfactory for occasional photography, is not recommended for serious use. The problems of vibration, alignment, and focusing the specimen's aerial image requires practice, patience, and a knowledge of the principles involved.

SLR cameras are frequently attached to a vertical eyepiece tube. This arrangement has three inherent problems: a short projection distance, intrinsic camera vibration, and focusing problems. The latter is the most troublesome of the three. The following paragraphs will define the problems and make recommendations for eliminating (or at least drastically reducing) these problems.

1. Microscopes are designed to produce their best projected image at 10 inches (250 mm) from the eyepiece. The short projection distance afforded by the ordinary extension tube and clamp-on device may cause

spherical aberration, since the design parameters of the microscope are not fully met. This problem can be eliminated by attaching to the camera a lens with a slightly longer focal length (80 to 100 mm) than the normal lens (50 mm). Although the shorter focal length solves the problem of short projection distance, it also produces an image smaller than the 35-mm format. It is preferable to have a simple, low-cost achromat, rather than a lens with many elements. This is one example where "less is better." The lens, if equipped with a diaphragm, should be opened to the maximum aperture and focused at infinity. The optimum distance of the camera lens from the eyepiece can be determined by raising and lowering the lens until it almost touches the eyepiece. There will be a point where the image fully and evenly illuminates the viewing screen.

2. The rapid start-and-stop action of the camera mirror and the focal-plane shutter causes the camera to vibrate. The vibrations will be amplified by the microscope if there is a firm connection to the camera. (Cameras with between-the-lens *leaf* shutters, such as the common add-on camera, rarely have vibration problems, since the action rotates around the optical axis, rather than across the axis, as with focal-plane shutters.) To eliminate vibration problems, the camera can be attached to a vertical stand, such as a drill press or copy stand, and suspended slightly above the eyepiece, with no firm connection. The space between the camera lens and the microscope eyepiece can be made light-tight by draping a tunnel-shaped opaque cloth around the camera lens and the eyepiece tube. Whenever possible, lock up the mirror before operating the camera shutter.

3. The standard focusing screen on an SLR camera makes it almost impossible to focus the aerial image from the microscope. The relative coarseness of the screen prevents specimen details from being visually resolved. This problem is exacerbated at low magnifications, where small details are barely visible on any focusing screen. If the camera has a removable screen, then substituting a screen with a clear center spot and crosshairs is desirable and becomes essential at low magnifications. Additional magnification of the screen's aerial image with a focusing magnifier is desirable. An SLR camera setup with the desired features is illustrated in Figure 7.4.

### Integrated Camera Systems

The *integrated camera system*, frequently called the *photomicroscope*, has a camera and exposure system as an integral part of the microscope. Problems due to external vibration, common with all other setups, are virtually eliminated. Internal mechanical functions produce no vibration effects. The integrated systems are designed to freely accept all combinations of illuminating systems,

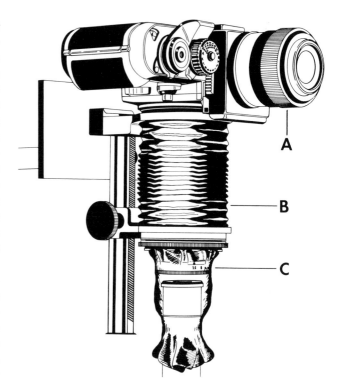

**FIGURE 7.4** This setup will produce excellent photomicrographs without the expense of purchasing a photomicrographic camera system. The camera illustrated is a Nikon F3 although other cameras can be adapted in similar fashion. (a) Nikon focusing magnifier DW-4, (b) type *C* focusing screen (not visible); (b) Novaflex bellows and (c) an 80-mm Schneider Companon enlarger lens. It should be noted that certain inconveniences will exist that are not present with a camera system designed for the microscope. Reprinted with permission from John P. Vetter, 1988. "Photomicrography: A Translation into the Vernacular". Part III, *Journal of Biological Photography*, Volume 56, Number 2, p. 54.

lenses, and many esoteric items without altering the basic unit. In addition, many of the time-consuming and easy-to-forget photographic procedures have been automated. This is especially valuable to the user with only cursory knowledge of the photographic process. For the research worker who may have to employ any number of special contrast-enhancement techniques, computerized image analysis, microspectrophotometry—fluorescent or the like—this may be the only practical type of unit to own.

### Large-Format Cameras

Almost all large-format cameras consist of add-on boxes or bellows attached to the basic add-on or integrated camera. Large-format cameras provide the ultimate high-quality photographic image. Intrinsic film factors, which may limit the quality of the image with small-format films, are virtually eliminated. The sheet film (cut

film) sizes used also allow customized processing of individual exposures to best suit the specimen.

Do not overlook the practical use of Polaroid Corp. (Cambridge, MA) print films with large-format cameras. The Polaroid print can provide an almost instant assessment of your optical and photographic configuration without the necessity of an empirical evaluation by wet processing and printing the negative. This is a valuable problem-solving and time-saving technique with an obstinate specimen. For details see the section on Exposure Determination.

## FILM SELECTION

Films, particularly color films, are constantly being improved by their manufacturers. Therefore, no single film will be recommended, except where the film is unique and unavailable from multiple manufacturers.

### Color Reversal Films

The bulk of films used in biomedical photography are 35-mm color reversal films. This film is relatively low in cost and available almost everywhere. Professional processing services are obtainable at local photographic supply houses and through mail-order services. The film is very popular for everyday photography; therefore current information on its use and characteristics is attainable in free literature from the manufacturer or at the local photographic supply house.

Two basic types of film are available: a *daylight-balanced film* and a *tungsten-balanced* film. The end results are similar, but not identical, as long as the color quality of the light source matches the film in use. Although there are many adherents to the daylight-balanced film, the tungsten film may offer a distinct advantage when photographing specimens at very high magnifications.

When using a daylight-balanced film the illumination from the microscope lamp requires a deep-blue color conversion filter to convert tungsten illumination to daylight quality. The density of the filter reduces the available illumination by a factor of 4. (Interference color conversion filters, such as Nikon NCB 10 or NCB 11 glass filters, are very efficient and reduce the illumination by a factor of only 2.) At low magnifications the reduced illumination rarely causes any exposure reciprocity effects,[1] although at high magnifications the amount of illumination at the film plane is a fraction of the illumination available at lower magnifications. Due to the reciprocity effects of film, this may result in exposures and color results not anticipated by the user. The effect is exacerbated with cut sheet film sizes and Polaroid color print films, since an additional exposure factor of $16\times$ or higher will be required to compensate for the increased

image size (and magnification) on large-format films. In contrast, tungsten film requires very little filtration, since in most instances, the color quality of the illumination approximates the color balance of tungsten film.

### Polachrome 35-mm Instant Color Film

Polachrome is a BW film emulsion coated on the base side of an additive color mask. The light passes through the additive color mask and then exposes the BW emulsion in proportion to the filtering effect of the mask. Polaroid makes a complete processing and binding kit that is convenient and easy to use. The color saturation is excellent, although the density of the film restricts its use to small audiences when viewed with standard slide projectors. Excellent duplicates can be made by copying the original film onto reversal duplicating color film with four times increased exposure over normal duplicates. The duplicates project with color and screen brightness equal to the common color reversal films.

### Negative-Color Films

The color quality, grain, and resolution of *negative color films* have been greatly improved over the last few years. In particular, Kodak Ektar 25 Professional (PHR) 35-mm film has contrast, grain, and resolution characteristics that make this the film of choice for exhibition prints,[2] when the use of large-format films cannot be accommodated by the equipment on hand. However, one must be aware of the difficulty of obtaining reliable color prints with negative color films of histological stains.

Several factors enter into this dilemma. Most commercial color printing houses are familiar with common everyday scenes, but the color of stained histological tissue sections is completely foreign to them. The automatic printing equipment and the supervision by the printer do an excellent job of determining the type of illumination employed in taking everyday scenes, whether daylight, electronic flash, or house lights. Mild variations in these scenes are acceptable, as they may be very pleasing to the eye, even though not true-to-life. Histological stains are easily recognized by their nuances of color *even though the microscope and the ambient illumination for viewing the print are dissimilar.* Color variations acceptable in prints of everyday scenes may not be acceptable in prints of histological sections.

If color prints from negative color films are needed, follow the procedures listed in the section on Printing Photomicrographs Using Color Negative Films. Another more economical method of obtaining color prints is to have reversal prints made directly from color transparencies.

## Special Considerations for Low-Contrast Specimens

William deVeer (1987) developed a scheme for processing Ektachrome film (a color *reversal* film) in color negative chemicals (C-41) to produce high-contrast color *negatives*. When these unique color negatives are printed, they exhibit increased contrast and color saturation. Although not tested by deVeer, it appears that these same high-contrast color negatives might be printed on Kodak Vericolor slide film to produce outstanding color transparencies of very low contrast specimens.

## Black-and-White Films

The principal film attributes for BW films are (1) resolution, (2) spectral sensitivity, and (3) processing flexibility. A selection of one or two films will provide all the flexibility needed in the course of everyday applications. The film's ability to resolve detail is the most important characteristic of 35-mm format films. It may also be important with large-format films when there is a need to record the maximum detail a microscope is capable of producing.

Kodak Technical Pan film (2415/Estar-AH base, 35-mm format and 4415/Estar thick base, sheet film formats) has several characteristics that lend themselves to exposure and processing manipulation for excellent photomicrographs. The film is extremely fine grained, with very high resolution capabilities and extended red sensitivity. The film responds dramatically to variations in processing techniques. The intrinsic characteristics of the film coupled with its wide processing adaptability make this an ideal film for the scientific photographer. A significant range of contrasts can be obtained with developer and/or processing variations. Due to the inherent high-contrast characteristics of the film, the film is sensitive to slight overexposure and/or processing irregularities, which can cause density and contrast results unexpected by the user. In particular, the recommended processing technique should be followed meticulously; otherwise density fluctuations will appear on the negative. Consistency of results can only be obtained by exercising a high level of laboratory proficiency.

Other makes and types of films should not be overlooked. While the above film will produce superb results, the reader may not have the darkroom facilities to carefully control all processing factors. Sheet films with long exposure toes on their characteristic curve, such as Kodak Ektapan film, will tolerate mild exposure and/or processing variations. They produce excellent results when processed in Kodak HC-110 or similar developers for specimens with normal contrast and in high-energy developers, such as Kodak D-11 developer, when a moderate increase in contrast is needed. All major film manufacturers make similar products, and the user should experiment to determine which combination best suits their needs.

## Resolution/Sharpness at a Glance

It would appear that any film that has high resolution capabilities would automatically produce images that appear "sharp." The perception of sharpness and resolution are not necessarily related. The visual effect of an image being sharp depends on the visual contrast between closely related areas. Therefore, other film characteristics might have to be considered to ensure the image will appear to be sharp. The other two characteristics, spectral sensitivity and processing flexibility, can be used to add the required specimen and detail contrast.

It is important to differentiate between specimen contrast and detail contrast, even though at times one may appear more like the other. *Specimen* contrast results from the contrasting color effects of histological dyes and usually involves comparatively large areas. *Detail* contrast results from the density difference at the edges of very small, discrete parts, from the surrounding area of the specimen. A film with a wide spectral sensitivity (panchromatic) will allow the user to select almost any color filter to increase (or decrease) specimen contrast within multicolored specimens. Detail contrast is best controlled by selecting the appropriate film, developer, and processing times.

## FILTERS

### Filter Types

**Conversion Filters.** *Conversion filters* produce major changes in the color temperature of the light source to match the color balance of the film (Table 7-1). The light from a 100-watt tungsten–halogen (TH) microscope lamp produces a color quality of illumination equivalent to 3200 Kelvin (K) (Table 7-2). Daylight film that is balanced to 5500 K would require an 80A filter in the light path to approximate photographic daylight for which the film is balanced.

**Light-Balancing Filters.** *Light-balancing filters* are mildly tinted filters that produce minor changes in the color temperature of the light source (Table 7-3). They are frequently used to fine-tune the color temperature of the light source. For example, the common 20-watt TH lamp emits 2900 K, at rated voltage. To match tungsten-balanced film, which has a color balance of 3200 K, an 82B light-balancing filter is inserted into the light path.

**Table 7-1  Kodak Conversion Filters**

| Filter Color | Filter Number | Exposure Increase* (factor) | Conversion in Degrees K |
|---|---|---|---|
| Blue | 80A | 4 | 3200 to 5500 |
| | 80B | 3.6 | 3400 to 5500 |
| | 80C | 2 | 3800 to 5500 |
| | 80D | 1.3 | 4200 to 5500 |
| Amber | 85C | 1.3 | 5500 to 3800 |
| | 85 | 1.6 | 5500 to 3400 |
| | 85B | 1.6 | 5500 to 3200 |

*These values are approximate. In photomicrography, exposure times are commonly determined by light measurement with the filters in the light path, and no filter factors need be considered.
When the exposure time has been determined by trial and error without filters, these filter factors can be applied.

**Color-Compensating Filters.** *Color-compensating filters* (often called CC filters) partially absorb one or two primary colors and pass the remaining incident illumination. In microscopy these filters are used to further balance the light as it passes through the many lenses, prisms, mirrors, and heat-absorbing glasses that can affect the color of the light. In addition, color-film reciprocity effects may cause further color imbalance of the image. All of these coloring effects can be offset with color-compensating (CC) filters to produce a natural-appearing photograph. Conversion, light-balancing, and color-compensating filters are filters for use with color film.

**Table 7-2  Sources of Illumination and Their Color Temperatures**

| Source | Color Temperature (Degrees Kelvin) |
|---|---|
| Skylight | 12000 to 18000 |
| Sunlight (mean noon) | 5400 |
| Photographic Daylight | 5500 |
| 500-watt (photoflood) approx. 34.0 lumens/watt | 3400 |
| 500-watt (3200 K photographic) approx. 27.0 lumens/watt | 3200 |
| 15-watt, Microscope Illuminator | 2850 |
| 20-watt, (TH) Microscope Illuminator | 2900 |
| 60-watt, Microscope Illuminator | 3050 |
| 100-watt, Microscope Illuminator | 3150 |
| 100-watt, (TH) Microscope Illuminator | 3200 |
| 251-watt, CSI* Microscope Illuminator | 3400 |
| 150-watt, XBO* Microscope Illuminator | 600 |
| Electronic Flash†, Microscope Illuminator | 5500 (approximate) |

*Since these gas discharge lamps have a discontinuous spectrum superimposed on a continuous spectrum the photographer should be aware of possible color distortions with some specimens.
†The color temperature of an electronic flash illuminator will depend on the electrical load and the tube characteristics.
(TH) = Tungsten-Halogen Lamp

**Table 7-3   Kodak Light-Balancing Filters**

| Filter Color | Filter Number | Exposure Increase* (factor) | To obtain 3200 K from: | To obtain 3400 K from: |
|---|---|---|---|---|
| Bluish | 82C + 82C | 3.3 | 2490 K | 2610 K |
| | 82C + 82B | 3.3 | 2570 K | 2700 K |
| | 82C + 82A | 2 | 2650 K | 2780 K |
| | 82C + 82 | 2 | 2720 K | 2870 K |
| | 82C | 1.6 | 2800 K | 2950 K |
| | 82B | 1.6 | 2900 K | 3060 K |
| | 82A | 1.3 | 3000 K | 3180 K |
| | 82 | 1.3 | 3100 K | 3290 K |
| No Filter Necessary | | | 3200 K | 3400 K |
| Yellowish | 81 | 1.3 | 3300 K | 3510 K |
| | 81A | 1.3 | 3400 K | 3630 K |
| | 81B | 1.3 | 3500 K | 3740 K |
| | 81C | 1.3 | 3600 K | 3850 K |
| | 81D | 1.6 | 3700 K | 3970 K |
| | 81EF | 1.6 | 3850 K | 4140 K |

*These values are approximate. In photomicrography, exposure times are commonly determined by light measurement with the filters in the light path, and no filter factor need be considered.
When the exposure has been determined by trial and error without filters, these filter factors can be applied.

**Heat-Absorbing Filters.** *Heat-absorbing filters* absorb the long-wave and infrared radiation from the microscope lamp. The heat radiated would otherwise be concentrated by the condenser and absorbed by the specimen and the eye, causing possible irreversible damage to the specimen, as well as considerable discomfort for the viewer. This is an essential filter in microscopy. Most, but not all, microscopes include the filter or heat-absorbing lens elements in the base of the microscope.

**Interference (Band-Pass) Filters.** *Interference (band-pass) filters* are multicoated glass filters that provide high transmission of specific wavelengths. The green/yellow interference filters sold by microscope manufacturers have specific band-pass properties that optimize the optics of their equipment. These filters provide an excellent balance between the manufacturer's optical system and most histological stains. They are highly recommended as the first filter of choice for BW photomicrographs.

**Contrast-Control (Color-Contrast) Filters.** *Contrast-control (color-contrast) filters* are deeply colored filters available in a range of colors and densities. They are available as solid glass or gelatin filter squares. The gelatin filters are highly recommended, since they are economical and come in a wide variety of colors and densities.

**Attenuation (Neutral-Density) Filters.** *Attenuation (neutral-density) filters* reduce the incident illumination in a predictable manner. Attenuation filters are available as interference filters (gray filters), partially reflecting mirrors and absorption filters. Perfect neutrality is rarely obtained, although the *gray filters* by Carl Zeiss, Inc. (Thornwood, NY) have linear absorption throughout the visible and near-visible spectrum and are highly recommended for all types of photography.

So-called *neutral-density* (ND) filters do not have uniform absorption throughout the photographic spectrum. A color tint will be apparent on photographs made through ND filters of high density. Filters below 0.6 density produce very little color tint and therefore may be acceptable for most applications. In photomicrography, attenuation filters are used to (1) maintain a narrow range of illumination at the film plane to eliminate the need to continually adjust for reciprocity effects (if any), (2) provide a comfortable viewing level at all magnifications, and (3) reduce the intense illumination at low magnification to within the speed range of the shutter.

## Where to Place Filters

Filters can be placed almost anywhere in the light beam. The most convenient position is above the light-exit port. Filters for special applications may require positioning before or after certain optical components. For these filters, the manufacturer will have designated light-path positions that must be adhered to.

## FILTRATION FOR BLACK-AND-WHITE PHOTOGRAPHY

Successful BW photomicrography depends on the ability to select the filters and the film/processing combination to change the colors of the specimen into meaningful tones of gray and to establish the perceived sharpness of fine specimen details. *The application of contrast-control filters is the single most important technique in the production of quality BW photomicrographs.*

The filters used in BW photography are called *contrast-control filters*. They have marked color density and saturation characteristics and produce obvious visual effects when viewing a colored specimen (a feature used in selecting filters). The photographic effect is also conspicuous. They are available as solid glass or gelatin squares.[3] The gelatin filters are recommended, since they are economical and come in a wide variety of colors and densities. Here are a few basic filters that have proven their worth: 11 (light yellow/green), 15 (deep yellow), 23 (light red), 44 (light blue/green), and 58 (green).

## How Contrast-Control Filters Work

At first it would appear desirable to render a colored specimen in its relative brightness value on the BW print. A Wratten 11 filter inserted into the light beam effectively produces an image, using panchromatic film and standard printing processes, that matches the color brightness response of the eye under tungsten illumination. Rarely is the photograph satisfactory, since the visual contrast of the specimen, due to the contrasting colors of the histological dyes, has been rendered in uninteresting tones of gray. With further examination it will be noted that the specimen may not have sufficient contrast to distinctly separate it from the background. The goal is to produce meaningful contrast tones between all important elements in the specimen and separate the specimen from its background.

If a multicolored specimen is viewed with a contrast-control filter, portions that are complementary in color (two colors that lie on opposite sides of a white point in a color map, such as blue and yellow, red and cyan) will appear dark, and the opposite is also true (Figure 7.5) (See Chapter 6, "Star of David"). Colors in the specimen can be made to appear in a wide range of brightness values by appropriately selecting a filter or filters. Appearance of lightness or darkness of a specimen detail depends on several factors: the spectral absorption curve of the specimen detail, the spectral sensitivity of the film, and the contrast properties of the film. Although it is seldom necessary or practical to deal with each of these

**FIGURE 7.5** (a) The Alcian blue stain is rendered dark by the 23A filter (light red), while (b) the orange G stain is rendered dark by the 44A filter (light blue-green).

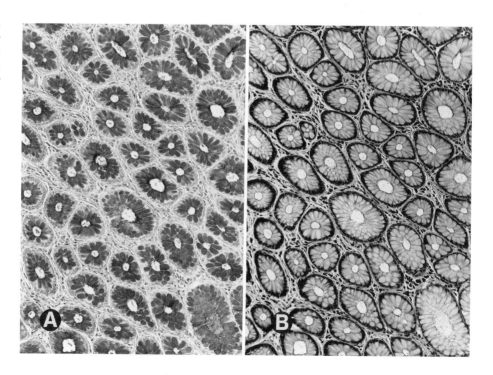

individually, their composite effect should be noted. Two systems for choosing the best filter combination will be discussed, as will their advantages and disadvantages.

## Visual Evaluation Technique

First, while examining the specimen through the microscope, evaluate the color and contrast, keeping in mind that an area that is dark in the print will attract more attention than a lighter-toned one. This refers to bright-field illumination. The opposite is true with dark-field illumination. (Occasionally, a specimen will be too dense in its natural state to allow intrinsic details to be seen. Under these circumstances, the filter should have a color that closely matches the color of the area where the details exist.) Choose a complementary filter that absorbs the specimen color selected to be darker in the print. While viewing the specimen, rapidly insert and then remove the filter from the light beam. It is usually profitable to select similarly colored filters and evaluate them, as opposed to your original selection. A projection print will have slightly greater contrast than the visual effect.

Another precaution must be taken. A filter that absorbs a portion of blue-violet light needs to be included in the filter pack for photography when none of the filters selected absorbs blue-violet light. This is important for successful evaluation, since our eyes are uniquely insensitive to blue-violet light, which film records with the greatest of ease. Excluding the filter may lower the overall contrast of the negative. Almost any light-yellow filter that absorbs radiation below 450 nm will suffice. A Kodak Wratten 3 or 4 gelatin filter is an excellent choice when combined with the filters selected visually.

## Matching Spectral Bar Charts

Matching spectral bar charts of stains and filters is a scientific and more effective method of selecting filters to obtain the maximum filter effect of either lightening or darkening a specimen feature. The charts are constructed from the absorption and transmission curves of stains and filters with over 10% absorption and transmission, respectively (Figure 7.6). These charts provide a graphic method of comparing and selecting filters to obtain the desired results.

The maximum *darkening* effect will occur when the stain absorption bar (black area) closely matches the filter transmission bar (white area). The maximum *lightening* effect will occur when any of the large white areas on the line for each stain is matched with a white area on the line for a filter.

The following example shows how the maximum darkening effect of a particular stain may be obtained. A section of intestine is stained with Safranin O (red-

orange) to demonstrate goblet cells. Without the benefit of filtration, the goblet cells are recorded with almost identical density as the surrounding tissue stained with light green SF (Figure 7.7).

Rendering goblet cells as dark as possible draws attention to them. Visually, the goblet cells (vivid red-orange) and the surrounding tissue (blue-green) have about the same brightness. The stains are complementary and create maximum visual contrast, which is not translated in the BW print as contrasting tones of gray in the example above.

The spectral absorption and transmission bar charts (see Figure 7.6), show that the principal absorption area of Safranin O is 470 to 550 nm and the Kodak Wratten 8 and 44 filter combination has important transmission between 480 to 540 nm (sometimes called a *band pass*). The absorption bar of the stain and the transmittance bar of the filters are almost identical, and thus complementary in color (Figure 7.8). Using this combination of filters, the goblet cells stained with Safranin O are recorded with the maximum contrast against the tissue and the bright-field background (Figure 7.9). Other combinations of filters can be used to render the cells with less than maximum contrast. In the above situation a 57 filter (475 to 485 nm) with a wider band pass than the 8 and 44 filters would reduce the contrast between the goblet cells and the surrounding tissue.

## Exposure and Filter Factors

Filters absorb certain portions of the incident illumination. The amount and color of light absorbed depends on the individual filter. For everyday photography the filter manufacturer provides *filter factors* to be applied to camera exposures determined by hand-held exposure meters. Through-the-lens metering on modern cameras can compensate automatically for most filters used on cameras. This is rarely true when using contrast-control filters and the automatic exposure control in a photomicroscopic setup. There are several reasons for the disparity: (1) contrast-control filters have marked absorption and transmission characteristics not found with everyday camera filters; (2) the spectral response curves of the photoreceptor cell and film *never* match; and (3) the specimen dye colors may add another filtering factor.

In a series of empirical tests of contrast-control filters, additional exposure factors had to be applied to produce acceptable negative images. These factors ranged from four times *more exposure* for blue-green filters to one-fifth *less exposure* for orange-red filters, a notable exposure range of twenty times. Filters near the peak sensitivity of the eye (green-yellow) required little or no compensation.

A table of filter exposure factors can be quickly developed with the use of Polaroid instant BW print film.

**FIGURE 7.6 (a) The approximate absorption (over 10%) of some histological stains. (b) The transmittance (over 10%) for some common Kodak Wratten gelatin filters and useful combinations (Reprinted with permission from Eastman Kodak Company, 1981).**

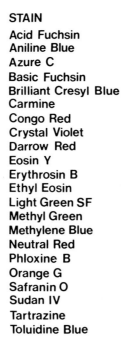

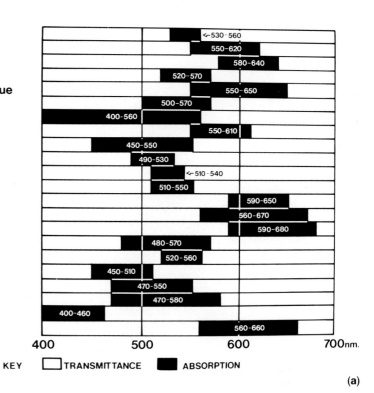

(a)

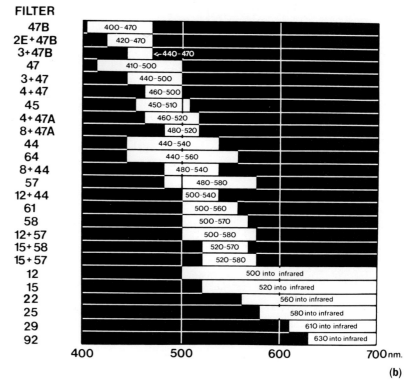

(b)

Although the Polaroid film does not have the exact color sensitivity of all panchromatic negative films, the exposure factors obtained are sufficiently accurate for practical application. Make these simple tests:

1. Select a specimen that represents your common or standard slide. Set up the microscope and follow the procedures in the Quick Procedure Guide at the end of this chapter.

2. Make an exposure with only a Kodak Wratten 3 or 4 filter inserted into the light beam. Correct the exposure by changing the International Standards Organization (ISO) index. The relationship is inversely proportional. Thus, decrease the ISO film speed when

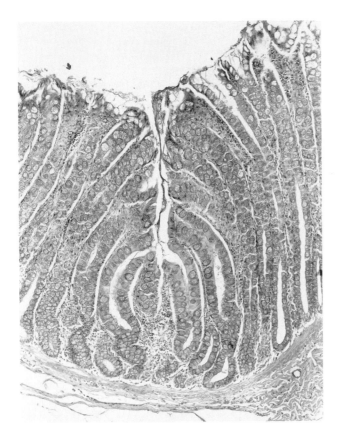

**FIGURE 7.7** Without the benefit of contrast control filters, the goblet cells and the surrounding tissue photograph with equal density. Reprinted with permission from John P. Vetter, 1984. Photomicrography, *Photography for the Scientist,* 2nd edition, Academic Press, London, p. 431.

more exposure is required, and increase the film speed for less exposure. The final setting will be your basis for all further tests for your personalized filter factor chart.

3. Insert a filter or filter combination, and correct the ISO index until you get a good overall exposure. Disregard the contrast effects of the filter. The corrected ISO index is your filter factor for the particular filter.
4. Repeat for all other contrast-control filters in your collection.

### Instant Print Evaluation

The following technique is highly recommended to determine the effective use of filters which have been selected after *visual* evaluation or by *matching spectral bar charts.* The effectiveness of a filter for a particular specimen can be evaluated almost instantly using the large-format Polaroid instant print films or Polaroid negative/positive films, which provide a high-quality negative along with a positive print. It should not be overlooked that the same high-quality Polaroid photomicrograph is suitable for use in publications.

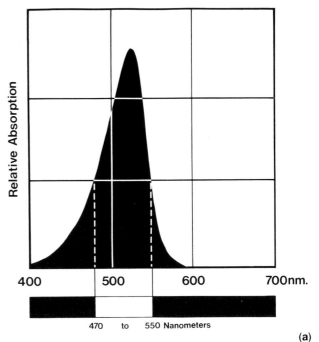
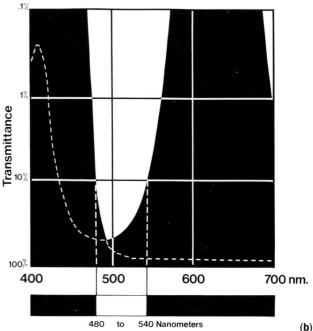

**FIGURE 7.8** (a) Absorption curve of Safranin O. Absorption range is 470 to 550 nm. (b) Transmittance curve of the 8 and 44 filter combination. Transmittance range is 480 to 540 nm. Reprinted with permission from John P. Vetter, 1984. Photomicrography, *Photography for the Scientist,* 2nd edition, Academic Press, London, p. 432.

If instant print film is used for filter evaluation when wet-processed negatives are anticipated, then the instant test print should have less contrast than desired for the final projection print. In general, a print made by projection printing will have an equivalent of one grade greater contrast than the instant test print. The spectral response of instant films may not accurately match pan-

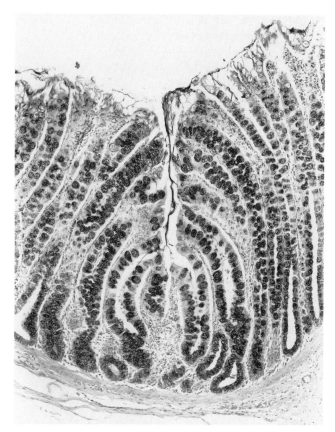

**FIGURE 7.9** Using an 8 and 44 filter combination, maximum photographic contrast is obtained. The goblet cells now stand out in contrast with the other specimen structures and the background. Reprinted with permission from John Paul Vetter, 1984. Photomicrography, *Photography for the Scientist,* 2nd edition, Academic Press, London, p. 433.

chromatic wet-processed films, but the dissimilarity will not interfere with the intended purpose.

## FILTRATION FOR COLOR-REVERSAL FILMS

The microscope contains many lenses, prisms, and mirrors, all of which tend to alter the color of the light on its way to the film. The more sophisticated the instrument is, the more likely additional elements will be involved and the color changes more pronounced. Instruments of current design will have nearly neutral effects, while those of older vintage will have marked coloring effects. The following empirical test procedures will effectively establish the correct exposure setting, the lamp electrical status, and a basic filter pack for any bright-field microscope. For this and all other tests, select a tissue slide that represents the most common tissue and stain in use. Without this *standard* specimen slide no future test can be effectively evaluated.

In preparation for the test it will be necessary to purchase two filters, in addition to the filter recommended by the manufacturer, an 82A and an 82C, 50 × 50 mm

Kodak gelatin filters. These filters can be purchased at any professional photographic supply house. Follow these procedures, noting any changes as they occur:

1. Load the tungsten-balanced film into the camera and set the film speed (ASA or ISO) and the lamp control knob as recommended in the camera/microscope manual.[4]
2. Place the standard specimen slide on the stage and focus with the 40× objective lens.
3. Verify Köhler illumination (see the section on Aligning the Microscope for Köhler Illumination) and adjust the aperture diaphragm for optimum imagery.
4. Make five bracketed exposures, one at normal speed and one at one step below, two steps below, one step above, and two steps above the normal speed. A *step* represents exposure compensation in one-third ISO units. This is the normal speed adjustment on hand-held exposure meters. *Do not have any filters in the light path at this time. Make a* blank *exposure between each series of filter/exposure tests when using 35-mm film. This will make it easier to identify each test after the film is processed.*
5. Add the 82A filter to the light beam and repeat step 4.
6. Repeat step 4 with the 82C filter only. Then repeat with the combined 82A and 82C filters.
7. With the filters 82A and 82C, raise the light level to the next higher notation on the voltage control knob. Again shoot five bracketed exposures for each voltage increase.
8. Make an exposure test with the manufacturer's recommended filter.

Have the film processed. Compare the finished transparencies with the previous notations. Select the film speed, filter(s), and voltage setting that produces the best transparency. If you are satisfied with the results, then these settings, along with the filters (commonly called a *filter pack*), can be your standard for all future photography with your present microscope and film. If the color is not quite up to your expectations, continue with the test in the section on Fine-Tuning the Color Photomicrograph.

### Fine-Tuning the Color Photomicrograph

Certain conventional histological stains, notably Eosin, Fuchsin, and Safranin O, do not produce well on color reversal films. If you are not satisfied with the color reproduction of these stains, add the following filter to your *standard filter pack* or include it in the following test: didymium color enhancement filter (BG-20, 50 × 50 × 0.5 mm thick. Schott Glass Technologies, Inc., York Ave., Duryea, PA 18642). The filter produces an enhancement of red and blue colors. It is recom-

mended that you purchase this filter and include it as step 1b of the following test.

To this point the light source has been color balanced to be within easy reach of fine-tuning the basic filter pack. If you are satisfied with the results, there is no need to proceed with the following test. In most instances there will be a mild color tint due to the many lenses, prisms, mirrors, and optical coatings, all of which have a cumulative effect on the final image. Older microscopes, particularly those with high-aperture and high-power objectives, introduce significant color effects. At home you may have an excellent, but older, microscope, for which the following set of empirical tests is useful.

1a. Photograph the *standard* tissue section at all magnifications you expect to use. Note the combination of objectives and condensers.
1b. Repeat the above test using the BG-20 listed above (if available).
2. Examine the processed color transparencies with "white" light reflected from white paper or card stock. The light from the common fluorescent lamp is not recommended for this examination.
3. Select a filter from a Kodak color print viewing kit,[5] which, in your estimation, nullifies the objectionable color tint. Hold the filter immediately behind the transparency. Quickly compare the overall color of the transparency with and without the filter.
4. Repeat the examination with various filters and filter combinations. If one or more of the filters improves the appearance, note its value, and make a photographic test using the same optical setup with the filter(s) added to the light beam. If it is noted that various other optical combinations produce assorted color tints, then repeat these tests for all affected optical combinations. It is not uncommon to find that low-power lenses require little or no additional filtration, while high-dry and oil-immersion lenses require significant amounts of color filtration.
5. Develop a chart listing all the optical variables and filters needed to produce good photographs. Use the recommended filter(s) to produce consistent results at all photographic sessions.

## FILTRATION FOR POLAROID COLOR PRINT FILM

PolaColor ER color print film can produce excellent photomicrographs when the reciprocity effects at low levels of illumination are taken into account. The normal sensitivity (ISO 100) and color balance (daylight) of the film is altered dramatically as less and less illumination falls upon the film. Determining the correct combination of exposure and filtration can be very frustrating, since the slightest change in illumination will make a visible change in density and color. Fortunately, Nippon Polaroid Co.,

in cooperation with Nikon Corporation (see section on Technical Publications From Optical and Film Manufacturers), has developed graphs that eliminate much of the guesswork in producing color photomicrographs with PolaColor film. (The following instructions assume that the reader has an automatic camera system for exposure determination. When a manual system is employed one should determine the basic exposure by the *test strips method* listed in the section on Exposure Determination.)

To eliminate the constant problem of referring to the graphs and making numerous tests to produce the "perfect" print, or for those who do not have the above publication, follow these few simple steps:

1. Select a bright-colored specimen. (A bright-colored specimen is preferable, as soft or weak stains will not reproduce well on color print film.)
2. Make a photomicrograph at the highest magnification you normally employ, using the above-listed graphs. For those without the publication, a suggested starting filter pack is CC35M + CC35B filters, with an ISO exposure index of 80. If available, a 2B or 2E ultraviolet (UV) absorbing filter should be included in the filter pack. The above filter pack is approximately correct when an exposure time of 1 second is obtained. As the exposure time increases, less filtration is required. The density and color obtained in this first test may not be totally acceptable.
3. If necessary, fine-tune the photograph by adding (or subtracting) color-compensating (CC) filters and adjusting the exposure time by changing the ISO index. Make very small adjustments and change only one parameter (exposure, filter, or lamp voltage) for each test.
4. When an excellent print is obtained, note all the photographic and optical variables, especially the exposure time or light reading. This is your *standard* setup for PolaColor print film. If you reduce the magnification *add* ND filters to the light beam to arrive at the standard exposure time (or light reading). By adding the ND filters, you, in effect, create the identical illumination level that was present with the standard setup; thus the reciprocity effect remains the same.

It is impossible not to have additional factors enter the setup, especially those due to the density and color of the specimen and their effects on the photocell. These factors are easily managed as one becomes more familiar with the personality of the film. This system can also be applied to any film exhibiting marked reciprocity effects.

## ALIGNING THE MICROSCOPE FOR KÖHLER ILLUMINATION

For the Köhler system of illumination to function properly, certain *optical parameters* must be met. The pa-

rameters are easy to obtain and confirm, by making the following adjustments:

1. Carefully focus on a specimen with a 10× lens. Reduce the *aperture diaphragm* until a distinct change in illumination is noticed.
2. Close the *field diaphragm* until the edge of the diaphragm is in view. At this stage of alignment the diaphragm may be out of focus and off to one side.
3. Lower or raise the substage condenser (use the substage focusing knob) until a sharp image of the diaphragm is obtained.
4. Using the condenser's radial centering knobs, center the field diaphragm to the field of view.
5. Adjust the field diaphragm to illuminate about three-quarters of the field of view.
6. Confirm accurate focus of the specimen. Refocus and recenter the diaphragm. For Köhler illumination, the specimen and the field diaphragm must be in identical focus (Figure 7.10).
7. Open the field diaphragm until it is just outside the field of view.

The requirements of the Köhler system of illumination are satisfied when the *aperture diaphragm* regulates the brightness, depth of focus, and edge contrast of the specimen image (Figures 7.11a,b) and the *field diaphragm* limits the field of view (Figure 7.11c). If either act in part as the other, then the required parameters have *not* been obtained (Figure 7.11d). Review the above procedures

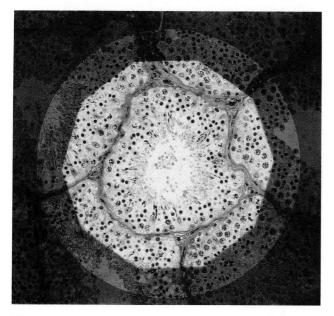

**FIGURE 7.10** A quick check method to verify that Köhler illumination has been obtained is to reduce the field diaphragm and verify that the field diaphragm is centered and in focus with the specimen.

beginning with step 5 to once again establish Köhler illumination.

### Setting the Aperture Diaphragm

The setting of the aperture diaphragm is the *most important optical adjustment* one can make on the modern microscope. It not only controls the amount of light entering the microscope, the apparent depth of sharp focus, and contrast in the specimen, but also the ratio between the unaffected rays (ordinary) and the diffracted and refracted rays produced by the specimen (its most important attribute). As the diaphragm is stopped down, less ordinary rays are available to the objective lens. Consequently, the diffracted and refracted rays are more pronounced. The following procedures are recommended for adjusting the aperture diaphragm:

1. With the selected lens in place, confirm that you have focused and aligned the light source for Köhler illumination.
2. Adjust the field diaphragm to be just outside the field of view.
3. Fully open the aperture diaphragm.
4. Slowly close the aperture diaphragm until a change of illumination is noted.
5. Remove one of the eyepieces and observe the rear lens of the objective (replacing the eyepiece with a phase telescope will provide a much better image of the diaphragm). The aperture diaphragm should be just visible at the periphery of the objective's rear lens. Replace the eyepiece. (This is an optional procedure.)
6. Slowly close the aperture diaphragm noting the change in depth of field, contrast, and illumination.
7. Continue to close the diaphragm until specimen structures are surrounded by diffraction lines and appear "granular." Where this appears will depend on the nature of the specimen. Specimens that depend primarily on histological stains for their visibility will produce few diffraction effects (for example, blood smears); specimens that are highly structured will be affected by the slightest reduction of the aperture diaphragm (for example, diatoms).
8. Open the aperture diaphragm until contrast, depth of field, and detail are in balance. (*This is a uniquely personal decision and will depend on several factors, including the specimen itself, whether fine detail is more important than contrast, and the degree of resolution capable of being recorded by the photographic process or printing press.*)
9. Close the field diaphragm to verify that the specimen and the field diaphragm are centered and in focus. Open the field diaphragm until it is just out of view.

Every time another specimen slide is introduced or the objective lens is changed, these procedures should be repeated.

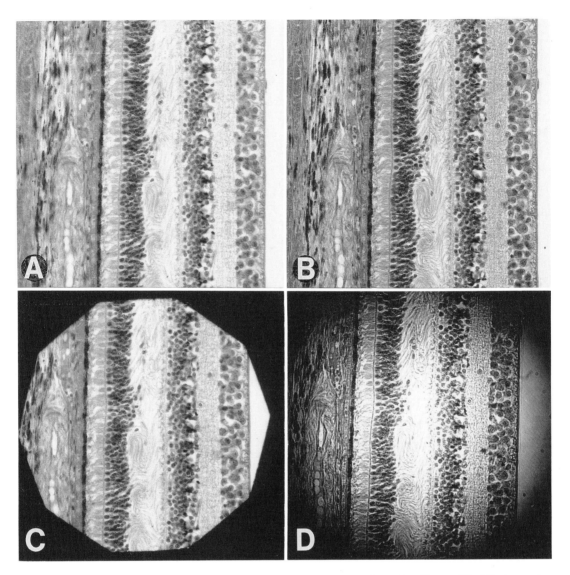

**FIGURE 7.11    The parameters of Köhler Illumination. Close examination of a and c will reveal that the image has not been altered except for the field of illumination but the image in b has increased edge contrast and depth of focus. The b image was actually darker but an increase in exposure was made to make visible the detail in this section of a human retina. d represents an image when the parameters of Köhler Illumination have not been met.**

## PRODUCING THE HIGH-QUALITY PHOTOMICROGRAPH

This section examines the practical aspects of photomicrography at the production level and clarifies several confusing issues such as virtual, real, and empty magnification, and the problem of focusing an aerial image. Exposure determination, processing procedures, and guidelines for preparing images for publication are also covered in detail. A Quick Procedure Guide and Common Problems and Their Solutions finalize the presentation.

## Magnification

The dictionary definition of magnification is *the process of enlarging the size of something, as an optical image.* Photomicrography further distinguishes between *magnification as a virtual image* and *magnification as a real image.* The distinction helps one to understand why a person sees what is seen, and how what is seen is measured and photographed.

The enlarged image of a specimen as seen through the microscope is a *virtual* image. The image appears to be at

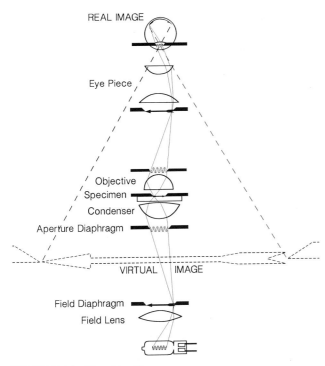

**FIGURE 7.12  The virtual image.**

If the observer steps aside and holds a white card above the eyepiece, however, a magnified image of the specimen can be seen. The image created is a *real* image; it resides in space. It can be viewed on a screen, imaged by a video camera, or further magnified by another optical system. The image can be seen by multiple observers. It can be recorded. In the final analysis, it is this aspect of microscopy that makes the practice of photomicrography possible.

Determination of magnification, virtual or real, means considering all optical factors (Table 7-4). If an intermediate lens system is present in the microscope, the magnification created by it must be factored into the formula. It is the *total magnification* of the image that must be known, however it is produced.

While a photographer needs to know the actual magnification as it exists on film or print, the pathologist (and other frequent users of the microscope) may associate an image's magnification by the objective lens (scanning, high-dry, or oil) used to create the image—in a sense, these are their own "conventional" terms for stating magnification. They may relate to the image by the visible detail and extent of the visual field they experience with a particular lens, and their terminology will remain the same whether it is a small photographic slide, or if the same slide is projected on a wall screen or reproduced as an exhibition print. Actual magnification is rarely stated.

As a photographer, it is useful to remember that your client expects to see in the slide or print the same field and detail evident with their particular objective lens. In practice, the knowledge of the power of the objective and the eyepiece used by the client will suffice to set up your combination of lenses.

or below the specimen stage (Figure 7.12). The image is visually magnified, but no image of it exists in the space where it appears. It is purely physiological. A quick glance at the stage confirms that no enlarged image is present. It is visible only to the observer. It cannot be photographed where it appears.

---

**Table 7-4   Formulas for Magnification**

---

**Virtual magnification (microscopy):**
Objective magnification × eyepiece magnification = virtual magnification.

Example:
  40x (objective) × 15x eyepiece = 600 times virtual magnification.

**Real magnification (photomicrography):**

$$\text{objective mag.} \times \text{eyepiece mag.} \times \frac{\text{project. dist (mm)}}{250} = \text{real image mag.}$$

Example:
  $40x \text{ (objective)} \times 15x \text{ (eyepiece)} \times \dfrac{125}{250} = 300 \text{ real image magnification}$

---

Whether you use small- or large-format films, the image in the focusing telescope will remain the same. The standard camera adapters sold by the manufacturer compensate for the size of the film in use. As an example, the 35-mm camera reduces the real image size by a shorter-than-normal projection distance; thus the reduced image will fit on the small 35-mm format and will match the visual field in the microscope. Cameras for larger film sizes have greater projection distances and operate at unit magnification, thus covering the standard 4 × 5 inch format and matching the same visual field as above, without the realization of the operator.

**Empty Magnification.**    At this point it is worthwhile to examine *empty magnification*. To a lecturer standing next to the projection screen, an image might appear to exhibit empty magnification, an image that is "fuzzy" at best. On the other hand, to the viewing audience whose position is farther away from the screen, the image will appear sharp and clear. It all depends on your viewpoint (not point of view). The author has provided a definition of empty magnification as related to the resolving power of the optical system and the position of the viewer:

> When the magnification of the image in the microscope is carried beyond a certain point, no additional resolution of detail can be seen. Magnification beyond this point is called "empty magnification." Where this occurs will depend on the numerical aperture (NA) of the objective, the position of the viewer and to some extent on the viewer's visual acuity and the inherent contrast of the specimen. (Vetter 1984).

From this definition certain useful assumptions can be made, depending on the final application. The practical limit of magnification (virtual) while viewing through the microscope is about 1000 times the NA of the objective. Therefore, an objective with an NA of 1.35 would allow a magnification of ×1350. For example, the above lens would probably have a primary magnification of 100×; thus a 15× eyepiece (100× objective times 15× eyepiece = ×1500) would provide the maximum magnification without objectionable empty magnification. If, on the other hand, an objective lens with a 0.32 NA was used to produce the same size image (a factor of 5000 times NA), only general outlines of details would be visible and of no practical value.

The arbitrary factor of 1000× objective NA can be applied to photomicrographs. The average print is viewed at 250 to 300 mm (10 to 12 inches). At this distance, the print magnification (real) can be about 1000 times the NA of the objective without loss of detail. Prints to be viewed at greater distances can have a proportionately greater multiplication factor without the appearance of empty magnification.

## Focusing Techniques

The occasional user of the microscope will frequently find it difficult to focus and critically examine a specimen. The proper use of the microscope and, in fact, of all optical instruments, requires the appreciation of a few facts about our eyes. Once these facts are understood and the microscope is adjusted to suit individual eye characteristics, the use of the microscope can be continued for long periods of time without undue eye strain.

## Errors of Refraction

The most common congenital eye problem is due to *refraction errors*. A person may have normal eyesight (emmetropia), be nearsighted (myopia), or farsighted (hyperopia). Mild refraction errors of the eye can be easily compensated for by slight focusing adjustments of the microscope. So, wearing glasses when taking photomicrographs is a matter of personal preference for people with minor refraction errors.

When the refractive error is extreme enough that corrective lenses (eyeglasses) must be worn to perform common everyday duties, glasses should be worn when using the microscope. Although image deterioration may occur when either the near- or farsighted person focuses without their corrective lenses, the nearsighted person faces the additional hazard of damaging the objective lens or specimen.

At first, the basis for this problem may not be apparent. Consider these seemingly unrelated factors: microscope lenses are par focalized for the normal relaxed eye, that is, as one switches from one objective lens to another, the specimen will remain in relative focus, requiring only a slight movement of the fine-focus knob to bring the specimen into sharp focus. A nearsighted person working without glasses will focus hyperclose to the specimen. A specimen is usually first examined with a low-power lens. Then, as more information is required, the user switches to a high-power lens. It is at this time, due to the hyperclose focus of the low-power lens and the shallow working distance of a high-power lens, that the high power lens may strike the specimen slide. To solve this problem, wear glasses (best) or defocus the image (acceptable) by lowering the specimen stage before switching to a high-power lens.

## Astigmatism

*Astigmatism* is caused by a nonuniform curvature of the cornea. Astigmatism of any appreciable degree will require the user to wear glasses at all times. A simple test can be conducted to determine if the wearer has suffi-

**FIGURE 7.13** Astigmatism, of any appreciable degree, such as illustrated here, will require the user to wear glasses at all times to fully realize the quality of the image. Reprinted with permission from John P. Vetter, 1984. Photomicrography, *Photography for the Scientist,* 2nd edition, Academic Press, London, p. 403.

cient degree of astigmatism to require wearing the glasses (Figure 7.13).

## Interpupillary Distance

On binocular instruments there is a scale near the eyepieces, marked in millimeters, indicating the distance between the eyepieces. The setting must match the viewer's *interpupillary distance*, or serious eyestrain will result. This distance can be determined by having a colleague hold a metric ruler near the bridge of your nose and while staring at a distant object, and observe the distance between the left (or right) side of the pupils. The procedure should be conducted in a well-lighted room. (Figure 7.14).

## Dominant Eye

The eye with the best visual acuity is unconsciously selected as the *dominant eye.* The dominant eye should be used to focus an image in any optical instrument. This is particularly important when focusing on a viewing screen or an aerial image in a focusing telescope. Make the following test to determine your dominant eye. Hold your arms out in front of you at full length and frame a distant object between the thumbs and index fingers of both hands. Then, while viewing the object with both eyes, without moving the arms or head, close one eye then the other (Figure 7.15). The eye that keeps the object in view is your dominant eye.

## Focusing the Microscope

Microscope users should develop a series of actions to ensure that their first look through the microscope will successfully find the specimen without eyestrain or undue risk to the instrument or specimen.

1. Adjust the binocular eyepieces to your interpupillary distance. (If this is not your personal instrument, remember the setting and return it to the original setting when finished.)
2. Rotate the microscope eyepieces to position the low-power lens (10×) over the specimen.
3. While viewing the objective lens and specimen from the side of the specimen stage, raise the stage slowly with the coarse-focusing knob until the lens almost touches the slide.
4. Remembering which way the focusing knob turned, look through the microscope and bring the specimen into coarse focus by reverse motion of the coarse-focusing knob. Then, with the fine-focusing knob, bring the specimen into sharp focus. Except for nearsighted persons not wearing glasses, the remaining

**FIGURE 7.14** The frequent user of the microscope should know his or her interpupillary distance so that the eyepieces can be quickly set on any microscope to eliminate eye strain. Reprinted with permission from John P. Vetter, 1984. Photomicrography, *Photography for the Scientist,* 2nd edition, Academic Press, London, p. 404.

**FIGURE 7.15** The dominant eye may be found by framing a distant object with the hands and then closing one eye and then the other. The eye which sees the object through the frame, is the dominant eye. Reprinted with permission from John P. Vetter, 1984. Photomicrography, *Photography for the Scientist,* 2nd edition, Academic Press, London, p. 404.

objective lenses can be switched back and forth without fear of striking the specimen slide.

## Focusing the Aerial Image in a Focusing Eyepiece

If the eyepiece has a graduated diopter scale, the setting can be set on zero for emmetropic users or those wearing corrective lenses. If the user desires not to wear glasses, the eyepiece will need to be adjusted to produce a sharp image of the crosshairs on the reticle. Follow these directions:

- Move any specimen image out of view, so that only the camera reticle is seen.
- Make three or more focusing adjustments until you arrive at one setting that consistently produces a sharp image of the reticle.
- Note the final setting of the diopter scale for future use. On eyepieces without a scale, mark the position with a pencil.

Following the diopter setting, bring the specimen into view and focus the specimen using the fine-focusing knob. You should focus on details bordering the crosshairs to minimize problems due to accommodation.

**Problems of Accommodation.**   There is a problem of focusing only seen in younger people, since their eyes can instantly accommodate (change focus) to images in different planes of focus without their knowledge. Thus, the crosshairs and specimen details may appear to be in identical focus while, in fact, they may occupy different planes. The problem is most likely to be observed in photographs made at low magnifications by those of almost any age. The ability to accommodate decreases by the square of the magnification. As magnification increases, the focusing problem due to accommodation rapidly decreases. As one ages, the ability to accommodate decreases and almost disappears by age 45, hence the use of bifocals.

Accurate focus can be assured at any age and magnification by attaching a magnifying focus-finder such as the Nikon 4× magnifying focus finder (No. 78834) to the focusing eyepiece. As long as the crosshairs and specimen are in identical focus, they will be in focus at the film plane. The additional magnification accorded by the magnifier renders any natural accommodation ineffectual. For the young person this is an essential piece of equipment. Integrated cameras often have a 4× magnifier built into the binocular viewing system.

Another method, not as convenient and requiring practice, is to use the technique of parallax focusing. While viewing a specimen detail near the reticle crosshairs and simultaneously adjusting the fine-focusing knob, move your head in a slight left to right direction. The focus will be correct when the specimen

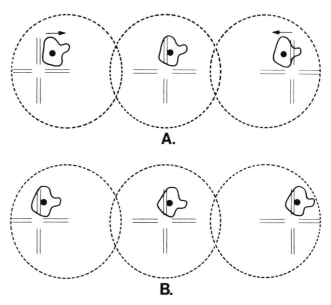

**FIGURE 7.16   (a) If the specimen and the reticle shift in opposite directions, the specimen and the reticle are not in the same plane of focus. (b) The focus is correct when they remain aligned regardless of the position of the head. Reprinted with permission from John P. Vetter, 1984. Photomicrography, *"Photography for the Scientist,* 2nd edition, Academic Press, London, p. 406.**

remains perfectly aligned, regardless of the position from which it is viewed (Figure 7.16).

## Focusing the Image on a Viewing Screen

On a large-format camera the small amount of light that reaches the viewing screen is scattered by the prismatic effect of the glass screen. Even under the best of circumstances, specimen details may be hardly visible. To facilitate focusing, the screen should have a clear spot with cross-lines. The clear spot allows all of the light from the aerial image to be intercepted by a focusing magnifier, while the cross-lines provide a visible reference to the focal plane. If a clear area is not present, one may be created by the following method:

- Remove a Fresnel screen if one is present.
- With a fine-pointed pencil make a set of cross-lines in the center on the roughened surface of the viewing screen.
- Put one drop of diluted mounting media or lens cement on the cross-lines and place a cover slip on top of the cement.
- Apply a light pressure to squeeze out excess cement. Immediately remove any excess cement.
- The screen can be used almost immediately. If a Fresnel lens was removed, allow 1 or 2 days drying time before replacing.
- Position a focusing magnifier over the cross-lines and carefully focus the image. The cross-lines and the spec-

imen must be in identical focus. Use the parallax focusing technique to ensure accurate focus.

## EXPOSURE DETERMINATION

### Manual Systems

**Test Strips.** Making a series of graduated test exposures using Polaroid Land instant films permits the determination of exposures. The system integrates all exposure factors and the results are available almost instantly. This system is particularly valuable with the use of BW films with contrast-control filters, since the effects of the filters are difficult to envision without a print to examine. Unfortunately, it is suitable only for large-format films.

There are some variations between wet-processed sheet film and the instant film, but these can be easily understood, and excellent results are virtually assured. For instance, our preferred sheet film is Kodak Ektapan film exposed at 200 ISO exposure index and processed

in D-11 for 5 minutes. Since the index is one-half the speed of Polaroid Land film 522, the exposure time from the indicated exposure should be doubled in the selected test sequence. To make a test strip, follow these directions:

1. Focus the specimen, add the appropriate filtration, and insert the film into the camera.
2. Withdraw the dark slide or film envelope to its limit.
3. Insert the dark slide (or envelope in the case of Polaroid Land 52 sheet films) progressively at 1-inch increments (or less), doubling the exposure on each occasion, except for the first two sequences, which are identical.

The example shown in Figure 7.17 represents a timed sequence that might be required for a microscope equipped with a low-wattage lamp. A similar exposure sequence can be obtained with an automatic exposure system by multiplying the film exposure index in reverse relationship to the previously timed manual exposure sequence. For example, Polaroid Land film 552 has an exposure index of 400 ISO. The first two exposures are

**FIGURE 7.17** Exposure determination by making a series of graduated test exposures. Reprinted with permission from John P. Vetter, 1988. "Photomicrography, A Translation into the Vernacular". Part IV, *Journal of Biological Photography,* Volume 56, Number 3, p. 93.

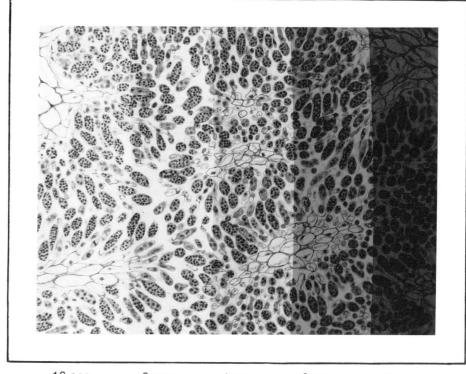

ORIGINAL TIMED EXPOSURE SEQUENCE
Direction of Darkslide or Film Envelope.

8 sec.    4 sec.    2 sec.    1 sec.    1 sec.

16 sec.    8 sec.    4 sec.    2 sec.    1 sec.

FINAL ACTUAL EXPOSURE SEQUENCE

at the 1600 ISO setting on the camera control box. The following exposures are at 800, 400, and 200 settings. The final exposure sequence represents exposures made at 1600, 800, 400, 200, and the 100 ISO setting, respectively.

## Automatic Systems

**Color Film.** Automatic exposure systems provide acceptable exposure over a wide range of specimen variables with little input from the user. These devices generally produce highly acceptable results when used with color film. Manufacturers have taken special care in designing their exposure device to ensure that the *average* histological specimen will receive an exposure acceptable to most users. To ensure that almost all specimens receive the *ideal* exposure, the best approach is to bracket the basic exposure one step less, normal, and one step higher than the ISO exposure index (a step is the next lower or higher index on the standard ISO scale). This simple approach will ensure that at least one of the three exposures will be excellent in the sequence.

**Polaroid Color Print Films.** Refer to the previous section on Filtration for Polaroid Color Print Film.

**Black-and-White Film.** BW photomicrography presents contrast and exposure factors not present in color photomicrography. The effects of filtration on stained specimens and the response of the photocell are variables; hence the value of the instant print with large-format films. Since processing of 35-mm format films is more extensive and time-consuming, test results are not instant. The low cost of making bracketed exposures of more than one set of filters provides an acceptable solution, if not a perfect one. The following system, designed for use with 35-mm films, can also be applied to large-format films (albeit at proportionately greater cost):

1. Make a filter selection based on visual evaluation or matching spectral bar charts (see section on Filtration for Black-and-White Photomicrography).
2. Place the filter(s) in the light beam. If you have made a table of filter exposure factors as described in the section on Exposure and Filter Factors, apply the related factors now to the ISO index.
3. Make a series of five bracketed exposures at two one-third steps, rather than at single one-third steps. The wide range of exposures should provide one or two acceptable frames with printable densities.

## PROCESSING PROCEDURES

### Color Films

The processing of color films with Kodak E-6 and C-41 chemicals for reversal and negative color films, respec-

tively, has become the de facto standard everywhere. Extending first developer processing times will increase speed and provide a small (but valued) increase in contrast with color reversal films. Almost all professional processing laboratories offer this service as an extra-charge item. E-6 color films can be processed in-house at double the ISO film index.

**Printing Photomicrographs Using Color Negative Films.** If the color negative film is daylight balanced, insert the appropriate color conversion filter. The following system will correct for minor illumination color imbalances for daylight or tungsten films:

1. Expose one or two frames of the negative film to a clear portion of the slide where no tissue is visible. If you have an automatic exposure camera system, the film will be slightly underexposed. This is desirable. There must be less density on the film than would occur if a specimen was in view at the time of the exposure. Manual exposure systems will need to be factored to produce about one-half the normal exposure.
2. Expose the remaining exposures in the same manner as you would with reversal material.
3. Take the film to a commercial printing house, and ask that the color print of the first film exposure be balanced for a neutral gray. Have them lock off the printer controls for color balance but not for exposure control for the remaining exposed frames.

The results, for the most part, will be satisfactory. For insurance, you may wish to supply the operator with a set of matching color transparencies as reference material.

### Black-and-White Films

You can routinely use Kodak Ektapan or TMAX 100 for BW photomicrographs. Ektapan film and TMAX 100 processed in either Kodak's HC-110 or D-11 developers, along with the appropriate contrast-control filters, is suitable for 95% of the histological specimens. The film and developer combinations are *user friendly* (Table 7-5). Films and developers with similar characteristics are available from all major manufacturers.

Kodak Technical Pan film can meet the contrast and resolving power required of almost any type of specimen encountered by the biological photographer. A significant range of contrasts can be obtained with developer and/or processing variations (Table 7-6). Due to the inherent contrast of the film, slight overexposure and/or processing irregularities will cause significant changes in density and contrast. In particular, the recommended processing technique should be followed meticulously; otherwise density fluctuations will appear on the negatives.

**Table 7-5    Processing Recommendations for Kodak Ektapan and Kodak T-MAX 100 Films**

| Films | KODAK Developer | Development Time* (minutes) at 68°F (20°C) | Relative Film Speed ISO | Visual Contrast |
|---|---|---|---|---|
| Kodak Ektapan (sheet) | HC-110 "B" Dil. | 5 | 100 | Medium |
| | D-11 Undiluted | 5 | 200 | Medium to Moderately High |
| Kodak T-MAX 100 (all sizes) | HC-110 "B" Dil. | 7½ | 100 | Medium |
| | D-11 Undiluted | 5 | 200 | Moderately High |

*Agitation 5 seconds every 30 seconds.

**Table 7-6    Processing Recommendations for Kodak Technical Pan Film**

| KODAK Developer | Development Time (minutes) at 68°F (20°C) | Contrast Index | Gamma | Tungsten Exposure Index ISO |
|---|---|---|---|---|
| KODAK Technidol LC (MX 1224) | 10 | 0.56 | 0.65 | 25 |
| HC-110 (Dilution F) | 8 | 0.85 | 1.20 | 50 |
| HC-110 (Dilution D) | 6<br>8 | 1.45<br>1.75 | 1.65<br>2.00 | 100<br>125 |
| D-19 | 4 | 2.40 | 2.90 | 125 |

Note:  Presoak film without agitation in ''wetted'' water for i minute. To make wetted water add 2 drops of wetting agent (Photo-Flo 200) to 16 oz. of water.

Agitate the film in the developer by slowly lifting film out of tank and draining from the corner for 5 seconds. Alternate corner drain each agitation sequence. Sheet film is processed for times and agitation sequence identical to roll film.

## GUIDELINES FOR PREPARING IMAGES FOR PUBLICATION

### Color-Reversal Films

It is relatively easy to judge whether a color transparency will reproduce satisfactorily in print. Obtain a white sheet of bond paper or use the white side of a Kodak gray card (R27). Then, examine the transparency by viewing it with light reflected off the paper. The light source can be the common tungsten lamp, a daylight color-corrected fluorescent lamp[6] (this is the preferred illuminant for evaluating color slides and prints[7]) or diffused sunlight. Whatever source is used, it must be similar to the ambient illumination, since the eye is easily misled when the examining and ambient illuminates have diverse spectral qualities.

A more serious discrepancy occurs when slides are evaluated by projecting them in a darkened room, since there is no ambient illumination or visible reference color. Without these references, the subconscious mind is free to replace density and color of the slide with those it expects in normal circumstances. Except for evaluating the clarity of the image, do not judge color slides destined for publication by projection. Carefully examine the transparency for fall-off illumination at the four corners. Lay the film on paper, so that the light is absorbed in both directions, thus emphasizing any density discrepancy.

Another problem might be introduced during the makeup of the color separations for printing. The operator, unfamiliar with the subject matter, might introduce density and/or color modification not suitable for the subject at hand. In one case, a slide, which was intended to demonstrate the quenching effect of fluorescence due to long exposure time to the exciting beam, was reproduced with almost perfect color and density. The remedy is to indicate clearly to the publisher that what you gave them is what you desire in the printed image, and that no correction should be attempted. Finally, identify the transparency with the author's name and figure number. Also indicate which side of the slide is top and front and, more important, the magnification.

### Color Prints

Most publishers who print color illustrations will accept either reversal films or color prints. If they have a preference, it is weighted for reversal films (chromes), but color prints may be necessary where *press-on* symbols and alphanumeric characters must be added to the print. Although the printer can add these symbols and characters to the reproduction of a color slide, mistakes are possible. A color print should be evaluated under the same lighting conditions as reversal films.

### Black-and-White Prints

The first consideration in making a print is to determine the magnification (or reduction) of the specimen on the print. The extent of this enlargement or reduction must be factored into the original magnification of the specimen's image on the negative. The following system eliminates any complicated formulas in determining this factor:

1. Place a common 3 × 5 inch index card in the enlarger negative holder (4 × 5 inch) at right angles to the negative aperture, thus allowing two sides of the card to be seen on the enlarging easel.
2. Enlarge the visible edges of the negative holder to cover the size of the print.
3. After carefully focusing on the edge of the index card, measure its image width. The ratio of the short side of the card (3 inches) to its projected image is the factor that needs to be applied to the image magnification on the negative.
4. Carefully replace the index card with the negative for the final print-making process. Note that if the image needs a slight touch for optimum focus (use a grain-focusing magnifier), raise or lower the position of the enlarger. Do not change the position of the lens relative to the negative.

In practice, it will be found that an enlargement of the index card image from 3 to 4.5 inches (and, subsequently, the negative) will completely fill the standard 5 × 7 inch print format. This represents an enlargement of 1.5 times the original negative image. For example, if the negative represented a specimen magnification of 200 times, then the 5 × 7 inch print would be 200 × 1.5 or 300 times larger than the original specimen.

Almost all publishers accept 5 × 7 inch prints for publication. A few publishers however, request that prints be scaled down to the width of one column. This practice, although convenient and economical to the publisher, can hamper the photographer from making the optimal print. A larger size, such as the 5 × 7 print, provides sufficient working area to use the common and acceptable printing techniques of *dodging* and *burning-in* to improve the quality of the printed image.

It is common for prints made from photomicrographic negatives to have slight variations in densities. These may occur due to uneven staining effects, which are not apparent when examining the image in the microscope. They occur most often, however, due to uneven illumination in the microscope, the enlarger, or both. Check to make sure that you have satisfied the parameters of Köhler illumination or the manufacturer's recommendation when Köhler illumination is not available. Next, without a negative in the enlarger negative carrier, make a light print. The print will quickly verify if the illumination is uneven.

**Table 7-7  Common Problems and Their Solutions**

| Visual Appearance | Cause | Cure |
|---|---|---|
| *Illumination Problems* | | |
| Uneven illumination (Color Plate 15) | Light source not centered to collector lens or aperture diaphragm. | Refer to the manufacturer's manual or place a section of translucent paper in the condenser's filter holder. Temporarily remove any diffusion screen from the light source and center and focus the light source image. A small hand mirror may be required to see the image on the paper (Color Plate 16). |
| Uneven illumination at low magnifications; a faint image of the lamp filament may be present (Color Plate 17) | Condenser out of focus; the image of the light source is at the focal plane of the specimen. | Refocus the condenser to provide Köhler illumination (if available). At very low magnification a diffusion filter may need to be inserted near the light source. |
| Yellow-colored transparency (Color Plate 18) | Light source operating below the recommended voltage or current (amperage). | Increase the voltage or current to the recommended level or add a blue light-balancing filter. |
| Very-warm-colored transparency (Color Plate 19) | Daylight-balanced film exposed by tungsten light without a color conversion filter. | Insert the appropriate filter in the light path (Color Plate 20). |
| Blue-colored transparency (Color Plate 21) | Blue viewing filter used with tungsten-balanced film. | Remove the filter. |
| *Optical Problems* | | |
| Image appears to have shifted during exposure, but exhibits good contrast. Image shifts when focusing. | Condenser not centered. | Close the field diaphragm and center the diaphragm's image. |
| Mild, but annoying, alternate blue and yellow off-colored images appearing only with objectives above NA 0.60 (Color Plates 22a and 22b) | All condensers, but, in particular, Abbe-type condensers, favor certain color portions of the illuminating beam at focal points above and below center focus. | After setting the *aperture* diaphragm for optimum imagery, focus the condenser to produce equal quantities of red and blue fringing around the *field* diaphragm's image. Any further alteration of the aperture diaphragm may require refocusing the condenser. An achromatic–aplanatic condenser virtually eliminates the problem (Color Plate 23). |
| Excessively hard-edged images. Loss of delicate details. Small subjects surrounded by light and dark rings (Color Plate 24). | Aperture diaphragm setting too small (closed down). | Readjust the diaphragm to produce the best ratio of transmitted light to diffracted light for the tissue in question (Color Plate 25). |
| Insufficient contrast (Color Plate 26) | Aperture and field diaphragm exceed the aperture (NA) of the objective and the field of view, respectively. | Most, but not all, specimens require reducing the aperture diaphragm below the aperture of the objective lens. Adjust the diaphragm to suit the specimen (Color Plate 27). Always set the field diaphragm slightly outside the field of view for the film format. |
| Images out of focus at low magnifications (Color Plate 28a) but not at high magnifications (Color Plate 28b). The problem occurs only with a young operator. | The tissue was not in focus with the reticle. A young person almost instantly adjusts their vision to various focal distances (accommodation); thus the reticle and tissue are not in identical focus. | Verification of actual focus can be made by slightly moving the head from side to side while observing the reticle and specimen. The focus is correct when both remain aligned. The use of a focusing magnifier will ensure exact focus. |
| Images are hazy when using high-dry lenses (Color Plate 29) | Excessively thick or thin cover slip. Incorrect setting of the lens correction collar. | Although more than one of the following solutions may be necessary, only two are practical on the modern microscope: (1) Adjust the correction |

**Table 7-7   Common Problems and Their Solutions** *Continued*

| Visual Appearance | Cause | Cure |
|---|---|---|
| | | collar (if any) until the image has maximum contrast (Color Plate 30), or (2) Reduce the aperture diaphragm to the smallest level consistent with acceptable image quality. |
| Images are hazy when using immersion lenses (Color Plate 31) | Air trapped in the immersion fluid (Color Plate 32, view at rear lens of objective). | Clean the lens and the slide of all immersion fluid. Focus the image with a high dry lens. Then rotate the lens out of the light path. Place a drop of immersion fluid on the slide and rotate (do not dip) the immersion lens into the fluid. |
| All images are out of focus at all magnifications. | The focusing eyepiece was not focused on the reticle. | With a relaxed eye, focus the eye lens of the viewing telescope to produce a sharp image. |
| Density artifacts (round), with light and dark rings, when using high-power objectives | Dirt on top of the projection eyepiece. | Clean the lens. |
| Density artifacts, usually irregular in shape (Color Plate 33) | Dirt on top or bottom of specimen slide (Color Plate 34). This can be verified by noting the artifact's position as the slide is shifted and focused above and below the specimen. | Clean the slide. |
| All four edges of field equally dark at very low magnifications (Color Plate 35) | On some inexpensive microscopes the illumination system will not fully illuminate the field of view for scanning lenses. | Try removing the condenser from the light path. A practical solution may not be possible. |

*Photographic Problems*

| Visual Appearance | Cause | Cure |
|---|---|---|
| Consistently dark or light images at all magnifications | (1) The exposure index (ISO) is set too high or low for the film in use or (2) the light-sensitive cell response does not represent the corresponding sensitivity of the film and filter in use (BW films). | (1) Refer to the film manufacturer's instruction sheet for the proper exposure index. (2) Devise a table of filter factors as related to the method of determining exposures (BW films). |
| Light images (overexposure) only at low magnifications | The camera shutter cannot operate at a sufficient high speed when intense illumination is present. | Insert an ND filter into the light path (try an 0.60 density). |
| Dark and off-color images at high magnifications; the effect is most likely to occur when using large format films (Color Plate 36) | Very low level of illumination at the film plane, thus requiring increased exposure times and a color correction filter due to reciprocity effects. | Lower the film exposure index and add the manufacturer's recommended color correction filter. |
| Film is overexposed only at low magnifications (Color Plate 37). | At low magnifications the illumination can be so excessive that the shutter speed available with automatic cameras, cannot adjust sufficiently to provide correct exposure. | Inserting a neutral density filter into the light path will correct the excessive illumination (Color Plate 38). |
| Tissue has mild bluish cast that cannot be removed by a mild yellow CC filter. | Some tungsten-halogen lamps transmit UV light. The CC filter absorbs very little of the UV light. | Insert a Kodak 2A or 2B filter in the light path. It is recommended that this filter be used with all color films. |

*Mechanical Problems*

| Visual Appearance | Cause | Cure |
|---|---|---|
| No exposure or partial exposure | Dark slide on camera fully or partially inserted | Self-evident |
| No exposure or multiple overlapping exposures; torn sprocket holes at the lead end of the film (Color Plate 39) | Film improperly loaded | Refer to the manufacturer's manual. |
| Ghost images (Color Plate 40) | Double exposures; film not advanced | Film must be advanced following each exposure. |
| Film does not rewind into cassette. | Film advanced beyond normal limit, causing it to be pulled off the spool. | Open the camera in the dark. Rewind the film into the cassette or cassette holder. Seal and mail to processing lab with note indicating problem. |

Reprinted with permission from John P. Vetter, 1988. "Photomicrography, A Translation into the Vernacular". Part IV, *Journal of Biological Photography*, Volume 56, Number 3.

The print must have a normal to *high* contrast appearance as opposed to a *soft* or low-contrast appearance. To prevent a mixup of illustrations, it is important to follow the publisher's instructions for identification. If instructions are not available, the following information will suffice: Across the top back of the print, neatly hand letter these items, using a soft pencil for fiber-based prints or a black Dixon film-marking pencil No. 2225 on RC (resin-coated) prints:

1. The author's name
2. The illustration numbered in Arabic numerals (Figure 1, Figure 2, and so on) or table numbered in Roman numerals (Table I, Table II, and so on)
3. The total magnification of the specimen (×300).

## COMMON PROBLEMS AND THEIR SOLUTIONS

Photomicrography is a marriage of two disciplines: microscopy and photography. For the uninitiated, a problem in one discipline may appear to be a problem in the other. For example, the aperture of an Abbe condenser must be set and focused carefully to eliminate the effects of chromatic aberration. When slightly out of focus, the resulting image may have a blue or red tint. To one not familiar with this effect, it would be surmised that an incorrect filter had been placed in the light beam.

Common problems, along with several illustrations, are listed in Table 7-7 to give the relatively inexperienced person an easy method by which to resolve both complex and simple problems. Readers need only match the appearance of their photographs with one or more of the listed problems to obtain the solution. This approach may not totally satisfy the technically oriented photographer, but it does work. A few notes are in order to ensure success:

1. List on an exposure sheet of paper all the variables known to exist (condenser, aperture setting, objective, filter, and so on). Make this record for all photographs you take now and in the future. A sample exposure sheet is included at the end of this chapter, and you are free to reproduce it.
2. Select the illustration that comes closest to your not-so-perfect photograph.
3. Keep in mind that more than one problem may exist. Eliminate the most prominent problem first. After the major problem is resolved, less obvious problems will become more apparent and easier to identify and correct.
4. The system works best with color films.

## A QUICK PROCEDURE GUIDE

This guide is designed to assist the photographer in aligning and adjusting the microscope for optimum pho-

tography using Köhler illumination. The steps should be followed in exact sequence.

1. Load the film into the camera.
2. Turn on the microscope lamp and adjust to a comfortable viewing level.
3. Place the specimen slide on the stage and focus with a 10× power objective lens.
4. Completely open the *field* diaphragm. The diaphragm is usually located on the base of the microscope (Figure 7.18a).
5. Completely open the *aperture* diaphragm and then close it until a definite change of illumination occurs. The diaphragm is attached to the substage condenser (Figure 7.18b).
6. Adjust the *field* diaphragm for a small opening. Focus the image of the field diaphragm by raising or lowering the substage condenser (Color Plate 41a and Figure 7.18c).
7. Center the *field* diaphragm image by using the radial centering screws (Color Plate 41b and Figure 7.18d).
8. Open the *field* diaphragm to three-fourths field of view (Color Plate 41c).
9. Adjust the *aperture* diaphragm for the best image quality. This adjustment should be made with extreme care.

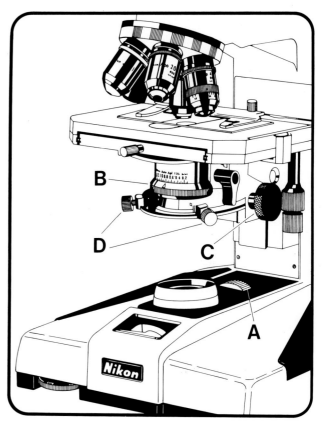

**FIGURE 7.18** **(a–c) This schematic identifies the four vital controls used when adjusting the microscope for Köhler Illumination. Reprinted with permission from John P. Vetter, 1988. "Photomicrography: A Translation into the Vernacular", Part IV,** *Journal of Biological Photography,* **Volume 56, Number 3, p. 107.**

**Table 7-8  Exposure Sheet for Photomicrography**

## EXPOSURE SHEET FOR PHOTOMICROGRAPHY

Microscope _____

Camera _____

Date _____

Film _____

| Exposure # | Tissue or Slide Number | Light Source Amperes or Volts | Filters | Condenser | Objective | Eyepiece | Magnifi-cation | Exposure Index ISO | Exposure Time | Other | Remarks |
|---|---|---|---|---|---|---|---|---|---|---|---|
| 1 | | | | | | | | | | | |
| 2 | | | | | | | | | | | |
| 3 | | | | | | | | | | | |
| 4 | | | | | | | | | | | |
| 5 | | | | | | | | | | | |
| 6 | | | | | | | | | | | |
| 7 | | | | | | | | | | | |
| 8 | | | | | | | | | | | |
| 9 | | | | | | | | | | | |
| 10 | | | | | | | | | | | |
| 11 | | | | | | | | | | | |
| 12 | | | | | | | | | | | |
| 13 | | | | | | | | | | | |
| 14 | | | | | | | | | | | |
| 15 | | | | | | | | | | | |
| 16 | | | | | | | | | | | |
| 17 | | | | | | | | | | | |
| 18 | | | | | | | | | | | |
| 19 | | | | | | | | | | | |
| 20 | | | | | | | | | | | |
| 21 | | | | | | | | | | | |
| 22 | | | | | | | | | | | |
| 23 | | | | | | | | | | | |
| 24 | | | | | | | | | | | |
| 25 | | | | | | | | | | | |
| 26 | | | | | | | | | | | |
| 27 | | | | | | | | | | | |
| 28 | | | | | | | | | | | |
| 29 | | | | | | | | | | | |
| 30 | | | | | | | | | | | |
| 31 | | | | | | | | | | | |
| 32 | | | | | | | | | | | |
| 33 | | | | | | | | | | | |
| 34 | | | | | | | | | | | |
| 35 | | | | | | | | | | | |
| 36 | | | | | | | | | | | |

J. Vetter 4/90

10. Refocus and recenter the *field* diaphragm. The image of the specimen and field diaphragm must be in identical focus to achieve Köhler illumination.
11. Open the field diaphragm until it is just outside the field of view or, for photography, just outside of the area included in the film format (Color Plate 41d).
12. Adjust the light source to the desired voltage (or amperage) and insert the appropriate filters.
13. Set the exposure device to the film exposure index.
14. Make the exposure.

When changing objectives, repeat steps 4 to 11. When changing specimens, repeat steps 6 to 11. *Please note that all exposure and optical variables, test or otherwise, should be recorded for reference purposes. An exposure sheet (Table 7-8) can be copied and printed on an office copier for your convenience.*

## ACKNOWLEDGMENTS

I would like to express my appreciation to the following people; without their assistance this chapter would not have been complete: Marjorie Sisak, graphic artist; Dennis Kostley, technical artist; Lee J. Shuett, Nikon Inc., for the loan of equipment necessary to develop this presentation; Martin Scott, for technical assistance on the photographic process; Sally Robson, Director, Scientific Imaging, at Kodak; the photographic staff at The Western Pennsylvania Hospital in Pittsburgh; and Bev Sarver, who reviewed and refined my manuscript.

## ENDNOTES

1. A simple photometric law, known as the *reciprocity* law, states that the amount of film exposure is given by the product of illumination and the time it is allowed to act. Thus, an exposure time of 1/20 second with illumination from a 100 candle power lamp would have the same photographic effect as an exposure time of 1/2 second with an illumination from a 10 candle power lamp at the same distance. However, in practice, the photographic effect of these two equivalent exposures on the film is not found to be the same. The failure of the film to respond equally to exposures of equal energy, but made up of time and intensity in different proportions, is known as the *reciprocity law failure* or *reciprocity effect*. Reciprocity effects vary with emulsion types and are most obvious with color film, since density and color effects are present. See Chapter 2, the section on Reciprocity Effect.
2. Large *poster-size* prints (20 × 30 inches) are available from Kodak and all major photographic laboratory facilities at $17 (1990). The competitive nature of the amateur photographic market will see film and print improvements from all manufacturers during the life span of this book.
3. In addition to the solid glass filters promoted by the microscope manufacturer, The Schott Glass Technologies, Inc., York Ave., Duryea, PA 18642, offers a wide variety of glass filters in colors and densities for microscopy, as well as for everyday photography. Kodak's *Kodak Filters for Scientific and Technical Uses* lists hundreds of filters for use in photomicrography, other scientific instruments, and everyday photography.
4. Lamp specifications: Manufacturers recommend voltage (or amperage) settings that they determine to be best suited for their particular microscope. If you find these settings unsatisfactory or unavailable, use the following settings:

    20-watt lamp: 100% of rated voltage/amperage
    50-watt lamp: 90% of rated voltage/amperage
    100-watt lamp: 80% of rated voltage/amperage

5. Kodak's *Kodak Color Print Viewing Kit* (Cat. No. 150-0735) is not only useful in determining which additional filter(s) is necessary to color correct a transparency or print in future exposures, but the kit filters can also be inserted in the light beam to obtain similar photographic effects. This is an economical method of determining which color-compensating (CC) filters are required without purchasing the full set of gelatin CC filters. It should be noted, though, that the filters are dyed acetate and cannot be used in systems employing polarizing elements. For polarized light examinations the gelatin or glass filter(s) is required.
6. One manufacturer of such fluorescent tubes is:
    Macbeth Color & Photometry
    P.O. Box 950
    Little Britain Road
    Newburgh, NY 12550
    914–565-7660
    Order tube No. Macbeth F40T1250
7. For detailed information:
    *Color Prints, Transparencies, and Photomechanical Reproductions—Viewing Conditions*
    American National Standards Institute (ANSI)
    1430 Broadway
    New York, NY 10018
    and
    *Part III, Lighting*, Sections 1 to 5
    Macbeth Color & Photometry
    P.O. Box 230
    Little Britain Road
    Newburgh, NY 12550
    800–431-4952

## REFERENCE

Vetter, J. P., 1984. Photomicrography. In Morton, R. A. (ed.) *Photography for the Scientist*, 2nd ed. London: Academic Press, Chapter 8.

## BIBLIOGRAPHY

Hartley, W. G., 1979. *Hartley's Microscope*, 1st ed. New York: Seneca Press.

Lawson, D. F., 1972. *Photomicrography*. New York: Academic Press.

Loveland, R. P., 1972. *Photomicrography: A Comprehensive Treatise*, 2 Vols. New York: Wiley.

Martinsen, Wm., 1952. "Gross Specimen Photography: A Review". *M & BI*, Volume 2, p. 179 et seq.

Needham, G. H., 1977. *The Practical Use of the Microscope*, 2nd ed. Springfield, IL: Charles C Thomas.

Shillaber, C. P., 1944. *Photomicrography in Theory and Practice.* New York: Wiley.

Smith, R. F., 1990. *Microscopy and Photomicrography: A Working Manual.* Boca Raton, FL: CRC Press.

## TECHNICAL PUBLICATIONS FROM OPTICAL AND FILM MANUFACTURERS

Carl Zeiss, Oberkocken, Germany.
Möllring, F. K., *Microscopy from the Very Beginning* (1976) (out of print).

Eastman Kodak Co., Rochester, NY 14650.

1. P-2, *Photography Through the Microscope.* (1988)
2. B-3, *Kodak Filters for Scientific and Technical Uses.* (1990)
3. E-37, *Kodak Ektachrome Professional Films.* (1988)
4. F-5, *Kodak Professional Black and White Films.* (1990)
5. P-255, *Kodak Technical Pan Film.* (1982)

Leitz, E., Inc., Rockleigh, NJ 07647.
*Photomacrography and Photomicrography.*

Nikon Inc., 1300 Walt Whitman Road, Melville, NY 11747-3064

1. *Photomicrography, Polaroid Photography Manual.* (1990)
2. *How to Use a Microscope and Take a Photomicrograph.* (1990)

Olympus Corporation, 4 Nevada Drive, Lake Success, NY 11042.

1. Abramowitz, M., *Contrast Methods in Microscopy.* (1985)
2. Abramowitz, M., *Microscope Basics and Beyond.* (1987)

Polaroid Corporation, 784 Memorial Drive, Cambridge, MA 02139-4688.

1. *Instant Films.* (1988)
2. *The Use of Filters in Black and White Photomicrography* (1980) (out of print).
3. *The Use of Filters in Color Photomicrography* (1980) (out of print).
4. *The Effect of the Aperture Diaphragm Setting on the Image* (1980) (out of print).
5. *Köhler Illumination* (1980) (out of print).
6. *At a Glance: The Basic Steps to Successful Photomicrography.* (1980) (out of print).
7. *Special Contrast Enhancement Techniques.* (1981)

# Chapter 8
# Close-up Photography and Photomacrography

## Michael Peres

*"The world is full of small things which no one, by any chance, ever observes."*

A. Conan Doyle (Sherlock Holmes) 1859–1930

This chapter discusses equipment and techniques suitable for close-up photography and photomacrography at various levels. It demonstrates the basic differences between the optical factors involved and those for ordinary photography. The chapter also includes basic theories and applications of close-up photography and photomacrography. Some points of discussion provide cross-references to other chapters to assist in concept development.

The basic premise of this chapter is that the reader is involved with photography at some level. Some of the concepts may be difficult to understand, but every effort has been made to simplify them. The chapter presents strategies for close-up photography and photomacrography, to enable photographs to be produced in many situations.

## TERMINOLOGY

### Language and Definitions

Before discussing the theory of close-up photography and photomacrography, some of the language and definitions will be introduced. Use of the proper terms is imperative for accurate communication and understanding of principles.

### Reproduction Ratio

In close-up photography, as with general photography, the image is generally smaller than the object. Close-up photography includes images with an image ratio or size relationship to object of 1 : 1 (or life-size) down through images that are 1 : 10 (or one-tenth life size). The name given to this type of relationship is the *reproduction ratio* or *repro image ratio*. It is a mathematical ratio of image size to object size (I : O) and can easily be calculated. These ratios are inscribed on most good-quality close-up lenses

for use in applied situations. *Reproduction* or *repro* ratios are used unless stated otherwise.

## Magnification

When the image size is larger than the subject, the image has been *magnified*. The ratio will have a larger first term, such as 20 : 1. The term *photomacrography* is used when photographic pictures are made by enlarging or magnifying the subject. The similar-sounding term *macrophotography* refers to the same process; however, *photomacrography* is preferred.

When indicating magnification properly, the upper case "X" or the multiplication sign "×", should be placed in front of the number. For example, if an image were magnified 20 times, it would be indicated X20, which eliminates the need to write the reproduction ratio as 20 : 1. Unlike some things that are easily defined, there is some confusion and debate as to where photomacrography ends and photomicrography begins.

Anything greater than 1 : 1 is universally accepted as a photomacrograph; however, there is disagreement about where photomacrography ends. In many writings, it is clearly stated as being either X40 or X80. The maximum degree of magnification achievable in photomacrography is better decided visually. Photomacrography can no longer be used when image loses its resolution. Another way to look at this decision is: At what magnification is the information still well defined? *Major considerations are: What is the final image going to be used for? and At what distance will the image be viewed?*

In photomicrography, there is a defined point where the magnified image potentially no longer contains fine detail. This point is called *empty magnification* (see Chapter 7). This also happens in photomacrography, but this point is not as clearly defined as in photomicrography. The point where the image is no longer resolved must be visually noted and is dependent on the photographic system used. It can be as low as ×40 in some cases and

may be as high as ×80 in others. The degree of magnification is limited by the subject, the correctness of the optics, technique, and ultimate viewing distance.

## Magnification of the Image

In close-up photography and photomacrography, the image is reduced or enlarged, respectively. The calculation of magnification is handled in a similar fashion regardless of whether a reduction or magnification has occurred. Image size is most easily determined by referencing the actual size of the subject; that is, reduction or magnification can be calculated by comparing image size to subject size. More simply stated, magnification is equal to the image size divided by the object size.

$$M \text{ or } R = \text{Image size/Object size}$$

An easier way to think about this might be: How big is the image on the film versus how big is the subject? The process of magnification does not end with the production of a magnified image in the camera. In fact, it follows the process all the way through, including prints as projected images.

This process of magnifying is routinely done in the darkroom with negatives and enlargers and/or with transparencies and slide projectors. The common enlarger is actually a photomacrographic device that uses the principles mentioned.

How much magnification occurs when a 35-mm negative is printed onto a 5 × 7 inch printing paper? This additional magnification is approximately ×5, which must be considered in determining final magnification of a print. For example, using a 35-mm negative with an image magnification of ×5, and subsequently making a 5 × 7 print from it, the total magnification in the print would be 5 × 5 or ×25.

Another reason to understand magnification is that a request may be made to produce a print at a specific magnification. Use ×45, for example. In this situation, the final magnification is already known, and the process must be worked backward. The print size might be 5 × 7 for this example. What magnification should be achieved in the negative? Dividing the ×45 by ×5, the enlargement factor, the required magnification in the negative is ×9.

Never try to achieve magnification *only* through the photographic enlargement in the darkroom. As much as possible, a required high magnification must be achieved in the negative. At moderate printing ratios, moderate enlargement is practical. As with any other photographic process, excessive enlargement of the image will cause film grain to become visible, and there will be a loss of edge sharpness and contrast. The display of minuscule details in the subject must be paramount in the execution of the photograph.

## Magnification Determination

One method of determining the image magnification is to photograph a ruler at the same magnification. When an image of the ruler has been made at this magnification, the image of the ruler can be used as a known reference scale to be compared mathematically to the image size. For example, if a photograph of a 1-cm ruler is made, and the final image ends up with a ruler magnification that looks like Figure 8.1, a mathematical comparison will determine what the magnification is.

Laying a metric ruler across the reference image and determining its distance, one should have found the original 1-cm distance to be enlarged to a 4-cm length at the image. The subject or distance was 1 cm before magnification and is now 4 cm in length. Using the equation

$$m = I/O$$

the magnification can be found to be X4. If the negative image is further enlarged by projection printing, then measuring the image (of the ruler) on the easel will give the total two-step magnification of the image.

## More on the Magnified Image

In more traditional types of photography, the subject is always farther from the lens than the film. This is also true in close-up photography. These distances between lens and subject and lens to film are referred to as *lens conjugates*. Figure 8.2 presents a closer look at these relationships.

## Working Distance

The distance from the front of the lens to the subject is the lens's *working distance* (see Chapter 2). The distance from the back of the lens to the film is the *image distance* or *bellows length* (see Chapter 2). In close-up photography, the working distance is longer than the image distance. When images are being made at 1 : 1, the working distance and the image distance will be equal to twice the focal length of the lens in use. Longer focal lenses will

**FIGURE 8.1** This figure shows a magnified portion of a centimeter ruler. Always use the longest reference distance possible for the most accurate results.

Typical subject/Lens/Image relationship

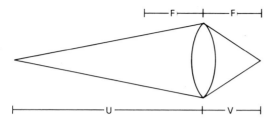

Photomacrography

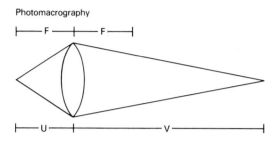

U = Subject distance
V = Image distance
F = 1 Focal length

**FIGURE 8.2** This figure shows the roles of image conjugates in common photographic versus photomacrographic situations. In a situation where there is image reduction, the subject distance *U* will always be longer than 2*F*. In photomacrography, the lens conjugate roles are reversed. *U*, or the subject distance, is now shorter than *V*, the image distance. These distances can always be related with the lens equation:

$$1/F = 1/U + 1/V$$

produce 1 : 1, just like shorter focal length lenses when their object and image distances are double the focal length. Thus a major consideration for using a longer focal length lens may be the increased working distance in front of the lens.

## Magnification and Focal Length

Much of the discussion to this point has been focused around the concept of magnification. The equation $m = I/O$ is not the only way to describe magnification. A better way to evaluate magnification of a camera system is by using the equation

$$v = (m + 1)F$$

where $v$ is the image distance, $m$ is the magnification of the system, and $F$ is the focal length used. For a better understanding of this refer to Figure 8.3.

This equation can be used effectively for magnification calculations in close-up photography or photomacrography, independent of the format of the camera system utilized. To reinforce these concepts, look at a few rela-

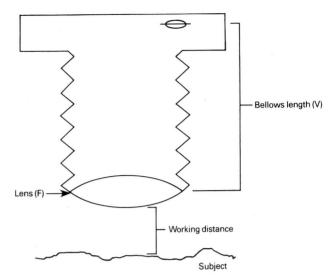

**FIGURE 8.3** This figure shows the components used in close-up photography and photomacrography. The equation that relates all the components together is

$$v = (m + 1)F.$$

**This equation can also be written:**

$$m = \frac{v - F}{F}$$

**when solving for magnification.**

tionships. In pictorial photography when a larger image size is required, a longer focal length lens can be used from the same vantage point. This produces a larger image on the film. For example, if using a 50-mm lens at 10 feet from a subject and a larger image size is needed, substituting a 100-mm focal length lens will produce an image that is twice as large on the film. In photomacrography the reverse is true. If more magnification is needed, substituting a 25-mm focal length lens for a 50-mm focal length lens will double the size of the image (at the same bellows extension). This differs from traditional relationships of image size to focal length.

There is one other aspect of focal length relationships worth noting. The longer the focal length of the lens, the greater the object distance for a given magnification. With increased working distance, the subjects can be accessed more easily. This will become especially important in subsequent discussions on lighting and subject management (Figure 8.4).

When a magnified image is required, photomacrography will be needed. Magnification in photomacrography is a function of two variables. One of these variables is the focal length of the lens and the other variable is the image distance (or bellows length).

Using the equation

$$v = (m + 1)F$$

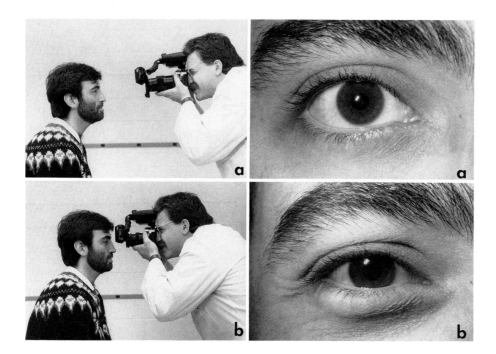

FIGURE 8.4 (a) The pictures on the top row were made with the 100-mm lens at 1:2, while (b) the lower row were made with a 50-millimeter lens at 1:2. Both fields are identical, but some of the spatial relationships have recorded differently. The different appearance of these pictures is also a product of the lighting, which had to be moved to accommodate the change in working distance.

virtually every conceivable situation can be explored prior to setting up a camera. Examine the effects on magnification using a system with a constant bellows length of 10 inches and a focal length that will be changed.

Many magnification problems can be solved using the equation:

$$v = (m + 1)F,$$

where $v$ is the image distance, $m$ is the magnification, and $F$ is the focal length used.

(1) $v = (m + 1)F$     (2) $v = (m + 1)F$
$10 = (m + 1)4$          $10 = (m + 1)2$
$10 = 4m + 4$            $10 = 2m + 2$
$6 = 4m$                $8 = 2m$
$m = \times 1.5$            $m = \times 4$

(3) $v = (m + 1)F$
$10 = (m + 1)1$
$10 = m + 1$
$9 = m$
$m = \times 9$

In situation 1, the image is one and a half times ($\times 1.5$) larger than the subject. In situation 2 the image is four times ($\times 4$) larger than the subject, and in the last situation the image is nine times ($\times 9$) larger than the subject. It can be easily seen from these mathematical relationships that *the magnification of the system can be increased by using shorter focal length lenses.*

The other factor affecting magnification is *changing the distance from lens to the film (bellows length).* Increasing the distance between the film and lens will increase magnification. The process is identical to how an enlarger works: the farther the enlarging lens is from the paper, the greater the magnification. This image distance change can be increased on a camera by using one of two pieces of equipment: a bellows, which has a variable length, or extension tubes. There will be elaboration on these pieces of equipment later.

The same equation of $v = (m + 1)F$ can be utilized to ascertain the system magnification regardless of the component parts used. For example, if you were using a 35-mm focal length lens with a bellows length of 20 inches (508 mm), the image magnification would be $\times 13.5$.

The results are the same even if we measure in millimeters, in which case $v = 508$ mm, $F = 35$ mm, and

$$508 = (m + 1)35$$
$$508 = 35m + 35$$
$$473 = 35m$$
$$m = \times 13.5 \text{ (image magnification)}$$

In using this equation, it is fairly easy to calculate and determine the focal length and the bellows extension necessary before setting up the system for a desired magnification. Note: The actual magnification obtained may differ slightly using the above formulas, since the equation is based on knowing the exact position of the lens rear nodal plane, rather than the lens itself.

## CLOSE-UP PHOTOGRAPHY

### Concepts of Applied Close-Up Photography

The concepts of magnification and the magnified image are important in close-up photography. It is difficult to delineate which magnifications lie in the realms of close-

up photography, photomacrography, and photomicrography; some ranges of magnification are presented below:

| Close-up photography | 1 : 10–1 : 1 |
| Photomacrography | 1 : 1–80 : 1 |
| Photomicrography | 2.5 : 1–1250 : 1 |

These magnifications are those initially recorded on film. Depending on the viewer's viewpoint, additional magnification by projection is usually warranted. Surprisingly, close-up photography does not require much additional equipment. While any format can be utilized, this chapter discusses 35-mm systems since this is the most common format in biomedical applications.

Most 35-mm camera systems can be set up to do close-up photography. The *lens* is the key element in the system. Whether the camera is manual or a sophisticated automatic is comparatively unimportant.

## The Lens

The *lenses* used in close-up photography are the critical element and are designated by manufacturers as close-up or macro lenses. Unfortunately, the term *macro lens* has evolved as a term synonymous with *close-up photography*. A *true* macro lens is specifically designed to produce *magnified* images of very small objects.

A buyer seeking to purchase a quality close-up lens will have to rely on the reputation of the manufacturer, since the term *macro* has been loosely applied to a wide variety of lenses, including some close-up lenses. Nikon's Micro-Nikkor and other similar lenses are high-quality *close-up lenses*. One capability of this type of lens that distinguishes it from other lenses is its ability to focus closer than normal lenses without any attachments; *closer* is distinguished as less than 18 inches. In contrast, a traditional (normal) lens is designed to have its plane of good focus at infinity, while objects photographed closer than 18 inches may be reproduced with less than ideal quality. The other real asset of a good close-up lens is its ability to deliver edge-to-edge image sharpness with no curvilinear distortion or curvature of field (Figure 8.5). A high-quality enlarging lens is designed with similar optical parameters and can be adapted for many close-up applications.

Photographic advertisements often praise the value of *macro zoom* lenses as suitable for close-up photography. Their design may allow the lens to focus close to the subject, but the actual image size may not be what is expected from the name "macro zoom." Many of these so-called macro zooms fall short of the mark in critical sharpness and fine detail rendering and are to be avoided for critical applications. A fixed-focal-length lens with a positive supplementary lens may perform much better for this type of work than multipurpose

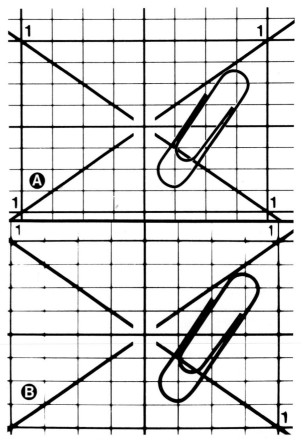

FIGURE 8.5   This illustration shows the capabilities of (a) the Nikon 55-mm Micro-Nikkor *f*/2.8 close-up lens compared with (b) the Nikon 50-mm Nikkor *f*/1.8 normal lens. Both photographs were made at the lens maximum aperture.

lenses such as a macro zoom lens. The section on The Lens in Use in Chapter 2 provides an interesting and valuable discussion of close-up, macro, and macro zoom lenses.

Another feature of good-quality close-up lenses is the additional engravings on their barrels. These engravings are referred to as the *lens reproduction ratios* (also known as *repro ratios*). These ratios represent the subject size compared with image size. The normal range is from 1 : 10 to 1 : 2, with a few reaching 1 : 1 without additional equipment. Some lenses will have two sets of numbers representing ratios with and without an extension tube.

## APPLIED CLOSE-UP PHOTOGRAPHY

In close-up photography, subjects are photographed using a relatively short working distance. To achieve a specific image size in close-up photography, traditional techniques must be abandoned and some close-up techniques used. First, determine what repro ratio will work best for the image size requirements by looking through

the viewfinder and determining when the image size is approximately correct. Next, refer to the lens barrel, and set the repro ratio that is closest to this size.

### Focusing

*Focusing* the image is accomplished in a slightly different mode from traditional approaches. Since the lens has been calibrated for specific repro ratios, these should be maintained. The image is brought into sharp focus by moving the entire camera system back and forth. The repro ratio must be recorded for future reference and calculating image size when printed.

Because focusing in close-up photography is accomplished by changing the working distance, an important piece of equipment is the *focusing rail*. The rail is a flatbed apparatus that moves back and forth on another rail and allows for precise control over subtle changes in the working distance. At 1 : 10 repro, no rail is necessary and may even be a hindrance in live subject photography, but at a 1:2 repro its advantages will be immediately realized. Focusing rails are available from major manufacturers of camera equipment and other suppliers such as Bencher and Spiratone.[1]

### Depth of Field

The amount of sharp focus in a picture is referred to as its depth of field (DOF). Having sharp pictures with good depth in their focus is important to quality work. The sharpness of a picture and the amount that is in sharp focus is based on how critical the viewer is. This judgment is subjective and varies with the individual.

The DOF of any image is affected by the aperture used and the image magnification of the system. By using a smaller aperture, a picture with more acceptable focus will be produced. This gain in DOF produced by the stopping down of the lens aperture can be offset by the need for greater magnifications. The closer the subject, the smaller the DOF. Even with small apertures the DOF tends to be small. At 1 : 2 at $f/32$, only approximately 2-cm plane of critical sharpness can be maintained (Figures 8.6 and 8.7).

### Techniques to Maximize Depth of Field

Because the DOF is limited, every trick to maximize the amount of focus must be used to maintain it. One way to accomplish this is through camera and subject orientation. The orientation of the film plane in the camera must be critically aligned to the *plane of best information* in the specimen; that is, the subject should be parallel to the

**FIGURE 8.6  A ruler photographed at 1:6 on the film shows the depth of a field change when the aperture is stopped down. The ruler was laid at a 45-degree angle to the lens axis and shows the effect of using (a) *f*/2.8, (b) *f*/16 and (c) *f*/32 on DOF.**

film plane. This is very easy to accomplish by using a spirit level if the subject is flat and stationary. When they are parallel to each other, very precise control of focus can be achieved. In this fashion, the subject can be photographed, with little or no concern for lack of sharpness across its surface, because all regions should fall within the limits of the DOF (Figures 8.8 and 8.9).

When the subject is not flat, as with a face or some other subject that has dimension, it must be analyzed for

**FIGURE 8.7  This figure shows the relationship of available depth of field to working distance. (a) This picture was shot at 1:6 using *f*/32; (b) this was shot at 1:4 using *f*/32; (c) this was shot at 1:2 using *f*/32.**

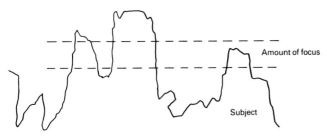

**FIGURE 8.8 This figure shows the surface of a subject and the author's choice of "the plane of best information." It becomes more difficult at higher magnifications to achieve focus throughout the subject.**

the most important parts to be photographed and their sharp focus maintained. To determine what is important, look at the subject and decide which plane contains the most important information. Once this has been determined, align your camera's film plane to this plane. This can be accomplished by choosing a *perspective* or viewpoint perpendicular to that plane. By doing this, the maximum subject focus can be achieved.

Perspective also has implications in close-up photography and photomacrography. *Perspective* is the visual or photographic appearance of objects in space as a function of the observer's (or camera) viewpoint. In close-up and photomacrography, a longer or shorter focal length lens will force the camera to be farther or closer to the subject, thus changing the perspective. The change of perspective will directly influence the appearance of shape and size of the subject's characteristics. The position of the viewer on examining the slide or print is another factor to consider.

To illustrate: photographs of an eye taken with a 50-mm and a 100-mm lens and subsequently enlarged to 8 × 10 inch prints will have a different appearance, since the photographer on using the 100-mm lens was forced to move away from the subject to obtain the identical scene area as the 50-mm lens. On the other hand, if the 50-mm lens was at the same distance as the 100-mm lens and the print was additionally enlarged to match the area made with the 100-mm lens, *the images would be identical*. See Chapter 2 for a discussion of DOF and perspective.

There is one other way to maximize the DOF in this type of picture making. All too often the little DOF potentially available is wasted. Consider a finger as the subject and that a picture of the finger's nail bed is needed. Based on previous experience, a 1:2 or even a 1:1 repro ratio will meet the picture's magnification requirements.

The DOF produced in a picture occurs above and below the plane of primary focus. However, there is more DOF produced below the plane of primary focus than above it. In the example of the nail bed, if the plane of focus is placed on the surface of the nail bed, some DOF actually occurs within the finger itself as well as above the finger (Figure 8.10).

The DOF in this situation most probably cannot cover the depth of field requirements of a finger. To capture the best possible focus in the picture and take advantage of the DOF realities, focus into the finger. The amount of DOF available can be visualized by using the DOF preview button. Carefully monitor what remains in focus as the focus is shifted into the subject. When the surface is no longer in focus, back up until it becomes well defined again. In this fashion, the maximum amount of focus available can be fully realized (Figure 8.11).

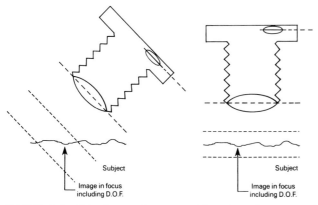

**FIGURE 8.9 This figure shows considerations for camera/subject alignment. If the camera is not perpendicular to the subject's surface (or plane of best information), the amount of image focus will be minimal. Care should be taken to ensure the best alignment of subject to camera.**

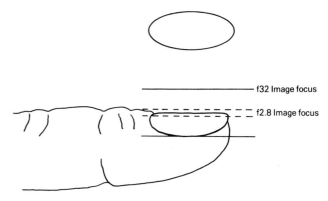

**FIGURE 8.10 Diagram of a nailbed being photographed. The lens' focus has been placed on the surface of the nail. The amount of focus produced using *f*/2.8 is represented by the dotted lines and the DOF when the lens is stopped down to *f*/32 is represented by the solid lines.**

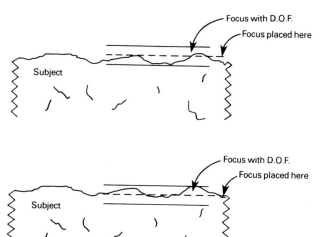

**FIGURE 8.11** This figure is similar to Figure 8.10. A way to achieve better focus is to use hyperfocal distance or focusing into the subject. Use the lens in a stop-down mode to allow previsualization of DOF while focusing up and down.

Magnification influences DOF. It is a function of the lens focal length and image distance of the system. The lower the image magnification required, the farther the lens will be from the subject. This results in easier subject management. When the subject is very close to the lens, moving the subject or making adjustments to the system is much more exacting and difficult because there is little space in which to operate. Using a longer focal length lens will produce a longer working distance and a more manageable subject.

In Chapter 2 (The Lens in Use) the general aspects of depth of field are discussed. The specific factors affecting close-up photography and photomacrography are covered in this chapter. The classical formula for total DOF (*T*) is:

$$T = 2CN \frac{(M + 1)}{M^2}$$

where *N* is the marked aperture on the lens, *M* the final magnification, and *C* is the diameter of a tolerable image blur (*circle of confusion*), an optical effect; its size is considered for any given application. When enlargement is involved the formula has to be modified:

$$T = 2CN \frac{(M + 1)}{mM}$$

where *m* is the camera magnification, *M* is the final magnification, and *C* the tolerable circle of confusion on the print.

These formulas are based on geometric rays, rather than the light path from the lens, and yield values practical for close-up photography. For photomacrography, however, a different approach is necessary. Gibson (1960, 1975, and 1986) developed a formula for the

physical optics involved that is more applicable to close-up work and photomacrography. The following table gives typical DOF values for close-up photography:

Depth of Field in Millimeters

| Magnification | $f/5.6$ | $f/8$ | $f/11$ | $f/16$ | $f/22$ |
|---|---|---|---|---|---|
| X0.1 (1 : 10) | 39 | 52 | 79 | 106 | 159 |
| X0.2 (1 : 5) | 10.5 | 14 | 21 | 28 | 42 |
| X0.25 (1 : 4) | 7.2 | 9.6 | 14.4 | 19.2 | 28.8 |
| X0.33 (1 : 3) | 4.5 | 6.0 | 9.0 | 12.0 | 18.0 |
| X0.5 (1 : 2) | 2.73 | 2.84 | 4.26 | 5.68 | 8.52 |
| X1.0 (1 : 1) | 0.75 | 1.00 | 1.50 | 2.00 | 3.00 |

The circle of confusion is 0.03 mm. Effects of effective aperture are incorporated into these values.

## Focal-Length Considerations and Relationships

Two very common focal lengths used in close-up photography are the 50-mm and the 100-mm focal lengths. These are by no means the only close-up lenses, but they represent the most common.

Nikon makes a lens specific to close-up photography, the Medical Nikkor, with a focal length of 120-mm. It functions solely on repro ratios and has a built-in electronic flash and focusing light. The 120-mm lens utilizes supplementary lenses (frequently called *diopters*) to change its focal length to access additional magnifications.

The use of a longer focal length lens for close-up photography has significant advantages. These are apparent where the subject is live and requires additional working space.

## Getting the Proper Exposure Information

Emphasis to this point has been on the techniques necessary to control the image-making aspects of close-up photography. Getting the proper exposure information for picture making is a function of photography that must be correct to obtain quality results.

Measuring the light can be accomplished either in the camera (*through-the-lens metering*, or TTL), if the system permits, or by a hand-held exposure meter. When metering through the lens, no compensation for the bellows factor need be taken (if the specimen represents an "average scene"). This method is the simplest and easiest way to obtain an exposure setting. The characteristics and reflection qualities of the subject really are the only influences on the reading. If the subject is similar to an 18% gray card[2] (an average scene) no correction needs to be made to the achieved reading. If the subject is very bright, the exposure must be adjusted to give more exposure to the film. If the subject is darker than 18% gray, the exposure will need to be reduced. As with the bright

subjects, the amount depends on how dark the subject is. With a little experience the amount of compensation is learned quickly (see Chapter 3).

When using a hand-held exposure meter, one must not forget that light loss will occur due to the bellows factor. In close-up photography, the closer the focus, the farther the rear element is moved away from the film. In fact, at 1 : 1 the rear element of 50-mm lens may be up to 100 mm from the film. At this magnification ratio, significant light loss occurs due to the decrease in illuminance as the lens-to-film distance increases. It is critical that the light loss be compensated for when an exposure determination is made with an external metering system. At the repro ratio of 1 : 1, open the lens two full stops. This will render a proper exposure. When making light measurements, the exposure can easily be adjusted based on the magnification being used. Chapter 2 discusses the parameters of exposure determination including compensation for increased lens-to-film distance (*bellows factor*).

Knowledge of the repro ratio can suggest which exposure compensation to give the film and can predict the depth of field. Additionally, the repro ratio can be used to describe the magnification of the taken pictures, which is important in clinical applications.

The *repro ratio* is a function of close-up photography and describes what magnification (reduction) the lens will reproduce on the film. What happens when the image size is not large enough? and When should photomacrography be used? are two questions that are often presented. The answers are simple and will be described as applied techniques.

## Supplementary Lenses

*Supplementary lenses* are a common piece of photographic equipment that can be used to change both the focal length of the lens and image size. Supplementary lenses are often referred to as *diopters,* the term that will be used in this text. They are used routinely in pictorial and other applications to change the focal length and the image size. This type of lens can affect image quality if it is not of high quality.

To get higher magnification in close-up photography, changing the focal length of the lens should be considered. Reducing the effective focal length of the primary lens can be accomplished by the addition of a plus (+) diopter to this lens. Diopters are available in a range from +1 up to +20. Their cumulative effect on the focal length of the lens at infinity can be calculated with the use of the equation shown below. Before the equation can be solved, the diopter must be converted to its focal length. The relationship of diopter to focal length is simple. The diopter value is nothing more than the lens' focal length in meters divided into one. Thus a +4 diopter has a focal length of 1/4 m or 0.25 m. Once converted, this represents a 250-mm lens.

$$1/F = 1/FC + 1/FS$$

F = system focal length, FC = focal length of primary lens, F/S = focal length of supplementary lens. For example, consider what the focal length of a 50-mm lens would be with a +5 diopter added to it. The +5 diopter using this conversion becomes a 200-mm lens. When added to a 50-mm lens, the new focal length is derived as follows.

$$1/F = 1/50 \text{ mm} + 1/200 \text{ mm}$$
$$1/F = 4/200 \text{ mm} + 1/200 \text{ mm}$$
$$1/F = 5/200 \text{ mm}$$
$$5F = 200 \text{ mm}$$
$$F = 40 \text{ mm}$$

Diopters are generally screw mounted to fit the lens being used. The diopter lens is screwed onto the front of the lens and effectively shortens the focal length of the prime lens. This, in turn, can create a larger image size for the bellows extension in use. Using a 50-mm lens with the diopters listed below, the following repro ratios might be produced throughout the lens near and far focusing range.

With a 50-mm lens:

|  | New Focal Length (mm) | Low | High |
|---|---|---|---|
| 0 | 50 | 1 : 10 | 1 : 2 |
| +1 | 48 | 1 : 9.6 | 1 : 1.9 |
| +2 | 45 | 1 : 9.0 | 1 : 1.8 |
| +3 | 43 | 1 : 8.5 | 1 : 1.7 |
| +4 | 42 | 1 : 8.3 | 1 : 1.6 |
| +5 | 40 | 1 : 8.0 | 1 : 1.5 |
| +10 | 33 | 1 : 6.6 | 1 : 1.25 |
| +20 | 25 | 1 : 5 | 1 : 1 |

The use of a diopter is an easy solution, but if the desired magnification still has not been achieved, the diopters can be stacked. They should be stacked by putting the diopter of highest power closest to the lens. This will insure the best possible image maintenance. When diopters are stacked, it is an additive process. Thus when a +3 diopter is added to a +1 diopter, the total becomes a +4 diopter.

Diopter lenses should be tested prior to critical use. They add additional refraction to the lens system, which is desired, but they also degrade image quality. The photographer's quality expectations will influence how many diopters are stacked. In most instances, manufacturers have designed their prime lenses to work alone. This should not preclude the use of high-quality diopters but should be a consideration in choosing to use or buy one. To determine the effect of such lenses on critical sharpness, a simple test of some finely detailed subject is helpful.

When using diopters, there is minimal light loss in the lens. If TTL metering can be used, there will be no problem in obtaining the correct exposure. If an external meter is being used, a quick lens transmission test of the diopter can be done to determine the exposure factor. This can be done by placing a white card at the subject plane and taking a reflected-light meter reading with the lens set at infinity. Record this value. Next, add the diopter lens and compare meter readings using the same criteria. If there is a difference, note this value and add this factor to your basic exposure calculation.

## Extension Tubes and Extension Bellows

*Extension tubes* are another piece of equipment that can be used to achieve higher image magnification. Extension tubes are simple to use and provide better image quality than diopter lenses. The extension tube is inserted between the lens and the camera body. Unlike diopters, which change the focal length of the lens, extension tubes achieve magnification by increasing the distance between the lens and film (in other words, the *image projection distance*). The tubes are usually sold in sets that vary in length from a few millimeters to several centimeters. Since the tubes can be stacked, there is a wide range of magnifications possible. Here is a list of the tube combinations and subsequent magnifications to give some sense of what can be expected with a Nikon 55-mm Micro Nikkor lens with tubes of varying lengths.

| Tube Length (mm) | Lens at Infinity | Lens Set at 1:2 |
|---|---|---|
| 8 (PK-11) | 1:9 | 1:75 |
| 14 (PK-12) | 1:7.5 | 1:3 |
| 27.5 (PK-13) | 1:6 | 1:1 |
| 52.5 (PN-11) | 1:1 | 1.7:1 |
| All four stacked | 2.2:1 | 2.6:1 |

There are advantages and disadvantages to using tubes. Tubes are very rigid in the magnifications they produce, since the tubes have specific lengths. Consequently, in some situations the magnification produced may be slightly greater or less than desired. For flexibility, additional magnification, and composition, tubes can be stacked. This gives a range of magnifications and can be varied quickly by changing or coupling the tubes.

Tubes are made of metal and are extremely durable. For this reason they make excellent field and location accessories. Using delicate equipment is often risky outside of protected areas like the lab or the studio. With tubes, damage is of no concern, as they can resist puncture and rough treatment.

When using tubes coupled to the camera, it is critical to check that all the parts of the system, the camera, the tube, and the lens operate together. When a camera and lens are coupled with no tube in place, the diaphragm of

the lens couples with the camera system automatically. The image in the viewfinder is bright, regardless of what aperture or *f* stop is set. When the shutter is depressed, the coupling mechanism closes the lens to the selected *f* stop. It is important to check to see if the tubes have the coupling mechanism and if it is operating.

A simple visual test of opening and closing the lens aperture will allow this determination. The diaphragm's operation can be observed by looking through the back of the camera into the lens. Set the diaphragm ring to *f*/11. If the tubes are properly attached, the lens should remain fully opened, but they close to *f*/11 when the shutter release is depressed.

Light loss is going to occur in photomacrography whether a tube or bellows is used. The amount of light loss depends on the length of the extension. For more on how to manage this light loss, refer to the discussion on bellows.

This discussion has focused on the use of traditional single-length extension tubes. Olympus Corp. (Lake Success, NY) makes a piece of equipment called an auto tube. This is unique because it functions like a bellows but is rigid and metal, like tubes. The auto tube consists of interlocking extension tubes that work together as a unit. Depending on the focal length of lens used, the auto tube can produce a range of magnification of ×0.5 up to ×10. This tube is specific to Olympus cameras.

## PHOTOMACROGRAPHY

### Getting the Magnified Image

Up to this point, no special equipment was needed to produce close-up photographs, except for a lens designed for close-up photography. Unfortunately, to achieve higher magnification at the film plane, many special types of lenses and equipment are necessary. Photomacrography as defined covers a range of magnification of 1:1 (life size) to about 80:1 (eighty times life size) on film.

There are several ways to produce these magnified images on film. Each technique has its advantages and disadvantages, and these will be discussed later. Since magnification is a function of the lens focal length and lens-to-film distance (bellows length), the focal length of the lens can be reduced or the lens-to-film distance can be increased for higher magnification, or a combination of both can be used.

### Bellows

Another piece of equipment available for achieving image magnification is a *bellows*. A bellows is a variable-length extension tube. In situations where the image is

too small or too large, the bellows can easily be adjusted to achieve just the right magnification. The bellows produces magnification by allowing the lens-to-film distance to be varied.

A bellows is a simple piece of equipment; yet it often causes problems for photographers because they do not understand its basic operation. A bellows consists of a lens board with a bayonet mount, an adjustable length tube made of opaque cloth, a camera mounting board with a bayonet mount, and a focusing rail. All of these parts can be disconnected from one another, which makes the bellows extremely versatile for many applications. Each part can be adjusted independently (Figure 8.12).

A bellows can have a price range from very expensive to relatively inexpensive; price is usually a function of brand. Surprisingly, the price and features of the bellows are not as important as whether the bellows is light tight and can be securely locked into position.

If buying a new bellows, these features can be checked prior to purchase. If a used model is considered, it should be checked for light leaks. Shining a bright light down through the bellows with one end closed will allow any pinhole leaks to be detected. If many pinhole leaks are present, this could produce less than optimal results, due to fogging of the film. To check whether the bellows can be securely locked, lock all adjustable parts, and attempt to move any one part. Any "slop" or play in the equipment will be obvious. If movement occurs in testing, this bellows could cause image quality problems during use.

As with tubes, it is critical to check that all components of the camera system are operational when coupled. Are the lens, camera, and bellows coupling appropriately? When the shutter is depressed on the camera, is the lens aperture engaging to the desired $f$ stop set? Does the image get dark when the lens aperture is stopped down?

These concerns are important to check prior to starting to produce photographs.

One way to check if the aperture engages is to observe the image in the viewfinder when the aperture in the lens is operated. If the image gets dark, the system is functioning properly. If the image does not get darker when the lens is stopped down, two things may need to be checked before use. The first and simplest approach is to check the coupling between the lens and bellows, as well as that between the bellows and camera. If all contacts are engaged properly, open the camera back. Set the shutter speed to $B$ and open the shutter. Look into the bellows and close the aperture. Is the aperture opening and closing properly? If it opens and closes, the system will be fine for photographing. If no activity of the lens aperture is observable during this test, two things can be attempted to remedy the problem.

Check for two controls on the lens board. Look for a place to attach a cable release or an adjustment knob to disengage the lens auto diaphragm couple. If one of these knobs is present, its operation will engage the aperture. Many of the higher-quality bellows need to be used with a dual-cable release, one for the aperture and one for the shutter. This type of cable release will have two extensions coming off a single plunger. Both extensions operate from the same plunger. This type of a cable is quite expensive, but very useful and simple.

If you do not own a double cable, two standard cables can be used to operate the system. Unfortunately, this requires the photographer to use both hands to make the picture. One cable is attached to the lens standard, which allows the aperture to be engaged when triggered. The other cable is attached to the camera body and used to activate the shutter when depressed. If two separate cables are used, the lens cable should be operated first. This allows the lens aperture to be engaged prior to firing the shutter. In this sequencing the film will receive the proper exposure. If the aperture couple is disengaged, only one cable will be required for operation.

There is one last characteristic of a bellows that should be mentioned. Some bellows have been designed with the capabilities of swings and tilts. These adjustments are similar to those found on a view camera and are useful for critical alignments. With these adjustments the subject and film plane may be aligned for better depth of field.

A bellows with these types of adjustments can have the lens board aligned with the plane of critical information. Because there is such limited depth of field in this type of photography, this feature is desirable. For more on this technique of alignment, see Chapter 2 on Scheimpflug techniques; also see References (Ray 1988; Stroebel 1980).

Any of the aforementioned pieces of equipment can be used to get more magnification on the film. Deciding which piece of equipment to use should be made by

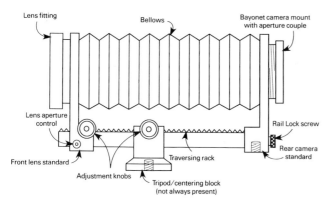

**FIGURE 8.12** A bellows is comprised of several parts. A female bayonet mount, a male bayonet, a focusing rail, a flexible accordion bellows (that is usually removable), a retaining screw to keep the standards on the rail, and a cable release site to operate the lens aperture.

evaluating what is available and what works most easily in a given situation. In situations where more magnification is needed, possibly a single bellows will work. However, if even more magnification is required, a second bellows can be stacked onto or coupled with extension tubes to achieve this higher magnification.

## Exposure Compensation

With the movement of the lens farther from the film plane as in a photomacrographic system, significant light loss occurs at the film plane. A camera with an internal metering system will automatically adjust for this loss. Unfortunately, many setups, especially the large-format cameras, need to have the exposure determined by an external meter. Some meters for scientific applications have sufficient sensitivity that readings can be made at the film plane, which, again, would automatically compensate for the loss of light at the film plane. Most photographers will need to determine the exposure by reading the light with a common hand-held exposure meter or spot meter and apply an exposure factor (commonly referred to as the *bellows factor*) to the indicated reading to obtain correct exposure. The amount of light loss depends on the distance between the lens and the film plane and follows the *inverse square law of illumination*. There are several equations that can be used to determine this exposure factor, but the two most popular are:

$$\text{Exposure factor} = (v^2)/(F^2),$$

or if you know the magnification, which at this stage is very likely:

$$\text{Exposure factor} = (m + 1)^2$$

In these equations $v$ equals the distance between the lens and film, $F$ is the focal length of the lens or in the latter equation, $m$ equals magnification.

On many cameras the exact position of the film plane is indicated by a circle with a line through it inscribed on the body ($\ominus$) (Figure 8.13). The exact position to measure at the lens is not inscribed but is generally accepted to measure from the diaphragm. To determine the exact magnification, it is best to use a draftsman's scale, such as Alvin No. 290 12 inch millimeter/inch scale (Alvin Corporation, Windsor, CT), for magnifications up to ×10 and a microscope stage micrometer for magnifications above ×10.

In copying or close-up photography the exposure factor can be applied to the lens opening, the exposure time, or a combination of both settings. In photomacrography the lens aperture is usually determined by observing the image as the lens is closed down, or it is predetermined by one of the following methods: (1) If the subject is opaque and has depth, then the aperture setting (*f*) is determined from a published formula or from Gibson's chart,

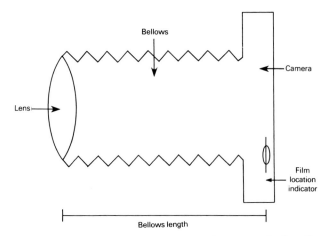

**FIGURE 8.13**  Measure from the (⊖) on the camera body or the camera back if no symbol is present, to where the rear of the lens joins the bellows (and/or tubes). This measurement can then be utilized in equations in Figures 8.2 and 8.3.

(Gibson 1986, p. 130) which represents the best ratio of depth of field and resolution. (2) When the subject is transparent, and especially so if it is a stained histological section that is sliced extremely thin (4 to 6 microns), the lens aperture must remain fully opened or nearly so, to accept all the diffracted rays from the specimen. The more image-created diffracted rays entering the lens, the more the image looks like the specimen. Restricting the aperture with thin and transparent specimens would drastically reduce the resolution potential of the lens, and thus the quality of the image would suffer needlessly. In summary, our only practical method of applying the exposure factor in any of these situations is by applying it to the exposure time. For example, for a magnification X8; a focal length of 35 mm, a bellows of 315 mm is produced. Thus:

$$\text{Exposure factor} = (v^2)/(F^2),$$
$$(315 \text{ mm})^2/(35 \text{ mm})^2$$
$$99{,}225/1225$$
$$\text{Exposure factor} = 81$$

Unfortunately, this method involves sizable numbers and division. The following equation is recommended for its simplicity:

$$\text{Exposure factor} = (m + 1)^2$$
$$(8 + 1)^2$$
$$9^2$$
$$\text{Exposure factor} = 81$$

If the basic exposure as determined with a spot meter was 1/10 second at our preselected *f*/8.0 stop, then the adjusted exposure would be 1/10 × 81 or 8.1 seconds exposure time. For practical reasons the exposure time can be rounded to 8 seconds.

The engravings on most macro lenses are not *f* numbers but, rather, are consecutive numbers such as 1, 2, 4,

8 (or 1, 2, 3), and so on. In each case, the next number represents a full stop difference. Then the question becomes: "How can one determine where a certain $f$ stop lies?" On the barrel of the lens, rather than the lens retaining ring, the aperture and focal length of the lens is engraved, such as 25 mm $f1 : 3.5$. Since this lens stop ($f/3.5$) is not common to photographers, we can resort to a formula (Stroebel 1986) or from the following chart to determine subsequent $f$ numbers: *2.8*, 3.2, 3.6, *4.0*, 4.5, 5.0, *5.6*, 6.3, 7.0, *8.0*, 9.0, 10, *11*, 13, 14, *16*, 18, 20, *22*, 25, 28, *32*, 37, 41, *45*, 52, 58, *64*, 74, 83, *90*

In this series of one-third stops, every italic number represents a full stop. It is easy then to find any related $f$ number for the engraved exposure factors by placing the maximum opening on the closest $f$ number and counting forward three one-third stops for each engraved number, that is, 1, 2, 4, (or 1, 2, 3), and so on. For the above 25-mm $f/3.5$ lens, the engraved number of 2 equals $f/5.0$, 4 equals $f/7.0$, and so on.

There are other methods of determining the proper exposure in a photomacrographic camera system. One of these is to determine the effective aperture of the system, rather than the engraved aperture. This relationship can be expressed as follows:

Effective aperture (EA) = marked aperture ($m + 1$)

Look at an example of how this method of determining proper exposure compensation works. In a situation where an image is magnified ×8 with $f/8$, what exposure correction must be applied to get the correct exposure?

$$EA = f/8(m + 1)$$
$$EA = f/8(8 + 1)$$
$$EA = f/8(9)$$
$$EA = f/72$$

In this example, the amount of light through the camera system will act as if $f/72$ (or $f/64$ + one-fourth stop) were used, not $f/8$. The separation of $f/8$ to $f/72$ is a little more than six $f$ stops. The exposure time must be calculated to equal the equivalent of 6+ stops increase exposure, which is about an exposure factor of 81. For practical use, the above equation relates this factor to tables that recommend effective apertures for resolution.

The last method of determining exposure factors is through use of an exposure compensation ruler. This simple device, which is designed for a 35-mm SLR camera, can be used without measuring or mathematics to determine the exposure correction required. It should be placed in the scene and aligned with one edge of the camera's viewfinder. Once this alignment has been accomplished, read across to the other side of the camera's viewfinder and read off the exposure compensation. This scale also has a ruler and image magnification information on it to make it more versatile (Figure 8.14).

As simple as the technique appears, it can present problems. Some situations or subjects will not allow this ruler to be used easily. In fact, using the ruler may contaminate or interfere with the subject. In these situations, the alternatives should be considered or the camera moved away from the subject to use the ruler.

## Metering

As the working distance gets smaller, the ability to meter gets more difficult. When using a 20-mm lens, for example, there is 20 mm (3/4 inch) of working distance, which is not enough room to fit even a small hand-held meter. With no available space to insert the meter, it becomes very difficult to achieve readings. For this reason, special

**1″ = 1″**

| INCH | | 1 | | 2 | | 3 | | 4 | | 5 | | 6 |
|---|---|---|---|---|---|---|---|---|---|---|---|---|

| 4X | 3X | 2X | 1.5X | 1X | 0.7X | | 0.5X | 0.4X | MAG. | 0.3X | | 0.25X |
|---|---|---|---|---|---|---|---|---|---|---|---|---|
| • | • | • | • | • | • | | • | • | | • | | • |

| 25 | 16 | 9 | 6.3 | 4 | 3 | | 2.3 | 2 | Exp. Fac. | 1.7 | | 1.6 |
|---|---|---|---|---|---|---|---|---|---|---|---|---|

| 4²/₃ | 4 | 3¼ | 2²/₃ | 2 | 1½ | | 1¼ | 1 | STOPS | 3/4 | | 2/3 |
|---|---|---|---|---|---|---|---|---|---|---|---|---|

| CM 1 | 2 | 3 | 4 | 5 | 6 | 7 | 8 | 9 | 10 | 11 | 12 | 13 | 14 | 15 |
|---|---|---|---|---|---|---|---|---|---|---|---|---|---|---|

**1cm = 1cm**

**FIGURE 8.14** This figure represents an exposure compensation ruler. This ruler is calibrated in units of centimeters, inches, exposure factors, and magnifications. Adjust the ruler so the left side of it is aligned to the left side of the viewfinder and read across to right side. The system's magnification, exposure factor, and $f$ stop required can be read there.

approaches must be used to get accurate exposure information.

Probably the easiest approach is to meter through the camera. This is not always possible, but when it can be done, it requires no exposure compensation to be added to the camera meter readings. There are some potential problems. Some cameras cannot provide shutter speed information longer than 1 second reading; in photomacrography it is not uncommon to get exposure times of much longer than this. In these situations, exposure information might be achieved with the lens aperture wide open. Once a value has been read, it can be applied to the desired aperture. For example, if a reading of 1/2 second and at $f/2.8$ is achieved, but $f/11$ is desired, the exposure of 1/2 second multiplied by $f/11$ divided by $f/2.8$ converts to an exposure of 8 seconds. The formula to use is

$$T = t \times F/f$$

where the small letters are the achieved value with the light meter, and the capital letters are the desired values.

If no in-camera meter is available or accurate exposure information is not obtainable using this approach, a spot meter should be considered. *Spot meters* are light-measuring instruments that are capable of taking a reading from a 1-degree area. This ability to read small areas from a distance presents a distinct advantage in photomacrography, where the working distances can be as small as 15 mm. Spot meters are capable of making only reflected light measurements. For this reason, consideration must be made as to how the subject compares to 18% gray. If the subject is denser than 18% gray, a correction must be applied to the reading, or the resultant image will be overexposed. If the subject is brighter than 18% gray, the exposure must again be adjusted, or the resultant image will be underexposed. For more information on metering and tone reproduction, see Chapter 3.

You may find that the image in the viewfinder of the spot meter is out of focus when working very close to the subject. The image of the scene is also out of focus on the photocell. This may seriously affect the readings, since the 1-degree spot area visible in the viewfinder is actually spread over an area larger than the photocell. The extent of the error depends on the tonal value of the adjacent area. If this is the case, attach an inexpensive 4+ diopter lens to the front of the meter's lens; this will alleviate the incorrect readings and focus problem. The 4+ diopter will be focused at 250 mm (about 10 inches) from the lens; higher diopter numbers should be used for closer focus conditions and vice versa. See Chapter 3, Close-up Measurements With a Spot Meter.

With some meters, attachments are available to reduce the size of the measuring device or to enable a ground-glass reading to be made. The Minolta Auto 4 has several versatile attachments that make this meter an ideal choice for this type of work. It has an accessory incident probe that can be plugged into the meter. This probe is approximately 1 cm in diameter and is affixed to an 8-inch flexible handle. Meter reading can be made in the incident mode in situations that have a small working distance.

Another attachment for this meter is a ground-glass metering attachment. With this attachment, meter readings can be made directly off the camera's viewfinder or focusing screen; thus no exposure compensation is required.

Last, there is a method employed by commercial and photomicrographers to determine exposure and filter effects that cannot be accurately determined by any other method. Polaroid instant print film can be used to make a graduated test exposure, not only to determine exposure but also filtration effects. The method is presented in Chapter 7.

In the event all of these approaches fail, there is one last alternative. Most photomacrographic cameras are coupled to a common rail that holds the lens board; this rail and the camera can be moved independently. This allows for the magnification to remain constant but also allows for the working distance to be changed. Once the lighting has been set up and everything is ready to photograph, carefully loosen the rail and back the camera away from the subject. This movement should be done carefully, to ensure no change or effect on the subject. When the camera has been retracted as far as necessary, take the meter readings. The meter readings may still need to be done with a spot meter, but moving the camera ensures that good measurements are obtainable.

## Reciprocity

The discussion on the wide-opening metering technique mentioned reciprocal exposures. *Reciprocal exposures* are exposures that produce equal amounts of exposure at the film through different combinations of shutter speeds and apertures (see the section on Reciprocity Law, Chapter 3). An example of two reciprocal exposures might be 1/4 second at $f/11$ and its equivalent of 1/8 second at $f/8$. When using traditional silver halide emulsions, this range is predictable. However, there are situations where this ability to exchange various combinations of aperture and shutter speed fails. This inability is referred to as the *reciprocity law failure* (RLF). This failure occurs primarily at exposure times longer than 1 second or shorter than 1/2000 second.

In photomacrography, with available (tungsten illumination) light photography, the exposures will often be longer than 1 second. For this reason the metered exposure must be corrected for the reciprocity effects. If this exposure is not corrected, the resultant images could be underexposed, and experience a color shift. Correction of reciprocity effects is generally done after all exposure

correction factors for bellows factors have been considered. Manufacturers generally supply reciprocity information packaged along with their professional line of films.

## MACRO LENSES AND OPTICAL CONSIDERATIONS

### Using Close-up Lenses in Ultra-Close-up Photography

*Macro lenses,* or *close-up lenses*—as they were previously called—have been designed to produce edge-to-edge sharpness. These lenses are referred to as *flat field,* and they will generally be in the range of 50 or 100 mm in focal length. These close-up lenses are designed with a lens barrel focus, and they have an automatic lens diaphragm for all photographic applications. The majority of close-up lenses can achieve an image magnification of 1 : 2 or 1 : 1 without additional equipment.

Looking at the front of any of these close-up lenses, the front element will be located well back into the lens barrel. This could be up to 1 full inch. In photomacrography, the working distance is a function of focal length used. The higher the magnification, the less the working distance. This means that when producing images with magnification, the subject could be less than 2 inches from a 50-mm lens. If a lens barrel intrudes into the working distance over 1 inch, there is less than 1 inch to manipulate and illuminate the subject. A mechanism (an extended helical threaded tube) is needed to move the lens farther from the film; thus, built into the lens is a "semi-extension tube" that moves the lens farther from the film.

### Reverse Mounting

With less than an inch between the lens and the subject, close-up lenses are not ideal for specimen management. The roles of the lens conjugates were reversed in photomacrography. This means that the subject is closer to the lens than the image. Close-up lenses, though, have been designed to have the subject farther from the lens than the image. To compensate for this, close-up lenses can be reverse mounted. Therefore the rear element of the lens will be close to the subject. Many lenses will produce sharper images at higher magnifications using this technique and there is no lens barrel to interfere with available working distance. A 50-mm lens, for example, is now a full 2 inches from the subject, allowing for easier access and subject management.

*Reverse mounting lenses* can be made using a reverse mounting adapter or by turning around the lens standard of the bellows. For the latter technique, some testing may be in order to analyze whether this will work on your system. The Nikon PB-4 will allow this to be done;

thus no reverse mounting adapter needs to be used. If the bellows will not permit this, a special reverse mounting adapter will need to be purchased.

One negative aspect to reverse mounting close-up lenses might be an image artifact of central flare. This flare has been thought to be caused by internal reflection of the elements. The flare may not always be present and is worse at higher magnifications, with small apertures. This lens aberration cannot be predicted or expected. The only way to determine its presence is through testing.

### True Macro Lenses

When using a 10-inch bellows fully extended and a 50-mm close-up lens, an image of ×4 will be produced. With the bellows fully extended, how can the magnification be increased? *True macro lenses* are special-purpose lenses designed for photomacrography. Macro lenses have been given other names that are appropriate for their size. Some of the names used for them include *short mount* or *thimble lenses*. With these true macro lenses of shorter focal lengths, higher magnifications can be achieved.

Macro lenses are different than close-up lenses. The first major difference is that this type of lens cannot be focused by itself. There is no focus collar, only a lens diaphragm collar. The aperture will be preset and not automatic. This means that, as the lens is opened or closed, the image will change brightness accordingly. Some lenses also have a second aperture ring that acts as a limiter. This limiter, when engaged, only allows the aperture to be used in a certain range. This is similar to the way in which a governor works on an automobile motor. With respect to these apertures, it may be noticed that many of these lenses have maximum apertures of $f/2.8$ and minimum apertures of $f/16$ or $f/22$, as contrasted with other lenses that go up to $f/32$ or $f/64$. This difference in aperture is due to the potential for diffraction at higher magnification and the need for resolution.

These lenses are equipped with standard microscope thread Royal Microscopical Society (RMS) or 39-mm screw mounts. This means that they cannot be used without a special adapter that is threaded on the camera. These adapters have a bayonet on one end, with the thread on the other. Different manufacturers make true macro lenses such as Zeiss Luminars, which range from 16 to 100 mm in focal length. Nikon makes a set, as does Olympus and others. These true macro lenses excel in their specific application of producing a flat, high-resolution image of a flat subject at the range of magnifications encountered in photomacrography.

When rummaging through old equipment at used camera equipment stores or flea markets, an older set of Bausch & Lomb or Wollensak lenses might be discov-

ered. Do not discount their quality without a test; some are quite good. Many of these lenses could range in focal length anywhere from 16 to 120 mm.

### Cine Lenses

'n the 1970s, an incredible change occurred in the way motion media were produced. No longer was 16-mm motion picture film the predominant choice of medium, but, rather, videotape became the way to go. This transition has been wonderful for photomacrographers. The wide-angle and normal focal lenses for 16-mm cameras, the 16-mm, 25-mm, and 50-mm lenses respectively, work well when used properly for photomacrography.

These lenses have been designed to work with a short rear image distance. Consequently, they have a short rear lens conjugate. For this reason, cine lenses can be reverse mounted onto a bellows and function as macro lenses.

Because these lenses normally screw into a lens turret, there are few obstructions from the lens to interfere with working distance. This is a tremendous advantage compared with traditional lenses reverse mounted, which have many additions to their design.

Cine lenses are not as well corrected as true macro lenses. Their traditional role was to produce a flat image of a three-dimensional scene that is reduced, not enlarged. They do make satisfactory "poor man's" macro lenses.

## FILM CONSIDERATIONS

There are no specific considerations in choosing a film to use when doing close-up photography or photomacrography. In choosing a photographic emulsion to use, all the same types of questions as for any type of picture making need be asked. What type of final image is required? Should it be black and white or color? Is the subject alive and mobile, or is it an immobile preserved specimen? What size print will be generated, or is it transparencies that are needed? These questions are generic to all photography, in general; they are also the considerations for this highly specialized type of photography.

The only real factors that may play a role in film selection, specific to close-up photography and photomacrography, may be the film's image granularity and the film's having a minimal departure from the law of reciprocity. Starting with image granularity, the end requirement for this work is image resolution. The lower the granularity, the higher the emulsion's potential to resolve fine detail.

Hand in hand with fine grain is a high degree of color saturation. Since good-quality magnification photography is designed to reveal information, a high degree of color saturation is also desirable. The slower the emul-

sion speed, the finer the grain, the higher the degree of resolution, and the higher the degree of color saturation. Emulsions that are well suited for this type of work are Ektachrome 100 or Kodachrome 40T. These two films are rated highly for producing fine-grain, high-resolution transparencies with good color saturation.

Another important characteristic is an emulsion's ability to deviate minimally from the law of reciprocity. This becomes important because, as mentioned, there can be significant light loss in the system when doing close-up or photomacrography. If the exposure times necessary cause the exposure to deviate too far from the law, compensation may be necessary. Uncompensated exposures will result in significantly underexposed images or poor color rendition.

The last consideration resides in the emulsion's color balance, based on the light source to be used. An emulsion has been designed to work with a certain color temperature, that is, daylight versus tungsten. Because significant light loss may occur from the bellows extension or other elements of the system, the use of a conversion filter, which will also cause light loss, is not desirable. Ideally, a film that is balanced for the predominant available light source should be used.

## Filters

In close-up photography and photomacrography, the selection and use of filters should be approached as with any other type of photographic application. In black-and-white photography, filters can assist in tone reproduction and enhancement. For specular reflections, the use of a polarizing filter might be considered. For additional information on filters, consult Kodak publication B-3.

## APPLIED PHOTOMACROGRAPHY

### Setting Up the Camera

Producing images in photomacrography is a straightforward process once the special problems are understood. The process can be very cumbersome if too many operations are used simultaneously. Attempting to make many adjustments too quickly is usually what causes the most frustration and lack of success.

The first step in generating a magnified image is to select a focal length lens that would seem to meet the magnification requirements of the subject. The shorter the focal length of the lens chosen, the higher the magnification of the image. If the subject is not microscopic, that is to say, it can be seen by the unaided eye and will not require large magnification, a 50-mm lens might be a good choice to start with. There is, however, a more

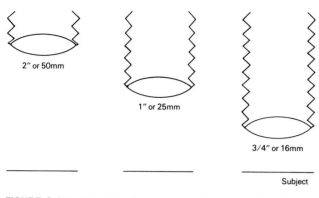

**FIGURE 8.15  This figure shows approximate relationships of working distance to focal length.**

scientific approach. Knowing the film dimensions, it is easy to calculate the image magnification requirements by simple division. Measure the long dimension of the area to be photographed, and divide this distance into the long dimension of the film. By dividing the object size into the image size, the magnification can be roughly determined.

Once the lens has been chosen and put onto the camera's bellows, the lens standard should be moved to the front end of the bellows. Lock down this standard. Next move the camera standard (film) up behind it. Do not lock this standard, as the camera will be moved and the magnifications changed. In producing photomacrography, starting to work with the lens at the end of the bellow's rail will make for easier changes in magnification as they are needed. The camera back can simply be moved closer or farther from the lens, based on the image magnification required.

The subject should now be placed at the front focal point of the lens. If the lens is a 20-mm lens, the subject should be placed 20 mm from the front of the lens. This distance will be approximately 3/4 inch. Using a 50-mm lens, the subject should be placed 50 mm or 2 inches from its front surface, and so on. Placing the subject at this distance is important. Once this has been done, the subsequent adjustments are easily accomplished (Figure 8.15).

Next, the film and/or camera body should be moved away from the lens several inches. This will produce some degree of magnification. When looking into the camera viewfinder, the image of the subject will be located there but may not be well defined. The definition can be easily adjusted minimally by changing the working distance. The critical focusing will be done prior to making the picture.

## Focusing

Focusing in photomacrography is quite different than in traditional types of photography, even more so than in close-up photography. A 0.1-mm error could result in images than are unacceptably soft.

The subject is placed at the lens front focal point and the bellows is moved back and forth to establish the system's magnification. All knobs on the bellows are then tightened down, the lens standard much more so than the film standard.

Gross focusing should be done by moving the entire camera system. Image magnification is dependent on focal length and bellows length; so by not changing the bellows distance the image magnification will remain constant. By moving the camera system closer to or farther from the subject, the working distance of the lens is changed. This, in turn, will bring the image into focus.

Critical focusing should be done with an instrument capable of finer movement and control, such as a lab jack or additional focusing rail. These pieces of equipment are capable of changing the working distance by 0.1 mm very easily. The precise control allows the focus to be placed exactly where it is most desirable. Lab jacks are commercially available from a variety of scientific supply houses, such as Edmund Scientific, Carolina Biological, or Ward's Natural Science.

The less-expensive models work well at low magnifications, such as ×3 to ×10. As the magnification increases, the inexpensive models are not effective, since movements are, in effect, coarser, and there is noticeable play in the mechanism. This results in less control over the change in working distance. If magnifications higher than ×10 are required, a more precise model will be required. Such a model can cost hundreds of dollars. Check around your institution if this higher magnification is needed. Often this type of apparatus can be borrowed from the chemistry department or other departments that use scissor jacks in their work.

If a lab jack is not owned or available, focusing the image can be accomplished in other ways. A slight movement of the lens board will change the working distance. By moving the lens slightly closer or farther, a focused image is produced. This technique is not ideal because it changes the image distance or bellows length and, consequently, the image magnification. Including a ruler in the picture will allow the actual magnification to be determined. If no lab jack is available and changing the magnification is not acceptable, an old microscope stage where the stage is moved by the coarse- and fine-focusing knobs is a very useful solution.

Applying the microscope stage to photomacrography can be simply accomplished by extending it. This is easy to do by taping a piece of glass onto the stage. The glass extends over the side of the stage and under the camera system. Another approach would be to dismantle an older microscope to use its stage. The stage, in turn, could be mounted onto a flat plate of aluminum, brass, or other heavy material; thus a permanent-quality focusing stage is available.

The last method for fine focusing a photomacrographic image is through the use of a traditional 55-mm macro lens with its lens cover. This lens can have its front and rear lens caps left on and be used as a quality lab jack. The lens moves in and out upon rotation of the focus collar; this movement, precise and smooth, results in precise control of the working distance and image focus. A small piece of background material can be placed on the lens cap and the specimen laid on top of that. By holding the base of the lens and rotating the focus collar, the image can be focused critically. The only drawback may come from the lens moving side to side when adjusting its focusing collar. This side-to-side movement could result in the image being moved out of the field of view.

## The Role of the Aperture in Photomacrography

The *aperture* plays a critical role in image formation during photomacrography, for many reasons. The most common influence that the aperture exerts on image formation is the effect on the depth of sharpness in a picture, better known as the picture's DOF.

The second and equally important effect resides in the aperture's influence on the ability of the lens to resolve detail. The following discussion will examine when and why to make aperture choices based on the magnification and characteristics of opaque specimens.

The amount of space that can be dedicated to this topic will not be sufficient to fully expand on all the details. For more in-depth explanations, Kodak publication N-12 (currently out of print) has numerous tables and illustrations that develop the concept in much greater detail. Copies of this valuable resource are still available in some libraries.

From past photographic experiences, including close-up photography, the use of very small apertures, such as $f/16$ or $f/22$, seems an appropriate choice when producing images using photomacrographic techniques because as the magnification increases, the depth of field is reduced. It also seems logical to want as much depth of field as possible in the final image. After all, the sole purpose of producing enlarged images is to be able to see detail that would not be easily visible without photomacrography. When the image magnification is less than the ×4 to ×5 range, the use of small apertures, $f/22$, for example, is still an appropriate choice. However, once this magnification has been exceeded, the use of small apertures can cause diffraction effects that will begin to degrade the sharpness of the final picture. The higher the magnification, the more diffraction effects are visible at the same aperture.

*Diffraction* is the deviation of a beam of light as it passes an obstruction. Many opaque objects and all transparent objects have the property of producing diffracted rays. When the diffracted rays are diverted away from the lens axis, it becomes difficult for the lens to gather these rays up and transmit them to the film. These rays are important to good image formation. The inability of the lens to collect these rays produces images that are soft, with details unresolved. The choice of the appropriate aperture thus becomes critical to image sharpness.

Several factors play key roles in selecting the optimum aperture. Magnification, subject characteristics, and shape factor of the subject all play a significant role in the selection of aperture as well as the DOF requirements. The photomacrographer is forced to balance the primary considerations and decide which of these is most important for the situation. This balance means that the resultant image has the maximum degree of DOF as well as the highest degree of resolution. Gibson, in his research for Kodak publication N-12 (1977) and also in his article in 1986, refers to this characteristic of the image as depth of detail, a balance between sharpness and DOF.

As the magnification increases, the detail to resolve is increased, while the DOF is lowered, which makes it hard to get a good image. With these considerations, what then are good starting points for aperture choice?

Gibson points out that for photomacrography there is an optimum $N$ ($f$ number) for each final magnification. Stopping down the lens for increasing depth of field should only go to the optimum aperture (Nopt). Beyond that, definition falls off until, one stop more, it becomes unacceptable. His papers show the values and derivations for the optimum $N$. The following table gives the numbers and optimal depth of sharpness (Topt) and the total depth of sharpness (T).

*Optimum Apertures for*
*Photomacrography Opaque Specimens*

| M | 2 | 3 | 5 | 6 | 8 |
|------|-----|-------|-------|-----|-----|
| Nopt | 64 | 45–64 | 32–45 | 32 | 22 |
| Topt | 20 | 12 | 7 | 3 | 1.5 |
| T | 22 | 11 | 3.3 | 2.3 | 1.4 |

| M | 10 | 16 | 20 | 25 |
|------|-------|-------|------|------|
| Nopt | 16–22 | 11–16 | 8–11 | 8 |
| Topt | 1.0 | 0.4 | 0.25 | 0.15 |

Some of the optimum $f$ numbers are not usually available.

The presentation was refined and supplemented with data for ultra-close-up photography (Gibson 1986). Also, the deleterious effects for obtaining the higher magnifications by enlarging were stated. As a general rule, most of the final magnification should be obtained in the camera (m). For a few ultra-close-up setups, moderate enlargement yields slightly more depth (T). Enlarging for $M > 3$ should be avoided if possible, as the table below indicates.

*Figures for the Ultra-Close-up Range*

| M | 0.5 | 1 | 1.5 | 2 | 3 |
|---|---|---|---|---|---|
| $M = m, T$ | 130 *128* | 48 *43* | 25 *24* | 16 *16* | 8.5 *9.5* |
| $M = 2m$ | 200 *213* | 70 *64* | 34 *33* | 19 *21* | 9.9 *12* |
| $M = 4m$ | 350 *383* | 100 *106* | 40 *52* | 24 *32* | 9.8 *11* |

These figures are given for $N = 32$. Those in italics were obtained from the classical formula; the others from Gibson's charts. It can be seen that enlargement of around two times yield figures slightly greater than those derived from the formula. The benefit is only slight and falls off between $M = 2$ and $M = 3$ (Figure 8.16).

## Considerations About the Shape Factor of the Subject

Different apertures can be used when making photographs of subjects that are flat versus subjects that are three-dimensional. Other aspects of the subject's shape should also be considered. For example, when photographing a subject that is spherical, 50% of the subject is totally invisible to the camera lens. For this reason, the DOF required for the subject might actually be one-half of what was originally considered. This is actually useful, since half of it is invisible to the lens. All subjects that are three-dimensional should be evaluated for what the lens can actually see versus what the subject's depth actually is (Figure 8.17).

## Aperture Settings for Transilluminated Specimens

Although some of the aspects of the previously mentioned aperture settings can be applied to thick transillu-

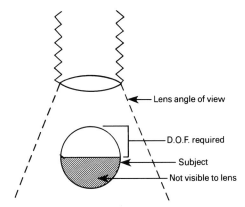

**FIGURE 8.17** This figure shows a three-dimensional subject and why a subject's entire DOF may not need to be maintained. Part of the subject may be invisible to the film.

minated specimens, they are not applicable to histological specimens. Histological specimens are cut extremely thin, a small fraction of the thickness of paper, and are stained for histochemical identification. A high-quality *true macro lens* is absolutely necessary for this type of photography.

The best type of illumination for these specimens is *focused transillumination*. As light passes through and around the specimen, three types of rays can be identified: the ordinary rays, the refracted rays, and the diffracted rays. The ordinary and the diffracted rays meet at the focal plane and produce interference effects; this is the basic phenomenon that produces an image. The more diffracted rays that can enter the objective lens, the more accurate the image.

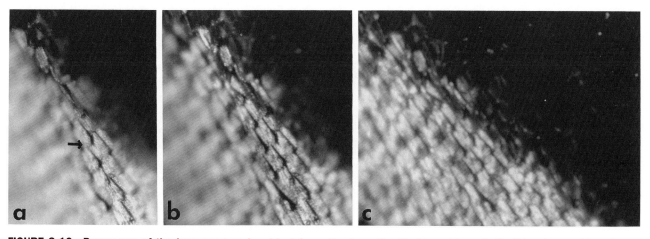

**FIGURE 8.16** Proper use of the lens aperture is critical for optimal results. Photographing a butterfly's wing positioned at a 45-degree angle to the lens, a series of pictures were made at ×16 (on the film). These three pictures were made using apertures of (a) f/2.0, (b) f/8, and (c) f/16. The f/16 (c) produces a totally unacceptable result, so the question is whether f/2.0 (a), which is sharper (notice the area adjacent to the arrow), contains enough information to be useful, or is f/8 (b) a better choice because of the increased depth of field?

Reducing the lens aperture reduces all rays; the highly diffracted rays that are essential for good imagery are affected the most, however. Careful examination of the image with a focusing magnifier[3] is essential to determine where and if the aperture can be reduced. With macro lenses of 25 mm or less focal length, it may not be possible to reduce the aperture at all.

The illumination system on photomacrography stands often have an aperture diaphragm also. This diaphragm can be reduced (slightly) to increase edge effects and contrast. Again, examine the image with a focusing magnifier as the diaphragm is reduced from its maximum aperture to determine the optimum setting. Do not insert filters of any type between the lens and the specimen. Filters should be placed in the illuminating light beam only.

## Bracketing Exposures

*Aperture* is a key component in the process of image formation. Specifically, the aperture influences the final depth of field and image resolution. When bracketing exposures, it is extremely important not to use the aperture to change exposure to the film. The best method of bracketing exposures then is changing the shutter speed or length of time used. In this fashion, the effect of aperture and choice of optimal aperture is maximized and maintained.

## Bellows Length Versus Focal Length Considerations

Another consideration that often arises is when to use a *longer bellows length versus* when to choose a *shorter focal length* lens to get a desired change in magnification. This question does not have a simple answer. In fact, the best answer to the question is, "It depends." It depends on what is easiest. It depends on whether a longer working distance provides any advantages. It depends on whether more exposure compensation is easier or whether less depth of field is acceptable. All of these plus personal preference are an issue in the decision.

It should be noted that there will be overlapping magnification ranges provided by the different focal lengths/bellows lengths combinations. For example, with a bellows length ranging from 3 inches through 12 inches, the following magnifications could be expected.

| Focal Length (inches) | 3-inch Bellows | 12-inch Bellows Extension |
| --- | --- | --- |
| 2.0 | ×0.5 | ×5 |
| 1.5 | ×1 | ×7 |
| 1.0 | ×2 | ×11 |
| 0.75 | ×3 | ×15 |

As can be seen from the table, there are very distinct regions of overlap. This is expected and quite useful when one lens is already on the camera. If a 1.5-inch lens is on the camera system and more magnification is desired, the camera/film could be pulled farther from the lens. By increasing magnification using this approach, the longer working distance is preserved. The disadvantage of this is, as with all increased magnification requirements, additional exposure time must be given to the film. This increased exposure time due to less illumination could force the film into reciprocity law failure or other problems previously discussed. The other way is to reduce the focal length and the working distance.

Which method is better? It depends on all the above and on personal preference. Before making any changes, think through all the pros and cons of changing magnification with each.

## Vibration

An additional factor affecting image sharpness is the vibration from the system or ambient vibration. When pictures are being made of subjects, such as in portraiture or other more typical situations, the problem of camera shake and other motion is present.

Fortunately, the image size is being reduced onto the film, and so the image flaws caused from vibration will also be reduced. These vibration effects must be very large to be noticeable in the final picture. In photomacrography, the effect of vibration on the final image is magnified by the same factor as the image is being magnified. That is, if the image has a magnification of ×12, the vibration effects will be increased by the same factor.

Vibration comes from a variety of places. It may be as localized as someone bumping the table, or the presence of a harmonic motion in the building when the air conditioning is on. Eliminating the vibration may be easy to accomplish by not walking when making an exposure, or it may not be resolvable, such as with the laboratory adjacent to the elevator shaft. In such a situation, shooting when the problem is minimal is the best solution. The use of an air release or cable release is essential to eliminate movement during exposure.

Another hidden contributor to vibration can be a SLR camera's mirror, which is used to relay the image to the viewfinder; it flips up, allowing the image to travel to the film for the exposure sequence. Many modern cameras allow the mirror to be locked up when not in use.

To use this technique, first do all of the critical procedures such as alignment, lighting arrangement, and focusing. Next, secure all movable parts and with extreme care, verify accurate focus, and lock-up the mirror. In this fashion, the final image will be as sharp as possible, with no loss of sharpness due to vibration from the mirror action. Although not commonly known, the action of

a focal shutter can cause vibration effects too. This type of vibration is best eliminated by using exposure times in excess of 2 seconds.

## LIGHTING

It is easier to demonstrate lighting than to write about it. Every situation will be different, and so general guidelines may prove more useful as starting points to lighting strategies. Every subject will have its own characteristics and must be handled as such.

### Considerations About Light Sources

The lights available for close-up work and photomacrography are not so different from everyday light sources used in more typical photographic applications. Start by comparing incandescent tungsten lighting with electronic flash. These two light sources are not unique to photomacrography; thus they do not require much elaboration about their operation. When making a decision about which source to choose, several factors should be considered. In using electronic flash, the picture might be sharper than with the incandescent light source, but this depends on how much current vibration effects influence the quality of the final results. The short burst of light produced by an electronic flash has the potential to eliminate image vibration problems.

Electronic flash, however, does not allow good preevaluation of the effect of the chosen lighting on the subject. Incandescent sources allow for precise and critical analysis of all lighting prior to the picture making. With electronic flash, the only way to previsualize what the effect of the light is on the subject is to have flash units with *modeling lights*. Modeling lights will provide some idea of the quality of the light, but they will not be exact. The modeling lamps produce an illumination that may be quite different in the final image because of the size of the flash filament versus the tungsten bulb.

When photographing live specimens, electronic flash is mandated. Trying to photograph live specimens with a continuous light source could produce longer exposure times. These longer exposure times require longer shutter speeds, resulting in significant image blur and producing a totally unsatisfactory image. These discussions about lighting pertain to work in the studio or laboratory. For information on field techniques see Blaker's work on field photography (1976).

Before going into any great detail, several aspects about lighting specific to close-up work and photomacrography should be considered. Two problems are unique to close-up work and photomacrography. One is the lack of working distance, and the other is the size of the light source and its effect on subject contrast. Working distance considerations will be discussed in the specialized lighting techniques section.

An important distinction about light sources for close-up work and photomacrography versus other more common types of work, such as clinical photography, is the physical size of the light that will be effective. It is a well-known fact that the larger the light source, the lower the contrast of the subject's image. This concept encompasses all types of photography. The size of the light source must be proportional to the subject for this to be true. Thus a light source that is 1 inch in diameter will be very large relative to a fingernail but very small relative to a full human torso. The proportionality of subject to light size is a very important consideration when selecting lights.

For this reason, extremely small light sources are ideal for photomacrography. The smaller the light source, the more useful it becomes for a variety of reasons. Tiny sources can be easily modified, if desired, whereas bigger sources cannot be easily made smaller. The ability of small light sources to remove or add contrast is invaluable in producing quality pictures with good subject information.

Because of the size of the subjects encountered in photomacrography using 35-mm format, the largest subject may be 1.5 inches in the long dimension or smaller. The maximum subject length can be predicted by referencing the dimensions of the 35-mm viewfinder, which are $1 \times 1.5$ inches. At a 1:1 repro ratio, the subject will be approximately 1.5 inches, since the image will be reproduced at the same size as the subject. At 2:1 and greater, the subject will be smaller than 1.5 inches and, consequently, will be magnified. These relationships are brought up as both a short review and a point from which to reference future considerations about light-source size.

It is for the rendered contrast that the size of the light sources chosen for photomacrography should be small, for example, 1 inch or less (the filament's long dimension). Having a light source that starts out with high contrast is invaluable for reasons other than contrast. Contrasty lighting produces images with excellent visual edge detail. This may not be desirable in all situations; however, the sharper the shadow, the more defined the edge detail will appear to the viewer. This direct contrasty light may or may not produce better resolution. Consequently, using raw direct light from a small source will produce images that look sharper, even though they may not contain more detail.

### What to Consider in Tungsten Light Sources

Small light sources are available in all sizes, shapes, and costs. Surprisingly, some of the best choices are actually some of the least expensive. Tensor brand desk lamps

are very practical lights for close-up work, as well as in photomacrography. From the perspective of cost and versatility, these lights can function in a variety of ways that make them more effective than many of their expensive counterparts.

Tensor lights have a very small light source that is enclosed in a white reflector housing. The reflector produces a soft, almost diffused, light with some directional effects. If more contrast is needed, the reflector housing can be cut off with a saw. The Tensor light produces nearly 3200 K at full power, which is more than acceptable for producing excellent color quality. The lamp itself is attached to a flexor arm, which allows the light to be placed exactly where required. For these reasons, this type of light source should be seriously considered where budget is an issue.

Another type of light to consider is an external microscope light source with a lens and adjustable field diaphragm. This type of light may no longer be available from microscope companies but still should be considered.[4] The microscope light will allow for better control of the size and direction of the light than with the Tensor lamp. The field diaphragm allows production of various beam sizes of the light.

External microscope lights, if not available from current microscope manufacturers, may be purchased from used microscope dealers or possibly found in the back corners of some labs. Its additional features, such as adjustable field diaphragm, adjustable height, and positionability, make the external microscope light a good choice. Some scientific supply companies such as Ward's Natural Science Establishment, Inc., sell dissection lights that function almost as well, but they are diffused, which makes for lower contrast.

Fiber-optic light sources are, by far, the best choice when used properly. However, their advantages are expensive. The light is sent from its source through a bundle of glass fibers, which can range in diameter from the thickness of a single fiber up through 1 cm. Because the light is traveling in flexible cables, it can be placed exactly where desired. The cables themselves can either be rigid or flexible; this should be considered when making a purchase. Fiber-optic light produces a very small point of light, so the light will be both directional and bright. In most instances, the light source is a 3200 K tungsten halogen light.

The use of fiber optics is not without potential problems. Some of these lights use a fan to cool the light source; thus there is the potential of fan vibration being transmitted to the camera setup. A simple solution is to place the light source on a separate table or towel to absorb vibration.

Another drawback to some of the models of fiber-optic lights involves control of the lamp intensity. If the voltage to the lamp is adjusted by a rheostat to lower the intensity, the change in brightness is accompanied by a change in color temperature. A lower color temperature of the light will produce an inaccurate color picture. The better-quality units have a graduated neutral-density filter to change intensity, thus maintaining color temperature.

## Strategies for Lighting

Lighting in close-up work and photomacrography should have no different an end result than lighting in any other illustrative photography, for example, clinical. *The end result of the lighting should be to communicate the characteristics specific to that subject.* Using that premise alone, the lighting strategies required to illustrate a subject should become apparent. Whatever approach is chosen—directional light, diffused light, or other—the lighting must delineate the specific characteristics of the subject for viewers who cannot be there to see the subject. Some of these subject characteristics might include shape, texture, color, transparency, or wetness.

If the subject is opaque and it is important to show its surface characteristics, many aspects of the subject's appearance must be considered before choosing a strategy. If its texture is to be shown, a very hard cross- or side-lighting should be used. If its color is to be highlighted, then a very flat, even light should be used. If the subject is metal, a white tent will need to be created. The possibilities are endless, but so are the subjects.

## Directional Versus Diffuse Illumination

Starting with the light from a bare lamp (no reflector or diffuser), the photographer has many choices about whether to maintain this quality of directional light or to modify it. The use of directional light produces lighting effects that are very contrasty. This will produce high-brightness areas adjacent to regions of deep shadows. This quality of light produces images that appear very sharp and is useful for showing texture.

The angle of the light to the surface of the subject will affect the degree of texture observed. The lower the lighting angle, the higher the degree of texture observable. The range is limited though by the lack of working distance between the lens and the specimen. For example, with a 20-mm lens, there is less than 3/4 inch of space between the lens and the subject (Figure 8.18).

## Lessening the Lighting Contrast

With a very low lighting angle, the maximum amount of contrast from that light will be produced; however, dark shadows will also be created. These shadows can be controlled by using another light source or reflective mate-

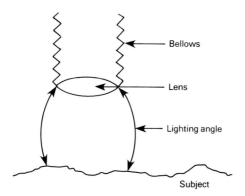

**FIGURE 8.18  With a subject that is 50 mm or less from the front of a lens, the lighting possibilities are minimal. As can be seen from this illustration, the photographer without special accessories is restricted to only side lighting approaches.**

rial on the opposite side of the specimen. The reflective material might be a small piece of white paper for soft fill, or a mirror chip for highly directional fill. When using a mirror, it is important to avoid producing another set of shadows.

In evaluating the subject and the effect of the lighting on the subject, the placement of the lighting should evolve and not be immediately established. Being too specific early on might minimize the possibilities. Carefully observe the effects as the light is moved around the subject. You may even find it necessary to switch to another type of lighting.

For example, when is diffuse light more advantageous than direct light? Subjects that are very reflective, wet, or shiny can be difficult to illustrate with direct light. The harshness of the light will cause undue reflection and not illuminate the subject to its best advantage. For this type of subject diffuse illumination is the preferred alternative. A directional light source can be diffused easily by placing frosted negative sleeves in the light path, or by bouncing the light off a white surface adjacent to the subject.

Several of the most effective diffusers turn out to be very common items. If fiber-optic lights are to be used, a very simple way to diffuse the light is through the use of a Ping-Pong ball. A hole can be cut in the ball and the light pipe inserted. This produces a beautiful soft light that is excellent for illuminating metals, minerals, and other reflective types of subjects.

Another approach for diffusing the light is the Styrofoam drinking cup. With the bottom cut out of the cup, it can be used as a tent to shoot through (Blaker 1989). The height and other modifications can be easily made with an artist's X-Acto knife. If the light is too diffuse, small holes can be punched in the cup, allowing some direct light to strike the subject and thus creating specular reflections. This often produces a livelier and better image of the subject. If a Tensor light is used, the cup will fit directly onto the front of the light and act as a diffuser. The possibilities are endless.

## Backlighting or Transillumination

If the object's shape is the most important characteristic, the subject can be lit from behind. Lighting from behind the subject can be accomplished by either putting the subject on a lightbox or by shining the light onto the background behind the subject. By having the illumination come from behind, the edges of the subject will be sharply defined. However, this type of strategy will show no information about the surface of the subject unless additional epi (top) illumination is utilized.

Another way to achieve effective backlighting is by producing a small circle of light with an external microscope illuminator or a Tensor light. The light can be shined on a piece of paper or fabric used as a background. This allows the light to wrap around and/or go through the subject, illustrating its shape or internal details.

## Dark Field

Many specimens encountered in photomacrography are semitransparent or virtually colorless. The lighting techniques using reflective light or shining light directly through will not generate much additional visibility for the subject; a much preferred technique is dark-field illumination.

In *dark-field illumination*, a brightly illuminated subject is seen against a field of black. This appearance is a product of the lighting; without it, the subject would be virtually invisible. See the illustration for the elements of a dark-field system and their placement (Figure 8.19).

In using dark-field illumination, two problems can occur if the system is not carefully established: (1) debris and/or dirt in the field of view, (2) the angle of the illumination. If direct illumination is entering the lens, flare can be produced, affecting image contrast.

To get pictures that are of higher quality, care must be taken to clean the subject and the glass or suspension material as thoroughly as possible. If this is not done, the resulting pictures will look as though surrounded by night lights, which is distracting.

## Axial

Lighting a subject from above and close to the axis of the lens is often impossible where the working distance is extremely short; therefore another methodology should be used. This technique of getting light on axis is called axial or on-axis illumination.

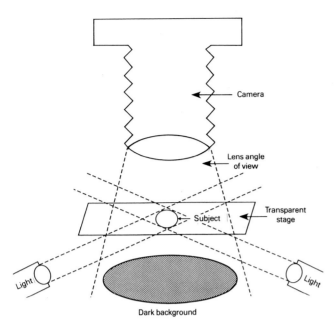

**FIGURE 8.19  Dark-field illumination is useful for transparent or semitransparent subjects. The lights should be arranged as illustrated at oblique angles to the lens. Two lights are desirable; however, one light will produce adequate results. Exposure determination using dark-field technique is difficult and will fool the meter into producing errors.**

This method of lighting produces a high-contrast lighting that is shadowless at the surface of the subject. Axial lighting works effectively on circuit boards, metals, and subjects having cavities that would otherwise fill with shadow using other techniques. It is also effective in creating the illusion of elevation by producing a wraparound light. This creates different reflectance back to the camera and visual topography (Figure 8.20).

The illumination technique can be seen in the diagram and can be established with a piece of thin glass. The higher the magnification, the smaller the size of glass required. In fact, microscope slides, or cover slips are effective as axial reflectors.

The working distance can be a problem with this technique. The illuminator should be placed at a height between the lens and the subject, where it is doing its job adequately. This can be determined by visual inspection. The higher and nearer to the lens, the larger the field of illumination that will be produced by the glass surface.

### Lieberkühn

A method that uses both dark-field and axial techniques is Lieberkühn lighting. This type of lighting is very soft and similar to the effect of ring lighting. The Lieberkühn system can be seen in the diagram (Figure 8.21). This technique is effective when color or surface information is more important than shape or texture. It is accomplished by shining light outside the field of view (similar to dark-field illumination) to a diffuse reflector that surrounds the lens. The resultant lighting is very soft, on axis, and can be used against any desired background.

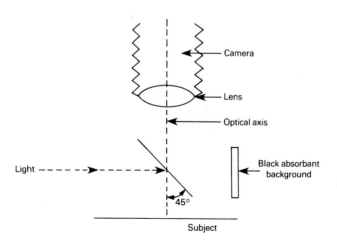

**FIGURE 8.20  Axial illumination produces lighting that is contrasty and comes from on lens axis. Alignment of the elements is critical for satisfactory results. As with dark field, metering can be a bit difficult and should be accounted for. Axial illumination typically will produce a better result working at apertures that are wide open.**

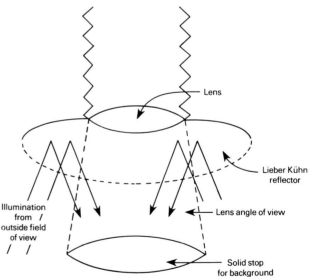

**FIGURE 8.21  The illumination starts out of the field of view of the picture-taking lens and is reflected back to the subject with a parabolic or semireflective reflector that surrounds the lens. Some manufacturers sell this accessory, but a Lieberkuhn reflector can easily be generated using foam core or other modifiable materials.**

## Focused Transillumination

By using backlighting or transillumination techniques, the subject that is semitransparent will be defined by showing its infrastructure or shape. This type of lighting is effective, but there are better methods. Through the use of *focused transillumination,* the results produced will have higher contrast and better resolution, similar to the difference in contrast produced in a diffusion versus condenser enlarger.

A practical setup for transillumination can be seen in Figure 8.22. The system uses a condensing lens that is 1.5 times the focal length of the picture-taking lens. In this relationship, the specimen beam produced is homogeneous and at full contrast at the specimen.

Using this technique is simple. Choose a focal length for the camera that will provide a field of view or coverage that is two to three times larger than the subject. Next, set up the camera with an approximate magnification. This can be done visually, as the subsequent steps will correct for any subtle adjustments required.

Close the camera lens diaphragm to its smallest opening. Place the specimen stage at an intermediate setting, so that the full range of the camera focus is available after the adjustment of the condenser/lens group is complete.

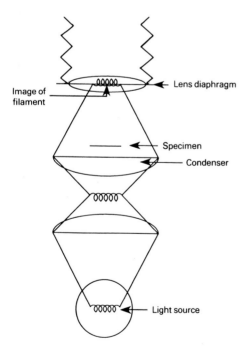

**FIGURE 8.22 Subjects that are transparent and require illumination to show infrastructure are best served by using a focused transillumination system. The elements required for this lighting technique and the location of filament focusing can be seen in the illustration.**

Holding a white file card at the front of the lens, raise and lower the entire camera system until an image of the filament from the lamp is sharply focused on the card. This may require rough centering of the filament first, but be patient and precise. Do this repeatedly until the image of the filament is defined. The image of the filament may be difficult to focus distinctly. In this situation, locate what seems to be the best height and lock in the system.

The final steps are to open the lens diaphragm and focus the image using the specimen stage. It is important not to move the camera system at this point, but, rather, the specimen stage. Any movement of the camera system will result in the condenser relaying the filament to the wrong image plane, and the illumination will be uneven at the subject. In focusing by moving the specimen, however, the illumination will remain even and the specimen well defined.

## SPECIMEN HANDLING

The specimen is the focus of all our efforts. However, space and time warranted considering the photographic aspects first. The subjects that will be encountered using these techniques will be different from one another and so approaches to their management should be as well. Many subjects can be handled similarly, but the personal experience gained from various encounters will serve as a better reference than any author. Think in terms of minimizing any damage to the subject, while presenting it in its best perspective.

## Props and Assists

As in any type of photography, the gadgets and accessories available make the job easier. In close-up photography and photomacrography, the gadgets and accessories must be small to be useful. To assist with this type of photography, a variety of tools and accessories not specifically designed for these applications is invaluable, including items such as spring-loaded clothes pins, a spirit level, alligator clips from electrical supply houses, several camel's hair brushes in various sizes, an ear syringe, modeling clay and/or Play-Doh, No. 00 insect pins, lab stands with arms and clamps from the chemistry department, dissection needles and other dissecting instruments, and any small items such as pieces of mirror.

The idea is to acquire smaller versions of all the props and accessories used in full-size photographic work. This list is only a starting point for the types of things that should be considered. Begin to collect these items and keep them. Simple things like paper clips can serve easily as fill card holders when seated in modeling clay.

## Camera Stands and Supports

The ability to suspend the camera over the subject must also be a serious consideration in close-up photography. A high-quality tripod and/or vertical camera stand are valuable tools and should not be underestimated in terms of their importance to the image-making process. Since most exposure times will be much longer than 1/250 second, there is no possible way to hand hold a camera equipped to do close-up or photomacrographic work in the studio.

If horizontal work comprises most of the situations that will be encountered, a tripod with a focusing rail will be most versatile. The tripod chosen should be the best that the budget will allow. The tripod should be the heaviest and strongest available. Cutting corners on the tripod can be very shortsighted, as the tripod is responsible for most of the image-softness problems caused from vibration. The tripod should have a rotational head that is also capable of tilts. The center column should be reversible for applications below the apex of the tripod's legs.

If most of the applications are of the table-top variety, a vertical camera stand should be considered. The only disadvantage to a vertical stand is that unless the subject is oriented differently, all views will be made of the top of the subject.

Vertical camera stands or copy stands are more stable than tripods, but less portable. Adjusting them is much easier. The subject can be placed on its base or platform and adjustments quickly made by moving the camera or subject. By using a copy stand for these applications, the parallelism between camera and subject can easily be adjusted.

Camera stands can be acquired commercially from sources such as Kinex, Bencher, or others. Unless a large volume of copy work is to be produced with the stand, side lights do not need to be purchased. The side lights that come with the copy stand are generally inadequate and poorly located for most of the applications producing this type of work.

Photography above five times magnification requires the stability of a specifically designed stand and illumination system. All major manufacturers of microscopes offer stands and lighting systems uniquely designed for photomacrography.

## Positioning

Because seeing fine detail is the reason behind this type of photography, special attention needs to be paid to the subject and its positioning. Since the depth of field is so minimal, special care needs to be taken with the subject to ensure maximum image quality.

For subjects that are almost flat and thin, using two pieces of glass is ideal. The subject is placed between the glass, and the glass is taped closed. This ensures maximum flatness and parallelism with the film plane. Other approaches might include the use of small insect pins to stretch out the subject, if possible, or modeling clay to hold it in the best position.

As with any type of photography, careful attention should be paid not to damage the subject, but to ensure its best orientation and presentation. There are countless ways to accomplish this task, some of which are better than others. Whether using glass to hold the subject flat, or by pinning it, the result of subject positioning is to handle the subject appropriately for its best presentation.

## Backgrounds

The final image produced in this type of photography, or in any photography, will be evaluated for all the technical factors such as sharpness, contrast, and lighting. However, as with all photography, aesthetics should be a concern. The considerations about the type of background to use should be part of the aesthetic process. A poor choice of background can compete with the image and be a distraction.

Almost anything can serve as a background. When producing pictures that need to be strong and attract attention, the use of a vibrant background is in order. However, as a rule of thumb, the background is just that, the background. It should add nothing to the subject and delete nothing from the subject. The background should be present but not a factor in evaluating the subject.

Staying with neutral colors seems to be the most beneficial in producing accurate color work. When photographing in black and white, this will be of no concern. Surrounding the subject with a bright color such as blue, red, or other vibrant color will influence the final color appearance of the subject. This influence is not warranted and can generate a false impression of the subject's subtle colorations. In fact, the influence of the surrounding color may be strong enough to create an illusion of what color the subject is.

Through the use of black, white, or gray background this color influence can be eliminated. Paper, fabric, or glass can be used as background materials. In many institutions, small pieces of Plexiglas are used as backgrounds. The Plexiglas is cleanable and reusable. The minimal DOF in this type of work actually is an asset in considerations for the background. The texture or surface markings on the background will be out of focus and will not compete with the subject. A small piece of black velvet serves as an excellent background.

When using any background, care must be taken to adequately light the subject and the background. For example, black serves as a very strong background; however, if the lighting is not correct, the edges of the subject may blend into the background. With the use of white, bad shadows from the subject may be cast onto the

background or flare produced from the reflection of this high brightness value back to the lens. This may degrade the final image contrast and should be avoided.

## Wet Specimens

Within the realm of biological photography, many subjects may come to be photographed as wet specimens. These subjects, when placed in ordinary lighting, produce results that have glaring highlights. The reflections are usually quite distracting and often mask important detail. The use of a very small light source will minimize the problem, but not eliminate it.

Specimens of this type can be more effectively handled by immersing them in a wet bath, which might be distilled water or, preferably, a saline solution. By submerging the subject totally, all specular reflections are eliminated from the surface of the subject. Petri dishes or other laboratory glassware can be used for these applications. Small holding tanks can also be built using lantern slide glass, which may still be found, or some similar material and silicon sealers. Note, though, that this may make the subject appear flat (contrastwise) and lifeless. However, the increased information that is produced is advantageous in the end analysis.

## Use of Scales

To ensure that accurate magnification is achieved, the use of a scale is valuable. The scale need not be on the subject, if aesthetics are a concern, but contained within the frame. Photographing the scale on the edge of the frame to ensure accuracy is acceptable; when printing, the scale can be maintained or cropped out.

Many pathology and forensic photography services require the inclusion of a scale. This allows immediate comparisons of size and anatomy to be done with minimal effort. Some institutions also put the case number on the ruler, so that no confusion arises as to what photographs correspond to what cases. Filing, image magnification, and management are easily handled when this is done.

The scale should be placed in the frame at the same height as the plane of principal focus. The magnification of an image is dependent on working distance; if the ruler is placed at a distance other than the subject's working distance, the scale will not be 100% accurate. This becomes important if critical measurements are to be made from the photograph.

## Using an Enlarger

Some subjects can be handled in a slightly different manner. For thin, flat, and semitransparent subjects, the con-

denser enlarger can serve as a photomacrographic camera. The image can be projected onto film or paper, and the magnification produced can be easily changed.

The subject should be placed in or on a glass negative carrier. If one is not available, a carrier can easily be fashioned using the normal 35-mm negative carrier and several precleaned microscope slides. These slides can be affixed to the carrier top and bottom. The subject can then be placed on the carrier and taped closed if necessary. This technique will function adequately, with minimal expense. Mask off the area of the carrier not being used, to prevent flare.

In producing images using an enlarger, lens aperture considerations from traditional photomacrography should still be maintained. This means that when selecting the lens aperture, consider the image diffraction and image resolution needs. This will become important with exposure control. The light intensity of the enlarger, although not really greater, is considerably higher when using film than with paper because of the sensitivity differences. The exposure times from a traditional timer may not be short enough at 0.1 seconds to be useful. Neutral-density filters or voltage reducers may need to be used to reduce illumination so that an adequate result can be obtained using more effective apertures.

## Scanning Photomacrography

In traditional photomacrography, getting specimen sharpness due to lack of depth of field is a real concern. This insufficient depth of sharpness sometimes can be minimized by using smaller apertures. If the lens is stopped down too far, however, *diffraction* may be created. Diffraction results in images that are unresolved. Consequently, the image may appear soft. These are some real problems for photomacrographers in making magnified images of quality.

Scanning photomacrography produces an approach where the image is shot at optimal aperture, and the DOF produced is, to say the least, unbelievable, for the specimen appears sharp throughout its depth. The technique involves transporting the subject through a beam of illumination thinner than the DOF of the taking lens. In essence, what is being produced is "an almost topographical mapping" of the subject (Figure 8.23).

Since the subject is moving through the illumination, traditional exposure times of 1/2 second for example, are not useful. It would be reasonable to guess that the image would be blurred; however, in reality, the image will be only partially exposed. Exposure to the film is accomplished by sequentially exposing the specimen as it traverses the beam of light. The faster the subject is moved through the light, the shorter the exposure time produced by the system. Conversely, the slower the transport speed, the longer the exposure time produced. Me-

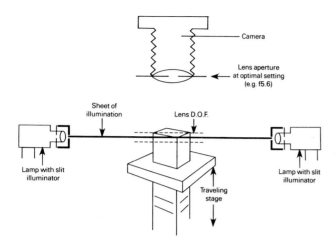

**FIGURE 8.23** This illustration represents the elements of a scanning system. Scan speed dictates the exposure times, but subject reflectivity plays a role as well. The more reflective the subject, the shorter the scan time required, as contrasted with a dark subject that requires slower scans. Subjects that are not truly opaque typically do not scan well due to ghosting affects.

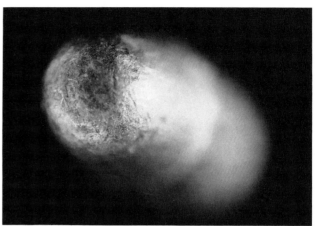

**FIGURE 8.24** These photographs were shot with a Nikon reverse mounted 50-mm enlarging lens at ×5. They demonstrate the advantage of using scanning photomacrography versus a traditional photomacrographic approach. The increased DOF is also accompanied by an increased sharpness. Most subjects because of the contrast will have an almost tactile appearance. In this illustration, the coverage by the sheet of illumination was such that no light covered the small triangle region at the base of the bullet, so it photographed dark. Care needs to be taken to establish the illumination.

tering in scanning photomacrography is very difficult, and so trial-and-error approaches or use of Polaroid materials are most useful.

The camera is suspended perpendicular to the subject, and the focal length required is chosen. The image magnification required is established using traditional photomacrographic techniques, but now the technique deviates radically from traditional techniques.

Focusing need not be done yet, but, rather, the alignment of illumination must be established. Using some sort of small rectangular-shaped object, focus the illumination in such a way that all illuminators are superimposed over each other under the lens. This will produce a sheet of illumination that is uniform in thickness. The lights used should all be focused where the specimen will be located. Once the illumination has been precisely focused and established, the camera can be focused where the beam of illumination is focused (Figure 8.24).

The subject's area in focus and illuminated remains equidistant from the lens throughout the photography. It is for this reason that an image of zero perspective is produced. There is not adequate space to fully discuss this technique. For additional reading on this approach, see Nile Root (1985).

### Specialized Equipment

No discussion on photomacrography would be complete without mention of some of the specialized equipment currently on the market. The two most common pieces of equipment specific to photomacrography are the Nikon MultiPhot[5] and the Wild Photomacroskop.[6] These two cameras are complete systems with a variety of accessories. The latter include transillumination stages, auto-

exposure capabilities, and fiber-optic lights. It is impossible to discuss their specific operations here, but any of the aforementioned techniques can be used in their operation. For more information about these instruments or others, contact your local supplier of scientific instruments.

### ACKNOWLEDGMENTS

This has been a huge project, and I would like to acknowledge those who helped me along the way. Martin Scott for his constant support from the beginning; Nile Root, Roger Loveland, and John Delly for believing in me; J. Wesley Morningstar for his graphic illustrations; H. Lou Gibson for his patience and assistance with technical information and editing; Rochester Institute of Technology, the place that provided me with the environment

and opportunities to grow, and the Eastman Kodak Company/Scientific Imaging for the resources and support to research in the area.

## ENDNOTES

1. Bencher Corporation
   333 W. Lake Street
   Chicago, IL 60606
   312–263-1808

   Spiratone
   P. O. Box 8051
   Pittsburgh, PA 15216
   800–221-9695

   Kinex Corp.
   34 Elton
   Rochester, NY 14607
   716–442-2360

2. Gray cards (18%) are obtainable from professional photographic suppliers. One such card is the R-27 Kodak Gray Card, Cat. No. 152 7795.

3. Magnifiers for the viewfinder on 35-mm cameras are available from the manufacturer. One such magnifier is Nikon's excellent waist-level magnifier for their F3 and F4 cameras.

   For examining the image on a ground-glass viewing screen the following magnifier is an excellent choice:

   Item: F30, 056, 9X Opaque Base Magnifier

   Edmund Scientific Company
   224 101 E. Gloucester Pike
   Barrington, NJ 08007-1380
   609–547-8880

   Ward's Natural Science Establishment, Inc.
   P.O. Box 92912
   5100 W. Henrietta Road
   Rochester, NY 14623
   716–359-2505

   Carolina Biological
   2700 York Road
   Burlington, NC 27215
   800–334–5551

4. Microscope lamps and other specialized items are available from:
   The McCrone Group
   850 Pasquinelli Drive
   Westmont, IL 60559
   708–887-7100

5. Nikon Instrument Division
   Nikon Inc.
   1300 Walt Whitman Road
   Melville, NY 11747-3064
   516–547-8500
   FAX 516–547-0306

6. Wild Inc.
   24 Link Drive
   Rockleigh, NY 07647
   201–767-1100

   Olympus Optical Co, Ltd.
   Crossways Park
   Woodbury, NY 11797

## REFERENCES

Blaker, A., 1976. *Field Photography: Beginning and Advanced Techniques.* San Francisco: W. H. Freeman.

Blaker, A. A., 1989. *Handbook for Scientific Photography*, 2nd ed.: Lighting Three-Dimensional Subject. Boston: Focal Press.

Eastman Kodak Company, 1990. *Handbook of Kodak Photographic Filters* (B-3). Rochester, NY: Eastman Kodak.

Gibson, H. L., 1960. Magnification and depth of detail in photomacrography. *Photogr. Soc. Am. J.* 26(6):34–47.

Gibson, H. L., 1975. Close-up photography and photomacrography. In *Eastman Kodak Publication N-16.* Rochester, NY: Kodak Publications.

Gibson, H. L., 1977. *Eastman Kodak Publication N-12.* Rochester, NY: Kodak Publications.

Gibson, H. L., 1986. Depth and enlarging factors in ultra-close-up and photomacrographic prints and slides. *J. Biol. Photogr.* 54(4):127–142.

Root, N., 1985. Deep field scanning photomacrography. *J. Biol. Photogr.* 53(2):69–76.

The Scheimpflug rule (Ray) and its use (Stroebel):

Ray, S., 1988. *Applied Photographic Optics.* Boston: Focal Press.

Stroebel, L., 1980. *View Camera Techniques*, 4th ed. Boston: Focal Press.

Stroebel, L., 1986. *Photographic Materials and Processes.* Boston: Focal Press.

## BIBLIOGRAPHY

Lefkowitz, L., 1979. *The Manual of Close-up Photography.* International Center for Photography, Garden City, NY: American Photographic Book Publishing Co..

# Chapter 9
# Public Relations Photography and Portraiture in the Workplace

John F. Zacher

*"The function of a Public Relations person is to make sure the public image the client wants to have and the public image the client actually has are one and the same."*

Sheila King, Publicist
Roosevelt University, Chicago, IL

In past years, the work of biological photographers within the health-science community was essentially technical; there was little room for flexibility. Increasing demands on institutional public relations groups with limited budgets have begun to affect the daily activities of many photographers specializing in the biological sciences. Many now wear second hats, using their skills in projects with goals as diverse as employee recruitment/retention, fund raising, and community education. Public relations photography requires more than simple photographic competence. This chapter explains the professional attitudes and techniques that are most useful in obtaining high-quality images for the public relations office of a large research hospital.

## THE HUMAN ELEMENT

Public relations photography deals with the human side of an institution; thus, its images almost always include people (Figure 9.1). If interacting closely with the public does not appeal to you, chances are you will not enjoy photographing the recipient of a 25-year service award or a group of teenagers donating money they raised from a carwash. To the interested public relations photographer, the assignments should be more than just "grip-and-grin" sessions; they should be opportunities to record major events in people's lives. The public relations photographer is the institution's visual historian and must attempt to attend as many institutional activities as possible to ensure that all key events are recorded.

## LAYING THE GROUNDWORK

Why should a biological photographer become involved in the institution's public relations work? First, you are familiar with the institution and are aware of what and who is photogenic. As a full-time employee, you have the opportunity to cultivate ideas, reshoot unsuccessful images, and store strong photographs for future use.

Second, the number of publications produced by health-care organizations is skyrocketing. Examples include newsletters, employee magazines, and recruitment brochures. Photographs are essential to the appeal of these documents because they add crucial visual interest that cannot be achieved by simply changing the style of type or the width of columns. More important, pictures illustrate the fact that institutions consist of people. They introduce new faces, depict contributions made by others, and, hopefully, entice the reader to stop turning the pages and read the article (Figure 9.2).

Each publication has its own style. Some are statistical and display copy only; others incorporate a high-gloss, high-tech look and are designed mainly for visual impact. Regardless of the style or the size of the publication's budget, you can provide the required photographic services.

### Beginning

To begin in public relations photography, you should:

1. Contact your public relations director and personally express your interest.
2. Present a small portfolio of your leisure-time photography to illustrate your skills.
3. Obtain permission to exhibit public relations photographs in prominent areas throughout your institution.
4. With the permission of your institution, submit photographs to the local newspaper or local health-care newsletters and tabloids.

Become acquainted with as many employees and visitors as you can. The more people you meet, the fewer strangers you will be asked to photograph. Your ability to make people feel comfortable will invariably be apparent

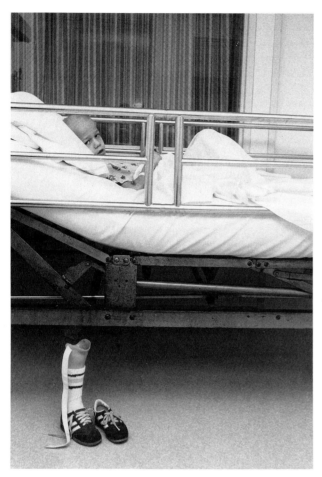

**FIGURE 9.1    The harsh reality of childhood catastrophic disease is difficult to explain, but photographs often succeed when words fail.**

in your work. The primary tool of communication for a photographer might be the camera, but photographic equipment and technique alone will not get the job done. Oral communication skills are mandatory. What value is the ability to determine composition if you fail to successfully direct the subject's pose and expression? A quick way to improve your communication skills is to listen carefully to what you say, think about how clear your instructions are likely to seem to the subject, and then practice using phrases that express your needs in a direct, unambiguous way. This may seem to be a trivial instruction, but photographers who must struggle to express clear instructions quickly lose both the attention and the confidence of their subjects.

Forming a strong working relationship with a publication's editor or author and with the graphic design personnel is very important. Regular meetings should be held to discuss photographic strategies, followed by conferences to review proof sheets and prints, confirming that your energies are being expended properly.

An alternative method to submitting proof sheets to the publications staff is to enlarge all frames you consider publication quality (Figure 9.3). This avoids the embarrassment that can result if someone on the staff selects a substandard frame. Keep in mind that the editor, not the photographer, has the ultimate responsibility for the publication's content. With this accountability, the editor has the right to select and use photographs as he or she desires. Be patient with the editorial staff; your sound photographic efforts will gain their confidence, and you will be allowed additional critical input on future projects.

## Compiling a Public Relations Image Inventory

Make a serious effort to construct a comprehensive file of public relations images. Accumulating both slides and prints in a wide spectrum of categories will enable you to deliver the needed product on demand. The following list includes categories and descriptions of essential public relations images.

**Exterior.**    Attractive exterior photographs of your entire facility should be kept on file and updated regularly. Take full advantage of atmospheric and seasonal conditions. A gray sky or out-of-season foliage can produce a lackluster image. Interesting cloud formations accented by using polarized filtration technique will add impact to the scene. One of the most popular exterior photographs is the wide-angle view of an entire building complex. Such images can be photographed from adjacent buildings, helicopters, or airplanes. These informational photographs are frequently used for brochures, map making, or illustrating construction progress. Do not hesitate to photograph your institution during peak activity; hallways and grounds devoid of people can give the impression of a ghost town. In the hospital setting, doctors, nurses, and patients walking in and out of buildings add to the authenticity and interest of the scene.

Commercial vehicles and advertisements should be avoided. Also, if you are photographing a large campus and your angle includes rooftops, consider the possibility of a night photograph (Color Plate 42). This can eliminate rooftop air-conditioning equipment and other unsightly items. Exposures made at dusk using both interior and exterior light can be striking. The use of a 4 × 5 inch view camera with full swings and tilts will allow you to control perspective, depth of field, and distortion and also supply you with a negative for high-quality prints at extreme enlargements.

**Interior.**    Interior photographs should reveal the personality of your institution. Inform and entertain the public by highlighting attractive areas such as lobbies, waiting rooms, surgical suites, and research laboratories.

**FIGURE 9.2** Artist Amy Nguyen prepares the layout of an employee newsletter. This wide-angle, aerial-type view helps to tell the story of her work. (*Photo by Jere Parobek.*)

**FIGURE 9.3** Use of a pure white backdrop and careful composition made this photograph suitable for the cover of an institutional magazine. Note the available space for insertion of the publication's title and other information. Pastor Jim Browning and patient.

Be prepared to photograph some interior work after normal working hours or on weekends. Keep records of the time of day and location of interesting natural light patterns that will add character and dimension to interiors. Consider rearranging or adding furnishings to create a better photograph. Space limitations make shooting through doorways and windows or from ladders a routine procedure. Architectural photography is done using the swings and tilts of a view camera; this produces distortion-free, high-quality images. Interior photography can be a costly, time-consuming venture, so avoid including items within the scene that will easily date the photograph. Do not waste your energies on unremarkable areas; such images are rarely used.

**Personnel.** When photographing employees, remember that the subjects should be concentrating on some task at hand, rather than peering into the camera. Images depicting human relationships, such as a nurse giving aid to a patient or an animated conversation between researchers, are action photographs necessary for a complete public relations file (Figure 9.4). Photographs illustrating emotions, such as compassion, intensity, and en-

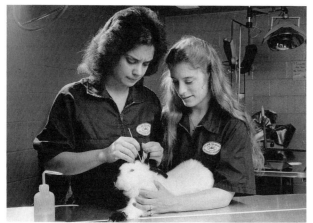

FIGURE 9.4 Animal research technicians care for their animals—use of hair light adds to the dimension of the photo.

FIGURE 9.5 Still life histology.

thusiasm, are often singled out for wide use. The photographer should be alert for photogenic employees, from housekeepers to administrators. The complete story of an institution cannot be properly illustrated if segments of the workforce are excluded.

**Still Life.** In contrast to the brief "half-life" of photographs involving people, still-life images may be current for years. Whether by changes in fashion, outdated equipment or politics, time erodes the value of photographs that center on people. To ensure that your still-life images endure, concentrate on ordinary items that do not show their age (pencils, glassware, dry ice, gas burners, culture plates, or stethoscopes). Such photographs have many applications. Publishers can screen them and print over the muted image, or editors can use them to add interest to a chapter heading. Still-life photographs are unequaled in their versatility (Figure 9.5).

### Ceremonies

The key to photographing a ceremony effectively is gathering all the necessary information. No one plans to fail; they fail to plan. Developing a checklist will keep you organized. Start with the five W's of journalism: who, what, when, where, and why. *When* and *where* are logistically easy to uncover. Much more difficult are *who, what,* and *why.* The *who* applies not only to *who* will be photographed but *who* is authorizing or paying for the photographic service. Next, determine *what* event is to be photographed and *why* the event is taking place. The following is an example of the information that is typically supplied to the photographer, followed by additional information that you will probably have to seek out, but that will make your assignment less stressful and yield a superior product (Figure 9.6).

FIGURE 9.6 It is often difficult to photograph groups of young people. In this shot, use of a high camera perspective allowed everyone to be seen without imposing undue restrictions. Children were allowed to be children.

## Basic Information

*Who?* The volunteer service department
*What?* Will hold an awards ceremony
*When?* April 17th at 7:00 p.m.
*Where?* The ballroom of the Down-Towner Hotel
*Why?* To recognize the volunteers' service

## Detailed Information

*Client:* Volunteer services, event chairperson, Joe Jones
*Photographer's contact:* Mary Smith, event M.C.
*Work authorized by:* Bill Miller, department chairperson
*Utilities:* Sufficient electrical outlets.
*Rehearsal:* April 16th at 7:00 p.m.
*Particulars:* One hundred twenty awards will be individually photographed during the ceremony. Three groups of eight participants each will also be photographed before the event takes place.
*Movement pattern:* Awardees move from their assigned seating in the audience to stage right. After receiving their award from the chief administrator, they will cross the stage and be photographed with the medical director, then exit stage left.
*Product:* Color 8 × 10 inch enlargements for each awardee; also supply hospital public relations department with historical documentation for file and news release.
*Date finished product is required:* One week from the event.
*Photographer's attire:* Suit and tie

## Check Presentations

There is no photographer on earth who has not uttered the phrase, "Darn, another grip and grin!" The demand for these hackneyed images greatly outweighs the desire to photograph them. However, images depicting a philanthropist's efforts merit professional photographic documentation. Apply the same techniques that have worked well in your more technical assignments. Demonstrate your initiative by being as creative as possible. Using the nearest white wall for a backdrop will only add to the static nature of the image. Making a visual connection to the contribution is important. For instance, if the donation is to be used for a building project, photograph the participants at the construction site. If the check is being allocated for a particular piece of equipment, why not escort the participants to the equipment site and photograph them in conversation with the operator? The possibilities are limited only by your imagination and enthusiasm.

## Celebrities

Sooner or later you will be called on to record the visit of a celebrity (Figure 9.7), and in all likelihood you will be totally unprepared for the accompanying confusion. The normal, level-headed employees you see every day can become pushing, shoving, autograph-seeking rowdies who want their photographs taken arm-in-arm with the star. The best advice is to keep your mind on your objective and continually check your equipment; there will be no opportunity for reshoots. Concentrate on obtaining a half dozen usable images instead of several dozen mediocre ones. Although photographing events spontaneously may produce good results, try to isolate the celebrity with an appropriate subject in a controlled environment. If such control cannot be achieved, exploit the festivities to your advantage. Using a wide-angle lens, portray the star surrounded by fans. Keep in mind that the moving crowd may negate many of your attempts, so do not undershoot the event.

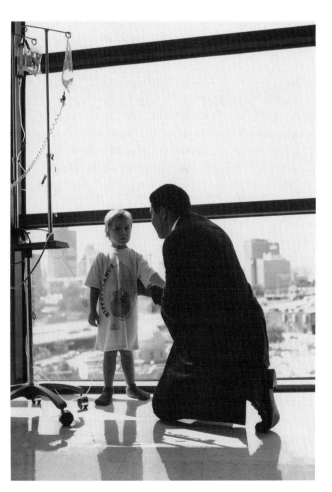

**FIGURE 9.7   This silhouette of Muhammad Ali demonstrates the gentleness of the former World Heavyweight champion.**

## Groups

For decades, professional photographers have reluctantly assembled their equipment and traveled to the sites of dreaded shots. In such situations, even the most conscientious photographer may give insufficient thought and effort to how the shapes of the group will appear on the film plane. Try to develop a game plan and a positive attitude. View the assignment from the participant's perspective. There are many important reasons to take group photographs: they document business relationships, which often become treasured keepsakes, and they have proved to be valuable resources to historians. Finally, you should not overlook the potential revenue that group photography can bring to your department.

Multiple subjects can create multiple problems for the photographer. The major challenge is to create an image in which numerous subjects look attractive, both individually and collectively. Think of a group photograph as a dual-purpose image, a picture within a picture. A traditional class graduation picture is a good example. Although the photograph has the primary aim of documenting the group's collective achievement, it also honors the contribution of each individual.

Most viewers look first at the entire assembly and then seek out a particular person. When photographers think of the group as a single form and fail to see the significance of each individual, they have seriously hurt their chances of capturing an attractive image. Each person should be seen as a vital part of the puzzle, so that each position and each expression becomes a factor in how the audience accepts the image. A well-conceived and well-executed group photograph can be both appreciated and profitable. Keep in mind that it is your shot; the photographer, not the subject, must take final responsibility for overcoming obstacles.

**Formal Groups.**    The main difference between shooting informal and formal groups is that with the latter, you should attempt to position each subject to achieve a reserved, conservative effect. Formal groups, including governing boards, faculties, or administrative bodies, should be asked to wear similar attire for photographic sessions. Your attire, in turn, should demonstrate respect for the event. Select a site that will reflect the dignity of the event, and take time to plan the job well. The need for sound planning takes on additional significance when you consider the time and expense of assembling prominent people for a photograph.

**Informal Groups.**    Although most group photographs are traditionally conservative, there is a niche for less-structured, more creative group images, which public relations departments use for annual reports and in-house publications. Advertisements often include this style of photography. Informal group photography should place less emphasis on uniformity and more on displaying the activity of the group. Identifying a realistic activity with high visual impact, on which the group can concentrate, is a difficult task. Visit several potential sites before a session, to gain a feel for the area and hopefully to stimulate your creativity.

### Specific Guidelines

1. Ensure that all participants can be clearly recognized. Alternate the number of persons in each row so that an even/odd pattern is formed. This will allow each person to be seen between the people in front of him or her.

2. Do not focus on any person with unusual clothing or positioning. If someone is dressed very differently, place this person in the second or a subsequent row, not in the front. Hand and feet positions should be uniform.

3. Arrange formal groups symmetrically.

4. Try to fill the full format of the negative.

5. Avoid positioning several subjects in a single row. If five or more persons are to be photographed, use two or more rows. Position individuals on the wings slightly forward and angled inward. This will allow all subjects to be an equal distance from the camera, thus having equal magnification in the photograph.

6. When more than two rows are needed, seat subjects on chairs in the first row, position subjects standing in the second row, and use a riser for subjects to stand on in the third row. If riser equipment is unavailable, use a reversed, rigid chair stable enough for subjects to stand on safely. Steps, bleachers, or a hillside can also aid in distributing subjects so they can be seen.

7. Use a large-format view camera in either of two situations: (1) when the group includes 20 people or more and (2) when the position of the film plane is not parallel to the subject. The improved image quality and distortion control offered by the view camera more than makes up for the inconvenience of the larger format.

8. If the photograph is to be taken outdoors, schedule an alternate date and/or an indoor site in the event of bad weather.

### Portraits

Portraits are continually used as public relations products. Hence, it is essential to develop good portraiture skills. When analyzing a subject's physical characteristics, use light, camera perspective, and pose to emphasize the subject's positive features while downplaying their negative features. Next, entice the subject into an interesting expression and trigger the shutter. In theory, these procedures will result in a photograph that pleases both the subject and the public. In practice, sound application

takes rehearsal. Remember that the objective of portraiture is not typically to capture the exact likeness of the subject, but rather to capture the person's perception of himself (herself) or the perception that others have. The reality of portraiture is frequently an illusion.

**Scheduling and Preparation.**    Setting the right tone with the client is important. The person responsible for scheduling portraits must communicate a positive attitude while arranging a photographic session. Being thoughtful and using common sense when dealing with clients will pay dividends. Here are a few suggestions:

1. Book portrait sessions when the customer is not stressed. Late afternoons and early mornings are convenient times for most customers. However, some people do not look their best early in the morning or after the stress of the day takes its toll. Men who are prone to 5 o'clock shadows should be photographed in the morning. Midmornings through early afternoon tend to be the optimal times for making portrait photographs.

2. Schedule a minimum of 30 minutes for each session. Every sitting may not exhaust the full time allotment, but if your client happens to be 10 minutes late, you will still have sufficient time to shoot a quality portrait. Tactfully suggesting an appropriate wardrobe avoids inconveniencing the client for reshoots. Suggest solid colors and nonpattern cloth for formal portraits. Women should be given ample time to prepare their hair and makeup.

The portrait photographer's ability to communicate with the client is essential. Mastering portrait techniques and becoming proficient with equipment alone will not bring you success. Your ability to communicate and put the subject at ease is also important. Greet the customers warmly as they arrive; then initiate a light conversation to give them a few moments to adjust to the new surroundings. Once they are comfortable, introduce them to your studio.

**Basic Portrait Lighting.**    Three illumination sources are generally used for basic portraiture: the main, the fill, and the separation light. The purpose of the *main* light, also referred to as the *key* or *modeling light*, is to produce form through highlights and shadows. The subject's facial characteristics will determine the position of the main light, which usually is placed above the subject's eye level and aimed at approximately a 45-degree angle from the camera's axis. The main light's position, relative to the camera's axis, determines how much or how little facial contours are visible (Figure 9.8a).

The function of the *fill* light is to alter the intensity of the shadow created by the main light. The fill light is normally placed beside or directly behind the camera. This soft, even source should fill but not create additional shadows. The fill light is usually positioned to represent one-half the intensity of the main light. This results in a 3:1 lighting ratio (Figure 9.8b).

The *separation* light adds dimension to the portrait by separating the subject from the background. It is usually positioned directly behind and below the subject, where it cannot be seen, and directed upward to illuminate the background (Figure 9.8c).

An *accent* light or *kicker* light adds additional life to the photograph, but it must be handled cautiously. If misdirected into the camera's optics, the light could produce optical flare and destroy your image. A good practice is to adjust each light source individually while the others are off. This procedure allows the photographer to visualize the light's effect on the subject (Figure 9.8d).

*Note:* These techniques are also effective when illuminating subjects for studio video production. Tungsten–halogen light sources commonly used in video work generate excessive heat. The potential for injury can be limited by using shields over the bulbs and stabilization equipment (that is, sand bags attached to the base of light standards).

**Posing.**    A subject's pose can make or break the shot by changing its mood. Posing is body language—the best vehicle for conveying the prevailing attitude of the subject.

Public relations departments tend to select head-and-shoulders portraits that convey an alert, attentive attitude. A person who is too comfortable will not give that impression. Do not position your subjects with their shoulders squared to the camera; some degree of angle is preferred. Ask them to sit upright, plant their feet securely, and place their hands in their lap, folded. To secure the impression of motion ask them to lean forward from the waist, lower their front shoulder slightly, and turn their head away from the center of their body.

Occasionally the photographer must make physical contact with the sitter in order to adjust a tie or straighten a collar. Contact with the subject is acceptable as long as you ask and receive permission.

It is difficult to separate lighting and posing in portraiture; they go hand in hand. Analyzing the sitter's physical characteristics will help determine both the lighting and the pose. For example, one side of a person's face is often more photogenic than the other. The more attractive side should be posed or turned toward the camera, to receive the bulk of illumination created by the main light; the other side should receive less illumination so that it appears less prominent. If a person has a striking defect, a more radical pose, such as a profile, or split-lighting technique might be helpful, as might lowering the camera angle to lengthen the neck, for example.

If you are called upon to photograph subjects with stocky figures, the following techniques can be helpful. When photographing the full figure, partially obscure

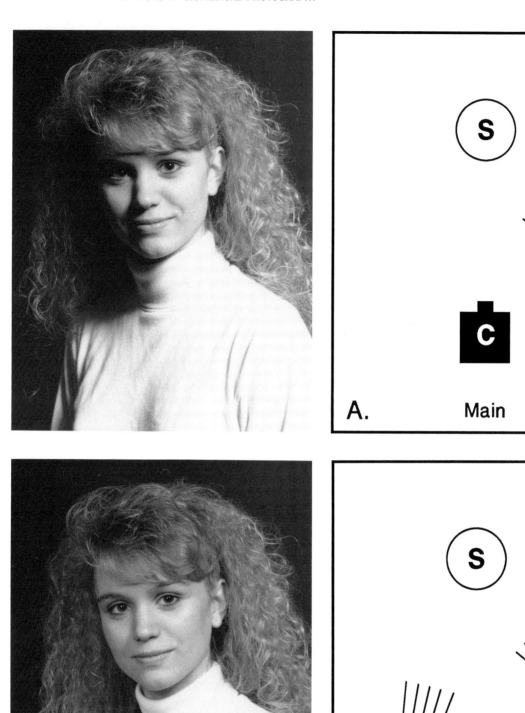

**FIGURE 9.8**   Studio Light examples (photographs and line drawings): (a) Main light only. (b) Main light and fill light. (c) Separating light only. (d) Combination of main, fill, separation, and hair light.

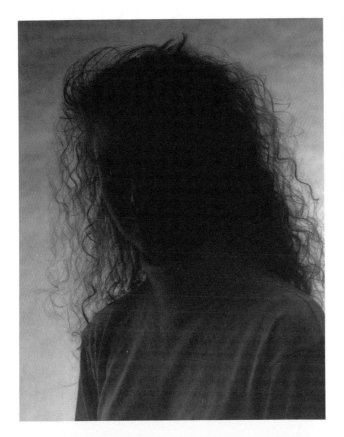

C.     Separation

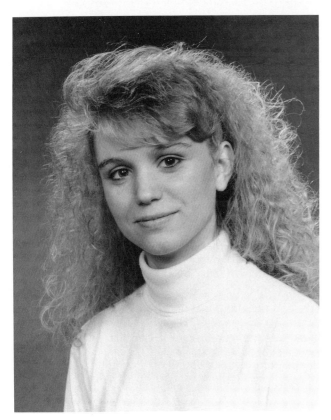

Main, Fill,
D. Separation and Kicker

**FIGURE 9.8** Continued

the subject with the use of a formal chair or desk. Use oblique-angle poses, although caution should be taken not to position the arm and shoulder too square to the camera. Implement *short-lighting* techniques by placing the shadowed side of the subject's face toward the camera.

If the subject is thin, poses that nearly square the subject to the camera can be used. Use small props to accompany slight-figured subjects. Slender faces call for *broad lighting*. The positioning of the main light source should be somewhat lower than normal, producing a highlight in the subject's eye that is located at either 10 o'clock or 2 o'clock. The main light should also be moved closer to the camera in order to illuminate both sides of the subject's face equally.

The rules of composition are also helpful in posing subjects. Folding the subject's arms, for example, establishes a strong foundation for a head-and-shoulders portrait. To help you develop additional ideas for posing compositions, clip useful photographs from magazines to build your resources.

**Environmental Portraits.**    The objective of environmental portraiture is to blend the character of the subject with his or her surroundings (Figure 9.9). Far too many portraits of this type depict man and machine as equal partners. Instead, consider portraying the person as the dominant element and his or her habitat as secondary. Most basic portraiture principles apply to environmental portraiture; however, the use of normal-to-wide angle optics is acceptable and frequently necessary to illustrate the ambience of the working condition. You may also find that unusual camera perspectives become commonplace in helping the photographer capture the relationship between the subject and environment. It is not always essential to display the subject's entire face; profiles can be equally effective. Use of lightweight, portable, studio-caliber electronic flash units allow you to go on location, rather than build expensive sets in the studio.

### TECHNICAL CONSIDERATIONS

#### Miscellaneous Guidelines

To prosper in public relations photography, you must be technically versatile. On Monday you may be a portrait photographer; on Tuesday you may shoot a product for an advertisement; on Wednesday you may take a group photograph; and so on. No one will expect you to excel at every photographic discipline; however, customers have a right to expect quality in whatever product or service they purchase.

**FIGURE 9.9   Child psychologist Dr. Raymond Mulhern listens attentively to his patient, showing obvious concern over her problem. This environmental portrait was used to introduce the Psychology Department in the 1988–1990 St. Jude Scientific Report.**

### TECHNIQUES FOR SUCCESSFUL ASSIGNMENTS

Because of the difficulty in recording useful public relations images, the photographer's best pictures are likely to be used many times. Pictures that served as a small single-column ad may be enlarged to serve as a full-page bleed. Thus, care should be taken when selecting a camera. Use the largest format practical for that assignment. Additionally, become knowledgeable about the characteristics of film emulsions and developers; they are critical in producing publication-quality prints. Converting color slides to black and white prints is certainly possible, but the quality of the image generally suffers. Of all the factors contributing to the quality of a photographic print, the role of using the correct *emulsion* cannot be overstated.

Photographing a variety of public relations subjects demands adaptability. Different tasks require different methods and assorted styles. When gathering images for a picture story, think of yourself as a photojournalistic fly on the wall. If you are creating a front cover for a brochure, you are likely to find that carefully orchestrating every element is the only way to get the job done. Whatever style or combination of styles you choose, keep in mind what separates public relations photographers from most of their media counterparts. You are paid to originate images that depict the aspirations of the institution. In other words, make sure you communicate the message your employer intended. Individual subjectivity is rarely called for in public relations photography.

If you are fortunate enough to have two photographers on your staff, the additional help can be an advantage on some assignments. Twice as many minds generate twice as many ideas. A partner can remind you of necessary equipment and assist you in lighting and metering the scene. A second person can also stimulate the dialogue needed to put the subject at ease, making the photographer's job much easier. Remember the value of your partners. Respect their opinions, and you will share the benefit of their talents.

## Motion

Countless methods have been developed to help photographers attract and hold the attention of the audience. Colored gels placed over light sources or special-effect filters on lenses alter the appearance of a scene. Methods for depicting motion, such as the use of extended shutter speeds or panning the camera, can be effective in generating interest in an otherwise static scene. Be aware of photographic trends, but do not overemphasize artificially created images. Photographic trickery is not a substitute for natural quality.

Biological photographers tend to think of themselves as technical experts. This perception can be advantageous in performing photomicrography, but it can lead to a complete loss of spontaneity when the photographer is confronted with a public relations assignment. Try to photograph events as they unfold (Figure 9.10). There will be occasions when you will need to interrupt the natural flow of events. In such instances, obtain the client's consent, briefly and unobtrusively take whatever steps are needed to acquire the image, and then remove yourself from the scene.

Manipulating the content of a scene or designing a setup photograph has produced many creative public relations images. If, however, such images are poorly conceived, they can bore an audience and fail to achieve their objective. Photography is frequently thought of as a visual testimony of truth. If it is obvious that the subjects

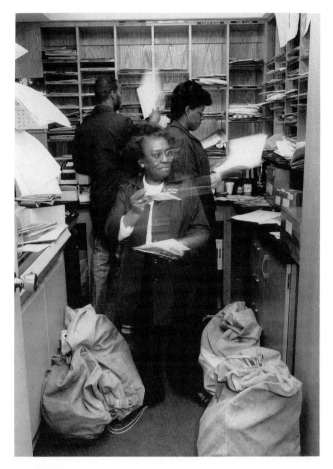

**FIGURE 9.10   Motion adds to the statement of a fast-paced work area.**

are playing a role, the viewer could lose confidence in the authenticity of the image. As you peer through the viewfinder, ask yourself if the scene is believable. If you have any doubts, the audience will probably have some too.

## Available Light

*Available-light photography* has applications in the field of public relations as well as in the fine arts. Pictures that use the existing light of a scene reproduce an array of tonalities that auxiliary sources cannot duplicate (Figure 9.11). Whether the abundance of light pouring through an unshaded window or the scarcity of illumination created by a single desk lamp, the feeling generated by existing light is often exquisite. When using available light, you record the scene in its natural condition. It is difficult to find a subject who is not intimidated or distracted by auxiliary light.

Modern high-speed film allows many public relations photographs to be taken inside buildings with little or no additional lighting. Usually, the existing interior light is

**FIGURE 9.11** The sunlight from the window and the shadows created by the blinds generated a dramatic light condition for this photograph. Positioning the patient's mother in shadow emphasizes the child as the primary subject.

daylight. A kicker light added to your main source, activated by a photocell, will add interesting dimensions to lifeless scenes. The aim is to produce a pleasant, interesting light condition that cannot be achieved with a direct flash.

Many public relations photographs are taken outdoors. An earlier example mentioned synchronizing the existing light of the interior scene with the light produced by your flash unit. The same effect can be accomplished outdoors by using synchro sun-flash techniques, which enable you to place subjects in advantageous positions, regardless of the shadows created by the sun. Again, simply fill in the shadows with your flash unit. Remember that the sun dictates the shutter speed, while the flash unit dictates the aperture. Example: an outdoor scene registers a meter reading of $f/16$ at 1/125 second; the subject to camera distance is 10 feet. Your flash unit requires an aperture of $f/11$ at that distance. Set your camera aperture at $f/11$, and adjust your shutter speed to 1/250 second. This exposure combination fulfills the flash unit's aperture requirement, and increasing the

sufficient to record midtones and highlights. However, holding proper shadow detail in the scene can be a problem. To add detail to the shadows without destroying the character generated by existing light, use 400 International Standards Organization (ISO) film and a small strobe to act as a fill source. An approximate exposure would be $f/4$ at 1/60 second. Adjust your strobe to discharge sufficient illumination for an exposure of $f/2.8$. Next, set your camera according to the existing light reading, $f/4$ at 1/60 second. The small amount of light generated by the flash will produce detail in the shadowed areas without overriding the existing light exposure. Your scene will retain its natural look (Figure 9.12).

Whenever the job requires electronic flash units, make every effort to diffuse the source. Bouncing the flash off a white card, wall, or ceiling will help soften the harsh light produced by your flash unit. If you use electronic flash units frequently, consideration should be given to acquiring monolights. The newest generation of monolights are both powerful and lightweight, and when outfitted with umbrellas, they can simulate soft natural

**FIGURE 9.12** A combination of available light and electronic flash produces the "edge" seen on this daydreaming patient's profile.

shutter speed makes the overall exposure correct. Reducing the flash output will reduce the percentage of shadow filled by the flash.

## Equipment

In addition to a good attitude, the most important thing any public relations photographer can have is *good optics*. If your budget is limited, earmark available funds for sharp, fast optics. With 35-mm formats, 28-mm wide-angle, 55-mm normal, and 105-mm telephoto lens will cover most events. With 2 1/4 formats, a 50-mm wide-angle, 80-mm normal, and 120-mm telephoto lens are satisfactory. Fixed focal length lenses are preferable to zoom lenses, a choice based on the quality of enlargements made from negatives shot by these two lens types. The fixed focal length lens outperforms the zoom lens nearly every time.

The public relations photographer should embrace the modern technologies offered by the newest generation of camera systems. Features such as through-the-lens metering, dedicated flash units, and high-speed motor drives are useful.

A good choice for shooting outdoor assignments is a camera equipped with a *leaf-spring shutter,* which fully synchronizes the flash at all shutter speeds. If 35-mm format is preferred, make certain the focal-plane shutter synchronizes up to 1/250 of a second, or a speed that will ordinarily take care of most of your synchro sun requirements.

Furnishing your studio with the appropriate equipment will simplify your work. When choosing a camera format, keep in mind that medium- to large-format cameras are superior to 35-mm cameras for most portrait photography. The larger negative size can be greatly magnified without loss of quality, and negative retouching is only practical with the larger-format emulsions.

Optics used for portraiture require longer-than-normal focal lengths. Head-and-shoulders portraits photographed with a 2 1/4 inch square format should rely on a 120-mm lens, 2 1/4 × 2 3/4 inches dictates a 135-mm lens, and a 4 × 5 inch format requires roughly a 210-mm lens. There are numerous lighting systems to consider. The most practical would be an electronic flash system including a minimum of three flash heads with modeling lights and slave units. Of course, a functional portrait studio must have a full complement of accessories: a sturdy camera stand, an adjustable posing stool, interchangeable backgrounds, reflectors, snoots, barn doors, scrims, umbrellas, booms, and the like. All of the necessary paraphernalia should be well organized and easily accessible.

## ACKNOWLEDGMENTS

A special thanks to Jerry Luther, department director, and to all of my co-workers in the Biomedical Communications Department, St. Jude Children's Research Hospital, for their contributions to this chapter, and the Scientific Editing Department for their editorial assistance. I would also like to thank my family and the special patients and parents of the best hospital in the world— St. Jude Children's Research Hospital, Memphis, Tennessee.

## BIBLIOGRAPHY

Freeman, M, 1984. *Studio Manual.* New York: American Photographic Book Publishing, Guptill Publications.

Eastman Kodak, 1987. *Professional Portrait Techniques,* O-4. Rochester, NY: Eastman Kodak Co.

Eastman Kodak, 1990. *Black and White Darkroom Techniques,* KW-15. Rochester, NY: Eastman Kodak Co.

United States Navy, 10355, 1969. *Photographer's Manual.* Washington, DC: United States Printing Office.

# Chapter 10
# Basic Videography and Editing

## C. Allen Shaffer and Marian L. Beck

*"The subject should have validity . . . not that it needs to be the most important subject in medicine, but a subject which is important enough to have taken the time and best energies of the intelligent people who are called to produce the film, as well as of the audience for which it is made."*

Warren Sturgis, R.B.P., F.B.P.A. 1912–

In today's cost-conscious medical environment, the biological photographer is often asked to assume additional roles. Your position as an image maker often designates you as a video expert for the institution, regardless of your level of actual education, experience, or interest.

Society's rapid acceptance of home video recording and subsequent demand for cameras, coupled with exponential technical advances in motion image recording has caused an explosion in the demand for basic video services in medicine.

This chapter will attempt to prepare you to meet this new demand for video. Certainly, the full range of practice in medical television is too broad, and too dependent on the equipment available at a particular facility, to be covered in one chapter. As in any discipline, only experience and thoughtful reflection will serve to make you a competent videographer and editor.

Medical television seeks to capture, in motion, those events and ideas that medical photography communicates through the still image. The medical television producer lights and poses patients, gradient subjects, and still lifes; makes images through the microscope; shoots in the operating room; and copies two-dimensional subjects onto tape. When the videographer interviews a subject, he or she uses the principles of portrait lighting (as outlined in Chapter 9 on Public Relations Photography and Portraiture in the Workplace). Therefore, the careful reader of this text needs only to be shown where medical television *differs* from the general principles of biophotography, and how to deal with the *unique* problems of the television medium and the development of a television service.

The authors assume that readers of this text are interested in a basic medical television service capable of documenting procedures, patient conditions, and simple procedures with a single camera, and using relatively inexpensive editing technology to produce a single-concept teaching production. To that end, the chapter begins with a basic exposition of the unique characteristics of the electronic imaging medium, progresses through the development of a television service in the medical setting, and concludes with the basic videography, lighting, and editing techniques necessary for the single concept medical teaching tape. The safety concerns associated with hospital teleproduction are included in these techniques.

Medical television is the natural extension of the already highly developed visual communication skills of the biophotographer. Archimedes, the Greek philosopher, stated, "Give me a place on which to stand, and I will move the world." This chapter gives biophotographers a solid place to stand in the world of electronic imaging in the hope that they will use it to advance their careers and the teaching of medicine.

## ELECTRONIC IMAGING AS A MEDICAL TEACHING MEDIUM

Electronic imaging has been described by the authors, in lectures and in conversations, as "the worst quality imaging medium since the cave painting." If this is so, why has it gained such wide acceptance?

Although the intrinsic image quality of television is not as great as silver film, it does have the ability to tell complete stories, to convey the feeling and atmosphere of a place or a person, to make linear relationships between facts and events, and to accomplish these goals in a rapid and comparatively inexpensive manner.

In medical education, including the public education used to market or publicize our institutions, the value of television will only be realized when it is used in a carefully designed manner, which maximizes its advantages as an educational tool. This chapter will not attempt to cover the subjects of instructional design, organizational communication, or marketing, all of which are fully developed disciplines, with excellent printed resources. However, a brief review of the authors' approach to a new production may give the reader a useful starting point for developing a personal approach to production design.

Recognizing the crisis-oriented, fast pace at which our

clients live, the first principle of our instructional design is practicality. Nothing is required from the client that does not have vital application to the production process.

To begin, the photographer should ask the client to define the current problem. This is done in an informal setting, conversationally, and the production team makes notes as the client talks. During this discussion, there are no solutions offered, and only vital questions are asked. At this point in the production design, the client should try to clarify the problem to be solved and also his or her attitudes, expectations, unspoken needs, and (perhaps) hidden agendas. For example, a client may define the problem as an instructional difficulty with third-year surgery students, when in reality their need is a production to take to an annual meeting, believing that an institutional problem will gain more support from the production staff. It is vital to discover the client's true needs and expectations before doing any subsequent planning.

After the problem is defined, discuss and evaluate the persons involved. Although this step is traditionally called *audience analysis*, it is important to consider capability for teaching and learning of both client and student. Certainly, the experience level, motivation, and attitudes of those watching the production are a vital component in designing a production. Those audience attributes will help determine what methods and techniques to use to carry the messages of the show. Producers must also consider the motivations, personal style, and skills of the authors of the program, and choose methods they can credibly and comfortably use in making the show.

After designing hundreds of medical television productions, the authors have learned the importance of trimming down what is asked for by the client into a production that has only one or a few major points. In instructional research, the most effective production is the *single-concept film*, a short show (8 to 12 minutes) with one major point to make. If clients have multiple instructional problems, encourage them to make a series of short productions rather than one lengthy one.

Many instructional designers recommend developing *learning objectives*, that is, a list of specific things to be learned by watching a television tape. It is more meaningful to agree on a description of the problem, how the show will attack that problem, and some informal ideas about how success will be measured. Although you will not write scripts or storyboards in the classical form, ask clients to *write down what you want to say to them*—that is, to write a narrative script. This serves several purposes. It forces the client to think in an organized way about the material to be presented, it reveals potential production mismatches between the amount of information to be presented and the visual material available to cover that narration, and it fixes the limits of the production. The narrative script is the best device for planning the production.

Part of the design process with an inexperienced client

is an informal discussion that covers all of the difficulties and delays a production can encounter. Inform the client of the various electronic disasters that can occur, demonstrate to them the cost in editing time of changes at various production stages, and let them see in outline the areas that depend on the performance of others. This type of "informed consent," when done with the same nonthreatening professionalism that clients exercise with their patients, takes the unexpected out of a complex and unfamiliar process.

Many producers exclude the client from decisions about graphic style, color choices, set dressing, and the use of visual effects. Many clients, however, enjoy participating in these decisions to some extent and feel that the resulting production better reflects their personal style. Some clients are quite uncomfortable, for example, with a teaching production that contains complex visual effects. Here again, evaluating design decisions in light of this particular production's place in the continuum of the educational process will help immensely. A perfect production that a client will not use because it does not match his or her style is ineffective and a waste of time and money.

## DEVELOPING A MEDICAL TELEVISION SERVICE

Many readers of this book work in an institution that currently has no medical television service and that owns no television production equipment. Neither of these situations constitute a barrier to the production of medical television programs or the development of an efficient service. In fact, many top television producers own no equipment and employ no staff. They rely instead on their personal creativity in designing programs and use readily available vendor services and the checkbook of a willing client.

Assessing the needs of the client, whether of an individual biological scientist or an institution, is the first step in developing television, and an ongoing challenge for the media producer. In assessing need, it is helpful to look at the overall mission of the client. In most parts of the scientific world that mission is the tripartite role of teaching, research, and service. In addition, science and medicine have recently recognized the need to support advancement; the fund raising, public relations, and public information activities that generate the needed support for the other missions of the institution.

The "mission" of an individual client can be viewed in the same light. Not only must clients teach, complete and publish research projects, and perform clinical duties, but they must also "advance" their personal careers by high-quality communication of the results of their efforts.

Resources, either personal or institutional, will be placed where the greatest needs are perceived. There-

fore, you must accurately assess, on an ongoing basis, the needs of your clients and the opportunity to fill them through television services.

The teaching needs of the client can take several forms. First, the client may need simple, silent motion sequences, of the kind Dan Patton has termed *moving lecture slides*. The gait of an orthopedic or neurological patient or a particularly skillful maneuver in the operating room may be best illustrated by a short motion sequence that requires only the narration provided by a lecturer. This need is the basis for the *video notebooking* concept of the Veteran's Administration media service.

The single-concept teaching production, usually carrying a title such as *Catheterizing the Patient* or *Use of the Dialysis Machine*, is the most obvious product of a medical television service. Such productions are limited in scope, short in viewing time, focused on a specific learning objective, and completed quickly. They most often fill specific situational needs and are real problem-solvers for clients.

With the explosion of video recording of medical and scientific images, such as those from arthroscopes, endoscopes, and ultrasound scanners, there has been a corresponding explosion in the need for editing these images. Lecturers wish to show and discuss highlights of many hundreds of instances of image documentation, supplemented with simple graphics or the addition of other information such as radiographs or patient photographs/videotape. This need is acute, because the equipment and time required for assembly of this information is normally unavailable to the lecturer.

Finally, teachers are charged with changing attitudes as well as passing information. Lecturers often wish for dramatic productions to help influence the thinking of their students, or to provoke debate and critical reflection. For example, an effective and sensitive television producer could uniquely capture the emotions of colostomy patients and the realities of their everyday routine. This would help to bring an attitude-changing dimension to the gastroenterology class. Clients will appreciate television assistance in teaching difficult concepts of ethics, compassion, and professionalism.

Research efforts can benefit greatly from television services, and can help in financing development of technical capability. Granting agencies are increasingly demanding video documentation of research procedures and results; they look favorably on the funding of a reasonable level of equipment to accomplish the task. This equipment is then available for other institutional uses at the conclusion of the project. Researchers often need unusual documentation services, such as 24-hour or time-lapse photography, which add to the diversity of the photographer's technical capability.

Video presentations can help a client or an institution receive more research grants. As part of an aggressive program of grantsmanship, video presentations of previously accomplished work and of the general capabilities of the individual researcher and/or the institution as a whole can be effective in presenting a positive image to the granting agency.

Television productions help the service mission in several ways. The individual client can often use well-planned productions to reduce instruction time to patients, or to increase the patient's understanding of instructions. Public information video, including footage provided to news organizations as well as completed in-house productions, can communicate vital information to the public.

This leads naturally into the newest area of need for television, advancement. In providing information to the public as a real service, educating them about an aspect of biological or medical science that touches their lives, there is an inseparable benefit for the institution or the individual client. It is the principle of this new activity, called *advancement*, that fundraising, alumni/volunteer/donor communications, public relations, and marketing and media relations are interconnected and should be coordinated and cross-supported. Using this model, the expanding medical television service may be able to fulfill needs in some very important and growing areas of the organization.

## BEGINNING TECHNICAL CONSIDERATIONS

Many people, when presented with the idea of developing television in their institution, say immediately "But we don't own *any* television equipment!" This is almost invariably untrue. The first step you should take is to identify every possible piece of television equipment owned by the institution, as well as every piece of equipment existing in your photographic laboratory that might double as television production equipment.

For example, consider the existing equipment in a 300-bed teaching hospital. First, there is a complete cable television distribution system already installed throughout all floors, and into every room in the attached nursing school. This system has television sets in every patient room, and in the cafeteria, staff lounge, doctor's lounge, and every waiting room. The vendor says that it would be easy and inexpensive to add channels for program distribution. Also, there are several extra television sets, used for backup in patient rooms, which are almost always available for production use.

A survey reveals that there are actually seven video recorders owned by the hospital, which are connected to medical imaging devices. Most of these are VHS format. In addition, the physical therapy department owns a camera and portable recorder it never uses, left over from a funded study.

In your photolab, you have tripods, tungsten lights and stands, simple roller backgrounds, and other studio

equipment. You have several rolling carts and a rear projection setup that could be used to put slides onto videotape. A casual lunchroom conversation reveals that the pathology department owns a video system that is permanently attached to one of its microscopes. It feeds a personal computer that takes in video and allows someone to draw on it and add letters.

From this example, you begin to see the possibilities for negotiation and compromise leading to the development of some television production at this hospital. Reducing the territorial inclinations of each of these departments to the point where this equipment can be used efficiently is a real challenge, but it might be possible. What are some other opportunities?

Once needs are proven, and funds are available, vendor services can be used to provide the technical capability to produce a program. This is the method chosen by many professional producers, who simply hire a crew in the city where the client's production is to be shot. Likely sources of production service for hire include television stations, college journalism or photo/cinema departments, independent production houses, or some churches. These sources may also be amenable to time-sharing arrangements, or may be willing to donate some services for tax credit, media attention, or unique access to your institution.

Not all television productions for your client need to be original television productions. First, you might choose to seek out an already completed production that meets your client's needs and buy the rights to its use. This might include changing some titles or references to personalize it to your institution. Secondly, you might choose to take existing footage, sometimes shot for another purpose, and use it to create a new program that meets your needs. (When this is done with videodisk images, it is called *repurposing*.) This might be done, for example, with news footage released to you by the station. Thirdly, you might choose to make a slide program with audiotape narration and have it transferred to videotape. If thoughtfully planned, the resulting product can look quite nice, reduce or eliminate production costs, and illustrate the convenience value of videotape as a final package for information without requiring up-front funding.

Your survey of equipment in the hospital will lead you to some decisions, the first of which is: What format will be best for this institution? Format refers to the combination of tape size, and its path through the machine, which was chosen by the individual manufacturer as a standard for their machines. Formats currently in use include 1/2-inch VHS (the common home format), 3/4-inch U-Matic, 1-inch Type C, 1/2-inch Super VHS and 1/2-inch Betacam (the professional formats), and many other dying or developing formats.

The decision to buy into a certain format is complex. Your survey will tell you what existing equipment you must interface with, and might influence this decision. Each format represents a different quality level. You must decide on the level of video quality your work will demand and on the level of quality your institution will support, with both equipment purchases and continued maintenance. Remember that higher quality levels mean that you can afford less capability in accessories, and that you will spend more in maintenance and parts.

Finally, format choice is somewhat based on the final use of your productions. If your final tapes are used primarily by broadcast news stations, your format choice will be very different from that of a producer who primarily prepares educational material for patients to take home and view on their home machines.

Your first equipment purchase may well be a simple *video playback unit*, which is often the best strategy to create production interest. By providing video playback and seeking out productions made elsewhere that meet certain needs within the institution, it soon becomes obvious that in-house productions could be made to meet other urgent needs. Before such a playback unit is purchased, survey existing equipment and seek an institution-wide agreement on format. Also, attempt to purchase a unit that is compatible with computer data display, to extend the usefulness of the equipment and broaden the support for its purchase.

## CREATING SUPPORT FOR TELEVISION DEVELOPMENT

Once you have identified client needs and have surveyed existing equipment, gather support for the development of a television service. This section briefly outlines some parts of that process as it has been successfully attempted at several institutions.

Gathering a group of supportive clients and administrators is the goal of the developer of the television service. In any institution, there will be persons who are quick to embrace new ideas and technologies and some who are slow to be convinced, but all will respond to the same truthful exposition of needs and opportunities. The first step in the campaign is to share with the clients your assessment of their needs and those of the institution.

This assessment should include medical or scientific benefits and examples. In your enthusiasm for the teaching advantages of video or for its power in the public relations arena, do not forget to highlight to basic scientists or clinicians the fact that motion images can directly contribute to their diagnostic or investigative ability. The demonstration of how video can fill their needs should also include the medicolegal or liability-reducing aspects of video documentation.

The survey of existing equipment can illustrate to your clients and administrators the real impact of video imaging at your institution and can validate your statements

of need. Your efforts to identify available resources and to coordinate their more efficient use are an additional point in favor of your proposal.

Every institution has its opinion makers. Part of your success in developing television will be to identify some of their needs, to attempt to meet those needs or to interest them in your proposal to meet their needs, and to use them to reach others. It would be unconscionable to show favoritism or to give preferential treatment; however, it is necessary to solve problems with television and make that problem solving visible to many in the institution. Therefore, do include institutional opinion makers in your strategy of development.

Perhaps a better strategy lies in identifying the most difficult problems of the institution and looking for ways to solve them with television services. If you can take a tough, recurring problem, such as the training of custodial workers who are frequently replaced, and solve it with a series of tapes, your proposal will receive serious attention. Look for situations in your institution or among your clients where large amounts of time are dedicated on a continuing basis to the passing of the same information to different audiences, or where variations in the quality of information transfer are costing time, money, or incurring liability.

Keep in mind that your proposal will be judged partially on its breadth. A television service that benefits only the clients who lecture frequently, or which only benefits the hospital administration, is doomed to failure or severe limitation. You must demonstrate how your new service can cross discipline and department lines to serve multiple needs in the institution. This spreads the cost of the service and increases the likelihood of funding.

Realize, however, that it is not enough to gain support, solve problems, and be diverse in your thinking. You must also be prepared to prove that the dollar cost of the equipment and time the new television service requires will be offset by greater cost saving for the institution, or increased revenue, or both. You can limit costs by use of existing equipment, cross-training of staff, time-sharing arrangements, and other strategies. You can estimate some cost savings to the clients or to the institution in cooperation with the managers of the activities affected. Finally, you can estimate some increased revenue from billing individual clients for research or private-practice-based activities that you may conduct, or from providing services such as video duplication to staff members of the institution. You should have a tough, well-prepared balance sheet you are ready to defend as the cornerstone of your proposal.

## YOUR TELEVISION EQUIPMENT PURCHASES

Your proposal has been successful. Now what do you do? First, you will probably purchase the bare minimum equipment required for the production of motion sequences and single-concept productions.

You will purchase a single, fairly high-quality *camera,* suitable for both portable use and for conversion to *tripod mounting* as a studio camera. This camera, and all your other equipment, should be purchased from a vendor who understands your developing operation, is willing to help you with your proposals and your decisions, and who comes highly recommended from others in your community who are further along in the development of their television service.

If your camera is not of the camcorder type (as discussed in the section on Basic Portable Videography, you will also need to purchase a portable *recorder* in the same format). Finally, you will purchase two video machines, one player, and one recorder/player, suitable for editing, with an editing controller to join them.

With these few items, supplemented by your photographic lighting instruments and control devices, you can make perfectly acceptable basic productions using straight cuts between scenes. This has often been referred to as *film style,* since many 16-mm films were made with one camera and straight-cut editing. To this equipment add graphics with title cards prepared by an illustrator or graphic artist. Next, you need to gain greater capability in graphics, through acquisition of either a *character generator,* an electronic device that types words on the screen, or a more complex device such as a *computer graphics device* that allows drawing and image manipulation.

Now more diversity in direction is possible. Certainly you will want to construct a permanent postproduction facility, whether it is a multilevel cart containing all of the editing and graphic machines or a room set up for the purpose. You may opt for more sophistication in editing, with digital video effects and multimachine editing with dissolves, or you may choose to purchase backup machines and cameras to improve the reliability of your basic service. You need to consider the needs and opportunities revealed by your ongoing evaluation of your clients and institution.

What about staffing? Books on television production list jobs for videographers, editors, writers, narrators, graphics producers, producers, and directors. Obviously, in a developing service these jobs must all be done. The question is: By whom? In many single-concept productions, these jobs are all done by one person. In fact, it is to your advantage to gain experience in each of these areas, so that you can hire and train others later on.

Although these jobs can all be done by one person, this limits the number of productions that can be accomplished. To expand your capability, consider cross-training other employees, giving them some opportunity to develop skills and interests in television writing, graphics, or videography. These volunteer assistants do not have to come solely from the media department.

Other departments may be willing to contribute some employee time in return for services. Also, some employees may donate time, out of their interest in the technology and creative opportunity of television. Also, there are many opportunities among community groups, schools and colleges, retired persons, and others to seek human resources for the development of a medical television service.

## BASIC PORTABLE VIDEOGRAPHY

Many people involved in biophotography now fill the roles of photographer and videographer. Until recently, most television production was done in the studio because of the large size and complexity of the equipment. Video productions required tremendous quantities of light and a great deal of supplementary instrumentation, as well as a team of people to make it all run efficiently.

The advent of portable equipment has added another dimension to productions. The need for commercial television stations to send reporters and cameras into the field to cover news stories brought about the rapid development of portable television equipment. This *electronic news gathering (ENG) equipment* was the forerunner of today's portable units. Advances in technology have initiated changes in ENG equipment, making it more compact and lightweight so it can be more easily taken on location and used under a variety of conditions, often without additional lighting.

Historically, studio production had often set limits on the types of subject matter videotaped. Now the studio comes to the subject in its natural environment, thus expanding production possibilities. The lower cost of a portable production equipment package compared with the cost of a studio production facility has led to a significant increase in the number of biocommunication centers that can offer television services to their clients. There are a number of basic techniques, along with some problems unique to portable videography. Here is some practical advice that can be applied to many levels and types of production. While camcorders have become popular in the last few years, the use of a separate camera and recorder is still common. This combination will be referred to in this discussion.

### Stability and Stamina

Though portable television equipment is much lighter than it used to be, it is still rather difficult to use it to make steady recordings. Of course, the best method of stabilizing any camera is with a *tripod*. One useful accessory is a quality tripod designed specifically for use with a portable television camera. Tripods designed for television cameras should have the following features: heavy-duty construction to support the weight of the camera, a tripod plate with a quick-release mechanism and multiple mounting holes to allow the camera to be correctly balanced and securely fastened, and a design that allows for smooth pans and tilts to follow the action of the subject. There is a big difference between quality tripods designed for videography and tripods of poor quality or those fashioned from still camera tripods.

While the greatest stability can be gained from using a quality tripod, ENG equipment is designed to be carried on the shoulder. The ability to support the camera on the shoulder well enough to obtain good, steady pictures takes practice, plus the ability to move quickly from one place to another without a tripod, makes it well worth the effort. Shooting from the shoulder is sometimes a necessity. In some situations, such as directly outside an emergency room or in the middle of a crowd, locking the camera down on a tripod is potentially dangerous. Also, the physical limitations of the environment might not allow for a place to set up a tripod.

**FIGURE 10.1  Posture is crucial to successful videography. When standing in the proper position, it should be possible to draw a straight line from the shoulder, down through the hip, to the ball of the foot.**

Posture and technique are also crucial to a videographer's stability. Since a tripod offers the best stability, your stance should imitate one. Like a tripod, the formation of a wide base offers the best stability; so stand with your feet wide apart. Once the base is established, achieve correct upper-body position. Proper upper-body position is probably one of the most difficult aspects of videography because of the cumbersome nature and weight of the equipment. Relaxation is the key factor here. With your feet apart, thrust your hips slightly forward. Relax your back and shoulders as much as possible. They should be almost sunken when you are in the correct position. You should be able to draw a straight line down from the shoulder, through the hip, to the ball of the foot (Figure 10.1). It is difficult to relax while performing such videographic isometrics, but with practice and patience this position will become second nature.

The right shoulder supports the camera. Place the right hand through the hand-hold (adjusted for a snug fit) and steady the camera body. By bracing the camera against your head, the camera will be wedged between it and the shoulder, offering additional stability. Your right thumb operates the on/off button, and the right fingers control the zoom function of the lens (Figure 10.2). Your left shoulder supports the recorder, while the left hand operates the focus, iris, and other camera controls. The left hand also provides additional support for the camera (Figure 10.3).

By carrying the recorder on the left side and the camera on the right, you can distribute the weight of the equipment more evenly and achieve better balance. Since your right shoulder and hand provide most of the support to the camera, the left hand can be used to operate the recorder.

Unfortunately, there are no cameras that are specially designed for the left-handed person. The best advice for the left-hander is to try to adapt as best as possible to the design of the camera.

A similar problem exists for people who have vision problems with the right eye that makes it difficult or impossible to use the viewfinder. Some viewfinders can be pulled away from the camera body far enough to accommodate the left eye, but most are designed to be used with the right eye.

**FIGURE 10.2  The right shoulder is the main support for the camera. The right hand fits through the hand-hold and controls the camera VTR button and zoom mechanism.**

**FIGURE 10.3  The recording deck hangs from the left shoulder, while the left hand offers additional support for the camera and operates many of the camera controls.**

Videography is part visual creativity and part athletic endeavor. As in any sport practice leads to relaxation, which culminates in a natural flow of movement. One of the first things the beginning videographer will notice is the cumbersome nature of the equipment. To ensure personal safety, there are a few guidelines that should be routinely adhered to. These are covered more completely at the end of this chapter. Every setting has the potential to explode with activity, so you must carefully consider an appropriate camera location. Whatever the location, an escape route should be planned that would leave no extra equipment behind in the path of traffic. Because of the size, design, and position of the camera while on the shoulder, the ability to see and hear past the camera is limited. While you are operating the camera, the right eye looks through the viewfinder and, depending on how the action is framed, the subject may be much closer than you realize. For this reason, the left eye should be kept open as much as possible. This allows the camera operator to occasionally check the camera to subject distance and to be aware of anything outside the frame that might cause a collision.

Under dangerous or crowded conditions, the *buddy system* is particularly useful. The buddy system employs one person as the camera operator and another as combination recorder, audio person, and equipment handler. In addition to easing the work load of the camera operator and monitoring the other equipment, the equipment handler also becomes the camera operator's eyes and ears. The equipment operator closely monitors the situation, and, if conditions become dangerous, warns the videographer or physically pulls him or her to a safer area (Figure 10.4). This system allows the videographer more freedom of movement and more freedom to concentrate on the subject. In addition, if both the equipment handler and camera operator are cross-trained and can switch jobs, they can extend taping time significantly. The equipment handler must be a help and not be an additional burden. A well-meaning "helper" who does not understand how difficult it may be for the videographer to see or move quickly may end up causing trouble, rather than preventing it.

## Lighting

Lighting for television has for many years been very bright, extremely harsh, and fairly complex. The portable lighting kits used by the news media may not necessarily be the best choice for every assignment. There are a number of different portable lighting kits available for videography. Some use a waist-belt battery pack that connects to the light, with the light bracket-mounted to the camera body. The battery belt and light used with our equipment weighs 18 lbs. (8.16 kg), about average for

**FIGURE 10.4    The buddy system is a must in crowded or potentially dangerous situations.**

most lighting kits of this type. That additional weight, when added to the weight of the camera (in our case weighs 21.2 lbs. (9.61 kg) and the recording deck (at 24.4 lbs. or (11.06 kg)) is a burden. Although this lighting option is the only practical choice in many situations, the weight will tire the videographer sooner and make it more difficult to move quickly if necessary. To solve the weight-related problems, a number of compact, lightweight modular lighting kits (about 1 pound) have been introduced. Because the lights in these kits are powered by the camera battery, taping time per battery will be somewhat reduced.

There may be occasions when supplementary lighting cannot be used because of the condition of a patient, or because the type of lighting offered by these portable lighting kits is not appropriate for the subject. Available light is acceptable in many cases, but modifying the light might sometimes be necessary. Proper positioning of the subject and the use of reflectors for fill will often yield surprisingly good results. Modifying the available light not only adds to the ease of production but also allows for creativity and variety in the lighting.

Reflectors can be used to modify and enhance lighting for videography. The problem of carrying large white cards can be solved by utilizing a number of different accessory items designed for this purpose. One of the most unique items of this sort is a device called Flexfill (Figure 10.5), manufactured by Visual Departures (New York, NY). Flexfill is a flexible, collapsible reflector disk that can be used like any other reflector. Unlike most reflectors, however, it can be twisted into a figure 8 and collapsed to a reasonable size for carrying (Figure 10.6). Although not specifically mentioned by the manufacturer, we have successfully washed off the disks after use to remove dirt and debris collected when they were used

**FIGURE 10.5** Using a flexible, collapsible reflector disk to provide fill is more convenient than carrying large reflector cards on location.

under field conditions. Flexfill comes in various sizes and reflective surfaces and is reasonably priced.

Another way to alter the effect of lighting is by using *filters*. Gel sample swatch books are available inexpensively at many theatrical or lighting supply houses and can easily be carried along on location. The filters can be used either to change the overall color balance of a scene or to change the color rendition of a subject when color is extremely critical to a diagnosis. Many laboratory subjects such as gels or agar plates fall into this category. Placing the proper color correction filter swatch over the camera lens, white balancing, and then removing the filter fools the camera, which then shifts its color reproduction toward the complementary color of the swatch. This shift in color balance can be used to alter the color of specimens as they appear on video or can be used creatively to make a scene appear warmer or cooler.

**FIGURE 10.6** When finished using the reflector disk, it can be collapsed to a more manageable size for carrying.

A combination of different types of lighting presents a challenge to the videographer. This is not always a negative situation, and in some cases it can actually enhance the lighting effect. An example of this occurred when a subject was interviewed in his home office. The main light was provided by a large picture window in the room. The weather that day was rainy, so the light coming in the window was "cool." The subject sat very close to the end of the couch near a table lamp so that the light coming from the lamp gave a much warmer feel to the picture. In this case, as in many cases, a deviation from normal lighting practices provided a welcome variation and enhanced the overall production.

In another example, the subject sat behind her desk, which was positioned to take best advantage of the light from two windows in the room. One window served as the main light, while the other acted as fill. Placing some white paper on the desk reflected some additional light onto the subject's face.

Personal interviews are used in many video productions. While these interviews are often conducted in the studio, sometimes they may need to be done on location, where lighting conditions can vary greatly.

It is probably foolish to think that we can invade someone's work area, set up strange-looking equipment, rearrange furniture, and then expect them to look and sound totally natural on camera. Sometimes it is helpful to let the person being interviewed select a comfortable spot within their work area. Many people are more at ease behind their desk or in their lab. As long as the location selected is compatible with your production needs, this is the best approach.

In addition, you should set up the equipment as quickly and efficiently as possible. This will help reduce the interviewee's anxiety and increase the chances for a more natural-sounding interview. Offering a review copy of the tape to the interviewee to allow him or her the opportunity to reject any objectionable segments of the recording is a good practice. For many people, it can be intimidating to be interviewed for television, so it is crucial to the quality of the interview to do everything possible to put the interviewee at ease.

## Environmental Precautions

Since location videotaping is done under a variety of environmental conditions, you can take a number of precautions. Protective gear for video equipment is a good idea, especially when outdoor work is involved. Dust, humidity, rain, and other problems are aggravated under unusual environmental conditions. A sturdy *carrying bag* for the recording deck not only protects the appearance of the equipment but can also prevent mechanical problems as well.

Because the recorder normally hangs loose from the shoulder, it tends to be banged around quite a bit more than the camera; therefore, the bag should be heavily padded to protect the deck from shock. The bag also completely covers the equipment, protecting it from dust, rain, and other contaminants, all of which can shorten equipment life or cause tape dropout problems. The camera should also have a cover to protect it from the elements (Figure 10.7). There are a number of different camera covers available (some of which are included with the purchase of the camera). An ordinary plastic bag and some tape or rubber bands will provide adequate protection, however, and these items can easily be carried in the deck bag. Equipment used in wet or dusty conditions should be thoroughly cleaned before storage.

*Tape* selection is an important consideration, especially when working under adverse environmental conditions. Personnel and time, as well as the sometimes nonrepeatable nature of an event, make the price of high-quality tape a bargain. There are a number of excellent products to choose from. One that is particularly useful under adverse conditions is MBR tape produced by 3M. MBR is a heavy-duty tape with a special antistatic backing that helps avoid dropout problems, which can occur more frequently under adverse conditions.

When using videotape, it is important to keep track of what has been recorded on each one. To help avoid confusion and to aid in later filing, a quick and simple method is to use a grease pencil, negative pencil, or china marker to make some type of notation on the outside plastic shell of each cassette after use. You can carry either of these items conveniently in the recording bag. When you are in a hurry, this can be quicker and easier than trying to affix a label to the cassette.

**FIGURE 10.7    Rain protection for the camera should always be available when working on location.**

## Recording Sound

The dynamics of recording audio are complex, because of different requirements for both the equipment and the types of sound to be recorded. There are a number of excellent references available that give detailed information on sound frequency and amplitude, types of microphones and their properties, the theory behind their design, and many other aspects of audio recording. This discussion, however, will cover the various types of microphones and their characteristics, and will also look at some of the problems that are unique to recording sound on location.

The dynamic, ribbon, and condenser microphones are the most commonly used types of professional microphones. The *dynamic microphone* is generally the least expensive of the three. It is rugged by design and therefore well suited for outdoor and portable use. The design of this microphone also reduces overload problems caused by the loud noises and wind often encountered on location.

The *ribbon microphone* is quite sensitive and must be handled carefully. It therefore may not be the best choice for some location shooting. The mellow sound quality produced by this microphone may compensate for its lack of ruggedness. However, you must take care to avoid sudden increases in loudness, which could damage the instrument's sensitive ribbon element. The ribbon microphone is substantially more expensive than the dynamic microphone.

The *condenser microphone* uses a battery or phantom power source. Because the condenser microphone will not operate without power, it is imperative to have a supply of fresh batteries or a backup microphone available. There are a number of condenser microphones on the market that are rugged enough for location use and that will produce a high-quality recording for less money than a ribbon microphone.

Every microphone has its own individual pick-up pattern. Some microphones are sensitive in all directions (*omnidirectional*), while others have a more narrow sound pattern (*unidirectional*). While it would be nice to have microphones especially suited for each situation, most videographers have only one or two microphones at their disposal. You should be familiar with the characteristics of the microphones you have and use them to their best advantage.

An *omnidirectional microphone* is used to record the voices of a number of people sitting around a conference table. When you are interviewing one person, a *unidirectional microphone* is the right choice. A *cardioid microphone* is extremely sensitive at its front, and, depending on the design, has varying degrees of sensitivity on the sides. This configuration allows you to be even more selective in miking sound. The cardioid microphone is an excellent choice when interviewing someone under noisy

conditions. It allows you to key in on the person's voice, yet still retain a certain amount of environmental sound that will add realism and make the production more interesting.

Two specialty microphones are the shotgun microphone and the wireless microphone. The *shotgun microphone* excludes sound from all directions except the front, allowing you to pinpoint sound in the midst of noisy environments. This microphone is very useful under extremely crowded, noisy situations or when the microphone has to be placed some distance from the subject. This microphone is particularly useful in veterinary applications when it would not be wise to be close to potentially dangerous animals.

The *wireless microphone* is useful when the speaker is moving around and changing the direction from which he or she is speaking. The wireless system usually consists of a small, unobtrusive *lavalier microphone,* which hangs around the neck or clips to the clothing. The lavalier mike is omnidirectional and will compensate for the fact that the speaker will not always be talking in the direction of the microphone. The lavalier microphone is then attached to a battery-powered transmitter, which sends its signal to a receiver. You can carry the transmitter or fasten it to your clothing. This allows the speaker to move about freely as long as he or she stays within range of the receiver. Because the transmitter frequency is often the same as that of radios used by businesses such as taxicabs, there are occasional interference problems from these sources.

One of the most frustrating problems involved with recording sound on location is the amount of extraneous noise in the environment. A *windscreen* should always be placed over the head of the microphone when shooting outdoors. A gentle breeze can sound like a hurricane when you are using a microphone without the windscreen. If a windscreen is not available, you can make one from gauze or thin foam and tape it onto the head of the microphone.

Placement of the microphone is always crucial to obtaining quality sound recordings. The closer the microphone is to the subject, the stronger the recording. When you are recording in an environment with a lot of background noise, the microphone should be placed as close to the subject as possible. This technique is called *close-miking,* and will remove much of the distracting background sound. *Baffling* the background sound is also helpful, and can be done by placing the person speaking with his or her back to the background noise or placing a physical barrier between the subject and the noise.

Television not only has the ability to recreate for the viewer some of the visual landscape, but some of the audible environment as well. The recording of a certain amount of environmental sound (natural sound, or *nat sound*) adds realism to the production and helps the viewer feel like a participant. Nat sound can be randomly recorded and mixed in later, but this may not be possible if noticeable differences in timing occur between the audio and video. As long as the background noise can be reasonably controlled, it may be just as easy to record usable nat sound at the same time as the interview. You may find it useful to keep a stock file of various natural sounds, such as operating room background sounds or traffic noise, that can be used to add interest to various videotape productions.

## Shooting for Variety

All dedicated videographers have a desire to distinguish their work from others. One of the best ways to achieve this is to develop the ability to shoot for variety.

Once you have mastered the basic shoulder taping position, you can modify this technique using many of the same principles. Having the camera on the shoulder allows the camera to be balanced and supported, much as it would be on a tripod. Also built in to a videographer's shoulder is a magnificent *fluid head* movement system. The design of the human body not only allows support of a video camera on the shoulder, but it also permits rotating or otherwise moving the shoulders and the rest of the body in just about any conceivable direction. The shoulder joint is the ultimate pan/tilt head. You can achieve smooth, effective, and aesthetically executed pans and tilts by planning the shot ahead of time. When you are panning the camera to the right, point your right foot in the direction of movement (Figure 10.8). By doing this, you keep your body in balance during the entire shot and avoid scrambling for footing part way through. Preplacing the foot also increases the size of the arc you are able to use during the pan.

Tilts are approached in much the same way. Place one foot slightly behind the other to help maintain balance while the camera is being tilted up or down (Figure 10.9). The fact that support for the camera is critical to obtaining quality images has already been established. Existing structures such as walls or fences are sources of additional support and are especially useful when trying to steady the camera outdoors in high winds. Use of these structures also allows the videographer to rest for short periods (Figure 10.10).

Low-angle shots add an entirely different perspective to an otherwise normal shoulder shot. By resting all or part of the camera on the ground for support and then rotating the viewfinder up far enough to look through, the videographer can create a number of unique effects (Figure 10.11). Modified tilt shots can be done by resting the back end of the camera on the ground and then raising the lens end upward. You can also rest the camera entirely on the ground for ground-level shots.

Sometimes the subject or area of interest lies somewhere between the shoulder and true ground level. An

FIGURE 10.8 Smooth, effective pans can be executed more easily with proper foot placement. Right: For a pan to the right, the right foot should be pointed toward the right (the direction of the arc the camera will travel during the pan). Left: With the foot in this position, the videographer is able to bring the camera to the point much more smoothly while maintaining his or her balance.

FIGURE 10.9 By placing one foot behind the other, better balance can be maintained during the tilt shot.

interesting shot to try is what the authors call *shooting from the hip*. With the viewfinder again rotated upward, the camera is rested on the leg; the arm is wrapped around the body of the camera, thus wedging it between the leg, the arm, and the ribcage. Bring your right hand through the camera strap from the top, and use your thumb to operate the VTR button and zoom mechanism (Figure 10.12). This type of shot is particularly useful for pediatric and veterinary medicine where the subject is usually relatively low and a high camera viewpoint (from the shoulder, for instance) would not be as visually effective (Figure 10.13).

Sometimes, the rules for steadying the camera need to be broken for the sake of getting the shot. When taping in a crowd, your only choice may be to shoot from overhead. For this shot, rotate the viewfinder downward so that it can be used when the camera is held overhead. You can establish the focus by estimating the distance and choosing another object to focus on, or by setting the focus on infinity. Then lift the camera overhead by cupping both hands under the bottom of the camera body (Figure 10.14). Because it is difficult to operate the controls while holding the camera overhead, you should preset the exposure, establish the limits of the shot, and start recording before lifting the camera into position. A wide-angle shot will deemphasize camera shake when holding the camera overhead. Although the overhead

shot is not often used or easy to execute, there are times when it may be the only choice. With most of these shots, it is best to have someone else handle the recording deck or place it on the ground. This will allow for more attention to camera operation. If the camera is placed on the ground, it should be within easy reach in case a hasty exit is required.

Variety of camera work not only adds interest to productions but also makes postproduction easier by offering more choices for editing. It is wise for the videographer to get in the habit of taping a subject in as many different ways as possible. Instead of taking just one shot, try to shoot a wide, medium, and close-up; some zooms; some static (nonzoom); some from low or high angles; and whatever special shots might suit the subject. It is much easier and more economical to come back to the editing room with a tape containing more than you need than to have to go back and repeat something. Sometimes repeating is not even an option, so it is best to cover all possibilities with variety in your camera work.

Practically anyone can pick up a videocamera and make pictures, but the professional biomedical videogra-

FIGURE 10.10  Using existing structures for support will help steady the camera.

FIGURE 10.12  By resting the camera on the leg ("shooting from the hip"), a low-perspective shot can be achieved that is very useful in pediatric and veterinary applications.

attentive, the videographer can learn enough about some clinical situations that he or she will soon assist the clinician by suggesting such things as optimum camera angle and lighting for that condition. By working with the clinician and demonstrating your interest and expertise, you can establish an excellent working relationship while providing a high-quality product with a limited budget and limited personnel in a short time.

## VIDEO EDITING

Before 1963, the only method of videotape editing was making the magnetic tracks visible by using a special

pher can do much more than that. Today, when many people own camcorders and can shoot videos themselves, it is important to be able to offer something extra to clients so that they will utilize your services. By being

FIGURE 10.11  Resting all or part of the camera on the ground, will result in some interesting low-angle perspective shots.

FIGURE 10.13  Left: Taped from the shoulder viewpoint, this dog looks awkward and out of perspective. Right: In this "dog's eye view," the camera position has been lowered, resulting in a less-distorted view, and one that revealed important diagnostic information not visible when seen from the shoulder.

**FIGURE 10.14    For the overhead shot, both hands are cupped under the camera body for support, while the scene is monitored through the viewfinder, which is turned downward.**

developer and then making a physical splice in the tape. This process was not only difficult to accomplish, but also ruined the tape for any future reuse.

At about the same time as the development of helical scan recording in 1963, the method of switching a videotape recorder instantly from play to record, which allowed the development of electronic editing, was perfected. Electronic editing allows the producer to rerecord, in order on a second tape, the desired scenes that make up the final program.

Electronic editing, therefore, requires two videotape machines. The first, called the *master* or *source* machine, functions only as a player of the tape shot in the field or in the studio. The second videotape recorder, called the *slave* or *destination* machine, records the scenes on a second tape in the order desired by the editor.

There are two different methods or modes of editing that these machines can be set to perform. To understand them, you must first realize that there are three kinds of signals recorded on the videotape. In addition to the video and audio, which are recorded in separate places and can be separately manipulated, there is a signal called the *control track*. It is recorded when the picture and sound are recorded originally and consists of 60 pulses per second, derived from the frequency of the electrical power that was running the recorder at the time. When a machine plays back a tape, it can compare these prerecorded pulses with the power line frequency and average out some of the errors. In editing machines, this control track runs timers, which allow precise editing.

In the *assemble mode* of editing, when the edit is made, the destination machine begins recording new video, audio, and control track from the tape in the master machine. In the *insert mode* of editing, new video, new audio,

or both may be inserted into the middle of a preexisting scene, but the original control track is left undisturbed. As you can see, assemble editing is used to tack complete scenes together to form a master tape, while insert editing is often used to change, correct, or add information to an existing tape.

In any type of electronic editing, edit points must be selected and precisely identified, the machines must be at full speed when the edit is performed, and the destination VTR must be switched into record at the edit point. These functions can be performed manually (after lots of coffee!), or by machine, with reference to the control track or to a special editing signal recorded onto the videotape. Before any type of editing is attempted, you must connect the video and audio outputs of the source player to the video and audio inputs of the destination recorder.

For manual editing, the editor must identify the points at which the next scene begins on the source deck and where that scene should start and the previous one end on the destination deck. These are the two *edit points*—the starting point on the source player and the starting point on the destination machine. These points can be identified with a stopwatch, or with the mechanical counter on the machines, or by identifying a particular audio or video event on the tape.

Then using whatever reference is available, both tapes are backed up (or *prerolled*) a certain distance from these edit points, usually about 5 seconds. This preroll allows both machines to stabilize at speed before the edit is made. Then, both machines are put into play at the same time, and the destination recorder is manually switched into record at the edit point. This method is used for both assemble and insert editing. The destination machine must also be manually switched out of the insert mode at the end of the desired insertion.

Although the manual technique is better than no editing at all, it is susceptible to many errors in timing. For that reason, control track editing systems were developed. *Control track editing* requires an additional piece of equipment, an *edit controller*, which is connected to both machines with a separate cable. The edit controller contains a timer for both machines, which is run by the control track pulses on the tape in that machine. The edit controller has the capability of automatic preroll, memorization of edit points, and has a full set of function buttons for each machine (play, record, fast forward, rewind). Editing is the same in procedure with this controller as with manual editing but is much more precise, since all of the edit point identification and preroll functions are precisely timed by reference to the control track.

A final and very satisfying approach to this problem is found in recording an editing code on an unused audio track, encoding it into the picture, or any of several methods that allow an editor to permanently assign a

unique code number to each frame of video. Editing computers can then use these unique code numbers to assist in the logging and editing of video in an efficient way. This equipment, however, is much more expensive than control track editing.

Many technical problems can occur in videotape editing; most are beyond the scope of this broad view of the subject. However, two warrant brief mention. A common problem in control track editing arises because the editing timers are inaccurate or stop altogether, making editing impossible. First, remember that control track timers simply count the pulses that they hear from the tape, and that an editing log made one day on one machine may be significantly different on another machine or on the next day. If highly critical editing of medical images is necessary, you cannot accomplish it from a control track-based edit log.

A lack of sufficient control track, and therefore a timer stop, can occur because of the position of the control track head in the machine. It is somewhat *downstream*, or farther along the tape, than the video head. If recording stops immediately at the end of the desired image on the screen, the accompanying control track will not be recorded. When attempting editing with a control track edit controller, the timer will stop at the end of the control track, and the edit will not be performed.

It is easy to prevent this condition by always recording 10 to 15 seconds more of every scene than you intend to use, so that there is sufficient control track for the editing process. You should particularly inform those who record arthroscopic, endoscopic, ultrasonic, or fluoroscopic motion images on video of this problem.

Perhaps the greatest problem in video editing is the inherent inaccuracy and error in the helical scan recording system, particularly in machines priced for the educational and industrial market. When you make a recording, timing and amplitude relationships in the live image are distorted by recording them on tape. When editing occurs, the original error recorded in the tape is raised by a power of 3 in the edited copy. Usually, a copy of the edited master is made for classroom or meeting use, which again raises the recording error by a power of 3. What can you do to maintain video quality through the editing process?

1. Obtain the highest-quality equipment consistent with your purpose and within your ability to properly maintain. Give some consideration to your entire system. It does no good to spend money on high-quality editing if the playback system is unable to take advantage of the quality.

2. You should evaluate closely your tape handling and storage habits and follow closely the recommendations of equipment and tape makers to achieve the maximum performance from both machines and materials. For example, it is important to accustom each new tape to the recording machine before use by fast-forwarding the tape to the end and then rewinding it. This takes the high factory tension off of the tape pack and eliminates some errors. This type of simple attention to detail is inexpensive insurance against waste of your valuable production time.

3. The most vital quality preserver in video editing is proper maintenance. Constant preventive maintenance eliminates creeping errors due to wear, which can negate hours of production labor. Let a qualified technical person teach you the limited maintenance procedures and tests you can perform. After that, be informed enough to accurately communicate your problems to the technician, and smart enough not to attempt to correct them yourself. For a view of one of the most useful test signals, the National Television Systems Committee (NTSC) color bar pattern, please see Figure 5.12 in Graphic Slide Production.

Special machines such as *time base correctors* and *processing amplifiers* help with the quality preservation of video during editing. They are expensive, can be somewhat temperamental, and definitely work better when previously mentioned operating practices are carefully followed.

Editing style and the conventions of editing, which help tell stories in the motion medium, are extensive studies that are more appropriately covered in other references. Some particular concerns unique to medical television will receive only passing mention here.

In medical productions, planning methods to avoid jump cuts during editing takes much time. In static situations such as surgical procedures, it is easy to encounter dozens of editing problems, which can only be avoided by preplanned changes in angle of view and the wise use of graphics and cutaways. A common question asked by beginning editors is: How do I decide which portion of a sequence to include in the tape? In a production such as a surgical procedure, where lengthy segments have been taped, it is often difficult to know what portion is best left in the final product. A good rule of thumb is to use the completion or culmination of the particular step being depicted. Imagine that every piece of narration in the script ends with the words " . . . until it looks like this."

Remember when you are editing that your viewer will be seeing the material for the first time, unlike your dozens of repeated viewings. Therefore, as you edit, keep in mind the time required for the first time viewer to orient to the new information provided by each scene, and the time necessary for that viewer to assimilate and categorize the information at the end of each segment prior to moving on to the next scene.

Because most medical television productions generate ten to twenty times as much original footage as can be used in the final show, reviewing all of the original footage is a bewildering and frustrating task for the client. It

is a good idea to routinely make a rough cut of the footage, using the previously requested narrative script as a guide, prior to any client review. Important, but missed, information can easily be retrieved from the original footage, since electronic editing does not destroy the original. If you select correctly, you have saved your client days of valuable time and have provided an excellent and professional service.

## STANDARDS CONVERSION

One special problem faced by workers in medical television is the difference in the television systems of the various countries in the world. The exact method by which color television is electronically displayed varies, and the variation is more complex than a mere difference in the electrical power in different countries.

There are four current *world standards* with which you should be familiar. The method of color television construction in the United States, Canada, Japan, and others is the NTSC system. Named for the *National Television Systems Committee*, a group of RCA scientists and engineers who invented it in the 1950s, it was the first system to go into widespread production.

The PAL system (*phase alternation line*), used in Great Britain, Australia, and most of Europe, with the exception of France, corrected many of the design flaws of NTSC. SECAM, the acronym representing *sequential color memory* in French, is the system used in France and many Eastern European countries. A variant of the PAL system, called PAL-M (M for modified) is the system of Brazil.

Tapes made under one of these systems, even though they are made on a standard VHS, Beta, or 3/4 inch tape, cannot be played on similar equipment in a country that uses a different system. To play an NTSC tape in London, for example, you must have your tape *standards converted* by a laboratory that specializes in such conversion. If that is not possible, you must arrange for a multistandard player and monitor that is capable of playing NTSC tape. (See Chapter 11 for a list of countries and their standards).

## PLAYBACK/DISPLAY

One of the biggest problems for medical television clients is their attempt to play back the programs created for them. There are several areas of possible confusion.

1. Educate your clients as to the various tape formats and how to tell them apart. Remember that format is a combination of both tape size and the path that tape takes through the machine chosen by the specific manufacturer of that machine. Therefore, there are many types

of *half-inch tape*. Your clients need to know how to tell 1/2 inch VHS from 1/2 inch Beta.

2. Educate clients about the difficulties of lecturing with videotape. Clients are used to determining the pace of their lectures because they have hands-on control of a tray of 35-mm slides. It is a great service to a client to insist on a trial run, where they actually attempt to lecture with a videotape that has a fixed running time and over which they have no manual control.

3. Clients should be trained to deal with the basic setup of the most common equipment and educated on the common problems to expect and how to solve them. Clients may attempt to play back a tape on equipment left for them in an empty hotel meeting room, and with no technical help available.

One great difficulty in the education of clients involves the bewildering variations in how an electronic image can be recorded and displayed. Clients often do not realize that a television image recorded under the NTSC system can be displayed as composite video, the way our home television sets work, as separate red, green, and blue signals, or in some other division of the components of the television signal, such as *luminance/chrominance* displays (the so-called Y-C system). Many times, clients are sold medical video equipment on the basis of its excellent video display, only to find out that the display system sold with the machine is a higher quality one, which is not common in the classrooms or meeting rooms where they want to use their tapes. It is your responsibility to become informed about these display options and other emerging video systems and formats to protect your clients from unnecessary expenditure and disappointment. One of the most difficult tasks you will face as your television effort grows is the tendency for each department and unit to purchase its own production and playback equipment, which may be incompatible with or which unnecessarily duplicates existing equipment.

## SAFETY IN TELEVISION PRODUCTION

As you become more involved in medical television, you must assume responsibility for your safety and the safety of expensive equipment. In addition, there is an ethical and legal responsibility to protect patients, colleagues, and institutions. Although many of the specific examples presented here are drawn from production experience in a large university veterinary teaching facility, the basic principles apply to all media production conducted in the medical environment. Following is a brief outline of safety considerations in five broad areas, including handling heavy equipment, physical limitations, shooting environments, electrical hazards, and management for safety.

It is easy to become so involved with the complexities of

a production and with the desire to please the client that you may neglect common safety practices. Videographers frequently overlook the simple, yet essential, aspects of safety, such as the technique for correct lifting and carrying of the heavy equipment necessary for tele-production.

## HANDLING HEAVY EQUIPMENT

So-called portable equipment may be both heavy and awkward to transport, but there are correct and efficient ways to lift these objects safely. Some of the serious injuries that can result from incorrect lifting are ruptured disks, hernias, and miscarriage. The most common lifting injury, however, is simple back strain, which can be very painful and cause weeks of lost work for an individual. You can obtain information on proper lifting techniques and muscle strain from your physician.

You can best avoid back strain by proper lifting, but the use of mechanical or human assistance can also be beneficial. Carts, dollies, or pneumatic lifting devices should be employed, even over short distances. Also, it is just common sense to ask coworkers to help transport equipment. Time pressure can lead to cutting corners, but this is a classic case of misplaced priority. You cannot meet clients's demands if you cannot get out of bed.

Heavy physical work of any kind generates fatigue, which, in turn, increases the risk of accident. Try to reduce tension and fatigue, especially during the more stressful portable productions, by taking breaks, varying position, and generally lightening the load. You can reduce the load by having a co-worker carry some of the recording or accessory equipment, so that you need only consider the camera's weight.

If you are working alone, put some of the equipment down whenever possible, making sure it is readily accessible in case you need to move quickly. Remember that even during a formal production, you, your talent, and the client may benefit from a few minutes of rest. It is easy to become exhausted, even to the point of collapse, especially under the studio lights or outdoors when it is hot. Heat exhaustion can be accelerated by the stress of holding the camera or by standing in one position too long. If it is not possible to take a complete break, shift your position or the camera position, to preserve your strength when you have an opportunity. Even mentally reminding yourself to relax is a help. It is easy to get tense when trying to hold a shot steady and you may even forget to breathe. Even if you are feeling all right, be considerate of other workers and offer them breaks whenever possible.

Posture and stance are crucial to good videography and the prevention of fatigue. The back, shoulders, and neck take an enormous amount of stress, which can be reduced by good technique. Also, remember to plan the route between shooting locations to avoid retracing steps with a full equipment load. By communicating with the client and developing a shooting plan, you will save a lot of mileage and stamina.

## PHYSICAL LIMITATIONS

Some safety concerns in videography are imposed by the physical limitations of holding the equipment. First, every videographer is partially blind. It is just not possible to see in all directions with a camera on your shoulder. Remind yourself of this fact, and remember to look around to check these blind spots (Figure 10.15). There are some ways to carry the camera on your shoulder that will enable you to see better. If you are shooting while moving, it helps to have someone to guide you. Objects may appear to be farther away than they actually are when you are looking through a viewfinder, so try to keep checking perspective and distance with the actual subject.

It is best to give and receive all instructions before shooting a segment because one ear is blocked by the camera, making it difficult to hear. It is also a nuisance to try to talk and shoot simultaneously, as well as being technically difficult.

Probably the biggest physical limitation in mobile videography is the difficulty of moving quickly when weighed down by equipment and tethered by cables. This problem arises frequently and is potentially very dangerous. For example, when you are shooting large animal neurological cases in veterinary medicine, it is not uncommon for a patient weighing a ton or more to fall down. In any situation, you should plan your shooting spot carefully to avoid collisions. Try not to shoot in busy traffic areas and always allow yourself an escape route (Figure 10.16).

**FIGURE 10.15  Simple techniques such as this rocking motion help the videographer see potential hazards.**

**FIGURE 10.16    Using existing structures can provide protection to the videographer as well as assisting in shot stability.**

Under extreme conditions of potential danger, the buddy system, where one person acts as videographer and one person carries the deck, is a good idea. The deck handler is the eyes and ears of the videographer and makes the decision for both to get out of the way if the situation worsens. Many times, the deck handler will hold the belt or shirt back of the videographer, to pull him or her in the proper direction to avoid danger.

The deck handler is responsible for supplying enough cable to allow the videographer freedom of movement, but not so much that it can trip him or her. In dangerous situations, if all else fails, drop the equipment and get out of the way. The equipment is replaceable—you are not.

## SHOOTING ENVIRONMENTS

Shooting environments can vary greatly, and they need to be considered carefully in order to best protect you and your equipment. *Dust* can quickly cause problems with equipment by jamming working mechanisms or by causing head clog, with resulting loss of video. If shooting under extremely dusty conditions, such as plaster cast

removal, cover the equipment and clean it thoroughly immediately after use.

*Rain* can be extremely dangerous. Equip your camera with a rain cover for bad weather, and always use it when there is a chance of rain. If it is raining beyond the protective capacity of the raingear, choose not to shoot at all to avoid equipment damage and the real possibility of electrical shock. Drying the equipment following a rain shoot is essential, as well as never shooting during an electrical storm.

*Humidity* is always a problem in equipment safety and performance, both indoors and out. Inside, it is sometimes best to leave the equipment on to prevent the buildup of humidity. When shooting outside, you can sometimes leave the recording equipment inside an air-conditioned car, or at least keep the equipment in the shade as much as possible. A silica bag is like a sponge; a dry one soaks up unwanted moisture, but a wet one delivers it. Be sure to dry out silica bags before use. Always ship equipment with silica bags in place.

When transporting equipment from a warm area to a cold one, or vice versa, *condensation* can be a problem, as can expansion and contraction stress on equipment materials. When moving from an air-conditioned building to the hot sun, condensation on the tape drum, heads, and guides can cause damage to the tape and the recorder. Our recorder has an automatic shutoff to deactivate the machine, but it takes several hours for the moisture to evaporate so you can continue. If possible, try to make transitions slowly to prevent condensation problems.

Occasionally you will be asked to shoot in the vicinity of *explosive gases*. This is a time where you really have to weigh the odds. Do not depend solely on the people handling the materials for information, because they might not be aware of the danger television equipment may pose in a particular situation. Educate yourself, and if you suspect that the conditions may not be safe, do not go.

Several months ago, a videographer received a call from a research laboratory requesting a videotape of a procedure on rats during which ether anesthesia was to be used. When the clients were asked about the potential explosion risk of ether when used around television equipment, they stated that there was no problem. The videographers decided to shoot the procedure, turning on all equipment prior to entering the room, to reduce the chance of sparking. The head of anesthesia later pointed out that even static electricity can cause ether to explode, to the point that grounded shoe covers were required when the gas was in common use. Fortunately, ether is not used widely in surgery anymore, but it is still common in many research laboratories. There are also some other applications for its use, such as making tape stickier or helping remove adhesive from the skin. You should investigate thoroughly before agreeing to shoot in a situation under unfamiliar conditions.

Oxygen and nitrogen are used routinely in biomedical institutions and do not pose a problem when used correctly. However, careful handling of the tanks is required, as they are pressurized between 2000 and 6000 pounds per square inch. If a tank is knocked over and ruptured, the rapid loss of gas creates a rocket effect. This occurred in one facility, destroying one wall and partially penetrating another, passing through an area that only minutes before was filled with people. Another consideration in working with oxygen is that it decomposes in the presence of heat and will thus encourage combustion, so that any fire that starts will burn uncontrollably. Because of the physical limitations mentioned earlier, it would be easy to knock a tank over, so use special care when moving around tanks. When you are shooting in surgery, check to see that the room is *scavenged*. This means that all waste anesthetic gases are removed from the room; most modern surgery rooms use this technique. Many physicians recommend that pregnant women should avoid being around anesthetic equipment in use, especially during the first trimester. Some epidemiological studies indicate increased risk of miscarriage and congenital birth defects for women working in operating rooms (Manley et al. 1980). While an occasional exposure may not be harmful, pregnant videographers should take these studies into account when shooting in the operating room.

Unshielded exposure to radiographic or fluoroscopic equipment can cause increased rates of cancer and birth defects. Any institution using radiation is required by law to have a qualified person responsible for all aspects of radiation safety. This person should also be sure that the video team shooting in this environment is properly protected. Ask questions if you have any concerns in the area of radiation equipment.

In veterinary medicine, wet environments present a potential risk of electrical shock. Large animal operating rooms are actually hosed down during the disinfecting process, and the water goes everywhere. Because of such practices, you need to be especially careful to avoid equipment damage or electrical shock when involved in veterinary work.

When shooting under adverse conditions, it is helpful to have a tape designed specifically for this purpose. The 3M Corporation manufactures MBR (a registered trademark of 3M, Minneapolis, Minnesota) tape, which has a heavy-duty backing and an antistatic layer to protect against dropout. It is superior to conventional tapes under a wide range of environmental conditions.

## ELECTRICAL HAZARDS

The tools of video production depend on electrical power, so an awareness of electrical safety is essential. The number of electrical accidents that occur is smaller than other types of accidents, but when they do happen, the fatality rate is high. Respiratory arrest can occur with as little as 20 to 40 milliamperes of continuous current.

When testing equipment, plug it into a circuit isolated from other equipment, to avoid interference or harming other equipment. Recently, a videographer plugged in a monitor that had been returned from repair. As soon as the connection was made, the plug blew, the cord split, caught fire, and destroyed a computer terminal and keyboard before anyone could disconnect the plug.

Electrical fires spread quickly, so be prepared if they do happen. A Class C fire extinguisher is designed specifically for electrical fires. Two types of recommended Class C extinguishers are $CO_2$ and halon. Neither leaves any residue damage on equipment (as they work by displacing oxygen), but the $CO_2$ type may cause some freeze damage to delicate equipment; therefore halon extinguishers are best for use with computer equipment. Because fire extinguishers work by oxygen displacement, there is a danger of suffocation to people in close proximity of the fire, especially with the $CO_2$ variety. It is important to use the correct type of extinguisher because misuse will aggravate the fire and can cause serious or fatal shock to the user (National Fire Protection Association 1987).

When you are setting up equipment in a room or helping to design a room for video, check with an electrician to ensure that the load capacity in the room is sufficient. You can ruin a lot of equipment and wiring by overloading the circuitry, you will also create a fire hazard. Any loose cords should be secured by tape if the condition is temporary, or in conduit or neatly off the floor if permanent.

Studio lighting for television is extremely bright, hot, and draws a lot of amperage. Remember to consider the health of the people or animals who may be under the lights. Check at frequent intervals to see if they are all right. The heat and brightness from these lights, which can throw off a high cumulative wattage, can cause heat exhaustion, dizziness, nausea, headache, eyestrain, and numerous other symptoms. If the patient is tranquilized or under anesthesia, you need to be acutely aware of this because normal feedback systems will be disabled. During most human surgery, the patient's eyes are taped shut, but in veterinary medicine many times they are not. It is easy to damage the anesthetized patients' eyes, so be sure to confer with the surgeon about your use of additional light for recording.

Before connecting studio lights, use circuit breakers to stop the current. Large *soft box* lights run about 34 amperes of current, enough to cause severe or fatal electrical shock.

## MANAGING FOR SAFETY

The final requirement for safe television production is the involvement and complete backing of the managers

of the media operation. Just as it is easy for us to forget safety concerns under pressure, it is also easy for our clients to be unwilling to take time to address these concerns. Occasionally it is necessary for a videographer to completely refuse an assignment for safety reasons. It is in these situations that the commitment of management to safe operation becomes crucial.

In the planning of media facilities, or lecture and seminar rooms where media will be used, managers can make a great contribution by incorporating safety concerns into the design. Making provision for sufficient electrical service, appropriate fire protection, and reducing hazards by incorporating necessary cables in wall or ceiling conduit are all examples of the contributions possible by managers.

As with other goals of a media production service, such as quality, timeliness, and service, the greatest contribution of management to safety is a consistent advocacy. When managers show concern for safety through training of new employees, proper design of facilities, and daily inquiry regarding safe practices, safety in television production becomes another natural part of the work of each employee.

## ACKNOWLEDGMENTS

The authors wish to acknowledge the photographic assistance of John H. Jewett and John J. Swartz, R.B.P. Dr. John A. E. Hubbell, chief of anesthesiology, contributed to the discussion of anesthetic safety. The authors acknowledge their deep debt of gratitude to Dan R. Patton, R.B.P., F.B.P.A., and to the support of the faculty and administration of The Ohio State University College of Veterinary Medicine.

## REFERENCES

Manley, S. V., and McDonell, W. N., Anesthetic pollution and disease. *J. Am. Vet. Med. Assoc.*, 176:516.
National Fire Protection Association, 1987. *The NFPA Catalog*, Batterymarch Park, Quincy, MA 02269. Phone: 800–344-3555.

## BIBLIOGRAPHY

Eastman Kodak, 1987. *Pocket Guide to Video*, New York: Simon and Schuster.
*Independent Video*, 1974. New York: Simon and Schuster.
3M/Magnetic Media Division, 1986. *Product Literature*, Building 223-5S-01, 3M Center, St. Paul, MN 55144-1000, Phone: 612–733-9369.
Parmeggiani, L., 1983. *Encyclopedia of Occupational Health and Safety*, 3rd (revised) ed. Geneva: International Labour Office.
*Video Glossary*, 1984. Rochester, NY: Eastman Kodak.
Wurtzel, A., 1983. *Television Production*, New York: McGraw-Hill.
Yoakam, R., and Cremer, C., 1989. *ENG: Television News and the New Technology*. Random House, Inc.

# Chapter 11
# Audiovisual Support: A Practical Approach

## Robert M. Grom

*In teaching the medical student the primary requisite is to keep him awake.*

Chevalier Jackson [1865–1958]
The Life of Chevalier Jackson, Ch. 16

Numerous reasons are suggested as to why a workshop, seminar, or individual presentation fails in assisting a speaker to communicate a message to the audience. Audiovisual (AV) support is often blamed for poor performance but is rarely acknowledged as the mortar that holds together an excellent presentation. In reality, the preparation of solid audiovisual support can be painless. Much anxiety may be relieved if simple, commonsense planning takes place well in advance of the date of the presentation(s).

This chapter deals with the day-to-day nature of many programs that rely on speakers, sites, and audiovisual (AV) requests that are not part of a routine staged event. It is aimed not so much toward institutions that have the luxury of dedicated educational centers, staffed by full-time professional personnel but, rather, it is directed toward those who must rely on audiovisual services provided in outside facilities. The preparation, planning, and staging of workshops and seminars is discussed with the novice in mind. However, many of the areas covered apply to those who are engaged in this activity on a more routine and structured basis within their institution.

## INTRODUCTION

The planning process for any event must begin well in advance of the target presentation date(s). The specifics of the type of event will always determine the lead time necessary to optimally plan for all situations requiring attention and remedy. Lead time is discussed in more detail later.

It is of the utmost importance that the AV component of any endeavor of this sort be included in the planning process. This component should be considered a valuable tool for the success of the program; it may provide insights that would otherwise be lost to an event-programming committee.

Committees in most educational institutions that would normally consider producing a biomedical workshop/seminar are usually comprised of an array of interested parties. The department chairman, educational department or committees, marketing personnel, and AV professionals will frequently be involved in endeavors of this sort.

The initial step in approaching any event of this nature must be an examination of the objectives of the program. This may be termed a pre-event survey and would include the following activities and determinations, which are first listed in general order, then described in greater detail.

## TARGET AUDIENCE

1. Determine what group(s) would be most likely to participate in the program and what objectives are to be met.
2. What style of program would be most effective in meeting these objectives? Straight lecture, multiple speaker seminars, and hands-on workshops are a few types that might be considered.

## SITE CONSIDERATIONS

1. Where is the program to take place? Is this site conducive to the criteria cited in the section on Target Audience?
2. Are areas available for planned exhibits, workshops, and breakout requirements?
3. Can these areas be scheduled for ample setup and breakdown times, or are there times when the areas must be vacated for other functions?
4. A site inspection should take place at the earliest possible time. The following areas must be canvassed for availability and range of service, taking particular note of detrimental attributes:
   a. electrical capacity to handle known requirements
   b. lighting fixtures and controls
   c. air-conditioning/heating
   d. furniture style and seating capacity

  e. ceiling heights/obvious obstructions
  f. availability of stages, risers, and podiums
  g. integral sound systems and microphone input capacity
  h. general AV compatibility for known resources
  i. availability, style, and size(s) of projection screens
  j. loading/transport/storage facilities for audiovisual equipment, exhibit materials, and the like.

Following this pre-event survey, formal contact with anticipated speakers must take place. Obviously, the program committee must have tentative speakers in mind and most likely would have checked availability of each speaker prior to this time. Once the site and style of program have been determined, the formal negotiation processes must take place. Speakers' arrangements, including tentative schedules, must be formalized by the committee, and a formal contract must be obtained for the site and services requested. Speaker booking is often a tenuous situation that must carefully weigh program development, speaker availability, and expense detail.

Once arrangements have been solidified with a speaker, the AV component of the committee becomes important. The AV coordinator of the event must survey the speakers to determine their requirements and compatibility with program, site, and expense limitations. In most cases the speakers have given their talks on many other occasions and can clearly indicate their requirements. In less frequent circumstances a speaker may be less familiar with the subject and may require greater counsel with the AV support component of the event committee. Listed below are many of the normal types of AV equipment requested by speakers. The individual listings will be discussed in further detail in a later section. A sample *equipment and supply request* form (Figure 11.1) is illustrated to facilitate the transfer of information from the speakers to the event committee. Common types of equipment frequently requested are:

1. 35-mm slide projector
2. overhead projector
3. 16-mm motion picture projector
4. video playback
5. front or rear projection
6. specific screen size and format
7. special microphone or sound amplification configurations
8. pointer(s)
9. remote controls
10. audio or video recording
11. international format compatibility
12. special preview area
13. poster display area
14. x-ray projection or display
15. newsprint tablet with easel
16. opaque projector
17. special slide tray type
18. spare equipment and supplies

Following formal contact with the program's speakers and a tentative idea of AV requirements, it is now time to review the site inspection information already collected. The AV requirements must be matched with the site information to determine several things. First, can the available site equipment and services be utilized, as they exist, and to what extent? Also, are modifications permitted or functional?

Use the following site survey list to help determine what pitfalls may exist.

## ELECTRICAL CAPACITY

All requested AV equipment need to be assessed to determine voltage/amperage requirements for any given site, whether the main presentation area, a breakout area, workshop room(s), and so on. Outlets must be available in strategic locations with ample power to supply the equipment. If you determine that power requirements are not satisfactory, contact the site manager to decide what options may be available to provide the necessary electrical power. This is usually easily accomplished at most education centers, rented facilities, and hotels and convention centers, but is best not left to chance. Extension cords and adapters should either be standard equipment of the AV team or appropriated from the site as part of the event contract for services.

## LIGHTING FIXTURES AND CONTROLS

Specifically, note the lighting situations in each function site to determine program compatibility. Low-hanging chandeliers are often a major problem at hotel meeting areas and should immediately be addressed. Often the seating arrangements can be changed to maximize optimal projection. However, in the event these cannot easily be changed, the host site must be contacted to determine the possibility of removing the obstructive fixture(s) or, if there is the capability, pulling the fixtures closer to the ceiling. This situation is best handled prior to the day of the event.

Lighting controls are equally important when considering their location and capabilities. The best scenario is to have access to lighting control(s) at or near the projectionist in each area. Most meeting locations today provide incandescent down lights and general illumination lights in each area. The function of each control should be noted in advance of the event.

## AIR-CONDITIONING/HEATING

Most facilities available outside your own institution are of the hotel/convention center type. In these instances, very little can be done to regulate the air-conditioning/

**FIGURE 11.1 Workshop and visiting professor equipment and supply request.**

**INSTRUCTOR — Please return this form not later than:**_____

## WORKSHOP AND VISITING PROFESSOR
## EQUIPMENT & SUPPLY REQUEST

Event Title: _____    Instructor: _____

Date(s) of Course:_____ Time:_____ Where:_____

_____ Time:_____ Where:_____

_____ Time:_____ Where:_____

A-V Equipment (please check)

☐ 35mm Slide Projector  ☐ Dual 35mm Projectors      ☐ Microphone: Podium ☐  Lavalier ☐

☐ Synchronized Slide/Tape Projector                ☐ Pointer: Electric ☐  Stick ☐  Laser ☐

☐ 16 mm sound Projector                            ☐ Tape Recorder: Cassette ☐  Reel to Reel ☐

☐ Overhead Projector  ☐Opaque Projector            ☐ Chalkboard ☐ Newspaper Pad and Easel

☐ Video Playback: ¾″ U-Matic ☐  VHS ☐  Beta ☐    ☐ X-ray Viewbox

☐ Video Projector  ☐ Large Screen Video Monitor    ☐ Other (please specify) _____

Please explain use of video playback: ☐ Data Signal    ☐ Video Signal    ☐ Audio

**Projectionist will be needed:** Yes ☐    No ☐    **Remote Control will be needed:** Yes ☐   No ☐

Special Equipment to be supplied or arranged by Instructor

Special Equipment to be supplied or arranged by Workshop Committee

Supplies (include printed matter) to be supplied by Instructor

Supplies (include printed matter) to be supplied by Workshop Committee

*Please Return Completed Form To:*    _____

_____

_____

_____

heating without the assistance of the sponsoring site. The majority of these facilities have maintenance personnel available to help regulate these systems. However, it will usually take valuable time to contact them while the program is in progress. Check the room temperature before the program commences to ensure that the area(s) are slightly on the cool side, but definitely not cold. Those attending will naturally add body heat to any confined space, proportionally equal to the number of people in that space. The projection equipment utilized in each area will also create heat, and naturally, the smaller the area the greater the heat.[1] The room should be comfortable and should not require those attending to wear heavy sweaters or coats. Of course, if the room is too hot attendees will become sleepy during the program, obviously affecting their retention of the subject matter. It is impossible to please everyone in attendance, as some people have their own normal range of comfortable temperatures, not consistent with the majority of those in attendance. Acceptable temperatures are within the 70 to 75°F range (see *Guidelines for Construction and Equipment for Hospitals and Medical Facilities* in the bibliography).

## FURNITURE STYLES AND SEATING CAPACITIES

Furniture styles and seating capacities are interrelated by function and therefore cannot be resolved individually. First, ascertain the type of function you will require. Then consider the various arrangements, including theater style, round table seating, conference table seating, stationary desk/seat configurations, and other styles. Normal lecture arrangements usually require theater style or conference table patterns. Theater style offers the most seating per event, but it is often uncomfortable for extended periods and offers no writing surface for those wishing or required to take notes. Optimum seating space per participant is 6 to 12 square feet, depending on the audience size.[2] The larger the audience, the less space normally provided.

Often, registration for events is better curtailed when the comfortable seating capacity has been obtained, rather than stretching the space to accommodate late registrants. If there is overwhelming demand for a particular program, attempt to relocate the site to a larger area or to add a second program to handle the overflow. Participants should not be crowded into a site, or their reaction to even the best speakers will be adversely affected as an extension of their discomfort. Obviously, this would be unfair to early registrants, as well as to the speaker(s).

## CEILING HEIGHTS/OBVIOUS OBSTRUCTIONS

Ceiling heights are as divergent as meeting sites and are an important consideration in AV planning. The single largest problem in holding an event at a site with low ceilings (under 12 feet) is the limiting effect on projection screen size. Optimum screen sizes will be discussed more thoroughly in a separate section.

Obstructions have been discussed in a previous section on lighting, with respect to chandeliers that are common in many facilities. Other types of obstructions that may be encountered are air-conditioning units, banners, flags, and structural intrusions and abnormalities. The best recourse is to always *look up* when making your initial site survey.

## STAGES, RISERS, AND PODIUMS

Site selection will determine the availability of a stage as a permanent fixture. If a stage is not present, a riser is of particular importance. Most hotel and convention facilities provide risers as part of their normal arrangements. Risers are generally available in 12-inch and 18-inch heights, and, in most cases, the 12-inch risers are sufficient to raise the speaker above the audience. A podium is also usually included as part of the fixtures in such facilities. The preference for most lecture style presentations is the full-standing floor podium. For panel discussions or round table presentations, a table podium is considered appropriate. The podium must be equipped with a reading light, and if possible, a speaker's timer. The light and timer should be inspected during the site survey and checked again on the day of the event to ensure proper operation.

## SOUND SYSTEMS

Sound amplification systems are as varied as the sites in which meetings may take place. They will range from minimal, nonadaptable styles to major technical marvels. The sound level required for any function depends on many factors and must be assessed before adequacy can be determined. Audience size, room size, style of presentations, and ambient noise levels in adjoining areas are just a few of the considerations that affect sound. The initial site visit presents the perfect opportunity for this extremely important aspect of program planning to take place.

Most meeting facilities today provide some type of sound system as part of their meeting package. However, as in most negotiating points, seeing (or in this case hearing) is believing. A good way to test the effectiveness of a system is to visit the facility on a day when a function similar to what you are planning is taking place. The facility management will normally accommodate this request without reservation. Being able to hear the actual system in use can ease any fears or raise a caution flag for further discussion and alternative planning. If the site is perfect in every way other than the sound system, there are alternatives available to provide satisfactory sound amplification. The most useful tactic is to provide your own system.

Sound systems may also be rented from AV equipment purveyors. You can usually rent a sound system easily. Most facilities have this resource available, with the caveat that the program committee must make the contact and pay any negotiated fees separately from any contract that may have been made with the site selected. In many instances the program committee may have had past experience with a company that is not recommended by the sponsoring site but that nonetheless has provided exemplary service. It is the committee's right to select the purveyor of their choice unless the function is being held in a location governed by strict union rules. Make this inquiry during the initial site survey, rather than be disappointed after the contract has been signed.

Another major consideration of the sound system is the type, number, and style of microphones available and how they compare to the anticipated requirements of the style of function being sponsored. The same guidelines examined above also hold true for microphones. Specific

styles and configurations of microphones will be discussed later in greater detail in the equipment section.

## GENERAL AUDIOVISUAL COMPATIBILITY

This subject requires that the committee, and most importantly the AV coordinator, already have a firm idea of the style of function being planned, the types of AV equipment normally utilized, and the flow of the program. Some other particulars to be considered, as well as situations that might arise, are:

A. Hands-on workshop areas may require many electrical outlets, multiple table tops, and other equipment.
B. Ambient noise in any function area may pose special problems. Check for any other activities scheduled in adjoining areas not under contract by your program committee. Weddings, bands, auctions, or any other activity drawing large crowds may interfere with your audience's ability to hear your speakers, even with the best amplification system. Many meeting locals also have attached dietary sections in or near the main meeting areas. Pots, pans, and the clanging of glass and silverware may have an unsettling effect on your speakers and the audience. Use areas attached to kitchen facilities for display areas or other noncritical functions. Note that, in this regard, a public address system cannot correct poor acoustics. In fact, in many cases it will only increase the distracting ambient noise.

## PROJECTION SCREENS

Many facilities provide projection screens for functions contracting activities in their meeting areas. In this, as in many cases during negotiating for a facility, everything should be viewed with a bit of skepticism. Once again the AV component of the committee must play a leading role in determining the appropriateness of any projection screen(s) offered. Particular caveats are size, surface type, age, location, and condition. Arriving at a facility on the day of the program and discovering a screen too small for the audience, or with black Magic Marker stains and taped-over tears, may cause unnecessary panic on the committee's part, as well as the speaker's. More detail regarding projection screens will be offered under the audiovisual equipment section of this chapter.

## LOADING, TRANSPORT, AND STORAGE FACILITIES

This particular subject is normally forgotten until shortly before the program date. For many reasons it is one that should be given considerable attention well before the contract is signed with any facility. These additional details need to be considered before making any final judgment on site selection:

A. Does the site possess ample loading/unloading areas within relatively easy access to the program area(s)?
B. Are elevators required to transport equipment to other floors in the facility? If so, are they of sufficient size and weight capacity?
C. Are there people at the facility available to help unload, transport, and reload equipment? Will there be additional expense?
D. Are there areas where special equipment can be stored? Is it secured in some manner? This is particularly significant if programs are held over weekends or holidays when it may not be possible to pick up equipment for several days following a function.
E. Are there provisions for insuring against loss or damage of any equipment being utilized? Who is responsible for damages? Is insurance available and, if so, from whom and at what cost?

## PROGRAM PLANNING LEAD TIMES

The following descriptions will indicate several examples of optimum lead times for program scheduling. These times may vary depending on the specifics of your program, but they should provide an overall basis from which to work.

*Visiting Speaker:* This type of program usually lasts from 1 hour to 1 day. This style of program can be coordinated with the shortest planning time. These types of arrangements normally require from 3 weeks to 1 month advance planning time. A sample *meeting service requisition* is given in Figure 11.2 as reference when planning in-house presentations and programs.

*One-day program with multiple speakers:* This type of program is naturally a bit more confusing, as the complication of arranging multiple schedules, AV requests, and logistics is involved. A lead time of 1 to 3 months should be allowed for these types of affairs.

*Multiple-day program with multiple speakers:* Programs of this magnitude require far more planning preparation than those discussed thus far. A lead time of 3 to 6 months is almost mandatory to sufficiently cover all of the details and arrangements required.

*Multiple-day program, multiple speakers, and hands-on workshops:* These types of events are the most complicated by nature of the undertaking. Preparation for this style of event requires a minimum of 9 to 12 months.

## AUDIOVISUAL EQUIPMENT

Once the site survey has been successfully completed, the need to further investigate each speaker's AV require-

**MEETING SERVICE REQUISITION**

FIGURE 11.2  Meeting service requisition.

DATE: _____ NAME: _____    COST CENTER: _____    PHONE # _____

**ROOM REQUEST**

Date(s) Room Required _____    Title of Meeting: _____

Start Time _____ ☐ AM ☐ PM    Finish Time _____ ☐ AM ☐ PM    Number of Participants _____

**AUDIO-VISUAL REQUEST(S)** — Will A Projectionist Be Required?  ☐ Yes    ☐ No

☐ Slide Projector          ☐ VHS Video           ☐ Podium            ☐ Stick Pointer

☐ Dual Slide Projector     ☐ ¾ U-Matic Video     ☐ Sound System      ☐ Electric Pointer

☐ 16mm Sound Projector     ☐ Video Projector     ☐ Newspaper Easel   ☐ Laser Pointer

☐ Overhead Projector       ☐ X-Ray View Box      ☐ Chalkboard        ☐ Cassette Tape Recorder

☐ Other: _____

**DIETARY REQUEST(S)** —

Type of Service Requested _____

_____

_____

_____

_____

_____

**FACILITIES/ENVIRONMENTAL SERVICE REQUEST(S)** — (Use Separate Sheet For Diagram If Required)

Special Furniture Arrangement _____

_____

_____

_____

_____

_____

OR - ☐ "U"-Shape w/Tables    ☐ Staggered At Tables    ☐ Classroom Style At Tables

☐ Auditorium Style    ☐ Rectangular Tables

* WILL YOU REQUIRE — Coat Rack(s) ☐ Yes ☐ No    Trash Receptacles ☐ Yes ☐ No

---

**FOR OFFICE USE ONLY**

| FACILITIES/ENV. SERVICES | DIETARY | ROOM ASSIGNMENT |
|---|---|---|
| SET UP AFTER _____ ☐ AM ☐ PM | SET UP AFTER _____ ☐ AM ☐ PM | |
| BUT BEFORE _____ ☐ AM ☐ PM | BUT BEFORE _____ ☐ AM ☐ PM | |
| **RETURN** | **PICK UP** | |
| AFTER _____ ☐ AM ☐ PM | AFTER _____ ☐ AM ☐ PM | |
| BUT BEFORE _____ ☐ AM ☐ PM | BUT BEFORE _____ ☐ AM ☐ PM | DATE _____  INITIAL _____ |

WHITE - Conference Coordinator        YELLOW - Dietary        PINK - Facilities        GOLD - Env. Services

---

ments again surfaces. This will necessitate frequent communication by the AV coordinator with each speaker, exhibitor, the program committee, site personnel, and rental and transport personnel. The various types of common AV equipment requests will now be discussed in greater detail than earlier. Most AV equipment manufacturers supply specification sheets, or usage publications, with each piece of equipment. Most offer valuable general information and a few contain some helpful specifics. However, most cannot begin to detail the trials of actual experience beyond what the manufacturers term *normal usage*. These are the tools of the AV profession; they can in many ways be adapted, manipulated, or otherwise made to perform in applications not considered in the manufacturer's material. This section will detail many of the different types of AV equipment normally requested, specific configurations, and some practical and useful tips on how they may be adapted to meet divergent needs. For a complete listing of available AV equipment and manufactures the *Equipment Directory of Audio-Visual, Computer and Video Products* is updated annually by the International Communications Industries Association (see endnotes for complete address).

## 35-mm Slide Projectors

The mainstay of most medical AV programs are 35-mm projectors. They are often designated as $2 \times 2$ projectors, reflecting the approximate size of the slide being projected, or simply as slide projectors. There are many manufacturers of slide projectors offering a variety of styles and models. These range from consumer versions to commercial systems capable of heavy-duty usage. The Ektagraphic series of slide projectors manufactured by Eastman Kodak Company (Rochester, NY) are the most commonly utilized by both medical and commercial institutions. This series of projectors comprises several models that are distinguished only by the number of features included on each machine. Possibly the most versatile model currently offered is the Ektagraphic III ATS slide projector, which includes, among other things, a pop-up screen which is small but functional. This particular feature can be an important tool at multiple-speaker programs since it may be used as a main projector or for previewing purposes. The ease of lamp exchange is also a benefit with this series.

Lamp exchange modules are also available for even more efficient changeover. Recently, other manufacturers have even provided lamp modules containing higher-powered lamps for use in special situations requiring this type of enhancement. However, caution should be exercised when utilizing this type of modification. It is strongly suggested that you read carefully the manufacturer's instructions. A speaker's slides may actually be destroyed with improper equipment use.

Although the Ektagraphic series of projectors is generally satisfactory, the manufacturer's lack of consistency in internal lens and heat filter color correction causes some problems when using multiple-image projection. Normally the problem is the heat absorption filter, which can easily be changed to more closely match that of another projector. Multiple projection with these projectors should be rehearsed prior to your function, and changes should be made in the heat filters of the offending machines. If a large enough number of these projectors are available, the most similar should be paired. In doing so, the images projected by each should be more closely matched in color and brightness.

The other cause of dissimilarity of image is usually the light source. Different lamps will provide remarkably different results, as will the manner in which the lamp is seated in the lamp-housing. Trained technicians can modify most projectors to match the respective projected images very closely. Kodak and other manufacturers offer projectors that provide the capability of aligning the lamp element to circumvent this situation. However, they are not generally utilized, mainly due to their cost.

Lenses for slide projectors also influence the appearance of the image. Assuming that the screen normally being utilized is of the front projection type, the room size, projection distance, and lens equally determine the quality of the image projected. A fixed focal length lens will provide the optimum image quality in controlled situations. Unfortunately, most workshops and seminars do not have this luxury. The next best option is a quality zoom lens that is adaptable to a multitude of environments. A zoom lens will not provide the brightest image or best edge-to-edge sharpness for a variety of technical reasons, but it can be an efficient tool. A zoom lens provides the capability of reducing or enlarging the projected image to fit and/or fill the screen.

Optimally, all slides should be presented in the horizontal format, allowing the zoom lens to expand the image to take full advantage of the screen size. In normal practice, speakers do not heed the advice of AV and photographic experts and continue to intersperse vertical format slides throughout their presentation, posing a serious drawback to the utilization of a fixed focal length lens. The zoom lens provides the only means of not penalizing speakers with properly configured slides, while affording the projectionist the ability to reduce the vertical image of other slides to a size capable of remaining within the screen dimensions.[3]

## Projector Placement

The location of a projector in a meeting area is vitally important. Obviously, the optimum situation is for the projector to be housed within a projection booth. However, this luxury is generally not available in the majority of rented facilities. The next best placement is at the rear of the room, near the lighting controls. Frequently, a projector is placed in the center of the audience for convenience, which poses several disadvantages. Noise, commotion, and a distorted or "keystoned"* image usually result. Placing the projector(s) in the rear of the room (front projection) removes the noise and activity from the audience's direct view. Situating the projector(s) at this distance necessitates variable focal length lenses or a zoom lens and an elevated projection stand. The elevated projection stand can be further enhanced by placement on raised platforms that are commonly available. Positioning projectors on a platform restricts movement of the audience around it and raises the projected image far enough above the heads of those standing to prevent interference with the projected image. Be sure that platforms are sturdy enough for the projectionist to walk on them without causing the pro-

* For a projector to produce the best image its beam must be directed perpendicular to the screen. When the projector is placed lower than the center of the screen, or conversely, the screen is higher, the beam will be projected at an obtuse angle producing an image which is wider at the top and narrower towards the bottom. This is commonly called "keystoning."

jected image to vibrate. They can often be stabilized by placing them against a wall, rather than situating them in a free-standing position.

## 35-mm Slide Trays

All slide trays are not created equal. Several different models are commonly encountered, each of which was designed with specific applications in mind. Most trays have spaces to hold eighty slides. Not all trays can accept thick mounts, such as those of glass-mounted slides, once commonly utilized in the United States and still currently encountered in many European countries. If your program includes one or several European speakers, make every effort to obtain slide trays designed for use with glass-mounted slides. One such slide tray is the Kodak Universal model.

Many people believe that more is better and often opt for slide trays designated to hold 140 slides. These are, for all practical purposes, a terrible solution and will often cause more problems than they could possibly be worth. Even though these trays hold 140 slides, the slides must be in thin mounts or they cannot even be placed in the tray. Providing these trays for use at a large meeting is inviting disaster because many speakers' slides may not be able to be utilized. These trays are also significantly more fragile than the standard eighty-slot trays, since they must be constructed of much thinner material to facilitate the extra sixty spaces. The mechanism utilized to advance the slides on the 140-trays is constructed of a thin piece of wire that often becomes bent and causes slides to jam. Stay with the normal eighty-slot trays, and have the projectionist change trays as frequently as necessary. A professional projectionist can change trays smoothly and quickly; in most cases the audience will probably not even be aware that a change has been made. Why flirt with disaster by using the 140-slot trays?

## Overhead Projectors

The overhead projector, long a mainstay of classroom instruction, has recently gained some prominence at medical meetings for a variety of reasons. It is also the cause of many difficulties for many AV professionals. While it allows the speaker to quickly and easily update information and enhance interaction with the audience, it does possess several disadvantages. The first is that a speaker requesting the use of an overhead projector is inevitably scheduled between several speakers using 35-mm slides, which requires a fairly different setup; and second, the addition or movement of sound amplification equipment at the projector. Other challenges also cannot be ignored.

If all speakers utilize an overhead projector or if only one speaker presents for an extended period of time, suitable arrangements can be made for optimal projection. Consider several general rules:

1. The use of an overhead does not require that the house lights be dimmed, as with 35-mm slide projection. As a result, audience interaction is obviously enhanced.
2. The distance to the last row of viewers should be no more than six times the width of the screen for optimal viewing. Note, however, that poorly made transparencies containing all words or excessively small type cannot be remedied by even the most proficient AV specialist.
3. A matte-white screen surface presents the optimum projection surface.
4. The size of the image should take full advantage of the screen size to enhance readability.
5. *Keystoned* images should be rectified by properly tilting the top of the screen toward the projector. A 90-degree angle is the optimum. This may or may not be practical, depending on the facility and whether the screens are adjustable. Once again, early planning, the site tour, and communication between the speaker and the AV coordinator are important prerequisites to a superior presentation (see *How to Use the Overhead Projector Effectively* in the bibliography).

## 16-mm Motion Picture Projectors

Although motion picture projection is currently out of favor and steadily losing ground to video presentations, the 16 mm offers one uncontested advantage—the best image. The quality of 16-mm film cannot be dismissed; however, the cumbersome system of projection and the fragility of the film are causing it to be supplanted by video. For the time being, 16 mm still appears at meetings and requires some attention to properly prepare for its use.

The projection of 16-mm film may be performed with optimal results by keeping a few cautions in mind.

1. The projector must be well maintained, lubricated, and cleaned.
2. The film should be inspected for tears and scratches.
3. The projected image, although of different dimension from 35-mm slides, may be suitably projected on the same screen as utilized for that purpose. Should the 16-mm film be the only piece of AV material presented, a screen of suitable format may be requested to complement that format. You can find exact requirements in the instruction booklet that accompanies each projector at purchase, or from any of several data guides available from projector or screen manufacturers.
4. Unless the user is especially proficient with this form

of equipment, the presence of a professional projectionist is mandatory because of the numerous problems that may be encountered.

## Video Playback

Video technology has come a long way toward becoming an acceptable alternative to 16-mm film for large audience motion pictures. Video offers two primary means of viewing the image: TV monitors or projection. Each system has its own advantages and drawbacks.

Small audience viewing may be handled well with monitors, as long as no more than twenty to twenty-five viewers are expected at each monitor. The monitor should possess at least a 25-inch screen; 27- or 30-inch monitors are preferred. Several monitors can be *ganged* for larger audiences, or a video projection system may be warranted.

The usefulness of video projection systems continue to expand by enhancing the acceptability of the projected image. Today there are several models of video projectors available for around $3000, approximately one-half the cost of just a few years ago. Improved technology also provides a lighter weight and easily portable package that relatively untrained individuals can operate with ease. Determining which system will work best with your program requires several considerations.

1. How large is the audience which will view the video?
2. What type of material is being presented? Will there be strictly motion-picture types of information; will real-time data be generated from an on-site computer; or will there be a combination of both?

This particular type of AV equipment will probably be the one item necessary to rent in either configuration. The AV coordinator will need to know the answers to these questions in order to arrange rental of the proper equipment and/or services.

## Front Versus Rear Projection

Due to the nature of the meetings under discussion, the best projection facilities are not always available. Rear projection, considered the optimum by many, is usually an unobtainable luxury, even with the benefit of sufficient planning time. Rear projection, by design, requires that all projection equipment be placed behind the screen, out of sight and sound of the audience and speaker. It requires some different equipment, particularly lenses; and the availability of a fair amount of space behind the screen for both the projection equipment and projectionist. This last requirement is the biggest drawback. Space is always at a premium; the AV component of most workshops and seminars is normally the first to suffer the consequence. This author has been an audiovisual consultant to well over a thousand functions of this type and estimates that under 1% of these functions had the space available to provide for rear projection. The other consideration is the limited amount of AV equipment that one organization can maintain. Rear projection screens are more expensive to purchase; are not generally available in a full range of sizes from rental sources; and do not offer significant enhancements to the projected image. Probably the most obvious advantage of rear screen projection is the aesthetic value of having AV equipment out of sight of the audience. One final caveat is the detrimental effect of removing the projectionist from the speaker's direct line of sight. A good projectionist can read the speaker's unspoken needs without distraction to the speaker or the audience, a practice that is virtually impossible with rear projection.

## Projection Screen Size and Format

There are many projection distance charts available on the market for determining the recommended screen size for a conference (see *Kodak Projection Calculator and Seating Guide* in the bibliography). These are helpful but of minimal practical use. Knowledge and experience are more valuable than a suggested standard when determining what size screen to use. To properly determine screen size, the AV coordinator needs to have specific information about the planned function. Knowledge of the size of the room, the anticipated audience size, the style of seating, and the type of material to be presented is mandatory. The size of the room will indicate the ceiling height and projection distance. The audience size and seating arrangement will also help determine the projection distance. The type of material to be presented will determine the format of the screen. The normal medical meeting will almost certainly contain a significant amount of 35-mm slide projection, which in itself provides a benefit, since this is the most frequently available screen format. Always select the largest available screen that will fit in the presentation room.

Although all photographers stress the importance of using only horizontally formatted slides and limiting the amount of material on each, presenters frequently pay little attention and include vertical formats and terribly congested material. By utilizing a large screen, the AV specialist can significantly enhance the audience's ability to read the content of a vertically formatted slide. The larger screen provides enough height to accept the image without the need to zoom down the lens. The other benefit to anticipating the worst is that the speaker with properly formatted (horizontal) slides will not be penalized by having an image projected on the smallest recommended screen. Even the best-prepared speaker has slides that, for the audience's benefit, can be better seen at a slightly enlarged projected image size.[4]

### Microphone and Sound Amplification Configurations

Next to the projected image, sound is probably the other most important aspect of determining the success of an AV presentation. The audience must be able to hear the presenter(s) from every seating area in the room. Consider areas that are not intended for seating also, since people have the tendency to migrate to any uncrowded space available. Inevitably someone will move a chair or a table to an area not designated for seating, then complain that they cannot hear the speaker. Anticipate rather than argue.

Most institutions do not have the luxury of packing up the sound equipment and transporting it to the meeting site. This equipment will normally either already be available in some configuration at the site or must be rented from an external source. Today, most conference facilities realize the advantage of good sound amplification and have made enormous strides in obtaining the necessary appropriate equipment. However, do not believe it until you have actually heard it. The best way to check out the sound is to arrange to visit the site before the date of your function, preferably during a function of the sort you are planning.

One short visit can do much to aid the planning process. Microphones are usually satisfactory at a site where the sound amplification system has already been inspected, however, verify that they are part of the system and not temporarily part of the program you have inspected. The sound being amplified is directly related to the quality of the microphone(s) being used. Find out whether the type of microphone you need is available and whether there are enough of them to fulfill your requirements. Some speakers may prefer or require a lavaliere or wireless type; panel discussions will normally require additional microphones; audience participation may also require placement of additional microphones throughout the audience. Generally a cardioid or super-cardioid type of microphone is the most advantageous, permitting slight movement of the speaker around the microphone.

Wireless systems, while glamorous, often create problems in areas where interference is caused by environmental factors. The use of a wireless system should be examined well in advance to ensure proper operation. If microphones are to be placed throughout the audience, a style containing an on/off switch will provide the ability to limit the ambient noise often generated in large crowded lecture areas. You need to consider several other types of arrangements also. Will there be a need to amplify the audio portion of a projected videotape or 16-mm motion picture? Will there be a need to amplify any audio recordings, or special requirements such as headphones with which each registrant will listen? You will need to know course design before finalizing the planning of this equipment.

### Pointers

Pointers come in four different styles. Stick, battery-operated flashlight, electric, and laser pointers are all used with varying degrees of regularity. Today the laser pointer is the accepted norm for ease of operation and enhanced performance. Laser pointers operating on two AAA batteries that are capable of lasting for 8 to 10 hours without being replaced are an improvement unimagined in the recent past. They offer a magnificently small and portable tool that produces a small, red, circular spot of light that may be easily followed by the audience. They are relatively unaffected by distance, since the spread of the laser does not become disproportional as do the electric or flashlight type pointers. Significantly, laser pointers do not become hot after long use as electric pointers do, previously a distracting sensation for the speaker. The stick pointer, often preferred by speakers standing in front of a screen, is not commonly used today, mainly due to the distance at which the speaker must be placed from the screen while presenting at larger functions. Laser pointers, such as Navitar's "Pocket Laser" (Navitar, Rochester, NY) which weighs five ounces and measures $6 \times 1 \ 1/2 \times 1/2$ inches are by far the best investment for this type of equipment.

### Remote Controls

Virtually every piece of AV equipment can be operated by a remote-control unit. The most common remote controls utilized today are for 35-mm slide projectors, video playback units, and computer display. The video and computer units are basically available only from the equipment manufacturer, due to the specific electronic configurations controlling their proprietary equipment. The 35-mm slide projector remote controls are another story entirely. From hard-wired units to infrared (IR) and radiofrequency controlled units, there are probably more types and styles available than there are models of projectors. By far the most useful are the IR controls, which enable a presenter to control a projector from practically anywhere in the presentation area. There are different models from various manufacturers available, some of which work better than others under diverse situations. One obvious requirement is that the control unit be in the same area, uninterrupted by walls, since the IR beam must be able to connect with the controlling device. The better units will not require a direct line of beam, giving the presenter a fairly free range of travel. These units are available to control more than one projector simultaneously, such as in dual projection, and they may be configured to control some or all of the functions available on the projector. Power to the projector, focus, and forward and backward ad-

vancement are the most frequently encountered remote control functions.

## Audio or Video Recording

There is a greater desire to record the proceedings of workshops and seminars today than any time in the last decade. A common practice is to offer participants an audio or video version of a meeting that they recently attended. A secondary benefit is the ability to offer the recordings to those who might not have had an opportunity to attend the actual program. Obviously, the more recordings sold, the less expense involved. Recording events of this nature, however, are not without problems and cost. The novelty and reported ease of use of sophisticated electronic video recording equipment can be alluring to the novice. A professional recording of the program requires much of the same planning and forethought as that already discussed in planning the event. Otherwise, you will obtain poor results and waste much time and money. The services of the AV coordinator of the planning committee should be relied upon.

Several questions involving the planning of recording a program should be answered before the project can begin. First, does the nature of the program lend itself more readily to audio recording, or are there obvious reasons to plan for video recording? Does your organization possess the equipment and expertise to provide the recording, editing, and packaging of the finished project? Are these services available and, if not, can the anticipated costs be recovered if you need purchased services?

One advantage of video is its natural ability to show motion; however, the expense is substantially higher. In either case, can the program be broken down into smaller segments? In anticipating the demand for the finished product, note that some participants will probably desire only certain segments of a program for future review. Can the expense of producing a recording be covered in this event, or will it be necessary to package the whole program as one unit? What is the length of the program? Audio recordings become very lifeless and boring if hours of program are required to transmit the details of the proceedings. Video can become equally boring if all that is recorded is the speaker's head talking to the audience.

A professional video recording will entail a lot of production time before, during, and after the program. Can an acceptable product be supplied in a reasonable time following the end of the event? Much of the demand for audio and video recording of a program ends when the audience leaves at the end of a program. Is there a way to promote an interest in the recording after the event? All of these questions require answers before committing to the expense and time of recording a program.

## International Format Compatibility

Speakers from many countries are often included in programs today. Potential problems may be encountered in the video field and with 35-mm slide projection. Sufficient caution is all that is required. The projection of 35-mm slides may be facilitated by use of slide trays that carry a *universal* designation. These trays will accept the thick slide mounts utilized in many European countries, as well as the full range of mounts available in the United States. Using these trays as the standard will eliminate problems or surprises. Video is an entirely different matter. PAL, SECAM, and NTSC are all different, noninterchangeable formats of video signal generation that reflect the different countries or continents of origin. (PAL means *phase alternation line;* SECAM is the acronym representing *sequential color memory* [sequential couleur a memoire] in French); and NTSC stands for National Television Systems Committee.) (See Table 11-1.) Remind speakers from foreign countries who desire to use video during your program of this problem and the potential expense necessary to correct the incompatibility of systems.[5] Remedies are available if sufficient time is permitted. Most large cities today have professional video studios that have access to equipment that can convert these foreign formats into those acceptable for use in the United States. The conversion may be obtained either by the speaker(s) themselves or by the workshop committee.

## Special Preview Area

Most large workshops/seminars involve many speakers. The courtesy of providing an area for them to preview their audiovisual presentations is advantageous to their presentation and for the professional appearance of your endeavor. By obtaining a small room or restricted area for the use of the speakers and providing the minimal AV equipment needed, you can achieve a professional result. Also, the time spent in preview may provide the AV material enough of an opportunity to adjust climatically to conditions widely divergent from those to which they were exposed during transport to the event. This effect is particularly noticeable on 35-mm slides. Slides transported from hot, humid automobile trunks to an air-conditioned room for projection will be very difficult to focus, even with the aid of an autofocusing projector. Glass mounted slides will inevitably be fogged with condensation, giving the appearance of the slide melting as it evaporates from the heat of a projector. This problem may become disastrous if you are using an Arc (Xenon) projector. The heat generated by an Arc projector during a prolonged period can literally cause the slide to melt.[6] Speakers and projectionists unaware of this effect can have some tense moments as audience

**Table 11-1  Video Geography**

| | | | |
|---|---|---|---|
| **NTSC** | Venezuela | New Guinea | French Guiana |
| Antigua | Virgin Islands | New Zealand | Gabon |
| Bahamas | Western Samoa | Nigeria | Germany (East) |
| Barbados | **PAL** | Norway | Greece |
| Belize | Afghanistan (Kabul) | Oman | Guadeloupe |
| Bermuda | Algeria | Pakistan | Haiti |
| Bolivia | Argentina | Paraguay | Hungary |
| Burma | Australia | Portugal | Iran |
| Canada | Austria | Qatar | Iraq |
| Chile | Bahrain | Saudi Arabia | Ivory Coast |
| Costa Rica | Bangladesh | Sierra Leone | Korea (North) |
| Cuba | Belgium | Singapore | Lebanon |
| Dominican Republic | Brazil (M) | South Africa | Luxembourg |
| Ecuador | Brunei | Spain | Malta |
| El Salvador | Cameroon | Sri Lanka | Monaco |
| Greenland | Canary Islands | Sudan | Morocco |
| Guam | China | Swaziland | New Caledona |
| Guatemala | Cyprus | Sweden | Niger |
| Guyana | Denmark | Switzerland | Poland |
| Honduras | Finland | Tanzania | Romania |
| Jamaica | Germany (West) | Thailand | Saudi Arabia |
| Japan | Ghana | Turkey | Senegal |
| Korea (South) | Gibraltar | Uganda | Syria |
| Mexico | Greece | United Arab Emirates | Tahiti |
| Micronesia | Hong Kong | United French Guiana | Tunisia |
| Netherlands Antilles | Iceland | United Kingdom | U.S.S.R. |
| Nicaragua | India | Yugoslavia | Zaire |
| Panama | Indonesia | Zambia | **MONOCHROME** |
| Peru | Ireland | **SECAM** | **625/50** |
| Philippines | Israel | Albania | Angola |
| Puerto Rico | Italy | Benin | Burkina Faso |
| Salpan | Jordan | Bulgaria | Burundi |
| Samoa | Kenya | Congo | Central African Republic |
| South Korea | Kuwait | Columbia | Equatorial Guinea |
| Surinam | Liberia | Congo | Ethiopia |
| Taiwan | Libya | Czechoslovakia | Yemen |
| Tobago | Luxembourg | Djibouti | Yemen (A.R.) |
| Trinidad | Malaysia | Egypt | Yugoslavia |
| United States | Netherlands | France | Zimbabwe |
| Uruguay | | | |

Reprinted with permission from WRS Motion Picture and Video Laboratory, Pittsburgh, PA

members rush to inform them of the melting images. Time for the slides to adjust to the new temperatures and climatic conditions is all that is necessary to remedy the situation and help the presentation run more smoothly.

Another method for avoiding this problem which is even more reliable is to dehydrate the slides before projection. Wess Plastics (Hauppauge, NY)[7] offers an inexpensive dehydrating kit containing storage bags and a silica gel desiccant. The slides and trays are placed inside the plastic bag with the silica gel for overnight dehydration. Remove the slides and trays from the bag immediately before projection to prevent them from resorbing moisture. The manufacturer also supplies information for reactivating the silica gel for repeated uses.

## Poster Display Areas

A poster display area, if required, is usually included in a breakout, demonstration, display, or registration area. The size and scope of the anticipated number of poster displays will help determine the location best suited to the purpose, as well as providing the workshop planning committee with information required for obtaining an appropriate site to begin with. Many medical specialty societies have provided poster displays for a long time and will normally supply rules governing the size, composition, and technical requirements of the display. Should your organizing body be unfamiliar with this type of presentation, many of the specialty societies will be

happy to provide copies of their guidelines for informational purposes. The Health Sciences Communications Association can also provide a brochure, *Effective Poster Sessions*, which contains valuable insights into producing a poster session.[8] The logistics of the presentation of poster displays falls under the purview of the workshop committee. Room, tables, lighting, display shells, and/or backgrounds are commonly required.

## X-Ray Projection or Display

The projection of x-rays at large meetings may be accomplished in two ways. The first is the use of a specialized projector designed specifically for this purpose. These are normally very large and expensive and will rarely be found at typical audiovisual rental companies. Probably the best alternative is to require speakers to provide images of any x-rays on 35-mm slides, which may be projected in the normal manner. The common overhead projector should not be utilized for this purpose, as it does not provide sufficient light output, is not evenly illuminated, and cannot displace the heat generated by the usually dense images contained on x-rays, which can cause them to melt.

## Newspaper Easels

Depending on the size of the audience, newspaper easels may or may not be a satisfactory AV tool. They are best utilized in small group sessions of not more than twenty-five participants. Speakers often request a newspaper easel or chalkboard for their presentations to audiences of one hundred or more. This is absolutely impractical, since the audience must be able to see anything that is written on a pad or chalkboard for it to be effective. Suggest instead that the information be transferred onto 35-mm slides if the lead time is available or encourage the speaker to use an overhead projector if the presentation is structured for participative response from the audience.

## Opaque Projectors

An opaque projector cannot commonly be rented, but should not be ruled out until an attempt is made to locate one if needed. These types of projectors are practical for small- to medium-sized audiences and are used to project opaque printed objects, as the name implies. Thus, pages from books, illustrations, or other materials may be effectively projected onto a screen for the audience to view. The opaque projector is limited in much the same man-

ner as an overhead projector; refer to the section on Overhead Projectors before making any decisions.

## Spare Equipment and Supplies

The subject of spare equipment and supplies may be the one area that is neglected more often than any other. Preparing for an emergency or unscheduled requirement can be a challenging, time-consuming, and seemingly wasteful effort if everything runs according to the rules. Do not count on it happening.

The complexity of each event will ultimately vary, and there is absolutely no way to be successful unless you have given ample attention to planning for surprises. Projection lamps, electric extension cords, spare slide trays, overhead film markers, masking or gaffing tape, batteries, and a long list of other potentially expendable supplies must be anticipated, to ensure an uninterrupted program. The audience, most assuredly, does not want excuses when a lamp burns out. They want, and in most cases will be paying for, an uninterrupted program. All AV equipment is subject to failure. You cannot anticipate what problem will occur, so it is necessary to organize a systematic approach to backing up every single item of AV equipment and supplies that can possibly be covered.

## SUMMARY

This chapter has dealt with many of the intricacies of developing workshops or seminars for biomedical audiences from the perspective of the AV support professional. Many of the subjects covered are part of larger event planning; others may be of aid on a more limited basis. The importance of permitting the AV coordinator to be an integral part of the planning process cannot be overemphasized. The AV component, no matter how limited in a program, can make or break the best presenters. Their expertise can save time, money, and, in most instances, make the job of the planning committee a more enjoyable experience.

## ENDNOTES

1. For a brief discussion on the heat generated by slide projectors, see Kodak's *Audiovisual Notes*, publication No. V9-2-2-5.
2. An excellent review of specific seating styles and arrangements may be obtained from Eastman Kodak Company's publication S-3 *Audiovisual Projection*.
3. Additional information regarding projector placement, projection distance, and the like may also be found in Kodak's publication S-3. Also available for information on legibility of the projected image is Kodak's *Audiovisual Notes* publication No. V9-2-2-5.

4. There are many valuable publications available on the proper preparation of slides. Two such publications that are available from Kodak are: *Planning and Producing Slide Programs*, publication No. S-30, and *Making Effective Slides for Lectures and Teaching*, publication No. M3-106.

5. A brief description of the different systems and a geographical map of their locations may be found in Kodak's *Pocket Guide to Video*, publication No. AR-29, pp. 48–49.

6. The heat generated by a projector is normally equal to nine times the amount of light output. This concern is important not only for the actual slide, but in computing the amount of heat generated within the room in which the projector is being utilized. See Kodak's *Audiovisual Notes*, publication No. V9-2-2-5.

7. One system that is available for purchase is the Silica Gel Kit item No. QS 0500, which may be obtained from Wess Plastics, Inc., 50 Schmitt Blvd., Farmingdale, NY, 11735-1484.

8. Up-to-date information regarding AV equipment availability and pricing may be found by consulting *The Equipment Directory of Audio-Visual, Computer and Video Products*, The International Communications Industries Association (ICIA), 3150 Spring Street, Fairfax, VA 22031-2399 (703) 273-7200.

## BIBLIOGRAPHY

Health Sciences Communications Association, 1987. *How to Produce Effective Poster Sessions*, St. Louis, MO.

*Kodak Projection Calculator and Seating Guide*, S-16. Rochester, NY: Eastman Kodak Company.

O'Neill, J. R. November/December 1980. *How to Use the Overhead Projector Effectively*. Audio Visual Directions. Torrance, CA: Montage Publishing. pp. 20–24.

The American Institute of Architects Committee on Architecture for Health with assistance from United States Department of Health and Human Services, 1987. *Guidelines for Construction and Equipment for Hospitals and Medical Facilities*. Washington, DC, p. 50.

# Part III

## Specialized Applications in Biomedical Photography

# Chapter 12
# Clinical and Operating Room Photography

## A. Robin Williams and Gigi Nieuwenhuis

*"And you who think to reveal the figure of man in words banish the idea from you, for the more minute your description the more you will confuse the mind of the reader. . . . It is necessary therefore for you to describe with pictures. . . . Then picture clearly the man and the woman, their measurements and the nature of their complexions, their colour and physiognomy."*

Leonardo da Vinci 1452–1519 *Dell' Anatomica.* Fogli A, Vol. I, Ch. III

The photography of patients, whether in the studio, clinic, or operating room, is surely one of the most challenging but also one of the most rewarding, aspects of biomedical photography. The object of photographing patients is either to assist in assessing progress or to provide material for medical research, publication, and teaching. These primary aims of clinical photography demand that the photographs are of the highest standard with regard to such factors as technical quality, sharpness of detail, clarity of image, use of lighting, perspective, and the accuracy of reproduction of both color and form. The general technical photographic skills common to the production of good photography are essential to the establishment of a basic technique. In addition, specific details and modifications are necessary, since the subject is unwell and therefore psychologically and physically disadvantaged. To fulfill its purpose, the photograph must:

1. meet the intention of the doctor's request
2. be obtained with the least inconvenience to the patient
3. be strictly comparable with others over a period of time
4. provide a precise record

It is almost impossible to produce good clinical photographs without a working knowledge of medicine and pathology. A good food photographer produces excellent results by understanding and having an appreciation for food. The nature photographer cannot begin to properly portray the subject without understanding something of its habitat. The same is true for the clinical photographer. An understanding of anatomy and pathology is essential to the production of photographs that are not only technically competent but also show the subject in the best way. The medically qualified reader will have an obvious advantage here, but those who are unfamiliar with such subjects will obtain some guidance in the later sections of the chapter. A basic knowledge of medical details should be obtained by using the texts mentioned in the bibliography. You can never overestimate the importance of understanding the patient's

condition, in addition to understanding how to record it. This chapter contains a description of the specialized knowledge and equipment required to produce a standardized record of a patient in the studio or on location. The reader should already be familiar with the contents of Chapters 1, 2, 3, and 8 and may later wish to refer to Chapters 13 to 18 and 20.

## CARE OF THE PATIENT AND OTHER ETHICAL CONSIDERATIONS

Never forget that the main purpose of any hospital is the care and treatment of the sick. Consequently, the most important consideration in patient photography is the patient. Subsequent sections will discuss and explain methods of photographing various conditions and diseases and specialized techniques of photography. However, before mastering these subjects, the reader must first try to gain an understanding of patients and learn to assume a responsible attitude toward them.

Remember that the subject of your precise camera and lighting technique is a sick person. This fact requires qualities of tact, understanding, infinite patience, and the avoidance of embarrassment. It is essential that the medical photographer present a professional image to the patient. You need to be aware of personal appearance and dress. You also need to have a firm, precise manner of speech, to be kind without condescension and, above all, to show an obvious efficiency that will inspire confidence. Only a thorough knowledge of the lighting, positioning, and camera techniques can give this degree of efficiency.

Try to remember that a patient may be feeling ill, but also remember that for many people the hospital is an unfamiliar place, full of strange equipment, and almost guaranteed to produce a state of anxiety. The photographer's task is lightened by having a relaxed and cooperative patient. The medical photographer must have a sympathetic attitude that will put patients at ease from the moment they enter the department. Realize that your

patient may sometimes be much more ill than he or she appears; also understand that what you have been asked to photograph may not be the main cause of the patient's disease. For example, the photography request form may ask you to record a lesion on the patient's ear, but the primary reason for the patient's being in hospital might be a severe heart condition.

## Management of the Photographic Session

Care of the patient includes seeing that the photographic department is clean and tidy and that no unpleasant sights such as pathological specimens are visible. The staff should all wear clean white coats and wash their hands before and after attending to any patient. Also, long hair should be restrained from coming into contact with the patient. Sterile procedures, which would involve the staff in scrubbing up and wearing a mask, gown, and gloves, are not normally necessary in the department, but cleanliness is an essential safeguard against infection. If you are uncertain about the cleanliness of your department, or require advice on risks of infection, consult the staff member responsible for infection control in your hospital.

**When the Patient Arrives.** It is important to plan an appointment system that will avoid keeping in-patients waiting. Inevitably, there may be delays for out-patients, and comfortable waiting facilities must be provided. Try to book in-patients at sensible regular intervals, avoiding the times when you know you have busy out-patient clinics. If an occasional delay is unavoidable, explain to the patient why he or she has been kept waiting. For example, you can say "The photographer is with another patient at the moment." If the delay is to be a long one, ask the patient if there are any visits to other departments that need to be made, or if going to have some refreshments may help pass the time.

Never turn a patient away if he or she is sent at a wrong or inconvenient time, and never allow the patient to become the object of your annoyance over someone else's mistake. The department or its staff should never give the impression of inefficiency or indifference. Remember that if it were not for the patients you would not have a job.

When you receive the photography request form, make sure you understand the request. Are there any unfamiliar terms? Consulting reference materials, or a glossary such as the one included in this work, can clarify terminology. Now is the time to check any details with the requesting physician, not when you get into the studio with the patient. At this point you should look at any previous records for the patient and check that consent for the procedure has been obtained.

When genitalia are to be photographed, a photographer of the same sex as the patient will cause the least distress. An exception may be the male homosexual patient suffering from acquired immune deficiency syndrome (AIDS), who may prefer a female photographer. If there is a choice of male or female photographer, always ask patients if they have a preference. If this is not possible, a chaperon must be present (1) to prevent any accusation of assault against the photographer and (2) to lessen embarrassment to the patient. There are widely differing views on the question of chaperons, and the best course of action is to avoid the problem altogether by using photographers of the same sex as the patient. Except in the case of very young children, patient's relatives do not make suitable chaperons. If, as is common, the departmental secretary is used as the chaperon, make sure that he or she wears a white coat.

As a general rule, do not photograph patients with infectious diseases in the department. Some contagious infections such as impetigo, fungal infections, and secondary syphilis, will, however, be photographed there, and precautions should be taken to avoid cross-infection. Avoid unnecessary contact with such patients by using latex surgeon's gloves; use disposable material for backgrounds or seating that will come in contact with the patient.

Patients in the hospital will often have a reduced resistance to infection; the effect on them of exposure to pathogens may be greater than on a healthy person. Staff with colds and influenza should <u>not</u> be in contact with patients. If this cannot be avoided, they should wear a surgical mask.

**Preparation of the Studio.** Once you have studied the photographic request form, think through the whole photographic session and prepare all the equipment you will need so that you do not have to leave the patient to load a camera or find some retractors. Preselect not only the photographic equipment but also the specialty items such as an examination couch, headrest, or box for the patient to stand on (Figures 12.1–12.3). Prepare other items such as dental mirrors or dressings in advance.

**Psychological Considerations.** It is always good practice to go to the waiting area and meet the patient. The patient's first impression of you is important. A smile is always welcoming, as is a courteous greeting.

Try to cultivate an awareness of, and concern for, the patient that will become second nature to you, so that you may, for example, anticipate the unexpected actions of children or elderly people in sufficient time to prevent an accident. Every patient is an individual personality and may require a different approach in order to obtain full cooperation. One person may need firm authoritative handling, while another responds better to the kindly, reassuring manner. Patients with differing diseases require different handling. For example, the advanced hy-

FIGURE 12.1    The clinical photography studio, with continuous white background, studio chair, portable equipment trolley and individually controllable studio lighting.

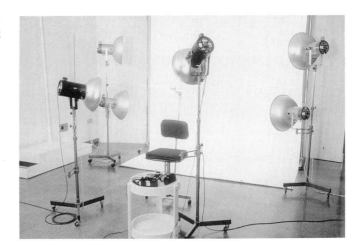

pothyroid patient may feel cold even in a heat wave and be slow in movement, while the hyperthyroid patient may be jumpy, talkative, and complain of the heat, even in a cold room. These patients are not being awkward and difficult. Their diseases produce these reactions.

Make the patients feel that you have plenty of time for them. It is very easy in a busy clinic or if you are rushing to complete a task to forget that you are photographing a person, not just a disease; your subject is a human being who is probably apprehensive of you and of what you are going to do, as well as of the disease and the likely prognosis.

You are the one who knows what is going to happen during a photographic session, so it is up to you to give patients sufficient information to reassure them that no harm will come to them while in your care. Explain to them what you require in simple terms. It is important that you speak clearly and explain precisely what you want. This may mean speaking slightly louder than normal if your patient is old and hard of hearing. Never use medical jargon when speaking to a patient. If you want something specific done, such as eye movements to dem-

onstrate strabismus, rehearse the movements before photography.

**Practical Considerations.** Assess which clothing, makeup, watches, and other jewelry need to be removed and explain your requirements clearly to the patient. Unless there are strong reasons to the contrary, such items should never appear in a clinical photograph (Color Plate 43). Many newcomers to medical photography and, incidentally, many physicians, doubt the necessity of removing all clothing from the field of view. To be convinced, you have only to see a series of pictures of a patient's facial surgery to realize that the most obvious changes from photograph to photograph are often the color and nature of the clothes and hair accessories. Exceptions are necessary to prevent patient distress or where clothes or other items are relevant to the condition, or in the final photograph of a series showing reconstructive surgery. You need to provide the facilities to remove makeup and nail polish. You will also need an adequate supply of natural-colored hair grips.

Dressings are often difficult and painful to remove.

FIGURE 12.2    The studio chair, with a locking mechanism for anterior and lateral viewpoints (left) and a headrest for ophthalmic and dental work (right).

**FIGURE 12.3  A box to raise the patient above floor level by about 18 inches. Note the attached scale for the assessment of stature and also the step at one end. The leading edge of the background roll is fixed to the floor to avoid accidental slippage.**

This is best done by a nurse in the ward or clinic before the patient comes to the department. A temporary dry dressing can be left in place to protect the lesion that the photographer can then remove simply and quickly, but carefully. Re-cover the lesion with a clean dressing for the return journey to the clinic.

Always allow the patient privacy in which to undress and dress, and never hurry an ill patient. If necessary, preserve modesty by the use of plain surgical drapes. Alternatively, the patient can wear a plain bikini-type garment in full-length pictures if it is not necessary to record genitalia. In cases when it is necessary to remove all clothing provide a dressing gown to change into prior to the actual photography.

Warn the patient if you are going to switch on bright lights or discharge an electronic flash. It is less disturbing to switch on a bright light while the lamp is pointing away from the patient and then to turn it gradually toward the patient's face. If you need to insert oral retractors, show these to the patient first and explain why you are using them. This approach to the patient will pay enormous dividends in a relaxed and cooperative patient, instead of one who is frightened, tense, and, as a result, difficult to photograph.

Take your photographs as quickly as possible. People who are ill tire much sooner than healthy ones. You

should never keep a patient standing or in a fixed position for any length of time. An assistant can often help in positioning the elderly or disabled patient.

Never leave the patient uncovered longer than is necessary, or ask them to remove more clothing than is required. Always take the most embarrassing photographs first, gradually allowing the patient to re-dress. If, for instance, full-length views are required, as well as views of the face, do the full-length views first, then have the patient partially re-dress, after which you may take the facial views. Help the patient to dress if necessary.

If a patient has an adverse reaction, such as a fainting spell or vomiting, always inform the patient's doctor or nurse. If this happens to an out-patient, do not allow the patient to go home until a medical officer has performed an examination. Never presume that someone else will look after the patient after he or she leaves your department; make sure yourself. Find out from your administration whether there is an accident report form that has to be completed or any other additional required action. Make personal notes of any incident immediately after the patient has been placed under medical care. Such notes, which should be signed and dated, should be kept to serve as a memory aid if further investigation is ever necessary. Make sure you know the hospital's procedure for calling a resuscitation team, but do not rely on it. As a member of the health care team, you will be expected to know how to employ cardiopulmonary resuscitation (CPR) techniques yourself. Your prompt action may save a life.

A patient's illness is a very personal thing, and the photography of the condition may well be embarrassing. Therefore, preserve as much privacy as possible. For example, make a point of not having onlookers while you are photographing a patient. The only exception is a chaperon. This intense personal concern with their illness will cause patients to ask your opinion of their condition. Never venture to give one. Only a patient's own doctor is competent to do this. Similarly, never talk about patients or their diagnosis within their hearing.

Medical photography is still a relatively new profession, and there is understandable ignorance about it. Patients commonly confuse photography and radiography. Patients may ask "Why am I being photographed?" They naturally assume that their conditions are rare and interesting, and therefore serious. The doctor should have explained the reason for the photographic session to the patient before he is sent for photography. However, this is not always the case; be prepared to explain the reason yourself. There are three possible answers you can give:

1. Diagnosis. Explain that the doctor needs the pictures as part of the patient's confidential medical records to help in understanding the condition and to assess its

treatment properly. This is particularly true for some invisible radiation procedures.

2. Record. Explain the value of the photographs for later comparison purposes in order to assess progress and to understand whether the treatment is working effectively.

3. Teaching. When the picture is obviously not for either diagnosis or record, willing consent will generally be obtained when you explain how valuable the picture is to the hospital, both for treating similar cases and for teaching medical, nursing, and paramedical staff.

When positioning patients, have your purpose clearly in mind, as well as the exact angle and the extent of the view. If you are uncertain, the patient will find it difficult to follow your directions. Point to a spot on the wall for the patient to look at or to demonstrate the action you require in, for example, filming a patient's gait.

During the photo session, talk gently to the patient in a reassuring manner. If the session is to be long, explain each step as you go and also check that your patient is not overtired. If you need to touch the patient, for example, to insert retractors or speculum, wash your hands (in the presence of the patient, if possible), and make certain that you use sterile equipment. Apart from the obvious risk of cross-infection, it is important psychologically for the patient to know you are scrupulous in this respect.

Never hurt the patient. No photography is worth such discomfort and distress to a patient that the prognosis may be affected in any way. If possible, ask the patient to take the required position, but if you have to assist in positioning, do so with tact and consideration. Do not be frightened to touch your patient unless there are obvious reasons why you should not. Some patients may be too ill to cooperate fully. In this case you should do your best and cause the least discomfort.

If you need to process the film before the patient leaves the department, for example, when doing a specialized technique such as infrared photography, make sure that any bright photographic lights are turned off and that the patient is comfortable and left in safety. If you are in any doubt, have an assistant remain with the patient.

**On Completion of Photography.** Allow the patient sufficient time to dress following the photography. There is nothing worse than half-dressed patients leaving the studio. If you asked the patient to remove makeup for the photography facilities, then allow time for replacement. Often makeup covers a disfigurement, and it is unkind to send patients off without the opportunity to replace the makeup.

Each hospital has arrangements for escorting patients to and from departments. Your responsibility is to arrange for the safe return of the patient from your de-

partment, so find out from your administration how you should do this. Hospital porters usually escort patients except where the patient's condition is sufficiently unstable to warrant a qualified nurse for accompaniment.

Check the changing cubicles after each patient has finished. The skin fragments from a patient with psoriasis or exfoliative dermatitis may not be infectious, but they are certainly a distressing sight to any subsequent patient using the cubicle.

If the patient's case notes have been sent to you, it is your responsibility to return them. Do not leave medical records where the patient can read them and, if they are given to the patient, make sure they are in a sealed envelope.

## Patient Consent and Copyright

Opinions and practices vary widely on the subject of patient consent, but a clinical photograph is part of the patient's confidential medical records. Its use for teaching or publication without the patient's consent would be a breach of medical etiquette. Many areas of the patient's treatment, such as giving a blood sample, having an x-ray, or receiving prescribed medicines, are not subject to written permission, but some are, including all surgical procedures involving general anesthesia. Since photography is not an essential part of the patient's treatment, it is usual to obtain written consent to photography, especially if the photograph may be used for publication or teaching. Have an area on the actual request form to be filled in by the patient. File this along with the negatives. Have a separate request form, which can then be filed in the patient's medical records.

To be effective, the consent must be informed consent. This involves a number of special features. First, clearly explain the purpose of the photography to the patient in an easily understood manner. Second, the purpose of the photography must be specific. You can no longer ask for a blanket consent to cover all purposes. The meaning of teaching, research, and record must all be clearly explained. When the purpose is publication, for example, the patient should understand that photographs might appear not only in medical publications but, if appropriate, other quasi-medical publications available to the general public. The patient must understand the audiences involved when the purpose is teaching. Does this mean teaching undergraduate medical students or does it involve teaching the general public as part of a health education campaign? Do not assume that the patient understands all of these possibilities. If you do not explain these possibilities fully, you will not have obtained informed consent. It is also imperative to explain to the patient which area of the body is actually to be recorded by the camera, whether full length, the face only, or

other parts, as this will have an effect on the patient's decision.

Informed consent has obvious complications for children under the age of consent and for adults whose mental state is compromised. For children, it is normal practice to obtain the parent's or guardian's consent. In the case of psychiatric patients, obtain the consent of the next of kin.

Last, consent is not valid unless a dated signature is obtained from both the patient and the physician who explained the process. Do not attempt photography without the patient's consent in the hope that it may be obtained retrospectively. This practice has, on occasions, led to complaints.

Sometimes it may not be possible to obtain informed consent. For example, in child abuse situations clearly the child cannot consent and quite possibly the parent may refuse. In such circumstances it is normal practice to proceed on the basis of the physician's signature alone. In some countries this is countersigned by the medical examiner, investigating police officer, or social worker. Make detailed and accurate records of the photography undertaken in such cases and sign and date these records. Child abuse photography is the principal reason for the photographer to be called to a court of law. There you will be asked detailed questions about the photography and how well you think your pictures represent the condition of the child at the time. You may even be challenged to prove that the pictures actually show the child in question. You cannot begin to justify the answers to such questions if you do not have accurate records.

The patient has a right to refuse to be photographed. If this happens you should inform the requesting physician of the circumstances. If, for any other reason, you are unable to obtain the requested photograph, you should also inform the doctor concerned. Always remember that you also have the right to refuse if you think the requested photographs make unreasonable demands of the patient, or if the patient proves too difficult.

Photography of the genitalia of young children is a problem legally. In England and Wales such photographs may be construed as pornographic, and the qualified medical photographer could face prosecution, even if in possession of a signed consent form. Check the current situation with regard to child pornography in your country.

Even where patients have signed a consent form, the publication of medical photographs needs careful consideration, but, like all aspects of copyright, the situation is extremely complex. The laws of copyright, though similar in principle, may differ in detail in various parts of the world, so you need to become acquainted with the law locally.

In the United Kingdom the copyright is vested in the author of the work concerned for a period of 50 years from the end of the year in which the author dies. The photographer is, however, not the author of the work if he is employed to take such photographs. In that case the copyright belongs to the employing authority, such as the health service, medical school, or research institution. In practice, however, the administration of the copyright of medical photographs is usually vested in the head of the medical illustration department. Although doctors may appear to be commissioning medical photographs when they sign a request form, legally they do not have either ownership or copyright of the resulting photographs. However, doctors who take photographs of their patients but who are not employed to take such records may own the copyright of these pictures. Since the legal situation on these issues varies considerably, you should ascertain the prevailing situation in your own country, but be prepared for confusing and conflicting information.

In theory, it is possible for the employing authority to sell the reproduction rights of medical photographs, but there is another complication, that of medical etiquette. Because the photographs are part of the patient's confidential records, you may not publish them, except with the permission of both the patient and doctor concerned, especially if the patient is recognizable in the photographs. Generally, if the picture simply shows a close-up of a lesion, this formal procedure may be unnecessary, but you should ensure that the picture is really anonymous.

The matter of recognition needs some careful consideration. It is not generally satisfactory to mask the eyes of a patient. To make a face unrecognizable you need to black out virtually the whole face, which would make the photographs quite useless. Recognition applies to other distinguishing features as much as to the face. If, for example, the photograph incorporates a tattoo, or the pictures are of a very rare condition, they may in themselves be recognizable and require specific permission for publication.

If color films are sent out to processing laboratories, take special care to protect the patient's identity. Do not record a patient's request card alongside pictures of the patient on the same film. Some departments refuse to send out processing of clinical work, even if the running of a color process is uneconomic. Other departments send work to laboratories in different parts of the country to avoid possible recognition of patients by the laboratory staff. Apart from in-house processing, the only satisfactory method is to have the laboratory insist on a disclosure of information clause in the contract of employment for their staff. This will effectively prevent them from divulging any information gained as a result of their employment.

When clinical photographs leave the hospital for any purpose, for example to be sent to a publisher, take great care to preserve anonymity. For example, does the pho-

tograph have a name and diagnosis printed on the print mount or slide frame? Take care also with the disposal of unwanted clinical photographs. These must be shredded or burned. Never leave photographs around the department for anyone to see. It is your job to maintain the patient's right to confidentiality; other staff do not have a right to see or comment on any patient's condition.

## A STANDARDIZED APPROACH TO MEDICAL PHOTOGRAPHY

*Standardization* is the key word in all discussions of clinical photography. It is critical from the doctor's point of view that serial photographs of a patient are strictly comparable. The only thing that should change in a series of pictures of a patient is the patient. All other factors must remain constant. A routine standardized procedure also saves time, since decisions are largely predetermined by a set of existing rules. The clinical condition requires a certain view, which, in turn, dictates a set scale of reproduction, which then dictates a set exposure under known conditions. This can become especially important in a department that employs several medical photographers, all of whom may have their own interpretation of the doctor's request. Every patient who attends for photography must be regarded as a potential candidate for serial recording, so it is imperative that the photographer not only use a standardized technique but also keep a meticulous record of all the data necessary to repeat the result.

In any scheme of standardization, the following factors must be considered:

Patient position
Viewpoint
Background
Lighting
Choice of lens
Color balance
Exposure and contrast
Presentation of the results

Decisions concerning the choice of viewpoint and positioning of the patient are affected by two criteria. The first is the need to standardize so that comparable records can be made over a period of time, in relation to one patient and also to enable comparable pictures to be achieved in a series of patients. The second is the need to show the condition to its best advantage in a single view, so as to make a good teaching picture. It may be that the two criteria of standardized record and best possible single picture are not compatible; in that case, both objectives can be met by taking separate pictures.

Work out a routine that you can follow so as to avoid unnecessary movements from camera to patient. For ex-

ample, have the camera magnification and aperture preset and the lights prealigned before starting to position the patient. Then work with the patient in achieving a standardized pose, returning to the camera for final adjustment and the actual exposure. Such a routine is particularly important if the position required for the patient is uncomfortable to maintain for more than a short period. Remember that you are not dealing with a professional model. Some positions, such as the extreme range of joint movements, may be impossible to maintain for more than a few seconds. In such cases, first ask the patient to demonstrate range of motion so that you can estimate the area to be covered by the camera and the exact viewing angle needed. Set up the camera, test again on the focusing screen, and make any final adjustments required while the patient relaxes. Then you can take the photograph with confidence when the patient repeats the movement.

It is highly desirable to have a standard set of views for each particular area of the body you regularly photograph. You should have either a standardization chart with small drawings of the different positions and viewpoints or example photographs of all the standard positions. These can be displayed on the studio wall out of sight of the patient or in a techniques album. While it is possible for you to devise all your own views, it is desirable to consult the medical staff to ascertain which standard views would be of most use to them.

### Working to Scale

Most photographers, amateur or professional, have been taught to fill the frame with their subject matter, then focus accurately. This approach is not suitable for patient photography. First, more space is required around the clinical photograph in order to demonstrate the orientation of the lesion; second, the photograph must be taken at a known magnification, which cannot be done if the photographer moves the focusing ring. The correct technique for the clinical photographer is to look at the patient, decide on the area to photograph, select a known scale/viewpoint from a chart, set the lens to that magnification, then move the whole camera back and forth until you have the principal plane of the subject in sharp focus. Some practice will be required before the technique becomes familiar. In the early stages of using such a technique it may be helpful to tape the lens once a magnification has been set in order to remove the temptation to change the focusing ring.

Most clinical pictures can be taken at one of a range of fixed magnifications. These are, in practice, all fractions and, therefore, some people prefer to use the term reproduction scale. One-tenth life size on the film, for example, would be represented as 1 : 10 reproduction ratio.

(Figure 12.4 and Color Plate 44). One suggested set of reproduction ratios for the 35-mm format is given below, but you can easily design your own system for other formats.

| Scale | Region |
|---|---|
| 1 : 50 | Full-length views |
| 1 : 25 | Upper half-length |
| | Lower half-length |
| 1 : 15 | Torso |
| | Back |
| | Upper legs |
| | Lower legs |
| | Forearm and hand |
| 1 : 10 | Head and neck |
| | Both hands and wrists |
| | Pelvis |
| | Buttocks |
| | Shoulder |
| | Both feet |
| | Knees |
| 1 : 8 | Face |
| | Axilla |
| | Breast |
| | Hair |
| | Hand |
| | Foot |
| | Knee |
| | Elbow |
| | Neck |
| 1 : 4 | Forehead |
| | Both eyes |
| | Cheek |
| | Fingers |
| | Perineum |
| | Ear |
| | Nose |
| 1 : 2 | Orbital region |
| | Nails |
| | Teeth |
| | Nipple |
| | Skin |
| 1 : 1 | Single eye |
| | Single nail |
| | Skin close-ups |

Obviously, you will need a certain amount of discretion when applying these scales. Large acromegalic hands will not fit into the 1 : 10 scale, and it would clearly be ridiculous to record a 2-year-old child full-length at 1 : 50. The critical factor is that you apply the scales consistently but intelligently. In dermatology, for example, it is important to take views that orient the lesion, but then also to take views that show the detail. Many modern lenses are marked with reproduction ratios such as 1 : 10, 1 : 8, 1 : 4, but if yours are not, it will be necessary to establish the ratios by experimentation or calculation and to mark the focusing ring accordingly.

## Perspective

In any recording system, objects of the same size will be recorded at different magnifications, depending on their position relative to the lens. Distant objects will be recorded smaller than those that are closer to the lens. This feature often helps the brain interpret depth within a scene and is called *perspective*. Perspective can be a serious problem for the clinical photographer. When photographing the face from the front, for example, the nose will be recorded at a greater magnification than the ears, causing a distortion in the record of the patient.

The perspective effect is controlled by camera-to-subject distance. The farther the camera is from the subject, the less the relative effect of perspective, and the more accurate the result. To some extent, though, the amount of distortion caused by perspective will depend upon the subject's depth. For a flat subject, such as a normal chest, the effect will be minimal, but for the face, where the depth of the subject from nose to ears almost equals the width, the effect will be prominent. To reduce the unwanted effect of perspective, clinical photographs should be taken from the farthest practical distance from the patient. Clearly, the size of the studio will limit the extent to which this condition can be met.

The determination of a magnification ratio involves both camera-to-subject distance and the focal length of the lens. Photographs taken at a specific magnification ratio are therefore only strictly comparable if they were taken with the same focal length lens. The appearance of a face taken at 1 : 10 magnification with a 200-mm lens is very different from that obtained at 1 : 10 on a 55-mm lens because, although the magnification is the same, the subject-to-lens distances, and therefore the perspective, would be quite different for each lens. This is a particularly interesting and useful experiment to conduct yourself. The results may even justify your obtaining a larger studio (Figure 12.5).

Some judgment, therefore, needs to be exercised in selecting lenses for patient photography. Ideally, the most distant viewpoint possible should be selected; use the longest focal length lenses to maintain a reasonable magnification on the film. In practice, however, the size of your studio will severely limit the application of this principle, and lenses shorter than one would wish will have to be used. Many workers advocate the use of a 105-mm lens for ratios of 1 : 15 and greater, with the 55-mm lens used for 1 : 25 and 1 : 50, but in very confined spaces, such as wards, even this may not be possible.

Use the longest focal length of lens consistent with the space available and use it repeatedly. It will not be suffi-

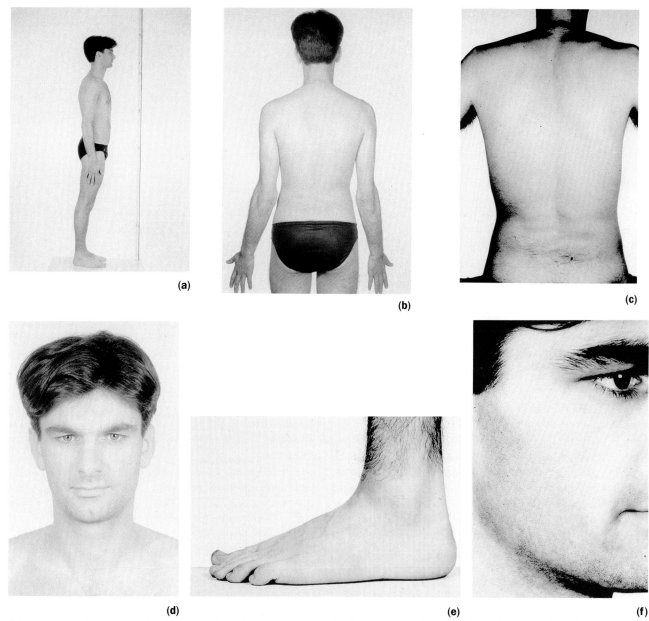

**FIGURE 12.4    Some examples of the Westminster standard reproduction ratios: (a) the whole body fits in at 1:50; (b) 1:25 covers the upper or lower half of the body; (c) 1:15 is suitable for the torso; (d) 1:10 for the head and neck; (e) 1:8 is useful for the foot or hand; (f) 1:4 is ideal for recording the cheek or nose.**

cient to work to scale. You will need to work to scale with set lenses. Advice that is often found about recording the face from certain "natural" distances is quite erroneous.

## Position and Viewpoint

In any standardized system of photography it is not sufficient just to take photographs to a set scale and perspective. It is also necessary to have fixed views of the patient positioned in a standard way. It is not possible to define exact viewpoints for every condition, but a range of ac-

cepted general positions can be described. It is desirable that, wherever possible, all clinical photographs should conform to set standards, but it is imperative that, if the standard view does not show the condition adequately, additional photographs be taken. It is also most important when devising a series of standard views to discuss them with the appropriate physicians and surgeons.

**Anatomical Orientation and the Full-Length View.**    Body posture is most important in all clinical photography. Many diseases are caused by, or are consequent on, some deformity in another part of the body. One example is

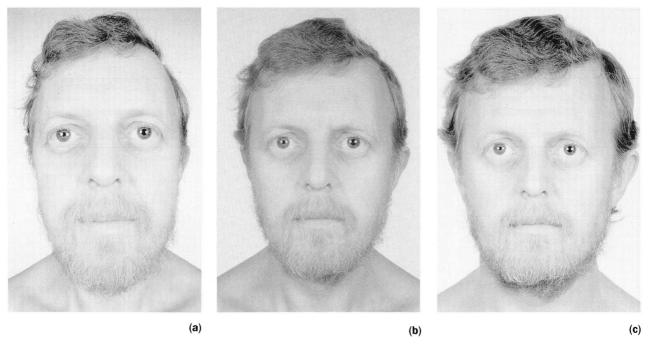

**FIGURE 12.5** The effects of changing focal length on perspective: each picture has been recorded at the same magnification with (a) a 35-mm lens, (b) a 55-mm lens, and (c) a 105-mm lens. Perspective is changed by any change in subject-to-camera distance.

the congenitally short leg causing a torticollis or wry neck, which results in the patient having a strabismus or squint. It is even possible to falsely induce some deformity by positioning the patient incorrectly. As a general rule, one should ensure that the patient's body is correctly positioned one joint above, and one joint below, the area of interest. For example, if the point of interest is the knee it is important to have both the feet and the pelvic girdle correctly oriented. If the point of interest is the face, the shoulders and neck must be correctly positioned.

In the studio, patients are either photographed standing or seated; in both cases, there is a standard anatomical position. In the standing anatomical position the body is upright, with the head facing forward, the arms at the side with the palms of the hands facing forward, and the feet slightly apart. To achieve this, it is usually best to start with the feet and work upward. One should aim to have the feet approximately 4 inches apart and in a natural stance. This can often be a difficult task. Trying to describe the movements required to the patient usually results in misunderstanding, and attempts to hold and position both of the patient's feet yourself usually results in the patient falling over. It is far easier to hold the patient's right foot in the correct place with your right thumb around the front of the ankle. It is then a simple matter for the patient to move the left leg until its ankle bone touches the other side of your outstretched palm. This leaves the patient in control, and therefore stable, and places the two feet aligned and a palm's width apart. Never attempt to force the patient to stand in such a way

that the feet are parallel, as almost everyone stands either with toes turned out or inward. Any attempt to force an unnatural foot position on the patient may completely obscure the relevant pathology.

Once the feet are positioned correctly, it is necessary to ensure that the patient is distributing his or her weight equally between the left and right legs. This is easily achieved by gently pushing back both the patient's knees, thus forcing leg straightening. A word of warning: the patient is very unstable in this position and will not be able to hold it for very long.

After positioning the legs, turn your attention to the pelvic girdle. It is usually sufficient to ask the patient to rotate the pelvis gently to the left and to the right and to stop in a comfortable position facing the front. Again, any attempt to force the patient so that the pelvis is exactly square on to the camera may obscure, or induce, an abnormality. What is comfortable for the patient will probably be a natural position. This will only be true, however, if you have been meticulous in positioning the feet and legs.

The next joints belong to the vertebral column but, in itself, this is impossible to position. By positioning the pelvic and shoulder girdles correctly, however, the vertebral column will automatically assume a natural position. The vertebral column may exhibit all kinds of bends and rotations. Never attempt to correct any of these curvatures. The shoulder girdle is positioned by using the weight of the arms, which are allowed to hang naturally to the sides of the body with palms outstretched and facing forward. Although this is a slightly uncomfortable

position for the patient, it does reveal the angle at the elbow and also ensures proper weight distribution about the shoulder. Again, if the patient places one shoulder farther forward than the other, do not attempt to straighten them up.

It only remains to position the head correctly. Again, this is a difficult task, since the head can rotate and tilt in two different planes. It is necessary to imagine two lines drawn on the face. The first, on the front or anterior surface, is known as the *interpupillary line* and is a straight line extending across the head and passing through the center of both pupils. The second, on the side or lateral surface, is known as the *orbit–helix line* or the *Reid plane*, and is a straight line drawn from the junction of the helix of the ear to the outer canthus of the eye. This line is parallel to the Frankfurt plane, which is a straight line drawn from the lower orbital margin and passing through the external auditory meatus. Anatomists conventionally refer to the *Frankfurt plane*, while orthodontists refer to the *Reid plane*, since the two are parallel it does not matter to which convention the medical photographer adheres.

First, position the head so that the interpupillary line is horizontal; then adjust the angle until the Frankfurt plane is horizontal. To position the head correctly it is necessary to be at eye level with the patient. Once again, it is necessary for you to position the patient yourself. This is best done by placing your middle finger on the crown of the patient's head and using your other fingers to rotate and tilt the head. You will need to move rapidly from the front to the side of the patient in order to check that both interpupillary line and Frankfurt plane are horizontal (Figure 12.6).

Have the patient bite lightly together with her back teeth and have her eyes open. You will need to exercise considerable skill in order for all of this to be achieved. With the head now correctly oriented, the patient will be in the standard anatomical position. When you are positioning the patient for the lateral views, the same technique applies, except that it is conventional to rotate the palms of the hands until they face the thighs. Although this seems difficult and laborious, with practice you should be able to position a patient in this way in a matter of seconds.

The seated position is most often used for photography of the head and neck and occasionally for other views if the patient is unable to stand. For the seated patient, much of the same advice applies. A good studio

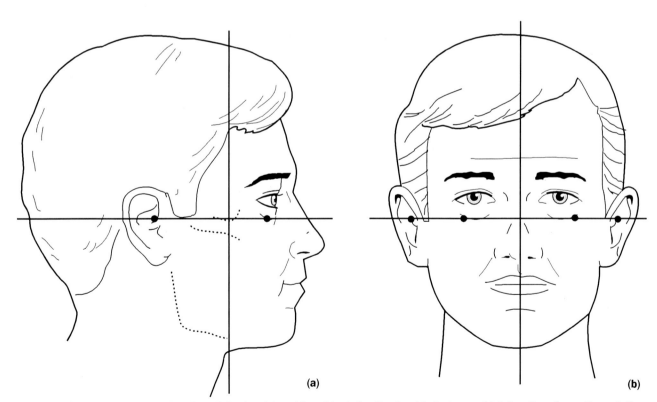

**FIGURE 12.6** The accurate positioning of the head is achieved by using the Frankfurt plane, which is a line drawn through the external auditory meatus and the lower orbital margin. This line can be identified from both the (a) lateral and (b) anterior positions and for photography should be horizontal in both cases.

chair will help immensely. Clearly, it is not so important to accurately position the legs and feet. It will, however, be necessary to apply light pressure to the lumbar region in order to make the patient sit upright. There is a real danger that the patient will slouch forward without this pressure, thus causing unnatural extension of the chin when placed in the Frankfurt plane. The hand position is also important with a seated patient; hands should be placed in a resting position in the lap.

**The Head and Face.** With important applications like orthodontics, dentistry, and plastic and reconstructive surgery, there is probably more need to standardize photography of the head and face than any other body area. As with all patient photography, you will need to discuss the choice of views with the doctors concerned, but as a basis for discussion the following are suggested:

1. anterior view (front view)
2. 45 degrees to median plane (left and right oblique)
3. 90 degrees to median plane (left and right laterals)
4. posterior view (back view)
5. inferior view (worm's-eye view)
6. superior view (bird's-eye view)

Views 1 to 4 are with the interpupillary line and orbit–helix line horizontal, (that is, in the Frankfurt horizontal as described) and with the camera back vertical. The patient should be seated in a studio chair ideally provided with both back and head rests. The head is set so that the interpupillary line is horizontal, then adjusted in angle until the Frankfurt plane is horizontal. Then set the camera to the appropriate scale (say 1 : 8 for 35-mm photography) and positioned so that the lens axis is horizontal and the camera back vertical. Then you only need to ensure that the patient is centrally placed in the viewfinder.

A viewfinder screen marked with a grid is of immense help in achieving this. Having all your equipment in a state of readiness close at hand will be a critical factor in your success at positioning the head. If, after carefully positioning the patient, you walk off to one side of the studio to collect a camera or lens, the patient will certainly follow your movement. Have your camera on a small trolley placed so that you can maintain eye contact with the patient from the time you finish the positioning until the time you press the shutter.

The anterior view should be relatively straightforward. The most common fault is having the chin too high or too low. The most frequently encountered problem with the lateral views is having the camera too far forward (showing the opposite eyebrow) or too far back (causing a compression of the front of the face). Ideally, the center of the frame should fall a little behind the outer canthus on the temporal bone. The great temptation with the lateral view is to align the front of the face with the edge of the viewfinder frame, rather than correct positioning of the Frankfurt horizontal. This can be a disaster when the patient has a micrognathia or prognathism, which is to be surgically corrected.

To obtain each of the angular views the patient is rotated around the head's central axis. Standardization of the oblique view is particularly difficult. Have a chair that locks in the required positions; but if this is not possible it may be helpful to mark these angles on the studio floor. You can also place markers around the studio walls so that when the patient looks at these, they will be in the correct angular orientation. (This can be particularly useful for children.) One commonly advocated method is to adjust the viewpoint until the nose-tip is just coincident with the cheek. This is completely useless where surgery involves the nose, as the angle that this produces will depend on the size of the patient's nose. Instead, you can rotate the head to the point where the inner canthus of the distant eye is just hidden by the bridge of the patient's nose. Although this method is very accurate, it is difficult to apply in practice when viewing the subject on a small ground glass screen.

The posterior view of the head is very good for demonstrating conditions like "bat ears," and the same rules of positioning as for the anterior view apply. Obviously, in such cases clip the hair back in order to show the ears clearly. The inferior view of the face from below the chin is especially useful for assessing deformities of the nose and the cheeks, but it is essential that the supra-orbital ridges are clearly delineated in addition to the zygomatic arches. There is a very narrow range of angles for achieving this. For the sake of the patient, it is usually best to ask them to tilt back as far as is comfortable and adjust the camera angle until it is the correct viewpoint. The superior view is sometimes requested by maxillofacial surgeons. This is a difficult view both to take and to standardize. Again, the patient will need to tilt back as far as is comfortable; then the photographer needs to assume a high viewpoint in order to achieve the correct angle. Backgrounds are then a problem. As with the inferior view, both the zygomatic arches and the supra-orbital ridges must be clearly delineated (Figure 12.7).

Take the inferior and superior views with the same perspective as the other facial views. This means photography at the same magnification with the same focal length lens, even if the subject seems very small in the frame. There are two standard reproduction ratios for photography of the head. Where only the face is concerned, 1 : 8 is appropriate, but if the pathology involves the whole head, 1 : 10 is the correct scale, especially if there is a possibility of using pedicle flaps. Orient the camera vertically for both ratios. Close-ups of various parts of the face such as the nose or cheeks may be required. The key feature here is not to get too close. Some orientation features such as the lips or the edge of the ear must appear, and the feature being recorded must be seen in the context of the face on which it sits.

(a)       (b)       (c)       (d)

**FIGURE 12.7** Four of the most commonly experienced faults in positioning of the head: (a) the anterior view with the chin too low, (b) the lateral view with the camera too far toward the back of the head, (c) the three-quarter profile at too shallow an angle, and (d) the inferior view with the patient tilted too far back.

The cheek, ear, and nose, for example, should each be recorded at 1 : 4 in the vertical format, while the forehead or periorbital region would be recorded at 1 : 4 horizontally (Figure 12.8).

**The Neck.** The contours of the neck vary greatly, according to head and shoulder position, so take great care to ensure that you place head and shoulders in the standard anatomical position, even though you are only photographing the neck. Double chins are removed very effectively by overextending the neck. Take care to ensure that no clothing marks from items such as a tight collar and tie are recorded. These can all too easily look like operation scars in the final picture.

(a)       (b)

**FIGURE 12.8** Photography of the nose is often done at too high a magnification; (a) at 1:2 the nose is distorted and too isolated from the face on which it sits; (b) at 1:4 it is much better proportioned.

Routine standard views for the neck are:

1. anterior
2. anterior with the chin elevated
3. posterior
4. laterals
5. selected views at angles to the median plane

These are all recorded with the camera oriented vertically and the lens set to 1 : 8 magnification.

**The Shoulder.** The shoulder needs to be photographed for a variety of conditions, but especially for bone and muscle deformities, for instance, problems of the scapulae and the pectorals. Dissolution or congenital deformation of the pectoral muscles causes a deep depression in the region medial to the head of the humerus.

Routine views, recorded at 1 : 10 horizontally, might be:

1. anterior
2. posterior
3. lateral
4. 45 degrees to median plane
5. superior

Take great care to ensure that the shoulders are neither unnaturally dropped nor hunched up. Place the arms in the standard anatomical position. Always record both shoulders so it is possible to see whether the deformity is unilateral, and look carefully to see if there has been any consequent distortion of neck/head position. If there has, record this as well.

**The Trunk and Back.** Both the chest and the back are recorded at 1:15 magnification in the vertical format. Anatomical positioning is the same as the requirements for whole body photography. Great care must be taken,

however, in photographing the over-the-shoulder position and also about the degree of inspiration. Obviously, breathing in and out affects the shape of the chest, so some point in the respiratory cycle must be chosen for standardization. Perhaps the best point is maximum inspiration with tidal, not forced, inspiration.

Even strong cross-lighting may not demonstrate spinal deformities adequately. It may be necessary to mark the cutaneous prominences of the spine with a skin marker in order to delineate the milder deformities. If you do this, mark the points with the patient in the position in which you will do the photographing. Otherwise the skin will move relative to the spine when you position the patient, and the marks will be inaccurate.

**The Female Breast.**    The thorax is most commonly photographed to show the appearance of the female breast, either for carcinoma or pre- and postoperatively for augmentation, mammaplasty, or contouring. You should notice that the breasts are situated normally, so that a view with one nipple oriented anteriorly demonstrates the other obliquely. A true lateral of the breast is not a true lateral of the thorax as a whole. For most views the patient should be standing and, again, meticulous care should be exercised over shoulder position, breathing cycle, and lighting angle. There has been much discussion about the correct position for the arms in breast photography, as raising the arms makes a huge difference to the shape of the breast. It is generally agreed that when recording the breast, views should be taken both with the arms in the anatomical position and also with the palms placed behind the head. It is essential to see the axillae if the photographs are recording carcinoma of the breast, but these may be the very patients who cannot raise their arms. Sometimes a compromise position has to be accepted.

Standard views for the breast might be:

1. anterior (to thorax)—arms up and down
2. anterior (to individual nipples)
3. tangential (variable for individuals, but lateral of the breast)
4. inferior (patient lying down)
5. superior (patient bending forward)

It is conventional to record both breasts at a scale of 1:10 in the horizontal format (occasionally it will be necessary to use 1:15), and individual breasts and axillae at 1:8 vertically.

The superior and inferior views of the breast are both most useful to the surgeon, but both are difficult to do. The inferior view is best taken with the patient lying supine on an examination couch with the lower part of the legs hanging over the end of the couch. A clean sheet should be draped over the patient's lower half, that is, tucked around the waistline and extending out over the legs and down over the end of the bed. This provides not only a neat edge to the picture but also preserves the patient's modesty, bearing in mind that you are going to be working close to the end of the couch, level with the breasts. A second piece of material is then draped across the patient at the neck level and supported on either side of the patient by stands, rather like the drape used by the anesthetist in the operating room. This provides a continuous background for the breasts. For the superior view it will be necessary to have the patient bend forward toward you so that the breasts hang downward. To avoid straining the patient's back it is essential to have a stool or small table for her as a support when bent over. A continuous background is achieved by stretching a piece of background material between two supports, but this time arranged at the height of the patient's umbilicus. The patient bends down over this. Even with support this is an uncomfortable position for the patient, and you will need to work quickly.

**The Arm and Hand.**    You can record the forearms and hands together at 1:15 magnification by having the patient stand behind a chair with a piece of background board arranged at a convenient angle (approximately 60 degrees to the chair seat) and resting the arms on this board. The arms are usually then presented at a convenient angle for photography in a standardized fashion. Where it is important to see the carrying angle at the elbow, however, it is critical to place the arm in the standard anatomical position. Then you will have to photograph the arms separately. You can record both palmar and dorsal views of the hands in the same way, at 1:10 magnification in the horizontal format. With these views you should try to achieve an even spacing of the digits by using a pencil as a spacer. The thumb should be its own length away from the base of the index finger. Again, use discretion here. If the purpose of the photograph is to show a deformed finger position, do not force it into a normal presentation. With dorsal views, always remember to remove all jewelry and nail polish. They have no place in the clinical record.

Individual hands are usually recorded in the vertical format at 1:8 magnification, except for the radial or medial views, which are conventionally taken horizontally. The radial view is especially useful for showing the thumb and fingers gripping items, while the medial view is useful for recording Dupuytren's contracture, where there is limitation of extension of the little fingers. In general, the practice of holding arms out in front of backgrounds, or worse still in front of the chest, is to be discouraged, as there is no control over angular presentation. For these two views, however, hands will need to be held out in front of backgrounds (Figures 12.9 and 12.10).

Standard views will include:

1. both arms, palmar and dorsal
2. both hands, palmar and dorsal

3. the arm in the carrying position
4. medial view of the hand
5. the upper arm, anterior and lateral
6. the elbow
7. individual fingers

**The Pelvic Region.** Conditions affecting the lower abdomen and the male genitalia are usually best photographed with the patient standing; many deformities of the scrotum seem to disappear when the patient lies down. It is best to approach the anus, perineum, and female genitalia by placing the patient into the semilithotomy position, that is, lying on a couch with the legs bent, heels to buttocks and knees out. For this position the couch needs to be covered with background material and another piece of material should be supported across the patient's waist to provide a continuous background behind the mons pubis. This can often be held by the patients themselves.

Usually, the male genitalia are photographed in the vertical format at 1:4, while the female genitalia are recorded in the horizontal format at the same scale. Often it will be necessary to retract the labia or the prepuce, if at all possible. It is best to have the patients do this. Whoever does this, patient or assistant, must wear gloves, as long or dirty fingernails should never appear in such photographs.

**The Lower Limb and Foot.** The position of the feet is very important in views of the legs, since the muscle shape is altered considerably with movement of the foot. Adopt the standard anatomical position for all photography. It is critical to include the area from the top of the iliac crest downward in records of the whole leg. You can usually accomplish this at 1:25 in the vertical format.

FIGURE 12.9 Hand photography is best accomplished by using a portable flashgun held beneath the lens (above) with the patient resting his hands on a sloping bedside table (below).

FIGURE 12.10 The dorsal view of the hand with shadows tightly placed in the spaces between the fingers by using the technique shown in Figure 12.9.

The knees are usually recorded together at 1 : 10 magnification with the camera held horizontally, as are both feet. Individual feet are normally recorded at 1 : 8, and toes at 1 : 4—again, all in the horizontal format.

Standard views of the foot will include:

1. dorsal views—at various angles from 80 degrees to true anterior
2. plantar views—weight bearing or "free"
3. medial views
4. lateral views
5. posterior view
6. toes
7. both feet to show walking

With the medial and lateral views, it is critical that the foot is seen to be weight bearing. A continuous background in such views would hide any abnormality (Figure 12.11). Sometimes it is helpful to have both feet represented from the side, one flat and weight bearing, the other balanced on the ball of the foot. This view is particularly useful for club foot, but it is difficult to get young children to adopt such a pose. You can ask the parent to hold the child under the arms and "walk" the patient across the box. You must standardize the dorsal view in terms of angle of view. Some orthopedic departments advocate three views: anterior to the toes, 45° to the foot, and 85° to the foot.

There are two types of plantar view: one for examination of the plantar surface, for conditions such as verrucae, the other to record the weight-bearing areas of the foot for conditions such as talipes equinovarus. You may best accomplish the first with the patient lying on an examination couch with the heels just over the end. Pushing the feet through a piece of background material with a pair of parallel 4-inch slits cut in it, approximately 4 inches apart provides a continuous background. The top of the material can often be held up by the patient while the bottom falls over the end of the couch. In an emergency, a pillow and a pillowcase will suffice if tucked carefully around the ankles. To demonstrate the pressure areas on the plantar surface it is necessary to use a specially designed piece of equipment. This allows the patient to stand on a strong plate glass surface, so that you can take photographs via a 45° mirror. Aim light at the feet, where there is intimate contact between the foot

**FIGURE 12.11** Feet must be photographed bearing weight; (a) the *floating foot syndrome* caused by the photographer's desire to achieve a completely uniform white background is useless to the orthopedist; (b) the correct lateral view is taken with the foot clearly bearing weight and from a viewpoint level with the surface on which the patient stands.

(a)

(b)

and the glass total internal reflection will cause a bright image. Where there is no contact, the image is much darker.

**The Oral Cavity and the Eye.**   Dental photography is a subject worthy of a complete text. The reader is referred to Chapters 17 and 18. Chapter 15 contains details about ophthalmic photography.

## Backgrounds

Give careful consideration to the choice of background. While there are some definite recommendations, there is also an element of personal choice. The critical rule is that you do not change background colors without good reason. If a department has been using white for many years, it makes no sense to change it to gray just because you prefer it. In two years the next photographer may prefer cyan. Consistency is everything. The background's purpose is to exclude other objects, or parts of the subject, so as to focus the attention on the important features and to provide adequate contrast with the subject. Choice of background is therefore inextricably linked with lighting technique. A plain white background will flare if overilluminated and will show shadows if underilluminated, while a black background requires rimlighting to prevent the loss of subject edges in shadow.

Black, white, or gray are the only acceptable backgrounds for monochrome work, but for color photography various colors may be selected. In practice there is no universal background, so some compromise has to be made (Color Plate 45, a toe).

A slightly off-white background is ideal for many subjects and can be illuminated independently of the subject to reproduce as white, regardless of the size of the subject or emulsion chosen. It is equally suitable for black-and-white (BW) or color photography. You should exercise meticulous care to avoid flare (see the section on Lighting). Some departments advocate midgray as the all-purpose background, since it is equally suitable for color or BW photography and for light or dark subjects. Again, however, you need meticulous lighting technique to avoid variations in the gray. Those clinical photographers who regularly work on color negative materials often favor an 18% gray background, as the background can then be read by the color printer to establish the correct filtration. Black backgrounds are quite popular in medical photography because color printers and publishers like working with color against black.

In color photography, you must exercise great care if a colored background is selected because it may easily introduce color casts. The use of a blue background too close to the subject for example, may falsely give the impression that the patient is cyanosed, or a red may give the appearance of erythema, and yellow-green can look like jaundice. Also be aware of the visual effect of different colors. Complementary colors will increase contrast with the subject, whereas similar colors will reduce contrast. A cyan-colored background will therefore provide maximum visual contrast for red medical subjects and is often recommended. Cyan reflects from 50% to 75% of the incident light; therefore it affords a light background. With the persistence of vision from red (the color of most medical subjects) cyan is particularly restful on the eye. Hence the choice of blue-green for operating room gowns and towels. Colored backgrounds are also very difficult to standardize in color from one batch of paper to another, or from one manufacturer to another.

## Lighting

Attainment of good photographic quality depends more on lighting technique than any other part of the photographic procedure. It is the key to excellence in patient photography, just as in other branches of photography, although the principles of general photographic lighting may have to be modified to suit the medical subject. All too often the clinical photographer takes the easy option with lighting and uses large *softboxes* and umbrellas. While undoubtedly convenient, these do not give a good representation of surface detail or modeling. An interesting experiment is to photograph the skin surface with individually controlled lamps fitted with narrow reflectors and then with umbrellas. Photographs taken with the umbrellas show little or no surface detail. Individual lighting control is critical for good patient photography.

Lighting for patients should be both natural in appearance and simple to achieve. It must demonstrate the contour, shape, and outline of the lesion and surrounding anatomy, but at the same time give controlled shadows and clear background. To meet the criteria of being "natural," all shadows should fall downward, as this is how the brain has learned to interpret the visual world. If you light a convex lesion from beneath, the brain refuses to believe that shadows fall upward and so interprets the lesion as being concave. This is a serious consideration when trying to light for texture and can easily lead to the interpretation of tumors as ulcers and vice versa (Color Plate 46).

Follow the general principles of lighting, irrespective of the type of lamp used, although electronic flash lamps, which are adjustable in output with proportional modeling lights, are the lighting of choice. With these lamps it is possible to change the quality of the light by changing the type of reflector used on the flash head. Reflectors are available to emulate everything from spotlights to diffuse daylight.

For cine and television it is still necessary to use tungsten lamps of the photoflood or tungsten–halogen type,

which are hot and of comparatively low intensity. Remember when filming patients that the heat can, at times, become unbearable. Metal objects in the field of view, such as instruments in the operating field, have become so hot that they have inflicted serious burns. Remember also that flash may alarm children or the elderly, but usually no problems occur if the patient is forewarned and the flash demonstrated.

Complex lighting arrangements are difficult to repeat, so in patient photography some compromise has to be made between the ideal lighting arrangement and one that is both practical and repeatable. There are several systems in current use.

**White Background Lighting.** Lighting a white background needs careful technique to avoid flare. A large roll of white background paper, when lit, becomes a huge *softbox* held behind the subject, and there is a serious risk that *non-image-forming light* or *flare* will enter the lens. (A better description of flare is light entering the lens that is not part of the focused image.) Flare has the effect of reducing contrast significantly, thus giving a poorer quality image. The aim of the exercise, therefore, is to produce a clean white background behind the subject with minimal flare. As a general principle, one should always use the smallest amount of white background consistent with the size of the subject. If photographing a hand, for example, you would only need a piece of background paper 8 × 10 inches, and if you only photograph the head and neck, it is not necessary to pose the patient in front of a 9-foot wide background roll.

The next important principle is not to overilluminate the white background. A thorough understanding of exposure measurement is necessary (see Chapter 3). When using the incident light method, the exposure for the background should be adjusted to be the same as the exposure for the lighting on the subject. When you are using the reflected light method, the exposure reading on the background should exceed the lighting on the subject by three stops, or three zones in the zone system. Confusion between these two methods of exposure assessment is one of the most common faults with white background technique. Photographers often wrongly give extra exposure to the background when working with the incident light method.

You can further control flare by reducing the amount of light that is allowed to spill on areas of the background not seen in the field of view. Use snoots, barn doors, and similar devices. You can make some assessment of the spill from the background by turning off the front lights and any other room lighting, then looking at the floor of the studio where an arc of illumination can be seen. Regard this as an arc of flare. If the patient is placed anywhere within this arc, flare is certain to result. Place the patient at least 3 feet in front of this arc. You can also control flare by employing an efficient lens hood. If you

use all these techniques, it is possible to record a white background as pure white on color transparency film with no flare.

Achieving an even illumination of the white background for large subject areas can be difficult. You will often need to use strip lights, or at least two lights on each side, for full-length views. Because of the ease of repetition, some photographers favor the use of a single light source placed axially, with a separately illuminated white background. This gives slightly darker edges to the subject, which are useful when using a white background. With this technique you can easily repeat the results in the studio or on location. Little in the way of texture lighting is possible, however, with this method.

By far the most commonly adopted lighting method is the use of two lights to illuminate the subject with a separately illuminated background (Figure 12.12). While this is not the easiest method to standardize, it is the most applicable to a wide range of medical subjects. The basic component is the modeling, or *key,* light. This is usually a directional source that is positioned to cast shadows to show contour, shape, and relief. The key light alone will produce a lighting contrast ratio that is too high. Therefore, the shadows cast are filled in with a lamp that will lower the lighting ratio by the appropriate amount for the film/processing combination in use. In practice, there are three ways to control the ratio between the main and the fill. One method is to have the main light set to a

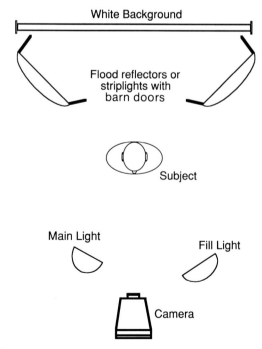

**FIGURE 12.12  A white background must be separately illuminated with flood reflectors or strip lights (these must be fitted with barn doors to prevent flare). The subject is then lit with conventional main and fill lighting.**

higher power output than the fill. Another is to have a narrow *hard* reflector on the main lamp and a broad *soft* reflector on the fill. Finally, you can position the two lamps at different distances from the subject. Whichever method is used, the aim of the exercise is to produce one-third of a stop more light from the main lamp.

Intelligent use of the key and fill lights allows a wide variety of lighting effects from fairly *flat* to strong *texture* lighting. A simple method of standardization for two lights is to attach lengths of string to each lamp. These are used to fix the distance between lamp and patient in a consistent manner, allowing the use of a constant lens aperture. This does not imply that the two lights are always at the same angle to the patient. For the anterior face, for example, the lights might properly be set to 30° from the lens axis. For the lateral views, move the main lamp so that it is above the camera lens and the fill lamp to the front of the subject. For the inferior view, have the main light alongside the lens and the fill lamp at 90° to the anterior surface of the face. Similarly, with photography of the breast, you might take the main lamp to a 45° position high above the patient and have the fill lamp diagonally opposite, near the floor. In each case, the angles selected and the relative position of the main and fill are chosen to be the best for the subject, but the distance of the lamps remains the same and is governed by the length of the string.

The lamps can be designated as *main* and *fill* by having them at different distances from the subject. To achieve this, it is simply a matter of having the two pieces of string set to different lengths. For full-length views, single main and fill lights are not sufficient to provide adequate lighting coverage. Two main and two fill lamps are often required.

Where two or more lights are used, take great care to avoid crossed shadows. This is particularly the case with photographs of the fingers and toes. For these subjects, use a single light source held underneath the camera lens so that the light is directed into the spaces between the digits. A portable flash head is useful here.

**Black Background Lighting.** Black backgrounds utilize the same main and fill lights for the subject but require a different technique from the white background method described above, since a black background requires all-around backlighting. This *backlighting* or *rimlighting* lifts the body outline from the dark background. Without it, the edges of the subject are lost against the background. This is one of the most commonly encountered lighting faults (Figure 12.13). The edges of the subject present an increasingly acute angle to the lens and will, therefore, reflect considerably less light (cosine $\theta^4$ law see Chapter 2). Subjects take on a very different appearance with and without this edge lighting. You should be careful to ensure that the edges are not bleached out by overexposure. The aim of the exercise is to light the edges of the

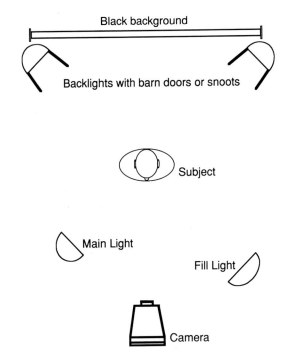

**FIGURE 12.13 Black backgrounds require the subject to be lit from behind, to provide some edge lighting; without this, edges are lost against the dark background. The backlights must be prevented from shining into the camera lens and causing flare by the use of barn doors or snoots.**

subject, not to produce a bright halo, as is often the case with the hair light in portraiture. A lighting ratio of 1 : 1 is appropriate. For the incident-light method, the meter should be aimed at the front lights, then taken around the back of the patient and aimed at the back lights.

Black background lighting is very sensitive to subject position. The farther the subject is forward of the lights, the thinner the rim lighting. Since the backlights are aimed at a specific spot, the patient must stand within a narrow area of correct lighting. This can be a real problem with children, who cannot be asked to pose as accurately as an adult. Some photographers describe a *pool* system of black background lighting to overcome this problem (Figure 12.14). This provides a pool of light in which the subject can move but still maintain adequate lighting. Four backlights balance the conventional fill and key lights, and a large umbrella provides soft toplighting. This technique does not cover full-length subjects adequately, but it does allow considerable freedom for the patient and photographer to move around.

Each of the backlights needs careful control to avoid shining them into the lens and causing flare. Snoots and an efficient lens hood are essential in this process. Once snoots are used, however, the size of the subject that can be illuminated by a lamp is severely restricted. For full-lengths, therefore, it is often necessary to use at least four lights on the back of the subject.

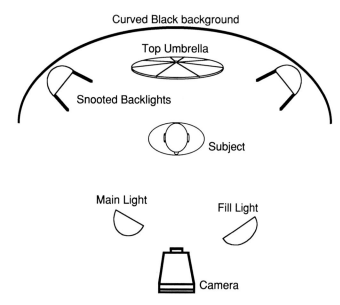

**FIGURE 12.14  Good black background lighting is dependent on subject position; in order to provide a larger working area in black background work the *pool* system has been devised. A curved background with conventional backlighting is supplemented by top/back lighting from an umbrella reflector.**

Photographers can encounter real difficulties when photographing hands and feet placed directly onto a black background, since there is no longer the possibility of backlighting. You can use a ringflash, which produces shadowless lighting. Exercise some care to ensure that the background is truly black and free of artifacts. Use well-brushed black velvet. Unfortunately, the ringflash does suppress texture in the resulting photographs.

Do not be afraid to break away from the standard lighting pattern if the subject demands something imaginative. Often slight swellings or muscle wasting will need strong cross or rimlighting, as will small pits in nails. Blisters and splinter hemorrhages may even require a degree of transillumination. Experiment if the standard setup does not show the condition adequately, but remember, the patient is a sick person and cannot sit all day waiting for you to organize your lights (Color Plate 47).

## Color Balance

Achieving accurate color rendition is clearly most important in clinical photography. Often the color of a patient's condition is critical in its proper representation: the blueness of cyanosis, the red of erythema, the yellow of jaundice, or the brown of Addison's disease are just some examples. In some circumstances, especially in dermatology, even the differentiation between minor degrees of redness is important. Surprisingly, even with the ac-

curacy of modern color emulsions, this degree of color fidelity is very difficult to achieve.

All color emulsions produce an image by the use of chemical dyes. The ability of these dyes to reproduce the colors appearing in medicine is still questionable. There is no such thing as a truly accurate color emulsion. Unfortunately for the clinical photographer, modern emulsions are often produced with a bias toward the accurate rendition of greens, blues, and browns, with the subtleties of red being inadequately represented. There are certainly variations, both between different manufacturers and different films from the same manufacturer, in the way that color is reproduced (Color Plate 48). Opinions vary greatly on the "best" film to use. Traditionally, films that have the dyes added during processing, such as Kodachrome, have produced the best color saturation and fidelity, but the modern range of emulsions, such as Kodak Ektachrome 100 Professional, are now remarkably accurate.

The variations in color produced by processing will exceed any variations in color balance of the film. One should therefore consider the total system—optics, film, lighting, and processing—when thinking about color balance. What is certain, however, is that different batches of the same emulsion vary in color balance and also that any one emulsion's color balance varies with age. Some manufacturers designate their films as being *amateur* or *professional*. Amateur films will probably be stored for some time at room temperature before being used and so have a color shift built into them to take into account this aging process. It is impossible to determine the optimal time to use such films to obtain correct color balance; the conditions of storage are critical. Professional films, however, are manufactured with as near perfect color balance as possible from the start. Their accuracy will deteriorate with age. Such films must therefore be kept in a cool, dry, atmosphere to maintain correct color balance.

Ideally then, the clinical photographer should purchase a large stock of professional film and store it in a freezer for bulk storage and a refrigerator for working stock. When you are purchasing such a large stock of film, it is advisable to ask for all the film to come from the same batch number. This will guarantee that it will have the same color balance. When a new batch of film arrives, it is usual to test the film on a color test chart and a range of typical subjects to ascertain if any color correction is necessary. Any such color correction will have to be provided by placing color correction filters over all the lenses used for clinical work.

The processing of color film introduces relatively large changes in color balance. Changes in color as a result of processing reversal film are obviously more critical than those induced in the processing of negative film, where there is a possibility of correcting the imbalance at the printing stage. All good processing laboratories monitor

their chemistry by processing regular test strips. These are plotted graphically to show variations in the yellow, cyan, and magenta dyes found in the emulsions. Correct any change in color balance on the test strip is then corrected by changing the processing for subsequent batches of film. Inevitably, this is a fallible process, and quite spectacular variations in color can be found between different laboratories and different processes from the same laboratory taken over a period of time. It is quite possible to receive blue results one week, yellow another week, and magenta yet another week. It is not that the laboratories are being lax in their monitoring or processing, but the ability to keep accurate color balance is seriously affected by the volume of work going through the processor; the laboratories have no control over this.

Many people suppose that it is better to run their own color processing, but this may not be the case if throughput is spasmodic. Running a color processing line is also a major commitment in terms of space, staff, and initial capital expenditure. The best advice is to use a reliable laboratory and to photograph standard color and 18% gray test cards on every film. Some departments advocate measuring the photographs of these test cards themselves; in this way they are in a position to advise the laboratory on any undetected color drift. It is essential to work together with the laboratory to achieve the best possible results. Often a medical photographer will be the laboratory's most critical user in this respect.

With the negative/positive color process there is the additional problem of color balance at the printing stage. Even when you have achieved correct color balance on the negative, it is possible to produce catastrophic results at the printing stage. All automatic color printers are designed on the principle that the average photograph integrates to gray. That is, if all of its colors were jumbled up they would make a gray tone with an 18% reflectance value. This assumption was based on analyzing thousands of amateur photographs, most of which contained blue sky and green fields. If, therefore, a clinical photograph containing largely reds is placed into such an automatic color printer a very strange color balance will result. It is essential, therefore, to image an 18% gray card onto every roll of color negative film and to ask the laboratory to print the whole roll with a filtration balanced for that gray card. The advantage of using color negative film is that if at the printing stage the color balance is incorrect it is possible to have them printed again for the correct color balance.

All color films are manufactured to be used with light sources of a specific color temperature. It is essential to match the film to the light source. Electronic flash is the most common form of lighting for all patient photography; this is matched for use with daylight-balanced films (5600 K). However, different electronic flash tubes vary in their spectral output, particularly at the blue end of the spectrum. Many manufacturers coat their tubes or fit filters over the reflector in order to reduce the blue/ultraviolet output of the xenon flash tube. It is essential, therefore, to test the particular flash/film combination you intend to use and add color-correction filters to the lenses or flash heads as appropriate.

You should also be aware of the influence of external lighting when working at wider apertures; an example is when working with low-powered electronic flash (particularly ringflashes) in brightly lit environments. Consideration should be made of the influence of the operating light—both from a point of view of exposure and color balance—as some older operating lights, particularly in Europe, are not daylight balanced. The same is also true of fluorescent lighting used throughout hospitals. There are three possible remedies to this problem: use the fastest possible synchronization speed, turn out the ambient light, or use a more powerful flash gun.

You must also be careful about the introduction of color casts from objects outside the field of view, such as from colored backgrounds. Many less obvious things will also cause color casts. For instance, colored walls, paintings, and other decorations can reflect spurious color onto the sides of the subject. This may be even just a spare roll of background paper on one side of the studio. Items on the patient, but just outside the field of view, are notorious for this effect. Brightly colored underwear or a shirt are good examples. One classic example is a color cast under the chin from a yellow or pink envelope of x-rays on the patient's lap (Color Plate 49).

In addition to these problems, even different lenses give slightly different color balance. So where color is particularly critical, as in the assessment of fine changes of erythema over a period of time, you must use the same camera, lens, and, light source and take all the photographs on a single roll of film, or rolls from the same batch, and have them processed at the same time. It is sometimes helpful to include a piece of control tissue alongside the pathology, such as a normal hand beside a hand exhibiting carotenemia.

## Exposure and Contrast

Clearly all clinical photographs should be exposed correctly. All photographic emulsions, however, have a range of exposure latitude (see Chapters 1 and 3). For clinical photography this latitude is severely restricted, since one-third of a stop on color reversal film makes a critical difference in color saturation (Color Plate 50). The reflectance of the subject can also be an important factor. Opinions vary, for example, about whether additional exposure should be given to very dark patients as opposed to very light patients. Some compensation clearly needs to be made in order to achieve adequate representation of detail in dark-skinned subjects, but too

much compensation can result in a very false representation of the patient's natural pigmentation. The recommendation is to *open up* by no more than half a stop.

Where the clinical photographs are to be used for the assessment of the efficacy of any therapy, it is critical to include some measure of density and contrast in each photograph. You can include both an 18% gray card and a standard step wedge somewhere in the field of view. With color photography there will be little opportunity to influence density and contrast, but with BW photography it is possible to compensate for variations and produce a highly standardized result.

## Presentation of Results

It is useless to go to a lot of effort in standardizing other aspects of clinical photography if the results are presented in a haphazard fashion. Again, consistency is the key feature. Prints must be presented at the same size and contrast and be mounted in the same way. Remember that the color of the mount will influence the viewer's perception of the photography. Ideally, 18% gray card should be used to mount clinical prints. For color transparencies there is the question of whether to provide these mounted, suitable for inclusion in the patient's medical records, or as loose slides for projection. When they are placed in a mount, you must question how these are to be viewed; held up to 5600 K daylight at a window, or to an x-ray viewing box at 3200 K? Even where such slides are to be projected, considerable variations in color and density will be experienced with different conditions of projection. The color temperature of the projection lamp, the lenses, condensers, and heat filters, the screen surface and color, will all seriously affect the result. For example, most heat filters induce a green cast. This is particularly important when using side-by-side dual projection to demonstrate *before* and *after* pictures.

## Standardization or Imagination?

This section has emphasized the concept of standardization for routine clinical records. The teaching picture, however, requires an understanding of the relevant visual pathology and the use of imagination to show as many facets as possible in a single picture. It can be very difficult for the clinical photographer, who is trained to produce highly standardized results, to forget the rules and tell a story with pictures.

In some conditions, such as contact dermatitis, you may need to emphasize the etiology, and an unusual positioning of the patient may be essential. An example is a rubber dermatitis in an office worker with one lesion on the wrist, over which a rubber band was often slipped and another on the calf, caused by the rubber threads woven into the top of the socks. Standard views cannot tell the story effectively. You must show the rubber band in situ and the legs with one sock up and one down, perhaps all in a single picture showing the patient pulling up the sock. The same is true of any occupational disease. Prepatellar bursitis can be recorded by standardized anterior and lateral views of the knees, but an interesting addition would be a transparency showing the patient kneeling at work laying carpet, if this is what caused the disease. It may even be possible to combination-mount aspects of a disease into one slide mount. A view of a gouty tophus, for example, is enhanced immeasurably by the addition of a cross-polarization photomicrograph of the crystals found in the fluid.

If the standardized view does not show the condition clearly or effectively, be imaginative with either lighting or viewpoint, or both. If in doubt, it is always better to take both the standard representational view for the records and the imaginative teaching view.

## THE MEDICAL PHOTOGRAPHY STUDIO

Many aspects of the clinical studio are the same as one would encounter in any photographic studio, but the demands of patient photography mean that certain aspects will need special attention.

## The Studio Environment

A proper waiting area must be provided for patients immediately adjacent to the studio, with seating, reading matter, and other amenities. The combination of anxiety and being unclothed in a cool studio is usually guaranteed to have children, if not adults, rushing to the toilet. Lavatory facilities must therefore be provided close to the studio and waiting area. You must provide adequate changing facilities that offer complete privacy. Ideally, the changing room will open both to the waiting area and also straight into the studio. Gowns, hair clips, and a mirror must be provided. Often the longest part of a photographic session will be the time taken by the patient to change, especially with the elderly, so it is helpful to have more than one changing cubicle. Access to the studio must be wide enough to accept a standard hospital bed, although most photography of this type will be done on location.

For clinical photography, the studio should be large enough to allow sufficiently large camera-to-subject distances, to avoid perspective distortion. To accommodate a separately lit background and full length views of adult patients, this will require a studio with a minimum length of 25 feet, a width of 15 feet and, ideally, a height of 12 feet. Height is usually the problem where a clinical studio is inevitably part of an existing hospital building. The

standard room height of about 10 feet is severely limiting, preventing the full range of lighting technique and precluding the use of ceiling mounted equipment.

In an ideal situation special studio areas would be designed for such specialties as ophthalmic and dental photography, but most often a studio has to serve multiple purposes. It is possible to have screened-off areas of a single large studio for such applications, and to have a separate studio stand for still lifes and equipment photography. Under no circumstances should you undertake specimen photography in the normal patient studio.

It is essential that walls and ceiling be painted in a neutral color. From a photographic point of view, black would be ideal, but this is rather depressing for both staff and patients. It is also essential for the studio to be totally blacked out for invisible radiation techniques.

The safety of the patient while being photographed requires a number of design features that are specifically necessary. The studio floor needs to be of a nonslip durable material that is both warm to the touch and easily cleaned. Electrical supply outlets should be childproof or beyond the child's reach. Ideally, all cables should be fed from ceiling-mounted sockets with switches located conveniently. There must be space for the safe storage of boom stands, background rolls, and other potentially dangerous equipment. All furnishings and fittings must be suitable for cleaning with antiseptic, and special containers should be provided for the disposal of soiled and infected dressings, linen, and other items. An essential article is a sink with elbow-operated hot and cold taps, soap, and scrubbing brushes. There must be facilities for soaking instruments like retractors in germicidal solution; it would be better still to have a small steam sterilizer.

## Background Support Systems

Where different backgrounds are used for monochrome or color work, it must be easy to change from one to the other. Pull-down backgrounds stored on ceiling-mounted rolls are best. Ideally, backgrounds should also be disposable or, at the very least, easily cleaned and disinfected. If you use a continuous paper roll for background and floor, make certain that it cannot slide on a slippery floor surface and endanger the unstable or elderly patient. A full-width (9 foot) roll is ideal, but if space is at a premium it is possible to manage with half-width rolls. You can devise various specialist backgrounds, such as large transilluminated ones or ones with grids etched on them for patient measurement.

## Lighting Equipment

Several types of lighting equipment will be required in order to produce quality photographs of patients. Electronic flash is always the lamp of choice, but both portable and studio-based types will be needed.

For work on location, such as in the clinic, ward, or operating theater, you should have a professional flashgun of the *press* type with separate power pack. This will provide high power output with fast recycling time. There is no place for the camera-mounted flashgun in patient photography, since some flexibility of position is always required. Various types of power pack are available. Most are rechargeable or accept rechargeable batteries; some offer very fast recycling and recharging. A wide variety of heads are available, some round and some rectangular. Most are designed to cover the angle of view of a normal lens, but some have a mechanism for *focusing* the reflector to match short telephoto or modest wide-angle lenses. Many have the ability to be angled upward and rotated on their handle to make bounced illumination possible. Some even have a smaller secondary tube. While bounced illumination is extremely useful for other types of photography, it is too soft for patient photography, and this facility is therefore superfluous for this application.

Ideally, there should be portable flashguns for patient photography, with a small viewing lamp so that the photographer might determine exactly where reflections or shadows would fall, but regrettably these are not manufactured. Some medical photographers tape a small penlight flashlight to their flash heads for this purpose. Some flash heads have special provision for fitting filters over the front that is useful for infrared and ultraviolet photography and for the fitting of color correction filters. At least one manufacturer supplies a portable flashgun especially for invisible radiation work.

Often portable flashguns are equipped with automatic exposure control systems. These offer three or four camera apertures at which the flash gun's sensor cell will automatically measure light reflected from the subject and cut off the flash output when the correct exposure has been reached. Although these make life easy, they can be disadvantageous in patient photography. The range of apertures offered is usually limited, especially for work at close range where a small aperture is desirable for depth of field. Also, the flash's sensor cell is easily fooled by the background into giving too much (in the case of black backgrounds) or too little (in the case of white backgrounds) exposure. Some sophisticated *dedicated* flashguns actually work with the cameras' automatic metering systems; these are much more useful.

A *ringflash* is an essential part of the clinical photographer's equipment. It can often be powered from the same portable power pack and designed in such a way that the flash tube surrounds the lens. These provide shadowless lighting and are useful for intraoral and cavity photography. Since they are normally used close to the subject, they are often relatively low powered, and some are usefully provided with modeling lights. Some

manufacturers supply *texture lights,* which are very similar to a ringflash in that up to four individually controlled tubes are located around the lens. This has the advantage that, in addition to true cavity lighting, it is possible to selectively turn out tubes for texture lighting.

For work in the more controlled environment of the clinical studio, conventional professional studio flash systems should be used. These have either a large floor mounted power pack that supplies several heads or each head has its own power supply built in. All are universally operated from the main electrical supply and have high power output and fast recycling. If they are of the type where several heads are run from one power pack, it is desirable to have individual control over output to each of the heads. A whole variety of stands are available for such lights, but ideally they should be ceiling-mounted on an *overhead grid,* or *gantry.* With this system, individual lights are supported on scissor-action pull-down mounts, which run along tracks, giving complete flexibility over lamp position but keeping the studio floor free of stands, and, more importantly, free of electrical cables. This is a most important point when dealing with subjects who may not be able to see very well, may not be agile, or who are young and inquisitive. If the pull-down system is not used, a boom arm is helpful for lighting various subjects while allowing free access for the camera.

These studio-type lighting systems provide the facility of being able to change the type of reflector fitted to them. A whole range from narrow *spot* types to broad floodlights are available. Some offer *focusing grids* or *honeycomb filters* to provide a sharp focused beam of light, and most offer snoots, barn doors, and other lighting control devices. Many allow the attachment of umbrellas and diffusion boxes, but while these are undeniably useful for many types of photography, they are too diffuse for patient work, with the exception of infrared photography where diffuse lighting is the technique of choice. Long strip lights are also available for systems; these are useful for lighting full-length views and for lighting backgrounds. Almost all these systems have viewing lamps built into the flash head. Where these are provided, make sure that their output is controlled in such a way that it is proportional to the output of the flash. The flash output is sometimes continuously variable, but most often it is controlled in steps.

As several heads will be in use at once, possibly as many as four on the background and four on the front for full-length views, you must provide some mechanism for synchronizing all the flashes together with the camera shutter. Many systems have built-in *slave* cells to do this; others provide these as plug-in accessories. It is possible to operate completely cable-free by using an infrared or radio-controlled flash synchronization device attached to the camera and one of the flash heads. The other heads are then slaved in the conventional manner.

## Cameras and Lenses

Camera equipment available on the market changes rapidly, and the choice of any particular make and model will largely be governed by financial considerations. The amount of close-up work in clinical photography and the need for really accurate viewing dictates that the single lens reflex is the only sensible camera option.

Most medical photographers now use the 35-mm format almost exclusively, but some prefer the larger image size and enhanced quality offered by medium-format cameras. You have to set against this the increased size and cost of the medium-format equipment and the increased costs of materials. Whichever camera system you choose must be capable of providing quality results with a wide range of materials. The ability to change lenses and viewfinder screens is essential. It is important that the camera's viewfinder presents an accurate image and that a wide range of lenses is available, including macro lenses marked with reproduction ratios. The camera must be easy to operate, reliable, and portable. While features like automatic metering, motorwinds, and so on are very nice, they are not essential for patient photography, almost all of which is done with off-the-camera flash. Most of the professional camera systems offer all of the foregoing facilities, and the choice will often be a matter of personal preference and budget.

In routine patient photography the range of subjects will vary from the full-length "giant" down to close-ups of skin at 1 : 1 or 2 : 1 magnification. As a medical photographer you will have to cover this range both in the studio and on location, and you will have to select a range of lenses to do this. Lenses of longer than normal focal length are always used for patient photography, but a modest wide-angle lens will be required to cover the full length of a patient confined to bed. Lenses for patient photography will always be used at relatively close distances and must be marked with reproduction ratios. Several manufacturers supply macro lenses which have been designed to meet these requirements: 55-mm, 105-mm and 200-mm focal lengths are popular. Some specially designated *medical* and *dental* lenses are available. These are macro lenses of longer-than-normal focal length with built-in ringflashes. While these are useful for cavity, intraoral, and operative photography, the flat lighting and low output of the ringflash limits their usefulness in other areas of patient photography. The lenses selected should have small minimum apertures —*f*/32 is useful—but they need not have wide maximum apertures, as there will usually be sufficient light for focusing. Zoom lenses can sometimes be useful in the operating room where speed of operation is essential; otherwise fixed focal lengths are always preferable.

Some means of using the lenses selected at high magnification will be necessary. Most often this is extension

tubes, but occasionally bellows may be used. Whichever method you select, you must preserve the automatic diaphragm mechanism. Several of the so-called macro lenses come with their own dedicated extension tubes to give 1 : 1 magnification.

### Specialized Equipment

Patient photography requires several other pieces of equipment and furniture. A good studio chair is essential; it will have to be made to your own specifications, as none are available commercially. At its simplest, this will be a standard laboratory-type chair with footrest, but without arms, and capable of height adjustment. This is then modified by the addition of a headrest and some mechanism for locking the chair in the various angular positions, such as 45° and 90°. At its most complicated, the studio chair will offer the facility of adjustable head and back rests, leg supports for raising the legs, arm supports that take a board for photography of the hand, and adjustments for height and back angle. A proper studio chair is one of the most useful accessories for the clinical photographer.

A box for patients to stand on in order to raise them above floor level is essential for photography of the feet and lower leg. This is even more useful if it has a detachable vertical scale attached to it to give an indication of size when taking full-length views. In order to cater to the different needs of children and adults, it is often better to have at least two such boxes of differing heights. The patient should be raised at least 18 inches off the ground, but do not expect the patient to be able to climb there in one step. You should add some steps on the edge of the box. As with all furniture in the clinical studio, these boxes should be made on the assumption that the heaviest patient will need to use them, and that they may also be blind and severely disabled. If the box is equipped with a scale, for example, make sure it is strong enough for a patient to use as support.

A small trolley on wheels, big enough to take all the equipment you need for any one session, is useful and should be kept close to you on the studio floor. A standard patient examination couch without sides is required for genitourinary and gynecological photography, and also for some inferior views, as is a mattress that can be placed on the floor for the photography of babies. Other more specialized items are described elsewhere in this and other chapters.

### WORKING ON LOCATION

All general principles of clinical photography described still apply when working on location in the ward or oper-

ating room. It will be much more difficult, however, to control the conditions of photography, as the patient will be less mobile, and the equipment must be portable.

### Photography at the Bedside

Generally, the main reason for deciding to photograph patients in bed is that they are too ill to be moved to the photographic department. Patients requiring complicated surgical dressings, having continuous uninterrupted therapy, or who are highly infectious may also be photographed at the bedside. The photography of genitalia can be less distressing to the patient in the more familiar surroundings of the ward and with the nursing staff assisting where necessary. Also, it may be better in the case of anxious children to take preoperative photographs when the child has been preanesthetized.

With this type of photography the patient is much more likely to be more ill and thus, less able to cooperate, while the inadequate space available and obtrusive background objects will all cause difficulties. Try to book appointments to wards to save yourself time and ensure that you fit into the wards' routine. It will be useful to arrange for a time when the patient's dressings would normally be removed. Before starting for the ward, make sure you have all the equipment you will require. Most departments have a case with a portable camera and lenses especially reserved for ward work. Because of the limited space available, full-length pictures will require the use of wide-angle lenses. For dealing with small areas, like the face, a portable background, such as a surgical drape, can be taken. Otherwise, you will need considerable ingenuity to keep backgrounds uncluttered. Illumination will generally be by portable flash unit, since these do not have built-in modeling lamps; be careful to consider the nature of the background and possible reflections from gloss-painted walls, which could cause obtrusive highlights.

Always announce your arrival on the ward to the nurse in charge. Then, at the bedside, introduce yourself to the patient and explain what you are going to do and politely request that relatives wait elsewhere. When the patient is in a ward or in a room with other patients, always draw the screens. Neither you nor the patient will want the neighbors to watch. When you are with the patient, go about your business in a quiet and methodical manner. If patients are very ill, do not move them without first ascertaining that it is safe to do so, and get a nurse to help you. Similarly, ask the nurse to help you to remove dressings. Wherever possible try to work with the patients on their beds. It is far more convenient for both of you.

Since you will almost certainly have only a single flash with you, give some thought as to lighting. With no separate background lighting, it is helpful to position the

patient as close as possible to the background. Have a nurse hold up the background cloth close to the patient or have the patient actually lie on the background. Then arrange the flash in such a way that any shadows actually fall behind the subject. For an anterior view of the head and neck, for example, aim the light axially from above the camera. This will cause the shadow to fall behind the shoulders. For a left lateral you would hold the flash to the left of the camera, causing the shadow to fall behind the head, and vice versa.

If you have to stand over the patient, on a bedside chair for example, make sure that you have firm support and that all equipment is secure. Do not uncover more of the patient than you need to in order to get a satisfactory photograph. See that he is kept warm and, when you have finished, make sure the patient is comfortably settled again. Before you leave the ward, replace any furniture or equipment that you have had to move, and inform the nurse in charge that you have finished. Complete any necessary documentation, such as a patient record card, before you leave the ward, as there is the possibility that you will forget the details by the time you arrive back in the office.

## Outpatients and the Accident and Emergency Unit

Much of the advice about the equipment and method of working on the wards also applies to outpatient clinics and to the accident and emergency unit. It is sometimes necessary to attend the emergency area to record recent trauma, especially in the case of road traffic accidents or industrial injuries. You must remember that these patients will be very distressed and in a state of shock, and you will need to moderate your behavior appropriately. You will also need to be very efficient in such areas, as all around you doctors will be dealing with potentially life threatening situations. The outpatient clinic is less pressured but again suffers from the problems of the ward, such as confined space, lack of privacy, poor control over lighting, and so on. It is best to resist photographing patients in this environment if at all possible. By definition, almost anyone who is capable of attending the clinic is capable of attending the photographic studio. Exceptions are the patient attending radiotherapy sessions, as the treatment often makes them severely ill, or the patients from the special or venereology clinic, who are best photographed on location in order to avoid embarrassment on the part of the patient and to avoid infection risk.

## The Operating Room

Photography in the operating room of new surgical techniques or findings is one of the most important aspects of the biomedical photographer's work. The surgeon is scrubbed up and so cannot undertake any photography or even supervise your work. With surgical procedures there will be only one chance to get it right. The atmosphere in the operating room is usually tense, and the pressure to get the job done quickly is great. Coupling that with the temperature, humidity, and the sight of large amounts of blood gives some understanding of why this is a critical area of work, demanding the highest professional standards. Photographs are used to record the rare and to teach the new. Often the photographs will act as the basis of artwork for publication. A proper rapport between surgeon and photographer, with mutual respect and understanding, is vital to success in this field. Surgeons can be quite demanding, and you have a responsibility to inform the surgeon about what you can see through the viewfinder, what is impossible to record, and so on.

Before entering the operating room (OR), the photographer must change completely into the special clothing and footwear, cap and mask, provided in the changing area. Hair, face, and hands should be clean. Some hospitals insist on all staff showering before dressing for the operating room. Occasionally, for particularly infective cases such as hepatitis or human immunodeficiency virus (HIV), there is a need for special precautions, and the qualified nursing staff will advise you. Even though you have prepared and dressed in this way, you are not part of the scrub team. The photographer must *never* touch drapes, gowns, trolleys, instruments, and the like found in the OR. The scrub team will have spent a long time scrubbing up to ensure that they are free of pathogens and then will have gowned themselves up in sterile clothing over the top of the normal OR clothing that you will be wearing. The photographer must understand that the nontouch attitude is a vital part of operating room behavior. Just touching the gowns of one of the scrub team could cause the operation to be delayed while the person re-gowns, and will certainly not endear you to an already anxious surgeon.

It is possible, however, to bring your equipment in and to move around the rest of the room with some freedom. Metal and glass are poor supports for pathogens, so it is usually sufficient if photographic apparatus is wiped over with a damp cloth that has been soaked in disinfectant. Camera cases should be metal, not canvas or other materials that might harbor bacteria, and equipment must never be taken straight from the postmortem room to the operating theater. When you arrive in the OR, always introduce yourself to the nurse in charge and to the anesthetist. They are each responsible for the patient's safety, and the surgeon may not have explained to them that you will be present.

Check with the anesthetist that no explosive anesthetic mix is being used that might preclude the use of electronic flash. At one time there was a very serious risk of

explosions in operating rooms, but explosive gases are rarely used today except occasionally for pediatric and open heart surgery. Make a point of getting a proper briefing from the surgeon: what the surgery is for, how it will progress, what views are going to be required at the various stages, and so on. In practice, this appreciation and understanding is more likely to influence the quality of the results you obtain than any other factor.

The key features to the selection of equipment for use in the operating room are reliability, flexibility, and speed of operation. A 35-mm single-lens reflex (SLR) camera with hand-held flash or ringflash is the easiest system to use. A longer focal length lens (90/100 mm) is useful to give sufficient free working distance, and a zoom lens is very useful for this type of work.

Lighting is often difficult. Sometimes you will need to photograph deep into a cavity, but also need to light a wet, specularly reflecting subject, where the ringflash is a disaster. Some photographers get around this by fitting a polarization filter over the camera lens at the expense of losing light and surface texture. Others use both ringflash and single head attached to the one power pack so they are both readily available, depending on the subject. The ringflash does not give adequate modeling for most applications, but it is useful for cavity illumination. Bear in mind that there is a limit to the size of cavity that can be adequately illuminated with a ringflash, especially if the size of the opening is small compared with the diameter of the ringflash. Where this is the case, select the longest focal length.

Recycling time of the flashgun is a major factor. This needs to be as short as possible. High-powered flash packs are now available for most professional flashguns, which will offer both longer life and faster recycling time; these are strongly recommended. Although they offer rapid film transport, motor-drives are rarely useful in surgical photography because the flash recycle time is the limiting factor in speed of work. Also, motor-drives are very noisy in the hushed calm of the operating room. Any equipment taken to the OR must be reliable. The last thing you need is a flash lead that connects intermittently or a lens hood that drops off into the operating field. Always have back-up equipment and film available.

It is generally preferable to photograph from the surgeon's viewpoint, as the resulting pictures can be surprisingly difficult to interpret, even by experienced surgeons, if they are taken from any other viewpoint. The surgeon is bound to have the best viewpoint. This is also the best viewpoint for the photographer. You can obtain this viewpoint by shooting over the surgeon's shoulder using a small stepladder to stand on, but on occasion the surgeon will have to move aside. If you do use a ladder, make sure it is safe and stable and that you are comfortable standing on it for what might be quite prolonged periods. If serial photographs are to be taken throughout the operation, the same viewpoint should be used wherever possible. Photographs taken from different angles can be extremely difficult to orientate, particularly if removal of part or all of an organ has taken place. Unless there is a need for close-up views of a particularly small area, the scale of the photographs should remain the same throughout the series.

By experience you will discover whether or not you need to alter your exposure to take account of any operating lights the surgeon may be using. It is not generally necessary to do so, but you should be aware of the possibility of overexposure and/or green casts appearing at wider lens apertures from the green line in the bright mercury vapor discharge tubes used in the operating lamp. Always be careful of reflections from retractors, particularly the large abdominal kind, as these can easily ruin a surgical photograph. Try to anticipate the angle of any reflection based on the position of your flashgun and then adjust the lighting angle and/or the angle of the retractor; the surgeon must do this. It is also usually possible to ask the surgeon to remove any unnecessary clamps and retractors or to cover them with clean drapes.

When the photographer is taking close-ups of the surgical field, some indication of size within the field of view is helpful to the viewer. Metal surgical rulers are not suitable, as they cause reflections from the flash. A gloved finger or the tip of some easily recognized instrument is better. Sometimes it will be impossible to approach the subject closely enough to obtain a satisfactory result, as for example, in open-heart surgery. On these occasions one can use a mirror mounted in the middle of the operating lamp and take the photograph via this with a long telephoto lens (200 to 1000 mm). Mount the camera on a tripod to provide image stability. It is even possible to provide cavity illumination when working in this way by aiming the flash into the mirror. Ideally, the mirror should be surface silvered and you must remember to *flip* the resulting photograph, as the mirror will have reversed the image.

You may find that when you are trying to focus, the viewfinder mists up with your breath, which is being forced out of the top of your face mask and is condensing on the cold camera. There are a couple of things you can do. First, always hold the camera close to your body between shots to keep it warmed up; second, you can tape the top of your mask to the bridge of your nose with Steritape to force your breath out of the bottom of the mask.

Speed and accuracy in this area of work are essential. While waiting to take photographs, look at the operating field and try to orientate the anatomy and to decide what you are likely to be asked to photograph next. Preset your apparatus and be ready to take your pictures as quickly as possible. Gray or green drapes around the operating field are better than white swabs that cause flare. In blood-free orthopedic surgery it may be necessary to underexpose by a half stop. Conversely, in deep

abdominal surgery it may be necessary to open up by a half stop. In very bloody fields, persuade the surgeon to cleanse the area, remove unnecessary swabs and instruments, and place new drapes across any visible edges. It may seem inappropriate to make such suggestions to tense and busy surgeons, but they will generally respect your professionalism and will certainly appreciate your advice when they see the results. Remember that one patient's gut looks much the same as any other, so you must keep meticulous records of your surgical photography.

Sometimes the clinical photographer will be asked to install automatic cameras in the operating room above the surgical table, so that the surgeon or his assistant can record important cases by pressing foot switches. Such cameras have been reviewed in the literature, and references can be found in the bibliography, but, in general, they are not terribly successful, as they rarely show the field of interest, lighting tends to be poor, and just the practicalities of keeping them loaded with the correct film, and other details, defeats many operating departments. Nevertheless, this is a legitimate request, especially for photography during the weekend and at night, and should be met with understanding. Clear instructions and regular support are necessary.

## WORKING IN THE SPECIALTIES

The following sections are not designed to be exhaustive treatments of the diseases concerned. They merely indicate some of the special features of photography in the various disciplines and describe some of the more commonly photographed conditions. These must be read in conjunction with the rest of this chapter and, where indicated, other chapters.

### Dentistry

The work of the dental surgeon is, like medicine, divided into general practice and specialist surgery. The photographer working in this field will be concerned primarily with the face, oral cavity, and the teeth. All the general guidelines given for clinical and operating room photography apply. The patients seen will vary in age from the very young to the very elderly, but all will share a common fear of the dental chair. Remember that the oral cavity is always heavily contaminated with potentially pathogenic organisms, and there is a real danger of cross-infection unless you take special precautions. All good intraoral and dental work is done with a dental chair and proper retraction. Full details of these important areas of work can be found in Chapters 17 and 18.

There are some specialized forms of photography that have application to this area of work. Photogrammetry,

or measurement by photography, is used extensively in dental photography and can provide quantitative details of changes in the face, teeth, and gingivae. Dentists and oral surgeons often use photography in planning surgery of the jaw, where transparencies are made to match radiographs of the subjects and the two are overlaid and cut up to estimate the effect of different degrees of movement. Details of the various techniques available can be found in the bibliography.

### Dermatology

Dermatology is the study of diseases of the skin, mucous membranes, hair, and nails. As diagnosis in dermatology largely depends on visible signs, the photograph is a valuable recording medium for visualization, record, teaching, and research. Photographs are probably of more value to the dermatologist than any other medical specialist. Dermatologists have a keen visual sense and are often capable photographers themselves. Working with them can be both demanding and rewarding.

The clinical photographer must acquire a knowledge of the structure and function of the skin and should be familiar with the specialized vocabulary of dermatology. Without this, the clinical photographer will struggle to interpret the often bewildering array of visual symptoms presented. The cause of skin changes may be a variety of internal and external factors such as trauma, bacterial infection, toxic reactions, constitutional disorders, tumors, and congenital disorders. There are a vast range of dermatological conditions beyond the scope of this chapter, and, initially at least, a good visual atlas should be consulted before attempting to photograph the patient. This way, you will gradually familiarize yourself with a wide range of pathology.

The attitude of the medical photographer to dermatological patients is important. Skin conditions are rarely infectious, but many are embarrassingly obvious. The physician will have spent some time trying to reassure the patient with advanced psoriasis or eczema, for example, and will not appreciate an ignorant medical photographer treating the patient as if contagious. With the exception of the common childhood ailments like measles and chicken pox, few skin conditions can be transmitted from patient to photographer. All require fairly sustained close contact. The simple precaution of washing the hands after contact with each patient will be sufficient to give adequate protection. Some conditions to beware of are: bacterial infections such as impetigo and syphilis, viral infections such as viral warts and herpes simplex, fungal infections such as tinea and candida, and infestations like scabies and lice. In these cases, you must wear gloves when handling the patients or instruments used on them.

Clinical photographs that include dressings and medi-

cations are untidy and often quite useless. Dermatological patients are often outpatients undergoing treatment and they often have creams, ointments, and dressings on their skin. Before an adequate pictorial record can be made, it is essential to clean the skin in a manner that is not injurious to the patient. Often plain soap and water is all that is required, but sometimes the cleansing process requires a mixture of 5% medicinal paraffin in ether. If you do not feel confident to do this, return the patient to the ward or clinic. Never attempt to clean raw or weeping areas. Seek medical assistance.

The views taken to illustrate skin conditions depend on the individual patients and their diagnoses, but it will always be necessary to take more than one photograph. There is a need for one or more views to show the distribution of the lesions. Where the lesions *are not* is almost as important to the dermatologist as where they *are*. For instance, are they unilateral, only on exposed areas of the body, only on areas within the reach of the hands, or only in the moist areas? This already gives the viewer a good deal of important information. In general, full-length views should be avoided, as insufficient detail of the lesions is recorded. It is much better to do two half-lengths. Once you have views showing the orientation and distribution of the condition it is necessary to get in close, very close, to show selected lesions. Dermatologists most commonly complain that the photographs taken by clinical photographers are not at a high enough magnification. Take views at 1:1 or even 2:1. Select a few representative lesions. It will often be possible to show early and late manifestations of the condition. Careful lighting is required in these close-up views in order to see the nature of the lesion. You should aim to demonstrate the size, shape, color, texture, and edge configuration of the lesions. Large reflectors, or worse still, umbrellas or softboxes will hide all surface detail in the close-up views. You will need small light sources or conventional lights at a distance. Color rendition is, of course, of critical importance, and the photographer should follow the advice in the section on Color Balance.

The rendition of some skin conditions can be enhanced by the use of invisible radiation techniques. The reader is referred to Chapter 13 for the general details of infrared and ultraviolet photography and to the end of this chapter for the specific applications to patient photography. Photographs taken with such radiation must always be accompanied with *control* photographs taken with visible light. Dermatologists will often have an incomplete understanding of these techniques, and the competent clinical photographer will always be capable of modifying requests or advising as appropriate.

Macrophotography of the skin is very difficult, but often required, for studies into skin surface topography, exfoliation, and hirsutism for example. One problem is that the skin surface is semitranslucent, so obtaining adequate sharpness and contrast is very difficult. Apart from the use of reflected ultraviolet photography, it is sometimes possible to apply a cream containing carbon powder or a similar dye to increase light absorption and contrast.

Another problem is that the subject cannot stay still enough for the photographer to obtain an adequately sharp record, especially when one bears in mind that depth-of-field is severely limited. One solution is the use of a focusing frame attached to the camera. This shows the extent of the subject covered and is fixed at the optimum point of focus. The frame is simply pushed into contact with the patient's skin over the important area and the shutter is released. One of the best ways of obtaining satisfactory records, however, is to *replicate* the skin by taking a plastic cast of the skin with a rubber/alginate solution. This solid replica can then be photographed at high magnification using conventional techniques. Again, the reader will need to consult the specialist literature for details of these techniques.

## The Endocrine and Metabolic Disorders

The *endocrine* or ductless glands consist of the pituitary gland, thyroid, parathyroid, adrenals, and gonads. They pass their secretions, which are known as *hormones,* directly into the bloodstream, through which they are distributed to all parts of the body. Among other effects, hormones frequently influence the metabolism or chemistry of the body. At the same time hormones may also act on other endocrine glands so that any one disorder may produce signs that are also common to others. Metabolic disturbances are concerned with biochemical abnormalities and diseases and may be the result of deficiency of vitamins or other essential requirements of the body. The results of endocrine disturbances tend to affect the body as a whole, particularly with regard to growth, distribution of fat, coloration of the skin, and other factors. As these effects are difficult to describe with precision, photography is often used to record these appearances and their changes in response to treatment or progression of the disease.

In addition to close-up views of special features, doctors will need full-length pictures of many of these conditions. The anterior and one lateral view are essential, but posterior and the other lateral views may also be required. Standardization is vital, as repeat pictures will be needed over periods of months, years, and even decades. Positioning must be accurate, and a vertical scale is usually included in the picture. Camera height should be constant at half the patient's height. The full-length views are frequently supplemented by anterior and lateral pictures of the head and neck.

Since photographs of the patient will be taken at full length in the nude, the whole procedure of informed consent will be all the more important. The studio tem-

perature should be warm, and all photographic preliminaries should be checked before you ask the patient to pose. Some patients suffering from endocrine disorders may be intolerant of heat or cold; these special considerations are covered below in relation to the specific disorders.

**The Commonly Photographed Endocrine Disorders.**  It is easiest to group these by the primary gland dysfunction.

**The Pituitary.**    The pituitary gland produces at least eight hormones of major importance, many of which control other endocrine glands, particularly the thyroid, the adrenals, and gonads. Through the medium of the hypothalamus, the pituitary is sensitive to blood levels of hormones produced by other glands, which induce a *feedback* system. Disturbances of the pituitary can thus cause many complex effects.

Tumors, generally *adenomas*, may cause signs of overactivity, or signs of hypofunction, depending on their nature and on the stage of the disease. *Gigantism* results from excess growth hormone in childhood. The growth pattern is normal but excessive. On the 35-mm format 1 : 60 as opposed to the standard scale of 1 : 50 is required to accommodate a patient with gigantism. *Acromegaly* results from excessive growth hormone later on in life. Growth in height does not take place, but the bones thicken, as do the soft tissues. The onset of the disease is insidious, so that comparison with old photographs of the patient is of great diagnostic importance. The nose, lips, ears, tongue, and lower jaw enlarge. The teeth separate due to enlargement of the mandible, which also protrudes forward of the maxilla. Frontal bossing or swelling is common due to enlargement of the frontal sinuses. The skin is greasy and thick, the scalp wrinkled, and the hair coarse. The hands and feet are large and the fingers thickened. There may also be a kyphosis and a goiter. Photography is of great importance in following the course of this disease. Apart from routine full-length pictures, the head and neck should be shown in anterior and lateral views and with the lips retracted to show teeth separation. Take individual views of the hands and feet with a scale and/or a normal control.

Hypopituitarism results in pituitary *dwarfism* when it occurs in childhood. Growth is simply retarded, but if hypogonadism with sexual underdevelopment also occurs, it is known as pituitary *infantilism*. The full-length pictures should include a scale with percentile marks on it for the appropriate age. In the adult, panhypopituitarism is known as *Simmonds' disease* and is most commonly seen in women after a severe postpartum hemorrhage causing pituitary necrosis (Sheehan's syndrome). This causes premature aging with loss of pubic and axillary hair, a waxy pallor, emaciation, lethargy, cold intolerance, and genital atrophy.

**The Thyroid Gland.**    Enlargement of the thyroid gland shows as a midline swelling of the neck and should be recorded by an anterior and lateral view of the head and neck to below the clavicles. When the lower pole of the gland is enlarged, it will extend behind the sternum and may press on the superior vena cava, causing obstruction. This may result in dilation of the veins over the front of the chest, which will be best shown with infrared photography. *Adenoma* of the thyroid is a nodular swelling that may be nontoxic or toxic when it produces the signs described under Grave's disease. *Thyroglossal cyst* is a midline swelling of the neck that moves up and down with protrusion and retraction of the tongue. Lateral views, with or without superimposition, will be needed to demonstrate this feature. *Hyperthyroidism* is also known as Grave's disease, Basedow's disease, exophthalmic goiter, toxic goiter, or thyrotoxicosis. It involves hypersecretion of the gland characterized by an enlarged thyroid gland; exophthalmos (pop eyes); nervous symptoms (overanxiety, excitability); emaciation, tremor of the outstretched hands, and sweating. The patient with hyperthyroidism will be intolerant of heat, and the studio should be kept as cool as possible.

*Pretibial myxedema* consists of plaques of thickened and possibly rough skin over the shins and dorsum of the feet. It is a rare feature of hyperthyroidism and should not be confused with generalized myxedema or hypothyroidism. *Hashimoto's disease* is a diffuse enlargement of the thyroid due to infiltration by lymphocytes and increase of fibrous tissue. It tends to produce myxedema.

*Hypothyroidism or myxedema* is subfunction of the gland in adulthood. In advanced cases, the face is coarse and even bloated from deposits of a mucinlike substance, which also shows markedly on the dorsum of the hands and in the supraclavicular fossae. There may be a violaceous hue of the lips and also dilated capillaries in the malar region. The hair is coarse, straight, and scanty. The outer third of the eyebrows is often lost. The skin is thickened, dry, and often rough on the dorsum of the hands. In addition, there may be a slow, hoarse voice, sluggish movements, and sometimes mental dullness, which can make these patients difficult to photograph. These patients are also intolerant of cold and will need a warm studio. In mild cases the changes can only be seen in relation to previous photographs of the patient or in comparison with those taken after treatment. In children, thyroid inadequacy produces *cretinism* with stunted growth, a swollen and protruding tongue, and a distended abdomen, which are all recorded with the standardized views. The child will probably exhibit arrested mental development and apathy.

**The Suprarenal or Adrenal Glands.**    These glands lie on the upper pole of the kidney. They contain two layers, each with a separate function. The inner layer or medulla secretes adrenalin and is concerned with the control of blood pressure. The outer layer, or cortex, secretes various corticoid and steroid hormones, some of

which are concerned with the fundamental chemistry of the body and the androgens and estrogens that affect gonadal activity.

*Addison's disease* is the result of adrenal insufficiency. The outstanding visual sign is a dusky brown pigmentation of the skin and mucous membranes of the mouth and tongue. This condition is most marked on the flexures, palmar creases, extensor surfaces of the fingers, and on old scars. Due to pigmentation of the nail bed, the lunula appears brighter by contrast. Muscular weakness causes a tired expression on the face.

*Cushing's disease* is the result of an excessive production of glucocorticoid hormones, generally from an adrenal tumor. There is a characteristic central adiposity that spares the limbs and that should be recorded full length, with a so-called Buffalo hump of fat at the back of the neck, which often requires a scale of 1:15 in a lateral head-and-neck view to accommodate it. The face is plethoric, skin dusky red, greasy, and often mottled; it is classically described as a moon face. Purple striae are seen on the abdomen, thighs, and shoulders. A downy hirsutism affects the face, trunk, and upper arms. Scalp baldness may occur in men. Muscular wasting with weakness and osteoporosis causing collapse of the vertebral bodies may show as deformities. Serial records of these patients are important in the control of long-term therapy.

*Androgenital syndrome* is caused by excessive adrenal androgens. In children, the male presents with excessive sexual development resulting in the so-called infant Hercules picture, while in females there is masculinization, with developmental abnormalities of the genitals, often called pseudohermaphroditism. In adults, the female shows regression of the breasts and hirsutism. Adult males rarely demonstrate the condition.

**The Gonads.**  Gonadal dysfunction is frequently secondary to adrenal or pituitary disorders and has been mentioned. There are, however, two important congenital disorders that may present for photography. *Turner's syndrome* shows hypogonadism in the female. Other signs may be webbing of the neck, low hair at the back of the head, increased carrying angle at the elbows, a bent little finger, widely separated nipples, and little or no pubic and axillary hair.

*Klinefelter's syndrome* produces testicular atrophy in the male. Genitals are small and the hairline is female in character. Frequently you will need to photograph gynecomastia. Doctors will often request full-length views to demonstrate the peculiar body development, with the sole-to-pubis measurement exceeding the crown-to-pubis.

*Gynecomastia,* or enlargement of the male breast, occurs in many of the above conditions, but may also be seen as an apparently isolated and temporary occurrence. Photograph these patients with the techniques recommended for the female breast. Have the photography of

these cases undertaken by someone of the same gender as the patient because they will be overly sensitive about their appearance.

**The Commonly Photographed Metabolic Disorders.**
The metabolic disorders are similar to endocrine disorders in that they tend to affect the body as a whole. The following summary present aspects of photographic interest. In each case the visual signs and symptoms described should be recorded with standard representational photography.

*Edema,* or the accumulation of excess fluid in the tissue spaces, may occur in many conditions. It is sometimes localized, such as around an area of inflammation, and sometimes generalized, as in the nephrotic syndrome. To demonstrate edema, a pit can be produced by pressing on the patient's skin with a finger for 10 to 15 seconds. The result should be photographed using oblique lighting.

*Diabetes* is a disorder in which there is a raised blood sugar level due to a failure of the pancreas to produce insulin, which is essential for the metabolism of sugar. The main visual aspects of the disease arise from the patient's susceptibility to infection and from vascular complications. These are septic spots, boils, rashes and eczema, gingivitis and fibrosed injection sites, ulcers and gangrene of the feet, and cataracts and diabetic retinopathy in the ocular fundus. *Necrobiosis lipoidica diabeticorum* occurs on the shins and shows as waxy yellowish degeneration with dilated blood vessels seen through the thin skin.

*Lipidosis* or *xanthomatosis* is due to an increased blood cholesterol (hypercholesterolemia). It occurs in many conditions and shows as yellowish plaques or nodules in the skin. Common sites are the elbows, knees, buttocks, hands, and eyelids, where the condition is called *xanthelasma*. The extent of these lesions is revealed well by infrared photography, though of course the results bear little relationship to the visual appearance, so a control picture must always be taken.

*Scurvy* is caused by ascorbic acid (vitamin C) deficiency. The gums, which are swollen and congested, bleed readily and, in advanced cases, the teeth may become loosened. Petechial rashes occur, particularly on the legs, possibly with larger ecchymoses as well. Bleeding into muscles may cause brownish swellings.

*Rickets* is usually due to vitamin D deficiency and affects children. Vitamin D is manufactured in the skin by ultraviolet radiation, so children of Asian or Negroid parents brought up in temperate climates tend to suffer from rickets. The child is often fat and flabby and has a distended abdomen. The limbs show swellings at the epiphyses, particularly marked at the wrists and ankles. There may be deformities of the forearms, angulation of the tibia, and genu valgum or varum. The skull shows frontal bossing. The thorax may be deformed with a "rickety rosary," due to bending at the costochondral

junctions and a transverse groove (Harrison's sulcus) at the insertion of the diaphragm.

*Chronic anemia* has a variety of causes, including lack of iron. There is a pallor of skin and conjunctiva and a general weakness. Cutaneous and mucosal hemorrhages occur. Often the doctor sees an enlarged, swollen tongue with papillary atrophy.

*Koilonychia* or spoon-shaped nails shows up most clearly when you place a drop of water into the dip of the nail prior to photography. *Chloasma gravidarum,* also known as melasma, shows as brown patches of pigmentation, especially on the face, and is mainly caused by oral contraceptives. *Argyria,* which shows as diffuse blue-black pigmentation of skin, mucous membranes, and nail beds, occurs in silver and other heavy metal poisoning.

*Icterus,* Gilbert's disease or jaundice, has a variety of causes but is essentially due to a disturbance of bilirubin metabolism in the liver. Patients present with yellow/ olive green skin and sclera. Slight variations in the color of skin are difficult to show convincingly in the absence of a normal control, so it may be helpful to include a portion of healthy skin in the field of view. There may be palpable hepato- or splenomegaly, but it is usually necessary to mark this with a skin pencil prior to photography.

*Portal cirrhosis* is a chronic structural disease of the liver that may alter all liver metabolism. It gives rise to bright red shiny lips, beefy red tongue, palmar erythema, finger clubbing, and spider nevi. The latter characteristically disappears on pressure. This can be demonstrated with a small piece of glass that is pressed onto the nevus, recording *before* and *after* release of pressure.

*Acanthosis nigricans* is characterized by dark-colored skin folds similar to those seen in Addison's disease. It appears as a result of metabolic changes due to malignant tumors of internal organs, especially the gastrointestinal tract.

*Cyanosis* is caused by a lack of oxygen supply to the tissues from any cause. The patient has a puffy face, magenta-colored nose and lips, and cold blue fingers and toes. Chronic cases are accompanied by finger clubbing. It is commonly seen in heart and lung diseases such as cardiac septal defects and carcinoma of the lung.

*Carcinoid* syndrome results in excessive circulating serotonin. It shows as redness and swelling of face, chest, and upper arms with telangiectasia.

*Ascites* is a marked accumulation of serous fluid in the abdominal cavity from a number of causes. The fluid-filled abdomen glows on transillumination and, if possible, should be photographed with this technique.

*Gout* is a metabolic disorder marked by an excess of uric acid in the bloodstream. It is characterized by a deposition of nodules of sodium biurate (tophi) about joints and cartilaginous areas such as the big toe and pinna of the ear.

*Beau's lines* are transverse white lines across the nail. These lines correspond to major episodes of illness. Ma-

jor disturbances of metabolism are often reflected in the nail bed.

*Porphyria* is a disorder of blood pigment metabolism giving rise to brown/yellow pigmentation of the skin in exposed areas, with bullous formation following exposure to sunlight. Plasma and urine samples fluoresce bright red under ultraviolet excitation.

*Pellagra* is a metabolic deficiency of nicotinic acid giving rise to dermatitis, dementia, and diarrhea. Areas of skin exposed to light develop a sharply delineated area of dusky red erythema. The tongue is beefy and swollen.

*Obesity* is caused by excessive subcutaneous fat deposition and may be due to endocrine disorders, metabolic disorders, or simply overeating. Patients are often very sensitive about their size. Standardized full-length records will be required to show the distribution of the adiposity. Breech obesity (lower-half obesity) means fat distributed around the hips, buttocks, and thighs. Silhouette photographs are useful for comparative measurement of obesity.

## Ear, Nose, and Throat Photography

Photography in otolaryngology is mostly cavity and endoscopic photography, since most of the structures of interest are hidden within the head. The photography of the face, nose, and pinna will form an important part of the work of a photographer working in this specialty, and the detailed advice for these views given in the section on the head and neck should be followed.

The nasal cavity is a narrow space having a depth of 3 inches and a vault rising over 2 inches, but its width never exceeds about an inch and its entrance is less than half an inch across. Photography through an endoscope is the only possible solution. A variety of companies supply rhinoscopes. The reader is referred to Chapter 14 for full details. The oral cavity is large in comparison with the nasal cavity, and all of the structures here can be photographed with conventional intraoral photography. Full details can be found in Chapter 17.

Photography of the ear drum is one of the most difficult tasks encountered in ear, nose, and throat photography. The drum is about 1/2 inch in diameter but lies at the end of a curved tube only a 1/4 inch wide. Just to make things more difficult, the ear drum is also angled in both anterior/posterior and inferior/superior planes. A depth of field of approximately an inch at a magnification of 2× is required. Photography through an auriscope severely limits the angle of view, and only a small portion of the tympanic membrane can be seen at a time. The answer again is the use of either a straight rod endoscope or operating microscope, both fully described in Chapter 14.

Photography of the vocal cords has always presented a challenge to the clinical photographer, with various sys-

tems utilizing mirrors and anesthetized patients described in the past. Today the task is relatively easy using the new generation of indirect laryngo-pharyngoscopes, which have a 90° field of view. Provided the patient is able to open the mouth, stick out the tongue, and say "aah," beautiful results can be achieved. Generally, no anesthesia is needed, and the instrument can be focused on everything from the vocal cords to the tongue. Again, the reader is referred to Chapter 14 for full details of endoscopic photography.

### Genito-Urinary Medicine and Gynecology

**The Female Reproductive System.** Gynecological photography is the application of orthodox methods to the photography of the vulva and the application of cavity photography for recording diseases and conditions of the vagina and cervix uteri. True *endoscopic techniques* may also be involved, as in *culdoscopy* where a straight rod endoscope similar to a *cystoscope* is inserted into the pelvic cavity through the vagina (see Chapter 14). Photography of the internal reproductive organs may also be required during surgery.

It is essential that the photographer is familiar with the anatomy of the female reproductive system. The external genitalia consists of the labia majora, mons pubis, clitoris, labia minora, vestibule, hymen, vaginal and urethral orifices, and fourchette. The intra-abdominal organs are the ovaries, Fallopian or uterine tubes, and uterus.

Tact and understanding of the patient's natural embarrassment with this type of photography are essential. Detached efficiency is the key to success. If a female photographer is not available, male photographers must always have a chaperone present. Such a person can be either a nurse or female assistant, but never a female relative of the patient. If no chaperone is available, photography should not be undertaken until one can be provided. This is simply to protect yourself. You have no record of the patient's psychiatric history. The patient should be allowed to undress in privacy and need remove clothing up to the waist only. A clean dressing gown is a necessity. Good hygiene is essential, particularly when dealing with cases of venereal disease.

For photography of the vulva, the patient should lie on a couch in the semilithotomy position, that is, on the back with thighs and legs flexed and abducted but with the heels flat on the couch (Figure 12.15). The buttocks should rest on a disposable white background. If the lesion to be photographed extends to the mons pubis, a background such as a pillow or sheet of background material may be required and can be held by the patient. Should it be necessary to separate the labia majora in order to demonstrate the lesion more effectively, always wear surgical examination gloves. It is usually best to get

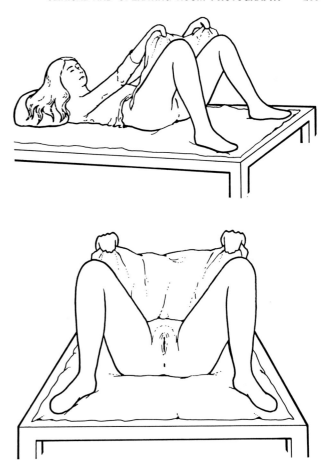

**FIGURE 12.15** The semilithotomy position is used for all photography of the anus and perineum and for the female genitalia. A clinical examination couch must be available in the studio for this type of photography.

a doctor to do this, or failing that, allow the patient to do it herself. Sometimes vulval lesions will extend into the vagina, in which case it will be necessary to insert a speculum to demonstrate the lesion more clearly. A doctor must do this. The routine view, taken to a scale of 1 : 4, should include the whole of the vulval area. Close-ups of particular lesions may also be required. The whole procedure should be carried out as rapidly and discreetly as possible. If the patient has to be operated on in the near future, it is often preferable to take the photographs while the patient is under a general anesthetic. Note that this does not negate the need for informed consent.

Photography of the vagina and cervix is usually carried out in the gynecological clinic, the ward, or the operating theater. The patient will normally be in one of the standard positions, such as Sims', knee–elbow, or lithotomy. The gynecologist will insert specula to demonstrate the lesion required and photography, according to the principles of cavity photography, is carried out. A black anodized speculum is best for this type of photography. Many clinics are equipped with a colposcope, which is a

binocular microscope especially designed for the examination of the cervix uteri. These often have a camera attachment with built-in electronic flash.

The conditions that you may have to photograph are carcinoma of the vulva, vagina, or cervix; congenital abnormalities of the genitalia; syphilitic chancre; cervical erosion, Bartholin's cysts; hemangioma; hematoma; leukoplakia; uterine prolapse; moniliasis or thrush; vulvitis; vaginitis; and vulval warts. Sometimes it is difficult to see a prolapse of the cervix. In such a case you will have to ask the patient to produce the prolapse. This occurs when the patient bears down, that is, contracts her abdominal muscles and pushes down, thereby presenting the prolapse *per vagina*.

### The Male Reproductive System.

Use standard photographic methods when you are photographing the male external genitalia. A doctor may require photographs of the internal reproductive organs during a surgical operation or as pathological specimens. The medical photographer must know the position and functions of the internal organs: the testes, the prostate, the seminal vessels, and the ejaculatory ducts, and also their relationship to the adjacent structures of the bladder, urethra, and perineum. The external organs are the penis and scrotum. The end of the penis is enlarged to form the glans penis, which is covered by a fold of skin, the prepuce. Circumcision is the excision of this fold of skin.

The choice of photographer and the need for a chaperon is just as important as in gynecological photography. It is kinder to the patient and will be appreciated by the female members of staff if a male colleague undertakes the case. Handle patients with venereal diseases with particular care because of the possibility of infection. Although it is essential that the photographer be familiar with the correct anatomical nomenclature, understand that the uneducated patient may not understand this terminology.

Views of the penis and scrotum can be taken with the patient standing if, of course, he is able to do so. Most inguinal hernias, for example, disappear when the patient is asked to lie down. Close-up views are best obtained with the patient lying on a low couch and will usually require the penis to be held so that the lesion can be clearly demonstrated. This is best done by the patient himself or an assistant. Always wear disposable latex gloves. Retraction of the prepuce may be necessary to show the glans properly. When you are photographing the scrotum, see that the penis is held out of the way in order to obtain a good picture.

Skin diseases, including the venereal diseases, will form the bulk of cases referred for photography of the external male genitalia. When requested to photograph the genitalia of patients with endocrine disorders, it is important that the photograph shows the degree of development in relation to the whole patient, his age, height, and other bodily characteristics.

A low-power electronic flashgun can demonstrate undescended testicles, hydrocele, spermatocele, and epididymal cysts by transilluminating the scrotum. Conventional views must also be taken as a *control*.

Other conditions frequently photographed are orchitis, seminoma, teratoma, and hernia. The most common site for a hernia is the inguinal region. They may be congenital or caused by excessive strain. In some instances it may be necessary to ask the patient to cough to bring down the hernia.

### The Urinary Tract.

Photography of the urinary tract is mainly confined to views of the kidneys, ureters, bladder, and urethra during operative surgery; to endoscopic views of the bladder; and to the portion of the urethra that is visible externally. The external meatus of the female urethra is situated centrally between the folds of the labia minora, anterior to the vaginal orifice. The external meatus of the male urethra is situated centrally at the end of the glans penis.

Hypospadias and epispadias are congenital conditions where the opening of the urethra is formed at some place other than the tip of the penis. A photograph taken during micturition will usually demonstrate this abnormality but, in practice, this is very difficult to arrange. In order to show an abnormally placed orifice, a doctor may need to insert a probe. This is generally more satisfactory.

## Neurology and Psychiatry

Photography plays an important role in recording the visible evidence of diseases of the nervous system and diseases of the mind. Most often there is a need to record movement, so cine and television techniques are required, but sometimes a single picture or short series of pictures will demonstrate and describe the condition effectively.

Deformities may be caused by a whole range of neurological conditions such as meningocoele, atrophy of muscles due to peripheral nerve lesions, poliomyelitis, paraplegia, and others, and the majority of these are adequately recorded by photography. Psychiatrists seldom request photographs of their patients, but occasionally they help to monitor progress, for example, anorexia nervosa or for use in teaching, such as the characteristic posture of a manic depressive.

The photographer needs to treat psychiatric patients very carefully when they are sent for photography. Whether they are suffering from mild mental illness such as anxiety states, phobias, and obsessional states, or are suffering from the more severe mental illnesses such as melancholia or schizophrenia with delusions and hallucinations, such patients may be unstable and behave in a very unexpected fashion. The problem of patient consent becomes very difficult with psychiatric patients be-

cause they are of unsound mind and, therefore, incapable of informed consent. As previously mentioned, any request/consent form signed by a psychiatric patient is, therefore, worthless in law. They may be suspicious of why you wish to photograph them; sometimes they may even be positively antagonistic. You must remember that the patient is ill, despite the absence of obvious physical signs of disease. Even though these patients may do bizarre things, treat them with respect. The neurological patient may have lost the use of limbs, have curious gaits or tremors, or be unable to talk coherently, but always remember that they can probably hear and understand you perfectly. Their mental faculties are rarely dulled.

Photography in this field of medicine is usually confined to the recording of deformities in neurology and the recording of characteristic attitudes in psychiatry. Both follow the normal principles of good clinical photography outlined earlier. Good lighting is the key to photographing the deformities; follow the advice given in the section on orthopedics.

Most often, there is a need for some record of movement and so you must use cine or television (see Chapter 10). This applies to all tremors or involuntary movements and also to abnormalities of locomotion. When photographs may be required for publication, still photographs should also be taken, as images taken from cine film or the television screen are always of poor quality. You can use a motor-drive to advantage to capture a number of key points in a movement cycle, and you can employ other ingenious methods to show movement in a still photograph. The hand tremor of Parkinson's disease, for example, can be demonstrated by asking the patient to write on a piece of paper and then photographing the shaky result; alternatively, a time exposure can be used to demonstrate tremor.

Neurological patients who exhibit involuntary movements may require some restraining during photography, while patients who have paralyses or weaknesses from other causes may require supports. Areas of paresthesia or anesthesia need to be marked with a black skin marker.

Sometimes in psychiatry candid views are required of patients taken through one-way mirrors. There are no special requirements for this, other than that you usually need to uprate the film to cope with the low lighting levels. You may also take still photographs of patients' activities in rehabilitation and occupational therapy centers. Often, neurologists and psychiatrists will accompany patients when they come for photography to ensure understanding on the part of both photographer and patient of what to record.

**Some Commonly Photographed Conditions.** *Anorexia nervosa* is a condition marked by great loss of appetite, leading to emaciation and metabolic derangement attended by serious neurotic symptoms. It occurs predominantly in Caucasian, middle-class, teenage girls. Full-length views should be taken to show wasting.

*Alzheimer's disease* is a progressive brain disease that usually occurs between the ages of 40 and 60 years; it is characterized by a generalized atrophy of the brain. The doctor needs cine or television records of difficulty of locomotion and speech.

*Argyll-Robertson pupils* are small and irregularly shaped pupils that respond to convergence but not to light. A short series of still photographs, with the patient asked to look at a close object and then one more distant, in both bright ambient room lighting and then darker conditions, is required. It is vital that the photographs are appropriately annotated.

*Bell's palsy* is a benign unilateral facial paralysis usually caused by a self-limited lesion of the seventh cranial nerve. The face is distorted, with the mouth drawn to one side. You can best demonstrate this by asking the patient to smile, blow, or whistle. There is absence of eyebrow movement and the inability to completely close the eyelid on the affected side. You will need to take a series of still photographs of the face. Annotate them, for example, *smiling, whistling, raising eyebrows, at rest,* and so on.

*Cerebral palsy* is really a group of disorders of the motor system that is present at birth but perhaps not evident until the child is 1 or 2 years old. It includes spastic paraplegia, with paralysis of both legs and the classic *scissors deformity* caused by spasm of the adductor muscles of the thigh, which can easily be recorded with a still photograph, and *athetosis* characterized by constant, slow, involuntary movements of the hands, fingers, and sometimes feet, which will require television.

*Cerebral vascular accidents* (apoplexy, stroke) are a variety of vascular accidents that lead to ischemia and neuronal destruction. The patient may exhibit any of the following: hemianesthesia, hemiplegia, aphasia, vertigo, and loss of vision.

*Cretinism* is severe arrested mental development caused by inadequate production of thyroid hormone in early infancy. There is stunted growth and a protruding, swollen tongue.

*Erb's palsy* is caused by injury of the brachial plexus during birth, particularly with a breech delivery. This condition gives rise to a flaccid paralysis of the muscles supplied. The arm hangs by the side with the forearm pronated and fingers flexed (the so-called policeman's tip position).

*Facial tics* are involuntary, brief, and recurrent twitching of a group of muscles under the control of specific nerve branches; an example is tic douloureux, involving the trigeminal nerve. Some of these tremors are very fine and very fast and will certainly require television or film to demonstrate them. The same is true of habit spasms or cramps, which are liable to occur in individuals of almost any handicraft, for example, in artists, writers, typists, and musicians.

*Herpes zoster* is an infection of the ganglia of the pos-

terior roots of the spinal nerves, or the fifth cranial nerve, by the varicella-zoster virus. It is marked by vesicular eruptions running along the cutaneous nerves and is usually unilateral.

*Horner's syndrome* presents as a combination of constriction of the pupil (meiosis), ptosis, and apparent enophthalmos. There is a cessation of sweating over that side of the face (anhydrosis).

*Huntington's chorea* is an inherited progressive dementia with bizarre involuntary movements. There is a curious springy gait that progresses to a drunken-type stagger. Facial grimacing is common.

*Meningitis* is an inflammation of the membranous coverings of the brain and spinal cord. Its features include headache, neck stiffness, pyrexia, and hemorrhagic rash. These patients are often photophobic and intolerant of repeated exposure to electronic flash.

*Munchausen's syndrome* is strictly described as the fabrication by an itinerant malingerer of a clinically convincing simulation of disease. It may include complex self-induced injuries, signs, and symptoms, and there is usually a long history of hospitalization, frequently under many different names. Clinicians may require a photographic record of the signs and symptoms for teaching or simply may need a facial record for distribution to other hospitals.

*Muscle wasting and atrophy* occurs whenever muscles are deprived of neurological stimulus for long periods. It may be symptomatic of a generalized motor neuron disease. There is gradual wasting of individual muscles or groups of muscles, often starting in the thenar eminences and spreading to the muscles of the arms, shoulders, and trunk. Strong cross-lighting will often be required to demonstrate such conditions effectively.

*Muscular dystrophy* causes symmetrical weakness and wasting of the muscles of the pelvic girdle and back in children. This makes the child walk with a waddling gait and an exaggerated lumbar lordosis. It also makes him rise to his feet in a characteristic way by climbing hand over hand up his legs. The degenerative process is steadily and rapidly progressive. Within 10 years the patient can seldom walk, and long periods of immobility cause osteoporosis and skeletal deformity.

*Myasthenia gravis* is a chronic disease characterized by variable degrees of muscular weakness leading eventually to paralysis. It begins with the muscles of the eye, causing ptosis and diplopia.

*Nystagmus* is a rhythmical oscillatory movement of the eyes resulting from a disorder of coordinated eye movement and fixation. *Jerky nystagmus* is characteristic of cerebellar disease, while *pendular nystagmus* is due to defects in ocular fixation.

*Parkinsonism*, or paralysis agitans, is characterized by stiffness and slowness of voluntary movement, stooped posture, propulsive gait, and rhythmic tremor of the limbs. There is also a rigidity of facial expression resulting in a masklike facies.

*Sydenham's chorea*, or St. Vitus' dance, is a benign disorder of childhood and one of the manifestations of rheumatic fever. In addition to the jerky movements of the limbs, the child makes smirking grimaces.

*Syringomyelia* is progressive cavitation of the gray matter resulting in sensory loss, lower motor neuron weakness, and trophic changes in the upper limbs and spasticity of the legs. There is also occasionally scoliosis of the lumbar spine.

*Tabes dorsalis* is the tertiary stage of syphilis, characterized by sclerosis of the sensory nerve roots. Symptoms include shooting pains, muscular incoordination and atrophy, and functional disturbances of major organs. There is often erosion and dislocation of joints, optic atrophy, and small irregular pupils, which react to convergence but not to light.

*Von Recklinghausen's disease*, or neurofibromatosis, is an inherited disorder characterized by multiple pedunculated tumors that follow the course of the peripheral nerves. There are also light brown café au lait spots on the skin in the early stages of the disease.

Doctors may require photographs of any neurosurgical procedure, such as removal of subarachnoid tumors, extradural hematomas, drainage of hydrocephalus, or correction of meningomyelocele. Normal photographic principles apply as described in the section on Outpatients and the Accidental Emergency Unit. Some special techniques have been described in the literature, specifically that of fluorescein tracers to establish blood flow to tumors.

## Ophthalmology

*Ophthalmology* is the study and treatment of diseases of the eye and its functional disorders. The ophthalmologist is a combined physician and surgeon. All medical photographers are called upon to undertake ophthalmic photography, even if only of the external eye. The more specialized techniques require the use of very intricate and expensive optical equipment, which is fully explained in Chapter 15. Doctors often require photography of the head, neck, face, and eyes. These pictures should be taken according to the principles already outlined in the section on The Head and Neck.

## Orthopedics

The word *orthopedic* is derived from two Greek words: *orthos* meaning straight and *pedion* meaning a child, and was originally applied to the art of correcting deformities in children. Modern orthopedics is, however, concerned with all age groups. It is not confined to bones and joints but covers many diseases of the associated muscles, tendons, ligaments, nerves, and blood vessels. Injuries to the skull and the jaws are, however, considered the special-

ties of the neurosurgeon and dental surgeon, respectively. Thus, there is bound to be considerable overlap with these and other specialties, such as endocrine, vascular, and plastic surgery.

In orthopedic photography there is particular emphasis on demonstrating, by suitable lighting techniques, external abnormalities resulting from skeletal deformities, and on recording and measuring of normal or limited joint movement by either still photography, cinematography, or television.

Deformities are defects causing the formation of an abnormal convexity or concavity in the normal peripheral shape of the body. The causes of deformities are:

1. congenital (born with): for example, syndactyly, Sprengel's shoulder, torticollis, and others, including deformations of growth, such as scoliosis, hallux valgus, kyphosis, and Marfan's syndrome
2. traumatic (injury): including fractures of all types, dislocations, burns, Volkmann's contracture, and many others
3. pathological: for example, osteitis deformans, all neoplasms, osteogenesis imperfecta, and others

While it is not necessary for the medical photographer to know in detail all 200 bones of the body, it is essential that he or she have a sound knowledge of the majority of them. It is also important to understand the vocabulary used in the examination of joints and their movements. *Adduction* and *abduction, extension* and *flexion, pronation* and *supination,* and *rotation* are all terms much used by medical staff when requesting photography of orthopedic patients, and you should become familiar with these terms. A good knowledge of standard clinical examination practice is of the greatest value, and the medical photographer should take every opportunity to attend some practical demonstrations.

When applying the general principles and practice of patient care given in the section on Care of the Patient and Other Ethical Considerations, it should also be remembered that many orthopedic patients will have long-term or *chronic* conditions. Their mobility, or lack of it, may not be obvious from their general appearance. Their attitude toward their disease may well be different from that of patients with acute conditions. Orthopedic patients are often sent for photography soon after surgical procedures. This is not only unkind but will also make the photographs of doubtful value as records of any improvement. Advise a later appointment.

Where patients' mobility is restricted, there is often the temptation to photograph them on the ward. Resist this where practical. Good orthopedic records require good lighting and backgrounds and full-length views, all of which are difficult to achieve on the ward. Have the patient brought to the studio in a wheelchair and use an assistant to help him stand. The patients will often appreciate and welcome this change from the confines of the ward.

No specialized apparatus or sensitive materials are necessary, other than those used in general photography of patients. As with so much of patient photography, standardization is the key to all orthopedic work. This is sometimes very difficult when you need nonstandardized creative lighting to show the condition properly. Matched photographs, taken over many months or years, will be used to assess the patient's progress.

Preparation and positioning of the patient is most important in orthopedic cases in order to establish the best viewpoint, both for observation of the condition and also so that the subject is correctly placed in regard to its natural function. This is particularly important when joint movements are being recorded, and where there is likely to be a long delay until future comparable records are requested. Where the stance of patients is of interest, care must be taken to ensure that they assume their natural positions and do not over- or undercompensate, in the mistaken belief that this is what is required of them.

Since much of orthopedics is concerned with normal or abnormal growth, the scaling of photographs is essential. The inclusion of a normal control patient within the photograph for immediate comparison can be of particular value for teaching.

In many orthopedic patients the only visual sign of deformity is that the normal contours of the body are either lacking, misplaced, or increased. The wrong choice of lighting during photography can easily diminish or exaggerate these changes so that they are presented inaccurately, as either too gross or too mild. The photographer must achieve the right balance of light and shade while still maintaining an uncomplicated lighting arrangement that can be matched in subsequent serial photographs. Correct choice of background, in conjunction with effective lighting, should ensure that the body or limb outlines are never lost. Black backgrounds with rimlighting are strongly favored in this area of photography. This is, of course, a general criterion for all patient photography but perhaps, above all, in orthopedics where the outline is of such importance.

A double exposure or multiple exposure technique can be effectively used to demonstrate a range of movement of either a single joint or of the spinal column in the cervical or lumbar regions. Separate exposures are made, usually at the two extremes of movement, against a black background. No exposure variation is necessary, but you must take great care with positioning the subject, so that the axis of the joint remains stationary. This may be relatively easy in, for instance, the case of a wrist joint, where it can, if necessary, be anchored while still allowing full range of movement of the hand. It may be far more difficult in the case of the spinal column, when the photographer is trying to record the patient's ability to bend forward and back while preventing the pelvis from moving. You can then overlay some form of grid or protractor at the printing stage. There may be some difficulty in

placing the center of the protractor over the axis of the joint, since not even all anatomists will agree as to its exact position. Filters can be fitted over the flash to emphasize the two different views in the one color photograph.

**Some Commonly Photographed Orthopedic Conditions.** *Scoliosis* is a lateral curvature of the spine. It is usually a primary curve with secondary compensating curves; one above and one below the main curve which may be lumbar, thoracolumbar, or thoracic. Doctors require photographs to show both posture and the deformity from anterior, posterior, and lateral viewpoints. An additional posterior view with the patient bending down, as though to touch the toes, will help to show the associated so-called rib hump deformity. Marking out the individual spinal processes with a skin marker is a helpful technique. Such marking must be done with the patient already in the intended position for photography. Otherwise, a movement, such as bending down, will alter the positions of the marks. When photographing scoliosis, it is important to show the whole patient, including the head and feet. Scoliosis may well either cause, or be the result of, other bodily abnormalities, which should also be recorded. Photogrammetry is widely used for the recording and early detection of this condition.

*Kyphosis* is an exaggeration of the normal dorsal curve (hunchback). *Lordosis* is an exaggeration of the normal curve in the lumbar region, with anterior protrusion of the lower abdomen. Full-length lateral views are required. It is often necessary to get the patient to flex the arms at the elbow so that the arms do not hang down and obscure the lumbar curvature. Do not get them to put their hands behind the head, as this will alter the spinal configuration.

*Hallux valgus* is a lateral deviation of the big toe. This often involves both feet and can give rise to a bunion caused by rubbing on the shoes. Additional deformities occur in advanced cases. Accurate serial photographs are required for evaluation during treatment, which is usually surgical.

*Talipes equinovarus* (congenital club foot) is characterized by the foot turned so that the sole is facing inward. There is adduction of the toes, relative to the hindfoot, and also plantar flexion. As this is a congenital condition, early and prolonged treatment is essential. Serial pictures will be needed over a lengthy period. With very young children some care will need to be exercised to ensure that the child adopts the abnormal stance. Both feet should be shown, as should the legs up to and including the patellae, in order to record the relative positions and angles. Both anterior and posterior views are essential. It is important to be able to see the surface on which the child is standing.

*Congenital dislocation of the hip* displaces the head of the femur out of the acetabulum in an upward direction. It is a spontaneous dislocation, present at birth. It is usually diagnosed at the postnatal examination, and special views may then be required. At a later stage, an abnormal gait, a delay in learning to walk, and restricted abduction of the affected limb, which may also show extra skin folds, are all characteristics that may be filmed or photographed. Photographs of the patient demonstrating Trendelenburg's maneuver, may also be required.

*Arthritis* is an inclusive term, covering both inflammatory and degenerative conditions in joints. There are many types of arthritis, including rheumatoid arthritis, tubercular arthritis, and osteoarthritis. Restricted joint movements, local swellings, and characteristic deformities, particularly in the hands, wrists, and feet, will concern the medical photographer most often.

*Ankylosing spondylitis* is a progressive condition of the spine, mostly affecting young men. The main feature of this disease is the pokerlike rigidity of the spine and consequent loss of its mobility. A lateral view, using a double or triple exposure technique, is preferable to separate photographs for recording this limitation of movement.

*Paget's disease* (osteitis deformans) is a progressive condition that affects the pelvis, the vertebrae, the femur, the tibia, and the skull. In well-established cases, softening of the bones leads to the patient having a characteristic posture and appearance, with marked bowing of the legs, a shortened trunk, and an enlarged skull.

*Achondroplasia* is dwarfism characterized by short limbs, caused by a defect of long bone growth, but with a normal sized head. Adult achondroplastics are usually less than 4 feet in height, and their hands are short and broad.

*Infantile torticollis* (wry neck) causes the head to be tilted to one side by contracture of the sternomastoid muscle. There may also be facial asymmetry. Photographs should show both of these facets, and also, if possible, the tightly contracted muscle that contrasts with the normal muscle on the other side of the neck. The view must include both clavicles. There may also be a squint, which will need recording in the nine positions of gaze.

*Dupuytren's contracture* is a condition of the hand in which there is a typical flexion of one or more fingers caused by a thickening of the palmar fascia. The first sign, before any flexion occurs, is a thickened nodule in the middle of the palm. The hand should be photographed in full extension from both the palmar and the ulnar aspects. The ulnar view is best taken from slightly above, rather than from on, a level with the palm.

*Chest deformities* include the long chest, the flat chest, the barrel chest, the pigeon chest (pectus carinatum), and the hollow chest (pectus excavatum). For these, it is important to show the line of the ribs and of the spinal column and the outline of the sternum. You may find it helpful to inscribe anatomical points on the patient with a skin pencil.

*Foot deformities,* such as pes planus (flat foot), and pes

cavus (clawfoot), which are characterized by flattened or raised longitudinal arches, respectively, are best recorded with both a medial view with the patient lying supine at rest, then another with the patient bearing weight.

*Knee deformities* such as genu valgum (knock-knees) and genu varum (bowlegs) need anterior and posterior views of both legs from iliac crest to floor, then anterior and lateral close-ups of both knees to demonstrate the deformity in detail.

*Gait abnormalities* include particular styles of walking, for instance, the lame gait of pes planus, the "heather-step" gait of alcoholic neuritis, the jerky gait of spastic paralysis, the tremulous short-stepped gait of Parkinson's disease, the bizarre, jerky gait of Huntington's chorea, the dragged leg of hemiplegia, and the waddling gait of congenital dislocation of the hip. The recording of gaits is most commonly carried out by cinematography or television. To make an intelligent representation of a gait with still photography calls for considerable patience and a very fast motor-drive. It is important that the patient has sufficient area in which to walk and that the area is evenly illuminated. The orthopedic surgeon may sometimes request a photograph of the walking surface of a patient's shoes, as these often clearly record abnormalities of gait and posture.

## Pediatrics

*Pediatrics* is the term applied to the development of children, their care, and the treatment of their diseases. The age range encompassed by pediatrics is normally from birth to 14 or 16 years, although some pediatric hospitals treat a small number of older children. The general techniques of medical photography can be applied to these patients, but you will see a number of conditions that would not be encountered in any adult hospital and, of course, the challenge of photographing very active, often extremely difficult, children makes this field unique and rewarding.

In general, children are not as cooperative as adults and often cannot understand what is required. It is very important not only to make the child feel at ease but also to instill a confidence in the parent, as the parent's reaction will often be transferred to the child. A professional approach is just as important in pediatrics as in adult photography. The use of white coats is an issue that causes much discussion. Many people prefer the photographer to wear a white coat when first meeting the parents and child in the waiting area, but to remove the coat when returning to take the child into the studio for the photographic session. In this way, you maintain the parent's confidence in your professionalism, but the child is not frightened by the symbol of authority. Some pediatric photographers advocate the use of a white coat at all

times in order to break down the child's fear that white coats always represent pain and discomfort.

Often the child that is ambulatory will arrive at the studio after a number of other tests and visits to other departments. This can make it extremely difficult for the photographer, especially if the child has just had a number of encounters with needles. It is therefore important to attend to the patient as soon as possible and to welcome the child and parent equally. The parent can often be the key influence in the success of a photographic session, so your relationship with the mother or father is very important. To alleviate any fear on the part of the patient, it is a good idea to run through what will happen to the child. A comparison with having photographs taken at home can often relax the child. Demonstrating the flash and showing the child the camera can be very helpful. Another technique is to pretend to photograph the parent first to show the child what to expect. Sometimes, however, there is nothing one can do to get the cooperation of the child, and the session should simply be deferred to another time. It is imperative, however, in this situation, to consult the doctor first, as sometimes the doctor will have had a longstanding relationship with the child and may be able to assist, but more important, will appreciate the need to reschedule the appointment.

Even when the child is confident that nothing in the photographic department will hurt him, everything must be ready. Any child's attention span is very short. As with all good clinical photography, equipment, views, and other items should all be organized before the patient comes into the studio. Always ask about the abilities of the child, for instance, to stand. This may not be obvious, and a discussion with the parents and child will help to determine the equipment you select.

Working to set magnification ratios is very difficult with children. First, it is impossible to apply the adult ratios, as the photographs of babies would be mostly background. Clearly the same scale used for a baby cannot be used effectively for a child of 16 years. Second, it is very difficult to get children to respond to demands for accurate positioning. However, there is probably more chance of children returning for follow-up photographs than any other branch of clinical photography. Some standardization, therefore, must be established. Doctors must be able to effectively compare photographs of the same patient from one month to another and sometimes over a period of many years.

Although in practice it may be impossible to completely standardize pediatric photography, several things can be done to improve comparability of the results. Keep an extra copy of all pediatric photographs in the department and use such previous views of the patient as a guide in the studio, not only to ensure the same scale but also to ensure the same viewpoint. It is also important to make meticulous records of the scales and viewpoints taken on each occasion. Many pediatric photographers

develop sets of scales of their own. One recommendation is to use the Westminster ratios as described for adult photography, but use the next scale down for children under the age of 6. The full-length photograph, for example, is done at 1 : 25 instead of 1 : 50, and the head is done at 1 : 6 instead of 1 : 8. Various other modifications of the adult ratios have been proposed, but, in practice, they are all something of a compromise. The most important thing is that you develop a working system that suits you and the pediatricians at your institution and then apply it consistently. In the case of an infant, full body views should be taken with the child standing next to a measure.

Babies are often the most challenging patients, especially when there is a need for a detailed series of views. It is usually quite easy to get the child to look toward the camera for an anterior view, as that is where the interest is. For other views, some distraction will be necessary to take the interest away from the camera. The use of squeaky toys, keys, or pictures on the wall can help immensely in this situation. The mother or father are also only too willing to help too and are good at getting the child's attention.

The demonstration of cleft lip and palate or a pediatric syndrome requiring up to a dozen different views will require the photographer's skill and tenacity. There are many helpful tricks which you can employ. Trying to photograph the palm of a small baby's hand can be almost impossible, as the tendency is to clench the fist, and babies can be surprisingly strong. A good way to solve this problem is to lay the baby on its stomach and gently position the hand on the child's back, palm up. It is very difficult to clench a fist in this position.

Accurate positioning of the head is a particular challenge. The use of a sponge anesthetic mattress, with a depression to accommodate the head, can be useful. The alternative is to have someone, usually the parent, gently hold the sides of the head, preventing any movement. Another technique is to sit the patient on the parent's lap with a background cloth placed over the parent's chest and have them hold the baby's head gently in the correct orientation.

Obviously, when you are photographing the palate, it is essential to have the baby's mouth open as wide as possible. It is ironic that the patient who has been crying the whole time in the waiting room will suddenly close the mouth very firmly when there is the prospect of you looking into it. Never pinch a baby just to get it to cry. The simple expedient of placing one's hands over the child's ears and gently tilting the head backward will usually achieve the desired outcome. For really professional results, use a pediatric palatal mirror for such views. Thankfully, most babies have an automatic feeding response, so the placement of a mirror on the tongue will ensure an open mouth.

When photographing the baby full length, the photographer must work very efficiently, as babies lose heat very quickly and cannot afford to be undressed for very long. For the full-length view, it will usually be necessary to have someone hold the patient's legs straight to get an idea of length, as the tendency is to curl the legs up. Spare diapers and backgrounds should be within easy reach, as many babies will urinate as soon as they have been undressed. Backgrounds should therefore be disposable. It is also good practice to keep camera equipment some distance away to keep it dry.

Some children will refuse to take their clothes off. In this case it is better to photograph the child with clothes on first and then try to persuade the child to remove all, or some, of its clothes. Even a picture with the child fully clothed is better than no picture at all. Indeed, for some purposes, the clothed view may be quite acceptable. Sometimes the use of a white gown to cover the parts of the child that are not being photographed can help to make the child feel more comfortable. Often clothing will only appear on the edges of the photograph, as for example in the views of the face, but it can be a great distraction. If the child will not remove such clothing willingly, the use of a white gown over the clothes can solve this problem.

Keep cables from trailing on the floor and keep camera equipment off the floor, as siblings may often run and trip in the studio. A stepbox is useful to raise children off the floor, especially when you are looking at the feet.

In the past, photographers have applied transillumination techniques to the infant skull, mainly to visualize hydrocephalus. To a large extent this has been replaced by the use of computerized axial tomography, but references for the technique can be found in the bibliography.

## Pathology

*Pathology* is the study of diseased tissue and deals mostly, therefore, with sections of tissues or with body fluids extracted from the living or the deceased. Details of the photography of gross specimens can be found in Chapter 16, while Chapter 8 and Chapter 7 fully cover that of macroscopic and microscopic proportions. Chapter 20 covers the photography of laboratory preparations.

Whole patients are rarely photographed, except perhaps in the postmortem room, which you can consider as a special kind of operating room. Instead of trying to prevent infection from entering the operating area, every precaution is taken to prevent infection from being spread to the rest of the hospital from the autopsy room. The medical photographer is one of the few individuals whose work takes them all over the hospital, and it is quite conceivable that you could be called straight from an autopsy to a ward or the operating room. Therefore, you have a special responsibility in preventing cross-

infection between these areas. Although the equipment required is identical, never take it from an autopsy to the operating room. Many photographers keep equipment especially for use in the operating room and different equipment for use in the postmortem area. If the same equipment has to be used, make certain to wipe it very carefully with disinfectant.

No photographer enjoys working in the postmortem room, but it is a legitimate part of the work. The atmosphere can often be unpleasant, with body odors combining with chemical fixatives and antiseptics. The sight of dead bodies in various states of dissection can also be distressing, especially in forensic work, or if you have previously photographed the patient while he or she was alive. Detachment comes with experience. Always remember that your photographs may help to explain a disease process and to improve medical care. They may even help to prevent death in the future. Although the photographs you take may not be of direct help to the patient lying in front of you, they may be of immense value to other patients.

Although there is no requirement to maintain asepsis, you should adopt the same techniques described for the operating room. The photographer should not touch the cadaver or fresh specimen. The pathologist or technician will orientate and move the subject as necessary. All the same lighting problems occur as in the OR, except that in the autopsy there are even more specular reflections. Backgrounds also present a problem. Try to use surgical towels to hide the autopsy table or to provide a background for other views. Wet specimens will leak fluid onto these, giving an unsightly appearance, so it is best to soak them first in saline. Although they then reproduce very dark, they do hide the leaking fluids.

## Plastic and Reconstructive Surgery

Plastic or reconstructive surgery is the removal, addition, replacement, or manipulation of tissue in order to repair, restore, or enhance appearance and/or function. Photography is used for records of the surgical stages, which may be of great number occurring over a period of many years, for teaching and publication purposes, for research, and for medicolegal purposes. The photography may be on behalf of patients, where evidence of original injury and subsequent treatment can help substantiate a claim for insurance or compensation, or on behalf of the surgeon in cases of litigation where the patient is not satisfied with the outcome of the treatment, or for encouraging a patient by showing first and last photographs of comparable cases, or to encourage patients during protracted treatment by showing photographs illustrating progress already achieved.

The general anatomical scope of photography for plastic surgery includes those parts of the body that are visible, including the palate, the nasal septum, and the interior walls of the nose. There is a certain amount of overlap with other surgical specialties such as oral surgery, neurosurgery, orthopedics, and pediatrics.

In the initial stages, the patient may be in considerable pain and unable to move around due to a graft and supporting bandages. In these cases, photography will have to be done on the ward and at times when dressings are being changed. Barrier nursing may be in effect on the wards in cases of burns. Patients undergoing cosmetic surgery will usually be particularly anxious about their appearance at all stages of surgery and may ask for the photographer's opinion of changes since the last photographs were taken. Never venture to give it. Be encouraging in an unspecific way, especially, for example, to parents of a child with cleft lip and palate deformity.

Plastic surgeons themselves have frequently commented on the need to standardize all parameters in the photography of their patients. Too low a viewpoint before rhinoplasty and too high after will make it appear that the surgeon has slimmed the nose and tucked the nostrils underneath, whereas in fact, he may have done nothing of the sort. Strong toplight may make breasts appear large and pendulous, whereas soft light angled upward will make them appear firm and smaller. It is most important to use the same type of lamp, directional or diffuse, in the same way. If a directional beam shows the lesion well before surgery then use it, but the subject area should be lit in exactly the same manner on follow-up, although the lesion itself may have been removed or reduced. Absolute professional integrity is required in lighting pre- and postoperatively. It has been said that much cosmetic surgery can be performed by lighting alone. The production of comparable and accurate serial records demands meticulous attention to standardization of all the factors.

Direct ultraviolet (UV) recording may be used to enhance the image obtained of scar tissue, but a control panchromatic record must always accompany such a picture. Fluorescence techniques are used in plastic surgery to examine the blood supply, particularly to pedicle flaps. Various workers have described this technique and its application to plastic surgery; see Chapter 13 and the bibliography.

## Vascular, Blood, and Lymphatic Disorders

In photographic terms, this section primarily covers local pathological changes caused by vascular insufficiency, visible changes in the vessels themselves, and neoplastic pathology. Patients suffering from such conditions need special care, ranging from avoidance of physical exertion to complete barrier nursing. The photographer should be aware that patients suffering from hypertension or angina pectoris often appear to be in robust health.

There is nothing in the recording of such conditions that is of a unique character, but without an appreciation of the fundamental anatomy, physiology, and pathology, the photographer will find it difficult to illustrate them intelligently. A meticulous and sometimes innovative approach is necessary. Color fidelity, for example, is particularly important where a slight blue cast from a colored background might quite erroneously suggest cyanosis. Slight overexposure of a color transparency might suggest pallor and ischemia where none existed. Good lighting is also important. The surface evidence of an aneurysm might be only a very delicate superficial pulsation, which will require expert lighting and cinematography to record it adequately.

Invisible radiation photography, especially infrared (IR), often records abnormalities in vascular pattern. Often the requesting surgeon or physician will not appreciate, or will misunderstand, the use of infrared photography for recording such conditions, and the good clinical photographer may well have to take the initiative in such situations. It is particularly important, therefore, for the clinical photographer to understand this technique. See Chapter 13 for general background and the following section for the full details of clinical application.

Peripheral vascular disease and arteriosclerosis are evidenced by ischemia, ulceration, or even gangrene of the extremities, which require accurate color photographs. In the short term, poor supply of oxygenated blood results in cyanosis, which needs accurate color photography. (It may be helpful to include some normal colored skin, that is, a nurse's hand, to act as a reference tone.) In the long term, finger clubbing develops, which requires lateral and anterior views of the fingers. Clubbing most often occurs as a result of pulmonary pathology, rather than vascular insufficiency.

## CLINICAL PHOTOGRAPHY WITH INVISIBLE RADIATION

One important function of medical photography is to extend the range of spectral visualization of the human eye: IR and UV photography are therefore acting as investigative tools, discovering new facts about the patient. In some fields of clinical investigation extensive work has been reported on the use of invisible radiation photography: other areas of application are still untouched and await the attention of the research-oriented medical photographer. Clinicians will often have an incomplete understanding of the value of infrared and ultraviolet techniques, and the competent medical photographer will always be alert to the possible application of these techniques to patient photography. These notes relate only to clinical applications of the invisible radiation techniques; the reader should consult Chapter 13 for background information. Because UV and IR photography present a visible interpretation of an invisible

state, always take a control photograph taken in visible light to provide an exact comparison rendering of the patient. Three techniques are commonly applied to patients: the UV reflected and fluorescence methods and the reflected IR method.

## Reflected or Direct Ultraviolet Photography

This technique actually records UV radiation reflected from the subject. All other radiation is kept from the film. A source of UV is aimed at the subject, which will selectively reflect/absorb and may emit visible light as an induced fluorescence. A UV transmission filter is fitted over the lens, which is visually opaque but transmits ultraviolet to the standard film (Figure 12.16).

Exercise caution with continuous sources of UV, as there is a real risk of burning yourself and/or your patient or of getting conjunctivitis. The eye cannot see below 400 nm, but the peak of erythemal activity occurs at 297 nm. Also, there is no heat emission from most sources of UV. Conjunctivitis and skin erythema appear only 4 or 5 hours after exposure to UV, so there are no warning signs to alert the operator that he or she is exceeding a safe dosage.

All silver halide is sensitive to UV, but gelatin itself absorbs UV, and many films have a UV filter built into the overcoating of the emulsion. High-speed film is therefore required, as four or five stops more exposure are required than the visible equivalent, and a relatively small aperture is required for depth-of-field in patient photography. American Standards Association/International Standards Organization (ASA/ISO) speeds are not indicators of sensitivity to UV, and some relatively fast films perform less well than medium-speed equivalents. Color film is not suitable because each layer of the tricolor pack will be exposed by the UV. Push processing for BW film is necessary to increase speed and contrast. Extensive testing of all the available emulsions showed that Kodak T-Max 400 push processed to 3200 ISO was best.

The only practical source of UV for patient photography is the standard xenon electronic flash tube. Many electronic flash tubes are coated with a gold UV-absorbing filter, but some manufacturers provide unfiltered lamps for UV work (for example, Bowen's and Courtney for studio flash and Nikon for portable flashes). Nikon manufactures a special flashgun, the SB140, for invisible radiation photography, both UV and IR. It comes complete with visible, UV, and IR transmission filters and has a useful exposure guide. Its tube is uncoated, and, in many respects, it is ideal for patient photography, especially on location.

There are very few filters available now for UV work. All are glass, since gelatin absorbs UV. The Kodak Wratten 18A is the standard filter and is still available from

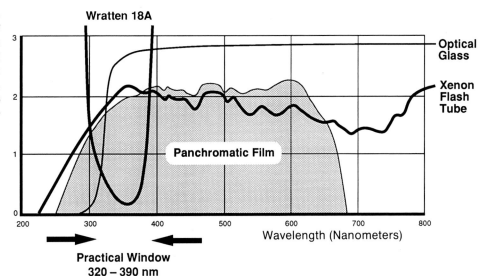

**FIGURE 12.16** A "harmonization" diagram for reflected UV photography, showing how the film, light source, filter, and lens transmissions coincide in the region of 320 to 390 nm, making photography of patients in this region a practical possibility.

Kodak (as a very expensive spare part). Note that this filter also has a transmission in the IR. Precision Optical Ltd. in England (West Midlands, UK) supplies Schott, UGI, UG5, and UG7 filters, (the equivalent of the old Chance OX1, OX5, and OX7 filters, which·are no longer manufactured). Oriel Scientific in the United States (Stratford, CT) supplies interference filters for UV and IR wavebands in 10, 20, 50, and 100-nm wavebands throughout the spectrum. Naturally, UV filters are opaque to visible light, so a light-tight filter holder is required so that the filter can be swung quickly into place immediately after focusing, that is, the Nikon AF1 holder for 35-mm cameras or Kodak Path's Porte-filter Professionel No. 2 for large-format work.

UV radiation is absorbed by several of the important components of the photographic chain. Optical glass absorbs strongly below 320 nm, gelatin at around 250 nm. The practical window of transmission therefore, extends from about 320 to 390 nm. Some specialist lenses are manufactured for UV work. These include the UV Nikkor 105 mm and the Hasselblad UV Sonnar 100 mm. These are extremely useful if you are considering any significant amount of patient photography in the ultraviolet region. They are made of fluorite and quartz and provide about 150% better transmission than their glass equivalents at 365 nm. They also do not suffer from problems of focus shift.

Glass used in lens manufacture brings light at different wavelengths to focus at different points. This can be a problem even in normal photography and is termed *chromatic aberration*. The difference between focus point for visible and UV is considerable, and at magnifications greater than 1 : 10 some focus shift must be applied to the lens after visually focusing. Interestingly, the shift is often in the same direction as for IR. The whole camera, or camera back in the case of the 4 × 5 inch camera, has to

be moved back away from the subject. This does seem to break the laws of physics, but is probably due to the complex nature of modern lens design and materials. As all lenses vary considerably in their performance in respect of chromatic variance, test all lenses for focus shift. The following shifts are recommended as a starting point. Move the whole camera back by the following amounts:

| 35 mm/105 lens | | 6 × 7 cm/135 lens | | 5 × 4/370 lens | |
|---|---|---|---|---|---|
| | | (camera back only) | | | |
| 1 : 10 | 96 mm | 1 : 10 | 10 cm | 1 : 10 | 0 mm |
| 1 : 8 | 47 mm | 1 : 8 | 44 mm | 1 : 8 | 0 mm |
| 1 : 4 | 21 mm | 1 : 4 | 30 mm | 1 : 4 | 3 mm |
| 1 : 2 | 7 mm | 1 : 2 | 16 mm | 1 : 2 | 6 mm |
| 1 : 1 | 4 mm | 1 : 1 | 7 mm | 1 : 1 | 10 mm |

There are so many variables affecting exposure that, as with focus shift, tests are required. Typical exposures using the Nikon SB140 hand flash, held at the camera back and T-Max, rated at 3200 ISO with the 105 UV Nikkor, are as follows:

$$1 : 1—f/32 \qquad 1 : 4—f/16$$
$$1 : 8—f/11 \qquad 1 : 15—f/8$$

Reflected UV photography suffers from the gamma/lambda effect, that is, a reduction in contrast with decrease in wavelength. Processing must be increased by 25% to 30% to achieve a normal contrast index; where push processing is being used to increase film speed, it will normally take care of this problem.

Many substances reflect/absorb UV radiation in a completely different way from that for visible light. Some materials that are jet black to visible light reflect UV so effectively that they record as white when you are using the reflected UV technique. Most medical subjects react rather less dramatically, but the principle is applied

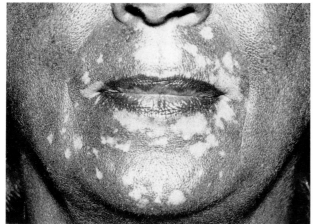

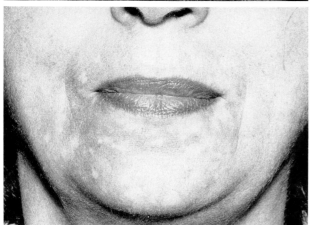

**FIGURE 12.17** Selective depigmentation of the skin in vitiligo is shown very clearly by the reflected UV technique (top), the conventional record (bottom) barely shows the condition at all.

widely. Tone and color differences so slight that they are barely discernible often become very clear in UV. Slight changes in pigment of the skin, especially those associated with melanin, show more clearly than by conventional methods. Unpigmented skin reflects UV strongly, whereas melanin absorbs it very heavily. The extent of hypo- and hyperpigmentary conditions is clearly delineated. Applications include vitiligo, pigmented nevi, halo nevi, malignant and benign melanomas, melasma/chloasma, albinism, scleroderma, keratin plugs, moles, and freckles (Figures 12.17 and 12.18). Pigmentary disturbances that will only become evident to the patient in midsummer can be mapped in midwinter by this technique.

Some workers have used television systems to be able to see in real time whether reflected UV photography would be of value in recording certain patients. The television system gives poor resolution, but it does at least enable you to determine whether it is worth pursuing the photography. Old traumatic lesions such as scars, bruises, bite marks, and others may sometimes be revealed by the reflected UV method months after they have faded visibly, and this has obvious forensic applications. This may be due to some disturbance of the pigment-producing cells in the basal cell membrane or to pigmentation following inflammatory reaction.

This technique is also very useful for enhancing surface detail of skin, specimens, and so on. There is virtually no penetration of UV into the tissues; therefore,

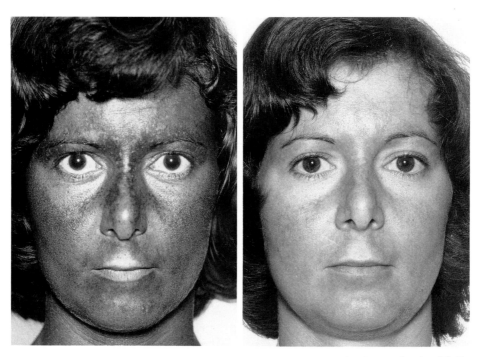

**FIGURE 12.18** Hyperpigmentation in this case of melasma is again shown clearly with the melanin absorbing the UV radiation strongly (left). The control photograph (right) shows the visible evidence.

there is no scattering and sharper pictures result. Reflected UV maps the surface blood vessels of the sclera, conjunctiva, and some visceral surfaces of internal organs with exceptional clarity. Disturbances in the skin surface texture, as in ichthyosis or poikiloderma, show up very clearly.

## Fluorescence Photography

Fluorescence is the emission of light from a subject of longer wavelength than the light impacting on it. High-energy radiation such as UV impinging on the subject causes the electrons of the subject's atoms to be raised to higher energy orbits. The electrons then slip back to their normal energy state, releasing energy as they do so, often in the form of light. The light emitted is always of longer wavelength than the light causing the stimulation. Thus, subjects irradiated with UV may release, for example, green, yellow, or pink light.

### Ultraviolet-Induced Fluorescence.
In this technique the photographer aims a source of UV radiation at the subject in a completely darkened room. The subject reflects UV and may emit a visible fluorescence. A UV-absorbing filter stops UV from entering the lens, and fast color film records the visible fluorescence emitted.

Films with conventional spectral sensitivity, either BW or color, are suitable for use, although color is most often used to record the characteristic colors of many types of fluorescence. Fast film is essential, as luminous intensity of most fluorescence is very low. Kodak Ektachrome P800/1600 pushed to 3200 ISO is best.

Sources of UV radiation are the same as for the reflected technique. Dermatologists use continuous high-pressure mercury vapor lamps for inspection, but electronic flash is always used for photography; otherwise, extended exposure may burn the patient. The radiation source must be fitted with a Wood's filter (Wratten 18A) so that only UV is allowed to reach the subject. All UV must then be absorbed by the filter fitted over the lens; use a Kodak Wratten 2B or 2E. UV-absorbing filters, especially gelatin ones, fade with exposure to UV, so they need to be replaced frequently. Also, some very short wavelengths (<300 nm) cause the filter itself to fluoresce. The remedy is to fit the filter to the rear of the lens so that the glass of the lens absorbs the very short wavelengths causing the fluorescence before they reach the filter. The excitation/barrier filter combination can be tested by photographing a metallic object, which will not exhibit fluorescence. If the filter pair are a perfect match and the barrier filter is working efficiently, nothing will record. Many workers prefer to mismatch excitation and barrier filters to allow some "background" illumination. Sometimes a pale cyan filter is also used as part of the barrier combination to absorb the red leakage of the Wratten 18A.

Fluorescence from patient's lesions is always very weak. Even with a powerful flashgun (GN 800 in feet at 3200 IS0), expect $f/4$ to $f/5.6$ at 1:8. For very long exposures, make allowance also for reciprocity failure, which may alter the color recorded. With some fluorescence there is also the problem of exhaustion extinction. The longer the subject is irradiated, the weaker the fluorescence becomes.

Many fungi and some bacteria exhibit fluorescence when stimulated by ultraviolet (Color Plate 51). The color is often characteristic, for example tinea fluoresces blue/white, pityriasis fluoresces gold, erythrasma fluoresces coral pink. In dentistry, ultraviolet fluorescence detects many abnormalities, can distinguish between natural enamel and restorative work, and can reveal such things as tetracycline uptake. In forensic work there are many compounds and body fluids that fluoresce. In research, fluorescent markers are added to growing tissue, including tumor studies and bone growth studies (Color Plate 52).

### Sodium Fluorescein Technique.
Sodium fluorescein is a protein dye, so some caution is required in its use. The body builds up its immune reaction to successive doses of the dye. It may cause severe anaphylactic shock and even cardiac arrest in some patients. It will certainly cause nausea. The dye will be passed out in the urine for many hours after administration. The immune response is cumulative, so patients should not receive more than about eight investigations with sodium fluorescein. Medically qualified help must always be available and resuscitation facilities at hand when undertaking this kind of photography.

Although it is often considered an invisible radiation technique, it is not a UV technique. It is actually yellow-green emission from the sodium fluorescein stimulated by excitation in the blue region. The most common example of this technique is fluorescein angiography of the retina (other applications can be found in Chapter 15), but it can also be used for patient photography. The principal use is in studies of blood flow to tumors, reconstructive flaps, grafts, and other areas. Surgeons often require an immediate result in the operating room to assess viability. Apart from the routine application of retinal angiography, the technique is used in ophthalmology for the assessment of corneal ulceration and for the fitting of contact lenses. In both instances a medical worker places the sodium fluorescein onto the anterior surface of the eye as drops.

The technique is basically similar to UV fluorescence, but here sodium fluorescein is injected into subjects before they are photographed with blue light. The yellow fluorescence is then recorded onto color film, while the blue light is absorbed by a deep yellow-orange filter over the lens. The excitation filter (deep blue) is usually a Wratten 47 or 47A. The 47A has been especially formulated to stimulate sodium fluorescein. Fundus cameras

often use high-quality interference filters, such as Spectrotech, with the same transmission. The standard barrier filter is a deep yellow Wratten 12 or 15. Often the photographer adds Wratten 2B or 2E UV-absorbing filter to the barrier filter.

Fast color film is routine for fluorescein studies of blood flow to areas of the body, contact lens fittings, corneal abrasions, and the like. The use of Ektachrome P800/1600 is recommended. As with all fluorescence photography, expect low levels of light. One critical factor in the photography of sodium fluorescein is concentration. Concentrations stronger than 0.1%, or weaker than 0.0000001%, do not fluoresce; maximum fluorescence occurs at 0.00001%, so take care in administering the dye to obtain optimum dye concentrations and, therefore, best photographic results.

## Infrared Photography of Patients

The range of IR radiation applicable to photography of patients extends from the termination of the red part of the spectrum at about 700 nm to a wavelength of about 900 nm; this limit is set by the sensitivity of the photographic emulsion. IR photography does not record heat wavelengths beyond 1200 nm. This is the province of thermography. The reflected IR technique works by using a source of IR radiation to light the subject, then filtering out all visible light by fitting an IR transmission filter over the lens. A specially sensitized film then records the IR reflected from the subject (Figure 12.19)

Emulsions have to be specially sensitized to radiation beyond the red region. There is little choice now in the range of film available for clinical IR work. Kodak supplies high-speed BW IR film in the 35-mm format (HIE

135) or as 5 × 4 sheet film (4143). Konica has recently reintroduced their BW IR emulsion in the 120-roll film format, but this only has a sensitivity extending to 800 nm and so only really records the far-red region. The Kodak products are extremely sensitive and must be handled at all stages in total darkness. The relative speed and contrast deteriorate rapidly if the film is not kept refrigerated. The shelf life of IR emulsions is severely limited, even when refrigerated, so take great care to use only fresh stock. IR-sensitive films all have a high granularity, so 4 × 5 film is often used to improve image quality.

Sunlight, tungsten lamps, and lasers all contain a lot of IR, but the only practical source for medical photographers is electronic flash. The xenon flash tube has plenty of output in the 800 to 900 nm region of the spectrum. IR photographs reveal density differences due to variations in the absorption characteristics of tissues, and any shadows cast by the lighting will cause confusion. Therefore, the subject must be evenly illuminated using several sources of radiation. Some workers go so far as to recommend the use of a white room or tent to obtain diffuse enough lighting. Soft lighting produces a dramatically improved IR record because the contrast of the resulting print can then be raised, thereby enhancing the record of the blood vessels. A modern version of the tent is the use of large diffusion panels such as those manufactured by Lightform. The P22 panels are approximately 6 × 3 feet; one placed on either side of the patient at 45° angles and lit by two lights provides really even illumination and good exposure levels. Illumination drops off very quickly with increasing angle in IR work, so dark edges to the subject appear all too easily unless you take special care to light these areas. Therefore, the important thing about lighting for IR is that it should be very even, soft, wrap-

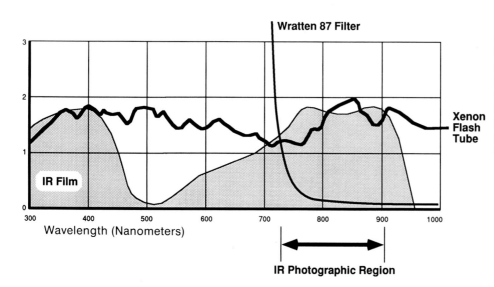

FIGURE 12.19 The specially extended spectral response of IR film is shown in this harmonization diagram with the transmission of the Wratten 87 filter and the spectral output of the flash tube superimposed. It can be seen that the window for photography is between 720 and 900 nm.

apply some focus shift. Establish the exact amount of shift required by testing specific lenses. The following table gives some recommendations. Move the whole camera back by the following amounts.

| 35 mm/105 lens | | 6 × 7 cm/135 lens (camera back only) | | 4 × 5/370 lens | |
|---|---|---|---|---|---|
| 1 : 10 | 53 mm | 1 : 10 | 56 mm | 1 : 10 | 0 mm |
| 1 : 8 | 32 mm | 1 : 8 | 44 mm | 1 : 8 | 0 mm |
| 1 : 4 | 8 mm | 1 : 4 | 24 mm | 1 : 4 | 2 mm |
| 1 : 2 | 4 mm | 1 : 2 | 6 mm | 1 : 2 | 3 mm |
| 1 : 1 | 2 mm | 1 : 1 | 2 mm | 1 : 1 | 4 mm |

When working with a 35-mm camera it is helpful to use some kind of focusing rack that allows one to quickly apply the focus shift, once you have obtained the point of visual focus. As with ultraviolet work, some kind of filter holder that allows you to place the filter rapidly after obtaining the visual focus is essential. Many lenses that have been corrected for wavelengths in the visible spectrum give an image of poorer quality when used in the IR range. This occurs even when the optimum IR focus has been obtained, and it is further exacerbated by diffusion and scattering of radiation within the patient's tissues. You can also see diffraction effects in the lenses used for IR photography, especially when using the new style 105-mm Micro Nikkor by Nikon at apertures smaller than $f/16$; the old-style lens did not suffer from this problem. All lenses likely to be used for clinical IR work should be tested at small apertures for this effect by photographing an evenly lit gray card.

Unfortunately, many materials transmit infrared freely, although they are opaque to visible light. Examples are the plastics used in the manufacture of dark slides, camera bellows, and developing tanks. Exercise great care, therefore, in the selection of equipment for IR photography. Metal is preferable to plastic. Uneven development also seems to be a feature of IR films; a meticulous agitation technique avoids this. The IR negative should look fairly dense and flat. Printing IR negatives is very difficult because there are no acceptable standards for what the subject should look like. No one has ever seen it. Basically, the technique is to print for the detail and ignore the flesh tones. The print should be just dark enough to show the faintest details or structures and just contrasty enough to show them clearly. The quality of the finished prints can be enhanced immeasurably by using an unsharp mask in contact with the negative during printing. This performs two roles: autododging shadow areas and enhancing fine detail by allowing a more contrasty grade of paper to be used. The unsharp positive area mask should be such that the lightest area presents a density of about 0.5. Contrast should be such that the ratio of darkest to lightest area is approximately 25% of the same ratio on the negative.

IR films are now remarkably sensitive and, when using even a modestly powered electronic flash unit, exposures

**FIGURE 12.20** Lighting for IR photography must be very even and diffuse; one method is to use large reflector panels such as those shown here.

around lighting (Figure 12.20). Bear in mind also that different backgrounds reflect IR light more or less successfully. A well-lit, pure white background might reproduce dark gray on IR. Many photographers prefer to work with an unlit black background for IR work.

Use a visually opaque IR transmission filter (Wratten 88A or 87) over the camera lens in a light tight mount. These are gelatin based and are easily available from Kodak, or the equivalents from many manufacturers. The most commonly used filter is the Wratten 88A, which cuts off effectively at 700 nm and allows the transmission of all the IR up to the limit of sensitivity of the film.

As with UV, IR rays are brought to focus at a point quite different from the visual focus. Many lenses are engraved with an IR focusing mark. These are virtually useless to the biomedical photographer, as they are usually an indication of the focus shift required at large distances. For patient photography, where you are working in the range from 1:10 magnification and upward,

of $f/32$ or $f/22$ are commonplace at magnifications from 1:1 to 1:10.

IR radiation has two useful properties when used for medical photography: first, it penetrates the superficial layers of the epidermis and reveals structures beneath them; second, the reflection and absorption characteristics differ in respect to the visible spectrum. These two properties form the basis of all the reported clinical applications.

Venous blood absorbs IR heavily, whereas oxygenated blood reflects IR well. Thus, vascular disorders such as varicose veins or venous obstruction are clearly delineated. Only the superficial veins can be recorded because of the limited depth of penetration. The sinuous curved stems of varicose veins can be clearly seen, and the changing pattern of superficial vessels in the breasts and abdomen due to pregnancy have been mapped. When one of the main venous trunks of the body is obstructed, a collateral circulation develops to circumvent the problem. These engorged and distended cutaneous veins stand out more vividly in an IR photograph; obstruction of the femoral, subclavian, and portal veins, the vena cava, and mediastinal tumors are classic examples of applications for IR photography.

Other researchers have reported the usefulness of the technique for studying venous patterns in congenital heart disease and pericardial effusion, in thrombotic conditions and in venous stasis, and for hypertension. Researchers have done a great deal of work on the vascular patterns of the female breast during pregnancy or in neoplastic disease. The vascular changes in diabetic patients have been mapped by IR, as have postprandial engorgements of veins. The clarity of the venous record obtained depends upon various factors, such as the thickness of subcutaneous fat, the thickness of the vessel walls, and the depth of the vessel from the skin surface (Figures 12.21 and 12.22).

In cases where an opaque cornea is obscuring the pupil, its size, shape, and position can be revealed by IR photography. Dark-brown pigmented irises often record lighter in tone than blue ones; the deeply pigmented trabeculae often register the lightest. IR color film has been used to penetrate a vitreous humor clouded with blood to provide a record of the fundus. Similarly, this film has penetrated cataracts to record retinal changes in retinitis pigmentosa, and melanotic lesions become strongly emphasized in the false color record. These techniques can distinguish scleral melanosis from associated vascularities, and vascular lesions of the choroid can be recorded through the retina. IR radiation can record the diameter of the pupil in numerous studies of physical and physiological effects in both human and animal subjects. Since the eye does not see IR, the pupil does not respond to this radiation.

Pathological applications include increased detail and differentiation between silicotic and pneumocotic lesions from the surrounding lung tissue. You can use injection techniques using mercuric sulfide (red cinnabar) into

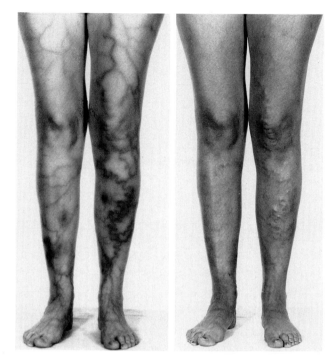

**FIGURE 12.21  Varicose veins are shown dramatically by IR photography (left) with a control panchromatic photograph (right).**

arteries and suspended carbon (India ink) into veins to record these vessels as white (reflecting IR) or black (absorbing IR), respectively. The translucent amniotic membrane is penetrated to reveal details of the fetus. It is possible to distinguish between otherwise visually similar substances, for example, silver sulfide deposits and melanin granules in localized argyria.

In dental photography, enamel photographs darker than dentine, although there is some evidence that this situation is reversed with pre-carious chalky degeneration. In the healthy living tooth you can clearly see the condition of the incisal edge. Uneven areas of thin enamel appear light in tone. The vascular network of the oral mucosa does not show well in the IR record, and the dorsum of the tongue and hard palate are too heavily stratified for sufficient penetration.

IR records are able to clearly show a variety of clinical conditions, such as the healing process under deep-seated lesions such as lupus vulgaris and eczema, hair stubble in shaved areas, and tattoo patterns obliterated to visual examination. Xanthomata also record very clearly. IR photography has been much used in the study of tumors, especially for delineating the increased blood supply to breast tumors and for differentiating between benign and malignant pigmented lesions of the skin. Much work has been done on the relationship between cirrhosis of the liver and collateral circulation, and IR photography is useful in the early detection of cirrhosis.

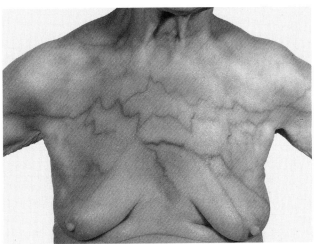

**FIGURE 12.22** One of the most frequent applications of IR photography has been the study of blood supply in breast tumors such as that shown here. The IR record is on the top with the control beneath.

There are conflicting reports on the value of IR photography for transillumination techniques. Some workers reported that there was little to be gained, especially with transilluminating the breast, while others reported greatly enhanced recording, particularly with infant skulls.

## CONCLUSION

Clinical photography is one of the most rewarding branches of photography; it provides photographs of patients from before they are born until after they die. In order to be useful, all clinical photographs need to be highly standardized. The only permissible variable is the patient's condition. You must control all of the photographic aspects. The clinical photographer must be acquainted with the special terminology of medicine and must have sufficient knowledge of the disease process to be able to interpret requests for photography sensibly. A knowledge of advanced photographic techniques, such as infrared, ultraviolet, and photogrammetry, is necessary so that the photographer can assist the physician, not only to record the patient's condition but also to help diagnose it and provide quantitative data on progress of treatment. Never underestimate the value of the clinical photograph in the teaching process. While no patient ever died for want of a photograph, thousands have had their treatment improved immeasurably by the use of photography in the training of medical, paramedical, and nursing staff. Above all else the clinical photographer should remember that the subject is a person, often in pain, and always apprehensive. Stripped of self-respect, privacy, and control, patients stand in the studio and entrust themselves and their images to the care of the medical photographer. Make absolutely certain that you prove worthy of that trust.

## ACKNOWLEDGMENTS

The author is indebted to the London School of Medical Photography for kind permission to use some of the contents from their now out-of-print *Medical Photography Study Guide*, which the author was privileged to edit. Also thanks to those patients, colleagues, and friends who allowed themselves to be photographed to illustrate some of the points made in the text.

## BIBLIOGRAPHY

### General Texts

Allen, G., 1978. Paediatric photography in comparison to adult patient photography. *J. Biol. Photogr. Assoc.* 46:57–67.

Davidson, T., 1979. Photography in facial plastic and reconstructive surgery. *J. Biol. Photogr.* 47:59–67.

Davidson, T., 1980. Photographic interpretation of facial plastic and reconstructive surgery. *J Biol. Photogr.* 48:87–92.

Davies, P. M., 1985. *Medical Terminology in Hospital Practice.* London: Heinemann Medical.

Dornette, W., 1975. Biological photography and the law. *J. Biol. Photogr. Assoc.* 43:78–82.

Duncan, A., Dunstan, G., & Welbourn, R., 1981. *A Dictionary of Medical Ethics.* London: Darton, Longman & Todd. Longman.

Dworkin, G., and Taylor, R., 1989. *Blackstone's Guide to the Copyright, Designs and Patents Act 1988.* London: Blackstone Press.

Ellison-Nash, D., 1973. *The Principles and Practice of Surgery for Nurses and Allied Professions.* London: Edward Arnold.

Gibson, L., 1972. *Clinical Photography.* Publication N3. Rochester, NY: Eastman Kodak.

Gillis, L., 1972. *Human Behavior in Illness.* London: Faber & Faber.

Gilson, C., and Green, P., 1984. Confidentiality of illustrative clinical records. *J. Audiovisual Media Med.* 7:4–9.

Hansell, P. (ed.) 1979. *A Guide to Medical Photography*. Lancaster, UK: MTP Press.

Irvine, R., 1976. Court appearances and the biophotographer. *J. Biol. Photogr. Assoc.* 44:21–23.

Phillips, R., 1976. Photography as aid to dermatology. *Med. Biol. Illustr.* 26:161–166.

Rogers, G., 1976. Paediatric photography. Ed. Newman, A. In *Photographic Techniques for Scientific Research*, Vol. 2. London: Academic Press.

Ross, J., and Wilson, K., 1986. *Anatomy and Physiology in Health and Illness*, 6th ed. Edinburgh: Churchill Livingstone.

Sclare, A., and Thomson, G., 1968. The uses of closed circuit television in teaching psychiatry to medical students. *Br. J. Med. Educ.* 2:226–228.

Stevens, G., 1978. Medical photography, the right to privacy and privilege. *Med. Trial Tech. Q.* 24:456–464.

Tarcindale, M., 1980. Medical photographer's role in protecting a patient's privacy. *J. Biol. Photogr.* 48:183–185.

Wallace, F., 1957. Neuropsychiatric photography. *J. Biol. Photogr. Assoc.* 25:96–97.

Whitley, R., 1959. Lighting in orthopaedic medicine. *Med. Biol. Illustr.* 9:226–230.

Williams, A. R., 1984. *Medical Photography: A Guide to Study*. Lancaster, UK: MTP Press.

Willey, E., (ed.), 1989. *A Glossary of Medical Terminology for the Health Professions*. Thorofare, NJ: Charles B. Slack.

Yonge, K., 1965. The uses of closed circuit television for the teaching of psychotherapeutic interviewing to medical students. *Can. Med. Assoc. J.* 92:747–749.

## Standardization

Chappel, J., and Stephenson, K., 1970. Photographic misrepresentation. *Plast. Reconstr. Surg.* 45:135–137.

Dickason, W., and Hanna, D., 1976. Pitfalls of comparative photography in plastic and reconstructive surgery. *Plast. Reconstr. Surg.* 58:166–171.

Duguid, K., and Ollerenshaw, R., 1962. Standardization in records of the foot. *Med. Biol. Illustr.* 12:241–245.

Gilson, C., and Parbhoo, S., 1981. Standardized serial photography in the assessment of treatment. *J. Audiovisual Media Med.* 4:5–10.

Jemec, B., 1981. Suggestions for standardized clinical photography in plastic surgery. *J. Audiovisual Media Med.* 4:99–102.

McCausland, T., 1980. A method of standardization of photographic viewpoints for clinical photography. *J. Audiovisual Media Med.* 3:109–111.

McDowell, F., 1976. On the necessity of precision photographic documentation in plastic surgery. *Plast. Reconstr. Surg.* 58:214–218.

Marshall, R., 1957. Photographic background control. *Med. Biol. Illustr.* 7:13–21.

Marshall, R., and Marshall, B., 1975. Routine medical photography with 35-mm black and white film. *Med. Biol. Illustr.* 25:115–119.

Mason, E., 1964. Some aspects of positioning and standardization in endocrinology. *Med. Biol. Illustr.* 14:8–12.

Morello, D., Converse, J., & Allen, D., 1977. Making uniform photographic records in plastic surgery. *Plast. Reconstr. Surg.* 58:214–218.

Rogers, G., 1971. Standard views in oral photographic practice. *Med. Biol. Illustr.* 21:143–141.

Stenstrom, W., 1978. Guidelines for external eye photography. *J. Biol. Photogr. Assoc.* 46:155–158.

Vetter, J., 1979. Standardization for the biomedical photographic department. *J. Biol. Photogr.* 47:3–18.

## Invisible Radiation Techniques

Anselmo, V., and Zawacki, B., 1973. Infrared photography as a diagnostic tool for the burn wound. *Proc. SPIE Seminar II* 40:181–188.

Benson, R., and Vogel, M., 1955. The principles of identification and measurement of vulvar fluorescence. *J. Clin. Endocrinol.* 15:784–800.

Blackburn, I., et al., 1975. Infrared time-lapse photography: A technique for analyzing night movement in affective patients. *J. Psych. Res.* 12:69–73.

Callender, R., 1977. An ultraviolet camera system for intra-oral photography. *Med. Biol. Illustr.* 27:113–115.

Cameron, J., Ruddick, R., and Grant, J., 1960. Ultraviolet photography in forensic medicine. *Forens. Photogr.* 2:23–28.

Casida, L., 1968. Infrared color photography: Selective demonstration of bacteria. *Science* 159:199–200.

Cubberly, M., 1976. Infrared photography as a diagnostic tool in ophthalmology. *J. Biol. Photogr. Assoc.* 44:80–85.

Erol, O., Spira, M., Justice, J., & Parsa, F., 1981. An improved method for fluorescein dye photography. *Plast. Reconstr. Surg.* 68:120–121.

Ford, R., 1974. Infrared photography of transilluminated infant skulls. *J. Biol. Photogr. Assoc.* 42:94–102.

Gibson, H. L., 1964. Diffuse lighting for clinical infrared photography. *Med. Radiogr. Photogr.* 40:38–41.

Gibson, H., Buckley, W., and Whitmore, K., 1965. New vistas in infrared photography. *J. Biol. Photogr. Assoc.* 33:1–33.

Gibson, H. L., 1978. *Photography by Infrared: Its Principles and Practice*. New York: Wiley.

Gilder, R., and Rutherford, A., 1970. Diffuse lighting for infrared photography in medicine. *Med. Biol. Illustr.* 20:227–230.

Grossman, J. A., and Lantzy, N., 1981. A simple technique for fluorescein photography. [Letter] *Plast. Reconstr. Surg.* 67:257–258.

Haxthausen, N., 1933. Infrared photography of subcutaneous veins: Demonstration of concealed varices in ulcer and eczema of the leg. *Br. J. Dermatol.* 45:506–510.

Hendrix, J., 1978. Monitoring tar therapeutics with fluorescence photography. *J. Biol. Photogr. Assoc.* 46:80–81.

Hodge, C., Yamamotox, Y., and Feindel, W., 1978. Fluorescein angiography of the brain—The photographic procedure. *J. Biol. Photogr. Assoc.* 46:67–79.

Kikuchi, I., et al., 1979. Reflection ultraviolet photography in dermatology. *J. Dermatol.* (Tokyo) 6:81–93.

Lunnon, R., 1959. Direct ultraviolet photography of the skin. *Med. Biol. Illustr.* 9:150–154.

Lunnon, R., 1961. Some observations on the photography of the diseased skin. *Med. Biol. Illustr.* 11:98–103.

Lunnon, R., 1968. Clinical ultraviolet photography. *J. Biol. Photogr. Assoc.* 36:72–78.

Lunnon, R., 1979. Direct or reflected ultraviolet photography. *Photogr. J.* 119:380–386.

McCarty, G., 1976. Intra-oral infrared color photography. *J. Prosthet. Dent.* 35:327–331.

Marshall, R., 1981. Infrared and ultraviolet reflectance measurements as an aid to the diagnosis of pigmented lesions of the skin. *J. Audiovisual Media Med.* 4:11–14.

Marshall, R., 1981. Ultraviolet photography in detecting 'la-

tent' halos of pigmented lesions. *J. Audiovisual Media Med.* 4:127–129.

Morton, R., and Miller, S., 1981. Infrared transillumination using photography and television (videodioscope). *J. Audiovisual Media Med.* 4:86–90.

Mustakallio, K., and Korhonen, P., 1966. Monochromatic ultraviolet photography in dermatology. *J. Invest. Dermatol.* 47:351–353.

Ruddick, R., 1974. A technique for recording bite marks for forensic studies. *Med. Biol. Illustr.* 24:128–129.

Ruddick, R., 1979. Ultraviolet fluorescence photography. *Photogr. J.* 119:381–385.

Schaefer, D., and Baldwin, E., 1970. The photography of fluorescein dye fluorescence in surgery. *J. Biol. Photogr. Assoc.* 38:70–74.

Stevenson, J., 1981. Penetration of eschar by infrared photography. *J. Audiovisual Media Med.* 4:141–143.

Welsh, J., 1982. The photography of fluorescein. *Plast. Reconstr. Surg.* 69:990–994.

Wilkin, J., et al., 1980. Infrared photographic studies of rosacea. *Arch. Dermatol.* 116:676–678.

## Special Techniques

Burgess, C., and Edwards, R., 1978. Hirsutography. *Br. J. Photogr.* 125:770–772.

Callender, R., 1974. The optical texture of human skin. *Med. Biol. Illustr.* 24:171–173.

Clark, M. et al., 1977. Photocephalography for evaluation of tissue reactions in mandibular surgery. *J. Oral Surg.* 35:319–320.

Dorrington, J., 1972. Macrophotography of the skin. *Med. Biol. Illustr.* 22:154–156.

Ebrahim, H., and Williams, A. R., 1981. Comprehensive photo-optical gait recording. *Br. J. Photogr.* 128:929–931.

Fanibunda, K., and Hill, B., 1981. Facial photoradiography; practical considerations. *J. Audiovisual Media Med.* 4:95–98.

Johns, M., 1979. Transillumination of the infant skull. *J. Audiovisual Media Med.* 2:140–149.

Kilshaw, J., and Ollerenshaw, R., 1954. Assessment of spinal movement. *Med. Biol. Illustr.* 4:166–177.

McLean, K., 1977. Photography of the plantar surface of the foot. *Med. Biol. Illustr.* 27:141–144.

Shurtleff, D., 1964. Transillumination of the skull in infants and children. *Am. J. Dis. Child.* 107:14–19.

## Operative Photography

Duguid, K. P., 1971. Remote photography of cardiac surgery via a membrane mirror. *Med. Biol. Illustr.* 21:73–74.

Ericksson, S., et al., 1971. Photographic trauma. *Med. Biol. Illustr.* 21:211–214.

Fletcher, R., 1969. Automatic theater cameras: a review. *Med. Biol. Illustr.* 19 (Suppl.):36–43.

Hansell, P., and Duguid, K., 1970. The use of membrane mirrors in surgical photography. *J. Biol. Photogr. Assoc.* 38:176–178.

Maehr, C., 1975. Surgical photography through sterile bags. *J. Biol. Photogr. Assoc.* 43:23.

Morris, M., Giannavola, S., and Williams, G., 1980. Techniques for photography of cardiovascular surgery. *J. Biol. Photogr.* 48:159–162.

Turner, B., 1977. Theater photography: Routine not ritual. *Med. Biol. Ilustr.* 27:159–162.

## Photogrammetry

Adair, I., Van Wijk, M., and Armstrong, G., 1978. Moir-topography in scoliosis screening. *Clin. Orthop.* 129:65–171.

Ainsworth, H., and Joseph, M., 1976. An assessment of a stereophotogrammetric technique for the study of facial morphology in the child. *Ann. Human Biol.* 3:475–488.

Ainsworth, H., and Joseph, M., 1977. A light-sectioning technique for contouring and measuring a child's face. *Ann. Human Biol.* 4:331–341.

Babcock, M., 1954. Method for measuring fingernail growth rates in nutritional studies. *J. Nutrition* 55:323–329.

Beard, L., and Burke, P., 1967. Evolution of a system of stereophotogrammetry for study of facial morphology. *Med. Biol. Illus.* 17:20–25.

Berghagen, N., Bergstrom, J., and Torlegard, K., 1968. Changes in the volume of the gingival tissues, A stereophotogrammetric study. *Acta. Odont. Scand.* 26:369–393.

Berkowitz, S., and Cuzzi, J., 1977. Biostereometric analysis of surgically corrected faces. *Am. J. Orthodon.* 72:526–538.

Bulstrode, C., Goode, A., and Scott, P., 1987. Measurement and prediction of progress in delayed wound healing. *J. R. Soc. Med.* 80:210–212.

Chmielewski, N., and Varner, J., 1969. An application of holographic contouring in dentistry. *Biomed. Sci. Instrum.* 6:72–79.

Ghosh, S., and Poirier, F., 1987. Photogrammetric techniques applied to anthropometric study of hands. *J. Biomech.* 20:729–732.

Karlan, M., 1979. Contour analysis in plastic and reconstructive surgery. *Arch. Otolaryngol.* 105:670–679.

Koepfler, J., 1983. Moir-topography in medicine. *J. Biol. Photogr.* 51:3–10.

Logan, M., et al., 1987. Photogrammetric analysis of changes in the body volume associated with the induction of anaesthesia. *Br. J. Anaesthol.* 59:288–294.

Loughry, C., et al., 1987. Breast volume measurement using biostereometric analysis. *Plast. Reconstr. Surg.* 80:553–558.

Lovesey, E., 1973. A simple photogrammetric technique for recording three-dimensional head shape. *Med. Biol. Illus.* 23:210–212.

Macgregor, A., Newton, I., and Gilder, R., 1971. A stereophotogrammetric method of investigating facial changes following loss of teeth. *Med. Biol. Illus.* 21:75–82.

Mikhail, E., 1971. Hologrammetric mensuration and mapping systems. *Photogram. Eng.* 37:447–454.

Savara, B., et al., 1987. Craniofacial biostereometrics. *Clin. Plast. Surg.* 14:617–621.

Schochat, S., et al., 1981. Moir-phototopography in the evaluation of anterior chest wall deformities. *J. Pediatr. Surg.* 16:353–357.

Slama, C. (ed.), 1980. *Manual of Photogrammetry.* Falls Church, VA: American Society of Photogrammetry.

Takasaki, H., 1979. The development and the present status of moir-topography. *Optica Acta.* 26:1009–1019.

Williams, A., 1977. Light-sectioning as a three-dimensional measurement system in medicine. *J. Photogr. Sci.* 25:85–90.

Williams, A., 1985. Photogrammetry. In: *Encyclopedia of Physics in Medicine and Biology.* McAinsh, T. (ed). Oxford, UK: Pergamon, pp. 572–580.

Zivi, S., and Humberstone, G., 1970. Chest motion visualized by holographic interferometry. *Med. Res. Eng.* 9:5–7.

# Chapter 13
# Ultraviolet, Infrared, and Fluorescence Recording

## D. Anthony Gibson

*"Never its mysteries exposed*
*To the weak human eye unclosed;*
*So wills the King, who hath forbid*
*The uplifting of the fringed lid;*
*And thus the sad Soul that here passes*
*Beholds if but through darkened glasses."*

Edgar Allen Poe, 1809–1849
"Dreamland" 1844

This chapter describes the electromagnetic spectrum with respect to photographic and electronic imaging of the ultraviolet (UV) and infrared (IR). It also describes the techniques of UV, UV fluorescence, IR, and IR luminescence photography. These methods are applied to the biomedical sciences and some similar electronic imaging techniques are noted.

The electromagnetic spectrum is continuous, and the boundaries where UV radiation meets radio waves, or where IR radiation meets x-radiation, are not precisely defined. (Holz 1972). To a lesser extent the same is true of the boundaries between the visible, the UV, and the IR (Graham et al. 1965). The eye, and particularly a young eye, can see well into the UV or the IR regions, but the accepted limits of the visible spectrum are from 400 to 700 nm.

Imaging methods allow records to be made of the electromagnetic spectrum from 0.5 to 10,000 nm (Eastman Kodak, *Scientific Imaging Products* 1989). This covers the UV spectrum from 0.5 to 400 nm, the visible, and the IR spectrum from 700 to 10,000 nm. Interest here is narrower than this because photography is limited by the spectral sensitivity of photographic emulsions and the capability of lenses to pass electromagnetic radiation from 250 to 1200 nm (Figure 13.1).

For photography, you should give special attention to: the characteristics of the emission source; the transmission properties of the lens, other optical components, and light filters; the medium (air, water, and others) through which the spectral radiation will pass; and the spectral sensitivity of the imaging material (film).

Over the past 20 years many electronic imaging methods have evolved to record phenomena in the invisible spectra, particularly in the far UV and IR, where photography cannot reach. These are beyond the scope of this book, but they will be mentioned when they touch on subjects of our interest.

## ULTRAVIOLET

The UV spectrum meets the visible spectrum at 400 nm. The range from 0.5 to 10 nm is called the extreme UV, from 10 to 200 nm the vacuum UV, from 200 to 275 nm the short UV, from 275 to 340 nm the middle UV, and from 340 to 400 nm the long UV (Figure 13.1).

All photographic emulsions are sensitive to UV down to about 250 nm. Below this level, photographic gelatin blocks UV transmission to the silver halide grains in the emulsion and effectively limits photographic recording. Experiments are under way with low-gel coating of Kodak Tri-X and T-Max films, but these films are not yet available. Picture contrast decreases with wavelength (the gamma/lambda effect, where photographs taken with short-wave radiation (SWR) are generally of lower contrast than those made with longer wavelengths) (Arnold et al. 1971), so for UV photography high-contrast films, or films developed to higher than normal contrast such as the Kodak T-Max series, are recommended. Kodak daylight color films have a UV barrier overcoat in front of the emulsion which makes them unsuitable for UV photography; use only tungsten-balanced color films. You can use SWR emulsions, made with a low gelatin content, below 250 nm. These are not made for conventional UV photography, but for applications such as vacuum UV photography and space exploration. Spectroscopic emulsions are also considered for applications below 250 nm.

Water and air with a high water content become opaque to UV at about 250 nm, and dry air blocks UV transmission below 185 nm. Glass lenses transmit UV freely down to 360 nm, then transmission falls off to zero by 320 nm. Many newer lenses have a fluoride coating to absorb UV, which improves their performance for normal photography and renders them a poor choice for UV photography. Quartz lenses transmit down to

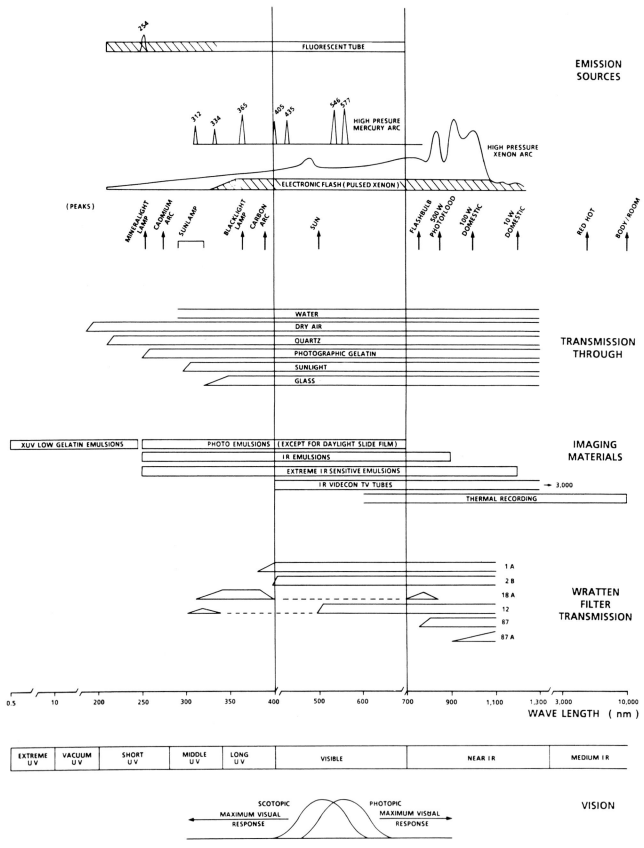

**FIGURE 13.1**   Demonstrates the relationship, in the electromagnetic spectrum, of the various factors involved in making visual images.

210 nm: examples are the UV-Nikkor 105-mm, the UV Sonnor (Zeiss, Oberkochan, Germany), and the Quartz Takumar 35-mm camera lenses. UV microscopy uses both quartz and catadioptric (reflecting) lenses.

Sources of electromagnetic radiation can emit a broad spectrum or broad and narrow spectral bands. The sun emits a broad spectrum, but the short wavelength radiation reaching the earth is limited by the filtering effects of water droplets in the air to about 300 nm at sea level (Eastman Kodak, *Ultraviolet and Fluorescence Photography* 1974). In a dry climate, and/or at a high altitude, transmission includes short UV; the limit depends on prevailing conditions.

Another broad-spectrum source is the fluorescent tube (low-pressure mercury vapor lamp). Electrical discharge ionizes the mercury vapor in the tube, and visible light and UV is produced. These tubes have emission peaks in the green and blue, and in the long and short UV. Fluorescent lamps provide even illumination over large areas, with peak emissions in the blue and long UV. Special versions of these lamps are offered as *blacklight* tubes, in which the glass tubes contain a chemical salt opaque to visible light: they are coated on the inside with a phosphor that absorbs short UV and emits long UV (peak 365 nm). The fluorescent tube envelope may be made of quartz, instead of glass, so that you can take advantage of the emission peak of mercury discharge lamps at 254 nm (90% of their energy). There are special hand-held versions of these lamps for use in laboratories and schools, with peaks at either 365 or 254 nm, and also at both (Ultra-Violet Products, Inc.) All these low pressure mercury tubes are of low power, from 4 to 60 watts, and although they are suitable for photographic use, exposure times are relatively long, of seconds or minutes duration.

Arc lamps are a powerful light source and have a continuous spectrum into the UV region. Cadmium arcs have a very bright emission at 273 nm. Cored carbon arcs have a useful emission in the long UV, peaking at 390 nm. Xenon arcs are a good source of long UV; their emissions tails off through the middle into the short UV (Figure 13.1).

The same spectral characteristics are available in electronic flash lamps containing xenon gas. Others containing a high percentage of krypton or argon gases emit more UV, and those with envelopes made of quartz are useful in both the long and middle UV regions. Unfortunately, many small electronic flash units have tubes coated with *gold* in order to reduce their UV emission, which is harmful for normal color photography; avoid these. Foil-filled flashbulbs are very bright and have a flash duration of 1/50 second. Although the percentage of long UV they emit is modest, their brightness makes them suitable for UV photography at short distances.

The high-pressure mercury arc lamp consists of a small quartz envelope in which an electrical arc produces mercury vapor under a pressure of several atmospheres.

The spectrum emitted is continuous from 300 to 700 nm, but with extremely bright peaks in the green and blue as well as in the UV. These lamps are most valuable for UV (and fluorescence) microscopy (Figure 13.1).

You can increase the effective intensity of all UV light sources up to 300% by using high-efficiency specular finish reflectors.

For photographs taken in artificial light or sunlight, a Kodak Wratten 18A (or similar) filter before the camera lens will cut out visible light and will also be opaque to UV below 320 nm. This is not a handicap when using glass lenses because they are also opaque to UV at 320 nm. Photography of the short UV (usually at 254 nm) must be performed using quartz lenses without filters in a dark environment (Frair and West 1989).

Focusing is a problem for a number of reasons. UV does not focus at the visible point: you would expect it to act as if the lens is of shorter focal length. In fact, as has been shown by actual tests of focus shift (Nieuwenhuis 1991), usually the focus is shifted away from the lens in the direction of the IR shift. This shift is usually greater than that of IR. Lenses do not all perform the same, partly because different lenses are made from different glasses.

At the time of exposure you cannot see through the lens, which is an added difficulty with living subjects. Most UV photography is carried out at close subject-to-camera distances, with wide lens apertures and a narrow depth of field. If focus is done visually, closing the lens aperture two stops smaller should bring the subject into focus. As an alternative, you can make trial-and-error focusing tests.

UV intensity meters are made by Ultra-Violet Products, Inc., and are sold by laboratory supply companies (Ultra-Violet Products, Inc.). They are available in two models: reading 300 to 400 nm and 230 to 270 nm. These are insensitive to visible light, so you can use them in normal ambient light conditions. Many photographic exposure meters have some sensitivity to the UV spectrum: if a Wratten 18A or similar filter is placed in front of the photo tube, readings of UV brightness can be made. Using a through-the-lens (TTL) meter in the camera, place the filter before the lens. Use care to exclude light leaks around the filter, or through the plastic of the meter's case. The meter will perform as a UV intensity meter, providing readings of relative intensity; these will have to be correlated, by trial-and-error exposure tests, to the film being used. Manufacturers' film speeds are used with visible light, and the effective speed to UV will be much slower (*Ultraviolet and Fluorescence Photography*, 1974). An example is using Kodak T-Max 400 film with a Pentax LX 35-mm camera, Pentax-A 50-mm lens, Kodak Wratten 18A filter, and TTL metering. The effective film speed is 1.0 International Standards Organization (ISO); using the same camera/lens/filter combination with the Pentax AF-200T small electronic flash unit, the flash factor is 6.0.

Many UV photographs are taken at an image scale between 1:10 and 1:1 life size. At these scales the positioning of the subject, camera, and UV source(s) is exacting. Exposure is affected markedly by minor adjustment of the equipment. You must observe the normal rules for photography at close distances: in particular, the inverse square law (halving the distance between the subject and the light source gives four times greater brightness) and the scale correction factor for exposure determination $(M + 1)^2$, where $M$ is the magnification expressed as a fraction).

UV absorbing safety goggles should be worn by anyone working with UV radiation sources (Ludvigh and Kinsey 1946). A group of subjects were tested for foveal sensitivity and critical fusion frequency to radiation between 320 and 400 nm. It was concluded that radiation in this long UV range is not harmful to these important functions of the human eye. Short and middle UV can give severe erythemal burns, such as sunburn. These burns and conjunctivitis take 4 hours to appear, so they are not evident at the time of exposure (Tyrell and Pidoux 1987). The possible cytotoxic effects of prolonged exposure to UV are also a concern.

## APPLICATIONS OF ULTRAVIOLET PHOTOGRAPHY

All terrestrial materials such as rock, sediments, soils, and vegetation have specific spectral reflection, absorption, emission, and polarization characteristics (Holz 1972). The visual appearance of these objects is familiar to us, but their appearance in the UV is likely to be different because one or more of these factors has changed. A better known parallel to this is the appearance of everyday objects photographed in the IR.

There are special cameras for use in the 250 to 400 nm spectral range. They use wide-aperture lenses made of quartz and lithium fluoride and are fitted with narrow band UV Fabry-Perot thin-film evaporated filters. The Perkin-Elmer Corp. (Wilton, CT) makes an aerial UV camera system to this specification. Kodak Aerographic black/white (BW) film type 2424 is recommended for aerial UV photography. IR scanners will record UV if the photomultiplier tube is replaced by a UV detector with a S-11 photocathode and is used with suitable narrow band UV filters. Hamamatsu Corporation in Japan markets electronic imaging equipment of this type to translate UV images to visible images; this equipment can be used to preview subjects prior to UV photography.

UV does not penetrate as deeply through the skin layers as does light and the near IR (Figure 13.2), so UV photographs will enhance detail on the surface layer of the skin that may be hard to distinguish with the eye or normal photography (Anderson and Parrish 1982). Melanin, the tanning agent in the skin, strongly absorbs ultraviolet between 330 and 400 nm (other epidermal

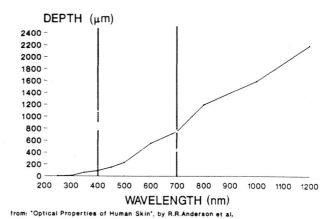

from: "Optical Properties of Human Skin", by R.R.Anderson et al.

**FIGURE 13.2  Comparing the very slight penetration of UV through skin, with that of visible light, and the much greater penetration of IR.**

chromophores do not), so small differences between pigmented and unpigmented skin are exaggerated by UV photography. Any photography of the skin surface has problems with specular reflections of the light source obscuring surface detail. This problem is exaggerated in UV photography because the radiation is reflected from closer to the skin surface and can be minimized by using a light source of small surface area or by moving it farther away from the subject.

Use long UV and glass lenses for these studies. The photographic exposure in living subjects is usually made using electronic flash and a Wratten 18A (or similar) filter fitted before the camera lens. Since you cannot see or focus with the filter in place, suitable arrangements have to be made to fix the subject/camera positions between focusing, fitting the filter, and exposure. An alternative method, if a totally darkened room is available, is to fit the filter over the light source. Viewing and focusing can be done under normal room illumination, and the room light can be switched off briefly for the moment of exposure. There seems to be no advantage in the use of color film; the ability to choose a photographic material with the correct (increased) contrast characteristics is most important. Next is a choice based on speed and resolution. In the past, Kodak Technical Pan and Commercial films (or similar) have been selected; today the choice may lie with one of the improved film types such as one of the Kodak T-Max films developed to a higher than usual contrast index. You may also take photographs of the subject by visible light for use as controls.

The characteristics shown by everyday materials to different forms of radiation will sometimes allow a UV photograph to show detail that cannot be seen or is difficult to discern by visible light. Examples of this are: fingerprints, where the oils left by fingerprints on many different surfaces can be clearly recorded (Ultraviolet and Fluorescence Photography, 1974); tire tracks and footprints, which become more obvious using UV pho-

tography; and writing or artwork that has been erased or altered can be revealed, which is helpful in detecting forgeries. See Chapter 12 for Biomedical Applications.

In dermatology, pictures may exaggerate freckles and other mildly pigmented lesions using this technique (Marshall, 1989). Many dermatological conditions of depigmentation or hyperpigmentation, such as nevi, melanomas, albinism, and vitiligo, in Caucasians have been photographed using long UV with good results (Williams 1988). Injury to the skin causes melanin to be released to the surrounding area. Melanocytes move to the edge of the wound as it heals, allowing the outline to be photographed when illuminated with long UV (Krauss and Warlen 1985). After the wound has faded and become invisible to the eye, it can still be recorded by UV photography for up to 6 months after injury. Bite marks where the skin is unbroken and similar trauma in rape, child abuse, and homicide cases can be recorded. It can also be used to make tattoos disappear. This happens because the pigment is under the surface layer of the skin and the UV is reflected from the unstained top layer (Frair and West 1989). One application of UV photography mentioned in the microbiology literature is the detection of aflatoxin-producing molds. These reproduced as dark colonies, contrasting with non-aflatoxin-producing molds, which appear as white colonies (Yabe et al. 1987).

There are two uses for UV microscopy: to show differences among structures that are poorly demonstrated under visible illumination, and to obtain sharper resolution than is possible with normal light. Biological materials have absorption characteristics different from UV compared with the visible spectrum. Higher absorption is obtained with short UV than with long UV. Using UV may increase the contrast between tissues in a specimen, although the overall image contrast will be low because of the gamma/lambda effect. Microscopes with glass lenses (apochromats are recommended) can be used for UV work at 365 nm. If you use spectral emissions lower than this, you should employ quartz or catadioptric lenses and condensers. Film and filter recommendations are the same as for UV photography.

High-pressure mercury arcs are common emission sources for UV microscopy. A comparison of the optical resolution at the emission peaks of these lamps would be: 0.21 $\mu$m at 546 nm (green), 0.17 $\mu$m at 435 nm (blue), 0.14 $\mu$m at 365 nm (long UV), 0.10 $\mu$m at 254 nm (short UV). Using monochromatic green will give better resolution than using the full visible spectrum by avoiding chromatic aberrations in the lens. As these figures show, there is a useful gain in resolution using illumination of 365 nm, over monochromatic green. Trial-and-error tests are needed, both to determine the photographic exposure time and to refocus the image, which will have shifted from the visual point when the UV filter is placed in the light beam. To minimize this shift, visual focus usually uses a monochromatic green or blue filter.

## FLUORESCENCE PHOTOGRAPHY

When materials are irradiated (illuminated) by electromagnetic radiation and, as a result, emit radiation of a longer wavelength, the phenomenon is called *luminescence.* If when the exciting radiation is stopped the luminescence ceases, the phenomenon is termed *fluorescence;* if the luminescence persists longer than $10^{-8}$ secs. it is termed *phosphorescence.*

Fluorescence can only be excited in a material by radiation of specific wavelength, and the resulting fluorescence will be at a specific wavelength(s). Materials with inherent fluorescence capabilities are said to exhibit *primary fluorescence* or *autofluorescence.* Others need to be stained or injected with a *fluorochrome.* Fluorescence can be induced by x-rays, electrons, UV, visible light, and IR when it is termed *IR luminescence.* Intensity of the fluorescent emission is proportional to the radiant power of the exciting radiation (Schenk 1973). The brightness of the fluorescence will always be weaker than the radiating source, in the range of from 100:1 to 1000:1 times weaker. To record fluorescence photographically, the photographer must block the exciting radiation from reaching the film. Photographic exposures of minutes or hours may be necessary. Such long exposure times can cause the fluorescence to fade by excessive irradiation of the subject. In addition, long exposures cause reciprocity failure in film emulsion. Therefore make every effort to keep exposure times as short as possible. (See Chapters 1 and 3)

This chapter has discussed the characteristics of UV emission sources previously. Quartz iodine lamps and photographic electronic flash units are good sources where blue light is the exciting radiation.

The irradiating source will emit unwanted wavelengths, and these need to be eliminated by an *excitation* filter, leaving only the wavelengths of choice to pass through and excite fluorescence. The photographer must prevent exciting radiation from reaching the film by placing a *barrier* filter before the lens. It is important to place the barrier filter before the lens of the camera or microscope because lenses, lens coatings, and some filters may exhibit fluorescence if UV radiation reaches them. For fluorescence microscopy, microscope manufacturers supply sets of excitation/barrier filters to match the specific requirements of materials exhibiting fluorescence. Although you can use these filters for photography, their diameters are usually too small to be used with camera lenses.

For UV fluorescence photography, suitable excitation filters are: Kodak Wratten 18A, Corning CS 7-60, Chance OX1, or Schott UV-IL; these will pass long, and some middle UV. Fit the filter and carefully seal it in front of the radiation source, allowing no light to escape. Other UV lamps can also be used for photography; sometimes these are fitted with their own particular exci-

tation filter, and the lamps usually have emission peaks at 254 or 365 nm. The Corning CS 7-54 filter passes short, medium, and long UV (range 250 to 390 nm) and is a useful general-purpose excitation filter.

Placing a Kodak Wratten 2B filter before the camera lens will eliminate UV and allow all colors from the fluorescing material to reach the film (Gibson 1962); using this filter and color film would give the photograph an appearance close to that visualized under a Wood's lamp. This is predominantly blue; and if green, yellow, or red fluorescence is also present, the blue would mask it. To record these other colors, replace the Wratten 2B filter with a Wratten 8 filter, which will suppress most of the blue and allow demonstration of the other colors. Unfortunately, the Wratten 8 filter will itself fluoresce under UV, so place an additional filter (Wratten 1A or 2B) before it to absorb the UV from the emission source. Using this combination will approximately double the exposure time of the 2B used alone. The range of Kodak Wratten filters that block UV and increasingly block more blue light is 1A, 2B, 2A, 2E, 3, 8 (Thomas 1973). Unlike UV photography, fluorescence photography does not have a problem with troublesome specular reflections from the surface of the subject because only the emitted fluorescence is being photographed, not the reflected radiation of the emission source. However, take care to illuminate the subject evenly. If only one emission source is used at one side of the camera, there will be a falloff of brightness across the subject, giving a misleading appearance. Usually a pair of UV sources should be used, one on each side of the camera to give even *lighting*. You might make an exception if an electronic flash unit is placed very close to the lens axis (or a ring flash) and used with an appropriate filter (Wratten 18A or similar).

Kodak Ektachrome 400 Professional color film and Kodak T-Max 400 Professional BW film are a good choice for most fluorescence photography and photomicroscopy. As with normal photography, better control over contrast is possible when using BW films rather than color films. For very faint fluorescence, use films with very high-speed ratings. Kodak Ektachrome P800/1600 Professional color film, Kodak T-Max P3200 Professional BW film, and Polaroid Land BW films types 47 (3000 ISO), 57 (3000 ISO), 410 (10,000 ISO), and 612 (20,000 ISO) are examples of suitable films. The two Kodak films can be *push processed* to even higher speeds. The Polaroid film 47 has a gamma/slope of 1.40, the 410 film a gamma/slope of 2.30, and the 612 film is also a high-contrast type. These films can also record bioluminescence and chemiluminescence; the technique is similar to that used for autoradiography. The film is placed in close contact with the material being studied to record the light emission, and a camera is not used (Kricka and Thorpe 1986).

Very sensitive photoelectric exposure meters can measure fluorescence brightness. You must use the same barrier filter(s) before the photocell that you use before the camera lens; these should also be carefully fitted and sealed. Otherwise, you will have to determine photographic exposures by trial and error. As a guide: fluorescence induced by laboratory *Fluorolamps* placed 12 inches from the subject will need approximately 30 seconds exposure using 254-nm lamps, and 4 minutes exposure using 365-nm lamps, both with 400 ISO film and a lens aperture of $f/4$ (Gibson 1959). Fluorescence photography can be applied to detecting forged documents; detecting fingerprints after they are dusted with a fluorescent powder; authenticating paintings by identifying the pigments used by the artist, after any varnish covering the painting has been removed; identifying minerals; locating cracks in metals after a fluorescent compound has been washed into any cracks present (Ultraviolet and Fluorescence Photography 1974); and demonstrating fluorescent bands in chromatograms (Eastman Kodak, *Photographing Chromatograms*). Forensic uses are detecting body fluid stains and gunpowder residue, and to determine whether metals have been in contact with the skin by treating the skin surface with chemicals that will fluoresce if traces of metal are present (Frair and West, 1989).

To photograph living subjects it is usually preferable to use electronic flash (with excitation filter) as the emission source. The very short exposure time will eliminate the possibility of subject movement, and if the ambient room illumination is kept at a low level, will allow ordinary visual focusing of the camera. In dermatology, irradiation by UV at 365 nm will allow photography to record the fluorescent appearance of tinea capitis (ringworm) lesions (Gibson 1962), and erythrasma caused by *Corynebacterium minutissimum*, which produces a porphyrin that fluoresces coral-red. The most common organism causing infection of burn wounds, *Pseudomonas aeruginosa*, is recognized early by its yellow-green fluorescence, which can be photographed. Fluorescence photography using UV at 365 nm can aid in the identification of some dental conditions; the dentine of normal teeth fluoresces a light blue color. Teeth with a covering of calculus will appear yellow-orange. Following antibiotic tetracycline therapy, the antibiotic is incorporated into the tooth structure and will appear yellowish-brown in visible light and will fluoresce bright yellow. Dental carnauba carving wax will fluoresce when irradiated with UV at 365 mu; this is demonstrated in Color Plate 53, where residual wax is seen as pale blue contrasted with the white plaster mold seen as dark blue in the fluorescence photograph.

Measurements of the rate at which the tissue of the skin surface (stratum corneum) is lost can be made using the same photographic technique. The skin is prepared by using the colorless, fluorescing chemical agent dansyl chloride, which is taken up by the stratum corneum. Over time, the stratum corneum is lost and replaced with

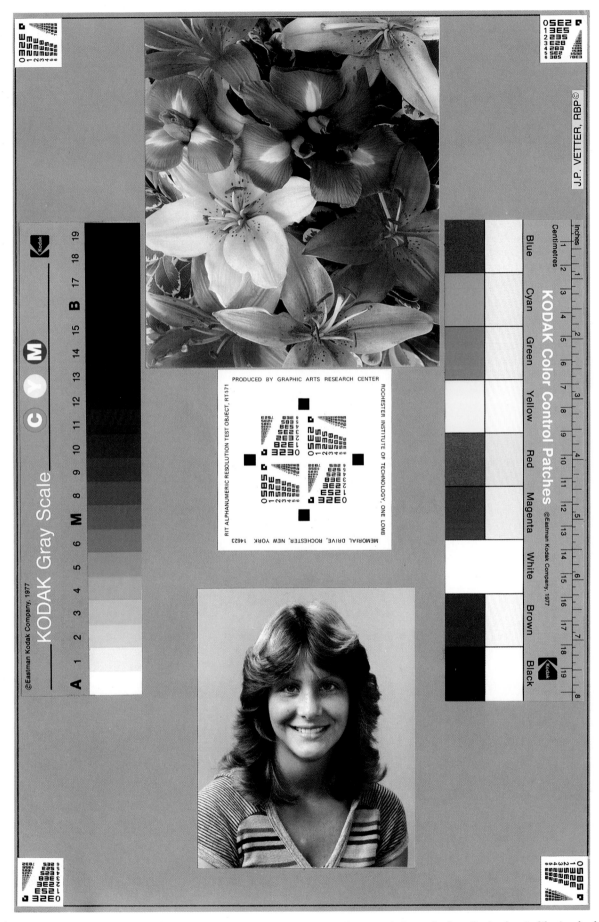

**COLOR PLATE 1** A test chart should contain a sampling of subject types that are photographed routinely along with standard test items. This chart contains Kodak's color control patches and gray scale, Rochester Institute of Technology alphanumeric resolution test object, a portrait and a flower image by Nikon electronic imaging system. (John Harcourt)

**COLOR PLATE 2** (a) A copy slide on daylight balanced film with an uncorrected viewbox with cool white fluorescent tubes. (b) A copy slide on daylight balanced film with a viewbox containing VitaLite brand fluorescent tubes. (c) A copy slide on daylight balanced film exposed with a Nikon SB-16 electronic flash as described under the title "Obtaining Proper Color Balance by Using Electronic Flash" and shown in Figure 5.9. (d) A copy slide with a 1% pre-flash exposure on daylight balanced film and a viewbox containing VitaLite brand fluorescent tubes. Compare to b. (e) This PET (Positron Emission Tomography) scan depicts brain images receiving auditory stimulation. (f) PET scan of a liver with cancer. (PET images provided courtesy of Siemans Medical Systems, Inc.)

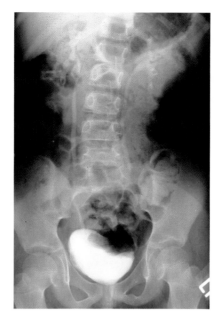

a

b

c

d

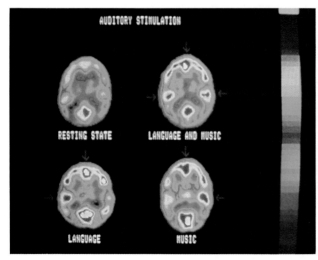

e

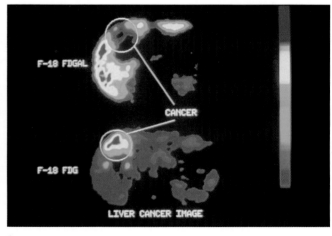

f

**Median Ring is a fibrous structure composed of:**

- Aponeuroses of the transverse abdominal muscle

a

**Median Ring is a fibrous structure composed of:**

- Aponeuroses of the transverse abdominal muscle
- Fused abdominal oblique muscles

b

**Median Ring is a fibrous structure composed of:**

- Aponeuroses of the transverse abdominal muscle
- Fused abdominal oblique muscles
- Abdominal tunic

c

COLOR PLATE 3 (a–c) The progressive disclosure technique allows the audience to see only what the speaker is discussing at present. What is to be discussed next is on the following slide. White is the best color to use for highlighting.

**Median Ring is a fibrous structure composed of:**

- Aponeuroses of the transverse abdominal muscle
- Fused abdominal oblique muscles
- Abdominal tunic

COLOR PLATE 4 Breaking the rule of never mixing fonts can be done occasionally. In this case Times Roman is used for the title and Helvetica is used for the body text. It is recommended that you be conservative; never use more than two fonts and avoid using stylized fonts altogether.

COLOR PLATE 5 The color is achieved by sandwiching a gel into the slide mount with the lith image. An X-Acto™ knife is used to cut a hole in the gel allowing the text to appear white. This is a basic graphic slide technique that is quick to produce and is popular with clients.

**COLOR PLATE 6** The *film model* used to teach photographic theory is made up of three slides, representing each layer in the color film. The steps to produce this model are listed in the text. You need to produce a set for yourself, to take full advantage of the explanation of color theory.

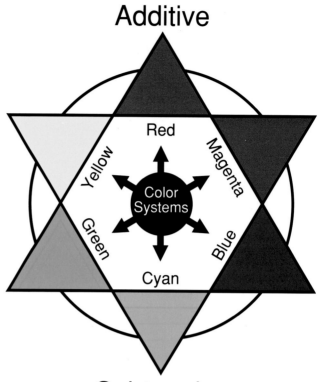

# Additive

## Subtractive

**COLOR PLATE 7** This Star of David color chart shows the three primary colors of the additive system in the triangle that points up, while the triangle that points down contains the three primary colors of the subtractive system. Each color is formed by combining the two colors on each side. If they are additive colors, you must mix wavelengths of light. If they are subtractive colors, you must superimpose dyes to produce the color in the middle. The color opposite another color is that color's complement and is used to nullify that color.

# Graph

*short for graphic formula*

a diagram, as a curve, broken line, series of bars, etc., representing the successive changes in the value of a set of variable quantities.

**COLOR PLATE 8** This is a three-color lithochrome produced by using the burn-through technique and Wratten filters. A chart describing the lithochrome color possibilities is included in the text.

**COLOR PLATE 9** The steps involved in producing the *watermark* graphic slide technique. (a) The image following step 3 of the watermark technique, (b) the image on color film following step 6, and (c) the *master* watermark slide following step 11. This is kept beside the duplicator for use on jobs as requested. (d) This is a sample of the graphic slide delivered to the client with the watermark subtly in the background.

a

b

c

d

a

b

c

d

**COLOR PLATE 10** (a–d) Vector graphic images are produced by placing objects in layers. Objects can be (but are not limited to) lines, squares, circles, polygons, or text. Each object has a set of attributes such as object type, size, location, fill, and color. This vector image is created in much the same way you would cut and paste construction paper to build an image with paper objects in layers.

a

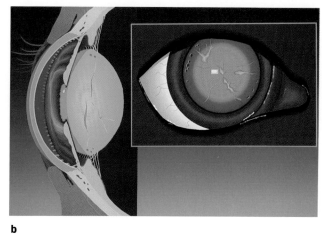

b

c

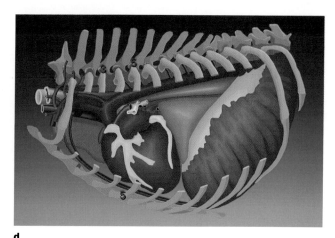

d

**COLOR PLATE 11** (a–d) In the hands of a talented illustrator, a vector graphic program can produce high quality educational slides. Each image exists on disk and can be altered to meet the needs of a different client.

**COLOR PLATE 12** (a) Raster graphic images are made up of small square picture elements called pixels. (b, c) Enlargements of the image in a. The individual pixels have only one color. The range of colors available is determined by the *bit* palette. The resolution is controlled by the number of pixels that make up the image. (d) This figure shows how the bit-mapped image can be placed into a vector graphic program to create a window effect.

a

b

c

d

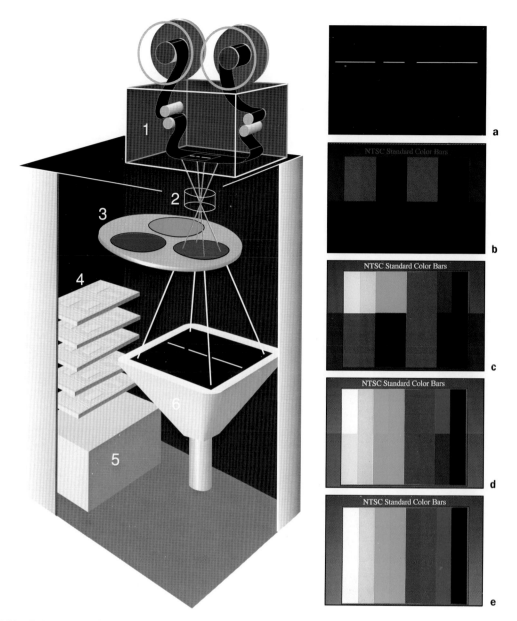

**COLOR PLATE 13** This diagram shows you the way a color film recorder (CFR) produces an image. The key components of a CFR are (1) the film chamber, (2) the lens, (3) the additive primary color wheel, (4) the computer-printed circuit boards, (5) a sophisticated power supply, and (6) the most important element, a flat-screen, high-resolution, black-and-white, cathode-ray tube (CRT). The image is *scanned*, which means there is never a time that the entire image is displayed on the CRT. (a) This is what you could expect to see if you looked through the lens during the time the red portion of the image was being recorded. The computer inside the CFR has divided the image into its red, green, and blue components and scans the exposure one line at a time on the black and white monitor. The color is reestablished by placing a filter wheel in the light path. (b) This figure shows what the film has recorded half way through the red scan. (c) This figure shows what the film has recorded with a full red scan and half of the green scan. (Note red and green forms yellow.) (d) This figure shows what the film has recorded with a full red scan, a full green scan and half of the blue scan. (e) This is the final image produced following all three scans. Over 16.7 million colors can be produced by this method.

**COLOR PLATE 14** After 1 hour of training, by our department, clients bring in their disks with files such as the one seen here. Their files are sent to the CFR and the slide is delivered the following day.

**COLOR PLATE 15** Uneven illumination.

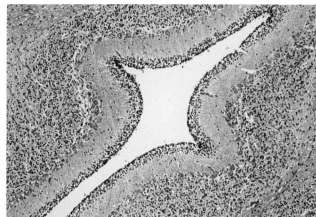

**COLOR PLATE 16** Temporarily remove any diffusion screen from the light source and center and focus the light source image on a section of translucent paper placed in the condenser's filter holder. A small hand mirror may be required to see the image on the paper.

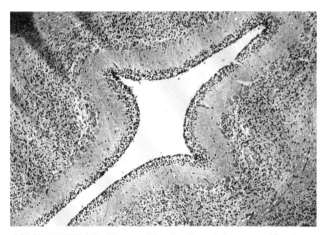

**COLOR PLATE 17** Uneven illumination at low magnifications: A faint image of the lamp filament may be present.

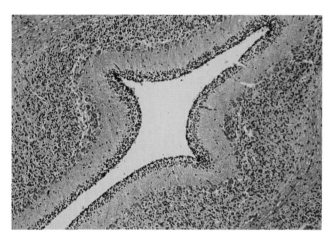

**COLOR PLATE 18** Yellow-colored transparency.

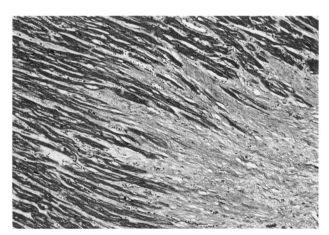

**COLOR PLATE 19** Very-warm-colored transparency.

**COLOR PLATE 20** Insert the appropriate filter in the light path.

COLOR PLATE 21   Blue-colored transparency.

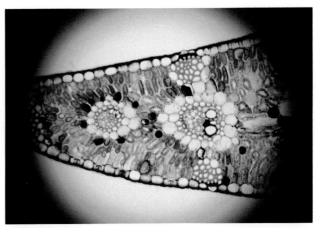

COLOR PLATE 22   (a) Mild but annoying alternate blue and yellow off-colored images appearing only with objectives above NA 0.60. Note the red fringe color of the diaphragm's image.

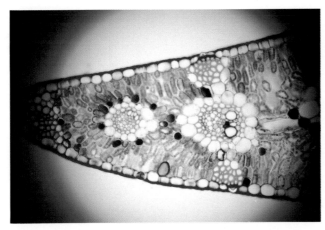

COLOR PLATE 22   (b) Mild but annoying alternate blue and yellow off-colored images appearing only with objectives above NA 0.60. Note the blue fringe color of the diaphragm's image.

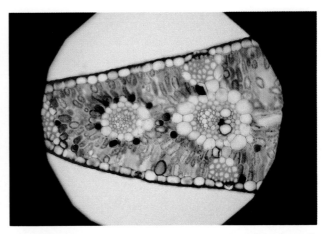

COLOR PLATE 23   After setting the *aperture* diaphragm for optimum imagery, focus the condenser to produce equal quantities of red and blue fringing around the *field* diaphragm's image. Any further alteration of the aperture diaphragm may require refocusing the condenser. An achromatic—aplanatic condenser virtually eliminates the problem as in this example.

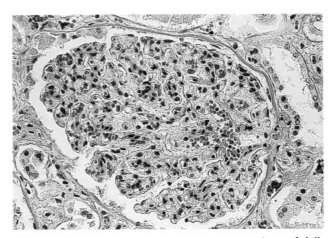

COLOR PLATE 24   Excessive hard-edge images. Loss of delicate details. Small subjects surrounded by light and dark rings.

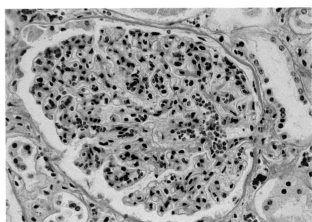

COLOR PLATE 25   Readjust the diaphragm to produce the best ratio of transmitted light to diffracted light for the tissue in question.

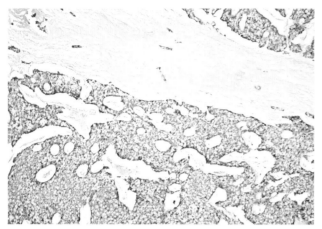

**COLOR PLATE 26**   Insufficient contrast.

**COLOR PLATE 27**   Most, but not all, specimens require reducing the aperture diaphragm below the aperture of the objective lens. Adjust the diaphragm to suit the specimen. Always set the field diaphragm slightly outside the field of view for the film format.

a
b

**COLOR PLATE 28**   (a, b) Images out of focus at low magnifications but not at high magnifications. The problem occurs only with a young operator.

**COLOR PLATE 29**   Images are hazy when using high-dry lenses.

**COLOR PLATE 30**   Although more than one solution may be necessary, only two are practical on the modern microscope. (1) Adjust the correction collar (if any) until the image has maximum contrast, or (2) reduce the aperture diaphragm to the smallest level consistent with acceptable image quality.

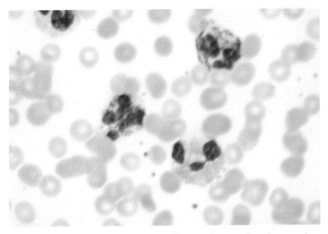

COLOR PLATE 31    Images are hazy when using immersion lenses.

COLOR PLATE 32    Air trapped in the immersion fluid (view at rear lens of objective).

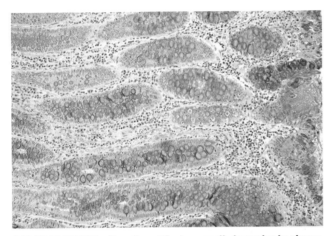

COLOR PLATE 33    Density artifacts, usually irregular in shape.

COLOR PLATE 34    Dirt on top or bottom of specimen slide. This can be verified by noting the artifact's position as the slide is shifted and focused above and below the specimen.

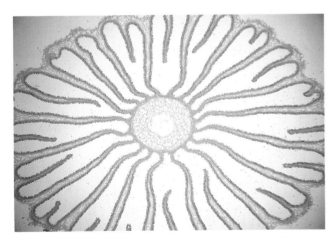

COLOR PLATE 35    All four edges of field equally dark at very low magnifications.

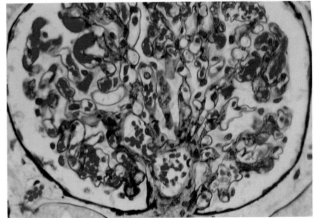

COLOR PLATE 36    Dark and off-color images at high magnifications. The effect is most likely to occur when using large-format films.

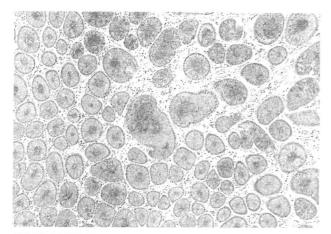

COLOR PLATE 37 Film is overexposed only at low magnifications.

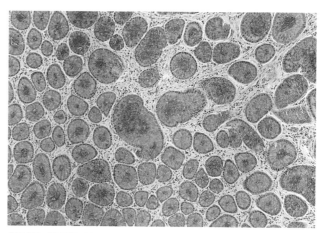

COLOR PLATE 38 Inserting a neutral-density filter into the light path will correct the excessive illumination.

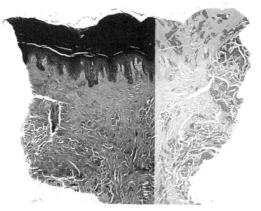

COLOR PLATE 39 No exposure or multiple overlapping exposures. Torn sprocket holes at the lead end of the film.

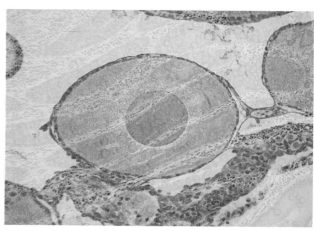

COLOR PLATE 40 Ghost images.

COLOR PLATE 41 Four easily identified images will confirm that Köhler illumination has been attained. (a) With the specimen in sharp focus adjust the *field* diaphragm for a small opening (Figure 7.18a) and focus the diaphragm's image by adjusting the substage focusing knob (Figure 7.18c). (b) Center the *field* diaphragm by using the radial centering screws (Figure 7.18d). (c) Open the *field* diaphragm to 3/4 field of view and adjust the *aperture* diaphragm for the best image quality (Figure 7.18b). Confirm accurate focus of the specimen and refocus and recenter the *field* diaphragm. For Köhler illumination the specimen and the *field* diaphragm must be in identical focus. (d) Open the field diaphragm until it is just outside the field of view.

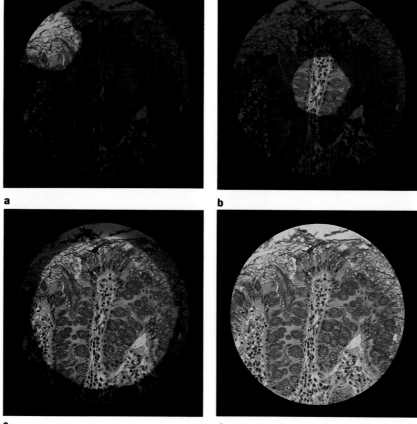

a

b

c

d

COLOR PLATE 42   Time exposure at dusk. (Jerry D. Luther)

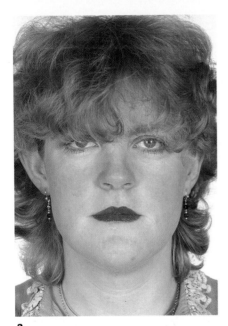 

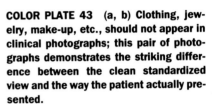

COLOR PLATE 43   (a, b) Clothing, jewelry, make-up, etc., should not appear in clinical photographs; this pair of photographs demonstrates the striking difference between the clean standardized view and the way the patient actually presented.

a

b

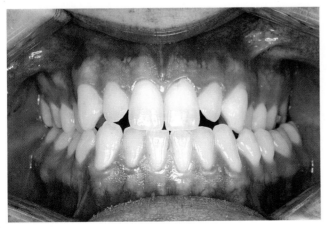 

a

b

COLOR PLATE 44   (a) 1:2 is just large enough to incorporate the complete dentition. (b) 1:1 is used for the big close-ups in dermatology and ophthalmology.

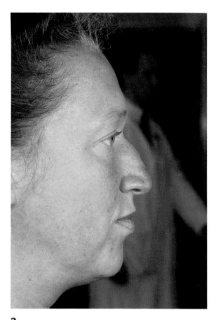

a

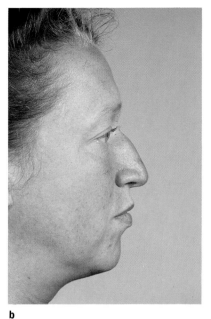

b

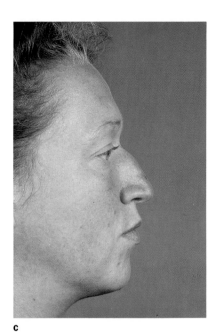

c

**COLOR PLATE 45** Control of the background is most important in patient photography. (a) Lack of a separately controlled background leads to disturbing artifacts. (b) Grey backgrounds are often selected for their neutrality of color and tone. (c–e) Other colors may be used but care should be taken in the selection of color. Each of the skin tones reproduced here is the same, but the viewer's impression of the skin color is influenced by the adjacent background color.

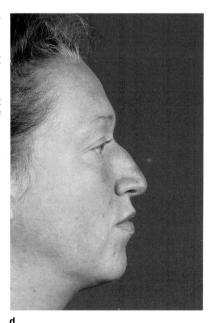

d

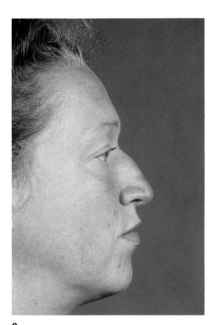

e

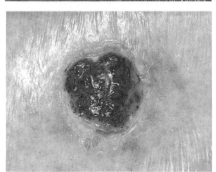

**COLOR PLATE 46** The direction of lighting can seriously influence our perception of a lesion. Light should always simulate daylight with shadows being allowed to fall downward (top); if the same protruding lesion is lit from beneath (bottom) it no longer appears to stand out.

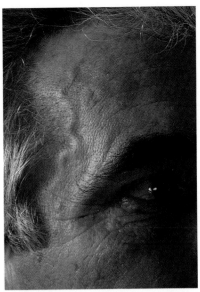

**COLOR PLATE 47** Strong cross-lighting is sometimes called for as in this distended temporal vessel, which would not have shown with the standardized lighting.

a

b

c

**COLOR PLATE 48** Selection of film type is critical in the achievement of a standardized result. There is no such thing as the perfect film, all films vary in their color response with age. (a) Recorded on Kodachrome 64 professional. (b) Recorded on Agfa 50RS. (c) Recorded on Fuji RFP 50.

**COLOR PLATE 49** Strange color casts can easily be introduced to patient photographs; this marked jaundice was actually yellow reflection from an x-ray envelope sitting on the patient's lap.

**COLOR PLATE 50** The effect of exposure can be critical to the appearance of a patient in clinical photography. The center photograph was recorded on color transparency material at the correct exposure, the top received just one-third of an f-stop more, and that bottom one-third of an f-stop less.

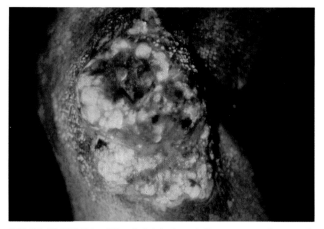

**COLOR PLATE 51** Ultraviolet induced fluorescence in an advanced carcinoma of the knee; injected fluorescein dye reveals the area of active blood supply as yellow, while bacterial invasion fluoresces red. Such photography is often used to assess blood supply before and during surgery.

**COLOR PLATE 52** Tinea capitis, a fungal infection of the scalp, is revealed by the ultraviolet fluorescence technique. Many bacterial and fungal conditions fluoresce with a characteristic color.

**COLOR PLATE 53** Residual dental carving wax, showing as pale blue fluorescence; on white a plaster cast that appears dark blue.

**COLOR PLATE 54** (a) Normal visible light appearance of a baby with a chondroma of the left chest wall. (b) Appearance of the same area photographed by the IR technique described in the text.

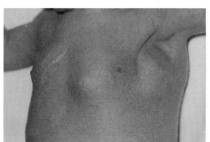

a

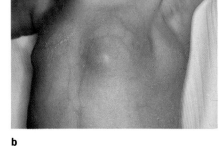

b

**COLOR PLATE 55** (a) Normal visible light appearance of a mycosis fungoides, tumor stage lesion of the external ear. (b) The same area photographed by the IR technique described in the text. Demonstrates the difficulty encountered with specular reflections.

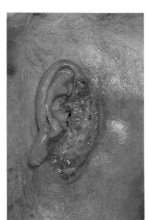

a

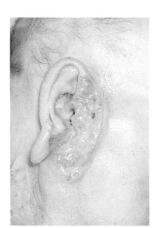

b

new unstained tissue from below. Taking a series of photographs at weekly intervals (Marshall 1989) demonstrates this. (See Chapter 12)

## INFRARED

The boundary between visible deep red light and the IR is 700 nm, although young people can discern radiation to about 800 nm (Graham et al. 1965). The other end of the IR spectrum is at about 1 million nm (1 mm) at which point the radiation becomes microwaves. Thermal (electronic) IR recordings can be made from 700 to 10,000 nm—from white heat down to body or room temperature. IR vidicon tubes allow the making of television pictures from 700 to 3000 nm. The sensitivity of film emulsions, even those with *extreme* IR sensitivity used for astronomy, extend only to 1200 nm. For all practical purposes, the sensitivity of IR photographic film sets the limit for IR photography, which is 900 nm. This is also the spectral range of Newvicon vidicon television tubes.

In the photographic range, IR passes more freely through air, glass, and water than visible light, so that IR photography is particularly valuable in penetrating atmospheric haze to produce a clear picture. However, water is opaque to parts of the IR spectrum within the range of IR television. There are IR transmission windows through water at 600 to 1300 nm and 1600 to 1850 nm (Hudson 1969).

IR radiation is usually produced by thermal means. For photography of reflected IR, IR luminescence, and false color IR, the emission source has to be white hot. Sunlight and other light sources can be used, with the exception of cool lights such as fluorescent tubes. Photoflood and quartz photographic lights are recommended. For photography of living subjects, use electronic flash and flash bulbs (Eastman Kodak, *Thermal Recording and Infrared Photography of Hot Objects* 1988). To photograph an emission source itself, the temperature of the source has to be greater than 480°F (249°C) to expose IR-sensitive film, and greater than 930°F (499°C) (dull red heat) to expose panchromatic film. It follows that photography cannot record the heat lost through the walls of a building, or the difference in temperature of parts of the body. That is the province of thermal electronic recording, which is often loosely called *thermal photography.* Photographs are made of the CRT images in these devices.

All photographic emulsions are sensitive to UV and blue light. Sensitizing dyes are used to increase emulsion sensitivity to longer wavelengths: to include green light (orthochromatic), green and blue light (panchromatic), and green and red light, and IR radiation (IR). Thus, IR films have the widest sensitivity. Take care that all unwanted radiation is removed with the correct photographic filter.

Black and white IR film is available in rolls and sheet film: for example: Kodak High Speed Infrared film 2481 (35-mm rolls and sheet film). Kodak Ektachrome Infrared film 2236 (35-mm rolls) will be discontinued when the stocks of E-4 chemicals are depleted. The following information is included for scientific interest only. The three emulsion layers in normal color films are sensitive to blue, green, and red light. In Ektachrome Infrared color film the layers are sensitive to green, red, and IR. If this film is used in the camera for visible light photography, the picture is a *false color* photograph. Care should be taken that IR films are purchased fresh from the manufacturer, and they must be stored in a refrigerator to retard deterioration.

Conventional lenses are suitable for IR photography. IR does not focus at the visible point; it acts as if the focal length of the lens were longer. Many camera lenses have a red (IR focusing) mark on the lens barrel: after setting the visual focus, adjust the lens from the visual mark to the red mark. If IR film is used to make false color photographs, adjust the focus to halfway between the two marks. For cameras and optical instruments without this red mark, make trial-and-error tests to find the point of optimum focus, and make a mark on the lens barrel. Once it is found for a particular lens, the mark can be used for any subject-to-lens distance. Modern cameras are safe for IR photography, but test to ensure that old cameras (bellows, shutters, and other parts) do not leak IR and fog the film. Make similar tests of the darkroom where the film is handled. Optical resolution in the IR is lower than in visible light, and many IR photographs record subsurface detail, where scattering within the subject will reduce sharpness even more.

Photographic filters for IR photography are made by a number of manufacturers, including Eastman Kodak, Tiffen Manufacturing Corp., Ilford Ltd., Corning Glassworks, Chance/Precision Optics, Polaroid Corp., and Oriel Optics Corp. A Kodak Wratten 87 filter passes IR longer than 750 nm, and blocks visible and UV radiation; the Wratten 88A is similar, but passes IR longer than 720 nm. For false color photography, placing a Wratten 12 filter before the camera lens will eliminate UV and blue light; it passes green, red, and IR.

IR photography has applications in many scientific fields. Aerial IR photography has been used to detect low areas where water collects and mosquitoes deposit their eggs in pools, rice field levees, ditches, and tire tracks (Welch et al 1989). IR photography can also help to detect alterations in paintings; some pigments that are transparent to IR allow an earlier painting below to show through. IR photography can see beneath what censors blank out, allowing the original writing to be discerned, and will also reveal the bleaching or forgery of documents. It will also help in the deciphering of charred, stained, and age-darkened documents, for example, the Dead Sea scrolls (O'Neill 1983).

IR photography can record human and animal behavior by taking a picture by invisible light, unseen in normal room light, or pictures can be taken in the dark so that animals will not be disturbed by a bright light. Photographs can be taken of the pupil of the eye, which will remain in the dark-adapted position. Use electronic flash for these IR photographs with a Wratten 88A or 87 filter fitted in front of the flash so that no visible light is seen (Eastman Kodak, *Applied Infrared Photography* 1987).

The same light/filter combination can be used to photograph the surface of the body to demonstrate subsurface vasculature. A single flash head mounted close to the lens axis will suffice (Color Plate 54), but because most parts of the body are rounded, two lights each at 30 degrees either side of the lens axis, or bounce flash in a white room, will provide more even illumination (Eastman Kodak, *Medical Infrared Photography* 1969). IR photographs require reflected IR radiation, so specular reflections of the IR source can obscure detail in shiny subjects (Color Plate 55). For this reason, it is better to use a compact flash unit, Perspex rod light pipe, or fiberoptic mounted close to the lens axis for photomacrography of small blood vessels in the eye, nailbed, or mesentery.

A similar technique demonstrates IR contrast angiography of the surface of the brain in dogs after injection of indocyanine green into the carotid arteries. You can see dye passing into the arterial capillaries and later filling the veins. Using false color IR photography, arteries appear to be yellowish, and veins are brownish (Choromokos et al. 1969). False color photography of black skin lightens skin tone. A darkly pigmented nevus appears lighter with a clearer border to the lesion. In skin and fundus photographs malignant tissue appears darker, suggesting that malignant tissue absorbs long-wave radiation (Breit 1988). (See Chapter 12 for Biomedical Applications).

## INFRARED LUMINESCENCE PHOTOGRAPHY

The technique used for IR luminescence photography is similar to that used for fluorescence photography; the pioneer work on IR luminescence photography was reported in 1962 (Gibson 1962, 1963, 1963). The photographer must remove IR from the light source, usually photoflood or quartz iodine lights, by an excitation filter; the lights are very hot, and you should protect the blue-green excitation filter placed in the light beam by a heat-absorbing filter. A Corning 4-76 molded blue-green glass excitation filter, and a Corning HR 1-59 heat absorbing filter, with the 1-59 filter closest to the light source, are a suitable combination. A Wratten 88A barrier filter is fitted in front of the camera lens. If a control photograph is taken, and the exposure calculated with only the excitation filter(s) in place and no barrier filter, the exposure with the barrier filter replaced will be about 20,000 times

greater. Because of the very long exposure times, take extreme care that the room or enclosure used for photography is *absolutely* dark. Chlorophyll, bilirubin powder, adrenal cortex, old teeth, and healthy skin (Kodak, *Applied Infrared Photography* 1987) have strong IR luminescence.

A similar technique may also record deep-red fluorescence. The UV/blue excitation combination of filters are a Wratten 34 (violet), with a spectral cut off at 500 mu to eliminate green, and the Corning 1-59 plus 4-76. Fit a Wratten 12 (yellow) barrier filter to the camera lens, with a Wratten 2E in front of it to eliminate all UV; UV causes the No. 12 filter to fluoresce. This technique may be useful to study the composition of gallstones and other physiological accretions. IR luminescence television microscopy of nailbed capillaries has been reported (Moneta et al 1987) using a modified Wild/Leitz fluorescent microscope, halogen light source, microchip IR television camera from Kranz Electronic (peak sensitivity between 650 and 850 mu), and a fluorescent tracer indocyanine green (peak fluorescence at 835 mu). Ditric Optics provided excitation and barrier filters; their spectral curves are close, resulting in a loss of contrast in the image.

## CONCLUSION

The period from 1955 to 1965 was an exciting time for those experimenting with photographic methods in the UV and IR following the introduction of improved films and light filters. Biomedical photographs were made of phenomena that had been seen previously, but not recorded. With the initial excitement over the applications of invisible radiation techniques to medicine there was a surge of publications about UV and IR photography. While invisible radiation techniques continue to enjoy popularity for the medical and forensic researcher, they have failed to find any routine application to clinical recording. There remains much to learn about the way tissues, particularly diseased tissues, responds to UV and IR radiation. Neurosurgery, fundus photography, forensic investigation, and the preservation and validation of works of art routinely use UV and IR photography.

Today these techniques, evolved through photography, can also be recorded electronically as television images. Then these images can be frozen in time or enhanced digitally with techniques easily learned on the personal computer.

## REFERENCES

Anderson R. R., and Parrish, J. A., 1982. *The Science of Photomedicine*. New York: Plenum.

Arnold, C. R., Rolls, P. J., and Stewart, J. C. J., 1971. *Applied Photography*. London: Focal Press.

Breit, P., 1988. The use of infrared photography in differentiating pigmented lesions. *J. Ophthal. Nurs. Technol.* 7:122–125.

Choromokos, E., Kogure, K., and David, N. J., 1969. Infrared absorption angiography. *J. Biol. Photogr. Assoc.* 37:100–104.

Eastman Kodak, 1969. *Medical Infrared Photography* N-1 (out-of-print).

Eastman Kodak, 1972. *Photographing Chromatograms* M-23.

Eastman Kodak, 1974. *Ultraviolet and Fluorescence Photography* M-27 (out of print).

Eastman Kodak, 1987. *Applied Infrared Photography* M-28.

Eastman Kodak, 1988. *Thermal Recording and Infrared Photography of Hot Objects* P-570.

Eastman Kodak, 1989. *Scientific Imaging Products* L-10.

Frair, J., and West, M. H., 1989. Ultraviolet forensic photography. *Kodak Tech Bits* 2:2–11.

Gibson, D. A., 1959. Recording fluorescent phenomena under ultraviolet radiation. *J. Biol. Photogr. Assoc.* 27:151–155.

Gibson, D. A., 1962. Fluorescence color photography of living subjects, *Med. Radiogr. Photogr.* 38:114–116.

Gibson, H. L., 1962. The photography of infra-red luminescence. *Med. Biol. Ill.* 2:155–166.

Gibson, H. L., 1963. The photography of infra-red luminescence. *Med. Biol. Ill.* 13:18–26.

Gibson, H. L., 1963. The photography of infra-red luminescence. *Med. Biol Ill.* 13:89–90.

Graham C. L., 1965. *Vision and Visual Perception.* New York: Wiley.

Holz, R. K., 1972. *The Surveillant Science: Remote Sensing of the Environment.* Boston: Houghton Mifflin.

Hudson, R. D., 1969. *Infrared System Engineering.* New York: Wiley-Interscience.

Krauss, T. C., and Warlen M. S., 1985. The forensic science use of reflective ultraviolet photography. *J. Forensic Sci.* 30:262–268.

Kricka, L. J., and Thorpe, G. H. G., 1986. Photographic detection of chemiluminescent and bioluminescent reactions. *Methods Enzymol.* 133:404–420.

Ludvigh, E., and Kinsey, V., 1946. Effect of long ultraviolet radiation on the human eye. *Science* 104:246.

Marshall, R. J., 1989. Revelations and numbers. *Photogr. J.,* June, 129:256–257, 293.

Moneta, G., Brulisauer, K., Jager, K., and Bollinger, A., 1987. Infrared fluorescence videomicroscopy of skin capillaries with indocyanine green. *Int. J. Microcirc. Clin. Exp.* 6:25–34.

Nieuwenhuis, G., 1991. Lens focus shift required for reflected ultraviolet and infrared photography. *J. Biol. Photogr. Assoc.,* 59:17–20.

O'Neill, J., 1983. Infrared photography and thermography, *Imaging Technol.* Nov., 6–15.

Schenk, G. H., 1973. *Absorption of Light and Ultraviolet Radiation: Fluorescence and Phosphorescence Emission.* Boston: Allan and Bacon.

Thomas, W. Jr., 1973. *SPSE Handbook of Photographic Science and Engineering.* New York: Wiley.

Tyrrell, R. M., and Pidoux, M., 1987. Action spectra for human skin cells: Estimates of the relative cytotoxicity of the middle ultraviolet, near ultraviolet, and violet regions of sunlight on epidermal keratinocytes. *Cancer Res.* 47:1825–1829.

Ultra-Violet Products, Inc., San Gabriel, CA, U. V. P. Product Catalogue.

Welch, J. B., Olson, J. K., Ingle, S. G., and Davis, M. R., 1989. Use of aerial color infrared photography as a survey technique for *Psorophora columbia* oviposition habitats in Texas ricelands. *J. Am. Mosq. Control. Assoc.* 5:147–160.

Williams, A. R., 1988. Reflected ultraviolet photography in dermatological research. *J. Biol. Photogr.* 56:3–11.

Yabe, K., Ando, Y., Ito, M., and Terakado, N., 1987. Simple method for screening aflatoxin-producing molds by UV photography. *Appl. Environ. Microbiol.* February 53:230–234.

## BIBLIOGRAPHY

Afromowitza, M. A., Callis, J. B., Heimbach, D. M., DeSoto, L. A., and Norton, M. K., 1988. Multispectral imaging of burn wounds: A new clinical instrument for evaluating burn depth. *Trans. Biomed. Eng.* 35:842–850.

Erlich, J., 1967. *Photographic Evidence.* London: MacLaren & Sons.

Gibson, H. L., 1973. *Medical Photography.* Rochester, NY: Eastman Kodak.

Gibson, H. L., 1980. *Photography by Infrared: Its Principles and Applications* (3rd ed.). New York: Wiley.

Jaeger, W., Gotz, M. L., and Blankenagel, A., 1986. Can the use of infrared photography give evidence of the prognosis of hereditary macular degeneration? *Klin. Monatabl. Augenheilkd.,* 188:178–181.

Keyes, R. J., 1980. *Optical and Infrared Detectors* (2nd ed.). New York: Springer-Verlag.

Kricka, L. J., Thorpe, G. H. G., 1985. Recent progress in bioluminescence and chemiluminescence. *Ann. Biol. Clin.* 43:457–462.

Lillesand, K., 1979. *Remote Sensing and Image Interpretation.* New York: Wiley.

Lloyd, M. J., 1979. *Thermal Imaging Systems.* New York: Plenum.

Lunnon, R., 1979. Direct or reflected ultraviolet photography. *Photogr. J.* 119:380–386.

Miwa, M., Matsumoto, M., Tezuka, M., Okada, S., and Fujiwake, H., 1986. Quantitative fluorographic detection of $^3$H and $^{14}$C on two-dimensional thin-layer chromatographic sheets by an ultra-high-sensitivity TV camera system. *Anal. Biochem.* 152:391–395.

Parrish, J. A., Kripke, M. L., and Morison, W. L., 1983. *Photoimmunology.* New York: Plenum.

Preece, A. W., Murfin, J. L., 1987. The use of an infrared camera for imaging the heating effect of RF applicators. *J. Hyperthermia* 3:119–122.

Ruddick, R. F. A., 1974. Techniques for recording bite marks for forensic studies. *Med. Biol. Ill.* 24:128–129.

Scharmann, A., 1985. Introduction to thermoluminescence: Simple models. *Strahlentherapie* 161:69–73.

Tredinnick, W. D., 1961. Futher advances in fluorescent color photography. *Med. Biol. Illus.* 11:16–21.

Walsberg, G. E., 1988. Consequences of skin color and fur properties for solar heat gain and ultraviolet irradiance in two animals. *J. Comp. Physiol.* 158:213–221.

## TECHNICAL PUBLICATIONS FROM OPTICAL AND FILM MANUFACTURERS

Eastman Kodak Co.
State St.
Rochester, New York 14650.

B-3, 1985. *Kodak Filters for Scientific and Technical Uses.*

CIS-13, 1982. *Your Guide to Ordering Kodak Materials for Use in Vacuum Ultraviolet & Mass Spectrography* (out of print).

E-77, 1986. *Kodak Color Films and Papers for Professionals.*

F-5, 1987. *Professional Black & White Films.*

L-10, 1989. *Scientific Imaging Products.*

M-2, 1987. *Using Photography to Preserve Evidence* (out of print).

M-23, 1972. *Photographing Chromatograms* (out of print).

M-27, 1974. *Ultravioliet and Fluorescence Photography* (out of print).

M-28, 1987. *Applied Infrared Photography.*

M-29, 1982. *Kodak Data for Aerial Photography.*

N-1, 1969. *Medical Infrared Photography* (out of print).

P-140, 1985. *Characteristics of Kodak Plates for Scientific and Technical Applications.*

P-315, 1987. *Scientific Imaging with Kodak Films and Plates.*

P-570, 1988. *Thermal Recording and Infrared Photography of Hot Objects.*

P7-670, 1981. *Hypersensitization of Infrared Emulsions by Bathing in Silver Nitrate Solution* (out of print).

SIS-583, 1986. *Tips for Successful Fluorescence Photomicrography.*

X2-25, 1989. *Kodak Professional Products. 1989; Technical Information.*

## SOURCES OF EQUIPMENT

Ultra-Violet Products Inc.,
5114 Walnut Grove Avenue
San Gabriel, CA
U.V.P. Product Catalogue

Corning Glass Works
Optical Products Department
Corning, NY 14831

Hamamatsu Photonics K.K.
1126-1, Ichino-Cho
Hamamatsu, Shizuoka-pref
Japan

Ilford Ltd.
30 Buckingham Gate
London SW1E 6LM
U.K.

Oriel Corp.
250-T Long Beach Blvd.
Stratford, CT 06497-0872

Pentax Corp. (owner of Takumar)
35 Inverness Drive East
Englewood, CO 80112

Perkin-Elmer Corp.
Electro-Optical Div.
Danbury Road
Wilton, CT 06897

Polaroid Corp.
International Business and Professional Products
575 Technology Square
Cambridge, MA 02139

Precision Optics Inc.
612-T Industrial Way W
Eatontown, NJ 07724

Tiffen Manufacturing Corp.
90 Osler Avenue
Hauppauge, NY 11788

Wild/Leitz (Instrumental) Ltd.
48 Park Street
Luton LU1 3HP
U.K.

## Suppliers of Scientific Optical Filters:

Corning Glass Works
Optical Products Department
Corning, New York, NY 14830
U.S.A.

Schott Glass Technologies Inc.
989 York Ave.
Duryea, PA 18642
U.S.A.

KAD Optical Products
Eastman Kodak Co.
1447 St. Paul Street
Rochester, NY 14650
U.S.A.

Tiffen Manufacturing Co.
90 Osler Ave.
Hauppauge, NY 11788
U.S.A.

Precision Optical Instruments (new name for Chance Optical)
425–433 Stratford Road
West Midlands, B 90 4AE
U.K.

## Publication:

U.V.P. Product Catalogue
by:
Ultra-Violet Products Inc.
5114 Walnut Grove Ave
San Gabriel, CA 91778
U.S.A.

# Chapter 14
# Photography Through the Endoscope and the Operating Microscope

## Scott Kilbourne

*"On the final test . . . you listen skeptically for any signs of trouble. Then, as you are forced, minute after minute, to come to the conclusion that the machine's running perfectly, a really great Quality feeling comes over you that pays you back for all the earlier gloom. When you've gone through that moment with a machine, you really own it. . . ."*

Quotation from *Zen and the Art of Motorcycle Maintenance,* copyright 1974 by Robert M. Pirsig

Endoscopes and operating microscopes are exotic and radically different visualization technologies. Taking full advantage of these visual aids in medicine involves an understanding of the technologies relative to their application with various procedures. Physicians use endoscopes and operating microscopes to investigate body cavities and examine very small areas. Medical photographers assist physicians in providing a permanent record of the images that appear through these instruments. This chapter discusses the appropriate utilization of each instrument, with an emphasis on the equipment necessary to produce the finest quality images possible.

Endoscopes are optical aids for the examination of cavities and usually take the form of tubes, either flexible or rigid (Figure 14.1). These tubes contain optical apparatus to carry light into the cavity for illumination and to provide the observer with an image from inside the cavity. Operating microscopes are rather sophisticated magnifying glasses, providing the physicians with relatively highly magnified ($1\times$ to $40\times$) stereoscopic images.

Discussion of each instrument will include an analysis of its anatomy, light sources, and light pathways and compatibility with camera equipment and film choice. This chapter will address appropriate use of photography with the endoscope and operating microscope with an emphasis on the interaction between physician and photographer during the procedure. Finally, each section will conclude with suggestions on ways to resolve various problems.

## PHOTOGRAPHY THROUGH THE ENDOSCOPE

*Endoscopes* initially can be divided into two categories. *Rigid endoscopes* are solid inflexible tubes, varying in diameter from less than 4 mm to 11 mm or more, and varying in length from 70 to 500 mm. They are used for procedures in which a straight-line approach to the area in question is possible. Typical rigid endoscopes include laparoscopes, for viewing the abdominal contents through an incision; otoscopes, for viewing the eardrum down the ear canal; and arthroscopes, for viewing the bony joints.

## Rigid Endoscopes

**Anatomy.** The rigid endoscope has undergone a significant evolution. Current instruments are similar to those first designed by Harold Hopkins; they consist of a series of lenses cemented together, forming a long rod with a few small air spaces. Distally, the subject is captured initially through an objective lens. The lens' angle of vision may be deflected by a prism to provide a side view, or even a slightly backward view, instead of the usual straight ahead one (Figure 14.2). The angle of deflection, if any, is very important in the use of the endoscope, and the instrument may be referred to by its deflection angle. A *90° endoscope*, for example, collects a view that is at a right angle to the axis of the endoscope. A *retrograde* endoscope may have a 135° angle, providing a view that looks back along the shaft of the instrument.

The image deflected by the prism and collected by the objective lens is passed through a series of relay lenses that form the bulk of the optical assembly and that serve to pass the image to the observer (Figure 14.3). The solid, cemented series of lenses—again, the Hopkins design—reduces flare and internal reflections that otherwise would be unavoidable in an optical instrument with multiple relay lenses. This significantly increases the image quality over older endoscopes with air-spaced lenses. This long column of cemented lenses contributes to the fragility of the instrument. The rigid endoscope is delicate and especially sensitive to being flexed. It should never be used as a lever. Many damaged endoscopes have either been dropped or have obviously been used as pry bars in surgery, particularly during the making of the second incision in double-puncture laparoscopy.

313

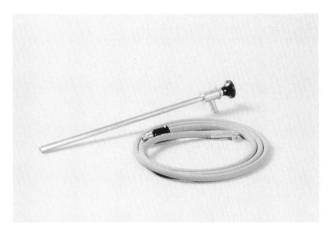

**FIGURE 14.1    Laparoscope with fiber-optic light guide.**

**FIGURE 14.3    Same as above, but showing the objective end of the endoscopes.**

The graduated-index single-lens system is a less frequently encountered arrangement for passing the image from the objective to the eyepiece of an endoscope. This system consists of a thin, cylindrical piece of glass that serves the same function as the cemented series of relay lenses in the Hopkins design. The *rod lens* is a single piece of glass with a nonuniform index of refraction. The index of refraction is least in the center of the cylinder and gradually increases to the outside of the cylinder. As light approaches the surface of the cylinder, it is refracted back into the center by the increasing index of refraction. This design, as produced in the Dyonics Needlescope, allows for an instrument with a smaller overall diameter than normally is possible with the Hopkins design. The rod lens system generally is restricted to endoscopes with very small diameters. The rod lens system produces images of slightly lower quality than images from endoscopes utilizing the Hopkins-style cemented relay lenses.

The photographer documents procedures through rod lens endoscopes with basically the same equipment and techniques as with a conventional rigid endoscope.

The *relay lens assembly*, or *rod lens*, passes the image to the eyepiece, which magnifies the image and focuses it at the appropriate distance for the viewer (Figure 14.4). The eyepiece is surrounded by a large round black flange, which serves as an eyebrow rest, as a registration point for the observer, and as an attachment point for any documentation equipment.

The rigid endoscope usually also provides illumination inside the cavity. This illumination is provided by a light source, commonly a focused tungsten bulb. The light source is contained in an external box, which rests on a nearby table and is plugged into a wall outlet. The illumination in the light source is collected, passed through a heat-absorbing filter, and focused on the end of a fiber-optic bundle. This bundle, the *light guide*, averages 2 m in

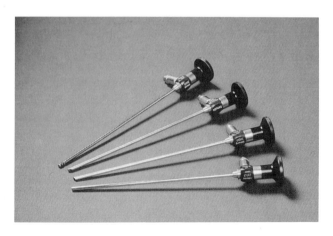

**FIGURE 14.2    Set of four sinus endoscopes 20, 30, 70, and 120 degree.**

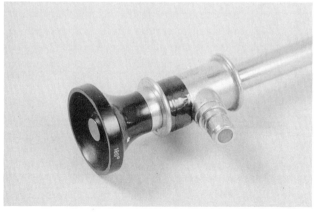

**FIGURE 14.4    Eyepiece of laparoscope, also showing light guide connection point.**

length and transmits the illumination from the light source to the endoscope. The light guide couples to the endoscope and illuminates a matching set of fiber-optic elements inside the endoscope; these elements pass the illumination from the light guide along the shaft of the endoscope, up to the objective or prism, where the illumination is projected into the cavity. Thus the endoscope carries the illumination into the cavity through the fiber optics, collects the resultant image, and passes the image back to the observer through the lens assembly.

You should understand this entire chain from light source to observer if quality documentation results are expected. The following components are essential to high-quality illumination of the subject: a powerful light source; a light guide in good condition and compatible with both the light source and the endoscope; and an endoscope in excellent optical condition, capable of transmitting an intense illuminating beam.

An overview of each of these elements will reveal their importance in optimizing the documentation results. *Proper lighting* is the key to effective, high-quality photography in general; endoscopic photography is no exception.

**Light Sources.** The most appropriate place to begin is with the *light source.* A wide variety of light sources are available for endoscopes; some are much better for photography than others. Light sources differ mainly in the type of bulb used to provide the illumination.

The most common light source encountered is the conventional tungsten bulb. This is the smallest and least expensive unit available; it is the most cost-effective light source for routine nonphotographic endoscopic use. Tungsten bulbs do not work well for photography, however, since they do not provide as intense a light as desired. This results in long exposure times (leading to blurring), the necessity for high film speeds (leading to grainy results), or underexposed photographs. The bulbs used in these units are similar to those used in slide projectors; they do not have enough power for high-quality documentation through endoscopes. The light produced by typical tungsten bulbs is roughly 3200 K (tungsten color balance), so tungsten-balanced film with a high American Standard Association/International Standards Organization (ASA/ISO) is required if you have to use one of these units.

More desirable from a photographic standpoint are xenon arc or metal halide light sources. Both types produce an intense illumination of 5500 K color temperature (daylight color balance). Daylight-balanced film is used with these units. The xenon arc light source is conceptually an electronic flash that remains on as long as required, rather than flashing quickly on and off. The metal halide lamp is a relatively new development and is capable of very high intensity levels. Either light source is suitable for endoscopic documentation efforts, although

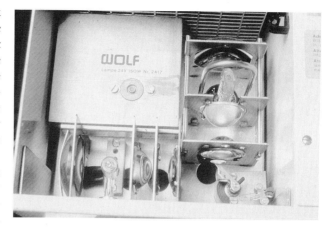

FIGURE 14.5    A view looking inside a typical electronic flash fiber-optic light supply.

each is much more expensive than a conventional tungsten light source. Some of these light sources also have a conventional tungsten bulb for routine viewing. With a combination light source, the observer can move the light guide to select either tungsten or xenon arc illumination. The xenon arc setting is appropriate for photography, while routine viewing is done with the tungsten bulb to conserve the expensive xenon or metal halide bulb, which normally has a short life.

An electronic flash light source, the final category of light source to be discussed, is actually two light sources in one (Figure 14.5). A conventional tungsten light source is deflected through a prism inside the light source onto the light guide end, thus providing the illumination (Figure 14.6). When a photograph is taken, the prism swings out from in front of the light guide, and an electronic flash fires, illuminating the guide (Figure 14.7). Thus, the photographer uses the tungsten light for viewing and the electronic flash for producing the photo-

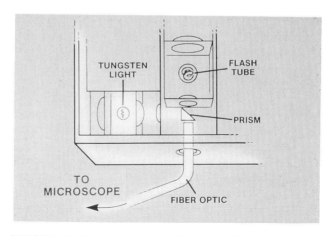

FIGURE 14.6    Schematic showing the light path inside the light source during routine viewing, utilizing the tungsten light.

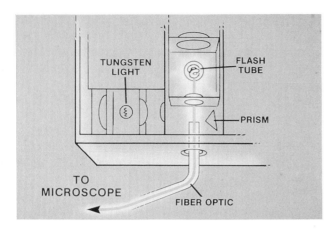

**FIGURE 14.7  Schematic showing the light path inside the light source during photography, utilizing the electronic flash.**

graph. He can synchronize the camera and the flash by means of a flash sync cable connecting the camera and the light source. The prism does take time to swing out of the way, however, so the photographer should use a shutter speed no faster than 1/30 of a second, regardless of the normal maximum flash synchronization speed of the camera. Since the light source uses an electronic flash, it is necessary to wait between exposures for the flash unit to recharge. An indicator light on the light source will signal when the light source is ready for another exposure.

There are disadvantages, however, to using electronic flash for endoscopic photography. Under normal circumstances, a photographic exposure by electronic flash is regulated by the aperture of the camera. In endoscopic photography, it is always important to keep the lens aperture wide open, and thus eliminate the use of the lens aperture to control exposure. Shutter speed cannot be used to regulate exposure with electronic flash. Therefore, exposure must be regulated either by the choice of film speed or by the flash unit itself. Older electronic flash endoscopic light sources have a switch allowing the selection of three or four preset flash intensities. Exposure is regulated with these units by film speed choice and flash intensity settings. An experienced photographer can achieve an acceptable percentage of successful endoscopic photographs with an electronic flash, but only after many trials and much note-taking.

Recent electronic flash units incorporate circuitry for automatic exposure. This technology relies on a photocell inside the camera body to meter the light striking the film during the actual exposure. When sufficient light has struck the film to produce a good exposure, the flash shuts off automatically. This coupling of camera metering circuitry and light source requires a high level of compatibility. The manufacturers of these automatic electronic flash light sources recommend specific com-

patible camera brands and models to be used with the light sources. Another brand or model may be incompatible, and in fact may damage the camera or light source. This automatic system can aid greatly in making high-quality still photographs through endoscopes easy and routine. However, electronic flash cannot be used for video or motion picture purposes.

To summarize, the easiest light source to use is the xenon arc or metal halide type. Both produce an intense light that facilitates focusing. The light from both types is daylight balanced, making film choice easy and accurate color balance possible without filtration. The continuous light output of these types of light sources means that a through-the-lens (TTL) meter in the camera can be used to adjust exposure by changing the shutter speed.

**Light Guides.**  A *light guide* is simply a bundle of very thin glass fibers that transmit light from one end of the bundle to the other. When a light ray enters one end of a fiber, it is either reflected or refracted inside the fiber and is unable to escape out the sides of the fiber. The light ray bounces or is bent continually down the length of the fiber until it eventually emerges from the far end. It makes no difference whether the fiber is bent, even into a tight circle. If the guide is bent too sharply, however, some of the glass fibers inside might break. These broken fibers will no longer transmit light. Light guides occasionally are treated rather roughly by operating-room staff, who sometimes are inadequately trained in the proper care and cleaning of precision optical equipment. It is important to use a light guide that has a minimum number of broken fibers.

An alternate type is the *liquid light guide,* which consists of a sealed flexible tube filled with liquid. Light is introduced into one end of the guide and is conducted to the far end, much the same as for the fiber-optic guide. However, it is common for a liquid light guide to transmit more light than a comparable fiber-optic light guide, and so it is preferable for photography. A fiber-optic guide also tends to color the light slightly green, resulting from the color of the glass fibers themselves. Other than differences relative to increased light transmission and purer color transmission, liquid and fiber-optic light guides are interchangeable.

Checking for damaged fibers in a fiber-optic guide is relatively easy. Grasp the ends of the light guide in each hand (Figure 14.8). Inspect the fiber-optic face at each end. The face should look smooth and fairly well polished, not charred or burnt. Charring results from the lack of a proper heat-absorbing filter in the light source, or from incorrect positioning of the guide inside the light source. Guides with charred or burnt ends can sometimes be repolished and restored to original condition (Figure 14.9).

Next, point one end of the guide at a bright light such as a fluorescent bulb. Hold the other end a few inches

**FIGURE 14.8** While pointing one end of the light guide at a light source, the other end is observed for dark spots, indicating broken fibers. This guide is in very poor condition.

away and look at the end of the fiber bundle. Although the bundle is quite bright, it may be possible to discern small black dots among the fibers. Each of these black dots may represent a broken fiber. Slightly move both ends of the fiber bundle. Some of the dark fibers may light up with this motion. These fibers are not broken, but you can assume that any fibers remaining dark are broken. If the percentage of broken fibers is more than 5% to 10% of the total fiber cross-sectional area, the guide is not suitable for documentation because it will not transmit as much light as necessary. It is not feasible to repair a light guide with broken fibers. However, light

**FIGURE 14.9** If broken light guides are used, fibers are broken or charred inside the endoscope, or if a poor physical connection is made between light guide and endoscope, then illumination from the endoscope will be weak.

guides with a number of broken fibers may be suitable for routine examination, since less intense illumination is acceptable for visual inspection.

The next aspect to consider is mechanical fit. Each rigid endoscope contains an internal fiber bundle. These fibers are arranged in a circular bundle at the point of attachment to the light guide. The diameter of the fiber bundle in the guide should closely match the diameter of the fiber bundle in the endoscope at this point. This compatibility is necessary for maximum light transmission from the light guide to the endoscope. Too small a diameter in the guide's bundle means that less light is carried to the endoscope than the endoscope can accept. Too large a diameter means that the fibers around the periphery of the guide do not have corresponding fibers in the endoscope. Thus, the light coming from these peripheral fibers will be wasted.

Equally important is the close and accurately centered positioning of the light guide fibers directly against the fibers of the endoscope. Some manufacturers recommend that a drop of mineral oil be placed between the fiber optics of the guide and those of the endoscope to reduce light spillage at this junction.

Correct alignment of the optical components inside the light source is also important. The illumination beam for the light source is prefocused to a specific spot. Position the guide inside the light source so that the face of the fiber-optic bundle lies precisely at this point of focus. If the face of the bundle is anywhere else, light will spill around the guide, resulting in decreased transmission of light. The use of incompatible light guide/light source combinations, poorly designed light guide/light source adapters, or incorrect positioning of the bulb in its socket can cause this misalignment. The manufacturer can provide information on how to check the alignment.

The best way to ensure proper mechanical fit of light source to guide to endoscope is to use a single manufacturer's matched equipment throughout the system. Manufacturer's technical representatives will be glad to help with any questions regarding optimal fit of components.

**Light Transmission in Endoscopes.** The fiber optics inside of the endoscope can be inspected for optimal light transmission in the same manner as for the guide, that is, by pointing one end at a bright light and examining the other end. A significant number of nontransmitting fibers in the endoscope indicates a proportional decrease in the intensity of the illumination delivered to the subject. Endoscopes with broken fibers can often be repaired.

Examine the glass eyepiece of the endoscope. It should be clean. Often a white crusty residue is apparent on the glass surfaces of the endoscope. This is residue from numerous sterilizing cycles and usually can be cleaned with distilled water and cotton swabs. Now examine the end of the endoscope opposite the eyepiece. Note the

larger dark area (the objective lens and, possibly, a prism) and a smaller area where the fiber optics exit the endoscope. If necessary, clean the objective or prism and the fiber-optic face. Clean the endoscope prior to any required sterilization. Since many endoscopic procedures are not sterile procedures, you can clean the optical equipment for these procedures at any time. Hospital personnel responsible for the care of endoscopic equipment appreciate a photographer who respects the instruments and helps keep equipment in the best possible condition. There is no substitute for a friendly working relationship with operating room personnel.

The choice of endoscope also influences the documentation effort. In some cases, there are a variety of instruments from which to choose. These endoscopes may vary in diameter, length, angle of view, and presence of channels for operating instruments. Larger diameter endoscopes carry more fiber optics for increased illumination and generally have larger diameter (sharper, brighter) image-carrying components. Longer instruments generally lose more light in transmission due to increased length. Instruments with prisms in front of the objective lens sometimes lose light-transmitting efficiency at this point. Instruments with operating channels have a diminished optical diameter because of the space that the operating channel takes. These instruments also have a smaller fiber-optic bundle. As a general rule, it is to the photographer's advantage to use the newest, cleanest, largest diameter, shortest, and most-direct viewing instrument without an operating channel that is available and that can be used safely. The final choice of endoscopes, however, may involve compromises for the photographer.

## Camera Equipment

The eyepiece lens on an endoscope is designed to accommodate the human eye. It projects an image through the lens of the viewer's eye onto the retina. For photography, the image projected by the eyepiece lens is focused onto film by a camera's lens. The procedure involves positioning the camera and lens in line with the eyepiece, adjusting the lens to focus the image sharply on the film, and then exposing the photograph. How to best facilitate this procedure is the subject of the next section.

**Camera Body Selection.** A 35-mm single-lens reflex (SLR) camera is the most convenient camera to use in most endoscopic photography. A 35-mm SLR allows the user to preview the composition and focus of the photograph before the shutter is depressed.

If you use a xenon arc or metal halide light source, there are two basic requirements for the camera body. First, determine the proper exposure through the lens with a TTL light meter system. Since the image of the subject may not fill the entire photographic frame—and possibly fills only a small portion of the frame—you need a strongly center-weighted or even center spot reading TTL meter. Thus, when the meter calculates the exposure, only the endoscopic image, and not the surrounding black area, is used in determining exposure. Use of an overall averaging metering system in endoscopy may result in overexposed photographs.

The camera must also be be capable of adjusting the shutter speed to regulate the exposure delivered to the film. The shutter speed is adjusted automatically or manually until the meter indicates a proper exposure. A camera that adjusts the shutter speed automatically but allows manual override in special circumstances is probably the most appropriate.

If you use an electronic flash light source, there are different requirements for the camera body. First, the camera must be a model in which the shutter speed can be adjusted to the shutter speed compatible with the light source flash synchronization. A typical setting for compatibility with endoscopic electronic flash light sources is 1/30 of a second. If the light source has an automatic exposure capability, the camera body must have compatible electronic flash metering circuitry. Center-weighted or spot-meter-type sensitivity of the camera's light meter is also important here. If the light source does not have automatic exposure capability, the camera body does not need any exposure metering capabilities. Manual endoscopic flash exposure is determined through trial and error and experience.

Automatic film advance, in the form of motor-drives or autowinders, is a distinct advantage in endoscopic photography. Typically, a series of exposures varying in exposure, focus, or composition will be recorded each time the camera is attached to the endoscope. Manual advance of the film is disrupting and often requires that the photographer's eye move from the eyepiece during film advance. A motor-drive or autowinder eliminates this annoyance and speeds the sequence. If you use an electronic flash light source, it is important to allow ample time for the flash to recycle.

A final consideration in choosing the correct camera body for endoscopic documentation involves viewing screens. The standard viewfinder screen in most SLR camera bodies is visually complex. It often incorporates a split-image rangefinder and other focusing aids. This visual clutter is distracting, and the low light levels encountered in endoscopic photography often cause the split-image rangefinder to black out. Alternative viewing screens include a plain ground-glass or even an aerial-image (reticle) screen. The ground-glass screen is not distracting and allows undisturbed composition of the endoscopic photograph. The aerial-image or *reticle*, screen is a clear viewfinder screen that transmits nearly all the light received by the lens through to the viewer. The screen has a pattern of black lines (the reticle)

superimposed on the endoscopic image. The photographer must use the reticle to focus the camera lens so that the endoscopic image is also in focus. Both the reticle and the endoscopic image must appear in focus to the photographer. This aerial-image focusing is an acquired art that requires practice. The aerial image is brighter than a comparable ground-glass image. Not all cameras allow an interchange of viewfinder screens, and those that do may have their light meters calibrated for the standard viewfinder screen. Any insertion of alternate viewfinder screens, particularly aerial-image screens, may affect exposure results. It is important to test any new viewfinder screens for proper light meter operation prior to documenting important endoscopic procedures.

**Camera Lens Selection.**    Two factors govern the choice of lenses used in endoscopic documentation. Maximum or minimum aperture of the lens is not a criterion, since the exit pupil of the endoscope limits the aperture. During endoscopic photography, the aperture of the camera lens is always set wide open.

The first factor in choosing a camera lens is *focal length*. Image size in endoscopic photography is a function of two variables—*endoscope optical design* and *camera lens focal length*. Different endoscopes project different image diameters. In general, smaller diameter endoscopes have smaller image diameters. Camera lens focal length is directly proportional to the diameter of the image on the film. Longer focal length lenses give larger diameter images on the film. Doubling the focal length of the camera lens roughly doubles the diameter of the image size. This can cause a problem because doubling the image size decreases the intensity of the image on the film by a factor of 4 (two stops) in a classic case of photography's inverse square law. Often this decreased light intensity is an acceptable light loss in view of the increased image size, but occasionally it is necessary to maximize image brightness on the film at any cost in order to record an exposure. Consider the variable of lens focal length versus brightness in conditions of extremely low image brightness. A 105-mm lens is a good compromise between image size and brightness in the majority of cases.

The second factor in choosing a lens is its *minimum focusing distance*. As the working distance from the endoscope to subject is changed, it is necessary to vary the focus of the lens. Progressively closer working distances produce greater subject magnifications; consequently, it is necessary to set the camera lens at closer focusing distances. A macro focusing lens is very useful for this purpose, especially since endoscopic photography often involves very close working distances. A lens without macro focusing capability is a distinct handicap in this situation.

New technology has lessened the problem. A few manufacturers now offer 105-mm macro lenses in which the lens does not lengthen physically as closer focusing distances are selected. These new lenses focus through internally shifting lens elements; this is a definite advantage since they do not shift the position of the camera or endoscope during focusing. Overall, a 105-mm macro lens mounted on an auto-exposure 35-mm SLR with motor-drive and ground-glass viewfinder screen is both a convenient and versatile basic configuration for routine endoscopic photography.

**Camera-Endoscope Adapter.**    Once the photographer chooses the camera body and lens, he or she must attach them temporarily to the endoscope for photography (Figure 14.10). This is a simple and straightforward matter. Most endoscope manufacturers offer convenient adapters that screw into the front of the camera lens in place of, or in front of, the camera lens filter. The endoscope adapter has a lever, which, when depressed, positions the adapter and the attached camera system over the eyepiece of the endoscope. Once the lever is released, the camera system is automatically aligned and securely attached to the endoscope (Figure 14.11). After making the exposures, reverse the procedure, and remove the camera system from the endoscope.

Most endoscopes manufactured since 1980 have standard eyepiece dimensions, a fact that allows one manufacturer's endoscope-camera adapter to fit another manufacturer's endoscope. You may need to purchase an adapter to modify the thread size of the front of the camera lens to fit the thread size of the endoscope adapter. Occasionally, it becomes necessary to use a spacer ring between the endoscope adapter and the camera lens for clearance between the adapter lever and the barrel of the camera lens. A skylight filter with the glass removed makes an adequate and inexpensive spacer ring.

**FIGURE 14.10    Thirty-five-millimeter single-lens reflex camera with 105-mm macro lens, an endoscopic adapter is about to be attached to lens filter ring.**

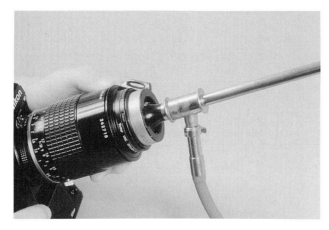

**FIGURE 14.11    Endoscope coupled to camera via endoscopic adapter.**

The rear of the endoscope adapter (nearer the camera lens) is a good place to position a color-correcting (CC) gelatin filter. The small diameter of the hole in the adapter means that only a small filter is needed. This location is also well protected from physical abuse. A piece of CC gelatin filter can be cut to fit and taped here.

### Film Choice

Proper film choice in endoscopic photography is as important as in any other area of photography. First, determine what is desired as the final product. If color slides are needed, color slide film is indicated; if black-and-white (BW) prints are needed, BW negative film is appropriate. Second, determine the color balance of the light source to be used and select a compatible film. Third, pick the appropriate ASA/ISO. Use the slowest possible film without sacrificing image quality due to subject or camera motion. These criteria shorten the list of possible films. It is better to err on the side of excess emulsion speed. Slightly grainy photographs are preferable to blurred photographs. Negative films tend to be more tolerant of incorrect exposures; hence, color negative film is the safest to use for those times when getting good photographs is absolutely critical. Exposure and color-balance mistakes often can be corrected in printing color negatives.

Sometimes it is impossible to get an exact color-balance match of film to light source. A variety of factors can influence the color balance of an endoscopic photograph. First, the light source may have a variety of voltage settings that can influence the color of the light emitted by the bulb. An endoscopic light source should always be operated at full brightness to optimize both color balance and light intensity. Also affecting light color is the fiber-optic light transmission path. Fiber optics often

color the light slightly green, and you may need to correct for this color cast.

Occasionally, it is necessary to use a film with a light source that does not match its color balance. The use of a tungsten light source with a high-speed daylight balanced color slide film is an example. Since high-speed tungsten-balanced color slide film is not routinely available, the photographer must use daylight-balanced film and a CC filter such as a Wratten 80A. A convenient location for this CC filter is between the endoscopic adapter and the camera lens.

### Endoscopic Procedure

Once equipped with the appropriate equipment and film, the photographer is ready to take photographs. Preparations include loading the camera with the correct film, setting the ASA/ISO on the light meter, mounting the macro lens and setting the camera aperture to wide open, positioning the endoscopic adapter, selecting the appropriate camera settings, and completing any of the other routine responsibilities necessary before the physician requests the first photograph. Before discussing the actual taking of photographs, it is appropriate to review endoscopic procedures in general.

Carelessness on the part of the photographer can be disastrous in endoscopic procedures. Few things are more embarrassing, or potentially dangerous, than contaminating the sterile field. Sometimes the location of an endoscope in a patient necessitates an awkward position for the photographer, and it is difficult to avoid touching a sterile towel or drape. In these circumstances, it is imperative to examine your surroundings before moving into position. If there is danger of contamination, ask the scrub nurse (not the physician, who is busy holding the endoscope) to be alert for any contamination of towel or drape. If it is impossible to avoid touching a sterile towel or drape, the scrub nurse can put a temporary drape in place before photography to protect the sterile field. Photography also slows down the endoscopic procedure, and surgical staff generally appreciate anything that the photographer can do to keep things moving smoothly.

The endoscope eyepiece is not usually considered sterile even in an otherwise sterile procedure because physicians touch the eyepiece repeatedly with their eyebrows. Connecting the camera to the eyepiece thus does not violate the sterile field. However, it is important to avoid touching any other part of the endoscope.

Focusing a camera attached to an endoscope can be dangerous because as most camera lenses are focused, the lens moves in and out (Figure 14.12). In an endoscopic procedure, this action tends to push and pull the endoscope in and out of the patient, potentially causing injury. For example, this movement is a very serious concern in photography of the eardrum. In examining

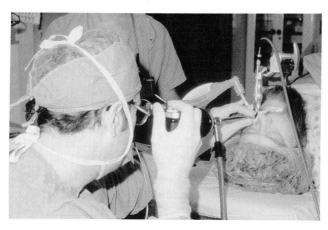

**FIGURE 14.12** Surgeon taking an endoscopic photograph during laryngeal procedure. Note hand holding endoscope to prevent further insertion into patient.

the eardrum, the physician ordinarily uses a compact and lightweight endoscope, which allows a very sensitive "feel" as the endoscope is inserted through the ear canal. When a heavy camera with motor drive is attached to the endoscope, this "feel" is lost, and possible damage, such as accidentally puncturing the eardrum, can result. It is important that the physician firmly hold the endoscope to prevent further insertion of the instrument into the patient. At the same time, the photographer must allow the camera body to "float" in and out to compensate for the lengthening and shortening of the lens as it is focused. With a bulky camera system, particularly with macro lens and motor-drive, this may seem rather unnatural to the photographer, but with a little practice it is not difficult to develop a feel for this movement. The photographer should attempt to move the endoscope from side to side or up and down only with the explicit permission of the physician. The photographer and physician should discuss whether the photographer should move the endoscope before the procedure begins, so there will not be any misunderstandings later.

It is the photographer's responsibility to monitor the endoscopic equipment so that quality photographs will result. Awareness of light source settings and endoscope conditions is essential. If the view through the endoscope is slightly hazy, for instance, it may mean that the instrument has mucous on the objective or that the objective has become fogged. The endoscope should be withdrawn, if possible, and cleaned. Soaking the shaft of the instrument in very warm water for a few minutes before it is used will decrease the incidence of fogging.

Preparation is important in endoscopic photography. Having a good light source, light guide, and endoscope in the procedure room and pretesting the equipment will greatly enhance both the percentage of high-quality photographs and the relationship with the staff. Stopping in

the middle of the procedure to fetch a new light guide could make a photographer less than welcome in future procedures.

## Taking the Photograph

Once the physician requests a photograph, the photographer approaches the table. The physician holds the endoscope securely in place and moves back so the photographer can examine the field. Then the photographer confirms what is visible through the endoscope—for example, "I see an ovary in the center of the field, with a fallopian tube at 3 o'clock and a corpus luteum at 10 o'clock." This confirmation of field of view is necessary because the endoscope can be jarred accidentally during the changing of observers, and a slight shift in endoscope position can produce a radically different and potentially useless field of view.

Once the field of view is confirmed or corrected by the physician, if necessary, the photographer can attach the camera system to the endoscope. With the physician firmly holding the endoscope shaft to prevent any movement, the photographer focuses the lens so as to provide the sharpest image possible. Focusing is a tricky and somewhat dangerous process. The camera viewfinder is usually quite dim, even with the best endoscopic light source, and accurate focus determination is largely a matter of experience and guesswork.

Once correct focus is set, determine the exposure and adjust the camera or light source to the appropriate setting. The exposure required varies from photograph to photograph, depending on the distance from the endoscope tip to the subject. A subject farther from the endoscope will be illuminated less brightly than one closer to the endoscope tip. Check the light meter in the camera and adjust the shutter speed until a correct exposure is indicated. If an automatic exposure camera is being used, this adjustment of shutter speed takes place instantly. If you are using a nonautomatic electronic flash light source, ask the circulating nurse or other non-scrubbed staff member to switch the light source to the estimated flash intensity setting. The patient should hold her breath at this juncture to prevent movement. (The anesthetist can stop the patient's breathing for a second if the patient is not awake.) As soon as settings are determined, release the shutter. The patient can resume breathing. After making exposure or focus bracketing adjustments repeat the hold breath/shoot/breathe cycle. When you are finished, detach the camera system from the endoscope and withdraw from the operating table.

## Video Recording

The use of video recording in the endoscopic procedure room is becoming more common. Many procedures,

such as arthroscopy, routinely are accomplished by watching the procedure through a video camera. The physician watches a video monitor rather than directly through the arthroscope. Video recording presents different problems than still photography. One common concern is a preoccupation with light sources. Video recording needs intense illumination for best quality. The same light sources are used for video as for still; the xenon arc or metal halide types are the most useful. The electronic flash obviously is not suited for video use, and most tungsten light sources are not bright enough.

Video camera quality is critical in endoscopic documentation, and a camera that was state-of-the-art 5 years ago is now nearly an antique. Any documentation effort can be limited through the use of a poor-quality video camera. The choice of video camera depends largely on how it is to be attached to the endoscope during the procedure. There are basically two methods of attaching a video camera to an endoscope; the method of attachment chosen determines what type of video camera to select. You need video cameras with good low-light level sensitivity for this work, even when powerful light sources are used. Newer video cameras tend to have more light-sensitive chips and to work better at lower light levels than older cameras.

Using an endoscope adapter on the end of the video camera lens in much the same way that a still camera is attached is the least complicated method of connection. Attach the video camera directly to the endoscope, and move the instrument and camera in combination. Use a video camera that is light enough to allow easy hand manipulation of the endoscope/camera combination. This restriction limits the choice of video cameras to single-chip cameras (Figure 14.13). Three-chip (or tube) cameras are too big to use in this manner.

The alternative approach to attaching a video camera to an endoscope is to use an *articulated arm*. This is an optical device that allows the physician to look directly through the endoscope at the same time the video camera is receiving the identical image through a flexible rod assembly. The articulated arm attaches to the endoscope eyepiece and contains a *beamsplitter* that passes a portion of the image to the physician and a portion of the image to the camera system. The image is passed through a long series of relay lenses that are linked with flexible couplings. The articulated arm attaches to the video camera in the same way that the endoscope does. Using this device has the advantage of letting the physician move the endoscope freely without moving the video camera.

Camera size and weight are not crucial considerations when using an articulated arm with an endoscope, so the photographer can choose a heavier, higher-quality three-chip (or three-tube) camera. The articulating arm's beamsplitter is adjustable to send the light in either 50/50 or 90/10 proportions to the camera and physician. For routine viewing, use the 50/50 setting. It affords the physician an excellent view through the endoscope, even with the camera attached. When recording is desired, adjust the beamsplitter to the 90/10 setting and most of the light will be routed to the camera. This adjustment provides sufficient illumination for quality recording, while it still allows the physician to view directly. The physician can also observe the procedure on a video monitor to position the endoscope in the cavity.

Many video camera adapters for endoscopes were originally designed to be used with 16-mm motion picture cameras. They use a lens mount called a "C" mount and work well with single-chip cameras, since the imaging chip is in a comparable location to the 16-mm film. When they are used with three-chip cameras, however, there is a major problem. Three-chip cameras have a prism in front of the chips to split and direct the light coming from the lens. This prism causes an increase in the *back focus* (distance from the lens flange to the chip) relative to the back focus in a single-chip camera. Endoscope adapters for three-chip cameras must be designed specifically for this increased back focus. These adapters often must be custom made.

Another consideration of video camera selection is the size of the sensor chip in the camera. Some cameras use 2/3-inch chips, while others use 1/2-inch chips. If all other components of the endoscope/camera system remain the same, a camera using the smaller chip will produce a larger image magnification.

In recording the endoscopic procedure with a video camera, the exposure is regulated both by controlling the intensity of the light source and by controlling the aperture on the camera lens. Most lenses on video cameras do not vignette the image through endoscopes unless stopped down to very small apertures; consequently, lenses provide a means of exposure control. Xenon arc light sources have intensity controls to allow adjustment of the illumination intensity without changing the color

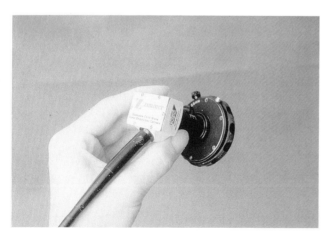

**FIGURE 14.13   A tiny one-tube video camera for direct attachment to an endoscope.**

balance of the light source. Some video camera systems have auto-exposure capabilities, electronically adjusting the gain inside the camera without using the lens diaphragm. The disadvantage of this system is the sacrifice of image quality. Switch off the automatic exposure system if possible, and use manual exposure control to provide a better video signal.

Use a *waveform monitor* to set exposure and color balance during video recording. If enough light for a proper video signal is not available, even with the light source at full brightness, use electronic gain of the signal as a last resort. This decision will degrade the quality of the signal compared with a nonboosted signal, but the increased image brightness may be worth the sacrifice.

The last factor to consider in video camera electronics is the camera's capacity to clip the output signal at 100% to 105% of the video signal. Sometimes it is necessary to image a subject that is a long way from the endoscope tip, and other tissue is visible in the foreground. Normally, this foreground tissue would be far too bright, disrupting the video signal for the entire scene. The clipping feature allows the user to open up the lens to image the background, with the foreground tissue very bright, but with no disruption of the video signal.

It is important to record the audio comments of the physician during the procedure, for editing purposes later. Most of the concerns and tips applicable to still photography are applicable also for video recording, particularly the admonition to frequently clean the endoscope tip of any mucous or fogging.

## FLEXIBLE ENDOSCOPE PHOTOGRAPHY

*Flexible endoscopy* is similar to rigid endoscopy, with a few exceptions. The latter are mostly related to the anatomy of the instrument itself.

**Anatomy.** The flexible endoscope has the same fiberoptic illumination system as the rigid endoscope, but differs in the method by which the image is carried back to the observer. With the flexible endoscope, a coherent fiber-optic array carries the image. An objective lens focuses the image onto the face of the coherent fiber-optic bundle. Each fiber of the bundle carries light to the other end of the coherent bundle, where the position of the fiber at the eyepiece end of the array is identical to its position at the objective end. The eyepiece projects the image appearing on this end of the array to the observer. The resolution of the image carried by a flexible endoscope is limited by the number of fibers in the coherent bundle (Color Plate 56). Each fiber carries an individual pixel of the final image. Recently manufactured flexible endoscopes tend to have a greater number of smaller fibers, a factor that accounts for the increased resolution of the newer instruments. Because it is flexible, this endo-

scope type permits directional control of the tip. An operating channel and other components are usually housed inside the endoscope body.

Attaching a still camera to a flexible endoscope is quite easy. Because of the increased complexity of the flexible endoscope eyepiece and handle assembly, camera adapters often are unique to a specific model endoscope eyepiece. Light sources are as critical in flexible endoscopy as they are in rigid endoscopy, but the physical attachment of the light source to the light guide is complicated by the addition of air channels. Thus, a light source/light guide mechanical fit is even more complex than in rigid endoscopy. The endoscope manufacturer's technical representative can provide information about equipment compatibility.

Once the still camera is attached, the same procedures apply as those for rigid endoscopy. Likewise, lens selection criteria are similar, with the exception of image size versus resolution. Once individual fibers of the coherent bundle are visible in a photograph, further magnification will not reveal any more detail in the image. No further resolution is possible because of the flexible endoscope design. Bigger image sizes provide only bigger, darker images, not more resolution.

Many physicians routinely videotape flexible endoscopic procedures. This taping is convenient and not difficult, with the same considerations as for rigid endoscopy. Still video printers can be attached directly to the video camera, and color prints can be produced instantly during the procedure. Resolution of such printers can be quite good if the print is done directly from the video camera. Replaying the video tape to produce the still video print does not produce as good an image as imaging directly from the camera, primarily because of the image quality lost by recording the video signal.

### Summary

Obtaining high-quality endoscopic photographs is a challenge that requires interaction of photographer and physician. An understanding of the differences in rigid and flexible endoscopes and their appropriate use in special procedures will facilitate the recording of images on film or tape. Below is a brief summation of miscellaneous tips and techniques for the photographer engaged in endoscopy:

1. Check the endoscopic equipment in advance. The best light source, light guide, and endoscope available should be ready for use (Color Plates 57 and 58).
2. Use the newest, cleanest, largest diameter, shortest, most-direct viewing instrument without an operating channel.
3. Clean the endoscope objective and eyepiece before sterilization or use.

4. Check the fiber optics in the light guide for breaks and charring. Better yet, use a liquid light guide.
5. Warm the endoscope tip and shaft in water prior to insertion.
6. Clean condensation from the end of the endoscope frequently.
7. Focus on specular highlights if the image in the viewfinder is very dim.
8. Have the anesthetist stop the patient's breathing during exposure.
9. Focus carefully, and bracket both focus and exposure.

Color Plates 59–61 are three typical photographs made through the endoscope.

## PHOTOGRAPHY THROUGH OPERATING MICROSCOPES

### The Instrument

Another challenge to the medical photographer is documenting procedures performed through an operating microscope. This sensitive instrument allows the physician to work on blood vessels, nerves, and other tissues on a scale not possible with the unaided eye. Vasectomy and tubal ligation reversals, reattachment of severed limbs, and surgery on the ossicles of the ear are only a few of the exciting new procedures possible since the advent of the operating microscope. Medical photographers are expected to be able to capture high-quality images through these sophisticated instruments. The technical considerations of photography through the operating microscope are described in this section.

**Anatomy.**   As with endoscopic photography, the photographer must understand something of the internal workings of the operating microscope. The instrument consists of a modular stack of optical components (Figure 14.14). An image enters the operating microscope through the bottom of this stack and travels upward, where it is magnified and directed through the instrument until it reaches the observer (Figure 14.15).

Most components, with the exception of the magnification changer and lights, can be interchanged easily; in fact, the photographer can reconfigure the entire microscope between cases to perform a wide variety of tasks (Figure 14.16). You can change components of the operating microscope by loosening and tightening handscrews or collars to remove or attach parts. In most cases tools are unnecessary. Most operating microscopes, colposcopes, and slit lamps are surprisingly similar in their basic structure and operation, differing only in details of the supporting stand and lighting. Zeiss operating microscopes are the basis for discussion here because they are the most frequently used. Instruments from other manufacturers are usually variants of the Zeiss design. There

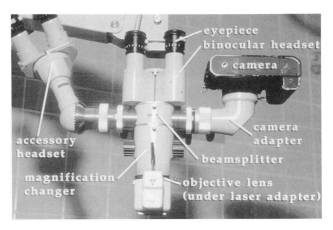

FIGURE 14.14   Zeiss operating microscope set up with beamsplitter, camera, accessory observer headset and laser adapter.

has been very little change in design of the operating microscope since its inception. No revolutionary design changes are apparent, and parts from the early operating microscopes (1960s) fit currently manufactured instruments. Functionally, the newest instruments are slightly better, particularly in lighting, but photographers familiar with the older models should have no problems adapting to current models.

The *operating microscope* is a stereo instrument, with a left and a right optical channel (Figure 14.17). This separation of left and right visual fields provides the surgeon with a critical stereopsis effect. When documenting procedures, the photographer must be aware of the discrepancy between the left and right stereo images the surgeon receives.

The operating microscope consists primarily of a *magnification changer* with an objective attached to one end and a binocular headset with eyepieces attached to the other. The magnification changer is manipulated either

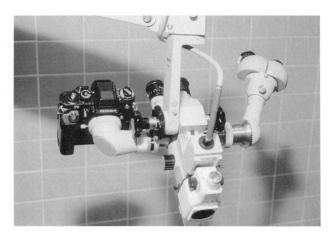

FIGURE 14.15   Same as previous figure from a different angle.

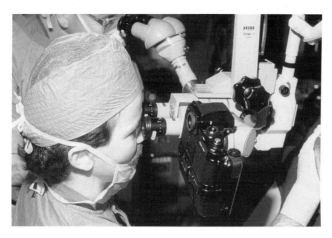

**FIGURE 14.16   Physician using operating microscope for laryngeal procedure.**

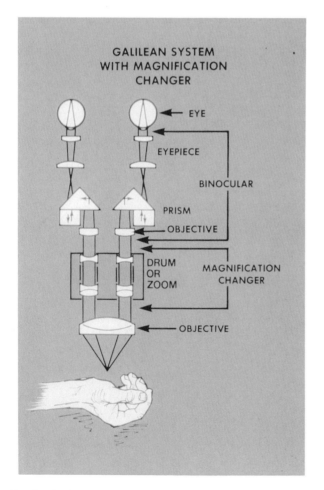

GALILEAN SYSTEM
WITH MAGNIFICATION
CHANGER

EYE

EYEPIECE

BINOCULAR

PRISM

OBJECTIVE

DRUM
OR
ZOOM

MAGNIFICATION
CHANGER

OBJECTIVE

**FIGURE 14.17   Schematic view of operating microscope, emphasizing the stereo nature of the instrument.**

by a drum assembly, yielding discrete predetermined increments of magnification, or by a continuously variable zoom assembly.

The stand that supports the operating microscope is attached to the magnification changer, as is the standard lighting equipment. The magnification changer has parallel but separate paths for the left and right optical columns.

Immediately below the magnification changer is an *objective lens*. As with other compound microscopes, this objective lens is the initial magnifier of the image. The objective lens is a single lens, but both the left and right optical columns travel through it. This lens is the first piece of glass encountered by the image, and it is easily interchanged with other objective lenses of longer or shorter focal length. Using a shorter focal-length objective lens results in a closer operating microscope/subject working distance and higher overall magnification of the image. Shorter focal lengths such as 150 to 200 mm are used commonly in microvascular reconstructive work. Longer focal lengths provide greater working distance and the resultant lower magnifications. Focal lengths from 350 to 400 mm are commonly used in ear, nose, and throat (ENT) microsurgery such as vocal cord procedures.

The objective lens used affects the photograph in a number of ways. First, the working distance will influence the intensity of illumination on the subject, with closer working distances usually having brighter illumination. Second, the objective lens is the closest part of the instrument to the patient and, consequently, it is often subjected to abuse. Surgical instruments may bump against it, or it may get dirty from splashed blood. Inspection and cleaning of the objective lens are essential. As with endoscopes, the care of operating microscopes sometimes is entrusted to people who are not fully trained in the proper care of precision optical instruments. If high-quality photographs are to be taken routinely, the operating microscope should be as clean, and the glass as dust-free, as a compound light microscope.

On most models, the *binocular headset* is immediately above the magnification changer. The binocular headset receives the left and right stereo images and sends them to the *eyepieces*. It also allows the interpupillary distance between the eyepieces to be changed readily for optimal comfort. Newer models may also allow pivoting of the binocular headset relative to the magnification changer.

The eyepieces are inserted into the binocular headset. They remagnify the left and right stereo images and project them to the observer. Although they are available in different magnifications, 10× to 12.5× eyepieces are the most commonly used. Differences in the magnification of the eyepieces are apparent only to the surgeon and have no direct effect on the photograph.

Eyepieces also have *focusing collars*, which are used to adjust the eyepieces to the surgeon's particular refractive

error and to lessen eye strain during long procedures. Eyepieces also may have a built-in *reticle* for focusing or compositional preview. A reticle is a flat piece of glass etched with a pattern of dark lines. The reticle provides the surgeon with a reference plane of focus and an idea of what the camera will record.

Since the operating microscope must be held steadily above the patient, it needs a *supporting stand*. The intended function of the microscope dictates the form of the stand. A colposcope, for example, has a very short stand that holds the instrument in a horizontal plane and at the same time permits the entire operating microscope to be pivoted rapidly into place or removed. A slit-lamp microscope is usually mounted on a table top in such a way that the instrument is supported horizontally and its movement precisely controlled with a mechanical joystick. An operating microscope designed for microsurgery has a very heavy floor stand in order to assure stability at high magnifications, and electronics for focusing, zooming, and panning by means of depression of foot pedals. A microscope for neurosurgery may have its movements electrically released or clamped by the surgeons' mouth or head movements.

These variations are all essentially stand modifications and do not affect the use of the operating microscope as a photographic instrument. It is an advantage to use a larger and heavier stand for operating microscope photography, but only because it makes the instrument more stable, resulting in the capability to use longer shutter speeds.

To the photographer, the lighting used by the operating microscope is more important. The lighting configuration of the operating microscope is geared specifically to the intended surgical task. The *lighting direction*, in particular, is critical to effective use of the instrument.

There have been significant advances in operating microscope lighting in the past 25 years. The earliest instruments were fitted with rather weak tungsten bulbs for illumination. These lights are no more suitable for photography through the operating microscope than conventional tungsten light sources are suitable for endoscopic documentation. Working with only these feeble light sources dooms the photographer to inadequate results. Newer and more sophisticated illumination sources have a much stronger tungsten light source routed to the subject through fiber-optic cables, and the most advanced products use metal halide lamp technology to provide a very intense light that is optimal for photography.

The anatomical description of the operating microscope given here is not meant to be complete, but only to briefly cover the essential optical components as used by the surgeon. The operating microscope is a modular instrument. If the binocular headset is removed temporarily, a *beamsplitter* can be inserted on top of the magnification changer. The binocular headset is then reattached. The beamsplitter divides the light, which is already in the left and right optical columns, and directs a portion (usually 50%) of the light out the side of the microscope through ports in the beamsplitter. Thus, the physician sees the same images that were present before the beamsplitter was inserted; the only difference is that the images are now slightly dimmer. There are two ports on the beamsplitter: one on the left side containing the left stereo image, and one on the right side containing the right stereo image. You can attach observer tubes or camera adapters to these ports on the beamsplitter. It is critical to remember that the right port on the beamsplitter carries only the image that the surgeon's right eye sees and that the left port carries only the image that the surgeon's left eye sees. There may be significant differences in these two images, particularly when the surgeon is working in a deep narrow cavity. A photographer must be continually aware that a camera attached to one port of the beamsplitter records only one of the two stereo images available.

Different types of camera *adapters* fit onto the beamsplitter. The primary difference between the adapters relates to the focal length; longer focal length adapters provide bigger image sizes for larger format cameras. Most adapters have a lens diaphragm built into them for exposure control. There is a danger in that some camera adapters can vignette the photograph if stopped down to very small apertures. This vignetting (darkening of the picture at the corners) is especially evident with some older Zeiss 35-mm camera adapters. There are also some camera adapters that do not completely fill the film with image, leaving the corners dark under all circumstances.

The fitting on the end of the Zeiss 35-mm camera adapter, a female circular dovetail, is not intended to fit any specific brand of camera. Consequently, a camera brand ring must be inserted between the camera adapter and the 35-mm camera body. Camera brand rings are not available for all makes of 35-mm cameras.

The fitting on the end of the video camera adapter for an operating microscope is usually a C mount thread, which requires that the video camera have a C mount. Technical representatives of the microscope's manufacturer are glad to help with the selection and ordering of appropriate beamsplitter, camera adapter, camera brand rings, and even cameras.

**Lighting.** Photography through the operating microscope is essentially high-magnification photography on an unstable platform and requires enough light for shutter speeds that will stop the relative motion of the subject and microscope due to vibration and sway. Thus, it has many of the same problems as outdoor nature photomacrography. For example, the subject may be moving and the camera swaying or vibrating slightly. In either case, it is necessary to stop the relative motion of subject and camera. With the operating microscope, the photographer can use either a high shutter speed or an electronic

flash to stop the motion. Both methods work and both have appropriate applications.

The built-in lights for an operating microscope vary, depending on the intended application. In the older Zeiss models designed for ENT work, a low-voltage tungsten light is mounted in a housing attached to the magnification chamber. Light from the bulb is collected and channeled into the magnification changer and then reflected through the objective to illuminate the subject (Figure 14.18). Light provided along the optical axis, that is, along the instrument's line of sight, is called *axial illumination* (Color Plate 62). When a microscopic procedure involves deep cavities, axial illumination is mandatory. Colposcopes have axial illumination because it is necessary to light the cervix at the end of the vaginal canal.

Microsurgical reconstructive procedures are often not in deep cavities and thus usually may not require axial

light. Instruments for these procedures have powerful light sources mounted on top of their support columns. Light is carried through fiber-optic bundles to the side of the instrument and projected onto the subject. This light is not axial in nature; thus it provides some highlights and shadows that enable the surgeon to discern structures in the operative field more easily.

Ophthalmological procedures require a microscope with the light sources mounted on outrigger arms, so as to provide the surgeon with specular highlights away from the optical axis. Slit-lamp microscopes have very specialized illuminators that provide a precise and adjustable slit of illumination, making possible the visualization of subtle defects in the otherwise transparent portions of the eye.

The type of illumination must fit the procedure. For example, working on an eardrum requires axial illumination, reattaching a surface blood vessel requires off-axis illumination. The illumination must also be bright enough to allow the camera to stop any motion. Some of the newer illuminators on operating microscopes work reasonably well for photography, particularly those light sources that utilize metal halide lamps. A minimum shutter speed of 1/30 second is usually necessary to achieve an acceptable percentage of adequately sharp photographs at moderate magnifications. Low-voltage tungsten lamps sometimes allow a shutter speed of only 1/2 to 1/15 second, depending on magnification and other factors. Metal halide lamps may allow much higher shutter speeds and thus permit high-quality photography without providing additional illumination.

In many cases the photographer must use an operating microscope with an inadequate (from a photographic standpoint) illuminator. In such circumstances the photographer must determine how to best provide additional lighting.

Electronic flash provides high-quality daylight balanced illumination, which stops action well, and which usually is easily integrated into the operating microscope setup. If axial light is unnecessary, the photographer simply can tape the flash unit onto the side of the magnification changer. If axial lighting is required, it may be necessary for you to fashion a special holder or even to modify the flash unit so that the flash tube is positioned very close to the optical axis of the microscope.

A major disadvantage of electronic flash is that it is difficult to determine the exact effect that the flash illumination will have in terms of highlights and shadows. The photographer can approximate the effect by manually triggering the electronic flash and monitoring the subject, but there still will be some variation and guesswork involved. Closely duplicating the path of the original illumination will usually suffice for additional lighting. However, it is crucial that the photographer avoid blocking out any of the instrument's built-in illumination, because the surgeon needs it for the operation.

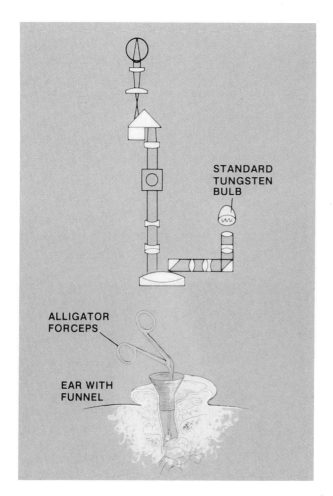

**FIGURE 14.18   Schematic view of the operating microscope and the path of axial illumination used in many procedures.**

**Camera Body Selection.** There is little reason to consider any style of camera body other than a 35-mm SLR for this type of photography. The fact that no camera lens is used in photography through the operating microscope also simplifies the selection. The camera body is attached to the adapter by means of the brand ring, which fits into the circular female dovetail of the camera adapter on one side and into the camera's lens mounting bayonet on the other.

However, there are a few things to remember when selecting an appropriate camera body. First, the manufacturer of the operating microscope must be able to supply a brand ring to couple the intended camera body with the camera adapter. If this is unavailable, the photographer must have a brand ring machined. In this situation, it is important to remember that the back focus (the distance from the female circular dovetail of the camera adapter to the assumed film position) is fixed, and should be matched precisely. The correct back focus usually can be achieved by modifying the thickness of the homemade brand ring.

Also important in selecting a camera body is compatibility with an automatic electronic flash to control the flash exposure based on the light reaching the film plane. This capability—monitoring the light striking the film and turning the flash off when a proper exposure has been reached—is called TTL flash metering; it requires close electronic coupling of the camera and flash. TTL flash is the preferred method of exposure control when electronic flash illumination is used with the operating microscope. If TTL control is not available, you can keep careful trial-and-error records and use manual flash control by means of film choice and flash power settings. This manual control is possible, but difficult. Older manual electronic flash units for the microscope provide excellent lighting but require detailed testing for exposure settings. Any change in objective lens, magnification, or other factors may invalidate the testing results and result in poorly exposed photographs. If you use one of these manual electronic flash units, a camera body capable of TTL flash metering is not necessary.

Other factors to consider when selecting a camera brand and model include the availability of a motor-drive or autowinder, as well as availability of an electrical remote release. Both the motor-drive and remote release are advantageous, particularly when the operating microscope must be covered with a sterile drape.

**Attaching the Camera.** There are a number of things to remember when considering photography through an operating microscope. First, the beamsplitter should be inserted between the magnification changer and any optics above. Other optical modules, such as secondary binocular headsets, are available and can be inserted into the optical stack. The camera's beamsplitter must be positioned directly above the magnification changer, with no other components in between, because additional components function by splitting some of the light away from the left and/or right stereo optical channels. The camera itself should receive the initial beamsplitting, so that the camera will receive the brightest possible image of the subject.

Next, determine which optical column (left or right) the camera should record. A few operating microscopes have beamsplitters with only one port; the other side is obscured deliberately. With such instruments, the photographer is restricted to the remaining side. There is normally a choice as to which side of the beamsplitter the camera should be attached; the camera should be mounted on the side matching the surgeon's dominant eye. If there is a significant difference in the left and right images, the view as seen by the physician's dominant eye usually is the more important view to record. When the procedure involves a deep narrow cavity, the other side of the stereo image may be partially blocked by the edge of the operative site.

The camera adapter is inserted into the beamsplitter and rotated so that the camera will be situated vertically above the beamsplitter port. This position minimizes torque on the microscope and facilitates the physician's positioning of the instrument. The brand ring is inserted into the camera body and locked in the same manner as a camera lens. The camera body is mated to the camera adapter and temporarily tightened in place.

Next, consider the physician's *eyepieces.* Usually, 12.5× eyepieces give the physician the most accurate representation of what the camera will record. The eyepiece on the camera side should contain a photography reticle. The surgeon should look through the microscope at an empty field far out of focus, a view that provides an essentially blank image. The image of the reticle appears as a pattern of black lines superimposed on this blank field. The surgeon should focus the eyepiece to provide the clearest image of the reticle. The entire eyepiece should then be rotated, without changing the focus setting, until the image of the rectangular box corresponding to the film is horizontal in the field of view. Then the other eyepiece should be adjusted for focus and both eyepieces taped securely in place. The photographer should loosen the lock screw on the camera adapter's circular dovetail and, switching between the camera viewfinder and the surgeon's reticle eyepiece, rotate the camera body on the adapter until the image through the viewfinder matches the image through the eyepiece as closely as possible. It is important to note any discrepancies between the images. Although minor differences due to magnification or other factors cannot be corrected, the photographer can easily compensate for them. The microscope should now be focused on a subject by using the reticle; and the photographer should look through the camera viewfinder to confirm that camera focus is identical to the focus in the eyepiece.

Once the camera is attached and adjusted, it is time to attach the motor drive and the remote electrical release. All mounting screws should be tight and collars should fit snugly. Tape the release cord securely along the arm of the microscope to ensure the instrument's freedom of movement. A foot pedal switch for the remote electrical release is convenient. Attach an electronic flash with fully charged batteries, either by means of a mechanical adapter or by taping it securely in an appropriate location. Again, the function of the operating microscope must not be impaired by the tape. The sync cord for the flash is routed past the magnification changer, along the camera adapter, and plugged into the camera. Tape the sync cord securely in place. The emphasis on cord and camera security is important—it can be very embarrassing when camera cords come loose during a procedure. Check and tighten all dovetail screws before the procedure. The camera, flash equipment, and cords present a real danger of contaminating the sterile field if they come loose during a sterile procedure.

The photographer should set the lens aperture on the camera adapter to wide open (*f*/14 on the Zeiss). After the camera is loaded with the appropriate film and the ASA/ISO on the camera meter is set, the photographer and equipment are ready. Obviously, you should do this before the physician needs to use the operating microscope.

**The Sterile Drape.** If a sterile environment is required, you can cover the operating microscope and camera assembly with a sterile drape (Figure 14.19). If you do this, you must consider several things. First, a plastic lens that is a part of the drape will cover the objective lens. Remove this plastic lens, if possible, since its position in front of the objective lens will reduce resolution noticeably. The necessity for appropriate lighting is second. The scrub

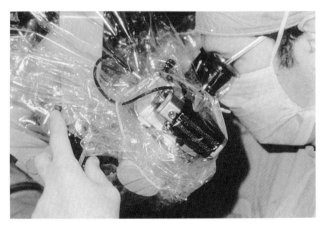

**FIGURE 14.19  Physician using a microscope encased in a sterile bag. Difficulty of release, film advance and use of viewfinder is apparent.**

nurse who attaches and arranges the clear plastic drape should stretch the drape carefully over the flash and lights so that they shine through only one layer of drape. Sterile drapes are usually quite voluminous, and unless they are spread flat, they can obscure the lights, lowering illumination levels to an unacceptable level. Sterile rubber bands or sterile tape can hold the drape in place. Spending a few minutes securing everything is important. This is another reason for maintaining a good relationship with the nursing staff.

**Film Choice.** Choice of film *emulsion* in photography through an operating microscope is straightforward. The three primary considerations in film choice are end product, color balance, and emulsion speed. The first consideration is end product. If you need slides, shoot a slide film; if you need BW prints, use a BW negative film. Color negative film is probably the safest choice if there is a question, since it is capable of producing color prints, color slides, or BW prints. The wide exposure latitude of color negative films makes moderate exposure errors only a minor problem; color balance inconsistencies often can be corrected during printing.

Color balance of the light source is an important consideration in the choice of film. If it is necessary to use conventional tungsten illumination, which is not recommended, a tungsten-balanced film is preferable. You can use a daylight-balanced film and a CC filter such as a Wratten 80A, but a significant exposure penalty will result. Metal halide, xenon arc, or electronic flash illumination are compatible with daylight-balanced film. Color balance is not a consideration if you are using BW negative film.

Use the slowest ASA/ISO film that allows acceptable shutter speeds. What constitutes an acceptable shutter speed varies considerably, depending on magnification and microscope stability. Low-magnification photography with a very stable instrument can produce an acceptable percentage of sharp photographs with a shutter speed as low as 1/8 second. High-magnification photographs taken with an unstable stand can be a problem, even with shutter speeds as high as 1/125 second.

Determining the appropriate emulsion speed for any given combination of equipment and procedure may involve some trial and error, but ASA/ISO 200 is a good starting point if you are using a metal halide or xenon arc lamp. It is better to err on the side of excess emulsion speed, rather than risk motion-blurred photographs.

Use 36-exposure rolls of film. Changing film is usually inconvenient and, if the microscope is draped, can be impossible without a major disruption of the procedure. For the same reasons, film should be used sparingly during a procedure.

**Taking the Photograph.** Before taking any surgical photograph, regardless of whether an operating microscope

is used, the surgical field should be prepared for photography. Complete hemostasis should be achieved and the field cleansed of any distracting blood, sponges, unnecessary instruments, and the like. The physician should position the microscope carefully so that as much of the subject as possible lies in a plane perpendicular to the optical axis. The depth of field in an operating microscope is minimal in the best of circumstances; do not stop down the camera adapter diaphragm unless previous testing has shown that diaphragm use does not vignette the image. Depth of field in photography through the operating microscope lies in a shallow plane at right angles to the lens axis. For example, repositioning the operating microscope slightly can keep a long blood vessel from running up or down out of the plane of focus. Sterile photographic backgrounds can be used in many microsurgical procedures and are available from suture manufacturers. Cut the background to an appropriate size before inserting it into the field. Clean and change the background as needed.

If the microscope is not draped, view the subject through the camera viewfinder, and instruct the physician to alter focus, position, and other factors appropriately until the photograph is properly focused and framed. Focus the microscope by moving it closer to or farther from the subject. If an electronic flash is used, it should be turned on and fully charged. When you are ready, release the camera shutter electrically by means of the foot switch; the film is advanced automatically by the motor drive or autowinder.

If the microscope is draped or the camera viewfinder is inaccessible for another reason, the process of taking the photograph is slightly more complex. You may need to use the reticle in the surgeon's eyepiece to focus and compose the photograph. The surgeon should look directly at the reticle to be sure that the image of the reticle and the subject are simultaneously in sharp focus.

After you have composed the photograph and compensated for any differences between what the reticle indicates and what the camera will record, release the shutter. Using the reticle to check focus is significantly more difficult than it sounds and requires practice. Physicians who routinely use microscopes usually have trained their eyes to focus on various focal planes inside their instruments in order to work at different distances without interruption. ENT physicians in particular often acquire this skill, probably because of the nature of their procedures and the difficulty of passing instruments, tiny sponges, and other equipment down the deep constricted cavities. Close attention to the simultaneous focus of reticle and subject helps to increase the percentage of acceptably sharp photographs.

**Miscellaneous Tips and Techniques.**    This section has centered on the basics of still photography through the surgical microscope. Although this discussion is valid for most operating microscopes, colposcopes, and slit-lamp cameras, each procedure has its own unique requirements, and adaptations may be necessary in particular circumstances. Some basic general principles to remember are:

1. Clean the microscope carefully, particularly the objective lens. The operating microscope is a precision instrument, much like a compound microscope used in histological photography.
2. Heavier, shorter stands for the operating microscope tend to be more stable and provide a better photographic platform. Camera/subject motion is a major problem in this type of photography.
3. Use the middle magnifications on the magnification changer whenever possible. Stay away from very lowest and highest powers on the magnification changer because they can vignette the image at the lowest powers and because they may lack sharpness at the highest powers.
4. Position the camera assembly vertically above the beamsplitter port to reduce torque effect.
5. Secure all setscrews and tape all cords and cables in place.
6. After draping the operating microscope in a sterile bag, remove the sterile plastic objective cover if possible and check for obstruction of the lighting and objective lens by the drape.

## Special Considerations

Different types of microsurgical cases demand different handling by the photographer. The following are some typical operating microscope procedures and special considerations applicable in each case.

**Plastic and Reconstructive Microsurgery.**    Photography of these cases tends to be uncomplicated, with dramatic and high-quality results possible (Color Plate 63). Electronic flash is easy to use, as most of the work tends to be near the surface and you encounter few deep cavities. Short focal length objectives (200 mm) are normal, leading to high magnifications. Very substantial support stands are used, often with fully motorized X-Y movements and focusing. Microvascular repairs and microneurorrhaphy benefit from the use of backgrounds to visually isolate the subjects. The surgeon can achieve complete hemostasis, resulting in clean and orderly surgical fields (Color Plate 64). Operating microscope lighting often consists of powerful fiber optic illumination; supplemental electronic flash is easily adaptable. Prepare the field adequately; pay particular attention to keeping blood vessels and nerves in the plane of focus.

**Ear, Nose, and Throat.** ENT procedures tend to be more complicated to photograph, both because of the lack of light in deep cavities and because of the complex anatomy involved. ENT operating microscopes often have lighter and less stable floor stands, and the illumination is often from low-voltage tungsten lights that are too weak for quality photography. The light in these procedures (laryngoscopies, otoscopies, and the like) frequently needs to be axial because the procedures often involve long and torturous passages, with the subject difficult to illuminate effectively (Color Plate 65). They require powerful axial flash or metal halide lighting. Bony surfaces frequently continue to seep blood, and complete hemostasis is difficult. The anatomy is three-dimensional, and depth of field can be insufficient. Drum-type magnification changers are often used. Focal lengths of 350 to 400 mm and long working distances are common. Glare from funnels and laryngoscopes is prevalent, although you can partly alleviate this problem with black anodized instruments. The surgeon may have difficulty focusing the camera, particularly when a reticle is required.

Intraoperative laryngoscopy is performed frequently with a suspension laryngoscope (such as the Dedo-Jako), which serves to hold open the passage through the mouth, pharynx, and upper trachea, thereby keeping the larynx in full view (Color Plate 66). Suspension laryngoscopes often include their own fiber-optic lighting. Powerful light sources such as metal halide illuminators with these fiber optics provides an efficient and flare-free illumination of the vocal cords. Minimize glare from the speculum.

**Neurosurgery.** Photographic techniques for neurosurgery tend to be similar to those used for ENT. Sterility of the operative field is critical in neurosurgical cases, and draped operating microscopes are the rule. Heavy camera stands are the norm; they often include sophisticated electronic clutches to facilitate microscope movement. The magnification changer is usually a zoom type, and lighting can vary widely. Since neurosurgical procedures often involve deep narrow cavities, axial illumination is required.

**Ophthalmological Surgery.** Photographic procedures for ophthalmological surgery performed with an operating microscope differ from those performed with a slit lamp or with a fundus camera. Operating microscopes for this specialty have heavy floor stands for excellent stability. Lighting is frequently provided by tungsten lights on outrigger arms; consequently, position of the specular highlights from these lights is critical. Any additional lighting should closely mimic the microscope's built-in lights (Color Plate 67). Additional beamsplitters for assistants in the procedure are common, so make sure that the camera beamsplitter is directly adjacent to the magnification changer.

**Slit-Lamp Microscopes.** The ophthalmological slit-lamp microscope has a slightly modified body and is mounted horizontally. It is positioned using a mechanical joystick and special height control. Attachment of the camera and reticle assemblies is routine, but the lighting for a slit lamp is critical. It is virtually impossible to effectively supplement the slit lighting supplied by the instrument because the illuminating slit's size and position are critical in visualizing the subject. Thus, the photographer must work with the built-in lighting, which may not be very intense by photographic standards. High emulsion speeds and long exposure times are routine.

Another problem in slit-lamp photography is the difficulty of exposure determination. The illuminating slit varies in height, width, intensity, and placement. Camera meters often misread the patterns of light and dark in slit-lamp photographs, a problem that results in poorly exposed photographs. High quality slit-lamp photography requires experience and skill, even with instruments specifically designed for photography.

**Colposcopy.** Colposcopic photography can be quite standardized, with the photographic situation varying little from patient to patient (Color Plate 68). The magnification changer is usually the drum type. The support stand is very short and holds the colposcope in a horizontal plane. Sufficient axial lighting is the main consideration because full visualization of the cervix is required. Unfortunately, lighting is usually provided by a low-voltage tungsten lamp, which is inadequate for photography. Since the basic photographic situation changes little from patient to patient, a manually controlled flash fastened closely on the lens axis can be useful. Test exposure levels at various settings of the magnification changer. Flare from the speculum is often a problem, but it can be alleviated with judicious framing of the photograph. Clear plastic specula tend to reflect less than polished stainless steel specula. Vertical format photographs are common; they require only rotation of the eyepiece with reticle and the camera.

## Video Recording Through the Operating Microscope

Videotaping through the operating microscope is common. Stability of the instrument, camera assembly, and lighting are crucial. A video camera is attached to the operating microscope in a manner similar to the attachment of a still camera; however, a slightly different camera adapter is used, usually one with a C mount (Figure 14.20). Heavy video cameras are not well suited to all models of operating microscopes because a heavy camera

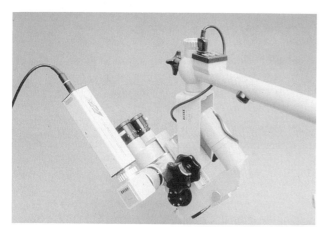

FIGURE 14.20  Operating microscope with compact one tube video camera attached.

on a light microscope tends to be unstable and unwieldy. Many photographers use high-quality single-chip cameras because of their light weight. The video camera adapters' lens diaphragms allow for exposure control and do not vignette the image. A waveform monitor is very useful for setting appropriate light levels, since specular reflections from instruments may mislead automatic diaphragm controls. Use electronic gain control or boost on the video camera only if this is absolutely necessary. A video monitor displaying the image from the camera facilitates previewing and focusing of the image.

Lighting considerations in video recording are the same as in still photography. The difference is that with a video camera the proper light level can be determined through the use of a waveform monitor connected to the camera. Provide any additional lighting through continuous light sources such as tungsten video lights. White balancing of the video camera to the operating microscope light source is required. Consider the comfort of the operating staff and patient safety when using additional lights. Lights containing focusing reflectors for increased efficiency are best for this application. Heat-absorbing filters and barn doors should be used on the lights; additional illumination should be turned on only during taping.

## Common Errors in Photography Through the Operating Microscope

A series of photographs (color plates 69, a to m) illustrate some of the problems when using the operating microscope. The newcomer can compare their not-so-perfect slide with the illustrations and learn what is wrong and the corrective measure to take.

## SUMMARY

Photography through the operating microscope and the endoscope is a matter of details. How to attach the camera, which light source to use, which film, what shutter speed is appropriate, are all considerations which involve a seemingly endless list of details. A photographer who understands how the instruments work will find it easier to put these details into perspective. As always, there is no substitute for some practical experience, which generally can be gained by asking. Residents in the appropriate services usually are eager to build up their reserves of teaching slides and are more than willing to show the photographer how to use the instruments. Residents can also provide test patients, with minimal risk to the photographer if their photographs do not turn out perfectly. Experimentation, adequate preparation, and experience bring the best results in both endoscopic and operating microscope photography.

Clarity of vision has always been an essential factor in medicine. Recording relevant pathology and techniques is often critical in teaching and in diagnosis. Hopefully, the preceding analysis has provided insight into the relationship necessary between photographer and hospital staff and has given an explanation of some of the technical details of this type of photography.

## EQUIPMENT SOURCES

List of sources for endoscopic and operating microscope equipment

Karl Storz Endoscopy-America, Inc.
10111 West Jefferson Boulevard
Culver City, CA 90230
213–558-1500

Richard Wolf Medical Instrument Corp.
7046 Lyndon Avenue
Rosemont, IL 60018
312–298-3150

Carl Zeiss Inc.
Medical Products Division
One Zeiss Drive
Thornwood, NY 10594
914–747-1800

Olympus Corporation
Precision Instrument Division
4 Nevada Drive
Lake Success, NY 11042-1179
516–488-3880

## BIBLIOGRAPHY

Berci, G., 1976. *Endoscopy.* New York: Appleton-Century-Crofts.

Daniel, R. K., and Terzis, J. K., 1977. *Reconstructive Microsurgery.* Boston: Little, Brown.

# Chapter 15
# Ophthalmic Photography

## Lawrence M. Merin

*"Who would believe that so small a space (eye) could contain the images of all the universe? O mighty process! What talent can avail to penetrate a nature such as these? What tongue will it be that can unfold so great a wonder? Verify, none! This it is that guides the human discourse to the considering of divine things."*

Leonardo da Vinci (1452–1590)

*eyewitness.* n. one who sees an occurrence or an object; esp : one who gives a report on what he has seen. *Webster's New Collegiate Dictionary,* 1973

Perhaps no single word describes an ophthalmic photographer as aptly as eyewitness. In conventional usage, this word can describe professionals working in a wide array of subspecialties within the biomedical communications family; to first observe and then record is a universal task for medical photographers and illustrators.

Upon amplification, the double meaning of eyewitness comes quickly to mind: skilled ophthalmic photographers witness eyes. They witness, often with the aid of dedicated optical devices but always with keen powers of observation, occurrences in the eye's function or appearance that may be ephemeral or may remain unchanged for decades. They seek to observe ophthalmic subjects that may be obvious or may be so elusive that only through extraordinary effort can their faint tracings be seen.

However, observation is only half of the story. During the observation, the ophthalmic photographer must consider simultaneously the task of creating an objective and impartial photographic record to be used to report on what he has seen. The creation of that image requires skilled use of photographic tools and adequate cooperation from a patient who may be in considerable physical or emotional distress.

If the ophthalmic photographer records capably what is seen, then a truly valuable photograph results. Such an image is an important part of the medical record, especially when used to augment the physician's clinical impressions. The photograph's reproducibility can quantify small changes and thus guide drug therapy or surgical intervention. Some forms of ophthalmic photography transcend documentation; the diagnostic value of these photographs is highly prized and is inextricably linked to the specialized treatment of several potentially blinding diseases.

This chapter will guide the reader through the several technologies of ophthalmic imaging in common use throughout the world. It will emphasize the importance of seeing the relevant pathology and will suggest methods to master the instrumentation to produce the best possible photographic report. The chapter will also consider techniques of patient management, since successful ophthalmic photographs can only be produced through a cooperative relationship between photographer and patient.

### ANATOMY AND FUNCTION OF THE EYE

The human eye is composed of numerous extremely specialized and interlinked systems, including muscular, neural, and vascular components. The ophthalmic photographer must have a general understanding of these systems in the normal eye. By mastering the terms used to describe various regions of the eye, the photographer will know where to find a variety of anatomical structures and various pathological conditions.

### Common Ophthalmic Abbreviations and Indications

*O.D.:* oculus dexter (right eye)
*O.S.:* oculus sinister (left eye)
*O.U.:* oculus uterque (each eye)
*Anterior:* in front of (closer to the observer)
*Posterior:* behind (farther from the observer)
*Anterior segment:* the front half of the eyeball, including the cornea, iris, lens, conjunctiva, lids, sclera, filtration angle, aqueous, and ciliary body
*Posterior segment:* the back half of the eye, including the retina, choroid, optic nerve, and vitreous
*Temporal:* pertaining to the side of the eye closer to the temple and ear
*Nasal:* pertaining to the side of the eye closer to the nose
*Inferior:* below the center or midline
*Superior:* above the center or midline

A basic description of the several major components of ocular anatomy (Figure 15.1) is provided for those read-

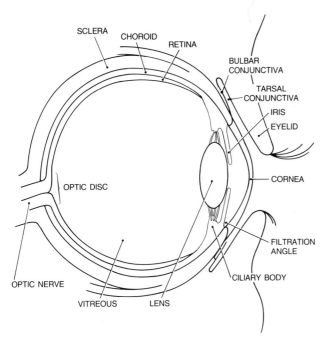

**FIGURE 15.1 Basic anatomy of the eye, as seen in cross section.**

ers who may not have much experience with ophthalmic subjects. The reader is urged to become familiar with the normal appearance (Jakobiec and Ozanics 1989) of the structures described. Thus any deviant presentation will necessarily suggest either a physiologic variant of normal or some form of pathology.

### Cornea

The curved, transparent front window of the eye, the *cornea,* is comprised of six clinically distinct layers: tear film, epithelium, Bowman's membrane, stroma, Descemet's membrane, and endothelium (Kaufman et al. 1988). Although in its normal state the cornea is glossy and crystal clear, the degree of transparency often changes when it is diseased. Tears maintain a smooth, slippery surface to the front of the cornea and lubricate the motion of the eyelids. The tears, epithelial cells, and Bowman's membrane provide a barrier against the penetration of foreign bodies and infectious agents into the deeper corneal structure. The *stroma* is the thickest layer of the cornea and is composed of regular lamellar fibers. The configuration of these fibers is responsible for corneal transparency. Bonded to Descemet's membrane is a single layer of corneal endothelial cells, which functions to pump water out of the stroma, thus maintaining proper thickness and transparency. When viewed in cross section, the normal cornea is thickest at the limbus and thinnest at the apex or center. Its curvature allows it

to refract light and to function as the major component of the optical system of the eye.

### Conjunctiva

Semi-transparent vascular tissue covers the anterior segment of the eye from the edge of the cornea to the lid margin. The *bulbar conjunctiva* is attached to the eyeball, whereas the *tarsal conjunctiva* lines the upper and lower eyelids. The location at which the conjunctiva, sclera, and cornea meet is called the *limbus.* When inflamed or infected (conjunctivitis), the conjunctival vessels become engorged, resulting in a grossly red or pink appearance of the external surface of the eye.

### Sclera

The tough white outer coat of the globe, the *sclera,* has a firm elastic structure that gives form and protection to the eye and its contents. A series of muscles attach to the sclera and, through pulling or relaxing, provide the mechanism for moving the eyeball to the various positions of gaze.

### Iris

Analogous to the photographic aperture, the *iris* controls incoming illumination to the retina. Unless prevented by disease, the iris typically dilates in low light and constricts in bright conditions. It is part of the uveal tract, which also includes the ciliary body and the choroid. Cells with pigment granules coat the iris and produce the spectrum of colors that are seen grossly; blue irises have less pigment than brown irises.

### Filtration Angle

The interior area where the flat plane of the iris meets the cornea, the *filtration angle,* denotes the region where the aqueous fluid produced inside the eye is drained away. If the flow of aqueous fluid through the small structures in the angle is impeded, then the pressure within the eye rises (ocular hypertension or glaucoma) and results in damage to the optic nerve.

### Lens

A biconvex structure located posterior to the iris, the *lens* is capable of changing curvature and thickness to focus either near or distant objects onto the retina. Clear at birth, the lens becomes more yellow and less transparent

with age. A *cataract* is a lens that is no longer able to transmit light readily due to opacities in its optical pathway. Cataracts may be surgically removed and replaced with a plastic intraocular lens (pseudophakos).

## Choroid

The *choroid*, the middle coat of the eye positioned between the sclera and the retina, is highly vascular. Anteriorly, the choroid becomes the ciliary body and iris, while posteriorly it nourishes the outer neural elements of the retina. It is composed of both large and small blood vessels; the very fine vessels are called the *choriocapillaris* and have a structure that permits serous fluid to pass freely through their walls.

## Vitreous

The *vitreous* is a clear, jellylike material that fills the interior cavity of the eyeball between the posterior surface of the lens and the retina. The clarity of the vitreous is necessary for good vision. Retinal hemorrhages sometimes diffuse into the vitreous and obscure the visualization of the retina.

## Retina

Analogous to photographic film, the *retina* is composed of pigmentary, vascular, and neural elements. After the cornea and lens focus light and project it through the vitreous, the retina receives it and converts it to electrical signals that are sent to the brain. The retina is the innermost lining of the posterior two-thirds of the eyeball. Its photoreceptor elements (*rods* and *cones*) are transparent, and the nerves can only be seen with monochromatic light. However, the retina's pigment layer and vascular supply are readily visible. In fact, the retinal vascular system, composed of *arterioles*, *venules*, and *capillaries*, is the only part of the body's circulatory system that is not obscured by overlying opaque tissues, thus making its detailed analysis relatively simple. The cells that form these vessel walls have tight junctions and normally do not allow leakage of serum. The *macula* is the region of the retina positioned directly behind the pupil and receives the most highly resolved light rays. The center of the macula is the *fovea*, where the highest concentration of pigment and neural elements (corresponding to highest visual acuity) is located.

## Optic Disc

Also known as the optic nerve head, the *optic disc* is the region of the retina just nasal to the macula where the retinal blood vessels and optic nerve enter the eye from the rear. Its color (variously pink, yellow, or white) and its discrete borders make the optic disc an easily recognizable landmark in the posterior pole. When viewed stereoscopically, the center of the normal nerve head appears to be indented. The topography of the optic disc is an indicator of pathological processes. For example, when the indentation or cupping is exaggerated, increased intraocular pressure may be present. If the disc appears elevated with indistinct borders, nerve inflammation or an intracranial tumor may be suspected.

## PREPARING FOR THE PHOTOGRAPHIC SESSION

Although the following statement may seem obvious to the reader, it bears emphasis because it is absolutely crucial to the success of every ophthalmic photographic assignment: *Prior to beginning the photographic session, understand exactly what the requesting physician requires.*

The following questions should be answered before bringing the patient into the camera room:

1. What type of photography is requested?
2. What is the disease or condition?
3. What are the typical signs of that condition?
4. What specific details must be recorded?
5. Which eye must be photographed primarily?
6. Where is the lesion located?

Although these questions may be answered through direct discussion with the physician, the answers may be highly detailed and complex. Verbal orders can be confusing, and the photographer runs the risk of forgetting them either before the photographic session or afterwards when checking the finished images against the orders. Rather than relying upon memory, the use of a photographic referral form will improve the percentage of assignments that meet the client's stringent requirements.

Such forms should contain a generalized anatomical diagram upon which the physician should sketch the location and nature of the pathology to be photographed (Figure 15.2). A place for special instructions allows the client to communicate specific wishes. By filling in various demographics such as patient name, address, age, and medical record number, a retrievable record can be maintained in the photography department.

If such forms are to be successful, they must be used. Some clients may require repeated requests before they start using them routinely, but when their benefits are explained, most physicians will comply. Referral forms may not solve every problem of understanding the assignment, but they should provide the photographer with sufficient information to at least begin the task (Merin 1984).

Ophthalmic photographers should be wary of assum-

# Cullen Eye Institute
## Ophthalmic Photography and Diagnostic Services
6501 Fannin      Houston, Texas 77030      (713) 798-5938

**Richard A. Lewis, M.D.**
Medical Director

**Lawrence M. Merin, R.B.P.**
Manager

Patient Name _____ Phone_____

Address _____

City _____ State_____ Zip_____

D.O.B. _____ Age _____ Race_____

Sex: M  F      Follow Up:  Yes   No    | BCM                          |

## Services Are Requested By: _____ **M.D.**
(Your original signature legally authorizes our staff to administer ophthalmic medications.)

## Diagnosis

**OD** _____ VISUAL ACUITY _____ **OS** _____ VISUAL ACUITY _____

Special Instructions:

**Physician:** Please **circle** desired procedures, and **sketch** areas of interest on diagrams.

### External Photography
*(Diffuse Lighting)*
Full Face  Profile  OD    OS    OU
Motility series *(nine gazes)*

### Slit Lamp Biomicrography
*(Emphatic Lighting)*
Lids          OD    OS
Cornea        OD    OS
Iris          OD    OS
Lens          OD    OS

**Goniography**         OD    OS
**Iris angiography**    OD    OS
**Specular Micrography** OD   OS

O.D.                                      O.S.

### Retinal Photography

Fundus          OD    OS
Fundus Map      OD    OS
2x Disc         OD    OS
2x Fovea        OD    OS
Monochromatic   OD    OS

Fluorescein Angiography
Indicate Primary Eye   OD    OS

**FIGURE 15.2   Photographic request form. Such documents provide an exact and retrievable record of the physician's photographic needs.**

ing anything about the intent of the assignment. If questions persist following a reading of the referral form, the photographer should contact the referring physician to obtain the needed information. Errors are extremely difficult to correct after the fact. Not only would it be an imposition for some patients to return for another photography session, but the fast-changing nature of some diseases means that if they are not recorded properly at a certain stage of their history, another chance may not be available.

To paraphrase an old axiom, "There's always enough time to do it right, because there won't be a chance to do it again."

### Techniques of Patient Management

Because ophthalmic photography is so intensively patient-oriented, photographers are advised to hone their skills in relating to patients in a health-care setting. A mixture of humility, firmness, humor, and compassion is needed, but the sensitive practitioner will adjust the mixture as necessary from patient to patient.

A warm and caring demeanor is never out of place and tends to put a human face on a sometimes impersonal hospital experience. This attitude should not be artificial, but rather should stem from the photographer's deeply held conviction that his work is meaningful and beneficial to the patient. Compassion should not be considered a luxury, and a gentle hand on the shoulder can provide the patient with just the right amount of reassurance.

Firm control is also necessary to manage the patient. Because the creation of successful photographs is the result of patient/photographer collaboration, specific directions must be given to the patient about such controllable functions as direction of gaze, blinking, and body movements.

Verbal communication is the major modality of conveying directions to the patient. Photographers should start talking to the patient at the beginning of the photographic session and should not stop talking until the session is finished. A steady stream of directions coupled with constant reassurances serve to remind the patient to concentrate on the task at hand. Silence may be appropriate for still life photography, but ophthalmic photography with its human interaction is a dynamic event. During the session, the photographer's patter might be: "Please open wide and look straight ahead. Can you see the little light inside the big one? Please look right at that little light. Now here come some flashing lights. Very good, you're doing great! Open very wide now. That's right, that's perfect. Now blink, please. Very good! Now follow the little light as it moves down just a bit. Perfect. Just a few more flashes now. Blink again. Fantastic! Open just as wide as you can now. Outstanding. We're all done!"

Another major part of patient management consists of adequate eyelid retraction. Unless asked to photograph the lids specifically, the photographer should make sure that the lids are separated sufficiently to reveal the entire subject of regard. When anterior segment photography is requested, the lids must be held far enough apart to avoid covering any details to be recorded. For retinal photography, the lids must not obscure any part of the pupil.

Many patients are able to keep their eyes sufficiently wide by themselves, but patients who are photophobic (light sensitive) or who have some lid ptosis (droopiness) may require assistance. Cotton-tipped applicators can be an effective and hygienic aid to lid retraction. Patients are often capable of gently pulling down their own lower lids, so that the upper lids may be retracted by the photographer (Figure 15.3). In especially difficult cases, the photographer should seek help from another staff member. Asking patients to blink every few seconds will improve both their comfort and ability to last through the photo session.

Finally, the ophthalmic photographer may be asked to administer eyedrops to the patient prior to the photographic session. If the patient is wearing contact lenses, these must be removed before drops are instilled. If dilating drops are to be used, a penlight should first be directed tangentially across the front of the eye from the temporal position, and the photographer should carefully inspect the iris. It should appear as a flat plane; if shadowed on the side away from the penlight (possibly indicating increased intraocular pressure), ask an ophthalmologist to examine the patient before proceeding. Similarly, an ophthalmologist should be consulted before administering dilating drops to a patient with an iris-fixated intraocular lens (in this case the pupil may appear

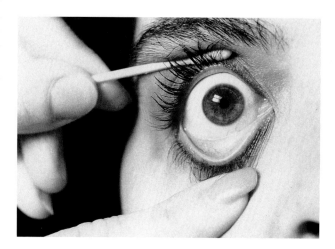

FIGURE 15.3   Lid retraction. Manual separation of the eyelids is often required if the lids or lashes obscure the subject of interest.

square rather than round, or clear plastic positioning loops may be seen in front of the iris) or an eye that looks red and inflamed and a cornea that appears cloudy.

To instill eyedrops, the photographer should ask the patient to tip his or her head back and look up (above the forehead). The photographer should pull down the lower lid gently and place one drop into the pocket formed between the lower lid and the eyeball itself. The tip of the bottle must not touch any part of the patient's eye or lashes; should this accidentally occur, that bottle must be thrown away. The drop should fall an inch or two through the air before hitting its target. When dilating a patient's eye, two different drops are often used. In this case, an interval of a minute or two between the two drops will increase the absorption of each medication. To further improve the action of the dilating drops, the patient should sit with eyes closed or their lacrimal punctum should be occluded (by gently squeezing the bridge of the nose close to the eye).

## Techniques of Ophthalmic Photography

The five major assignments in ophthalmic photography consist of external ocular photography, slit lamp biomicrography, corneal specular photomicrography, fundus photography, and fluorescein angiography. Although the use of electronic imaging is increasing, this modality is not yet considered the industry standard. Thus, we will assume the use of conventional silver-based 35-mm films.

## EXTERNAL OCULAR PHOTOGRAPHY

Of all the types of ophthalmic photography, external eye photography relies least on sophisticated instrumentation. In fact, the required camera body, lens, and flash are often standard equipment in many medical photographic departments.

These components can be configured into an apparatus that can be used for the majority of external eye assignments. Based on the *simple system* (Gibson 1973), this portable instrument can be readily used for photography of one eye alone, both eyes together, and full face views.

The camera body of choice is the ubiquitous 35-mm single lens reflex. When selecting a brand, the photographer should avoid the siren call of the new autofocus models; an all-manual version is much better for this application. Helpful features include a highly accurate viewfinder and the ability to change viewing screens. The best screen for external eye photography is either an all-matte screen or an all-matte screen with grid lines.

The highest magnification generally considered useful for external eye photography assignments is 1:1, or life size on film, combined with a sufficiently long focal length to provide natural perspective and adequate space for suitable lighting technique. Several lens and accessory combinations will provide these parameters, including a macro lens plus bellows, a macro lens plus teleconverter, and a macro lens with integral extended focusing mount. Of these choices, the last two are the most practical.

The combination of a 50-mm $f/2.8$ or $f/3.5$ macro lens and a 2× teleconverter can be focused from infinity to a 1:1 magnification ratio without supplemental close up devices. Several longer focal length (90-mm or 100-mm) macro lenses are available with extended helical focusing mounts, which allow them to focus to the same magnification, again without additional components. The difference between the two types above is the wide-open viewing aperture; the latter lenses allow a fairly bright $f/2.5$ or $f/2.8$ view, while the former configuration only transmits light through a rather dim aperture of $f/5.6$ or $f/7$. The brighter view is especially useful when attempting to photograph a dark iris.

The next component, the light source, should be selected from the variety of small electronic flash units that are commonly available. A manual flash is perfectly adequate for this application, although if the camera body is equipped with *off-the-film* (OTF) flash control circuitry, an automatic flash dedicated to that exposure system is also acceptable.

The *point source** quality of illumination from the standard electronic flash will yield high-quality photographs in any of the three standard magnifications (one eye, both eyes, and full face). Because the cornea acts like a convex mirror, the reflection of the electronic flash will appear in the photograph. When a single eye is photographed, the light source must be small so that its reflection will not obscure any required detail.

A ring flash has also been used successfully for photography of strabismus cases in which the standard view is both eyes together (Szirth et al. 1986). In that application, its reflection on the cornea is acceptably small. It cannot be used for successful photography of a single eye, however, because its proximity to the eye creates a very large reflection on the corneal surface that may obscure detail. If only one camera setup is to be used for all external ocular photographic assignments, then one with a point-source type of electronic flash is more universally applicable.

The electronic flash is attached to the front of the macro lens by means of a special rotating flash bracket. One of the most useful brackets has set-screw adjustments that allow the flash to be positioned in five

---

* In addition to the photographic definition of *Point source* (Stroebel and Todd 1974), this term is frequently used by biomedical photographers to indicate a relatively small light source of illumination as opposed to a broad one.

different positions within a 180-degree arc, thus enabling the light source to be positioned with precision (Figure 15.4).[1] This bracket is also a boon when camera orientation must be varied between horizontal and vertical.

This camera outfit can be used as a portable instrument in the clinic, in patient rooms, or even in the operating room. However, a higher degree of focusing accuracy and compositional standardization can be achieved by mounting the camera on a focusing stand, which also has provision for patient head support. Sometimes such stands can be adapted from pieces of obsolete clinical equipment. If such dedicated equipment is not available, the photographer should stabilize the patient's head in another way. The use of an examination chair with headrest can be a useful expedient for external ocular photography. An even simpler solution would consist of asking the patient to sit against a wall, and then to press the patient's head back so that it touches the wall.

A number of color transparency films are suitable for external ocular photography. For finest granularity, a film of medium speed (ISO 64 or 100) is preferred. When attempting to obtain the most lifelike recording of skin, the flash output may require modification with a UV-absorbing filter such as a Wratten 2E.

As with any other clinical photographic equipment, a series of tests should be undertaken to determine the proper flash settings and exposure parameters before using the equipment on real patients. If a manual flash is used, the exposure test should include a series of bracketed exposures (at half-stop increments) at the three customary magnifications: 1:1 (one eye), 1:4 (both eyes together), and 1:10 (full face). If an automatic flash is used with OTF metering, the goal should be a rather small f-stop (that is, f/22) for single-eye views, where depth of field would otherwise be quite shallow.

The actual photography is fairly straightforward. For photography of one eye at 1:1 magnification, the angle of the flash is set to aim at the eye from the superior temporal or temporal position. The location and angle of the flash is adjusted so that the anticipated location of its reflection misses the major pathology. The lens magnification is preset to its 1:1 setting, and the aperture is set to the predetermined setting. The patient is instructed to look in the direction that will present the proper aspect of the eye to be photographed. Although the conventional anterior-posterior (A-P) straight-ahead gaze photograph is often appropriate, additional photographs in which the camera position or the patient's direction of gaze is changed may often result in a more informative image. Next, in a smooth continuous movement, the photographer should move the camera in toward the subject while carefully assessing the composition and focus in the viewfinder. Small specular highlights often provide a useful clue about focus; they are smallest when the camera is focused on the plane where they are located. At the instant the subject comes into critical focus, the photograph is made (Color Plate 70). With practice, this technique will allow fast and accurate focusing.

By presetting the magnification ratio and then focusing by moving the entire camera assembly, the same magnification for all images is assured. Focusing the lens by adjusting its focusing ring will also change the image magnification and thus compromise the scientific validity of the image. This technique and equipment are also applicable to ophthalmic surgical photography; rapidly leaning in, taking the photograph, and leaning away, limits the interruption to the procedure.

An appropriate reproduction ratio for a photograph of both eyes together is 1:4. This places the center of the image at the bridge of the patient's nose, with a complete view of both eyes and both temporal orbits. Careful camera work will result in a symmetrically composed photograph (Color Plate 71). The plane of sharpest focus should be at the level of the corneas; again, a small specular reflection will provide adequate focusing information. Placing the electronic flash directly above the lens provides even illumination of both eyes.

Although the primary gaze (A-P) position is usually appropriate, on occasion a different camera position might be required. For example, in the case of thyroid ophthalmopathy, the bulging of the eyes may be best recorded by shooting down from above the patient's head, thus recording the abnormal eye position.

On occasion, the ophthalmic photographer may be asked to produce a *motility series* or views of the *nine cardinal gazes*. These assignments are often requested to document cases of muscle imbalance or nerve disease and require a standardized series of photographs in

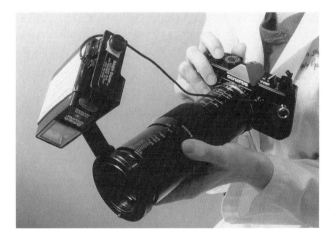

**FIGURE 15.4 External camera. Incorporating a single-lens reflex camera body, macro lens, and an electronic flash attached with a special rotating bracket, this portable apparatus is capable of producing a full spectrum of external ocular photographs.**

which only the direction of the patient's gaze changes from photograph to photograph (Shields and Pulschen 1982). These directions are precisely ordered and include straight ahead, straight up, up and right, straight right, down and right, straight down, down and left, straight left, and up and left. For documentation of a muscle imbalance, an assistant should gently raise the patient's upper eyelids for the three views that include a downward component. An assistant can give the patient a target for proper positioning of the various gazes. Patients have a tendency to turn their heads in the direction of eye movements. Therefore, remind them to maintain a fixed head position and to move only their eyes during the photographic session.

Because facial photographs are uniquely recognizable, the patient should be asked to sign a photographic release prior to photography. If the requesting physician later desires to publish the photographs, the necessary legal document will already be available.

Photography of the full face requires a magnification ratio of 1:10. Because this size allows a small area of background to appear in the photograph, the photographer should choose the color of background carefully. To avoid any unusual color casts on the subject resulting from reflected light, a matte-finish, neutral gray color should be used. If neither a formal photographic studio room nor the space for a roll of seamless background paper is available, one wall of a room in the clinic may be finished with neutral gray paint of between 18% and 36% reflectance. If space permits, seat the patient several feet away from the wall to avoid recording any wall texture or sharply defined shadows. The camera must be positioned parallel to the frontal plane of the face. However, patients frequently incline their heads when posing. The photographer should be prepared to request that the chin be lowered until the proper orientation is achieved. The camera must be held on the same horizontal level as the center of the face, because undesired psychological effects may result if the camera is directed at the patient from either a superior or inferior position.

Although serviceable facial photographs may be produced with the simple system, an improved recording of the three-dimensional aspect of the face can be achieved with more advanced studio lighting techniques, such as a two-light arrangement incorporating a key light and a fill light (Color Plate 72) (See Chapter 9). Because theatrical lighting is simply not appropriate for clinical recording, the standard studio lighting protocol should not exceed a 2:1 ratio, created when both key and fill lights are of equal intensity. This ratio creates highlights on the face that are one stop brighter than the shadowed areas. Specialized additional lighting, such as hair lights and kickers, add needless complexity to the task and should be avoided, although a simple background light may be a useful addition.

## SLIT-LAMP BIOMICROGRAPHY

One of the most challenging forms of ophthalmic photography is the recording of the anterior structures of the eye with the use of a photographic slit-lamp biomicroscope. This instrument, with its built-in variable magnification and binocular eyepiece head, functions as a compound microscope. As such, it provides a continuation of the photographer's armamentarium from the external camera's 1:1 magnification up to nearly ten times life size. The flexibility of the biomicroscope's light source, located on a rotating arm, is also an important part of the instrument's ability to function as a complete photomacrographic apparatus.

The challenge of slit-lamp biomicrography stems from the instrument's unusual flexibility. The user must choose from a wide range of magnification and lighting choices in order to best observe and record the lesion of interest. The actual photographic recording is fairly straightforward, and, by bracketing exposures, successful images from a photographic point of view can usually be obtained. More problematic for the neophyte biomicrographer is learning how to use the instrument the same way the client-physician uses it during the clinical examination to reveal what is often an extremely subtle or faint condition.

A unique problem, and one that is often crucial in understanding how a technically good photograph may not precisely match the client's expectation, stems from the contrast between the dynamics of the clinical slit-lamp examination and the nature of still photography. Ophthalmologists use the biomicroscope in a fluid manner. They constantly move the slit back and forth and adjust the width and focus of the illumination while observing the play of light on the lesion of regard. Throughout the examination, they synthesize intellectually a continuous stream of images into a final composite impression that may, in fact, be greater than the sum of its parts. The photographer reproduces this process of scientific investigation in a few static photographs (Martonyi et al. 1984), each of which must reveal maximum information about the subject.

Not surprisingly, the observation and recording of opaque ocular tissue can be fairly simple, since the light may be adjusted to reveal either overall color and morphology or angled in such a way as to emphasize surface texture. Considerably more challenging is the recording of nominally transparent structures such as the cornea and lens (Meyner 1976). In some ways this task is similar to the photography of glassware; frontal, side, reflected, or even silhouette lighting can often reveal dramatically different aspects of the same subject.

Perhaps the best education for the beginning slit-lamp photographer can be obtained by asking a client ophthalmologist to demonstrate interesting pathology at a clini-

cal slit lamp. Many clinical slit-lamps can be fitted with auxiliary observation tubes that allow a second observer to witness the examination. By investing a few hours in this way with a corneal specialist, the photographer may glean invaluable information concerning the art of seeing pathology of the anterior segment.

Although there is considerable variation among the several photographic slit-lamp biomicroscopes currently available, all are derived from the clinical slit-lamp biomicroscope and share certain basic features of that instrument, including optical design, illumination systems, and the rotating arms upon which those two components are mounted.

The optical part of the biomicroscope consists of the objective lens assembly and the eyepiece head. The objectives can be either individual lenses of varying powers that are rotated into position or a zoom lens system. Typically, the range of magnification extends from slightly less than life size on film up to about nine power (nine times life size).

After being formed by the objective, the image is then projected to the eyepiece head, which is composed of a binocular fixture with two eyepiece lenses. Both the interpupillary distance of the binoculars as well as the individual focus of each eyepiece are adjustable. Because the photo slit-lamp biomicroscope utilizes an aerial image focusing system, the eyepieces must be critically focused by the photographer to ensure acceptably sharp photographs. An eyepiece reticle is provided to assist in this task.

Depending on the model, some form of a beamsplitter or movable mirror system diverts the image to the 35-mm camera body for photographic recording. On most biomicroscopes, the camera will record a view identical to that in the eyepiece. If the eyepiece reticle is interchangeable, it must be placed on the same side of the binoculars as the camera to ensure parallax-free recording.

The second major component of the biomicroscope is the illumination system. Through a system of condensers and special knife-edge aperture diaphragms, the modeling lamp—and, in photographic instruments, the electronic flash that shares the same optical pathway—is projected onto the subject's eye as highly collimated and focused rays. When the knife-edge aperture is adjusted to project a very thin slit beam, the play of light clearly differentiates the component parts of such structures as the cornea and lens. The *optical section* effect produced by the thin slit beam shows the observer a view suggestive of a histopathological specimen viewed with dark-field illumination; the structures highlighted by the beam appear bright against a dark background.

In addition to its thin slit configuration, the light may also be broadened until a wide area of the eye is illuminated with focal rays. For still wider coverage, especially at low magnification, some instruments provide a diffu-

sion cap, which is placed over the exit prism to diffuse and broaden the beam.

Unlike a clinical slit-lamp biomicroscope, the photographic version is equipped with some means of providing general diffuse illumination from another light source. This supplemental lighting may be a complete fixture with modeling lamp and separate flashtube, or the lighting may come from the main flashtube via a fiber-optic cable.

The flexibility of the slit lamp and the relationship between the optical and illumination components and the subject to be observed are both defined by two arms that rotate about a common pivot point. On one arm is mounted the optical system, while the other contains the light source. The pivot point represents the plane on which both the microscope optics and the focal light source are focused (although the light may also be decentered for special effects); that point also corresponds to an imaginary vertical axis line drawn through the subject being observed. Thus, both the microscope and the light source may be independently rotated about the subject while maintaining the focus of image and illumination.

The film for biomicrography is selected according to the efficiency of the optical system and the amount of available flash power. Color transparency film rated at ISO 200 is most commonly used.

When producing slit-lamp biomicrographs, the sequence should begin with a general overview of the eye and then proceed with more and more emphatic use of magnification and lighting effects. The photographs should tell a story; the first photograph serves as "Once upon a time . . ." and the subsequent shots develop the story until the final visual punch line. The following illumination techniques are variously applicable to a wide variety of anterior segment conditions, although not all will be useful for every subject.

## Dual Diffuse Illumination

Low-magnification survey photographs in which the eye is diffusely illuminated demonstrate the general condition of the eye and its surrounding tissue (Color Plate 73). The slit beam is opened to its maximum width, the diffusion cap is placed over the slit prism, and the illuminator is angled approximately 45 degrees to one side of the microscope. The background illuminator is turned on, or, if the instrument is so equipped, the fiber-optic background light is activated. The power setting and/or aperture control is set to the proper setting as demonstrated by practice or by prior testing. Unless the eyelids are the subject of interest, they are retracted fully to provide a clear view of the cornea and surrounding sclera. The first survey photograph should show the eye in the A-P position, achieved by asking the patient to look straight ahead. Subsequent diffusely illuminated photo-

graphs at low to moderate magnifications may feature a different direction of gaze so that the lesion of interest is centered in the view. The microscope is focused on the reflection of the light source on the cornea or on the plane of the lesion. Although such low-power, diffusely illuminated photographs are unable to resolve small or faint lesions well, they are able to demonstrate the relative transparency of the cornea, the general size and morphology of the lesion, and the degree of involvement of adjacent tissues.

### Thin-Slit Illumination with Background Light

When configured to project a thin-slit beam, the slit-lamp biomicroscope is uniquely able to emphasize topographic changes and to reveal changes in the structure of transparent media (Color Plate 74). When the thin beam strikes an opaque lesion at about a 45-degree angle, the resulting undulations provide visual clues about the three-dimensional nature of the lesion and its surface texture. When directed at a transparent structure (such as a cornea), the beam will similarly reveal structural information. If the surface is elevated, the slit beam will appear to deflect toward the light source, whereas a depression in the surface will divert it away from the incident beam.

When observed and photographed at high magnification, three layers of the cornea will be visible as alterations in the brightness of the beam: the corneal epithelium will be a fine bright line closest to the light source, the stroma will be a relatively thick band of medium brightness, and the endothelium will appear as a very thin bright line farthest away from the incident light. In its normal state, neither Bowman's nor Descemet's membrane will be visible in thin-slit illumination.

The anterior chamber of the eye (the space between the cornea and the iris) is filled with normally transparent aqueous fluid. When a thin-slit beam is directed to the front of the eye, it will first appear on the cornea and then will appear on the iris plane or the front surface of the lens. The gap between the two slits can be useful in demonstrating the depth of the anterior chamber. If there is diminished space between the iris and the cornea, or if local adhesions (*synechiae*) have formed between the two structures, then thin-slit illumination is likewise useful in delineating those changes.

To perform this type of biomicrography, use the slit-width adjustment to almost close the knife-edge diaphragm. The resulting thin vertical beam should then be projected onto the lesion of interest. The patient's gaze should be directed to the point at which the lesion is centered in the eyepiece.

When properly adjusted and focused, the thin-slit beam should intersect the very center of the crosshair reticle, and it must remain centered when the illuminator is swung in an arc around the biomicroscope. (If it cannot be brought to this point and remain sharply focused, then the instrument is misaligned and must be repaired by a service technician.)

### Broad Tangential Beam

The slit-beam aperture control is continuously variable from fine slit to very wide beam, and photographs may be made at any point in that continuum. A particularly useful configuration for illumination of either transparent or opaque tissues is the broad-slit beam angled far to the side so the light just grazes the surface.

When an opaque lesion is to be photographed, such lighting creates highlights and shadows and thus imparts strong visual clues about its three-dimensional nature. The most pronounced chiaroscuro effect of light and dark is achieved by removing the diffusion cap so that the raw beam illuminates the subject. At higher magnifications, the tiny specular reflections and crisply delineated shadows produced by this raw lighting are absolutely necessary to fully resolve fine detail (Blaker 1977; Merin, 1982).

Broad tangential lighting is also valuable when applied to the photography of corneal lesions, although its effect is quite different than when opaque subjects are recorded. When contrasted with thin-slit illumination, which reveals structural detail and topography only in one very thin slice, tangential illumination does not provide information about the full thickness of the cornea, and the observer will not be able to identify the specific layer that contains the lesion of interest solely from this illumination technique. However, broad tangential illumination is able uniquely to reveal changes in corneal transparency over a much wider area than that of a thin-slit beam (Color Plate 75).

The photography of broad-beam tangential illumination is fairly simple. The background illumination source must be turned off, because its diffuse quality would otherwise lessen local contrast by filling in the shadows. While focusing critically on the area of interest, rotate the main light to the side and position it so that the best illumination is achieved. If possible, position large or distracting reflections from the light source away from the lesion of regard (this may also necessitate a slight adjustment in the direction of the patient's gaze). Close attention to the overall brightness of the image may suggest changing the aperture or power setting. Some corneal lesions are very highly reflective, while others are quite faint. Bracketing the exposures will increase the probability of success.

### Retroillumination

In addition to front and side lighting, a third type of illumination provided by the biomicroscope is rear or

retroillumination. Although one obviously cannot move the slit-lamp light source behind the cornea or lens, the photographer should direct the beam eccentrically at a structure behind the subject of interest, so that the light reflects back through it. Thus, the object of interest may be observed in a silhouettelike fashion, in which various opacities appear contrasted against a bright background.

When the slit-lamp biomicroscope is configured in the usual fashion, both the slit beam and the microscope are focused to the same plane. However, all slit-lamp biomicroscopes allow the slit beam to be decentered laterally away from the point of its prime focus. By manipulating this control, the microscope can allow continued focus and observation of the lesion while the lighting is diverted and bounced off posterior structures for special effects.

Reflective structures that lend themselves to this bounce-lighting effect include the iris and the retina. Either may be used for retroillumination of the cornea, while the retina provides an excellent reflector for photography of the lens or iris.

To use the iris for this effect, the corneal lesion is first viewed with direct thin-beam illumination. While the microscope remains unchanged, the slit beam is then slightly widened and displaced laterally. The desired effect is achieved when the appearance of the lesion reverses, from brightly lit against a darker background to a silhouette seen against a light background. Interesting lighting effects can be achieved by situating the lesion midway between the reflected beam and the unilluminated adjacent area. Placing the edge of the pupil behind the lesion can also yield rather striking visual effects.

For retroillumination views of the iris or lens, the retina is the only structure behind them capable of acting as a reflector. To direct light to the retina, it must pass first through the pupil. This is achieved by simply bringing the illuminator to a position just adjacent to the microscope, creating a semi-coaxial illumination. The retina is not uniformly reflective, however. The brightest area of the retina is the optic nerve head, and the brightest reflection or *red reflex* is achieved when the illuminating beam strikes the nerve. To achieve this, position the slit-lamp illuminator to the temporal side of the biomicroscope.

Retroillumination views of the iris are usually designed to demonstrate defects in its structure caused by pigment migration and atrophy. The resulting absence of pigment in various areas (*transillumination defects*) can be dramatically illustrated by directing the beam through the pupil to reflect from the retina. If the patient's pupil is undilated, then its physiological response to the light will result in automatic constriction (preventing sufficient light from reaching the retina). Similarly, if the patient is fully dilated, the iris structure retracts into itself, causing the atrophic areas to disappear. The best moments in which to produce retroillumination photo-

graphs of the iris occur a few minutes after dilating drops are instilled, when the pupil just begins to dilate. The slit beam is first shortened and configured into either a small square or a circle, depending on the capability of the instrument. The dialating drops are administered to the patient while he or she is seated at the biomicroscope. The photographer directs the beam at the pupil and closely observes the effects of the dilating process. Take a series of photographs as the pupil begins to dilate. At one point during this process, the incident beam will just fit through the pupil; with enough backlighting from the retina, the defects will appear as orange lights visible through the darker background iris.

The retina is also used as the reflector for photographs of the lens, but in this application the pupil must first be widely dilated. The slit beam is adjusted to a moderately thin width, and then the slit-lamp illuminator is positioned nearly coaxial to the microscope. While moving the illuminator from side to side, a reddish-orange reflection will be seen emerging through the pupil. The relative positions of microscope and light source are fixed when the brightest reflection is obtained. Next, the light must be trimmed or fine-tuned. To do so, the slit is decentered laterally so that the beam is brought to a position just inside the pupil edge. The beam is then shortened and slightly widened. The purpose of this trimming exercise is to obtain the brightest reflection possible, without having any light spill over onto the iris (thereby lessening image contrast), and also without having too large a reflection on the lens (thereby obscuring needed detail). On some slit lamps, a combination of slit width and height adjustments may be used to form the beam into a half-moon shape that can be tucked neatly into the curve of the pupil border.

Because the lens has considerable thickness, it is usually impossible to record more than just a shallow plane when retroillumination is used. Consequently, several photographs focused on different levels of the lens opacities may be required to completely illustrate the pathology. If no opacities are present, an adequate retroillumination recording of the lens may be achieved by focusing on the pupil border (Color Plate 76).

## Sclerotic Scatter

Although the broad tangential beam is capable of revealing a relatively large amount of cornea in a single photograph, it cannot be used to illuminate the entire corneal surface due to the curvature of the eye. If pathology is widespread geographically, then sclerotic scatter illumination may be a useful addition to other lighting techniques.

The regular orientation of lamellar fibers that constitute the bulk of the corneal stroma can serve as a fiber optic. When a strong light is applied to one end of a fiber, it is conducted (through internal reflection) to the other

end. Under such illumination, the length of the unblemished fiber is dark, and the light only appears at the distal end. Any local change of texture or uniformity of these fibers will result in the light appearing at that location.

To observe the cornea under sclerotic scatter illumination, the photographer should first carefully focus on the most anterior portion of the cornea (the *apex*). The background illuminator should be turned off, and the slit beam should be moderately wide. The beam is then decentered laterally so that it illuminates the limbus. (If it cannot be sufficiently decentered, the top of the slit-beam prism may need to be removed and replaced off-axis.) After careful adjustment of the beam, the limbal area on the opposite part of the eye will glow, as will all lesions involving the corneal stroma (Color Plate 77). Any non-involved portions of the cornea will remain unilluminated, as will the iris and pupil. Because this technique can portray faint lesions, care must be exercised to place the incident beam so that little light spills onto either the cornea or the iris. The choice of either the three o'clock or nine o'clock limbus will be decided by the location of the lesion of interest; to ensure that no extraneous light from the incident beam contaminates the area of regard, the beam should be directed to the limbus farthest from the lesion.

## Goniography

Because light is refracted strongly by the cornea in the region of the limbus, direct observation of the interior structures of that area, along with the anterior vitreous and retina, is not possible. The use of special contact lenses will neutralize this refraction.

One common lens is the Goldmann three-mirror lens, consisting of three mirrors, each mounted at a different angle inside a short cone. The narrow end of the cone is equipped with a concave lens, which is placed onto the cornea, while the broad end of the cone is finished with a piece of flat glass. Optically, the use of this lens is akin to a bank shot in billiards, in which the cue ball must first strike a bumper at such a precise angle that it will ricochet to the required destination. In this application, the incident beam and its equivalent observation are directed to a mirror in the lens and then on to the region of interest located 180 degrees opposite the mirror position.

To begin a goniography assignment, the photographer should first understand the exact location and nature of the lesion to be photographed, because the lens must be placed on the eye with precision so that the mirror to be used is in the proper location. Preset the various settings of the biomicroscope as much as possible, including the power setting or aperture, and set the magnification changer to low power. The plane surface of the goniolens must be cleaned scrupulously, since any fingerprints or dust will degrade the final image.

Next, anesthetize the patient's eye with a drop of topical proparacaine hydrochloride anesthetic. Then fill the small concave end of the lens with a drop or two of either 2% or 2 1/2% methylcellulose, a viscous solution matched to the refractive index of the cornea. (*Note:* Any tiny bubbles suspended in this solution will also degrade the image through flare. To prevent this, store the bottle upside down. When ready to use, squeeze some fluid onto a tissue until no bubbles appear; then immediately transfer the fluid stream into the cup of the lens.)

Neophyte goniographers can be intimidated by the steps required to place and maintain the goniolens on the patient's eye. At first the procedure may seem daunting, but it becomes much easier with practice. Bring the patient's head into proper position against the headrest of the slit lamp, and ask the patient to look up. Pull the lower lid down, place the lower edge of the lens on the eye at the lower lid margin, then press the lens into full contact with the eye, and direct the patient to look straight ahead. The photographer should quickly look through the lens for bubbles; if these are present, they may be forced out by spinning the lens while it is pressed gently onto the eye. However, if this maneuver is unsuccessful, the only recourse is to remove the lens and begin again.

Use the thumb and forefinger to keep the lens on the eye (Figure 15.5). Only moderate pressure is required, and the photographer's little finger may sometimes be hooked over the forehead support bar to provide extra stability. A special support device, designed for ophthalmic laser surgery, is available to provide an elbow rest for lengthy sessions.

Once the lens is securely placed, rotate it to bring the appropriate mirror to a meridian 180 degrees opposite

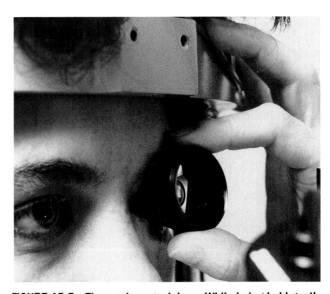

**FIGURE 15.5   Three-mirror goniolens. While being held gently against the cornea, this device allows the viewer to observe and record details in the filtration angle, anterior vitreous, peripheral retina, and posterior pole.**

the lesion. Of the three mirrors in the Goldmann lens, the small half-moon mirror, set at 59 degrees, is used to visualize the filtration angle. The middle-size mirror, set at 67 degrees, may also be used to view the angle, as well as the peripheral retina and anterior vitreous. The largest mirror is set at a 73 degree tilt and allows observation of more posterior details in the retina and vitreous. You may achieve direct observation of the posterior retina by looking through the clear center region of the lens.

After the goniolens has been set into its approximate position on the eye, direct the microscope and a moderately wide-slit beam into the chosen mirror. Locate the pathology, and then adjust the magnification to provide the best coverage (Color Plate 78). To obtain the highest possible photographic contrast, trim the slit beam so that no extraneous light spills onto adjoining structures. Location of the subject in the frame, avoidance of reflections, and clarity of view can all be modified by slight changes in lens yaw or pitch; the view through the eyepiece will confirm the optimal position.

The photographer should work quickly once the goniolens has been placed on the eye. With prolonged contact, the cornea may become edematous, and the view will deteriorate with increased corneal swelling.

Efficiency is also necessary when considering the comfort of the patient. Even though the expected foreign-body sensation is effectively blocked by the topical anesthesia, the patient can still feel the pressure required to hold the lens in place and may grow restive with a lengthy session.

When the photographic series is finished, the lens is removed. At times, suction will develop between the lens and the eye, but by firmly twisting and tilting, the lens may be removed. The excess methylcellulose is then irrigated from the eye with a stream of sterile saline solution, and the lid and cheek are wiped clean.

## Special Techniques: Tarsal Conjunctiva

The conjunctiva that lines the upper and lower eyelids is often the site of infection and is a common subject for slit-lamp biomicrography. Because the depth of field of such work is limited, special techniques designed to present a flat plane of tissue to the microscope are also valuable for photography.

The upper eyelid conjunctiva is often the site of diseases such as giant papillary conjunctivitis. To observe and photograph this area, evert the eyelid. Lid eversion is initiated by having the patient look down. Next, the unwrapped end of a cotton-tipped applicator stick is applied about halfway across the first skin fold above the lid margin. The eyelashes are grasped and used to pull the lid up and over the stick; the lid should fold and reveal the inner conjunctival lining. As the photographer continues to press back against the lashes, the stick is removed and the photography is performed. The patient should be reminded to continue looking down, as this will minimize any discomfort. The direction and pressure of holding the lid can be changed so that a reasonably flat plane is presented to the viewer. Dual diffuse, thin-slit beam, and broad tangential illumination may all be used to reveal the texture and morphology of any conjunctival lesions. Because the tissue is moist, reflections from the light source are commonly observed, but by suitably angling the incident beam, they can usually be suppressed.

The photographer can examine and photograph the lower tarsal plate by first directing the patient to look down. The lower lid should be firmly retracted. While maintaining its retracted position, ask the patient to look up. The lower conjunctival surface will unfold and present itself to the biomicroscope. By changing the direction of pressure on the lower lid, the tarsal conjunctiva can be formed into a nearly flat surface for maximum image sharpness.

## Special Techniques: Vital Dyes

To enhance the appearance of alterations in the corneal epithelium, two dyes may be applied to the eye. Rose Bengal is a brilliant magenta solution that is attracted selectively to abnormal epithelial cells, while topical sodium fluorescein is a fluorescent yellow-green material capable of revealing areas where the epithelium is absent.

Rose Bengal is applied by first asking the patient to tip his head back while looking down. Retract the upper lid and place a small drop of the dye onto the superior bulbar conjunctiva. Instruct the patient to blink several times. Excess dye may be irrigated with sterile saline solution or gently swabbed from the lower cul-de-sac with a cotton-tipped applicator. The lesions revealed by this solution can be recorded with either dual diffuse or broad tangential illumination.

A common form of topical sodium fluorescein consists of paper strips impregnated with dried solution that may be activated with a drop of sterile saline solution. Place this onto the bulbar conjunctiva and, after the patient blinks several times, the excess is immediately irrigated out by a minimal stream of saline solution. The lesions of interest are recorded by blue light, achieved by either dialing in the appropriate filter or placing the special cobalt blue filter cap onto the slit-lamp prism. The background light must not be illuminated, as it would obscure the fluorescent pattern. The photographer must be prepared to take the photographs immediately after instillation of the fluorescein, as the dye will diffuse into surrounding unaffected tissues in a short time and no longer sharply delineate the lesions of interest. A variation of this technique is the Seidel test to demonstrate leakage from a corneal wound. Immediately following application of the dye (excess solution is not irrigated away in this application), blue-light photographs are

made that may reveal a dark stream of aqueous through the brightly fluorescent concentrated dye.

## SPECULAR MICROGRAPHY OF THE CORNEAL ENDOTHELIUM

The posterior lining of the cornea is comprised of highly specialized endothelial cells. Only one cell thick, this layer is responsible for corneal transparency through a process whereby excess water is pumped from the cornea (Kaufman et al. 1988). In childhood, the endothelium averages about 2500 cells per square millimeter. These endothelial cells do not regenerate, and as cells die through age, disease, or trauma (including intraocular surgery), the remainder increase in size to fill the void. If great numbers of cells die, the functional capacity of the remaining cells is reduced, resulting in corneal edema.

By quantifying the number and health of endothelial cells, ophthalmologists are better able to assess the benefits and risks of planned surgical procedures, particularly if the patient has previously undergone intraocular surgery and thus already has a compromised endothelium. This information is also valuable for the evaluation of endothelial function following long-term contact lens wear, a condition suspected of causing some endothelial change. Because the single cell layer of endothelium is firmly attached to Descemet's membrane, the flat surface of the cells presents a single plane for observation. If light strikes that plane at a given angle, it is reflected at an equal and opposite angle; this optical property makes possible the observation of the corneal endothelium. In focal illumination, the surface of the cells is observed to be brightly reflective. The cell borders, representing a more posterior plane, do not reflect the incident beam at the same angle and therefore appear dark.

Under the highest magnification, a standard slit-lamp biomicroscope may allow the observation of endothelial cells, although their small size may prevent precise quantification. However, the use of dedicated instrumentation, including noncontact- and contact-mode specular microscopes, enables the recording of highly magnified images of these living cells for structural assessment and computation of cell-population density.

Noncontact specular micrography often uses a slit-lamp biomicroscope equipped with an accessory objective lens that provides higher magnification than the standard optics. Under high magnification, the distance between the eye and the microscope is quite critical and changes even with the respiration of the patient. As already described, the angles of illumination and recording must be in a precise relationship. Because of the air interface between the cornea and the optics of the microscope, noncontact microscopes are limited as to the size of the recorded field.

Contact-mode specular microscopes utilize an objective lens akin to a light microscope's oil-immersion objective lens, but, instead of oil, methylcellulose is used as the optical coupling solution. Because the cornea is *applanated* (flattened), there is less focus shift during observation and photography. A relatively wide field of view is obtained and is therefore capable of providing greater coverage of the endothelium to demonstrate local variations in cell density.

As the recording medium, specular microscopes may utilize either black-and-white film or a monochrome video camera and videocassette recorder. Although either is capable of providing sufficient resolution to quantify cell density, the higher resolving power of silver-based film may provide either cell quantification or publication-grade prints of fine intracellular detail (Merin and Koch 1989). Either high-speed (ISO 400) or medium-speed (ISO 100) film may be used, although the latter emulsion provides a superior image (Carlson et al. 1988).

To perform contact-mode specular micrography, anesthetize the eye with topical proparacaine hydrochloride. Although either artificial tears or methylcellulose may be used as the optical coupling medium, methylcellulose remains viscous longer and allows a more extensive series of photographs to be produced. Place a drop of this solution on the tip of the objective lens, taking care that no bubbles are present to cause image-degrading flare. Position the patient at the instrument and ask her to look straight ahead without blinking. Move the microscope forward until the cornea is applanated. Basic focus is obtained when the regular mosaic pattern of the endothelium comes into view (Figure 15.6). A series of photographs (or several feet of videotape) is produced while adjusting the focus very slightly anterior and posterior, thus ensuring critical sharpness of the image.

**FIGURE 15.6  Fuchs' dystrophy. Specular photomicrography of the corneal endothelium reveals the mosaiclike pattern of endothelial cells. The dark areas are excrescences of Descemet's membrane (cornea guttata) that push the endothelial cells posteriorly away from the plane of reflected light.**

The specular microscope also may record different areas of the endothelium away from the corneal apex. One way to sample these different regions is simply to slide the microscope in the desired direction while maintaining contact with the cornea. Although it is somewhat difficult to recognize how far the microscope should be moved (particularly if repeat studies are indicated), the *posterior corneal rings* (PCRs), a series of concentric dark rings that are visible in the microscope viewfinder as it moves away from the apex, may be used as landmarks. Some clinicians request that photomicrographs be made of the apex and the area at the first superior PCR to provide adequate documentation of the endothelium.

Following the photographic session, the cells are counted either manually or by computer. If manual methods are employed, a print of the cell image combined with a standard grid is produced, and the cells enclosed within the grid are counted according to a specific protocol (Keeler-Konan Company 1981).

## FUNDUS PHOTOGRAPHY

For over a century, a long list of researchers, clinicians, and photographers have worked to perfect the technique and application of retinal photography. The earliest known fundus photographs, made in 1886 with exceedingly primitive instrumentation (Jackman and Webster 1886), required the viewer to have an active imagination to understand even the gross anatomy they portrayed. In contrast, modern fundus cameras are able to resolve detail even smaller than their theoretical optical limits, and the advent of image analysis technology further increases their capabilities.

### Camera Design

Historically, the biggest impediment to direct observation of the fundus has been the highly refractive (and reflective) cornea. True coaxial illumination is required to illuminate the deep recesses of the eyeball without creating obscuring reflections, along with an optical system that includes an aspheric front element to examine the curved retinal surface. These components are intrinsic to modern fundus cameras.

From the standpoint of camera function, all conventional film-based fundus cameras are similar (Gutner and Miller 1983). Both the viewing bulb and the electronic flash are directed along the same optical pathway (through a series of beamsplitters, condensing lenses, and mirrors) until their rays emerge as an annulus or ring of light from the front objective of the camera. The annulus is projected through the cornea, pupil, and lens to the interior of the eye, where it spreads out to the retina. The image-forming rays reflected from the field

of interest in turn proceed back through the center of the annulus, through the eye and camera optics, and finally reach the eyepiece and camera body. Because the incident and reflected light paths do not overlap at the cornea, the majority of reflections are avoided, while the small remaining ones are collected and absorbed by a tiny black dot found on the rear surface of the objective lens. All conventional fundus cameras require that the pupil be dilated, although the minimum pupil size varies with the size of the projected annulus. Some cameras require a minimum 3.5-mm pupil, while others need up to 7.5 mm. Because some common eye conditions prevent patients from being maximally dilated, the use of an instrument with minimum pupil requirements can be advantageous.

The view through the fundus camera is truly remarkable: a bright, erect view of the retina much superior in clarity to that of the direct ophthalmoscope. The standard magnification of the fundus camera is $2.5\times$, and its standard field of view is approximately 30 degrees. By using either zoom optics or auxiliary lenses, some cameras allow the angle of view to be modified. It may be reduced to 15 degrees ($5.0\times$ magnification), to record the optic nerve head alone or the center of the fovea, or expanded to 60 degrees ($1.25\times$ magnification) for recording intraocular tumors or widespread retinal pathology such as diabetic or hypertensive retinopathy. Experienced ophthalmic photographers recognize the compromise between field size and magnification of fine detail and choose the recording angle to best photograph the most important aspect of the pathology (Color Plate 79a–c).

### Focusing the Eyepiece

To ensure that the observer is given the brightest possible view through the eyepiece, all fundus cameras utilize aerial-image focusing. A crosshair reticle is found in the camera eyepiece, and the photographer must always use it in order to produce sharply focused photographs. The reticle and the film plane are exactly the same distance from the objective lens (Tyler 1981); thus, if the fundus image is focused to the plane of the reticle, the recorded image is likewise in focus. Novice fundus photographers sometimes forget that the reticle must be clearly seen at all times and that it provides a crucial reference point for focusing the fundus image (Wong 1976). Virtually all problems with focusing the fundus camera can be attributed to lack of attention to this vital point.

A simple procedure can be used to focus the crosshair reticle. First, the viewing lamp is turned on and a plain piece of paper is placed in front of the objective lens. Next, the eyepiece is rotated out to the highest plus diopter setting (plus and minus settings are marked on the eyepiece). Both eyes are kept open, and the dominant

eye looks through the eyepiece. In one smooth motion, the eyepiece is turned toward the minus setting. The crosshairs will come into view, first as fairly wide blurry lines and then as fine sharp ones. At the instant when the crosshairs are at their thinnest, the eyepiece setting is noted. To check accuracy, the procedure should be repeated several times. Under no circumstances should the eyepiece be turned back and forth in an attempt to sharpen the focus, as this in fact will stimulate the accommodative response of the photographer's eye and will make accurate focusing impossible. The focused crosshair must remain visible whenever using the instrument, and critical focusing is accomplished by bringing the retinal image to the same plane of sharpness as the crosshair adjacent to it.

Although some experienced photographers focus routinely while closing one eye, keeping both eyes open is less taxing physically. Consistency is of paramount importance, however, regardless of the method used.

## Camera Alignment Techniques

The subject eye has been considered an integral part of the fundus camera's optical system. Consequently, the spacing and orientation between the camera's objective lens and its projected light annulus to the patient's eye must be accomplished with great precision. When aligned correctly, the annulus is collected by the cornea and projected in its entirety through the pupil, thus providing uniform illumination of the retina. Distinct changes occur in the observed lighting patterns if the alignment is either too close, too far, or eccentric to the eye.

To obtain the correct alignment of the camera to the eye, the patient's head is first positioned in the instrument's head-support bracket so that the chin rests in the chin cup and the forehead is firmly pressed against the support bar. The camera is moved laterally until it is roughly positioned in front of the eye, and then (if possible) the joystick that controls lateral movements is locked in its vertical position. Most fundus cameras are correctly aligned when approximately 50 mm separate the front objective lens from the cornea. The camera-elevation control is next used to center the camera lens vertically in front of the pupil. The next step is to maneuver the patient's head (via the head-support bracket) fore and aft while closely observing the patient's cornea. The correct spacing will reveal a ring-shaped reflection of the light source, sometimes replete with an image of the viewing-light filament, centered on the cornea in front of the pupil.

At this time, the photographer should look into the eyepiece. If the preceding steps were carefully followed, the retina should be in view, although the composition and focus may not be correct. The patient is asked to

follow the external fixation light to obtain the desired field of view, and then the instrument is coarsely focused.

The camera eyepiece tells the photographer the exact status of camera-to-eye alignment (Allen 1964). When correct, the view has deeply saturated color throughout. If the camera is much too close to the eye, the eyepiece will show a desaturated image with a brilliant bluish-white reflex towards the center. This problem is solved easily by pulling back slightly on the joystick. If the incident beam is both too close to the eye and also eccentric to the pupil, a bright orange crescent will appear along part of the image periphery. To correct this alignment error, the camera is moved in the direction opposite the location of the crescent and pulled back very slightly. If the camera is too far away from the eye, the image will again appear to be desaturated, but this time a rather diffuse bluish-gray ring will be seen around its circumference. The solution is to push forward slightly on the joystick. The final, correct alignment for fundus photography will produce an evenly illuminated image of deep color saturation in the eyepiece. Interestingly, moving the joystick forward or backward has absolutely no effect on image focus; only the focusing knob controls that function.

## Composing the View

Inherent to all forms of pictorial and technical photography is the process of selection. The desired image can be thought to exist within a much larger whole, surrounded by extraneous material. By selecting and refining a point of view, all surplus visual elements are removed, leaving just the desired image within the confines of the frame.

This exact process is used to create a fundus photograph. The recording angle of the fundus camera provides a frame into which the pertinent pathology must fit. The knowledgeable photographer angles the camera and directs the patient's gaze so that only the subject of regard is recorded.

Questions about how much retina should be included and its orientation can be partially answered by using the previously cited photographic referral form, on which the referring physician indicates the area of interest. If still not clear, the photographer should ask the client-physician for specific instructions.

Because much retinal pathology occurs around the disc and macula, a standard for photographic composition has evolved. This basic field of the posterior pole is based on a 30-degree camera; in it, the fovea is in the exact center of the field, and the entire disc is just inside one edge of the image. Thus, the entire macula, the entire optic disc, and the major vascular arcades are recorded in one view. Of course, if the camera records a wider-angle field of view, then centering the fovea results in a greater percentage of peripheral retina recorded nasally, temporally, superiorly, and inferiorly.

Another protocol provides a standardized technique of creating a photographic montage that covers a much wider field of view. Referred to as the Airlie House Classification, the Seven Standard Fields, or the Diabetic Retinopathy Study Protocol, this convention describes three overlapping views along a horizontal meridian, and then two superior and two inferior overlapping views (Figure 15.7).

Photography of the retinal periphery is often technically challenging. One reason stems from the fact that the entrance pupil becomes elliptical as the gaze moves eccentrically. As the eye moves farther and farther away from its primary position, a point will be reached where the image-forming rays will be bisected by the pupil border, resulting in shadowing or vignetting that cannot be removed. Another problem is caused by directing the imaging rays obliquely across the cornea and lens, resulting in severe astigmatic distortion. Extremely fine vertical or horizontal camera movements may partially overcome this distortion. On some cameras, a special astigmatic control knob will further neutralize this effect.

### Focusing the Retinal Image

The fundus camera is capable of only shallow depth of field, so the major concern in the focusing process is to determine on what structure to focus. Because the fundus is evenly illuminated, there are no highlights or shadows to provide visual clues about relative elevations.

The only useful data comes from knowledge of the three-dimensionality of the normal posterior pole and of various pathological conditions, coupled with the apparent differences in sharpness of select parts of the retina as seen in the eyepiece.

The normal retinal surface has a uniform concavity except for a very small depression at the fovea and a greater indentation at the optic disc. The small blood vessels surrounding the fovea and the slightly grainy texture of the retinal nerve fibers provide easily seen targets on which to focus.

Many retinal and choroidal diseases produce elevation in specific areas. Typical of these is papilledema (Kritzinger and Beaumont 1987), causing a pronounced swelling of the optic nerve, and idiopathic central serous choroidopathy, producing a domelike elevation of the retina. When the camera is focused critically on the center of these lesions, the surrounding tissue will appear somewhat blurry and such discrete objects as vessels will be less sharply rendered. Customarily, the fundus camera is focused on the most anterior structure in the field, although additional photographs taken at levels between the top and the base can also be useful.

As the patient's eye is an intrinsic component to the camera optics, any decrease in transparency of any part of the eye's media will be deleterious to the final image. The cornea, lens, and vitreous must all be crystal clear in order to obtain sharp and saturated views of the retina. In some cases, however, compensation can be made for less than ideal clarity of these structures. If the cornea is edematous, a drop of topical proparacaine hydrochloride followed by a drop of topical glycerin may improve the view temporarily. If the patient has a cataract, careful movement of the camera within the pupil margin may reveal a part of the cataract that is less opaque and thus will yield an improved view of the retina. Unfortunately, the view through a hazy vitreous cannot be improved by camera work.

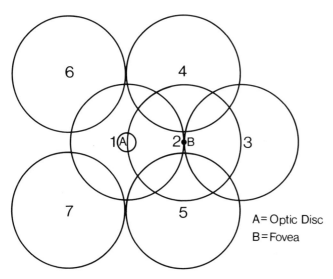

**FIGURE 15.7  Airlie field diagram (left eye). A standard approach to documenting multiple fields of the retina utilizes the reproducibility of this plan. The optic nerve is positioned exactly in the center of field 1, the fovea is centered in field 2, and the peripheral fields are positioned in relation to these two landmarks and to each other.**

### Stereo Fundus Photography

Stereoscopic photography enables the viewer to understand the three-dimensional spatial relationships of the subject. In fundus photography, this provides a more complete understanding of the nature of lesions by identifying whether they are deeper or more shallow than other known anatomical reference points.

Standard pictorial stereophotography duplicates human stereoscopic vision by photographing the same subject from two slightly offset camera positions. The apparent depth is influenced by the distance between the two positions, with greater distance enhancing and less space diminishing the effect. For close-up or macro views, the two camera positions must be offset and also converge. The viewer is able to reconstruct the spatial configuration

of the subject when viewing a pair of stereo photographs set in proper orientation (Ferwerda 1982).

The stereo base used in fundus photography is necessarily limited by pupil size. In this application, convergence of the two points of view is especially important. Happily, the refractive power of the cornea provides this convergence. By merely moving the camera from one side of the corneal apex to the other, the same point in the fundus may be observed from two points of view. The two camera positions are parallel to each other, and the cornea provides the necessary convergence of the image-forming rays.

Two basic methods may be used to obtain stereo fundus photographs. The first utilizes specially designed stereo fundus cameras that produce simultaneous stereophotographs in split-frame 35-mm format. Because their narrow field of view limits their use to photography of the optic nerve head, these cameras are infrequently used. The other method produces sequential stereo slides, in which each half of the stereo pair is produced as a separate exposure. Although patient movement, blinking, and other artifacts at times ruin the stereo effect, any fundus camera can be made to produce sequential stereo photographs.

Pupil dilation limits how much stereo separation is possible. For well-matched stereo pairs, the minimum pupil size should be about twice the size of the illuminating annulus; a smaller pupil will still allow stereo but with some vignetting. To perform stereo fundus photography, the camera is first aligned with the eye, the view is composed, and the image is focused critically. The joystick is then slowly moved to the left while the fundus is observed. The catoptric image or orange crescent will appear on the left edge, but the joystick should be moved still farther to the left. The crescent will sweep to the center of the field and then disappear. At this point the photograph is taken. Next, the joystick is moved to the right. The crescent reflex will appear on the right side this time but will again disappear with further movement, at which point the right half of the stereo pair is taken. To make sure that no blinks prevent proper stereo imaging, an extra stereo pair or two should be taken.

## Artifacts

Beginning fundus photographers are sometimes dismayed to find that they have produced less than optimum photographs. Since some time may elapse between the photography session and the availability of the finished slides, they are unable to recall why the photographs look the way they do. In fact, fundus photographs tell the observer as much about camera technique as they do about the illustrated pathology.

Ideally, the fundus photograph should be sharply focused, of deeply saturated color, and evenly illuminated. Only the subject's retina should be visible; anything else is an artifact (Color Plate 80a–d). Several of the more common artifacts and their remedies are:

Orange crescent: Camera misaligned. Move camera in opposite direction.

Blue peripheral haze: Camera too far away from eye. Move camera forward.

Bright blue-white central reflection: Camera much too close to eye. Move camera backward.

Pale vertical tan or white streaks: Lashes. Retract eyelid during photography.

Spots or streaks remaining in field regardless of subject position: Tears, dust spots, or dirt on objective lens. Clean.

Orange or red image with no detail: Closed eye or blink synchronized with flash. Retract eyelid.

## Selected-Wavelength Fundus Photography

Fundus photography produces a full-color record that duplicates exactly the natural appearance of the retina. By using black-and-white (BW) film and special filters, however, specific features of the fundus may be enhanced selectively (Ducrey et al. 1979).

The monochromatic filters for this assignment are chosen according to the specific nature of the anatomy to be enhanced. Filters that pass shorter wavelengths will emphasize more anterior structures, and those that transmit longer wavelengths show deep retinal or choroidal lesions. Thus, a blue filter will show the internal limiting membrane and the retinal nerve fiber layer, while a red filter will emphasize the outline of a choroidal nevus. Most fundus cameras come equipped with at least two filters useful for these techniques: the blue exciter filter for fluorescein angiography (490 nm) and a green filter for red-free photography (540 nm). The former filter is useful for retinal nerve fiber studies, and the latter can be used to clearly delineate the pattern of the retinal vasculature (Figure 15.8).

Films used for selected-wavelength photography should be of moderate contrast and fine granularity. Conventional BW emulsions with an ISO of 100 or ISO 125, as well as technical panchromatic line films, are capable of producing high-quality photographs (Sommer et al. 1983), and many laboratories routinely produce red-free monochromatic photographs of excellent quality on ISO 400 film as part of the fluorescein angiogram.

## FLUORESCEIN ANGIOGRAPHY

Highly detailed though they are, color fundus photographs record only the surface appearance of the retina. Until 1961, many questions about the function of the retinal circulation and the patency of the barrier lay-

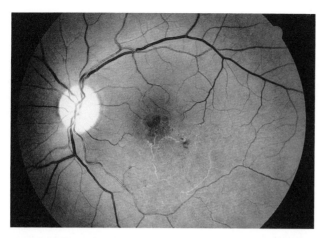

**FIGURE 15.8** Branch retinal vein occlusion. A variety of filters may be introduced into the camera for selected wavelength or monochromatic photography. One of the more common is the red-free filter (in this case a 540-nm green filter) that accentuates blood vessel patterns on black-and-white film.

ers between the choroid and the retina could not be answered. In that year, two medical students named Novotny and Alvis reported on the first successful attempt to photograph patterns of fluorescence that depict the dynamic process of human retinal circulation (Novotny and Alvis 1961; Alvis and Julian 1982). That first report energized clinicians and researchers around the world, and in the ensuing three decades, fluorescein angiography has contributed a vast amount of knowledge about the microcirculation of the retina and choroid.

The procedure for fluorescein angiography is straightforward, but only experienced fundus photographers should attempt angiography. Fluorescein angiography is performed with a series of fundus photographs as a solution of sodium fluorescein is rapidly injected into a vein in the arm or hand. High-speed BW film is used. The fundus camera is equipped with special filters that create and enhance the fluorescence patterns. The camera power supply is capable of producing high flash output at a sequence of one flash per second, and the camera body is equipped with a motor drive and an automatic device that imprints the film with the elapsed time in seconds. For the first 30 to 45 seconds, the photographs are produced in rapid sequence; the final photographs in the series are made some 5 to 10 minutes later. After processing, the negatives are read by the ophthalmologist or used to generate a contact sheet or enlarged paper prints.

## Sodium Fluorescein

Although sodium fluorescein is available in solutions of 5, 10, 20, and 25%, 5 cubic centimeters of 10% solution is the most common adult dosage of the dye. In its concentrated form, sodium fluorescein is a medium-to-dark red color, but when diluted it appears as a brilliant fluorescent yellow liquid.

Fluorescein has been categorized as a "generally regarded as safe" (GRAS) drug, and adverse reactions to it are remarkably infrequent. Intravenous fluorescein is contraindicated in two groups of patients: those with a previous severe reaction to sodium fluorescein and pregnant patients. All patients will undergo two side effects: skin staining and urine coloration. As the dye travels through the capillaries in the skin, the patient's complexion will take on a yellow or jaundiced appearance for up to 12 hours. Because the dye is captured and excreted through the kidneys and bladder, the patient's urine will appear to fluoresce for up to 36 hours following the procedure.

Fewer than 10% of patients undergoing this procedure will have untoward side effects or reactions (Yannuzzi et al. 1986). The most prevalent of these are nausea (although vomiting is rare, an emesis basin should be kept available) and urticaria or hives, which may be treated with diphenhydramine hydrochloride. Because severe allergic reactions can occur, including anaphylaxis and even death (Yannuzzi et al. 1986), emergency medications and procedures must be prepared in advance, so that the photographer and ancillary personnel are certain of their responsibilities and know how to obtain appropriate and timely care for their patients.

Because fluorescein angiography is considered to be an invasive procedure, many institutions mandate the use of a properly executed consent form. The physicians or photographers working in such laboratories must obtain consent before the angiogram is performed. Any questions concerning medico-legal issues or malpractice coverage should be addressed to the institution's administration or legal counsel.

To prepare for angiography, the dye is transferred from its ampule into a 5-cubic centimeter (cc) syringe using a 5-micron filter needle to ensure that no glass particles contaminate the dye. A winged infusion set (butterfly needle) of at least 21 gauge with a section of clear tubing is fitted to the syringe for ease of venipuncture.

The dye is injected into a large vein in the antecubital fossa of the arm or in a wrist or hand vein. The person performing the venipuncture must be extraordinarily careful in positioning the needle, because if any dye is injected inadvertently into the skin, the patient will experience an intense burning pain at the injection site. On cue from the photographer, the dye is rapidly injected into the vein. The butterfly needle is held in place until the initial rapid photographs have been completed to maintain an open line in case emergency medications need to be administered, and because removal of the needle may distract the patient just when the photographer requires the patient's utmost concentration.

## Filtration and Film

An exciter filter and a barrier filter are both required for fluorescein angiography. The exciter filter is responsible for creating fluorescence—that phenomenon in which photons of a certain wavelength are released from a fluorescent material while being irradiated by slightly lower wavelengths. Through repeated investigation and improvements through the years, the optimum exciting wavelength has been found to be 490 nm, a medium bluish-green color.

As it is irradiated, fluorescein emits yellowish-green photons at about 525 nm. During that irradiation, two colors are simultaneously projected toward the camera: 490 nm (exciting wavelengths reflected back from the retinal surface) and 525 nm (fluorescing wavelengths). The BW film used to record this phenomenon is essentially colorblind, however, and is unable to differentiate the blue light from the yellow light. Consequently, a yellow barrier filter is used that effectively blocks all 490-nm reflected light and allows only 525 nm wavelengths to reach the film. The final fluorescent patterns that delineate retinal vascular and pigment patterns reach the camera as yellow light against a black background.

The film of choice for fluorescein angiography is BW film nominally rated at ISO 400 (Merin and Lewis 1988), although it is customary to process it to a higher exposure index (Tyler 1979). A specific speed rating is meaningless, however, as the photography of fluorescence is in fact the recording of a light source—and this situation does not equate to conventional sensitometric parameters.

## Terminology of Dye Location and Concentration

The following terms are commonly used to describe the quantity of dye and its location in tissues or in spaces around or adjoining anatomical structures.

*Hypofluorescence:* less dye concentration than expected in a given tissue at a given time during the sequence

*Hyperfluorescence:* more dye than expected, concentrated in a given place at a given time

*Pooling:* dye that has leaked from the normally closed retinal vessels into a three-dimensional anatomical space

*Staining:* dye that has leaked into a tissue or a structure

## Timing and Phases of Retinal Angiography

During the 10-minute span of the usual fluorescein angiogram, fully 90% of the information is obtained during the first 60 seconds. The photographer is charged with recording the rapidly changing view through the eyepiece by having absolute mastery of camera, venipuncturist, and patient—all the time realizing that there will be no second chance to correct any error.

The photographer will witness privately some fascinating dynamic events as the dye enters the retinal vessels, delineating both normal and abnormal tissue with amazing clarity. The skilled ophthalmic photographer anticipates what may happen during the angiogram so that the relevant pathology is recorded in the correct field in each eye and at the proper time.

The events revealed during a fluorescein angiogram sequence can be described as *phases*—blocks of time, occasionally with rather indistinct starting and stopping points, during which the transit of dye reveals certain elements of the retinal circulation. Phases describe only components of circulation that occur during the angiogram, and sodium fluorescein is only a marker that delineates what occurs continuously as the retina is perfused. To provide a basis for comparison, a normal angiographic sequence in a young, healthy patient will first be described (Figure 15.9).

**Choroidal Phase.**    Because the dye is injected rapidly, it assumes a wave-front configuration as it travels through the blood vessels. From the injection site, the leading edge of the dye column travels through the arm to the heart, then to the lungs, returns to the heart, and then moves up the carotid artery to the eye. Typically it will travel through the short posterior ciliary arteries and into the choroid and choriocapillaris about 8 to 12 seconds following the onset of the injection (Gass 1987). The *retinal pigment epithelium* (RPE) serves as a mask of varying density to the more posterior layers of the eye, and the onset of choroidal fluorescence (called the *choroidal flush*) appears patchy and rather faint except where the RPE is absent or thinned. In individuals with a hyperpigmented RPE, the masking effect may prevent entirely the visualization of the choroidal phase.

**Arterial Phase.**    About 1 second following the first appearance of choroidal fluorescence, dye flows through the central retinal artery and emerges into the retinal circulatory system at the optic disc. The dye front immediately fills the larger and then the smaller arteries; when filled, these appear uniformly bright at this time. (*Note:* Although the continuous flow of the retinal vascular system is well understood, the normal progression of dye through these vessels is so rapid that the dye wave-front can neither be seen nor its movement recorded by either standard observation or still photographic recording.)

The retinal vascular system has been likened to a tree because the larger vessels branch and become smaller, and these become still smaller, finally ending in the capillary network. During the arterial phase, the dye flows through all the branches connected to the central retinal

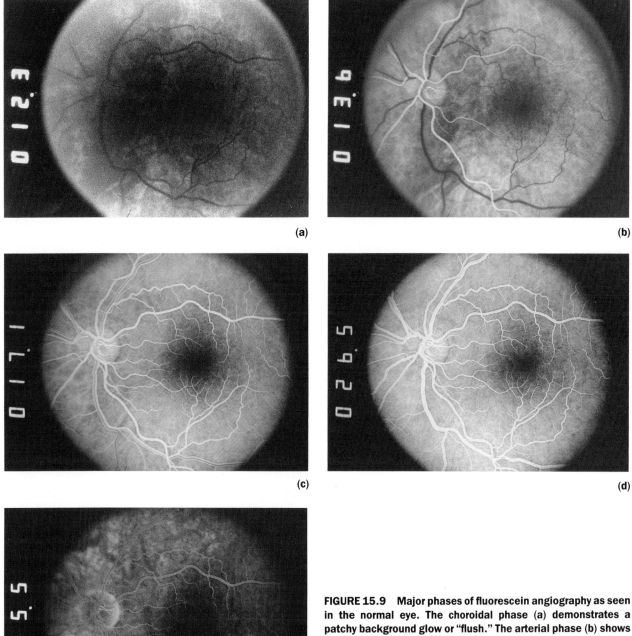

(a)

(b)

(c)

(d)

(e)

**FIGURE 15.9** Major phases of fluorescein angiography as seen in the normal eye. The choroidal phase (a) demonstrates a patchy background glow or "flush." The arterial phase (b) shows dye filling the arteriolar side of the microcirculation. During arteriovenous (A-V) phase (c) the veins appear to be striped (laminar flow) as they begin to drain the dye from the retina; in venous phase (d) they are completely filled and their brightness is equal to or greater than that of the arterioles. In late phase (e) the choroid appears to be mottled, while the retinal vessels have become much darker.

artery, thus making them visible while the venous side of the circulatory system remains dark.

**Arterio-Venous Phase.** The capillary bed may be considered as both the end-point of the arterial system and the beginning of the venous system. Once the dye front reaches the capillaries, it immediately begins to travel through larger and larger venous vessels. The veins appear to be striped, with brighter edges and a dark center. This appearance reveals *laminar flow*, a condition of fluid dynamics in which separate streams do not mix in the absence of turbulence. Although the photographic ren-

dition appears two-dimensional, laminar flow really depicts concentric cores of flow in the vessel tube, rather than streams in a flat bed (Wise et al. 1971).

A few seconds later, the laminar striping gradually fills in, until a point is reached when both the arteries and the veins are filled with dye at the same high concentration. During the arterio-venous phase, the retinal vasculature has the greatest accumulation of dye in its vessels, and both the large and the small vessels are seen in bright relief. At this time the ring of capillaries that surrounds the fovea is most clearly seen (although this is most prominent in heavily pigmented patients), as is the capillary bed in any other part of the retina that may be analyzed.

**Venous Phase.**    After a few more seconds, the arterial side begins to grow dimmer, as the long dye column has now passed. A subtle laminarlike appearance of the arterioles may be occasionally detected, as the vessel walls stain softly. During venous phase, the brightness of the capillary bed also fades, and the venules appear to be the brightest structures in the posterior pole.

**Late Phase.**    The veins will continue to drain the residual dye from the retinal vascular system, so that after 10 or more minutes the normal retina will appear fairly dark. Because fluorescein stains the vessel walls, they may still be faintly visible for some time, and the optic nerve head will also stain. In late phase, the large choroidal vessels may appear in silhouette against a softly stained background.

Ophthalmic photographers who perform fluorescein angiography usually adopt a standard protocol. They produce a *name tag* photograph first, so that the patient's name and the date of the angiogram is permanently attached to the film. Next, a *red-free* monochromatic photograph is made of each eye, using a green contrast filter to provide a moderate-contrast, black-and-white rendition of the retina. The fluorescein butterfly needle is then placed in the vein, but the venipuncturist does not actually inject any dye until the photographer is ready to begin. When the command is given (a code word may be better than saying "Start injecting now!") the dye is smoothly but rapidly injected and at the same instant the photographer resets the camera timer to zero and takes a single photograph—the so-called *control frame* through both the exciter and barrier filters. The photographer begins counting the seconds while watching the view through the eyepiece with great care and begins the rapid-sequence photography as soon as the choroidal flush is seen. This is frequently rather difficult to visualize, and the neophyte may often miss this phase. The early arterial phase is much more noticeable, however, and rapid-sequence photography at one frame per second should always record this portion of the dye transit. After the required sequence of the primary eye is com-

pleted, comparison photographs of the other eye should be routinely produced. The timing for late-phase photographs, typically 5 or 10 minutes or even longer, should be specified by the requesting physician. Stereo fluorescein angiography is especially valuable in helping to identify the topographical nature of some hyperfluorescent lesions that may look alike, and it should be performed whenever possible.

Because every retinal disease has its own angiographic signature, the knowledgeable photographer will tailor the angiographic procedure to best record their special signs. Two of the most frequently encountered diseases in fluorescein angiography are macular degeneration and diabetic retinopathy.

**Macular Degeneration**

Macular degeneration is the leading cause of blindness among the elderly. Also known by the abbreviations ARMD (*age-related macular degeneration*) or SMD (*senile macular degeneration*), this disorder describes a spectrum of retinal changes including drusen, subretinal neovascular membrane formation, and disciform scars (Gass 1987). Of these, the only clinical entity that is sometimes treatable by laser surgery is the *subretinal neovascular membrane* (SRNM) located outside the foveal avascular zone, and a fluorescein angiogram is crucial in determining its treatability. The photographer should always expect an SRNM to be present when performing fluorescein angiography for macular degeneration.

*Drusen bodies* are small round defects in the retinal pigment epithelium and will appear in the angiogram as small spots of hyperfluorescence. They do not themselves fluoresce, but function as openings in the opaque RPE that allow visualization of the brightly fluorescent choroid—thus they are appropriately described as *window defects*. Drusen will appear first in the choroidal phase of the angiogram and will fade in late phase.

Subretinal neovascular membranes are formed when a sprout of choroidal vessels breaks through the pigment epithelial barrier layer and into the subretinal space. These abnormal vessels naturally leak fluid and cause a detachment of the neural layer and sometimes also the pigment epithelium. Because they are fragile, the vessels often bleed and eventually form a fibrotic macular scar, resulting in a permanent dark spot in the patient's visual field.

Angiographically, the early choroidal and arterial phases are crucial in recording a subretinal neovascular membrane. Because it is choroidal in origin, the membrane will become hyperfluorescent early in the sequence. Because choroidal vessels naturally leak dye, the membrane can be most sharply delineated in early arterial phase before diffused fluorescein obscures its borders. In late phase, the SRNM will appear as a bright area

of diffuse hyperfluorescence (Figure 15.10). Fluorescein angiograms of these cases may need to be processed immediately (*stat* processing) so that laser surgery can be undertaken without delay.

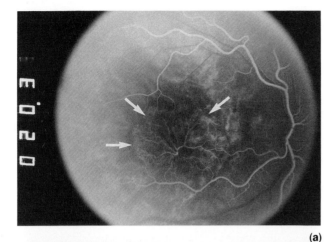

**(a)**

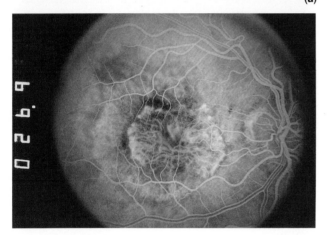

**(b)**

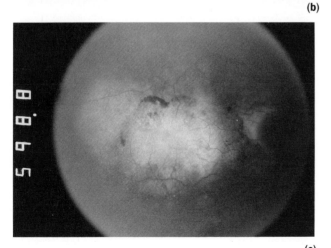

**(c)**

**FIGURE 15.10  Subretinal neovascular membrane. (a) During very early arterial phase, the distinct outline of this large complex of choroidal vessels is clearly seen (arrows). (b) During the arteriovenous phase, dye begins to leak from the vessels in the membrane. (c) In late phase, the membrane's borders have become totally obscured by dye leakage.**

## Diabetic Retinopathy

While macular degeneration is caused by choroidal blood vessels, the affected vessels in diabetic retinopathy are entirely retinal in origin. Two major variants of this disease are *nonproliferative (background)* and *proliferative.*

Background diabetic retinopathy is so named because of the widespread involvement of the fundus. Important features of this disease that are visible readily during an ophthalmoscopic examination or during color fundus photography include microaneurysms, hemorrhages, and exudates (Benson et al. 1988).

Microaneurysms are small saclike outpouchings in the small vessels and capillaries. Hemorrhages represent blood that has already leaked from vessels; they will appear as either *dot and blot* hemorrhages if in the middle or deep layers of the retina, or as linear streaks that conform to the orientation of the retinal nerve fibers if superficial. Larger amounts of pooled blood in front of the retina often assume a boat-shaped configuration with a curved bottom and a flat top. The exudates found in diabetic retinopathy come from a profound disturbance of the vessel walls, which permit serous fluid, protein, and lipids to pass out of the normal retinal circulation. The yellow deposits may be seen as either individual spots or clusters or organized into a ringlike or *circinate* pattern that typically suggests a major leakage site of microaneurysms or other abnormal vessels within its boundary.

The fundus in proliferative diabetic retinopathy has the same appearance as in background disease but also has retinal neovascularization. Networks of fine new vessels arise from the venous circulation and may either lie flat against the retinal surface or may grow up into the vitreous. These vessels may grow from the optic nerve head (known as *neovascularization of the disc*, or NVD) or in other areas of the posterior pole (*neovascularization elsewhere*, or NVE). The fragile new vessels are prone to breakage and may bleed into the vitreous, causing a sudden and occasionally severe loss of vision.

Fluorescein angiograms of diabetic retinopathy reveal a vast amount of information that simply cannot be seen in the color fundus photographs. The major vessels are still visible, but angiograms clearly demonstrate multiple changes in the capillary bed.

Because the majority of changes in diabetic retinopathy are located in the fine vessels and capillaries, the arterio-venous phases are most important angiographically (Figure 15.11). The fine vessels in the fovea should be photographed—the capillaries that normally form a smooth ring around the fovea will appear ragged and irregular in many diabetic patients. The microaneurysms seen on the fundus photographs, and many more not originally seen, will appear as bright spots of hyperfluorescence. The hemorrhages will appear as dark spots and will block underlying fluorescence. The exudates

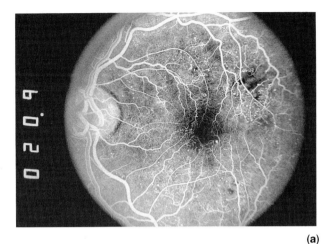

(a)

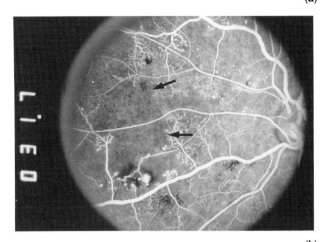

(b)

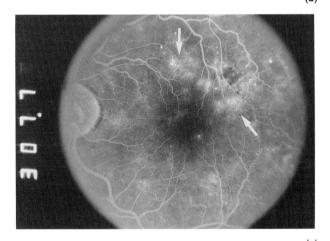

(c)

**FIGURE 15.11   Background (preproliferative) diabetic retinopathy. (a) In the arterio-venous phase, numerous microaneurysms (white dots) and several hemorrhages (black areas) are seen. The ring of capillaries surrounding the fovea (center) is discontinuous and eroded. (b) As the arterio-venous phase continues, the nasal field reveals large areas of peripheral ischemia (arrows) in which the capillary bed has died. (c) In late phase, the diffuse white areas (arrows) reveal significant macular edema.**

will not appear on the angiogram at all and will neither fluoresce nor block other fluorescence. The capillaries will appear dilated in certain areas and completely absent in others.

A standard protocol for routine angiography of diabetic patients might begin with a typical posterior polar composition, making sure that the entire disc and macula are included. As soon as the angiogram progresses to arterio-venous phase (the photographer will know this by seeing the striped appearance of the larger veins), the camera is shifted to record four other views: nasal to the disc, temporal to the macula, superior to the macula, and inferior to the macula. This survey of a large portion of the retina can be performed quickly, taking just one photograph of each of the additional areas. The peripheral areas may show that the capillary bed has died (a condition called *ischemia* and thought to be one of the causes of retinal neovascularization). The survey photographs will also demonstrate the presence and location of new vessels. As soon as the middle-phase photographs of the first eye are finished, the camera is immediately moved to the other eye, where photographs of the same posterior pole and peripheral views are made. After 5 or 10 minutes, a last pair of posterior pole photographs of each eye are made to complete the angiogram.

## Processing and Printing Fluorescein Angiograms

The exciter and barrier filters used during the early years of fluorescein angiography were poorly matched, and extraordinarily contrasty processing was needed so that a print with useful values could be produced. With the advent of narrow-band interference filters, a high-quality angiographic image is projected to the film, and heroic darkroom measures are no longer required.

The quality of BW films is similarly much improved over earlier emulsions. Tablet grain technology and its offshoots allow films to be thinner and of significantly higher resolving power—attributes that allow fine capillary detail to be recorded with high accuracy (Merin and Lewis 1988).

Although some workers continue to process these new films in older contrast process or line developers, several of the standard metol-hydroquinone or phenidone-based pictorial developers are better able to portray the brightness range of the angiographic subject. The film should be overdeveloped from the recommended processing time for pictorial subject matter by 25% to 50%. This extra development will increase the highlight density (seen in areas of hyperfluorescence) and will extend the midrange values, but should not be so vigorous as to induce base fog.

Since the negative may be fully processed within minutes of the angiography session, many physicians assess the patient's condition by reading the negative directly

(Merin 1981). A positive contact sheet or enlargement may skew inadvertently the density range and contrast and may even obliterate some hyperfluorescence within the darker areas. Consequently, reading the negative is both more expedient and more accurate.

If positive copies are required, the fluorescein angiographic negative may be used to easily produce them. Common formats include contact sheets on either paper or lithographic film, positive 2 × 2 inch slides of individual frames from the sequence, and enlarged paper prints.

The development of the negative should yield sufficient contrast to print easily on a grade three paper. If a condenser enlarger is used, the optic disc may need to be burned in and the macular area held back to reproduce the density range of the original negative. Conversely, the use of a cold-light enlarging head will facilitate the production of straight prints that require little or no local exposure control. The fine angiographic print should have a full range of well-differentiated gray values as well as pure black and pure white—not unlike a fine pictorial print.

The contact sheet should exhibit the same range of values as seen on the negative. If lithographic film is used for this application, it may be exposed in a standard contact printer and developed for 1 or 2 minutes in dilute paper developer. Pinholes and dust specks can be a special problem here because they mimic hyperfluorescence and might be misread as pathology. Meticulous attention to cleanliness will keep these spots to a minimum.

Finally, a slide duplicator and technical line-type film may be used to produce individual slides from angiographic negatives. Since they lend themselves to projection to large groups, the resulting positive slides are especially useful in medical education.

## SUMMARY

As eyewitnesses, ophthalmic photographers observe, record, and, by so doing, explain and demystify. Their work reveals the transient and minuscule, and allows us all to share in the appreciation of many aspects of the eye that were formerly hidden from view. By providing this service, those engaged in the craft, science, and art of ophthalmic photography are full participants in modern eye health care.

## ACKNOWLEDGMENTS

The author wishes to thank Richard A. Lewis, M.D., for his wise editorial counsel; Susan Lilienfield, C.R.A., and Velva J. Gordon for help with the illustrations; and Kay Bolton for assistance in preparing the manuscript.

## ENDNOTE

1. Such a device is available from Adolph Gasser, Incorporated, 5733 Geary Boulevard, San Francisco, CA 94121, U.S.A. (*Note:* The author has no proprietary interest in this device or company.)

## REFERENCES

Allen, L., 1964. Ocular fundus photography. *Am. J. Ophthalmol.* 57:13–28.

Alvis, D. L., and Julian, K. G., 1982. The story surrounding fluorescein angiography. *J. Ophth. Photo.* 5:6–8.

Benson, W. E., Brown, G. C., and Tasman, W., 1988. *Diabetes and Its Ocular Complications.* Philadelphia: W. B. Saunders.

Blaker, A. A., 1977. *Handbook for Scientific Photography.* San Francisco: W. H. Freeman.

Carlson, A. N., Merin, L. M., Wilhelmus, K. R., and Jones, D. B., 1988. Use of specular photomicrography with a new type of film. *Am. J. Ophthalmol.* 105:217–218.

Ducrey, N. M., Delori, F. C., and Gragoudas, E. S., 1979. Monochromatic ophthalmoscopy and fundus photography II. The pathological fundus. *Arch. Ophthalmol.* 97:288–293.

Ferwerda, J. G., 1982. *The World of 3-D, A Practical Guide to Stereo Photography.* Haren: Nederlandse Vereniging voor Stereofotografie.

Gass, J. D. M., 1987. *Stereoscopic Atlas of Macular Diseases, Diagnosis and Treatment.* St. Louis, C. V. Mosby.

Gibson, H. L., 1973. *Medical Photography; Clinical-Ultraviolet-Infrared.* Rochester, NY: Eastman Kodak.

Gutner, R., and Miller, D., 1983. Inside the fundus camera. *Ann. Ophthalmol.* 15:13–16.

Jackman, W. T., and Webster, J. D., 1886. On photographing the retina of the living eye. *Phil. Photographer* 23:275.

Jakobiec, F. A., and Ozanics, V., 1989. General topographic anatomy of the eye. In *Duane's Biomedical Foundations of Ophthalmology*, Tasman, W., and Jaeger, E. A., (eds.). Philadelphia: J. B. Lippincott.

Kaufman, H. E., Barron, B. A., McDonald, M. B., and Waltman, S. R., 1988. *The Cornea.* New York: Churchill Livingstone.

Keeler-Konan Company, 1981. *Pocklington Specular Microscope Clinical Manual.* Broomall, PA.

Kritzinger, E. E., and Beaumont, H. M., 1987. *A Colour Atlas of Optic Disc Abnormalities.* London: Wolfe Medical Publications.

Martonyi, C. L., Bahn, C. F., and Meyer, R. F., 1984. Clinical slit lamp biomicroscopy and photo slit lamp biomicrography. *J. Ophth. Photo.* 7:1–80.

Merin, L. M., 1981. Aesthetics in angiographic imagery. *J. Ophth. Photo.* 4:22–29.

Merin, L. M., 1982. Umbra, penumbra. *J. Ophth. Photo.* 5:26–28.

Merin, L. M., 1984. Photography request forms. *J. Ophth. Photo.* 7:88–92.

Merin, L. M., and Lewis, R. A., 1988. New film alternatives for high resolution fluorescein angiography. *J. Ophth. Photo.* 10:36–38.

Merin, L. M., and Koch, D. D., 1989. Improved resolution of specular micrographs. *Ophth. Surgery* 20:427–429.

Meyner, E.-M., 1976. *Atlas of Slit Lamp Photography and Introduction to Its Technical Problems.* Stuttgart: Ferdinand Enke Verlag.

Novotny, H. R., and Alvis, D. L., 1961. A method of photographing fluorescein in circulating blood in the human retina. *Circulation* XXIV:82.

Shields, W., and Pulschen, H., 1982. Strabismus and eye plastic photography. *J. Ophth. Photo.* 5:29–35.

Sommer, A., D'Anna, S. A., Kues, H. A., and George, T., 1983. High resolution photography of the retinal nerve fiber layer. *Am. J. Ophthalmol.* 96:535–539.

Stroebel, L., and Todd, H. N., 1974. *Dictionary of Contemporary Photography*. New York: Morgan & Morgan.

Szirth, B. C., Kimm, G. L., and Murphree, A. L., 1986. Flash selection in strabismus photography. *J. Ophth. Photo.* 9: 60–63.

Tyler, M. E., 1979. Total tonal information in fluorescein angiography. *J. Ophth. Photo.* 2:62–64.

Tyler, M. E., 1981. A way to sharper ophthalmic photography through astigmatic correction for the photographer. *J. Ophth. Photo.* 4:20–21.

Wise, G. N., Dollery, C. T., and Henkind, P., 1971. *The Retinal Circulation*, New York: Harper & Row.

Wong, D., 1976. Techniques of fundus photography. In *Biomedical Photography, A Kodak Seminar in Print*. Rochester, NY: Eastman Kodak.

Yannuzzi, L. A., et al., 1986. Fluorescein angiography complication survey. *Ophthalmol.* 93:611–617.

# Chapter 16
# Gross Specimen Photography

## John Paul Vetter

*"Medicine, to produce health, must examine disease."*

Plutarch (46?–120?)

Gross specimen photography is one of the most common tasks of a biomedical photographer. The need for photographs to be used in teaching, patient records, and research is consistent for all disciplines in the biomedical field. This chapter examines the four principal areas of gross specimen photography by providing a method of preserving color, listing and evaluating equipment, clarifying all photographic considerations, and offering a systematic approach that will provide excellent photographs on routine procedures.

The equipment and procedures have been designed around the size and type of specimens most frequently encountered in human medical practice. The procedures are, for the most part, identical to those found in other branches of biophotography, although other specialties may have to adjust the physical structure of the equipment to accommodate the size of the organs, whether those of a tiny mouse or those of a very large animal, such as a horse or a cow.

## INTRODUCTION

With an increasing number and variety of medical meetings, holding audience interest and maintaining suitable attendance at hospital and teaching center conferences is becoming more difficult. Purely verbal descriptions may not only lead to misunderstandings, but often promote boredom in the audience.

Experience has shown that one excellent stimulant is the free use of color slides. Gross specimen slides, carefully arranged, accelerate the tempo of conferences while giving considerably more information than is possible in a straight discussion without visible aids. When gross specimens and other pathology slides, such as photomicrographs, are intermixed with those showing data from other disciplines, the typical conference can become a revealing and informative experience.

The photography of gross specimens presents several intrinsic problems, such as the leaking of body fluids, obscuring of details by specular highlights, conflicting background shadows, hyperclose exposure factors, and the need to make critical equipment choices and to construct or fabricate equipment not available from commercial houses. These problems and others can be effectively eliminated, or at least significantly reduced, by using color-preserving fluids, recognizing several principles of illumination and optics, standardizing photographic procedures, and obtaining the services of a craftsman.

Although the small-format camera dominates the biomedical field, the instant color print can now assist the pathologist in orienting the features of the surgical specimen to specific areas selected for microscopic examinations.

## THE PHOTOGRAPHIC PROCEDURE

In our institution, as in most other hospital environments, gross autopsy examinations are conducted once a week, while surgical examinations are conducted daily, except on Sunday. Gross autopsy and gross surgical examinations and photography are very similar, except that the autopsy specimens are always thoroughly fixed in a color-preserving fluid and rinsed in running aerated water for about 30 minutes in preparation for the autopsy conference. Surgical specimens seldom receive fixation in the color-preserving fluid and, for the most part, are photographed within an hour or two after receiving them from the surgical department.

A pathologist uses the following procedures to examine specimens with the assistance of a diener (morgue attendant), a photographer, and a photographer's assistant. Frequently, the diener substitutes for the photographer's assistant. It is easy to reconcile the procedure to the prevailing laboratory practice.

The photographer arrives early to set up the camera and gross specimen stand. The lamp's distance and angle are adjusted to obtain the predetermined level of illumination with an incident-light exposure meter. This level of illumination is standardized, as are many of the photo-

graphic parameters, to eliminate, or at least reduce, all time-consuming procedures. The diener begins rinsing the specimens 1/2 to 1 hour before the autopsy conference commences.

When the pathologist wants a specimen to be photographed, he verbally gives the diagnosis and physically outlines the area to be photographed with an instrument or his finger. The photographer's assistant, who is gloved, records the patient name, organ, diagnosis, pathology number, and film exposure numbers. The assistant then lightly blots the specimen and places it on the glass-topped specimen box for photography. The photographer places an appropriately sized scale near the bottom of the specimen and takes a photograph of the desired area (Color Plate 81). The photographer, who is not gloved, avoids handling the specimen to prevent contamination of the photographic equipment. Following the photographic exposure, the assistant removes the specimen and the photographer cleans the glass with household glass-cleaning solution or with an equal mixture of water and alcohol using paper hand towels.

Many specimens require the use of physical aids, such as small sections of colored Pick-Up-Stix (Steven Manufacturing Co., Hermann, MO), surgical towel clips, and other devices to expose hidden areas or demonstrate small perforations. Artist nonhardening clay, such as Plastelene (Van Aken Co., Rancho Cucamonga, CA), can be fashioned to support loose and round-bottom specimens. The decision and placement of these ancillary devices are completed before the specimen is placed on the specimen box by the assistant.

Questions sometimes arise as to the possible infectious nature of specimens. The photographic crew is alerted to specimens that might contain infectious organisms and should question the pathologist about proper handling techniques. Additional clean-up procedures may be required to ensure the safety of the photographic crew.

Since the total procedure is organized and the photographic parameters are standardized, one photographic exposure can be made every 3 minutes. The quick turnaround of the photographic procedure pleases the pathologist and rarely interferes with the normal operating schedule of the laboratory team.

## SPECIMEN PREPARATION

The photography of fresh specimens is sometimes necessary and poses several problems, as stated previously, such as oozing body fluids, annoying specular highlights, and cleaning the bench top after the body fluids have dried. Most of these problems are eliminated or effectively controlled by the use of a color-preserving fluid. The following solution will sustain the natural color and plasticity of the specimen for about 5 to 6 weeks. Unfortunately, the depth of fixation is very limited (about 2 to

4 mm), and sections for histological examination must be removed before the preservation procedures. In an emergency, a section can be shaved off the preserved specimen for acceptable histological examination. Since this solution contains chemicals similar to the historical Jores color-preserving fluid (Mallory 1938) in vogue many years ago, we call it a modified Jores solution.

### Modified Jores Solution

| | |
|---|---|
| Water | 20 liters |
| Sodium chloride | 90 g |
| Sodium bicarbonate | 162 g |
| Sodium sulfate (desiccated) | 200 g |
| Chloral hydrate | 360 g |
| 100% Formalin[a] | 400 ml |

[a] 40% formaldehyde. Formalin fumes are toxic, and, therefore, suitable ventilation must be available where mixing and storage facilities are provided. The solution can be stored in any metal or plastic containers that have air-tight lids.

### Preservation Procedure for Autopsy Specimens

The prosector opens and divides the organ to expose the surface of greatest interest and preserve only those tissues of greatest interest, for example, a 2.0- to 3.0-cm slice of liver, one-half of each lung and kidney, a one-half section of the spleen, and so forth. All unnecessary tissue is trimmed off at this time. Before placing the specimen in the preserving fluid, it receives a short rinse in aerated water to remove excess body fluids. If, for unavoidable reasons, the specimen must remain exposed, it should be bathed in clear body secretions and covered with paper towels dampened with the body secretions.

Following dissection, the specimen is placed in a large plastic bucket (an excellent choice is the common 5- to 10-gallon household plastic waste bucket with lid) making sure that the specimen is fully bathed with the preserving fluid. Care must be taken to ensure that the specimen is dunked several times in the fluid. Paper towels wetted with the solution cover the specimen. The ratio of one part specimen to ten parts of preserving fluid should not be exceeded. After a few hours, the specimens are stirred in the preserving fluid to present fresh fluid to all surfaces. These first few hours of preservation are the most critical hours for good color maintenance.

After a 24- to 48-hour fixation period, the specimen is removed, quickly rinsed with aerated water to remove excess preserving fluid, and photographed. If the specimen is to be preserved for extended periods, it should be placed in fresh preserving fluid at equal ratios of specimen and preserving fluid. Color begins to fade gradually after 4 to 6 weeks. After 6 months, the specimens will resemble those fixed in a standard 10% formalin solution.

This procedure can be followed for all organs except the brain, which is bathed in a revised Jores preserving

solution, in which the formalin is increased from the original 2% to 10% by adding 1600 milliliters of 100% formalin to 20 liters of modified Jores solution. The additional formalin provides excellent preservation of the brain tissue, though the natural color of the brain will be maintained for a period of only 1 to 3 days. During this period the brain can be handled easily and the surface details photographed without injury to the specimen. Following the photography of the brain's exterior details, it is returned to the revised preserving solution for additional fixation. In about 4 to 6 days the brain can be sectioned for critical internal examinations.

## Preservation Procedures for Surgical Specimens

Surgical specimens are sectioned almost immediately for gross examination, obtaining appropriate tissue blocks for histological examinations. If the gross examination can be delayed an hour or two, the specimen can be placed in the preserving fluid previously recommended for the brain. A 1- to 2-hour immersion period provides sufficient surface fixation to allow the specimen to be lightly rinsed and blotted (do not wipe!) to eliminate detail-obscuring specular reflections (Color Plate 82a and b). Due to the short fixation time, further dissection reveals areas where no fixation has occurred. The specimen can be returned to the revised Jores solution for additional photography or sectioned and processed for histological examination.

For the most part, gross surgical examinations are conducted almost immediately after specimens are received in the laboratory, leaving no time for fixation or color preservation. Under these conditions, other means can be employed to reduce specular reflections, although it should be noted that complete elimination of reflections is possible but rarely desirable. The techniques for control of specular reflections will be discussed later.

## EQUIPMENT

### The Specimen Box

The specimen is supported on a glass-topped wood box measuring 16 × 20 ×6 inches deep (inside dimensions) constructed from 3/4-inch high-grade pine (Figure 16.1). A recessed area on the top of the box supports a sheet of double-strength float or window glass measuring 16 1/2 × 20 1/2 inches. The top of the glass should be flush with the top of the wood box for ease of cleaning. A protected wood cover (not shown in Figure 16.1) is recommended to prevent someone from laying equipment on the specimen box glass when not in use. (The scratches that may be incurred will be very visible against

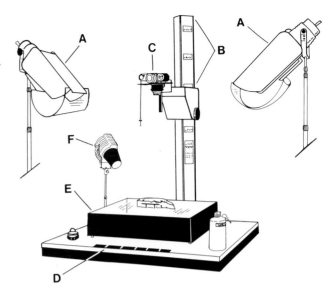

FIGURE 16.1  The photographic setup consists of (a) two lamps with barndoors and UV absorbing filters, (b) camera column with marked camera positions, (c) single lens reflex camera, (d) quick estimate scale (ruler) for specimen size, (e) specimen box, and (f) spot light with snoot.

the black background.) Also, a finger notch is made at one end of the box to facilitate the easy removal of the glass.

The inside of the box is painted with flat black paint. On the four bottom corners of the box are ball-bearing coasters, which allow the box to move smoothly across the Formica-covered table top.

A piece of 1/4-inch plywood is cut (15 × 19 inches) to fit snugly inside the bottom of the box. It is covered with black velvet cloth to produce an absolutely black background. Avoid using black paper, black paint, or coffin paper, since they photograph as a dark gray tone rather than an absolute black. In addition to the standard black velvet background, other colored material, such as Crescent or Bainbridge mat board or Coloraid paper, can be cut to the same dimensions and stored under the standard background board for use when a black background is not appropriate.

The black background can be used almost exclusively, since specimen shadows are not visible, maximum color purity and saturation is maintained, and it eliminates the necessity of switching backgrounds to complement various colors of the specimens. Empirical tests determined that bright-colored backgrounds affect the color purity of the specimen (Color Plate 83a–d). Also, when slides with black backgrounds are projected in a suitably darkened conference room, the specimen appears suspended and three dimensional. We attribute the popularity of our specimen slides to the almost exclusive use of the black background.

## Small Specimen Holder

Specimens smaller than 2 inches cannot be photographed conveniently using the specimen box. A small laboratory jack (labjack) is used to hold two pieces of 3 1/4 × 4 inch lantern slide glass painted with black asphalt paint on the reverse side. The lantern glasses are bound together with black binding tape with the painted sides facing each other (Figure 16.2). Critical focus is provided by the thumbwheel on the labjack after setting the lens to a preset position on the bellow's focusing rail.

## Scales (Linear)

Originally, we used small (150-mm) plastic scales (rulers) available from most laboratory supply houses. Unfortunately, the scales contained bold advertisements of the laboratory supply house, which was very distracting. Also, as many of our gross specimen photographs began to be duplicated for incorporation into collections of other medical teaching institutions, we sought a way to include the name of our hospital.

An oversized drawing of three scales—10 cm, 5.0 cm, and 2.0 cm—with the hospital name was designed and photographed. Several prints were made and pasted up so that one exposure would represent several scales of any one size. A litho direct-reversal negative was made to

life size and printed on RC paper to produce white lettering on a black background.

The scales are rubber-cemented to small stands of various heights (1/4 to 1 1/2 inches in 1/4 inch-steps) made from photographic dark slides with small flathead machine screw bolts and nuts permanently attached by one of the instant cements. The bolts and nuts were completely coated with nonreflecting black paint before cementing to the sections of dark slide. The stands are stored on magnetic strips attached to a piece of Formica board, thus making it very easy to pick up and return for safe storage (Figure 16.3). The scales eventually become soiled but can be easily stripped from the dark slide material and a new scale attached.

## Lighting Equipment

As previously mentioned, it is important to provide good to excellent color photographs on a fast, routine basis. In order to accomplish this, as many of the variables as possible should be standardized. Our standardized lighting system has only three light sources. Although other light sources may be desirable on rare occasions, the time-consuming procedures needed to light an unusual specimen to make a prize-winning photograph can be avoided. When an unusual and intriguing specimen is encountered, it usually is set aside for photography after the gross conference or even transported to the studio for special treatment, such as transillumination, backlighting, or whatever puts it into a special class. The decision to spend the time and equipment to make such a photograph is a personal one and must be balanced by the desires of the client and the time available.

**Tungsten Lamps.**  Tungsten–halogen (TH) illumination is preferable, although electronic flash units with

**FIGURE 16.2**  (a) Small specimens are photographed on a bound set of lantern glass which has been painted black on the reverse sides of the glass. (b) A small 2.0 cm scale is placed near the specimen. The specimen and glass support are placed on a small laboratory jack for final positioning and critical focus.

**FIGURE 16.3**  The scales are fabricated from photographic dark slides and machine bolts and nuts of assorted lengths and heights to accommodate various-sized organs. The assembled scales are stored upright on a board with magnetic strips that hold them upright and in place.

modeling lights are also acceptable. Our two principal light units are the Smith-Victor #710 with barndoor units and DYH-3200K 600 watt lamps.[1] If Kodachrome type A film is used, the lights are furnished with DVY-3400K 650 watt lamps. Since the lamp and its reflector are small, the size of the spectral reflection is also small, thus reducing the possibility of detail-destroying highlights being present on the specimen. The lamps are mounted on standard adjustable studio light stands.

The lamps are positioned, more or less equally, at 45° angles to the specimen box. To provide a small degree of light modeling, one lamp may be positioned slightly above and nearer to the specimen than the second lamp. The lamps, even though positioned at times to produce a quasi-portrait illumination, are adjusted to meet the same level of illumination as standard balanced illumination. This is important, since the additional time it takes to meter and then adjust for another stop, shutter speed, or a combination of both may annoy the laboratory personnel.

In the past we mounted a Mylar-type ultraviolet (UV)-absorbing material (LLumar[2]) on the barndoors to eliminate any UV light illuminating the specimen, which can produce a bluish cast to the photograph. Fortunately, most TH lamps are now coated with a UV-absorbing material. If you find the color photographs bluish, write the lamp manufacturer for the identifying number or series with the appropriate coating. The coating (if present) is visible as a mild brown coloration at the base of the lamp's envelope. As a personal safety factor and to ensure that no UV light is present, the Mylar shield should be employed since, on a few rare occasions, the lamp has exploded, spraying hot, broken glass, which was, fortunately, safely captured by the Mylar shield.

The third unit is a small Photogenic 150 watt spotlight with snoots of various sizes. A gelatin Kodak Wratten Light Balancing filter, No. 82B, is attached to the end of the snoot to match the color quality of the TH lamps. The spotlight is usually employed to illuminate an area (such as a cavity) that is not fully illuminated by the two previous lamps or to emphasize tissue elevations (Color Plate 84a and b). Metering the illumination in a cavity is not necessary, since a visual evaluation of the effects will reveal if sufficient illumination has been obtained.

**Electronic Flash Lamps.**    Electronic flash units have two advantages over tungsten lamps: they develop no appreciable heat during operation, and they produce insignificant spectral highlights on the specimen due to their relatively small lamp/reflector size and the distance from the specimen. Since the lamps are operated 4 to 5 feet from the specimen, their rated flash guide number can be small, such as 100 to 150 with ISO 100 film. Flash units with autoexposure sensors must have their sensors switched off. The lamps should contain small modeling lights for ease in positioning the lamps.

**A Note on Specular Highlights.**    The complete elimination of specular highlights may take away the effect of a fresh specimen being photographed. The highlights, however, should always be small and unobtrusive. The lighting system discussed in this presentation will produce small highlights. It is especially important to avoid large reflectors and diffusers. If the small highlights produced by the listed light sources are objectionable, a large reflector coated inside with a heat-resistant black paint with TH lamps will make insignificantly small highlights. Ellis (1977) describes a system of photographing specimens under a fluid to eliminate bothersome reflections.

Complete elimination of highlights may be desirable for certain gelatinous specimens. This requires obtaining polarizing lamp filters and a polarizing filter for the camera lens. The lamp and lens filters, such as those made by Tiffen, can be purchased from most professional photographic supply houses.

The exposure increase is significant (three full stops or an eightfold increase in exposure *time*), and, in addition, a color balancing filter may be required to eliminate any mild coloring effects from the polarizing filters. The polarizing filters on the lens and on the lights must be cross-polarized. This is easily determined by placing a coin on the specimen box and, while looking through the viewfinder, turning the lens polarizing filter until all reflections are eliminated. If a projection system is used for focusing and composition, it is necessary to view the coin from the position of one of the lamps (see Chapter 4).

## Photographic Equipment

**Gross Specimen Bench.**    The best and simplest system is a bench designed for copying flat material. There are more than twenty manufacturers of copy benches ranging from simple, inexpensive setups to those designed for highly specialized copying techniques at correspondingly high cost. Certain criteria may be helpful in selecting a workable bench without excessive cost:

1. The system must be sturdy without any play in the mechanical parts.
2. The camera upright must be vertical, and the camera arm must move smoothly and effortlessly up and down the column.
3. The height of the bench top must be at a convenient level for the operator to place and remove specimens without being in a stooped position.

About 24 inches is the recommended height of the bench top, since the specimen box will add another 6-7 inches to the working level. Do not forget to consider shorter individuals—can the stand be reduced in height to accommodate them? A tall person is easily accommodated by a short stand, since blocks of wood can be placed under the legs to raise the working level. Bencher[3] offers

a wide range of reasonably priced stands that will satisfy most requirements of gross specimen and copy photography. (See Chapter 4 for an excellent discussion on (copy) benches.)

**Camera.** A single-lens reflex camera with waist-level viewfinder and magnifier, bellows, copy lens, and a black camera shield are absolutely necessary. A black shield must be mounted between the lens and the camera body to prevent reflections of the camera on the glass support. A 5 × 7 inch photographic dark slide makes an excellent and durable shield, although other black material may be easier to fabricate. It is advisable to use a long (18 inch), black cloth–covered cable release to eliminate its reflection in the glass.

The position of the camera relative to the size of the specimen is indicated on the camera column (see Figure 16.1). The photographer needs only to estimate the dimension of the specimen, using a ruler attached to the front of the table, to determine proper camera positioning. The actual size of the image can be determined by an equation for magnification, but it is much easier to place a ruler on the specimen box and measure a series of field sizes such as 2" × 3", 3" × 4 1/2", 4" × 6", 6" × 9", 8" × 12", and 12" × 18". These premeasured camera positions reduce the need to move the camera up and down the column two or three times trying to find the appropriate image size. One soon learns how to select a premeasured position or one that is intermediate.

When the 50-mm lens is attached to the bellows, a similar operation occurs. The camera is set at a predetermined position, and the labjack is adjusted for various image magnifications. Magnification of the image, lens positions on the tract in millimeters, and exposure information is predetermined and printed on card stock, along with the basic exposure, and attached to a wall near the camera (Figure 16.4).

**Bellows.** The bellows attachment and camera should be made by the same manufacturer to eliminate the possibility of a coupling mismatch and to ensure the operation of any automatic features. Most bellows will have a millimeter scale marked on the focusing rail, but the appropriate exposure factor, as the lens is extended from the infinity position for certain lenses, may not be present. This factor is commonly called the *bellows factor*. Unfortunately, this factor, if not present on the rail, must be calculated by the user. At this point it is worthwhile to discuss all the factors involved with exposure determination.

It is important to reduce all the factors that can enter into the exposure calculation, thus avoiding unnecessary and extensive exposure calculations every time a photograph is taken. You may find the following information very valuable for photography of many medical subjects, as well as gross specimens.

**GROSS STAND**

FILM: EPY 64T Emulsion No.      ISO:      Meter:

**80mm Lens**
Basic Exposure 1/8 sec. at *f*/16

**50mm Lens**

| Bellows | Magnifica-tion | Shutter | *f* number |
|---|---|---|---|
| 40mm | X 1 | 1/2 sec. | 16 |
| 71mm | X 1.5 | 1/2 sec. | 12 |
| 90mm | X 2 | 1 sec. | 14 |
| 140mm | X 2.9 | 1 sec. | 11 |

**FIGURE 16.4** This information is printed on a card and posted on the wall next to the camera setup. The emulsion number and any illumination adjustment is noted to alert the photographer to a film speed change. If a film speed change is required, an increase in illumination is indicated rather than a change in shutter time or aperture setting to maintain exposure standards. When the 50-mm lens is attached to the bellows for photographing small specimens, the millimeter scale on the bellows rail is used to indicate the magnification and exposure.

The level of illumination is standardized to eliminate one of the variables in exposure determination. The lamp distance and angle is adjusted to obtain the predetermined level of illumination with an incident-light exposure meter (Sekonic Exposure Meter L-28C and Luminsphere with the "Hi" slide inserted).[4] The standard level of illumination is originally determined from the exposure meter and fine-tuned with empirical film tests. For our setup the basic exposure is 1/8 second at *f*/16 (Ektachrome EPY).

An additional exposure compensation is made for very bright tissue by closing the aperture diaphragm one-third stop. In like manner, dark specimens may require opening the aperture diaphragm one-third to one full stop. One quickly develops the ability to evaluate specimens for the need of an exposure adjustment.

Another variable, which can cause the largest loss of productive time and must be considered, is the *bellows factor*. As noted previously, the increased distance between the lens and the film as the camera is focused on close objects requires an exposure increase. It is necessary to make fractional exposure increases by adjusting the *f*-stop, since exposure *time* is always in set speeds— 1/2, 1/4, 1/8, and so on—on the camera and the speeds cannot be adjusted to mid-fractional units of time such as 1/3, 1/6, and so on, that may be required as the lens is extended.

The amount of exposure increase can be determined from the following simple equation:

$$\frac{F}{v} \times \text{metered } f \text{ number} = f \text{ number set on lens}$$

where $F$ = focal length of lens and $v$ = distance between the lens and the film plane. Although this equation is satisfactory for an occasional photograph, it is a time-consuming process, and another method was needed to eliminate this waste of time for the laboratory team.

To simplify the process, the bellows track is marked with white dots (or slashes) to indicate the exposure increase required for the particular lens extension. Since basic exposure is 1/8 second at $f/16$, one dot would indicate that the diaphragm must be opened one-third stop to $f/14$, two dots to $f/12.5$. A slash indicates a full stop increase to $f/11$ or 1/4 second at $f/16$ (our preferred exposure setting) (Figure 16.5). There is no need to refer to any equation or pocket calculator to determine exposure time and lens opening. All tedious and time-consuming exposure functions are thus eliminated.

The problem is how to determine where to put the marks on the bellows-focusing rail for your lens. First, carefully focus on a distant object, then with a pencil mark the lens standard position on the focusing rail. This is your pseudo infinity setting. Now we must calculate the distance from this infinity mark to a position equivalent to a one-third $f$-stop increase in exposure, and another for a two-thirds $f$-stop increase in exposure, and so forth. Use the following set of equations as a one-time series of calculations to determine the extension from the infinity marking.

$1.14 \times F$ = additional bellows extension to add to the infinity mark for one-third stop increase exposure ($f/14$)

$1.27 \times F$ = additional bellows extension for two-thirds stop increase exposure ($f/12.5$)

$1.45 \times F$ = additional bellows extension for one full stop increase exposure or 1/4 second at $f/16$

$1.6 \times F$ = additional bellows extension for one-third stop increase exposure at 1/4 second at $f/14$

$1.77 \times F$ = additional bellows extension for two-thirds stop increase exposure at 1/4 second at $f/12.5$

$2 \times F$ = additional bellows extension for one full stop increase at 1/4 second at $f/11$ or 1/2 second at $f/16$

Note: The numbers have been adjusted to closely match the numbers on the meter's calculator.

Using a small, pointed artist brush, mark these positions with correction fluid. The Kodak Pocket Photoguide (AR-21) provides a wealth of information on films, exposure, filters, lenses, flash, and a *dial calculator for close-up photography*.

**Lens.** A short-mount 80-mm lens combined with a bellows is preferable for two reasons: (1) it results in good perspective, and (2) the camera is conveniently positioned high enough above the specimen to eliminate inhaling the odors from certain specimens. Focal lengths longer than 100 mm can be a great inconvenience when large specimens are to be photographed and/or when a short person is taking the photograph. A 60-mm lens may be more desirable for smaller individuals. A shorter focal length lens (50 mm) is necessary for close-up and photomacrography of very small specimens such as coronary arteries and fetal organs.

The lenses must have excellent resolution at hyperclose situations. Some lenses on the market are listed as macro capable, which can be misleading. Many of these lenses can focus close to the subject but cannot produce an image of suitable size or quality. Other lenses with similar sounding names, such as the Nikon Micro-Nikkor lenses, are excellent for gross specimen photography and can photograph a specimen at natural size (1 : 1) without the addition of a bellows. Although these lenses can photograph at a magnification ratio of 1 : 1, there are times when higher magnifications are necessary. The increased magnification can be obtained by adding extension tubes or close-up accessory lenses. If one chooses the close-up lens, it is important to use one or two smaller $f$-stops than normal.

It should be noted that these lenses are often autofocus and autoexposure, which may be an advantage depend-

**FIGURE 16.5**  (a) The bellows factor can be quickly determined by noting the position of the lens standard in relationship to the dots and dashes. (b) The Nikon camera's pentaprism is replaced with a Nikon 6× magnifier and E screen to ensure accurate focus and positioning of the specimen and a bright screen without ambient reflections. (c) A black shield is cemented to the rear bellows standard to prevent reflection of the bright camera parts on the specimen box glass.

ing on the metering system employed in the camera. A new series of Nikon cameras have a centered-weighted and spot exposure system which would ensure a consistently high percentage of excellent exposures. (Again, see Chapter 3 for definitive information on exposure metering and technique.)

A high-quality enlarger lens can be used with confidence since the image-to-subject ratio approximates the ratios encountered in gross specimen photography. We use a Schneider Componon $f/5.6$, 80-mm lens for the majority of normal-sized specimens and a Nikkor-El $f/2.8$ 50-mm lens for small specimens or hyperclose photographs of larger specimen details.

**Film.** The film requirements for gross specimen photography are not any different than for film used to copy flat material. Of course color balance, tungsten or daylight, must be taken into consideration depending on the light source. Films with low ISO speeds generally have improved grain and resolution characteristics, and these are the films of choice. Ability to separate like color tones and resolve detail is a consideration here, as it is in ordinary photography. If one desires robust color and high resolution, Kodachrome 25 (KM) (daylight balanced) or Kodachrome 40 (KPA) (tungsten balanced at 3400K) is appropriate. Kodachrome remains the standard against which to judge all other films. The need to process film in-house for quick turnaround may mean selecting another color film, such as Kodak Ektachrome 64T Professional (EPY) film for tungsten illumination or Kodak Ektachrome 64 Professional (EPR) film for electronic flash illumination. Almost all manufacturers produce films with similar characteristics, and the user should test a few films on an identical subject before settling on one product.

**Exposure Meter.** Selecting a specific type of exposure meter is complicated by whether it is best to measure the *light falling on the subject* (incident-light exposure meter) or measure the *light reflected from the subject* (reflected-light exposure meter). This can be complicated by the type of illumination the meter responds to (tungsten, electronic flash, or both) and the meter's acceptance angle. (See Chapter 3 for technical information on exposure meters.)

Both types of meter produce the same exposure if the subject represents an average tonal value of 18%. The incident-light meter *assumes* that the subject represents an 18% gray tone, and the reflected-light meter *makes* the image an average 18% gray. In practice the incident-light meter is the easiest to use since the color of the specimen and background have no influence on the reading. The reflected-light meter, due to its broad acceptance angle, is influenced by the brightness of the specimen *and* the background. As a practical recommendation, we suggest the incident-light exposure meter.

**Incident-Light Exposure Meter.** This type of meter assumes that the subject will reflect an average of 18% of the light falling on the specimen. It does not take into account whether the subject is black, white, or a mixture of tones. The meter is easily recognized by a white plastic integrating sphere resembling one-half of a ping-pong ball. Almost any exposure meter can be utilized as an incident- or reflected-light exposure meter, but most are more suitable for one or the other.

There is one caveat when determining exposures with incident-light meters. The range of exposure values a film can record is limited, therefore, a one-third stop less exposure should be given to specimens nearly white in color brightness—a section of a brain is a good example. At the other end of the scale, the recommendation becomes a little less precise since some specimens can be close to black—a fixed specimen with an extensive hemorrhage is a good example. The increase in exposure for this type of specimen can range from one-third stop to one full stop more exposure. Fortunately, the correct adjustment is learned very quickly.

**Reflected-Light Exposure Meter.** This meter measures the light from the specimen over a certain acceptance angle. The exposure produces an image with an average tonal value of an 18% gray card. The angle of acceptance is designed to be approximately the angle of view of the standard camera lens, which is somewhere between 30 and 53 degrees. These angles of acceptance will exceed the area of many specimens therefore, a gray card should be metered when in doubt.

**Spot Meter.** All spot exposure meters are reflected-light–type exposure meters. They have the ability to measure the reflected light over a 1 degree angle. The exposure represents an integrated tonal value of 18%. There is one precaution to observe: the objective lens on the meter is focused for distant objects, therefore, as you move closer to the subject, less than 3 feet, the image of the area you are measuring is increasingly out of focus on the photocell (not visible to the user), and the meter may furnish incorrect exposure depending on distance and the surrounding tissue or background (see Chapter 3). If you are inclined to use a spot meter at hyperclose distances, then attach an inexpensive close-up lens to the meter's objective lens. The diopter size should represent the distance between the meter and the specimen; for example, a 4+ diopter lens will bring the spot meter into focus at 250 mm or approximately 10 inches from the specimen. Positive diopter lenses of less power have longer focal distances and vice versa.

**Through-the-Lens Metering.** The new breed of super-automatic cameras feature the ability to measure the light off the film or other optical devices inside the camera. In general, they are not recommended for gross

specimen photography since the area they measure is frequently larger than the specimen, thus the meter is influenced by the background or surrounding tissue. Certain cameras have small, well-defined center-weighted metering and can be used very effectively if the specimen occupies this area or slightly more. The Nikon N8008 can measure a center-weighted spot represented by the 12-mm circle on the viewing screen as well as three other metering configurations suitable for everyday photography. This area, which is 13% of the screen's image, represents 75% of the photocell's sensitivity, and the remaining 25% is gradually diminished to the full viewing area.[5] The Nikon N8008S, in addition to the previously listed metering assortment, can make accurate spot readings represented by the 3.5-mm inner circle on the viewing screen. This area, which is 1.0% of the screen's image, represents 100% of the photocell's sensitivity. Since all specimens will occupy more than the 1.0% and most will occupy more than 13% area, consistent exposures can be expected for the majority of the specimens.[6] Specimens occupying less than the 13% area on the N8008 camera will need an adjustment to the indicated exposure. The increase or decrease of exposure can be learned through experience. As with all reflected light meters, the exposure, as determined by the meter, will represent an 18% tonal value.

### Instant Color Prints

Instant color prints of certain surgical specimens enable the pathologist to indicate on the print where sections were removed for subsequent microscopic examinations.

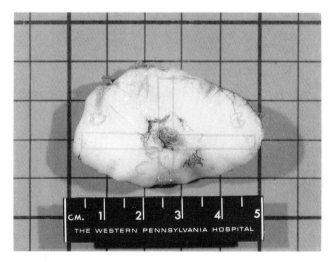

**FIGURE 16.6** A Polaroid instant print is made of certain surgical specimens to provide the pathologist with a method of precisely identifying where sections are removed. The marked print is attached to the surgical report for anatomical orientation of the disease process during the microscopical examination.

This assists the pathologist in relating the gross appearance of the surgical specimen to the microscopic field.

A Polaroid MP-3 stand is used to make these photographs. The specimen is placed on a gray plastic board which has been ruled in 1.0-cm squares. Immediately after photography, the instant print is dried with a small hair dryer. The prosector then marks the print with a grease pencil to indicate where sections are removed (Figure 16.6). The tissue is sectioned, and each section is suitably identified.

Following the standard histological sectioning and staining, the pathologist can relate the particular section removed to its microscopic appearance. This has proven to be very valuable in cases where tumor presence or metastasis needs to be identified.

## ACKNOWLEDGMENTS

The author is indebted to many past and present pathologists, employees, students, and in particular to Ms. Nancy Schmetzer, who assisted with the photographs, and the artist Ms. Marjorie Sisak. The author wishes to thank Keith Duguid, editor, for permission to use the illustrations published in Vetter, J. 1983, The colour preservation and photography of gross specimens. *Journal of Audiovisual Media in Medicine* 6(1). (January, 1983).

## ENDNOTES

1. These lamps have been superseded by #740-SG (401106) lights and the Mini Spot (401148) and Optional Snoot (401160), from Smith-Victor, 301 N. Colfax St., Griffith, IN 46319.
2. From Brandon's, 1819 King's Avenue, P.O. Box 5519, Jacksonville, FL, or Garrick Chemical and Equipment Co., Swan House, 20 New Wharf Road, London N1, England.
3. Bencher, Inc., 333 W. Lake St., Chicago, IL 60606, tel. (312) 600-0713, fax. (312) 263-3750.
4. The listed Sekonic meter now carries the name Studio Delux II model L-398M. It is essentially the same meter.
5. In addition to the Nikon 8008 camera, several other makes of SLR cameras have similar, if not identical, metering means.
6. The N8008S camera exposure system represents, for all practical purposes, a multifunctional exposure system for a wide variety of biomedical subjects.

## BIBLIOGRAPHY

Burgess, C. A., 1975. Gross specimen photography—a survey of lighting and background techniques. *Med. Biol. Illus.* 25:159–166.

Harp, D. R., 1965. Adjustable scale stand for gross specimen photography. *J. Biol. Photogr. Assoc.* 33(3):125–127.

Vetter, J. P., 1960. An integrated method of preserving and photographing gross specimens. *J. Biol. Photogr. Assoc.*, 28(1):21–27.

Vetter, J .P., 1969. Photographing gross specimens. *Lab. Med.,* 7(8):24–25, 28, 43–44.

Vetter, J. P., 1983. The colour preservation and photography of gross specimens. *J. Audiovisual Media Med.* 6(1):7–12.

Vetter, J. P., 1984. The color photography of gross specimens. *J. Coll. Am. Pathologist,* 38(3):155–161.

Williams, A. R., 1977. Control of scale in specimen photography—a look at telocentric systems. *Med. Biol. Illus.* 27:55–62.

## REFERENCES

Ellis, J. S., 1977. Under-fluid gross specimen photography—recent observations. *J. Biol. Photogr. Assoc.* 48(3):98–99.

Mallory, F. B., 1938. Pathology technique. *Preservation of Gross Specimens,* Chap. 17. Philadelphia: W. B. Saunders Company.

# Chapter 17
# Techniques for Dental Photography

## Lewis J. Claman and Robert Rashid

*. . . She puzzled over this for some time, but at last, a bright thought struck her. "Why, it's a Looking Glass book of course! And, if I hold it up to a glass, the words will all go the right away again."*

*Through the Looking Glass*
Lewis Carroll, 1832–1898

## INTRODUCTION

Dental photography is one of the most varied and specialized areas of documentation within the health professions. Aesthetic considerations and a multitude of structures requiring accurate reproduction make the selection of equipment and use of techniques particularly demanding. Chapters 17 and 18 are companion chapters; the authors first establish the principles for dental photography, then present specific clinical techniques. Finally, equipment and technical information are presented. These chapters, along with other chapters in this textbook, provide a guide to dental photography for both the biomedical photographer unfamiliar with dentistry and dental personnel unfamiliar with photography. Additionally, basic techniques for dental photography provided in these chapters may be applied to other photographic disciplines, such as videography.

The oral cavity is a unique and challenging environment to photograph. The primary objective of this chapter is to provide the reader with the expertise for making professional quality intraoral photographs. Assuming a knowledge of general photographic principles and equipment for dental photography, the chapter begins by critically analyzing two dental photographs from both general photographic principles and those specific to dental photography. A detailed guide to technique for making basic as well as supplemental segmental photographs follows. Mirrors and retractors designed for use in the oral cavity are the instruments that allow the dental photographer to meet the photographic challenge. Their usage and application is specifically addressed for each intraoral view. Examples of special intraoral views are also discussed, and guidelines for producing facial portraits for dental documentation provided. A discussion of the photographic requirements for each of the dental specialties follows. Finally, a discussion of photographic copywork applicable to dental photography is presented with reference to other chapters in this textbook, where these techniques are described in detail.

## ANALYSIS OF AN INTRAORAL PHOTOGRAPH

In the scope of biomedical photography, dental photography presents a considerable challenge. The dental photographer must contend with a moist environment that is difficult to keep dry and thus produces distracting reflective surfaces. A single image may need to accurately record, at the same time, bright tooth structure, deeply pigmented soft tissues, and metallic dental restorations. Specular highlights must be minimized. Both tooth structure, which may be highly reflective, and soft tissues, which may vary from coral pink to dark red, must be accurately captured. Although many structures within the oral cavity are accessible, there are also deep recesses that limit access and illumination. For longitudinal documentation, multiple photographs of the same view must be reasonably reproduced with use of a hand-held system.

In the Color Plate 85a,b, as well as many of the other photographs in this chapter, nearly ideal results were obtained through the use of correct equipment, basic photographic principles, and special dental photography techniques. These photographs were made with a 35-mm format bellows system using a 100-mm bellows lens and a point flash (single, directional electronic light source). (Dental photographers use the term *point flash* for the small, commonly available, electronic flash units. Photographically, they are not a point source of light.) The lens aperture was set at $f/22$ with magnification ratios of approximately $1:2$ and $1:1.2$, respectively. Kodachrome 64 film was used with a UV filter placed over the lens. (See Chapter 18, Equipment for Dental Photography.)

### Exposure

Ideal exposure is present when there is detail in both tooth structure and tissues. This occurs when the inevitable specular highlights are completely burned in, but areas adjacent to the highlights still show detail. The

most frequent error made in dental photography is to overexpose teeth in an attempt to make them look white, resulting in lack of detail in the teeth and soft tissues. Most determinants for exposure in a manual system do not vary once the camera system is assembled. Control of aperture is the usual method for varying exposure, although some systems have variable illumination or are automated. Subject-to-illumination distance is almost totally offset by the bellows factor between 1:2 and 1:1 magnification. This makes exposure adjustment unnecessary for most intraoral photography even in a manual system (see Chapter 18). Exposure is also dependent upon the subject itself. When the teeth are highly reflective and the tissue dark, it may be impossible to produce ideal exposure for both entities. In Color Plates 86 and 87, taken with the same photographic condition as Color Plates 85a and 85b, the patient had highly reflective teeth and fairly red soft tissues. Therefore, the contrast between tooth and soft tissues was considerable and the detail seen in tooth structure was diminished. The use of mirrors may also affect exposure because they serve to reflect light onto the subject. Thus, mirrors, when properly placed, help even out illumination through a wide range of distances because, while the mirror is closer to the posterior teeth, the light source is farther away (Color Plates 87, 88, and Figures 17.3, 17.4). Additionally, oral structures not included in the photograph serve as reflectors, thus contributing to subject illumination. Properly retracted tissues such as the cheeks can even illumination by scattering light from the flash. Finally, in high-contrast subject circumstances, film selection may affect exposure of specific structures.

## Color Rendition

In Color Plate 85a,b the color is nearly ideal, with accurate rendition of slightly yellow tooth structure and variations from pink to red in the soft tissues. There are many natural variations in the gingival (gum) tissues with some individuals exhibiting a pale pink coloration and others showing intense red. Some of these color variations are seen in other examples in this chapter. For example, Color Plates 86 and 87 show distinctly different coloration than Color Plate 85a,b. In addition to the film and the illumination source, color rendition may also be affected by the color saturation of reflective surfaces, such as the tongue and cheek, which may not be seen in the photograph. Color rendition can be a problem in dental photography because of film characteristics with electronic flash. The most common problem occurs with Kodachrome film, which often appears overly magenta or red, especially in subjects that are already red. Depending on the light source, color correction can be obtained using Kodachrome 64 with pale yellow and/or cyan filters, with a color shift away from magenta or red.

## Sharpness

The dental structures in Color Plate 85a,b are sharp and show detail because the basic principles of photography have been combined with techniques unique to dental photography. The quality of the lens, film, and processing are assumed. Lens aperture and magnification affect depth of field, the zone of acceptable sharpness. Since magnification is determined by the dimensions of the subject, the aperture must be minimized at $f/19$, $f/22$, or smaller to ensure adequate depth of field between 1:2 and 1:1 reproduction ratio. A dental photography mirror (Figure 17.3) has allowed the mirror (virtual) image of the buccal surfaces of the posterior teeth to appear parallel to the film plane (Color Plate 87). Without the mirror, a large range of distance would be encountered, causing some of the areas to be out of focus. Detail, and therefore image quality, are also affected by how well the field is dried. Proper isolation of the photographic field is a critical aspect of photographing surgical procedures, where hemostasis may be a problem. Special techniques for producing a clear field will be discussed separately.

## Magnification

Magnification in dental photography depends on the subject matter. Color Plates 85a and b were photographed at magnification ratios of 1:2 and 1:1.2, respectively. Magnification should be adequate to show dental structures in detail with a minimum of distraction, but at times must also show surrounding information. The general rule is to make the subject fill, but not overfill, the field. Multiple photographs may be used, with lower magnifications used for orientation and higher magnification used for detail.

## Viewpoint Distortion (Perspective)

Viewpoint distortion due to lens focal length is avoided by use of proper equipment for dental photography (see Chapter 18). Viewpoint is also significantly influenced by the viewing angle. Since access to the oral cavity occurs from an anterior approach, it is through mirrors that the correct image orientation is attained.

## Illumination

Color Plate 85a,b shows optimal illumination for intraoral systems. Distracting specular highlights have been kept to a minimum. The illumination is reasonably even. There is a modeling effect without harsh shadows. As will be discussed, in Chapter 18, neither ring flash nor point flash systems satisfy all requirements at all times.

The ring flash is easier to use and illuminates the deep recesses, but takes away from surface detail, creates distracting highlights (proportional to the reflective area of the flash), and in certain views creates uneven illumination (Color Plate 85c,d). Under most circumstances, the point flash gives the best photograph. This is especially true for photographs that will later be reproduced for publication. However, the point flash technique is more difficult to learn, is inconvenient, and produces harsh shadows for certain views. In addition to the lighting sources, proper placement of mirrors helps illuminate the field properly by reflecting light onto the subject and evening out the exposure, as previously discussed. The retractors, which pull the lips out of the field, also open up the field for illumination, thus avoiding harsh shadows.

## Composition

Assuming that the technical principles described above are followed, the quality of an intraoral photograph is ultimately determined by composition. Although there are variations in acceptable composition, certain principles must be followed. Color Plates 85a and b are well composed because general photographic principles and specific techniques for dental photography were followed. The magnification is sufficient to avoid distracting images. Teeth and surrounding tissues fill the field with a minimum of other structures showing. The camera and mirrors have been oriented to allow the borders of the field to be in alignment with the teeth. The mirrors have been angled to allow reproducible orientation in standard anatomical planes. Dental retractors have taken distracting anatomical structures out of the photographic field while they have uncovered the entire subject. The field has been dried and is free of extraneous material.

These two photographic examples should help the dental photographer understand the characteristics of an ideal photograph. In the next section, specific guidelines for making intraoral photographs are given.

## ANALYSIS OF DENTAL PHOTOGRAPHIC PRINCIPLES

In the previous section, a dental photograph was analyzed from the aspect of basic photographic principles. In this section, the reader will learn the basic methodology for making dental photographs. Figure 17.1a shows a line drawing of dental structures in the oral cavity from the facial aspect. Photographers unfamiliar with the oral cavity may refer to the bibliography.

In all technique sequences shown in the section on basic intraoral views and section on supplemental posterior segmental views from the oral aspect, the desired ideal view is shown in a color plate. The technique is then shown in a series of corresponding black and white figures starting with an orientation view of the patient, camera, flash, photographer, and assistant positions. A closer view or views will then show mirror and retractor positions and variations.

## Image Orientation

For standard intraoral photographs, the film plane and the image, whether direct or indirect, should be parallel to an anatomical plane, tooth surface plane, or tooth axis (Figure 17.1b). The three standard anatomical planes that apply to the oral cavity are the frontal plane, the mid-sagittal (median) plane, and the occlusal plane. The fourth reference is a plane parallel to the outer (buccal) or inner (palatal or lingual) surfaces of the posterior teeth. This plane diverges slightly from the sagittal plane. The fifth reference is the long axis of the teeth.

For anterior views, the image should be parallel to the long axis of the teeth and the frontal plane (see Color Plate 86 and Figure 17.2). This means that the camera should not be pointed toward the nose or chin and should approach the anterior teeth straight on. For the posterior segments, the image should be parallel to the plane of the inner or outer aspects of the teeth and in line with the long axis of the teeth, as if the teeth were being viewed through the cheek (see Color Plate 87 and Figure 17.3). For occlusal views, the image should be parallel to the occlusal plane, as if one is looking straight down on the occlusal surface (Color Plates 88, 89, and Figures 17.4 and 17.5). Later in the discussion, the exact positioning of mirrors, critical in attaining these views, will be shown.

The image should also be properly aligned and composed in the field. For photographs showing both maxillary and mandibular teeth in occlusion (together), the occlusal plane should be in the center of the field and parallel to the upper and lower borders of the field (see Color Plates 86 and 87). For whole arch occlusal views, the right and left sides of the field should be symmetrical and the midline of the arch centered (Color Plates 88, 89, and Figures 17.4 and 17.5). For views showing a segment of only maxillary (upper) or mandibular (lower) teeth, the occlusal surface or incisal edges of the teeth should be parallel to and close to the upper or lower edges of the field (Color Plates 90–93 and Figures 17.6–17.9). Positioning the image in the field is a function of camera position.

## Use of the Dental Operatory for Patient Position

Self-contained hand-held intraoral systems, rather than mounted camera systems and external illumination sources, allow for ease of use and convenience while both patient and photographer discomfort are minimized.

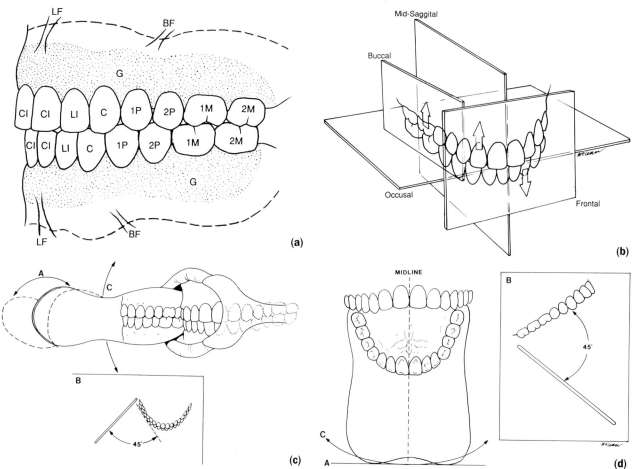

**FIGURE 17.1** Dental structures and orientation references. (a) Facial aspect of the dental arch showing teeth and associated structures from the left side. The teeth are identified as follows: CI = central incisor; LI = lateral incisor; C = canine (cuspid); 1P = first premolar (bicuspid); 2P = second premolar (bicuspid); 1M = first molar; 2M = second molar. The third molars (wisdom teeth) are not shown. The soft tissues are identified as follows: G = gingiva; LF = labial frenum; BF = buccal frenum. (b) References for dental photography. The three standard anatomic references are the frontal, mid-sagittal, and occlusal planes. The fourth plane (buccal) is parallel to the buccal, palatal, or lingual aspect of the posterior teeth being photographed, which is at a slight angle to the mid-sagittal plane. The fifth reference is the long axis of the teeth (arrows). (c) The three essential components of mirror orientation (for the buccal view). A: Plane of the mirror; B: angle of the mirror (inset); and C: rotation of the mirror. (d) The three essential components of mirror orientation for the occlusal view. A: Plane of the mirror; B: angle of the mirror (inset); and C: rotation of mirror.

The technique should permit ideally oriented photographs through correct positioning of the patient and the photographer. Thus, rather than rigidly following external references such as the plane of the floor, the photographer positions the patient, then uses through-the-lens viewing to orient the camera with respect to anatomical planes and landmarks (Figures 17.2a, 17.3a). The patient is usually seated in a fully adjustable dental chair with the chair back angled between approximately 20 degrees and 70 degrees, depending on the area being photographed, the patient's size, and the photographer's height. The level of the chair base is upwardly adjustable for tall photographers, but step stools may be needed for photographers of short stature. The patient's head should be rotated toward or away from the photographer, depending on the area of the mouth being photographed and the photographer's location (right side or left side). This allows the photographer to gain the proper camera orientation without being forced to straddle the chair or to crouch. Specific positions for each intraoral view will be discussed later.

**Photographer and Camera Position**

If the patient is positioned properly, the photographer should be able to assume a comfortable position. The photographer is usually in front of and above the patient with the camera pointed outward and downward. Since the system is hand-held and viewed through the lens, once the patient and mirrors are positioned properly, the photographer should direct and turn the camera to line up the image in the correct orientation.

## Dental Operatory Lamps

Proper illumination of the subject significantly helps in critical focus, especially for close-up views, where there is a bellows factor. The lamps used on dental units have lenses that concentrate the light. If the film speed is reasonably slow (ISO ≤ 100), the dental operatory light and overhead lights will aid in viewing without affecting the photograph. However, if the film is fast, the room lights will affect exposure, sharpness, and color and must therefore be subdued by focusing the most intense portion of the light slightly out of the field.

## Assistants

One or more persons to assist the photographer are recommended for intraoral photography. The assistant's functions are to position the patient, place and position the dental retractors and dental mirror, and provide help in drying and isolating the field. An assistant stands on the side of the chair opposite the photographer and behind the patient. In the event that adequate assistance is not available, the patient may be able to hold the mirror and retractor in place once the photographer has placed and positioned them. In views requiring two retractors and a mirror, additional assistance is required. Moreover, certain procedures require positioning of dental instruments and therefore require an additional set of hands.

## Electronic Flash Position

When a point flash is used, precise flash positioning is essential for proper illumination. When a mirror is not used, the rule is for the flash to be positioned to prevent strong shadows cast by the lips and cheeks. For the full arch frontal view, a flash position at 12 o'clock is ideal if there is enough retraction, but may cast a lip shadow if retraction is inadequate. When mirrors are used, the rule of thumb is for the flash to be on the same side as the mirror, thus allowing the light source to bounce from the mirror to the subject (see Color Plate 87 and Figure 17.3a). Exceptions to these rules will be discussed in the next section.

## Dental Mirrors

Front surface intraoral mirrors provide three important functions. As noted earlier, properly placed mirrors allow for viewing angles in true anatomical planes, enhance sharpness by producing mirror images that are parallel to the film plane, and provide reflective surfaces to illuminate the subject. Mirrors should be used for all standard intraoral photographs except the frontal view. (See Figure 18.2 for available mirror shapes).

In order to understand the principles of mirror placement, it is essential to be familiar with the anatomical planes and their relationships to the film plane, the mirror plane, and the plane of the mirror image (see Figure 17.1b,c,d). In mirror views, the orientation is much more complex because mirror orientation, film plane, and orientation of the mirror image must be taken into consideration (Color Plate 87 and Figure 17.3). The result should be a mirror image of the teeth that is parallel to the film plane in the proper anatomic plane, as previously described. To accomplish this, three mirror orientations are made (see Figure 17.1c). The plane of the mirror face is parallel to the long axis of the teeth and perpendicular to the occlusal plane but forms a 45-degree intersect angle with the buccal surfaces of the teeth. With the mirror principle—the angle of incidence equals the angle of reflection—the 45-degree angle establishes optimal image orientation and subject illumination. The mirror rotation is aligned so the edge of the mirror does not cut off the image. Properly angled and magnified mirror photographs should show little or no direct image. (Mirror orientation for each of the specific views will be discussed in the next section). For optimal image quality, intraoral mirrors must be kept clean and dry. Additionally, mirrors must be warmed prior to use to prevent condensation from forming on optical mirror surfaces. They should be placed in sterilized beakers prior to the first photograph and when needed between photographs. The mirrors may be dried with high grade, lint-free absorbent paper toweling and determined to be free of smudges. The presence of imperfections or foreign material on the mirror surface does not generally block the image unless it is excessive. However, every imperfection degrades image quality in some way.

## Dental Retractors

Dental retractors provide two main functions. They retract the cheeks, thereby allowing visualization of the subject, and at the same time aid in illuminating the subject. They may also provide space for the mirror with certain techniques. Color Plate 86 and Figure 17.2 illustrate ideal retraction. A retractor should provide both vertical clearance and horizontal retraction of the lips and cheeks. Dental retraction may be active, requiring moderate tension as in the frontal view (Color Plate 86 and Figure 17.2), applied with a light force, or applied passively as in some mirror views, where only vertical retraction is desired. The general rule is to use two retractors at all times. However, sometimes the use of two retractors significantly encumbers the process, interferes with mirror position, inordinately stretches the lips and cheeks, or prevents optimal jaw opening. The proper selection of retractor size and shape may in part overcome these problems. It is also possible in several views to utilize one strategically placed retractor and still achieve

optimal results. An optimally placed retractor should accomplish its goal without appearing in the actual photograph. (See Figure 18.4 for available retractors).

### Methods for Drying the Field

A photograph can be no better than the visibility the field of view allows. In most cases, the field must be kept as dry as possible, although there are times when having tooth structure bathed in fluid is preferable. There are three methods of drying (see Figure 18.5). The first is through the use of gauze squares, which may be applied to slightly moist areas. An air syringe with compressed air is recommended for final drying in areas where mirrors are not used. In areas where a mirror is being used, air is not recommended because moisture will be directed onto the mirror. For mirror views, a surgical suction aspirator is efficient in making the area reasonably dry.

### A Standardized Approach to Dental Photography

When photographing sequences, it is important to produce consistent views. Although precision photography is not possible with hand-held systems, a reasonably standardized approach is possible if certain guidelines are followed. Magnification can be reproduced by following standard ratios. Mirrors can be lined up in correct planes. Additionally, reference points seen through the lens in sequences taken the same day or from transparencies in sequences over a period of time can be used to compose the photograph with consistent orientation.

   Another key to consistency is to establish a systematic sequence of preparatory steps. Assuming the camera settings are correct, the recommended order is to:

1. establish chair position
2. establish patient position
3. place retractors
4. place mirrors
5. determine magnification
6. check for correct point-flash position
7. isolate and dry field
8. compose
9. focus
10. release shutter

### Patient Comfort

It is important for the dental photographer to be cognizant of the patient when performing intraoral photography. Head position, jaw opening, mirrors, retractors, and methods for drying tissues may cause patient dis-

comfort, especially when the patient is already symptomatic. Limited jaw opening, the presence of oral lesions, or a strong gag reflex may make ideal photographs impossible, requiring a compromise. The photographer and assistant should make certain that the mirror end, although beveled, does not apply excessive force to the oral tissues. Mirrors should be warmed but not hot.

### Infection Control

The concern for infection control mandates proper aseptic technique for the oral cavity. Although dental photography procedures are not in themselves invasive, all dental instruments entering the oral cavity must be sterile prior to use. Contact between dental instruments and mucosal surfaces, especially when there is loss of the tissue integrity during surgery or in the presence of oral lesions, provides an opportunity for cross-contamination. The materials and methods for sterilizing mirrors and retractors are presented in Chapter 18.

## BASIC INTRAORAL VIEWS

   frontal
   right lateral (buccal)
   left lateral (buccal)
   maxillary occlusal
   mandibular occlusal

Five photographs are included in the basic intraoral photographic series. These photographs encompass a view of the entire dental structures. The sequence of photographs for each view has been previously described. (See Chapter 18 for mirror and retractor designs).

### Frontal View (Color Plate 86, Figure 17.2)

   Field: entire dentition from the facial aspect (1 : 2 magnification)
   Image orientation: direct frontal with film plane parallel to the frontal plane
   Final composition: midline symmetry with the occlusal line centered and parallel to the horizontal borders of the frame
   Chair back position: approximately 45-degree angle
   Point flash position
      standard: 12 o'clock
      variations: 10–11 or 1–2 o'clock
   Mirrors: none
   Retractors (types shown in Chapter 18 (Figure 18.4))
      type (number): large (2)

(a)

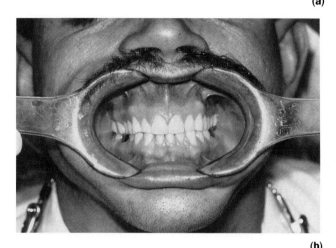

(b)

**FIGURE 17.2  Technique for the frontal view (Color Plate 86). (a) Orientation view with dental chair reclined, patient's head turned toward the photographer, film plane parallel to the long axis of the teeth, and flash set at the 11 o'clock position. (b) Dental retractor position showing large dental retractors pulled straight out and slightly forward with visualization of muscle attachments and tissue folds.**

> variations: smaller retractors depending on mouth size
> placement: bilaterally
> direction of pull: outward and forward
> tension: active

The frontal view includes all the teeth from their facial aspect with a frontal orientation (Color Plate 86). The photographer sets the magnification to include the teeth, but not the lips or cheeks. Sometimes pretreatment and posttreatment photographs require standardized magnification ratios. A good example is orthodontic views where there will be growth and development over time. In that case, the photographs are taken at a straight 1 : 2 magnification ratio even if distracting images appear at the periphery of the field. The patient is seated with the dental chair back at about a 45-degree angle with respect to the horizontal plane. The patient is instructed to turn his or her head toward the photographer, reducing the

need to straddle the chair. The camera is oriented so that the film plane is parallel to the long axis of the teeth and at right angles to the occlusal plane (Figure 17.2a). If a point flash is used, it should be positioned at 12 o'clock (on top).

For frontal views, large adult retractors with adequate width to create vertical retraction of the lips and teeth are placed in the vestibule and applied outward with a slight forward pull. If the retractors are properly positioned, the vestibular fornix (fold between the lip or cheek and the dental arch) and the tooth-associated tissues can be seen for each arch and the four buccinator frenal attachments are visible because there is lateral tension on them (Figure 17.2b). If adequate vertical retraction is not possible, a shadow will be cast in the maxillary vestibular area. Placement of the flash at the 10 o'clock or 2 o'clock position then would be preferable, thus casting a shadow posteriorly. If the retractors are oversized for the patient, complete closure will be impossible or the lips will evert, obscuring the vestibular area. The teeth may be dried with any of the three methods, but the use of an air syringe is most effective in allowing surface detail to show up. The photographer should then compose the field so that the orientation is correct and the incisal edges of the teeth are parallel to the top and bottom edges of the field. With the magnification already set, final focus is accomplished with a rocking movement. The shutter is released during an inward course with critical focus slightly posterior to the maxillary central incisors. This allows the anterior and most of the posterior teeth to fall within the depth of field. However, it is essential that the anterior teeth not fall out of focus, whereas having some of the posterior teeth not completely in focus is acceptable.

### Right and Left Lateral (Buccal) Views (Color Plate 87 and Figure 17.1C, 17.3)

**Field**
> Standard: cuspids to second molar (1 : 1.2 magnification) (Color Plate 87a)
> Variation: midline to second molar (1 : 1.5 magnification) (Color Plate 87b)
> Image orientation: parallel to the buccal surfaces and the long axis of the teeth
> Final composition: occlusal line centered and parallel to the horizontal borders
> Chair back position: approximately 45 degrees
> Point flash position: mirror side

**Mirror and Retractor Combinations.**

1. Two-retractor method (Figure 17.3b)
   Mirror
   > type: 1B (long end)
   > plane: parallel to the long buccal surfaces and the axis of the teeth

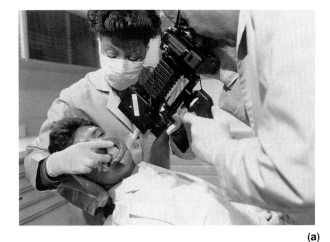

(a)

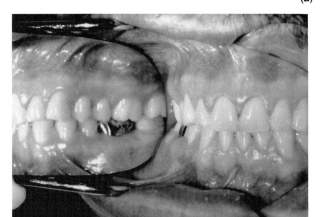

(b)

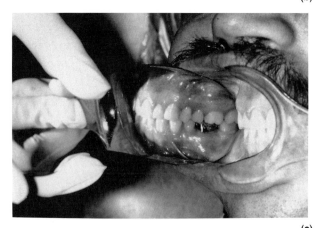

(c)

FIGURE 17.3 Technique for the buccal (lateral) view (Color Plate 87) (a) Chair, assistant, and camera orientation showing the patient's head turned toward the photographer's side and the flash on the same side as the mirror. (b) Mirror and retractor positions for the two-retractor method. (c) Positions for the one-retractor method.

> angle: 45 degrees to buccal surface of teeth
> Retractor, mirror side
>     type: wire
>     direction: outward
>     tension: active

Retractor, nonmirror side
    type: adult
    direction: outward
    tension: passive
2.  One-retractor method (Figure 17.3c)
    Mirror (types designated by evaporated metal products—see Chapter 18.)
    type: 2B
    plane: same
    angle: same
    Retractor
        type: adult
        placement: nonmirror side
        direction: outward
        tension: passive

The field of view is usually from the mesial aspect of the mandibular canine to the distal of the second molar (Color Plate 87a). The mirror image should show the buccal surfaces of the posterior teeth to be equidistant. The image is parallel to the buccal surfaces of the teeth and the long axis. Where standardized magnifications are used, 1 : 1.2 is best. Alternatively, standardized magnification at 1 : 1.5 includes the central incisors on the same side (Color Plate 87b). The chair back should be at about a 45-degree angle, and the patient's head should be turned so that the photographer doesn't need to straddle the chair or to crouch. If the photographer is on the same side as the buccal segment being photographed, the patient's head is turned toward the photographer (Figure 17.3a); if the photographer is on the opposite side, the patient's head is turned away. If a point source is used, the flash should be positioned on the mirror side with a 3 o'clock position for the patient's right side and the 9 o'clock position for the patient's left side.

Mirror positioning is a critical factor (Figures 17.1c, 17.3b, 17.3c). The long end of the appropriate mirror should be oriented at about 45 degrees with respect to the buccal surface of the posterior teeth with the face of the mirror parallel to the long axis of the teeth and the buccal surfaces of the teeth being photographed (perpendicular to the occlusal plane). The mirror should not contact the most posterior teeth, if possible. The mirror should be rotated so that the image is not cut off anteriorly. At the same time the mirror is placed, the nonmirror side retractor should be passively positioned to provide vertical retraction and illumination. Care must be taken not to place tension on this retractor, as it will force a more acute mirror angle. If two retractors are used, the wire retractor should be placed on the mirror side and pulled laterally with the mirror fitting into the space between the wire. For final framing, the camera should be rotated so that the cusp tips parallel the upper and lower borders of the frame.

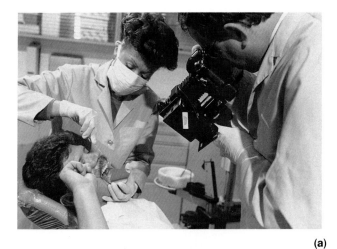

(a)

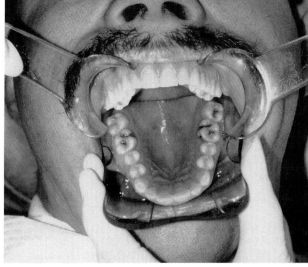

(b)

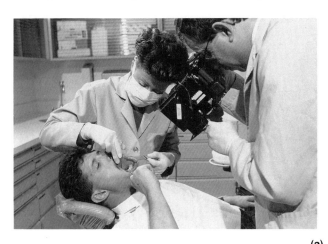

(c)

**FIGURE 17.4** Technique for the maxillary occlusal view. (Color Plate 88) (a) Chair and camera orientation showing the patient reclined, the assistant holding the mirror and one retractor, and the patient holding the second retractor. The flash is in the 9 o'clock position. (b) Mirror and retractor positions. The mirror plane is perpendicular to the sagittal plane, angled at about 45 degrees with respect to the occlusal plane and separated from the teeth at the intersection. Two small retractors are being directed outward and upward. (c) Use of split retractors.

## Maxillary and Mandibular Occlusal Views (Color Plates 88 and 89) and (Figures 17.1d, 17.4 and 17.5)

Field: entire maxillary or mandibular arch (1 : 2 magnification)
Image orientation: parallel to the occlusal plane

Final composition: midline symmetry, the midline parallel to the vertical borders of the frame
Chair back position
    maxilla: approximately 60 degrees
    mandible: approximately 20 degrees
Flash position: 3 or 9 o'clock

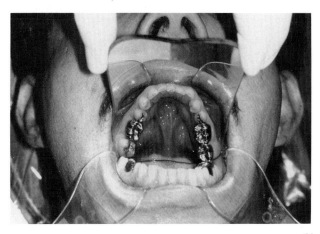

(a)

(b)

**FIGURE 17.5** Technique for the mandibular occlusal view. (Color Plate 89) (a) Chair and camera orientation. (b) Mirror and retractor orientation.

Mirror
    type: occlusal (3B)—either end
    plane: perpendicular to the sagittal plane
    angle: 45 degrees to occlusal plane
Retractors
    types: small or split
    placement: bilaterally
    direction: maxilla—upward/outward
                mandible—downward/outward
    tension: light

This view should include the occlusal surfaces of all the teeth in one arch (Color Plates 88, 89). The magnification is 1 : 2. In the optimal image, the view is parallel to the occlusal plane so that one is looking down on the occlusal plane with all the cusp tips appearing equidistant. It is sometimes impossible to include all teeth if third molars are present. The chair back position should be about 60 degrees for the maxillary teeth while for the mandibular occlusal views, the chair is much more horizontal (about 20 degrees). If a point flash is used, it may be positioned at either the 9 o'clock or the 3 o'clock position (Figures 17.4a, 17.5a). The occlusal views are the only exceptions to the rule that the flash should be on the mirror side.

The occlusal mirror plane is positioned perpendicular to the sagittal plane (Figures 17.1d, 17.4b, 17.5b). The optimal angle between the mirror and the tooth surfaces being photographed (in this case each occlusal surface) is about 45 degrees. The view will therefore be looking straight down on the teeth without an anterior vantage. Additional clearance for this view is provided by having the patient open wider, permitting separation between the mirror and the teeth posteriorly. For the mandibular occlusal view, the tongue should be retracted behind the mirror unless the tongue itself is the subject. Retracting the tongue allows the floor of the mouth to be visualized. In cases where jaw opening is limited, the orientation will not be true, the mirror angle will be less than 45 degrees, and the anterior teeth will appear to be closer.

Retractors will prevent the lips from obscuring the occlusal surfaces and optimize illumination. However, overretraction can prevent the proper mirror angulation. This may be overcome by directing small retractors upward/outward for the maxillary teeth and downward/outward for the mandibular teeth with a light force (Figures 17.4b, 17.5b). Also, a helpful adaption is to have the retractor cut in half longitudinally, creating two asymmetrical smaller split retractors that permit the correct retraction without interfering with the mirrors (Figure 17.4c). For final framing, the camera should be rotated to establish bilateral symmetry.

## SUPPLEMENTAL SEGMENTAL VIEWS FROM THE ORAL ASPECT

The basic series fulfills intraoral dental needs for the most part. Supplemental views, as opposed to occlusal views, provide higher magnification photographs from the oral aspect (palatal or lingual aspects) of the teeth. There are six standard close-up views, each of which shows a particular segment of the dental arch. For certain dental specialties, both basic and supplemental views are required for the standard series (see section on the dental specialties).

### Maxillary Anterior Palatal View (Color Plate 90 and Figure 17.6)

Field: cuspid to cuspid, palatal aspect (1 : 1.2 magnification)
Image orientation: parallel to the frontal plane and the long axis of the teeth
Final composition: incisal edges parallel to and close to the lower border of the frame
Chair position: approximately 60 degrees
Point flash position
    standard: 3 or 9 o'clock (Figure 17.6a)
    variation: 6 o'clock (camera inverted) (Figure 17.6b)
Mirror
    type: 2B (either end) or 1B (narrow end)
    plane: approximately parallel to the long axis of the teeth and the frontal plane
Retractors
    type (number): small or split (2)
    placement: bilaterally
    direction: upward and outward
    tension: light
    variation: one large retractor centered on the upper lip and directed upward with light force (not shown)

The maxillary anterior lingual view shows the palatal aspect of the anterior teeth and encompasses from canine to canine (Color Plate 90). The image is parallel to the frontal plane and to the long axis of the teeth. The magnification is about 1 : 1.2. The dental chair back is at approximately a 60-degree angle, and the patient's head is rotated toward the photographer (Figure 17.6a). The standard flash position for the point flash is from the 3 o'clock or 9 o'clock position allowing light to enter from the side (Figure 17.6a). A useful but awkward alternative is to invert the camera and place the flash at the 6 o'clock position effectively eliminating shadows (Figure 17.6b).

The mirror is placed with its plane as parallel as possible to the long axis of the teeth and the frontal plane so that the images appear to be from the lingual rather than the incisal aspect. The appropriate mirror end is determined by the size and shape of the arch. Small dental retractors are placed bilaterally in an upward and outward direction with a slight force (Figure 17.6c). Small or split retractors are an advantage in that they allow for lip retraction and illumination without interfering with mirror angulation or appearing in the field. Alternatively, one large retractor directed upward is sufficient, but increased shadowing and reflections from the retractor are likely.

(a)

(b)

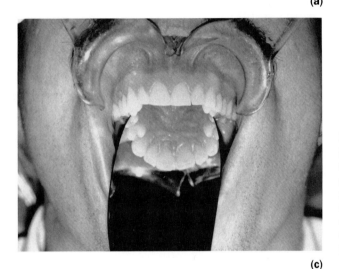

FIGURE 17.6 Technique for the maxillary anterior palatal view (Color Plate 90) (a) Orientation view with standard flash position at 3 or 9 o'clock position. (b) The camera has been inverted, allowing the flash to come from the 6 o'clock position. This method avoids shadows and was used for Color Plate 90. (c) Mirror and retractor positions. Small retractors are pulled slightly upward. The mirror is oriented as vertically as patient opening will permit, and the mirror plane is parallel to the frontal plane.

(c)

## Mandibular Anterior Lingual View (Color Plate 91, Figure 17.7)

Field: mandibular cuspid to cuspid (1 : 1 magnification)

Image orientation: parallel to the frontal plane and long axis of the teeth

Frame orientation: incisal edges parallel to and close to the upper border of the frame

Chair back position: approximately 30 degrees

Point flash position

standard: 3 or 9 o'clock

variation: 12 o'clock

Mirror

type: 2B or 1B narrow end

plane: parallel to the frontal plane and long axis of the teeth

Retractors

type (number): small or split (2)

placement: bilaterally

direction: downward and outward

variation: one large retractor centered on the lower lip and directed downward with a light force

This view shows the lingual aspect of mandibular anterior teeth and tissues (Color Plate 91). The method is similar to that for the maxillary anterior teeth, but reversed. The image is oriented parallel to the frontal plane and the long axis of the teeth. The chair back is at about 30 degrees, and the patient is turned toward the photographer. The standard point flash position is the 3 o'clock or 9 o'clock position, but the 12 o'clock position results in less shadows (Figure 17.7a).

The plane of the mirror is as parallel to the long axis of the teeth as the jaw opening permits, the objective being a true lingual view. True angulation is frequently not possible due to a limited opening. Two small-ended retractors or split retractors are pulled outward and downward with a light force (Figure 17.7b). Although not ideal, one large retractor, applied in a downward direction, may also be used.

## Maxillary Posterior Right and Left Palatal Views (Color Plate 92, Figure 17.8)

Field: cuspid to last molar (1 : 1.2)

Image orientation: as parallel to the palatal surfaces

**(a)**

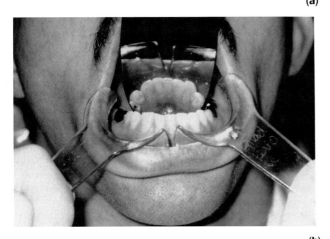

**(b)**

**FIGURE 17.7 Technique for the mandibular anterior lingual view. (Color Plate 91) (a) Orientation. (b) Mirror and retractor position.**

and the long axis of the teeth as palatal contours permit
Final composition: occlusal line parallel to and close to the lower border of the frame
Chair back position: approximately 45 degrees
Point flash position: mirror side
  right side: 3 o'clock
  left side: 9 o'clock
Mirror
  type: 2B wide end
  plane: parallel to long axis of teeth, perpendicular to the occlusal plane
  angle: 45 degrees to lingual surface
Retraction, one-retractor method (Figure 17.8b)
  type (number): large (1)
  placement: nonmirror side
  direction: outward and upward
Retraction, two-retractor method (not shown)
  one adult retractor on the nonmirror side directed outward with a light force

one small or split retractor on mirror side directed outward and upward with a light force

This view encompasses the palatal aspects of the maxillary posterior teeth and includes from the canine to the last molar on right and left sides, respectively (Color Plate 92). The mirror image should appear to be parallel to the sagittal plane. The dental chair is at about a 45-degree angle, and the patient's head is turned slightly away from the photographer when the photographer is on the same side as the segment being photographed (Figure 17.8a). The patient's head is turned toward the patient for the opposite side. The point flash should be on the same side as the mirror, positioned at 3 o'clock for the patient's right side and at 9 o'clock for the patient's left side. The wider end of the 2B mirror is used with the plane of the mirror parallel to the palatal surfaces and

**(a)**

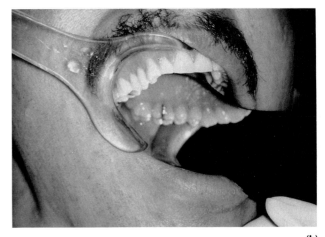

**(b)**

**FIGURE 17.8 Technique for the maxillary posterior palatal view. (Color Plate 92) (a) Orientation. The flash is on the mirror side (3 o'clock position. (b) Mirror and retractor positioning (one-retractor method). The short, more curved end of the mirror is used. The mirror plane is parallel to the long axis of the teeth and angled close to 45 degrees so that the mirror image lines up as a true sagittal view. The retractor is on the nonmirror side and pulled upward and outward.**

long axis of the teeth and intersecting the teeth at about 45 degrees. The mirror should not contact the teeth or tissues at the intersection, if possible. (Figure 17.8b) The cusp tips should be at the bottom of the field, and the top of the mirror should show the palate. In some circumstances, the palate is shallow, and in order to have a true angle, the teeth will appear in the center or top of the field with the palate out of the field. In that case, an acceptable compromise is for the mirror plane to be shallower (more occlusal).

## Mandibular Posterior Right and Left Lingual Views (Color Plate 93, Figure 17.9)

Field: mandibular cuspid to last molar
Image orientation: parallel to the long axis of the teeth and the lingual surfaces of the posterior teeth
Final composition: occlusal line parallel to and close to upper border of the frame
Chair back position: 45 degrees
Point flash position: mirror side
  mandibular right: 2 o'clock
  mandibular left: 10 o'clock

Mirror
  type: 2B, wide end
  plane: parallel to long axis of teeth and perpendicular to the occlusal plane
  angle: 45 degrees to lingual surfaces of the mandibular posterior teeth
One-retractor method (Figure 17.9b)
  type: adult
  placement: nonmirror side
  direction: outward and downward
  tension: light
Two-retractor method (Figure 17.9c)
  one adult retractor on the nonmirror side directed outward with a light force
  one small or split retractor on mirror side directed outward and downward with a light force

These views encompass the lingual aspects of the mandibular posterior teeth and tissue from the cuspid to the last molar at approximately 1 : 1.2 magnification (Color Plate 93). The mirror image should show the lingual aspects of the posterior teeth and be parallel to the sagittal plane. The dental chair is at about a 45-degree angle, and the patient's head is turned toward or away from the

(a)

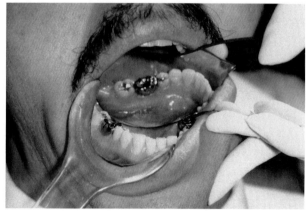

(b)

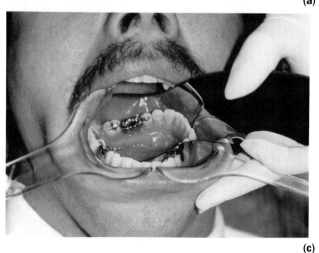

(c)

FIGURE 17.9 Technique for the mandibular posterior lingual view. (Color Plate 93) (a) Orientation. (b) Mirror and retractor placement. The mirror should be placed at a 0-degree angle and then pulled to a 45-degree angle, thus capturing the tongue. (c) The two-retractor method with the small or split retractor on the mirror side.

photographer, depending on the side being photographed. The flash is on the mirror side and is at the 2 o'clock position for the patient's right side and the 10 o'clock position for the patient's left side (Figure 17.9a). This variation from the standard position of 3 o'clock or 9 o'clock prevents a shadow around the cuspid. The curved end of the 2B mirror has a gradual curve and a steeper curve. Depending on the retractibility of the tissues and the size of the arch, either curvature may be used, but usually the edge with the more gradual curvature is used. The plane of the mirror should be parallel to the plane of the long axis of the teeth and perpendicular to the occlusal plane. Photographing this view is difficult because of the need to retract the tongue and the continual outpouring of saliva. However, with proper technique, it is one of the easiest views with which to attain an ideal result. After placing the retractors and drying, the mirror is first positioned against the teeth at a 0-degree angle and then pulled outward and toward the midline to establish the standard 45-degree intersection with the lingual surface of the teeth. The mirror should not quite contact the teeth and tissues, and thus, it also serves to retract the tongue. (Figures 17.9b & 17.9c)

## SPECIAL VIEWS

There are several views that differ from the standard photographs already shown. These specially oriented views can be useful in showing certain aspects of the oral cavity. A few of these variations are illustrated in Color Plate 94.

At times, vertical orientation is of value when the field is to be filled vertically with maximum magnification. In Color Plate 94a, the point flash is at the 3 o'clock position, allowing the illumination to enter without a lip or cheek shadow. An occlusal view of the posterior segment, shown in Color Plate 94b, is useful in photographing dental restorations and occlusal anatomy. In this view, the mirror is placed on the lingual or palatal side, and the plane of the mirror is made to be almost parallel to the occlusal plane. The point flash is then placed on the mirror side.

In Color Plate 94c, the camera is pointed upward to capture the tissue fold where the gingivae (gums) meet the lip (depth of the vestibule). Tooth profiles can be especially useful. In Color Plate 94d, the incisors and tissues are seen in profile.

In Color Plate 94e, the photograph encompasses labial and lingual aspects of the mandibular anterior teeth by including both mirror and direct views of the area. The focus is slightly posterior to the anterior teeth in the direct view, thus allowing depth of field to include the direct as well as indirect images. The mirror is tilted enough in this view to show the incisal and lingual aspects

of the teeth and soft tissues. The technique for showing both direct and indirect images in the same photograph can be employed for several of the views.

Sometimes, an extraoral close-up view is important to show aesthetics. In Color Plate 94f, the appearance of the anterior teeth is shown as the patient smiles. In addition to the special views discussed above, several other examples are shown in the section of this chapter on the dental disciplines.

## PORTRAIT PHOTOGRAPHY FOR DENTAL PATIENTS

Portrait photographs are valuable documentation for the dentist, especially when there will be comparisons between pretreatment and posttreatment facial contours. Procedures in orthodontics, prosthetic dentistry, and oral and maxillofacial surgery frequently result in facial changes and are therefore the most important to document. The objective of this section is to present patient and camera positions. Techniques for ideal illumination, also crucial to portrait photography, are covered in detail in other sections of this book. The reader should refer to Chapter 9 (Portraiture in the Workplace) and Chapter 12 (Clinical and Operating Room Photography) for illumination techniques.

In order for comparisons to be valid, it is paramount that a reasonably standardized protocol be followed for magnification, patient head position, and camera position. Ideal frontal and lateral (profile) photographs with accompanying line drawings are shown in Color Plate 95 and Figure 17.10. The magnification ratio should be about 1 : 10 (encompassing from the crown of the head to the clavicle), ideally with a 105-mm lens (35-mm format). If the patient has long hair, it should be brushed behind the ears. The best way to position the patient's head is through *natural head position*, which occurs when the patient is standing and the visual axis is horizontal (the patient is looking at an object that is forward and at eye level).

An alternative method to position the patient's head and verify natural head position is through anatomical reference points. For the frontal view, the interpupillary line should be parallel to the horizontal plane. A line from the lateral canthus of the eyes (outer angle of the eyelids) to the superior attachment of the ear (not the top of the ear) should also be parallel to the horizontal plane, as well as the Frankfort horizontal (line from the infraorbital rim to the external auditory meatus, Figure 12.6). The distance from the outer canthus to the hairline should be approximately equal on each side.

For lateral (profile) views, the line from the outer canthus of the eye to the superior attachment of the ear should also be parallel to the horizontal plane. For a true lateral profile, the inner and outer aspects of one eye should be visible, the structures of the outer eye hidden,

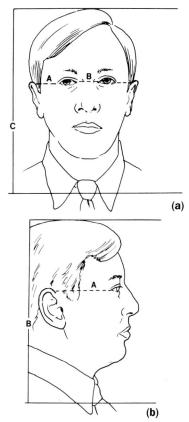

**FIGURE 17.10** Line drawings for portrait views. (a) Frontal view. The reference lines shown are A: the lateral canthus of the eye to the superior attachment of the ear (not top of the ear); B: interpupillary line; C: crown of the head to the clavicle. (b) lateral (profile) view. Reference lines are A: the lateral canthus of the eye to the superior attachment of the ear and B: crown of the head to the clavicle. (See Color Plate 95.)

with the nose appearing more distant than and anterior to the eye.

The camera should be oriented vertically. When the camera is ideally positioned, a line from the middle of the lens to the eye should be parallel to the horizontal plane. The lens should be centered between the eyes, resulting in equal space visible between the hairline and the outer canthus of the eye on both sides for the frontal view.

When ideal illumination conditions are not possible, the patient should be positioned about 24 inches from a plain background. The single point (directional flash) should be positioned at about 2 o'clock for frontal views. For lateral (profile) views, the flash should be on the same side of the nose at the 3 o'clock or 9 o'clock position, depending on the side of the face being photographed.

## PHOTOGRAPHIC REQUIREMENTS OF THE DENTAL DISCIPLINES

Dental photographic techniques are applicable to each of the dental disciplines. However, specific needs and re-

quirements for photodocumentation exist in each area. For some of the dental specialties, photographic requirements for case documentation are specified by national specialty boards.

### Periodontics

Photographs of high reproducibility are required for documentation prior to treatment, after initial treatment, during surgery, and following treatment. Reproduction of the soft tissues is essential with clear distinction seen between the different periodontal soft tissues.

For the standard periodontal series, there are nine views (including three of the five basic views and all six segmental views to represent the palatal and lingual tissues). They are the frontal, right and left buccal, maxillary anterior palatal, mandibular anterior lingual, right and left maxillary posterior palatal, and right and left mandibular posterior lingual views. Maxillary and mandibular occlusal views may be used in place of the palatal and lingual segmental views, but they are not preferable.

Photographing any sequence involving multiple photographs of the same site requires consistent reproduction of magnification, orientation, and exposure. In periodontics, photographs of the same site are taken prior to treatment, following completion of the nonsurgical phase, and following completion of treatment. Photodocumentation of surgical procedures is especially time consuming and arduous. Patient comfort, length of the procedure, hemorrhage, continual need for suction, and the need for retraction of tissues in the surgical field are some of the factors that complicate photodocumentation.

The recommended surgical series includes photographs of the surgical site from facial and oral (palatal or lingual) aspects. Photographs are taken prior to surgery and following initial incisions, debridement, bone surgery, and suturing. Photographs are also taken at appropriate intervals during healing (usually 1 and 4 weeks). Three individuals are required to photograph during surgery. The surgical assistant suctions and reflects tissues, the surgeon holds the mirror and retractor(s), and the photographer makes the photograph. Alternatively, the patient can hold the mirror and retractor with the guidance of the photographer, and the surgeon can wear overgloves and photograph the procedure. Hemostasis is maximized by the use of tissue infiltration with local anesthetic containing epinephrine (1 : 50,000) when it can be used. The surgical assistant should suction the area free of blood until the instant the photographer is ready. The photographer must then be prepared to make the photograph without delay (Color Plate 96a).

## Prosthodontics and Restorative Dentistry

The basic five-view intraoral series is recommended for the prosthodontist and other restorative dentists (Color Plates 86–89). For photographing restorative procedures at higher magnification, segmental views are very useful. In addition, several of the special views are useful. The posterior occlusal view (Color Plate 94b) is especially useful in photographing restorative treatment sequences. Incisal tooth profile is valuable in documenting crown contours (Color Plate 94d). An extraoral view showing the appearance of the anterior teeth is especially valuable to show aesthetics (Color Plate 94f).

In Color Plate 96b, slight intentional underexposure and greater magnification of the area show excellent detail within tooth structure and restorations. Teeth are generally dried when photographs are made. However, when aesthetic restorations are dried, they may show imperfections and therefore may not photograph as they normally appear. To simulate normal conditions, the area is dried and then the restoration is remoistened. One problem in photographing teeth is that the electronic flash may make the teeth or dental restorations fluoresce and thereby alter color. Placement of a UV filter over the flash may help reduce this problem.

Although the point flash is generally superior to the ring flash in showing tooth structure with minimal specular highlights, there are times when the ring flash is preferable, as when the magnification is too high for point flash. In Color Plate 96c, a ring flash was used, which helped illuminate the threaded internal fitting of a dental implant. Portrait photographs are frequently required, particularly when treatment results in changes in facial contours or other aesthetic alterations.

## Orthodontics and Pediatric Dentistry

The basic five-view intraoral series is recommended for orthodontic patients (Color Plates 86–89). Because growth and development is frequently followed, standardized magnification is essential. The magnification ratio for the occlusal and frontal views is 1 : 2, whereas the magnification ratio for the buccal views is 1 : 1.5.

Frontal and lateral profile views are required prior to and following treatment (Color Plate 95 and Figure 17.10). The photographs should be as standardized as possible. In addition, three-quarter profile photographs are valuable (not shown).

The most difficult problems in photographing pediatric patients are the frequent lack of cooperation and small mouth size, which impedes retraction, illumination, mirror position, and frequently results in distracting noninformational material. Little can be done to minimize these problems. Smaller mirrors and retractors are available and permit adequate visualization.

## Endodontics

The endodontist's need for dental photography is generally limited, except for documentation of surgical procedures. The photograph shown in Color Plate 94c would provide good angulation for endodontic surgery of that region because it is oriented toward the tooth apex (root tip). Clinical documentation of endodontically related lesions requires views and techniques already described. Photodocumentation of endodontic (root canal) procedures requires the use of ring flash because the areas photographed are deeply recessed.

## Oral Pathology

The oral pathologist has the most need and the greatest challenge in photodocumentation of the oral cavity because lesions may occur at any location. Frequently the deep recesses of the oral cavity or even the oropharynx must be viewed. Often, the surfaces being photographed are glistening and highly reflective, making the ring flash unusable. If a point source is used, proper placement of the flash and drying of tissues is essential. Reflections can also be minimized when photographing flat reflective surfaces, such as the cheek, if the camera is angled at 45 degrees to the surface, thus eliminating specular highlights in the subject area.

## Techniques for Photographing Special Areas of the Oral Cavity

**Buccal (Cheek) Mucosa.**   For photographing the cheek, one large retractor should be placed on the side being photographed. The jaw should be open enough to slightly stretch the cheeks vertically. Moderate lateral force should be placed on the cheek side retractor to bring the cheek away from the teeth. If a point flash is used, the flash should be on the side being photographed at the 3 o'clock or 9 o'clock position. As the camera is directed toward the subject, it will assume a film plane-to-subject angle of approximately 45 degrees and thereby minimize specular reflections (Color Plate 96d).

**Lateral Border of the Tongue.**   The tongue should be grasped with gauze, pulled forward, and dried. A 45-degree angle between the tongue and film plane will minimize highlights, although some are unavoidable (Color Plate 96e).

**Ventral Surface of the Tongue and Floor of the Mouth.**   For a direct view, the patient should pull the tongue backward and touch the palate. The technique for mirror views is shown in Color Plate 89 and Figure 17.5.

**Soft Palate, Uvula, and Posterior Aspect of Tongue.** A ring flash is recommended for photographs of the posterior aspect of the oral cavity and when the deepest aspects of the vestibule are photographed, since point flash illumination will create strong shadows in these areas. When photographing posterior structures, anterior structures will appear out of focus and overexposed, but this distraction can be minimized by having adequate magnification and using bilateral retractors (Color Plate 96f). Frequently, a small mouth mirror may be used to depress the tongue out of the field for views of the soft palate and uvula. Flat, shadowless illumination of the vestibule is shown in Color Plate 96g. With proper flash and retraction technique, however, many areas can be photographed with the point flash producing minimal highlights and outstanding detail in teeth, tissues, and deep recesses (Color Plate 96h).

## Oral and Maxillofacial Surgery

The requirements of the oral and maxillofacial surgeon are similar to those of the periodontist for surgical documentation. There is frequently a need to photograph the face in order to show changes before and after maxillofacial surgery.

## General Dentistry

The general dentist may perform procedures common to each of the dental specialties described above and may, therefore, have similar photographic needs to each of the specialty. The general dentist most frequently needs to photodocument dental restorations.

## SPECIAL COPYWORK

Several areas of copywork require special consideration for the dental photographer. Many of the copywork techniques have been extensively covered in other chapters of this book.

## Radiographs

Whenever multiple radiographic images or large films must be reproduced for projection, an image-forming system and special film are required. The copied radiographs should retain or improve on density and contrast characteristics of the original film. The most frequent error in reproducing radiographs is an increase in contrast, with a resultant loss of gray scale. (See Chapter 5, Photographic Copying of Diagnostic Images.)

## Dental Diagnostic Casts (Models)

Dental casts present a copywork challenge in that they are monochromatic (generally white). Proper illumination techniques are therefore essential. Generally, casts are photographed in the five standard views (frontal, right lateral, left lateral, maxillary occlusal, and mandibular occlusal), similar to the basic intraoral views. Additionally, the casts can be photographed in occlusion from behind. A black velvet seamless background is recommended. (Illumination techniques for small objects are described in Chapter 20, Laboratory Photography.)

## Extracted Teeth and Surgically Removed Tissue

Proper illumination techniques and noncompeting backgrounds are essential when photographing tissue specimens. (See Chapter 16, Gross Specimen Photography, and Chapter 20, Laboratory Photography, for specific techniques.)

## Metallic Instruments

Shiny objects are a challenge to photograph. Proper illumination techniques are crucial. (See Chapter 20, Laboratory Photography, for specific techniques.)

## ACKNOWLEDGMENTS

The Ohio State University College of Dentistry furnished the facilities. The authors are indebted to Michael Wojcik, D.D.S., who graciously served as the patient for numerous photographic sessions, to Barbara Clark, D.A., for her assistance, and to Lori Howard. The authors are grateful to Dan Patton, R.B.P, F.B.P.A., and his staff for their technical expertise and help in preparing the photographs and line drawings.

## BIBLIOGRAPHY

### Articles in Refereed Journals

Claman, L., Patton, D., and Rashid, R., 1990. Portrait photography for orthodontic patients. *Am. J. Orthod. Dentofac. Orthop.* 98:197–205.

Davidson, T., 1979. Photography in facial plastic and reconstructive surgery. *J. Biol. Photogr. Assoc.* 47:59.

Freehe, C. L., 1984. Dental photography. *Functional Orthod.* 1(4):41–48.

Freehe, C. L., 1985. Dental photography (second in series). *Functional Orthod.* 2(1):34–44.

Gordon, P., 1987. Principles of close-up photography. *Br. Dent. J.* 162:229–239.

Gordon, P., and Wander, P., 1987. Techniques for dental photography. *Br. Dent. J.* 162:307–316.

Kumagai, T., Fedi, P., and Ishii, M., 1988. Standardized intraoral photography for the dental team. *J. Am. Dent. Assoc.* 116(5):677–680.

Stutts, W., 1978. Clinical photography in orthodontic patients. *Am. J. Orthodont.* 74(1):1–31.

Swift, E., Quiroz, L., and Hall, S., 1987. An introduction to dental photography. *Quintessence Int.* 18(12):859–868.

Williams, R., 1985. Positioning and lighting for patient photography. *J. Biol. Photogr.* 53:132–143.

## Monographs or Chapters in Textbooks

Freehe, C. L., 1981. Clinical dental photography: Equipment and techniques. *Clinical Dentistry*, J. W. Clarke, ed. Philadelphia: Harper and Row.

Freehe, C. L., 1983. Symposium on dental photography. *Dent. Clin. North Am.* 27(1):1–218.

## Handbooks and Textbooks

Daniels, T. E., and Sherrill, C. A., 1974. *Handbook of Dental Photography.* San Francisco: University of California Press. Can be ordered from Trojan Camera, 834 W. Jefferson, Los Angeles, California 90007.

Freehe, C. *Dental Photography.* Published and distributed by CL Freehe, 6917 Wahle Road East, Sumner, Washington 98390. Also distributed by Washington Scientific Camera Company, P.O. Box 88681, Tukwila, Washington 98138.

Goodlin, R., 1987. *The Complete Guide to Dental Photography.* Montreal: Michael Publishing.

## Information About Dentistry

*Dorland's Illustrated Dictionary.* 1988. Philadelphia: W. B. Saunders Company.

Jablonski, S., 1988. *Illustrated Dictionary of Dentistry.* Philadelphia: W. B. Saunders Company.

Woelfel, J., 1990. *Dental Anatomy,* 4th ed. Philadelphia: Lea & Febiger.

# Chapter 18
# Equipment for Dental Photography

## Robert Rashid and Lewis J. Claman

*"While there is perhaps a province in which the photograph can tell us nothing more than what we see with our own eyes, there is another in which it proves to us how little our eyes permit us to see."*

Dorothea Lange
American Photographer
(1895–1965)

The goal of this chapter on dental photographic equipment is to provide the reader with the knowledge to make an informed purchase and the information to obtain the proper equipment for accurate and diagnostic intraoral and extraoral dental patient photographs. Rather than cite specific models of equipment, which may become rapidly outdated, the principles behind the features present in various camera systems will be discussed, especially as they affect dental photography. The reader should be familiar with basic photographic principles. After a discussion of the equipment requirements for dental photography, an overview of various systems is presented.

### REQUIREMENTS OF A DENTAL PHOTOGRAPHIC SYSTEM

There is no *best* photographic system for dental photography. Examination of the variety of clinical views in Chapter 17 reveals that the majority of the photographs were made with a point flash and bellows lens system. Point flash and ring flash are discussed and defined in the section following on flash systems. A number of photographs would be unacceptable with this system, however. Very high-magnification photographs made with a point flash system often result in images with long shadows and contrasty side lighting. This is because the light source, positioned on the side of the front of the lens at close distances, must come from off the lens axis. This problem can be avoided by the use of a ring flash, which illuminates from nearly all angles, providing a very diffuse shadow that is not easily seen.

The ideal dental photographic system would have an easily focused lens that reproduces in the range of portrait reproduction to twice life size. This lens would have high resolution, good contrast, and adequate depth of field to capture all the teeth in sharp focus at high magnifications. The ideal light source would provide shadowless and controlled shadow illumination, with enough light to expose the best high resolution films available. It would add no additional color shift to the final image.

Finally, the ideal film would have latitude, contrast, and color balance capable of accurately capturing the subtle shades of the highly reflective teeth as well as the darker tissues in the recesses of the oral cavity.

The ability to view structures in the mouth in a well-illuminated and controlled setting is a luxury not frequently seen in dentistry. Good dental photography allows the visualization of all areas of the oral cavity with a resolution and clarity not possible in a routine examination using a dental mirror and operatory light. As a diagnostic aid it is an invaluable tool; as documentation of treatment, it is unsurpassed. Intraoral photographs allow a dentist to present treatment needs and plans to the patient more clearly. They also allow the presentation of dental treatment to peer groups and students. Intraoral photographs of poor quality obscure information, leading to confusion. Perspective can be distorted and colors can be inaccurate, misleading, or confusing to the audience. Areas not properly illuminated or out of focus offer little information about the subject, but provide great distraction.

Accurate and reproducible intraoral photographs require specific photographic equipment. Despite this, dental photographers have a bewildering assortment to choose from. Many systems can be justified by criteria such as simplicity of use, the need to save money, or the need for instant photographs. However, for a high-quality final image, the system of choice is a 35-mm macrofocus camera system. Macrofocusing accurately refers to magnifications of life size and greater. This is a stricter definition than that used by lens manufacturers, some of whom label lenses as macrofocus despite the fact the maximum magnification may be only one-quarter or one-fifth life size. In this section, we will use the term *macro* to refer to any magnification one-half life size or greater.

The dental photographic system must minimally include a camera body, a close-focusing lens system, and a light source with necessary hardware (usually a flash bracket) to position the flash at the front of the lens. This system is not the answer for a total photographic novice

and is not specifically suited for instant photography. This slight lack of flexibility is more than compensated for by the high resolution and accurate reproduction of intraoral structures.

## Camera Bodies

The minimal camera body requirement for dental photography is one with manual exposure and a provision for electronic flash synchronization at a shutter speed of 1/60 second or faster. This minimal requirement can be enhanced with the inclusion of features such as automatic exposure, through-the-lens (TTL) flash exposure, autofocus, and motorized film wind and rewind.

A wide variety of camera bodies is available, ranging from simple mechanical units to those with complex electronics capable of control and automatic focus. The minimal requirements for dental photography are the ability to view and focus the subject through the lens, full control of aperture and shutter speed, and connection for electronic flash synchronization.

These requirements can be met by many inexpensive manual single lens reflex (SLR) camera bodies. Rangefinder cameras are generally not useful for dental photography due to the parallax corrections necessary.

A manual SLR camera meets the minimum standards for cost and capabilities. Viewing through the lens allows for accurate focusing and composition. A majority of SLR cameras incorporate TTL exposure. While this feature is not necessary for intraoral photographs, it is useful in other situations such as copystand photography. This feature is important to the dental photographer with only one camera system. While the biomedical photographer may possess camera bodies and lenses adaptable to a wide variety of photographic needs, the dental photographer with only one system needs some versatility.

In an effort to make 35-mm cameras more foolproof, a number of systems, while having a full range of shutter speeds, lack the manual selection of a specific speed. These cameras do not lend themselves well to a dental photography system. Generally, their flexibility for copystand work or small object photography is limited, and modifications must be made to override the automatic settings. Typically, these cameras have only one setting for exposure control, a *programmed setting* in which the camera sets both shutter speed and aperture. With no manual override capability, the photographer is at the mercy of the manufacturer's chosen speeds and apertures. This may be adequate for routine photography, but it is unacceptable for dental photography.

At the other extreme of the camera body spectrum is the professional camera body, with a plethora of settings and override capabilities. While this type of camera can be readily adapted for dental photography, the cost and complexity generally make it a less-than-ideal choice for all but the most serious of photographers. The complexity is generally not necessary, and the additional weight usually encountered is tiring when used to make hand-held intraoral photographs in dental photography.

It would seem that autofocus is the answer to the dental photographer's prayers. With limited depth of field, focusing difficulties are usually the first problems encountered. Autofocus cameras have a small focusing area, usually centered in the viewfinder. For routine intraoral photographs, this is frequently not the area of desired sharpest focus. For frontal views the area of sharpest focus would be the central incisors. There is an area of acceptable sharpness in front of and behind the sharpest focus area. This area of acceptable focus should extend posteriorly to the first molars and would be wasted on the area in front of the anterior teeth. Focusing on the distal surfaces of the lateral incisors causes the areas of acceptable focus to extend anteriorly to the central incisors and posteriorly to the second molar region. The central incisors will have adequate sharpness for all but the largest of enlargements, and the overall picture will increase in apparent sharpness. This provides more information and is less distracting to viewers.

Attaining sharpest focus with an autofocus camera in the lateral incisor area would require that the focus be locked on this area and the image then recomposed. During this time, the photographer is likely to have moved, making the locked focus inaccurate.

It is important to note the relationship between magnification and focus. During normal photography, focusing the lens by turning the focusing ring brings different image areas into focus, but the magnification remains relatively constant. When working in macrophotographic ranges, changing the distance from the subject by adjusting the focus also noticeably changes the magnification. This can result in undesirable changes in composition and image size. The preferred technique for intraoral photography is to grossly adjust the focus until the desired composition and magnification is obtained. This requires the photographer to move toward or away from the patient to maintain a sharp image during the change in magnification. When the correct magnification is obtained and the image is properly composed, the photographer then makes the exposure. Normal movements by the photographer and/or the patient cause the sharpest plane of focus to constantly change. By moving toward and away from the subject, the photographer can predict when the sharpest plane of focus will be on the desired area and time the shutter release appropriately. With autofocus cameras, the initial composition can be assisted by the autofocus mechanism, but the final focus decision is still best left to movement by the photographer and the appropriately timed release of the shutter.

If a motor drive is not built into the camera, purchase of a separate unit is highly recommended. This allows

better concentration on the photographic composition, without the frustration of an inoperable shutter because the film was not advanced. When photographing a full series documentation, the time savings can be important, especially if all images are being bracketed or shot in duplicate. By not needing to remove the camera from viewing position to advance the film, the image composition and focus can be maintained. Patients appreciate this time saving, since retraction and mirror placement are uncomfortable.

A number of camera bodies, especially those designed for professional use, allow interchangeable viewfinder screens. Because of the high magnification and limited illumination for viewing intraorally, the normal focusing aids used in standard screens are nonfunctional. They usually present a dark and distracting image. Moving the eye horizontally or vertically makes certain portions of the microprisms in the screen appear dark. Modeling lamps in some flash systems provide light for viewing, but not enough light to render the microprism and range-finder focusing aids usable. Most camera manufacturers offer screens designed for low-light, high-magnification work. The best screens for intraoral use are matte surface, with horizontal and vertical orientation lines. The matte surface has a bright image and allows focusing to be done on any part of the viewfinder image without the need to recompose the image. The lines aid in orientation and composition.

## Lenses

Lenses for use in dental photography must be capable of magnification within the range of one-tenth life size to full life size (1 : 1). Additionally, they must portray an accurate image on film in terms of both color and perspective. Lenses should have a maximum aperture or $f$-stop of $f/2.5$ to $f/4.5$ to allow adequate light for accurate focusing. More importantly, the lens must have a minimum $f$-stop of at least $f/22$. $F/32$ is preferable, giving greater control of exposure in those situations where light-colored subjects are photographed in high magnification. The minimum $f$-stop of $f/22$ (or 32) also provides for reasonable depth of field for intraoral views.

Lenses used in dental photography systems can be grouped into three categories: standard camera lenses, true macro lenses, and bellows lenses. The first group includes lenses of a focal length near 50 mm that, with the aid of accessories such as extension tubes or close-up lenses, have been made to achieve nearly 1 : 1 or life size magnification. When this is done, the image produced by the lens usually has a perspective distortion (Color Plate 97). This distortion exaggerates features in the center of the picture and minimizes features close to the edges. A frontal view of the whole mouth would show central incisors that are relatively larger than the adjacent lateral

incisors and canines. In a close-up portrait using a wide-angle lens, the nose is usually centrally located and assumes undue prominence. A 300-mm lens has the opposite effect, appearing to flatten the facial features. Use of a lens with a focal length in the 90- to 135-mm range minimizes this perspective distortion.

The ideal focal length for a dental photography lens is in the range of 90 to 135-mm. This range is chosen optimally to minimize perspective distortion on the reproduced slides. Some lenses in this range are designed as true macro lenses. They are designed for work at magnifications near life size. Some of these lenses are supplied with a life-size adapter. Without the adapter, they focus to one-half life size. With the adapter, they focus within the range of one-half life size to full life size (1 : 1). While this type of lens may have excellent resolution and good capability for flat-field reproduction, it is limited due to the need to place the adapter on and off for intraoral views. Several macro lenses now focus from infinity to life size without the need for an adapter. (Some of these do not offer quite the flat-field reproduction accuracy that lenses designed solely for high magnification reproduction do.) However, these lenses offer much in the way of convenience in dental photography. They provide connection to the camera body for automatic lens control (metering and stopping down the diaphragm), and frequently provide maximum $f$-stops in the 2.5 to 2.8 range, which helps in focusing, providing a bright viewfinder image.

Another lens classified as a macro lens is the bellows lens. This type of lens has no focusing capability within the lens barrel but, instead, relies upon a *bellows* unit to provide extension to and from the camera body. These lenses have been designed for flat-field reproduction in ranges from one-half life size to much higher magnifications. Bellows lenses in the range of 90 to 135 mm are ideally suited for dental photography. When connecting a bellows lens and bellows system to the camera body, some automation may be lost. The simplest systems mount with no interaction between the camera body and the lens. This is found in most bellows systems (even some labeled as *automatic*). This means that exposure must be determined with the aperture manually stopped down prior to taking the photograph. On these bellows systems, this requires a dual cable release. Both cables are connected to the same release. The first cable, connected to the lens, stops down the lens diaphragm, followed closely in time by the second cable, connected to the camera body, which triggers the shutter to fire. There is a brief but perceptible time during this process when the viewfinder darkens, but the camera has not fired. It is then easy to lose the view of the desired composition. The possibility of movement out of the plane of planned exposure is also increased. For this reason, these semi-automatic bellows lenses are not preferred for dental photography. Connecting the bellows and lens to the

camera body with full electronic and mechanical linkages allows the combination to behave like any other automatic lens, with release of the shutter also triggering the lens diaphragm to stop down to the preset aperture. The timing is so short that it is not perceived by the photographer. At least one retailer of dental photography equipment has modified a small bellows unit for automatic diaphragm control. This is the only unit currently manufactured that does not require a dual cable release.

There are times when greater magnification is required than can be provided by the standard photographic unit. When the need is infrequent, it can be met very satisfactorily with the use of extension tubes and close-up lenses. As with bellows units, extension tubes may lack some automatic features between the camera and lens.

Close-up lenses, attached to the front of the macro lens, provide higher magnification with slight loss in image quality. For the infrequent exposure, they provide a practical solution to the need for high-magnification images.

There has been much controversy over the relative merits of the various macro lens systems. Lens designers have used various optical designs to meet the different demands of the macrophotographer (including the dental photographer). Lens size, aperture, ability to reproduce flat objects, and working distance have all been compromised to some extent in each lens. Some lenses have the advantage of being relatively inexpensive, with a larger maximum aperture for focusing ease. They also are compatible with many camera features such as full aperture metering. They may fully couple with the camera body, allowing the use of a single cable release instead of the dual release required by some nonautomatic lenses and bellows units. Other lenses provide greater working distances, allowing better flash positioning and subject illumination. When focused on a subject at a specific magnification, the distance from the front of the lens to the subject is the working distance. This distance is dependant on the focal length and design of the specific lens. As seen in Figure 18.1, when focused on a subject at life-size magnification, the lens with the shorter focal length has the greater working distance. Normal optical formulas would lead to the opposite expectation. However, lens design for the bellows unit provides greater working distance than some nonbellows lens. This additional working distance provides room for mirrors and retractors and minimizes shadows caused by light coming from a flash that is off the lens axis. The greater the distance between the subject and lens, the less the angular difference between the flash and lens axis.

## Electronic Flash

The working distance of the lens influences the choice of flash. The primary goal of the flash is to illuminate the

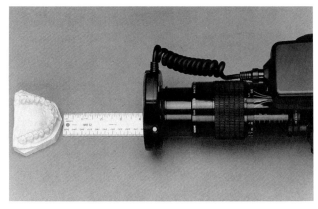

(a)

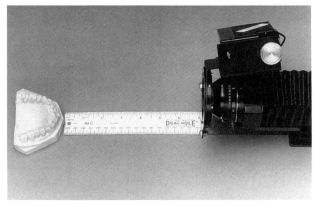

(b)

**FIGURE 18.1** The ability to maintain distance from the subject when at maximum magnification is diminished with some lenses. The working distance required for a life-size photograph is approximately (a) 4 1/8 inches for the 105-mm macro lens and (b) 7 inches for the 100-mm bellows lens.

oral environment. Second, the flash must provide proper color balance of light for the film to accurately render tissue colors. Finally, the flash must provide modeling of the tissues, giving clues to the information lost in the transition from the three-dimensional subject to the two-dimensional film.

Dental photography flash units must be able to be mounted near the front of the lens, as close to the long axis of the lens as possible. This frequently requires the use of a flash bracket, sold by each of the dental camera manufacturers noted in the Reference list. Mounting the flash on the front of the lens provides illumination of the subject with minimal extraneous shadowing. A side benefit is that, when magnifications reach approximately one-half life size to full life size, the light loss due to magnification, (bellows factor) is offset by the increased light because the flash is moved closer to the subject during focusing. This is shown in Table 18-1, made for a specific lens and flash combination. A similar table can be constructed for any lens and flash combination after suitable measurements are made to determine the true power of the flash and the optical center of the lens.

Many of the current flashes manufactured now have some degree of dedication with one or more camera systems. A basic, nonautomatic flash fires for a fixed interval, providing a constant, fixed source of light. With the addition of a light sensor in the body of the flash (automatic flash), the light output can be controlled, providing some automatic exposure control in a variety of situations. Since this control is done by a sensor in the flash body that is not connected to the camera's metering system, it does not compensate for exposure factors due to the different magnifications used intraorally. There is no compensation unless calculated by the photographer and adjusted on the *f*-stop of the lens.

Flashes have electronic connections to the camera body and light meter beyond that necessary to fire the flash. They can set the camera shutter speed to the fastest speed available for flash photography. This is the *x-sync* speed on some shutter dials or, more commonly, a speed such as 1/60 second. Dedicated flashes can also implement TTL flash exposure.

With TTL flash exposure, the camera electronically communicates with specific dedicated flash units and controls the amount of light output by the flash. A sensor in the camera body registers the amount of light falling on the film (including light from the flash) and stops the flash output when adequate light has reached the film to effect a proper exposure. Exposure is determined by the light reflecting from the surface of the film at the time of exposure. This allows the camera to control the duration of flash firing, and thereby the quantity of light for exposure. Since the light is measured at the film surface, the exposure factor due to magnification needs no further compensation.

While this feature is desirable, it has a potential drawback for dental photography. Most dental photography involves the recording of hard and soft tissues. The teeth are usually very reflective and light colored, while the soft tissues range in reflectance but are dominated by the pink-to-dark red tissues of the cheeks and gums (gingivae). Most TTL flash systems use averaging exposure systems, where all brightness values in the scene are averaged together to arrive at the final exposure. A view encompassing mainly tooth structure would be rendered slightly underexposed by TTL flash systems, and any soft tissues visible would appear darker red or magenta. Similarly, scenes in which soft tissues predominate would end up with overexposed tooth structures and loss of detail and subtle shadings.

Dental photography utilizes two types of flash light sources: point flash and ring flash (see Color Plate 85, Chapter 17). A point flash can be defined as one with a short, straight flash tube. While this is not technically a true point source of light, the effect of the lighting in photographs resembles directional illumination, rather than illumination from a more generalized source. Most flashes used in general amateur photography fall into this range. Point flashes vary by head design and power.

A small, battery-powered unit, with the option of ac power, with a guide number of approximately 40–70 (ISO 100/ft) will provide adequate illumination with most lenses.

Ring flashes differ from point flashes by the use of one or more curved flash tubes in the shape of a circle surrounding the front of the lens when mounted on the camera. While some units are a single curved tube, newer ring flashes may have multiple tubes, with the ability to turn each tube on or off separately. This can provide generalized lighting from multiple angles or light from a single angle (similar to a point flash). Color Plate 85, (Chapter 17), illustrates the differences between ring and point flash illumination.

Which type of lighting is preferable has been, and will continue to be, debated in dental photographic circles. The answer must take the film, lens system, and subject into account. As will be discussed later, some films require greater amounts of light for proper exposure. With few exceptions, ring flashes are generally more expensive and have more limited light output than their point flash counterparts. This requires either a lens that brings the flash closer to the subject or use of larger apertures, limiting depth of field for the image. Use of a short-focal-length lens, such as a 90-mm lens, or use of a lens with a short working distance will necessitate lighting that is close to the lens axis and can provide minimal shadowing. At life-size magnification, most point flashes cannot be placed close enough to the lens center when used with a lens having a short working distance. This causes shadows that are difficult to control. Ring flashes provide better illumination in these cases. Frequently, the disadvantage of lower power is offset by the closer working distance.

Ring flashes cause an increase in specular highlights when used at magnifications near one-half life size such as frontal and buccal views. Here point flashes have the advantage, with less detail lost due to reflection of the flash off the tooth surfaces. The point flash also provides modeling of the soft tissues and teeth, which aids in the three dimensional appearance of the final image.

### Special Intraoral Equipment

**Intraoral Mirrors.**  The preferred mirrors for intraoral use are front-surface, metal film–plated glass mirrors. Figure 18.2 shows the three recommended shapes of mirrors for intraoral use. These mirrors have a thin layer of rhodium deposited onto the surface of plate glass. The use of a mirror with reflective coating on the front or first surface provides a single image from the front surface. A rear-surfaced mirror, one that is coated on the back or second surface, has a primary image from the back reflective surface but also a secondary image from reflection off the front glass surface. This is most often obvious in high-contrast situations and appears as a distracting ghost image.

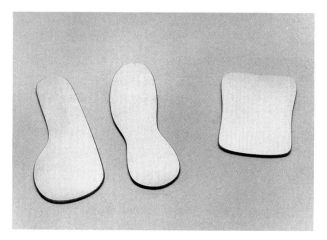

**FIGURE 18.2    The 1B, 2B, and 3B (left to right) mirrors used in intraoral photography. The 1B mirror requires the use of the metal retractor shown in Figure 18.4.**

**FIGURE 18.3    Warmed mirrors minimize fogging of the image, requiring less use of compressed air for a clear picture.**

Mirrors made completely of metal do not exhibit ghost imaging, but also do not provide an image as true or bright as when using glass mirrors. They can be deformed during use, are easily scratched, ultimately not providing an accurate image of the subject. Metal mirrors are thinner than glass mirrors, the edges are more uncomfortable, and they easily injure tissues.

The 3B mirror is used for the occlusal maxillary and mandibular views. It is available in both adult, oversize, and child sizes. The adult mirror is applicable for a wide range of dental arch sizes. When used in mouths with smaller dental arches, the smaller end is placed in the mouth first. Otherwise, the larger end is placed closest to the throat for the photograph. This mirror is used with a pair of plastic retractors (split, reduced, or standard).

The longer end of the 2B mirror is used for photographs of the buccal (cheek) surfaces of the posterior teeth. The shorter end is for photographing the palatal or lingual (tongue) surfaces of both the posterior and anterior teeth. This mirror is too large to use with the wire retractor and is therefore used with a single plastic retractor on the opposite side of the mouth for buccal photographs. The shorter end of the 2B mirror provides retraction of the tongue for lingual and palatal views of the posterior teeth. Additionally the ends can be used for close-up views of the anterior segments of the dental arch. Paired plastic retractors eliminate unnecessary structures such as the lips in these views.

The 1B mirror is an alternative to the 2B for buccal views. This mirror requires the use of two retractors, including the wire retractor, to keep the lips out of the buccal view. The large end of the wire retractor is used to provide space for the long end of the mirror. Placement is otherwise similar to that of the 2B mirror.

When mirrors are placed in the mouth, fogging can be a problem. Prewarming the mirrors in a container of very warm water minimizes this problem (Figure 18.3); however, after a while, it is necessary to use a gentle blast of air from the air syringe to eliminate the fogging. The air syringe tip should be out of the image area, and the air should be directed to minimize the chances of splashing saliva or debris onto the mirror. Direct the air for the duration of focusing and exposure to aid in seeing the images of teeth in the camera viewfinder.

**Lip and Cheek Retractors.**    Figure 18.4 shows the variety of retractors used in intraoral photography. The retractors in Figure 18.4A are used most frequently, with the paired plastic retractors being indispensable for high-quality intraoral images. The full-sized plastic retractors can be purchased in pairs from dental photographic suppliers. However, many situations arise where these are unsuitable. It is recommended that a second (and even third) set be acquired and modified as follows: One pair can be trimmed so that the curved ends of the retractor are shorter, for smaller mouths. The ends should be polished after trimming to avoid damage to the patient's lips. Another pair should be split lengthwise, providing two pairs of split retractors. These are especially useful for photographs of the occlusal surfaces of the maxillary or mandibular teeth using the 3B mirror. When this mirror is used, the standard (and reduced) retractors tend to interfere with proper mirror placement, while the split retractors allow the mirror to be rotated 45 degrees from the occlusal plane more easily.

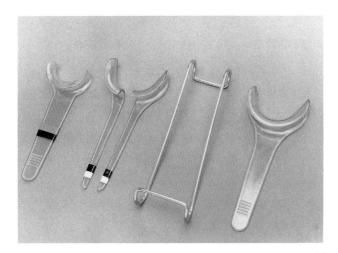

(a)

(b)

**FIGURE 18.4**   (a) Standard retractors, left to right: a reduced plastic retractor, a pair of split plastic retractors, a metal retractor, and a full-sized plastic retractor. (b) Alternate retractors for special situations, top to bottom: Clear and Dry retractors (Caulk), dental mouth mirror, and tongue blade.

**Accessory Equipment and Expendable Supplies.**   Other equipment and supplies used to improve the final image include 2 × 2 gauze squares, suction and surgical suction tips, and the air/water syringe found in dental operatories (Figure 18.5A). Figure 18.5B,C,D illustrates the use of these items.

One of the difficulties in dental photography is maintaining a clean and dry field. Besides saliva bubbles, there is material around the teeth from lack of cleaning by the patient, and there can be debris from dental procedures. While this may be hardly noticeable with a quick inspection or through the viewfinder, the magnification and illumination in a dental photograph transforms the debris into highly visible and distracting items.

Gauze squares can be used to dry the tissues and teeth. Care must be taken not to leave small threads of gauze when doing this. The dried tissues and teeth are not desiccated, as they can become with an air syringe. When photographing restorations, desiccation will change the surface texture appearance and possibly the color. However, gauze can irritate tissues if used carelessly. Gauze is inappropriate for views where the focus is the plaque or bacterial collections around the teeth and views of inflamed gingival tissues, such as in periodontal disease. For these images, the air syringe can dry without smearing the plaque or harming the fragile tissues. The air syringe is also best for minimizing fogging of the mirrors, as described previously. Care must be taken to maintain a gentle airstream. Air pressure that is too great can splash saliva into areas to be photographed and onto the mirror, requiring more time to clean the mirror and make the photograph.

Suction with a vacuum aspirator, especially using a small surgical vacuum tip, provides the best method of saliva, moisture, and debris control. The small tip is easily placed and can rapidly remove moisture and small debris without affecting adjacent structures.

### Films

Dental photographers can choose from black-and-white, color print, and color slide films in the 35-mm format. When the photographs are to be used for publication in black and white, then a high-resolution black-and-white film is the best choice. Film speed should match the flash system used. A low-powered ring flash system may provide more depth of field through a smaller aperture if a medium-speed film is used. A higher-powered point flash system could use the same aperture with a finer-grained, slower film. Color print film is not useful in dental photography unless a large number of prints is required. Without significant control exerted by the color laboratory, color balance may be shifted, especially during the printing phase. Color slide films can record the range of brightness levels found in the mouth with greater accuracy than color print films. Prints can be made from slides when necessary, and slide film resolution can match or exceed that of equal speed print film.

The choice of the best slide film requires analysis of the needs of the photographer and the limitations of the photographic system. Generally, ring flash systems will not have adequate power to expose low speed (ISO 25–50) films at the small apertures best used intraorally. Either the photographs are underexposed, or there is a narrower field of acceptable focus, with loss of information in the other image areas. For these systems, films in the ISO 100–200 range are required. This gain in sensitivity to light by the film is offset by a loss of resolution in the final image because of the film's increased grain structure. Dental photographic systems with point flash can gain resolution and maintain adequate depth of field by using films with speed in the ISO 25–64 range. This

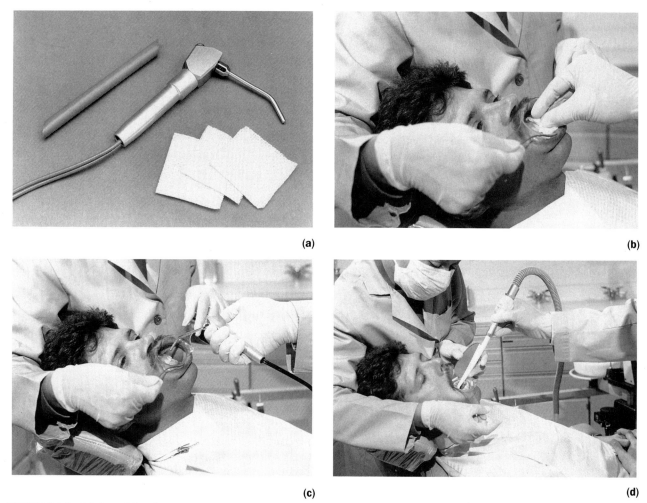

(a)    (b)    (c)    (d)

**FIGURE 18.5**    (a) Use of 2 × 2 gauze, air-water syringe, and vacuum evacuation will remove distracting moisture and debris from the photographs. (b) The use of the gauze is shown; (c) air-water syringe use is shown; (d) surgical aspirator tip is shown.

generally allows use of a small aperture, such as $f/22$, for intraoral views.

In each of the film speed ranges, there is a choice of film-processing types. The Kodachrome films are not easily returned in less than one day, as processing is only done at a handful of laboratories. Most photographers will have film processed at these laboratories, then mount the processed film in their own plant. The other major process (currently E-6) is used by almost all other slide films. This process is available at a number of local custom photofinishers, with a short turnaround time of 1 to 2 hours for slide processing. With rare exception, E-6 films do not have resolution equal to that of similar speed Kodachrome films.

A final factor to be considered in slide film choice is color balance. Each film reproduces different colors with varying accuracy. Dental photography requires accurate rendition of tissue and tooth colorations. These shades are predominately in the purple-red and yellow-orange ranges. Consistent color rendition inaccuracies in a film

can be corrected with gelatin filter over the flash or a glass filter in front of the lens, but minimal filtration is preferred.

The authors have had the best results with Kodachrome 64 film for general intraoral use. The color cast, while slightly magenta, can be reasonably corrected with a very light green or yellow filter placed over the flash head. The amount of filtration depends on the film and flash being used. Some flashes require little or no filtration, so analysis of the slides is mandatory prior to filtration.

### Infection Control

Although intraoral photography is not normally considered an invasive procedure, asepsis and sterilization is an essential concern. The photographer with an assistant is at an advantage. The assistant is able to manipulate the sterilized items with gloved hands, leaving the photogra-

**FIGURE 18.6    This unit utilizes a point flash on a flash bracket at the front of the lens. The 100-mm bellows macro lens permits reproduction from infinity to life size while maintaining maximum distance from the subject.**

pher free to use the camera without gloves or mask. However, if the photographer helps with mirrors and retraction, then gloves should be used, and the camera should be disinfected with a surface disinfectant to prevent cross-contamination. Iodoform solutions can be used as surface disinfectants for focusing knobs, pistol grips, and cable releases. This presents a strong argu-

ment for their use, as they eliminate the need to subject the camera body to potentially destructive chemicals.

Metal retractors and evaporated metal glass mirrors may be sterilized by a variety of methods. Steam autoclave or chemical autoclaves are common and reliable methods for sterilization. When mirrors are sterilized, porous material such as paper towels must be placed between each mirror to ensure penetration of the steam or chemicals to all surfaces of the mirror. Without this precaution, the mirrors will stick together and may not be completely disinfected. The materials used to package the mirrors can deposit a residue on the mirror during the sterilization process that must be carefully cleaned with a soft towel or lint-free paper. Other techniques, such as dry heat or ethylene oxide, can also be used.

The plastic retractors are damaged by the heat in dry heat, steam, and chemical autoclaves and can be disinfected in a cold sterilizing solution. A common material used is activated glutaraldehyde. This material, when properly used, will inactivate all microorganisms including spores, but this requires an immersion time of 10 hours. Glutaraldehydes are caustic to tissues, and caution must be taken in their use. Gloves are recommended when rinsing off the glutaraldehyde solution. Thorough rinsing is mandatory to prevent introduction of the chemical intraorally.

**Table 18-1    Subject Distance, Magnification, and Bellows Factors for Typical Dental Photography Setup**

| Bellows (mm) | Magnification[a] | Bellows Factor[b] | Object Distance (mm) | Uncorrected f-stop[c] | Marked f/stop[d] | Subject Area (mm × mm) |
|---|---|---|---|---|---|---|
| 48.00 | 0.05 | 1.10 | 2100.00 | 4.29 | 4.00 | 720.00 × 480.00 |
| 53.00 | 0.10 | 1.21 | 1100.00 | 8.18 | 8.00 | 360.00 × 240.00 |
| 58.00 | 0.15 | 1.32 | 766.67 | 11.74 | 11.00 | 240.00 × 160.00 |
| 63.00 | 0.20 | 1.44 | 600.00 | 15.00 | 13.50 | 180.00 × 120.00 |
| 68.00 | 0.25 | 1.56 | 500.00 | 18.00 | 13.50 | 144.00 × 96.00 |
| 73.00 | 0.30 | 1.69 | 433.33 | 20.77 | 16.00 | 120.00 × 80.00 |
| 78.00 | 0.35 | 1.82 | 385.71 | 23.33 | 16.00 | 102.86 × 68.57 |
| 83.00 | 0.40 | 1.96 | 350.00 | 25.71 | 19.00 | 90.00 × 60.00 |
| 88.00 | 0.45 | 2.10 | 322.22 | 27.93 | 19.00 | 80.00 × 53.33 |
| 93.00 | 0.50 | 2.25 | 300.00 | 30.00 | 19.00 | 72.00 × 48.00 |
| 98.00 | 0.55 | 2.40 | 281.82 | 31.94 | 22.00 | 65.45 × 43.64 |
| 103.00 | 0.60 | 2.56 | 266.67 | 33.75 | 22.00 | 60.00 × 40.00 |
| 108.00 | 0.65 | 2.72 | 253.85 | 35.45 | 22.00 | 55.38 × 36.92 |
| 113.00 | 0.70 | 2.89 | 242.86 | 37.06 | 22.00 | 51.43 × 34.29 |
| 118.00 | 0.75 | 3.06 | 233.33 | 38.57 | 22.00 | 48.00 × 32.00 |
| 123.00 | 0.80 | 3.24 | 225.00 | 40.00 | 22.00 | 45.00 × 30.00 |
| 128.00 | 0.85 | 3.42 | 217.65 | 41.35 | 22.00 | 42.35 × 28.24 |
| 133.00 | 0.90 | 3.61 | 211.11 | 42.63 | 22.00 | 40.00 × 26.67 |
| 138.00 | 0.95 | 3.80 | 205.26 | 43.85 | 22.00 | 37.89 × 25.26 |
| 143.00 | 1.00 | 4.00 | 200.00 | 45.00 | 22.00 | 36.00 × 24.00 |

[a] Magnification formula: (image size)/(object size).
[b] Bellows factor formula: $BF = (Mag. + 1)^2$.
[c] This f-stop indicated ignores the bellows factor exposure corrections.
[d] This is the f-stop to use when the flash is mounted at the front of the lens.
100-mm Minolta Macro Bellows lens.
Manual flash with guide number 9 (ISO 64/m).

**FIGURE 18.7** The ring flash eliminates the need for a rotating flash bracket since it usually has provisions for screwing onto the front of the lens. The lens illustrated, a 105-mm macro lens has a shorter working distance, requiring either light closer to the lens axis or ring flash to minimize shadowing at magnifications between one-half and full life-size.

### Camera Systems

The camera system shown in Figure 18.6 represents a typical point flash bellows system. The working distance available allows the angle of illumination from the point flash to be close to the lens axis, even at life-size magnifications. This system provides good modeling of teeth and tissues, with minimal specular highlights (see Color Plate 87). Exposure is set manually. This does not normally pose a problem, as there are no changes necessary to the aperture when photographing most intraoral structures in the magnification range from one-half to life size. Table 18-1 shows the apertures used for a point flash with a 100-mm bellows lens and Kodachrome 64 film.

Figure 18.7 shows a typical ring flash system and non-bellows macro lens. This lens also focuses from infinity to life size. It has a larger aperture, which aids in focusing and composition. The shorter working distance of this lens at life-size magnification, along with its large diameter, would increase shadowing from lips and other oral structures if point flash is used. The ring flash, while increasing specular highlights and decreasing the modeling of the teeth, minimizes the shadows and therefore allows for better imaging of vestibular tissues. If the lens has a long working distance, use of a lower powered ring flash would necessitate an aperture of $f/19$ instead of $f/22$ for most intraoral views, with a resultant loss of depth of field. Systems are manufactured with both point and ring flash available. With these systems, the lens is

usually similar to that in Figure 18.7. The shorter working distance makes the ring flash a viable lighting source. Because of the additional diameter of the ring flash, the point source flash is even farther off the lens axis and causes significant shadowing for images at near life-size magnification.

### ACKNOWLEDGMENTS

The authors wish to acknowledge the invaluable assistance of Dan Patton, R.B.P., F.B.P.A., and his staff in the preparation and production of the photographs. Dr. Rashid is also indebted to the patience of the editor, Jack Vetter, and coauthor, Lew Claman, and the support of his wife, Joyce.

### REFERENCES

#### List of Suppliers

Lester A. Dine, Inc.
100 Milbar Blvd.
Farmingdale, NY 11735
(516) 454-6100

Adolph Gasser, Inc.
5733 Geary Blvd.
San Francisco, CA 94121
(415) 751-0145

Trojan Camera Company
834 West Jefferson Blvd.
Los Angeles, CA 90007
(213) 747-7700

Washington Scientific Camera
P.O. Box 88681
Tukwilla, WA 98188
(206) 863-2854

### BIBLIOGRAPHY

Claman, L., Patton, D., and Rashid, R., 1990. Portrait photography for orthodontic patients. *Am. J. Orthod. Dentofac. Orthop.* 98:197–205.

Freehe, C. L., 1981. Clinical dental photography: Equipment and techniques. *Clinical Dentistry*, Vol. 1, J. W. Clarke, ed. Philadelphia: Harper and Row.

Freehe, C. L., 1983. Symposium on dental photography. *Dent. Clin. North Am.* 27(1):1–218.

White, Jr., W., 1984. *Close-Up Photography.* KODAK Workshop Series, KW-22, Cat No. 146 1161. Rochester, NY: Eastman Kodak Company.

# Chapter 19
# Veterinary Photography

## C. Allen Shaffer, Dan R. Patton, and Debi Stambaugh

*"He prayeth well who loveth well*
*Both man and bird and beast."*

Samuel Taylor Coleridge,
''Rime of the Ancient Mariner''
1772–1834

In this chapter, the differences between medical photography as it is practiced in the veterinary world and as it is usually practiced in human medicine are introduced. Beginning with an introduction to the historical and current applications of veterinary medical imaging, the important customs, terminology, ethical considerations, and special technical considerations that are unique to the animal environment are presented.

This chapter includes, by implication if not by direct reference, the technical information provided in many of the other chapters of this book about clinical, surgical, and specimen photography. The only information directly presented is the additional knowledge that extends the previously acquired skills into the veterinary arena.

## INTRODUCTION

From the very dawn of time, humans have created depictions of animals that were meant to serve a purpose. It is suspected that cave paintings and other prehistorical depictions of animals were an attempt to exert a controlling influence over the animals portrayed, as well as to educate inexperienced young hunters about the form and behavior of their prey.

True medical illustrations of animal disease are recorded in the works of Egyptian scholars who studied animal diseases and their treatment. In this early society, as reflected throughout history, the economic and emotional importance of animals fueled interest in their well-being, which gave rise to documentary and teaching materials about their diseases.

Photography joined in this movement from its earliest beginnings and contributed in unique ways to the advancement of knowledge about veterinary medicine. The animal motion studies of Eadweard Muybridge, commissioned to settle a bet by Leland Stanford (founder of Stanford University), were the first to reveal that a trotting horse does, indeed, have all four feet off of the ground at a certain point in its stride. Information derived from these studies influenced the diagnosis and treatment of lameness, the design of racing surfaces, and the shoeing and equipping of racing horses, as well as opening a new method of scientific inquiry still in use today.

The modern veterinary medical photographer, a relative newcomer to the biophotographic specialty scene, works in an environment characterized by its broad range and its connections to many other disciplines and endeavors (Color Plate 98). In the teaching of veterinary medicine, media make possible the teaching of a complex, multispecies, advanced medical curriculum in the same 4 years allotted to human-directed medical education (Color Plates 99a and b). In the past 15 years, ten new schools or colleges of veterinary medicine have opened in North America alone, reflecting the growing recognition of the value of biological scientists educated in the disease problems and health maintenance of all species. Veterinary medical photography for educational purposes has realized a corresponding growth and will continue to be important. Private institutions of great renown, such as the Animal Medical Center in New York City, also have active teaching programs that use medical photographs.

Veterinary photographs for research documentation are produced by both academic institutions and industry. Veterinary research contributes to human and veterinary medical treatments, improvements in animal agriculture, and the solution of environmental problems. Government agencies in many countries employ veterinary photographers in public health and regulatory capacities. Veterinary inspection of food production, processing, and distribution has been responsible for a dramatic drop in the incidence of foodborne disease; photographs are needed both for the prosecution of violators and for the education of inspectors.

Medicolegal photographs are often required of veterinary photographers, partially because of the aforementioned regulatory activities. Many laws and regulations cover the use and humane treatment of animals, the production and processing of foods, and the care and conservation of wildlife resources, and veterinary pho-

tographers have contributed immeasurably to the enforcement of these important laws (Color Plate 100a–c). Additionally, animals can generate great economic activity, necessitating photographic documentation of their medical conditions for insurance or litigation purposes.

Client education, whether that client is a dairy farmer with a 1000-animal herd or a 10-year-old with her first puppy, is a priority for veterinarians. Photographers contribute heavily to this effort, and may find that their greatest opportunity to exercise creativity lies in the public information arena (Color Plate 101).

Veterinary photography has connections to many large and diverse activities, such as agribusiness, the racing and showing of horses, advanced biological science disciplines, and the growing ecological sciences. Because of these diverse connections, the veterinary photographer relies on his or her ability to quickly study new aspects of assignments, meet new people and take interest in their disciplines and needs, and produce products that are acceptable in a breathtaking range of situations (Color Plate 102).

## LEARNING ANATOMY

In any aspect of biological science, learning the language of the discipline is the first task of the aspiring professional. In veterinary medicine, a working knowledge of the anatomy of domestic animals is a great help to the photographer or videographer.

Obviously, the key to this statement is the word *working*. The knowledge that clients have of veterinary anatomy is far greater than that which would be useful to a photographer, just as a knowledge of photographic laws would be superfluous to the client's daily work. What should be the level of knowledge of the veterinary photographer?

First, it would be impossible to learn about all of the species that the photographer *could* be faced with in veterinary medicine. In daily practice, the photographer should be most familiar with the dog, cat, cow, and horse (Color Plate 103). On a regional or specialty basis, other food animals such as the pig, sheep, or chicken may be more important. Veterinary medicine is certainly experiencing a rise in public interest in pocket pets (for example, gerbils, guinea pigs) and birds, which may demand greater familiarity with those species in the future (Figure 19.1).

The anatomical details that are important to the photographer are usually the features of surface anatomy, which serve to locate or to orient. These surface features may be external, or they may be internal structures viewed at the surgical table or through the endoscope (Color Plate 104a and b). There is generally no need, except as a matter of personal interest, for the photogra-

**FIGURE 19.1** Wild, exotic, or semi-wild animals, such as this immature robin, are a particular challenge to the veterinary photographer's knowledge of behavior. The ethics of proper treatment of wildlife are an essential consideration for the photographer. (Photograph by Marian L. Beck, R.B.P.)

pher to have a greater than undergraduate-level acquaintance with comparative anatomy.

However, there are often multiple names for anatomical features of animals—usually one set of names used by animal owners and breeders and a set of names used by medical professionals. To further complicate this problem, these names are often used interchangeably by veterinarians who deal with both nomenclatures daily. For example, the third metacarpal bone in the front limb of the horse and the corresponding third metatarsal bone of the hind limb are both called the *cannon* bone by horsemen—a reference to its cannonlike shape. You can easily see how a request to photograph this area of the horse might cause confusion if one is not familiar with these terms.

For those who wish to learn more about veterinary anatomy, survey-level courses are offered by veterinary colleges and courses in comparative anatomy are offered by zoology departments. Although veterinary texts such as Sisson and Grossman's *Anatomy of the Domestic Animals* are excellent and widely available, they contain far more detail than is necessary for the photographer. To tune in to anatomical names used by laypersons, seek out basic horsemanship, dog handling, or animal science texts, which usually list these terms. Some of these texts are also excellent sources for beginning to understand the respective industries or endeavors, their particular customs, and the standard photographic depictions of the breeds of animals involved.

## BREEDS

How many of you know the breed of the black and white cows you see in the fields as you drive through the coun-

try? They are Holsteins, and this breed provides over 80% of the milk processed in North America. A veterinary photographer soon realizes that much of the animal-related activity he or she documents is organized along breed lines. Animals are bred for specific traits that suit them for specific uses, and visual characteristics tend to be quite similar within a breed (Color Plate 105). In fact, breed is one of the basic ways that a request for photographic services will be communicated to you, as in "Go up and take a picture of that Hampshire in ward 2." If you know that Hampshires are pigs, and specifically that they are black pigs that look as if someone painted a white ring around the trunk at the shoulder, then you will have no trouble finding your patient. Your client, the veterinarian, meant to communicate to you in the most exact way as to which animal in ward 2 was to be photographed, inasmuch as every other pig in the ward was a Poland-China. The veterinary photographer uses his or her special expertise in breed identification as a communication tool with the client and as a sorting and locating tool.

Breed will also give the photographer information as to the possible temperament of the animal, its intended use, and what conditions are normal and abnormal. Someone who has never seen or heard of a Clydesdale horse (the kind made famous by Budweiser) may think that its large size is caused by glandular disease, when, in fact, this horse was bred for great size to allow it to carry medieval knights in full armor. The extreme leanness of the greyhound and the loose, wrinkled skin of the Chinese Shar-Pei are as far apart in looks as the dog world can manage, but both are normal for the breed. Certain diseases are associated with breeds, such as Collie eye anomaly and Afghan hound necrotizing myelomalacia, which might give the photographer a clue to determining what is wanted when the request was not clearly communicated and the client is not available.

Again, the tools for learning these breeds, and their associated uses and characteristics, are observation, questioning, and a keen interest. We have initiated many conversations with owners about the lore and finer points of their animal's breed that were instructive and enjoyable to both owner and photographer and conveyed a sincere interest beyond the job. Breed magazines and books such as the *American Kennel Club Breed Register* can help the new veterinary photographer quickly orient to the major breeds. Some materials available through 4-H clubs and animal science departments assist in breed identification and background as well.

## CUSTOMS

Animal-related activities are filled with customs and practices that must be observed by the photographer or videographer in order to achieve a successful result. The photographer's competence will be measured, in part, by his or her knowledge of and compliance with these customs. What are some of these unwritten rules?

First, it is customary not to pet or otherwise touch a pet animal without the permission of its owner. This is sound from an infection-control or safety standpoint, as discussed later, but it is also common courtesy to the owner. It is advisable to ask the name of a pet animal and to address the animal by name (especially in the presence of the owner).

At a dog or cat show, it is even more important not to touch an animal and disturb the careful grooming and preparation that has been made for the animal's performance in the show. Likewise, disturbing animals or their owners while training efforts are in progress is not acceptable.

Horses are usually led or worked with from their left side. Loud noises and sudden movements can frighten the horse and are unacceptable. When driving in areas where horses (or any animals) may be moving about, be extremely careful and give right of way to animals and their handlers.

When visiting farms where horses or food animals are kept, it is customary to stop at the farmhouse or office and announce your presence, even if you know where the animal you are to photograph is housed and you are expected. The primary rule on farms is: Leave every gate the way you found it—leave open gates open and closed gates closed. Before opening and closing gates and entering new areas, look to see what problems your entry or exit might cause.

Moving around farms and animal facilities, you can collect quite a bit of mud, excrement, blood, or other fluids on your clothing. It is customary to carry and use protective coveralls and boots and to remove these protective clothes when moving into cleaner areas of the farm such as the office area.

The photographer's best protection—and opportunity for learning—is to confess ignorance of the particular customs of a place or an activity if he is unsure or new to the effort. Most persons expect the photographer to be as familiar with these environments as their veterinarian, but are glad to help if they know you are not.

## ZOONOSES

A zoonosis is a disease that is transmissible from animal to human (and vice versa). Well over 1500 diseases are classified as zoonotic and are therefore of concern to the veterinary medical photographer.

The most talked about and perhaps the most dangerous of the zoonoses is rabies. Spread by touch, rabies can be found in any warm-blooded species—and any animal showing neurological signs is a rabies suspect until

proven otherwise. Rabies in humans is one of the most terrible of diseases and is invariably fatal.

The first and best protection against rabies, and many other zoonoses, is to refrain from touching all patients. Although this is difficult, especially for the lovers of animals who gravitate to veterinary photography, it is best for both patient and photographer. The second protection against disease transmission is the washing of hands and the use of appropriate protective clothing such as boots and coveralls. Material from one farm or one patient area should not be tracked into another area. It is customary when visiting different farms to use disposable boot covers or to wash boots between visits with a strong disinfectant and a stiff brush to remove material.

Third, the photographer should seek information about each patient that he or she is called upon to have contact with regarding possible disease hazard. In addition, strict control should be maintained of all biological materials such as gross specimens and culture plates, as mentioned elsewhere in this text.

## BEHAVIOR AND SAFETY

One of the chief skills of a veterinary photographer is his or her ability to predict and adapt to animal behavior and to use behavior to obtain the best possible images. In addition to the normal challenges of working with animals, the subjects of the veterinary photographer are often injured, weak, or in pain—and certainly they are in unfamiliar areas with unknown people. These conditions can lead to unusual behavior that makes photography difficult and safety uncertain. For this reason, the initial approach to every patient should be slow and certain, with plenty of opportunity to observe the animal's reaction to your approach.

Animals react to change—movement, noise, light, and smell. Therefore, it is to your advantage to have as few changes in the shooting environment as possible. If lights can be turned on and equipment positioned before the animal's arrival, the animal will evaluate and accept that condition as normal. Any change you make, such as making a noise, will then serve the purpose of attracting the animal's attention in a controlled manner.

It is helpful, in positioning a patient for photography, to have that patient isolated from the sight, sound, or smell of other animals. For example, horses communicate by both vocalization and the release of pheromones, making it nearly impossible to control some female horses within the sound or scent range of a male horse. In addition, physical proximity of patients makes a confrontation possible, with injury to handlers as well as patients.

Some animals are more controllable than others, and some are more amenable to training and domestication. Most dogs, for example, are quite compliant and are also

physically small enough to exercise good restraint (Color Plate 106 and Figure 19.2). Cats are more independent and less subject to command, but even smaller in size and restrainable. However, according to Dr. Barbara Stein of the Chicago Cat Clinic, "with cats, less restraint is more." Horses are usually fully *broken to lead*, meaning that they will accompany an experienced handler and allow most positionings (Color Plate 107). Cattle, if trained for show purposes, can be reasonably led and positioned, but many are herded from place to place and must be physically or chemically restrained for photography.

In the case of herd animals unused to handling, feeding and other herd behaviors may help in positioning for photographs. Often during feeding or milking (routine behaviors for cows) these animals will be stationary for long periods of time.

Safety is a prime consideration for all persons involved in the treatment of animal patients. Sick and injured small animal patients, or even perfectly healthy and seemingly innocuous patients, may inflict dangerous bites on the unwary. Keep out of positions, such as on the

**FIGURE 19.2   Most dogs are quite compliant and are also physically small enough to restrain. (Photograph by John J. Swartz, R.B.P., and Marian L. Beck, R.B.P.)**

exam room floor with the animal, in which you are invading the animal's territory and are unable to move quickly out of the way. Avoid proximity to the animal if possible, and never allow yourself to be alone with a patient. If anything should happen, there would be no one to help you handle the incident.

When working around animals, and in unavoidable proximity to danger (such as within striking distance of a horse hoof), attempt to position yourself so that the least vulnerable areas of the body are within reach of the patient. With animals that kick, being close to the animal affords a degree of safety, in that the animal cannot get a full swing of the limb to strike you (Figure 19.3). A photographer who kneels beside a horse to shoot, or takes any position that limits quick escape, is inviting injury or death from hoof strike.

Perhaps the greatest danger to the photographer exists when a flash unit is fired. It is prudent practice to fire the flash units several times prior to actually photographing the animal and observing the animal's reaction. This accustoms the animal to the stimulus and provides some information as to the animal's likely reaction. However, there is some possibility of danger at each firing, which is also the moment when your attention is most fixed on considerations other than the animal.

FIGURE 19.3 There is no substitute, whether working on a pet animal or a large horse, for properly applied restraint and a complete consciousness of proper safety procedures. (Photograph by John J. Swartz, R.B.P., and Marian L. Beck, R.B.P.)

When using a single-lens reflex, the photographer is totally blind at the moment of exposure due to the momentary mirror lockup.

You may find, to return to the behavior issue, that animals will react to the noise of your camera firing. Dr. Robert Copelan of Lexington, Kentucky, taught one of the authors to overcome this problem with thoroughbred racehorses by singing during the exposure! He had experienced this problem with horses reacting to the mechanical noise of the timer in the x-ray machine and had determined that horses were quite used to, and perhaps somewhat quietened by, the singing of their caretakers. He used the singing to successfully mask the noise of the machine and recommended the technique to us. This is the sort of skillful observation and integration of behavior and environment of animals and the challenges of working around them that the veterinary photographer must develop.

## VETERINARY PATIENT PHOTOGRAPHY

The veterinary patient comes in all sizes and shapes, and his or her native habitat is the air, water, field, pig sty, or living room sofa. It is from this range that the unique nature of veterinary patient photography springs.

It will save much time and effort if you establish a standard series of photographs to be taken for case documentation. A standard series will provide you and your client with consistency between cases, making cases easier to compare. In a notebook, you should record all pertinent technical data that would make the series repeatable, and have examples of each standard series for new client and staff education.

The first and most vital consideration in veterinary photography is the elimination or minimization of background distractions. Veterinary photographs have all too often been a documentary record of cages, walls, floors, newspapers, towels, and any and every thing that surrounded a patient, when the goal should be to force the viewer to concentrate on the patient. In the case of large animal patients, it is often difficult to move the patient to a location with a suitable plain background.

Many solutions have been effectively used for this problem. The establishment of a suitable studio for small animal photography is a priority, and areas in the small animal wards can be set up for the proper photography of patients who cannot travel to the studio (Color Plate 108). Likewise, areas in the large animal wards can be painted in a plain color, or roller backgrounds can be erected to make an appropriate background. Large animal patients are often photographed outdoors, and here care should be taken to exclude automobiles, billboards, or any other distracting or dating element.

Backgrounds for motion studies in veterinary medicine, requested for the documentation of lameness or

neurological disease, are the most difficult because they require larger amounts of space. Again, outdoor photography is often the best choice, sacrificing control of the elements and some lighting control for plainness and suitability of background.

An important consideration at this point is the medical condition of the patient—is this patient ambulatory enough to be taken to the studio and positioned under lights for photography? Only the attending clinician can adequately answer this question for the photographer.

Positioning the animal patient requires great patience and the assistance of one or more handlers. Most often, the patient will be wearing a collar and leash, halter and lead rope, or some other form of restraint. In the case of small animal patients, if they are cooperative, the photographer will often attempt to take the picture with collar and leash removed, relying on the handler to restrain and position the animal. Good photographs can often be obtained by instructing the handler to release the hold on the animal at the last moment before the photo is taken and to move quickly out of the frame. If this is unsuccessful, or if the animal is fractious, the image must be made with restraint in place.

The halter and lead of a horse is never removed, and photographs are always taken with it in place. The handler holding the lead is positioned outside the photograph and does not show. The same holds true for cattle, sheep, and goats.

Care must be taken with the positioning of animals so that their weight falls evenly on all four legs, unless their condition is marked by a favoring of one leg. The patient should, if he or she is not demented or debilitated, have an interested and uncowed expression—eyes bright, attention caught from reacting to a noise or motion made by photographer or assistant. This includes having the ears in an up position in animals capable of elevating their ears (some dogs, all horses).

Perspective, in animal photography, is an important consideration. There is a tendency for photographers to shoot at eye level, and this technique works well for many large animal patients and for human patients. However, photographing a small animal from eye level can be misleading, unless the intention is to show a superior view.

If possible, it is preferred to use a 90/105-mm macro lens instead of the 50-mm normal, as the macro can be used for close-up work. The 90/105 macro lens provides a comfortable working distance; not only is the animal more comfortable with the camera at a greater distance, but the additional space can make the situation safer for the photographer. Additionally, less perspective distortion of the subject occurs with the longer lens.

Although not essential, it is useful to have a motor drive if the subject will tolerate the additional noise. This decreases the length of the photo session, which is impor-

tant when working with impatient, ill, or frightened subjects.

## Lighting

Electronic flash is a necessity, both for its mobility and its flexibility. To give shape to a subject and/or fill in the shadows, more than one portable unit is required. One flash unit is placed on the camera, and one or more other units can be fired using slave units. The additional units can be fastened to portable stands, held by assistants, or clamped to doors, walls, or whatever surface is available.

For close-up work on location, a flash bracket that holds two flash units (one on either side of the camera) is ideal. A 0.30 or 0.60 neutral density filter can be placed over one of the units, with a diffuser over the other, to give lighting that will provide shape to the subject. This system is also good when photographing surgery or close-ups of lesions. Another useful flash bracket is one that holds the flash close to the lens. This setup is useful when photographing surgery or when shooting into deep body cavities.

Exposure will vary with different coat colors. Using studio lighting and a flash meter reading, you will need to stop down approximately one-half to one stop for white or light-colored subjects. For subjects with a black or dark coat, you will need to open up approximately one stop. It is a good idea to do an exposure test with various colors of animals to determine how much variation there will be with your equipment. Record the results, and include some examples in your photo record book.

Outdoors, a slightly overcast day provides the best lighting, but it is usually not possible to wait for natural lighting conditions to be perfect before scheduling a session. The least preferable time to photograph a subject outdoors is between 10 a.m. and 2 p.m., because the angle of the light creates undesirable shadows.

## VETERINARY SURGICAL PHOTOGRAPHY

First-time visitors to a modern veterinary teaching hospital almost always speak the same words as they look through the operating room observation window: "It looks just like a human surgery room!"—and so it does. Total hip replacements, transplant surgery, and other advanced procedures are commonplace. Therefore, there are very few differences between human surgery and small animal surgery (Color Plates 109a and b).

One of the few differences lies in the small size of the smallest surgical patients. In that regard, veterinary small animal surgery can occasionally resemble pediatric challenges, where extremely small surgical fields must be photographed.

In large animal surgery, there are major variations from human or small animal surgery technique. First, the sheer size of the patients can dictate a need for special equipment or procedures. In equine abdominal surgery, the photographer can be faced with a field 4 × 4 feet, located 5 or 6 feet above the ground. Lighting, appropriate lenses, and a good ladder are all needed for this challenge. Since many bovine (cow) surgeries are performed with the animal standing, the photographer must work in deep cavities with the minimum of tissue retraction to document the structures.

Backgrounds can be a problem in large animal surgery, inasmuch as the 5-foot-long limb of a racehorse being operated on leaves a lot of room for distractions in the final image. Many photographers solve this problem by having circulating nurses hold a large drape behind the limb, or by letting the flash fall off to subdue the background.

There is considerable danger in some large animal surgery due to the massive loss of fluid by the patient, the amount of flushing solution used to clear a large surgical field, or the fluid used by an operating arthroscope, any and all of which can end up on the floor of the surgery room. This constitutes a slippage hazard and an electrical danger if powered lights or other equipment are being used.

## VETERINARY GROSS SPECIMEN PHOTOGRAPHY

Just as in human pathology, "death delights to help the living" through the instruction provided by tissue specimens. There is also a standard nomenclature of veterinary pathology that should be referred to by the veterinary photographer when filing or classifying these images.

There are two main problems in veterinary gross specimen photography, the first of which is anatomical position (Color Plate 110). The convention in human medical photography is to depict an organ in the position in which it is found in the erect body. Due to the difficulty in determining a standard anatomical view for the various species and the great disparity in viewing angle between an upright human and an animal on the ground, it has been conventional in veterinary photography to compose some specimens in anatomical position and others in compositionally pleasing but not in anatomical correct position (Color Plates 111a and b).

The second problem relates to the potentially large size of veterinary specimens. It is possible to have a specimen 4 feet square weighing 200 pounds which must be cleaned, dried, properly lighted, arranged on a large plain background, and provided with a meaningful scale. This is not a particularly difficult task, but it does require some preplanning, perhaps some special construction of

a suitable gross specimen stand, and the assistance of several persons to properly prepare and arrange the specimen.

The post-mortem examination in veterinary medicine is called a *necropsy* rather than the familiar *autopsy* of human medicine. In all other respects, it is conducted in the same manner and for the same purposes. As in veterinary surgery, the size of large animal patients presents challenges of scale. In some cases, the photographer may be called upon to document a *field necropsy*, which is a post-mortem examination carried out on a farm animal or a horse at or near the location of its death. The challenge in this documentation lies in the primitive nature of the available facilities.

In such cases, it is wise to pack extra equipment, some drapes to be used as backgrounds, and some twine to act as a positioning aid or a rudimentary retractor. To achieve a higher position to shoot from, bales of straw can often be carried into position to form a crude shooting platform in the field.

Necropsy photographs are often taken for medicolegal or insurance purposes, and as such need to include photographs that identify the animal. Whole body shots, including distinctive patterns in the hair coat (such as white markings on a horse), are quite useful. Many animals are tattooed or freeze-branded for identification, and this should be photographically recorded. In such cases, ask the veterinarian for specific help in planning the shots for identification.

## FILING AND RETRIEVAL OF VETERINARY IMAGES

Many items of information must be coupled to each veterinary medical photograph or motion sequence that is captured for future use. First, the case number is recorded, along with the date of the photograph. Then, both the name of the animal and the full name of its owner is recorded, as are the species (canine, equine, bovine) and the breed within that species (Basset hound, Thoroughbred, Holstein). Finally, the basic information should include the age of the animal and its sex, including whether the animal has or has not been neutered.

Recording the diagnosis is often a problem for several reasons. First, a diagnosis may not have been made when the photograph is taken, or it may change in response to later information. Second, diseases as well as anatomical parts have both medical and lay names, and you may receive a lay name when you ask the diagnosis and then be asked to retrieve the photograph from its medical description (for example, bucked shins = inflammation of the third metacarpal). However the diagnosis is recorded, it is necessary to recover images of the same disease as it manifests itself in different species, as well as to

retrieve slides of a certain species showing all of its possible afflictions.

## OPHTHALMIC AND ENDOSCOPIC VETERINARY PHOTOGRAPHY

Most medical photographers are surprised by the relative cooperation of animal patients undergoing ophthalmic photography. For external photography of the eye or for examination and photography with the slit-lamp apparatus, only manual restraint is generally required. In external photography, the coat color of the animal does influence exposure as with other forms of patient photography in veterinary medicine.

Fundus photography, as well as slit-lamp photography, is best accomplished with animal patients by using a hand-held camera, in contrast to the table-mounted units common in human ophthalmology. The hand-held units allow the examiner/photographer to move with the animal and are probably less threatening in their appearance to the animal.

Fundus photography in animals can also be accomplished by the indirect method, where a hand lens, head-mounted light source, and a simple, hand-held 35-mm camera are used to photograph an aerial image of the retina. This method requires much less expensive equipment and is quite satisfactory once the photographer learns the technique. In all respects except the camera, it is a familiar technique to veterinary ophthalmologists, and they will readily teach you the basic skill.

Fluorescein angiography is routinely performed in animals, but it is limited by hand-held equipment to one photograph every 1.5 seconds. For this reason, a few veterinary facilities maintain a table-mounted photography unit solely for angiographic use to achieve higher rates of image capture.

Veterinary medicine makes heavy use of endoscopes for the diagnosis of gastrointestinal or airway disorders, the retrieval of swallowed foreign objects, or the performance of surgical procedures through the laparoscope or arthroscope. Photographs or electronic images from these endoscopes are frequently used in medicolegal and teaching applications.

For many years, veterinary medicine has used endoscopes designed for humans that carry images back to the camera on fiber-optic bundles. These endoscopes can be difficult for the photographer, especially in situations like the airway of the horse, where the structures are so cavernous as to dissipate the light needed to make an adequate exposure. The scarcity of good solutions to the problems of adapting these endoscopes to veterinary use has given great impetus to their replacement by newer scopes that use electronic imaging. These scopes make bright, clear images of high quality which can be recorded on videotape, printed by thermal printers, or captured by 35-mm film recorders.

The chief drawback of all of these new scopes is the sheer volume of the images that they create. In the absence of a rigorously thought-out filing system that is unerringly maintained, the volume of these images can be frustrating for clinician and image maker alike.

## MOTION STUDIES IN VETERINARY MEDICINE

From the work of Eadweard Muybridge in the 1800s through yesterday's production at every veterinary college in the world, the recording and analysis of an animal's gait has remained an important contribution of the profession of photography to animal health (Figure 19.4). Films like *Normal Locomotion in the Dog*, produced by Professor Geoff Sumner-Smith of the University of Guelph, and *Thoroughbred*, produced by the Jockey Club, are instructive and lyrical tributes to the miracle of animal locomotion.

Standardization, background control, perspective management, and an understanding of disease symptoms—the hallmarks of good patient photography—are all equally important to the documentation of motion. A further requirement is an appreciation of the intrinsic rhythms and pace of the gaits of different animals, which leads to an effortless observation on the part of the camera.

Videographers or cinematographers who do not have, or who have not yet developed, this rhythm and pace continually lead or lag the subject. This disparity is fatal to the viewer's concentration on the features of the animal's gait.

When consulting with clients about motion documentation, they may often ask about the production of slow-motion images. In our experience, this decision should be carefully evaluated. The diagnosis of lameness in horses, for example, is made by veterinarians who have educated themselves to observe the discontinuities of gait at normal speed. Their experiences of the various lamenesses have all been observed at normal speed. Although slow-motion images have their place in teaching, research, and continuing education, it must be carefully evaluated whether or not they truly are useful to the intended audience for the stated learning purpose.

## ETHICS OF VETERINARY PHOTOGRAPHY

From its earliest beginnings, the veterinary medical profession has fostered the development of an ethical code through lively discussion and debate. Veterinary ethics speak to three broad themes: the duties owed to the animal itself, the duty owed to the owner of the animal,

FIGURE 19.4    The motion documentation of animal gait was the beginning of veterinary video and cinema and is still a major contribution to veterinary knowledge. (Photograph by John J. Swartz, R.B.P.)

and the responsibility of the profession to the animal industry and the integrity of the food chain.

Veterinary biophotographers, in addition to facing the ethical and legal challenges common to all photographers, are involved in many of the special ethical concerns that arise from this unique profession. They have traditionally adapted the attitudes and ethical codes developed by their veterinary colleagues and have informally debated specific concerns in such forums as the meetings of the Biological Photographic Association. There has been no formal codification, however, in the ethics of this subspecialty of biophotography.

## Ethical vs. Legal Problems

As in any study, the definition of certain terms can be troublesome as agreement is sought between students. This chapter explores the areas of ethics, professional conduct, and legal concerns. Ethics, in this context, is the study of those things that may be generally considered right or wrong to the majority of practitioners of the discipline. Professional conduct is that attitude, demeanor, and set of actions that may be expected of the veterinary biophotographer. Finally, legal concerns are considered, where the product of ethical debate has been given the force of law.

Surprisingly to some, the veterinary biophotographer now functions in a highly regulated environment, where local, state, and federal laws apply to many actions. One effect of the actions of humane groups and animal rights activists has been to raise the level of regulatory interest in research involving animals. The photographer's participation in such projects must be a carefully planned and reviewed part of the research protocol prior to the beginning of the project, and the protocol must be carefully followed to assure conformity with the applicable law.

As this chapter addresses only those concerns unique to the veterinary biophotographer, many of the potential legal pitfalls common to all areas of our profession will

go unmentioned. One principle worth remembering, however, is that animals are considered personal property in most states, therefore, any damage suffered by an owner to his property by the acts of the photographer may be recovered in civil action. Although the ethical person cares about far more than simple compliance with law, this is an area where new legislation is occurring daily, making regular study obligatory.

## Duties to the Animal

It would be hard to find any issue in modern society more hotly debated than the intrinsic rights of animals. In recent years, the traditional advocates from the humane movement have been joined by hundreds of thousands of new partisans—ranging from scholarly advocates of partial alternatives to animal research to highly trained and dedicated guerilla forces. The debate will not be settled here, but somehow, veterinary biophotographers must decide what their duties are to the animals they come in contact with, no matter what their economic or sentimental value.

One possible clue lies in the veterinary profession's avowed commitment to the "relief of animal suffering." Many veterinary biophotographers feel that their chief duty to the animal is to prevent its mental or physical suffering by employing efficient and, where possible, nonthreatening techniques. This may be very favorably compared to the human situation, where the patient may experience pain from positioning, fatigue, or fear, all of which one would attempt to reduce through reassurance and/or expeditiousness.

A gentle and animal-aware approach is not only ethical and excellent professional conduct, but it may also benefit the veterinary biophotographer. An animal afraid for the safety of its young or instinctively responding to a source of pain or threat may convince the unthinking biophotographer that unethical conduct has more than a moral penalty.

## Duties to the Owner

Veterinary biophotographers have often heard their colleagues say, "I wish I had your lack of problems—no patient privacy to deal with, no release forms. . . ." In fact, nothing could be further from the truth. Both ethically and legally, the right of privacy of the animal owner should be treated in the same manner as the rights of humans as patients.

The need for a right of privacy in the treatment of an animal stems from two sources: economics and emotions. In the first case, veterinary patients such as successful racehorses or premier bulls can represent a center of economic activity valued at tens of millions of dollars (see Color Plate 105). On a more routine level, veterinarians treat show or guard dogs worth many thousands of dollars. When medical information about these patients could lower or eliminate their economic value to the owner, such as a report that an animal may have breeding difficulties, a strong need for privacy is created. Along this line, the biophotographer must be aware of accidental conflicts related to economics. In one recent case, an identifiable picture of a certain disease-free dairy farm was almost used in an exhibit detailing a devastating, incurable disease of dairy cattle. The possible implication of the existence of the disease on the pictured farm could have meant economic harm to the innocent farmer—with attendant legal and ethical implications.

The emotional involvement of owners and animals is the second source of ethical concern within the privacy issue. Regardless of one's personal level of emotion as regards pet animals, they are as dear as human family members to many owners. In that light, photographs, videotapes, or other information made public through the action of the veterinary biophotographer may be devastating to the individual owner. In addition to legal recourse, owners can appeal (and certainly have) to the veterinary professional and specialty organizations at the state and national levels when they feel that the private nature of their relationship with the veterinarian has been violated.

With the deep emotional involvement of many owners, it is crucial for the veterinary biophotographer to adopt a professional, sensitive demeanor consistent with that of the rest of the medical team. In addition, owners may seek information about their animal's case from the biophotographer—a situation that requires tact coupled with firm refusal.

## Duties to the Client

As veterinary medicine has felt a duty to the larger profession and to the animal industry, so too have biophotographers felt an ethical duty to both their clients, that is, the medical professionals whom they assist through image making, and their colleagues in biophotography.

The veterinarian or researcher expects more than technical competence in image production. They rely upon the fact that the photographer has some reasonable knowledge of the conditions he or she is to document, a good knowledge of safety practices normally followed when working with particular species, and a sensitive regard for the feelings and circumstances of the owners.

Professional conduct demands that the photographer meet their expectations in these regards. General texts such as the *Merck Veterinary Manual* are inexpensive, readable references that veterinary biophotographers can use to review the chief symptoms, sites of lesion

occurrence, and human infection potential of diseases to be photographed. Numerous texts and videotapes exist regarding both physical hazard avoidance and disease control for the animal worker.

Regard for the economic or emotional impact of animal disease and a sensitivity to the situation of the owner develop naturally over time in the mind of the thinking professional. The process may be hastened by reading breed journals, texts on dairy or animal science, and especially by taking advantage of natural waiting periods to inquire of both veterinarian and owner about the nature of their work, the impact of disease, and its economic base. In our experience, a biophotographer who admits honest ignorance and a willingness to listen is a welcome guest on any farm.

Our chief duty to our colleagues in the profession of biophotography is to continue to expand the dialogue on ethics and professional conduct, free of the ignorance that is sometimes encountered. For example, natural science photographers have been excluded from some discussions on ethics because they supposedly have no problems with ethics and don't understand the subject. In fact, those who work in the natural sciences have an exquisite appreciation of the ethics of their craft, which they share freely with others.

The veterinary biophotographer must be a full participant in the existing ethical conduct of veterinary medicine, humanely assisting in the relief of animal suffering and remaining sensitive to the rights and needs of the animal owner. In the rapidly changing world of medicine, and given society's changing attitudes toward animals, some reading and study time must be devoted to this subject, and more debate and discussion must be conducted among professionals. A profession is defined as *a line of endeavor with a defined body of knowledge and a recognized code of ethics.* As we attempt to convince others that ours is indeed a profession, half the measure may lie in the strength of our ethical dialogue.

## ACKNOWLEDGMENTS

Ms. Stambaugh wishes to recognize Belinda Lawler Goff, Ph.D., Department of Veterinary Microbiology, Iowa State University, for her assistance, support, and encouragement. Mr. Shaffer and Mr. Patton gratefully acknowledge the continuing support of the faculty and administration of the Ohio State University College of Veterinary Medicine, whose dedication to the improvement of veterinary education has fueled much progress in veterinary biophotography.

## BIBLIOGRAPHY

Dickinson, D., 1987. *Photographing Horses and Other Livestock,* 1st ed. Flagstaff, AZ: Northland Press.

Fritts, D. H., 1976. Basic veterinary field and clinical photography. In *Biomedical Photography: A Seminar In Print.* Rochester, NY: Eastman Kodak Company. (out of print)

Gunn, D., 1986. Basics of photography in veterinary photography. *Practice* 8(3):101–109.

Houpt, K. A., and Wolski, T. R., 1982. *Domestic Animal Behavior for Veterinarians and Animal Scientists.* Ames, IA: Iowa State University Press.

Kilgour, R., and Dalton, C., 1984. *Livestock Behavior: A Practical Guide.* Boulder, CO: Westview Press.

McGavin, M. D., and Thompson, S. W., 1988. *Specimen Dissection and Photography: For the Pathologist, Anatomist and Biologist.* Springfield, IL: Charles C. Thomas.

Sisson, S., and Grossman, J., 1975. The anatomy of the domestic animals. *The Merck Veterinary Manual.* Merck, Sharp and Dohme, 5th edition, Philadelphia, PA: W.B. Saunders.

Suschitzky, W., 1841. *Photographing Animals.* London and New York: The Studio.

# Chapter 20
# Photography of Small Laboratory Objects

## Leon J. LeBeau

*So, naturalists observe, a flea*
*Hath smaller fleas that on him prey;*
*And these have smaller still to bite 'em*
*And so proceed* ad infinitum.

Jonathan Swift, 1733

Every day in the research or diagnostic laboratory one sees equipment, glass or plastic ware, machinery, and objects produced as the results of experiments. These may involve cultures of microorganisms or animal cells, immunological or chemical reactions, genetic studies, plants and animals, or parts of them. Any or all of these objects may require photographic documentation. Sometimes the laboratory environment, a laboratory bench, a piece of equipment or a broken part, may be essential to emphasize or verify a point that the scientist wishes to make.

Unfortunately, very little information on laboratory photography can be found in the references usually available to the scientist. Consequently, the approach to laboratory photography is too often like that used to photograph vacation scenes, offspring, or family parties. The results, therefore, often seen at professional meetings and in journals, reveal less information than they should.

This chapter deals with the factors that help to simplify photography of laboratory objects. The starting point is an examination of each object to be photographed to determine what is to be emphasized. Form, shape, size, color, elevation, texture, opacity or transparency are all features that may characterize the object. To emphasize any or all of these properties, one needs a means of presenting the object to the camera and lens. Such equipment is rarely available commercially and must be fabricated. The next critical feature is elimination of nonessential background (racks, holders, labels, distracting and unrelated equipment or view of the laboratory). Next, effective lighting must be set up to provide a clear image of form, texture, color, and density, as well as pathology. Finally, appropriate photographic equipment is essential. This is particularly important in close-up work, since the bulk of laboratory objects are quite small and special lenses are usually required.

This chapter provides the information necessary for the scientist with limited knowledge of photography as well as for the less experienced biomedical photographer to produce acceptable images of laboratory objects.

These guidelines are, at best, starting points. Experience may very well prompt adaptations of these techniques and lead to even better procedures.

## INTRODUCTION

Color Plates 112–119 show examples of small laboratory object photography. The elements incorporated in the images for meaningful visual communication to the biomedical student, scientist, or clinician include:

1. brilliant colors
2. unencumbered backgrounds
3. good separation of object from background
4. lighting to emphasize elevation or texture, as well as density changes
5. reflections and shadows limited to those needed to characterize the specimen
6. emphasis of unique aspects of the specimen as well as the expectations of the client

Examples might include areas of pathology, hemolysis, or pitting of colonies; comparison of reactions in adjacent tubes or trays; or emphasis of stained or unstained electrophoretic bands. Incorporating these elements amounts to meaningful communication and represents the biomedical photographer's obligation to the scientific client.

There is one other reality to consider. Most biomedical photographs are records or documents for patient or research files and publications. This is not often discussed but is usually appreciated. In fact, too many biomedical photographers see in these photographic documents a uniformity or pattern that can be resolved into a formula. This trend fails to recognize, in each assignment, either its uniqueness or the client's expectations. I emphasize the point because this chapter deals largely with techniques. The *how-to* presentation leads the reader to imitate the illustrated procedures. While such repetition will usually assure acceptable results, it is the author's hope that the reader will use these techniques as

a starting point to produce even better images. By considering the visual communication required by the unique appearance of each specimen and devising modifications of angle, lighting, and staging, the photographer can make each image an ultimate means of scientific communication.

The following section deals with techniques of staging, lighting, and handling of specimens. It will discuss the basis for decisions and illustrate the techniques, as well as expected results. The next section covers, with detailed drawings and directions, the necessary stands, stages, and accessories used in the techniques section. While separating these two sections may seem a terrible inconvenience upon first reading, it will make the first section a handy and quick reference for subsequent, periodic use.

## Equipment

**Cameras.**    Most of the work described herein was accomplished with 35-mm cameras. While the author has personally chosen the Nikon single-lens-reflex (SLR) camera, Canon and Olympus cameras were also used with satisfactory results. Regardless of the brand chosen, one must know the exact area being photographed, whatever system is used for colored slide work, final composition is decided in the view finder for slides. With print work, the camera composition can include an area other than that required, with the final composition being made during the printing process. Some cameras only put 93% or 97% of what is seen in the viewfinder onto the film. Others capture 100% or 103%. If one knows what the camera can do, compensation can be made to assure full coverage in the frame.

**Lenses.**    For biomedical work with small objects (close-up photography), Micro-Nikkor 50-, 55-, 105-, and 200-mm focal length lenses were used primarily. When tilts and swings were needed to assure a full field in focus for three-dimensional perspective of small objects, the Nikkor PB-4 bellows with 105- or 135-mm short-mount lenses were used. For photomacrography at 1:2 to 10:1 (one-half to ten times life size, respectively), the PB-6 bellows with macro 19-mm or 35-mm focal length lenses were used. The Wild/Heerburg Photomakroskop was particularly valuable for images between 1:1 and 20:1 magnification.

**Tungsten Lights.**    Only tungsten–halogen lamps are recommended. Barndoors are essential for each lamp housing to control the light path. Sturdy adjustable stands ranging in height from 2 to 9 feet are required.

**Electronic Flash Lights.**    *Techno/Balcar* studio flash units were valuable for illuminating larger setups, but most of the photography of small objects could be accomplished with small flash units such as Vivitar 283 or Sunpak 322S. Most of the flash photography involved two to four flash units.

**Film.**    Fast film was rarely required, since small object work usually involves a light path of only 2 to 4 feet distance. An ISO rating of 50 to 100 is quite suitable.

**Tungsten-balanced.**    Ektachrome 50 and 64 and Kodachrome Professional 40 films were preferred.

**Daylight-balanced.**    Ektachrome 50HC, 64, 100, 100-Plus, and 100HC as well as Kodachrome 64 and Fuji Velvia are all recommended.

**Exposure Meters.**    In all of the work presented in this chapter, except the section dealing with auto exposure cameras, the exposure was determined with hand-held, incident-light exposure meters. While several meters from different manufacturers produced satisfactory results, it should be understood that differences in readings of the same lighting setup can be given by different meters. It is wise, therefore, to keep records of exposures and check these records against the photographic results for the best exposure. This accumulated data will lead to conclusions concerning ideal exposure and what adjustments are required for other meters.

The introduction of digital meters with the capacity to read both ambient and electronic flash illumination, and even incorporate repeated flash data into an exposure prediction, led me to switch almost completely to these meters. Almost all of the digital, multifunctional meters are convenient and reliable.

With small specimens the reflected-light class of exposure meters tend to read areas larger than the specimen. Therefore, backgrounds and surrounding areas will influence the meter and may cause over- or underexposure of the specimen. Spot-meters can eliminate this problem when the design parameters of the spot-meter are understood (David 1956; Schutz 1958; Blaker 1965; Weiss 1968; Harrison 1975).

[Spot-meters are designed to measure very small areas (1-degree acceptance angle) at distances normally encountered in everyday photography. In close-up photography (less than 2 feet) the image from the meter's lens is out of focus. This can seriously affect the readings, since the image in the 1-degree zone is spread over an area larger than the photocell. This is easily remedied by attaching an inexpensive 4+ diopter lens to the front of the meter's lens, which will alleviate the incorrect readings and the focus problem. Since the 4+ diopter lens will focus the specimen at 250 mm (about 10″), this is the proper meter-to-subject distance; lower or higher diopter numbers can be used for greater or shorter focus conditions, respectively. (*Note:* The area measured should represent a midtone value or, otherwise, an 18% gray.)]

The incident-light class of exposure meters measure the light falling on the subject and are not influenced by background or the surrounding colors of the specimen. For this reason, the hand-held, incident-light exposure meter is preferred for small object photography. (See Chapter 3 for more information on exposure meters and exposure techniques.)

## PHOTOGRAPHING PETRI DISHES

### Introduction

It should be understood from the beginning that the growth of the organisms on a culture plate along with any changes occurring in the medium are the essential features of petri dish photography. It is necessary, therefore, to appreciate colonial morphology. A microbiology text (Howard 1987; Schaechter 1989) or publications on colony photography (Le Beau 1976, 1983) should suffice to introduce the subject. In general, seven properties characterize a colony:

1. Size—for most bacteria colonies are 1 to 3 mm in diameter; mold colonies are larger
2. edge—entire, irregular, rhizoidal
3. elevation—thin film, flat, raised, convex, concave
4. surface and texture—fuzzy, rough, smooth, mucoid
5. pigment—most colonies are gray or white, but some are black or colored; some even produce soluble pigments
6. density—opaque, translucent, transparent
7. medium change—soluble products, chemical change, hemolysis, precipitation

### Preparation of Petri Dishes for Photography

Almost all culture dishes have identification labels, marker pen or wax pencil markings, as well as manufacturer's printed information. All of this is usually on the underside of the dish, the section containing the media. These markings should be removed for a clear view of the media and the colonies. (*Note:* It is possible that an important notation or identification number may be written on the bottom of the plate, so the photographer should check with the client before removing it. If the information should be retained, the client may copy it, or it may be transferred to the top of the lid.)

Pen and pencil markings can be wiped away easily with alcohol or lighter fluid–dampened gauze pads. Xylol should not be used because it is a carcinogen. In addition, it will actually soften or melt a plastic dish.

Gummed labels should be peeled away. Since many mastics are now made so they cannot easily be removed, it may be necessary to scrape the label off with a single-edged razor blade, taking care not to scratch the plastic surface, and then remove the remainder with alcohol or lighter fluid. Should glass or plastic be scratched, it could, under some lighting conditions, glow brightly and be distracting. Such glass or plastic specimens can be wiped lightly with mineral oil to fill the scratches and minimize the reflections, but the oiled specimen should be checked in the specific lighting because the treatment may simply result in a smudged specimen. This is particularly evident in darkfield illumination. Since most petri dish cultures are photographed with the lid removed, it is unnecessary to remove any writing from the top. **WARNING:** Always check with the client regarding any infectious hazard that may result from removing the lid. Most cultures are safe, but it pays to be certain in the event that the culture in hand might be a dangerous airborne pathogen.

### Staging the Culture Dish

Figure 20.1 illustrates the use of a plastic cylinder stage and a pedestal (see Figure 20.34). The petri dish is set atop the white plastic diffuser. The base of the stage has a foil reflector. The cylinder stage is elevated on top of the black pedestal, which is located on a black velvet background. The *Lowell* light (on flood setting) is set about 24″ to 30″ from the stage. Note that the lower barndoor is opened sufficiently to allow light to strike the foil reflector but not the velvet background, and the upper barndoor is raised to allow light to fill the reflector card but not hit the lens. Should no transillumination be required, the stage can be inverted and the dish placed on top of the black disk. In this event the lower barndoor is raised to a level just below the petri dish.

**FIGURE 20.1** A petri dish on a clear plastic pedestal is transilluminated from a foil disk on the bottom of the cylinder.

## Illumination of Petri Dish Cultures

Once one recognizes the important colonial properties, it should be easy to plan a lighting system to emphasize the important characteristics on the plate to be photographed. Table 20-1 relates colonial properties with lighting that might be expected to emphasize these characteristics.

## Texture Light with Bounce Fill and Transillumination

Ninety percent of the colonies are suitably illuminated with texture light and bounce fill. Sometimes transillumination is also required. Figure 20.2a shows the lighting and Color Plates 112 and 113 illustrate colonies with such lighting.

## Bounce Light

Reflected illumination is particularly useful for lighting mucoid or highly reflective colonies. Light from a low angle strikes only the white or foil card, reflecting down onto the plate (or any other highly reflective object) as shown in Figure 20.2b.

## Axial Illumination

This lighting is essential to show a thin film, mounded, or volcano like colonies. The principle is shown in Figure 20.2c and illustrated in Figure 20.3. Note that the light

**Table 20-1  Lighting Setups Suggested by Colonial Morphology**

| Colonial Properties | Proposed Lighting |
|---|---|
| Size, edge, pigment and a smooth or mucoid surface | 90, 60, 40, or 10 degrees (softened with a bounce card) <br> 60–20 degrees using tent or bounced from a reflector card (Figure 20.2b) |
| Elevation and texture | 10–15 degrees with or without fill and/or transillumination (Figure 20.2a) |
| Transparent, spreading film, or pitted colonies | 90 degrees or axial illumination (Figure 20.2c) |
| Media change (color or density) | Transillumination or darkfield |
| Fluorescence | 10–15 degrees with foil bounce fill (blue light, 390–450 nm) (Figure 20.2d) |

path, limited by the barndoors, strikes only the 5″ × 7″ sheet of glass, which is at 45 degrees to the optical path. The glass can be tilted slightly until the view screen reveals no spectral glare from the media, but reflections from the colonies reveal shape and elevation, as shown in Figure 20.4. The object is to take advantage of the difference in reflective properties between the medium and the colonies. It is essential to have a black velvet drape on the other side of the stand, since 50% of the light goes through the glass and would reflect back toward the glass if a light-colored wall were there. Such reflected light would be partly directed by the glass up into the lens to create unwanted flare in the image.

## Illumination for Fluorescing Colonies

Ideally the Nikon SB-140 UV flash unit is recommended, however, most older flash units without a built-in short blue wavelength absorbing filter will work. A Schott BG-12 filter or a Wratten 47A would serve well as an exciter filter when placed in front of the flash. Figure 20.2d shows a diagram of the lighting setup, which is basically texture light with a foil-covered card for reflected fill. Generally speaking, the fluorescence is more evident in the image when the blue light is removed with a barrier filter on the camera lens. A Wratten 2A, with or without a Wratten 12, is recommended (See Chapters 12 and 13).

## Exposure

*Note:* Most media are darker in color than an 18% gray card. As a consequence, black or dark shades of brown, red, green, or blue media require additional exposure. Often colonies growing on a colored medium will absorb some of the pigment and may appear darker than the medium. One should open the lens an additional one-half to one *f*-stop to compensate for the dark color.

1. Texture lighting with fill lighting with or without back light as well as for bounce lighting:
   a. Read the incident meter at the petri dish site.
   b. Make allowance for the magnification and the color.
2. Axial illumination:
   a. Read the incident meter at the petri dish site.
   b. Allow for magnification and color of the medium.
   c. Open an additional stop because half of the light coming from the plate to the sheet of glass is reflected back into the light source, thus reducing by one stop the light actually reaching the lens.
3. Fluorescence illumination
   The exposure cannot be predicted since the output of the blue wavelength will vary with each flash unit and

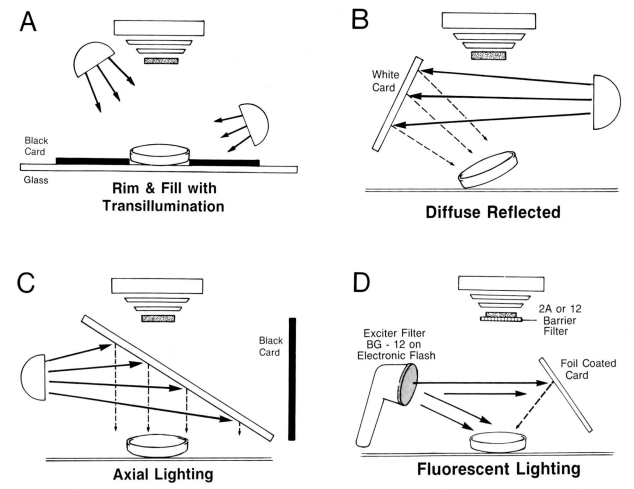

**FIGURE 20.2    Illumination of microbial culture plates. (a) Combined transillumination with rim light at a 10-degree angle and a fill light at 60-degree angle to the culture dish were used. Examples of petri plate photography with this form of illumination can be found in Color Plates 112 and 113. (b) Diffuse bounce lighting reflected at about 60 degrees from a white card providing soft directional illumination. (c) Axial lighting. The glass need not be as large as shown, but a black card or a black velvet drape is essential on the side opposite the light to avoid flare. (d) Lighting for fluorescing colonies. A Nikon SB-140 UV flash unit placed at 45° above the culture plate with a foil-covered card used to spill as much exciting radiation as possible back onto the plate.**

flash meters are unreliable when used for a very limited portion of the spectrum. It is recommended that a series of trial exposures be made to serve as the basis of subsequent bracketed exposures.

### PHOTOGRAPHING TUBES AND THEIR CONTENTS

#### Introduction

A few papers have dealt with photography of tubes, but they largely covered a solution for recording the specific types of tubes or contents on hand (David 1956; Marshall 1957; Vetter and Dukes 1969). If one examines, however, photographs of tubes and their contents made over the last 50 years, one can make some valuable generaliza-

tions. The contents may be liquid, solid, or semi-solid. They may contain ground meat or plant fragments; seeds, cells, tiny glass insert tubes, or serological reactions with a precipitate or clumped cells. These contents may be colored, with froth or bubbles, transparent, turbid, opaque, or fluorescing.

All of these conditions alter the appearance and, if significant to the client, must be emphasized in the photograph. Further problems involve common distractions seen in many photographs of tubes: writing or labels on tubes, wire racks and holders in the photograph, shadows of tubes and the holder on the background, and busy backgrounds that distract from tubes.

In appraising these challenges to the photography of tubes, one is drawn to the use of (1) a stage or holder, which will present tubes of varying size or shape in a fixed

position without shadows, (2) reproducible, nondistracting backgrounds, (3) lighting that will accent the properties of the contents.

## Preparation of Tubes

Most tubes have wax pencil or marker pen notations or gummed labels. In addition, most tubes are now from manufacturers of prepared, tubed media. They usually have printed identification markings on the tube. All of this can be quite distracting when included in the image and should be removed. Wax pencil, marker pen notations, and the manufacturer's printing can be wiped away with alcohol or lighter fluid. Gummed labels are often coated to make them less permeable to water. It is a good idea to use a single-edged razor blade to cut away most of the label, leaving the mastic and bits of paper, which can be removed with alcohol or lighter fluid. Xylol has been used in many laboratories as a solvent-wipe. Since xylol is a carcinogen, its use is to be discouraged.

## Staging or Holding the Tubes

The holder and the stand shown in Figure 20.5 (Le Beau et al. 1980; Le Beau 1983) describe and illustrate a holder that presents tubes of all sizes in a straight line at measured intervals. Backgrounds of almost any color can be accommodated. In practice, the stand is attached to a tripod, with the holder in place and tubes lined up in a row in front of the background card (Figure 20.5b). The tubes are held securely by the brushing. Sometimes, after extensive use, the tubes force the bristles apart and bend them, thus weakening the grip. This can be corrected quickly with a pocket comb.

## Illumination of Tubes

After much experimentation, it became apparent that very few lighting setups were effective. Lighting tubes from in front resulted in excessive specular reflections unless the light was placed well above or below the plane of camera and tubes. (*Note:* With lengthy illumination of tubes, condensation will form within the tubes. To avoid this distraction, adjust lighting, focus, and determine exposure using some other tubes. Once the preliminaries are accomplished, remove the stand-in tubes and insert the required tubes in the holder for photography.)

**Tubes with Colored Backgrounds.** The technique that was consistently effective is shown in Figure 20.6a. Two lights were placed about 10″ behind, above, and to the side of the background card. The lights, set at flood, with the barndoors carefully closed to limit illumination only

FIGURE 20.3 (a) Axial illumination is conveniently accomplished at the stage by using the clamp and pole system to hold the sheet of glass at a 45° angle between the culture plate and the lens. (b) A closer view of the glass and holder.

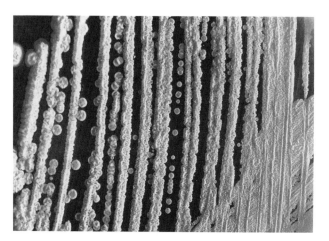

FIGURE 20.4 Roughly textured colonies of yeast illuminated with axial lighting to place highlights on the peaks and open the shadows in the recesses.

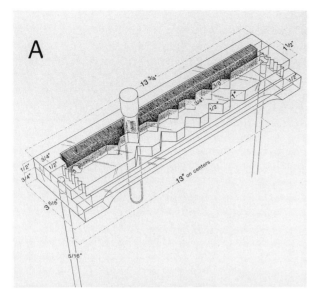

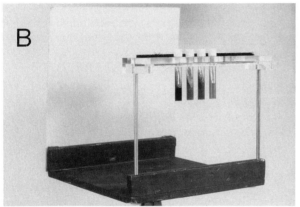

**FIGURE 20.5**   A specially designed holder and base holds illuminated tubes. (a) The reversible notched bar gives great latitude for spacing, while the strip of brushing firmly holds the tubes of varied diameter. (b) The test tube holder, support base, and background card form a complete stand for staging tubes for photography.

on the tubes, will prevent any light from falling on the lens. When the background card was colored and needed to be illuminated, a third light was placed 4′ above and 4′ in front of the tubes. The lamp was set for flood and aimed at the background card. The lower barndoor was dropped to allow texture light to skim across the front of the tubes when colonies on agar slants were to be accented. Color Plate 114 shows tubes photographed with this lighting.

**Tubes with Black Backgrounds.**   For black backgrounds the setup shown in Figure 20.6b suffices. No background light is required. The colored background should be replaced with a card covered with black velvet.

**Tubes with White Backgrounds.**   Figure 20.6c shows the lighting arrangement with two flood lamps set 15″ in front and to each side of the white card. Each light should be aimed at the far edge of the card with the barndoors closed to limit access of the light solely to the card. Particular care should be taken to avoid any direct illumination striking the tubes.

**Tubes with Fluorescing Contents.**   Figure 20.6d illustrates a flash with an exciter filter. It is placed at the lower left corner of the background card and aimed up at the tubes. If texture illumination is required, a foil-covered card should be placed 12″ in front of and above the tubes. A barrier filter, Wratten 12, should be used over the lens to remove the blue rays to emphasize the yellow-green fluorescing colonies.

### Camera and Lens

Because the assignment may require a photograph of only one tube or as many as six, the composition may change, and with it, the position of the camera and tripod. It is wise, therefore, to mount the camera on a focusing rail. More convenient, however, has been the use of a Vivitar Series I, 90/180-mm Zoom-Macro lens because the camera and lens can remain stationary while the zoom component is used to compose the image. It is strongly recommended that a bellows-hood be used for photography of tubes to prevent flare.

### Exposure

The exposure objective is to relate the exposure of the tubes to that of the background. Simply stated, the tubes should be correctly exposed while a white background is rendered pure white; a black background, jet black; and colored backgrounds must be balanced to the exposure of the tubes and the color rendered the same shade each time that card is used.

**Tubes with Colored Backgrounds.**   Incident meter readings should be taken from behind the tubes, facing the lights. Experience has shown that this reading measured one and a half stops more than actually reached the camera. This was confirmed with a spot-meter reading of the tubes. One should, therefore, open the lens one and a half stops more than the meter indicates. This will provide correct exposure of the tubes and their contents. One must then ensure that the background illumination is balanced to match the tubes. To do this, the corrected meter reading should be obtained when the meter is placed in front of the background. By moving the front light backward or forward until the appropriate reading is obtained at the background card, one can easily bal-

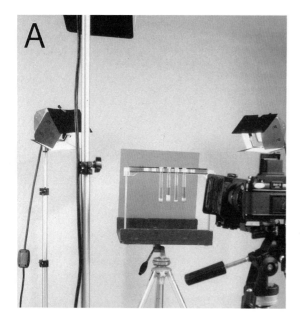

**FIGURE 20.6**   Positioning lights for photography of test tubes. (a) Tubes photographed against a colored background require two side backlights with a single front light for the background card. Color Plate 114 was photographed with this lighting. (b) Darkfield illumination of tubes and their contents is better achieved with two back lights because the lights cause the contents to glow brightly and produce a tiny edge of reflected light all around the tubes. (c) For a white background, the light should be moved in front of the tubes, one on each side. In this instance, the edges of the tubes will appear darker than the contents and the background. (d) In photographing the fluorescing contents of the tubes, the Nikon SB-140 ultraviolet flash was placed at a point below and to the side of the background card. The fluorescing tubes glow a bright blue.

ance the lighting. For example, initial reading from behind the tubes: 1/4 sec. at $f/16$ (open lens 1/4 stops); correct exposure: 1/4 sec. at $f/9.8$ (about half way between $f/8$ and $f/11$). The meter at background must read 1/4 second at $f/9.8$, so move the background light until the meter reads 1/4 second at $f/9.8$. (Compensation for magnification usually requires an additional one-half to two-thirds larger aperture setting.)

**Tubes with Black Backgrounds.**   There is no need for background illumination, so the incident meter reading

from behind the tubes is the only measurement required. The lens should be opened an additional one and a half stops for correct exposure. Compensation for magnification is usually an additional one-half to two-thirds stop.

**Tubes with White Backgrounds.** The incident meter reading should likewise be taken from behind the tubes, with particular care that only the reflected light from the white background is read and no incident light hits the meter. This reading would underexpose the tubes so that the lens should be opened one to two stops to correct the exposure and opened an additional one-half to two-thirds stop to compensate for magnification.

**Tubes with Fluorescing Contents.** Since the fluorescence cannot be metered, it is prudent to make a test exposure series to determine a reliable exposure range for subsequent use.

## PHOTOGRAPHY OF COMPARTMENTALIZED TRAYS, PLATES, STRIPS, AND SLIDES (Schalow 1955; Hopkins 1975; Murey and Ollerenshaw 1975)

### Introduction

With greater frequency clinical and research laboratories are using a variety of trays with microcompartments to replace culture and serological tubes. The advantages to the laboratory worker include reduction in size, reduction of cost, improved quality assurance, and convenience. The overwhelming acceptance of these products in the laboratory has placed a new challenge before the biophotographer. Accurate reproduction of metabolic reactions and color changes, as well as visualization of faint turbidity in the compartments free of shadows or reflections from the ridges, requires innovative approaches to lighting. (A more detailed discussion of these problems and their solutions can be found in Le Beau et al. 1981.)

### Light Source

The Aristo DA-10 light box[1] shown in Figure 20.7 has a cool, rectangular, fluorescent light source contained in a box, open on top and bottom. The outside dimensions are 15 × 10 1/2 × 4 3/4 inches. The inside light chamber measures 10 1/4 × 12 1/2 inches. An opal plastic lid slides into slots provided at both top and bottom to give even, diffuse transillumination. While daylight-balanced film is recommended with this box, a CC30M or CC35M filter is usually required to assure acceptable color rendition. Each box varies somewhat, so a series of test exposures should be made. Filter selection based on *Minolta Color*

**FIGURE 20.7** The Aristo DA-10 light box has the top and bottom open, and grooves are provided for insertion of the opal diffuser, as well as for background or reflector cards.

*Meter II* readings proved accurate in every instance. Bear in mind that exposure compensation should take into account the filter factor.

### Light Box Support

The simple frame illustrated in Figure 20.9b&c can hold the light box when darkfield illumination or mirror reflection of the bottom of the specimen tray is wanted. (*Note:* For routine transillumination or shadowless incident lighting, the light box need not be elevated on the frame, but can be placed directly on the base of the cabinet stand.)

### Lighting

**Incident Lighting.** Opaque specimens such as white plastic trays with bacteria growing in cupules (Color Plate 115) are best photographed with soft incident light. Serological reactions involving hemagglutination and coagglutination of staphylococci, latex or carbon particles on white or black glass, plastic or paper strips are appropriate objects for photography in flat, shadowless lighting, such as the light box. In addition, opaque, dry, stained chromatographic strips and metal or plastic prostheses or implants or pacemakers can all be photographed with this setup.

**Lighting Setup.** Figure 20.8a shows the light in the upper position with the specimen at the bottom of the light box on a background card. The background can be any color compatible with the specimen. *Crescent* board, flocked or *Colorvue* paper, and even a black velvet–covered card give satisfactory results. A mask, black on

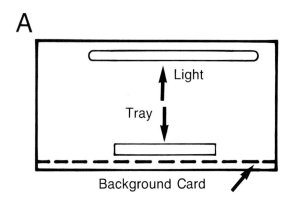

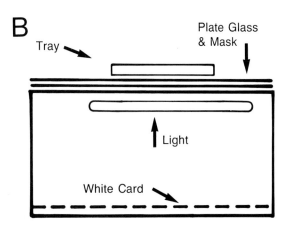

**FIGURE 20.8** Lighting specimens with the Aristo light box. (a) Flat, almost shadowless, incident illumination is achieved when the rectangular light tube is in the upper position and the specimen is placed on a background card at the bottom. An example of a specimen photographed with this technique is provided in Color Plate 115. (b) For transillumination the diffuser lid or a sheet of glass can be placed in the grooves on top to hold the specimen. Note that a peripheral mask is used to prevent flare.

both sides, should be placed over the light box with an opening only as large as necessary to avoid occluding any part of the specimen and to prevent flaring of the image.

**Exposure.** An incident meter reading at the bottom of the box from the site of the specimen will provide the basis for accurate exposure, however, one should remember to compensate for magnification and filtration. For a given box, the exposure for each type of lighting is unlikely to vary, so a note indicating the correct exposure should be taped to the box and referred to before use, for example, Incident Light: 1/2 second at $f$/22 (ISO 100)

**Transillumination.** Appropriate specimens might include transparent trays with layers of agar media in a series of compartments, and stained, dried tissue cultures, as well as stained immunoelectrophoretic gels on glass or clear plastic sheets.

**Lighting Setup.** Figure 20.8b shows the box with the light in the upper position and a white reflector card on the bottom. The opal plastic diffuser or a sheet of clear, single-strength glass can be inserted in the top of the box. In any event, a mask and/or specimen holder of solid black Crescent board should be placed over the top. The specimen should be set on top of the tray or in the specimen holder.

**Exposure.** A meter reading, taken at the opening facing down toward the light source, can be used to calculate exposure, however, it will suggest a setting that will underexpose the specimen by two and a half $f$-stops. One must open the lens accordingly and also open further to compensate for magnification and filtration. Once experience has provided the ideal exposure, it should be recorded on the box for reference, making subsequent measurements unnecessary.

**Darkfield.** Appropriate specimens for darkfield illumination might include unstained serological precipitates in gels, tissue culture slides and plates, and bacterial agglutination on plates. Thin, compartmented, and channeled trays are also best illuminated by darkfield technique. One must be aware that any dirt, debris, or scratches on the glass holding the specimen will glow brightly like a starry sky, so the glass must be scrupulously cleaned and frequently dusted during the photographic session. Lint and dust, rather than grease smudges, are the real problem. A *Mini-Vac* is particularly useful in controlling this problem.

**Lighting Setup.** A simple darkfield technique using the Aristo light box is shown in Figure 20.9a. The wooden holder (Figure 20.9b,c) suspends the light box 12″ above the base. A mask of solid black Crescent board is used to hold the specimen. The lamp in the lower position sends light to the specimen from 45 degrees. A black velvet baffle, halfway up the box, occludes all but peripheral rays. The specimen holder and peripheral masks are described in detail in the Equipment and Materials section of this chapter. An example of a specimen photographed by this technique is given in Figure 20.10.

**Exposure.** Vellum, onion skin paper, tissue, or ground glass should be placed on the mask opening in place of the specimen. A reflected light meter reading should be taken at the glowing opening. The diaphragm of the lens should be opened three stops more than the meter indicates and opened still further to compensate for magnification and filtration.

### Photography of the Bottom of Compartmentalized Trays

An example of a microtiter tray with 120 cupules can be seen in Figure 20.11c. These and similar trays contain translucent, colorless cells, opaque, colored cells, or chemical reactions that change depending on the meta-

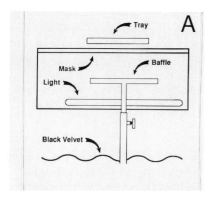
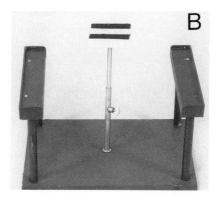

**FIGURE 20.9**   The Aristo light box, stand, and baffle used to produce darkfield lighting are diagrammed (a) and illustrated (b and c). The baffle (dark-ground stop) is elevated about 2 inches up into the middle of the box. A mask in the upper slots is used to hold the specimen.

bolic activity. All of these specimens, with reactions at the bottom of each cupule, have in common the need to be interpreted while examining the underside of the tray. It is appropriate, therefore, that the underside of these trays be photographed rather than the top.

### Lighting Setup

**Transillumination.**   Figure 20.11a,b illustrates an inverted light box with the lamp in the lower position and a white reflector card in the top slots and with or without an opal plastic lid in the bottom slots. The box is set on the end shelves of the holder (Figure 20.11b). An inch below are ridges, on which a sheet of glass or a mask is placed so as to support the specimen tray. A mask is essential to eliminate extraneous light. Below this a front-surface mirror can be positioned at 45 degrees. The mirror provides an image of the bottom of the tray,

**FIGURE 20.10**   The ophthalmic aspiration needle placed on a plate glass stage above the Aristo lightbox as shown in the darkfield lighting illustration (Figure 20.9c). Fill-light from a pyramidal tent, placed over the lightbox (Figure 20.21), was also used. The image-to-subject size ratio was 1 : 3.

which is readily accessible to the camera lens (usually 90- or 200-mm focal length) on a tripod a few feet from the mirror. This transillumination is used for trays with colored reaction or with opaque, white, or colored cells. Some of the cells may be clumped or even destroyed so that change in the appearance represents an important part of the image.

**Darkfield Illumination.**   When translucent, colorless cells are in the cupules, a white background will not differentiate the cells, so darkfield is required. For darkfield illumination the box should be reversed so that the light is in the upper position. A black velvet card should be placed over the upper opening of the box. As described above, the specimen on the holder and mask is placed below the light box.

**Exposure.**   Through-the-lens metering results in underexposure, and to make it worse, the amount of underexposure varies with specimens and, sometimes, with successive readings. It is recommended, therefore, that a reflected light reading be taken at the mirror (take care not to scratch the front surface mirror). The lens must be opened three stops more than the reading indicates and further opened to compensate for magnification and filtration. Experience with several such light boxes has shown that the exposure, using ISO 100 film, is almost always 1/2 second at $f$/4–5.6. This exposure can be used as a starting point if one wishes to make a series of tests.

## PHOTOGRAPHY OF FLAT OBJECTS FROM CLINICAL AND RESEARCH LABORATORIES

### Introduction

Many flat specimens are generated in the laboratory. Some are encountered occasionally in the photographic studio, but almost all types need to be photographed at some time. This is most frequently accomplished by the research team using instant film, but when more infor-

**FIGURE 20.11** The holder for viewing the bottom of the tubes differs from the light box holder shown in Figure 20.9b,c in that the bottom of each end bracket support for the box must have a 1/2″ ledge to hold the specimen stage (a and b). A board to hold the right-angle mirror should be in place under the box. The mirror is attached to the board with Velcro. (c) The specimen can be seen reflected in the front-surface mirror.

mative images are needed for publication, the specimen may be brought to the photographic studio. The photographic techniques vary with each type of specimen, but the equipment and film choice are usually the same in each instance.

## Equipment

**Cameras, Lenses, and Film.** SLR cameras with macro lenses are more frequently used, however, the 4 × 5 format is preferred for this copywork in some studios. The 55-mm Nikon Micro Nikkor lens is popular, but better perspective on some specimens can be obtained with a 90- or 105-mm macro lens. For convenience, scientists and technicians who make their own records prefer instant film. For studio work, both color transparency and black-and-white negative film are required.

**Black-and-White Negative Film.** Technical Pan, T/Max 100, and Kodalith Pan are in common use. Often soft developers such as D-76 or HC-110 (D dilution) are preferred, although D-11 is sometimes recommended with Kodalith film. Meats, et al (1991) recommends a Wratten #12 filter for Komasi Blue and silver stains and Wratten #58 for Ponceau S stain on gels with Kodak. Technical Pan Film exposed at ISO 50 and processed for 8 minutes in HC-110 (F dil.) at 20°C.

**Color Transparency Film.** Most lower-speed color films work well for slide preparation. These would include Kodachrome 25 and 64, as well as Kodachrome Professional 40; Ektachrome Tungsten 50 and 64T, Daylight 64, 100X, 100HC, and 100; and Fuji Velvia 50. Lighting recommendations for each type of specimen are given in Table 20-2.

**Table 20-2   Types of Flat Specimens and Appropriate Lighting Setups**

| Type of Specimen | Lighting Setup |
|---|---|
| Transparent | |
| Stained (wet) | Transillumination |
| Polyacrylamide slab gels | |
| Disc electrophoresis gels | |
| Stained (dried) | Incident light against a white |
| Immunoelectrophoreses | background |
| Immunofixation | |
| Cellulose acetate | |
| (clarified) | |
| Unstained (wet) | Darkfield illumination |
| Immunoelectrophoresis | |
| Radial diffusion | |
| Translucent, stained | Transillumination best, |
| cellulose acetate | incident gives less detail |
| Fluorescing specimens | Incident—300–500 nm |
| Opaque | Incident illumination with or |
| Chromatograms | without a colored |
| Dipsticks | background |
| Wet serological reactions | |

## Specimens and Techniques

**Transparent, Stained Wet Gels** (Williams 1969; Hassur and Whitlock 1974; Bidigare et al. 1984; Meats 1991).

**Slab Gel Electrophoresis Specimens.** This technique is more popular than any other electrophoretic procedure. Therefore, these gels are more likely to appear in the studio with a request for photography. An example is shown in Figure 20.12a.

The size of the gel may vary with the size of the electrophoretic chamber. It is important to be aware of the sizes more frequently encountered in the studio so that photographic specimen chambers can be constructed. The size of the chamber should be at least 1/2″ larger than the gel on all four sides. (See the Equipment and Materials section and Figure 20.12b for construction directions for specimen holders.) Usually the gel is brought to the studio in a glass, plastic, or metal tray full of fluid that is colored by dyes leached out of the gel. One should ask the client for additional suspending fluid to rinse the specimen and resuspend it. Inquire if the gel can be

suspended in distilled or tap water. Whichever fluid is used, it should be at room temperature and cover the specimen by 1/4 to 1/2″. Removing the gel from the tray can be difficult and certainly embarrassing if it is lifted clumsily and ripped. It is recommended that one use a sheet of double-strength cellophane or plastic (1/4″ wider than the gel and 2″ longer). It should be stiff, but flexible enough to be bent. The plastic sheet should be gently slipped under the front edge of the specimen and slid all the way across the bottom. The gel can be lifted and supported underneath to transport it to the photographic chamber. Slip it into the chamber filled with suspending fluid, all the way across the bottom. It should be in position without ripples or bubbles. The plastic can be removed by gently floating the gel and swiftly withdrawing the plastic, leaving the gel in position. If the gel is wrinkled, it can be adjusted by gentle movement to refloat and settle the specimen. Sometimes bubbles will occur in the fluid on standing. This can be prevented by preboiling and cooling the suspending fluid to remove dissolved air.

Specimens of slab gels are usually stained with Coomassie blue or a silver deposition process. Because the gels are transparent with stained areas, transillumination is the appropriate lighting. The Macbeth Proof Light,[2] which is 5000 K, is preferred for color work, or the Aristo light box, which produces light with excessive green, can be used with black-and-white (BW) film. For BW film a yellow or yellow/green filter can be used to enhance contrast for Coomassie blue–stained gels. When red or pink stains are used, such as Ponceau red, a green filter will emphasize contrast, or Kodalith ortho film can be used with D-76 or HC 110 development. With the silver stain a considerable amount of silver is adsorbed to the gel base, giving it a pale amber color. This background defect can be filtered out with the use of an 80A filter. For color slide film, contrast color filters are inappropriate since they add color, however, contrast can be enhanced slightly for both color and black-and-white film with use of a polarizing filter.

A meter reading of the light at the opal diffuser will indicate an exposure for about 18% gray. If the lens is opened two and a half stops, the background will appear pure white and the stained areas will be properly exposed. Since these light boxes continue to give the same light output for years, it is suggested that, once the proper exposure is established, it be recorded on the top of the box for a handy reference.

**Polyacrylamide Gels from Disc Electrophoresis** (Oliver and Chalkey 1971; Fiske 1974; Ellis 1978; Le Beau 1980b). While this technique has largely been replaced by slab gel electrophoresis, some laboratories still produce the slender gel cylinders. An entire issue of the *Annals of the New York Academy of Sciences* in 1964 dealt with this technique, and Le Beau (1980b) covers the photographic procedures in detail. Usually photographers

**FIGURE 20.12** The flat, moist electrophoretic slab gel (a) lying on the bottom of a specimen chamber (b) with a 1/2-inch of suspending fluid and transilluminated on a Macbeth proof light. The gel tray was fabricated from single-strength clear glass. The glass pieces were cemented in place with Dow Corning sealant. The small specimen chambers were cut from 3 1/4 × 4″ lantern slide glass to produce a vessel 3 1/4 × 4 × 2″ high.

place one or more gel cylinders on a glass sheet above a light box for photography. With this technique, problems frequently develop:

1. Rarely can the gels be straightened or aligned properly.
2. As the gels dry, they adhere to the glass and are damaged.
3. The bands appear spindle-shaped.
4. Contrast and resolution of faint bands are usually poor.

To correct these problems, the chamber shown in Figure 20.13 (described in the section on Equipment and Materials) is needed. The troughs, filled with appropriate suspending fluid, prevent the cylinders from drying and assure alignment. The superimposed glass rods act as lenses to straighten and widen the bands. An Aristo light box is used without the opal diffuser. Light bounced off the white card on the bottom of the box gives transillumination, while the rectangle of fluorescent light at the top of the box gives back light at a low angle to abet contrast.

**Transparent, Stained, and Dried Gels** (Snowman 1968). These specimens include immunoelectrophoretic gels, immunofixation gels, double diffusion gels, and clarified

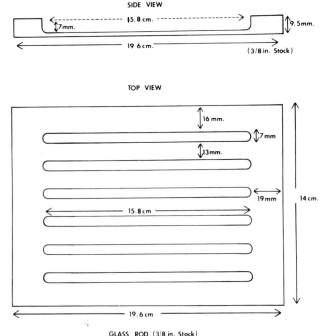

**FIGURE 20.13** When disc electrophoretic gels are placed in the plexiglass troughs and covered with a glass rod, the suspending liquid can be added to the end of each trough until it replaces all the air and eliminates the bubbles.

cellulose acetate–based strips. All of these must be on clear glass or plastic supports. Since these specimens have stained areas on a transparent support, they could be transilluminated. An innovative and superior technique involves setting the strips over a pure white paper background on a copystand. If the strip supports are other than glass, they are likely to be warped or rippled. A sheet of clear glass over the strip will produce a flattened specimen. An incident meter reading will provide a suitable basis for exposure. One should remember to make allowance for magnification (and color correction filtration if color film is used with the Aristo light box). This technique is effective because the light passes through the clear base and support and is reflected from the white background. On the other hand, where stained areas exist, the light is absorbed as it passes through the strip to the white background and again as it reflects up to the lens. This doubles the apparent contrast.

**Unstained Wet Gels with Precipitin Bands.**    This category includes immunoelectrophoresis, immunofixation, and, less frequently seen, double diffusion, radial diffusion, and octerlony plates. Only darkfield illumination emphasizes the precipitin bands in a clear gel. By transillumination many of the gels appear clear, but in darkfield illumination slight turbidity often becomes evident in the agarose gel all around the brightly glowing precipitin bands. This reduces the contrast between the bands and the background.

**Photographic Setup.**    Many darkfield systems have been reported (Jackson 1959; Klontz et al. 1960; Murchio 1960; Reed 1960; Bartlett 1961; Glazier 1966). The technique described in the Equipment and Materials section and shown in Figures 20.9b and 20.9c, however, is simple, practical, and effective. The Aristo light box is recommended as illustrated and described in the Compartmentalized Trays section. Most gels received from clinical immunology laboratories are proprietary products in plastic trays and plates (many with plastic covers). The covers should be removed and the bottom cleaned of all labels and writing before photography. Appropriate peripheral masks and specimen holders should be fabricated to facilitate staging of the specimen. These staging aids are described in the Equipment and Materials section.

**Exposure.**    Transparency color film or black-and-white negative film can be used. Exposure can be determined by placing a sheet of vellum or tracing paper over the peripheral mask opening and taking a meter reading off the glowing tissue. This reading is for 18% gray, so the lens should be opened two and a half stops to make the precipitin bands pure white. Remember that additional compensation is required for magnification and, for color work, color correction must be considered.

**Translucent, Stained Electrophoretic Strips** (Tyson 1963). Serum protein electrophoresis in cellulose acetate on clear plastic or glass support appears opaque in incident light, but with back lighting it is obvious that the strip is translucent. It also becomes obvious that considerably more contrast and resolution of faintly stained areas are visible with transillumination. Both staging and photography can be achieved as described in the section on Transparent, Dried, and Stained Gels.

**Fluorescing Specimens** (Gjersvik 1967; Jackson 1968). The first stage of the Southern Blot Test fluoresces yellow/green. Most researchers use instant film to record these smears of fluorescence. Only occasionally must the photographer document this reaction. On the other hand, many chromatograms from toxicology laboratories have stained, fluorescing areas requiring photography. Some chromatograms fluoresce with a single color, while others may have a variety of substances that separate into different areas, some fluorescing in one color in one area and other colors in other areas.

**Photography Setup.** The specimens are largely opaque, so flat-copy lighting is appropriate. A flash that can provide radiation 300 to 500 nm, such as the Nikon SB-140, is desired. Two units with appropriate filters aimed at 45 degrees from each side will comprise this copy lighting setup. A barrier filter should cover the lens.

**Exposure.** For both black-and-white negative and color slide films exposure is not easily determined from meter readings. It is far better to run a test exposure series. Process the film and determine which exposure is appropriate for the film used. One should keep records of this data as a starting point for subsequent use. Once exposure has been determined for one film, calculations can be made to establish a bracketing range for other films.

**Opaque Dry Flat Specimens** (Berry et al. 1954)

**Stained, Dry Chromatograms.** These are flat specimens that can be recorded in black-and-white or color film on a copy stand much like a flat, printed object.

**Dipsticks and Impregnated Paper Discs and Strips.** A great variety of reagent-impregnated, dry paper strips are used for instant chemical reactions when dipped into serum or urine. Other paper discs or strips with incorporated reagents are used dry with bacteria or clinical specimens rubbed on the surface. A color or turbidity change represents the significant reaction. On the rare occasion when such specimens are received in the studio, the photographer needs to be able to plan the photographic session.

**Photographic Setup.** Use of two Aristo light boxes, as shown in Figure 20.14a, provides illumination for the specimen, as well as for a white or colored background card. Obviously, the two boxes should be closely color-balanced. This implies that each box should need about

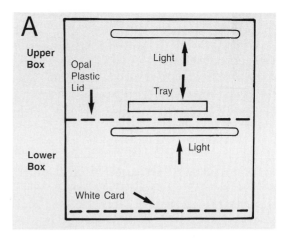

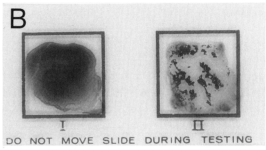

**FIGURE 20.14** When an Aristo light box (a) in the incident light position (Figure 20.8a) is placed on top of an identical box in the transilluminated position (Figure 20.8b), even incident light surrounds the agglutinated red blood cells on the slide (b), while the bottom box provides an illuminated background that eliminates shadows.

the same color correction. Both boxes have the lamp in the upper position. The bottom box provides light for a background card. In addition, the lower box should have a sheet of glass in the top slots as a specimen stage. If the specimen is warped, another small sheet of glass should be placed over the specimen to press it flat. The upper box can have a 6" high ring of fiberglass cloth placed in front of the rectangular lamp as a diffuser to give even softer illumination on the specimen. A solid black mask above the upper box should have an opening large enough to permit complete view of the specimen, yet small enough to prevent stray light from flaring the image.

**Exposure.** A meter reading of incident illumination will suffice as a basis for exposure. The bottom box, lighting the background card, can be ignored since the intensity of reflected light will be less than that of the top light. These specimens are usually small so exposure compensation should take into account magnification as well as color correction.

**Wet Serological Reactions on Paper, Plastic, or Glass.** These specimens are handled much like those described above. Since these strips, slides, trays, and

plates have areas with wet antigen/antibody reactions within printed compartments, they should not be covered with a sheet of glass. Also, the photographer should handle these specimens with great care. Tipping, dropping, or blotting can destroy the specimen and, if the specimen contains living organisms, can also lead to contamination of the studio. Figure 20.14b shows a wet, flat specimen.

## PHOTOGRAPHY OF VERY SMALL BIOMEDICAL OBJECTS
(Gibson 1968, 1975; Tau and Krass 1969; Dommasch 1970; Johns 1974; Ellis 1977; Hund 1979; Lefkowitz 1979; White 1984, 1987; Williams 1984; Bruck 1985)

### Introduction

Some biomedical objects are quite tiny (5–6 cm to 0.5–10 mm). Examples of tiny specimens might include: biopsy specimens, extracted teeth with caries, laboratory animal necropsy specimens, clarified zoological specimens, jellyfish, cysts, insects, leaves and petals, metal instruments and component parts, microchips, as well as miniversions of plastic and glass trays, slides, and plates. Handling such specimens presents unique problems and almost always requires uncommon techniques, as well as special staging and lighting (Ogrodnick 1987; Le Beau 1991).

### Camera and Lenses

The Nikon F-3, occasionally on a copy stand or largely on the Bogen Light Modulator, was used for this work. In addition to the Micro Nikkor 55-mm lens with the Pk-3 ring, the Nikon 35-mm and 19-mm Macro lenses on the PB-4 or PB-6 bellows, sometimes with the extension attachment PB-6E, provided images magnified 1:5 to 15 times. A Nikon Lieberkuhn mirror was sometimes used with the 35- or 19-mm lens.

### Lighting Systems, Fiber Optics, and Light Pipes

The unit used in this work was American Volpi Intralux 5000, 110/120 power unit with a quartz-halogen 20 volt, 150 watt bulb providing 4.9-m lux at a color temperature of 3190 K. It was fitted with a trifurcated gooseneck fiber-optic unit. Each bundle was 5.2 mm in diameter and 600 mm in length. This unit was used to illuminate specimens on a special stage, described in the section on Equipment and Materials. For such work done on the copy stand, a laboratory jack under the stage was used for focusing. Fiber-optic bundles were also used to supplement the illumination of the Bogen Light Modulator.

### Lighting Systems, Light Pipes

The Bogen Light Modulator looks more like a science fiction, robotic spider than a macro stage and illumination system. The base of the Modulator is a box that contains the light source for the positionable 4 3/4 × 7 inch transillumination port. In addition, it supports the camera stand and the holder for the elevatable stage. At each corner of the base are attachment rods for the four articulated arms, three with lamp heads and a fourth used to hold a reflector or a specimen clamp. The front of each lamp housing has a series of four troughs, which can hold filters and light pipes. Illumination is provided by 50 watt quartz-halogen bulbs, producing a color temperature of 3300 K. The light pipes are glass rods that pass the light, with very little loss, through the pipe and out the tip, thus concentrating the beam of light onto a small specimen. The diameter of the pipe determines the area and intensity of illumination. Because filters are available for the lamp housing, as well as at the transillumination port, the specimen can be flooded with colored light from almost any angle.

### Lighting Techniques

The lighting techniques used varied largely with the types of specimens to be photographed (Table 20-3). For these specimens, colored backgrounds or colored illumination may improve the image. For a specimen that might collapse on a flat surface, a glass chamber with water was used to suspend the specimen. (See the section on Equipment and Materials.) Whether fiber-optic bundles or light pipes were used, arrangement of lights was fairly consistent.

**Incident Lighting.** Usually a texture light was provided by placing a fiber-optic port or a light pipe 3 to 8" from the specimen at an angle of 3 to 5 degrees. On the opposite side fill illumination was produced by setting another light unit 6 to 10" away at a 45 to 60 degree angle. A third light unit, about 8 to 10" above and a little behind the specimen, gave an overall illumination. An adaptation of this lighting is shown in Figure 20.15a and the resulting

**Table 20-3  Types of Specimens and Appropriate Lighting Setups**

| Type of Specimen | Lighting Setup |
| --- | --- |
| Opaque | Incident lighting with or without transillumination |
| Opaque, reflective | Tent illumination |
| Very flat or deeply mottled | Lieberkuhn |
| Transparent or translucent | Darkfield illumination |

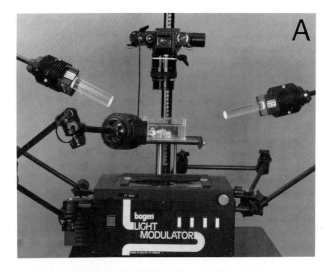
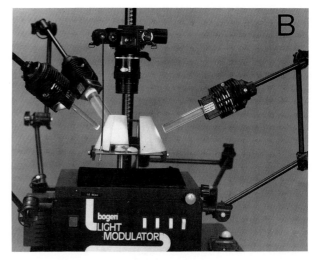

**FIGURE 20.15**    Lighting specimens with the Bogen Light Modulator. (a) Incident lighting is shown with the light pipes aimed from three directions to provide even illumination across the specimen. If texture lighting were needed, the light pipes would be placed at an angle of 10°. An example of this lighting of a specimen within the specimen chamber is shown in Color Plate 116. (b) The tent halves surround the specimen and the light pipes are set to provide twice as much light on one side than the other side. (c) The Lieberkuhn mirror is shown with the light pipes directing light onto the surface of the mirror without any of the light spilling on the opening of the lens. (d) For darkfield illumination of a specimen, the light pipes were placed at 45 degrees under the specimen, equidistant around the stage, to edge-light the perimeter of the specimen.

image is illustrated in Color Plate 116. More often than not, the image is enhanced with colored transillumination to provide a colored background. With the light modulator, this is no problem because the incident light is almost always three times brighter than the back light. When the portable stage is used in conjunction with fiber-optic incident illumination, it is necessary to ensure that the incident light is two to three times brighter than the transillumination or the background color will appear washed out.

**Tent Lighting.**    A plastic tent is provided with the Bogen Light Modulator, but a styrofoam or white plastic cup can be a satisfactory tent for very small object work. (See the Equipment and Materials section.) This lighting setup can be seen in Figure 20.15b. Often the photographer places one lamp with equal light output on each side equidistant from the tent. It is worth the effort to put one light unit about 2″ from the tent on one side and two units (one above the other) 2 to 3″ away on the other side. A colored transillumination background may likewise improve the appearance of a tented object. When plastic or styrofoam cups are used as tents, much blue light is filtered out, giving an unnatural yellowish appearance to the image. A CC5B or CC10B filter should be used to correct the unwanted color shift.

**Lieberkuhn Lighting.**    Either lighting system can be used to pour light onto the curved mirror (Figure 20.15c). This technique should be used for objects less than 2 inches across. It is particularly useful when the object surface is composed of several materials of different reflectivity or is deeply mottled or even raised in some places and pitted in other places.

**Darkfield Illumination.**    The fiber-optic units or light pipes should be placed under the specimen at an angle of 45 degrees. A black velvet card should be on the base below the specimen, as shown in Figure 20.15d. Ordinarily this lighting is limited to transparent specimens with several planes (Figure 20.16) as well as translucent specimens that glow brightly in proportion to respective density of their component parts.

While the limited area of illumination achieved with fiber optics was apparent with most specimens, it was particularly noticeable in darkfield illumination. Only specimens less than 3 to 4 cm in length could be evenly illuminated on their perimeter.

An interesting extension of darkfield is to have it produce a peripheral light about an opaque object and use a tent around the specimen for internal tent reflection so as to flood a soft fill-light over the entire specimen.

### Exposure

In each instance an incident meter reading at the site of the specimen will predict the appropriate base exposure, however, compensation for magnification and filtration should be made. Additional compensation may also be required if the object is very dark. Often these objects are so small that compensation for magnification might be four to eight stops. Calculating this can be complicated

**FIGURE 20.16  Darkfield illumination (Figure 20.15d) was used to light these implant lenses at 1 : 1.**

(see the Equipment and Materials section and Figure 20.37 for use of a magnification direct-read rule) (See Chapter 8).

One should be aware of vibration during any photomacrography and avoid blurred images by locking the mirror in the up position once focus is achieved.

### PHOTOGRAPHY OF TINY REFLECTIVE BIOMEDICAL OBJECTS (Harding 1944; Coffey 1955; Blaker 1965, 1977; Smialowski and Currie 1965; Mineo 1966; Whitley 1966; Keeling 1971; Johns 1974; Hund 1979; Pinckard 1979; Bruck 1985)

### Introduction

Most biomedical photographers are reminded of product or commercial photography when they think about the photography of shiny subjects such as silverware and glassware. However, a large number and variety of small and reflective objects are often the subject for the biomedical photographer.

In the last 50 years many articles have appeared in the *Journal of Biological Photography*, as well as the *Journal of Audiovisual Media in Medicine*, dealing with some aspect of photography of reflective objects. A number of texts and monographs have touched on the subject as well. These authors were faced with unique problems and wrote a review of each solution. Most of the authors were concerned with black-and-white images captured with a 4 × 5 camera. This section, on the other hand, will largely examine the overall situation, looking at the general categories of tiny, very shiny objects with particular reference to 35-mm slide production.

The various requirements of the ideal photograph of a shiny biomedical instrument or implant include the following:

1.  three-sided (oblique) perspective (30- to 60-degree camera angle to subject), rotated to show the top and two sides
2.  depth of field over the whole subject plane
3.  reduction of contrast (highlight to shadows) for greater shadow detail
4.  reduction or elimination of shadows on the background
5.  accommodation for a variety of background colors

Each of these points may not be of equal significance in every photograph, however, most of them work in combination to facilitate the recording of an outstanding image. Because of the great demand for 35-mm color images of reflective biomedical objects, these requirements will be discussed in detail in the context of a 35-mm format. This topic is considered at length in Le Beau and Wimmer (1982).

## Three-sided Perspective

Biomedical photographers working with a 35-mm format are apt to handle most tiny objects on a copy stand with the camera positioned directly above the object. This produces a photographic image of the top of the subject, that is, of a single plane. On the other hand, if the object is at an angle to the camera and is viewed at 30 to 60 degrees, the top and two sides can be seen and greater detail is revealed.

## Enhanced Depth of Field

Unfortunately, a 30- to 60 degree angle of view on a long object or a series of objects gives improved appearance of three sides, but at 1:8 ratio and a large lens opening, the sharply focused area is limited to a few centimeters on either side of the point of focus. Closing the lens aperture helps considerably to broaden the area of acceptable focus. The matter is further complicated by the fact that greater magnification results in an even smaller area of sharp focus. As photographers working with a 4× 5 inch format well know, further enhanced sharpness of the subject can be achieved with tilting the lens and/or the film plane. When the lens is tilted so that the subject and film planes along with the lens plane all have a common point of intersection, the area of sharp focus encompasses the entire depth of the subject. This Scheimpflug principle (Figure 20.17) is easily employed with the swings and tilts of a view camera (Stroebel 1973; Shamen 1977).With 35-mm camera work, however, use of swings and tilts with the rigid bellows is not ordinarily possible. The Nikon PB-4 bellows is made for the 35-mm camera, permitting it to approach some of the versatility of a view camera.

## Lighting to Reduce Reflections and Improve Shadow Detail

A sharp image with good depth of field is still inadequate if stark reflections and harsh shadows produce an extreme contrast range devoid of appropriate detail. Soft light, usually from a broad or multidirectional source, softens shadows and lessens the glare of reflections, resulting in contrast reduction. Many lighting systems and procedures help in producing this desirable effect. The list below contains several simple techniques that provide varying degrees of reflection control and softening of shadows:

| Tents | Umbrellas | Bounce Light Cards |
| Soft Light Box | Diffusions Systems | Cross-polarization |
| Dulling Sprays and Rubs | | |

**Tents.**  Simply stated, tents are translucent materials surrounding an object to be photographed. An opening is strategically placed as a window through which the camera can view the subject. For larger objects, commercially available tents are quite effective. For very small objects, smaller tents are more appropriate. A variety of simple materials can be used to fabricate a tent, and Figure 20.18 illustrates the relative size and shape of such tents.

Styrofoam cups, white plastic ice or paint buckets, specimen containers, gallon pickle jars, and pails make excellent tents for vertical work once the bottom has been removed. Larger containers work equally well with holes cut in the sides. Plastic sheeting, vellum, and translucent

FIGURE 20.17  The Scheimpflug effect diagram shows how the planes intersect at point a. This produces a plane of sharp focus, a–d. (a) Point of intersection. (b) Film plane. (c) Lens plane. (d) Plane of sharp focus. (f, g, h, i) Out of focus.

FIGURE 20.18  Tents can vary in size, shape, and translucency. The choice of tent is influenced by these factors and should be based on the desired rendition of the subject.

paper, such as tracing or typing paper or *Strathmore* single- or double-strength paper, can also be used to construct cones or pyramids with the apex cut away or an opening made in the side. Sometimes these materials can be fashioned in the shape of a letter C to form a partial wraparound tent (Figure 20.19b).

**Color Temperature of Tented Light.**  Most of the common materials suggested for fabricating tents absorb varying degrees of blue light. The resultant color photographs tend to have a slight yellow or amber cast. This can be corrected with a CC05 or CC10 blue filter.

**Lighting the Tent.**  The lighting of a subject in a tent is usually accomplished by illuminating the outside surface of the tent so that only diffused light reaches the subject. Rather than illuminating the tent evenly from all sides, it is a good idea to provide slightly more light from one side to give some direction to the lighting. In the extreme, tent lighting can produce images of such low contrast that they appear dull and lifeless. In such cases, a small light or mirror or even a color reflector inside the tent can emphasize elevation, texture, and acceptable levels of reflection on the metallic or shiny surface. The tent can be elevated 1/2 to 1″, or a half-inch ribbon of black paper can encircle the object at the inner perimeter of the tent to create a dark rim around the subject.

**Exposure Determination in Tents.**  A hand-held incident-light meter placed within the tent in the position of the object to be photographed will give accurate exposure settings.

**Bounce and Umbrella Reflector Systems.**  As indicated previously, the broader the light source, the softer the light; hence, light off a wall or ceiling is almost shadow-free and produces minimal glare. A mini-version of this would be the light coming solely from a photographic white umbrella. Generally speaking, however, except for quite large objects, umbrella lighting is less practical than a smaller procedure such as reflection from a bounce card as shown in Figure 20.20. A variation of the reflector system which gives even softer light than an umbrella is the use of a large, wraparound, C-shaped tent, as diagrammed in Figure 20.19a,b, illustrated in Figure 20.19c, and described in the Equipment and Materials section. The sides are made of wood. The top, back, and bottom are formed from a single sheet of bent paper, held to the wooden sides with Velcro fasteners. A tungsten–halogen light or a flash unit at the lower right corner of the opening, aimed at the opposite upper corner, works well. If the power of a single flash unit is insufficient, a second unit can be added. Place one in each front corner, aimed at the opposite upper, back corner. A photograph made using this unit is shown in Color Plate 117.

**Wraparound Light Box.**  The Aristo light box, described in detail in the section on photography of compartmen-

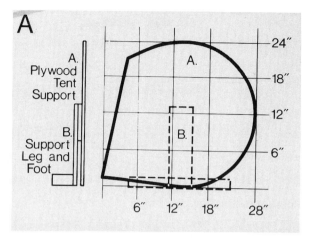

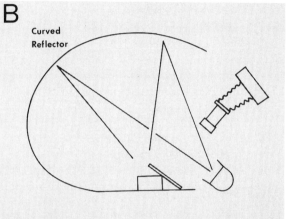

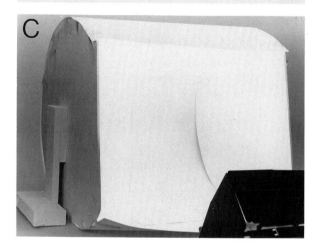

**FIGURE 20.19  The C tent. (a) The side forms were cut from 3/8″ plywood. The leg assembly was cut from 1/2″ lumber. Note that the leg was set back from the side form by a 3/4″ thickness of wood support to facilitate attachment of the paper or plastic to the side walls. The foot was cut from 2 × 4″ lumber. The wooden parts were painted flat white. An example of illumination using this lighting system is illustrated in Color Plate 117. (b) The curved reflector or C-shaped tent assures even, multidirectional, and virtually shadowless light. (c) The plywood side frames with attached legs and feet. The paper tent is attached with Velcro fasteners to increase the convenience of setup and disassembly, as well as to assure firm attachment.**

**Flat Reflector**

**FIGURE 20.20**  A simple reflective surface such as a gray, white, or foil-covered card can provide controlled reflection.

ducing no background shadows. One can also set the box up for darkfield illumination with the pyramidal tent on top of the box to give edge lighting to the specimen as well as soft bounce light over the top of the specimen. In each instance the meter reading should be taken at the specimen site for incident light, ignoring any reading of the background illumination.

talized trays and shown in Figure 20.7, can be used to provide shadowless incident light as diagrammed in Figure 20.8a. Depending on the shape of the object and its reflectivity, however, a ring of reflection from the fluorescent, rectangular tube may appear on the top of the subject. By the same token, a faint glow on the background may represent a reflection of light off the object. Such reflections, though, can be softened effectively by placing a ring of fiberglass cloth in front of the rectangular lamp. An interesting white-transillumination setup using the light box and internal tent bounce-fill light is shown in Figure 20.21. This has the advantage of pro-

**Pyramidal Reflector**

**Plate Glass**

**Light**

**White Background Card**

**FIGURE 20.21**  All of the incident light reflects off the inside walls of a pyramidal tent placed over the sheet of glass on top of the light box, the lighting becomes quite soft, and reflections are minimized.

17"

1/2"

3/4"

20"

Wood screw threads

1/4–20 inside threads

**FIGURE 20.22**  A simple diffuser holder can be constructed inexpensively from scrap lumber and wooden dowel rods. Velcro glued and stapled to the ends of the upper and lower slats can be used to secure the diffuser.

**Diffusion Systems.** The section on Equipment and Materials describes diffusion materials, as well as a simple and practical holder (Figure 20.22). Diffusion material, placed in front of the light source, reduces the glare of reflections, but it cannot be expected to eliminate all shadows and reflections. Figure 20.23a diagrams the positioning of lights and diffusers to soften the light. Figures 20.23b and 20.24 show how bounce light can be added to provide transillumination to eliminate shadows of the specimen from appearing on the frosted glass stage.

**Polarizers and Polarized Light in Reduction of Glare.** Use of polarizing filters has long been advocated for control of harsh reflections (Cox 1974; Langford 1980). A polarizing filter over the lens alone or in front of the light source alone will not reduce reflections, however, if cross-polarization is used, reflection control can be so effective as to produce an image with no vitality. Slight reflection is sometimes essential to convey important information about the specimen. This can be achieved while still reducing the bulk of the glare by revolving the polarizing lens on the camera lens to reduce glare yet permit a small amount of reflection to pass to the film. Unfortunately, the reflection one sees in the camera viewfinder and that recorded on film are rarely identical. It is often easier to use a very small spotlight or a miniature but powerful flashlight to give a tiny area of unpolarized light on the specimen to record a like area of reflection. One should bear in mind that after all this filtration, only one-fourth to one-eighth of the light reaches the film, so any incident meter reading requires adjustment of exposure by opening the lens two to three stops or making an equivalent increase in exposure time.

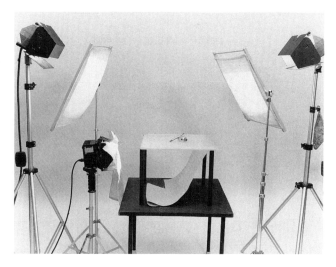

**FIGURE 20.24   The principle diagrammed in Figure 20.23a is illustrated here. The reflected light from under the specimen washes out any shadows cast by the subject on the ground glass stage. If colored paper replaces the white reflector, colored backgrounds can be achieved.**

**Matte Surface Dulling Sprays and Rubs.** One popular means of dulling otherwise highly reflective surfaces is to spray them with a lacquerlike material that dries to an irregular, matte surface so that reflected rays disperse at all angles, providing a dulling effect. Such sprays are commercially available from professional art and photography suppliers. There is a report of success using rubber pencil erasers or beeswax on the shiny surface (Dommasch 1970). Others have used putty (Jackson 1972), as well as milk or Plasticine (Freeborn 1953), as a rub or spray to reduce reflections. In the author's experi-

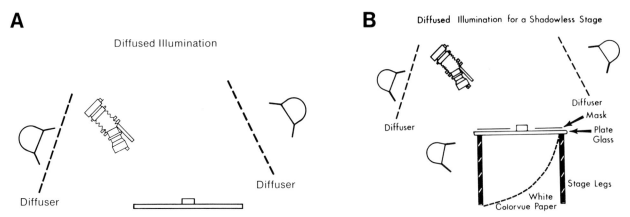

**FIGURE 20.23   Diffusers in small reflective object photography. (a) Diffusion material placed between the light source and the specimen does much to soften the shadows and reduce stark reflections. (b) Reflected back light combined with the diffuse light on the subject produce shadowless images with reduced reflections. *Note:* A mask is needed to prevent flare from the back lighting, and a stage with a ground glass surface prevents unwanted reflections.**

ence, the rubs were far more effective than most of the commercially available sprays.

## Reduction or Elimination of Shadows on the Background

Reduction of shadows can be accomplished in a number of ways. These fall into the following categories: diffused light, soft lightbox, transillumination, and black background. As mentioned earlier, diffused light lessens the size and intensity of shadows. On the other hand, soft light box and transillumination wash out any shadows, and a black background makes them inapparent.

**Aristo Light Box Shadowless Lighting Configurations.** Several configurations have already been discussed in other contexts. Figure 20.8b has shown use of the transillumination, and Figure 20.14a touched on the use of two lightboxes, one on top of the other. The bottom box can produce white transillumination to wash out shadows, while the other provided incident light on the specimen. Figure 20.21 showed how to get transillumination and internal tent-fill light on the specimen.

**Transillumination for Shadowless Backgrounds.** As shown in Figures 20.23a and 20.24, bounce light under the ground glass stage gives adequate transillumination to remove shadows of the specimen from the stage. Grossman described in 1980 and 1981 the use of a translucent sweep of opal plastic. A variation of this is described in Le Beau and Wimmer 1982 and illustrated in Figure 20.25. Light from under the sweep assures transillumination, while bounce light from the sailcloth above the sweep assures soft light on the specimen. Since the workable specimen area of the sweep has a diameter of 3 feet, this system is particularly useful for illuminating a series of reflective objects such as surgical instruments.

**Black Backgrounds to Mask Shadows.** In principle this procedure works, but when reflective specimens are involved, the black background is reflected at the base of the object and blends into the background, eliminating edge definition. For opaque, nonreflective objects, on the other hand, this technique is quite effective in masking shadows. Also, it should be noted that black backgrounds are recorded as black only when they fail to reflect light. Consequently, black shiny surfaces like black glass or a smooth surfaced black paper may actually reflect so much light as to seem mirrorlike if the angle of incidence is such that it sends a reflection of the light source to the lens. A highly textured surface, such as black velvet, usually works well regardless of the angle of incidence. In addition, if the specimen is elevated on a glass stage above the black background, adequate definition of the edges is achieved along with elimination of shadows.

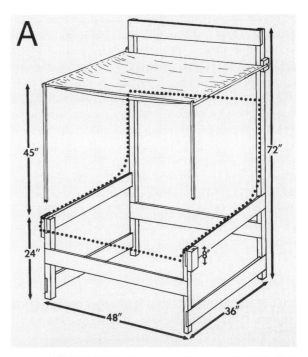

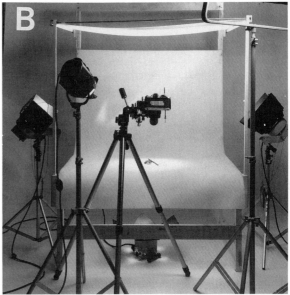

**FIGURE 20.25 The stand and sweep are shown diagrammatically (a) with the dimensions indicated and illustrated (b). The plastic sweep is represented by the dotted line. The white sailcloth reflective curtain is held taut by curtain rods.**

## Colored Backgrounds

Too often specimens are photographed on either a white or black background for a transparency or a printed page in color. Quite obviously colored backgrounds in tents or in a C tent, such as shown in Figure 20.19c and illustrated in Color Plate 117, give satisfactory images of a specimen on a colored background. It should be re-

membered that a highly reflective object set directly on a colored background may reflect the color all along the lower portion of the object, often giving an erroneous appearance. On the other hand, a colored background card on the bottom of a light box as shown in Figure 20.8a gives no color reflections on the specimen and yet renders reflective objects well. Another technique that provides colored backgrounds and handles reflective objects with reduced glare is shown in Figure 20.14a. While this lighting depicts use of a white background, quite obviously it can be used for colored backgrounds as well. One point must be remembered, however: the background light, when measured with an incident meter from just below the specimen, must read one to three stops less intensity than that of the incident light or the color will appear washed out.

## SMALL MEDICAL OBJECT PHOTOGRAPHY ON LOCATION
(Anderson 1957; Wilson 1979; Le Beau and Prashall 1985; Le Beau et al. 1985; Parish 1987)

### Introduction

Not all biomedical photography occurs in the studio. Some laboratory specimens are so fragile that they cannot be moved. Some reactions may last only a few minutes and must be recorded on site as the reaction occurs. In addition, biological photography often involves recording specimens on field trips. For all this work a portable system that assures studio quality is required.

### Portable Bracket for Camera and Flash Units

While multiple flash brackets have been commercially available for some time (Parish 1987), only the Lepp Dental-Medical-Bio Bracket[3] has stood the test of time

FIGURE 20.27   One flash at 10 to 20° from the subject plane serves as the main or texture light; the other is placed close to the opposite side of the lens and has additional neutral density filtration for fill illumination. Color Plate 118 is an example of a specimen photographed with this system.

for production of 35-mm color slides on location. The Lepp system (Figure 20.26) is a bracket that holds the camera with two mini-flash units set at desired positions above, below, in front, behind, or on both sides of the lens.

Biomedical applications of the bracket are presented in Le Beau et al. 1985. As a starting point the texture light should be placed at 10 to 20 degrees from the plane of the specimen and the fill light set adjacent to the lens on the opposite side (Figure 20.27). While the two flash

FIGURE 20.26   The macro bracket consists of a crossbar that holds the camera and ataches to a pistol grip. Side arms that hold the flash units are connected by clamps to the crossbar.

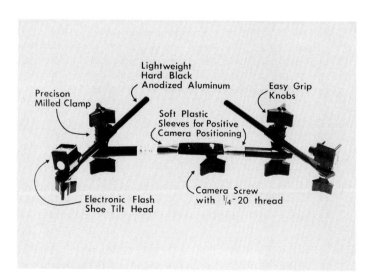

units are identical in output, the fill light should deliver half as much light as the main or texture flash. This is easily accomplished by placing a 0.3 neutral density filter (one stop) over the flash. Usually a 55-mm macro lens is used, although a 60- or 90-mm macro lens that can focus from infinity to 1:1 is especially handy for field work. With tiny flash units (EV 35-40/ISO 100) and film with ISO 100, exposure of $f$/16–32 at synchronization speed is a good starting point for an exposure test series. The results of this test will establish a single exposure setting for any magnification from 1:8 to 1:1. This holds true because, as the camera gets closer to the specimen a larger aperture is usually required; but the two flash units move closer at the same time compensating for the magnification. Color Plate 118 shows a field photograph made using this system. Similarly, small patient lesions, biopsy specimens, and even petri dishes or chromatograms can be photographed effectively with this equipment on the ward or in a laboratory.

## PHOTOGRAPHY OF SMALL LABORATORY ANIMALS

### Introduction

Laboratory animals have been of interest to biomedical photographers for more than 40 years (Latven 1950; Brunst and Clayton 1953; Gunn 1986). The advent of the electronic flash led to sharper photographs of the skittish subjects (Dragesco 1952; Anderson 1957). For many years it was common practice to sedate animals to quiet them and prevent them from running away. Some authors, however, complained that animals so treated did not appear lifelike. Brunst observed in 1960 that most laboratory animals feared heights. Such reports led to these guidelines for photography of laboratory animals:

1. Sedate animals only if absolutely necessary.
2. Develop a stage with an area one to two times larger than the length of the animal and elevate the stage to three to eight times the animal's height.
3. Use electronic flash as opposed to a continuous light source.

Subsequent research by Le Beau et al. in 1987 led to development of a platform stage to hold the animals, as well as a special tent which assured even lighting. (See Equipment and Materials.)

### Turntable Pedestal Stage

A pedestal stage was designed and constructed as described in the Equipment and Materials section and shown in Figure 20.28. The turntable permitted 360 degree rotation so that the photographer could rotate

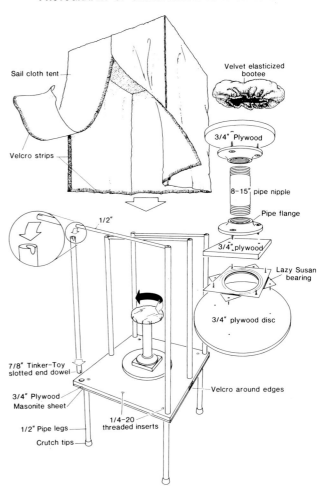

**FIGURE 20.28  Specifications for components of the animal tent, frame, table, and pedestal are provided. The stage base can be bolted to the table to prevent a large animal from tipping the stage. The velvet cover on the stage is necessary to avoid reflections under the animal.**

the stage as needed to keep the moving animal in a suitable position.

### Animal Tent

A tent with unusual specifications was required. It should be tall enough to illuminate the animals on a pedestal stage. The base of the tent should be a table at a comfortable working height. It should have the lighting on the inside to provide considerably more illumination than might be expected from a tent with the lights outside. To accomplish this, a tent platform and skeleton were constructed (Figure 20.29). A tent was fabricated from white sailcloth.

### Lighting Within the Tent

A pair of Vivitar 283 or Sunpack 223 flash units was used. One electronic flash unit was placed in each front corner

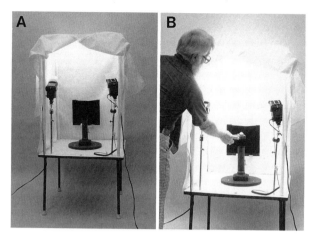

**FIGURE 20.29** Illustrations of the tent, frame, and table. (a) The flash units in each front corner were elevated to about half the height of the tent and aimed at the opposite rear-upper corner. A small white card was affixed with Velcro to the top of each flash to deflect some of the light onto the front of the animal. (b) Exposure determination is simple and accurate using an incident electronic flash meter placed on the stage. The reflected light from above and behind gave a light intensity of twice that from the front. The correct position for the light meter, therefore, was facing the camera.

and elevated about half the height of the tent. Each light was directed to the opposite rear, upper corner. A 3 × 4″ white card was attached with Velcro to the upper front of each flash unit to deflect some of the light down onto the front of the animal. A black velvet background card was placed behind the subject. This lighting arrangement is shown in Figure 20.29a. The light bouncing off the top and back of the tent produced about one stop more illumination from above and behind the animal than from the front. An incident electronic flash meter reading taken at the stage (facing the camera, not the top of the tent) was used to establish the exposure as shown in Figure 20.29b. Bracketing of exposures was rarely required, however, photography of colored animals usually required a one-half to one stop exposure increase. For most of the work, a black stage and background was used. This was particularly effective because the lighting naturally gave a faint edge glow to the animals, assuring separation of the animal from the background. When a colored or white background and stage were used, additional direct illumination of the background had to be arranged without any of this light striking the subject. This was achieved with suitably placed gobos shading the animal. When the photography assignment included a specific lesion or required exhibiting elevation or texture in a small area of the animal, a third, comparable flash unit was used. The third unit was fitted with a black paper cone and positioned to direct the light, so as to skim across only the area of interest. A small mirror was

sometimes used to direct additional light to the front underside of some animals when unpleasant shadows were noticeable. It should be noted that uncontrolled use of a mirror can result in unwanted highlights on adjacent fur, particularly in elevated or prominent contiguous areas. Therefore, once the mirror was clamped in place, reflection was restricted with strips of black masking tape on the mirror so that only the area requiring additional illumination was affected. Photographs of laboratory animals made with this system are illustrated in Color Plate 119 and Figure 20.30.

## Control of Animal Movement

It was not usually necessary to sedate the animals. Only rats with large abdominal or mammary tumors required sedation in order to place the animal on its back, so as to better view the tumors. The small animals studied included rabbits, guinea pigs, hamsters, rats, mice, frogs, and chicks. All, except a few of the hamsters and most of the bullfrogs, were intimidated by the height of the stage. The limited diameter of the stage limited animal movement mostly to rotation. This often presented an unwanted view of the animal, but a minor adjustment of the turntable at the base of the pedestal quickly returned the animal to a desired pose. Since hamsters and bullfrogs were willing to jump from the pedestal, it was necessary to put Velcro fasteners all around the bottom of the tent and the edge of the table to limit any subsequent jumping to the floor. While it was inconvenient to keep moving the animal from the floor of the tent back to the pedestal stage, the photographic session usually proceeded with dispatch.

**FIGURE 20.30** Examples of laboratory animals photographed using the tent system (see Color Plate 119). (a) Hamsters are active and playful. While their activity can prompt them to move about on the stage and even jump to the floor of the tent, it also assures a variety of interesting poses for the photographer with patience. (b) Gerbils also move about in and out of focus, but they frequently stand, look about, and pause to listen. This is usually a photo opportunity.

## USE OF THE AUTOMATED CAMERA FOR SMALL BIOMEDICAL OBJECT PHOTOGRAPHY

### Introduction

Autofocus/autoexposure cameras are so convenient and reliable that they are worth considering for biomedical photography. Attempts to use the autoexposure feature usually leads to disappointment, since the reflected light may be integrated over an area larger than the specimen and, like reflected-light exposure meters, is influenced by extensive background areas of black or white. At the same time, many small medical objects are customarily photographed against white or black backgrounds. While many of the autofocus/autoexposure cameras have a spot metering option, such a system is more adaptable to handheld photography than to work done on a copy stand or tripod. Spot metering was selected on several occasions; however, this must be set when focus is centered on the area of critical exposure. The image then must be recomposed to give the field of view desired. This was only practical when the camera was handheld. The situation became even more interesting and the solution of the exposure problem more convenient with the availability of dedicated autofocus speed lights and the multicontrol camera back. Compensation for exposure can be made at camera, flash, and/or multicontrol back. With such opportunities to maintain control of difficult exposure situations, it would seem inevitable that the challenge of automatic camera use in medical photography could and should be met. This investigation was limited to work with the Nikon F4S and the autofocus Micro-Nikkor 55-mm and 105-mm lenses and SB-24 and SB-23 autofocus speedlights. In the following paragraphs, the lighting and staging particulars are given along with workable exposure recommendations for each situation. In all instances the exposure data relates to use of daylight film with ISO 50.

### Petri Dish Cultures

The same techniques described in the section on Petri Dish Photography were used with the automatic camera. Instead of a tungsten–halogen light, a SB-24 autofocus speedlight was used along with black Crescent board barndoors attached to the flash head with Velcro fasteners. For accurate placement of the flash illumination, a special adaptation was required. A Mini Maglite[5] was rotated to spot-setting and fastened to the top of the flash head with Velcro. As the flash head was moved into place, the spotlight indicated the point of focus. This proved particularly helpful for axial and bounce lighting.

**Texture Lighting with Fill and Transillumination.** The lighting setup imitated that shown in Figure 20.2a: *ISO 50 film, Flash at 28 mm—Exposure Correction: + 1/2.*

**Bounce Light as Adapted from Figure 20.2b.** *ISO 50 film, Flash at 70 mm—Exposure Correction: + 1/2.*

**Axial Illumination as Adapted from Figure 20.2c.** *ISO 50 film, Flash at 85 mm—Exposure Correction: −1.*

### Test Tubes and Their Contents

**Colored Backgrounds.** Lighting included two Nikon SB-24 flash units placed one to each side and behind the background card as shown in Figure 20.6a. A Nikon SB-23 was positioned 2 feet above and 3 feet in front of the tubes in order to illuminate the background. Mini Maglites, attached to the flash units, facilitated accurate aiming of lights. *ISO 50 film, Flash at 70 mm—Exposure Correction: − 1/2 to −1.*

**Black Backgrounds.** Two Nikon SB-24 autofocus speedlights were arranged as shown in Figure 20.6b. *ISO 50 film, Flash at 70 mm—Exposure Correction: −2.*

**White Backgrounds.** Two Nikon SB-24 autofocus speedlights were placed as shown in Figure 20.6c. *ISO 50 film, Flash at 50 mm—Exposure Correction: + 1/2 to +1.*

### Tent Lighting for Reflective Objects

Two Nikon SB-24 flash units were placed at a distance of 14" from each side of a Techno/Balcar[6] tent.

**White or Light-Colored Background (Bottom of Tent).** *ISO 50 film, Flash at 35 mm—Exposure Correction: + 1/2 to +1.*

**Black Background (Bottom of Tent).** *ISO 50 film, Flash at 35 mm—Exposure Correction: −1.*

### C Tent

Two Nikon SB-24 flash units, one at each bottom, front corner of the tent, were aimed at the opposite upper, back corners as adapted from Figure 20.19c: white or light colored background *ISO 50 film, Flash at 70 mm—Exposure Correction: 0 to + 1/2.* Black or dark colored background *ISO 50 film, Flash at 50 mm—Exposure Correction: − 1/2 to −1.*

## Transillumination

The lighting chamber (described in the Equipment and Materials section) illustrated in Figure 20.31 was required. A white foam core rectangular board was placed at the bottom of the box to enhance reflection. Two Nikon SB-24 flash units were attached to the ends of the base board and the flash heads positioned in the holes on each end of the box. The light was aimed at the opposite interface of the floor and side wall. Since the flash units do not have built-in focusing lamps, a tensor lamp was set at one of the side openings, next to the flash, providing a little light to facilitate focusing. A peripheral mask was placed on top of the chamber with a specimen holder over the central opening. These are described in the section on Equipment and Materials and shown in Figure 20.31b. *ISO 50 film, Flash at 24 mm—Exposure Correction: 0 to +1.*

## Darkfield Illumination

The same lighting chamber as described above was needed, but the baffle platform with a darkfield stop consisting of a black card was set in place 2 to 3" below the specimen. Exposure had to be adjusted depending on how much of the specimen filled the field relative to how much of the field was black background.

Specimen at a 1:2 ratio filled the entire field: *ISO 50 film, Flash at 35 mm—Exposure Correction: 0 to −1.*

Specimen (contact lenses) at 1:1 covered one-eighth of the field: *ISO 50 film, Flash at 35 mm—Exposure Correction: −2 to 2 1/2.*

Specimen (small plastic syringe with butterfly needle) at 1:8, placed on a sheet of glass with a pyramidal tent over the glass to give internal tent fill illumination: *ISO 50 film, Flash at 35 mm—Exposure Correction: 0 to −1.*

## Right-Angle Mirror-Image Photography

The right-angle mirror and holder described and illustrated in the section on Equipment and Materials was required along with the light chamber.

**Transillumination.** The chamber, set for transillumination, was inverted on top of the right angle mirror holder. The specimen was a tray with colored reactions or colored cells in the cupules: *ISO 50 film, Flash at 24 mm—Exposure Correction: + 1/2 to +1.*

**Darkfield Illumination.** The specimen was a tray with translucent cells in the cupules: *ISO 50 film, Flash at 35 mm—Exposure Correction: 0 to −1.*

## Summary

These suggested approaches for use with automatic cameras are, at best, starting points for further experi-

**FIGURE 20.31** Light cabinets and specimen stands for automated cameras. (a) The light chamber for the Nikon F4 camera consists of a box with openings on the sides through which the heads of the Nikon SB-24 speedlights can be inserted. Note that the interior of the box is white plastic bonded to the masonite sides. The box was mounted on a baseboard. Two tilt-tops were bolted at the ends of the baseboard to hold the speedlights at the illumination ports. (b) The light chamber, ready for use, has the SB-24 speed lights aimed at the lower opposite sides. The peripheral mask is in place on top of the box. Various sizes of specimen holders are shown in the foreground. One of these can be placed over the opening in the mask to hold the appropriate tray or plate securely. This setup provides transillumination, but with the addition of the baffle and darkground stop, as in Figure 20.9b,c, the chamber can be converted to a darkfield illumination unit for the automatic camera/flash system.

**COLOR PLATE 56** Photograph through older fiber-optic endoscope, showing image broken up into pixels by individual fiber-optic strands.

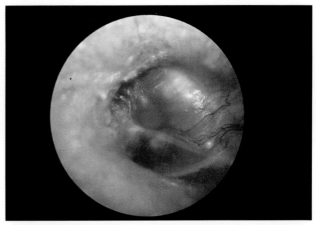

**COLOR PLATE 57** Eardrum as photographed through an otoscope using electronic flash light source.

**COLOR PLATE 58** Same as Color Plate 57, but with standard tungsten light source. Image is off-color and blurred from movement.

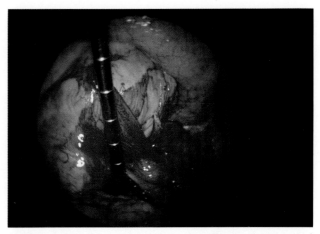

**COLOR PLATE 59** Laparoscopic photograph of ovary and probe.

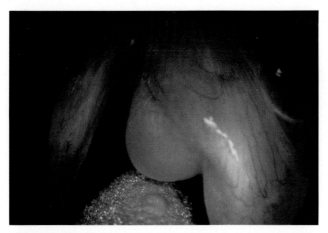

**COLOR PLATE 60** Intraoperative laryngeal photograph taken through 10-millimeter laparoscope inserted through Dedo-Jako suspension laryngoscope.

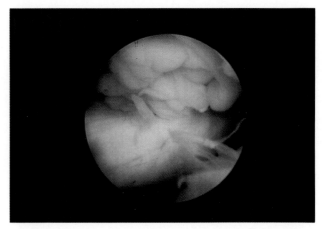

**COLOR PLATE 61** Knee joint as photographed through an arthroscope.

**COLOR PLATE 62** View of objective lens and illuminating prism from below demonstrating the nearly complete axial path of the light.

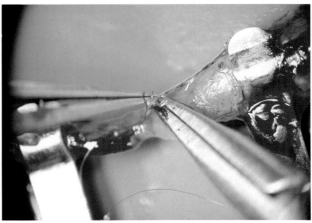

**COLOR PLATE 63** Vasectomy reversal—an example of the high quality photography that is possible through the operating microscope.

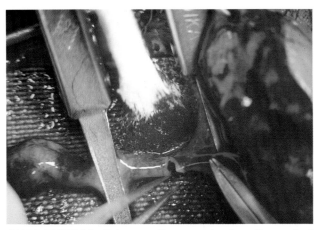

**COLOR PLATE 64** Using a cotton spear to clean the surgical field prior to photography.

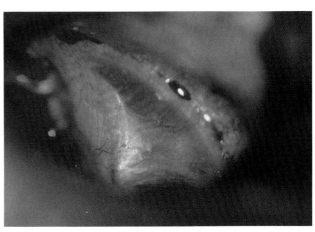

**COLOR PLATE 65** Intraoperative photograph of an eardrum.

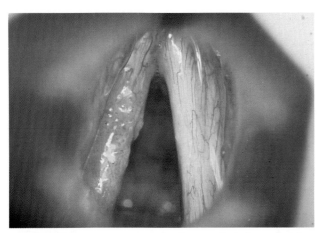

**COLOR PLATE 66** Intraoperative laryngeal photograph taken with axial flash.

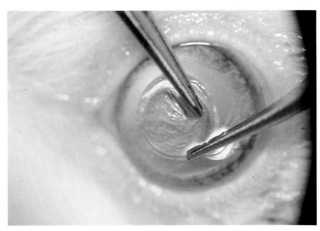

**COLOR PLATE 67** Photograph of rat corneal surgery taken using TTL flash.

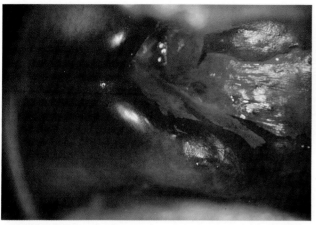

COLOR PLATE 68 Colposcopic photograph of cervix stained with iodine.

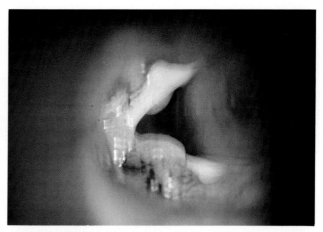

COLOR PLATE 69 (a) Camera/subject motion. This is caused by using insufficient illumination or an unstable operating microscope. The solution is to use a better light source or faster film (giving higher shutter speeds), or to stabilize the operating microscope and subject.

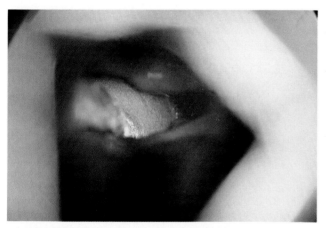

COLOR PLATE 69 (b) Focus miss. This is usually caused by not focusing the reticle and subject simultaneously. This can be differentiated from the previous problem by the fact that there is something in focus in this case, but it is not the plane of focus originally desired.

COLOR PLATE 69 (c) Insufficient depth of field. This is not really a problem in the sense of a mistake. The depth of field will always be limited; it is necessary to work with what you have. Keep the subject in the same plane, perpendicular to the lens axis. Some camera adapters may allow stopping down the diaphragm, which helps somewhat.

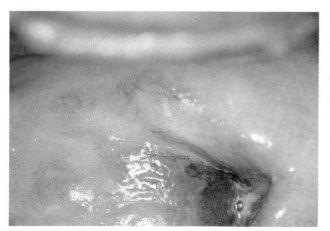

COLOR PLATE 69 (d) Poor crop. This is caused by not properly aligning the camera and reticle at the beginning of the procedure and then noting any discrepancies.

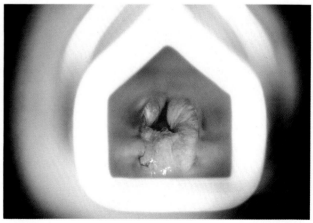

COLOR PLATE 69 (e) Insufficient magnification. This is caused by not paying attention to the reticle or forgetting about the reticle/viewfinder discrepancies.

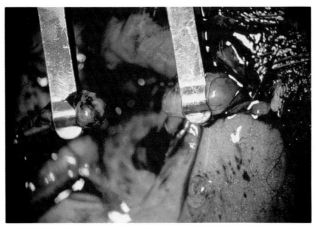

COLOR PLATE 69 (f) No background/bloody field. This is caused by insufficient preparation, although it is not possible or practical to use backgrounds with all microsurgical cases.

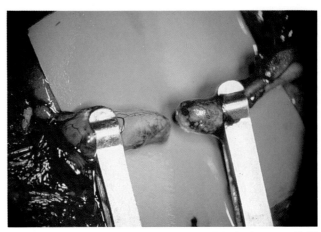

COLOR PLATE 69 (g) With background. This is the same field as the previous image, but with background added and field cleaned up.

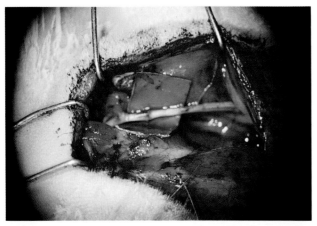

COLOR PLATE 69 (h) Image dark at edges. This is caused by having the camera adapter diaphragm partially closed (can be previewed in viewfinder). Not all adapters have this problem. Open up the diaphragm if this occurs. The color balance is also yellow, caused by tungsten light/daylight film mismatch.

COLOR PLATE 69 (i) Bad color balance. This is usually caused by using daylight film with conventional tungsten lights. A slight green cast sometimes can result from the fiber optics used to conduct the light from the light source. Color correcting filters can be inserted in the optical path to correct for these problems, although these filters will affect exposure. Also, the image is not sharp due to subject movement during long exposure.

COLOR PLATE 69 (j) Glare from instrument. These direct specular reflections are often caused by a speculum, laryngoscope, funnel, or other polished instrument. Use sandblasted or black anodized instruments whenever possible. Change the lighting position if possible. It is difficult to preview this problem when using electronic flash.

COLOR PLATE 69 (k) Twin shadows. This is caused by the use of two light sources, most commonly twin fiber optics. Use a single light source whenever possible.

**COLOR PLATE 69** (l) Shadow on subject. This is caused by using non-axial light on a subject in a deep cavity. Move the light to a more axial position. This is also difficult to preview in the viewfinder when using electronic flash.

**COLOR PLATE 69** (m) Blocked subject. This is caused by the physician using the wrong eye to compose the photograph. As previously stated, only one side of the stereo image is recorded. Put the reticle on the same side of the operating microscope as the camera, and use the reticle to compose the photograph if the viewfinder is not accessible.

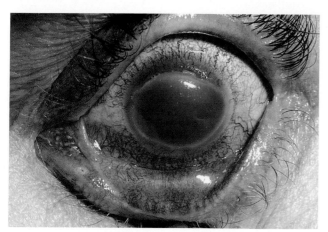

**COLOR PLATE 70** Failed corneal graft. This photograph depicts proper composition for 1:1 magnification (life size on film) external eye photographs. The tiny specular highlights indicate optimal focusing.

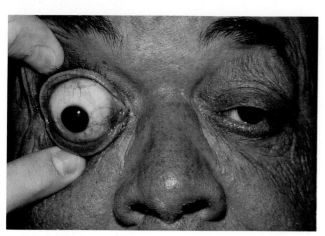

**COLOR PLATE 71** Spontaneous subluxation of the globe. The 1:4 magnification ratio allows for the recording of both eyes together. The composition is symmetrical and includes both temporal orbits.

**COLOR PLATE 72** Adenoma sebaceum in tuberous sclerosis. Standardized facial photography in ophthalmology can be achieved by presetting the lens to a 1:10 reproduction ratio. Studio lighting at a 2:1 ratio was used for this view.

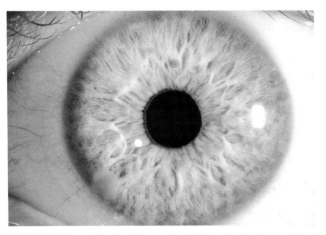

**COLOR PLATE 73** Lisch nodules. When the photo slit-lamp is configured for dual diffuse illumination, overall morphology and color of the subject are effectively rendered.

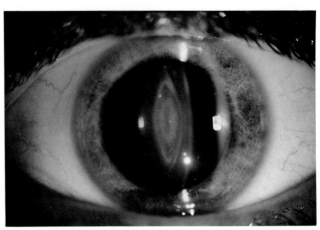

**COLOR PLATE 74** Congenital cataract. The focal, thin-slit beam reveals topographical information about the cataract, while the diffuse background illumination provides anatomical reference points to the subject of regard.

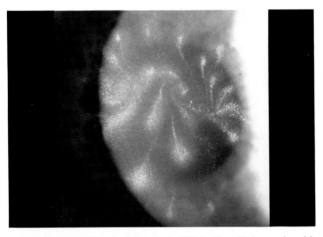

**COLOR PLATE 75** Viral keratitis. When the slit beam is widened and tangentially applied to the lesion, the geographic distribution of the subject is revealed.

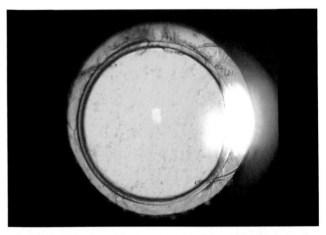

**COLOR PLATE 76** Posterior chamber intraocular lens. By decentering the slit beam and reflecting it off a posterior structure (such as the retina), details of the cornea or lens may be seen in silhouette.

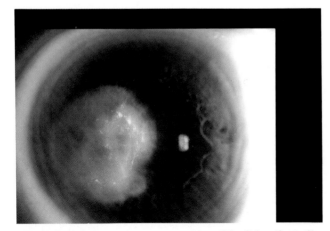

**COLOR PLATE 77** Herpetic stromal keratitis. Sclerotic scatter illumination utilizes the lamellar fibers of the cornea to transmit the incident beam to the opposite limbus. Lesions that interrupt those fibers appear to be illuminated from within.

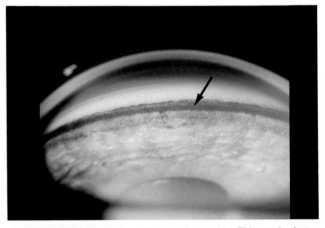

**COLOR PLATE 78** Pigment in filtration angle. This goniophotograph looks from the pupil to the angle and shows the iris plane along the bottom, the structures of the filtration angle (arrow), and the cornea above.

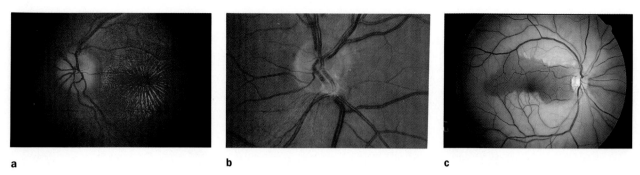

a           b           c

COLOR PLATE 79    (a) Neuroretinitis with macular star figure. The 30° field of view shown here is considered to be the standard magnification for fundus cameras. (b) Glial veil. An angle of 15° is ideal for the recording of optic nerve pathology. (c) Central retinal artery occlusion with cilioretinal artery sparing. When extensive pathology is present, a 60° view can illustrate a wide area of the retina in a single photograph.

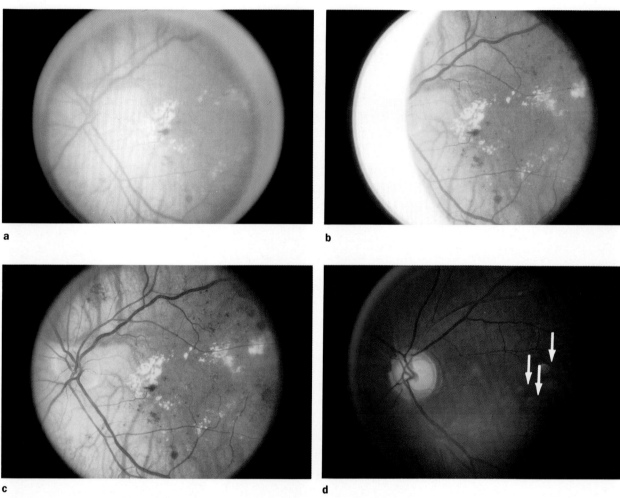

a           b

c           d

COLOR PLATE 80    Fundus camera artifacts. Optimum alignment of the fundus camera requires that the objective lens be centered to the pupil and spaced precisely to the cornea of the subject's eye. If the objective lens is too far away from the subject, a diffuse bluish-gray haze will be seen around the entire periphery of the image (a) and the image itself will appear washed out and desaturated. To remedy this, move the joystick forward slightly. Conversely, if the camera is too close or eccentric to the pupil, a bright orange-yellow crescent (b) will appear at one edge of the fundus image. By increasing the lens-to-eye spacing and moving the camera away from the position of the reflex, this alignment problem may be remedied. When optimum alignment has been achieved, the image will be uniformly illuminated and of deep color saturation (c). Because the aspheric front lens of the fundus camera transmits both the illumination and the image-forming rays, its cleanliness is doubly important to image quality. A dirty object lens (d) may be caused by dust spots (arrows) or tears and is clearly visible to the viewfinder. When this condition is seen, the photographer must stop and clean the lens prior to continuing with the photographic session.

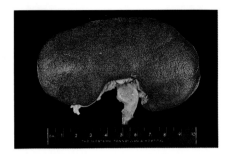

**COLOR PLATE 81** For aesthetic reasons, the specimen should appear centered in the field with relatively small areas of surrounding background. A scale with white numbers on black prevents distracting the viewer's attention from the specimen.

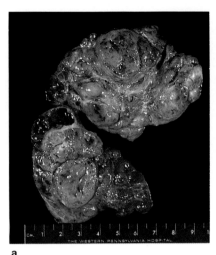

a

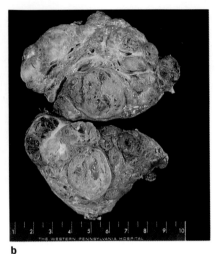

b

**COLOR PLATE 82** (a) A fresh surgical specimen. (b) After fixation for 1 hour in the modified Jores color-preserving solution with additional formalin, the specimen shows more information and can be blotted dry to remove excess moisture.

a

b

c

d

**COLOR PLATE 83** (a–d) The photographic effects of bright color backgrounds cause the specimen to lose contrast and color saturation. Although the dark blue and black backgrounds produced satisfactory photographs, the black background eliminates multiple background shadows from the lights.

**COLOR PLATE 84** (a) Normal balanced lighting tends to diminish the effects of elevations. (b) Elevations can be emphasized to any degree by lowering the spotlight to a position near the horizontal plane for an increased perception of depth. (Brian Dukes)

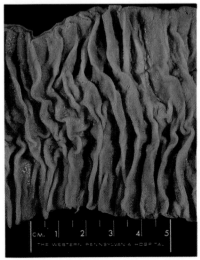

a

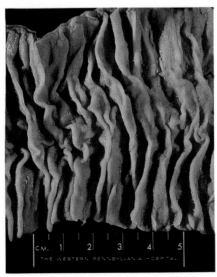

b

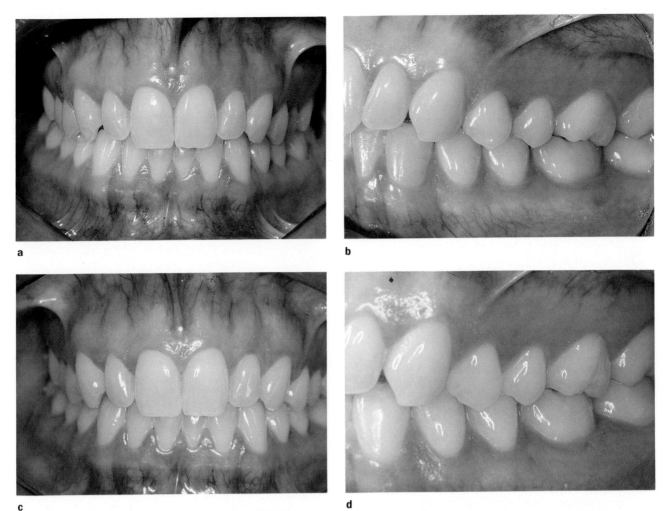

a

b

c

d

**COLOR PLATE 85** Basis for analysis of an intraoral photograph. (a) Frontal view, point flash illumination. Characterization of surface detail is good, but shadowing is present. (b) Buccal view, point flash with ideal illumination. (c) Frontal view, ring flash with good illumination of the vestibule, but flatter lighting. (d) Buccal view, ring flash. The highlights are more extensive and the illumination is uneven.

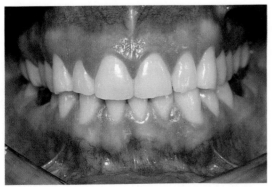

**COLOR PLATE 86** Standard frontal view showing the facial aspects of all teeth in occlusion.

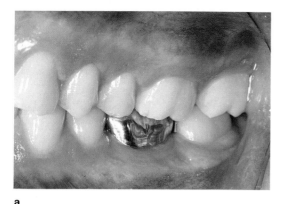

a

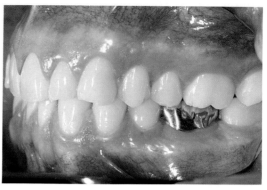

b

COLOR PLATE 87   The right buccal (lateral) view. (a) The cuspid to last molar at 1 : 1.2 magnification. (b) Buccal view at 1 : 1.5 magnification.

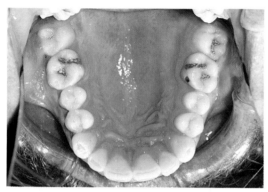

COLOR PLATE 88   Maxillary occlusal view. All maxillary teeth are included, and the mirror image of the occlusal surfaces of the teeth is parallel to the occlusal and film planes.

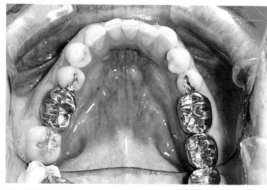

COLOR PLATE 89   Mandibular occlusal view, similar to that of the maxillary view.

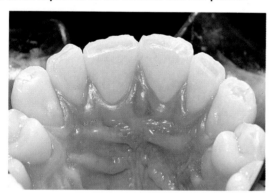

COLOR PLATE 90   Maxillary anterior palatal view, including palatal aspects of the anterior teeth (including the cuspids) with the mirror image parallel to the long axis of the teeth and the frontal plane.

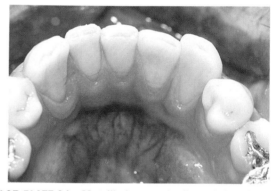

COLOR PLATE 91   Mandibular anterior lingual view (similar to maxillary anterior views).

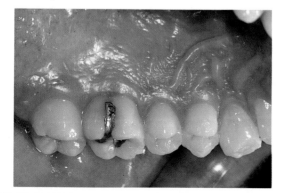

COLOR PLATE 92   Maxillary posterior palatal view, including the palatal aspect of the maxillary posterior teeth.

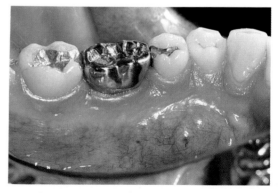

COLOR PLATE 93   Mandibular posterior lingual view. The mechanics are similar to that of the maxillary posterior teeth shown in Color Plate 92.

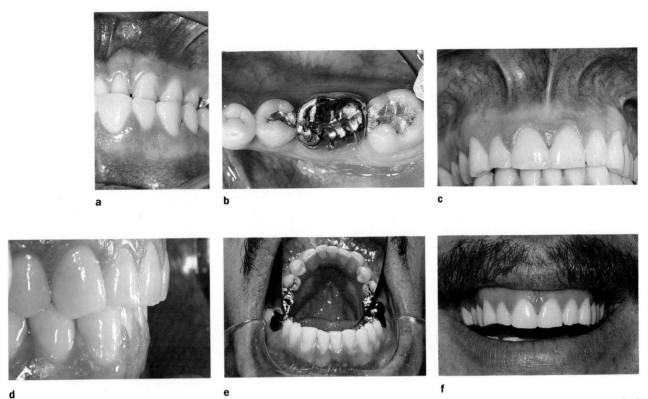

**COLOR PLATE 94** Special views. (a) Vertical orientation with cuspids in center of photograph. (b) Posterior occlusal view at 1:1 magnification. (c) Photograph oriented toward the maxillary vestibular fold. (d) Photograph in focus on the incisor showing tooth profile. (e) Multiple view showing facial, incisal and lingual aspect of the mandibular anterior teeth. (f) Extraoral photograph for esthetics.

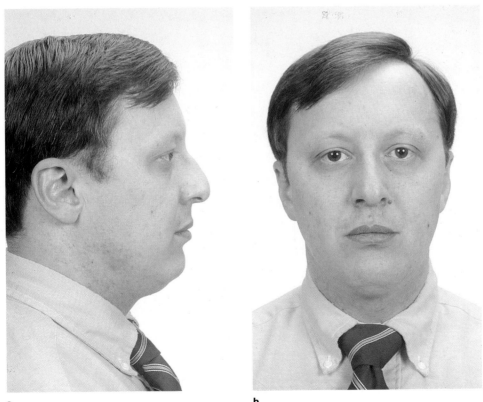

**COLOR PLATE 95** Portrait views. (a) Frontal view. (b) Lateral (profile view). (From Claman, C., et al. "Portrait Photography for Orthodontic patients." *Am J Orthod Dentofac Orthop* 98:197–205)

**COLOR PLATE 96** Photographs in dental specialties showing special techniques. (a) Buccal view of maxillary teeth during periodontal surgery. The retractor (metal instrument) has reflected away the soft tissue allowing visualization of the bone. Suction and use of epinephrine have helped hemostasis. (b) Slightly under-exposed view with 1:1 magnification showing detail in tooth structure of contrast between natural teeth and porcelain restorations. (c) View of several implants. The ring flash has permitted visualization into the threaded fixture (courtesy of Edwin McGlumphy, D.D.S., prosthodontist). (d) View of the buccal (check) mucosa showing an oral lesion (*Lupus erythematosus*). The camera is at 45 degrees to the cheek, eliminating undesirable highlights in the subject area. (e) Technique for retracting the tongue to visualize the lateral border (benign migratory glossitis). (f) Use of the ring flash to illuminate the posterior aspects of the oral cavity (ectopic thyroid tissue). Closer structures are out of focus (d, e, and f courtesy of Carl Allen, D.D.S., oral pathologist). (g) Frontal view with ring flash and optimal retraction showing excellent visualization of the vestibule. (h) Buccal view showing optimal detail in tooth, tissues and vestibule with point flash.

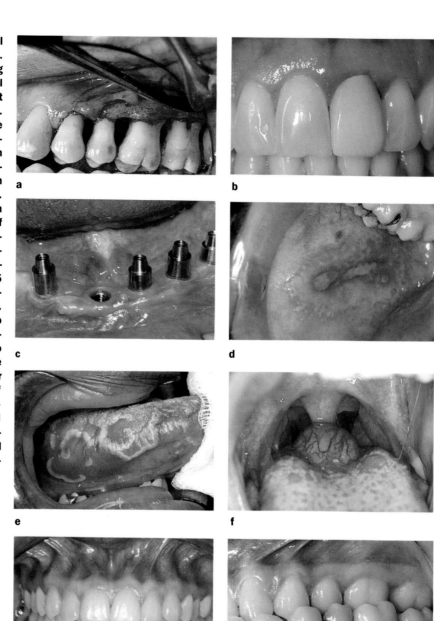

a

b

c

d

e

f

g

h

a

b

**COLOR PLATE 97** Equal magnification frontal portrait views taken with (a) a 35-mm lens and (b) a 300-mm lens illustrate the perspective distortion that occurs in the central portion of the picture. (From Claman, C., et al. "Portrait Photography for Orthodontic Patients." *Am J Orthod Dentofac Orthop* 98:197–205)

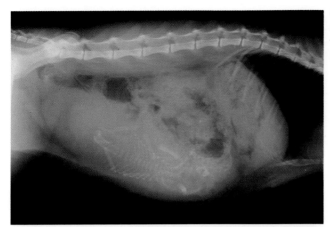

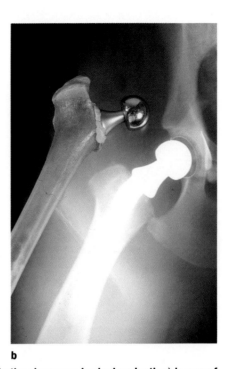

COLOR PLATE 98   Veterinary radiographs, although using the same film sizes and equipment as human radiography, cover a wide range of subject matter. Shown here is a canine lateral radiograph showing a fetal skeleton. (Dan R. Patton)

a

b

COLOR PLATE 99   (a, b) The comparison of two images (usually achieved in the classroom by dual projection) is one of the best teaching methods in medicine. This view of a canine total hip replacement implant, compared to a combined image of an implanted specimen and its corresponding radiograph, transfers more information than the simple sum of its parts. (John J. Swartz)

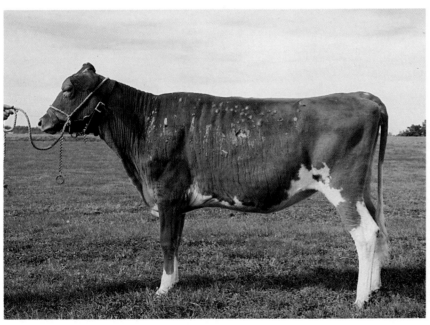

a

b

c

COLOR PLATE 100   (a–c) This series, taken 1 hour after a barn fire at a state fairground, shows burn trauma to a bovine patient. It illustrates the principles of proper orientation, standard positioning, and control of background—all necessary to eliminate distractions. (Dan R. Patton)

COLOR PLATE 101   The bond between people and animals is always a welcome sight and forms much of the public relations photography in veterinary medicine. This bonding has been shown to have medical impact on both animals and their owners! (John J. Swartz)

COLOR PLATE 102   Exotic and avian species, as represented by this injured great horned owl, form a particularly challenging part of the work of the veterinary photographer. (Debi Stambaugh)

COLOR PLATE 103   Even with a species, patients come in all sizes. This comparison between a large draft horse and a miniature horse demonstrates the range of sizes a veterinary photographer may encounter in practice. (John J. Swartz)

b

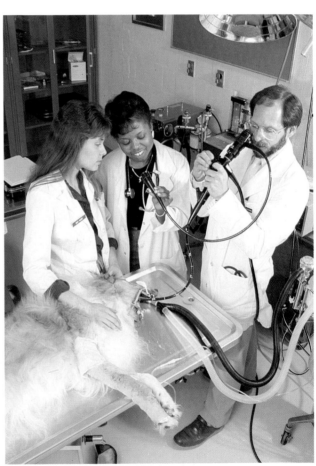

a

COLOR PLATE 104   (a, b) Electronic images captured through the arthroscope and the endoscope are becoming a major tool of the veterinarian. Photographers are called upon to help document these images and to turn them into prints and slides for publication and teaching purposes. (John J. Swartz)

COLOR PLATE 105 The recognition of breeds, such as this prize-winning Charolais bull, is a necessary job skill for the veterinary photographer. This animal, worth many millions of dollars, is a good example of the economic aspect of veterinary medicine. (Dan R. Patton)

COLOR PLATE 106 When restraint of the animal cannot be removed during the photograph, it can be minimized with good positioning and lighting, as in this case. (John J. Swartz)

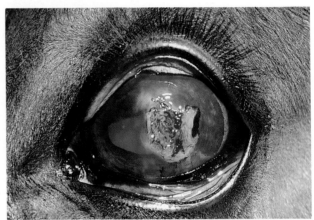

COLOR PLATE 107 This photograph of a corneal ulceration of the eye of a horse demonstrates the high quality that can be achieved through good restraint, proper photographic technique, and an understanding of behavior. (John J. Swartz)

COLOR PLATE 108 A well-equipped and spacious studio, with suitable backgrounds for the photography of small animals, is essential to the efficient practice of veterinary medical photography. Cleanliness is necessary to prevent the spread of disease from animal to animal. (John H. Jewett)

a

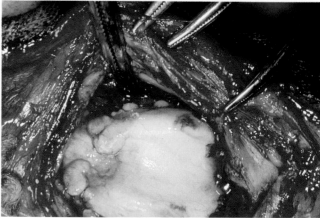

b

COLOR PLATE 109   (a, b) Veterinary surgical photography again emphasizes the necessity of coping with a wide range of subject sizes and patient positionings. This photographer, documenting a canine orthopedic procedure, may well be working deep within the abdominal cavity of a horse within the hour! (Dan R. Patton)

COLOR PLATE 110   Skeletal specimens are usually depicted, as in human work, in a lifelike position or pose. In the case of this snake skeleton, that principle is followed by the photographer in depicting the skeleton in a coiled pose. (Debi Stambaugh)

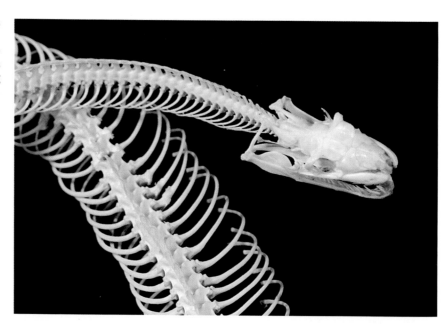

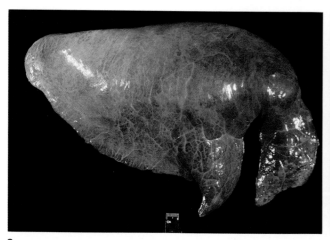

a

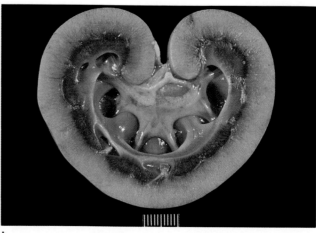

b

COLOR PLATE 111   (a, b) Large gross specimens, such as the organ on the left, require that the veterinary photographer be properly equipped for both their size and weight. Even small gross specimens, such as the kidney on the right, may present problems of proper orientation due to the lack of a single standard anatomical position across the various species. (John H. Jewett)

COLOR PLATE 112 *Streptococcus hemo-lyticus* colonies photographed at 1 : 1 with combined illumination of a low-angle texture light, reflector-fill light, and reflected transillumination.

COLOR PLATE 113 The giant colony of *Penicillium sp.* at 1 : 4 is typical of mold growth. A low-angle light is used to emphasize the texture, while fill illumination softens the shadows in the depressions.

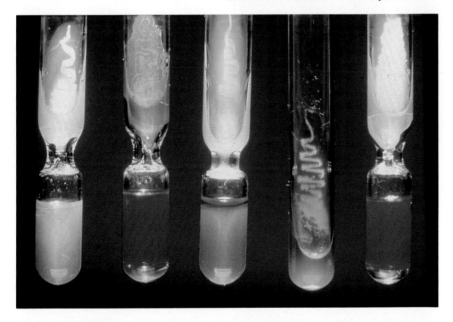

COLOR PLATE 114 Constricted tubes require back lighting to avoid harsh reflections from the angled surfaces. Rear/side lighting emphasizes the brilliant colors.

COLOR PLATE 115 The API strip has 20 cupolas of raised, clear plastic wedded to an opaque plastic base. It is long, narrow, and thin (220 × 30 × 3 mm). The strip is appropriately lit with soft incident light, as shown in Figure 20.8a.

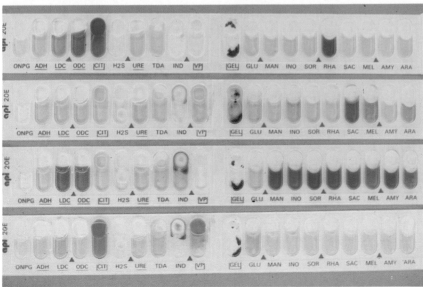

COLOR PLATE 116  The 13-week-old embryo is suspended in water in the specimen chamber (Figure 20.12B). Incident illumination with the Bogen Light Modulator (Figure 20.15A) lights the perimeter of the specimen. The background light port is covered with a blue gel to provide a blue background. The reproduction ratio is 1:4.

COLOR PLATE 117  Shell casings on orange flocked paper inside the C tent (Figure 20.19).

COLOR PLATE 118  A caterpillar occupies a leaf on a small bush in a forest preserve. The Lepp bracket (Figure 20.27) holds the camera and two flash units.

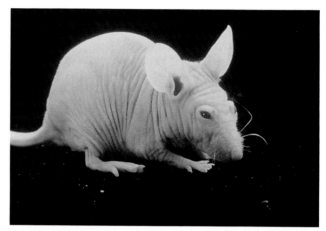

COLOR PLATE 119  The animal tent and pedestal stage shown in Figure 20.29 are used to pose and illuminate the nude mouse.

COLOR PLATE 120  On the left, ×64 magnification of the surface of an autochrome demonstrating the distribution of the colored starch grains and the lamp black in the interstices. Note how the dyes have faded over the years. On the right, the same field under cross-polarization, demonstrating the typical Maltese cross pattern identifying the starch.

mentation. Since all of the recommendations were reproducible on several occasions, the use of automatic cameras certainly can be approached with confidence if a willingness to adapt and modify is manifest. It should be noted that each of the recommendations gives the best exposure in each instance. When bracketing is planned, full stop intervals rarely are ideal. Some guidelines can be offered:

1. For petri dishes:
     for light-colored specimens: +1, 0, and −1
     for dark colors: 0, + 1/2 and +1
2. For test tubes: bracket by 1/2 exposure correction unit
3. Tent and C tent: bracket by 1/2 exposure correction unit
4. Transillumination: bracket by 1/2 exposure correction units
5. Darkfield illumination: This causes greater problems because autoexposure depends largely on the relative area of black field compared to how much of the field is filled with the glowing specimen. Only experience will provide the best guidelines.

## EQUIPMENT AND MATERIALS

### Introduction

Too often the photographer assumes that camera, lens, film, and lights are all that are required to document any medical object. In reality, two other features make the difference between a vague representation and a photograph loaded with meaningful information. *Staging* involves positioning the subject in such a manner that the visual information is apparent and no distracting elements are in the field of view. Proper staging also takes into consideration placement of the specimen so that the light path is unimpeded. *Lighting* is the second essential feature for meaningful photographs of small medical objects.

In order to control staging and lighting, special equipment is often required. This section will describe and illustrate the construction of such photographic aids, while the main body of the chapter will emphasize preparation of the specimen, staging, and lighting, as well as any precaution or special consideration unique to the specimen.

### Cabinet-Mounted Photographic Stand

Many photographers prefer to use a standard copy stand to photograph small medical objects. While this procedure may suffice on rare occasions, it is far better to make a stand specifically for photography of small medical objects. What is needed is a table or cabinet 18″ to 20″

high. In order to accommodate a variety of holders and specimens, the table top should be at least 36″ wide and 30″ deep. The top of the cabinet can support the camera stand and any other accessories to hold the specimen so that it may be illuminated at any angle from above or below. A taller stand facilitates use of longer-focal-length lenses to provide the appropriate perspective and a full view of compartmentalized objects, such as a microtiter plate.

The cabinet should be fitted on top with a 4 foot to 5 foot tall stand, bolted to the top at the rear edge, halfway across the table (Figure 20.32). The camera holder should be movable, both up and down, as well as front to rear. Three 1/4-20 threaded inserts should be screwed into the table top: one 2″ in front of the stand, as well as one each at the back corners, 3″ in and 4″ from the side edge. These are valuable in securing poles to hold gobos and reflectors.

It is wise to consider building more than a table by fitting the under portion with shelves or drawers. This storage space for accessories has proven invaluable in making readily available masks and reflectors, as well as poles and clamps needed for small-object photography, items that were always deposited and forgotten all over the studio before the cabinet was built. After a few weeks of use it became apparent that uncontrolled reflections were coming from the light color of the unpainted wood. Since then, all cabinets and other wooden accessories have been painted flat black.

This cabinet and stand can be used for most fairly flat specimens for which a view from above is required. When a three-sided perspective is necessary, the cabinet top can still be used, but the camera should be on a tripod in front or to the side of the cabinet.

### Pole and Clamp System—An Extra Pair of Hands

Obviously, assistance is not always available, so if one needs to have a gobo or a reflector in a specific position, it would be helpful to have a system that would satisfy these functions without calling on an assistant. The system described herein is very effective, but commercially available systems (Grip-it[7], Climpex[8]) may function equally well. Figure 20.3 illustrates the poles and clamps in use, and Figure 20.33 shows diagrams of each component.

The poles were made of stainless steel 3/8″ in diameter. Some were 5″ long and others 13″ long. One end of each rod was milled to produce a 1/2″-long 1/4-20 threaded bolt. About half of these rods were milled at the other end to form a 1/4 × 1/4″ rectangle, 1/2″ long. The other half of the rods were ground out on the end opposite the bolt to accept a 1/4-20 threaded bolt. Having rods with a bolt on one end and a receptacle on the other permitted connection of the rods to produce poles 26 or 39 inches long.

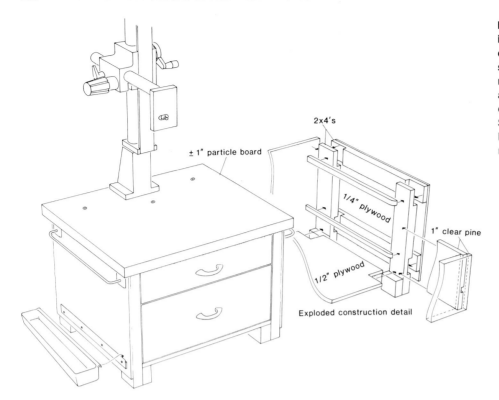

± 1″ particle board

2x4's

1/4″ plywood

1″ clear pine

1/2″ plywood

Exploded construction detail

**FIGURE 20.32** The photo cabinet is designed to be low enough to support various stages and lighting equipment required below the specimen, and yet have the camera at a comfortable working height. Storage drawers are built in to hold the variety of routinely needed equipment.

Sometimes a specific pole height was needed. To achieve this, an additional holder was required. Figure 20.9a&b shows a 5/8″ stainless steel pipe with a 3/8″ internal diameter in both 12″ and 7″ lengths. The bottom has an attached base with a 1/4-20 threaded bolt, 1/2″ long. Two inches from the top a perpendicular hole was drilled, and a 3/8″ pipe, 1 inch long, was welded over the hole. The interior of the little pipe was milled to accept a lock bolt. In practice, one of the 5″ or 13″ poles was inserted into the holder and locked in place at the desired height as in Figure 20.9a and b.

An accessory platform was often needed at the top of

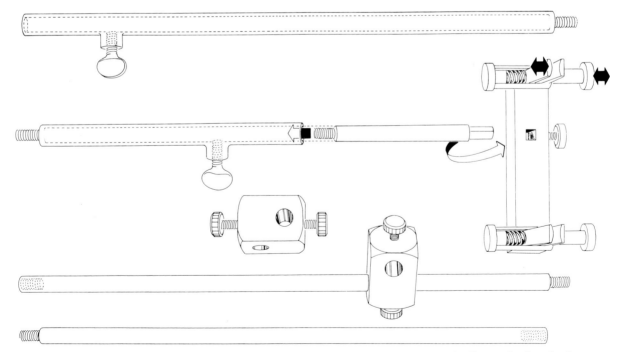

**FIGURE 20.33** The components of the pole and clamp system for positioning gobos and reflectors is given in diagrammatic form. See the text for statistical information.

the pole. A 3/4″ board 4 × 4″ was drilled in the center of the underside and fitted with a 1/4-20 threaded insert. Velcro strips (3/4 × 2″) were glued and stapled to each corner of the top surface (Figure 20.9b).

The clamps (Figure 20.33) were milled from stainless steel bars 1/2 × 1/2″ × 1′ long. Holes 7/16″ in diameter were drilled through the bars. The center of each end was milled to receive a small bolt that could be tightened to secure an inserted pole in place. The corners and edges of the clamps were rounded as a safety precaution.

In practice, the bolt end of a pole could be screwed into the threaded insert in the photo cabinet top. (*Note:* A 3/4″ washer should be used between the threaded insert and the pole to assure a tight, perpendicular attachment.) Figure 20.1 illustrates the pole and clamp in position to provide reflected-fill illumination, while Figures 20.3a,b shows the system used to produce axial illumination. In each instance a spring-clamp holder is being used.

The spring-clamp holder (Figure 20.33) was constructed by soldering two spring clamps (used to clamp rubber tubing and available from laboratory supply houses) to a brass bar. The bar was notched on one side to accept the rectangular tip of one of the poles. A small bolt on the side, perpendicular to the hole, was used to lock the pole in place. (*Note:* The retaining bars of each spring-clamp should be coated with black latex or covered with black tape to avoid reflections and to secure the reflector cards or glass sheets firmly while preventing scratches on the glass.)

## Petri Dish Holder

The purpose of the holder is to position a petri dish so that texture, fill, and back illumination can be achieved from a single light source. Figure 20.34 offers a diagram of the components. A 6″ cylinder was cut from 95-mm diameter Lucite clear tubing (called Perspex in some parts of Europe). It was capped with an opal plastic disc to serve as a diffuser. The bottom of the cylinder was fitted with an aluminum foil-lined black wooden disc. Usually this unit was placed on top of a 90-mm diameter tin can, painted black. A 95-mm black wooden disc was screwed to the top of the can. Figure 20.1 shows the can and cylinder assembly placed on top of a 14 × 10″ black velvet card. The topless petri dish was set on top of the opal plastic top of the cylinder.

## Test Tube Holder

A practical holder for tubes should present them free of shadows and position them in front of a suitable background. It should also facilitate lighting. Attempts to secure tubes to plate glass or tape them to rods or slats of wood usually result in unwanted reflections or shadows.

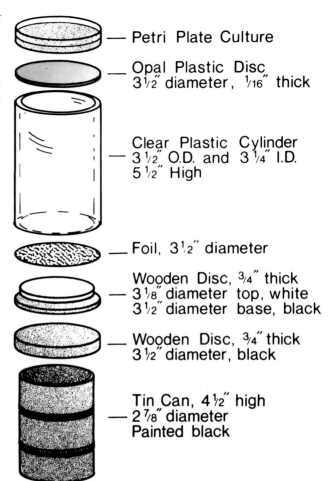

**FIGURE 20.34** The plastic cylinder stage has the petri dish culture on top of the opal plastic diffuser disk. A foil reflector is on the bottom of the cylinder to provide transillumination.

— Petri Plate Culture

— Opal Plastic Disc 3½″ diameter, ¹⁄₁₆″ thick

— Clear Plastic Cylinder 3½″ O.D. and 3¼″ I.D. 5½″ High

— Foil, 3½″ diameter

— Wooden Disc, ¾″ thick 3⅛″ diameter top, white 3½″ diameter base, black

— Wooden Disc, ¾″ thick 3½″ diameter, black

— Tin Can, 4½″ high 2⅞″ diameter Painted black

At the same time, it is necessary that the holder secure the tubes so that none of them can drop and break because hazardous contents are frequently present. Since the tubes often contain liquid or a soft gel, they must be maintained in a vertical position. Tubes with solid contents are safe in a horizontal position. It is very unlikely that acceptable photographs will be produced when such tubes are placed on the base of a copy stand. With a light background, harsh shadows appear on each side of the tubes, and with a black background the contents take on a dull gray appearance and the strong reflections of the light source can be seen on the glass.

The tube holder shown in Figure 20.5 is constructed of clear plastic so as to cast little or no shadow on the tubes. While its brush-retention feature appears difficult to fabricate, it has the advantage of firmly holding any combination of tubes of varied diameters erectly and with even spacing. As shown in Figure 20.5b, the tubes are held snugly by the brushing while the opposing notched reversible plate aligns the tubes at a fixed distance from

each other. The front and back support brackets are cemented to the side-end pieces, which have been bored underneath in the center, with holes to accommodate the support poles of the base support unit.

The base support consists of a piece of 5/8" plywood 14 1/4 × 14 1/2", to which 5/8" boards 2 1/2" wide are attached on top, both front and back, with screws to form thin ledges. Into the front ledge two holes should be bored 13" apart 3/4" deep and of a diameter to fit the metal poles used to support the plastic tube holder. On the back side of the rear ledge should be attached a spring clamp 1/2" from each side edge. Finally, a 1/4-20 threaded insert should be screwed into the bottom center of the base unit. In order to avoid unwanted reflections, the base unit is painted flat black.

## Aristo Light Box Holders

In order to illuminate flat specimens with darkfield using an Aristo light box or to photograph the bottoms of microtiter or similar trays, a holder for the box is required. The simple holder seen in Figure 20.9b,c is practical yet compact. It can be disassembled for storage to a packet only 11 × 14 × 2 1/2". The base is a piece of 3/4" thick plywood or pressed wood 14 × 11". Three-quarter inch holes should be drilled in each corner 3/4" in from the long as well as short sides. A piece of 11 × 14" pressed wood or masonite 1/8" thick should be glued or tacked to the underside. Four dowel rods 8" tall and 3/4" in diameter serve as support units. Thin slits 3/4" long cut into the middle of the top as well as bottom of each dowel will assure easy insertion, as well as a snug fit.

The two top-end units are made from 3/4 × 2" boards, 10 5/8" long. A 3/4" hole should be drilled 13/16" from each long end and 3/4" in from the narrow side. A cap of 1/8" masonite should be glued to the top of each end unit. Retainer sides and backs for the end units were cut from masonite strips 1/8" thick and 1 1/2" wide. They should be glued and tacked to the rear and side edges. All of the components should be painted flat black.

For photographing the bottoms of trays, slight modifications should be made to the holder or an additional, altered holder, could be constructed. Modifications include:

1. Make the dowel poles 10" high.
2. Attach a 1 × 14" strip of masonite or pressed wood 1/8", thick to the front of the base board so that it rises 1/4" above the level of the base. Similar strips should protrude 3/4" inward from the bottom of each of the top-end units. (Be careful not to cover the holes for the dowel poles.) All components should be painted flat black.
3. A sheet of masonite or pressed wood should be cut to fit inside of the holder, as shown in Figure 20.11a.

The entire sheet should be painted flat black. Velcro strips (3/4 × 2") should be glued to the front of this panel 2" from the top and 1 1/2" from each side. The companion Velcro strips should be glued on the rear top edges of an 8 × 10" front surface mirror. The completed unit is illustrated in Figure 20.11b.

## Diffusion Materials and Diffuser Holder

Almost any translucent material can be used as a diffuser. These include: spunglass, fiberglass cloth, tracing paper, vellum, denril, drafting film, thin sheet styrofoam, opal plastic sheeting, Strathmore paper, and nonrip nylon. Additionally, high-quality Rosco[9] diffusion products include: tuffspun, tuffsilk, tuff frost, lite frost, and heavy frost.

The diffusion material placed in front of the light source softens the shadows and reduces glare of reflections, but it cannot be expected to eliminate all shadows and reflections. Often diffusion materials are conveniently taped or clipped to the lights or barndoors. More effective and controllable diffusion can be achieved when movable holders position the diffusers between the objects and the lights. Diffuser holders are commercially available but are costly and usually too bulky for small object work. Figure 20.22 provides a diagram of a simple, compact, and inexpensive holder (17 × 1 × 1/2" strips of wood and 18" lengths of 3/16 or 1/4" doweling). Velcro strips, glued and stapled to the inside of the wood strips, are used to hold the diffusion material. Of course, companion Velcro must be sewn or glued to the corners of the diffusion material. As shown in the diagram, the inner sides of the wooden strips should be drilled to produce holes equal to the diameter of the dowels. Further, the dowels should be slit with a jig or band saw 1/2" on each end to assure easy penetration of the holes, as well as a snug fit. The underside of the bottom strip of wood should have a 1/4-20 threaded insert placed in the center. This insert can accept a tilt-top to allow positioning the diffuser at any desired angle. This is illustrated in Figure 20.24.

Table 20-4 provides information to assist in a choice of diffusion material. It is apparent that diffuser density is not necessarily directly related to the diffusion material's ability to soften shadows or reduce reflection. Also, it should be noted that many common products frequently used to fabricate tents, diffusers, or reflectors either absorb part of the blue rays or reflect additional yellow rays, making compensatory filtration desirable or essential.

## Wraparound or C-Tent

Curved paper reflectors open to the front have long been advocated for convenient soft lighting. Usually they are

**Table 20-4  Rank Evaluation of Diffusion Materials**

| Product | Diffuser Density[a] | Softening of Shadow Edge[b] | Shadow Contrast Reduction[c] | Reflection Contrast Reduction[d] | Comments |
|---|---|---|---|---|---|
| Strathmore paper | | | | | |
| Double strength | 1 | 1 | 3 | 1 | CC5Y shift |
| Single strength | 2 | 3 | 6 | 3 | |
| 2½-mm opal polyethylene | 3 | 2 | 11 | 4 | CC5Y shift |
| Fiberglass cloth | 4 | 9,10 | 1 | 12 | CC5Y shift |
| Rosco Tuff Frost | 5 | 4 | 5 | 11 | |
| Fiberglass sea cloth | 6 | 11 | 4 | 5 | CC5Y shift |
| Vellum, denril, and tracing film | 7 | 7,8 | 10 | 7 | CC10Y shift |
| Tracing paper | 8 | 5 | 13 | 2 | |
| Rosco Tuff Spun | 9 | 9,10 | 9 | 13 | Uneven |
| Spun glass | 10 | 6 | 2 | 8 | Mottled |
| Rosco Heavy Frost | 11 | 7,8 | 7 | 6 | |
| Rosco Lite Frost and Dbl Nonrip Nylon | 12 | 12 | 12 | 9 | |
| Rosco Tuff Silk and Sgl Nonrip Nylon | 13 | 13 | 8 | 10 | |

[a] Diffuser density = no diffuser EV minus diffuser EV.
[b] Softening shadow edge = differ mm reduction of shadow compared to shadow length without diffuser.
[c] Shadow contrast reduction = EV diffused shadow/EV diffused light.
[d] Reflection contrast reduction = EV of diffused reflected light divided by EV of diffused light.

designed as needed and constructed somewhat differently each time. Figure 20.19c illustrates such a tent, but it can be assembled in a few seconds and broken down and packed away just as quickly. Figure 20.19b provides a drawing of the component parts. Note that the wooden sides composed of plywood, as well as 1 × 4″ and 2 × 4″ boards, form the framework to which the paper sheeting of the tent can be affixed with Velcro. A single light entering at the front lower right should be directed to the upper left corner. The barndoors must be adjusted to assure that no direct light hits the object. While the wooden parts were painted flat white, it was noticed that the reflected illumination shifted about CC10Y, so a corresponding CC10B filter was used for correction. With a little effort the wood could be painted with a product providing full color reflection; however, the *Strathmore* double-strength paper used also absorbed blue light, requiring at least CC5B filtration. Note that this unit is not limited to a white background. Black or colored flocked paper and either Colorvue or Coloraid paper sheets (20 × 20″) placed in the bottom of the tent gave exciting color to the background with even lighting (Color Plate 117).

## Softlight Sweep

A sweep with illumination from beneath becomes a form of transillumination. When this is coupled with soft lighting from above, the photographer can achieve even, shadowless illumination with a minimum of glare. Figure 20.25a illustrates the use of such lighting and Figure 20.25b diagrams the modifications made to a standard opal plastic sweep to accomplish the task. The wooden stand supporting the sweep was lowered for working convenience. The frame also supported a white sailcloth reflector above the sweep to provide soft bounce light down onto the object.

## Liquid-Containing Specimen Chambers for Photography

Obviously, thick glass or plastic vessels are inappropriate since they are likely to reduce image quality, therefore, thin, white, high-quality glass would be more desirable. These recommended properties can be found in 3 1/4 × 4″ glass slides, formerly in common use for preparation of lantern slides. Single-strength, clear glass from most glass suppliers is adequate and can be precut to appropriate size. Sides should be bound edge to edge and to the bottom piece with *Dow Corning Sealant* or an appropriate substitute. To maintain shape of the chamber, transparent tape was placed over the outside of each corner as soon as the sealant was applied. The tape was removed in an hour or two. Figure 20.12b illustrates the chamber and its component parts. Chambers were made for a variety of uses including electrophoretic gels, tiny gross specimens, and gel-like aquatic animals. The size of the chamber should be an inch or two larger on all sides than the specimen. The height is also dictated by the elevation of the specimen. The surrounding liquid should cover the specimen by a few millimeters. For flat gels the height of the chamber should be about 1 inch. A similar tray was described in 1987 by Ogrodnick.

## Polyacrylamide Gel Disc Electrophoresis Specimen Chamber

While this electrophoretic procedure has largely been replaced by slab-gel electrophoresis, some laboratories still use the technique, so the photographic chamber and its accessories are presented here.

**Holder for Cylinders.** Figure 20.13 illustrates a clear plastic tray of 3/8″ stock cut to a 14 × 19.6 cm rectangle. Six 7-mm-wide and 7-mm deep troughs were routed out to a length of 15.8 cm. This tray could hold six gels. The top was painted matte-black to serve as a permanent mask around the troughs.

**Glass Rods.** Stock 3/8″ in diameter was cut into 15 cm lengths, and the ends were ground to remove sharp edges.

**Storage Wallet.** Because it was easy to scratch the chamber or the rods, a flannel pocket was made into which the chamber fit snugly. The flap-cover to the wallet had a second piece of flannel sewn to it to form a series of eight narrow chambers large enough for insertion of the rods. The cover was attached at the top of the chamber pocket, and the other end of the cover gripped the bottom of the pocket with Velcro fasteners.

## Portable Stage

Most photomacrographic units have limited potential for backlighting tiny specimens, particularly when the specimen is to receive incident light as well. Figure 20.35 diagrammatically shows a simple and inexpensive box, which is both a stage and a source of white or colored transillumination for small specimens. The prototype was made of Crescent board and 3 1/4 × 4″ glass slides (Figure 20.36). Subsequently a unit was constructed from sheet metal and was equally effective but more sturdy. The reflector was made from foil mat board. A diffusing material (Technifax drafting film P3MA #420207, 3mil) was glued to the underside of the glass stage, and another piece of the film was attached to the back of the box opening. A tensor lamp set to the high position was placed 1/2″ from the front of the box. The tensor lamp was rated 120 volts 0.25 amps with a #93 25 watt bulb. Roscolene gels served as filters on top of the stage. The color temperature through the diffusers was 2729 K. With saturated color filters the color temperature of the light source was irrelevant; however, when white light backgrounds were desired a 80D filter was placed in front of the diffuser at the opening of the box to bring the transillumination to 3100 K. A second glass slide on top of the filter gel was used to hold specimens. In most instances the specimens were placed directly on top of the glass slide. In a few situations plasticine or stickum

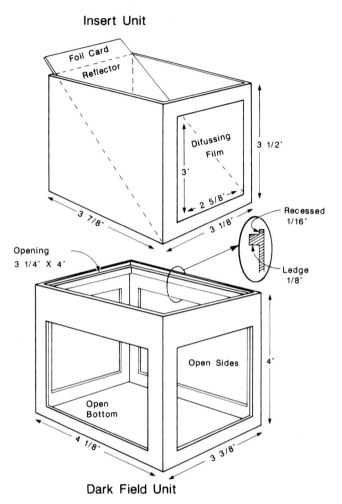

Insert Unit

Dark Field Unit

**FIGURE 20.35  Specifications for a small, portable specimen stage. The outer frame, shown on the bottom, was painted black and is open on the sides, as well as top and bottom. It is used for darkfield illumination. The inner frame, shown on top, provides an illuminated white or colored background.**

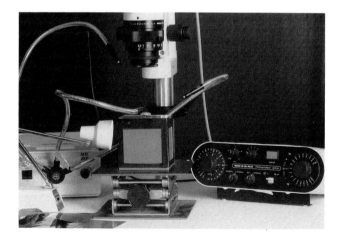

**FIGURE 20.36  The portable stage, placed on a labjack, was illuminated by a tensor lamp in the high position. The fiber-optic cables provided incident lighting on the specimen. Fine focusing was usually accomplished by moving the labjack up or down.**

was used to prop a specimen in an appropriate position. The outer chamber, also seen in Figure 20.35, was open on all sides so that fiber-optic units or light pipes could be positioned to provide darkfield.

### Laboratory Animal Tent

Photography of laboratory animals is complicated by two major problems: (1) hyperactivity of the animals, and (2) difficulty in evenly illuminating animals with white, black, or spotted—white and black—fur. The solutions for these problems are simple enough but require construction of appropriate aids.

**Turntable Platform Stage.**   Most laboratory animals are acrophobic, therefore, elevating them four to eight times above the body height usually discourages them from jumping from the stage and running away. A platform stage only slightly longer than the body length limits movement to squirming in circles. Finally, a turntable at the bottom of the stage platform can be used to reposition any squirming animal.

A 5″ in diameter wooden disk of 3/4″ plywood was attached by flange and pipe construction to a turntable which, in turn, was affixed to a 12″ disc base as shown in Figure 20.28. The 15″ pipe was interchangeable with others of 10 or 6″ when a lower stage was required. Three sizes of interchangeable stages were made (5, 8, and 15″ diameter). The 8 and 15″ discs also had a flange on the underside for rapid attachment to the pipe stand. Black velvet booties of appropriate diameter were made with elastic around the perimeter to hold each velvet cap securely to the respective disc. The stage could be rotated 360 degrees so that the photographer could move the stage as needed to keep the animal in a suitable position. Figure 20.29 illustrates the stage ready for use.

**Animal Tent and Table.**   While tents have been used for many years to reduce shadow and reflection, as well as contrast, this tent was altered in concept by placing the lights inside the tent to deflect about 10% of the light to the front of the animal, and the remainder bounced about the interior of the tent to give even fill illumination. Figure 20.28 shows a diagram of the components while Figure 20.29 illustrates the unit. The 18″ long galvanized pipe legs offered a convenient working height. The scaffolding system supported the box tent, which was fabricated from sailcloth. The wooden interior of the tent was painted flat white. The pedestal stage was bolted to the floor of the tent table.

### Lighting Chamber for Autoexposure Cameras

Incident lighting with multiple flash and off-the-film-plane exposure is simple enough to achieve; however,

darkfield and transillumination present a greater challenge. The lighting chamber, described herein, addresses this problem and is shown in Figure 20.31. The base holds the box, as well as 1/4-20 bolts to position tilt-tops and flash units appropriately so as to direct the light of each flash to the opposite side/floor interface. While the exterior was painted flat black, the interior of the box was constructed of white plastic-laminated masonite. The interior frame work and floor were painted flat white. The top has a 3/4″ ledge all around the interior. The masonite walls extend above the shelf by 1/8″ to form a retaining wall. The top shelf served to support sheets of glass, specimen holders, or masks. A 1/4-20 threaded insert was in the center of the box floor.

### Tents for Small Object Photography

Simply stated, tents are translucent materials surrounding an object to be photographed. An opening is strategically placed as a window through which the camera can view the subject. While for larger objects, such as a series of surgical instruments, a commercially available tent is recommended, for tiny medical objects a little more ingenuity is appropriate. A variety of simple materials can be used to fabricate a tent, and Figure 20.18 illustrates the relative size and shape of such tents. Styrofoam and plastic cups, plastic jars and bottles, plastic pails and specimen containers make excellent tents for vertical work. Once the bottom has been removed, the tent can be inverted over the object to provide adequate view of the field. Plastic sheeting, vellum, and translucent paper such as tracing and typing paper or even Strathmore single- or double-strength paper can be used to construct cones or pyramids with the apex cut away or portion of the side opened. It is important to note that most of the materials listed above are not pure white, so they may absorb some portion of the spectrum. As a general rule, blue rays are removed so that it is often necessary to correct the color by use of a CC5B of CC10B filter.

### Masks

When light boxes are used, peripheral, extraneous light should be eliminated with a mask. A pair of simple L-shaped masks (made from black construction or Crescent paper) often can be placed in apposition to form masks of varied size. For use with the Aristo light box, however, more sturdy masks are recommended.

**Peripheral Masks.**   Basic masks and specimen holders should be cut from solid black mat board, but the board must be heat-matted on both sides. Masks 10 1/4 × 12″ will slide into the slots of the light box. The inner opening should be 4 × 6″.

**Specimen Holders.** One needs to hold the specimen securely and yet make certain that all of the contents are revealed. To ensure that the specimen cannot slip through the opening in the mask, peripheral ridges should be glued around the opening, thus preventing the tray from moving more than a millimeter in any direction. The outer dimensions of the holder should be cut 5 × 7″. The opening should be 4 mm smaller than the tray. Each specimen holder should be custom-fitted, however, since specific trays and plates produced by a given manufacturer are identical in size, once these masks are made, they can be used over and over again. The peripheral retaining ridge for a specimen holder should be made of 3-mm-wide strips of the same mat board glued to the mask about 2 1/2 mm in, so as to surround the opening. A few examples of internal openings and retaining ridges for specimen holders will make this more understandable:

1. Petri dish:  Opening—95 mm diameter
   Retaining Ring—I.D. 100 mm; O.D. 105 mm
2. Microtiter tray:  Opening—115 mm × 75 mm
   Retaining rectangle—Inner, 120 mm × 88 mm
   —Outer, 126 mm × 94 mm
3. Microscope slide:  Opening—70 mm × 20 mm
   Retaining rectangle—Inner, 77 mm × 26 mm
   —Outer, 83 mm × 32 mm

*Note:* Should cuts be less than clean, the edges of the holder can be filed with an emery board to provide a smooth surface.

## Background and Reflector Cards

**Background Cards.** When any background card is used over a period of time, it will become tattered or soiled and need to be replaced. It is, therefore, a good idea to record the color designation or catalog number on the bottom edge of the card so that the exact color can be reproduced for a background. The cards used in the work reported herein were cut from Crescent board.

**Test Tube Backgrounds.** Experience has shown that backgrounds for test tube photography are best limited to fairly neutral colors. Black, gray, and white are always acceptable. In addition, medium blue and beige have been used with some success. The size is usually 15 × 15″.

**Aristo Light Box Backgrounds.** A wide variety of colors for backgrounds is not only acceptable, but desirable. Boards cut 10 1/4 × 12″ will slide into the slots of the box. Materials which have worked well include Crescent board, flocked paper, and paper with printed color

such as Colorvue and Coloraid. Crescent board is thick and stiff enough to hold most specimens, however, the other products mentioned are papers and need to be placed over a board in the box if they are expected to support the weight of a specimen.

**Black Velvet for a Variety of Backgrounds.** For petri dishes, test tubes, the Aristo light box, the animal tent, as well as darkfield baffles, black backgrounds are often required. In addition, one may wish to use a black velvet card as a gobo. Often a photographer prefers to drape black velvet as needed, however, when specific sizes are repeatedly required, there are advantages to cutting a matboard card to the specific size and draping the velvet over the card, cutting it 2 inches longer than the card and stretching it tightly before taping it securely across the back. Storage, as well as use, are facilitated and wrinkles never occur. If pressure marks or lint appear, it is an easy enough task to comb them away with a velvet brush.

**Tent Backgrounds.** Usually the curved surface of a tent or sweep requires a flexible background. Velvet, flocked paper, or paper with printed color all work well. The paper should be no larger than is required to fill the photographic field, since reflection from the white surface all around the tent is the desirable function and the purpose for using the tent.

**Reflector Cards.** Generally speaking, reflector cards are usually white, light gray, or foil, however, for planned color casting or color accent reflections, bright colors can be desirable. Matboards, cut to proper size, have proven effective. It is possible to find matboards with a gold or silver foil coating, but if these are not available, foil can be taped to a piece of matboard to produce a satisfactory reflector.

**Card Holders.** At most well-stocked photographic supply stores, one can find flat-jawed clamps with dimensions of about 1 1/2 × 3″. The other end is usually fitted with a receptacle for a 1/4-20 threaded bolt, thus it can be attached to a tilt-top. All of these units have a smooth surface so that reflectors, gobos, and glass eventually slip out of position or even fall out. Sheet rubber can be purchased at most hardware stores and sometimes can be found with a textured or rough surface. This can be glued to the inside of the jaws with the roughened surface out. This adaptation has been efficient in holding cards and even large sheets of glass.

## Holders for Lengths of Velvet Drapes

Often taping or tacking up a length of velvet is not desirable. Whenever it could be hung from a stand as a freestanding unit, the following accessory will be of great help. A board about 2 inches longer than the velvet should be cut from 1 × 2″ stock and painted jet black. A

1/4-20 insert should be fixed to the center point of the bottom of the board. Velcro should be glued and stapled every 12″ along the side of the board. Corresponding Velcro should then be sewn at equal distances along the inside (not the textured side) of the velvet. In use, the board can be attached to a tilt-top by way of the 1/4-20 threaded insert. The tilt-top should be connected to a light stand and positioned to whatever height and angle is required. The velvet can be attached to the holder with the Velcro fasteners. This system also works quite effectively in hanging out the wrinkles that sometime develop in velvet that has been folded and stored for some time. When hanging does not remove the wrinkles, the suspended velvet can be stroked with a velvet steamer, which immediately eliminates wrinkles.

### Holder for Insects and Similar Small Specimens

Hobby shops and electronic shops often stock a small stand with articulated arms and alligator clips, which is particularly useful in presenting small biological specimens to the camera. To facilitate this, one can also find at art supply stores 2-inch-long T pins. When these are painted flat black, they are ready to use in securing the specimen with the point. The T end can be locked in the alligator clip of the holder and the arm moved and locked to position the specimen as desired. Such holders are available with two or three arms, making it easy to compose a scene with several specimens in appropriate relationship. This holder has also been used to place a millimeter rule in a position adjacent to a small specimen.

### Direct-Read Ruler to Establish Compensation for Magnification

When specimens at magnifications in the range of 1× to 10× are photographed at the exposure prescribed by a hand-held incident-light meter, the film will be underexposed by several stops. The extent of this error and the compensation of additional exposure to correct the error is illustrated in the following example. At 6× magnification and a meter reading of $f/22$ at 1/8 second, complex calculations show that the lens must be opened an additional 5 3/4 stops. With this compensation, our actual setting of the lens and camera would be 1/8 second at a little more then $f/2.8$ or 1 second at a little over $f/5.6$.

This task can be simplified, however, with the use of a direct-read ruler, such as shown in Figure 20.37. It should be held at the subject plane so that the arrow can be seen in the camera viewfinder at the left edge of the field. The exposure correction can be read directly from the top row at the right edge of the field. The magnification and working distance can also be read from the ruler at the same time.

### ENDNOTES

1. Aristo Grid Lamp Products, Inc., 65 Harbor Road, P.O. Box 769, Port Washington, New York 11050.
2. Macbeth Color and Photometry, P.O. Box 950, Little Britain Road, Newburgh, New York 12550; tel. (914) 565-7660.
3. Saunders, 21 Jet View Drive, Rochester, New York; tel. (716) 328-7800.

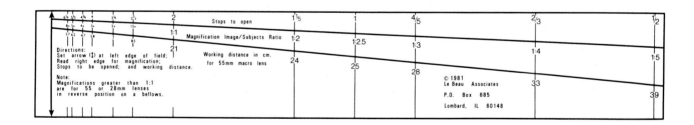

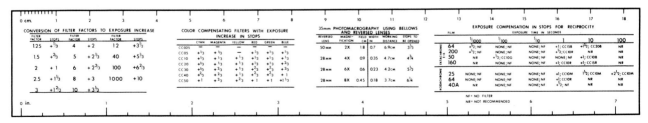

**FIGURE 20.37** The direct-read exposure compensation ruler indicates the allowance in f-stops to be made for image:subject ratios of 1:5 to 8x. When the rule is placed over the field so that the arrow is in the left edge of the field of view, the compensation, magnification, and working distance can all be read at the right edge.

4. Several of the recently introduced automated cameras have features that allow metering a center-segment (centered-weighted) area of the viewfinder field for accurate exposure control of small objects. For example, the Nikon N8008 can concentrate 75% of its sensitivity in a 12-mm circle outlined in the viewfinder.
5. Mini Maglite, Model M2A01H, Mag Industries, 1635 South Sacramento Avenue, Ontario, California 91761.
6. Balcar, 100 West Erie Street, Chicago, Illinois 60610.
7. Delta-1 Products, CPM Inc., 10830 Sanden Drive, Dallas, Texas 75238-1337; tel. (214) 349-9779.
8. Edric Imports Inc., Columbia, Maryland.
9. Rosco, 36 Bush Avenue, Port Chester, New York 10523.

# REFERENCES

Anderson, D. C., 1957. Speedlight in the color photography of living insects. *J. Biol. Photogr. Assoc.* 15:136.

Bartlett, E. C., 1961. A simplified method of recording agar diffusion plates. *J. Biol. Photogr. Assoc.* 29:7–10.

Berry, J. et al, 1954. Photography of paper chromatograms. *Med. Biol. Illus.* 4:223–228.

Bidigare, R. R., et al., 1984. Silhouette photography of polyacrilamide slab gels. *Analyt. Biochem.* 137(2):297–301.

Blaker, A. A., 1965. *Photography for Scientific Publication*, Chap. 5. San Francisco: W. H. Freeman and Co.

Blaker, A. A., 1977. *Handbook for Scientific Photography*, Chaps. 6, 12, 13. San Francisco: W. H. Freeman & Co.

Bruck, A., 1985. *Closeup Photography in Practice*, pp. 74–91. London: David and Charles, Newton Abbot.

Brunst, V. V., and Clayton, R. J., 1953. Photographing small laboratory animals. *Lab. Invest.* 2:376.

Brunst, V. V., 1960. Use of the 35 mm camera for photography of small laboratory animals. *J. Biol. Photogr. Assoc.* 28:53–62.

Coffey, L., 1955. Photography of surgical and research apparatus. *J. Biol. Photogr. Assoc.* 23:1–11.

Cox, A., 1974. *Photographic Optics*, 15th ed., pp. 553–557. London: Focal Press.

David, R. E., 1956. Photography of bacterial culture tubes and plates. *J. Biol. Photogr. Assoc.* 23:118.

Dommasch, H. S., 1970. Corrective copying and small object photography. *J. Biol. Photogr. Assoc.* 38:130–133.

Dragesco, J., 1952. Electronic flash in photography of small animals. *J. Biol. Photogr. Assoc.* 20:16–20.

Ellis, J., 1977. Underfluid gross specimen photography—recent observations. *J. Biol. Photogr. Assoc.* 45:98–99.

Ellis, J., 1978. Fiber-optic photography of polyacrilamide disc gels. *J. Biol. Photogr. Assoc.* 46:167–169.

Fiske, P., 1974. Auxilliary cylindrical lenses for recording bands in narrow tubes. *Med. Biol. Illus.* 24:160–161.

Freeborn, E., 1953. The photography of surgical instruments. *Med. Biol. Illus.* 3:77–86.

Gibson, H. L., 1968. *Defining Power in Photomacrography.* B.P.A. Publication.

Gibson, H. L., 1975. *Closeup Photography and Photomacrography.* Rochester, NY: Kodak Technical Publication N 12.

Gjersvik, T., 1967. Low power photography of fluorescent immunoelectrophoresis slides. *J. Biol. Photogr. Assoc.* 35:21–23.

Glazier, R. M., 1966. A simple apparatus for dark ground illumination of precipitin lines. *J. Biol. Photogr. Assoc.* 34:51–52.

Grossman, J., 1980. Exposure booth: An instant studio, *Indust. Photogr.* 29:30–32.

Grossman, J., 1981. Large product lighting for small product photography, *Indust. Photogr.* 30:27–29.

Gunn, D., 1986. Basics of photography in veterinary practice. *In Practice* 8(3):103–109.

Haberlin, C., 1979. In *Guide to Medical Photography*, Chap. 6. Baltimore, MD: University Press.

Harding, F. R., 1944. Photography of white objects. *J. Biol. Photogr. Assoc.* 13:98–100.

Harrison, J., 1975. Medical photography in bacteriology. *Br. J. Photogr.* 38(122):832.

Hassur, S. M., and Whitlock, H. W., Jr., 1974. Direct-contact photography—a convenient and versatile technique for cameraless photography of polyacrilamide gels. *Analyt. Biochem.* 62(2):609–614.

Hopkins, W., 1975. Illuminating plastic appliances for photography. *Med. and Biol. Illus.* 25:170–171.

Howard, B. J., ed., 1987. *Clinical and Pathogenic Microbiology.* St. Louis, MO: C. V. Mosby.

Hund, D., 1979. In *Guide to Medical Photography*, Chap. 7. Baltimore, MD: University Press.

Jackson, R., 1959. Photographing precipitation bands in agar gel plates. *J. Biol. Photogr. Assoc.* 27:133–138.

Jackson, R., 1968. Ultraviolet recording of thin layer chromatograms. *Vis. Sonic Med.* 3:4–6.

Jackson, R., 1972. Natural science photography. *J. Biol. Photogr. Assoc.* 40:35–50.

Johns, M., 1974. Plexiglass cone. *Med. Biol. Illus.* 24:165.

Keeling, D., 1971. Image illumination and depth. *Br. J. Photogr.* (August):733–734.

Klontz, G. W., et al., 1960. An illuminator for observing and photographing precipitin reactions in agar. *J. Biol. Photogr. Assoc.* 28:11–14.

Langford, M. J., 1980. *Advanced Photography*, 4th ed., Appendix II. London: Focal Press.

Latven, A. R., 1950. Catatonic immobilization of laboratory animals for photography. *J. Biol. Photogr. Assoc.* 18:16–20.

Le Beau, L. J., 1976. Effective lighting systems for photography of microbial colonies. *J. Biol. Photogr. Assoc.* 44:4–14.

Le Beau, L. J., 1980a. A versatile and compact stage for photographing small objects. *J. Biol. Photogr.* 48(1):3–13.

Le Beau, L. J., 1980b. Photography of polyacrylamide gels from disc electrophoresis. *J. Biol. Photogr.* 48(3):141–144.

Le Beau, L. J., et al., 1980. Photography of tubes and their contents based on image requirements and tube configuration. *J. Biol. Photogr.* 48(2):93–107.

Le Beau, L. J., et al., 1981. Photography of compartmentalized plastic strips, trays, plates and slides used for microculture and serological reactions. *J. Biol. Photogr.* 49(1):3–19.

Le Beau, L. J., and Wimmer, A., 1982. Photography of tiny reflective biomedical objects. *J. Biol. Photogr.* 50(4):101–120.

Le Beau, L. J., 1983. Anatomy of discovery. *J. Biol. Photogr.* 51:73–80.

Le Beau, L. J., and Wimmer, A., 1984, You can make it yourself—4. Petri dish holder. *Br. J. Photogr.* (Sept. 14):966–967.

Le Beau, L. J., et al., 1985. Evaluation of the medical-dental-bio-macro bracket for small object photography. *J. Biol. Photogr.* 53(1):19–29.

Le Beau, L. J., and Prashall, R. F., 1985. You can make it yourself—diffusion bracket. *Br. J. Photog.* 132(6529):1057–1058.

Le Beau, L. J., 1987. Photography of small laboratory animals, Part 1: Care and handling. *J. Biol. Photogr.* 55(1):31–36.

Le Beau, L. J., et al., 1987. Photography of small laboratory animals, Part 2: Techniques and procedures. *J. Biol. Photogr.* 55(3):99–105.

Le Beau, L. J., 1991. Photography of very small biomedical objects. *J. Biol. Photogr.* 59(2):77–87.

Lefkowitz, L., 1979. *Manual of Closeup Photography*, Chaps. 7, 8, pp. 75–209. Garden City, NY: Amphoto Publications.

Marshall, R., 1957. Photographic background control. *Med. Biol. Illus.* 7:13–21.

Meats, K. C., et al., 1991. Photography of electrophoresis gels for reproduction. *J. Biol. Photogr.* 59(4):135–140.

Mineo, J., 1966. Reflection control in small object photography. *J. Biol. Photogr. Assoc.* 34:102–106.

Murchio, J. C., 1960. Photography of agar-gel diffusion slides. *J. Biol. Photogr. Assoc.* 28(2):65–68.

Murey, R., and Ollerenshaw, R., 1975. Large field darkground illumination. *Med. Biol. Illus.* 25:153–155.

Ogrodnick, J., 1987. Photographing the caddisfly larva—a natural science series. *J. Biol. Photogr. Assoc.* 55:11–14.

Oliver, D., and Chalkey, R., 1971. An improved photographic system for polyacrilamide gels. *Analyt. Biochem.* 44:540–542.

Parish, L. E., 1987. The L. P. macro-flash bracket. *J. Biol. Photogr.* 55(2):67–68.

Pinckard, B., 1979. *Creative Techniques in Studio Photography*, Chap. 4. Philadelphia: J. B. Lippincott Co.

Reed, F. C., 1960. Lighting technic for photography of agar diffusion plates. *Am. J. Clin. Path.* 33(4):364–366.

Schaechter, M., ed., 1989. *Mechanisms of Microbial Disease*. Baltimore, MD: Williams and Wilkins.

Schalow, E., 1955. Transillumination in biological photography. *Med. Biol. Illus.* 5:143–145.

Schutz, J. N., 1958. Darkfield illuminator for petri dish photography. *J. Biol. Photogr. Assoc.* 26:159.

Shamen, H., 1977. *The View Camera, Operations and Techniques*, Chap. 6. Garden City, NY: Amphoto Publication.

Sherril, C., 1976. *Professional Techniques in Dental Photography*, pp. 35–36. Rochester, NY: Kodak Publication N-19.

Smialowski, A., and Currie, D. J., 1965. Elimination of surface reflections in copying. *J. Biol. Photogr. Assoc.* 33: 79–81.

Snowman, J. H., 1968. The reproduction of electrophoresis patterns. *J. Biol. Photogr. Assoc.* 36(2):79–83.

Stroebel, L., 1973. *View Camera Techniques*, Chaps. 1–3. New York: Hastings House Publishers.

Tau, A., and Krass, W. H., 1969. A multipurpose transilluminator. *J. Biol. Photogr. Assoc.* 37:106–108.

Tyson, D. R., 1963. Starch gel electrophoresis photography. *J. Biol. Photogr. Assoc.* 31(3):89–97.

Vetter, J. P., and Dukes, B. M., 1969. Improved culture tube holder and suggested lighting arrangements and exposure determination. *Photogr. Appl. Sci. Med.* 23:28.

Weiss, C. J., 1968. Fungus photography: Culture plates with ultraviolet fluorescence. *J. Biol. Photogr. Assoc.* 36:145.

White, W. J., 1984. *Closeup Photography*. Rochester, NY: Kodak Publication KW-22.

White, W., ed., 1987. *Photomacrography, An Introduction*, pp. 97–133. Boston: Butterworth Publications.

Whitley, R., 1966. Photographing surgical instruments. *J. Biol. Photogr. Assoc.* 34:22.

Williams, A. R., 1984. Closeup photography and photomacrography. In *Photography for the Scientist* (Morton, R., ed.), pp. 355–391. London: Academic Press.

Williams, L., 1969. Routine photography of clinical electrophoresis gels. *Med. Biol. Illus.* 19:105–108.

Wilson, A., 1979. *Creative Techniques in Nature Photography*, Chaps. 8–10. New York: J. B. Lippincott Co.

# Part IV

## Management Principles

$$\frac{DK\text{-}50}{DDQ}$$

# Chapter 21
# Managing the Biomedical Media Department

## Kenneth V. Michaels

*"Management is work. Indeed it is the specific work of a modern society, the work that distinguishes our society from all earlier ones. For management is the work that is specific to modern organizations and makes modern organizations perform. As work, management has its own skills, its own tools, its own techniques. . . . But management is also different work from any other. Unlike the work of the physician, the stonemason or the lawyer, management must always be done in an organization—that is, within a web of human relations. The manager, therefore, is always an example."*

<div align="right">

Peter F. Drucker (1909- )
*Management: Tasks, Responsibilities, Practices. 1985*

</div>

This chapter provides an overview of management philosophy and practice as applied to institutionally based biomedical media departments. It defines and describes the functions of management and discusses the use of computers as management tools. Topic discussions include management of the departmental mission, fiscal resources, information, physical resources, and human resources.

## INTRODUCTION

This chapter is devoted to those biomedical photographers who are employed by institutions of teaching, of research, and of healing. Indeed, it is devoted to the majority of all who practice biophotography, for it is such institutions that gather together biomedical imaging specialists and organize them into departments charged with various support tasks in service of the institution's overall mission.

The biomedical media department is first and foremost a service organization. While traditional definitions of the service sector of the past described it as consisting of industries whose output is intangible, modern thinking holds that service is not a unidimensional thing, but rather a primary product. "Service is as much a commodity as an automobile, and as much in need of management and systematic study" (Albrecht and Zemke 1985). Especially in today's turbulent health-care market, effective management of related support services is probably more a challenge than ever before.

## WHAT IS MANAGEMENT?

Whether management is an art or a science has been debated at great length. While it is beyond the scope of this chapter to resolve the debate, probably the most workable perspective is one that recognizes both art and science as contributory to effective management.

> Art is the imposition of a pattern, a vision of a whole, on many disparate parts so as to create a representation of that vision; art is an imposition of order on chaos. The artist has to have not only the vision that he or she wants to communicate but also skills or craft with which to present the vision. This process entails choosing the correct art form and within that art form, the correct technique. In good art, the result is a blending of vision and craft that involves the viewer, reader, or listener without requiring that he separate the parts in order to appreciate the whole. (Boettinger 1975)

Science and art are thus not necessarily mutually exclusive, but can be complementary. "A manager must know and understand not only the concepts and principles of management (the science of management) but also how to use them (the art of management)" (Rue and Byars 1977).

### Management Defined

Management has been defined in numerous ways, yet no universally accepted definition exists, as different experts continue to form their own descriptions of management with slightly different slants. This should really be no great surprise, as theories and accepted practices change from time to time, shifting with varying schools of thought. What probably is universally agreed is that management is evolutionary in nature, and its philosophies continue to change as society, technology, and concepts of work change. For the purposes of this chapter, the following definition is probably no worse than any other: "Management is a process or form of work that involves the guidance or direction of a group of people toward organizational goals or objectives" (Rue and Byars 1977).

## The Functions of Management

The functions of management have been described in as many ways as management has been defined. Probably the four most universally agreed functions of management are:

1. planning
2. organizing
3. motivating
4. controlling

*Planning* is the function that many contend separates managers from supervisors, the former being those who do the planning, and the latter those who see that plans are carried out. Planning amounts to making decisions regarding the current status of the group or organization, the environment and its potentials, the objectives that the group should achieve, what will be necessary to achieve those objectives, and creating a plan by which the needed resources can be acquired to achieve them. It also involves coordinating of the planning process itself and adjusting plans as needed to adapt to changing conditions. Some authors describe this management function as *goal setting*.

*Organizing* is the management function that identifies specific actions or functions to be performed in plan implementation. It involves acquisition of all needed resources (including staffing) and positioning them according to a structure in which they can be most effectively utilized. Decisions regarding assignment of personnel responsibilities and delegation of authority are key aspects of organizing human resources.

*Motivating* is the management function referred to by many as *directing*. The essence of this function is to guide human beings toward goals achievement. Those who contend that the planning function divides the managers from the supervisors usually agree that motivating is the function that unites them, as both share key responsibilities in this part of the process. Styles of direction/motivation vary greatly among individuals, but the end purpose in any case is the same—to make the decisions necessary to maximize the contributions and output of the people involved, and to ensure that the output is properly channeled toward reaching the desired organizational objectives. With greater emphasis today being placed upon humanistic approaches to dealing with people, the term motivating probably better describes this function than directing.

*Controlling* is the function of management that involves measurement of results, evaluation of such measurements, and making decisions as required to correct deviations and improve deficiencies. Effective control also requires ongoing review of all other functions, to be certain that those factors that are most easily measurable do not become themselves more important than the original goals.

## Decision Making in Management

Decision making has also been described by some as a management function. A quick review of the foregoing, however, should make it obvious that decision making permeates all aspects of management, and in fact none of the four basic management functions can be successfully performed without making decisions. Rather than a function of management, decision making is probably better thought of as a necessary activity that enables the manager to perform any of the functions of management.

The decision-making process is thus fundamental to management and has itself been often studied and analyzed. Rue and Byars (1977) and Shrode and Voich (1974) offer excellent discussions. Suffice it to say here that, similar to the science vs. art argument regarding management itself, much of the study of decision making distills down to science vs. intuition (or emotion) as dominant opposing forces.

## Decision Making and Personal Style

The scientific approach to decision making places greatest, if not exclusive, emphasis upon pertinent factual data as the most important basis for decision. Logical thought processes interpret the data and forecast probable outcomes. The best decision is one that the hard data most clearly supports and that can logically be expected to result in goal achievement. When all pertinent facts are not known or when data are questionable, strictly scientific decision makers tend to prefer a delay to verify or gather more information rather than take risky action.

Decision makers who rely more upon intuition also consider the factual data present, but tend to be less demanding in terms of its completeness. Intuitive decision makers tend to prefer action to delay, even in situations where facts are sketchy or incomplete. Relying upon an undefinable general sense of what is the right thing to do, they are able to make snap decisions with confidence.

In the game of golf, there is usually ample time to study all pertinent factors before deciding how to play a putt, and the decision, once made, is, if not scientific, at least duly deliberated. In the game of tennis, however, there is less opportunity for analysis of how to play the oncoming ball, and without intuitive movement (that is, spontaneous decision making) any return at all, much less a good one, is unlikely.

There is ample room in good management for individuals with leanings toward both ends of the science vs. intuition spectrum. It follows that if good management involves both science and art, the best decision makers are probably those who appreciate the value of intuition as well as logic and allow themselves to be guided by

either or both, depending upon the situation. The final result of how the individual balances one against the other defines personal management style.

The importance of personal style in decision making, and thus in management itself, should not be overlooked. Although there are many versions of worthwhile rules and guides for managers, and while good managers do seem to exhibit certain common characteristics, there is no magic formula that should be expected to work equally well for all. While rules and principles can be taught, personal style cannot. Personal management style must be developed and is a combination of innate ability, intellect, and insight gained through experience.

## THE COMPUTER AS A MANAGEMENT TOOL

Effective management was possible (and naturally occurred) long before the invention of computers, although rare is the effective manager today who does not employ and depend upon them. The power of today's computer hardware and software is so great, in fact, that it is hard to imagine how many tasks now computerized could ever again be acceptably performed manually.

It is necessary to describe computer applications throughout this chapter, as it is the author's belief that effective management of the media services department today demands the use of the most effective tools available, and in an increasing number of instances that tool is a computer. Whether it be a massive mainframe device or a desktop-sized PC (a term used generically to replace personal computer, microcomputer, and minicomputer to differentiate from the larger mainframes), the computer has become practically an indispensable tool for a great many biomedical media department managers.

### Computer Fundamentals

Computers are certainly both economical and efficient. Christopher Evans once figured that "If the efficiency and cheapness of the car had improved at the same rate as the computer's over the last two decades, a Rolls Royce would cost about $3.00, would get three million miles to the gallon, and would deliver enough power to drive the Queen Elizabeth II" (Evans 1979). And that was over a decade ago!

On the other hand, a computer in and of itself guarantees nothing. Computers alone do not create order from chaos. A manual system that is inefficient because it is poorly organized will probably remain inefficient even after it is computerized, unless the basic organization is somehow improved in the process. People create order from chaos; the computer can help by forcing the people who use it to reorder and better organize their thinking.

Use of a computer does not guarantee accurate results in calculation or analysis. Flawed logic or outright error in programming will cause the computer to commit errors over and over with great reliability. People cause computer errors; the computer pretty much does as it's told. Early results from any newly computerized system or operation should be scrutinized for logical and programming error, a process usually referred to as debugging. It should be kept in mind that a computer is no more than a tool, albeit a powerful one.

### Determining Factors in Computerization

Some functions may still be better done by other, noncomputerized means. In a management situation that appears to need a system to be developed, the decision of whether or not to use a computer should take several factors into consideration:

1. size of the application
2. complexity of the application
3. availability of resources
4. subjective considerations

**Size of the Application.** The size of the application is a key concern. Although a computerized database program for tracking work in progress would be useful virtually anywhere, the department of two persons who communicate well has less need for it than does a department of thirty or more that performs fifteen times as much work.

**Complexity of the Application.** Complexity of the job at hand is another significant factor in deciding whether or not to computerize. A simplified example of a multiunit biomedical media service's annual budget is shown in Figure 21.1. Each number in the grid is totaled vertically and horizontally to provide work unit totals as well as income/expense category totals.

Any competent manager should be able to develop an annual operating budget in this simple format with the use of a tool no more sophisticated than a calculator, and in fact did so not many years ago. It takes only a little experience in developing tables such as this one, however, to discover how maddening it can be when repeated summing and resumming of rows and columns fail to agree because of minor keypress errors. Note also that repetition of totals is required in both directions when any number in the grid changes. A person can certainly perform this task without a computer, but the same individual trained in the effective use of a suitable spreadsheet will do the job in a fraction of the time and be able to pay fuller attention to the numbers themselves, rather than the routine and repetitive mathematics.

**Availability, Including Support.** Availability of a computer seems too obvious to be worth mentioning. Avail-

| | Art | Photo | TV | Office | Total |
|---|---|---|---|---|---|
| Capital Outlay | 19,525 | 16,575 | 22,875 | 5,200 | 64,175 |
| Repairs & Maintenance | 5,350 | 4,000 | 5,750 | 1,050 | 16,150 |
| Salaries & Benefits | 132,075 | 114,825 | 71,450 | 71,650 | 390,000 |
| Contracted Services | 145,250 | 23,500 | 3,500 | 1,575 | 173,825 |
| Consumable Supplies | 11,250 | 86,150 | 9,950 | 1,150 | 108,500 |
| Mail & Telephone | 2,350 | 2,375 | 1,675 | 7,250 | 13,650 |
| Education & Travel | 2,575 | 2,575 | 2,575 | 1,500 | 9,225 |
| Miscellaneous Expense | 2,000 | 2,000 | 2,000 | 1,000 | 7,000 |
| EXPENSES | 320,375 | 252,000 | 119,775 | 90,375 | 782,525 |

| | Art | Photo | TV | Office | Total |
|---|---|---|---|---|---|
| Cash Transactions | 1,150 | 9,550 | 1,025 | 0 | 11,725 |
| Grants & Contracts | 12,000 | 9,750 | 25,025 | 7,575 | 54,350 |
| Internal Transfers | 259,500 | 192,520 | 25,125 | 2,575 | 479,720 |
| Appropriation | 52,150 | 43,725 | 71,450 | 71,650 | 238,975 |
| INCOMES | 324,800 | 255,545 | 122,625 | 81,800 | 784,770 |
| Budget Net | 4,425 | 3,545 | 2,850 | (8,575) | 2,245 |

**FIGURE 21.1 Sample biomedical media department budget. Budget overview and similar tables are simple work for spreadsheet application software.**

ability of proper training and software, however, may be a significant barrier. Some of the particular needs of the media services manager may require specialized applications not available for outright purchase. In such cases, the manager is faced with the choice of developing sufficient staff or personal expertise to develop the application, or engaging a computer professional to assist as programmer, consultant, or both. Some knowledge of computers and their capabilities is required in either case, and either choice will cost money. The more available the computer, the lower the cost, and the less reason to stick with manual methods.

**Subjective Considerations.** Should a word processor functioning on a network be used for sensitive confidential communications? Practically all password and protection protocols in existence can be foiled in some way or another. Will computerizing the system in fact cause it to function better, or really end up creating extra work or regimentation for the people who will ultimately have to use it? In some situations, the high-touch alternatives may simply be preferable to the high-tech methods for human reasons.

**PC vs. Mainframe**

Before the advent of the PC, computers were unwieldy devices that occupied huge areas, required legions of attendants, and operated pretty much on their own terms. The power of computers was recognized soon

enough, but the ability to purchase and operate them was limited. The concept was developed of allowing a number of subscribers to connect to one of the early mastodons and share the use of its central processing unit (CPU), paying fees for the privilege proportional to actual time used, and this was, not surprisingly, called *time-sharing*. When mass production of the microchip revolutionized the industry (less than 25 years later!), it quickly became possible for any business, and even most private citizens, to be able to afford impressive computing power of their own. With some departments even able to afford to buy a mainframe of their own, the entire concept of sharing time on somebody else's mainframe seemed to many a technological step backward.

Advantages to timesharing still exist, however, most notably that actual operation of the computer, including backup of files, is the responsibility of the mainframe's owner, not the user. A well-managed and service-oriented central institutional computing facility which operates a properly maintained and accessible mainframe should not be overlooked as a possible solution to meeting the media department's needs (Michaels 1984).

**Applications Software for Managers**

Effective leaders have long relied upon the ability to communicate in writing, organize their resources, and evaluate various options available. It is not surprising, then, that the three most common general classifications of computer applications employed in management today are:

1. word processing
2. database management
3. spreadsheets

**Word Processing.** The PC equipped with word-processing software has today almost completely replaced the typewriter in many media departments as the basic tool for production of written communications. Text editing and formatting features readily and affordably available with almost all quality software provide the manager and clerical staff alike with powerful abilities to produce correspondence, reports, and other documents with far greater ease than previously possible. Storage of documents in magnetic form on disks is efficient in terms of both time and space. Better grades of software also feature an on-line thesaurus, a spelling checker, and some are even able to evaluate syntax and grammar, which may contribute to improved quality of writing when properly used.

**Database Management.** Database-management software is used in a wide variety of applications in both mainframe and PC environments to store, organize, up-

date, and report information. Be it small and simple or large and complex, the database manager's forte is its ability to quickly reorganize all information in memory at the will of the operator, and to report in varying levels of detail, including greatly compressed summary form.

**Spreadsheets.** Spreadsheet software is essentially designed to perform mathematics and usually comes preprogrammed with an impressive array of mathematical functions ready for the using. From simple summing of values in a row or column to calculation of double-declining depreciation or calculation with trig functions or logarithms, all operations are performed at the operator's command with speed and accuracy when properly invoked. Spreadsheets are sometimes referred to as *what if?* programs; their ability to rapidly recalculate and provide new results each time experimental changes are made to individual values in a complex formula or table make them valuable tools for modeling, situation analysis, and decision making.

Some spreadsheets are capable of producing graphs, charts, and other graphics directly from numerical data stored, which can be of value to management function. Most word-processing software provides the ability to import such graphics and merge with text, which is of value in producing documents such as proposals, forecasts, and various other reports. *Integrated* software packages provide smooth interface and information exchange among the three. (Dominic Screnci's bibliography of applications software (1987) specific to uses in photographic department operation may be consulted for further reference.)

## Networking

Among the greatest advantages that computers have to offer in management is the ability to share information, which many believe to be effective management's most precious commodity.

**Local Networking.** In the biomedical media department, a local area network (LAN) offers the advantage of allowing many individual computers/terminals to be interconnected in a number of ways. A simple network might allow several workstations to share a peripheral device (for example, a printer) rather than bear the cost of purchasing several similar devices. More sophisticated PC networks permit access to actual data files stored in memory on the various stations involved, in effect emulating the mainframe timesharing scenario, where remote terminals share the activity of one CPU. Specific privileges of each user can be regulated to permit only those activities allowed by the network owner. In some circumstances, it may be desirable to allow certain workstations to read files only, but not make changes, to

protect data integrity. In other situations, it may be important to allow fuller privileges to network stations, including updating of community files from all points.

**Wide-Area Networking.** A MOdulator-DEModulator (MODEM) further expands the information-sharing ability of the computer, allowing it to communicate via telephone line with virtually any other computer in the world, including other LANs.

## Notes on Systems Design

Although computer software is commercially available, no two departments are alike and no two managers have exactly the same methods of organization or preferences for information in terms of what kind, how much, and how often. There are valid reasons for starting from scratch and tailoring a system to particular needs, but the decision to do so should be carefully weighed, since complete design and creation of a new system can involve enormous amounts of time and energy. Whether one undertakes the complete design of a large and complex system or the creation of a small database, a few principles should be observed.

**Open Architecture.** One should consider every possible future use for the database as early in the process as possible, and the structure should be created in such a way as to accommodate those applications later, if not now. This design attribute, which allows for relatively easy future addition of new functions, is sometimes called *open architecture.*

**Data Entry.** Data entry is the activity during which practically all errors are made, and data entry errors can compromise the value of any database. Special attention should be paid to the most critical information associated with each record, and safeguards devised to ensure accuracy. One simple technique is the use of a data entry screen which requires the operator to perform a certain sequence of keystrokes to save the information while it is displayed on the screen, on the supposition that if screen blanking is delayed, the operator is more likely to spot a keyboarding error and correct it before saving the record. Numerical data can be validated in some cases by a math algorithm that tests the value against fixed criteria, such as a date range.

**Reference Files.** Character data poses special problems. The name "Mc Clure" might be entered as "Mc Clure," or "MC CLURE," both of which are correct. As not all databases at present can be blinded to upper and lower case, however, a search of records would not find the two to meet the same search criteria. The incorrect (but common) variations an operator might enter include

"McClure," "MCCLURE," "Mac Clure," and so on. Misspelled entries have the potential to seriously impair the quality of reporting in a large database, and some form of quality control should be designed in whenever possible. Some sophisticated databases allow the creation of reference files from which information is read and transferred at data entry. The operator might be prompted for a client's name, for example, and once it is entered, the computer immediately searches the reference file for that name and displays it, along with associated data such as department, account number, telephone number, mailing address, and so on. The operator might press one key or perform a series of keystrokes to accept all information, which is automatically copied into the correct fields for the current record. A feature like this guarantees that all data involved are entered with accuracy, and it speeds data entry to boot.

**Data Entry and Validation.**   Data entry speed is itself an important concern. In the case of a job-information system, it will presumably occur while the client is being interviewed with respect to the job and should therefore be an efficient process. System design plays a major role in determining how quickly accurate data entry can occur. Depending on the database, the record structure could contain hundreds of fields for storing detailed information. Although the information might be of great value, consideration must be given to the effort required in storing it, otherwise the time spent in data entry alone may be more valuable than being able to report minute details. Data entry shortcuts can be programmed and hierarchical screens arranged in such a fashion that inapplicable fields can be skipped quickly. For example, a data entry screen in a photography jobs-management system might contain a logical (true/false) field to indicate whether or not the job involves photography of a patient. If answered true, the entry program might then prompt for name, unit number, and other information, but if answered false would skip such items and proceed on to the next category of information.

## MISSION MANAGEMENT

It has been said that, ultimately, the goal of every business is to survive. Introduction of new products, redirection of corporate emphasis, and changes in marketing plan are essential survival tactics upon which vital businesses rely. In the case of service and support groups such as the biomedical media department, the formula for survival, simply stated, is to meet the needs and expectations of the mother institution.

The ability of the biomedical media department to produce work and provide services, even when it is high-quality work and technically competent service, is not necessarily a guarantee of survival. Peter Drucker once defined efficiency as "doing things well" and effectiveness as "doing the right things." If the institution no longer requires a certain product or service of its media professionals, their expertise in producing or providing it will be of no consequence. To remain viable, the department must be effective as well as efficient in order to meet the institution's requirements over the long haul.

As technological and societal changes change the roles of scientific, educational, and health-care institutions, changes in mission focus are inevitable. A critical role of the manager of an effective support group is to maintain awareness of such changes in focus and guide the department's activities accordingly in order to maintain vitality.

### Planning for Mission Achievement

A pitfall that entraps workers at all levels, including management, is becoming so involved in affairs of the moment and day-to-day routine that the real reasons for doing the work are obscured or even forgotten. This problem is especially serious when it befalls the manager, whose responsibilities usually include policy formation. Policies are by nature general guides from which specific actions are derived; they form the framework within which operational decisions are made. A proper sense of overall mission must be maintained in order to avoid flawed policy making. As policies tend to be broad and general in nature, an expansive, global statement of mission can form a useful foundation for the department's guidance.

### The Institutional Mission

The development of a mission statement for the biomedical media service (or any other support service for that matter) should logically begin with the mission of the institution itself. Health-care institutions, especially those associated with universities, frequently describe in some fashion or other their purposes as being threefold, embracing education, patient care, and research. A simple statement such as "To teach, to serve, to search" may in some cases be the only mission statement that exists. In other institutions, the mission statement may take the form of a well-developed document addressing both philosophical and operational issues, produced in book or handbook form for distribution to all faculty and staff. Regardless of form, the thrust of the institution's statement of purpose must form the basis for the subservient missions of all its support services.

### The Departmental Mission

The departmental mission statement should provide guidance for all staff members. It should be clear enough

to be of value to the newest team member in terms of describing what the organization is all about, and be far-reaching enough to be of continuing value to the senior staffer as well. Unlike short-term goals and objectives, the mission statement should be free of specifics and state in general the ultimate aim of the department's work. A major goal of good management is to combine the creative energies of all staff members and channel their various talents and abilities toward a common purpose. The articulation of that purpose in the form of a mission statement may well be the department's single most important document.

A sample mission statement is shown in Figure 21.2. It addresses the traditional three stated purposes of the institution, and defines its role in terms of the enhancement of the institution's reputation and function. It does not incorporate technological limitations by addressing specific functions that might lead to its premature obsolescence. It could just as easily have been written in 1960 as in 1990 and should be as relevant in the year 2020. In broad terms, it articulates the department's reason for existence, and all departmental policies can be tested for validity against it by asking the question "What aspect of the department's stated mission does this policy serve?"

While a broad statement of mission is of value in terms of overall direction, it may be too abstract and intangible to have daily value to the workers in the trenches. This particular mission statement was further expanded by its author, as shown in Figure 21.3. The mission statement's usefulness is enhanced by the expansion with fuller explanations of key points in plainer language and addresses more specific professional responsibilities and ethical matters. This mission statement is further supported by a set of performance ideals (Figure 21.4) stated in such a manner as to be easily remembered by all staff members and to have value in day-to-day function at all levels.

## Mission Statement of the University of Arkansas for Medical Sciences Media Services

The mission of Media Services is to achieve and maintain high standards of performance in the creation and packaging of information and scientific knowledge, to document clinical and research achievements, to facilitate learning, and to enhance the prestige and reputation of the University of Arkansas for Medical Sciences.

**FIGURE 21.2   A global mission statement forms a useful foundation for the department's guidance.**

## The expanded Mission Statement of the University of Arkansas for Medical Sciences Media Services

*"...to achieve and maintain..."*
Evaluation of the effectiveness of our performance with accurate measurement must be ongoing.

*"...high standards..."*
We are responsible for keeping current in our professional specialties, knowing where the state of the art is to be found, and striving for it when possible. The ultimate standard, however, is that imposed by the client. The worth of our efforts (like beauty) is in the eye of the beholder.

*"...of performance..."*
We use this term in its broadest sense, to include everything articulated in the "Cornerstone Principles" (Q-R-S-T).

*"...creation and packaging..."*
All jobs, from start to finish, and all points in between, including "riding herd" on work contracted to outside sources. We fully manage every job we accept. We encourage creativity for all of our staff.

*"...of information and scientific knowledge..."*
Our work is serious. Secondary or unrelated work can never interfere with important priorities.

*"...to document clinical and research achievements..."*
Valid documentation imposes absolute requirements for accuracy. Our work can never be allowed to "doctor" the data, knowingly or otherwise.

*"...to facilitate learning..."*
We believe that effective use of print, graphic, photographic, and electronic media makes important contributions to the education of students, faculty, staff, patients, and the general public.

*"...to enhance the prestige and reputation of the University of Arkansas for Medical Sciences..."*
All of our work and activity which achieves the public eye must reflect highest credit upon the University, to the fullest extent of our ability to control.

**FIGURE 21.3   Dissection and expansion of the global mission statement enhances its usefulness.**

## UAMS Media Services Cornerstone Principles

*The Performance Ideals To Which We Aspire*

*Quality:*
The work we do measures up to the highest standard of quality possible within the time and cost parameters given.

*Reliability:*
We don't leave our clients "on their own." If we can't meet a client's needs, we do everything possible to find some other source who can. We're here when we're supposed to be, and when we make promises, we deliver.

*Service:*
We provide professional service in consultation, creation and job completion, and we do it with a positive, helpful attitude.

*Timeliness:*
We finish the work within agreed upon deadlines.

**FIGURE 21.4   Simply stated performance ideals clearly articulate daily staff expectations.**

## FISCAL MANAGEMENT

Almost all biomedical media departments are funded in one of three ways, depending on the institution and its fiscal policies regarding support services. These are (1) full institutional support, (2) full cost recovery, and (3) a mixture of the first two.

### Full Institutional Support

Essential support services, depending on the institution, might be deemed to include upkeep of space assigned, utilities, mail and communications services, security, and others. In the scenario referred to as full institutional support, the costs of providing these essential services are paid from centrally managed funding sources as general operating overhead. Most biomedical media departments in the United States originated as fully funded essential services, available to support all other departments and divisions within the institution.

Other departments (*user departments*) in the institution avail themselves of the services of the biomedical media department with no money changing hands, as all operating costs have already been provided for, usually by an annual appropriation, which forms the basis for an annual operating budget. Requests from all authorized sources are simply met as time and resources allow, with minimal energy expended in record keeping and accounting.

In the best of all worlds, full institutional support makes necessary services available to all who need them, and does so cost-effectively. It is not necessary for every department that requires occasional photography to purchase cameras, train personnel, and dedicate space to photographic operations; the central service does it for all. Also the ideal central service is adequately staffed and equipped to meet all needs, and all work requested is performed promptly in the order in which it is received. User departments request only work that is necessary to their function, with adequate lead time and consideration for other user departments who share the support service.

Ideal function, however, is rare if not outright unrealistic. In such situations, the services provided are perceived by many user departments as free of cost, inasmuch as money (in any form) does not change hands as jobs are performed. The perception of a *free* service can easily incline some users to commission work that is not absolutely essential, and the service unit itself may end up expending considerable time and energy on relatively unimportant tasks simply because they arrived first, while more critical jobs stand by awaiting their turn.

The institution may attempt to remedy such situations by setting up systems of internal allocation, granting potential users of the services an appropriate portion of the service unit's time and effort. Allocation systems can be plain and straightforward, but they usually turn out to be rather complex. Some involve creation of a method for comparing relative effort involved in completing greatly different types of work; others require pricing the work somehow and providing allocations expressed in dollar amounts, giving rise to the term *funny money*, as the dollars are not dollars at all and only have value for record-keeping purposes.

> Health care has been a seller's market for so long that the people in it have had no concept of competition, marketing, pricing, or promotion. The wrenching changes that have hit health care in the last five years have caused confusion, pain, and a very late awakening. (Albrecht and Zemke 1985)

The abruptly changing financial climate that brought about this awakening caused many institutional administrations to view their totality in a new light and differentiate in many cases essential support services from desirable services. A great many biomedical media units were affected by such redefinition and converted either gradually or suddenly from full institutional support to full cost recovery.

### Full Cost Recovery

In a full-cost-recovery scenario, the biomedical media department is provided with no appropriation at all to support itself and functions as a free-market business venture operating on the institution's property, even paying rent on the space and service charges for utilities consumed. All costs of operation must be fully recovered in fees paid by user departments for services rendered. Payments for services are paid in real dollars from user-department general operating funds, usually by internal transfer mechanism into the media department's account.

### Hybrid Funding

The Association of Biomedical Communications Directors performs an annual survey of its members, who are directors of biomedical media services, situated for the most part at major medical, dental, and veterinary colleges and universities in the United States and Canada. According to the academic year 1989–90 survey report, only four of the sixty-seven participating institutions reported a funding situation with no recovery requirement. Three of these reported grants and other sources of income in addition to institutional support; only one claimed to be fully supported by institutional appropriation. On the other hand, only four departments re-

ported full cost recovery funding with no institutional support at all.

A mixture of institutional support and cost recovery via earned incomes is thus by far the most prevalent scheme for funding the biomedical media department in North America today. On average, roughly 60% of cost is recovered by payment of fees for services, and 40% of total cost is defrayed by institutional appropriation (Manning 1990). The undeniable result of this shift is that future management of the institutional based biomedical media department will require even keener attention to free-market business practices including marketing, promotion, and competitive pricing.

### Organizing Fiscal Affairs: Cost-Based Pricing

A fee-for-service media service must develop a strategy for pricing its goods and services that will lead to achievement of its financial objectives, whether the institutional funding scheme requires it to recover all of its costs, some percentage of its costs, or even its costs plus a surplus. An important starting point is knowing what the costs of operation actually are.

Piece-rate pricing is both popular and practical in situations involving batch-production methods such as processing of photographic film. Processing machine costs and lab technician time are usually not practical to apportion exactly to individual items on a run-by-run basis, as actual costs will vary with volume. The more practical method is to consider the longer view, taking into account a period of several months or a full year. Total cost of operating the service (including maintaining the hardware, chemistry and supplies, staff salary and benefits, and other costs) can be divided by the total number of units of production, and result in an average cost per unit. This will not necessarily be the price actually charged but, if calculated correctly, forms the basis for determining actual price, the difference being profit per unit.

While the typical photographic-services unit uses piece-rate pricing for most of its products, time charges are by far the more prevalent method of assessing client fees in biomedical media departments. By using a strategy similar to that already described (calculation of average cost over an extended period), an actual hourly cost of operation can be determined and form the basis for establishing hourly rates actually charged to clients. Figure 21.5 shows a formula for determining hourly cost of operation, and Figure 21.6 shows a sample calculation of costs for a hypothetical five-person graphics work unit.

Direct labor costs are those that are explicitly assignable to jobs, including personnel salaries that support time working on billable projects. In the example, it is assumed that only 40% of the unit manager's time will be

$$(DL + IL + DE + OH) / BH = HC$$

Where:　DL　= Direct labor cost

IL　= Indirect labor cost

DE　= Direct expenses

OH　= Overhead

BH　= Billable hours capacity

HC　= Hourly cost of operation

**FIGURE 21.5　Determination of hourly cost of operation. Actual cost of operation forms the basis for establishment of hourly rates. This simple formula describes pertinent factors and how they are used to calculate hourly cost of operation.**

spent in actual production, with the remaining 60% devoted to managerial activities. Reserves for pay increases, bonuses, and fringe benefits paid by the department are included as direct labor cost.

### Costs

| | | |
|---|---:|---|
| **Direct Labor** | | |
| 40% Unit Manager | 12,200 | |
| 4.0 FTE staff | 77,200 | |
| | 89,400 | |
| Reserves (22%) | 19,668 | |
| | 109,068 | DL Total |
| **Indirect Labor** | | |
| 60% Unit Manager | 18,300 | |
| 15% Administrative | 17,500 | |
| | 35,800 | |
| Reserves (22%) | 7,876 | |
| | 43,676 | IL Total |
| **Direct Expense** | | |
| Equipment Repairs & Svc. | 9,250 | |
| Consumable Supplies | 11,750 | |
| Capital Outlay | 4,000 | |
| | 25,000 | DE Total |
| **Overhead** | | |
| Mail & Telephone | 1,850 | |
| Office Supplies | 3,250 | |
| Staff Travel | 2,500 | |
| | 7,600 | OH Total |

**FIGURE 21.6　Hourly cost determination sample. Sample data for a hypothetical five-person work unit to illustrate hourly cost determination formula. Derivation of factors DL, IL, DE, OH is shown.**

Indirect labor costs include salary and fringe benefits paid to individuals who do not contribute billable time to production or provide other chargeable services. In the example, the nonbillable portion of the unit manager's salary plus percentages of salaries of administrative and clerical staff who provide nonbillable support to the work unit are included.

Direct expenses are those that directly impact on production of charged goods and services. In the example, they include cost of repairs and service contracts on production machinery, consumable supplies, subsidiary services contracted to outside vendors, and capital outlay for production equipment.

Overhead includes nonlabor costs that do not directly impact on production of charged goods and services. In the example, these include mail and telephone costs, staff travel, and office supplies. Total cost of operation for the example (DL + IL + DE + OH) is thus $185,344. The accuracy of this figure is a function of how well costs in all categories mentioned are estimated.

Determination of billable-hours capacity is a three-part process and is detailed in Figure 21.7. First the number of working days per person is figured, adjusted according to institutional benefits policies. Second, total daily billable hours is figured, using target values determined by management. Note that the unit manager's daily target is 40% that of the other staff, according to previously mentioned apportionment of time. The final step is to multiply total days available by daily billable hours to arrive at total annual billable hours.

Establishment of the daily target for billable hours is critical. Most managers agree that the notion that every staff member will bill a full 8 hours during an 8-hour shift is unrealistic. It is inevitable that a certain amount of staff time will be consumed in organizing, planning, consulting, handling inquiries and problems, and various other activities for which a client is not billed. The shop standard for billable time will vary widely with management philosophy regarding such matters and probably ranges from 3 to 6 hours daily.

The final calculation for the sample is shown in Figure 21.8. The total annual operating cost of $185,344 divided by annual billable hours capacity 4,796 yields the result of $38.65 per (billable) hour. This figure represents the hourly charge that should be assessed in order to break even and relies upon the accuracy of all assumptions from which annual costs and billing capacity are derived. A formula such as this is an excellent candidate for commitment to a spreadsheet in which adjustments to the many factors involved can be quickly tested for final result.

The formula may be adjusted to meet changing requirements. If generation of an operating surplus is expected, the amount required can simply be added to the list of costs in the overhead category. Fat can be added to the entire calculation by adjusting the daily billable hours target. As is true with the previous example, the calculation's final result does not in itself determine price. Rather, it establishes the base from which a pricing structure can be formulated.

## Billable Hours Capacity

1. Working Days Per Person

| 52 weeks @ 5 days/wk : | 260 | |
| Adjustments (–) : | 12 | Holidays |
| | 12 | Sick Leave |
| | 18 | Vacation Leave |
| Productive Days/Person : | 218 | |

2. Daily Billable Hours

| Daily Target = 5 hours | |
| Unit Manager (40%) : | 2 |
| Staff (4.0 FTE @ 5 ea.) : | 20 |
| Billable Hours Per Day : | 22 |

3. Billable Hours Capacity

(Days) × (Hours/Day) = (Billable Hours Capacity)
218 × 22 = 4,796 BH Total

**FIGURE 21.7  Hourly cost determination sample. Derivation of BH—billable hours capacity—is a three-part process (see text).**

## Controlling Fiscal Affairs: Reporting

An orderly system of regular reporting of fiscal affairs is vital to achievement of financial goals. The simple fact of routine report generation, however, is in itself insuffi-

## Cost of Operation

| DL = 109,068 | BH = 4,796 |
| IL = 43,676 | |
| DE = 25,000 | |
| OH = 7,600 | |
| 185,344 | |

(DL + IL + DE + OH) / BH = HC

185,344 / 4,796 = 38.65   Hourly Cost of Operation

**FIGURE 21.8  Hourly cost determination sample. Final calculation of hourly cost of operation.**

client, as the greatest value of financial reports is in the messages that underlie the numbers. The manager's role in the process is to ferret out those messages and decide what action, if any, they suggest.

Income and expense figures should be interfaced with production data for validation and compared with similar reporting periods from previous years for evaluation of seasonal fluctuations. Regardless of the frequency of reporting or the source of reports, the department head should study the figures with care and provide some form of interpretation of their meaning with every report distributed.

## INFORMATION MANAGEMENT

### Internal Information Systems

A busy biomedical media department may have a hundred or more jobs in progress in its various divisions on any given day. A valuable working translation of this situation is that at any given time there are dozens of clients essentially waiting for the media service to complete work on their particular jobs. The service-oriented manager and staff who maintain keen awareness of the expectations of their clients place great emphasis upon not only performing high-quality work with efficiency, but also upon the manner in which it is done.

The manager who frequently complains of the annoyance of client inquiries regarding work in progress has probably (at least temporarily) lost sight of an important precept of a service organization. The total workload of the media service and related factors (equipment breakdowns, manpower shortages) are generally of little interest to the average client who inquires about work in progress. Typically, the client simply wants to know when the work will be finished and has a perfect right to a responsive and accurate reply. It is readily observable that the faster and more reliable the service, the fewer the inquiries, suggesting that frequent interruptions over such queries may properly be viewed as a strong indication that services need to be improved in the first place. Sensitive managers usually regard frequency of client inquiries as an important indicator of weaknesses in the organization's function and analyze operations accordingly.

**Job Tracking.** The effectiveness of daily operations relies upon a well-planned scheme of job handling and various production operations. Function of the organization can be maximized by adjusting and redirecting resources as necessary with changing workloads, and client satisfaction can be improved when the same information is readily available to answer inquiries when they occur. The purpose of an information system (as this chapter describes it) is to assist in meeting both of these needs. As

is true with other systems, an information system may be either manual or computer-assisted. A chalkboard with a simple listing of all jobs in progress and some method of indicating current status constitutes an information system. In a small department where all work enters and exits through one door and in which all incoming telephone calls are handled by the sole customer service representative, a chalkboard in the front office may be thoroughly effective and the only information system needed.

Manual methods of tracking work in progress will obviously be less effective, however, for departments of great physical size (especially when units are geographically separated), large staffs, great diversity of function, and large workloads. The bigger the department and its workload, the more a sophisticated system is indicated.

Computer-supported information systems may be either PC-based or mainframe-based, depending upon the factors described earlier. In simplest terms, a computer-supported information system is a database in which a record is created for each job as it enters the department and that is subsequently updated as the job status changes. At any time during work in progress, an operator at a computer terminal can retrieve the record to verify current status.

The minimal suggested information each record should contain includes the following record fields:

1. Job number (if used). Most departments attach some sort of internal coding for various record-keeping, filing, or audit purposes.
2. Client name. The client should obviously not be expected to memorize an arbitrarily assigned job number. The most common inquiry takes the form of "Are Dr. Jones's slides ready?"
3. Client department.
4. Client contact information (telephone or pager number).
5. Description of the work to be performed.
6. Date work received.
7. Date finished work is due.
8. Date actually finished.

This information is completely adequate for purposes of quantifying current work in progress and verification upon client inquiry that a specific job is either in progress or completed. By sorting the database according to job due dates, immediate production priorities become obvious, and overdue work (if any) is highlighted, presumably for immediate attention. This database can also be used to select all completed work awaiting pickup and generate a call-these-clients list.

**Integrated Information Systems.** If the sole purpose of the information system is to understand current workload and handle client inquiries effectively, each record can be simply deleted from the database once the job is

completed and delivered to the client. The hypothetical manual system described above would probably do so; when the finished job leaves the department, the job reference is erased from the chalkboard.

It is probably obvious that a computerized system can yield far greater management value by simply archiving all records of finished jobs. Movement of finished-job records to a separate database is recommended to keep the jobs-in-progress database as small as possible for efficient operation.

The archival database with records accumulated over a long period of time can be used for a number of valuable purposes including evaluation of accuracy in meeting deadlines and workload analysis. Given the basic information supplied, the department's workload can be evaluated in terms of total work performed, individual department or client use of services, and seasonal variation.

Additional data items added to each record and additional reporting routines can fairly easily result in an integrated information system that provides vastly expanded value, including

1. accounting and billing functions
2. production reporting
3. forecasting and scheduling
4. label generation

Additional fields for client account numbers, billing amounts, and related information (depending on the institution's fiscal procedures) can easily automate the process of periodic billings to intrainstitution departments. Accounting and billing functions are in fact usually among the original purposes for development of job management systems to begin with.

Depending on the nature of the work unit and its products and the level of detail desired, any number of fields can be added to each record in which reportable production data can be stored. One photographic unit manager may be satisfied with knowing how many total slides the work unit produces. Another may consider it vital to know how many of the total slide count are from live shooting, as opposed to copywork or duplication. Yet another may wish to know how many of the slides produced by the copy stands are full color, line positives, or other types.

With proper programming, an information system can also be used to generate production schedules that take into account the quantity and mix of work currently in hand. Most orders in the photography unit require a certain sequence of events, such as (1) shoot internegative, then (2) process internegative, then (3) make prints from internegative. Additional record fields can be added to indicate steps in a multistep process, providing the computer the information required in order to stage the job.

A final bonus to be obtained from a versatile job-information system is actual help with filling the order.

Once the pertinent information has been added to the record created for the job, the computer's ability to report selected portions of the record back in a variety of formats can be used to print vital information directly onto packaging materials or label stocks, speeding the process of order completion. Printers should be selected with the total variety of possible materials to be used in mind. Effective job information systems have been described for use with PCs (Hurtgen 1987), with department-owned mainframe computers (Lund 1986), and in mainframe timesharing situations (Michaels 1984).

## External Information Management: Marketing

As discussed earlier, the increasing emphasis in so many institutions upon cost recovery has caused most sizable biomedical media services to experience increased pressure to function competitively—essentially as small businesses housed within the institution. Depending on the situation, the entire gamut of small-business concerns may be involved, including self-promotion as a means of maintaining vitality. Even in less pressuring situations, it behooves all biomedical media services to turn at least some attention toward marketing.

Marketing need not be a mystical process. According to one successful businessman, "Quite simply, marketing is accurately assessing the marketplace, finding out what the consumer wants, asking 'how can I deliver the goods?' and then doing it" (Cowling 1986a). The manager who simply pays attention to the technologies and the clientele probably fits this description without particularly identifying it as marketing.

In a situation where competition and fiscal pressure is weak, an abbreviated credo may be all the market plan required. A more competitive environment, however, may demand greater attention including the development of a well-thought-out written market plan. If handled properly, this can be a useful management exercise when performed as a group by the department's managers and not only lead to development of a plan, but address many key issues of operations along the way in the form of impromptu discussions and descriptions of current problems. The following seven-point plan is derived from recommendations of businessman Dan Cowling (Cowling 1986b):

1. Situation analysis. The situation analysis is the most objective description possible of who the customer is, what the customer wants, and what the current goods and services are. ("Where are we now?")
2. Statement of problems and opportunities. This step takes a critical look at the situation analysis for the purpose of identifying deficiencies. ("What's wrong, or what are we missing?")

3. The positioning statement. The positioning statement is usually philosophical in nature and begins the process of outlining the plan itself. It may describe the organization as it is or as it desires to be. One department's positioning statement may emphasize experimentation with and reduction to practice cutting edge imaging technologies; another's may concentrate on providing standard core services at high response levels. In any case, the positioning statement should provide overall direction. ("Where do we want to be?")

4. Statement of goals and objectives. A set of realistic and achievable goals are framed based upon the information from preceding steps. Specificity is urged. *To speed job turnaround* is a worthy goal for a service-oriented production unit, but can lead to frustration due to its difficulty of measurement. *To complete all line copy slide orders within 8 working hours* is a preferable statement of a specific objective. ("How do we get there?")

5. The strategy. The strategy is a broad, general description of how the organization will proceed in order to achieve its desired position. It is an outline of sorts of the plan itself. ("What is the overall plan?")

6. The plan. The market plan itself specifically details the products, services, promotion and advertising moves, personnel, and all other factors necessary in achieving the stated goals and objectives. Action steps should be stated forthrightly, in a manner that allows for objective measurement. The plan must describe steps that will work. Once written, it is advised that the strategy be reviewed in the context of the plan, and one or the other or both amended, if necessary. While conventional wisdom holds that tactics are derived from strategy, there are persuasive arguments to the contrary. Sound, workable tactics in some cases may properly form the basis for an overall strategy, rather than the other way around (Ries and Trout 1986). ("What specific steps do we take?")

7. Tracking the results. Frustration is certain to result when any group of people strive to achieve a goal that cannot be objectively defined. It is essential to the vitality of any market plan that sound forms of measurement be included at the start and mechanisms set up to track progress and provide feedback. ("Did we make it?")

**Market Plan Development.**   Development and implementation of a market plan requires time and commitment. It further requires cooperation among those who put it together and those who make it work. As an ongoing project, following such a plan provides the additional bonus of regular opportunities for involving all managers and staff in participation in the direction of the organization.

**Advertising.**   Advertising is fundamental to marketing in the commercial world. Health-care professionals, in particular, have traditionally considered advertising unprofessional, and institutional support services have considered it unnecessary. Increased competition appears to be causing these attitudes to change.

> The prospect of a physician advertising on television for patients may seem bizarre, but the prospect of a lawyer doing it was equally bizarre before the legal field got overcrowded. In a recent questionnaire survey we conducted among physicians, 37 percent of them expressed the intention of using "marketing methods" in promoting their practices. (Albrecht and Zemke 1985)

The establishment of department identity is in itself a passive and subtle form of advertising. This is especially true when it includes development of a logo and labeling of products such as slide mounts, slide boxes, envelopes, and such. Every appearance of the logo is a quiet reminder that the department is there, ready to serve.

A more active and less subtle form of advertising that has become popular is the regular production of a departmental newsletter aimed toward current and potential clientele within the institution and widely distributed intramurally. Depending on the individual newsletter's style, it may focus on image advertising in the form of departmental achievement and function highlights, tips and pointers on effective use of media, and technology developments. Others may include more overt forms of selling the department's goods and services or announce new products and promotions. Newsletters can be effective, although they involve a long-term commitment of time and energy to do well.

Very active and not subtle at all is outright advertising, the time for which has come in some institutional environments. In some environments, the in-house media department competes head to head with the commercial sector in such arenas as 1-hour processing and sales of photographic equipment and supplies. Regular advertising and promotion in such environments is usually essential to the overall business plan.

## MANAGEMENT OF PHYSICAL RESOURCES

### Planning and Organizing Facilities

The opportunity to plan a facility for biomedical media operations is challenging and exciting, whether it be ground-up construction or renovation of an existing facility. While minor remodeling of existing facilities is frequent and ongoing for a dynamic department, completely new construction or major renovation is an exercise that most managers will experience only once or twice during an entire career. Design of a new facility can be both physically and mentally taxing, but it is worth the energy spent since, once completed, many of the deci-

sions made during the process will have to stand on their own merit for decades.

It is beyond the scope of this brief treatment to identify every pitfall or provide complete instruction—some general guidelines will have to suffice. First and foremost is to recruit and accept help from wherever and whomever possible. Local architects, engineers, and contractors are naturally obliged to assist in the case of new building construction, as they are being paid to do so. In most cases, professionals in these fields have good reference materials available, if not actual experience in design of specialized facilities such as photolabs and television production facilities. What these people are unable to do, however, is forecast the future of biomedical media technologies and production trends and design for long-term needs. Moreover, they are usually motivated by economics to complete the work in the most expedient manner and move on to the next job. By all means listen carefully to the advice these people have to offer, but bear in mind that it will be you, not the consultants and construction personnel, who will have to live with the outcome of the decisions.

Professional colleagues who successfully manage similar departments are probably the best resources and also probably the least biased. Those who have personally experienced the process of design, construction, and settling in are the very best of all, especially if they are inclined to freely share their "If I had it all to do again . . ." stories. When possible, the process of designing a new facility should include tours of other departments during regular working hours, conducted by the manager(s) who operate them. Although no two institutions are identical and what works in one setting is not necessarily optimal in another, valuable ideas can be obtained during unhurried visits to similar operations. Some key general concerns in facilities planning are:

1. size
2. work flow
3. ergonomics
4. technology
5. safety

**Facility Size.** Total size of the facility is usually not within the total control of the manager/designer. Space assignments in new construction generally undergo a process of request, justification, negotiation, and ultimate determination, seemingly in such a way that nobody gets quite what they asked for to begin with. In the case of renovation of existing areas, the overall dimensions are pretty well firmly established from the start.

An initial space request can be perplexing, as the total area needed depends (in small part) on such factors as where in the building it is located with respect to elevators, stairwells, exterior doors, and so on, as well as (in large part) its geometry. A square room that measures 20 feet on a side and a rectangular room that measures 10 feet by 40 feet occupy exactly the same area in square feet (400), but by no means do they offer the same possibilities for utilization.

Biomedical media departments vary greatly in staff size and in physical area. The two factors (size and staff) can be correlated as shown in Figure 21.9, which may be of some use as a starting point in developing an initial space request. These data are derived from the 1989–90 academic year annual survey of biomedical media departments (Manning 1990). Note that figures shown in the table are mean values. Sample sizes for all space classifications/FTE counts shown range from 50 to 67.

A final word regarding facility size—bigger is not necessarily better. Although spacious areas may be beneficial psychologically, they may also create fatigue. A compact printing photolab, for example, is probably preferable to a large one in which the operator is constantly walking back and forth from enlarging station to processor. Steps and time are saved in the smaller lab, and it will be more productive and less wearing on the operator in almost every case (Renner 1979).

**Work Flow.** In the ideal production situation, jobs in progress follow a continuous path through the production facility from point of entry through all intermediate steps along the way to job completion. Of all the important considerations in facility layout, work flow is paramount from an efficiency standpoint. This is probably the greatest single reason why the work unit manager who understands the nature of the work and how it is actually handled is the best person to make final layout decisions. Poor work flow patterns are certain to result in excessive time spent physically moving jobs in progress from work area to work area and can easily result in

|  | Mean Area* | Mean FTE | Area per FTE |
|---|---|---|---|
| Administration | 925 | 3.7 | 250 |
| Audiovisual Services | 1,114 | 3.7 | 301 |
| Illustration | 758 | 2.7 | 231 |
| Photography | 2,019 | 6.5 | 311 |
| Television | 2,368 | 3.9 | 607 |

*Area in square feet

**FIGURE 21.9 Mean work unit sizes (area). Correlation of work unit area with full-time equivalents (FTE) assigned to the space. (Derived from the 1989–90 survey of the Association of Biomedical Communications Directors.)**

mishandling and temporarily lost jobs. While the actual arrangement of the department is dictated by other factors (described earlier), virtually any floor plan, regardless of its geometry, will be most efficient when it reflects the production sequence of the majority of the workload.

In photographic departments, the normal sequence of events amounts to shoot, process, and finish. It stands to reason, then, that studio, photomicrography, and copy photography areas should be located near the front end of the work space, with the processing labs, print labs, and finishing areas downstream. An overall circular pattern within a basically rectangular facility may be the ideal, allowing jobs to traverse the circle in unbroken flow, ultimately arriving back at the point of entry, which is usually also the point of finished work delivery or pickup. An early order of business in the design process should be to test the first sketches of the layout by envisioning a series of sample common jobs and tracing the path each will follow. Jobs that bounce from place to place rather than move smoothly through should quickly disclose flaws in the layout's organization.

**Ergonomics.** In the process of evaluating work flow patterns, it is of equal importance to consider the positioning and normal functions of the people involved as well as the hardware and room design. Work flow might indicate the placement of the photomicroscope, for example, in a certain location that, for human reasons such as distractions and interruptions, may compromise its efficiency. After work flow patterns are determined, a second look at the design sketches specifically with the facility's staff in mind is a good idea.

It is surprising how few pieces of furniture and equipment seem to be designed with operator comfort in mind, when practically everybody knows that operator fatigue is both inefficient and demoralizing. Standard counter- and table-top heights do not necessarily apply to specialized facilities and should be considered in context with the nature of the activity to be performed. Back pain resulting from too-low counters, copy stands, and enlarger stations is far too common. Eye strain resulting from extended use of video display terminals seems to be on the increase and can be prevented or minimized by considering lighting conditions and specifying arrangements to reduce screen glare and control ambient light with dimmers.

Not only in facility design, but in the course of routine facilities management, attention paid to operator comfort and contentment will pay dividends. Ultimately, it is the people who work in the facility who get the job done, not the facility itself.

**Technology.** A pitfall that has ensnared more than one planner is designing to accommodate the equipment and procedures of today, rather than those of the future. While it is unrealistic to expect the facilities designer to anticipate all future changes in the imaging technologies and design accordingly, a reasonable effort needs to be made to design in such a way that predictable changes are taken into account.

*Technology management* is an ongoing and everyday process that becomes especially important when planning a new facility. Special consideration should be given to experimental and emerging technologies that could be commonplace by the time the new facility is ready for use. Spaces should be designed for highly specialized purposes only in situations where confidence is high that such purposes will enjoy reasonable longevity.

**Safety.** One of the most valuable contributions that professional architects and designers bring to the planning process is their knowledge of building and fire codes and other considerations for human safety. Not only is this input valuable, adherence is generally mandatory in any case. It should be borne in mind, however, that building codes until recently permitted the use of asbestos insulation, the removal of which subsequently cost millions of dollars. In other words, building and fire safety codes are helpful but in and of themselves may not completely fill the bill.

In the process of design, all possible personal hazards should be identified and communicated to the experts for suggestions. From flooring materials in areas where fluid spills might occur to acoustic design in areas where noise-producing equipment is to be housed, good facility design demands the extra attention required to ensure the well-being of the inhabitants. (For further discussion of the many aspects of effective facilities design, see Eastman Kodak Publication K-13.)

## Controlling Consumable Supplies

Control and management of consumable supplies presents an interesting challenge to the manager of a media service, especially the photography division. Most busy, medium-sized photographic services commonly stock 150 items or more to meet the diverse needs of scientific applications required by their clientele. Many of the products are dated and must be used within a specified time after manufacture, or they may require special storage conditions. Of course, many institutions have carefully regulated procedures for purchasing of commodities, making it difficult to run down to the corner store for a roll of film.

A practical system's objectives are to keep enough supplies on hand to guarantee that function will not be disrupted and to achieve that end with as little administrative energy and cost as possible. A control system for consumable supplies can be managed either manually or with the aid of a computer, but in either case its effective-

ness will relate directly to how well organized it is (de Veer and Michaels 1988).

The organization of the control system begins with storage of the supplies themselves. At some convenient regular interval, physical inventory of supplies on hand will occur in order to determine whether or not the stock is adequate. In many departments, this occurs monthly and results in a monthly order of consumables. It stands to reason that if various supplies are stored in numerous locations scattered about the facility, monthly inventory will involve a good deal of movement about the area and may take a significant amount of time. If possible, supplies should be stored in a minimum number of locations to facilitate the process. Four interrelated and key decisions in developing a consumable supplies control system are (1) what to inventory, (2) how often physical inventory will occur, (3) how much of a given item should be ordered at one time, and (4) at what stock level a given item is placed on order.

**Inventory and Ordering.** What to inventory is dealt with straightforwardly by making a complete list of items to include when counting supplies. In a computer-supported situation, a database record should be constructed for each item. Sample record fields are shown in Figure 21.10, and sample record data in Figure 21.11.

Category—A sort field for grouping of similar items.
Item and item size—Each item should be listed with

| Category: | Film, 35mm Color |
| Item: | Kodak Slide Duplicating #5071 |
| Item Size: | 35mm X 100 ft. |
| Order Unit: | Roll |
| Order Specs: | Spec 404 — All same emulsion |
| Vendor: | (Blank — none specified) |
| Order Point: | 20 |
| Order Quantity: | 50 |
| Unit Price: | 26.50 |
| Location: | 3 |
| Inventory: | (Blank — for current inventory data) |
| Remarks: | |

**FIGURE 21.11 Sample record data—supplies inventory. Sample data for the fields described in Figure 21.10 (see text).**

sufficient specificity to differentiate it from all others on the list.

Order unit—The unit of order should be the same unit as that inventoried to prevent confusion.

Order specs—For special instructions to the vendor pertaining to the item.

Vendor—For those items on the inventory available from a sole source. The name of the vendor is entered only when applicable, and items with blank vendor fields compose a bid list.

Order point—The inventory level at which an order should be placed.

Order quantity—The quantity to place on order when the order point is reached.

Unit price—The last price paid for the item.

Location—Sort field to allow printing inventory sheets showing items stored in a given location.

Inventory—The field into which current stock level is entered following inventory.

Remarks—A standard field in most databases for storing miscellaneous comments.

| Field | Field Type | Field Length |
|---|---|---|
| Category | Character | 15 to 20 |
| Item | Character | 30 to 35 |
| Item Size | Character | |
| Order Unit | Character | |
| Order Specs | Character | 30 to 35 |
| Vendor | Character | 20 to 25 |
| Order Point | Numeric | |
| Order Quantity | Numeric | |
| Unit Price | Numeric | |
| Location | Character | 2 or 3 |
| Inventory | Numeric | |
| Remarks | Character | 30 to 35 |

**FIGURE 21.10    Record fields—supplies inventory. Sample record fields for consumable supplies inventory database and suggested field lengths. Other fields can be added to meet specific needs.**

Determination of the frequency at which regular inventories will be taken must balance the value of time required by staff personnel to do so against the consequences of running short of critical items. It is a subjective judgment that will vary from situation to situation. Inventory frequencies of biweekly to monthly should logically afford greater insurance against shortfall but may be impractical unless the procedures for performing inventory and dealing with the results are fine-tuned.

Less frequent inventory (every 3 months or more) conserves not only staff time spent in taking the inventory, but administrative time as well, as it is cheaper for the department to generate three or four major orders per year than dozens of smaller ones.

How much and when to order are decisions influenced simultaneously by several factors including order history, storage space available, technical factors, economy, and lead time required. History of utilization of each item is an important factor in deciding how much to order. Good record keeping should make it possible to determine a typical volume of need on an annual basis.

Availability of storage space and consideration of its quality in terms of temperature and humidity control and other factors that impact product longevity in storage must be taken into account. Plenty of freezer space, for example, would make storage of large stocks of certain films practical. Storage of relatively large stocks of certain films may be desirable for technical reasons, because doing so reduces the frequency of having to test and adjust filter packs coincident with changes in emulsion batches.

Retailers for the most part order goods from manufacturers or wholesalers in large quantity and expend energy in opening cases, stocking shelves, affixing price tags, and so on. When the department is able to order in even case quantities, retailer handling may amount to little more than taking a full case of goods from an incoming truck and placing it onto the delivery vehicle. The vendor's relative ease of handling should translate to a lower bid.

Lead time required in ordering due to various rules and regulations of purchasing departments or agencies is the very reason why a consumable supplies control system is necessary in many cases. If time elapsed between generation of the purchasing document in the department and actual delivery of the goods routinely runs 2 to 3 months, the when-to-place-the-order decision must naturally take that into consideration.

Once the system is in operation and inventory taken, an order for the specified quantity of each item will be generated each time the order point is reached. Subsequent inventories should be reviewed closely to evaluate effect, and adjustment to order quantities and order amounts should be ongoing.

A computer-supported system for consumable supplies control can provide a number of related benefits. It can quickly provide dollar-value estimates of each order by performing arithmetic on the order quantity and unit price fields. For departments that purchase goods from retailers and sell them back to other departments internally, the database can be instructed to produce sale price listings, with or without a percentage markup. It can perform additional tasks such as that described in Figure 21.12—pricing an item that involves purchase of other items.

**Algorithm for sale price determination of a 36 exposure roll of film when raw stock is ordered in long roll.**

Formula:    $[(A/18 + B] \times 1.25 = C$

Where:  A = cost of 100 foot roll of film (look up value)
18 = number of 36-exposure rolls from 100 feet
B = cost of film cassette (look up value)
1.25 = provides a 25% markup
C = final sale price of 36 exposure roll

**FIGURE 21.12  An algorithm can be built into the inventory system to automatically calculate repackaged costs for short rolls of film based on purchase prices when buying bulk.**

### Controlling Equipment Inventory

**Equipment Inventory.** Most institutions have systems in place for keeping track of movable equipment. The existence of a method of properties accounting is in fact required by law for most public agencies. Practically all such systems reside on central institutional mainframe computers and are designed primarily to meet the information needs of the properties accounting officials, rather than those of the actual custodians of the hardware itself. Many department managers elect to maintain collateral equipment inventory systems to meet more specific needs.

In one institution, for example, a portion of end-of-year fund surpluses is retained by the media department for future use in financing capital projects, and the excess amount is returned to the institution. The ceiling level for retention is defined as a percentage of the current value of income-producing equipment owned by the department. While this particular case may not be all that common, other circumstances may form a rationale for maintaining an inventory system locally. Some managers will elect to maintain such systems solely for the reason of full control.

Equipment inventory may be maintained in spreadsheet form, but database software is preferable. The departmental inventory can usually be managed with equal effectiveness on either a mainframe or PC-based system. A typical list of data fields is shown in Figure 21.13.

Category—A standard set of descriptors for general classification of equipment into some logical grouping.
Item—Describes the item in generic terms.
Description—A field for additional descriptive information about each item, including manufacturer and manufacturer's model number.

| Field | Field Type | Field Length |
|---|---|---|
| Category | Character | 15 to 20 |
| Item | Character | 30 to 35 |
| Description | Character | 30 to 35 |
| Serial Number | Character | 14 to 16 |
| Institution ID# | Character | (see text) |
| Location | Character | 2 or 3 |
| Date Purchased | Date | |
| Cost | Numeric | |
| Value | Numeric | |

FIGURE 21.13 Record fields—equipment inventory. Sample record fields for an equipment inventory database and suggested field lengths. Other fields can be added to meet specific needs.

Serial number—Manufacturer's number, if applicable.

Institutional ID#—Field size depends on the institution's system for properties tagging and identification.

Location—Field to contain a standardized entry to identify a home location for each item, even if portable, to aid an in-place inventory.

Date—Date of purchase.

Cost—Contains the item's cost at time of purchase.

Value—Calculated field. Contains an algorithm that calculates an estimated present value (or estimated current replacement cost) for the item based on the two previous field values. The formula can be simple and linear and figure present value as a function of time elapsed since purchased (by performing date arithmetic on purchase date value) multiplied by an inflation factor. At the manager's option, however, a higher level of sophistication might be employed. A series of algorithms might be developed for different rates or methods of depreciation, for example, and this database used to depreciate equipment as well as keep track of it.

The above fields are vital. Any number of optional fields can be added to meet more specific needs of the department. In the case of the department referred to earlier, which must separate income-producing equipment from other equipment, a logical field for that specific purpose would make sense.

## MANAGEMENT OF HUMAN RESOURCES

Most experienced managers will readily agree that management of the human resources available—working with people—is the most challenging aspect of leading a successful and effective organization, as well as the most important. A biomedical media department might be well equipped, generously budgeted, and housed in excellent facilities, yet still fall short of goals achievement and operational effectiveness, for reasons of poor individual and group performance. It is the staff, individually and collectively, who ultimately determine whether or not the department fulfills its mission. It is, therefore, a critical responsibility of the leader to ensure that the staff are properly focused on what needs to be done, aware of why it needs to be done, and encouraged to make it a personal priority to see that it is in fact done.

## Planning—Staff Size

The price of understaffing is heavy in terms of personnel. The need for excessive overtime or frantic work shifts to barely meet heavy workload demands on an extended and routine basis will quickly kill the spirit of even the most dedicated employees. A serious case of understaffing may eventually destroy the department itself, as missed deadlines undermine client confidence and staff fatigue plays havoc with morale and ultimately customer service. As is true with physical resources, however, bigger is not necessarily better, and overstaffing may be just as damaging.

Recognizing that seasonal fluctuations in the workload occur, it is tempting to describe the optimum staff size as that required to handle the load at peak periods. Extra time that becomes available during periods of lowered demand is directed toward maintenance and other internal self-directed activity.

Difficulties can be expected to arise, however, when the work day is not full and active. Periods of inactivity can in fact be more fatiguing than a steady work pace. Morale suffers when people are assigned low-priority work during such periods, as most resent the feeling of being assigned busy work.

A media department of one individual essentially enjoys the commitment of 100% of the total staff time available to production. Doubling the staff to two persons, however, does not double production, as one of the two will probably be designated the superior and be obliged to spend a certain amount of time supervising and evaluating the work of the other. Additional time will be spent simply keeping each other up to date on jobs and projects. As more people are added to the staff, the burden of supervisory activity, which is necessary but not related directly to production, continues to increase, yielding diminishing returns. A staff size large enough to handle the full workload at annual peak times without working overtime could probably be reduced by 20% to 25% according to one study (Renner 1979).

The most effective working environments in terms of staff size are those in which the workload is manageable

by the regular staff most of the time. Brief periods of increased activity are offset by similar stretches of reduced load, varying with seasonal fluctuation.

## Organizing

Organizing, as described earlier, involves positioning resources according to a structure in which they can be most effectively utilized and identifying specific actions or functions. New personnel selection and orientation are two important activities in organizing people, and the job description is an important tool.

**Selection.**    Interviewing candidates for vacant positions is one of the most important functions in management and should always be approached seriously, as hiring decisions affect people's livelihoods as well as the department's welfare. One effective agenda for applicant interview begins with an opening statement on the part of the interviewer that briefly describes the institution, the department, and the department's mission, following which the interviewee is asked to respond. The interviewer should thereafter answer direct questions succinctly and concentrate upon listening to the applicant, asking open-ended questions, and paying careful attention to answers.

In order for the manager to select the best individual for the position, it is vital that as much as possible be learned about each applicant during the short time available. Checking references and other information provided by application form or resume can be thought of as the scientific or factual aspect of personnel selection. Drawing the interviewee out into conversation regarding work and career and giving undivided attention to views and ideas expressed is a more intuitive exercise, and no less important. Most alert job applicants have a pretty good idea what a potential employer wants to hear and are not shy about describing their abilities and attributes in favorable terms. It is up to the interviewer to develop a feel for whether or not the candidate's statements are genuine and sincere.

The interviewer should always keep in mind the position for which the candidate is applying and constantly gauge the applicant's suitability for that position. Presumably, all those selected for interview have met minimum qualifications. Caution is advised in cases where the applicant's qualifications far exceed the job's requirements, and direct questioning on the matter is indicated. Motivating workers whose true abilities and skills are grossly underutilized in their daily assignments is as difficult if not more so than motivating those who are properly positioned. An overqualified staff member will rarely remain content in a position that lacks challenge.

**Job Description.**    During the application and selection process, the departmental mission statement, organiza-

tional chart, and a job description should be provided to the applicant. A rather traditional job description is shown in Figure 21.14. When the employment contract is formed, the new staff member deserves to have the employer's expectations made clear.

**Orientation.**    New employee orientation is a necessary process that deserves thoughtful planning. In the institutional setting, the personnel department normally conducts new staff orientations on a regular basis to take care of such matters as tax and employment forms, insurance and other fringe benefits, parking decals, identification badges, and the like. A format of briefings interspersed with audiovisual presentations is sometimes used and may consume a full day.

An orientation to the biomedical media department should be conducted as well. In the author's department, orientation involves presenting each new staff member with a full packet of information. Bearing in mind that the new employee is virtually bombarded with information during orientation, everything is provided in written form for later reference. The supervisor and new staff member follow a prepared checklist of items to discuss, which corresponds with the written information sheets in the packet. As each item is completed, it is initialed, and

### Medical Photographer I

**Job Summary:**

The Medical Photographer I works under general supervision. Photographs various subjects; assists in production of specialized projects; maintains photographic equipment; occasionally performs any duties of Photo Lab Technician; performs other duties as assigned.

**Job Duties and Responsibilities:**

1. PHOTOGRAPHS VARIOUS SUBJECTS:
   receives assignment for still or motion picture photography in any of the following: 1) clinical photography, e.g. surgical, intra-oral, ophthalmic, patient and cadaver and 2) conventional photography, e.g., graphic art, portraiture and public relations; utilizes specialized techniques, e.g., photomicrography, photomacrography, infrared, ultraviolet and fluorescence, high speed, time lapse, etc.; determines optimum combination of equipment, technique and process; sets up and adjusts equipment to achieve desired effects; determines and sets critical exposure time and lighting required; levels, crops and masks subject; makes or requests other necessary adjustments be made depending upon subject and setting; photographs subject; obtains consent for release of photograph when necessary.

2. ASSISTS IN PRODUCTION OF SPECIALIZED PROJECTS:
   contributes as a media specialist on photographic features such as films, slide packages, etc.; discusses educational and training items which have been suggested or could effectively use photographic services; performs photographic assignments related to special projects.

3. MAINTAINS PHOTOGRAPHIC EQUIPMENT:
   performs periodic maintenance on optical, camera and lighting equipment.

4. OCCASIONALLY PERFORMS ANY DUTIES OF PHOTO LAB TECHNICIAN:
   mixes chemical processing solutions; develops negatives, positives and transparencies determining process and conducting and monitoring various stages involved; makes prints in monochrome or color according to order; performs other required duties.

5. PERFORMS OTHER DUTIES AS ASSIGNED.

**FIGURE 21.14  Sample job description. A traditional job description whose purpose is to set forth the employer's expectations of the staff member.**

the finished checklist is added to the employee's personnel file. Some sample items from the department checklist are:

performance evaluation procedures
salary verification
department policy manual
work schedules and overtime policy
building evacuation
handling medical emergencies
reporting on-the-job injuries
telephones and pager system
locker assignment and key issuance
material safety data sheets notebook

The department checklist does not duplicate items covered in other orientation sessions, except for certain safety and emergency procedures deserving extra emphasis.

## Direction—Motivating

**Theory X, Theory Y.**  Douglas McGregor's famous 1940 discussion described two opposing concepts of the worker. *Theory X* described work as inherently distasteful to humans and a consequent lack of initiative and ambition to perform it. The Theory X manager would be inclined to employ methods of tight control and output measurement on workers and extend little or no opportunity for independent judgment below upper-management level.

The diametrically opposed *Theory Y* described work as natural and rewarding and humans as creative and self-actuated under proper conditions. The Theory Y manager would place far greater emphasis on creating those conditions in the organization than on controlling workers and would allow them to function with minimal supervision. According to McGregor, all management styles exist on a continuum between the two (McGregor 1960).

Few Theory X managers thrive in today's environment. The most successful managers have learned that energy spent in understanding their staff members' needs and attitudes pays greater dividends in the long run than energy expended in driving and pushing workers with an eye only on the bottom line.

Whether the department is large or small, the manager should try to view the workers on two levels: as members of the team and as individuals. The cooperative effort of an effective team is vital to the smooth function of a group of workers, and more vital the larger the group. Yet, effective team play cannot and should not require complete loss of identity and independence for the individual. The reality is that some individuals are stronger team players than others. Some people thrive on social interaction and group effort and in fact require the sup-

port of associates to achieve their potentials. Others, whose requirements for interpersonal relations are less, do their best work when left alone. The manager with keen sensitivity to the needs and preferences of individual staff members as well as to the staff as a whole can optimize overall productivity by regulating the degree to which each will have to subordinate personal drives to the collective effort of the team.

**Work Environment.**  The most motivating work environments are those in which staff members (1) feel valued and appreciated, (2) feel informed, (3) feel pride in the organization, (4) feel secure, and (5) enjoy personal freedom.

**Self-Worth and Value.**  According to Robert A. Whitney, "Making people feel important is management's greatest tool to increase worker productivity and job interest" (Whitney 1975). The supervisor who takes time to show interest in what the people are doing generates enthusiasm and bolsters self-esteem. Visits to the various work areas by the department head, during which genuine interest is expressed in both the work and in the methods, can be enlightening for manager and worker alike.

The importance of recognition of effort cannot be overemphasized. Few things are more damaging to the productivity of the workplace than individuals who grope their way through the work day feeling that nobody cares how hard, how much, or how well they do what they do. The workplace in which praise and recognition is rare but criticism and complaint is common fosters such feelings. Recognition need not be formal to be effective. A simple, sincere "Good job!", when properly placed, can be a more meaningful motivator than a certificate of merit.

The work itself is certainly a factor affecting feelings of self-worth. Enthusiasm for the job will not last long in even the most motivated worker whose days amount to nothing more than tedious, repetitive tasks. A worker who is "bored with dull routine will affect the morale of the entire department, resulting in diminished productivity" (Stenstrom 1976). Work loads that include a blend of challenging assignments with the less exciting go far to prevent boredom.

**Feeling Informed.**  Technically speaking, a worker only needs to know enough to accomplish the immediate task to be productive. People are most productive, however, when they understand a good deal more than simply the job at hand. Most individuals wish to know how their function contributes to the overall operation and to generally be apprised of events taking place around them. A conscientious manager should maintain ongoing communications with people at all levels to keep them informed about current and planned events.

**Feeling Pride in the Organization.**  The manager of a media department that functions within a large institu-

tion may have relatively little influence over staff attitudes regarding the institution itself, but certainly has influence over attitudes regarding the media department (Stenstrom 1976). Instilling pride in staff members is an important responsibility, not only because it is beneficial to the mental health and satisfaction of staff members, but also because it contributes to productivity. Members within a department who share a feeling of pride in their department and the institution of which it is a part and who share a feeling of pride in their department's capacity to produce seem to produce at higher levels than those who do not have such loyalties and self-esteem (Likert 1961).

There are sound reasons why production statistics should be publicized from time to time. Favorable production reports for the department touch every member of the department, as each individual feels pride in the knowledge that personal effort contributed to achieving a record level of output. Most people translate good production numbers into hard work, and virtually all individuals desire to be recognized as hard workers. The manager who interprets and makes known to the staff how departmental activities contribute to larger institutional achievements bolsters these feelings further.

**Feeling Secure.**   According to Maslow's hierarchy of personal needs, feelings of safety and security are critical to human motivation at a very basic level, second only in importance to survival itself. Human beings must feel secure before they can be motivated by higher ideals (Maslow 1970). Insecurity in the workplace distracts workers from their tasks, reduces productivity, and can even damage the organization itself.

A manager's antidote to insecurity should include honesty, good communications, and even-handed dealings with all staff members, directed toward the development of trust and confidence, which are the cornerstones of security. Rumors of possible policy changes, salary adjustments, changes in duties, and the like have vast potential to distract and disrupt and must be controlled. Regular communication, which includes honest explanation of possibilities under consideration and the likelihood of eventual realities, can be highly effective in controlling damaging rumors.

Perhaps the most common fear shared by the greatest number of human beings is fear of the unknown. In the workplace, people have a right to know what is expected of them and also what to expect from their employer. A well-organized department should have clearly codified policies and procedures that explain responsibilities of both workers and management. All staff personnel should have easy access to or personal copies of pertinent rules and regulations.

This author believes that the fewer rules the better, but also that some people in the organization feel more secure when certain matters are spelled out, making at least some rules necessary. Far more important than the number of rules and what sorts of things they attempt to control, however, is how they are applied. Inconsistent application of rules creates perceptions of favoritism and discrimination and is destructive to morale and feelings of being dealt with fairly. If a rule cannot be applied fairly to all for any reason, it is inherently flawed and should be changed or eliminated.

**Personal Freedom.**   At the student or apprentice level in practically any field of endeavor, an individual's need for careful supervision and regular assistance is great. As skill in performing tasks increases and understanding of the principles involved is gained, these needs diminish. Just as too little or too infrequent supervision can impede the learner's progress, however, so can too much or too frequent supervision obstruct it. Continuing development of the learner/worker relies upon ever-lessening supervision.

Theoretically, the ultimate ideal of management ought to be to assist the development of all staff members to the point at which none of them requires any supervision at all. Practically speaking, the manager should certainly endeavor to achieve minimal supervision for all, recognizing that some will likely always require more than others.

The value of allowing individual freedom in the workplace should not be overlooked. A great many people, if left alone, will voluntarily set for themselves a work pace even greater than that which a supervisor might impose. To be effective, staff member freedom requires a high degree of interaction between worker and manager. The manager who keeps in close touch with the work of a subordinate will probably find it natural to impose ideas, some of which may be unwanted. The manager who leaves subordinates completely alone deprives them of stimulating interaction. "A supervisor's active interest in the progress of subordinates, combined with a hands-off policy concerning direction will result in greater productivity" (Stenstrom 1976).

## Control Functions

The job description was previously described as an essential tool in communicating the employer's expectations to staff members. It is exactly that, and it is traditionally used as the basis for regular evaluation of performance. The larger view of job performance, however, requires a larger view of the job itself. The manager who pursues the larger view probably considers the job description a misnomer, amounting to a mere listing of tasks.

**Mission Statement.**   The sample departmental mission statement discussed earlier (Figure 21.2) describes the job. A work environment in which all members of the team are doing the same job is stimulating, and all staff members of the biomedical media department do the

same job as described by the mission statement, regardless of specifications in the individual job descriptions.

Getting the job done is the highest level of performance, and certain workers require no further specificity than the mission statement and its cornerstone principles. It may be valuable to bear in mind the reality that no artistic or scientific breakthrough has ever occurred because it was called for in a job description.

Satisfactory accomplishment of the tasks as articulated in the job description itself lacks meaning. The manager who motivates will take extra care during discussion of performance expectations and subsequent evaluation to place the tasks called for in the job description into the larger context of the department's overall mission.

**Performance Evaluation.**    Performance evaluation conferences should occur at the same frequency for all staff members, regardless of the likelihood that some will require more counseling than others. Although many institutions require performance reports on an annual basis, once a year is hardly an effective schedule for providing meaningful feedback. A brief monthly conference at which recent events are fresh in both minds, with notes taken, is useful. Exceptional performance as well as deficiencies should be duly noted. When the annual performance evaluation comes up, the manager will have notes of eleven performance discussions to use as a guide.

The manager has many ways of communicating expectations to staff members. The regular performance discussion is one such venue, but it should not be used for that purpose exclusively. A good manager is invariably a good listener, and two-way communication should always be encouraged. This is especially so in private face-to-face discussion.

**Human Resources: Tools**

**In-service Education.**    Some departments follow regular schedules of in-service education, known by various names ranging from Technical Conference to Audio Visual Grand Rounds. In one format, each assignment selected for presentation is given a brief introduction by the producer, and images are shown and discussed, the critique session being moderated by the department head. It may deal with specific matters of lighting, exposure, positioning, and such, as well as the assignment's overall purpose. The objectives of such sessions are to educate and improve, and they serve the underlying purpose of maintaining continuing emphasis on quality. Junior staff members are able to gain experience quickly, and experienced staffers are afforded the regular benefit of constructive assistance, as well as recognition for work well done.

A word of warning should be added. The value of these sessions will be a direct reflection of the skill and

sensitivity of the moderator. Unless conditions are right, such discussions can easily and quickly cause wounded pride, jealousy, and other destructive outcomes. This is probably not an exercise for a staff that is not already functioning at some level as a supportive and motivated team.

**Professional Activity.**    Professional associations provide opportunities for enrichment beyond the ability of most workplaces, where day-to-day activities tend to dominate thought and action. Attendance and participation at local and international meetings of appropriate organizations can be professionally refreshing and stimulating and should be supported and encouraged to the extent of the manager's ability for as many individuals as possible.

**Staff Newsletter.**    Heads of larger departments may find value in the regular publication of a staff newsletter, the thrust of which is different from that of a newsletter that circulates throughout the institution for marketing purposes. A staff newsletter may be used effectively to keep all team members informed of events such as acquisition of new equipment, computer application software, or new books added to the department library. It provides a convenient vehicle for recognition of the accomplishments of individuals and work groups and advising all of important upcoming events. New members of the staff can be introduced with brief biographies. Such a newsletter will probably be of greatest effect when it is personally written by the department head, as it becomes a more personal communication. The department head can use it to announce changes in departmental policies or procedures or for editorial purposes, providing the whole staff with insights as to future directions and interpretation of current institutional events. The newsletter, wisely used, can also be used to keep time-costly general staff meetings lean, reduce them in number, or perhaps even eliminate them.

**Staff Recognition.**    Programs of staff recognition can be of value in departments of sufficient size. To have value, the nature of any recognition must be meaningful. Nobody benefits from what amounts to a teacher's pet award, but an Outstanding Contributor of the Year or Employee of the Month award, duly recognized in a proper setting and determined by a legitimate participative process, can be of value to the individual and the department alike. In the process of selecting one person for such distinction, management sends to all staff members the message that excellence in performance is important and does not go unrecognized. The process of nomination, election, recognition, and tangible rewards to be given (such as a framed certificate, news release, free parking in a prestige location) should be thought through carefully, and a process of input and acceptance at all levels should precede implementation.

## CONCLUSION

According to credible analysts, as much as 88% of the American work force will be engaged in service jobs by the year 2000. In the closing paragraphs of *Service America!*, Karl Albrecht and Ron Zemke remind us that management is a service, too: "Doing business in the new (service) economy will require new ways of managing. . . . We believe a new philosophy of management is beginning to take shape in the United States in response to the need for more creative ways to think about, organize for, and deliver service" (Albrecht and Zemke 1985).

This assessment is probably no truer for any service sector than it is for health care, an industry that is undergoing transforming changes at present, a reality that holds promise, challenge, and warning for those who manage all health-care support services.

## REFERENCES

Albrecht, K., and Zemke, R., 1985. *Service America!* Homewood, IL: Dow-Jones Irwin.

Boettinger, H. M., 1975. Is management really an art? *Harvard Business Review* (Jan-Feb):54–55.

Cowling, D., 1986a. Opinion. *Arkansas Business* 16:18.

Cowling, D., 1986b. Opinion. *Arkansas Business* 14:17.

deVeer, W., and Michaels, K., 1988. A systematic approach to inventory control with (or without) a computer. *J. Biol. Photogr.* 55(1):13–17.

Drucker, P. F., 1985. Management: Tasks, Responsibilities, Practices. New York: Harper & Row.

Eastman Kodak Company, 1977. *Photolab Design*. Rochester, NY: Kodak Publication No. K-13.

Evans, C., 1979. *The Micro Millennium*. New York: Viking Press.

Hurtgen, T. P., 1987. Media management information system (MMIS)—A dBASE III Plus applications program for media department management. *J. Biol. Photogr. Assoc.* 55(2):53–62.

Likert, R., 1961. *New Patterns of Management*. New York: McGraw-Hill.

Lund, R. E., 1986. Data base management in a large cost-recovery laboratory. *J. Biol. Photogr. Assoc.* 54(1):25–28.

McGregor, D., 1960. *The Human Side of Enterprise*. New York: McGraw-Hill.

Manning, T. R., 1990. Annual survey report of departments of biomedical communications based on data from the 1989-90 academic year. Shreveport, LA: Association of Biomedical Communications Directors, Inc., LSU Medical Center.

Maslow, A., 1970. *Motivation and Personality*, 2nd ed. New York: Harper & Row.

Michaels, K. V., 1984. Computers in media services management: The case for timesharing. *J. Biol. Photogr. Assoc.* 52(1):1–4.

Renner, W. E., 1979. Circumventing the law of diminishing returns. *J. Biol. Photogr. Assoc.* 47(3):123–126.

Ries, A., and Trout, J., 1986. *Marketing Warfare*. New York: McGraw-Hill.

Rue, L. W., and Byars, L. L., 1977. *Management Theory and Application*. Homewood, IL: Richard D. Irwin.

Screnci, D., 1987. An overview of computer applications for biophotography. *J. Biol. Photogr. Assoc.* 55(2):47–51.

Shrode, W. A., and Voich, D., 1974. *Organization and Management: Basic Systems Concepts*. Homewood, IL: Richard D. Irwin.

Stenstrom, W., 1976. Management involves everyone. *J. Biol. Photogr. Assoc.* 44(2):47–48.

Whitney, R., 1975. Management by commitment. Lecture to sales and marketing executives, Dallas, TX.

# Chapter 22
# Conserving and Storing Photographic Images

## R.F. Irvine

*"That which is New at this time, will one day be Ancient; as what is Ancient was once New. It is not Length of Time which can give value to Things, it is only their own Excellency."*

William Heberson (1710–1801)

The purpose of this chapter is to guide the photographer in the proper identification, care, and storage of historic and modern photographs. As these are sometimes the sole surviving documents of our past, the challenge and rewards offered by such an undertaking are well worth the effort involved. The chapter is divided into identification, preventive conservation including final storage and retrieval, and a short list of the suppliers of archivally acceptable enclosures. "We humans are looney enough to acquire, cherish, and protect all sorts of delicate and fugitive plants, creatures, objects, and artifacts, why discriminate against [color] photographs?"(Coleman 1980).

## INTRODUCTION

At the outset, it should be made clear that conservation in the context of this chapter concerns only the preservation of the photographic image and prevention of further deterioration. Restoration techniques, a few of which are discussed, should never be expanded to include chemical treatments, which are so often irreversible. In the latter case, the trained conservator must be consulted.

Most institutes of learning, whether they be hospitals or universities, have collections of documents and photographs either displayed or stored away. Often these artifacts are of tremendous historical interest, but unfortunately storage facilities are miserably inadequate even for minimal protection of both negatives and prints, and they are more often than not certain to destroy their usefulness. It is predictable that sometime, somewhere, someone will want to rescue these images from the past. Often they are already badly damaged. The task of attempting a rescue often falls upon the shoulders of the institute's photographic department.

## IDENTIFICATION

The first step in the rescue attempt is, of course, the correct identification of the negative or print. This will in turn assist with dating. Unfortunately, sources vary as to when processes were actually announced, so accurate dating is not always possible.

### Calotype (1835)

This rare and valuable paper negative is sometimes impregnated with oil or wax. The paper is usually a high-grade writing paper or Whatman paper. It is nearly always watermarked. Since these are extremely rare in North America, they should be taken to a professional photographic or paper conservator for authentication and storage.

### Daguerreotype (1834–1844)

This photograph has a very distinctive mirror appearance showing both positive and negative images depending on the direction of the light falling on the plate. These delicate images were often tinted with dry pigments to give the appearance of a color picture. This was generally done by a colorist or the photographers themselves. Since these images were extremely fragile, they were protected in elaborate containers, hence the term *hard-case photographs*.

The sizes of the cases were relatively standard and are often referred to as *international sizes:*

| | |
|---|---|
| whole plate | 6 1/2″ × 8 1/2″ |
| half plate | 4 1/2″ × 5 1/2″ |
| quarter plate | 3 1/4″ × 4 1/4″ |
| sixth plate | 2 3/4″ × 3 1/4″ |
| ninth plate | 2″ × 2 1/2″ |

Smaller miniatures were also produced for lockets and dress rings. The most popular format for portraits was, however, the sixth- and ninth-plate sizes. The casements chosen for the daguerreotype were often quite elaborate, with plush velvet lining and protected with carved wood, Bakelite, papier-mâché, or leather enclosures. The pho-

tograph itself was usually matted with a gilt frame and protected with a cover glass.

During the preparation of the plate and prior to sensitizing, it was very carefully polished. Under-low power magnification, these polishing marks can be seen. If they appear to run vertically, in other words, at right angles to the image, this suggests that the daguerreotype might have been one of a stereo pair. When one would view the image using a stereoscope, the light would probably come from above, which would make these abrasion marks less obvious.

### Ambrotype (Collodion Positive) (1854—1860)

This is also a hard-case photograph, mounted and presented in much the same manner as the daguerreotype. Unlike the daguerreotype, which under certain lighting conditions appears as a negative image, the ambrotype is always a positive image. When placed side by side, the daguerreotype mirror finish is much more brilliant, and the ambrotype appears, in comparison, drab and flat. This positive image is produced when a collodion emulsion is backed with a dark material, (cloth, paper, or enamel) (Figure 22.1). The quality of the photograph obtained is dependent upon the density, thickness, and color of the emulsion, unlike images created with gelatin. When dark amber or blue glass was used as the support, these were called Amphitypes.

### Ferrotype (Tintype, Melainotype) (1855—1860)

This image was created by the application of a collodion emulsion to an iron support which had been painted brown or black. The iron plate was often very crudely cut and mounted either in an album, or a slip-in type of card mount, or in a hard case. On the verso of the card support, the name of the photographic studio and advertisements the studio deemed suitable to publish often appeared! Also on the verso may be seen small brown spots similar to foxing, due to high humidity causing the iron to rust. If in doubt as to whether the photograph is indeed a ferrotype, it may be confirmed by testing with a magnet.

All these hard case photographs were fairly common and were often favored by learning institutions for portraits of prominent teachers, medical practitioners, researchers and senior administrative officers.

### BLACK-AND-WHITE NEGATIVES

### Rigid Supports—Glass

**Albumen Dry Plates (1847—1855).**    In this type of plate, egg white was the binding medium for the silver salts. As

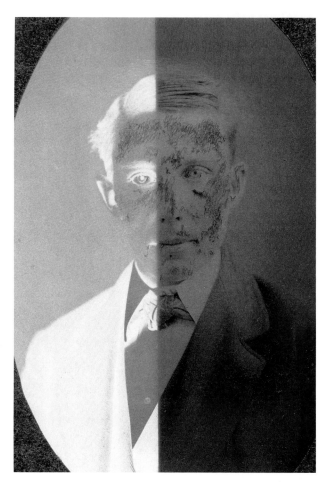

**FIGURE 22.1    A collodion negative, showing a positive and a negative image. Half of the negative has been backed with black paper.**

a result, they have a brown cast to them and the emulsion is quite shiny. A low sensitivity to light made these plates very unsuitable for anything but landscapes. Not surprisingly, this type of plate was quickly replaced with the introduction of the more sensitive wet collodion plate.

**Collodion Wet Plate (1851).**    This wet-plate emulsion usually has a slight brown cast and is fairly glossy (compared to gelatin). However, under certain lighting conditions, it can have a creamy appearance. When used for an ambrotype, it has the ability to reverse the negative image when backed by a dark material. The early wet plates were produced by the photographers themselves on crudely cut pieces of glass. The emulsion was poured onto the glass by hand. As a result of this practice, ripples around the edges may be seen, and sometimes the thumbprint of the photographer can be detected at the corners. Tong marks may also be found on the edges of the plate, where it was grasped during the sensitizing process. Retouching marks may also be observed, usually in pencil. On some portrait negatives, for instance, where the face was overexposed, abrasion patches may be seen

(Figure 22.2). Here a very mild abrasive was used in a circular fashion to try to reduce the density, which made the plate easier to print.

**Collodion Dry Plate (1864).**    This plate was commercially prepared, rather than being prepared by the photographer, therefore the emulsion is much more evenly spread without any of the blemishes characterizing the wet plate.

**Gelatin (1891–Present Day).**    This is a clean cut, commercially prepared plate. The emulsion is gray and dull, and can thus be identified, since its appearance is similar to present-day emulsions.

Identification of the various emulsions involves the placing of a small drop of water and a small drop of alcohol [ethyl] on the very edge of the plate, always being careful to avoid the image area.

*Albumen* negatives do not react to either solvent.
*Collodion* is unaffected by water, but becomes sticky with alcohol.

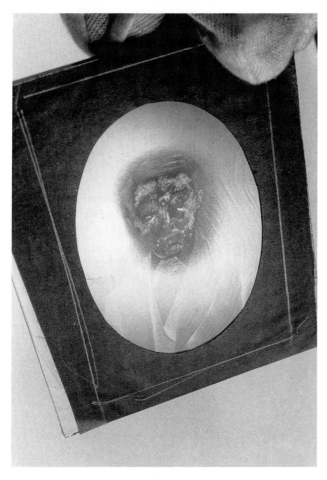

**FIGURE 22.2    A wet collodion negative demonstrating: (1) the uneven surface of the emulsion as a result of hand pouring, (2) abrasion of the face to reduce the density of the negative, for ease of printing.**

*Gelatin* is unaffected by alcohol, but swells with water. This swelling can be readily observed under low-power microscopy (×10).

**Autochromes (1905–1932).**    Although not a negative, the autochrome starts off as a gelatin negative and is reverse-processed, as will be explained. The first commercially produced color photographs were introduced by the Lumiére brothers, Auguste and Louis. This process was an offshoot of James Clark Maxwell's experiments with additive color in 1861. These autochromes, as they were called, were produced commercially in 1910 and used extensively until the introduction of Dufaycolor and, later, Kodachrome in 1935.

Briefly, the process used a 3 1/4 × 4 1/4″ glass plate coated with gelatin, overlaid with a very thin layer of red-, green-, and blue-colored starch grains with carbon black brushed into the interstices. On exposure the light passes through what in effect are red, green, and blue filters. The plate was then reverse-processed. The end result was then a positive image coated with red, green, and blue starch grains, which on projection gave a full color positive image. Since this is an additive color process, only one-third of the light is transmitted, which results in an image that is somewhat dull compared with modern-day subtractive color transparencies. The autochrome is quite distinctive and does not require any special technique to identify it. However, if in doubt, low-power microscopy will reveal the morphology of the layers, and cross polars will identify the starch grains with their typical Maltese cross appearance (Color Plate 120).

### Flexible Supports: 1888–Present Day

The first flexible support for the photographic emulsion was introduced by George Eastman in 1888. It was made from cellulose nitrate (pyroxyline), now commonly referred to as nitrate film. This was a great step forward for photography. Cameras became smaller, and on the first Kodak camera, as many as 100 photographs, circular and 2 1/2″ in diameter, could be taken on a single roll of film. However, the film is highly flammable. When used for motion pictures, the film would burn if jammed in the projector. Many fires were caused this way. American government legislation in 1951 forced the industry to investigate alternate nonflammable supports. Cellulose acetate, triacetate, and later the thinner polyester (Mylar) film bases were then introduced. Apart from being safer, these supports have greater flexibility and strength and, if processed properly, superior keeping properties. These are all important characteristics for a quality negative material.

In contrast, the early nitrate films had very poor keeping qualities, were chemically unstable, and, if improperly stored, produced noxious and damaging acidic fumes. More significantly, if they are exposed to too high

a temperature (38°C), they can spontaneously combust. For these reasons, it is always advisable to duplicate the negative and transfer the original to a facility that can ensure proper storage. Remember, if deterioration of the original has started, it will progress rapidly.

Nitrate film can be identified in a number of ways:

1. It has an acidic smell.
2. It burns fiercely.
3. It will sink in trichlorethylene.
4. No edge marking—"Safety Film" is marked as such.
5. Often stained brown.

All films, ancient and modern, were and are very sensitive to the blue end of the spectrum. The addition of cyanine dyes to the emulsions, referred to as optical sensitizers, were used as far back as 1880 with collodion emulsions. Unfortunately, this only extended the color sensitivity to a limited extent. These plates were called orthochromatic, and their ultra-sensitivity to blue caused the sky in landscapes to be overexposed and therefore lacking in any cloud detail. It was not until 1920 that the large-scale manufacture of panchromatic film began. From that point on, photographers were able to control the gray scale of their negatives almost completely; the use of filters increased this control even further. Furthermore, as sensitivity was extended to 900 nanometers and beyond, infrared photography became possible.

Cellulose acetate, triacetate, and polyester-base film, with gelatin emulsions, are usually labeled in some way to distinguish them from nitrate base (for example, *safety film*). If in doubt, the same tests used for identifying nitrate film can be undertaken: (1) safety film smolders but does not burn, and (2) safety film will float in trichlorethylene.

## SIGNS OF DETERIORATION

### Daguerreotype

*The image surface is extremely delicate and should never be touched!* The cases are also fairly fragile. The hinge, which is usually a cloth material of some kind, is often the first thing to be damaged, and the soft brass closure fittings are often bent or even broken. The cover glass may be very dirty, or it may have started a chemical breakdown known as *weeping glass*. Sometimes the appearance of the cover glass gives the impression that the daguerreotype is in poor condition when, in fact, all that needs to be done is either to clean or replace the glass. Silver tarnish often forms on the surface of the plate due to breakdown of the tape that is used to bind the photograph, the gilt mat, and the cover glass together. This allows aerial contaminants, such as sulfides, and moisture to attack the silver surface.

Currently, there is no recommended way to clean a daguerreotype. In fact, chemical treatment, even by a trained conservator, is not recommended as there is no guarantee that the image will not inexplicably disappear within a few months, or even a few seconds, to say nothing of destroying the delicate coloring.

### Ambrotype

Like the daguerreotype, the ambrotype is also prone to case damage. However, the photograph itself is considerably more robust. The main problem is the loss of the black backing to the negative (Figure 22.3). This is easy to diagnose and simple to correct. But caution is advised when dismantling these hard cases: it should not be attempted by anyone who is not dexterous, and only archivally acceptable materials should be used.

### Ferrotype

The ferrotype is often badly bent (Figure 22.4), the varnish coating the image will have yellowed with age, and the back of the cardboard mount or paper mount may show brown rust spots, similar to foxing. If the photograph is loose in its mount, the varnish on the back of the support has often worn off, which permits rust to take hold.

## BLACK-AND-WHITE NEGATIVES ON GLASS SUPPORTS

### Albumen

The emulsion is fairly robust and is less likely than gelatin to suffer from edge peeling. The main degradation problems observed are: (1) brown staining, (2) fading in the highlights, (3) microscopic cracks in random patterns, and (4) broken or cracked glass.

**FIGURE 22.3    Ambrotype with a damaged backing; some of the black has been detached.**

**FIGURE 22.4   A ferrotype showing an enclosure and the bent iron support typical of this kind of artifact.**

### Collodion: Wet and Dry

The collodion plate has a similar brown shiny emulsion and is often confused with the albumen. However, both the wet and dry plates will show a tendency to edge peel and crack, particularly if they have been stored in an unfriendly environment, which will accelerate the breakdown of the cellulose nitrate.

### Gelatin

The damage most likely to be seen in old gelatin emulsions is peeling, particularly around the edge of the plate. This again is caused by poor storage, particularly at high temperatures, when the emulsion loses its plasticity and can become very brittle. Great care must be used in handling such a negative, as the flaking emulsion is extremely fragile. Other problems encountered include staining (poor developing and fixing techniques), bronzing (sometimes referred to as silvering or dichroic fog), and broken or cracked glass. The bronzing appears as a metallic sheen often seen around the edges and is due to the migration of elemental silver to the surface of the plate.

One type of deterioration common to all gelatin emulsions, regardless of the kind of support, is fungus (mold or mildew). This is almost always the result of storing in high humidity, rather than high temperatures, as fungus will grow and spread whatever the temperature. These conditions are commonly found in basements and cellars—where of course old photographs seem to gravitate! Fungus can be detected with either low-power microscopy or ultraviolet light, which causes the affected areas to fluoresce a bright blue. The latter technique is especially useful in investigating negative material, as there are no brighteners in the support to quench the

fluorescence, and the fungus will often attack the emulsion from the underside, between the emulsion and the support, where it is not apparent on visual examination. If fungal growth is to be stopped, one must also be cautious in the use of aqueous-based treatments. For example, some fungus when it attacks gelatin will make it soluble in cold water. One of the fungicides recommended is HYAMINE 1622 (Rohm and Hass Company, Philadelphia, PA). Insects and rodents are also very partial to the high protein of gelatin and cellulose and can completely destroy both negative and prints. There are many methods suggested to halt this kind of degradation, including ultraviolet radiation, fumigants (sulfuryl fluoride), even gamma radiation, but the latter is not only exotic but dangerous!

There is probably no better method of preventing further damage to photographic material than ensuring that all enclosures and the environment in which they are stored are scrupulously clean. There is no substitute for good housekeeping. Furthermore, remember that fungal growth, in particular, is like a contagious disease: it can be transmitted on contact to other photographs.

## FLEXIBLE SUPPORTS

### Cellulose Nitrate

As previously discussed, identification of nitrate film is quite simple. Of all the films, whether on rigid or flexible supports, nitrate film is the most unstable. Typical signs of breakdown are a smell of acidic nitric oxide gases, brown staining, cracking of the emulsion, and small entrapped bubbles of gas. The flexible film is quite thin compared to modern-day acetate and triacetate panchromatic products, and, if in poor condition, will crack and break.

During the transition period between the use of nitrate-base and acetate-base films, cellulose nitrate was sometimes used as a subbing layer between the gelatin emulsion and the acetate base. When the unstable subbing layer broke down, gases were formed that crazed and lifted the emulsion (Figure 22.5).

### Cellulose Acetate and Triacetate

Poor processing and poor storage will produce observable defects. Staining and bronzing are the most common of these. Negatives that have been inadequately fixed will not only stain, but will also darken over a period of years, even when stored under optimum conditions. Modern emulsions and processing techniques considerably reduce this kind of chemical damage. Nevertheless, scratches and dust, for instance, can disfigure the film, and proper storage and handling precautions need to be taken.

**FIGURE 22.5  Damaged negative resulting from the use of cellulose nitrate as a subbing layer between the emulsion and the support.**

## IDENTIFICATION OF BLACK-AND-WHITE PAPER PRINTS

There are a great many types of old photographic prints, many of which the average photographic department is unlikely to come across. Most prints, whether nineteenth century or twentieth century, will, however, have either albumen or gelatin emulsions. A short description of paper prints prior to albumen coating is, therefore, indicated.

### Salted Paper Prints (1840–1855)

These prints can be identified by the appearance of paper fibers visible at ×10 magnification, which confirm that the paper is not coated. They are often colored purple, red, brown, or yellow. Other types of salted paper prints include cyanotypes and platinotypes (later replaced by palladiotypes). The cyanotype can be distinguished by the bright uniform blue color of the image, usually on paper but sometimes on cloth. The cyanotype was, for a time, very popular with the amateur photographer.

The distinguishing feature of the platinotype is its ability to resist fading. Platinum, like gold, is a very inert metal. These prints have excellent keeping properties. One method of suspecting a platinotype, especially if it has been stored in an album, is what is called a catalytic *transfer image*. Platinum is a well-known chemical catalyst, and its contact with paper or cardboard often causes a duplicate reverse image to form on that board or paper.

### Albumen Prints (1840–1895)

The binding medium for the silver salts was fermented egg white. This coating, impregnated with sodium

chloride, was applied to very thin paper and then calendered to obtain a very high-gloss surface. Because of the thinness of the paper, many albumen prints were subsequently mounted onto highly acidic cardboard. Hence, many of these mounts deteriorated rapidly, and it is quite common to find these mounts breaking down, especially at the corners. The prints themselves are often brown or yellow, although many different hues were obtained by toning with gold chloride. On microscopic examination, the surface of the albumen print can vary from small cracks to large fissures through which can be seen the paper fibers of the support. They must not be confused with emulsion coating, as the albumen paper was sensitized by floating on a 10% solution of silver nitrate.

### Collodion Printing-Out Paper (POP) (1885–1890)

The first emulsion-coated paper used silver chloride as the active ingredient. It has a high gloss and was often gold toned giving brown to purple hues to the image. One of the biggest problems facing the users of this popular paper was its tendency to curl, because collodion does not retain moisture and dries out quickly.

Later, in the 1890s, a matte collodion was introduced and proved to be even more popular than the glossy version. At ×10 magnification both collodion papers exhibit a very smooth surface, which is difficult to distinguish from gelatin coating. However, paper fibers are sometimes visible on the matte surface paper.

### Gelatin Printing-Out Paper (POP) (1885–1893)

Apart from the tendency of matte collodion papers to curl, there is little obvious difference between the two papers. In an attempt to match the quality of the collodion prints and produce a less expensive product, one method was to coat the paper with baryta (barium sulfate), then apply an emulsion. This practice is still carried on today with the inclusion of optical brighteners to brighten the highlights.

All of the above prints were produced in contact frames, which required a period of hours of exposure before toning and fixing. The surfaces of these three types of prints can be identified in the same way as negatives. When a small drop of water is placed on the edge of the print, the gelatin will swell, whereas the albumen and collodion will not. This phenomenon is best observed under low-power microscopy using raking light.

### Gelatin Developing-Out Paper (DOP) (1890s)

The introduction of developing-out paper proved to be a great advance: long exposure times were no longer necessary to obtain a print, and results could be seen

almost immediately. However, there were a few disadvantages. Developers were unpleasant to use—pyrogallol for example, stained the fingers a dark brown—and the exposure of the prints to more chemicals has accelerated their deterioration. It should be noted that laboratory analysis is the only definitive way to distinguish between POP and DOP prints.

## COPYING PRINTS AND NEGATIVES

Repairs to photographs, regardless of type, should rarely go beyond the removal of surface dust and accumulated dirt. No attempt should be made to remove prints from their mounts, especially albumen prints. Even the qualified conservator would hesitate to tackle such a tedious, time-consuming task. Repairs of broken glass negatives require adhesives that do not yellow and have the same refractive index as the glass itself; other treatments involve floating the emulsion off and reapplying to a more stable and secure support—a formidable task indeed!

The best that a photographer can do is to copy as closely as possible the original print using standard copy-lighting techniques (See Chapter 4). Occasionally polarizing filters and screens may be necessary, but careful exposure with the correct filter/film combination is usually all that is required. Stained prints can be photographed using Kodak Technical Pan film #2415 with a Wratten filter #25. A heavily sepia-toned, high-contrast original could again be copied using Technical Pan film, but with a #47A or #47B filter, and processed for lower contrast with Kodak HC 110 film developer at the 'F' dilution. There are many ways of controlling final print quality, but always remember that the result should look as much like the original print as possible, including toning.

Obvious defects like fading, poor contrast, stains, and tears can and should be eliminated in the copy print as far as is practical, but one should make at least one negative and print that exactly matches the original. It is a great temptation to try to enhance the original, as many of us have had to do with underexposed x-ray film, but in documenting old photographs, we do not know what the original intent of the photographer was, therefore, every effort should be made to maintain its integrity.

Stereo pairs were often mounted on curved cardboard mounts. At first, one might assume that they had curled with age and poor storage, but *please* under no circumstances attempt to flatten them! They were intentionally made this way in order to compensate for the curvature of field of the lenses in the Victorian stereoscope through which they were viewed.

### Copy Negatives

Kodak Professional Duplicating film #4168 is a first-class material for duplicating negatives involving both flexible

and rigid supports. It is a fine-grain, low-sensitivity orthochromatic film and should be developed in Kodak Dektol 1:1 for 2 minutes using archival processing methods. Exposure is quite long. The film to be copied is carefully placed emulsion to emulsion with the copy film (a clean sheet of thin glass may be used with thin flexible film) and exposed under the light from a condenser enlarger. Typical procedure would be using an enlarger with a 150 watt bulb at 120 volts, a 50-mm focal length enlarging lens at an aperture of $f/4.5$, 76 cm (2.5 feet) from the film, and a test strip made at 10-second intervals. For the average density negative, the exposure would be about 40 seconds. This method can also be used to duplicate lantern slides.

## STORAGE

### Hard-Case Photographs

Special enclosures have been designed for these artifacts (Figure 22.6). They are constructed of acid-free, lignin-free, buffered cardboard sealed with Velcro tape fasteners. They are sturdy and easily opened without danger of damaging their contents. Documentary evidence can be written on the outside of the container. Information such as the type of photograph, nature of the case (if known),

**FIGURE 22.6  Custom-made storage containers for hard-case photographs or albums.**

photographer and date (if known), and the subject should be included. If a daguerreotype, ambrotype, or ferrotype is *uncased,* then the first two should be stored in a sink mat, and the ferrotype should be stored in polyester or triacetate sleeve with a piece of acid-free mat board behind the photograph for support and protection.

## Glass Negatives

Most collodion and albumen emulsions adhere very well to their glass supports and, if not broken or cracked, can be stored vertically in acid-free paper envelopes. Envelopes with center seams should be avoided, but if no alternatives exist, the envelope should at least conform to ANSI standards (ANSI IT9.2 1988), and the emulsion should face away from the seam. Other enclosures such as polyester sleeves constructed of frosted Mylar type EB 11, containing silica, can be used with reasonable safety. Silica is especially good for preventing ferrotyping. This is a problem often encountered with glassine envelopes, when the envelope and the negative stick together and are almost impossible to separate. A glassine negative envelope can be recognized by its translucent appearance and crackly texture. They are often sold in camera stores. It is poor-quality paper and should definitely be avoided. If the glass plates are cracked, they should be sandwiched between two sheets of the same size acid free mat board. Broken plates should be stored in a sink mat.

If the emulsion is gelatin (this applies to Autochromes as well) and has been badly stored, the chances are good that the emulsion will become detached from the glass support and will start peeling from the edges. If this happens, a piece of unbuffered paper should be laid on top, a piece of four-ply acid free matboard on top of that, and the board taped to the glass.

## FLEXIBLE SUPPORT FILM

### Nitrate

The most important step here, after identification, is complete isolation from other photographic materials. The fact that it is edgeprinted *nitrate* does not, in itself, identify the negative, since it could be a duplicate on safety film. If it is a nitrate film, it must be stored in a buffered paper envelope, which will allow any harmful gases to escape.

### Gelatin

There are many enclosures available for modern gelatin emulsion on acetate, triacetate, or polyester supports.

ANSI recommends plastic enclosures rather than paper: clear uncoated polyester (polyethylene tetraphthalate), cellulose triacetate, polyethylene (uncoated) and polypropylene.

Polyvinyl chloride (PVC) *should be avoided* at all costs. Acceptable trade names for polyester are Du Pont's Mylar D and I.C.I. Melinex 516. It should be noted that, although cellulose triacetate is recommended, it is still under investigation.

As the reader will probably have realized by now, finding suitable storage materials is not an easy task. We are dealing with a relatively new specialty, and much work has yet to be done to ensure the materials we are using are suitable. For example, a common dilemma is when to use a buffered or unbuffered enclosure. For some artifacts, a buffered material is strongly recommended, yet there are photographs that are adversely affected by alkalies. Cyanotypes, for instance, should be stored in as neutral an enclosure as possible: the higher the pH, the more rapidly degradation occurs. Currently, it is recommended to store albumen prints in unbuffered envelopes.

## PRINTS

### Mounted

Unless one can confirm that the mount is of museum quality, the safest method of storage is encapsulation in polyester. As already remarked, the mounts of many albumen prints, often of inferior quality, quickly show signs of deterioration after improper storage. The mount starts to crumble, particularly at the corners, and will eventually disintegrate completely, perhaps taking the photograph with it. Encapsulation (Figure 22.7), if not eliminating the problem, slows down this deterioration, yet allows the photograph to be viewed and handled easily.

**FIGURE 22.7    Encapsulated print with a deteriorating mount.**

## Unmounted Prints

Many unmounted prints, regardless of their support, have a tendency to curl, particularly collodion emulsions, panoramic prints, and ferrotyped fiber core prints. The temptation is very strong to place weights on these prints to flatten them. This should not be attempted, as the emulsion is likely to crack. Unless the photographer has access to a humidity cabinet, which at 90% relative humidity (RH) would certainly help to flatten the prints, they are best left alone and stored in appropriately sized acid-free tubes.

Following is a list of acceptable enclosures that can be obtained from most suppliers of archival materials.

1. Polyester or triacetate sleeves inside paper envelopes: the optimum, but also the most expensive.
2. Paper envelopes: buffered and unbuffered. For most prints unbuffered paper envelopes are satisfactory. Glass plate negatives should be stored in paper envelopes. Buffered paper envelopes are suitable for nitrate and early acetates.
3. Three- or four-flap seamless paper envelopes: particularly useful for very fragile photographs.
4. Buffered and unbuffered paper folders: Suitable for oversized photographs.
5. Plastic sleeves and envelopes: Polyester:- most suitable for this group, but prone to static electricity. Triacetate:- Softer and tears more easily than polyester, can be ordered from Kodak through local camera stores. Polyethylene:- softer and less rigid than (uncoated) polyester.
6. Plastic pages: Can be filed alone or in file folders. (polyethylene, polyester, polypropylene).
7. Polyester encapsulation: Useful for protecting fragile prints.
8. Heat seal envelopes: Paper envelopes lined with aluminum and polyester. Recommended for cold storage of color materials and nitrate negatives.

Having chosen the appropriate enclosure for each negative and print, they can then be placed in file boxes, preferably constructed with acid-free and lignin-free cardboard with flip tops for easy access. The contents of each box should be legibly typed on the outside. Hard-case photographs have their own enclosures and also benefit from storage in such fileboxes.

Single photographic prints when placed in a file box have a tendency to curl (Figure 22.8). An expanding spacer can be easily constructed to fit the filebox and help keep the prints flat and upright (Figure 22.9). Photograph albums should have acid-free tissue placed between each page (Figure 22.10) to minimize any migration of chemicals from the pages to the photograph, and the whole album placed in a box similar to those used for hard-case photographs.

All enclosures, whether they be fileboxes, sink mats, or

FIGURE 22.8   Flip-top cardboard container showing unsupported curled prints.

FIGURE 22.9   Insert for cardboard containers to help keep the photographs from curling.

FIGURE 22.10   Photograph album with protective acid-free tissues placed between the photographs and the preceding pages.

specially designed boxes, should be stored for easy access (Figure 22.11) on baked enamel metal shelves. Wooden shelves, particularly particle board or plywood, should be avoided at all costs.

No mention of resin coated (RC) papers has been made in this chapter. This is intentional. Although the keeping qualities of properly processed RC papers look most promising and the manufacturer claims great longevity, polyethylene, one of the coatings used, is still suspect. Until more work has been done on this material, it should not be chosen in preference to fiber core papers.

## COLOR

The preservation of color slides and prints is also becoming more important as more and more people are turning to color from black and white. As demonstrated in Figures 22.12 and 22.13, the yellow dye in both negative and positive material is the least permanent of all three dyes. Color negative film is especially unstable. It is not

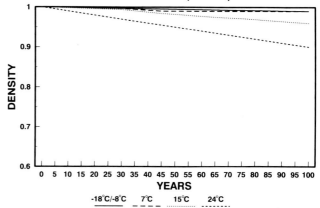

FIGURE 22.12  Graph showing the effect of lowering storage temperatures on the dark fading properties of Kodachrome slide film—this is for the yellow dye, which is the least stable.

intended for projection beyond the enlarger, and after 2 years of usual departmental storage, printing filtration has to be changed, and after 10 years could well be unprintable. The only satisfactory method of storage is to use heat-sealed envelopes kept at between $-8°C$ and $-18°C$. A good-quality home chest freezer is quite adequate.

### Slides

Slide material can be stored safely in the polystyrene carousel trays or kept flat in polyethylene or polypropylene pages. A common question is: Should they be dark-stored? It has been found that Kodachrome, for

FIGURE 22.11  Storage facilities demonstrating metal shelves, plenty of room for air circulation, and convenient design for easy access.

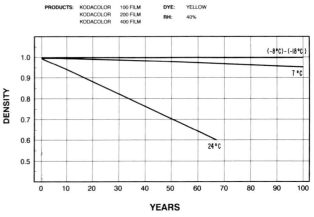

FIGURE 22.13  Graph showing the effect of low storage temperatures on the dye in color negative film. Note a 0.5 density drop in 5 years at 24°C.

example, has far better dark-storage properties than Ektachrome, whereas Ektachrome has far better light storage properties. One solution would be to photograph on Kodachrome and use a duplicate made on Ektachrome for projection. For example, 10 minutes of continuous projection with a 500 watt projector will reduce the density of the yellow dye by 1%.

The following list gives a few examples of dark-keeping and light-fading properties of the more common films. They are listed in descending order of stability:

| Dark-keeping | Light-fading |
|---|---|
| Kodachrome 25 [K-14] | Ektachrome 50 [E6] |
| Kodachrome 40 Type A | Ektachrome 160 [E6] |
| Kodachrome 11 [K-12] | Ektachrome 400 [E6] |
| Ektachrome 50 [E6] | Fujichrome 100 [E6] |
| Ektachrome 400 [E6] | Fujichrome R100 |
| Fujichrome 100 [E6] | Ektachrome X [E4] |
| Ektachrome X [E4] | Ektachrome HS [E4] |
| Ektachrome HS [E4] | Kodachrome 25 [K14] |
| Fujichrome R100 [E4] | Kodachrome 11 |
| Agfachrome 100 | Agfachrome 64 |
| Fujichrome 400 | GAF 500 |

A few of the older films have been included. Agfa and GAF films are particularly sensitive to fluctuations in RH, and the dark-keeping stability of these films is greatly improved by low RH and temperature.

The whole subject of color-dye stability in photographic film is very complex, and manufacturers' research departments are constantly working towards developing more stable dye couplers. Although the subject is clearly beyond the scope of this chapter, correct storage is not! Remember:

1. Choose the right enclosure.
2. Keep the relative humidity at 35%.
3. Keep the temperature as low as possible.

Preventive conservation is our profession's contribution to the preservation of our cultural legacy. Not only will the dedicated people working in research laboratories, conservation laboratories, museums, and galleries appreciate our efforts, but we are also preserving the essence of our labors as photographers: the photographic image itself.

## ACKNOWLEDGMENTS

My sincere thanks to Margaret Bignell, Conservator, for supplying the photographic artifacts and who knew precisely who I should contact for information. To John McElhone and Betty Walsh, Conservators who supplied that information, and to Deborah Brown, Art Historian, who helped me with putting this information into a readable form.

## ENDNOTES

### Suppliers of Archival Materials

#### United States

Conservation Resources International
8000 H. Forbes Place
Springfield, VA 22151
Products include storage boxes, folders, photographic enclosures. The catalogue has an informative introduction on the chemistry of paper.

Hollinger Corporation
3810 South Four Mile Run Drive
P.O. Box 6185
Arlington, VA 22206
The catalogue includes file folders, document and record storage boxes, map folders, acid free papers, and encapsulating materials.

Light Impressions Inc.
439 Monroe Avenue
Rochester, NY 14607-3717
Besides archival storage materials, Light Impressions has a wide selection of photographic enclosures, albums, and boxes.

Process Materials Corporation
301 Veterans Blvd.
Rutherford, NJ 07070
Specializes in acid-free storage papers, photographic enclosures, storage boxes, record sleeves, adhesives, and mat boards. Catalogue available.

University Products Inc.
South Canal Street
Holyoke, MA 01041
A wide selection of storage materials, including file folders, storage boxes, map folders, photographic enclosures, acid-free papers, and encapsulating supplies.

#### Canada

BDH Chemicals
60 East 4th Avenue
Vancouver, B.C. V5T 1E8
"ColorpHast" pH strips, solvents.

R. Bury Media and Supplies Ltd.
B5 - 4255 Arbutus Street
Vancouver, B.C. V6J 4R1
Distributor for Gaylord and University products. Products include file folders, storage boxes, map folders, photographic enclosures, and encapsulating supplies.

Behnsen Graphic Supplies
1016 Richards Street
Vancouver, B.C. V6B 3B9
Suppliers of Bainbridge Alphamount, Alpharag, Alphamat acid-free boards.

Carr McLean Co.
461 Horner Avenue
Toronto, Ont. M8W 4X2
Supplier to archives and libraries, includes file folders, storage boxes, acid-free papers, photographic enclosures.

Opus Binding Ltd.
15 Capella Court
Nepean, Ont. K2E 7X1
Suppliers of Solander boxes.

## REFERENCE

Coleman, A. D., 1980. Collecting photographs. Part VI. Advice on color: Don't . . . but if you do." *Camera* 35:73.

## BIBLIOGRAPHY

American National Standards for Photography (Films and slides)—Black and White Photographic Paper, Prints, Practice for Storage. ANSI/ASC. PH 1.48 1982, New York.

American National Standards for Photography (Processing)—Processed Films, Plates, and Paper. Filing Enclosures and Containers for Storage. ANSI/ASC. PH 1.53 1984, New York.

Coe, B., and Haworth-Booth, M., 1983. *A Guide to Early Photographic Processes*. London: Victoria and Albert Museum.

Coleman, A. D., 1980. Collecting photographs. Part VI. *Camera* 35:73.

Feldman, L. H., 1981. Discoloration of black and white photographic prints. *Journal of Photographic Engineering*, 1:1–9.

Eastman Kodak Ltd., 1985. *Conservation of Photographs*. F-40, Rochester, NY: Eastman Kodak.

Hendricks, K. B., 1985. *Bulletin #16. Storage and Care of Photographs*. New York: Cooper Hewitt Museum, New York State Conservation Consultancy.

Irvine, R. F. Ensuring permanence of contemporary photographs *J. Audiovisual Media Med.* 1989, 12 135–137.

Polaroid Corporation, *Storing, Handling and Preserving Polaroid Photographs—A Guide*. Boston: Focal Press.

Reilly, J. M., 1980. The history, technique and structure of albumen prints. AIC Preprints (May):93–98.

Reilly, J. M., 1986. *Care and Identification of 19th. Century Photographic Prints*. Rochester, NY: Kodak Publication G25.

Ritzenthaler, M. L., Munoff, G. J., and Long, M., 1984. *Archives and Manuscripts: Administration of Photographic Collections*. Chicago: Society of American Archivists.

Swann, A., 1981. Preservation of daguerreotypes. *AIC Preprints* (May):164–172.

Weinstein, R. A., and Booth, L., 1977. *Collection, Use, and Care of Historical Photographs*. Nashville: American Association for State and Local History.

# Chapter 23
# The Management of Collections of Photographic Images

Richard Morton and Julie A. Dorrington

*"For 'tis a truth well known to most,*
*That whatsoever thing is lost,*
*We seek it, ere it comes to light,*
*In every crannie but the right."*

William Cowper (1731-1800)

This chapter looks at the medical photographer's role as picture librarian and offers guidance on the many aspects involved in setting up and running a picture library. The process of managing a picture collection includes consideration of how best to keep the pictures and an understanding of suitable classifying, cataloguing, indexing, and filing systems. Effective retrieval calls for the use of a data management system, the computer being the tool par excellence for this task. The use of a computer in picture bank management is illustrated with a description of an actual picture library database management system. The chapter includes a brief look at the electronic storage of images and ends with a discussion of some legal, ethical, and practical matters.

## INTRODUCTION

### A Medium of Lasting Value

"Slides have gradually asserted themselves as a medium of lasting value in the medical context" was the conclusion reached by the author of a major survey of medical slide collections (Sutcliffe 1990). It would seem, however, that many medical photographers involved in the day-to-day business of producing slides to meet specific requests from medical, academic, and administrative staff overlook the value of keeping copies of the pictures they take for the purpose of building up a collection to act as a resource for teaching and publication. Holding such a collection should be one of the important functions of the medical photographic department, as, apart from making a valuable contribution to the teaching needs of the academic community, it can be a valuable source of income by supplying stock pictures to the publishing industry.

It is not suggested that copies of all the photographs taken by the department be kept for library purposes. There are, after all, many images that will only be mean-ingful to the member of staff for whom they were produced. It is the photographs of diseases, including photomicrographs and records of diagnostic imaging, as well as shots of techniques, treatments, procedures, apparatus, buildings, and so on, that can have valuable secondary usage.

### Pictures for the Library

The pictures that are used to stock the library, if they are transparencies, can be produced as a second shot when the subject is photographed, although modern duplicating films are of such high quality that duplicates are a very acceptable alternative. In many cases it is likely that the decision to keep a library copy of a picture will be made after it is taken, in which circumstance a duplicate will have to be produced for the library.

Once it is decided to keep copies of pictures, the collection may grow at the rate of several hundred new items per year. Soon a vast number of pictures will accumulate and, before long, a cataloguing and retrieval system becomes essential. It goes without saying that the value of a collection of photographs is lost if images cannot be found when they are needed.

### Planning

At an early stage in planning a picture bank, it is essential to give careful consideration to the design of the cataloguing, filing, and retrieval systems that will be used in its management. Time and effort devoted to these matters is always well spent and will be repaid many times over in the effort saved in retrieval. It is important that pictures are properly catalogued from the start of a collection and that the process becomes a routine activity; there is nothing more demoralizing than having to catalogue and file a large backlog of pictures.

## Definitions

Before discussing the details involved in managing a picture collection, it is worth defining some of the terms used to avoid ambiguity. *Cataloguing* is the process of deciding what each picture shows. It involves choosing descriptors to apply to each picture from an established nomenclature or *classification scheme*. The *index* is a list of the descriptors indicating what is available in the collection. It is compiled during the process of cataloguing. The index gives information as to where each picture, or set of pictures, may be found within the collection. *Retrieval* is the process of locating pictures in the collection. The ability to successfully retrieve pictures showing particular features will depend on the amount of information held in the index. This information depends on the comprehensiveness and appropriateness of the classification system and the thoroughness of the cataloguing process.

## Data Management

In the simplest terms, any collection of photographs can be managed by arranging to keep the pictures in a certain order, conforming to the order the terms are listed in the catalogue. However, although it may be relatively simple to find pictures showing one particular feature, any single slide may show a number of different features, and selection can involve a complex process of cross-referencing. With pictures of patients, for example, it may be necessary to make a selection on the basis of a number of criteria, such as disease, treatment, anatomy, age, skin color, consultant, patient's name, hospital number, date photographed, and so on. In these circumstances considerable cross-referencing is involved, which will not be possible without some kind of data management system.

## Other Media

Although this chapter concentrates on the management of collections of transparencies, it is hoped that the medical photographer, when faced with the task of managing collections of other media, will find that the fundamental principles outlined here will be easily adapted, whatever the task.

## ORGANIZING THE PICTURE FILE

### Storage

Even with the most sophisticated cataloguing system, the final selection of an image from a picture library will be made by a process of visual evaluation. So, although there are many possible ways to keep slides, there are obvious advantages in using a system that allows the pictures to be easily viewed, and one of the most convenient and economical methods is to use plastic pocket files held in standard office filing cabinets (Figure 23.1). Pocket files of this kind, each holding 24 slides, can be bought for about $0.36 each when purchased in bulk, and one drawer will hold up to 150 such files. This means that a single drawer of a filing cabinet can accommodate up to 3600 slides. An alternative method is to use plastic pocket files in ring binders where each book can be devoted to a different subject area. Rigid translucent plastic trays stored in boxes are also available and serve much the same purpose as pocket files in ring binders.

If visual surveying of large numbers of images is a top priority, regardless of cost, slide storage cabinets of the Abodia[1] type (Figure 23.2) are recommended. Cabinets of this kind are popular with academic staff who wish to maintain their own collection and who rely, to a large extent, on visual selection of images.

## In What Order Should They Be Filed?

A good cataloguing and retrieval system should enable pictures to be found, regardless of the storage method used. However, the order in which pictures are kept can affect the ability to find the best image for a particular purpose.

**FIGURE 23.1   The plastic pocket file is a convenient and economical way of storing slides in a manner that allows the images to be easily viewed for selection purposes. One drawer of a filing cabinet can hold up to 3600 slides when they are stored in this way.**

**FIGURE 23.2   The Abodia A6000 cabinet holding 6000 2 × 2 slides. Each rack allows 100 slides to be viewed against the lightbox at the back of the cabinet. Additional storage capacity is provided in the base unit. Other models in the range accommodate from 1000 to 12,000 slides. Storage cabinets of this kind are ideal for slide collections where visual selection is a top priority (Photo courtesy of DW Viewpacks Ltd.)**

When building up any kind of collection, it is essential to assign a number to each item, as it is only when the items bear unique identification that they can be properly managed. It is usually sufficient to simply use sequential numbers, although there can be advantages in some circumstances in using identifiers that combine sequential numbering with other information, such as a date or category code.

It could be argued that a collection in which each item is assigned a sequential number should be kept in numerical order. However, although this may have the advantages of simplicity, it will have the disadvantage that pictures of similar subjects will be scattered throughout the file. Consideration needs to be given, therefore, to the idea that similar items should be kept together. Perhaps diseases should be kept together, or anatomical regions. The problem here is that, in grouping them by anatomy, for example, diseases will be split up, and vice versa. Other seemingly logical groupings, such as placing them in order of clinical specialty, will result in the same difficulties.

As always, some kind of compromise is required so that the most important groupings can be maintained. It is usually best to try to group pictures of patients by disease, particularly if they are to be used primarily for teaching. However, even then difficulties will arise. Let us say that pictures of eye diseases will be kept in one place in the file, and endocrine diseases in another. However, diabetes mellitus, which is an endocrine disease, manifests itself as a form of retinopathy, which is an eye disease. Where, therefore, should pictures of diabetic retinopathy be filed?

The answer lies in developing a system whereby a duplicate slide is placed in the file every time there is a picture with two diagnoses. Alternatively, some kind of marker can be placed in the file to alert the user to the existence of a picture elsewhere (Figure 23.3). It should then be possible to find any picture showing any disease, wherever it is kept. Other ways of listing features of the pictures, and grouping them accordingly, can be covered in the index with appropriate cross-references.

## CLASSIFICATION SCHEMES

### Why Have a Classification Scheme?

The primary purpose of a classification scheme is to provide a system whereby pictures can be placed in some logical order within the file. A second and equally important purpose is to ensure that useful and accurate information is available for each item in the collection and that standard terms are used in their description.

Medical terminology is littered with synonyms, and a classification scheme helps to ensure that a particular disease can be located by whatever name it might be called. An example is the condition known as Graves' disease, or hyperthyroidism, or thyrotoxicosis. A classification scheme will act as a thesaurus to ensure that diseases can be identified, regardless of the name used. A further important function of a classification scheme is to provide a way of coding so that lengthy verbal descriptions, which could take up a lot of space in an indexing system, and may be too lengthy to be written on a slide, are unnecessary.

**FIGURE 23.3   Pictures showing more than one diagnosis can be cross-referenced with a 2 × 2 marker card inserted in the file to indicate the existence of another picture filed under a different diagnostic category.**

## Which Scheme to Use

A classification scheme can be devised from scratch by the picture librarian, but this can prove a tedious job requiring a very thorough knowledge of medicine. Also, it will need to be constantly modified as unanticipated subjects occur. In choosing an existing scheme, the first requirement is that it is reasonably definitive, to cover all possible categories, and at the same time detailed enough to give sufficient discrimination between similar subjects.

It has to be recognized that collections, or parts of collections, that relate to very specific or esoteric subject matter may call for a purpose-designed classification scheme, but for the majority of collections containing pictures of diseases, such as those likely to be found in the medical photographic department, there are a number of excellent well-established schemes available. In *The Management of 35-mm Medical Slides*, Stroheiln (1975) lists no fewer than 15 possible classification schedules appropriate to medical slide libraries. And since the book was published, several new systems and modifications of existing systems have been developed.

For the classification of collections of pictures of diseases, as opposed to collections of nonclinical subjects, a particularly suitable scheme is the *World Health Organization International Classification of Diseases (ICD)* (WHO 1977). This classification scheme is the one the authors of this chapter are most familiar with and, in the findings of a survey of medical slide collections, was the one used in nine out of ten centers included in the study (Sutcliffe 1990). Without suggesting that other systems should necessarily be dismissed, ICD will be described here in some detail. Before doing so, however, a word of caution: make sure that the ninth edition of ICD is used. This edition introduced changes to some of the coding numbers used in previous editions and is not totally compatible with them.

ICD uses a numerical coding system of three digits and one decimal. An example is given in Figure 23.4. It should be pointed out that ICD was designed by the WHO for use in the compilation of medical statistics, not for cataloguing pictures. However, its advantage is its comprehensive nature and the possibilities it offers for modification. Indeed, one well-known modification to ICD has made it considerably more useful for medical slide bank applications. This is the modification known as ICD-9.CM—*International Classification of Diseases, 9th Edition with Clinical Modifications* (NCVHS 1980). The advantage ICD-9.CM has is that more detailed classifications are given to some of the diseases that are grouped together under "other diseases" in ICD. The use of ICD-9.CM in picture library management has been fully described by Naylor (1990). An example of ICD-9.CM is shown in Figure 23.5 demonstrating the use of a second decimal number to enable more detailed classifications to be made. The WHO ICD listings are published in two

volumes, one containing an alphabetical list of diseases including synonyms, the other giving full numerical listings.

## Classifying Nondisease Features

Using ICD, the pictures of a patient with thyrotoxicosis, for example, will be catalogued with the ICD number 242.0. Typical pictures of thyrotoxic patients show their eyes and their necks. But it is only the descriptors for the disease itself that can be catalogued using ICD; the actual anatomy depicted may not always be clear from the ICD code. And so, as there is often a need to catalogue the anatomy or anatomical region shown in a photograph, as well as the disease, it may be necessary to use a list of simple anatomical descriptors alongside the ICD codes. One way to obtain such a list is to compile it from terms selected from the index of a textbook of human anatomy. Such a list, concentrating on surface anatomy and body systems, is shown in Table 23-1. It was specially compiled for slide library cataloguing by the department of medi-

NERVOUS SYSTEM AND SENSE ORGANS

374.4  *Other disorders affecting eyelid function*

Ankyloblepharon                          Lid retraction
Blepharophimosis

Excludes:   blepharospasm (333.8)
            tic (psychogenic) (307.2)
            organic (333.3)

374.5  *Degenerative disorders of eyelids and periocular area*

Chloasma           ⎫                     Madarosis
Hypertrichosis     ⎬ of eyelid           Xanthelasma
Vitiligo           ⎭

374.8  *Other disorders of eyelid*

Retained foreign body in eyelid

374.9  *Unspecified*

**375       Disorders of lacrimal system**

375.0  *Dacryoadenitis*

Chronic enlargement of lacrimal gland

375.1  *Other disorders of lacrimal gland*

Dacryops                                 Lacrimal:
Dry eye syndrome                            atrophy
                                            cyst

**FIGURE 23.4    Part of the numerical listing from Volume 1 of ICD. The broad disease categories are identified with three digit numbers, a decimal being used for the subdivisions.**

## NERVOUS SYSTEM AND SENSE ORGANS

**374.53  Hypopigmentation of eyelid**
Vitiligo of eyelid

**374.54  Hypertrichosis of eyelid**

**374.55  Hypotrichosis of eyelid**
Madarosis of eyelid

**374.56  Other degenerative disorders of skin affecting eyelid**

**374.8  Other disorders of eyelid**

**374.81  Hemorrhage of eyelid**
*Excludes:* black eye (921.0)

**374.82  Edema of eyelid**
Hyperemia of eyelid

**374.83  Elephantiasis of eyelid**

**374.84  Cysts of eyelids**
Sebaceous cyst of eyelid

**374.85  Vascular anomalies of eyelid**

**374.86  Retained foreign body in eyelid**

**374.89  Other disorders of eyelid**

**374.9  Unspecified disorder of eyelid**

**FIGURE 23.5  An example of the numerical listing from ICD-9.CM showing how a second decimal place is used to allow more detailed classifications to be made than is possible with ICD (see Figure 23.4).**

cal illustration and the department of pathology, University of Aberdeen.

### How a Classification Scheme Is Used

The process of cataloguing involves the allocation of an ICD category and an anatomical code (where necessary) to each picture. (Sometimes there may be difficulty in obtaining accurate diagnostic information—this matter is discussed at the end of the chapter.) Other descriptors, apart from anatomy, might include information such as the patient's age (usually adult or child is sufficient), sex, and skin color. A record of the consultant caring for the patient is also often required.

When it comes to allocating diagnostic descriptors, it is necessary to look them up in the alphabetical list in Volume 2 of ICD. Some classification systems are available in a computer-readable form, which can greatly facilitate the cataloguing process.[2] Once the correct ICD number has been identified, it is allocated to the slide and the information logged into the indexing system. Likewise,

descriptors for anatomy and the other features to be listed are also allocated.

The care with which a picture is catalogued is reflected in the ease with which it can be retrieved. Cataloguing is a time-consuming process. It is usually necessary for it to be undertaken by experienced senior staff, as the information assigned to each picture can, to a greater or lesser extent, depend on the cataloguer's knowledge of the subject matter. Pictures that are difficult to categorize can be put to one side and assistance from clinical colleagues sought in helping to catalogue them.

### RETRIEVAL: NONCOMPUTERIZED SYSTEMS

A number of ingenious mechanical retrieval aids, suitable for picture bank management, have been available for many years. These systems, based on various kinds of cards with holes punched in them, have been largely superseded by computers, and the following description is included more out of historical interest than as a detailed guide for the implementation of such systems today.

### Punch Cards

In conventional punch card systems, each item in a collection has a card associated with it. (In some cases the actual pictures are attached to the cards.) The cards have rows of holes punched near to each edge. Each hole represents a particular feature, or descriptor, of the pictures in the collection. The holes in a card relating to the features of the picture to which that card refers are clipped out to become notches so that when a long needle is inserted through all the holes in a stack of cards, those cards with notched holes fall out of the stack. The needle may then be inserted in different holes to make a series of selections narrowing the selection criteria each time.

Another punch card system relied on a pattern of holes in small flexible cards which could be searched by a machine that sensed the position of holes. These were commonly known as Hollerith cards and were also used as a means of data entry with early computers.

### Feature Cards

Feature cards (also known as optical coincident cards) work on opposite principles to punch cards in that there is a card for each *feature,* while the *items* in the collection are represented by a number in a grid of sequential numbers printed in exactly the same place on each card. The number of cards depends on the number of categories or features used to describe the collection, each card representing one feature and each grid number repre-

**Table 23-1    Anatomical Classifications Concentrating on Body Systems and Surface Anatomy***

| Cardiovascular System | | | | Other | |
|---|---|---|---|---|---|
| | | UF | Vagina | | |
| | | UG | Vulva | | |
| CA | Heart | UH | Testes | OA | Spleen |
| CB | Aorta | UI | Epididymis, spermatic | OB | Peritoneum |
| CC | Arteries *ats* | | cord, and seminal | OC | Diaphragm |
| CD | Veins *ats* | | vesicles | OD | Breast |
| CE | Capillaries *ats* | UJ | Prostate | OE | Nipples |
| CF | Blood *ats* | UK | Penis | OF | Placenta |
| CG | Bone marrow *ats* | UL | Scrotum | OG | Umbilicus |
| CH | Lymphatics | | | OH | Skin *ats* |
| | | **Nervous System** | | OI | Hair *ats* |
| **Respiratory System** | | | | OJ | Nails *ats* |
| | | NA | Brain | OK | Pigment *ats* |
| RA | Nose and nasopharynx | NB | Meninges *ats* | | |
| RB | Larynx | NC | Nerves *ats* | **Site** | |
| RC | Trachea and bronchi | | | | |
| RD | Lungs and pleura | **Musculoskeletal System** | | 1 | Whole body |
| | | | | 2 | Trunk |
| **Digestive System** | | MA | Bones *ats* | 3 | Chest |
| | | CG | Bone marrow | 4 | Abdomen |
| DA | Lips | MB | Joints *ats* | 5 | Pelvis |
| DB | Mouth | MC | Cartilage and | 6 | Spine |
| DC | Teeth | | ligaments *ats* | 7 | Buttocks |
| DD | Gums | MD | Muscles and tendons | 8 | Genitalia |
| DE | Tongue | | *ats* | | |
| DF | Buccal mucosa | | | 9 | Head |
| DG | Salivary glands and | **Endocrine System** | | 10 | Neck |
| | ducts | | | 11 | Face |
| DH | Palate | EA | Pituitary | 12 | Cheek/Jaw |
| DI | Tonsils | EB | Thyroid and | 13 | Ocular area *(excl.* |
| DJ | Oesophagus | | parathyroid | | *eyelids)* |
| DK | Stomach | EC | Thymus | 14 | Scalp |
| DL | Duodenum | ED | Suprarenal and | | |
| DM | Jejunum, ileum, and | | adrenal | 15 | Axilla |
| | caecum | EE | Pancreas | 16 | Whole arm |
| DN | Appendix | | | 17 | Upper arm |
| DO | Colon | **Sight and Hearing** | | 18 | Lower arm |
| DP | Rectum | | | 19 | Shoulder |
| DQ | Anus | SA | Eye | 20 | Elbow |
| DR | Liver | SB | Eyelids | 21 | Wrist |
| DS | Gall bladder and | SC | Conjunctiva | 22 | Hand |
| | biliary ducts | SD | Cornea | 23 | Fingers |
| DT | Pancreas | SE | Sclera | | |
| DU | Mesentary | SF | Iris | 24 | Groin |
| | | SG | Lens | 25 | Whole leg |
| **Urogenital Systems** | | SH | Choroid | 26 | Upper leg |
| | | SI | Retina | 27 | Lower leg |
| UA | Kidneys | SJ | Lacrimal glands and | 28 | Hip |
| UB | Ureters | | ducts | 29 | Knee |
| UC | Bladder and urethra | SK | External ear | 30 | Ankle |
| UD | Ovaries | SL | Internal ear and | 31 | Foot |
| UE | Fallopian tubes, uterus, | | eustachian tube | 32 | Toes |
| | and cervix | | | | |

* Specially compiled for cataloguing medical slide libraries. Some anatomical features are classified *according to site*, (ats). Such features will have a combined alphabetical and numerical code, e.g., a picture showing cartilage of the knee would be coded as *MC29*.

senting one item. The size of a collection a feature card system can be used for is limited by the number of grid positions on the cards, the upper limit being in the order of 10,000.

Holes are punched in the cards at the grid number representing any particular photograph, which shows the features, or descriptors, that card represents. When a search is made, two or more cards are superimposed on a

lightbox and any coincident holes will indicate the existence of a picture having the features represented by each of the cards. Any number of cards can be added to narrow the selection. The use of a feature card system for the management of a medical slide collection has been described in detail by Headley and Morton (1976).

## COMPUTER-BASED RETRIEVAL

It has already been pointed out that the retrieval of items from a collection of photographs requires some kind of data management system. One of the first descriptions of the use of a microcomputer for the retrieval of medical slides was by Gilson and Collins (published in 1982). Now that microcomputers are widely available, sophisticated yet inexpensive computerized systems can be used for a range of picture library-management tasks.

Computer systems comprise two basic components: hardware, the machine itself, and software, the programs that enables the computer to carry out its tasks.

### Hardware

When choosing a machine for picture library management, the basic considerations to be taken into account are the storage capacity and the amount of data it can handle at one time—the so-called random-access memory, or RAM. For the majority of picture collections the capabilities of the current generation of microcomputers, such as IBM PCs (and other MS-DOS computers) and Apple Macintosh machines, are well suited to the task. Hard disc storage capacity of 20 megabytes (= 1M) will be more than adequate in most cases. A RAM of 640 kilobytes (= 1K) is usually the minimum found on modern machines, and again this will prove to be adequate for most applications.

### Software

As data handling is one of the basic uses to which computers are put, a wide range of software is marketed for this purpose, designed for use with all popular machines. The generic name for the computer software used for data handling is a *database* or *database management system* (DBMS). It is beyond the scope of this chapter to describe the advantages and disadvantages of the many different proprietary database packages. Advice should be sought from experts in the field when selecting a suitable program for any particular application. However, the basic tasks the program will be required to perform include (1) data entry, (2) sorting, (3) searching, and (4) printing.

In a computer database the data are divided into *files, records,* and *fields*. A file is the complete collection of data, held in one place and accessible as a whole. Within the file there are any number of records, each of which describes one particular item. Each record is made up of a number of separate fields describing each feature of the item.

### Data Entry

The first task, once a suitable database program has been acquired, is to decide how many fields will be required in each record to hold the information needed for all possible retrieval requirements. It is also necessary in most cases to decide the maximum size, in terms of number of characters (or numerals) each field will be. In fact, this information should be ascertained before the hardware is purchased, as it will help to determine the storage capacity required.

Before the data can be entered, the database program has to be structured for the particular needs of the information it is to hold. This involves setting up and defining the name and size of each field. This initial process can usually be undertaken by personnel with only basic computing skills—no knowledge of programming is needed.

### Sorting

Once the system has been structured and the data have been entered, there may be a need to sort the records into a particular order. Database programs often have sophisticated sorting options enabling complex listing tasks to be performed. The speed at which these tasks are carried out will depend on the capacity and other specifications of the hardware.

### Searching or Selecting

The ability to make quick and detailed searches of a large amount of information is the main reason why the computer represents such an important tool in data management. The searching process involves asking the computer to find, from within all the data in a file, records containing a particular word, description, or number. The way such tasks are carried out and the general sophistication of the searching process varies considerably with different database programs. Again, a clear specification of the searching needs is required to help in deciding what type of database software to purchase.

### Printing

Information held in a database may be required in a printed form. For example, the information retrieved by a search of the database is often most useful as a printed

list on paper. If a printed index is required, it can be produced by first sorting the database alphabetically and then printing it.

A print option is one of the facilities offered by database programs, and a printer of some kind will always be a necessary item of hardware for a picture library management system. Printer types and their suitability to perform different tasks (for example, printing slide labels) is a complex matter and is another area where expert help should be sought.

## A Database in Practice

A screen from the database ideaList[3] used to manage a large United Kingdom picture library—the National Medical Slide Bank (NMSB)—is shown in Figure 23.6 together with the relevant slide. There are over 12,000 pictures in the bank, and so the NMSB database file contains this number of records. Each record consists of eight fields as follows:

1. Picture number—a discrete number given to each picture when it is added to the collection. (With many database programs this number can be provided automatically as new data are added.)
2. First diagnostic number using ICD (see under indexing systems above).
3. Second diagnostic number for pictures showing more than one disease.
4. and 5. First and second diagnosis in words.
6. Anatomical description.
7. Any additional information.
8. Source of picture (in this case a simple three-character code).

ideaList is a sophisticated program with many advanced features such as windows, pull-down menus, and on-screen help. Records can be any length and, within records, fields can be of any size. ideaList's search facilities enable pictures to be found with a minimum of information, as any word, part of a word, or number appearing in any record anywhere in the file can be found in a fraction of a second. Having asked the system for a list of records, conforming to primary search criteria, the list can be widened or narrowed by carrying out secondary searches.

As an example of how a search of the NMSB datafile is carried out, let's say that pictures of spider nevi on the face in alcoholic cirrhosis of the liver are required for a teaching program on liver disease. First, a search is carried out on *cirrhosis*. This gives a *hit list* of eighty-three records. (A hit list is all the records that are located by a search.) This means that eighty-three pictures have the word *cirrhosis* somewhere in the record describing them. These records are then searched for *spider,* giving a hit

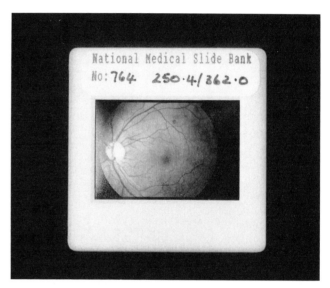

**FIGURE 23.6** **(a) A record screen from the database program ideaList used for managing the National Medical Slide Bank. (This is the record for the picture shown in b.) The information in each field is (from top to bottom): (1) picture number, (2) first diagnostic number using ICD, (3) second diagnostic number (for pictures showing more than one disease), (4) and (5) first and second diagnosis in words, (6) anatomical description, (7) any additional information, (8) picture source code. (b) Picture number 764 from the National Medical Slide Bank. The information applying to this picture, held in a computer database record, is shown in (a).**

list of thirteen records. These are all the records with both *spider* and *cirrhosis* in them. A further search of this hit list of thirteen records is made on *face* revealing that there are seven records conforming to all the search criteria. At any stage in the search the records in the hit list may be stepped through on the computer screen so that other information about the pictures can be ascertained, and so that the pictures themselves can be located from the data given.

## Computer Management of Other Tasks

Not only does the computer provide the ideal tool for picture retrieval purposes, it can also be used for general management tasks in the medical photographic department. Likewise, many of the complicated activities involved in running a stock picture agency can be computerized, but these topics go beyond the scope of this chapter.

## Learning from Others

The purpose of this section has been to outline the enormous advantages of computerized retrieval in picture library management. By giving details of one particular database, some of the outstanding advantages of using a computer for this purpose have been highlighted. It has to be stressed, however, that as computerized data management is a highly involved and complex area, it can only be dealt with at a superficial level in a general chapter of this kind. For those who are new to computing, there is a lot to learn and it is hoped that the medical photographer, before embarking on the computerization of a retrieval system, will find the opportunity to visit colleagues with experience in using a database management system of this kind and see it operating firsthand.

## IMAGE DATABASES

### Visual Selection

Whatever cataloguing and retrieval system is used in picture library management, the choice of a picture for any particular purpose requires a final process of visual assessment. This usually means that a number of images from the collection are selected and presented to the user so that he or she can see what is available. An image database is a term used to describe a system whereby pictures from a collection can be easily viewed for selection purposes without having to access the original images.

In the past, color microfiche has been used for providing a visual catalogue. Such a system has been described in detail by Dr. James McArthur of the University of Washington in Seattle as a way of providing a visual catalogue for the American Society of Hematology Slide Bank. Dr. McArthur was also a pioneer in the use of optical videodisc technology, which he used for the same picture bank in 1980 (McArthur 1982).

Optical videodiscs are now recognized as a highly convenient method for rapid searching and picture selec-

tion. The advantages of using a videodisc in this context is the quick access time to any image on the disc and the fact that the disc player can be controlled from a computer database for rapid and easy selection of images. Once mastered onto videodisc, several copies of the disc can be pressed at low cost so that the collection can be viewed at different locations.

### Properties of the Optical Videodisc

Optical, or Laservision, discs have been fully described in the literature (Morton 1986). One side of a Laservision disc can hold 54,000 still frames, each of which can be identified numerically and displayed as a perfect still frame. On the latest generation of players, the access time to any frame from any other is under 2 seconds. In the context of picture libraries the massive storage capacity, quick-search properties and high quality still frame replay capability makes videodisc an ideal medium for the selection and display of images.

The disadvantage of using Laservision discs for recording still frames is that the transfer of images onto disc can be an expensive and time-consuming process. As the Laservision disc itself is not a recordable medium, the use of a video recorder with single-frame recording capability is required in order to capture the images in the first place. Following this, a highly specialized manufacturing process is involved to produce the Laservision discs. Once in production, however, any number of discs can be pressed at relatively low cost.

### Recordable Discs

A recordable videodisc has recently become available—the Sony CRVdisc (Figure 23.7). Although having a lower capacity than Laservision—36,000 frames—and being incompatible with it, the Sony system has the same kind of sophisticated rapid access and computer control facilities of Laservision. This equipment now means that the medical photographer can produce, in-house, an image database for the purpose of rapid visual selection of images. It also provides a mastering system from which conventional Laservision discs can be produced, if necessary.

Transferring slides to a video format involves the use of some kind of specialized apparatus. In professional television a slide scanner or multiplexer is used. For the medical photographer, the more familiar photographic slide duplicator—a standard item of equipment in most medical photography departments—can be used for this purpose, a video camera replacing the usual 35-mm camera.

**FIGURE 23.7   The Sony CRVdisc videodisc recorder is an ana-logue write-once device suitable for the production of an image database to aid selection of images from a picture library. (Photo courtesy of Sony (UK) Limited).**

### Digitized Images

Modern computing techniques for digitizing pictures mean that images recorded via a video camera can be held in computers. However, in computing terms, a digitized picture takes up a large amount of storage space—a single video frame can be as much as one megabyte—and very large and expensive storage systems are required if pictures are to be held in this way. Some of the problems in this area have been overcome with write-once read-many (WORM) optical discs that have a very large capacity. There are many new developments in this area, including the Kodak Edicon Photo-image Management System. Also, the recent announcement by Eastman Kodak of Photo-CD, aimed at the consumer market, suggests that it will soon be possi-

ble to record pictures on a compact disc format at low cost. There is no doubt that developments in the electronic recording of images will provide the picture librarian with an increasing array of techniques in the future.

Once images from a picture library are recorded electronically, a range of other uses for the pictures becomes possible. For example, a comprehensive collection of images of diseases can act as a resource for computer-assisted learning—so-called *interactive video*—thus adding a further and important dimension to the value of a clinical picture library.

### DISCUSSION

This chapter has provided information on a number of practical issues involved in the management of collections of photographic images. Some of the important ethical and philosophical matters are discussed in this final section as well as one or two practical hints.

### Copyright and Confidentiality

Collecting and supplying photographs will involve the medical photographer in the difficult and vexing area of copyright. Different countries have different laws of copyright, but the fundamental principle that financial gain must not be made from someone else's property applies everywhere. Pictures may be held in an institution's teaching collection for legitimate educational use within that institution, but if they have been supplied from elsewhere, they may not be duplicated without permission. Most important of all, they must never be sold (or given away), either as duplicates or for reproduction.

A related problem, and a potentially more serious one, is that of confidentiality. It is generally recognized that a photograph of a patient constitutes part of the patient's clinical record and, as such, is confidential material. It is essential, therefore, that confidentiality and anonymity are maintained at all times. It is never permissible to allow the publication of a picture in which a patient can be recognized without the written consent of the patient concerned. In most organizations it is usually necessary to get the permission of the doctor caring for the patient before pictures can be used in any way other than that for which they were requested in the first place.

These matters are fully dealt with in the publication *Code of Practice on Confidentiality of Illustrative Clinical Records* (Institute of Medical Illustrators 1989).

### Lost Pictures

Any librarian will tell you that borrowed items are not always returned. To be charitable we can say things get

lost—and the 35-mm slide is, after all, small enough to be easily mislaid. It is a recognized practice that publishers are charged a high fee for any lost or damaged pictures, but academic staff will seldom be willing to pay for lost slides. In any case, many pictures are irreplaceable.

The answer to this problem, now that high-quality duplicates can be easily produced, is to hold two copies of all pictures: a master set and a working set. This may seem an expensive solution, but it is the only one that will guarantee valuable pictures can be replaced. Whenever possible the master set should be made up of original transparencies that are never released. In practice there may be occasions when having two copies means a request can be met when a picture from the working set is elsewhere.

### Obtaining Diagnostic Information

However comprehensive the range of pictures in a clinical slide library, the reputation of the curator and the department in which the collection is held will suffer if the pictures are not correctly catalogued. This chapter has discussed various requirements in this regard, but it has supposed that the medical photographer, when coming to catalogue his or her pictures, has full diagnostic information available. Unfortunately, this will often not be the case and it will be necessary to evolve a strategy to obtain this information. In the first place the photographer, when undertaking a photographic assignment must make every effort to note all relevant details at the time of taking the photograph. Most departments make use of carefully designed record cards for this purpose. It must be recognized, however, that in some cases patients will have lesions that have not been diagnosed at the time the photograph is taken, and, in these cases, it will be necessary to have a procedure for obtaining information when the results of diagnostic tests are known. It has already been pointed out that clinical colleagues can be called on to help identify pictures of more obscure lesions if diagnostic information is not available.

### Follow-up Records

As one of the most important uses of medical photography is to record the progress of a disease over a period of time, many patients will have a series of photographs taken of them. Also, on any one occasion, a photographic session may comprise several shots. Therefore, quite frequently one patient will have a large number of pictures associated with them. Throughout this chapter it has been implied that each picture requires individual cataloguing, but, in practice, the cataloguing process will often be applied to a complete set of pictures. All the pictures in these series should be kept together, not just

for cataloguing purposes but also to allow serial records to be easily compared. Often these series illustrate the progress of a disease and the effects of treatment and are particularly valuable for teaching purposes.

### A Source of Expertise

Organizing a slide collection calls for a high level of knowledge of information-management methods and is an area in which expert guidance can be of great help. Fortunately, such expertise is at hand in the medical library, and it is strongly recommended that the assistance and cooperation of a professional librarian is sought by anyone contemplating the establishment of a picture collection. Not only will the librarian be able to advise on retrieval methods, he or she will have access to the latest editions of published classification schemes.

### A Special Contribution

In conclusion, setting up and managing a picture library can bring many rewards, and the medical photographer should not miss the opportunity to show initiative in this area. In providing such a resource the medical photographic department can make a special contribution in serving the needs of the institution of which it is a part.

### ENDNOTES

1. Abodia cabinets are available from Elden Enterprises Inc. 1 Ramu Rd., POB 3201, Charleston, WV 25332.
2. ICD-9.CM is available on computer diskette from Health Care Knowledge Resources, 3853 Research Park, Ann Arbor, MI 48106.
3. ideaList is available from Blackwell Scientific Publications Ltd, Osney Mead, Oxford, England and 3 Cambridge Center, Suite 208, Cambridge, MA 02142.

### REFERENCES

Gilson, C. C., and Collins, J. M., 1982. Use of a microcomputer in a department of medical illustration for retrieval of clinical teaching slides. *J. Audiovisual Media Med.* 5:130–134.

Headley, A. J., and Morton, R., 1976. The clinical slide library: A valuable learning resource in continuing medical education. *Med. Biol. Illustration* 26:203–207.

IMI, 1989. *Code of Practice on Confidentiality of Illustrative Clinical Records.* London: Institute of Medical Illustrators.

McArthur, J. R., 1982. Conventional and high-technology teaching methods for educating health professionals in developing nations. *J. Audiovisual Media Med.* 5:21–26.

Morton, R., 1986. Image permanence: The videodisc, a hope for the future. *J. Audiovisual Media Med.* 9:5–7.

National Committee on Vital Health Statistics, 1980. *International Classification of Diseases, 9th Revision, Clinical Modifica-*

*tion*, 2nd ed. Ann Arbor, MI: Health Care Knowledge Resources.

Naylor, J., 1990. The CPHAs ICD-9.CM as a coding source for medical slide filing. *J. Audiovisual Media Med.* 13: 55–60.

Stroheiln, A., 1975. *The Management of 35mm Medical Slides.* New York: United Business Publications Inc.

Sutcliffe, G. S., 1990. Management of slides by departments of medical illustration and medical libraries in university teaching hospitals. *J. Audiovisual Media Med.* 13:135–142.

WHO, 1977. *International Classification of Diseases: Manual of the International Statistical Classification of Diseases, Injuries and Causes of Death,* 9th rev. ed. Geneva: World Health Organization.

# Chapter 24
# Health Hazards in Biomedical Photography

## Leon J. LeBeau

*"Out of the nettle, danger, we pluck this flower, safety"*

William Shakespeare (1564–1616)
*King Henry IV*

Most health hazards fall into one of five categories: mechanical, electrical, fire, chemical, and infectious. Mechanical hazards involve injury due to carelessness or negligence, such as dropping heavy equipment on oneself, injury following misuse of cutters, or fingers caught in moving parts of equipment. These are rare and avoidable accidents.

Electrical hazards can be found in frayed cords or gang plugs. Adequate wiring in the area where photography is done can help to avoid these accidents. Most newer photographic facilities have sufficient circuits, grounded plugs, and circuit breakers on major pieces of equipment, thus substantially limiting these hazards.

Fires in photography departments occur, as in any department, through carelessness, but problems more common to photography are overloading of circuits and faulty fuse boxes or circuit breakers.

Chemical hazards are associated with processing chemicals. Proper procedures in handling aerosols, dust, and skin exposure greatly reduce the danger.

Infectious hazards are commonly found in medical installations, but when they occur in the studio, photographers are usually unaware of the danger. Further, infectious hazards are found in the morgue, patient rooms, animal cages and pens, as well as on nature field trips. Precautions and preventive measures, however, can lower the risk and prevent accidental infection.

## INTRODUCTION

A warning appears on most developer cartons, bottles, and cans regarding danger of skin irritation, contact dermatitis, and even poisoning if inhaled or swallowed. At the same time, photographers working in a hospital ward or autopsy room could come in contact with an infectious agent. The consciousness of health hazards certainly is manifest in the medical photographer's concern about the threat of AIDS. Yet a more certain danger lurks in the average studio with electrical cords strewn across the floor, two or three triple sockets plugged into a wall socket, and heavy objects stored on top shelves. Similarly, inexperienced workers using a heavy-duty paper cutter or heavy crates containing new equipment carried by a couple of photographers, rather than hauled on a hand truck, are very real accidents waiting to happen.

Consideration of these few highlighted health hazards might lead one to think that the biomedical photography facility is about as safe as a war zone. This chapter is not intended to be a horror story or an author's scare tactic. Rather, by listing some of the hazards and indicating appropriate preventive measures, the improvement of hazard awareness and safety practices in biomedical photography will do much to keep us from harm while practicing our profession.

## STUDIO AND DARKROOM—GENERAL SAFETY REQUIREMENTS

Minor accidents in the biomedical facility are not uncommon and often result from carelessness, haste, and lack of knowledge relative to the environment within which one is working. It is the employer's responsibility and intention to provide the employees with a safe working environment. It is every employee's responsibility to adhere to the safety standards set forth in the biomedical photography facility's safety manual. Carelessness, negligence, and unsafe practices result not only in serious injuries to oneself, but to coworkers and patients as well. Everyone is encouraged to be conscious of health and safety hazards and report all hazards, or potential hazards, to the immediate supervisor.

## ROUTINE SAFETY HAZARDS AND PRECAUTIONS

The following sections are intended to give a brief overview. For more complete information, the reader is advised to consult the references provided.

## Chemical Hazards

McCann (1985) and Stecker (1983) dealt very briefly with the hazards involved in using photographic chemicals, but they realistically recognized the extent of danger and advised appropriate preventive measures. Shaw in 1983 and 1991 extensively covered chemical problems and even described in detail the pathological disease that would ensue. Unfortunately, she failed to put into perspective the frequency of exposure and dose levels involved. This unrealistic presentation so concentrates on inevitable and dire pathology that it almost trivializes a real, but very uncommon, darkroom tragedy rather than concentrating on preventive measures that would lower the risk and make occupational poisoning or disease even more rare than it already is.

Chemicals that cause harm can be divided into four physical categories: liquids, powders, aerosols, and fumes.

**Mixing Chemicals.** No photographic activity is more fraught with danger than the preparation of photographic solutions. The manufacturer's directions should be followed without deviation. While some chemicals are to be used directly from the bottle, many are to be mixed with other chemicals or water. Each chemical should be completely dissolved before the next is added. Mixing with rotary paddles or propellers, and to a lesser extent with magnetic stirrers, produces an aerosol above the solution. Protection includes careful pouring of liquids so as to avoid splash or production of an aerosol. Suppression of an aerosol can be achieved by using gentle tumble-mixing along with use of a cover on the tank or vessel during the mixing process. It is wise to do all pouring at a low table or sink so that the adding of photographic chemicals is always done below head and eye height. Chemical splashes that reach the eye are always serious, whether the photographic chemical is concentrated or diluted. The eye should be rinsed immediately, and not just for a minute, but for 10 to 15 minutes at a water faucet eye wash dispenser or at least with an inexpensive bottled kit for eye wash.

Powder chemicals measured from bulk or poured from a packet usually produce a cloud of dust. Powder spills on the workbench or floor should not be swept with a broom, since this would only create a room full of dust. Rather, an industrial shop vacuum should be used to remove the dust and stow it safely.

Accidents occur during pouring and mixing of liquid chemicals which can produce fumes, splashes, spills, or aerosols (see *Safe Handling* 1979). One must remember, when dealing with strong acids, that it is important to add acid to water and never water to acid, otherwise bubbling or spattering could occur. Spills and splashes represent not only an immediate problem, but a persistent one as well if not cleaned up immediately. When solutions dry, a fine powder is deposited. Subsequent activity in the darkroom will disturb the deposit and form a fine dust cloud. Breathing in this dust is dangerous and is even more dangerous when it settles in a coffee cup, on a sandwich, or a cigarette. Such coated items, then placed in the mouth, constitute a secondary hazard from the spill. This also explains why smoking, drinking, and eating must be forbidden in the darkroom.

There is a common misconception that no fumes or vapors from processing chemicals escape to the air when automated processing equipment is used. This is not true because the constant movement of chemicals in a thin film on rollers and paper or film surfaces fosters evaporation and fume and aerosol production. It is important, therefore, that rooms with such equipment also be well ventilated.

**Health Hazards.** These include contact with dangerous chemicals by way of ingestion. Alkali, as a pure chemical or as developer, and concentrated acids or a stop bath or fixing bath can be caustic. Developing agents such as hydroquinone, *p*-phenylenediamine, and phenidone are highly toxic. Therefore, smoking, eating, or drinking in the darkroom, storeroom, or chemical preparation room should be forbidden at all times. Skin contact can result in direct damage from strong acids or alkali. Frequent, or at least repeated, immersion of hands in some developing solutions can produce allergy or contact dermatitis. Other agents that are active on skin include formaldehyde, gold and platinum salts, metol, and chlorinated hydrocarbons.

Formaldehyde, ammonia, acids, alkali, and organic solvents can irritate the conjunctiva and, if concentration is sufficient, cause severe eye damage. Plastic contact lenses in the presence of heavy concentrations of organic solvent vapors are known to fuse to the cornea and then have to be surgically removed.

Inhalation can result in asthma, as well as pulmonary edema. Agents causing lung pathology include concentrated acid, alkali, ammonia, solvents, and formaldehyde, and, with prolonged and repeated contact, *p*-phenylenediamine and amidophenol developers.

**Protection.** Use of protective clothing, such as plastic disposable aprons and gloves, goggles, and surgical masks or even filtering respirator masks is essential for protection against aerosol, splash, or powder-cloud contamination. In departments where large volumes of chemicals are made from bulk powder chemicals, it would be wise to install an extraction hood to remove any dust as soon as it is formed. Every darkroom and closed chemical mixing room should have adequate ventilation. The ventilating fan should be able to replace room air at the rate of ten times per hour. For small rooms the rate of twenty times per hour is recommended.

# The Gallery of Biomedical Photography

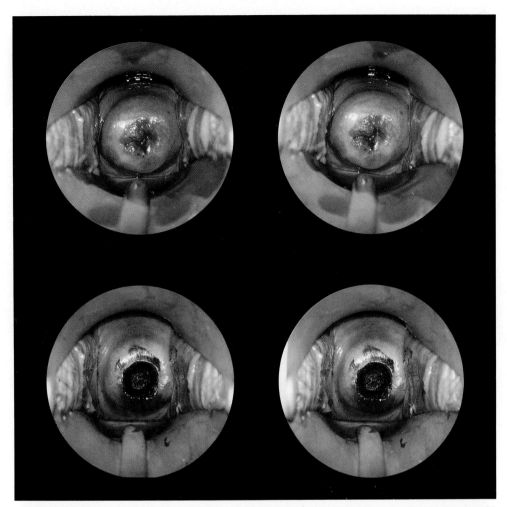

**COLOR PLATE 121** Stereophotocolposcopy. Before (top pair) and after laser treatment (lower pair) for pre-cancerous cervical erosion. There is nothing more frustrating than coming across stereo-pairs in books and journals and not having a suitable stereoscope available. The answer is *free viewing.* To free view the stereo pairs, press your nose between the pair of images. The images will be blurred but if you relax your gaze you should be able to superimpose them. Slowly move away from the page and try to keep the pictures superimposed as your eyes focus on the images. It will take quite a bit of practice but it is worth mastering. (Richard A. Morton)

**COLOR PLATE 122** Mother hampster with young. (Leon J. LeBeau)

**COLOR PLATE 123** Bursaria truncatalla, acilliated protozoan. Photomicrograph ×90. (Michael R. Peres)

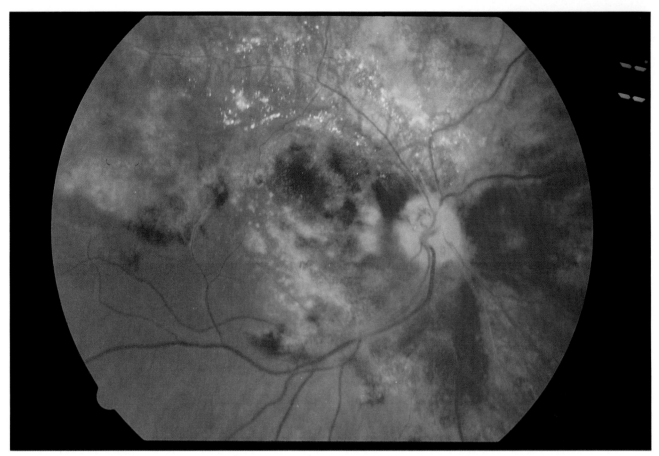

COLOR PLATE 124   Cytomegalo Virus (CMV) Retinitis in a patient with AIDS. (Lawrence M. Merin)

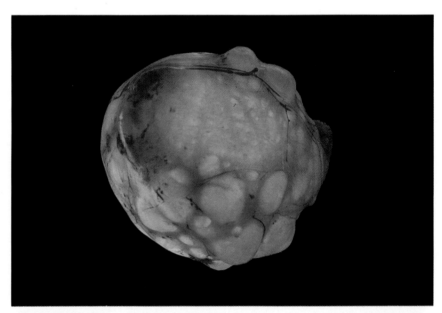

COLOR PLATE 125   Bronchogenic cyst, three millimeters in diameter. Transillumination. (John F. Zacher)

COLOR PLATE 126  Dermatitis Herpetiformis, granular IgA deposits. Fluorescent photomicrograph ×594. (John Paul Vetter)

COLOR PLATE 127  Three-dimensional contour photograph of identical twins. (A. Robin Williams)

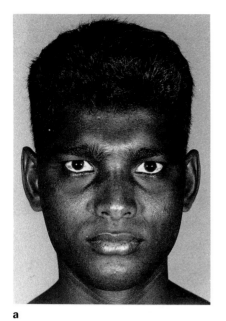 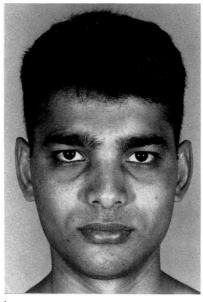 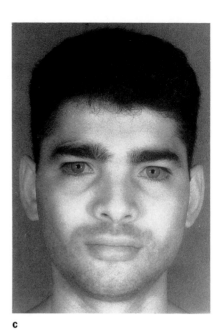

a    b    c

**COLOR PLATE 128** (a) Ultraviolet, (b) normal, and (c) infrared records of a face. (Gigi Nieuwenhuis)

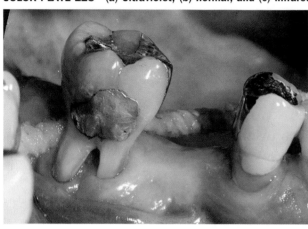 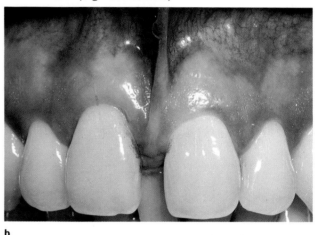

a    b

**COLOR PLATE 129** (a) Mirror view of molar tooth with severe recession, and (b) spaced dentition with prominent labial frenum. (Lewis J. Claman)

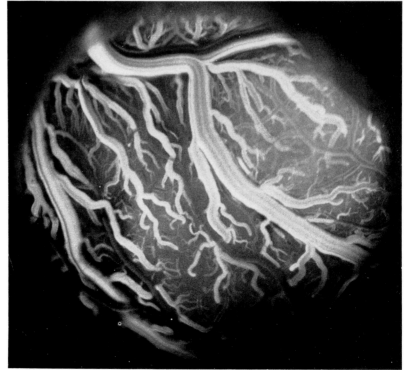

**COLOR PLATE 130** Cerebral circulation in rabbit demonstrating laminar flow. Ultraviolet illumination and fluorescent dye, burr hole less than 5 mm diameter. (Ronald F. Irvine)

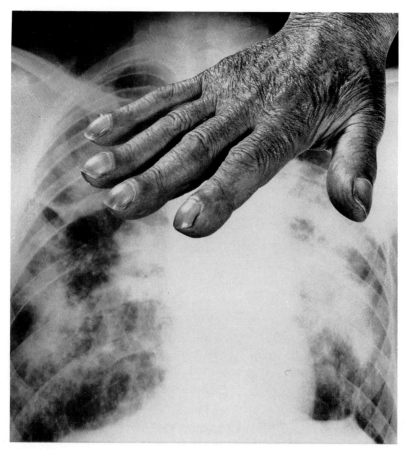

COLOR PLATE 131   Clubbing of the fingers associated with pneumoconiosis. (Julie A. Dorrington)

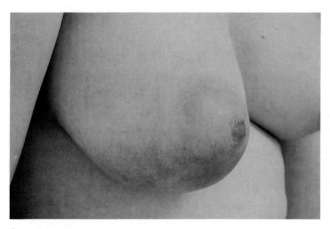

a

b

COLOR PLATE 132   Fibroadenoma of the breast. (a) Photograph made on common color film, (b) infrared "false color" film image of the same breast demonstrating marked vascular blood supply to the tumor. (John Paul Vetter)

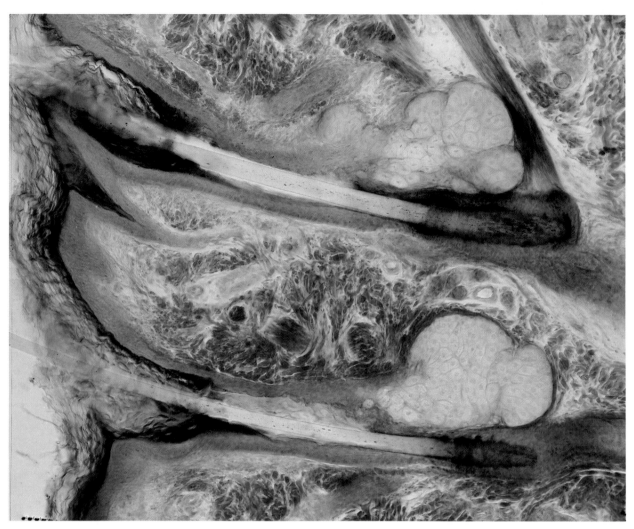

**COLOR PLATE 133    Human scalp. Photomicrograph × 134. (Martin L. Scott)**

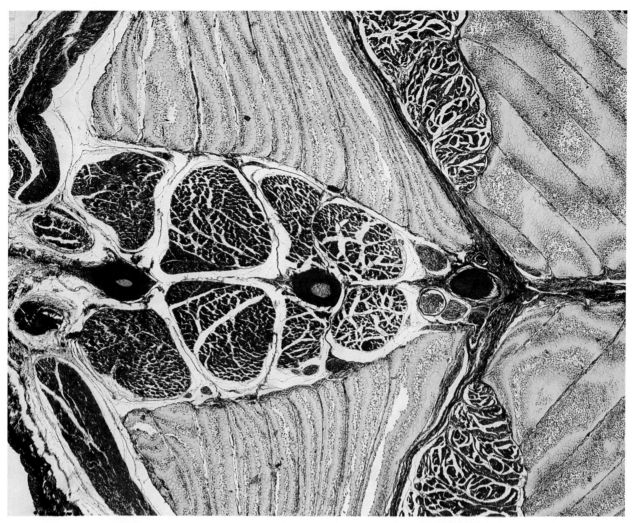

**COLOR PLATE 134** Electric organ of an electric eel. Photomicrograph, ×54. (Martin L. Scott)

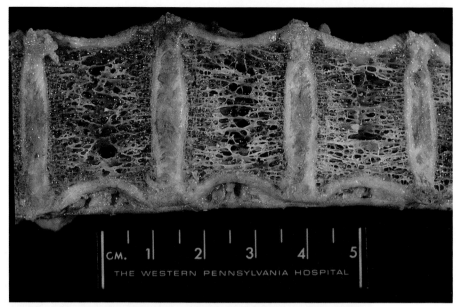

COLOR PLATE 135 Vertebrae-osteoporosis. Gross specimen. (John Paul Vetter)

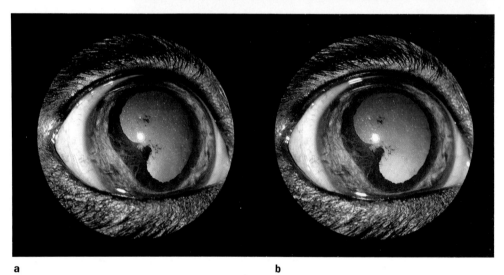

a                                    b

COLOR PLATE 136 (a, b) Stereo pair of a canine eye with anterior uveitis causing the posterior synechia at 7 o'clock. There is also evidence of early cataract formation. (Dan R. Patton)

COLOR PLATE 137 Headache special effects shot. (C. Scott Kilbourne)

**Chemical Waste.** Photographic chemical waste disposal is regulated by municipal, state, and federal laws. Since it is unreasonable to summarize regulations and safe practices here, the reader is referred to Kodak Publication J-55, *Disposal and Treatment of Photographic Effluent.*

## Glassware

Whenever possible, plastic, Teflon, or stainless steel containers or volumetric graduates should be used. Glassware should be avoided to prevent injury resulting from dropped and shattered glass.

## Electrical Safety

**General.** Shocks, burns, and studio fires result most often from neglect or ignorance concerning electrical systems. Unsafe wiring or overloaded outlets should be reported to the supervisor for corrective action. Gang plugs, quad boxes, and multiple outlet attachments are a convenience and are seldom considered hazards, yet they usually result in overloading the circuit.

If additional outlets are required and the circuits are not loaded, there are commercially available two-, four-, and six-outlet plug-in safety boxes, which are grounded and have built-in circuit breakers, to provide additional security. In areas where electrical service is limited, overloading of circuits is a frequent problem. Obviously, additional lines should be installed. Personnel required to work in the studio should be aware of the location of the studio circuit breakers and have access to them.

**Precautions.**

1. The location of master switches and circuit boards should be known to all personnel.
2. Frayed or worn plugs or cords should be repaired or discarded.
3. Outlets must not be overloaded. Gang-type plugs should not be permitted.
4. All electrical equipment must be grounded.
5. Loose extension cords strewn over the floor must be avoided, except for a temporary emergency situation, and, even then, the cords should be attached to walls and secured to the floor with gaffers tape if at all possible.
6. Instruments and equipment must be unplugged before beginning repairs.

## Infectious Hazards

**Introduction.** Day after day the biophotographer encounters infection or infectious agents on wards or in clinics as well as in animal quarters or in the natural habitat of rodents, birds, or fish. Too often, however, the greater hazards are right in the studio where cultures, autopsy specimens, infected animals or insects, or even live wet mounts of organisms for photomicrography represent potential sources of infections. Further complications occur after breakage of culture vessels or specimen containers, as well as in the persistence of infectious agents that may contaminate the studio or equipment.

**Assessing Infectious Hazards in Biophotography.** There is very little information in the available literature relating specifically to the medical photography environment. Only Le Beau (1973) has dealt with the subject, but related reports dealing with hazards in the medical laboratory shed some light on the subject. Paneth (1915), Phillips and Briggs (1965), Pike et al. (1965), and Wedum (1964) pointed out that 100% of mechanical injuries were recognized as occupationally acquired, but the source of infection was more difficult to ascribe to an on-the-job occurrence. Their reliable data could only identify on-the-job–acquired infections in 50% to 80% of the cases. Specific data on the source of contamination in the laboratory environment was reported by Pike et al. (1965) and Wedum (1964). Simple procedures such as opening a petri dish culture or removing a plug from a tube culture sent as few as four and as many as twenty-five bacterial cells into the air up to 2 feet away. During a necropsy, thirty bacteria were isolated 2 feet from the activity. This certainly leads one to believe that photographing a petri dish or fresh gross specimen could be hazardous. Le Beau (1973) examined this situation and showed that organisms are almost always found on the plate glass used to hold autopsy specimens as well as on the focusing ring of the camera and on the cable release. Usually these are normal flora organisms and not a potential hazard. On the other hand, when the autopsy involves a patient who died with an infectious bacterial disease, the number of pathogenic organisms recovered from the environment is significant. With the passage of time the number of viable cells decreases, so that only a few can be recovered in a week or two. If the photographer disinfected the environment and equipment, virtually no organisms could be recovered after treatment or on subsequent examination. This leads one to ask: What are the sources of organisms that might be hazardous to the photographer and what preventive or protective measures can be taken?

## Specific Infectious Hazards

**Photography in the Morgue.** As stated above, one expects to find bacteria in and on autopsy specimens when a bacterial infection preceded the death of the patient, but more important is the great number of viable organisms

that can be found in the fluid exuding from the specimen. This fluid collects on the specimen tray, the plate glass stage, as well as props for the specimen, and on the hands of the photographer who moves the specimen. Secondary contamination from hands to camera, lens, and cable release can occur. Most control measures are obvious though somewhat inconvenient and, therefore, unfortunately overlooked. In these days of AIDS consciousness there is no room for carelessness. With more than 1 1/2 million Americans serologically positive for the HIV virus, it would be wise to take appropriate precautions in working with all gross specimens unless otherwise advised by the pathologist.

**Photographing Clinical Laboratory Specimens.** Fortunately, there are few requests for photography of such specimens. Most specimens are not hazardous, while a few are exceedingly dangerous. Specimens might include tissue, feces, urine, blood, pus, and aspirates. Any of these could be dangerously contaminated, as could be the containers. Transmission of organisms from such specimens or the containers could occur by means of direct contact, splash, or aerosol.

**Photographing Living Cultures.** Agar plate cultures of bacteria or molds and tissue cultures of viruses are particularly dangerous because of the high concentration of organisms that they contain. It should be remembered that the simple action of opening a culture plate can create an aerosol or cloud of spores in the air around the photographer. It is routine practice to photograph cultures with the top section of the plate removed, but one should first consult the laboratory technician to be certain that this is a safe practice. Tubes need not be opened, therefore the hazard in working with tubes is largely associated with dropped and broken tubes, which seriously contaminate the work area and may create an aerosol. Tubes and plates should be kept in racks and trays to avoid serious contamination, which would occur if any of them fell to the floor and broke.

**Photographing Patients.** Obviously patients in hospitals are sick, but relatively few have serious communicable diseases. Photographing such patients requires no more precaution than used in the studio or in other areas of the hospital unless the physician recommends particular safety measures. When a patient, however, is highly contagious, the room is so posted and safety precautions are listed. These usually require gowns and masks to be worn by all visitors. When a photographer is called to the room, it is essential that all posted precautions be observed. Transmission of infection from the patient to a visitor could occur via three primary routes: (1) direct contact, which represents the greatest opportunity for transmission, but should never happen since a photographer, under no circumstances, need ever touch a patient, (2) indirect contact, which would involve touching something which has been contaminated by the patient and is also unnecessary, and a more subtle form of transmission, (3) via respiratory droplet. This refers to contamination of the air from the patient's sneezing and/or coughing. Proper use of the face mask and gown will provide adequate protection. Of course, the mask and gown should be removed upon leaving the room and be discarded in the hamper provided at the door. Another precaution, which is often overlooked, involves the photographer's gear. Rather than risk contamination of equipment, it is a good idea to leave photographic equipment at the door and bring into the room only what is required at the time. It is always wise to wash your hands with disinfectant soap as soon as possible after leaving the patient's room.

Most of us are very conscious of hazards in the patient environment, however, we rarely appreciate that the visiting photographer represents an infectious hazard for the compromised patient. The photographer must respect the precautions listed at the door of the compromised patient.

**AIDS in Relation to Biomedical Photography.** The Centers for Disease Control recommendations (*Recommendations* 1987) clearly delineate the dangers and the necessary precautions relating to AIDS. The following is adapted from that document.

> Human immunodeficiency virus (HIV), the virus that causes acquired immunodeficiency syndrome (AIDS), is transmitted through sexual contact and exposure to infected blood components and perinatally from mother to neonate. HIV has been isolated from blood, semen, vaginal secretions, saliva, tears, breast milk, cerebrospinal fluid, amniotic fluid and urine and is likely to be isolated from other body fluids, secretions and excretions. However, epidemiologic evidence has implicated only blood, semen, vaginal secretions, and possibly breast milk in transmission.

Studies of health-care workers who suffered a needle-stick and mucous membrane exposure at CDC and NIH (Henderson et al. 1986) have shown that 0.1% to 0.3% of those investigated converted to HIV-seropositive. This would indicate that the risk is less than many health-care workers fear.

Brown (1987) reviewed the history of AIDS and recommended precautions for biomedical photographers. The CDC universal blood and body fluid precautions have proven effective and should be observed by all medical photographers having any contact with body fluids (*Recommendations* 1987). The recommendations recognize that it is impossible to know in most instances which patients have AIDS, so all patients need to be suspect. Precautions include:

1. Use appropriate barrier precautions to prevent skin and mucous membrane exposure when contact with blood or other body fluids from any patient is anticipated: gloves, masks and protective eyewear or face shields, gowns or aprons.
2. Hands and other skin surfaces should be washed immediately if contaminated or immediately after gloves are removed.

3. Every care should be taken to prevent injuries caused by needles, scalpels, or other sharp instruments.
4. Medical photographers who have exudative lesions or weeping dermatitis should refrain from direct patient contact.
5. Dental photographers should be aware that all blood, saliva, and gingival fluid should be considered infectious. In addition to wearing gloves for contact with oral mucous membranes of all patients, dental workers should wear surgical masks and protective eyewear or chin-length plastic face shields during dental procedures in which splashing or spattering of blood, saliva, or gingival fluids is likely (*Recommended Infection Control* 1986). Obviously, retractors and mirrors should be sterilized immediately after use.
6. All persons performing or assisting in postmortem procedures should wear gloves, masks and protective eyewear, gowns and waterproof aprons. Equipment surfaces that become contaminated during postmortem procedures should be decontaminated immediately with appropriate chemical germicides.
7. Standard sterilization and disinfection procedures for patient-care equipment currently recommended for use (Favero 1985; Larson 1988) in a variety of health-care settings are adequate to disinfect the photographic environment and equipment.

Sher (1988) summed up the situation very well:

Because health-care workers, including photographers, have always been subject to occupational infectious hazards, they are more safety conscious. The anxiety expressed by health-care professionals, although warranted by the seriousness of contracting AIDS, should be tempered by scientific reality and sound judgment. The evidence, to date, is that risk from casual contact is minimal.

**Photographing Small and Large Domestic or Wild Animals.** While medical photographers would never consider removing a patient's dressing, veterinary and nature photographers are sometimes inclined to handle or touch an infected animal. Since many infections of animals are readily communicable to humans, such practices are dangerous even though humans may be less susceptible than animals to many veterinary infections. The greater risk, noted by most veterinary photographers working with large animals, is traumatic injury. One should, however, also have concern for transmission

of infection from large or small animals and, to a greater extent, from wild animals encountered in nature photography. Recognizing the ways that infections are transmitted helps to institute precautionary measures as shown in Table 24-1.

### Precautions and Control Measures

Specimens: Handle only with disposable plastic or rubber gloves. Wear a disposable plastic apron. Keep specimens in covered metal trays or containers.
Containers: Autoclave metal or glass containers; incinerate plastic bags.
Plates and tubes: Stow in racks and trays so they will not fall over or off the table and break. (This could produce clouds of spores or an aerosol containing organisms.)
Cleaning rags: Store in closeable plastic bags and launder.
Tissues: Stow in closeable plastic bags and incinerate.
Props: Use plastic, metal, or glass and autoclave. Paper or cardboard should be placed in plastic bags and incinerated.
Plate glass or stage: Wash with detergent and water, then wipe with a cloth saturated with disinfectant.
Camera, lens, and cable release: Wipe exterior with disinfectant.
Disposal of specimens: Always return the specimen or object to the client as soon as possible.
Spills: Contaminated spills should be flooded with disinfectant and the area left undisturbed for at least 5 minutes for the chemical agent to destroy the organisms. If glass fragments are present, they should be swept into a pile with a piece of cardboard after disinfection and then pushed into a dustpan and discarded into a sharps-keeper or cardboard box. The box should be sealed and labeled *Broken Glass* before it is discarded in a designated glass-disposal container.
Personal: Wash hands with soap and water, and rinse with disinfectant.

**Discussion.** While it is evident that the biophotographer is bound to come in contact with a wide variety of infectious organisms in the course of his work, the infrequency of documented infections of photographers raises the question: Why don't more frank infections

**Table 24-1   Control of Animal-to-Human Infections**

| Mode of Transmission | Protective Device | Control Handling | Equipment Control | Personnel Protection |
|---|---|---|---|---|
| Inhalation | Mask | — | — | Immunization |
| Food and drink | — | Cook and boil | — | Immunization |
| Direct contact | Glove and protective clothing | — | Disinfect | — |
| Environment and water | Boots and protective clothing | Boil | Disinfect | Immunization |
| Insects | Protective clothing | — | — | Repellents |

develop? Obviously, the extent of contamination of the biophotographer and his equipment varies with different photographic assignments. But the number of organisms in the environment represents only one of three factors necessary to initiate infection. The virulence of the offending organisms is likewise important. Studies in human volunteers have shown that some organisms are more able to infect than others. *Francisella tularensis*, for instance, has been shown to infect man with as small an inoculum as ten cells (Saslow et al. 1961). Experimental salmonellosis, on the other hand, requires as many as 1 million organisms before infection will develop in humans (McCullough and Eisele 1951). Since some organisms infect with low doses while others require large numbers, it is apparent that infection is associated with the interplay of numbers and virulence. The third factor of significance is the resistance of the photographer. For example, the photographer who has never had mumps and has not been immunized is more likely to contract the infection than a partner who has had the disease as a child and is sharing the photographic assignment in the pediatric ward with several cases of mumps. This helps the reader to understand why infections are infrequent and affect some, but not all, who come in contact with a communicable disease. By following safety precautions, however, the risk diminishes but one rule must be first and foremost: *The photographer should inquire of the pathologist or other clients what, if any, hazards are involved in the assignment and what precautions are recommended.*

## GERMICIDAL SUBSTANCES FOR DISINFECTION IN BIOPHOTOGRAPHY

(Further information can be found in Favaro 1985 and Larson 1988.)

### o-Phenylphenols—Vesphene, Staphene, Amphyl, and O-Syl

**Concentration:** 2–5%; Exposure time: 5–10 minutes

**Use:** Recommended for bench tops and plate glass, floors and walls, wood and metal furniture, and trays and containers. Acceptable for rubber or plastic tubing and equipment, metal instruments, as well as the exterior of cameras and lenses.

**Comments:** Active on most molds, yeast, and bacteria, including mycobacteria and spores, as well as HIV (AIDS) and lipophilic viruses (adeno 2, herpes simplex, vaccinia, and Asian flu). Good wetting action and residual activity. Sensitizes skin of some users. Odor. Corrosive. Stable in organic matter.

### Halides, Iodophors—Wescodyne, Betadine, and Pharmadine

**Concentration:** 75–150 ppm; Exposure time: 5–10 minutes

**Use:** Acceptable for bench tops, plate glass, floors, walls, trays or containers, rubber or plastic tubing, wooden or metal furniture, and metal instruments or equipment. Recommended for the exterior of cameras and lenses and for skin antisepsis.

### Hypochlorite—Clorox

**Concentration:** 200–250 ppm (available $Cl_2$); Exposure time: 10 minutes

**Use:** Recommended for floors and walls. Acceptable for bench tops, plate glass, trays, containers, and metal or wooden furniture.

**Comments:** Active on most bacteria, yeast, molds, and viruses. Relatively inactive for spores. May temporarily discolor. Slightly unstable. Corrosive.

### Quaternary Ammonium Compounds—Ceepryn and Zepharin

**Concentration:** 0.1–1%; Exposure time: 5–10 minutes

**Use:** Acceptable for bench tops, plate glass, wooden and metal furniture, floors or walls, and the exterior of cameras or lenses.

**Comments:** Bland, active on gram-positive bacteria. Inactivated by soaps and anions. Absorbed by many fabrics.

### Alcohol—Ethanol and Isopropyl

**Concentration:** ethanol, 70%, isopropyl, 90%; Exposure time: soak 1–10 minutes

**Use:** Acceptable for rubber and plastic tubing, metal equipment and instruments. Most often used for skin antisepsis.

**Note:** Disinfection of dental mirrors and retractors is a major concern in our A.I.D.S. conscious times. The following procedure is practical and effective:

1. While wearing rubber gloves wash the mirrors and retractors in detergent and warm water and then rinse them in running warm water.

2. Dry them with paper towels.
3. Soak the mirrors and retractors in 95% ethanol for 10 minutes. (Some laboratories soak the instruments in the ethanol until needed. Such storage vessels should be covered to prevent evaporation.)

*Caution:* The 95% ethanol should be replaced with fresh solution frequently; daily, if used several times a day; and once a week or every two weeks if used occasionally.

**Comments:**  Tuberculocidal and sporicidal in 5–10 minutes. Neutralized by organic matter. Volatile, flammable. Dissolves some lens cement.

### Alcoholic Solution of Formaldehyde

**Concentration:**  8%; Exposure time: 1–10 minutes

**Use:**  Not recommended unless nothing else is available.

**Comments:**  Active on most bacteria spores and fungi. Sensitizing. Persistent unpleasant fumes.

### Activated Glutaraldehyde—Cidex

**Concentration:**  2%; Exposure time: 5–10 minutes

**Use:**  Recommended for bench tops, plate glass, trays and containers, as well as cameras and lenses. Acceptable for wooden and metal furniture, rubber or plastic tubing, and metal equipment or instruments.

**Comments:**  Active on most viruses, molds, yeast and bacteria, including spores and mycobacteria. Low toxicity, nonirritating, noncorrosive, and not neutralized by organic matter. Does not affect lens cement. Unstable—lasts only a day when activated.

### Acid—Hydrochloric Acid

**Concentration:**  2.5 N; Exposure time: 1–2 minutes

**Use:**  Select only with great reservation. Acceptable for treatment of bench tops or plate glass, trays and containers, and recommended for rubber or plastic tubing and metal equipment.

**Comments:**  *Extremely caustic.* Must be rinsed off after treatment. Use only on spores and hepatitis virus. Sterilizes most organisms in less than an hour.

### Sources of Disinfectants

Vesphene and Staphene: Vestal Laboratories, St. Louis, MO 63110

Amphyl and O-Syl: National Laboratories, Lehn & Fink, Indust. Prod. Div. of Sterling Drugs, Montvale, NJ 07645

Wescodyne: West Chemical Co. 4742 So. Kedzie Ave., Chicago, IL 07670

Betadine: Purdue Frederick Co., Yonkers, NY 10701

Pharmadine: Sherwood Pharmaceutical, Hackensack, NJ 07601

Ceepryn: Wm. Merrell Co., Div. Richardson-Merrell, Inc. Cincinnati, OH 45215

Zepharin: Winthrop Labs., Div. of Sterling Drugs, New York, NY 10016

Cidex: Furgikos, Inc., Arlington, TX 76010

## SAFETY CHECKLIST

### General

1. Is there a detailed safety manual for the photo department?
2. Has a safety coordinator been designated for the department?

### Personnel

3. Are new staff members briefed in their first week regarding safety policies?
4. Are protective immunizations required? (typhoid, tetanus, diphtheria, prevalent strain of influenza, and possibly BCG in high-risk TB facility)
5. Are gloves, masks, gowns, and aprons available in the studio and clinical areas?
6. Are gloves, aprons, safety goggles, and respirator masks available in the chemical preparation area?
7. Is there an eyebath faucet or an eye wash bottle and kit within 24 feet of the darkroom and chemical preparation area?
8. Are hand-washing facilities and antiseptics available in the studio and other hazardous locations?
9. Is there a ventilation system in each darkroom that exchanges room air at least ten times per hour?
10. Does the photo-requisition form have a box to check off for
    a. infectious hazard (environment, patient, or material)?
    b. high-risk patient, environment, or procedure?
11. Are *HIGH RISK* labels available and used on requisition slips, as well as hazardous items?
12. Is a list containing the following information posted in the studio for staff and security personnel to call in an emergency?

a. Name and phone number (office and home) of infection control chairman or director

b. Name and home phone numbers of photography director and/or supervisor, so security personnel can call responsible parties if accidents or a break-in occur during off-hours in the photography department

c. Phone number for the poison control center in the state, as well as the Kodak and Ilford 24-hour safety hot line numbers

d. Emergency room phone number

e. Installation security force phone number

f. Phone number for reporting a fire

## Availability of Control Measures

13. Are appropriate disinfectants, maintained in stable condition and correctly diluted for immediate use, supplied in areas of need?

14. Are plastic bag–lined and covered cans provided for safe disposal of
    a. Chemically soaked towels and rags?
    b. Microbially contaminated specimens?

15. Are there stainless steel covered trays or containers for holding contaminated instruments and dressings, etc.?

16. Are racks and baskets in the studio when petri plates and tubes are to be photographed, so they will not tip over?

17. Are there autoclavable plastic bags and outer, heavy duty bags stored in the studio for safe double bagging of accidentally contaminated materials?

18. Are there sufficient and proper fire extinguishers in the photographic facility?

19. Is the escape route, in the event of a fire, diagrammed and posted prominently in the department?

20. Are the locations of all departmental circuit breakers posted prominently? Are the circuit breakers available to night and weekend workers?

21. Are all electrical connections for heavy equipment equipped with built-in circuit breakers?

## Standard Operating Procedures

22. Is there a policy for handling risk-carrying objects brought to the studio from the time of receipt to return to the client?

23. Are high-risk items expected to be maintained in safe containers and never left open to insects or unattended?

24. Are all bottles and containers clearly labeled with
    a. product name?
    b. concentration?
    c. recommended use?
    d. expiration (or discard) date?

25. When applicable, do bottles bear *Poison* and/or *Flammable* labels?

26. Is there a policy for handling spills involving
    a. contaminated materials?
    b. concentrated chemicals?
    c. diluted photographic chemicals?

27. Is there a policy for safe and legal disposal of chemical waste?

28. Is there a policy forbidding eating, drinking, and smoking in the studios, darkrooms, the chemical preparation area, or control booths?

29. Is there a policy for periodic inspection and replenishing of fire extinguishers and other fire-control equipment?

30. Is there a policy for inspection of electrical plugs and wires for faulty connection and frayed wiring or damaged insulation?

31. Are there policies for safe planning and conduct of field and veterinary assignments?

32. Are protective clothing, gloves, boots, and insect repellant required and provided for field and veterinary assignments?

33. Is there a policy for reporting and managing treatment of injuries received while on a field or veterinary assignment?

34. Is there a policy requiring a report to the supervisor of all occupationally related incidents affecting a worker's health?
    a. Infections?
    b. Mechanical injuries?
    c. Human or animal bites or traumatic injury?
    d. Electrical shock or burn?
    e. Chemical irritation, burn, or other injury?
    f. Fires in the photographic facility (no matter how small)?

35. Is there a policy requiring investigation and corrective action following all incident reports?

36. Is there a policy requiring an action report from the supervisor to the director regarding all incidents reported?

## BIBLIOGRAPHY

Brown, S., 1987. Photographic documentation of AIDS. *J. Biol. Photogr.* 55(1):3–10.

*Disposal and Treatment of Photographic Effluent*, 1990. Kodak Pub. J-55. Rochester, NY: Eastman Kodak Co.

Favero, M., 1985. *Sterilization, Disinfection and Antisepsis, Manual of Clinical Microbiology*, 4th ed. Washington, DC: American Society for Microbiology.

Henderson, D., et al., 1986. Risk of nosocomial infection with human T-cell lymphotropic virus type III/

lymphadenopathy-associated virus, and a large cohort of intensively exposed health care workers. *Ann. Int. Med.* 104:644–647.

Kodak Publication J-SS. Disposal and treatment of photographic effluent.

Larson, E., 1988. Guidelines for use of topical antimicrobial agents. *Am. J. Infect. Control* 16(6):253–266.

Le Beau, L., 1973. Control of infectious hazards for the biophotographer. *J. Biol. Photogr. Assoc.* 41(4):131–135.

Mc Cann, M., 1985. *Health Hazards Manual for Artists*, 3rd ed. New York: Nick Lyons Books.

McCullough, N., and Eisele, E., 1951. Experimental salmonellosis. *J. Infect. Dis.* 88:278–289.

Paneth, L., 1915. Zur Verhutung von Laboratoriumsinfektionen. *Med. Klin.* 11:1398–1399.

Phillips, G., and Briggs, 1965. Microbiological hazards in the laboratory. *Control J. Chem. Ed.* 42:A43–A49.

Pike, R., et al., 1965. Continuing importance of laboratory-acquired infections. *Amer. J. Public Health* 55:190–199.

*Recommendations for Prevention of HIV Transmission in Health Care Settings*, 1987. MMWR 36:25–185.

*Recommended Infection Control Practices for Dentistry*, 1986. MMWR 35:237–242.

*Safe Handling of Photographic Chemicals*, 1979. Kodak Pub. J-4. Rochester, NY: Eastman Kodak Co.

Saslow, S., et al., 1961. Tularemia vaccine study: 1. Intracutaneous challenge; 11. Respiratory challenge. *Arch. Int. Med.* 107:689–714.

Shaw, S. 1983. *Overexposure—Health Hazards in Photography*. Carmel, CA: Friends of Photography.

Shaw, S., and Rossol M., 1991. *Overexposure-Health Hazards in Photography*. New York: Allworth Press.

Sher, P., 1988. AIDS and the laboratory: A time for reason. *Lab. Med.* 19(2):77.

Stecker, E., 1983. Throwing some light on darkroom safety. *Photomethods* (November):35–37.

Wedum, A., 1964. Laboratory safety in research with infectious aerosols. *Public Health Rep.* 79:619–631.

# Appendix 1
# Prefixes and Suffixes Commonly Used in Medical Terms

| | | | |
|---|---|---|---|
| a-, an- | absence of | co(n)- | together, with |
| ab- | away from | crani(o)- | skull |
| acr(o)- | extremity | cry(o)- | cold |
| actin(o)- | ray | crypt(o)- | concealed |
| ad- | towards | cyan(o)- | blue |
| aden(o)- | gland | cyst(i)(o)- | bladder, sac |
| adip(o)- | fat | cyt(o)- | cell |
| -aemia, -emia | blood | | |
| -aesthesia, -esthesia | sensation | dactyl(o)- | fingers or toes |
| -algia | painful condition | dent(i)(o)- | tooth |
| amb(i)- | on both sides | derm(a)(o)-, dermato- | skin |
| an- | without | -desis | binding, fusion |
| andr(o)- | male | dextr(o)- | right |
| angi(o)- | vessel | di- | two |
| ankyl(o)- | bent, adhesion, fusion | dia- | through |
| ant(i)- | opposed to | dipl(o)- | double |
| ante- | before | dors(i)(o)- | back |
| arthr(o)- | joint | dys- | difficult, abnormal |
| -ase | enzyme | | |
| astheno- | weakness | e- | out |
| atel(o)- | incomplete | ect(o)- | outside |
| auri- | ear | -ectasia, -ectasis | dilate |
| aut(o)- | self | -ectomy | cutting out, excision of structure or organ |
| bi- | two | -emesis | vomit |
| bili- | bile | -emia | blood |
| bio- | life | en- | in or into |
| blephar(o)- | eyelid | encephal(o)- | brain |
| brach(io)- | arm | end(o)- | within, inward situation |
| brachy- | short | enter(o)- | intestine |
| brady- | slow | epi- | upon, above, beside |
| | | erythr(o)- | red |
| calc(i)(o)- | calcium | eu- | well, easily |
| cardi(o)- | heart, orifice to stomach | ex- | away from, without |
| caudi- | tail, lower part of the body | extra- | on the outside |
| -cel(e)(o), -coele | cavity, tumor, swelling | | |
| -centesis | perforate | fibr(o)- | fibers |
| cephal(o)- | head | -fugal | move away from |
| cervico- | neck | | |
| cholangi(o)- | bile ducts | gastr(o)- | stomach |
| chol(e)(o)- | biliary system | gen- | referring to production |
| cholecyst- | gallbladder | -genic | producing |
| choledoch(o)- | common bile duct | genu- | knee |
| chondr(o)- | cartilage | gloss(o)- | tongue |
| chrom(o)- | color | -graphy | recording |
| -cide | destroy, killer | gyn(e)(o)-, gyneco- | female |
| circum- | around | | |
| cleid(o)- | clavicle | haema-, hem(a)(o)- | blood |
| | | hemi- | half |

| | | | |
|---|---|---|---|
| hepat(o)- | liver | oste(o)- | bone |
| heter(o)- | different, abnormal | -ostomy | making an artificial opening |
| hidr(o)- | sweat, sweat gland | ot(o)- | ear |
| hom(o)- | same, similar | | |
| hydr(o)- | fluid, water | pachy- | thick |
| hyp(o)- | beneath, less than normal | pali(n)- | again |
| hyper- | above, in excess | pan- | all |
| hyster(o)- | uterus | par(a)- | near, accessory to |
| | | -pathy | abnormality |
| iatro- | medicine, physician | ped(o)- | child |
| idi(o)- | self, one's own | -penia | deficiency |
| in- | in, into | per- | through |
| in- | not | peri- | around |
| infra- | below | phag(o)- | devour |
| inter- | between or among | -phil(e) | affinity for |
| intra- | during, within | phleb(o)- | vein |
| isch(o)- | deficiency, suppression | -plasia | formation, development |
| iso- | same | -plasty | moulding |
| -itis | inflammation | -plegia | paralysis |
| | | -pnea | breathing |
| juxta- | situated near, adjoining | pneum(o)- | lung |
| | | poly- | many |
| kary(o)- | nucleus | post- | after |
| kat(a)- | down, against | pre-, pro- | before |
| kerat(o)- | horny tissue or cornea | proct(o)- | rectum |
| kine-, kino-, kinesi(o)- | movement | prot(o)- | first |
| koil(o)- | hollow, concave | pseud(o)- | false |
| | | psych(o)- | of the mind |
| labio- | lip | -ptosis | falling |
| lapar(o)- | abdomen | pyel(o)- | kidney |
| leuk(o)- | white | pyo- | pus |
| lien(o)- | spleen | | |
| lingu(o)- | tongue | retr(o)- | behind |
| lip(o)- | fat or lipids | rhin(o)- | nose |
| lith(o)- | stone | -rrhagia, -rrhage | excessive flow |
| -logy | science of | -rrhaphy | suturing |
| lymph(o)- | lymphatic system | -rrhea | flow |
| lymphangi- | lymph vessels | | |
| -lysis | dissolve, destruction | salping(o)- | tube, uterine tube |
| | | sangui- | blood |
| macr(o)- | enlarged | sapr(o)- | decay |
| mal- | bad | sarc(o)- | flesh |
| -malacia | softening | schist(o)- | divide, cleft |
| mamm(o)- | breast | scler(o)- | hard |
| mega- | large | spondyl(o)- | vertebrae |
| men(o)- | relationship to menses | -stasis | standing still |
| mes(o)- | middle, moderate | steth(o)- | chest |
| meta- | change | stomat(o)- | mouth |
| my(o)- | muscles | sub- | under |
| myel(o)- | bone marrow or spinal cord or myelin | super-, supra- | above |
| | | syn- | together, union, association |
| nan(o)- | small size | syring(o)- | tube, fistula |
| ne(o)- | new, recent, or immature form | | |
| necr(o)- | death | terat(o)- | monster |
| nephr(o)- | kidneys | thromb(o)- | clot, thrombus |
| neur(o)- | nerve | tom(o)- | section, designated layer |
| | | -tomy | cutting, incision |
| ob- | in front of | toxic(o)- | poison |
| ocul(o)- | eye | trachel(o)- | neck |
| odont(o)- | tooth | trans- | through, across |
| -odynia | painful condition | -trophy | nourish |
| -oid | form | | |
| olig(o)- | few | -uria | urine |
| -oma | tumor | | |
| onych(o)- | nail | vas(o)- | blood vessel, duct |
| ophthalm(o)- | eye | vesic(o)- | bladder, blister |
| orchi(o)-, orchid(o)- | testes | | |
| ortho- | straight | xanth(o)- | yellow |
| | | xer(o)- | dry |

# Appendix 2
# Common Medical Abbreviations

| | | | | |
|---|---|---|---|---|
| AAA | abdominal aortic aneurysm | | CBC | complete blood count |
| a.c. | before meals | | CC | chief complaint |
| ACTH | adrenocorticotropic hormone | | cc | cubic centimeter |
| A.D. | right ear | | CCU | coronary care unit |
| ad lib | as tolerated | | CHB | complete heart block |
| ADM | admission | | CHF | congestive heart failure |
| AFB | acid-fast bacillus (TB) | | CIS | carcinoma in situ |
| AI | aortic insufficiency | | CNS | central nervous system |
| AIDS | acquired immunodeficiency syndrome | | c/o | complains of |
| AKA | above-knee amputation | | CO | cardiac output |
| ALL | acute lymphocytic leukemia | | $CO_2$ | carbon dioxide |
| AMA | against medical advice | | COLD | chronic obstructive lung disease |
| AMI | acute myocardial infarction | | CP | chest pain |
| AML | acute myelogenous leukemia | | CPR | cardiopulmonary resuscitation |
| amp | ampule | | CR | cardiac rehabilitation |
| angio | angiogram | | CRF | chronic renal failure |
| A&O | alert and oriented | | C-section | cesarean section |
| AODM | adult onset diabetes mellitus | | or C/S | |
| AP | anterior–posterior | | CT Scan | computerized tomography scan |
| ARDS | acute respiratory distress syndrome | | CTB | cease to breathe |
| ARF | acute renal failure | | CTS | carpal tunnel syndrome |
| A.S. | left ear | | CVA | cerebrovascular accident |
| ASA | aspirin (acetylsalicylic acid) | | Cx | cervix |
| ASAP | as soon as possible | | CXR | chest x-ray |
| ASHD | arteriosclerotic heart disease | | D&C | dilatation and curettage |
| ATN | acute tubular necrosis | | DJD | degenerative joint disease |
| A.U. | both ears | | dl | deciliter (mg/dl) |
| AVM | arteriovenous malformation | | DM | diabetic mellitus |
| AVR | aortic valve replacement | | DOA | dead on arrival |
| BBB | bundle branch block | | DOB | date of birth |
| BCP | birth control pill | | dr | dram |
| BE | barium enema | | DTs | delirium tremens |
| bid | two times daily | | Dx | diagnosis |
| Bil | bilateral | | ECG | electrocardiogram |
| BG | blood glucose | | ECT | electroconvulsive therapy |
| BKA | below-knee amputation | | EEG | electroencephalogram |
| BM | bowel movement | | ENT | ears, nose, and throat |
| BP | blood pressure | | E.R. | emergency room |
| BPH | benign prostatic hypertrophy | | ETOH | ethyl alcohol |
| BPM | beats per minute | | F.B. | foreign body |
| BSO | bilateral salpingo-oophorectomy | | Fe | iron |
| BTL | bilateral tubal ligation | | FS | frozen section |
| Bx | biopsy | | Fx | fracture |
| $C_1$, $C_2$, | first cervical vertebra, second, etc. | | G | gravida |
| etc. | | | GC | gonococcus |
| c̄ | with | | GI | gastrointestinal |
| CA | carcinoma | | gtt | drops |
| CAD | coronary artery disease | | GU | genitourinary |
| cal | calorie | | GYN | gynecology |
| cap | capsule | | HBP | high blood pressure |

| | | | | |
|---|---|---|---|---|
| Hct | hematocrit | | O.U. | both eyes |
| HEENT | head, eyes, ears, nose, and throat | | oz | ounce |
| Hgb | hemoglobin | | $\underline{P}$ | pulse |
| H&H | hemoglobin and hematocrit | | p.c. | after meals |
| HIV | AIDS virus | | PA | physician assistant |
| HMO | Health Maintenance Organization | | PAP smear | Papanicolaou smear |
| H&P | history and physical | | P.E. | physical exam |
| HR | heart rate | | pH | hydrogen ion concentration |
| Hx | history | | PMS | premenstrual syndrome |
| ICU | intensive care unit | | p.o. | by mouth |
| IgA | gamma A immunoglobulin | | PO | postoperative |
| IgD | gamma D immunoglobulin | | polys | polymorphonuclear leukocytes |
| IgE | gamma E immunoglobulin | | Pre-op | preoperative |
| IgG | gamma G immunoglobulin | | PREP | preparation |
| IgM | gamma M immunoglobulin | | prn | as needed |
| IM | intramuscular | | q | each |
| IUD | intrauterine device | | qd | every day |
| IUP | intrauterine pregnancy | | qh | every hour |
| IV | intravenous | | q2h | every 2 hours |
| IVP | intravenous pyelogram | | qhs | every night |
| JODM | juvenile-onset diabetes mellitus | | qid | four times daily |
| K | potassium | | qod | every other day |
| Kg | kilogram | | qs | quantity sufficient |
| $L_1, L_2,$ | first lumbar vertebra, second, etc. | | R.A. | rheumatoid arthritis |
| etc. | | | RBC | red blood cells |
| Lab | laboratory | | RCA | right coronary artery |
| LAD | left anterior descending | | Rh | rhesus factor |
| lb | pound | | RLL | right lower lobe |
| LBP | low back pain | | RLQ | right lower quadrant |
| L&D | labor and delivery | | R/O | rule out |
| lg | large | | RR | recovery room |
| LLL | left lower lobe | | RUL | right upper lobe |
| LLQ | left lower quadrant | | RUQ | right upper quadrant |
| LP | lumbar puncture | | RV | right ventricle |
| LUL | left upper lobe | | Rx | treatment |
| LUQ | left upper quadrant | | $S_1, S_2,$ | first sacral vertebra, second, etc. |
| met. | metastases | | etc. | |
| MG | myasthenia gravis | | SAH | subarachnoid hemorrhage |
| mg | milligram | | SIDS | sudden infant death syndrome |
| MI | myocardial infarction | | SLE | systemic lupus erythematosus |
| MICU | medical intensive care unit | | SOB | shortness of breath |
| min | minute | | ss | one-half |
| ml | milliliter | | SSSU | surgical short stay unit |
| mm | millimeter | | Stat | immediately |
| mono | monocyte | | Sx | symptoms |
| MS | multiple sclerosis | | $T_1, T_2,$ | first thoracic vertebra, second, etc. |
| Myelo | myelogram | | etc. | |
| Na | sodium | | T. | temperature |
| N/A | not applicable | | T&A | tonsillectomy and adenoidectomy |
| NaCL | sodium chloride | | tab | tablet |
| NB | newborn | | TAH | total abdominal hysterectomy |
| Neg | negative | | TB | tuberculosis |
| Neuro | neurology, neurologic | | temp | temperature |
| NG | nasogastric | | TIA | transient ischemic attack |
| NKA | no known allergies | | tid | three times daily |
| nl | normal | | TMJ | temporomandibular joint |
| NPO | nothing by mouth | | TPR | temperature, pulse, respirations |
| NTG | nitroglycerin | | Tx | treatment |
| N&T | nose and throat | | U | unit |
| N/V | nausea and vomiting | | UA | urinalysis |
| $O_2$ | oxygen | | VA | visual acuity |
| OB | obstetrics | | VD | venereal disease |
| O.D. | right eye | | VS | vital signs |
| ONC | oncology | | WBC | white blood cells |
| O.T. | occupational therapy | | W/O | without |
| OPD | outpatient department | | Wt | weight |
| OR | operating room | | y.o. | year old |
| O.S. | left eye | | | |

# Appendix 3
# Academic Degrees and Professional Qualifications

These abbreviations are printed in the text without punctuation (.).

| | |
|---|---|
| A.A.S. | Associate of Applied Science |
| A.B.I.P.P. | Associate of the British Institute of Professional Photographers (United Kingdom) |
| A.I.M.I. | Associate of the Institute of Medical Illustrators (United Kingdom) |
| A.R.P.S. | Associate of the Royal Photographic Society (United Kingdom) |
| B.A. | Bachelor of Arts |
| B.Appl.Sc | Bachelor of Applied Science (United Kingdom) |
| B.F.A. | Bachelor of Fine Arts |
| B.S. | Bachelor of Science |
| B.Sc. | Bachelor of Science (United Kingdom) |
| B.S.N. | Bachelor of Science in Nursing |
| B.S.W. | Bachelor of Science in Social Work |
| C.D.E. | Certified Diabetes Educator |
| C.N.S. | Clinical Nursing Specialist |
| C.N.S.D. | Certified Nutrition Support Dietitian |
| C.O.P.R.A. | Certified Ophthalmic Photographer Retinal Angiography |
| C.O.T.A. | Certified Occupational Therapy Assistant |
| C.R.A. | Certified Retinal Angiographer |
| C.R.N.A. | Certified Registered Nurse Anesthetist |
| C.R.N.I. | Certified Registered Nurse Infusion Therapist |
| C.R.N.P. | Certified Registered Nurse Practitioner |
| C.R.T.T. | Certified Respiratory Therapy Technician |
| C.T. | Cytotechnologist |
| D.D.S. | Doctor of Dental Science |
| D.M.D. | Doctor of Dental Medicine |
| D.O. | Doctor of Osteopathy |
| Dr.Med.Vet. | Doctor of Veterinary Medicine (Europe) |
| D.V.M. | Doctor of Veterinary Medicine |
| Ed.D. | Doctor of Education |
| F.B.I.P.P. | Fellow of the British Institute of Professional Photographers (United Kingdom) |
| F.B.P.A. | Fellow of the Biological Photographic Association |
| F.I.S.T.C. | Fellow of the Institute of Scientific and Technical Communicators (United Kingdom) |
| F.M.P.A. | Fellow of the Master Photographers Association (United Kingdom) |
| F.R.C.A. | Fellow of the Royal College of Arts (United Kingdom) |
| F.R.M.S. | Fellow of the Royal Microscopical Society (United Kingdom) |
| Hon.F.I.M.I. | Honorary Fellow of the Institute of Medical Illustrators (United Kingdom) |
| L.P.N. | Licensed Practical Nurse |
| L.P.T. | Licensed Physical Therapist |
| M.A. | Master of Arts (United Kingdom) |
| M.A.A. | Medical Artist Association (United Kingdom) |
| M.D. | Doctor of Medicine |
| M.Phil. | Master of Philosophy (United Kingdom) |
| M.S. | Master of Science |
| M.Sc. | Master of Science (United Kingdom) |
| M.S.N. | Master of Science in Nursing |
| M.S.W. | Master of Science in Social Work |
| M.T. | Medical Technologist (ASCP) |
| N.A. | Nurses' Aide |
| O.T.R. | Registered Occupational Therapist |
| P.A. | Physician's Assistant |
| Pharm.D. | Doctor of Pharmacy |
| Ph.D | Doctor of Philosophy |
| R.B.P. | Registered Biological Photographer |
| R.D. | Registered Dietician |
| R.M.I. | Registered Medical Illustrator (Australia) |
| R.M.I.P. | Registered Medical Illustrator Practioner (United Kingdom) |
| R.N. | Registered Nurse |
| R.N.A. | Registered Nurse Anesthetist |
| R.PH. | Registered Pharmacist |
| R.P.S. | Royal Photographic Association (United Kingdom) |
| R.P.T. | Registered Physical Therapist |
| R.R.A. | Registered Record Administrator |
| R.R.T. | Registered Respiratory Therapist |
| R.T.T. | Respiratory Therapy Technician |
| S.W. | Social Worker |
| V.M.D. | Doctor of Veterinary Medicine |

# Appendix 4
# Professional Biomedical Organizations

Asociación Española de Técnicos Especialistas en Fotografía
   Cientifica (AETEFC) (Spain)
José A. Ramirez, President
P.O. Box 21058
Madrid, 28080, Spain
Tel. 91 544-1131, FAX 91 533-5655

Association of Biomedical Communicators Directors (ABCD)
Herbert R. Smith, FBPA, President
Medical Illustration
Baylor College of Medicine
One Baylor Place
Houston, TX 77030
U.S.A.
Tel. 713 798-4681, FAX 713 798-6853

Association of Medical Illustrators (AMI)
William H. Just, Executive Director
1819 Peachtree Street, NE
Suite 560
Atlanta, GA 30309
U.S.A.
Tel. 404 350-7900

Australian Institute of Medical and Biological Illustration
   (AIMBI)
Bob Walters, Secretary
Veterinary Clinical Sciences Building
Sydney University
Sydney NSW 2006
Australia
Tel. 02 692-3986, FAX 02 692-4261

Biological Photographic Association, Inc. (BPA)
Thomas P. Hurtgen, Executive Director
115 Stoneridge Drive
Chapel Hill, NC 27514
U.S.A.
Tel. 919 967-8247, FAX 919 967-8246

British Institute of Professional Photography (BIPP)
Ralph Marshall, Secretary of the Medical Group
Fox Talbot House
Amwell End
Ware Herts SG 12 9HN
England
Tel. 0920 464011, FAX 0920 487056

British Ophthalmic Photographic Association (BOPA)
Mr. Richard Hildred, Secretary
Medical Imaging
AMI Priory Hospital
Priory Road
Edgbaston, Birmingham B5 7UG
England
Tel. 021 440-2323

Deutsche Gesellschaft für Photographie (DGPh) (Germany)
Peter Kaubisch, Director Medical Section
Overstolzenhaus
Rheingasse 8-12
D-5000 Koeln
Germany
Tel. 221 240-2037, FAX 221 240-2035

European Federation of the Scientific Image (EFSI)
Jean-Pierre Stepanow, President
12, Rue Forest 13007
Marseille
France
Tel. 91-59-21-91

Eerlkolsalojen Valokuvaajat (EAV) (Finland)
Auvo Ahvenjärvi, Secretary
Valtion Teknillinen Tutkimuskeskus
Vuorimiehentie 5
SF 02150
Espoo 15
Finland
Tel. 90-4564436

Föreningen För Medicinsk Och Tecknisk Fotografi (FMTF)
Ole Roos, Secretary
Department of Biomedical Communications
Sahlgren Hospital
413 45 Göteborg
Sweden
Tel. 031 60 2326, FAX 031 82 3931

Health Sciences Communications Association (HESCA)
Lionelle Elsesser, Executive Director
6105 Lindell Boulevard
St. Louis, MO 63112
U.S.A.
Tel. 314 725-4722

Institute of Medical Illustrators (IMI)
Angus J. Robertson, Secretary
Department of Photography
Medical and Dental Illustration Unit
University of Leeds
W. Yorks
England
Tel. 0532 336258

Institusjons Fotografenes Forening (IFF)
Anne-Lise Schiódt, Chairman
Museet for Samtidskunst
Postboks 158 Sentrum
N-0102 Oslo 1
Norway
Tel. 02 33 58 20

Internationaler Arbeitskreis für
Medizinische Bilddokumentation (Austria)
Dr Erwin Weihs, Secretary Foto-Medico
Tivoligasse 70/1d
A-1120 Wien
Austria
Tel. 0222 94 54 313

Medieforbundet—Fotografisk Landsforbund (M-FL)
Grafisk Forbundshus
Lygten 16
DK-2400 Kobenhavn NV
Denmark
Att: Jesper Bentsen
Tel. 31 81 42 22, FAX 35 82 15 45

New Zealand Association of Medical and Scientific Illustration
(NZAMSI)
Mrs. Leah Dome
Central Photographic Unit
Massey University
Palmerston North
New Zealand
Tel. 64 63 69079

Ophthalmic Photographic Society (OPS)
Denice Bartlett
William E. Jackson, M.D.
1721 E. 19th Avenue, Suite 550
Denver, CO 80218
U.S.A.
Tel. 303 861-2655

Royal Photographic Society (RPS)
Andrew Roland, Honorary Secretary, RPS Medical Group
Medical Photography and Audio Visual Unit
St. George's Hospital Medical School
Cranmer Terrace
London SW17 0QT
England
Tel. 081 672 9944 Ex. 56102, FAX 081 767 4696

Selskabet for Medicinsk Og Biologisk Illustration (SMBI)
(Denmark)
Preben Holst, Secretary
The John Kennedy Institute
Department of Medical Genetics
Gl. Landevej 7
DK-2600 Glostrup
Denmark
Tel. 42 45 2228 Ex 224, FAX 43 43 1130

Société Française D'Iconographie Medicale et Scientifique
(SFIMS)
Jean-Pierre Delmas, Secretaire
12, Rue Forest 13007
Marseille
France
Tel. 7851 0826

South African Institute of Medical Illustration (SAIMBI)
Hoosain Ebrahim, Secretary
Department of Medical Illustration
Medical University of South Africa
PO Box 214
Medunsa 0204
South Africa
Tel. 012 5294541

# Glossary

## DENTAL

**Anterior:** Situated in the front part.

**Buccal:** Pertaining to or directed toward the cheek.

**Distal:** A position on the dental arch farther from the median line of the jaw.

**Endodontics:** The specialty of dental science concerned with the diagnosis and treatment of disease of the dental pulp.

**Frontal plane:** Any plane passing longitudinally through the body from side to side at right angles to the median plane and dividing the body into front and back parts.

**Labial:** Pertaining to or toward the lip.

**Lateral:** 1. Denoting a position farther from the median plane or midline of the body or of a structure. 2. Pertaining to a side.

**Lingual:** Pertaining to or toward the tongue.

**Mandibular:** Pertaining to the lower jaw.

**Maxillary:** Pertaining to the upper jaw.

**Median:** Situated in the midline of the body or a structure.

**Mesial:** Nearer the center line of the dental arch.

**Occlusal:** Pertaining to the opposing surfaces of opposing teeth.

**Occlusal line:** The line of contact between the maxillary and mandibular teeth when the jaws are closed.

**Occlusal plane:** The hypothetical horizontal plane formed by the contacting surfaces of the upper and lower teeth when the jaws are closed. Pertaining to the contacting surfaces of opposing teeth.

**Occlusion:** Any contact of opposing teeth.

**Oral pathology:** The branch of dental science that deals with the study of oral diseases.

**Oral surgery:** That branch of dentistry dealing with the diagnosis and the surgical or adjunctive treatment of diseases, injuries, and defects of the mouth, the jaws, and associated structures.

**Orthodontics:** That branch of dentistry concerned with the proper positioning and relationships of teeth.

**Palatal:** Pertaining to the palate; sometimes used to designate the lingual surface of a maxillary tooth.

**Pediatric dentistry (pedodontics):** The branch of dentistry concerned with the diagnosis and treatment of conditions of the teeth and mouth in children.

**Periodontics:** That branch of dentistry that deals with the diagnosis and treatment of diseases and conditions of the supporting and surrounding tissues of the teeth.

**Posterior:** Situated in back of or the back part of a structure.

**Prosthetic dentistry:** That branch of dental art and science pertaining to the restoration and maintenance of oral function by the replacement of missing teeth by artificial devices.

**Sagittal plane:** Any vertical plane that passes through the body parallel to the median plane (midline) and divides the body into left and right portions. Parallel to the median plane of the body.

**Vestibule of the mouth:** That portion of the oral cavity bounded on one side by the teeth and gingivae (gums) and on the other side by the lips and cheeks.

## ELECTRONIC IMAGING

**Assemble edit:** Electronic rearrangement of recorded scenes onto a new sequence.

**Adapter:** Device used to match signals from a 75-ohm antenna lead to a 300-ohm input, or vice versa.

**Audio dub:** Changing the audio track of an existing recording.

**Audio head:** Magnetic head that records or plays back sound.

**Beta:** One of the ½-inch video cassette formats.

**CCD (charge-coupled device):** Solid-state light-sensing chip used to form the image in some video cameras.

**C-mount:** Standard screw thread used for mounting lenses on some video cameras.

**CRT (cathode ray tube):** Device used to display a picture on a TV or electronic viewfinder.

**Cable capable/Cable ready:** TV or VCR that has extended tuning capabilities, rendering a cable decoder box unnecessary for most unscrambled cable channels.

**Camcorder:** Combined video recorder and video camera.

**Clogging:** Buildup of tape oxide or foreign debris on the video head, causing a loss of picture quality.

**Comet tailing:** Cometlike smear created when recording a moving light source under low light levels.

**Composite video:** Combination of video, audio, and synch signals in a single RF signal.

**Control head:** Magnetic head that records and plays back control signals.

**Control signal:** Series of pulses recorded on tape to control transport speed.

**Chroma or chrominance:** The color portion of the video signal.

**Direct access tuning:** VCR feature that allows pushbutton tuning of all unscrambled cable channels.

**Dropout:** Short loss of audio or video signal that appears as horizontal white lines on the screen.

**Erase head:** A magnetic head that wipes the tape clean of previously recorded material.

**Field:** Half a complete TV picture. Two fields interlace to create complete frame.

**Follow-image:** *see* Comet tailing.

**Frame:** A single complete TV picture. In the United States the frame changes every 1/30 second and has 525 lines.

**Frame advance:** VCR feature that allows viewing of individual consecutive frames at a controlled rate.

**Freeze frame:** VCR control that stops the tape for close inspection of a particular frame.

**Front-loading:** VCR that has the cassette access door at the front.

**Gain switch:** Switch on a video camera used to amplify the video signal when taping in low light.

**Glitch:** Interference moving through picture.

**Helical-scan:** System of recording video signals where the slow-moving tape moves over a fast-spinning drum containing the record heads, so the signal is recorded in long spirals.

**Horizontal resolution:** A measure of the ability of a camera or recorder to capture fine detail. The higher the number the better.

**Image retention:** *see* Comet tailing.

**Insert edit:** Process of electronically replacing a scene in an existing recording with a new scene of the same length.

**Iris:** System of sliding blades in the video lens used to adjust the aperture size.

**Lag:** *see* Comet tailing

**Luminance:** The brightness portion of the video signal.

**Lux rating:** Specification for a video camera indicating the lowest operating lighting level.

**MTS-capable:** TV or VCR capable of receiving multichannel TV sound. When available, MTS broadcasts will include stereo sound and second audio programming (Audio II) for bilingual broadcasts.

**Metal evaporated tape:** Metal tape coating made without adhesive binder, permitting denser packing of magnetic material.

**Metal oxide tape:** A form of magnetic coating used on Beta and VHS tapes.

**Metal particle tape:** A type of tape made from metal particles without oxide. Provides a denser magnetic coating than metal oxide.

**Mixer:** Unit into which a number of sound sources can be fed to create a single sound track.

**Monitor:** High-quality TV set used to display the composite video signal from a camera, computer, or VCR.

**Monitor/Receiver:** TV that has separate video and audio inputs and outputs in addition to an antenna socket.

**NTSC** (National Television System Committee): TV standard used in the United States.

**Newvicon tube:** One type of light-sensing tube used in consumer video cameras.

**Noise bars:** Narrow horizontal interference lines in the video picture.

**PAL** (Phase Alternation Line): TV standard for most of Europe.

**PCM:** Pulse code modulation method of digital audio recording used for some 8-mm VCRs.

**Picture search:** *see* Search.

**Programmable tuner-timer:** Device on a VCR that permits the unattended recording of broadcast programs.

**RF** (radio frequency): Wave pattern, such as broadcast TV, made up of video, audio, and synchronization signals.

**Receiver:** Regular domestic TV with an antenna input only.

**SECAM** (sequential couleura memoire): TV system used in France and other countries.

**Saticon tube:** One type of light-sensing tube used in consumer video cameras.

**Search:** VCR feature that allows the review of a tape at several times normal speed.

**Shadow mask:** Screen inside TV tube that ensures that the electron beam strikes only phosphor dots of the intended color.

**Smear:** *see* Comet tailing.

**Snow:** Random interference in a TV picture, creating white specks on screen.

**Splitter:** Device used to make two signals from a single incoming signal—can be used to run two TV sets from one antenna.

**Timeshifting:** Recording of a program at its normal broadcast time to watch it at a more convenient time.

**Top loading:** VCR that has the cassette access door on top.

**Tracking control:** Control that adjusts the video heads to match record and playback paths.

**UHF:** Ultra-high-frequency transmission.

**VCR:** Video cassette recorder.

**VHF:** Very high-frequency transmissions.

**Video disk:** Replay system for prerecorded video and audio on a rotating disk.

**Video head:** Magnetic recording head that records and plays back pictures.

**White balance:** System for matching the sensitivity of a video camera to the color of the ambient light to produce TV images in natural color.

## OPTICAL AND PHOTOGRAPHIC

**Abbe condenser:** Two- or three-lens combination with relatively inferior corrections suitable for routine examinations but limited in value when combined with objectives of high numerical apertures.

**Aberration:** Departure from ideal imagery as calculated by Gaussian optics. Usually applied to the residual errors of optical correction of a lens.

**Accent or kicker light:** Light frequently used to outline the subject from a dark background, add detail to the hair, or for dramatic pictures as a facial backlight. It is usually placed slightly higher than the subject and on the same side as the key light.

**Achromat:** Lens corrected for axial chromatic aberration by having a common rear principal focus for two spectral lines (color).

**Achromatic objective:** Objective corrected chromatically for light of two wavelengths. When preceded by the prefix plan—additional lenses have been added to improve the flatness of the image.

**Aerial image:** A real image in space that can be focused on a ground glass screen or recorded directly on film.

**Afocal lens:** Lens whose principal foci are located at infinity in both object and image spaces.

**Airy pattern:** Theoretical image intensity distribution of a point source of light as formed by a perfect lens whose performance is limited only by diffraction effects.

**Anamorphic lens:** Optical system that gives different magnification in horizontal and vertical directions.

**ANSI:** American National Standards Institute

**Antilog (antilogarithm):** Ordinary number that corresponds to a logarithm (log). For example, the log of 100 is 2, and the antilog of 2 is 100.

**Antireflection coating:** Thin coating of magnesium fluoride or other suitable material applied to lens surfaces that are exposed to air to reduce the reflection and increase the transmission of light. Also called lens coating.

**Aperture stop:** Opening in a lens or optical system determining the cross-sectional area of an incident beam of light and hence image illumination. Also called diaphragm opening.

**Aplanat:** Lens fully corrected for spherical aberration and coma.

**Apochromatic objective:** Objective corrected chromatically for three colors and spherically for two colors. These corrections are superior to those of the achromatic objectives and when preceded by the prefix plan—are particularly well suited for photography.

**Arithmetic speed:** Nonlogarithmic film or paper speed obtained by dividing the exposure required to produce a specified density into a constant. ISO film speeds are given as arithmetic speeds (formerly ASA) and logarithmic speeds (formerly DIN), such as ISO 100/21°, where the first number is the arithmetic speed.

**Artificial midtone:** An 18% reflectance gray card, which can be placed near the subject for reflected-light exposure meter readings. Also called neutral test card.

**Aspheric surface:** Lens or mirror surface that is not part of a sphere of revolution.

**Astigmatism:** Monochromatic lens aberration where the image of an off-axis object point is a tangential line in one focal surface and a radial line in another.

**Back focal distance:** Distance from the vertex of the rear surface of a lens to the focal plane when focused on infinity.

**Barndoor:** Adjustable attachment for lights used to control the distribution of light.

**Beamsplitter:** Optical device that divides incident radiation into two or more portions, which also may be further differentiated by wavelength bands.

**Behind-the-lens (BTL):** Identifying a camera exposure meter that has the photocell located at any of various positions inside the camera body. Also called through-the-lens (TTL).

**Bounce light:** Light reflected off of a large white reflector, wall, or ceiling. The effect is soft, shadowless, and often very flattering illumination.

**Broad lighting:** Key or modeling light that illuminates the side of the face turned toward the camera. The effect is to deemphasize facial features and broaden thin or narrow faces.

**Bromide streak:** Region of lower density on a negative caused by a flow of partially exhausted developer from an adjacent area having higher density. The effect is caused by inadequate agitation during development.

**Calculated midtone:** Identifying a method of using a reflected-light exposure meter to obtain the equivalent of a midtone reading by averaging a highlight reading and a shadow reading. Also called brightness range, luminance range.

**Camera exposure:** Combination of the *f*-number and the shutter speed used to expose film in a camera. Also called camera exposure settings.

**Camera exposure meter:** Exposure meter that is an integral part of a camera, as distinct from a separate hand-held exposure meter. Also called camera meter.

**Camera flare:** Non—image-forming light in a camera caused by the reflection of light from interior surfaces of the camera and resulting in an increase in 'flare' light falling on the film and a decrease in contrast of the image.

**Catoptric lens:** Lens using only reflecting surfaces to form an image.

**Catadioptric lens:** Lens using both reflecting and refracting surfaces to form an image.

**Center weighted:** Through-the-lens exposure meter designed so that the meter reading is determined more by subject luminances on or near the lens axis than by those nearer the edges of the field.

**Characteristic curve:** *see* D-log H curve.

**Chiaroscuro:** Effect of light and dark elements in a picture, usually when referring to a work of art.

**Circle of confusion:** Diameter of the image of an axial point at the limit of resolution of the eye.

**Cold mirror:** Form of dichroic mirror that reflects visible light but transmits infrared radiation.

**Collimator:** Well-corrected lens system used in conjunction with a light source at its focus to give a parallel beam of light.

**Color analyzer:** Light meter that measures red light, green light, and blue light, typically used in a color printing darkroom as an aid in obtaining the correct color balance and exposure.

**Color temperature:** Actual temperature in degrees Kelvin (K) of a blackbody heated to a temperature that produces a visual color match with the light being calibrated.

**Color temperature meter:** Photoelectric instrument that compares the relative illuminances of two or three different colors, typically red, green, and blue, and indicates the color temperature of the light being measured.

**Coma:** Monochromatic aberration of a lens characterized by the smearing out of off-axis image points.

**Compound microscope:** Microscope consisting of two magnifiers (two simple microscopes)—one acting as an objective lens and the other as an eyepiece lens. The visual magnification of a specimen is the product of the magnifying powers of the objective and eyepiece lenses.

**Concave surface:** One whose center of curvature is in front of the surface.

**Condenser enlarger:** Projection printer that uses one or more relatively large lens elements between the light source and the negative holder to produce a cone of light that is directed toward the enlarger lens, as distinct from diffusion enlargers.

**Condenser lens:** Form of field lens used with light sources to collect light over a large angle and direct it into an optical system or lens.

**Conjugate:** Distance between an object or image point and its corresponding principal point.

**Convex surface:** One whose center of curvature is behind the surface.

**Contrast:** Actual (objective) or perceived (subjective) variation between two or more parts of an object or image with respect to any of various attributes such as luminance, color, or size.

**Contrast index:** Slope of a straight line connecting two points, the maximum and minimum densities normally used to make high quality negatives, on the D-log H curve.

**Cosine-corrected:** Identifying a light meter designed to respond to changes in the angle of the incident light as specified by the cosine law of illumination.

**Cosine law ($\cos^4\Theta$ law):** Illuminance on an inclined plane varies in proportion to the trigonometric cosine of the angle of incidence of the light rays falling on the surface.

**Curvature of field:** Monochromatic aberration of a lens causing the image surface to be curved instead of planar.

**Darkroom meter:** Light meter designed to be used to determine print exposure time and possibly color filtration with color print materials. *See also* Color analyzer.

**Degree of development:** Portion of the contrast of a photographic image that is attributed to the combination of the sensitized material and the development. Gamma and contrast index are measures of the degree of development.

**Density:** Logarithm of the ratio of the light falling on a sample and the light transmitted or reflected by the sample.

**Depth of field:** Range of distances about the point of focus in the object space giving an acceptably sharp image.

**Depth of focus:** Range of distances about the focal plane of a lens in the image space giving an acceptably sharp image.

**Development:** Process of converting a latent image to a visible image.

**Diaphragm:** One or more opaque plates, fixed or variable, that obstruct radiation in an optical system, except through an opening that is normally centered on the optical axis. *See also* Stop.

**Dichroic mirror:** Mirror consisting of multilayer coatings, which selectively reflects certain wavelengths and transmits the remainder of the complementary color.

**Diffraction:** Deviation of a beam of light passing an obstruction, explained by considering light as a wave motion.

**Diffusion enlarger:** Projection printer in which the light from the source is diffused by passing through ground glass or other translucent material or by reflection from a white surface. *See also* Condenser enlarger.

**Diopter:** An optical unit defined as the reciprocal of the focal length of a lens in meters, it is a measure of refracting power of lenses, mirrors, and other optical systems.

**Direct light:** Main light without any reflector or diffusion material. The effect is similar to a sunny, bright day. Some fill-in light is necessary to represent sky light.

**D-log H curve:** Graph of the logarithms of a series of exposures received by a sensitized photographic material (input) and the corresponding resulting densities (output). Also called characteristic curve, sensitometric curve.

**Effective aperture:** Diameter of an entering beam of light that just fills the opening in the diaphragm of a lens.

**Effective exposure time:** Time duration between the half-open position and the half-closed position of the shutter blades or curtain. The open position for a lens shutter is where the shutter blades have just uncovered the diaphragm opening at any $f$-number setting.

**Effective film speed:** Film speed number that may be higher or lower than the published film speed, but that should be used to obtain normal density in a negative or transparency. Factors that can cause the effective film speed to be different from the published film speed include age and storage conditions of the film, type of developer used, and degree of development. Also called exposure index.

**Electromechanical shutter:** Mechanically powered shutter in which the duration of exposure is controlled electronically rather than mechanically.

**Electronic flash:** Light source in which a high-intensity flash of short duration is produced by passing an electrical discharge through an atmosphere of xenon or other inert gas in a sealed transparent or translucent tube.

**Electronic shutter:** Shutter that is powered by an electromagnet in which the exposure time is controlled electronically.

**Exit pupil:** Image of the iris diaphragm of a lens as seen from the image side of the lens.

**Exposure:** Quantity of light per unit area received by photosensitive materials, specifically, the illuminance multiplied by the exposure time.

**Exposure factor:** Number by which the indicated exposure should be multiplied to compensate for a change in conditions, such as an increase in lens-to-film distance for a close-up photograph.

**Exposure meter:** Light-measuring instrument designed to indicate appropriate camera aperture and shutter-speed settings to obtain a desired exposure effect.

**Exposure value:** Number obtained by adding the light value and the film speed value, which also equals the sum of the aperture value and the time value in the additive system of photographic exposure (APEX).

**Field angle:** Angle included by the line joining the point in the image plane to the lens rear principal point and optical axis of the lens.

**Field of view:** Size of the angle of the image area or conjugate image area. The angular measure is twice the angle subtended at the first nodal point by the optical axis, and a straight line to an object point is imaged at the extreme edge of the field.

**Field stop:** Mechanical aperture that restricts the size of the image area formed in a lens system. It is usually positioned at the image plane in the form of the film gate of a camera.

**Field lens:** Lens situated in the focal plane of an objective with the function of refracting the light into the entrance pupil of another lens.

**Fill light:** Larger, diffused light source that is usually placed near the camera axis. Used alone, no flattering contours or modeling of the subject is visible. The fill source is usually a soft white umbrella or parabolic reflectors with diffusers.

**Filter factor:** Number by which the indicated exposure should be multiplied to compensate for the absorption of light by a filter when it is added to a camera or other optical system.

**Flare:** Non-image-forming light in a camera or other optical system due to light that is reflected from the lens and other surfaces.

**F-number:** Number that is obtained by dividing the focal length of a lens by the effective aperture, $f/11$, for example.

**Focal length:** Distance from the sharpest image of a distant object formed by a lens and the image nodal plane.

**Focal-plane shutter:** Mechanism that controls the exposure time in a camera by moving an opaque curtain or opaque blades containing a slit across the film aperture close to the film.

**F/16 rule:** Correct exposure for a front-lit normal subject in direct sunlight during the middle hours of the day will be obtained at $f/16$ and a shutter speed equal to the reciprocal of the film speed, for example, 1/125 second with an ISO 125 speed film.

**Fresnel lens:** Flat plastic lens with molded grooves and ridges whose optical properties correspond to a plano-convex lens of equivalent focal length.

**Gamma:** Slope of the straight-line part of a film D-log H curve, a measure of development contrast.

**Gobo:** Small opaque panel, usually mounted on a stand, used to shade selected areas of a subject.

**Gray card:** *see* Artificial midtone.

**Guide number:** Number used to obtain a desired exposure effect when making photographs with a flash or electronic flash light source. The guide number is divided by the flash-to-subject distance to obtain the $f$-number.

**Ideal curve:** In a tone-reproduction graph, a straight 45-degree line representing facsimile reproduction.

**Illuminance:** Measure of the strength of the light received at a point on a surface, commonly measured in footcandles or lux.

**Image distance:** Linear separation between the position of the image produced by a lens, as in a camera, and the image nodal plane of the lens.

**Incident-light exposure meter:** Exposure meter that measures the light falling on a subject, as distinct from a reflected-light exposure meter.

**Intensity:** Measure of the rate of emission of light from a source in a specific direction, commonly measured in candelas.

**Interference:** Interaction of two coherent beams of light giving reinforcement or cancellation of intensity.

**Inverse square law:** The intensity of illumination in a given plane is inversely proportional to the square of the distance from the (point) light source.

**ISO:** International Standards Organization

**ISO film speed:** Pair of numbers, one arithmetic and the other logarithmic, based on the amount of exposure required to produce a specified density in the processed film, designed to be used with exposure meters.

**Key or modeling light:** Dominant light of the scene. Usually a contrasty light source as compared to the fill light. The effect varies depending on the source such as a spot light (maximum effect), parabolic reflector, or small silver umbrella (minimum effect).

**Keytone method:** Method of using a reflected-light exposure meter whereby the correct exposure can be obtained with a camera by taking a reflected-light reading from a lighter or darker area than a midtone and making an adjustment for the difference in reflectance.

**Large format:** Identifying a still camera that uses sheet film that is $4 \times 5$ inches in size or larger.

**Latent image:** Invisible image formed on a photosensitive material by exposure before it is made visible by development.

**Lateral color:** Chromatic aberration of an off-axis subject point giving transverse variation in image position with wavelength.

**Lens shutter:** Mechanism for controlling the exposure time with a lens, typically located between the lens elements but sometimes directly in front of or back of the lens.

**Logarithm (log):** The power to which 10 is raised to produce a specified number. Since $10^2 = 100$, the logarithm of 100 is 2.

**Logarithmic speed:** Film speed number based on the exposure

required to produce a specified density and expressed in logarithmic form. ISO film speeds are given as both arithmetic speeds (formerly ASA) and logarithmic speeds (formerly DIN), such as ISO 100/21°, where the second number is the logarithmic speed.

**LPM:** Line pairs per millimeter. A measure of the resolving power of a lens.

**Luminance:** Light produced, reflected, or transmitted by a unit area of a surface in a specific direction, commonly measured in candelas per square foot or candelas per square meter.

**Magnification:** Defined as the ratio of real or apparent size of an image to the true size of the object.

**Metamerism:** The phenomenon of color appearing to change under different light sources.

**Microscope:** An optical instrument to produce magnified images too small to be seen by the unaided eye. *See also* Compound microscope and Simple microscope.

**Midtone:** Subject or image area that is intermediate in lightness between two other specified areas, commonly the lightest and darkest. *See also* Artificial midtone.

**Negative film:** Photographic film that with normal exposure and development records subject tones so that the light-to-dark relationship is reversed.

**Neutral-density (ND) filter:** Filter that absorbs approximately the same proportion of all wavelengths of light.

**Newton's rings:** Interference phenomenon due to a thin film of air between two surfaces of almost identical contours.

**Nodal points:** Two points on the lens axis such that an undeviated ray of light directed toward one of them appears to leave from the other. Nodal planes are planes that include the nodal points and are perpendicular to the lens axis.

**Nomograph:** Graph used to obtain information about complex relationships between variables by drawing straight lines between appropriately constructed scales.

**Object distance:** Linear separation between the plane focused on and the front nodal plane of a lens.

**Perspective:** Appearance of objects in space as perceived by the viewer (or recorded by all lenses) at a specific distance.

**Photocell (photoelectric cell):** Device that either generates electricity or changes the strength of an electric current when exposed to light.

**Photogenic:** Attractive or visually stimulating as a subject for photography or videography.

**Photographic exposure:** Total amount of light received at a point on a sensitized material, the product of the illuminance and the time. Commonly measured in lux-seconds.

**Photometer:** Instrument for measuring or comparing light levels, calibrated in luminance or illuminance units.

**Photometry:** Branch of physics concerned with the measurement of light. The term is often extended to include the measurement of ultraviolet and infrared radiation.

**Photomicrography:** Making of photographs through a compound microscope of objects too small to be seen by the unaided eye. The range of magnification is approximately 20 to 2500 times life size.

**Point source:** A source of illumination small enough and far enough away that it's physical size may be neglected. Such a source obeys the inverse-square law with insignificant error. *See also:* Inverse square law.

**Preferred curve:** Tone-reproduction curve that represents a photograph judged to be excellent by a large number of people and, therefore, serves as an aim curve. *See also* Ideal curve.

**Principal planes:** Two unique conjugated planes perpendicular to the optical axis of a lens such that a ray entering the first plane emerges from the second plane at the same height above the axis.

**Printing-out paper (POP):** Photosensitive material that produces a visible image through exposure, without development, and commonly used for proof prints.

**Quadrant graphs:** System of representing tone reproduction graphically, where separate graphs or quadrants are used for camera flare, the film curve, the print curve, and the reproduction curve.

**Quench:** (1) An automatic exposure control process used with electronic flash light sources to terminate the flash when a sensor signals that enough light has been emitted. (2) Reduction of fluorescence or phosphorescence with continuous exposure to radiant energy.

**Reciprocity effects:** Experimental observation that equal exposures do not produce equal photographic images when the light level is very weak or very strong and the corresponding exposure time is very long or very short. The effects include a decrease in density, a change in contrast, and with color materials, a change in color balance. Also called reciprocity law failure (RLF).

**Reciprocity law:** Photographic density will be constant if the quantity of light received by the photosensitive material is constant regardless of the values of illuminance and exposure time. The law is valid only for a limited range of illuminance and time.

**Reciprocity law failure (RLF):** *See* Reciprocity effects.

**Reflected-light exposure meter:** Light-measuring instrument with a restricted angle of acceptance, designed to be aimed at the subject to measure luminance (light that is reflected, transmitted, or emitted by a surface).

**Refraction:** Change in direction of a ray when passing through the interface between two optical media of different densities.

**Refractive index:** Ratio of the velocity of light in a vacuum to its velocity in an optical medium.

**Relative aperture:** *See f-*number.

**Resolving power:** Ability of an optical or camera system to just distinguish two subject details. In photography, the image resolution depends on the ability of the recording medium (emulsion) to resolve details and on that of the lens.

**Reversal film:** Photographic film that produces a positive image when exposed in a camera, achieved by using a special (reversal) processing procedure.

**Scale of reduction:** Ratio of an object dimension to the corresponding image dimension (O:I).

**Scale of reproduction:** Ratio of an image dimension to the corresponding object dimension (I:O).

**Sensitivity pattern:** Distribution within the camera picture format of the response of the metering system, such as uniform, center weighted, and spot.

**Separation or background light:** Small light placed between the subject and the background that helps to provide a tonal separation between subject and the background.

**Short lighting:** Key or modeling light that illuminates the side of the face turned away from the camera. This technique tends to emphasize facial contours and has a narrowing effect on broad or plump faces.

**Simple microscope:** Microscope consisting of a single lens or a group of lenses functioning as one objective lens. The *pocket* or *reading glass* is by definition a simple microscope.

**Small format:** (1) Identifying a still camera that uses 35-mm or smaller film. (2) Identifying a still camera that uses film smaller than 4 × 5 inches.

**Snoot:** Metal sleeve attached to a spotlight to produce a small, somewhat defined area of light on a subject.

**SPSE:** Society of Photographic Scientist and Engineers.

**Spot meter:** Identifying a reflected-light exposure meter that has a relatively small angle of acceptance, for example, one degree.

**Spherical aberration:** Monochromatic aberration that is a variation of principal focus with height above the optical axis. The rays from the periphery of the lens focus closer than the central rays to the lens.

**Stop:** (1) Lens diaphragm. (2) *f*-number. (3) Change in the size of a diaphragm opening that doubles or halves the amount of light

transmitted, as between $f/4$ and $f/5.6$. Also known as a whole stop.

**Stop down:** To reduce the size of the diaphragm opening, which corresponds to an increase in the $f$-number.

**Synchronization:** Correspondence in time, as between when a shutter opens and a flash fires.

**Telephoto lens:** Long focal-length lens that has a shorter lens-to-film distance than a conventional lens of the same focal length.

**Through-the-lens (TTL):** Camera exposure meter with the photocell inside the camera so that it measures light transmitted by the lens. Also called behind-the-lens (BTL).

**Time gate:** With a flash meter, a limitation on the period the meter will respond to light, which may be adjustable so that it can be set to correspond to the camera shutter-speed setting.

**T-number** (transmittance number): $F$-number of an ideal lens (100% transmittance) that will produce the same image illuminance as the lens being tested at a given diaphragm opening.

**Tone reproduction:** Study of the way in which different subject luminances are represented in an optical or photographic image.

**Transparency:** Image, normally positive, on a clear base that is intended to be viewed by transmitted light as on a viewer or by projection.

**Value:** In the zone system, subject values identify subject luminances that vary in a ratio of 1 to 2, and print values identify a series of densities that vary from maximum white to the maximum density that paper can produce.

**Variable-contrast paper:** Black-and-white printing paper that contains a mixture of high- and low-contrast emulsions that have different spectral sensitivities so that the contrast of the print can be controlled by using color filters on the enlarger.

**Whole stop:** Change in the size of a diaphragm opening that doubles or halves the amount of light transmitted.

**Wide-angle lens:** Relatively short focal length lens that has considerably greater covering power than a normal type lens of the same focal length.

**Window light:** Fashionable use of the short lighting technique. Skylight tends to add small but important highlights to facial texture. Again, some fill light from a reflector or electronic flash may be necessary.

**Zoom lens:** Lens whose equivalent focal length can be varied but whose image plane, for a given object plane, stays at a fixed distance from the lens without need for refocusing.

**Zone system:** Method invented by Ansel Adams of controlling the exposure and development of film in a camera and exposure of the printing paper to achieve desired tone-reproduction results.

# Index